# The Art Museum as Educator

# The
# Art
# Museum
## as
# Educator

**A Collection of Studies
as Guides to Practice and Policy**

Council on Museums and Education
in the Visual Arts

Barbara Y. Newsom and Adele Z. Silver, Editors

University of California Press
Berkeley  Los Angeles  London

This project is supported by grants from the National Endowment for the Arts and the National Endowment for the Humanities in Washington, D.C., federal agencies, and from three private foundations—the Rockefeller Brothers Fund, the Edward John Noble Foundation, and the Ford Foundation. The findings, conclusions, and recommendations in this study do not, however, necessarily represent the views of either the endowments or the foundations.

International Standard Book Number:
0-520-03248-9 (clothbound)
Library of Congress Catalog Card Number:
76-14301
University of California Press, Berkeley and Los Angeles, California
University of California Press, Ltd., London, England

Design by Peter Bradford and Wendy Byrne

## Council on Museums and Education in the Visual Arts Staff

**Project Director: Barbara Y. Newsom**
**Deputy Project Director: Adele Z. Silver** (eastern Midwest)

### Reporting Staff

Barbara K. Beach, Austin, Texas (Southwest)
Elsa S. Cameron, San Francisco (West Coast)
Barbara C. Fertig, Alexandria, Virginia (Southeast)
John A. Hagerty, Minneapolis (upper Midwest)
Emmett Hannibal, Boston (Northeast)
Sue Robinson Hoth, Washington, D.C. (Southeast)
Frederick G. Ortner, New York City (Northeast)

### Supplemental Research

Arthur Giron, New York City (Northeast)
Barbara N. Salter, Chestnut Hill, Massachusetts (Northeast)
Ida Talalla, New York City (Northeast)
Ruth S. Wilkins, Fort Worth, Texas (Southwest)

### Editorial Staff

Barbara Y. Newsom
Adele Z. Silver
Judith Murphy (August 1974–March 1975)
Anne V. Berrill (April 1975–May 1976)
Norma J. Roberts
Cynthia Dax Toner

# Contents

## PART I:   The Art Museum and Its General Public

### Chapter 1:   Profiles of Museums as Educational Institutions

### Chapter 2:   The Individual Visitor and Exhibitions Designed to Teach

# PART II: The Art Museum and the Young, Their Teachers, and Their Schools

## Chapter 10:   Visual Arts Programs for High School Students in Museums and Schools

## Chapter 11:   Teacher Training and Classroom Materials

# PART III:   The Art Museum and Its College, University, and Professional Audience

## Chapter 12:   University-Museum Relations

## Chapter 13:    The Artist and the Museum

## Chapter 14:    Training for Museum Education

## Chapter 15:    Cooperation among Museum Professionals

# Foreword

In spite of the title of this book and the debates the reader will find raging within it, it should be understood at the beginning that the art museum is above all about art—about those manmade creations that give order, beauty, and clarity to the human experience. To "educate" the art museum's visitors to take pleasure in that visual order is indeed one of the art museum's missions, and this book is meant to describe the myriad ways the museum goes about that task.

But those who read the reports and essays here should try to keep in mind that the beginning and end purpose of the art these museums contain is, in Robert Coles's words, "to help give sanction to the thoughtful reveries of . . . people [who] struggle for coherence, vision, a sense of what obtains in the world. . . ."

Art museum staffs are made up of people with a wide variety of interests and talents, all of them with instincts to save what has visual meaning—some to conserve and protect it, some to arrange and classify it, some to exhibit it, some to explain it. None of this activity could take place without the works of art themselves: no matter how dedicated a museum might be to social, educational, even economic, and sometimes political purposes, its first obligation—the one that society and any number of legislative acts have assigned to it—is to preserve works of art and make them both physically and intellectually accessible. An art museum is not a school, a day-care center, a business, a library, a university, or a settlement house, however many of those functions it may sometimes serve. It is a museum, a word that has been given to it because none other fits.

The dilemma most art museums must live with is that for many twentieth-century Americans art is difficult. In museums art is often torn out of its original context, it seems to have little connection with anything we know in our daily lives, and we are not used to deriving personal truth from it. So for most of us, art requires education—a sometimes slow and circuitous process that demands long exposure and often a sympathetic hand. Art museum staffs understand this, and they make many efforts to help, some of them more successful than others, as this book attests.

Important as the educational process is, the museum is less a place to learn about art than a place in which to enjoy it. An art museum exists for our pleasure—for re-creation and the kind of quiet contemplation that suits each of us best. Certainly we can learn many things along the way, about the past, about other people, about aesthetic and philosophical ideas, and about ourselves. In that sense, a museum is a kind of tuition-free open university. But it is above all an institution, as one museum director has put it, that does what it does "for sheer beauty, not just for education," and the educational ideas described here should be regarded as paths to the museum experience, not as the experience itself.

—B.Y.N.

# Preface

## How and Why This Study Was Done

This is a book of reports and case studies in museum education. Although it is concerned primarily with the visual arts and with art museums, it has been written for readers, in this and other countries, with either a professional or a layman's interest in the educational activities of all museums and in the young people and adults whom museums serve.

The aim of the book is to broaden understanding of the educational aspect of museum operations, to stimulate thought about it, to encourage new kinds of thinking, and at the same time to improve the ways in which museums help all of us to perceive the world around us—both the world we have inherited and the one we have created.

The idea for a book of case studies, like so many ideas in the field of museum education, may have been put forward several times during the last hundred years. In this instance, the idea emerged during a meeting of the Council on Museum Education in 1972. The council, a small discussion group brought together in New York City by three foundations— the Edward John Noble Foundation, the National Endowment for the Arts, and the Rockefeller Brothers Fund— originally had not thought of taking on such an enterprise. The council had been formed to explore issues in museum education, primarily though not exclusively in New York City, and to indicate ways in which foundation and government grants might be most useful in this field.

But the longer the council members talked about the issues facing museum education in New York City, the more they realized how universal many of these issues were. It soon became apparent not only that there was a great wealth and diversity of educational activity taking place in museums throughout the country, but that the field of museum education might benefit substantially from an effort to investigate and report what was happening in museum and visual arts

education countrywide, with some interpretive comment that could help the professional understand what had been successful and what had not—and, where possible, why.

Among the reasons why the council felt the study might make a contribution was the possibility of raising the level of the discourse among art museum educators. Often shunted aside physically (many education departments have shared basement quarters with carpenters' shops and packing boxes), fiscally, and psychologically, museum educators have long suffered from a sense of professional inferiority in the museum pecking order; meetings on the subject of museum education have thus tended to center more on matters of professional status than educational substance.

Furthermore, and perhaps more central to the public's interests, it is clear to anyone who travels around the museum world that many educators new in their jobs are expected to invent programs with only the sketchiest ideas to guide them. Until recently there has been no course of study to prepare museum educators for their work, and what research has been done in the field offers few specific suggestions about how a museum educator might proceed. The result is that each generation seems to start all over again, repeating rather than building on the mistakes and successes of the past. It was time, the council thought, to try to define the field better and to give both educators and policy makers a realistic picture of what museums are doing and, perhaps, what it is possible for them to do.

The Museum Panel of the National Endowment for the Arts agreed and in the fall of 1972 voted a $75,000 grant for the project. The Council on Museum Education reconstituted itself as the Council on Museums and Education in the Visual Arts, invited new members to join it from other parts of the country, and asked Sherman E. Lee, director of the Cleveland Museum of Art, to become its chairman. The Cleveland Museum accepted responsibility for administration of the

grant funds that were given to the project by four more foundations—the Rockefeller Brothers Fund, the National Endowment for the Humanities, the Edward John Noble Foundation, and the Ford Foundation. In addition to its grant, the Rockefeller Brothers Fund offered space for the project's headquarters in New York. By summer 1973, the council had hired a staff, and the study began.

## A Precedent for the Project

The literature of museum education—from Benjamin Ives Gilman and Henry Watson Kent to Theodore L. Low, Alma Wittlin, and Thomas Munro—is rich in philosophy, hopes, exhortation, and historical perspective. But the only attempt to follow a museum program as it works itself out over time—beyond concept and purpose into the natural combination of success, failure, and unmeasurable ambiguity—that has surfaced in our research is a book by Lydia Bond Powel called *The Art Museum Comes to the School*. Published in 1944, it describes from beginning to end a three-year project funded by the General Education Board (later absorbed into the Rockefeller Foundation) in which five art museums experimented with programs designed to bring high school students and art museums into closer rapport.

Mrs. Powel, a museum educator with a gift for expressing her observations clearly, made no pretense to evaluation or measurement. She recorded what she saw and gave it weight in the context of her experience. The result is a straightforward summary of the five programs, warts and all.

We have tried in the present study to build on Mrs. Powel's model. Our purposes are (1) to describe the state of visual arts education in the early 1970s as it is practiced in art museums and, to the degree that art museums are affected, as it is also practiced in schools, community arts organizations, colleges, and universities; (2) to give museum, school, and university educators a sense of the ideas behind these programs and of the techniques used and the pitfalls encountered as the program authors tried to carry out each project; and (3) to help museum, educational, philanthropic, and legislative policy makers think more clearly about the possibilities and the limitations of museums as educational institutions by trying to focus their thinking on the realities of the museum world.

We chose certain programs to follow here—there are 105 in all from 71 institutions—not because they were necessarily the best, but because they seemed to us instructive and representative of a range of efforts in the particular ways we will point out as we go along.

## Role of the Council

The overall direction and ultimate responsibility for the project were assigned from the beginning to the 29 members of the council. As directors, administrators, and trustees of museums and community organizations, educators in schools and universities, and representatives of private foundations, the council members all had some experience with visual arts education and museums. Most were deliberately chosen, furthermore, because they and their institutions had become known as leaders in the field of museum and visual arts education and could be expected to contribute substantively to the project. As they were also well dispersed geographically, they were able to serve as counselors for staff members in various regions of the country.

The council met three times during the course of the study, first at the Cleveland Museum of Art in May 1973 to launch the project, then at the San Francisco Museum of Art in November 1973 to help select programs for study, and finally at the Minneapolis Institute of Arts in November 1974 to react to early drafts of the program reports and chapter introductions. Between council meetings, the members took on a variety of tasks. Although direction of the project fell most heavily on the chairman and vice-chairman, several members helped raise funds for the project, introduced staff members to programs and persons in their regions, arranged for and served as hosts for meetings of the council and the staff. They have also been assiduous readers, accepting assignments to study large notebooks of reports and to review a long chain of manuscript drafts. Members of the executive and "final product" committees were given still more work. They gave up several working days to attend extra meetings and to help with the organization and publication of the book.

## The Choice of Staff

Important to this project as the guidance of the council has been, the individual staff members are the spectacles through which these programs have been viewed. Every member of the reporting staff had had experience in the arts, in museums, or in education; several had careers in all three. One was a writer, critic, and art museum instructor; one was a painter and writer; another a craftsman and the director of a museum studio school; still another a Ph. D. candidate at the Harvard Graduate School of Education. Two had been both art museum curators and educators; one directed a graduate program in museum education. Two held graduate degrees in education, one in literature; seven had taught in museums, five in elementary or high school classrooms, and one in state prisons. In age, at the time of the study, they ranged from 25 to 48; the median was somewhere between 35 and 40.

To recruit the reporting staff, we had to find people who not only were qualified by background to examine these programs perceptively but were well located geographically to travel within their circumscribed regions and were free to do so. In addition, we tried to make sure they had personal attitudes that would not be threatening but would invite the

cooperation of people whose programs were under study. On the whole, and with the few exceptions that must be anticipated in any human enterprise, the staff worked hard and long on this study, maintaining interest, enthusiasm, and patience to the end of what became an even more difficult job than the most realistic of us had expected at the beginning.

## Geography of the Project

The project was designed to be carried out in six (eventually seven) regions of the country, determined mainly by airline travel routes from the cities where staff members lived. Later on in the study some assignments fell to certain staff members because the subject or the participants were especially appropriate for them—the work of community arts groups, for example, or prison arts programs, or university-museum relations—and they were asked to move out of their geographical regions to follow such programs elsewhere.

But most of the work was done by staff members within these six regions, each of which had an institutional sponsor: in the Northeast, the Metropolitan Museum of Art, New York City; the Southeast, National Collection of Fine Arts, Washington, D. C.; eastern half of the Midwest, the Cleveland Museum of Art; upper Midwest, the Minneapolis Institute of Arts; the Southwest, the Kimbell Museum, Fort Worth; West Coast, the Neighborhood Arts Program, San Francisco. Because of the heavy concentration of museums and educational programs in the Northeast, New England was later added as a seventh region, without an institutional sponsor. The sponsoring institutions helped recruit staff members, offered them logistical support and office space once they were hired, and helped arrange the staff's bimonthly meetings, each held in a different region of the country during the 18-month reporting period. Three of these institutions—the Cleveland Museum, the Neighborhood Arts Program, and the Minneapolis Institute of Arts—also served as hosts to meetings of the council.

## Methods of the Study

As this was to be an inductive examination and the researchers were to be controlled by the data they collected, not by preconceived assignments or theories, each reporter was asked to start by conducting a methodical survey of visual arts institutions and programs. Each was to visit every major art museum, art center, university, and community arts organization in his area, and to investigate all the leads he had time for that pointed to interesting school or small community programs. The results of this survey, which was made during the first six months of the project, appear in Appendix II. Though most staff members took this assignment seriously and several were able to scour the countryside quite thoroughly, the survey was obviously incomplete. We mis-

sed several important institutions and programs, as anyone familiar with the American art museum landscape can plainly see. How much these omissions have affected the final product we may never know. We regret them all the same.

**Choosing the programs.** From their surveys, staff members picked those programs they felt were worth following over a period of a year and submitted one-page descriptions to members of the council, who met with the staff in San Francisco in November 1973 to consider the choices. The criteria, again, were that the programs be instructive to practitioners first and policy makers second, and that they embody a range of policy issues, educational styles, and ways of using art objects in education. The programs could be successes or flops; the measure was that there was enough thought and planning behind them so that educators, both present and future, could learn from and build upon them—and perhaps avoid their more obvious mistakes.

The original plan for the project had been that it develop between 40 and 60 full-length case studies, covering all facets of each program—who designed it and why, what its educational objectives were, who took part, what it cost, what the institution and the other participants thought of it, what went well and what wrong, what larger issues it presented. But it was clear that winnowed down to 50 or 60, the list of 120 programs the staff had offered the council would lose some of its variety and many of its more interesting lessons. It was also clear that not all the programs warranted full-scale case-study treatment.

So the decision was made to try to include almost all the programs the staff presented to the council, giving them unequal weight: some might be case studies, others shorter descriptions, still others brief reports. Thus, in this book that is how the programs have been treated. The 103 reports here are not all the same length, do not include all the same kind of detail, are not based on the same number of interviews and observations, and should not be regarded as equal in complexity and importance, as the reader will soon discover. The variation is both intentional and unavoidable.

A few of the choices were institutions rather than programs. In these cases the focus is on the way a museum or school conceives and carries out its educational mission in all its programs.

**Training and supporting the staff.** To make sure the project stayed on course and staff members took the same approach to their research, the staff met every other month, each time in a different region. The first meetings were training sessions, at which several consultants, most of them experienced in observing and evaluating educational programs, described the way they worked. Among them were Howard Gardner and David Perkins from Harvard's Project Zero, which conducts basic research in art education; Henry S. Dyer, a former vice-president of Educational Testing Service

in Princeton and the author of several assessments of education, including an analysis of the Coleman report (see *On Equality of Educational Opportunity,* edited by Frederick Mosteller and Daniel P. Moynihan); Kathryn Bloom, director of the Arts in Education Program of the JDR 3rd Fund and a member of the council; and Peter Lenrow, a member of the faculty at the Harvard Graduate School of Education.

As the research progressed, the staff meetings focused on specific problems in reporting programs, on the issues they raised, on the development of a uniform body of information about each project, and on critical analyses of the reports. At some of the meetings the staff members visited local programs and institutions together to test one another's reactions. Staffs of local museums, especially those from sponsoring institutions, were often invited to join the meetings; they became useful participants—and critics—in the discussions.

Between meetings, staff time went to writing and traveling, both extensive. As the distances between programs and between staff members were considerable, communication depended on mail, phone, and airplane schedules. In the early stages of the project, staff members were required to circulate monthly reports describing where they had been and what programs seemed promising. Once the survey phase was over and the report-writing began, copies of report drafts went to each staff member, who was expected to bring his comments with him to the bimonthly meetings.

**Interviews and observations.** The basic ingredients of all the reports are interviews, most of them tape-recorded, with the participants (the authors of programs, sometimes their bosses, the people who manned the programs, and the learners they were designed to teach), visits to the site of each project to see how it was carried out, and a reading of the literature about each program and its institutional sponsor. This research process is the heart of the council study. From it have grown not only the reports themselves but many of the issues discussed in the introductions to each chapter in this book.

Though in some ways the research was similar to the investigations educators often do for themselves when they are trying to pick up new ideas, what was probably distinctive about it is that the reporting staff had the chance and indeed was obliged to observe each program more than once; for more complex programs, the visits and the interviews usually took place at regular intervals over several months (even, in a few cases, years). The objective in each case was for the staff to become familiar with both the program and the people who were a part of it so that a staff member was himself a participant-observer, as one of the staff's trainers, Peter Lenrow, described the role.

The research process yielded several by-products. One of them was the stimulus it offered museum, university, and school staffs to ask their own questions about programs that many of them had begun to take for granted. Often their observations were as telling as any we were able to make—and in several institutions the council exercise led to changes that only a fresh self-analysis could have produced.

**Network-building.** Another by-product of the study—intentional on the council's part—was an effort by the reporting staff to put museum educators in touch with one another and with potential allies in nearby schools, community organizations, and universities. Although organizations like the American Association of Museums President's Committee on Education and the museum educators' groups in some of the larger cities have helped in recent years to bring museum staffs out of isolation, in many parts of the country the council staff found museum and school people who had no contact with each other and museum educators who had little chance to trade their ideas and experiences with their counterparts in other museums.

In several such areas, council reporters were able to set up meetings or arrange workshops and informal visits where educators could learn to know one another and discuss their work. Sometimes the meetings did not take, and there seems to have been little further exchange; but in a few places the alliances caught hold, and we are happy that the council project could play a part in encouraging them.

**Institutional feedback.** A crucial ingredient of the study from the beginning was the cooperation and the response of the institutions and the persons in them with whom the staff members worked. Each institution was asked, first, to give the council formal, written permission to make its study. This meant access to the staff, to funding information, to program statistics, and to the operation of the programs themselves. To the degree that the study was successful at all, the council owes a great deal to the cooperation the 71 institutions in this study gave the council staff. With remarkably few exceptions, museums, schools, universities, and community organizations alike were warm in their welcome and unfailingly patient with what must often have seemed to be endless probing on the part of the council staff—and sometimes endless paperwork, too.

Once the staff reports were written, copies went to each institution for review—often by several members of the institutional staff. This review was meant to make sure that we had the facts straight; it also allowed the institution to respond to the staff's analysis. Although the council reserved the right in its original correspondence to come to its own conclusions about a program, the facts about it were another matter, and we have tried to represent them accurately. If there are still mistakes in these reports, they rear their heads in spite of the best efforts of both the participating institutions and the council staff, for we have all worked hard to avoid them. If, on the other hand, the analysis is open to debate, the council and its staff must be the target, not the cooperating institution.

**Editing and checking.** An inevitable step in the study process has been the editorial grinder through which all these reports passed when they left the reporters' hands. Like most projects that grow larger once they are under way, this one took longer than planned, and few members of the staff met the final reporting deadline in the fall of 1974. Program reports, in fact, were still being finished by editorial staff members many months later.

If the institutional review was one test of a report's accuracy, the editorial process, which began in late summer 1974, was another and, as it turned out, an even more severe one. No matter how valid the reporting staff's observations, the sentences had to parse; figures had to add up; gaps in information and sequence had to be filled. An editor of a large urban newspaper, berated by a large urban museum for printing a story without verifying a reporter's facts with the museum itself, once snapped, "If we had to check every story we print, we'd never get the paper out." This project may just be testimony to that frustration, for it has often seemed that verification—never mind editorial restructuring—would be the death of nearly every piece we touched. Undoubtedly, there are many points that deserve still more verification in this book, but after 18 months of steady checking, we can assure the reader only that we have finally come close to satisfying ourselves.

Each report in this book is signed with the initials of the original staff reporter, an indication that its basic content is derived from his or her analysis. Added initials are either those of a co-reporter or, more often, of the editor who has had a heavy hand in further research and rewriting. In most cases, this editorial work simply reflects the fact that verification, getting at the truth, can be an endless process, and if the editors had to ask further questions about a program, sometimes they turned up information that might have filled a gap but that might also have changed the nature of the report. For many of these reports, interviews and observations went on long after the original reporters had left the council staff. The work was not completed until March 1976.

## What This Study Left Undone

For every program described in this study, there are untold others of equal interest to students of visual arts education and museums. Several surfaced in this project which we had neither the staff nor time to pursue; others developed too late in the council's reporting period or ended before it began. We regret that they are not in this book.

Just as frustrating are the many ideas, books, articles, and people we were unable to do justice to here. In addition, a few program reports proved to be too sketchily researched to complete in time and had to be dropped from the final manuscript. And some of our most carefully laid plans—for well-annotated bibliographies, an annotated index, and profiles of some of the interesting figures in the museum education field

—in the end were too complicated to carry out. Two chapters—one on video and film and the other on the scholarly resources of museums, for both of which the staff had done some research—were not strong enough to survive.

Perhaps the greatest gap of all, one that this book does not begin to fill, is in the area of educational effect. It is not only that the research here did not try to discover the results of the museum programs, for the simple reason that it was beyond our capacity and time to do so, it is also that many museums and schools themselves have not followed up their efforts in visual arts education. Art museums continue to focus their educational programs primarily on children, yet no museum staffs encountered in this project seem ever to have conducted research of their own to determine whether programs for children had succeeded, over time, in developing either lovers or practitioners of art. The closest we came to evaluation in our own research was probably the East Cleveland report (Chapter 6). And the best survey work we have seen was the study by the National Research Center of the Arts in 1973 and 1975, *Americans and the Arts,* which indicates that most regular museum-goers were exposed to museums as children. It would be useful for the field if individual museums could follow up to see which programs in their own communities were remembered best.

We wish we could have done it all. But what we have left unfinished we hope will serve as the starting point for other students, reporters, and interpreters in this field. Several topics that are barely touched on in the "Issues in Art Museum Education: A Brief History," for instance, might lend themselves to more extended research projects—the effect on museums of educational theories popular in the schools, the history and the implications of volunteerism in art museums, the context in which art museums once felt obliged to teach industrial arts, the role of art museums in adult education movements.

So we look on this work as one stage in the development of a body of literature about art museum education. Perhaps this "textbook" will spawn others. Above all, we hope it will stimulate educators in museums, schools, and universities to a still more intelligent use of the visual arts in education and will help to enlarge the educational contributions of art museums everywhere.—*B.Y.N.*

## The Plan of This Book and Ways to Use It

*The Art Museum as Educator* has been conceived as a combination reference work and textbook that will attract browsers and scholars alike. It is not meant to be read cover to cover. We hope, in fact, that the reader will find the index, checklists, and even tables of contents as interesting as the essays and reports.

To make the best use of this book, there are several things the reader should know.

**The basic content: program reports.** The book is built primarily on 103 case studies in art museum education. "Case study" is a term we use loosely here to describe both carefully wrought, deeply researched studies in the classic case-method mold and shorter, more superficial reports about less complex programs. Alongside them are several reports about visual arts education programs in schools, community centers, and universities that have a relation to or hold lessons for art museums.

The focus of the book is the art museum, what it does, what it can do, and what it cannot do as a deliberate, overt educator. The book takes up only tangentially the ways the art museum educates merely by collecting, conserving, and exhibiting its wares.

**Time.** Most of the programs in this book were studied during the 1973/74 academic year, though a few were added later. Many of them have changed direction since we observed them, and some are no longer in operation; their authors or their funding or their reason for being may have disappeared. Even though a program may have ended soon after we observed it, it is likely that the report about it is written in the present tense. In most cases, we have not tried to change this, because we consider these programs typical of many that have been undertaken in the past and will be tried again in the future. It was never the purpose of this study to serve as a "finder" for people who wanted to look at programs for themselves. Rather, we meant to catch certain programs and "freeze" them for generations of educators still to come, who might otherwise be forced, as have so many educators before them, to start all over again from scratch.

**Authors.** Nearly every report is the result of interviews and observations conducted by a single staff member whose initials appear at the end of each piece. Although all reports were reviewed by the staffs of the institutions that sponsored the programs and many were subjected to considerable editing, the conclusions are fundamentally those of the original reporters, whose names appear in the staff listings at the front of this book. Where more than one author was involved or the report has been either rewritten or heavily edited, other initials have been added, but the original reporter's appear first.

**Organization: by audience and activity.** The case studies, or program reports, are divided into three parts by audience—adults; young people, teachers, and schools; and professionals (college and university students, artists, and museum educators themselves)—and into 15 chapters according to activity.

**Chapter introductions.** Each chapter is introduced with an essay that tries to draw out the issues the programs have in common and to enlarge the discussion with references from an historical perspective.

**Bibliographies and other sources of information.** Each chapter introduction also includes a list of the books and articles the editors have found most useful on the subject. Each program report, in turn, lists all its sources—site visits, the names and titles of persons who have been interviewed, and brochures and articles about the program.

**Program checklists.** The basic information about each program—its objectives, staffing, sources of funds, audience—precedes each report as a brief, relatively value-free outline.

**Institutional checklists.** Less visible but intrinsic to the reports are institutional "profiles" that contain the basic facts about all the institutions in this study—dates of founding, strengths of the collections, annual operating budgets, size of staffs, membership costs, educational services. Because in several instances there is more than one program report from a single institution, these checklists are grouped together in alphabetical order in Appendix I. In cases where the program report describes the entire institution (the University of Rochester Memorial Art Gallery, the Museum of Modern Art, and the Everson Museum, for example), this checklist also accompanies the report. But in every case, the institutional checklist is meant to show the context in which the program takes place; it is thus integral to the report and should be studied together with it.

With few exceptions the data in these checklists are for the fiscal year 1973/74, again, the period when most of the programs in this book were observed.

A careful reader will notice some discrepancies in these checklists. Descriptions of the same city, for example, are not always alike: the reason is that several persons gathered the information, and their perceptions of the context varied with the purposes and character of each program. We have intentionally left these descriptions alone.

Museum budgets have been something of a problem. We have tried to be as specific as possible here, so that the reader can get an idea of the relation between the cost of a particular program and the total expenditures of the institution, not to mention the total cost of its other educational activities. We had also hoped to compare figures between institutions. But as anyone knows who is familiar with art museum bookkeeping procedures, operating figures and educational expenditures are not often accounted in the same way by various institutions; on expenditures for education, for example, some museums include staff salaries and overhead, others do not. So these numbers may be relative within a museum profile, but few of them can be reliably compared from one institution to another.

**Index.** Ideas, issues, names, program titles, and institutions have been culled from both essays and reports to form what is intended to be not only a guide to the material in this book but also a tool to help practitioners find usable suggestions for attacking if not solving specific problems.

**Proposal.** In general, this is not a prescriptive study. Though individual authors obviously take positions, the council itself has made few specific recommendations. The single important exception is the proposal for a center for museum education; it is outlined at the end of Part Three.

**Survey.** In Appendix II, listed alphabetically by state, are the names of all the institutions and programs the CMEVA staff visited during the 18-month reporting period. From this survey the council members and staff chose the programs that are described in this study.

# Acknowledgments

The many persons who have contributed their time and knowledge to this project are named in various places throughout this book—in the lists of interviews at the end of each report, in the preface, and on the opening pages. We would like to thank them all here—the members of the council, who have offered advice, worked hard in long meetings, and responded thoughtfully to the manuscript drafts they were assigned to read; the staff, whose dogged and often exhausting pursuit of programs and people gave this study its basic content and whose good humor and stamina throughout the project, not least during the marathon days and nights of staff ''retreats,'' were essential to the success of the study; the staffs of the sponsoring institutions, who were often called on to make sacrifices unforeseen when the project began but made with grace and flexibility once the project was under way; and perhaps above all, the hundreds of people in schools, museums, universities, community centers, foundations, research centers, and libraries who were called on to give so freely of their time and to offer their programs to our scrutiny.

At the risk of neglecting some who have been equally helpful to this project, we would like to single out a few who have been particularly encouraging from the beginning: Harold Snedcof, staff associate at the Rockefeller Brothers Fund, who assembled the Council on Museum Education in 1971 and whose imagination and energy gave this project its initial impetus; Harry S. Parker III, the father of the idea for this collection of case studies in museum education; Tom Leavitt, the council's vice chairman, who has been a calm, wise adviser during these last three years and well before; Blanchette Rockefeller, who has taken a special and selfless interest in this project, as she has in the subject of art museum education over the years; William M. Dietel, president of the Rockefeller Brothers Fund, who has encouraged us with unfailing good cheer, in the face of the considerable inconve-

nience it has often caused him and his staff; Evan Turner and the members of the museum panel at the National Endowment for the Arts, which he chaired when this idea was first discussed and which voted the project its first major grant; trustees and staff members at each of the foundations that supported the council—the National Endowment for the Arts, the Rockefeller Brothers Fund, the Edward John Noble Foundation, the National Endowment for the Humanities, and the Ford Foundation.

In addition to such moral and financial support, the council's staff was given a home base in the offices of the Rockefeller Brothers Fund in New York, where the project director and editorial staff were housed, and at the Cleveland Museum of Art, which handled the fiscal administration for the council and provided office and staff back-up to the project's deputy director. At each institution people have gone out of their way to give us their aid and advice: Russell A. Phillips Jr. and Madeline Farnsworth, among many others at the RBF; A. Beverly Barksdale, Albert J. Grossman, Janet G. Moore, James R. Johnson, Gabriel P. Weisberg, James A. Birch, Kathy Coakley, and Bernice Spink, among others at the Cleveland Museum. Research help came from many sides, but the library staff at the Cleveland Museum—Daphne C. Roloff, Georgina Gy. Toth, Sue Wheeler, and Al Habenstein—and two members of the Case Western Reserve University faculty, Anita Rogoff and William B. Levenson, were especially generous with their time.

In preparing the manuscript, we had the good fortune to find an editorial craftsman in Judy Murphy, who began the massive job of shaping the research and endowing it with her uncluttered, readable style; Anne Berrill, who picked up where Judy's prior commitments forced her to leave off and who not only edited many of the reports here but cheerfully took on a large burden of editorial detail; Norma Roberts, who labored over the often conflicting and sometimes confus-

ing numbers and other data in the checklists and compiled the index. Throughout all the editorial process, drafts were typed and retyped by a long-suffering crew whose principal members were Genevieve Jelinkey at the de Young Museum in San Francisco and Jude Pease, Betty Welch, Patricia Badum, and Cynthea Greene in New York. In addition, several people rallied to the cause when deadlines were upon us, and we would like to thank in particular here Paulette Rosselet, Marilyn Goacher, Susan Guthrie, Ann Thornburgh, Dianne Berry and her husband Jim, Janet Leonard, and Joyce Sparbeck.

In the University of California Press we were blessed with a publishing staff that has been unfailing in its interest, patience, and professionalism, starting with Tom McFarland, who had sufficient faith in the project to gamble on it well before the manuscript was completed; David Antin, before whose critical eye the manuscript passed its first editorial test; Susan Peters, who directs the Press's editorial staff, and Nancy Jarvis, who read the entire manuscript and helped us correct its several copy-editing errors.

For all the help this project has had, however, no one has sustained it longer or more imperturbably than Sherman Lee, its chairman, chief fund-raiser, chief critic, and sympathetic taskmaster. No one has worked more steadily, typed more drafts, or carried more of the endless detail than Cynthia Toner, who during the entire three years had the job of managing the staff reports, making out budgets, keeping track of expenses, Xeroxing the output, and coordinating the complexities of the paperwork. No one has sacrificed or endured more or done so with more understanding than our husbands, Jack Newsom and Daniel Silver. Finally, few participants in this project have had as broad an education or found as much satisfaction, however hard-won it has seemed along the way, as the two of us, who shared the work and learned anew from each other at every step.

—B.Y.N. and A.Z.S. May 1976

# Issues in Art Museum Education: A Brief History

In the beginning, there were no art museums. Innocent irreverence reminds us that museums are inventions of men, not inevitable, eternal, ideal, nor divine. They exist for the things we put in them, and they change as each generation chooses how to see and use those things.

Art museums as we know them were born of eighteenth-century enthusiasm for an enlightened citizenry and bred in the nineteenth century's earnest, often solemn respectability. Even the most august public museums in Europe bring barely two hundred years of tradition to this last quarter of the twentieth century. American museums, the oldest just a century old, most half that age or younger, are only now examining the shape of their own history.

It is common to wrap old traditions around art museums, to draw their lineage from the much deeper past—from the muses of Greek mythology, "who by their dance and song helped men to forget sorrow and anxiety . . . [who] were credited with creative imagination, with infinite memory, with which they could succor mortals, and with foresight,"[1] or from the temple at Delphi or the library at Alexandria, or from the royal and princely collections of Europe. It is probably more appropriate to cite the Louvre as the prototype of the "modern" art museum, revolutionary both in its collection of great masterpieces, arranged and exhibited according to historical principles, and in its desire to serve the public. That desire was based on the notion that "the public was entitled to enjoy the advantages of free citizens in a democratic society . . . [including] access to the greatest works of art. . . . Such access, however, was not solely for the indulgence of the senses . . . but for the inculcation of political and social virtue."[2]

## The educational premises

Although those who run American museums never have fully agreed on what museums should teach, to whom, for what ends—or, for that matter, what constitutes "virtue"—these institutions have undertaken educational programs almost from the time they were established. The Metropolitan Museum in New York offered a lecture series for adults in 1872, just two years after its founding, and the Boston Museum of Fine Arts turned over unused rooms to adult classes in 1876. The idea of the museum as an agent of education has been so pervasive that some American art museums set up their education programs even before buildings were built or collections were in hand. The Toledo Museum was one that did this when it was established in 1903; the Cleveland Museum was another, its education program beginning in 1915, a full year before the museum opened. The growth continues, the National Endowment for the Arts reports: "Significantly, about half (51 percent) of the museums have increased their educational activities since 1966," and the increase has been concentrated largely in programs for children and school groups.[3]

A basic early premise of educational activity, common to most American art museums, was pronounced at one museum dedication in 1880—"that the diffusion of a knowledge of art in its higher forms of beauty would tend directly to humanize, to educate and refine a practical and laborious people."[4] This has been a tenet of faith by which most American art museums have explained their specifically instructional activities—and by which some have justified their existence—through many decades. But it is not the only conviction that has helped shape the instructional programs devised by museum workers over the decades. Indeed, there has been much shifting of attitudes toward art and education, with the result that an idea that surfaces in one decade may languish in the next, only to reappear several decades later in new garb or in another part of the country, or even in some other institution. These are a few, if not all, of the ideas that have influenced art museums as educators.

**Art and industry.** From the beginning, American art museums saw an ambitious educational model in London's Victoria and Albert Museum, founded in 1852 as "the first fruit of the effort to meet the problems of the industrial age."[5] Like John Ruskin and William Morris and their followers, who feared that art and handicraft were threatened by the industrial revolution, the Victoria and Albert took an interest in the decorative arts and crafts of past times as sources of inspiration and instruction for the artists and craftsmen of the new industrial age. (It might be worth noting that industrial arts—perhaps best defined in this context as industrial design—were the first arts introduced into American public schools; in 1864 the Boston public schools were the first to require drawing, and within five years Massachusetts industrialists had encouraged the state legislature to require that art be taught to boys over the age of 15 in cities of more than 10,000 population, presumably future factory workers.)

The Victoria and Albert's ideas directly influenced American art museums: in the 1870s, the programs and even the charters of the Metropolitan Museum and Cooper Union Museum in New York and the art museums in Philadelphia and Boston were based on what was seen as a necessary connection between art and industry—"the application of arts to manufacture and practical life," as one charter put it.[6] The museum art schools that appeared early in American museum development were founded on the same connection. Half a century later, the idea still had force: the articles of incorporation of the Cleveland Museum of Art in 1913 specified as one of the museum's purposes to "maintain an industrial training school."[7]

The concern about art and industry, according to Theodore L. Low, peaked about 1930 and has been on the decline ever since.[8] Nevertheless, the tradition continues in the art schools of the Museum of Fine Arts, Boston, and the Art Institute of Chicago, and also in the Design Collection of the Museum of Modern Art, which was begun in 1932 and reinstalled in 1974 as a significant (and now unusual) American museum study collection of industrial craft and design.

**Moral uplift and popular taste.** Inspiration for artists, craftsmen, and factory workers was only one sort of instruction American art museums intended to provide, however. They also proposed to inspire the American citizenry and to elevate popular morals and taste. C. B. Fairbanks, a young Boston journalist who wrote under the engaging name of "Aguecheek," summed up the late-nineteenth century's spirit of uplift: "Art is the safest and surest civilizer. . . . Open your galleries of art to the people, and you confer on them a greater benefit than mere book education; you give them a refinement to which they would otherwise be strangers."[9]

Another Bostonian, Benjamin Ives Gilman, secretary of the Museum of Fine Arts, Boston, 1893–1925, saw the museum as "primarily an institution of culture and only sec-ondarily a seat of learning." Insisting that the art museum was "not didactic but aesthetic in primary purpose," that works of art have as their primary "usefulness" their capacity to be enjoyed, and that "beauty is of longer life than utility," Gilman was nonetheless the museum man who first, in 1907, introduced docents, or teacher-lecturers, to provide "gallery instruction." Their stated purpose was not to spend all their time teaching—"it is fatal to make an exclusive business of talking about art," he warned—but, when they took visitors into the galleries, to teach "toward" the work of art, not *from* it or *about* it. Gilman's complete faith in the work of art as the central point of teaching was based in his faith that art, which teaches by the example of its very existence, is "one of the ways in which the good word is passed among the children of men."[10] It is a touching faith and one deeply held over the generations since Gilman. George Heard Hamilton, for instance, in 1975 ascribed to art a "function as the principal and primary humanizing element in the development of human consciousness,"[11] and Francis Henry Taylor, director of the Metropolitan Museum from 1940 to 1954, argued during World War II that the American "museum must become the free and informal liberal arts college for a whole generation of men and women."[12] He was convinced that had German museum men had the will, they could have helped crush nazism and its ideology. Many who share Taylor's faith in the humanizing capacity of works of art find it difficult to make that particular leap of faith; who can persist in believing that acquaintance with great art improves the morals of men when Goering and the Borgias too yearned for masterpieces?

**The museum as library, seat of learning, and source of self-improvement.** Another view of the museum as educator has been held by people who have not shared Gilman's total confidence in the work of art but instead have placed their faith in man and his capacity to learn. In the same year that Gilman introduced docents into the galleries of the Museum of Fine Arts, Henry Watson Kent became the supervisor of museum instruction at the Metropolitan, and promptly urged the establishment of branch museums to reach out to a wider public.

This impulse inside the museums was matched by a late-nineteenth-century impulse on the part of the American public that spurred the establishment of lyceums, Chautauquas, reading groups, clubs for middle- and upper-class women, settlement houses, scholarly and professional societies, mechanics' institutes, and even country fairs. Americans were moved to seek out their own education wherever they could find it, including, most notably, museums. Several generations of men and women educated themselves before education became compulsory—and before museums and other cultural agencies were relegated to "leisure-time activity." The drive toward self-improvement was so strong in the 1880s, in fact, that 10,000 persons signed a petition demanding that the Metropolitan Museum and its sister across Cen-

tral Park, the American Museum of Natural History, be opened on Sunday, the only day of the week, said the petition, when the working man was free to visit.

Perhaps the most aggressive advocate of museums as institutions primarily designed to teach and educate the public was John Cotton Dana, director of the Newark Museum from its establishment in 1909 until his death in 1929. He scorned mere "gazing museums" and declared that "probably no more useless public institution, useless relative to its cost, was ever devised than that popular ideal, the classical building of a museum of art, filled with rare and costly objects."[13] Like Kent, who was his close friend, Dana believed the museum existed to serve the American people: "There is only one solution of social problems—the increase of intelligence and sympathy,"[14] he declared, finding it perfectly logical that an art museum, as a public institution, could take a hand in this social process.

It is probably no accident that both Kent and Dana began their careers as librarians. The practices and attitudes of the public library movement, which was becoming increasingly professional toward the end of the century (Melvil Dewey had proposed his decimal system in 1876), were an important influence on many who were drawn into museum work. Francis Henry Taylor commented on the metaphor that called the museum and the library "the two halves of the public's memory of the past," agreeing that "the justification of the museum as a public institution" is that in it all men "may see a parade of history based . . . upon the personal testimony of the eyewitness." But Taylor cautioned against too close a parallel: ". . . the museum, because of its obligatory emphasis on quality, is indeed much more."[15]

Implicit in the metaphor is the idea that works of art are, like books, social documents classifiable into any number of historical and philosophical pigeonholes. Those who, like Taylor, reject the exact comparison, remind us that art objects are unique, not replicable like books. At most, they say, an art museum is comparable to a library of rare manuscripts.

But perhaps the most vehement protest against the seat-of-learning theory of museums was aroused not so much by the librarians as by the scientists—especially one: George Brown Goode, an assistant secretary of the Smithsonian Institution and the first U.S. museum man to create a logical and coherent theory of museums in his 1895 *The Principles of Museum Administration*. Goode once made a pronouncement, as long-time museum student Richard Grove has noted, that got him into permanent trouble with art museum people in general and Benjamin Ives Gilman in particular: "An efficient educational museum," Goode wrote, "may be described as a collection of instructive labels, each illustrated by a well-selected specimen."[16] Wrote Gilman in response,

When we apply Dr. Goode's formula to collections of fine art we find it talking nonsense. . . . For a collection of works of art is not a collection of specimens, but a collection of their opposites, namely unica. . . . An object of science being specimen, and an object of art unicum, in a

museum of science the accompanying information is more important than the objects; in a museum of art, less. . . . Thus, as Dr. Goode well said, in a museum of science, the object exists for the description; but as he was not yet ready to say, in a museum of art the relation is reversed—the description exists for the object.[17]

**Social reforms and educational experiments.** There is little doubt that the economic and social upheavals of the period between the two world wars affected museum efforts to define their educational purposes. Alma Wittlin notes that museum education as missionary work peaked at that time.[18] During the Depression museum workers lucky enough to hold their jobs often took salary cuts; programs were restricted and galleries closed—though the recognition that museums provided some respite from the grim world outside, and that people unaccustomed to museums were seeking such refreshment, prompted museums to try to keep their doors open. The Syracuse Museum ran regular workshops for men on relief, and the Metropolitan began its free gallery talks with a program for the unemployed.

The 1930s compelled museums "to realize that they should attempt to obtain their major support from public sources," says one chronicler, who believes "museums in that period first justified their requests for support, and their very existence, by their educational programs."[19]

Work-relief for destitute artists was one project of the missionary zeal of the period. Although the effort to employ artists was most often made through the WPA in public works,[20] some art museums undertook to provide showcases and marketplaces for private patrons, attempting to educate the public to see, understand, and—if possible—buy the works of American artists.

During the 1930s, a combination of New Deal money and private foundation funds was injected into all kinds of experimental educational programs. Though the Depression curtailed programs at first, the educational atmosphere became increasingly progressive as federal programs for the schools grew. Because jobs were so scarce, adult education courses proliferated, especially in the public schools, and educators began to pay more attention to the high schools, one of the few alternatives for young people who might in earlier years have left school to go to work. The Carnegie and Rockefeller foundations, for example, began to look at museums—along with the growing array of public media, including radio—as part of a system of out-of-school education in the late thirties.

Oppressive political ideas that seemed to most Americans in the 1930s to threaten democratic institutions and the independent citizenry they require, alarmed museum workers and impelled them to greater efforts at education for a broad adult audience. An advocate of the museum role in adult education, T. R. Adam, wrote in that period, "If critical intelligence is to survive in a civilization flooded with propaganda and intellectual authoritarianism, the longing for

first-hand information must be kept alive. . . . ''[21] And the movement flourished, as if the adult public hoped the museums might yield some secret source of wisdom. The Brooklyn Museum's influential director, Philip N. Youtz, joined Adam in support of the idea that adults ''who live in a complex civilization where most adventures are second-hand'' could get from the museum ''a fresh visual knowledge of the great art of their own and past cultures.''[22]

The debate continued between those who believed the museum to be, in Gilman's words, ''aesthetic in primary purpose'' and those who regarded it, with Taylor, as ''the midwife of democracy,''[23] and thus essentially educational in its basic intent. The first approach of American art museums had been to an already educated audience; any effort to reach beyond, to working-class people and immigrants, for example, began in earnest only after the turn of the century. The growing desire to ''do good'' for as broad a public as possible, fueled by Dana and Kent, was kindled in Theodore Low, among others in the 1930s and 1940s, who encouraged museums to teach ordinary men and women, that adult public of no special cultivation, education, or distinction, which he labeled ''the middle classes.''[24]

By the end of the 1930s, the balance seemed to Frederick E. Keppel, president of the Carnegie Corporation, to be heavily weighted on the side of Taylor and the educational purpose of museums. In his 1939 report he stated, ''The shift in emphasis from the custodial function of the American museum to its opportunities for educational and other services is now nearly everywhere an accomplished fact.''[25]

By the end of the 1940s, Low, too, was convinced that museums were broadly and basically educational institutions. He contended that the development of this educational premise was the essential philosophy of American art museums and that the ''conservative'' cultural posture of Gilman was bound to fail: Dana was the wave of the future. Low argued that the question then facing museums was not who is served (the answer: everybody), but how.

He explained this change as having been forced by the Depression: ''Museums became aware that they existed to serve a public which was willing to be served but which had definite needs and desires and refused to be fed nectar of the museum's choosing.''[26]

**Cultural history—and power.** One of the nectars particularly favored by museum workers during the 1940s was what Low called ''culture history,'' which places works of art in a broad historical context.[27] With Adam, Youtz, and Low, some museum educators in every generation have argued that museums are an ideal place to teach *from* works of art to a broad understanding of a society and its values. This belief was, at least for a time, widely shared by intellectuals outside the museum world, probably a natural reaction to the events of the thirties and their climax in World War II. At the annual meeting of the American Association of Museums in 1946, Archibald MacLeish summoned U.S. museums ''to devote themselves explicitly and affirmatively to the demonstration of that unity and wholeness of knowledge and of art'' expressed in their collections.[28] His was a reflection of the powerful hopes placed in all American institutions during the late forties and throughout the fifties.

The idea that museums might be agencies not simply of cultural history but of cultural indoctrination and that, indeed, they might be quite powerful social institutions, was not lost on the reformers of the sixties. As the nation's racial minorities began to take courage from the educational and social victories conceived in the Supreme Court decision on equal educational opportunity in 1954 and brought to life in the Kennedy-Johnson social programs of the early sixties, they challenged not only schools and universities but other institutions to serve them and their special needs. Art museums were accused of being elitist, dominated by the rich and by a Western European aesthetic and cultural exclusiveness that ignored most of the rest of the world and the heritage of large portions of the nation's own population.

Museums responded in a variety of ways. The most common solutions were ''outreach'' programs that sought to educate, in a rather diffident sense of the term, the ''other Americans'' where they were—in community centers, on the streets, in churches, and in ghetto schools. One large museum, anxious not to lose its support when city budgets were being prepared, organized its community services during this period by political districts to make sure no vocal minority protesters could fairly complain about being given the cultural cold-shoulder.

Several communities created their own responses to cultural domination by organizing art centers and storefront museums that freely dispensed ideologies and aesthetics designed to teach a different kind of cultural history to a new generation and to counteract what they saw as the pernicious influence of establishment museums. Though by the early 1970s a number of these community arts programs had withered away for lack of money, many survived, some to enter into alliance with large established museums, especially through their education departments, and to begin to influence their educational attitudes.

**Schools and art education.** Inevitably, the museum as educator has had to explore and define its relationship to the school, society's primary educational mechanism for the young. Throughout the development of the American art museum in the first half of the twentieth century, there was the nagging question of how to supplement—or supplant— the art education offered in American schools. Like art instruction in the schools, museum education to some degree reflected American society's changing educational values. Theories of education sometimes contradicted one another, based as they were on conflicting premises and derived from different views of human nature, but all held out a single

promise: education, however defined, can save the young. Two art educators summed up a long history of art education in the schools this way:

> If society saw education as a means of creating an individual culture, art was seen as a tool for developing cultured tastes and cultural accomplishments. If schools were to prepare citizens to contribute to the economic welfare of the nation, art was to be taught as an important vocational skill. If the school's major task was to develop man's creative intelligence, art became a means for unlocking the child's potential creativity.[29]

As noted, the first arts introduced into the schools were industrial arts, although even earlier, in the 1840s, Horace Mann had published the drawing lessons of Peter Schmid in *Common Schools Journal,* in the belief that drawing was an aid to hand-eye coordination and legible penmanship. A later concern for the culture of the schoolchild, which Joshua Taylor has characterized as an "uplifting missionary fervor," spawned in the 1890s an art appreciation that was a "quiet sentimental pleasure."[30] Until about thirty years ago, such art appreciation dominated the schools, consisting of "the study of tiny prints, about the size of playing cards, of well-known paintings."[31]

As the child development movement gathered force in the 1920s and 1930s, the study of high art was seen to compel children to be imitative, and to inhibit their creativity. The educational ideas of John Dewey, with their emphasis on learning by doing and allowing the child to give vent to his "constructive impulse," found their parallel, if not necessarily their highest expression, in the numberless studio classes that began to be offered to children in art museums in the twenties and thirties, when Dewey's ideas began to catch on in the schools.

Then Herbert Read could summon the teacher to be a "psychic midwife," and Viktor Lowenfeld, one of the most influential investigators of the growth and development of children through art, could argue for "art as a true means of self-expression" that "grows out of, and is a reflection of, the total child," and challenge the art teacher "never [to] forget that the development of creativity is one of the basic reasons for art's existence in the secondary schools."[32] By 1949, the policy statement of the National Art Education Association included the declaration that "art is less a body of subject matter than a developmental activity."[33]

Counterrevolution was brewing. In 1954, Rudolf Arnheim lamented that the schoolchild was encouraged to work only on impulse and for "raw effect" and was not learning to use "pictorial work for clarifying his observation of reality and for learning to concentrate and create order."[34] By 1968 the NAEA credo had been modified to declare art "both a body of knowledge and a series of activities which the teacher organizes to provide experiences related to specific goals."[35]

Some curriculum reformers in the 1950s and early 1960s argued that the key educational task was to give students an understanding of the fundamental structure of a discipline and to help them discover that structure—to behave like the artists they can become, as some theorists put it. But there were always art educators who warned against the structural and sequential approach: "We have not analyzed adequately our subject areas to be able to develop a structure of sequential basic concepts," wrote one in 1962,[36] and in 1970 one state curriculum cautioned, "There are few clues in the content of art to suggest a 'proper' sequence for art activities to follow."[37] Throughout the sixties and early seventies, art education in the schools (and in many museums, too) also tried the behavioral approach, the new sensory approach, the use of interrelated arts—efforts based, it seemed, almost as much on the grant money that was available as on educational theorizing.

## And the results?

If those seem quite clearly to be the concepts that have given energy and direction to the educational efforts of museums, it must be said that the results of those efforts are not as apparent. Most affected, perhaps, has been the museum itself, for the programs it has designed have inevitably determined the kind of educational staff it hired and the way the staff was deployed. The fact that such a high proportion of that deployment went to the education of children has made the art museum a kind of field-trip heaven for schools during many of its weekday hours; it has meant also that a good deal less educational energy has been invested in adults.

What is not so clear is the effect of the museum's educational practices on the audience and the world around the museum. Have the museum's educational efforts made the American populace, or even a small portion of it, visually literate? Have art museums helped to make of us, as someone once said, an art-loving, art-producing people?[38] Agnes Mongan, former director of the Fogg Museum at Harvard, is one who thinks not. Returning to a Midwestern city after the ambitious education program its art museum had devised had been in operation for nearly a generation, she found the city was no better designed and showed no sign of improved visual awareness than it had exhibited twenty years before. Museum education programs as they have long been conducted, says Mongan, are a waste of time.[39] Richard Grove, a long-time student of museum education, agrees with her:

> Art and culture have been high on the list of official values all along. That's why we have so many art museums. That's also why they have so little effect on the cities around them or on the interiors of most homes. Or on the school curriculum, because that's where we come down to real values, a consensus on what our children really need to know, and no fooling.[40]

Museum administrators and theorists have had instinctive reactions to the question of educating children in art museums. Systematic and intensive cooperation with the public schools was seen by one early authority, Paul Marshall

Rea, as "the most distinctive educational activity of museums," and he warmly endorsed the idea.[41] A president of the Metropolitan Museum, Robert de Forest, called it "good politics as well as good policy" to develop relations with the public schools.[42] But the opposing point of view was stated even earlier, and never more succinctly or vividly, by George Brown Goode, who cautioned: "I should not organize the museums primarily for the use of people in their larval or school-going stage of existence."[43]

Statistics that might prove the point are not easily found—and may not be altogether persuasive. The nature of the art experience, as most educators would point out, is not always measurable in numbers. Yet some research is available, almost all of it conducted by the National Research Center of the Arts. A 1973 study by the center, for example, found a "striking" correlation between childhood exposure to the arts and frequent attendance at cultural events in adult life.[44] And in its follow-up study in 1975 of public attitudes toward arts and culture, the center found, again, that "the more frequently people went to museums when growing up, the more likely they are to go more frequently today."[45]

The 1975 study observed that as "early exposure to the arts is a very significant factor in adult participation in the arts," museum programs for children "are likely to increase museum attendance in the future."[46] Yet in another study conducted by the same center in New York State in 1972, it developed that among those people who go to art museums frequently, 60 percent attributed their interest to the fact that someone in the family took them when they were children and 77 percent were influenced by friends or teachers when they were young. Only *3 percent* of the regular art museum goers credited *school* trips with stimulating their interest. Among those who do not attend cultural events as adults, most could not remember any strong personal influences in their childhood.[47] Thus, if these statistics are at all indicative of the truth, the kind of childhood exposure to the arts that makes a difference in later life has a good deal more to do with sustained personal influences than with the relatively light sprinkling that so many museum education programs seem to afford.

People who do not go to art museums still outnumber those who do. The National Research Center of the Arts has estimated that 43 percent of Americans went to an art museum in the twelve months before June 1975. But the study reports that art museum attendance is up over 1973: that year the public said it went to art museums an average of 1.2 times a year; by 1975 the figure was 1.7 times.[48]

## The present and the future

Nevertheless, pressures on the art museum to serve as educator to a broad audience have not abated, though they are less strident and less likely to make headlines in the 1970s than they were in the 1960s. Exploring their capabilities for broad public education, many art museums have come to recognize—all over again, a student of history might say—

that they are not isolated but are part of a vast array of nonschool learning places. Education policymakers promise museums that there will be throughout the 1970s and 1980s a rising demand for education and for continuing re-education. They base their predictions on analyses of a public need for new skills and an increasingly sophisticated desire for new understanding, trends they relate to the nation's post-World War II effort to answer the educational needs of the "baby-boom" generation, now adult and still expecting all of its educational needs to be met.

At the same time, museum educators trying to break ground in the area of "self-directed learning" and to share their ideas with other educational institutions, both school and nonschool, are warned—often by the same policymakers who hold out such tempting promises—that they will have to compete with those very institutions for funding, energy, and audiences, as resources and population shrink. Is that paradox the next dilemma to face the American art museum, which has lived with, accommodated to, and sometimes even helped ameliorate American society's problems in every generation of its brief history?

Brief it is. America's art museums, not old nor venerable enough to have forgotten their origins, recognize that they are inventions of men, especially of men, as Germain Bazin says, with a sense of history, who gather around them the relics of time. "Man consoles himself," in Bazin's phrase, "for what he is by what he was."[49] Perhaps the characteristically American revision would read, "Man consoles himself for what he is by what he can be." American museums exist for the things that are in them, and they change as each generation chooses how to see those things and discovers the hope and encouragement they hold.—*A.Z.S.*

## Notes

[1] Alma S. Wittlin, *Museums: In Search of a Usable Future* (Cambridge, Mass.: M.I.T. Press, 1970), p. 290.

[2] George Heard Hamilton, "Education and Scholarship in the American Museum," *On Understanding Art Museums,* ed. Sherman E. Lee (Englewood Cliffs, N.J.: Prentice-Hall, 1975), p. 104.

[3] *Museums USA* (Washington, D.C.: National Endowment for the Arts, 1974), pp. 37, 41.

[4] Quoted by Calvin Tomkins in *Merchants and Masterpieces: The Story of the Metropolitan Museum of Art* (New York: E.P. Dutton, 1970), p. 16.

[5] Walter Pach, *The Art Museum in America* (New York: Pantheon, 1948), p. 53.

[6] The Metropolitan hoped "to show to students and artisans of every branch of industry . . . what the past had accomplished for them to imitate and exceed." Joseph Choate, *Annual Report of the Metropolitan Museum of Art* (New York, 1889), pp. 176–177.

[7] Carl Wittke, *The First Fifty Years: The Cleveland Museum of Art 1916–1966* (Cleveland: Cleveland Museum of Art, 1966), p. 176. Only a judicial decision in 1953 made it possible for the trust established to pay for such a school to provide money "for charit-

able educational purposes . . . in lieu of operating an industrial training school'' (p. 139).

[8] Theodore L. Low, *The Educational Philosophy and Practice of Art Museums in the U.S.* (New York: Teachers College, Columbia University, 1948), p. 59.

[9] Quoted in Adele Z. Silver, ''Keeping Behind the Times in Cleveland,'' *The Reporter,* June 29, 1967.

[10] Benjamin Ives Gilman, *Museum Ideals of Purpose and Method,* Museum of Fine Arts, Boston (Cambridge, Mass.: Riverside Press, 1918), pp. xi, 98, xviii, 315, and 95.

[11] Hamilton, ''Education and Scholarship,'' p. 99.

[12] Francis Henry Taylor, *Babel's Tower: The Dilemma of the Modern Museum* (New York: Columbia University Press, 1945), p. 50.

[13] John Cotton Dana, *A Plan for a New Museum* (Woodstock, Vermont: Elm Tree Press, 1920), pp. 9–10.

[14] D.B. Updike, *John Cotton Dana* (Merrymount Press, 1930), p. 23.

[15] *Babel's Tower,* p. 26.

[16] Museum-History and Museums of History,'' *Annual Report, U.S. National Museum, 1897,* Part 2, p. 72.

[17] *Museum Ideals,* pp. 80–81.

[18] *Museums: In Search of a Usable Future,* p. 179.

[19] Mark Luca, ''The Museum as Educator,'' *Museums, Imagination and Education* (New York: UNESCO, 1973), p. 145.

[20] One American director, William Milliken of the Cleveland Museum of Art, was appointed regional director of the Public Works of Art Project in December 1933. His job was to persuade tax-supported institutions to hire artists, and he had to choose the artists who would get the jobs. The salary budget was $156,125.80, to be distributed in weekly paychecks ranging from $26 to $42.50. There were more artists than he could find jobs for. He announced that his decisions on which artists got the jobs ''struck out for a happy medium between the financial needs of the artists and quality.'' (From an interview with William Milliken, by M.A. Goley, January 8, 1973, in ''New Deal in Ohio Archives,'' *Archives of American Art,* 1973 [folder: Milliken], reels 603–606; quoted in Karal Ann Marling, ''William M. Milliken and Federal Art Patronage of the Depression Decade,'' *Bulletin of The Cleveland Museum of Art,* December 1974.)

[21] T. R. Adam, *The Civic Value of Museums* (New York: American Association of Adult Education, 1937), p. 9.

[22] Philip N. Youtz, ''Progressive Education in the Brooklyn Museum,'' *Progressive Education* 14:536 (November 1937).

[23] *Babel's Tower,* p. 52.

[24] Theodore L. Low, *The Museum as a Social Instrument,* a Study Undertaken for the Committee on Education of the AAM (New York: Metropolitan Museum of Art for the AAM, 1942), p. 32.

[25] Quoted by Thomas Munro in *Educational Work at The Cleveland Museum of Art,* rev. 2nd ed. (Cleveland: Cleveland Museum of Art, 1952), p. 7.

[26] Low, *Educational Philosophy,* p. 67.

[27] Ibid., p. 57.

[28] Quoted in ibid., p. 176.

[29] Elliot Eisner and David W. Ecker, *Readings in Art Education* (Waltham, Mass.: Blaisdell, 1966), p. 12.

[30] Quoted in ibid., p. 239.

[31] Manuel Barkan, ''Transition in Art Education,'' *Art Education* (Journal of the National Art Education Association), Vol. 15, no. 7 (October 1962), p. 14.

[32] Viktor Lowenfeld and W. Lambert Brittain, *Creative and Mental Growth,* 6th ed., first published 1947 (New York: Macmillan, 1975), pp. 8, 9, 291.

[33] ''As an Art Teacher I Believe That,'' *Art Education,* vol. 2, no.2 (March–April 1949), p. 1.

[34] Rudolf Arnheim, *Art and Visual Perception* (Berkeley and Los Angeles: University of California Press, 1954), p. 168.

[35] *The Essentials of a Quality Art Education* (Washington: National Art Education Association, 1968).

[36] June King McFee, *Western Arts Bulletin,* September 1962, pp. 16–30.

[37] *Guidelines for Planning Art Instruction in the Elementary Schools of Ohio* (State of Ohio Department of Education, 1970), p. 133.

[38] See Edgar P. Richardson, ''The Museum and Education,'' *Museums and Education,* ed. Eric Larrabee (Washington, D.C.: Smithsonian Institution Press, 1968), p. 19.

[39] Interview, May 28, 1974.

[40] Research memorandum for CMEVA, September 15, 1974.

[41] Paul Marshall Rea, ''Educational Work of American Museums,'' *Report of the Commissioner of Education for the Year Ended June 30, 1913* (Washington, D.C.: U.S. Bureau of Education, 1914), p. 305.

[42] Quoted by Tomkins, *Merchants and Masterpieces,* p. 119.

[43] Goode, ''Museum-History,'' *Annual Report, U.S. National Museum, 1897,* Part 2, p. 72.

[44] *Americans and the Arts,* a Survey of Public Opinion (New York: Associated Councils of the Arts, 1975), p. 66.

[45] *Americans and the Arts II,* conducted for the National Committee for Cultural Resources (New York: National Research Center of the Arts, August 1975), p. 35.

[46] Ibid., p. 36.

[47] *Arts and the People,* A Survey of Public Attitudes and Participation in the Arts and Culture in New York State (New York: American Council for the Arts in Education, 1973), pp. 71–73.

[48] *Americans and the Arts II,* pp. 4, 23.

[49] Germain Bazin, *The Museum Age,* trans. Jane van Nuis Cahill (New York: Universe Books, 1967), p. 6.

## Bibliography

The books listed here have been particularly useful in assembling this history; most of them are now classics in this field.

Adam, T.R. *The Civic Value of Museums.* New York: American Association of Adult Education, 1937.

American Association of Museums Special Committee. *America's Museums: The Belmont Report,* A Report to the Federal Council on the Arts and Humanities. October 1968.

Bazin, Germain. *The Museum Age,* trans. Jane van Nuis Cahill. New York: Universe Books, 1967.

Coleman, Laurence Vail. *The Museum in America.* 3 vols. Washington, D.C.: American Association of Museums, 1939.

Connally, Louise. *The Educational Value of Museums.* Newark, N.J.: Newark Museum Association, 1914.

Dana, John Cotton. *The Gloom of the Museum.* Woodstock, Vt.; Elm Tree Press, 1917.

*The New Museum.* Woodstock, Vt.: Elm Tree Press, 1917.

*A Plan for a New Museum.* Woodstock, Vt.; Elm Tree Press, 1920.

Gilman, Benjamin Ives. *Museum Ideals of Purpose and Method.* Cambridge, Mass.: Riverside Press, 1918.

Howe, Winifred E. *A History of the Metropolitan Museum of Art.* 2 vols. New York, 1913.

Kent, Henry Watson. *What I Am Pleased to Call My Education.* New York: Grolier Club, 1949.

Low, Theodore L. *The Educational Philosophy and Practice of Art Museums in the U.S.* New York: Teachers College, Columbia University, 1948.

*The Museum as a Social Instrument.* New York: Metropolitan Museum of Art for the American Association of Museums, 1942.

Luca, Mark. "The Museum as Educator." *Museums, Imagination and Education.* (New York: UNESCO, 1973).

*Museums and Education.* Ed. Eric Larrabee. Washington, D.C.: Smithsonian Institution Press, 1968.

*On Understanding Art Museums.* Ed. Sherman E. Lee. Englewood Cliffs, N.J.: Prentice-Hall, 1975.

Pach, Walter. *The Art Museum in America.* New York: Pantheon, 1948.

Parr, A.E. *Mostly about Museums.* New York: American Museum of Natural History, 1959.

Powel, Lydia Bond. *The Art Museum Comes to the School.* New York: Harper, 1944.

Ramsey, Grace Fisher. *Educational Work in Museums of the United States: Development, Methods and Trends.* New York: H.W. Wilson, 1938.

Rea, Paul Marshall. *The Museum and the Community: A Study of Social Laws and Consequences.* Lancaster, Pa.: Science Press, 1932.

Ripley, S. Dillon. *The Sacred Grove: Essays on Museums.* New York: Simon & Schuster, 1969.

Taylor, Francis Henry. *Babel's Tower: The Dilemma of the Modern Museum.* New York: Columbia University Press, 1945.

Tomkins, Calvin. *Merchants and Masterpieces: The Story of the Metropolitan Museum of Art.* New York: E.P. Dutton, 1970.

Updike, D.B. *John Cotton Dana.* Merrymount Press, 1930.

Wittke, Carl. *The First Fifty Years: The Cleveland Museum of Art, 1916–1966.* Cleveland: Cleveland Museum of Art, 1966.

Wittlin, Alma S. *The Museum, Its History and Its Tasks in Education.* London: Routledge & Kegan Paul, 1949.

*Museums: In Search of a Usable Future.* Cambridge, Mass.: M.I.T. Press, 1970.

# Art Museums and Education

The founders of our earliest major art museums in Boston and New York (1870) were firm believers in the educational values they embodied in the charters of their institutions, and from the beginning they conceived of these museums as having educational responsibilities. Although they may not have thought of these institutions as *primarily* educational, that concept grew with the pragmatism and "progressive" education of the twenties and thirties and, in particular, with the intensified money pressures that came to a climax with the Tax Reform Act of 1969. The difference in gift benefits that accrued to museums, on the one hand, and "educational and charitable organizations," on the other, was sufficient to persuade the art museums and their spokesmen that they were, and should be considered as, educational institutions under the law.

One can understand the reasons for the determined stance of museums in favor of this legal change, but the fact is that the implications of the change were never examined for their full consequences. These implications go to the heart of traditional American concepts of education in what is essentially a word- and sound-oriented society. In those terms the art museum is not fundamentally an "educational" institution. Nevertheless, what and how it exhibits obviously may educate, even through a kind of educational function presently unrecognized by legislators and even some educators.

In the world of visual images, however, the museum is *the* primary source for education. Merely by existing—by preserving and exhibiting works of art—it is educational in the broadest and best sense, though it never utters a sound or prints a word. Until such an approach is accepted within our social structure, art museums will continue to be second-class citizens in "educational" country. And until the original worth of visual images is reincorporated into a basic concept of education as the transmission of *all* knowledge, some persons will continue to deny that art museums are primarily "educational" institutions. The submission of vision to literacy is not a victory but a tragic defeat—and one we could see about us if we were truly more than literate and believed in a broader concept of education.

## The place of education in an art museum

What then can the art museum do in education after its primary functions of collecting, preserving, and displaying are well achieved? Its holdings are a part of both material culture and Matthew Arnold's "higher" culture. Too often the nature and monetary value of the museum's collections encourage a spurious cultural veneer to become a dominant goal. Trustees, staff, members, and public become primarily concerned with the "furnishings" of the art world—who said what, how much was it, a litany of names—all this meaning the use and abuse of art for mere entertainment and superficial social ends. Rather than accept the visual arts as furnishings of an alert but shallow material existence, we should insist that the art museum's first responsibility is to consider its holdings as an integral part of a creative and rational continuum comprising past and present, science and art—all that we can properly call knowledge and culture.

Education in the visual arts in art museums by verbal and literary means does have an important, but not crucial, role to play. If we accept this ordering, the museum educator should be in a more relaxed, flexible, "loose" position—freer to be both more creative and focused in his teaching. What is included in this kind of education for the museum teacher or administrator of teaching? Much can be included under the rubric "transmittal." First, there is still a vast amount of mere information to be handed on—in labels, catalogs, and special didactic exhibitions. This information, fundamentally factual, is essential to thought about art or art history as well as science. Too much art education assumes that feelings and attitudes need not be supported by accurate information. Yet

this is a primary part of art education. Second, techniques must be transmitted. These can be looked on as part of factual information; but the *doing* of them, or even just observing the doing, is fundamental to understanding and evaluating works of art. The separation of art history and art practice, of eye and hand, in departments of our colleges and universities has led not only to rivalry but to unfamiliarity by one faction with the information and techniques taken for granted by the other. Any educational endeavor that ignores the transmission of techniques can only become amateurish in the worst sense of the word—and, incidentally, that is one reason why the current fashion for various manifestations of folk art is a parallel to that for astrology in the popular hinterlands of science. Both are primitivistic rather than truly primitive or archaic. To indicate the subtleties and difficulties involved here, we should note that Dubuffet as well as the Chinese late Ming literati demonstrate that sophistication can be masked as naiveté—the result, however, being a far cry from folk art.

Still a third part of the transmittal aspect of education involves achievements of past and present as possible models for starting points or variations in the present. Of course this involves evaluation and selection. What models are to be singled out for more than usual attention? Here there is room for individual taste as well as for the cumulative verdict of history. Yet, unless transmission includes models, configurations of fact and technique, the educational process becomes fragmented and immersed in detail. An atomistic view of history or education has its attractions, particularly when the imposition of patterns, models, or configurations becomes unreasonable and unsupported, or when it becomes dogma. Free movement among these three parts of educational transmittal—information, technique, and achievements as models—is essential.

In addition to transmission, education should be concerned with innovation. Techniques can be a part of this, but facts should not be invented. Science and technology, individual imagination, or philosophic innovation can all provide the occasion or the means for quantum jumps in the arts. The invention of porcelain as well as that of abstract art are examples of innovations of major concern to art educators. The developments of Gestalt psychology in relation to visual images are yet another area of educational innovation, and they are still in process. The "Print Teams" of the People's Republic of China produce work by cooperative means that should be of more than passing interest to the educator. Innovation is particularly important in the posing of problems and questions. A monotonous skepticism is usually counterproductive, but the new problems posed in painting by Picasso and Braque from 1907 to 1913 were as much questions of past assumptions as they were new discoveries. Innovation, whether in education, art, or science, does relate to the past, whether in constructing new models explaining history or in extracting from that history facts, techniques, or models that can be put in contemporary and different configurations. Education, particularly education in the visual arts,

should know that the protean achievement of Picasso demonstrated that the past spurs modern innovations.

## Art and free choice

Before turning to specifics in art education and their relation to art museums, we should consider a fact, or is it a shibboleth, much discussed by intellectuals today—leisure and its concomitant, work, with particular relation to education and the arts. Although it is true that many people have more leisure than before, many still continue to have little if any leisure. Those who do might well wish to spend some of their leisure being educated, enjoying art, or reading. But our consumer society has a particularly large industry dedicated to filling leisure by producing entertainment, and the distinctions between entertainment and enjoyment, or fun and experience, have become, at the least, somewhat blurred. We speak often of *popular* entertainment in music or theater and almost equally so of elitist or "high-brow" fare. And we all know what dominates entertainment for leisure time. I do not now or later advocate that art is necessarily good for anyone or that it is necessarily ennobling, nor that leisure should properly be filled with art or education. What does need clarification is the currently assumed dichotomy of nasty "elitism" and virtuous mass education in many disciplines.

Once again we are confronted with the importance of words and their meanings. If we speak of mass education favorably and then juxtapose as its opposite "elitism," we have made a choice harmful to understanding. Rather than elitist I would urge the word "aristocratic" in such a juxtaposition. Then our pejorative instincts will be well placed, for the assignment of merit by blood can be appealing only to those possessing it. But reason has properly denied that merit can be recognized by aristocratic right. The word "mass" is equally unilluminating, for it not only carries with it remnants of a discredited aristocratic snobbism, but it fails to recognize the humanity of man as an individual as well as a mere unit within a whole. Pride of lions, flight of ducks, mass of people—these may do for behaviorists, but for shared humanistic beliefs and assumptions, "mass" is simply inappropriate.

I suggest that we speak of democratic education and of the place of veritable elites within such a system. Bertolt Brecht's definition of democracy is relevant here. It is, he says, "to turn 'a small circle of the knowledgeable' into a large circle of the knowledgeable." No one winces when gifted dancers, creative writers, brilliant athletes, or wise committee members receive their justly deserved plaudits and respect. Such persons are members of an elite—a gifted, trained, and experienced set of persons preeminent within their chosen discipline. The sum of these elites is the glory of a democratic society. To denigrate the concept of an elite because of the abuses of hero worship and the star system is to look only at the rectifiable abuses of a fundamentally open system that makes possible the highest fulfillment of human capabilities. The problem is not how to destroy the concept of

elites but rather how to broaden access to them and to cross-fertilize them, not by blood but by rational and emotional empathy. Other and radically different social orders, such as the People's Republic of China, consciously recognize the value of words and unconsciously admit the value of elitism when they substitute the term "responsible member" for chairman. Celebration and study of elites should be the order of the day in all areas of human endeavor—unless we have other and antidemocratic social *ends* in view.

If we can bear to accept elitism, then it has a creative function within the framework of a democratic culture and education. We speak of standards and goals; a currently fashionable word is *paradigm*. All of these imply a qualitative judgment of the standard and goal as worthy of emulation and effort—more worthy than other possible models discarded because they were not good enough. Behind all such judgments are knowledge, wisdom, experience, genius, dedication, and the many other extraordinary qualities that democratic elites bring to problems. Only the most obtuse totalitarian would find the combination "democratic elites" puzzling. The plural is essential to the meaning—not an elite, but many elites, as many as there are disciplines, games, studies, and arts in the complex mosaic of society.

## The place of art in our culture and education

The visual arts are a part of this mosaic, and their place in the plane varies from culture to culture, geographically and chronologically. It is generally accepted now that art as experienced in any given culture is unlike art in a different culture. But that different culture may see, experience, even incorporate, the first culture's art in its own way. Neither vision of art, the given original or the absorbed reflection, is "correct," though one may be considered preferable. These elementary propositions cause the frequent dissents between, say, artists and curators, connoisseurs and anthropologists.

Art is also but one of the numerous parts composing culture. It may *seem* universally important to an art historian or collector, but then so does music, dance, or chess to the true devotée. What is certainly true is that in our modern Western culture, and particularly in what we can call Anglo-American culture, the visual arts occupy a relatively minor and isolated position. Hence, our passion, anguish, and evangelism; hence, the failure of *any* weekly general magazine—whether *Time, Newsweek, The New Yorker, The Times Literary Supplement,* or *Saturday Review*—to provide *regular* weekly columns on art. Literature, cinema, music, theater—yes; art—no.

We sense our loss of cohesion, our lack of visual literacy when we study Japanese culture, even in its present Western-influenced form. There the penetration of visual concern is to be found at all levels of society, as is easily demonstrated by an examination of the contents of department stores, fabric shops, or hardware stores, or by the enormous attendance figures at *all* exhibitions, whether of ancient or modern art. Even though one unsympathetically chooses to describe Japanese aestheticism as a mask, worn at home, or on vacation, or in temples, or on ceremonial occasions, in contrast to the implications of modern industrial sprawl in the urban areas of Tokyo, Nagoya, and Osaka, it nevertheless is an accepted mask used effectively by all, in contrast to our isolated and largely unattended efforts. Visual artistic competence is simply traditional, accepted, and integrated into the social and educational fabric of Japanese society.

This is so despite, or perhaps because of, the uselessness of art. Buddhist quietism in Japan may well encourage acceptance of useless aestheticism where the activist Protestant tradition in England and America occasionally attempts to legitimize art by making it useful (Wm. Morris and J. Ruskin) or, worse, informational (art history and iconography are symptoms—though I do *not* in any way discard these disciplines as essential parts of artistic knowledge). The uselessness of art, its failure to provide useful information, lies at the root of its peripheral position in American education. Changing the nature of art, making it "fit" the curriculum, is not the answer to our problem of visual illiteracy. Changing the curriculum to make it "artistic" is equally futile. A place must be found for the visual arts as peers of other and different disciplines. Otherwise we shall, if we strive even harder, only increase an unhealthy and largely unrecognized tension.

## The universality of the study of art

Perhaps one entering wedge capable of redressing the educational balance in our society is to be found in the very complex and catholic nature of the visual arts. That taste varies, we know; the favorite cliché is that art is all things to all men. This widespread net may well be a saving grace for the visual arts, rather than a diffusion and weakening of particular strengths. Fritz Saxl's Warburg Institute in London taught us that the subject matter of art reaches deep into the philosophy, literature, mores, the very fabric of the culture of a time, reaching from that culture's present into a dim, even mythic, past. Psychologists and scientists exploring phenomena of light and color have revealed layers of visual complexity, largely unknown to even the cultivated connoisseur. Literacy studies, particularly those related to seventeenth- and nineteenth-century art, have rehabilitated whole schools of narrative painting hitherto scorned by critics dedicated to "significant form."

These nonartistic disciplines, and many others, have discovered unexplored territories in the visual arts and in doing so have revealed the inherent capability of the visual arts to be all things to all disciplines—in short, it can well be argued that the study of art (art history, for want of a better term) is the most fruitful interdisciplinary study available to the academic world at all levels from elementary through graduate school. To understand a work of art fully requires much more ancillary knowledge than to understand a work of literature, music, science, or technology. Furthermore, the

knowledge so acquired has in art a natural living focus rather than an artificial one. The history of art can be an organic mode of penetrating the culture of a given historical unit, whether chronological, geographic, or cultural, to a degree no other single discipline can achieve. Such a claim must inevitably draw resistance from other disciplines, but I find it persuasive and look forward to a day when art history becomes *the* catholic rather than *a* parochial member of those studies comprising the pregraduate curriculum.

## The context of art in art museums

What, then, is the place of the art museum in relation to art and the study of art? The haphazard accumulation of works of art within a structure dedicated to their display and preservation may well have no purpose beyond that of the accumulations of squirrels. But the effect of the holdings of art museums is, or should be, rational. Meaningful juxtapositions can be made as part of the museum's program or, where no such program exists, by the knowledgeable visitor who can mentally order the disparate exhibits. The essential thing is that these collections exist and that they are available year to year, decade to decade. As a resource not unlike a library, the museum's collections make it possible for each individual, group, or generation to arrive at its judgments and provide its insights about the past. But even more, these accumulations are meat for the present, the charnel grounds over which the living ride—as Blake and Cézanne, among others, acknowledged. The art museum is both dead and living, but always a primary source for much of what is seemingly contemporary in our interpretation of what we see.

The extent to which works of art are placed in meaningful contexts, whether historical, material, technical, aesthetic, or other, represents the decisions of those responsible for the museum's policies and programs. However, one should realize that such contextual displays are arbitrary. Like a work of art or science, such contexts represent one ordering of data, and the effectiveness of the ordering is subject to exploration and evaluation. Still, one would probably not wish to apply the Dewey decimal system to the display of works of art. Retrieval for *all* of knowledge is not governed by the same assumptions as those required within a particular discipline. Specialized libraries use different systems, and art museums can present (retrieve) their works in contexts indebted to history, technique, media, subject matter, or aesthetic form—but these contexts must be consciously chosen and their components carefully organized. In short, the art museum has a responsibility to organize its primary sources, and in doing so it is performing a basic educational function.

However, there are different kinds of art institutions. A museum devoted to ceramics or art technology might well be expected to order its materials and its educational programs differently from those provided by a museum of fine arts, a museum of Christian art, or a museum devoted to contemporary art. Here we encounter a semantic problem, not only in terms of function but especially in terms of public and governmental acceptance. The word "museum" has, perhaps properly so, an aura of general acceptability. Accordingly, many other worthy activities, related but not by any means identical, are subsumed under the museum heading; the differing functions of these activities thus become commingled and result in a whole equal to less than the sum of its parts. We are in urgent need of an expanded vocabulary covering the often widely divergent needs and purposes of various individuals and groups devoted to the arts. In order to qualify for certain types of funding, the art museum tries to assume the role of elementary school; to qualify for other kinds of support, the cooperative art group may attempt to take on the role of the art museum. Furthermore, the art museum or the art center may even try to absorb all of these functions and many more. Such an undifferentiated organization runs the risk of becoming merely diffuse. Lack of differentiation may be very effective in a preliterate society, but it is usually ill-adapted to more complex, literate cultures. What we need is sharper differentiation, a more certain and precise perimeter within which we can effectively operate. The educational potentials of all art institutions, organizations, or groups are present and could be accounted for if only we know where to look. A large part of that search is for identification. We need to know with precision whether we are looking at a museum, an art center, an artists' guild, an art school, or a center for the performing arts. There is need and ample room for all these as well as for various kinds of art museums, but we need to define their functions. And, as the Bible warns us, their names are more important than we know.

## The art museum's purposes and public needs

All of this leads to the specific question of what is a real art museum and what are its educational responsibilities. It has already been indicated that the existence and availability of an art museum satisfies a large part of that responsibility. This massive, if passive, contribution should extend to the visual presentation of quality, always remembering that quality is more definable within given related types. Still, the dumb presentation of Botticelli with Jacopo del Sellaio is itself an education in the difference between the best and the good. If we extend this visual presentation to include the hundreds, thousands, or, in the case of a major institution, tens of thousands of objects, then the size of the educational impact becomes evident.

Evident it may be, even to the untutored but apt pupil; yet it would be the sheerest snobbism to hold that better results could not be achieved by doing more than just presenting works of art, no matter how cunningly they may be arranged. The question then becomes, what kinds of educational efforts will be useful to the fundamental purposes of the institution and the needs of its publics—not only as stated by them but also by their critics?

Most critics could agree that a lack of visual perceptiveness is a major failing of people educated in our literary and auditory society. Aesthetic education would then seem to be a unique and all-important activity for an art museum. Before considering that primary task, however, what of other educational approaches that may be both good in themselves and of assistance in the fundamental aim of aesthetic education?

We have already urged the utility of art history as a particularly suitable vessel for "interdisciplinary studies." The historical context, symbolic content, literary background, and technological fabric of the work of art cut across many humanistic disciplines and a few scientific ones. If the work is studied, examined, interpreted, and experienced by enlightened and profound means, it can be seen to contain a concentrate of the culture of a place in time and to be capable of stimulating reactions within the student's mind involving *his* culture.

The art museum and the teacher of art should use history, not only as a general screen behind the observed work, but as a specific and detailed part of that work. Frederick Antal's analyses of Florentine painting and the sources of its economic and social support, taken together with Millard Meiss's study of the religious confraternities and their impact on Florentine art, provide a profound reading of history as well as of art. If Ancient, Medieval, and Renaissance history are now rarely taught in secondary schools, perhaps art history could remedy at least a part of that loss. And what of early undergraduate exposure to the humanities? Is this not a proper and potentially fruitful opportunity for the study of art history, especially by nonmajors in that discipline?

Emphasis on "aesthetic form" in the first half of the twentieth century played havoc with literary painting and the literary "reading" of subject matter in art. Although one would not substitute art history for literature, full exposure to the complexity of art history by secondary school and early college nonmajors in art might profitably stimulate longer, deeper, and more imaginative readings of the subject matter of art and of its sources. The very process of transforming literary description or narrative into visual imagery, for example, is an intriguing and necessary human activity enlightening to those with unspecialized interests. One thing seems clear to me as a teacher: the competent student of art history understands more of the Vulgate and King James Bible than most of his high school and college peers. Well-explicated comparisons of Rembrandt's and Guido's Biblical subjects are effective means for understanding the Reformation and Counter-Reformation in the seventeenth century—and, of course, they provide other intellectual and affective benefits as well.

On the other hand, it is a commonplace that students of art history are seldom aware of the material and physical properties of the works about which they so freely extemporize stylistic and iconographic essays. Measurement, the chemistry of pigments and grounds, the physical properties of metal or stone, all have existence in themselves and as determinants of the final aesthetic shape of the work of art. Scientific theories have their reflections, sometimes dim but still discernible, in the artistic set of mind. Theories of indeterminacy, the Copernican "revolution," and Chinese prescientific cosmogony are a legitimate part of the history of art, and exposure to such phenomena would be salutary for students, particularly those who customarily avoid the sciences.

These aspects of art history are concerned with more advanced education. This need not be totally so, but it seems likely that such complexities embodied by the artist in his works are more accessible to secondary school and college students than to those in the lower grades.

## Aesthetic education and the schools

Here we must take up a primary educational task of the art museum and the schools—especially the latter. Most people can read (even if they do not) and can understand written or verbal exposition because they were taught to do so. Our compulsory mass educational system teaches students to recognize and to make meaningful combinations of visible and auditory symbols. They may not fully comprehend difficult texts, but *f-i-s-h* is elementary. Not so with visual forms (as distinct from linguistic symbols). The color wheel, the concepts of values, saturation of hues, the simultaneity of negative and positive shapes, the mathematical structuring of pictorial composition, and all such elements of visual vocabulary and syntax are not a regular part of the early school curriculum. There is simply no time in the school day for the visual arts, and the proof, if any were needed, is the unseemly haste with which art teachers are released when school budgets are reduced. One need say nothing of the kind of teaching, the quality of the teachers, or of their preparatory institutions. The evident fact is that the visual arts are a poor last in the educational order and that as a nation we are indeed visually illiterate.

We got here through the public school system, aided by long traditions of grassroots neglect of the arts. I assume that visual literacy can be achieved only by reversing matters. In terms of quantity the art museum can be only a minor part of the process. The mass educational system will need to be changed by pressures from without and within before any large-scale amelioration of the situation can occur. What then should the art museum do about mass education in the visual arts?

If we consider the numbers of public school students within cities or counties that contain adequate art museums and then add the number of those students in areas beyond easy reach of such art museums but who could use the museum's facilities, the physical impossibility of the museum's meeting this mass educational charge becomes crushingly evident. Recommendations that art museums should attempt to perform this task surely stem from ignorance. One-shot class tours are still the bread-and-butter ef-

fort of the museum for mass education, and in some cases they are at least a palliative. However, on balance (particularly considering how long they have been practiced), such tours have had no visible impact on the mass improvement of visual literacy.

The concentrated program (see chapter 6) involving lengthy and continuous exposure of the student to the art museum's environment and concerns has proved effective. If such a program cannot be physically provided at a major museum for all schools, it can at least offer a model for the schools themselves to use if they will. This kind of influence, achieved through models, pilot projects, teacher training, and special classes for those who *will* to have them, seems to me to be reasonable, effective, and attainable for the art museum with adequate professional educational staff and facilities. More could and will be done with older high school students (see chapter 10). The cooperation of museums and colleges or universities (see chapter 12) is growing and should lead to more and better exposure of the college student, even the non-art major, to the visual arts. These programs can be correlated or integrated with adult education efforts on the part of both museums and institutions of higher and extended learning. Still, if these future efforts are to succeed, they will have to be made within the perimeters of a reasonable and just estimate of what art is and what it can and cannot do. I have tried to indicate that these boundaries do not contain the notion of universal admiration for and need of the visual arts; nor do they include that therapeutic area where art is somehow *good* for anyone. Mutual respect among various disciplines, sports, and amusements may be more useful in the long run than anything else we could accomplish.

## Idealism and realism in the art museum

What I plead for is a pragmatic and realistic approach to the broader, larger considerations—and paradoxically, for high idealism in and dedication to details. This method of operation for the art museum, and particularly for its educational program, may not save the world, but it can help us to provide the most perfectly calculated displays of works, accurate and intelligent catalogs, well thought out and persuasively taught seminars or workshops, carefully conserved works of art, truth in labeling, recognition and use of the concept of quality, an almost infinite number of particulars. However, let us not deceive ourselves on too-perfect, all-embracing aims and purposes—just enough at a time to make the mark, always remembering the overriding need for the contents of the art museum to be visible now and in the future. The burning of books in China under the first universal emperor Shih Huang Ti, in Alexandria by some know-nothing Christians, in Germany within our memory, are concrete examples of man's willful destruction of his own accumulated wisdom and knowledge. The very possible atrophy of the art museum by misuse would be an even worse tragedy, for it shall not have been willed but accomplished by a lethal combination of good intentions and default.

Perhaps a postscript is in order here to ask for patience and objectivity in reading and evaluating the large quantity of following matter. The governing committee for the survey and its executive professional staff thought and debated at length the quantity of reports to be presented and the question of whether they should just report, take strong evaluative positions, or vary, depending on writer and report. The last tack was the one we chose, and we hope that all, including the writers here, will examine our present state of education in the visual arts with sympathetic but clear eyes.

As marginal institutions, suppliants to the private and public purse, art museums (meaning of course all those who staff them and make their policies) are understandably sensitive to reasonably objective study, let alone criticism. Tearing to tatters may be commonplace in the criticism associated with literature, music, and drama, but positive thinking and the maintenance of a solid, if mute, defensive front are standard good form in education and the visual arts—especially with regard to art museums. Critical (in the best sense of the word) studies and attitudes are uncommon in this area for a variety of reasons—penury, servitude, sloth, good manners, and not many others. The proof of the pudding is to be found in the literature associated with art museums (seldom, if ever, passionately for or against anything) and in the simple fact that most of the gifted talents in the field of art history and criticism gravitate at graduation to the colleges and universities. The complaint of many museum recruiters is not that nobody is available but that no person can be found. The intellectual stimuli symbolized by the healthy give-and-take of responsible criticism are largely absent from the "universe" of the art museum.

This lack of a critical climate both justifies and explains the style and content of the following reports. In this field we all need help, whether proffered in positive or negative form. Boosterism has no place in institutions claiming a rightful place in the intellectual community. And if art museums are not a part of that community and do not subscribe to what should be its tough standards, then they are indeed unworthy of the kind of unqualified support they request and urgently need. The breadth, depth, and detail of the studies represented here provide different insights and critiques useful in different ways to a world of varied individual art museums. May this prove to be another of Gibbon's "damned, thick, square book[s]."

*—Sherman E. Lee*

# I.

## The Art Museum and Its General Public

# Part I
# The Art Museum and Its General Public

When it comes to describing the educational role of the art museum for the general public, perhaps no one has come closer than Francis Henry Taylor, director of the Metropolitan Museum at the time of its diamond jubilee. He promised on that occasion that at last the museum would be able "to weave its incredible resources into the fabric of general education and take its rightful place as a free informal university for the common man."[1] Indeed, it is one of the art museum's attractions, for those who have learned to use it, that it is an open, unprogramed place, where people of every educational background can roam free. Any visitor can wander in and help himself.

The chapters in this section indicate, however, that many museum staffs think this kind of self-help needs to be made an inviting task. As the chapters in this section also indicate, simply opening the doors may mean that anyone can wander into a museum, but it does not always guarantee that everyone will. So some of the programs here deal with the various ideas that the museum and other institutions, especially community arts organizations, have come up with in their attempts to interest and serve parts of the general public who do not choose to come to museums.

## What art museums do for the adult visitor

Because there are no prerequisites to admission, most museums try to prepare themselves for a fairly mixed audience. But the nature of the subject matter often means that the art museum audience is smaller (according to the National Endowment for the Arts survey in 1971/72, though art museums represent 19 percent of all museums in the U.S., they attracted the lowest share of museum attendance, just 14 percent of the total number of museum visits)[2] and better educated than the audiences of other kinds of museums (for some statistics, see the introduction to chapter 2). It has thus been traditional in art museums to assume some

preparation on the part of its visitors and to aim at the upper end of the educational scale in exhibition themes, labels, lectures, catalogs, and other written material.

What were art museums in the early 1970s doing to provide educational experiences for these visitors? In the face of considerably higher costs and at a time when some museums were closing in whole or in part several days of the week to make ends meet, visitors found that more than half (54 percent) were still open 41 or more hours a week, 37 percent were open at least one evening a week, and 84 percent were still free at all times.[3]

Although some museums offer lunch-hour talks and weekend and evening programs, most museums schedule exhibitions and programs during weekday work hours. There is only scattered and inconclusive evidence in the National Endowment for the Arts study that museum educators are impelled by the art museum's self-proclaimed educational role to work on Saturdays and Sundays when general adult attendance is highest, or in the evenings, the only other time when employed adults are free to visit. Consultants to the Endowment study cited evening hours and evening attendance as "subjects worthy of future investigation."[4]

Slightly over half of America's art museums regularly provide guided tours, gallery talks, lectures, clubs, classes, and study groups for adult visitors, compared with the 70 percent that regularly provide similar services for schoolchildren.[5] Neither the Endowment study nor this one takes proper account of the energy and time that museums invest in these tours, lectures, and classes. Although they are sometimes conducted by volunteers and lecturers who are not always the most gifted teachers (the grim art historical lecture still lives, and so does the incomprehensible gallery tour led by the flippant star performer), visitors often can find in tours not only stimulation and information they could find nowhere else, but exceptionally talented educators, curators, artists,

and even museum directors whose observations embody a lifetime of thoughtful looking and learning. Painter Louis Finkelstein says in an interview later in this book (see chapter 13) that he has frequented museums from the time he was eight years old: "I learned as much in museums as from books, and I learn to this day. I could not be the person I am, much less the painter or artist or whatever, without just that access to the museum." And he learned, he says, particularly from gallery tours—"who Hatshepsut was . . . what Chinese white was, and how James McNeil Whistler made etchings. . . ." That kind of education must be acknowledged in any larger assessment of the museum's educational role.

That larger assessment must also consider the noneducational—some would say basic—and often overlooked functions of the museum. What art museums must do, for it is the task our society assigns to them alone, is to acquire, care for, fix, clean, study, record, classify, and store works of art. If the visiting public could see all that goes on behind the scenes in order for a museum to perform the basic irreducible core of custodial work, it might well wonder that there is time and money left to do anything called "education."

## The possibilities for educational effort

At least some segments of the public seem to understand that art museums do an important part of their educational job simply by staying open and exhibiting their holdings in ways that visitors can understand. But there is, of course, a great deal more that the museum can do, and the questions about how much more it *should* do tantalize the minds of museum workers. For example, is the primary educational purpose of the art museum to try to lead the visitor toward an aesthetic experience, which many museum workers feel is a form of spiritual experience? Or is it to give a greater understanding of art history, and through it, all history? Or to explore intriguing or provocative ideas, recognizing that however intriguing or provocative they might be, they are not necessarily approaches to the aesthetic experience? Or, if the collections and the way they are exhibited represent the primary educational efforts of an art museum, how shall "teaching" be based on them? Shall art museums devise an assortment of programs and approaches, or just exhibit the works of art and let them speak for themselves?

This last idea—that art tells its own story—appeals to many traditionalists. They observe, with satisfaction, that a museum is the "original drop-in learning center," offering a random-access educational environment rare in American society. To overlay on this free-choice, free-movement environment a series of programs and activities is, they say, to destroy one of the valuable and probably unique aspects of the museum as an educational enterprise. As an example, one critic, who says he finds it "less and less common not to have a visit interfered with by some group activity," believes the proliferation of such activity "damages other visitors' privacy with the objects." (Some who share his uneasiness

speculate that increased programed instruction for the individual adult visitor may have something to do with rising admission fees and the resulting obligation museum workers feel to offer more for their money to paying customers; they contend unhappily that increased distractions in the gallery offer the adult visitor less rather than more.)

## Answering the question of educational service

The programs in this section illustrate several perplexing issues that preoccupy museum educators and directors. One issue is a sense of distance that seems to exist between the museum and its several audiences. Sir Kenneth Clark has said that "museums should just put on the best they can and buy the best things that they can and people will come up to them. The moment a museum or gallery thinks it is going to go down to the people, that is insulting and degrading, and ruins the museum."[6]

Every museum worker in America recognizes the image and its implications: what does the notion of coming "up" to the museum or the museum going "down" to the public suggest about the relative postures of art museums and their audiences? And every museum worker knows that the slum, the corporate headquarters, and the union meeting room can be and often are equally "distant" from the museum. Reaching and teaching a broad audience over such an unexplored psychic distance, without condescension or superficiality, is a major educational challenge that faces art museums from the day they open their doors.

Another is the museum professional's uncertainty as to who comes to museums, and why. Are there whole sections of the community who do not come, and ought the museum do more to invite them in? Can a museum affect the makeup of the audience by what it plans, buys, exhibits, teaches, offers? By its public posture? What accommodations can and should an art museum make to a changed, or changing, audience?

One of the most important questions has to do with the need for widening the audience. Jolted by "community" demands in the 1960s, many art museums began to take another look at who their audiences were, and who they might be if museums responded in ways that representatives of minority groups urged. Branch museums, extension galleries, and outreach programs sprang up in many cities; a number of examples are reported in chapter 3.

An obviously neglected audience were those Americans who lived in rural areas or in towns too small to afford museums. Without the pressures others exerted in the 1960s, they, too, might have remained invisible. In the 1950s, the state-supported Virginia Museum of Fine Arts took the lead in designing mobile exhibitions of original works of art that traveled by van all over the state; where physical distance prevents people from easy access to a museum, mobile units provide one possible solution, and many art museums have now tried this "outreach" idea.

Though much of the turmoil has subsided in the more

conservative seventies, many art museums are still trying to understand their new "community" audience. Barry Gaither, visual arts director of the Elma Lewis School of Fine Arts and also director of the National Center for Afro-American Arts museum in Boston, makes clear that "emerging" institutions need and welcome all the help they can get from established institutions, but that they have learned one specific lesson: "Ultimately, if you want an institution to serve you, you have to make it."[7] This posture of independence is struck by most of the community museums and art centers that have survived the sixties and of those that are included in chapter 4. Just how they have survived and how they regard their relations with established institutions is a subject dealt with in all the reports in that chapter.

## Who teaches?

The final studies in this section deal with the volunteer docent, or instructor, in an art museum. Generally a well-educated, prosperous, white woman, free to spend her days in volunteer activity, the docent as traditionally observed seems an anachronism, a relic of a time when art museums were, as many people charge, the private preserve of the privileged. Certain changes in the character of docent groups—a few men, some students and retired people, occasional members of ethnic and minority populations—may mitigate that charge.

Two other aspects of volunteer docentry are also of interest. Though it is often overlooked, docents are the single most "museum-educated" audience in the nation. Their training courses, brush-up sessions with curators, exams and research papers, ought to qualify them as expert audiences, whatever their strengths or weaknesses as instructors. No studies exist, including our own, to prove or disprove the impact of continuing "museum education" on a self-selected adult audience. The other puzzling aspect is hardly ever overlooked: Why do institutions that increasingly call themselves, and are expected by the public to be, "educational resources" use unpaid nonprofessionals to do their teaching for them? This study discerns a growing interest in professionalizing museum education, a lack of definition of the profession, and the very real human and financial difficulties museums face in trying to replace their volunteer docents with professional instructors.

But it is plain that there is afoot an effort by museum educators to turn their field, no matter how slowly or clumsily, into a profession. What demands that will put on volunteers and what place that will leave for them are issues that will inevitably be raised, if not satisfactorily resolved, in the process.—A.Z.S.

## Notes

[1] Theodore L. Low, *The Educational Philosophy and Practice of Art Museums in the United States* (New York: Teachers College, Columbia University, 1948), p. 86.

[2] *Museums USA* (Washington, D.C.: National Endowment for the Arts, 1974), p. 48.

[3] Ibid., pp. 52, 53, 55.

[4] Ibid., p. 53.

[5] Ibid., p. 38.

[6] Conversation with Kenneth Clark, "The Museum's Duty, the Uses of Art History, the Education of the Eye," *ARTnews*, October 1973, p. 15.

[7] Transcript of meeting of community programs called by the CMEVA staff, New York City, May 13, 1974, p. 47.

# Profiles of Museums as Educational Institutions

## Introduction

To the casual user of any given American art museum, it may not be immediately evident that this "heaven of the certified beautiful," as it has been called, is conceived and administered with anything more than visual pleasure in mind. But as any history of American art museums attests, the idea of "education" has been a banner under which many a new institution has been dedicated—and dedicated many have remained over the years to that educational mission.

When the National Endowment for the Arts asked American art museum directors in 1971/72 which purposes and functions they considered "very important" for their museums, 94 percent of them chose "providing educational experiences for the public," and 74 percent listed educational experiences as one of their two priorities (for 64 percent, exhibition was the other).[1] As Sherman Lee's essay in this book suggests, what the proprietors of museums mean by

that word "education," to which they have tied so much of their purpose, is not so easily understood. Museum directors tend to include "everything" under "education": "Everything we do is educational," they declare, and go on to cite literally everything, from collecting and cataloging to exhibiting works of art and selling reproductions of them. "Looking at a painting," one museum director has said, "is educational." Says another, "Art is a language that has to be learned, and the museum is the place to learn it."[2]

Some members of the museum public are less inclined than museum directors to require educational purposes of the art museum—or at least to define them so broadly. A study of its visitors made by the Metropolitan Museum in 1973 found that "a bare majority," 51 percent, felt that the museum's main obligation is to educate the public; 41 percent thought "the museum should be a repository for collecting, preserving, and exhibiting great works of art," and among New Yorkers and regular visitors (usually also New Yorkers), the

majority felt the museum should be a collector rather than an educator.[3]

Why, then, do museum directors and trustees lay such stress on education? If their interest is more than legal—for the purposes of tax advantage, for instance, as Sherman Lee implies—what do they mean by education? And if museums feel so strongly about their educational role, how do they go about implementing it administratively, practically, and ideologically? What form does the educational priority take? And what educational level does it seek—the university or the school?

## Two "educational" art museums

To look for some answers to these questions, it may not be fair to pick out any museum as typical, for each American art museum has made its individual choices, depending on circumstance, community, source of support, collection, and, perhaps, directorial predilection. But there are, still, some common issues that art museums face in becoming primarily "educational" in purpose and style. The two museums described here—the Memorial Art Gallery in Rochester, New York, and the Museum of Modern Art in New York City—illustrate several of these issues, and the ways they have dealt with them may lay the basis for at least part of the examination of museum programs in the chapters that follow.

**The Memorial Art Gallery.** Legally a department of the University of Rochester, the Memorial Art Gallery was founded and is largely supported by private citizens in Rochester as "an instrument of art education," "a community art center," and a "teaching collection." Rochester, a city of only 300,000 people, is blessed with a wider variety of cultural institutions than some cities its size, and the gallery functions much like many urban art museums in the United States. It carries on educational programs that can be found in one form or another in most American art museums and art centers—a heavy schedule of group tours for children and services for their teachers and schools, an art school for interested amateurs, outreach programs for minority and special audiences, intensive training courses for a relatively large corps of volunteers who conduct school tours, special events organized by the education department for the public, and exhibitions to introduce local artists. What is extraordinary about the gallery is that it carries on all these programs and that perhaps more than most museums its size responds so readily, energetically, and flexibly to the educational needs of its community.

So primary is the gallery's commitment to education and its community, in some ways the province of its education department reaches well beyond what most museums are willing to grant. Labels for the permanent collection and much of the basic research for museum publications have long been the responsibility of the education rather than the curatorial staff. And the collection itself until only recently has been regarded and treated as an instrument of education,

not the museum's essential reason for being. (It is a distinction that may not be the happiest one for art museum directors, but one that is often made between the "repository," where the collection is the main objective of the institution, and the teaching institution, where the collection is secondary, meant to serve educational purposes rather than provide the inspiration and basic structure for them.) For the administrators of the Memorial Art Gallery, dependent on the steady flow of contributions for its annual budget, the important thing has been to design an educational program "that would appeal to our supporters"; "the basic motive has always been the fact that we had to keep very close to the people. They were the source of our support."

**The Museum of Modern Art.** A somewhat different educational aim motivated the founders of the Museum of Modern Art in New York City, an institution that has had spectacular success as an educational force. The group that began MOMA in 1929 was interested in winning acceptance and respectability for twentieth-century art. To do so, it created what Joshua Taylor has called "a new image of what a museum is." "From the beginning," says Taylor, "its goal was largely didactic . . . [its staff] concerned at all points with its relationship to the public."[4] Literally everything the museum did—exhibitions, publications, scholarship, studio classes, even the design of the building itself—was meant to spread its message to the public.

It was, as art critic Hilton Kramer has pointed out, a public "that was multi-leveled in its education, in its tastes, in its appetites."[5] But it was also an unusual public, in large part made up of New York architects, designers, museum-goers, gallery-owners, art buyers, young artists, students, art historians, decision-makers, intellectuals, and their children—the people who could most influence the course of the art's leading edge. There was no attempt, because no need, to reach the audiences that became important to the creators of community museums in the 1960s. So MOMA's techniques were tailored, at least at first, to an elite rather than a democratic experience. Nevertheless, in Kramer's view, the museum understood that however sophisticated its elite public may have been, it did not have to apprehend "fully" the values of high culture in order to get something out of an experience with it.

## The administrative and practical problems

Both museums have succeeded in doing what they set out to do. The Memorial Art Gallery has indeed become a community art center, staying close to its supporters, drawing large crowds to its events, and responding flexibly to the requirements of the public as they arise. The impact of the Museum of Modern Art has been so widely felt that no postwar museum or collection was built or gallery opened anywhere in the country without reference to it; the work of architects, designers, scholars, and artists alike was affected by what MOMA chose to collect, exhibit, and propagate.

The success of these two institutions has led them both to the point where certain issues might usefully be raised that apply to the educational responsibilities of many art museums. The Memorial Art Gallery, by the admission of its staff, has favored its educational mission at the expense of its collections, and the question is whether that imbalance is fair to the works of art it has amassed, however haphazardly, and the generations that might learn from them in the future. The Musem of Modern Art has "coasted," as *New York Times* critic John Canaday describes it, past the point where its original educational mission was accomplished, and the question, now that its collection has become "classic," is what educational role it should devise next.[6] The issues are partly administrative and partly philosophical and for art museums almost wholly universal.

**The proper province of the museum educator.** One issue has to do with the relationship between curator and educator, and it is one faced by both the Memorial Art Gallery and the Museum of Modern Art. In the report here, the gallery had not solved it. Its education staff was in what many museum educators might consider the enviable position of being able to write labels and undertake basic research for museum publications, in addition to its more usual activities. The curatorial staff—outmanned by the education department, counting volunteers and part-time instructors, by about 170 to 4—was barely able to gain access to the education department's research, let alone "firmer control" over it.

The Museum of Modern Art, in contrast, has brought its educational function firmly under control. Once atomized, its education department large, expensive, and separate, the museum has drawn together its curatorial and educational functions by an administrative device that makes education a part of the director's office. The assignment to the director's assistant for education is to make sure that curators are an integral part of the museum's educational activities and that those activities support, not operate apart from, curatorial objectives. When he hired his special assistant for education, MOMA's director was determined, as he pointed out, to find someone who was "a marvel of tact" and who could draw ideas out of curatorial departments as well as plant them there.

For both observers and administrators of art museums, the curatorial-educational encounter has become increasingly bothersome in the last decade. Joshua Taylor, director of the National Collection of Fine Arts, calls the relationship between the curatorial staff and "the activity of the increasingly aggressive education department" in art museums of the 1960s "a major problem," noting that it grew "with the orientation of museums more and more toward the public."[7] Hilton Kramer, who covered the 1975 meetings of the American Association of Museums in Los Angeles for the *New York Times,* has found the division between curatorial and education departments that exists in most art museums "an endless source of conflict."[8] Kramer would like to see

educators trained as curators are trained, then attached to each curatorial department to help the public understand the curators' installations and exhibitions.

It is a plan closely akin to the one put forward in the past by Metropolitan Museum Director Thomas P.F. Hoving, who would disperse the educational staff throughout the museum and fuse the two functions under curatorial control. On paper, the Metropolitan has effected a modification of this idea with its vice-director for curatorial and educational affairs, a single administrator to whom both staffs report. In practice, the two staffs are still physically separated, though education staff members work closely with curators and exhibition designers in carrying out educational plans for special shows.

To the degree that an art museum conceives of itself as the deliverer of specific services to the public, there will always be a need for a separate department of education. Art classes, lectures to 5th graders, the manning of mobile units, and the training of volunteers have not proved very appealing to curators educated to the higher reaches of scholarship and connoisseurship. On the other hand, if museum administrators really believe that "everything" the museum does is educational, perhaps there is a better way to join the particular talents and interests of the curator of art and the interpreter of it than the organizational divisions museums have so far designed. The Museum of Modern Art's plan may be one useful alternative, for it has succeeded in attracting the support of curators for educational activities and in several cases their interested participation as well.

**The confusion between education and fund raising.** Privately and publicly supported art museums share the problem of attracting funds and justifying them. As it happens, both the Memorial Art Gallery and the Museum of Modern Art are "private" institutions, whose income derives mainly from memberships, gifts, and endowments. But both museums are also the recipients of public funds—the state arts council, the National Endowments for the Arts and Humanities, and, in the case of the Memorial Art Gallery, "token" support from the city and county. Both, too, are tax exempt, as gifts to them are, a benefit that brings with it a responsibility to serve the public. Once an art object passes into a museum's hands, museum directors are wont to say, it becomes the property of the people, a public possession beyond price. As one art museum trustee has put it, "the people should be able to say that 'this institution belongs to me.'"[9]

For many art museums, self-conscious of their opulence in a society that is at least nominally egalitarian, educational activities are the ultimate justification for the amassing of artistic wealth. Public school tours do provide statistical evidence to lawmakers that a museum is carrying out its educational responsibilities; so do community workshops and special programs for the poor. Few museums undertake such programs cynically; most, including the two described here, have a genuine sense of educational mission, which they

work hard to fulfill, and most are concerned about enlarging their audiences by taking the educational initiative toward various levels of the public.

Yet art museums, public and private, are dependent not only on the good will of public officials but on the generosity of the well-to-do. Both the Memorial Art Gallery and MOMA are typical in their need for private funds and in their several methods of attracting them—and some of these methods are educational. The Memorial Art Gallery has its Women's Council and its intensive courses for volunteers, almost all of them members of the white, upper middle class that has the leisure to take part and the social leverage to keep the gallery in close touch with its supporters. The interest of these groups in the museum is as inevitable as it is helpful.

At the same time, there is no question that the gallery, like almost every other art museum in the United States, expends a good part of its educational energies on a relatively small number of people whose financial support is important to the museum. If money were not ultimately involved, might those energies be as usefully spent on schoolteachers, university students, young artists, or blue-collar workers, for whom a museum could work equally hard to design attractive social events and educational programs?

The Museum of Modern Art has been as assiduous, in its way, as the Memorial Art Gallery in its attention to private sources of funds. Its Junior Council, like the gallery's Women's Committee, has been responsible for a good many programs that have served new audiences—in prisons and senior citizen and community centers. But the museum's dependence on private wealth has meant that the Junior Council, which has been called a kind of training ground for the museum's board of trustees, is composed largely of the young rich, for whom, over the years, alliance with the museum has delivered a certain panache. Clearly, other young people are available to be advisers to museums like MOMA—working men and women, artists, university instructors, schoolteachers, and lower-middle-class parents who readily volunteer their time to other causes—and if funds were not so crucial a factor to the museum's survival, such people could be well used on Junior Councils and Women's Committees.

At MOMA, Victor D'Amico's educational efforts, too, were benefiting primarily the upper middle class, and it was not until the late 1960s when the museum felt the full force of community pressures that its leaders realized the education department was costing too much ''to service a very few'' and the D'Amico Art Carnival finally moved into the storefronts of Harlem. The museum had decided early in life to reach for the decision-makers first, yet that service continued long after its original educational mission had been accomplished; when money became available for cultural institutions to reach out to the poor, MOMA's educational programs, like those of other American art museums, changed to take advantage of it, and when that money dried up, most of the programs for the poor did too.

Art museums are obviously caught in this money bind, and they must be as adroit as they can in wriggling free. The point here is that their educational stance and specific educational programs easily become the tools to pry themselves loose, and thus the educational role of the art museum has sometimes been perverted by its need to raise funds—and its educational responsibilities compromised as a result.

**Popularization versus trivialization of art.** A third issue that is involved in the museum's overall educational role—and closely related to its fund-raising problems—is popularization: in order to attract audiences, and with them support, art museums face the need to make high art ''accessible.'' Frank Oppenheimer, director of the Exploratorium in San Francisco and a physicist who by interest and upbringing bridges the world of science and art, sees some dangers in popularization of art because it so closely borders on ''trivialization'':

A possible contributing factor to the trivialization of art, of the lack of conviction that art communicates important and valid perceptions, may stem from the way people react to the forefront of art. Neither school students nor the general populace are expected to extract meaning from a contemporary issue of the *Physical Review*. Their education starts with reexpressed ideas of Newton, Galileo, and Faraday. But contemporary artists either tend to sneer at people who cannot extract meaning from their works or alternatively deny that their works have meaning and insist that their works should be appreciated as meaningless aesthetic experiences. An abysmal contradiction in terms! . . .

This attitude has permeated art education. There is no longer a felt need to start children (or art students) with simple pattern perceptions and long-ago discovered ways of recording them. Art is not taught to students in such a way as to heighten awareness of the world around them or of themselves, nor is it taught as a way to relate to and make this world more accessible. It is not taught as a process of learning and discovering and of communicating what has been learned. It is not taught as a way of unifying separateness. It is too often taught, as science is also taught, as a nonexperiential and hollow mimicry of what artists (or scientists) are publishing at the forefront of the field.[10]

Trivialization is not a charge that has been leveled at the Museum of Modern Art, at least not often. Its methods of educating its public to the forefront of art over the years seem to have won the approval of many parts of its audience. The museum continues to insist, into its present period, on aiming its educational programs at people who come to modern art with some prior knowledge—high school and college students, teachers, and scholars, in particular. If MOMA has had any trouble with its audience in recent years, its teacher audience, for example, it has been in overestimating audience sophistication rather than overpopularizing the museum's art.

But for many museums the dangers of trivialization are real. When attendance goes down, as someone has recently commented, "the gimmicks go up." The Everson Museum in Syracuse (see chapter 3) is one institution that has been accused of gimmickry in its attempts to reach out to all segments of the community, and the wide swing that institution took from preoccupation with the collection to preoccupation with the community is instructive here. The Memorial Art Gallery was founded on the premise that it, too, should be nearly all things to all people—and, again, it has pretty well succeeded. Against this is the paradox, as Walter Darby Bannard writes in his essay for the American Assembly on "Art Museums in America," that the art museum cannot be all things to everyone.[11] When a museum tries to do everything, some things are not done as well as others. And the Memorial Art Gallery has made its compromises—partly, in the eyes of some observers, in the care of its collection.

There are other signs, too, that when the audience comes first, standards often come second. In making art accessible, museums sometimes give people the impression that art is easy. Frank Oppenheimer talks about "hollow mimicry" of what artists are doing, and it is a phrase that comes to mind when small children, as they are described in the Memorial Art Gallery report, are asked to "stretch this way and that" in front of a piece of contemporary sculpture. Social events clearly bring people to the museum, but do they make the art in it any more accessible? Does art, instead, become a vehicle for a social gathering, a kind of backdrop for a community center? Does the museum in that case "trivialize" its subject matter, underlining its own lack of conviction, in Oppenheimer's words, "that art communicates important and valid perceptions"? Is there a distinction between making art accessible and betraying it?

It is clear that an art museum must begin somewhere in its attempts to reach its public. But like the church, though its congregation is mixed, its subject matter cannot be diluted. As for its primary audience focus, in many cases museum dependence on private contributions leaves it little choice but to court, and at the same time to direct much of its educational activity toward, people whose understanding of the subject matter is crucial to the museum's survival.

It is a peculiarly democratic dilemma, and one these two museums are not alone in their attempts to resolve.—*B.Y.N.*

## Notes

[1]*Museums USA* (Washington, D.C.: National Endowment for the Arts, 1974), pp. 25, 30, 31.

[2]Comments at a meeting of the American Assembly on "Art Museums in America," Arden House, November 1, 1974.

[3]"A Study of Visitors to the Metropolitan Museum of Art," presentation charts, March 1974, #7, "Role of the Museum."

[4]"The Art Museum in the United States," *On Understanding Art Museums,* ed. Sherman E. Lee (Englewood Cliffs, N.J.: Prentice-Hall, 1975), p. 46.

[5]"Culture and the Present Moment, a Round-Table Discussion," *Commentary,* December 1974, p. 33.

[6]"The Agony of the Museum of Modern Art," *New York Times,* June 4, 1967.

[7]"Art Museum in the United States," *On Understanding Art Museums,* p. 65.

[8]Interview, September 17, 1975.

[9]Comment at meeting of the American Assembly, November 1, 1974.

[10]Letter to Junius Eddy, Rockefeller Foundation, October 16, 1975, p. 6.

[11]"The Art Museum and the Living Artist," *On Understanding Art Museums,* p. 166.

## MEMORIAL ART GALLERY, UNIVERSITY OF ROCHESTER: "AN INSTRUMENT OF ART EDUCATION"

Memorial Art Gallery
University of Rochester
490 University Avenue
Rochester, New York 14607

**This small-city art museum has dedicated itself to education and to the well-being of its community, a commitment it has carried out for more than half a century with a wide array of programs that grow and change in response to new needs— ethnic, social, and economic. How this "community art center" employs its collection and its programs for the educational benefit of its various audiences is the subject of this report. It is a story that may help, inspire, and sometimes—but not always—comfort other art museums in similar circumstances anywhere in the United States. CMEVA interviews and observations: November 1973; February, May, June 1974.**

**Some Facts About the Museum**

1. **General Information**
   Founding: 1913.
   Collections: Approximately 5,000 objects survey world art from ancient Egypt to contemporary America. The collection includes a good selection of American painting and some American folk art. No masterpieces.
   Number of paid staff: 40 full-time; about 50 part-time art instructors.
   Number of volunteers: 230 (Women's Council and docents).
   Operating budget: $745,000 (for fiscal 1973/74).
   Education budget: $35,000 (special programs not included).
   Source of funding: From membership fees, about 50 percent; university support, about 12 percent; New York State Council on the Arts, about 10 percent; class fees, about 9 percent; endowment, about 10 percent; plus admissions fees, gifts, token support of city and county.

2. **Location/Setting**
   Size and character of city: Rochester's population of about 300,000 includes the highest percentage of skilled, technical, and professional employees of any major metropolitan area in the country. Rochester is sixth highest of all American cities in per capita income and has one of the nation's highest ratios of Ph.D.s and millionaires. The black population increased from

6,500 in 1950 to 33,000 in 1964; 15,000–20,000 Puerto Ricans reside in Rochester.

Climate: Cool, temperate winters due to closeness of Great Lakes; supposedly has fewer sunny days than any U.S. city except Portland, Oregon.

**3. Audience**

Membership: Approximately 8,600: 800 are "special gift" memberships costing $30 and up; 241 are corporate memberships at $25 and up; the rest are family memberships at $20.

Attendance: 170,000 in 1973/74, of whom 36,000 attended the Medieval Faire and 60,000 the Clothesline Show. Admission to the museum is 50ᵉ; senior citizens are admitted at half-price.

**4. Educational Services**

Organizational structure: The Memorial Art Gallery is legally a department of the University of Rochester, but it functions as a totally independent institution. The assistant director for education of the museum heads a separate department and reports to the director of the museum.

Size of staff: 5 full-time, 6 part-time. In addition to the regular staff (some of whom spend time on special programs), 49 part-time workshop instructors and aides assist in Creative Workshop and Allofus Art Workshop activities, along with 110 volunteers.

Budget: $35,000 annually for the operating expenses of the education department ($26,000 pays a portion of staff salaries, the rest for supplies, equipment, telephone). Other gallery activities that are educational in nature are funded by separate budgets: exhibitions, lectures and programs, the library, Creative Workshop, Allofus Workshop, and others.

Range of services: Gallery tours, loan materials, travel-exhibits, in-school lectures, visiting artists, Creative Workshop, Allofus Workshop, library, classes for the handicapped, some lectures and films, teacher-training classes, community art shows, and special events for children.

Audience: Serves most segments of Rochester community but reaches primarily the white middle class.

Objective: "To be an instrument of art education."

Time: Open year-round.

Information and documentation available from the institution: None.

---

Rochester is a confident city. Incorporated in 1834, it began as a mill town and developed into a center of highly skilled manufacturing. Western Union started here, Eastman-Kodak and Xerox are based in Rochester, General Motors and General Dynamics have local divisions. Not only does Rochester have the highest percentage of skilled, technical, and professional employees of any major metropolitan area in the country, but it also has the highest per capita income of any city in New York state (it is sixth highest of all American cities),[1] and one of the nation's highest ratios of both Ph.D.s and millionaires. The city claims the first Community Chest in the country and is proud of its schools and its many old established social service agencies.

The people of Rochester who acquired money and education developed an active club life and a wide range of cultural and intellectual institutions. The University of Rochester,

with an endowment of $450 million, includes a good medical school and one of the nation's best music schools, the Eastman School of Music. The city's second major university, Rochester Institute of Technology, and the School for American Craftsmen constitute a national center of contemporary craftsmanship. The International Museum of Photography contains the largest collection of photographs in the world; the museum and science center recently completed a $3-million planetarium; a complete list of Rochester's cultural institutions would be too long for this report.

Given Rochester's resources and cultural accomplishments in other areas, an observer might expect the city to be the home of a first-class art museum, well-endowed with money and collections. The founding purpose of the Memorial Art Gallery, like that of many museums, was "to be an instrument of art education." Unlike many of its sister institutions, however, the gallery took this declaration with deadly seriousness: it has billed itself as a "community art center," its collection as a "teaching collection."[2] The Memorial Art Gallery is supported largely by memberships—about 8,600 in 1973/74—for its endowment is small. Some of its education programs have been in continuous operation for more than 50 years, affording an unusual opportunity to study the development of a museum as an educational institution, the impact such a museum can have on its community, and the impact on an art museum of a primary devotion to education.

## The development of an educational museum

An art museum for his city was the passion of George L. Herdle, painter and president of the Rochester Art Club. In 1912, after many years of agitation, he and President Rush Rhees of the University of Rochester convinced Mrs. James Sibley Watson to donate to the university funds for a museum building in trust for the people of Rochester, as a memorial to her architect son.

The university accepted the gift of the gallery without any accompanying endowment. To pay for the basic necessities of heat, light, and security, just to keep the museum open and going, the Memorial Art Gallery turned to the citizens of Rochester. Of the gallery's long tradition of concentrating on education, a former director says: "The basic motive has always been the fact that we had to keep very close to the people. They were the sources of our support. We needed to get the people in."[3]

The Memorial Art Gallery's educational emphasis began with George Herdle, its first director, and was continued by his two daughters, Mrs. Gertrude H. Moore, who succeeded him as director in 1922, and Miss Isabel Herdle, who joined her sister at the gallery in 1932 as associate director. Each daughter retired after 40 years, but both are still active in gallery affairs. Mrs. Moore sees the gallery's design to educate its supporters as a "very interesting dichotomy, to have a program that would appeal to our supporters—that was absolutely essential—but to induce these supporters to have

enough community feeling that they wanted to support something that would be valuable to the citizens.''

Harris K. Prior, the gallery's director since 1962, says of his predecessor, ''Mrs. Moore was always primarily interested in the impact of this museum on the public, on using the works of art that are here for the benefit of this generation rather than hoarding them for future generations which wouldn't, perhaps, care much about them at all if the present generation were ignored.''

Robert G. Koch, dean of the University College of the University of Rochester and a long-time resident of the city, observes that belonging to various cultural organizations is a firmly established social habit of upper-middle-class Rochester, whose attendant desire to educate other classes may be sometimes naive but has, he believes, ''a certain earnestness and concern about it. . . . There has been a faith in the ineffable effects of high culture.''

Membership has risen steadily, from 294 at the beginning to nearly 8,600 in 1974. Patronage has not; no major collectors or patrons beyond the original donor family have appeared. The collection consequently has grown unevenly, an unplanned amalgam of gifts of varying quality from local supporters. Even a $400,000 bequest in 1938 did not guarantee the resources to build either a specialized collection or a collection of masterpieces, and the gallery still had no focus for its growing collections.

The university connection helped provide that focus. Until the 1930s, all university art history and art appreciation classes were held in the gallery. Although Mrs. Moore and Miss Herdle—the only staff professionals until the late 1930s—made all purchases, university faculty endorsed important accessions, which were intended to be useful illustrations for university courses. Partly by choice, partly by necessity, the collection became a wide-ranging teaching collection that surveyed world art.

**Present relations with the University of Rochester**

Legally a department of the University of Rochester, the Memorial Art Gallery functions as a totally independent institution with its own board of managers. Trustees of the university must approve the managers, but their approval has always been a formality.

Originally located in the center of the university complex, the gallery housed all art history classes, and students wandered in and out. So reminisces Dean Koch, who was a student at the university and remembers the rich sense of the gallery's presence as a part of the university. As the university expanded, first the men's campus and then the women's campus moved to a new site along the Genesee River on the outskirts of town. By 1955 gallery and school were isolated from each other. The university decided against moving the museum to its River Campus; as it had been given to the university in trust for the people of Rochester, the easy access its central location offered to a wide public seemed more important than proximity to the university.

Chiefly because of its location, the gallery is now used very little by the university. A dwindling department of art history is a factor; the university has recently dropped its M.A. program in art history, and at one point there was discussion about abandoning the entire department. But the relationship has not atrophied entirely: classes still occasionally visit the collections, some gallery staff members have given courses at the university, and the museum exhibits the work of university faculty biennially and lends framed prints and reproductions to university students. The gallery's art reference library cooperates with the university's; the gallery library has most of the general art books, the university the specialized ones, and they try not to duplicate each other.

The gallery also serves the university as a show place, where trustee meetings and other events are held. The chairman of the university art department says that the gallery's comprehensive collection is a useful teaching resource and that he regularly assigns papers on its objects, because he believes that no student should go through a history of art course without a visit to the gallery. In 1970/71 the university tried to increase gallery use by running shuttle buses between the two institutions; the project has not been repeated.

The university contributes $92,000 a year to the gallery, approximately 12 percent of the museum's annual operating budget. According to Dean Koch, the university is satisfied that the services it receives from the gallery more than equal this investment.

## Volunteer Docents: One of the Gallery's Important Programs

Langdon F. Clay, assistant director for education, calls the volunteer docent program one of the gallery's two most important educational activities. School classes in the gallery had once been taught solely by the professional staff—that meant Mrs. Moore and Miss Herdle, and after 1937, Mrs. Susan E. Schilling—though in the 1950s members of the Women's Council began serving as volunteer guides through special exhibitions. When the gallery closed in 1966 for the construction of a new wing, Clay and Mrs. Schilling thought it the perfect time to expand the program.

One volunteer studied and visited numerous volunteer programs in art museums across the country, searching for models for a more permanent and expanded organization at the gallery. Her research provoked staff and volunteers to long discussions, out of which the present docent organization developed.

During the two years when the building was going up, the staff trained volunteer docents, only to find, when the museum reopened in 1968, that its nine trained docents could not handle the unprecedented demand for group tours. That year 4,000 schoolchildren trekked through the enlarged museum. In 1969 the number doubled, and the education department held a second training session.

When the number of children reached 11,000 in 1970, the training sessions became an annual affair. A part-time department secretary had till then scheduled tours, but it quickly became necessary to hire a full-time coordinator to organize and give focus to the docent program; one of the early volunteers, Jacquie Adams, requested and got the job. The program continued to grow; by the 1973/74 academic year, 50 active guides (6 were inactive) gave more than a thousand tours to 13,432 visitors.

As the docent program grew, it also became more rigorous. The original group of docents, working with the staff, formulated its own by-laws. In 1971, Mrs. Adams wrote a stricter set of rules, instituted over the strong objections of a few volunteers. Docent evaluation forms to be used by teachers with visiting school groups roused some docents, who felt that their freedom was being threatened and that it was unfair to subject volunteers to such a critical process. Ruffled feathers smoothed, most volunteers today eagerly check the evaluation forms to see how well they did—and in turn evaluate their visiting school groups. Mrs. Adams says, and Clay agrees, that a tight rein over volunteers is essential if they are to be responsible and if their organization is to be more than social.

Mrs. Adams believes she is able to control docents' activities as firmly as she does because the docents have an independent organization that sponsors both social and educational programs and events for its members, with some help from Mrs. Adams in planning their lectures. By giving docents their own area of authority, Mrs. Adams feels she is free to act in those areas in which her control is important.[4]

**Requirements for docents**

Qualifications for volunteer docents are simple: membership in the gallery and the interest and time to do the work. Some docents have art or teaching experience, but most do not. New members are added every other year, after making application, being interviewed, and joining a provisional class (limited to not fewer than ten and not more than twenty candidates). Between 60 and 75 percent of the candidates usually complete the class requirements.

The class meets weekly throughout the year for a mandatory art history course conducted by museum staff. Trainees must pass two examinations and submit a written sample of a one-hour tour, an exercise that, Mrs. Adams says, helps docents organize their thoughts. During the training each candidate is assigned to a "big sister" for an apprenticeship that includes demonstration tours for docents and staff and may last from six months to a year, depending on the candidate's aptitude.

Active docent status is conferred when a docent successfully completes two school tours monitored by a member of the education department. A minimum of two years' active service, including a minimum requirement of two tour-hours per month (and the clear expectation of one tour per week), seems a heavy schedule to some docents. On completing this minimum commitment, a docent may request inactive status, which means a continuing welcome at docent meetings and social events. For two years, an inactive docent is allowed to return to active status by preparing a sample tour and giving two tours supervised by a member of the education staff. Five years of docent service is rewarded by honorary status and lifetime membership in the docent organization.

Although active docents are expected to keep up with new gallery acquisitions and inform themselves about temporary exhibitions, special mandatory training sessions are held several times a year. Mrs. Adams plies the docents with batches of mimeo sheets: sample tours for different grade levels, technique guides, gallery games, age and grade characteristics, outlines of local social studies curricula, and much more.

Among other research materials available are reports on objects in the collection prepared by docents as penalties for having failed to meet their minimum time requirements. Docents who cannot fulfill the time requirements also must find their own substitutes. But they are generally expected to meet the tours assigned to them a month in advance, and, according to Mrs. Adams, assigned with the talents of the individual guide in mind. She believes that continuing education, personal attention, and firm control are critical to the success of the docent program.

**Who the docents are**

The Memorial Art Gallery docents, like volunteer docents in nearly every American art museum, are almost entirely white, middle- and upper-middle-class women. Attempts to recruit docents who would more accurately mirror the community have been unsuccessful. Two men—both middle-aged lawyers—have become active docents, but they are rarities; Mrs. Adams believes blacks, university students, and most men simply do not have the leisure time to do the work.

The gallery's docents are an active, even exuberant group. Their services are broadening, largely on their own initiative, beyond their original purpose of guiding school groups. Docents helped with the "Medieval Faire" (see below), and individual docents have conducted art workshops, presented slide lectures at several high schools, and ventured into other corners of the community for the gallery.

## School Programs in the Museum and in the Classrooms

### Group tours

Regular school lectures began at the gallery in 1917. In 1918 the gallery sought its first bus fund to bring children from crowded areas of the city to the museum. Early photos show children standing in stiff lines holding each other's hands as they obediently receive their art instruction. This first school program grew so quickly that it became an irritant

to some of the gallery's more conservative supporters: noisy schoolchildren simply had nothing to do with gentlemanly contemplation of works of art. A compromise was struck; on Fridays children were kept out and the gallery was kept quiet.

By 1924 the museum had grown; in addition to the director, Mrs. Moore, there was a librarian, a guard, a building superintendent, a janitor, and a secretary. In that year, besides organizing all exhibitions and taking care of all accompanying bulletins and publicity, the director gave 213 public lectures. The gallery's first full-time museum educator, Mrs. Schilling, says her initial task in 1937 was to ''revitalize'' the public schools' interest in the gallery, for the school program had not changed much since 1917. Working with teachers, she devised tours related to the schools' social studies curriculum, concentrating on grades 4–8.

Although she did ask the children questions on these tours, Mrs. Schilling says she did much more talking and presented many more facts than do tour guides today. Observing that the gallery's methods of reaching children on group tours have changed greatly since the 1930s and 1940s, she agrees this has been largely for the better, although she finds the new ways sometimes too permissive.

Almost all Rochester city schools, as well as outlying schools in a 45-mile radius, now send classes to the gallery. Mrs. Adams says that the thousand tours given by the docents in 1973/74 constitute a very full load and a healthy cross-section of the Rochester population, although better busing on the part of the schools could increase the number. Teacher evaluation forms reveal that approximately one-third of the children who come to the gallery for group tours have been there before with their class.

Appointments for group tours are made through the Rochester Board of Education Transportation Office or the Memorial Art Gallery's education department. When a teacher has made an appointment, the gallery mails out a package of information,[5] including a notice that, two weeks before the visit, 23 slides of gallery objects and a six-page written commentary will automatically be sent free of charge. A teacher who does not want this preparatory material is asked to call or write the education department. The system began in the fall of 1973; since then only two teachers, both in rural schools without slide projectors, have refused the slide sets. The slides are returned by mail or brought back on the day of the visit. Small greasy fingerprints and cracked glass, as well as comments on post-visit teacher forms, testify that the slides are well used; but the clearest indication of their success is the response of the class in the gallery, when the children recognize objects they have seen in slides and press the docents until particularly popular objects are included in the hour-long tour.

## Docents and school classes

On arrival, classes are divided into groups of ten and each group assigned to a docent; the museum can accommodate six such groups at one time. Most elementary school groups request a general tour, which the gallery hopes will give the students a basic sense of the collection and make them feel eager to return. No tours are canned; the docents try to adjust each to the school curriculum and to the special interests and capacities of each group, based on the teacher's return information sheets. The docents are encouraged to try various approaches until they find one that engages a particular group.

Each docent is free to determine the kind of tour she wants to give, but the general emphasis is on student participation. The gallery uses the term ''arts awareness'' to describe its tours, which are a freely interpreted mix of the techniques promulgated by Phil Yenawine (see the report on the Metropolitan Museum's Arts Awareness program, chapter 10), those of Muriel Christison from the University of Illinois, straight lectures, and everything else the staff has seen or heard about. Docents in front of a work of art may ask the children to try to express its mood by using their bodies. Or they may discuss subject matter, ask the children which picture they would like to live in, talk about the way of life a painting represents, point out similar formal elements in different objects, encourage the children to identify with the person represented in a portrait, explain materials and techniques used in the making of a work of art, and try to get children to equate an object with a physical sensation.

Together the docents and their children browse through the whole collection, picking out an object here and there, passing others by as they move around both floors of the gallery. The impression that comes across most strongly to an observer is that the docents are trying very, very hard. Some are doing things they clearly feel they are supposed to do, others seem to be following their own feelings with ease and sincerity. A group of bewildered-looking children stretch this way and that with a docent in front of a piece of contemporary sculpture. A docent sitting quietly on the floor with her group patiently explains the difference between the *stacco* and *strappo* methods of detaching a fresco from a wall; the children are only just beginning to fidget.

One of the docents' more direct approaches is taking into the galleries small straw baskets filled with pieces of fabric, statuettes, and other small art objects or reproductions that illustrate various materials and textures. In one gallery of paintings, where each child received an item from the basket and set out to find a painted surface with an illusion of the same texture, some children settled on the floor in front of a Rigaud portrait and carefully pored over pieces of brocade, silk, and velvet while they talked about the picture.

**Evaluation of the tours.** Between 60 and 70 percent of the visiting schoolteachers return the evaluation form sent to each class after its visit. According to education department reports, evaluation responses ''indicate that visits were not only enjoyable but reinforced and enriched the curriculum.''[6] A more elaborate evaluation form used in 1973/74 showed a similarly favorable response to tours, guides,

and slide sets. Some teachers wanted more preparatory material, especially materials for temporary shows, a desire the education department shares but cannot afford to satisfy; the department does fulfill individual requests. Other suggestions by the teachers included more careful use of vocabulary, more participatory tours, and more time for the students to see the museum on their own. Most teachers were not interested in extended visits, that is, a full or half-day in the gallery or a series of short visits. Mrs. Adams suggests that unavailability of buses may be a factor in this response.

Burt A. Towne, supervisor for art and humanities of the Rochester Board of Education, thinks there may be other reasons. A member of Memorial Art Gallery's board of managers and of the education department's advisory committee, he insists he staunchly supports the gallery's educational activities in general but reports he has received mixed reviews about the tour program from his staff of 70 art teachers. (Towne notes that his teachers represent only a small portion of the 2,000 teachers employed in the district.) He says he does not necessarily object to group tours, for he believes it valuable to get children into the gallery by whatever means; but he thinks that in-school programs would be a better use of the museum's time and money.

Like many school people, Towne notes that bus outings and field trips are less frequent than in the recent past because of increased demands on teachers' time and emphasis on "accountability": instruction in the primary areas of reading and math have diminished teacher concern for art instruction, social studies, and science. He finds many teachers no longer willing to spend a day or a half-day on an outside trip.

Education department head Langdon Clay, surprised by Towne's comments about the group tour program, stresses that the teachers who report to Towne make up only a small proportion of those who use the gallery. Clay adds that very few art teachers use it; on the whole, he observes, art teachers seem more self-protective than the elementary-level general teachers and social studies teachers who are the majority of gallery users. He speculates that art teachers trained in studio art in preference to art history may find the gallery intimidating or, conversely, unnecessary to their purposes. In any event, he is sorry that art teachers, a special group who could use the gallery in special ways, use it so little.

### In-school programs

**Loan materials.** The Memorial Art Gallery first prepared loan materials in 1926 when the museum closed for the construction of its first addition. The loan program was expanded in the 1940s when the war made bus trips impossible and again in 1970 when new information sent out to the schools triggered so many requests that new loan materials had to be made. Racks on both sides of a long corridor in the education department contain 500 framed reproductions, portfolios of 20 mounted pictures on a theme, and reproductions and photographs mounted on three-part, folding 3' x 6' screens.

Written commentaries, films, film-strips, slide tapes, and books, as well as 63 slide sets on 21 subjects, are also available.

Original materials are lent in either shadow boxes or special exhibits. The shadow boxes are glass-fronted wood cases, about the size and shape of a small suitcase, with a carrying handle on top. Mounted inside are inexpensive original objects and reproductions related to a single subject; the ten subjects covered range from primitive to Venetian art.

Special loan exhibits, which are offered to city elementary schools, are also thematic and contain original materials as well as reproductions; ten to thirty objects are packed in a large carrying box. When these exhibits were first designed in 1926, the objects could be used and handled in the classroom, but later they were locked in display cases, which the gallery occasionally lent along with the objects. There have been few problems with theft or vandalism, but in the last 15 years some objects whose value has increased have been withdrawn. Miss Herdle was known for constantly changing the material in the school loan exhibits; rummaging through the gallery storerooms and the loan exhibits, she chose objects she felt might appeal to children. Some objects that started out as loan materials are now on permanent display in the galleries.

Lists of available loan materials are sent to all school librarians in the nine neighboring counties and to all teachers who request group tours. Teachers may call the museum to reserve materials or visit the education department to browse and discuss their needs with the staff. Framed reproductions may be borrowed for one month, everything else for two weeks. In 1971/72 there were 2,400 loans; in 1972/73, 3,600 loans. Today the racks of loan materials are stuffed, and the program cannot be expanded unless additional storage space is found.

**Lectures in the high schools.** High school students traditionally make up the school group hardest to get to a museum. During World War II, when busing to the gallery had stopped, Mrs. Schilling and an assistant began giving lectures and slide talks in area high schools. As the program continued, Mrs. Schilling realized that with the proper materials, teachers could do many of the things she was doing.

Working with several teachers in one of Rochester's larger high schools, she began to organize an art and culture unit to be incorporated in the 10th-grade world history curriculum. Together they developed outlines on 14 periods of world art; each included a bibliography and was coordinated with loan materials available from the gallery. Besides the slide lectures on each period given by gallery lecturers in the schools, eight or ten slide sets with accompanying texts were produced for teachers who felt competent to do their own lectures.

Incorporated into the world history curriculum of the Rochester schools, the art unit was a model for the gallery's correlation with social studies curricula in all classroom lec-

tures, group tours, and loan materials for elementary and secondary schools.

Whenever money and staff were available, in-school lectures for high school students with slide and loan materials continued. Between 1970 and 1973 the program was funded by the New York State Council on the Arts. The lectures continued to be closely related to school curriculum, but became increasingly conceptual—for example, "Alienation in Nineteenth- and Twentieth-Century European Art," and "Man's View of God through the Ages." During those three years the program grew steadily; before it ended, it had reached 12,000 students, some of whom wrote privately to the gallery staff to express their gratitude for the program, as did many teachers.[7]

Nevertheless, when the gallery turned to the school system for support of the high school program, its proposal was turned down. So the gallery chose to put its arts council money into a new community workshop. Towne says the school system, then $6 million in debt, could not continue the program and speculates that even if money had not been an issue, the program might have been changed to make it more practical for the students.

At present the only gallery lectures in high schools are those done by volunteer docents on their own initiative.

**Art Ambassadors.** School case exhibits have been part of the Memorial Art Gallery's education program for 48 years. Like the group tours, this long-established service is being given one of the periodic boosts that characterize most of the gallery's traditional educational services.

In 1972 an evaluation form sent to city schoolteachers asked about appropriate materials and topics for the loan exhibits and about their usefulness. Many teachers proved to be unaware of the exhibits or unprepared to use them; one who knew them well was no more comforting, describing them as "dusty, old, greenish-gray" with poor quality objects, poorly presented.

In fall 1973, trying to make better use of the school case exhibits, the gallery sent three volunteer docents each month into three selected city elementary schools. While they were in each school to change the exhibits, the volunteers either brought classes to the case and explained the exhibit or brought the objects to the classes so the children could handle and discuss the material before it was arranged in the case.

Teacher response indicated a need for more volunteers. By the end of the academic year there were 17 volunteers serving 15 schools, or half of the city schools that requested the service. Solicited from among the docents and docent applicants who were well-informed enough to perform this service without special training, the volunteers, with Mrs. Adams, decided to call themselves "Art Ambassadors."

The gallery planned to hold its first training session for the Art Ambassadors in fall 1974. The five two-hour sessions were to be aimed at volunteers who already had art or teaching experience. For the first time the museum would use video equipment, obtained under a New York State Council on the Arts grant, to interview the students and teachers the Art Ambassadors work with and to allow the docents to watch themselves at work, especially trying out the discovery techniques emphasized in the training session.

The program leaves most of the initiative to the individual volunteer: each Art Ambassador is assigned to her own school, schedules her own visits and workload. Some spend one day a month at school, visiting classes and changing the exhibits at the same time; others change the case exhibit and ask teachers to sign up for a visit two weeks later, after the children have grown familiar with the exhibit. Most Art Ambassadors meet with the teachers beforehand to choose the exhibits and methods of presentation that might be most successful. The Art Ambassadors usually spend between 15 and 20 minutes with each class they visit.

**Visiting artists.** The Memorial Art Gallery's visiting artist project, funded first under a Title III grant and then by the state arts council, began in 1966. Unlike other gallery programs, it changes as much as possible so that it can continue to be funded as "innovative." The original purpose of the program—to send artists and their work into rural schools whose students could not easily visit the gallery—has shifted; today the program includes primary and secondary schools, only 60 percent of which are outside the city, as well as a home for the aged. The reason for the shift is simple, says a gallery staff member: rural schools did not ask as often or as early as city schools did.

About 15 or 20 local artists—the number varies from year to year—are paid between $25 and $75 a day, depending on how much time the artist spends; each artist may take as much as a full day in each school, presenting his work and conducting workshops. The gallery believes that the 60 visits made in 1972/73 reached about 6,000 students. Although Towne says he lacks information, he suspects the program may be operating on a reduced scale and that artists may be doled out selectively to those teachers who have used the program before. Because he has 70 art teachers working directly under him, he believes he is in the best position to communicate information about a program quickly and efficiently. But gallery staff say in response that they have found dealing directly with interested teachers produces the most successful working relationship.

The city school district has applied for a $20,000 grant to start its own visiting artists program. Although it would expect to work with the gallery and the Rochester Arts Council in locating artists, writers, actors, and others, the school system would maintain control over the program. The gallery's program is designed for a countywide area; the funding for which Towne's program is proposed is available only for urban schools.

## Relations with school administrators and teachers

Probably the most notable quality in the Memorial Art Gal-

lery's relations with schools, and indeed with all outside groups, is its ready response to specific requests. Teacher training at the museum, begun only recently, consists chiefly of occasional classes requested by a school or group.

But the gallery also takes part in the Rochester Arts Council's popular semiannual in-service course for teachers designed to introduce them to 12 local cultural organizations, including the Memorial Art Gallery. In spring 1974, 42 teachers took the course, receiving Rochester Board of Education credits toward pay raises.

In a short-lived program initiated by a parents group distressed by the city's dearth of elementary school art teachers, the gallery also helped to train volunteer art paraprofessionals for city elementary schools. The program was ended by mutual agreement between Towne and gallery staff, primarily because of the high rate of attrition among the volunteers.

The single largest cooperative effort Towne has participated in with the gallery was the school system's Title I mobile unit project. Between 1966 and 1971 (beginning the year the gallery closed for the addition of its new wing), the mobile van carried thematic exhibitions to schools all over the city. Besides providing office space and professional help, the gallery gave Towne a free choice among its collection, and some of the gallery's best objects spent a year in a specially designed tractor-trailer the size of a moving van.

Of the museum's receptivity to requests by outside groups, Towne says,

[When] somebody wants to come in and do something at the gallery, [or] with the gallery's support or just use their facilities, the gallery almost invariably says, "Yeah, let's do something about it." And they're only too glad to sit down and expound upon the possibilities.

He says that the gallery does far more for the schools than any other cultural organization in Rochester and compares the museum to Avis Rent-a-Car—it tries harder. He says,

It's a vital institution, and I think it's doing as much as one could expect. I certainly have more positive feelings toward the gallery—far more positive—than I have negative feelings. I think most of the people in the school system feel the same way. . . . The gallery is making valiant attempts to do things for the schools, and the problems that exist are as much the school's problems as the gallery's problems—you know, our inabilities as well as their lack of resources.

The relationship between Towne and the museum's education director began in 1960 when Towne was teaching art appreciation in a Rochester high school and Clay would visit regularly to lecture to the students. The two men still occasionally talk, primarily by phone, about programs, docents, students, and teachers, though each acknowledges that they have been trying for some time to arrange a meeting to share ideas about mutual concerns. Both are busy men; that meeting was still in the future when this report was written. Nevertheless, Towne says, all the requests he has made of the gallery, as well as those of his students (who are often assigned projects in the museum), have been met. Towne's teachers often ask to hold their meetings at the gallery and have never been turned down.

Despite all this, Towne says that relations with the gallery are of necessity a low priority in his order of business. He questions how important a role any art museum can play in the day-to-day process of art education in the schools.

## The Museum and Its Community Audience

### The Creative Workshop: a studio in an art museum

Studio art classes were among the very earliest education activities at the Memorial Art Gallery. They grew out of Sunday story hours for children; in an effort to give the children more intimate contact with the works of art, an hour of studio work was added to the story hour. The original idea of the Creative Workshop, to use studio work as a form of art appreciation, was a reaction against school art programs that stressed rote copying. Soon gallery members were asking for after-school classes for their children; by 1920 the museum had a regular staff for its art classes and by 1926 facilities comparable to those of an art school.

That was the beginning of the Creative Workshop which is responsible, according to Koch, for a "long-term rubbing-off" on thousands of Rochesterites, and for instructing many competent amateur painters. Mrs. Moore's belief that the best understanding of a work of art comes from working at art—at the quality of line or the wetness of watercolor—is the continuing basis of the program. Other approaches have been and continue to be used—modern dance, lectures in the galleries—all based on the gallery's collections.

Today the Creative Workshop is located in a neo-Gothic building connected to the gallery by a modern covered walkway. Once the university cafeteria, the space is well-designed and professionally equipped. The more than 30 classes offered each year to adults and children—in weaving, enameling, jewelry, ceramics, printmaking, painting, sculpture, and drawing—range from beginning level to some with professional standards. No credit is offered; the program is aimed strictly at amateurs. All classes include an introduction to the collection and tours led by the staff of the education department.

Open to those who pay $20 to become gallery members, Creative Workshop classes are offered at cost—$70 for a 29-week children's class, $145 for a 29-week adult class. Since 1939 the gallery has made available scholarships to the Creative Workshop, approximately 90 each year, or 20 percent of total enrollment. Virtually all paying participants are white and middle class or above, in contrast to the scholarship students, who generally come from minority groups.

In recent years other organizations have begun to offer credit and noncredit classes that parallel those of the workshop in both quality and range. Creative Workshop enrollment in 1962 was about 1,300 exclusive of scholarship students and special classes for the handicapped; in 1973 it was

1,200. An expensive program, budgeted at about $80,000 per year (its building is rented, and its instructors well paid), the workshop is intended to be self-sufficient. In 1973 the program lost $7,500; in 1974 it lost about $9,000.

Unable to subsidize such losses, the gallery has made a number of changes in an attempt to make the workshop more attractive to the community and to keep it solvent: more publicity, more flexible schedules, classes opened to non-members (with a 10 percent discount for gallery members), and summer extension classes in outlying areas. Clay admits that the traditional approach of the Creative Workshop may have lost some of its appeal, but he is still not sure whether the program will have to be dropped or simply revamped. He says, "If the changes do not work, and it comes to the time when the workshop is not needed, then we'll go into another business."

Memorial Art Gallery began offering outreach art classes in 1939, to bring the Creative Workshop to poor children in some of the most blighted parts of the city. The classes took place after school and during the summer in three neighborhood settlement houses and one school in a poor immigrant area. In cooperation with eight social work and religious groups, the program served Italian, Jewish, and mixed neighborhoods. Classes in painting, modeling, and weaving were taught by some of the ablest teachers from the Creative Workshop, with students from the workshop as assistants. Students in outreach classes who showed special talent were given the gallery's first scholarships to the Creative Workshop.

Special art classes at the museum also include the physically disabled. In the 1920s, with a special bequest, the gallery began its classes for the handicapped. Originally for retarded children, this project has developed into two 36-week workshops for deaf children in the gallery, and a class for children with orthopedic handicaps that meets at a city school. For a number of years the gallery also ran arts-therapy classes, developed under the Red Cross, as part of an arts and skills program at an outlying Veterans Administration hospital; and for 20 years, the gallery has conducted a ceramics class for the blind in the Creative Workshop.

### Outreach programs: exhibitions

Like most of the gallery's programs, the exhibition program tries to reach out into the community: the program of the 1970s continues the original purpose of the 1920s. Rochester is a city of many ethnic groups, all of whom have been invited at one time or another to exhibit their arts at the gallery. The museum participated in a statewide "Homelands Exposition" in 1920, followed it up throughout the thirties with a series of small ethnic shows, accompanied by Sunday afternoon performances of folk songs and dances. During the 1940s the gallery's attention turned to another aspect of Rochester's diverse population, and it held a series of exhibitions based on religious groups in the city.

Exhibitions have developed out of the staff's interest in Rochester's immigrants—like an exhibition of Lithuanian printmakers, prompted by the discovery of an important Lithuanian graphic artist who had fled from the Russian invasion and had found a job in a baby-food factory. With funds from local businesses, the gallery has also mounted special exhibitions and demonstrations in factory cafeterias; Miss Herdle remembers giving a slide talk to a group of Italian tailors, recent immigrants who were so excited when they saw pictures of their country that her lecture could not be heard over their talk.

Exhibitions for special groups in the 1970s are aimed, in Rochester as elsewhere, at nonwhite communities. Among other shows, the gallery sponsored one by ten local black artists at a Rochester health center. The Haiti Gallery, which shows African artifacts and the work of local black artists, has done one cooperative project with the Memorial Art Gallery and has sold work by its artists to the gallery. Carmen Fernandez-Teremy, director of the Puerto Rican Art and Cultural Center, which represents the 15,000–20,000 Puerto Ricans in Rochester, is pushing the gallery for more art exhibits in the inner city.

Both the Haiti Gallery and the cultural center want expert help from the Memorial Art Gallery. Haiti Gallery staff complain that the museum neither approves of its standards, nor works closely enough with community groups or accepts them on an equal level; they see part of the problem in the fact that the gallery and the community groups compete for the same grant money. Mrs. Fernandez-Teremy, who is already getting help from the gallery, concedes that her group is always allowed to use its auditorium and other facilities, but says the gallery is less cooperative in projects outside its own space.

### Memorial Art Gallery's response to changes in its city

The black population of Rochester jumped from about 6,500 persons in 1950 to 33,000 in 1964. In July of that year the arrest of a black youth on charges of drunkenness set off four days of rioting that left four persons dead, hundreds injured, a thousand arrested, and a million dollars' worth of property destroyed.[8] Forced to face the problems of their changing city, Rochesterites began the long process of integrating another new, unskilled, and disenfranchised population into their labor force, their schools, their social structure, and their cultural life.

Changes in the neighborhood around the Memorial Art Gallery reflect the changes in the city as a whole. Palatial homes on broad lawns along elm-lined streets were vacated by the rich on their way to the suburbs; in their place came social agencies with long names on ugly signs, and landlords with a knack for making one room into two and a half. On one side of the gallery a neighborhood that had been home to some of the wealthiest men in the country became "mixed," on the other side a neighborhood that had been middle class became a black ghetto.

In the gallery's search for the role it would play in this social change, Clay and Prior decided to hire a black staff member who could help reach Rochester's new poor and define the ways the gallery could serve them. With funds from the New York State Council on the Arts, they offered a job to Luvon Sheppard, a black painter and printmaker who grew up and went to school in Rochester and had worked as a recreation leader and teacher for the city and in several community and storefront art programs.

Sheppard knew that his community art activities needed better facilities and established backing if they were to flourish. That meant having an institution behind him. So he accepted the position of coordinator of neighborhood services and went to work in fall 1971.

**Coordinator of neighborhood services.** Charged to develop outreach programs, Sheppard spent his first year getting to know the institution and strengthening his wide acquaintance in the community, which included street people, ex-convicts, teachers, artists, and the men and women who organize and pay for social service projects. A member of several neighborhood and arts boards, Sheppard already enjoyed the apparent trust of both blacks and whites; his new position added to his prestige and tended to validate his community position at the same time it confirmed the gallery's trustworthiness. Clearly the gallery administration thought him a good choice and encouraged him to write his own programs. Clay calls Sheppard's program one of the two most important at the gallery—the other is the docent program—and Prior has said that even if state council funding ends, Sheppard's job with the gallery is secure.

Although Sheppard has succeeded in bringing minority audiences into the museum for special events, he is not satisfied with efforts to recruit nonwhites as gallery members. At one point, he tapped the resources of Mrs. Ophelia Liberty, who in one year's work in the membership campaign recruited an unprecedented number of members from the inner city. During her second year, Mrs. Liberty wanted the membership fee adjusted to income and asked the gallery to hold a fund-raising smorgasbord. Told that museum regulations could not accommodate either request, Mrs. Liberty quit.

Sheppard has started neighborhood art-lending galleries in three locations, where people can borrow reproductions and paintings donated by local artists. The month-long loans are free, but some of the paintings have been stolen, thefts Sheppard tolerates because he considers them an unavoidable element of a necessary program.[9]

But his central purpose as coordinator of neighborhood services is both broader and more specific than increasing art appreciation. He wants the gallery to help teach useful skills that will increase its clients' earning power. He had tried this approach before coming to the museum, organizing a short-lived art group in downtown Rochester and an inner-city art workshop taught by drug addicts in rehabilitation programs.

(Some of the "former" addicts, it turned out, were still using drugs, and when parents of children in the program complained, Sheppard agreed to kill the project.)

**Allofus Art Workshop.** Those two early art workshops served as preliminaries to Sheppard's chief venture for the gallery. He had been working with a group of community artists—public school teachers, art school dropouts, and some M.A.'s from the Rochester Institute of Technology—who called themselves "Allofus." In exchange for studio facilities for themselves and for their classes, the group wanted to offer free art classes for the community. The gallery accepted the proposal, and Sheppard, as both the leader of the Allofus group and the gallery liaison, began working to bring the idea to reality.

The project became a cooperative venture among Allofus artists, the gallery, the New York State Council on the Arts, the Rochester Public Library, and the Rochester Bureau of Recreation. Allofus artists did the teaching. The gallery provided the resources of an established institution—administrative skills, bookkeeping, publicity, and, most important according to Sheppard, credibility and moral support. Many storefront operations have come and gone in Rochester, leaving the black community increasingly suspicious of ventures that might use rather than serve them; Sheppard believes the effort to canvass the neighborhood and gain the confidence of the residents was important in planning Allofus.

With the museum backing for the project, the white community, too, found Allofus credible. The state arts council put in $10,000 a year for the workshop's operating expenses, the public library gave enough books to start a small art library, and after a year of negotiations, the city Bureau of Recreation gave the program the use of a fine old building. Massive but dilapidated, it had been used in turn by the city as a police station and jail, by the Police Athletic League, and by the Bureau of Recreation. The bureau's program had been resented by the mostly poor surrounding community, and the building was heavily vandalized before the program was finally shut down. It was now up to Sheppard to show the city, the gallery, and the state council that the old building could be put to good use.

The jail with its heavy steel door and barred windows had been turned into a boxing ring. Now it changed again, and with the addition of some ingenious homemade easels and a few pictures on the wall became the center of the Allofus Art Workshop's children's classes. In the basement an ancient pool table was used for rolling out clay. A kitchen on the third floor became a darkroom. A small room on the first floor was converted by the addition of black lights and psychedelic posters into a lounge of eerie intimacy. Sheppard and his artists scavenged for materials to change the nondescript and often forbidding spaces of the police station into studios for printmaking, painting, figure drawing, sculpture, pottery, stained glass and jewelry making, photography, and dance.

The workshop opened its doors early in 1972. By spring 1974 more than 500 persons were enrolled in 28 semester-long classes. Few of the original Allofus teachers were left, but Sheppard had put together a faculty of 22 who were each paid $15 for a two-hour session. Serious about the quality of the instruction at Allofus, Sheppard frequently uses the word "professionalism": high staff salaries are the first priority of his budget; he wants to bring top talent to the inner city and at the same time give a break to local people who have proved themselves in the community. As black artists in Rochester are few, most of the Allofus teachers are white, but Sheppard believes black instructors are crucial to its flavor and give black kids someone to look up to.

Because Allofus is subsidized by the state arts council, the charge for classes is only $2; even with extra materials fees for certain courses, Allofus is close to being a free school. Paradoxically, many of the participants at Allofus are white. Although the neighborhood changes between the museum and Allofus, only three blocks separate the two facilities. Suburbanites who drive in to the gallery's Creative Workshop apparently find it much more attractive to park at Allofus and take a $2 course there rather than go to the museum where classes cost $140. Sheppard believes they also come for specific vocational programs and for the ambience at Allofus.

**Creative Workshop and Allofus compared.** The paying participants of the Creative Workshop are almost exclusively white middle class, though, again, 90 scholarships—one-fifth of the enrollment—go mainly to minority students. Allofus, which is aimed at a minority audience, is serving as many whites as nonwhites. Facilities at the Creative Workshop are excellent, the spaces well-designed, neat, and professionally equipped. Allofus, by comparison, is run on a shoestring, much of the equipment either homemade or pieced together from odd gifts. There is no regular maintenance at Allofus (something promised by the Bureau of Recreation that has never materialized); when Sheppard has the time, he and a few friends do the job. Despite Sheppard's interest in professionalism and vocational training, the quality of instruction at Allofus appears to be lower than that at the Creative Workshop. To an outside observer it may appear that the gallery's Allofus Art Workshop is just a cosmetic program.

The people in the community do not accept this view. Nor does Sheppard, who proposed Allofus and is satisfied with its progress. The key factor in the difference between Allofus and the Creative Workshop is ambience, he says: Allofus is as much a community center as it is an art workshop. People who would never take an art class come in to see Sheppard, drink coffee, and hang around. Kids can get help with their math, family visits are encouraged. A neighborhood youth who once pulled a knife on Sheppard now helps him with the chores. There have been minor thefts from Allofus, but the vandalism that forced the closing of the building when it was operated by the Bureau of Recreation has stopped. Sheppard believes that Allofus participants feel it is their place, that they have some control over the programs, and he insists the resulting sense of independence is critically important.

Community organizations lodge only two complaints against Allofus. They argue that it should be located farther away from the gallery—in the heart of the inner city—and that the minority people it attracts are those who have already acquired some money and leisure, not the street people who really need to be served. Pat Wild, director of the Rochester Arts Council, says Allofus may be just a first step but that it is terribly important. According to Mrs. Wild, other arts organizations have tried to serve the city's black residents, but the gallery is the only one really doing it. She calls Allofus a "remarkable breakthrough in many ways because Luvon Sheppard is just fantastic. He's very sharp, and he has credibility in the black community."

The ratio of blacks to whites is balancing out as Allofus matures. Although it is obvious that a few people who can afford to pay more for art classes are taking advantage of the program, Sheppard and the gallery staff are unsure what, if anything, to do about the situation; they are, in fact, pleased that Allofus has turned out to encompass literally "all of us" and believe that the ethnic mix at Allofus is perhaps its greatest strength. An unusual ease between racial groups and classes, among people who generally have no occasion to meet or work together, characterizes the open, casual style of Allofus.

Catering to artistic dropouts or those who cannot afford the more expensive tuition at the Creative Workshop, Allofus welcomes and encourages everyone. The emphasis is on self-expression, though Sheppard observes that artists in a poor community cannot afford "just to express themselves." They need money. Pushing toward his goal of offering instruction in marketable skills, he now plans for Allofus students to make posters and earn money to purchase new equipment. He intends Allofus to offer both fine arts and vocational training, rather than to duplicate the Creative Workshop's primary devotion to the serious amateur.

The two workshops share some faculty and equipment. A few clients move back and forth; successful students at Allofus may move on to the Creative Workshop (and to local universities), while students at the older workshop who want a more relaxed atmosphere or classes not offered there go over to Allofus.

Enrollment at Allofus is low but steadily rising; enrollment at the Creative Workshop is declining. Clay attributes the low attendance at Allofus to the low financial commitment it requires; attendance at the Creative Workshop pretty accurately reflects enrollment. Because the Creative Workshop is user-supported, it is the more stable of the two programs. Allofus will probably fold if it loses its outside support. The gallery's attitude is that although one workshop instead of two might be obvious and practical, each workshop serves audiences and purposes still too disparate to be joined. Hav-

ing created a second workshop, rather than adapting and enlarging the existing one, the gallery tries to ensure that the two facilities complement rather than duplicate each other.

**Special education programs for the public.** That the gallery has been courageous over the years in leading the Rochester public is demonstrated by the fact that its first exhibition of American folk art was in 1932 (the same year the Museum of Modern Art sponsored its first big show of folk art) and its first exhibition of African art in 1936. Both shows were publicly criticized as "improper" for an art museum, as were, on the other occasions, an exhibition of George Bellows paintings that a former mayor called an insult to decency and a picture of a languishing nude that brought a protesting delegation of solemn citizens to the gallery's doors.

The gallery staff has used radio and television to reach its public. In the 1950s Clay did a weekly 15-minute daytime television program about art and related subjects on Rochester's educational station. His later efforts have included a series of 32 15-minute programs and two series of 15 half-hour programs. Both focused on ways to look at art, and both have been shown repeatedly for a number of years. Occasional hour-long shows appear; on a recent one, Clay and a local rabbi discussed with three artists relationships among art, the community, and the individual; the show included visits to the artists' studios.

The gallery operates a large lending and sales gallery for its members, largely as a service to local artists; any artist may submit work, which is juried several times a year. Since 1913 the gallery has sponsored lecturers—from historian James Breasted to designer Emilio Pucci—as well as talks by its own staff. Throughout the year concerts and films, dinner dances, and other social events take place at the museum. In one randomly selected month, gallery programs included a panel discussion, a two-piano recital, two concerts of chamber music, five lectures on different subjects, a demonstration, a film, an art tour to Ithaca, New York, and a "champagne gala" for members, sponsored by and held at a local department store to raise money for Allofus.

**The Medieval Faire.** Probably the single largest public event in the history of the gallery was its "Medieval Faire," a three-week spectacular in March of 1974. Proposed and sponsored by the gallery's Women's Council and the Junior League, the Faire got such extensive publicity that the gallery was afraid it might draw as many as 1,200 people into the museum on weekend days. In fact, weekend attendance exceeded 3,000 people a day; total attendance was 36,000, more than 20 percent of the gallery's annual figure.[10]

The Medieval Faire opened with a medieval banquet for members, who were encouraged to wear period costumes. Other activities, concentrated on weekends, included two puppet shows; a series of mystery plays and other dramatic events performed by local companies and children's groups;

wandering storytellers, balladeers, and jugglers; performances of medieval songs and instrumental music; dance recitals; lectures and films.

On view in the galleries were the museum's medieval collection and a few loan objects, along with a medieval town square, cloister garden, and bestiary built especially for the occasion. The town square consisted chiefly of a row of shops in which craftsmen's demonstrations were held, and a medieval inn where visitors could buy homemade bread, wine, and cheese. (The food stall made most of the unexpected profit, about $1,800, which has been turned back to the gallery to mount a traveling exhibition of medieval objects that will go to local schools.)

An elaborate sound-and-light slide show played in the museum's fountain court, itself a medieval period room. In craft workshops, children could make shields and swords and play at jousting contests and old games. "The Middle Ages—A Modern Legacy," a booklet prepared by Mrs. Schilling of the education department, included an essay on medieval art and life, reading lists, games, and crafts projects.

School groups flooded the gallery during the Faire's three-week run, 60 children scheduled to arrive every half-hour. The gallery staff and docents gave 320 tours to 5,132 students during the Faire, more than half of the year's total school tours.

The Medieval Faire was the gallery's first major educational endeavor in which the education department played only a peripheral role. Though the education staff had worked with the curatorial department, the Women's Council, and the Junior League in planning it—especially in deciding the Faire should be designed for 6th-grade level—most of the work was done by the curatorial department with the help of more than 600 volunteers.

Acknowledging that the Faire was a phenomenal success in drawing people to the gallery, education staff and many others judged it to have only minimal educational value. Clay thought the sound-and-light show, which he had hoped would illuminate the permanent installation of the fountain court as well as show slides, was more useful to adults than to 6th graders. Mrs. Adams also had hoped the 6th-grade focus would be clearer; with better planning, she says, demonstrations of crafts and the town square could have operated when school groups were in the museum instead of only on weekends. Had she been given more advance notice of particular activities planned for the Faire, and had there been more weekday activities, Mrs. Adams believes she could have brought in as many as 350 schoolchildren at a time, given them a ten-minute preparatory session in the auditorium, and then turned them loose to go to the various interest centers.

**Programs for senior citizens.** Senior citizens make up the single largest specialized audience in Rochester. The Rochester metropolitan area has the highest percentage of senior

citizens in the country and 130 senior citizen organizations. There may be as many as 100,000 elderly residents of Rochester, which has been called the "St. Petersburg of the North."

Since the 1940s the gallery has been making various attempts to reach this audience. The first effort—visits to nursing homes—was unsuccessful, because the residents appeared interested in nothing more than sitting around. Groups are now occasionally brought to the gallery, usually for relaxed social affairs, and admitted at half-price (25¢).

At the gallery's request, the Rochester Arts Council has formed a committee of local cultural organizations to study the role the arts can play in the lives of the aging. Among planned activities in which the gallery will take part are in-service training courses for nursing home personnel, special art classes, and a series of concerts and events that each institution will sponsor for one month. A museology student from Syracuse University spent the summer of 1974 at the gallery working on these plans.

**Artists.** If Rochester has not produced a patron to endow the Memorial Art Gallery with masterpieces, it has been the home of numerous regional artists who have served and been served by the museum. It was the Rochester Art Club (founded in the 1870s, it is the third oldest organization of its kind in the United States) that first pushed for an art museum in Rochester and provided the gallery's first director. Many graduates of Rochester Institute of Technology and the University of Rochester remain in the area, and the School for American Craftsmen, the Visual Studies Workshop, and faculty at area universities provide new ideas and a high level of professionalism for art in the Rochester area. Classes at the gallery and the Rochester Institute of Technology have built up a large community of art amateurs. Dean Koch and Langdon Clay agree that to a large extent the Memorial Art Gallery must be given credit for the development of many commercial art galleries—about 15, at last count in 1974—and of so many area art exhibitions that the list of them, compiled by the Rochester Arts Council, is ten-and-a-half pages long.

Many American art museums were founded by artists, but the Memorial Art Gallery is one of the few that has maintained a close working relationship with its local artistic community. Half of the 25 temporary exhibitions the gallery puts on each year serve Rochester area artists and craftsmen. The largest of these is the "Fingerlakes Exhibition," which originated under the sponsorship of the Rochester Art Club and has been held since 1879. Since 1914, the year the gallery opened, the exhibition has taken place there. In the 1930s, after serving on the jury of the Cleveland Museum's "May Show," Mrs. Moore opened the show to nonmembers of the Rochester Art Club, made it regional rather than citywide, and added a jury. Today first prize in the Fingerlakes show is the highest honor a local artist can win.

The museum's other important service to local artists, the "Clothesline Exhibition," has become the activity by which most people in Rochester identify the gallery. The exhibition was first held in 1957 when a clothesline was literally strung around the gallery so local artists and craftsmen could display and sell their work. Today the show, which takes place every year the weekend after Labor Day, uses snow fences and tables instead of a clothesline. The lawns around the museum are turned into a giant fairgrounds, with food concessions operated by the Women's Council, lottery drawings for works of art, pony rides, and a "paint pen" for visiting children. In 1973, 525 exhibitors drew an estimated crowd of 60,000 persons; the gallery says the number may actually have been twice that. In two days, sales totaled $98,000. A survey recently conducted by the New York State Council on the Arts revealed that some Rochesterites who knew about and had attended the Clothesline show had never even heard of the Memorial Art Gallery.[11]

Burt Towne says about the Clothesline exhibition,

A lot of people seriously interested in the arts are appalled by the gallery's involvement in the Clothesline show because there's so much garbage being peddled out on the lawn. Obviously that's a factor the gallery's aware of, but they still decide that, in terms of public relations and community involvement, it's worth it. Get the people over there. Show the people that there is this vitality whether there is some crap thrown in with the good stuff or not.

Dean Koch agrees: "[The show] can be an abomination. . . . You can see some of the worst stuff . . . but the gallery is the place people think of if they think of art. . . . It *is* the focal point, no question in my mind about that." Gallery staff members are well aware of such comments, and most acquiesce in the judgments.

## Money and Power

On a small budget, the Memorial Art Gallery sponsors a wide range of varying educational projects. Its 1973/74 budget was $745,000, of which educational services accounted for $35,000. There are separate budgets for related programs— the Creative Workshop and scholarships for it, for example, cost a total of $89,000 in 1973/74. An additional $40,000 to $50,000 comes from the New York State Council on the Arts annually. The budget for the curatorial department includes $57,500 for exhibitions and $24,500 for conservation. The gallery's professional staff is small, and the museum relies heavily on large numbers of volunteers.

### Money for programs and operations

Langdon Clay says that with better funding his education staff would go ahead full steam with many programs it has planned, but he has to choose his priorities very carefully. The gallery's program of curriculum-related talks in the schools—to which the education department was deeply committed—was dropped in favor of the Allofus Art Work-

shop. There was simply not enough money for both programs. The department's greatest budget problems are with continuing programs, because government funding is usually available only for new programs. Though the gallery has a remarkable record for maintaining its commitment to established programs, Clay says, "If you see a possibility of funding and it is primarily for innovative programing, you darn well start thinking in that direction."

The most encouraging element in the gallery's financial situation is its substantial membership, the twelfth highest art museum membership in the nation. In 1973 there were 8,584 members—out of a metropolitan area of over 700,000—who contributed $368,000 to make up approximately half of the gallery's annual operating budget.[12]

Rochesterites are induced to join the gallery through an efficient annual campaign refined by many years of experience. The museum had a full-time membership secretary long before it had a curator. The campaign is run by a chairman, usually a member of the board of managers, who presides over a campaign run like a United Community Fund drive, with divisions for corporations, special gifts, and general solicitation. Each division has its own chairman (and often an associate chairman), who supervises captains, who in turn supervise workers. This structure depends on about 800 volunteers each year.

During the year the membership secretary compiles lists of 17,000–20,000 names, working from donated club and church lists and also from purchased lists. Names are checked repeatedly to guard against irritating any prospective member with multiple requests. The campaign begins in the spring of each year with a series of meetings to settle dates and plan strategies. Participation in the membership campaign has an inescapable element of social prestige, which some workers see, paradoxically, as a negative factor in attracting new members.[13]

In 1973 the membership campaign brought in 241 corporate members who pledged an average of $50 (11 corporate members gave over $1,000) for a total of $84,000; approximately 800 contributing members who pledged $100,000 (417 patrons gave $100 and up); and pledges from general members that pushed the total amount pledged to over $350,000. A high percentage of pledged money is collected, although there are defaults every year—about $34,000 in 1973/74.

### The Women's Council

An important factor at the Memorial Art Gallery is the Women's Council, which one member of the board of managers believes is probably more influential than the board itself. Formed in 1939, the Women's Council took as its first project raising money for the early scholarships to the Creative Workshop. The council still provides this service and helps to support a majority of the gallery's other educational efforts.

Wives of doctors, lawyers, professors at the university,

Rochester business leaders, the 230 members of the Women's Council make up one of the most socially prominent groups in Rochester. Their president admits that the group is exclusive—new members must be sponsored by a current member and accepted by group vote—but describes the council as a hard-working service organization in which open membership would reduce the responsibility to the gallery each member now feels. She says members "are chosen on the basis of demonstrated leadership, a record of volunteer commitment to the gallery, and other qualifications which indicate that their membership and support will be in the best interests of the gallery."[14]

Members pay annual dues of $10, used to pay for the Women's Council's operating expenses; to help support the work of the volunteer docents, the majority of whom are on the council; to sponsor a prize at the Fingerlakes exhibition; to send a delegate to the VCAM (Volunteer Committee of Art Museums); to purchase flowers for gallery events; and to hold holiday parties for children and foreign students.

Volunteer activities of the Women's Council include staffing the lending and sales gallery and the gift shop; supplying drivers for the art class for the blind; helping the curator make inventories and working in conservation; sponsoring the annual members' dinner and open house; serving as hostesses and decorators for gallery functions; and sponsoring art tours to Europe and other art trips.

But the most important function of the Women's Council is to raise money. Its fund-raising efforts net an average of $15,000 a year ($17,000 in 1973) from a variety of activities. The Women's Council operates the food concessions at the Clothesline exhibit, whose profits, $3,347 in 1973, pay for scholarships to the Creative Workshop—21 to the regular session and 70 to the summer session in 1973. Money earned from other events goes chiefly toward new acquisitions, the most recent a painting by Asher B. Durand that required the accumulation of several years' earnings. Some funds are occasionally put into special projects; the Women's Council and Junior League each contributed $4,000 to the Medieval Faire.

Special fund-raising events are usually elaborate social affairs aimed at Rochester's prosperous citizens, but all have some kind of educational rationalization.[15] All are aimed at good social page news—a prime factor in inducing people to attend events that cost $30 a couple and up. The Women's Council recognizes that the character of its fund-raising projects could give it and the gallery a bad image in some segments of the Rochester community; hoping to remedy that problem, the council sponsored a holiday buffet before the annual members' open house and a "Beer, Brush, and Bluejeans" evening at the gallery in 1973, offering two rock bands. Eight hundred people, mostly college students, paid $2.50 each to come to the latter; the profit was $1,000.

During all these affairs the entire museum is open, and visitors are allowed to wander around the gallery with drinks in their hands. During the Medieval Faire, one unfortunately

placed sculpture was knocked off its pedestal, but the gallery says there have been no other accidents.

## The Collections

No institution can do all things equally well. With its long history of devotion to education programs, the Memorial Art Gallery did not hire a full-time curator until 1972. Robert Henning, the curator, says the gallery is still in the process of establishing consistent curatorial techniques and professional standards for presentation, organization of material, and record-keeping. Seventy-five percent of the collection is still unresearched. The museum's valuable print collection is in what Henning calls an "abandoned state"; storage conditions are "treacherous." The curator's files are confused, incomplete, and contradictory.

Henning estimates that the gallery has close to 5,000 exhibitable objects in addition to 2,000 prints, but he cannot be sure. He has no complete inventories. As he has begun to delve into the storerooms, he says he has unearthed works of art that are seldom seen or have not been exhibited together for years. Slowly he is beginning to bring these objects out, catalog them, and see that they are properly conserved. He says that the collection, as he found it, was presented from a point of view that overlooked its variety, range of representation, and vast potential.

Henning makes it clear that the state of the gallery's collections is in no way an indictment of his predecessor, Miss Herdle, the assistant director for curatorial affairs. He says Miss Herdle knew every object in the collection and could have professionalized the museum if that had been where her priorities lay. He calls Miss Herdle a genius as an educator, "terrific" as a contact with the community and as a lecturer. He sees his role in the museum as an attempt to fill Miss Herdle's shoes and at the same time raise curatorial standards. Henning says that this work will require a long time and great effort and that he simply does not have the staff to do it. The curatorial department now consists of the curator, assistant curator, registrar, and secretary.

Education of the general public is largely the responsibility of the curatorial department, the assistant curator planning most lectures and related programs. Basic research on the collection for labels and other publications has been done largely through the education department by persons who, according to Henning, sometimes do not have background or special knowledge in a particular field of art history.

The labels present a particular problem to Henning. They were done recently by four part-time researchers working for the education department under a two-year New York State Council on the Arts grant. Each researcher chose to write the labels his own way, and consequently some are anecdotal, some scholarly, some casual, some expressive; all are accompanied by maps, photographs, and other pictorial references. The curatorial department argues that they are too long

and use information in a glib, off-hand way, and that their purposes have not been properly analyzed. (The guards are reported to enjoy them and to report in turn that visitors read them, but Henning claims that a visitor could spend 120 minutes reading the information in one case.) The curatorial department would like access to the education department's research and firmer control over it.

The reversal of conventional department responsibilities derives from an earlier time when both the gallery and its staff were smaller. (Until just a few years ago, there were fewer than a half-dozen professional staff members.) Henning and his assistant curator have been with the gallery only two years. Mrs. Adams and Sheppard, who supervise the two programs Clay thinks most important, have been at the gallery four and three years, respectively. Clay has been there for twenty-two years, Mrs. Schilling for thirty-seven, and both are aware there are new ideas and new problems stirring.

Harris K. Prior, director since 1962, characterizes some of the changes he has seen and taken part in during the last 12 years:

> [We have opened] up the gallery, through both educational and curatorial programs as well as public relations, to greatly increased numbers; to much more widely diversified age and social groups; and, as a beginning, to members of minority groups. Internally, the organization has expanded to become more structured and professional, as exemplified in a clear-cut table of organization and individual job descriptions. . . . Physically, the plant has been doubled in size, the collection has increased greatly, and security has been improved. Greater interpretation of the collections has been attempted through extensive re-labeling.[16]

## Some Conclusions—and Some Questions

Periodically during its history, changed circumstances have forced a re-evaluation of the Memorial Art Gallery's programs and a new burst of energy. The most recent re-examination began in the 1960s, prompted as much by social unrest, new populations, and new government funding as by new staff and new museum facilities. To this re-examination of purpose and program, the gallery brings a special asset: its long history of educational service.

On that tradition it can build, and is building, new educational and community service programs. Granted, there are no educational activities at the Memorial Art Gallery that cannot be found in more spectacular form in some other American museum; but the gallery can claim distinction for long-term commitment to its programs and for the total, and totally generous, response to the city's educational desires that those programs mirror.

Perhaps an equally notable characteristic of the Memorial Art Gallery is the catholicity of its programs. At a time when group tours and volunteer docent programs were meeting

increased criticism in most museums—as ideas whose time had passed—the gallery was unself-consciously building up its tour and docent programs. At the same time, it gave remarkable freedom to a new black staff member to try experimental programs. Without apparent regard for any philosophical or ideological stance, without much money or fanfare or claim to inventiveness, the Memorial Art Gallery picks up on whatever it feels it can do well—and leaves the rest undone.

That is the hard question: is it unavoidable for an art museum to skimp on its curatorial responsibilities if it devotes itself so thoroughly to education? Without outside pressure, the Memorial Art Gallery has devoted nearly all its energies to serving the people.

What does the Memorial Art Gallery's experience serving the people of its area suggest to other art museums? A critic might claim that

- School people do not understand your efforts; witness the school art supervisor who says that cooperation with the museum is a low priority and who doubts the value of an art museum in a school art program.
- Prosperous patrons use you for their own purposes: witness a Women's Council designed to "support" the activities of an art museum, that charges only $10 a year for dues and spends much of its energy in entertainment, when annual dues of $100 per member would instantly raise $23,000, nearly a third more than all the parties and other fund-raising activities now make.
- Minority audiences do not appreciate your willingness and what it costs you: witness an effective school program correlated with the social studies curriculum sacrificed for a studio workshop that would make nonwhites feel "comfortable," but that they do not attend in substantial numbers.
- Observers are bound to misinterpret what you are doing; witness the inferences listed here.

More sympathetic observers defend the gallery's performance:

- Teachers do respond, even if administrators do not: witness the repeated and enthusiastic use of loan materials and requests for even more.
- Patrons do give much of themselves: witness the hours volunteers invest to help schoolchildren, curators, and the gallery's shaky finances—and some even give money, too.
- Unfamiliar audiences do gradually come round: witness the slow but steady increase in attendance at Allofus by neighborhood people who were at first wary, some of whom may yet choose to become part of the devoted art museum public that selects itself from every segment of the society.
- Artists, amateur and professional, do nourish themselves on the gallery's offerings and in turn nourish the community: witness the art activity in Rochester, at least some of it credited to the gallery over many years.

The critic may take Rochester's Memorial Art Gallery as a warning, the sympathizer as a model for the museum as a generous educational institution. The use of its objects has been Rochester's primary focus. If utilization is a valid priority for an art museum, then where is the balance struck between utilization and conservation, education and solid curatorial work? The differences between staff members interviewed at the Memorial Art Gallery are not the stereotyped differences between curators and educators but the beginnings of an unusual debate between these two museum professions: what is the best way to carry out educational practices? As part of its unusual devotion to education, the gallery has long entrusted certain traditional curatorial prerogatives to its education department; now that the staff structure is becoming more conventional, the debate may become so too. There is a fine line between generosity and an indiscriminate eagerness to be helpful, and the Memorial Art Gallery treads it with prudence. Its philosophy is itself a statement of generosity:

> The guiding principle behind the educational activities of the Memorial Art Gallery is the same as for the Gallery as a whole, namely, that the inherent capability in human kind to create, contemplate, use and enjoy the visual arts needs greater development in our time. The Gallery attempts to provide the maximum number of people with the maximum number of opportunities to develop this capability. . . .

Without the opportunity to develop one's aesthetic muscles in our mechanized society, they will tend to atrophy, resulting in an under-designed, chaotic and ugly environment and a populace unhappy and unfulfilled.

There are of course many practical limitations in attacking such a broad goal, such as funds, plant and staff. But within these limitations we believe in trying as many different approaches as we can and evaluating the results in terms of their impact.[17]

—*F.G.O.*

## Notes

[1] From a full-page advertisement run in the February 5, 1967 issue of the *New York Times* and quoted in "Eastman Kodak and Fight," a case study prepared by the Northwestern University School of Business (1967, p. 2).

[2] Publicity brochure, Memorial Art Gallery.

[3] For sources of quotations without footnote references, see list of interviews at the end of this report.

[4] In 1973/74 the docents had 30 meetings. Activities included a series of weekly discussions on objects in the collections and methods of presenting them to children, conducted by the museum staff; a series of review sessions which covered periods of art represented in the gallery, conducted by the docents; a study group in "arts awareness" techniques, conducted by the docents; a diorama committee, which researched material used by the docents; a dance performance and dinner; a tour of a local historic site (with lunch at Dolly Madison's diningroom table); a workshop in panel painting; and numerous lectures by the mu-

seum staff and guest lecturers in areas of art in which the docents felt they needed more information. Of particular note was a series of five lectures and tours on local architecture given by a docent who is also an architectural historian.

[5] One sheet in the package explains the mechanics of bringing a group to the gallery, lists some rules of conduct, recommends a wide range of available loan materials, and includes "A Story About the Memorial Art Gallery" written for elementary school-children. A second sheet is an information form, which asks the teacher to choose a type of tour, to tell what cultures or countries the class has studied, what art experiences or preparation the class will have had for the visit, what the average ability and attention span of the class is, and whether the class has been to the gallery before. On the back of this sheet are forms that the docents use to evaluate the tour after it is over.

[6] Educational Department Summary Report, 1972–1973, Memorial Art Gallery.

[7] Ibid.

[8] "Eastman Kodak and Fight," p. 1.

[9] There is hardly a program at the Memorial Art Gallery that does not have some precedent. The gallery's first community art-lending service was started in 1939 by Miss Herdle, and she describes it as her biggest failure. With money donated by the gallery's Women's Council, Miss Herdle put together a collection of 200 framed reproductions. To initiate the program she held an exhibition and tea at a school in a poor neighborhood. No one came. Miss Herdle met with leaders from the area to try to sell her plan, and even abolished the 25¢-a-month rental fee. Still everyone was suspicious of the program, and Miss Herdle was stuck with 200 reproductions. The problem was resolved by an agreement with the Visiting Nurses Association, which made visits to house-bound patients. The nurses brought different pictures with them each month; the service was gratefully received and eventually taken over by volunteers from the Women's Council. Approximately 40 persons were served.

[10] The "Medieval Faire" was also celebrated all over Rochester. The Strasenburgh Planetarium put on a special related show called "Sky-Scanning—Medieval Lore of the Heavens," the public library mounted medieval puppet shows, a local church sponsored a concert of medieval music, and the University of Rochester Medieval House held special lectures.

[11] The New York State Council on the Arts-Whitney Museum Audience Response Survey, conducted by George Nash, Director, Drug Abuse Treatment Information Project, Montclair State College, compared audiences in Rochester and New York City in an attempt to determine why people do or do not come to museums. Nash's chief conclusion: that ennui keeps people away, and the only people who complain about museums are those who go to them.

In downtown Rochester 213 persons were interviewed in April 1974. They were 85 percent white, all white-collar workers—people who would normally be considered likely to come to an art museum. Seventy-one percent had been to the Memorial Art Gallery, 51 percent more than once. Fifty-three percent had attended the Clothesline Show (a remarkable figure for an event that takes place only one weekend annually). Sixty-six percent had been to the International Museum of Photography, 45 percent more than once. Seventy percent had been to the Museum and Science Center, 51 percent more than once. Eight percent were members of the Memorial Art Gallery. Thirty-one percent were interested or said they might become interested in being members. Thirty percent painted; 45 percent had taken art or art appreciation courses; 39 percent owned works of art; 93 percent had visited some museum.

[12] Annual family membership costs $20. There are also contributing memberships at $30 and up, patron memberships at $100 and up, corporate memberships at $25 and up, and student memberships at $10. Membership benefits include free admission (regularly 50¢): a special lecture series; invitations to openings and events; an annual members supper and open house; eligibility for the Creative Workshop (as of 1974, with a 10 percent discount); use of the lending and sales gallery and a 10,000 volume library; participation in gallery-sponsored art tours; discounts on publications and on items in the gift shop; a free subscription to *Gallery Notes*, the monthly announcement of gallery activities; and professional consultation on antiques and art objects.

[13] In an attempt to determine the kinds of people who become members, the gallery sent all members a questionnaire in 1973. Approximately 1,800 were returned. The results, in percentages, are as follows:

| Age: |
| --- |
| 1.6 were under 25 |
| 27.7 were between 26 and 36 |
| 39.5 between 36 and 50 |
| 24.5 between 51 and 65 |

| Marital status: |
| --- |
| 78.3 were married |
| 57.9 had children |

| Occupation: |
| --- |
| 47.4 were professionals |
| 25.4 had management positions |
| 19.4 had other white-collar jobs |
| 0.8 were blue-collar workers |
| 1.0 were students |
| 3.6 were retired |

| Salaries: |
| --- |
| 43.0 earned over $25,000 per year |
| 42.6 earned $12,000–$25,000 per year |
| 11.8 earned $6,000–$12,000 per year |
| 2.3 earned under $6,000 |

| Reasons for joining: |
| --- |
| 63.9 from a general interest in art |
| 54.3 to benefit the community |
| 47.3 because of the programs offered |
| 32.2 to take advantage of the art classes |
| 1.3 for other reasons |

Included in "reasons for joining" were: "It runs in the family" and "During my bachelor days it seemed like a good way to meet girls." Of the respondents, 491 had been members for more than ten years; 267 for six to ten years; 541 for three to five years; 535 for one to two years. Ninety-four respondents said they would not renew their memberships: 31 of these were moving; 28 said they did not use their memberships enough; 16 said membership was too expensive. Most comments about the gallery were warmly supportive. Many expressed concern that the gallery was too elitist and too isolated from its community. Other comments ranged from exhibitions, programs, and classes at the gallery to complaints about the quality of the sherry served at openings.

[14] Janet Forbes, president of the Women's Council, quoted in a letter forwarded by Langdon Clay, August 19, 1974.

[15] A Venetian Ball, which was held in June 1973 and netted $5,300, followed the gallery's first-class art tour to Venice. An "Executive Art Auction," the other special fund-raising event of 1973, sold off works of art that top Rochester executives had made for the occasion; with dinner and cocktails at the gallery, it earned a profit of $5,100. According to the president of the Women's Council, the event was very successful in attracting a new audience of business people. For a "Gatsby Evening," in July 1974, the gallery was transformed into an evocation of the 1920s. The doors of the gallery were measured to see if a 1929 Rolls Royce could drive through; another antique automobile was stationed outside the main entrance, and a third in the sculpture court.

[16] Letter from Harris K. Prior, September 30, 1974.

[17] Ibid.

## Interviews

Adams, Jacqueline. Coordinator of Educational Volunteers, Memorial Art Gallery. November 11, 1973; February 7, May 20 and 21, 1974.

Bellman, Eric. Associate in Education, Memorial Art Gallery. February 2, 1974.

Bennett, Margaret. Membership Secretary, Memorial Art Gallery. May 21, 1974.

Clay, Langdon F. Assistant Director for Education, Memorial Art Gallery. November 12, 1973; February 7, May 21, 1974.

Davis, Eddie. Instructor, Allofus Art Workshop. February 7, 1974.

Fernandez-Teremy, Carmen. Director, Puerto Rican Art and Cultural Center of the Ibero-American Action League, Inc. Telephone. May 29, 1974.

Forbes, Mrs. Charles. President, Women's Council of the Memorial Art Gallery. May 21, 1974.

Henning, Robert, Jr. Curator, Memorial Art Gallery. May 21, 1974.

Herdle, Isabel C. Curator Emeritus, Memorial Art Gallery. May 21, 1974.

Koch, Robert G. Dean of University College of Liberal and Applied Studies, Director of Evening Session and River Campus Summer Session, University of Rochester. May 20, 1974.

Merritt, Howard. Chairman, Department of Fine Arts, University of Rochester. Telephone, May 4, 1974.

Moore, Mrs. Gertrude H. Director, Memorial Art Gallery, 1922–1962. May 21, 1974.

Nash, George. Director, Drug Abuse Treatment Information Project, Montclair State College. May 29, 1974.

Prior, Harris K. Director, Memorial Art Gallery. May 20, 1974.

Rongieras, Joan G. Assistant Curator, 'memorial Art Gallery. May 21, 1974.

Sanford, Clyde. Director, The Haiti Gallery. Telephone, June 14, 1974.

Schilling, Susan E. Lecturer and Research Curator, Memorial Art Gallery. May 21, 1974.

Sheppard, Luvon. Coordinator of Neighborhood Services, Memorial Art Gallery. February 7, 1974.

Towne, Burt A. Supervisor for Arts and Humanities, Rochester Board of Education; Member of Memorial Art Gallery Board of Managers. May 20, 1974.

Wild, Mrs. Pat. Director, Arts Council of Rochester. May 20, 1974.

# THE EDUCATIONAL MISSION OF THE MUSEUM OF MODERN ART

Museum of Modern Art
11 West 53rd Street
New York, New York 10019

**How a major American museum with a spectacular educational past shifted gears to adjust to the realistic, less spectacular present, aiming, along the way, at two specific educational goals: educating teachers and fusing museum educators with curators.** CMEVA **interviews and observations: December 1971; January, March, July 1972; February, October–December 1974; March, April 1975.**

## Some Facts About the Museum

1. **General Information**

   Founding: 1929.

   Collections: About 40,000 works of art from the period 1880–present, generally agreed to be the most comprehensive collection of modern art in the world. The collection includes 3,000 paintings and sculptures, 2,600 drawings, 10,000 prints, 800 illustrated books, 3,000 examples of furniture and useful objects, an unknown number of architectural drawings, 2,000 posters, 14,000 photographs, 4,500 films, in addition to a reference library of 30,000 volumes.

   Number of paid staff: 365; 61 of these are staff of the six curatorial departments, 31 of the curatorial staff are professionals. Education staff, 4 full-time employees and one part-time employee.

   Number of volunteers: 50 members of the Junior Council; 175 members of the International Council; occasional other volunteers.

   Operating budget: $6,317,402 (1973/74). The 1973/74 education budget was $212,000, or 2.65 percent of the museum's operating budget. Except for a few functions, primarily the curatorial study centers, this sum includes all the museum's educational expenditures, including staff salaries.

   Source of funding: Admissions fees, membership dues and contributions, exhibition fees, grants, endowment funds, federal and state government support.

2. **Location/Setting**

   Size and character of the city: New York is the nation's largest city, with a population of 7.9 million in a standard metropolitan statistical area of about 15.5 million (1970 census). This includes about 1.6 million blacks and nearly a million Puerto Ricans (70 percent of the Puerto Ricans in the continental United States reside in the New York area).

   New York is the country's leading industrial and commercial city as well. Its five boroughs boast 42 museums plus many parks, zoos, botanical gardens, theaters, and concert halls. Its educational facilities include 6 universities, 23 colleges, 976 public schools, over 1,000 private schools, and 199 public libraries.

   Climate: Temperate. Lowest average monthly temperature over a 30-year period is 33°F., highest 77°F. The weather seldom affects attendance at cultural institutions.

   Location of institution: Commercial area in mid-town Manhattan, near several other museums, just off Fifth Avenue, one of New York's main shopping centers.

Access to public transportation: Subway is right across the street, other subway and bus routes in the area.

**3. Audience**

Membership: 30,000.

Attendance: 900,000 annually.

**4. Educational Services**

Organizational Structure: Director's special assistant for education runs an education office; there is no separate education department.

Size of staff: Three full-time, one part-time, one intern.

Budget: $212,000 in 1973/74.

Source of funds (1973/74): $75,000 from the Noble Foundation, $15,000 from the Noble Foundation Endowment, $41,000 from the New York State Council on the Arts, $10,000 from the Howard Johnson Foundation, $5,000 from the museum's operating budget, $50,000 from the National Endowment for the Arts and the National Endowment for the Humanities and other foundations, $13,000 from the New York City Board of Education, $3,000 from the Gallery Dealers Association.

Range of services: Special admission rates for students from junior high through college age; teacher orientation (including preparatory materials and tours); New York City Public High School Program (guided tours, student training program, student seminars, teacher and student passes, films, slide sets); graduate study hours; museum training program (internships, volunteers, museology visits); lectures, gallery talks, study centers, library; Museums Collaborative workshop and forum; distribution of books to community organizations.

Audience: 6th grade through college students from both public and private schools. Complexion of public school groups reflects the population of the New York City public schools, 36.6 percent black, 27.1 percent Spanish-surname, 34.3 percent other. Beyond the services to schools, education programs tend to concentrate on a specialized audience of scholars and college and university students in the New York area.

It can be said that most art museums are born of a cause. Few museums, however, have had such a specific, focused, burning purpose as the Museum of Modern Art in New York. In his book about MOMA, *Good Old Modern,* Russell Lynes writes of the museum's "missionary zeal," its "missionary spirit," and the scheme of its first director, Alfred Barr, to use the museum "as a means of educating the public not merely in what was new in the arts but in how they had evolved and where they seem to be heading." "Figuratively speaking," says Lynes, "Barr was conducting a public course in the history of the modern movement, and his blackboard . . . was the Museum."[1]

Before MOMA opened in 1929, there had been only two exhibitions of modern art of any significance in the United States—the 1913 Armory show and a 1921 exhibition of Impressionists and Post-Impressionists at the Metropolitan Museum. In a climate where Cubism and abstract art were considered the work of madmen, MOMA became the first museum to bring contemporary art seriously before the public and to devote itself totally to that cause. According to its president, Mrs. John D. Rockefeller 3rd, MOMA invented the museum of contemporary art.

Over the years, MOMA assembled the greatest collection of modern art, 1880 to the present, in the world. In the process, it did a great many other things: in its effort to help people understand modern art, it brought a totally new style to the way art is exhibited; it set up the first film library, giving impetus to the acceptance of cinema as an art form; it was the first museum to exhibit photography as art (1932) and the first to establish a department of photography (1937); it organized the first department of architecture and design (1932); it set new standards for museum publications; its exhibitions—of posters in 1933, machine art in 1934, African sculpture in 1935, household objects in 1938, American Indian art in 1941, to name a few—gave birth to ideas and styles that still nourish museums all over the country a generation later; and it opened the first branch museum, the Boston Museum of Modern Art (now the Institute of Contemporary Art) in 1935.

By the time of its 25th anniversary in 1954, MOMA had been so successful at its missionary task that Paul Sachs, one of the founding trustees, could say of the men and women who had built it, "They have made the Museum a telling instrument in the field of general education. . . . Their influence and example have liberalized the policies of every one of our leading museums—even the most complacent." Finally, said Sachs, the museum had won the battle for the public mind:

> Through courageous, audacious and crusading leadership, the Museum has changed the climate of public opinion from one of hostility to one that is today open-minded and receptive to all aspects of modern art. No longer is the new dismissed with contempt and ridicule. Instead, there is in the art world of America an attitude of curiosity, reflected in books and periodicals, in the daily press—yes, even in the universities.[2]

MOMA reaches its fiftieth anniversary in 1979. A museum that started as a forum for its own time has been a success. In 1929 fewer than five galleries in New York showed contemporary art; today there are close to four hundred. When the museum was founded, there were no books on contemporary art; now, says a MOMA curator, "you have to fend them off."[3] Then no respectable American museum would touch contemporary art; now it is a rare museum that refuses to hang it and does not vie in the marketplace for the works of living "masters." The museum of contemporary art that invented the breed has been replicated many times over across the country. MOMA's influence on the course of twentieth-century art, architecture, and design has been incalculable.

For MOMA itself, success has brought with it new questions and new problems. MOMA began with the intention to teach, and exhibitions were its first priority; building a collection was secondary. Today with the best collection of modern art in the world, MOMA has joined other museums whose educational and curatorial tasks are quite different from those

institutions that have little to care for. As its president recently remarked, "In the process of inventing a modern museum, we have accumulated a classic collection, and that has changed the teaching character of the museum."

Now the collection has become MOMA's primary resource. That single fact has meant substantial change—in staff,[4] motivation, leadership, audience, finances, and educational impact. What has happened to the Museum of Modern Art—how it carried out its educational mission when that mission was fresh and revolutionary and its crusading spirit at its peak, as opposed to how it views its educational role today—holds several lessons for any art museum that looks carefully at its own educational responsibilities. If MOMA's problems seem to be larger than most (few museums, for example, have been through the kind of debilitating strikes that afflicted MOMA in the early 1970s, nor are museum deficits generally so high), they are not unique. It is a rare art museum that will not recognize in this report something of itself.

### The collection as education

Any museum that is firmly didactic in purpose starts with the premise that the museum as a whole is educational, that "education" is not exclusively or perhaps even primarily the province of the education staff but that the collection itself and the curators who tend and exhibit it are actively a part of the educational function.

Even though MOMA has had in the past a large, separate education department and is one of the few art museums today with a special endowment for its education activities, it is one of those institutions, as its director says of it, whose rationale "is to be educational in everything."

For MOMA this rationale starts with its collections.

Whether or not MOMA should build a collection in the first place was a debate that began early in the museum's life. Trustees in the early thirties spoke of "retirement by sale" of museum acquisitions. MOMA's president then, Conger Goodyear, once compared the "permanent" collection to a river: "The Museum of Modern Art," he said, "should be a feeder, primarily to the Metropolitan Museum, but also to museums throughout the country."[5]

In the end, the river idea gave way to the pride of possession. By the time the museum was 25, says Lynes, MOMA owned "much of the best of all that mattered in the arts of the last seventy-five years."[6] It still does. So the museum's most important role now is to exhibit its collection, to fill it out, and to show works of art that can be seen nowhere else.

**Reinstallation of the collection.** In 1973 the museum reorganized its permanent collection of paintings and sculpture and designed a new "educational installation," as the curator of the collection, William Rubin, calls it. According to the museum's director, Richard Oldenburg, the purpose of the installation is to be art historically complete. Rather than exhibit only the best pictures, the museum shows, for example, a Boccioni instead of another great

Matisse. Art critic Barbara Rose, in a review of the new installation, wrote that "the museum has become a kind of living textbook . . . illustrating didactic points." "The sense of history," she pointed out, "the obligation of scholarship to make history visible and intelligible, has clearly motivated the reorganization of the collection. . . . The museum is pledging itself to an increased consciousness of modernism as a coherent movement rooted in historical time, which exhibits not random developments but certain orderly connections."[7]

**National program of circulating exhibitions.** MOMA has always considered itself a national and even international museum, with a responsibility not simply to its New York City community but to the rest of the world as well.

One manifestation of this role has been the use of the museum's collection for shows prepared by curatorial departments expressly for circulation to universities and smaller museums throughout the United States. These shows were originally administered by the Department of Circulating Exhibitions, set up in 1933 in response to requests, as one museum director put it, for "worthwhile exhibitions of modern work."[8] The MOMA shows were so popular that in one year, 1954, nearly a third of the museum's 820 exhibitions were circulating shows. Between 1931 and 1959, says one MOMA brochure, the department sent out more than 500 exhibitions to 894 localities in the United States and Canada.[9]

The program has slacked off in recent years because of its high cost to the museum, but there is still great demand for the exhibitions and a desire on MOMA's part to respond. Although these shows have tended to be adaptations of exhibitions originally prepared for the museum itself—as opposed to the special shows prepared exclusively for travel—MOMA circulated 15 exhibitions in 1972/73 for showings in 20 states. For the Bicentennial, the museum planned a circulating exhibition, "American Art since 1945," for eight museums from Massachusetts to California. The show was accompanied by educational materials and a lecture series organized by the museum.

**The International Program.** Exhibitions that circulate abroad are also prepared by the curatorial departments, but they are sponsored by the International Council, set up as a separate corporation in 1956.[10] Administration of the exhibitions comes under the International Program, a seven-member staff within the museum. The council, which listed 168 members in 1972/73, draws its backers from all over the world—18 states and 20 foreign countries. Its aim is "specifically, to increase knowledge of, and appreciation for, [modern] art and connoisseurship" abroad.[11]

Although some members of the staff question the financial wisdom of sending costly exhibitions abroad, for others the international exhibitions are basic museum educational activities. One curator has found that print shows have had a particular impact in India and South America; professional

artists in India, seeing Picasso for the first time, often stayed in the gallery as long as it was open.

## MOMA's first education department

Even though the Museum of Modern Art's most important educational impact has undoubtedly been made through its collections and the exhibitions the museum organized over the years, its influence has been significant in educational activities more narrowly defined. For more than three decades, these centered on the teachings of Victor D'Amico, head of MOMA's education department from its beginning in 1937 until his retirement in 1970.

D'Amico, then head of the fine arts department at the Fieldston School in New York, was hired part-time in 1937 "to work out an educational project through which the Museum's material would become more useful to and more used by secondary schools in New York,"[12] the educational level the museum had been addressing itself to particularly since 1932. The project was meant to be a response to the Packard Report, which laid out suggestions for MOMA's relations to schools and colleges. The report urged "the provision of facilities for popular instruction *in accordance with the public need*" and called for, among other things, educational films, a gallery for beginners, and ways to interest men as well as women in art.[13]

The Educational Project, as the department of education was first known, became an official part of the museum in 1938, and that year D'Amico began working full time at MOMA. Over the next 30 years, MOMA was to "pioneer," as D'Amico puts it, a score of art education programs that have become sign-posts of the time—among them, the Young People's Gallery, the National Committee on Art Education, the People's Art Center, the Children's Carnival of Modern Art, art classes for schoolteachers, an NBC television series called "Through the Enchanted Gate," parent-child art classes, and a second television series based on the idea and called "Art for the Family."[14]

**Victor D'Amico's philosophy.** Though his methods seem to have fallen out of fashion in recent years, Victor D'Amico was an important figure in art education and probably the single most influential museum educator of his generation. His educational philosophy deserves a summary here to help put MOMA's programs in perspective.

To D'Amico, "the principal aim of teaching is to develop each individual's sensitivity to the fundamentals of art and thus to increase his creative power and his awareness of the vast heritage of contemporary art and that of the past."[15] He feels that people of all ages can derive satisfaction from an art experience regardless of artistic talent, a belief he carried out in classes at MOMA that attracted New Yorkers from age three to sixty.

For children D'Amico's basic rubric is that each "must work in a way natural to him." The real problem, D'Amico writes in his book, *Experiments in Creative Art Teaching,*

"is to free the child of his clichés or imitative mannerisms and to help him discover his own way of seeing and expressing."[16] D'Amico disapproves of teaching children to copy because imitation, he claims, produces a result without the experience of creation. He opposes, as well, the use of coloring books because they require a precision and rigidity unnatural to a child. Once given the time and encouragement to explore and express ideas freely on his own, D'Amico believes, the child will learn perspective and other mechanical techniques as he needs them.

Despite D'Amico's emphasis on inventiveness and imagination, however, he argues that children, as well as adults, "need the guidance of experienced and sensitive teachers." It is "a grave misconception," D'Amico writes, "that children are self-taught." In all his programs he placed importance on the role of the teachers and the understanding of the parent. "The art teacher," he says, "is vital to the education of the individual: his selection and preparation are, therefore, of greatest importance."[17] MOMA's free art classes for teachers from the public schools and the roster of staff members that D'Amico built up during his years at the museum are evidence of his convictions here.

As for the adult, D'Amico's ideas are not much different. Adults, like children, learn best by combining the manual with the visual. But in addition to his interest in helping adults gain personal satisfaction in "sensitive expression," D'Amico looks for an enlightened public, "so that the need for good art education will be recognized." In his work at MOMA, he wanted parents, administrators, and members of school boards "who dominate the curriculum" to "understand the basic aims and methods of art education" so that they could see it as an indispensable element in a well-balanced education.[18]

In all of this, D'Amico feels, the art museum itself has a fundamental responsibility. Although D'Amico does not urge every museum to offer studio classes, he feels that only in communities where "sufficient creative opportunity is given to children in the schools" should the art museum be let off the hook. Otherwise, he finds the needs of art education so great that duplication of effort by museums, schools, and commercial producers of art equipment and visual materials is not really an issue. Museums must "supplement or offer art because schools fail to do so." Even more important, the museum "is the last remaining area" for exploring new teaching methods and techniques and experimenting with new materials, which schools do not have the time to do.[19]

**The New York City high school program.** What D'Amico came up with in response to his initial assignment was a program for New York public high school students and teachers. In cooperation with the city's board of education, the museum offered the schools traveling panel exhibitions on modern art, slides, slide talks, teaching portfolios and models (see below), films, books, and libraries of color reproductions to be borrowed by students.[20] In addition, there

were free passes for students and teachers to visit the museum and special art classes in the museum's People's Art Center for interested students whom their schools recommended.[21]

The program was one of five funded as part of a three-year experiment by the Rockefeller Foundation's General Education Board to bring museum art to secondary schools (the project was reported on in Lydia Bond Powel's book, *The Art Museum Comes to the School*). Of all the programs in the experiment, MOMA's is the only one still in business. It was so well regarded by the schools that when the General Education Board grant ended and the museum could no longer finance the program itself, the board of education agreed to put up half the $14,000 annual cost and finally all of it.[22] By 1960, more than 130 sets of materials were circulating each month to 58 high schools with a total enrollment of about 175,000 students.[23]

As a durable and apparently successful attempt by a museum to provide teaching materials to the schools, MOMA's high school program offers a useful model. D'Amico sought ideas for the materials and evaluation of them from chairmen of high school art departments, teachers, and the director of art for the New York City schools, who took a personal interest in promoting them within the system. A high school art teacher himself, D'Amico "knew us well," as one former art department chairman put it: "We grew up with each other." Louise Kainz, one of the first faculty members at New York's High School of Music and Art and a longtime user of MOMA materials, remembers that they reflected "all of our desires; we had conferences about them and about the course of study, and we asked the city to pay for them because we needed all the programs we could get." Olive Riley, for 19 years the schools' director of art, wrote of the program: "[The MOMA] staff, in actively servicing the schools, has always been conscientious and thorough; the material has been delivered promptly and equitably. That these rich and varied materials serve their purpose is clearly shown by the keen interest evinced by the boys and girls who view them."[24]

Some of the packages were large. The Teaching Models came in cabinets mounted on rollers and, according to Louise Kainz, were not always easy to manage. Each contained a small exhibition, background readings for the students, materials to construct or assemble. "Victor always had something for the students to manipulate," Mrs. Kainz noted; "he didn't believe in just looking at something." Subjects included neighborhood planning, interior design, costume, abstract design, display, lettering, and theater art.

As the evaluations dictated over the years, the program moved away from large exhibitions for use in school corridors toward materials that could be passed among students in the classroom. To accommodate students with language problems—presumably growing numbers of postwar refugees and Puerto Rican students—the texts changed from longer paragraphs to "simple terse sentences."[25]

For teachers who fought the battle for art in the schools during the D'Amico years, the Museum of Modern Art was an important ally. "We never got close to the instructors at the Metropolitan," said Mrs. Kainz. "We couldn't take high school classes easily to the museum, and the Metropolitan didn't send materials. We could sign up for a certain number of lectures there, but then the museum dropped it because the students got too rambunctious. But we were always closer to MOMA because it gave materials to work with in the schools."

**Studio classes.** Part of the high school program was the Young People's Gallery, opened in 1938, to which students were invited on Saturdays to mount their own exhibitions and do their own work. The gallery was the beginning of D'Amico's studio classes at the museum that were so basic to his educational philosophy. "When people know how to create," he has said, "they respect others' creativity. . . . Talking about color doesn't really help. But working with it is very exciting."

From the Young People's Gallery it was an easy step to classes for participants of all ages. These classes were taught in what came to be called the People's Art Center. Renamed in 1948, it grew from a wartime center for veterans, set up in 1944 as the museum's first classes for adults. The aim of the People's Art Center was "to develop the artistic sensibilities of children, young people, and adults and to help them understand and enjoy the art of our time."[26] Each week 800 children and 500 adults took classes in painting, clay work, collage, and construction. The fees were reasonable and 35 scholarships were awarded each year on the basis of need and interest, but the center still served primarily an upper-middle-class audience.

**Children's Art Carnival.** Perhaps D'Amico's favorite program and the one for which he gained international fame was the Children's Carnival of Modern Art, "a dramatic demonstration of art education"[27] conceived by D'Amico in 1942 as an annual MOMA event. The carnival has endured in other guises as well. It provided the theme for his television program, "Through the Enchanted Gate"; for the "Children's Creative Center" at the international trade fairs in Milan and Barcelona in 1957 and the 1958 World's Fair in Brussels; for a training center for teachers at the National Children's Museum in New Delhi; for a MOMA outreach program in Harlem; and for D'Amico's dream of an art caravan for the New York City schools.

The carnival's basic formula consists of two galleries: an "inspirational" or motivational area and a participation or studio workshop space. Children enter through a metal wire "Contour Gate" that outlines the head and shoulders of a four-year-old and a twelve-year-old, the carnival's age limits. Aside from the teachers who help in the studio space, adults are not admitted.

The mood of the inspirational area is semidark, cool, quiet, "intended to be one of magic and fantasy." Toys and art games are lighted to look like jewels. Music—"The Nutcracker," "Swan Lake," "Hansel and Gretel"—plays in the background. The child can manipulate the games to form geometric and free-form shapes, each meant to give him a sense of color, texture, and rhythm.[28]

In the studio workshop, whose light and open atmosphere contrasts sharply to the inspirational area, are adjustable easels in bright colors, and in the center of the room, turntables filled with materials for making mobiles, collages, or constructions. The emphasis is on independence; teachers help only when they seem to be needed. Carnival sessions usually allow a half-hour in the inspirational area and an hour in the workshop.

For D'Amico, the purpose of the carnival is to expose the public, parents, and teachers to what children can do when they are stimulated to work creatively. "Creative children," he writes in his book, "are the result of an education that develops creativeness; uncreative children are the victims of indoctrinary teaching. It is that simple."[29]

At the end of his MOMA career, D'Amico hoped to perpetuate the carnival not only in the Harlem center where it became one of MOMA's first efforts "to expand its usefulness to the community"[30] in 1969 (in 1972 the Harlem Carnival was incorporated as a separate organization), but in a touring art caravan that would move from school to school throughout New York City. He saw the caravan as a way to involve the children and the schools, leaving behind it plans and ideas for the teachers; as an observation center for student teachers; and as an evening community center open to anyone, adults and children alike. It was to have a "circus atmosphere," constantly bringing its ideas of art education to "where the people are."[31] In 1972 the New York Board of Education's Learning Cooperative introduced the two-gallery caravan model, built by D'Amico and his wife, to a large gathering of local educators, offering its wares to any school district that was interested. But the estimates to build the caravan in 1972 were upwards of $400,000, and no donors could be found to contribute the funds.

**The National Committee on Art Education.** In their day, the young Turks with whom Victor D'Amico was allied had as burning a mission as MOMA itself. In 1942, rebelling against the "compromises" and "business interests" and the restrictions on freedom of expression imposed by "a large national art association," D'Amico and a few of his friends formed the National Committee on Art Education. It was "devoted to education and to excellence in creative teaching at all levels."[32] From a dozen members, the committee grew in the next few years to over a thousand, most of them art directors, supervisors, artists, and teachers.

The committee met annually under MOMA's sponsorship, its agenda a list of dislikes and "dangers"—contests, copy books, paint-by-numbers kits—and concerns for better television programs and teacher training. Guest speakers talked about art in a free world, education and the imagination, and most of all art education. Herbert Read was one speaker; others were Margaret Mead, Archibald MacLeish, Walter Gropius, and Meyer Schapiro. It called itself "an avant-garde group," an organization "with national influence and prestige."[33] Lynes refers to the committee as MOMA's "shock troops or, perhaps more accurately, its educational underground," and he quotes one museum trustee as saying of the committee, "It was one of the finest things that happened to the Museum, because when it came to exploring the potentialities, Victor discovered that the greatest obstacle was that there weren't any teachers. So the big task was to educate the teachers first."[34]

**The demise of the D'Amico department of education.** During the late 1960s the wealth of educational activities that Victor D'Amico had brought to MOMA began to diminish. The National Committee died in 1963. The population of the New York schools was shifting; some of D'Amico's colleagues were retiring; expenses of the high school program, especially for trucking the large panel exhibitions, were rising precipitously, and the program was badly in need of evaluation; the museum was getting interested in other things, notably higher education and scholarship. The leadership of the museum was undergoing a series of changes, and D'Amico himself was nearing retirement. By 1969 when the Art Carnival was set up in Harlem, it was all over.

As D'Amico moved among his packing boxes one day in the late fall of 1971, he remarked sadly, "The art school closed here because there was no trustee interest in art or art education." He felt he had finally built up the ideal art center, and now it would not continue. Trustee Eliza Bliss Parkinson agreed that the board would have to be aroused in order to start anew in education. But she found D'Amico's work really "separate from MOMA" and his teaching kits perhaps not only over the heads of students and teachers but out of touch with today.

There was also among those close to MOMA a sense that the D'Amico program, excellent as it had been in its way, was elitist. Curator Arthur Drexler said that it served "the needs of the literate, upper-middle-class New York." The acting assistant director for the Bureau of Art at the board of education, Grace George Alexander, felt that the program, basically for "the turned-out parent who knew that his child could have creative art experiences," could have happened in a studio space anywhere; there was no connection between the children and the museum as a whole. Said MOMA director, Richard Oldenburg, "D'Amico's school took a lot of time, space, and money to service a very few."

Perhaps most disappointing to the museum, in the words of its president, Blanchette Rockefeller, was that for all the effort that went into educating the New York teachers, the public schools did not pick up D'Amico's ideas. "This is

largely a privately supported museum," she said, "and without public funds, the program simply cost too much for what we could do."

Nevertheless, for its time, the D'Amico program seems to have matched the excitement and the mission of the museum. His teaching was an extension of the museum: with his various games and devices to encourage "creativity" and individual expression, almost all of them directing the student to the techniques of abstract art, D'Amico was freeing people from the traditional disciplines of pictorial art. ("In those days," D'Amico told Russell Lynes, "Kandinsky was not only an unexplained wonder, he was considered a hoax, but if you could get the kids making their own abstractions and begin to wonder why it was better if they did it this way rather than that way, and then you showed them the Kandinsky, they got the idea.")[35] He was also selling modern art, making it popular, helping people discover abstract elements in the world around them and turning them into receivers of the new art.

If D'Amico's classes served a relatively small elite, they also attracted several young people whose influence is still being felt in the art world: Arthur Drexler, director of MOMA's Department of Architecture and Design, and William Rubin, chief curator of the Collection of Painting and Sculpture, were both members of D'Amico's early classes; so were students who have since become artists, writers, critics, art teachers, designers, and serious consumers of modern art. D'Amico was no deep theorist; he championed art as a process and a life experience, a position that may not have informed the textbooks of art education but that inevitably made him a successful proponent of the message MOMA meant to put across.

## The Lillie P. Bliss International Study Center

As D'Amico's program wound down, the museum turned increasingly toward scholarship and advanced education. Although MOMA had always taken a scholarly attitude toward modern art—indeed, Alfred Barr's books on some of the great figures in modern art have recently been reissued in paperback by the museum, largely for university audiences—MOMA's collection had become internationally renowned, attracting museum directors and art scholars from all over the world to study there. Now the educational emphasis was on the International Study Center, set up by René d'Harnoncourt in spring 1968.

It had been d'Harnoncourt's "great dream," in Mrs. Rockefeller's words, to put the museum's archives in order and to make the collection available to the growing number of serious students of twentieth-century art. Much of the museum's collection was stored either in warehouses, nearby brownstones, or inaccessible areas of the museum building. D'Harnoncourt wanted more open storage areas where scholars could view objects conveniently. He also wanted, according to a 1968 brochure, to conduct training programs and encourage "significant" research. The center would not

"in any way" substitute for nor compete with the university but would be "a research institute of brand-new dimensions, in which there was a constant interaction between pure research, experimentation, and practice."[36]

D'Harnoncourt hired a director for the center, art historian Anne Hanson, set up an advisory committee headed by Robert Goldwater, and began attracting donors to the idea. Hanson was given the assignment, starting in the fall of 1968, to administer the collection of materials—such things as handwritten notes from artists, which were scattered around the museum in curatorial offices and which, drawn together, could provide valuable research for scholars—the research fellowships, and a program of lecture series and symposia; she was also asked to coordinate other educational activities in the museum.

The summer before Hanson arrived, d'Harnoncourt was killed in an automobile accident. When Bates Lowry was appointed to succeed him as director of the museum in the fall, it soon became clear that the museum's financial situation was not all that secure, funds were shrinking, and money that might have gone into the Study Center was needed for operating expenses. Although there were enough fellowships to allow about ten scholars a year, from both the United States and foreign countries, to work at the center, the funds necessary for the rest of the center's program were never raised.

Hanson left the museum, as did Lowry, in 1969, and the museum, then facing growing administrative as well as financial turmoil, did not appoint a new director of the center. By the fall of 1971, the Study Center's functions were being carried out by individual curatorial departments, and the center's small staff was reduced to supervising four New York State Council interns in museum training, helping the remaining Study Center Fellows, and administering the New York City Public High School Program. In the end, the sole staff member was Joan Rabenau, whose job was mainly to schedule visits of high school classes and fill orders for the slides and films (where the museum had offered as many as 130 slide and film topics in 1960, the number was down to about a dozen in each medium in 1971).

MOMA's education program was virtually at a standstill. To try to revitalize it, the trustees set up an ad hoc committee on education that eventually designed the museum's present educational structure.

## The Junior Council

While the ad hoc committee worked, some of the slack in education was taken up by the Junior Council, a group of about 50 volunteers organized in 1949 partly as a training ground for future trustees (several members, including the council's current chairman, have moved onto the board), but partly, too, to create experimental museum programs.

Its membership includes architects, graphic designers, publishers, and what one observer has called the "young rich" (the general age limit for new members is 35–40). "It

is," he said, "a closed club," something akin to "the upper-middle-class audience of D'Amico's classes." As a MOMA curator described the council's work,

> The Junior Council is essentially a sort of imaginative sand pile. It's a place where you can take a group of very bright, creative people and let them play, and they will come up with ideas that haven't been thought about before. . . . Nevertheless, this is a thing that is very useful for us, the professionals here, because the council members don't have any preconceived notion of what is or isn't allowed. And because they want to do things, they are progressive. They've done things that have shown us other things to do.

The council's chairman, Barbara Jakobson, would probably agree with this description: "Our own thing," she has said, "is really to invent new projects. . . . We have this thing called the new projects committee, and we just sit around and say 'Okay, now what?' I mean, we have so many lists of undone ideas that surface."

Except for publication of the museum's annual appointment calendar and Christmas cards and sponsorship of the museum's art lending and art advisory services,[37] most of the council's projects are not "institutionalized," Jakobson says of them, but are invented by committees year by year. (One year it served as the institutional sponsor for a prison arts program devised by the Black Emergency Cultural Coalition and now a successful federally funded program operating in several states. Recently the council has initiated a program of visits to senior citizen centers.) During the interregnum, before the new educational structure was worked out, the council conducted several educational projects, some of which it has continued to sponsor.

**Student evenings.** Perhaps the most enduring of the Junior Council's education programs have been the special evenings set aside for college and university students in the New York area, nearly always in connection with one of the museum's major exhibitions. The council began with a series in 1968, primarily to give the students, minority students in particular, a chance to visit the museum in a more "freewheeling atmosphere," in Mrs. Jakobson's words, than they would ordinarily find there. But the council's purpose, too, was to convince the museum to institute student memberships. That year the council sent ten student tickets to each art department chairman and for the evening brought in musicians and poets who had been influenced by contemporary painters to perform in the galleries.

Later evenings were built around, for example, an exhibition of African textiles and decorative arts in 1972, at which black filmmakers and other black artists were invited to perform. One of the most successful of all student evenings was the one arranged for the Duchamp retrospective in 1973. Planned with the help of the education office and funded by the Mobil Oil Corporation, the event included a lecture-demonstration by composer John Cage; two performances by an experimental theater group called Mabou Mines; a chess exhibition by U.S. Chess Master Larry Evans (he played 30 boards at once); and a continuous program of Dada and Surrealist films and an hour-long filmed interview with Duchamp.

Between 1,300 and 1,600 students attended the evening, and the answers given in the evaluation forms returned at the end of it indicated that the council's bet had paid off: almost all of the respondents rated the exhibition as the chief attraction of the evening, a sign that the event was an important factor in getting the students to the museum in the first place. By contrast, when the council has organized student evenings without relation to exhibitions, as it did with its showings of avant-garde films in fall 1974, attendance has been so poor—about 200 for one—that the guards left early because there were not enough visitors to keep them busy.

## The new education office, 1972

The trustees' ad hoc committee on education, convened in 1971, came out with its report in the spring of 1972. There were two results of the committee's work: (1) a policy—devised largely in reaction to the museum's experience with the large superstructure of the International Study Center and the growing separate structure of the D'Amico program—that would integrate curatorial and education activities, and (2) a $1-million, six-year grant to the museum, half to be used for education operations and half for an education endowment. The grant, made by the Edward John Noble Foundation, whose president chaired the ad hoc committee, is one of the rare endowments specifically for museum education in this country.

The committee had concluded, as had most of the rest of the MOMA community, that the conflict between educators and curators had to be ended; that there could be no more large, expensive, separate programs to divide the museum staff; that the curators, anxious to do more educational work, ought to be encouraged to develop their own programs; and that rather than generate educational programs on its own, the education staff should work closely with curators and aim at special-interest groups who come to the museum with some background in modern art. Said former MOMA president Eliza Parkinson in a 1971 interview soon after the ad hoc committee was formed, "The curators have good ideas in their own fields about education, and some of them are marvelous teachers. . . . We should help schools to provide education, but then the museum should work with elite groups, using the *best* teachers, whether it is the director, the museum educator, or the curators." More recently, Blanchette Rockefeller agreed: "We have always been conscious that the curators wanted to do more educational work. They were the ones who cared." For MOMA Director Richard Oldenburg, the notions of the curator-educator, of the museum as a resource, of teachers as part of the museum, and of galleries as classrooms, are the foundation of the museum's educational mission now. "The more you use curators," he has said, "the better."

**The invisible structure of the education office.** The basic guideline of the Noble grant, then, was that there should be no separate education department or empire, and education was to be unified with other museum activities. To make sure the education office would not get out of hand, the museum gave its new education head the title of director's special assistant for education and limited the size of the education staff, which had reached a high of 31 under D'Amico (including 24 full- and part-time teachers) in 1960, to its present 3½ in 1974. When he was looking for his new education assistant in 1972, Oldenburg said he wanted someone who was "a marvel of tact" and had enough curatorial experience so that he could go to the curators and find out what they needed. Above all, he did not want a program that was predetermined.

So the person MOMA chose as its new special assistant for education was Bill Burback, then an assistant curator at the Albright-Knox Art Gallery in Buffalo, New York. He had also been a member of the Art School staff at the de Young Museum in San Francisco and a curatorial intern in photography at MOMA. Though Burback does indeed have many of the usual education department responsibilities—guided tours, special events, relations with schools and teachers— he says of his role, "I see myself as a museum person, not as a museum educator."

In describing what he does, Burback often uses words like "catalyst," "broker," "liaison," "expedite," "evolve." He talks about providing access to the museum and its expertise, fulfilling requests, and using resources outside the museum: "It's picking up on a germ of an idea from another thing, expanding, but also knowing that there are other groups that can help us share in the work. . . . They are very much a part of the same business we are. We just like to help them as much as possible."

As for his relations with the curators, Burback finds that his efforts to share and help, to be a "catalyst behind what other departments are doing," are paying off. Curators are "beginning now . . . to come up with ideas," which the education office helps them expedite. "We didn't have a very extensive program of lectures, certainly not with every exhibition," he notes. Now "they come to us with [questions like] 'What do you think of this lecture program?' and . . . they know we respect and support their basic ideas, so . . . as soon as they start thinking of something, we're percolating together."

Arthur Drexler reinforces Burback's point: he feels that educational activities should come from the curatorial departments, not from "the notion that there is some educational expertise or mystique independent of the subject that is being discussed. So in this museum the tendency [is] to avoid letting such things get started and concentrate on the point of view of the individual departments."

**How the money is used.** The Noble Foundation grant generates about $45,000 in program money each year. Although the education office has access to other funds earmarked for education activities, its maneuverability comes mainly from this grant. The office regards this as seed money to get something going and on its feet, then to pull out and free the money for a new project, the original project, if it is successful, meanwhile being picked up with curatorial department or outside funds.

One example is the lectures scheduled for an exhibition of the work of photographer Edward Weston. The education office, which was brought into the exhibition in its early planning stages, helped to program the lectures into the show's budget and thus to have part of their cost covered by a grant from the National Endowment for the Arts. Should the lectures fail to break even by a combination of ticket sales and the Endowment grant, the Noble funds would be used to ensure that the series would be paid for.

Another example is the development of educational materials to accompany a curatorial exhibition. At first, the education office staff might be used to help design and prepare the materials. Once the pattern had been established and the idea of supplementing the exhibitions firmly rooted in a curatorial department's thinking, education materials can be built into the exhibition budget and the museum can seek outside funds to pay for them.

**Revitalizing old programs: relations with the New York City schools.** Even though the education office is determined to stay small and flexible and to develop its support of the curatorial departments, it has found several longtime MOMA programs worth keeping. Two of them are based on MOMA's partnership with the Board of Education's Bureau of Art—the museum coordinator program and the high school program.

*Museum Coordinator.* In New York City, the board of education's largest single financial contribution to museum education is its loan to local museums of licensed teachers to conduct tours for public school students. The Bureau of Art has six such teachers in five museums (two are at the Metropolitan Museum); starting in 1937, MOMA has been one of these. As the museum coordinators are art teachers who might otherwise be placed in schools, and as there is an inordinately low number of both art supervisors and teachers in the city's thirty-two districts (as the result of an over-all budget crunch, in 1974/75 only eight districts still had art supervisors, and the number of art teachers had been cut by two-thirds in the last five years), the Bureau of Art considers its museum coordinator program a considerable sacrifice of scarce personnel. Nevertheless, the bureau staff says it backs the program enthusiastically.

At MOMA, the museum coordinator, Sylvia Milgram, leads two tours daily, each an hour and a half long, mainly for grades 6 through 12; gives free gallery talks to the general public (these are paid for out of the museum's operating budget); supervises six- to eight-week seminars on the his-

tory and social history of modern art, offered for credit to 11th- and 12th-grade students; conducts biweekly orientation sessions for an average of eight to fifteen teachers planning to bring classes to the museum on their own; and gives seminars at the museum for an alternative public high school program called City-as-School.

*New York City Public High School Program: Teaching Materials.* Without sufficient staff and leadership after D'Amico left, the mechanism that supported the New York City High School Program had run down. According to Oldenburg, there was no structure for getting out the free passes to the schools, and the tours were not well scheduled. Partly because the program is the only one in the city for which the Bureau of Art, in addition to providing the museum coordinator, actually pays a museum money (in this case $13,000 a year), one of Burback's first tasks was to rebuild the program. The cumbersome teaching models had been abandoned, and the slide and film sets had not been changed much since the sixties. The museum sent out evaluation forms to find out how the materials were being used, then began to add new sets and dropped some of the older ones.

An important part of the reevaluation of the high school program has been the work of an intern, Julie Schimmel, paid by the New York State Council on the Arts, who made visits to 15 schools in 1973/74 to see how the slide sets were being used and what teachers wanted from the loan materials. Because the principals control the arts budgets, the intern tried to talk with them as well as teachers and to include them in the department's mailings.

As a result of the visits, the museum learned several things:

- Teachers want materials that are easy to handle, require little exhibition space, can be passed around to the class.
- Teachers did not know what the dots on the slides meant. A note on the front of each slide set now explains the slide's correct position in the projector, a necessity in showing some modern art.
- Schools do not have the elaborate dual-projection machinery available to graduate schools of art history. Slide sets have therefore been adjusted for single projection.
- So that they can use the slides in any order they like, teachers want commentary on each slide in addition to the background essay in which the museum notes the title and number of the slide at the appropriate place in the text.
- It is difficult for teachers to make the subject matter mean something to their students, and they often miss obvious chances to treat the slide shows as something more than isolated events.
- Some teachers understand the content of the slide sets, but many do not and are too embarrassed to ask about it.
- Teachers want more "supplies" to help them teach modern art—reproductions for bulletin boards, posters, an outline of the history of modern art, information about current shows, gallery maps of the museum, slides, and original objects.

The education office has made several adjustments in the sets in response to its findings. One important change has been to bring in outside writers to loosen up the approach and the language of the slide texts, a move that initially brought some unease to the curators with whom the texts have always been discussed and checked, but one that curators have come to approve. A typical text for a 1972 set on Picasso reads,

*Three Musicians* represented a magisterial recapitulation of the artist's powers rather like a "masterpiece" in the old guild sense.

A 1973 set on twentieth-century sculpture:

Rodin concentrated on the surface of a piece, breaking it up into planes that catch light and hold shadows, similar to the broken facets of color in Impressionist paintings.

By contrast, in a recently completed set on pop art by art writer and critic Amy Goldin, the twentieth century is described this way:

It seems to be characteristic of the twentieth century that people get fed up with things and refuse to go on doing what it seems they have always done. Women got sick of having to look pretty all the time, blacks got sick of having to be especially polite to whites, and artists got sick of making nice paintings that people would put in gold frames and hang over the living-room couch.

Another education office response, this one to teacher needs for understanding how to use the films and slide sets, is the museum's effort to collect ideas from teachers and put them into the packets. Teams of teachers write the notes, taking suggestions from artists as well as teachers. In one packet they have included a tape by video-artist Andy Mann that documents how artist Nancy Graves works with students in their classrooms. Teachers were originally given $50 worth of MOMA books for their work, but starting in fall 1975 they received in-service credit from the Bureau of Art.

In these packets Burback wants to avoid preaching to the teachers; he has chosen to be descriptive instead. "The real issue," he says, "is how not to be overhanded in suggesting things for the teacher in her class. . . . Teachers need to know that we respect them and are truly collaborating with them." One place where Burback draws the line on collaboration, however, is the writing of the slide sets. Grace George Alexander, the acting assistant director of the Bureau of Art, has suggested that MOMA invite teachers to apply for this job and pay them either fees or royalties. Burback has countered by saying that MOMA can supply the expertise but can draw teachers into the museum community by working with them "at the very beginning point" and by "building in steps" in each program where teachers are included.

Much as the board of education appreciates the work the museum is doing with teaching materials, Georgie Alexander would rather have programs in the museum to "make the children feel they belonged there, that they have something to give the museum." What she has described is regularly scheduled workshops in sculpture, film, video, industrial design, and construction of architectural models, all supervised

by a full-time studio coordinator. "It sounds to me," said one observer, "a little like Victor D'Amico's program."

The chances that MOMA would resurrect such an activity are dim. Yet the museum staff is not quite satisfied with the high school program as it stands, either. Although the number of participating schools has increased (from 53 in 1973/74 to over 80 in 1974/75), the intern who visited the schools says she finds the slide sets can be dry and often badly used. Better, she feels, are the films.

*Films—and a Lesson in Working with Teachers.*  When the education office took over the New York City High School Program and began sifting through the slide sets and films, the staff decided to ask each curatorial department to recommend films to replace some of those that the office felt should be thrown out. The staff then screened the curators' suggestions and picked seven to show to a group of high school art department chairmen, teachers, and some of their students. All seven were enthusiastically received by this group and subsequently purchased by the education staff. In all, the education office had added ten new films by the end of summer 1974.

In September 1974 the office arranged a special screening of five of these films for New York City public high school teachers. The staff prepared notes to go with the films and asked four artists (two of whom made the films) and a film critic to help lead the discussion. The whole purpose of the evening, called "Saturday Night at the MOMA," was, according to an interoffice memorandum, to "focus attention on the major revitalization of the New York City Public High School Program."[38] A handsome invitation went out to all art supervisors and art department chairmen, enclosing forms that faculty members could use to apply for tickets to the screening. The event was also announced in the teachers' union newspaper and in Bureau of Art mailings to the art departments.

More than 500 teachers received tickets, and as the auditorium seats only 480, there was even a wait list. In spite of bad weather, about 400 people came to the screening. But the reactions were unexpected. As one after the other of the avowedly avant-garde films came on the screen, the mood of the audience turned increasingly hostile. By the time Nancy Graves's *Aves*—a 23-minute film of birds in flight, each sequence creating a new abstract pattern—was shown, there was laughing, snickering, and growing restlessness as the audience first waited for the narrative and then realized it would not come at all. More than half the teachers left before the discussion period. From those who stayed, the questions and comments gave evidence that the teachers did not know what was going on. One teacher was outraged at the cost of the Christo project, *Valley Curtain,* documented in one of the films. Others could not understand how they could apply such abstract concepts in their classrooms.

To some observers the evening was a disaster. But Bur-

back was undaunted. The unexpected response gave him a sense of mission. He sat down with the bureau staff to analyze the mistakes: there were too many switches in content, the teachers should have been told that these were the most difficult and provocative films in the loan program, the discussion should have taken place just before and after each film to prepare the teachers for what they were to see and to catch their reactions while they were fresh.

The result was a follow-up letter to the art supervisors in October, explaining the evening and the films, and inviting teachers back for two workshops in November and another screening in the spring of 1975. Thirty teachers (the most "committed," said one observer, "those who needed it least") came to the workshops; they saw segments of five films in each session and then filled out evaluation forms on each film, which the education office is using to adjust the commentaries that accompany the films. The office has also decided to send out full scripts of films in which the dialogue is important and to recommend that the films be shown more than once if they are to be fully understood.

*Other Services for Schools.*  In addition to the films and slide sets, MOMA extends itself for the New York area schools in several ways:

• *Admission passes.*  For both students and teachers, the admission fee is a barrier to frequent visits, and for many years MOMA has given out passes to these groups. All New York City public junior and senior high school groups with reservations are admitted free. In addition, coupons good for one free student visit are distributed to all high school teachers. Coupons are also distributed through their art departments to the city's free colleges and universities (the 22 campuses of the City University of New York and Cooper Union, whose open-admission policies draw many students from poor families), and the instructors can get as many coupons as they want.

• *Distribution of museum materials.*  Rather than prepare special school packages for each MOMA show, Burback tries as much as possible to make use of posters, catalogs, labels, and other efforts for distribution to schools. For the "New Japanese Photography" exhibition, he folded the poster, which had been designed so that folding would not crease the images, and used the silk screen made for the wall labels to print a description of the show across one of the folds. About 2,000 of these posters were sent free to colleges and high schools within a 50-mile radius of the museum. Color plates for the catalog of "Eight Contemporary Artists" were used for a pamphlet distributed free to all teachers who made appointments for tours and to all students who took advantage of the special study hours for college students (see below).

• *Art-writing seminar.*  An example of some of the special programs the education office offers from time to time is a seminar taught by two young poets in the fall of 1974. One

of the poets, Howard Levy, had taught in "arts awareness" classes at the Metropolitan (see chapter 10), and the seminar drew on these techniques. According to the announcement of the seminar, "The student is called upon to use his own intuitive and imaginative resources and verbal skills to parallel the artists' explorations and discoveries, as well as to enter into a group process of exploration." It was to be, in other words, not a creative writing class but a way to use words to help students understand works in the collection.

Eight students from four New York City public high schools were chosen, with the help of the Bureau of Art, to participate in the seminars (there were seven sessions, in all). The students were asked to chart an artist's progress across the canvas through such concepts as color, line, space, and mass, and to map them by placing words on paper that seemed to match what the artist was doing. The point of the exercises was to force students to look. (As proof that the technique worked, Levy noted that when students were asked to describe an apple, by the fifth or sixth session they were all seeing it in terms of its perceptual qualities—mass, color, volume—rather than as an object.)

**Relations with the Bureau of Art.** Board of education staff members Stanley Rose and Georgie Alexander are enthusiastic about the MOMA programs. Said Rose in an interview, "The museum's services go far beyond the board's compensation [the annual $13,000 the Bureau of Art pays for the high school program]. . . . It is the only museum that really meets with us and fills our needs. The staff goes out of their way to sit with us and go over plans.

Though Rose compliments the Metropolitan Museum as well (he has few good things to say about the Whitney, whose staff does not work as well or as closely with the bureau as MOMA's [see report on the Whitney Art Resource Center, chapter 10]), he is a particular fan of MOMA: "[It] should be seen as the precursor of good school-museum relations. It's in the forefront of school-museum planning, one of the few museums that take into account school and teacher needs in planning their programs."

For Georgie Alexander, the relations she and the MOMA education staff have established are rare. She also feels they are necessary. Museum people and art education people, she says, are rich natural resources for each other: "Better . . . use of museum resources in this city is a *top* priority—not as a palliative, not as a substitute, but as a collaborative." Teacher training is for her the bureau's biggest problem, and she thinks museums can help:

[Our greatest need] is getting more teachers [to be] more competent, more confident, and more capable of developing and executing programs within their own classes. . . . I think museum experiences can help. . . . Take a teacher who is not confident, who does not have an art supervisor in her district, who has nobody to consult with in her school and may even have an unsympathetic principal. She needs some kind of support, some kind of wellspring to get her moving. And that just might happen with a museum experience, because if she is consulted, if she's part of the planning of a museum program, working together with museum people and [offering] her own expertise in dealing with children, she'll be offering something that immediately makes her feel more valuable and more comfortable and more confident.

Too often, she thinks, museum educators, like everyone else, disregard schoolteachers.

Everybody looks down on schoolteachers, we know that. They get too much money for too few hours; they think they know it all; they are bossy. . . . I think the way you can break down this chasm . . . is to offer physical working opportunities for [bringing teachers and museum educators] together. . . . The planning and conceptualizing of a program should be collaborative from the beginning so there's a real understanding of what you are after, what the goals are, who's going to participate, what's going to happen to them afterwards.

Ms. Alexander goes so far as to suggest that schools should have control over museum education programs.

One reason why Rose and Alexander are so supportive of what MOMA does for them is that they have so little to work with themselves. Georgie Alexander is frank about the problems at the board of education: there is no money to support the turned-on teachers, and even when the money sometimes comes, in a large bureaucracy there is no way to plan—you are told, she says, "to spend this yesterday." The quality of many teachers is low, she admits. But she confesses, too, that the Bureau of Art does not even know the number of art teachers in the city, let alone many of the teachers themselves. The MOMA staff feels its list of art teachers may be more accurate than the Bureau of Art's because the museum's education staff has more regular contact with the teachers.

Burback's careful, patient work with the bureau and with the teachers he has come to know, he feels, has paid off. Several teachers now drop in at the education office, something teachers have not done before, and Burback is proud of this. He is also building relations with the teachers college faculty members who asked that the film screening be repeated for their students. He says he wants to show the schools that art is important, and he is eager to help revive teachers before they become demoralized and tired. Clearly, he respects them and will take infinite trouble—from garden parties to thoughtfully prepared seminars with well-known artists—to show them he thinks they are as deserving of MOMA's courtship as the richest donors and collectors.

**Higher education.** At both the high school and college level, the education office works closely with the curatorial departments in a variety of ways. Most efforts are meant

to serve small groups of students with special talents and interests in programs that are described later. But there are two areas for which the education office has special responsibility, college study hours and internships.

*College Study Hours.* Each Tuesday the museum is open to college classes from 9:30 to 11 A.M., when the public arrives, and between 6 and 7:30 P.M., after the museum closes. Classes cannot be larger than 30 and must schedule their visits two weeks in advance, reserving a part of the museum for serious study of original materials without interruption by the public.

The program—funded for one year starting in January 1974 by the Art Dealers Association Foundation, which has been asked to renew its support—began in response to a request from the director of the Yale Art Gallery, Alan Shestack (see chapter 12), to bring a class to study the Gertrude Stein show in 1970, for which Yale had lent several of its own objects. Shestack's request for a group visit was refused. But that was before Burback came to the museum. When he learned about the "affront," Burback set up several sessions for the Yale class and then decided to make the same offer to other college and university art and art education departments in the New York area.

At first the program did not take: although the study hours were well attended during the Duchamp exhibition in January and February 1974, they were poorly used the rest of the term. But once the education office began sending out the exhibition schedule for the year, allowing classes to plan their trips well in advance, and opened the study hours to undergraduates as well as graduate students, the program was heavily booked—three groups in the morning, three in the evening, and occasionally some classes on days other than Tuesday. During 1974/75, 32 colleges reserved galleries for 75 classes with a total enrollment of 1,500 students.

The program follows a pattern that Burback, the curators, and the museum administration are comfortable with—a simple extension of facilities. Says Burback,

> The point is not to set up a fake atmosphere of cooperation, but a real one, so we can develop a situation where we will get more requests [on which we] again can build and be more useful to other institutions. . . . By opening up the galleries to teachers and professors, we not only extend our facilities but we enlarge our staff. These faculty members become docents. . . . We are trying not just to set up programs in a vacuum here, but to build up a community where we work together. And the curators have been very happy about that.

*Internships.* The museum supports three interns in conservation and, depending on the circumstances, anywhere from none to six in other fields. The conservation interns—two from the Cooperstown School of Conservation and one from New York University's Institute of Fine Arts—receive partial support from the education office budget, though the

museum has asked the National Endowment for the Arts to take over the costs. In addition, students work as volunteers on special study projects in 14 departments throughout the museum.

**Community programs.** As with other education office programs, what MOMA has done in "the community" in the last two or three years has grown out of individual situations—free passes to community groups for special shows and participation in meetings organized by Museums Collaborative, a local organization founded in 1970 to help museums devise programs for underserved segments of the New York community (see chapter 4).

MOMA's special contribution to the Museums Collaborative program was a massive giveaway of its overstocked publications to small arts organizations. The ground rules were very simple: books were to be used as part of the arts programs—torn up for collages, taken apart and reordered, or made the basis of an art reference library; they were not to be resold or used for fund-raising. The first year, 1973, MOMA offered the Collaborative 29 titles—almost all of them still on the bookstore list and therefore salable as remainders—and 40,000 books went free to such groups as Hospital Audiences, the Children's Art Carnival, the Gallery Association of New York State, drug rehabilitation centers, state and local prisons, mental hospitals, and community centers. The total retail value was over $250,000. The cost of the contribution otherwise was $35, part of it for an offset announcement to community groups and the rest for a luncheon for volunteers who manned the giveaway desk.

The MOMA giveaway led to a second sponsored by Museums Collaborative, in which 56 organizations gave and 59 organizations received a total of 93,000 items—everything from catalogs, posters, old annual reports, and greeting cards to rabbits, snakeskins, antlers, and toys. In 1975 the idea turned into a swap sheet instead of a swap day; the Collaborative put out a list of recycled museum items—plexiglass sheets, wood cases and pedestals, parts of film projectors and tape decks—which needy recipients could arrange to pick up directly from the donating organizations.

**Education office relations with curators.** As much as possible, Burback and his staff try to draw on curators' ideas for educational programs in the museum and to win curatorial participation in them as well. Sometimes curators themselves take the initiative, but more often Burback and the chairman of the trustee committee on education, June Larkin, feed ideas to the curators from which they can choose. On occasion, there is also some arm-twisting: "I worked on one curator for two years," Larkin noted, "to persuade him to undertake one program."

For MOMA Director Oldenburg, close relations between the education office and curators are almost a matter of policy. "No educational materials," he has said, "should be prepared that are outside curatorial control. There shouldn't

be education people developing a separate profession and the idea that they are the only ones who can communicate. Some curators need a translator, others don't. [But in general], the more you use curators, the better.''

Perhaps predictably, most MOMA curators seem to welcome being used, though not all of them work evenly with the education office, and some offices are so pressed—the film department, for example—that they have very little time to think about special education programs at all. Several curators have found the integration of educational programs with curatorial purposes a new and refreshing experience. Riva Castleman, curator of prints and illustrated books, contrasts the MOMA policy with her experience at another museum:

[There] we never knew that there was education going on. It was always a world entirely apart. . . . The people involved in education were usually educators [who] seemed to have learned about what . . . to convey to people in an entirely different way. They saw things [differently] than curatorial departments did, which is one of the reasons, I guess, that we have always been [so] hostile to that sort of education.

In making his first approaches to the curators, Burback dealt with one situation at a time. ''It was a matter,'' he says, ''of plugging things into existing shows, talking to the curator and expanding his sense of meeting the needs of the general public.'' Now there is more planning. When an exhibition is approved, the development, publicity, and curatorial staffs meet with the education office so that the education office understands the curatorial view and can work with it. Burback feels, too, that his own curatorial background is a help.

Burback can point to several achievements that demonstrate the effect of his office's cooperation with the curatorial and service staffs:

- Films suggested for the New York City High School Program have now been added to the museum's film department collection and will be shown to the public.
- The two education office student volunteers have cataloged 150 films and interviews for the museum's television archive.
- The registrar's office has asked the education office to help produce three videotapes on museum registration, the first on handling works of art. The office sought the necessary grant from the New York State Council on the Arts; it found a way to produce the tapes inexpensively, and also laid plans for sale and rental of the tapes later.
- A bibliography on modern art for high school students was compiled from lists supplied and finally approved by the curators.
- In connection with an exhibition called ''Gods, Heroes, and Shepherds,'' the department of prints and illustrated books wanted an education program that would (a) draw people into its out-of-the-way space and (b) alleviate the viewers' usual visual frustration with illustrated book exhibitions, not being able to turn the pages. The education office suggested lunch-hour talks by graduate students in classical literature that would, among other things, provide something calming to the frenetic surrounding business community, the audience that, along with school and college groups, the education staff had in mind (it had mailed posters to every corporate office within walking distance of the museum). One of the curator's basic points for the program was that lecturers not talk about art, on the grounds that telling people what they are seeing before they have a chance to look at it themselves changes how they view it. So the students chosen as lecturers were from classical rather than art history departments; they talked about myths, Greek history, and read from the books' texts. The exhibition proved to be one of the most popular the department has ever mounted.
- To celebrate the twenty-fifth anniversary of the Abby Aldrich Rockefeller print room in 1974, the curator pointed out, the museum would normally have given a cocktail party. But now when every penny counts, she said, each activity should have a return, preferably educational. So the department held a symposium instead. It brought together 140 (75 had been expected) American printmakers, scholars, artists, curators, and museum members (who were charged $30 each to attend the day-long session; nonmembers paid $35). Through letters to 15 local colleges and universities, the education office found 12 students, whom it admitted to the symposium free and to whom the symposium gave a rare opportunity to meet with professionals in the print field.

**The Marcel Duchamp retrospective.** Unquestionably the single largest cooperative venture between the MOMA education office and a curatorial department was a retrospective exhibition on Marcel Duchamp. The show, which ran from December 1973 to February 1974 at MOMA, was prepared by curators Anne d'Harnoncourt at the Philadelphia Museum of Art and Kynaston McShine at MOMA and was on view not only at both those museums but the Art Institute of Chicago as well.

At MOMA's invitation, the education and curatorial staffs of the three museums held a meeting in spring 1973, several months before the show was to open in Philadelphia, to plan common educational components whose costs and preparation the three museums would share. The MOMA staff brought films from its collection that related to the show and that the other museums borrowed for their programs. As a result of the meeting, too, the Philadelphia Museum was able to carry out one of its long-cherished ideas, before not economically feasible for its tight budget, to print a one-page giveaway in newspaper format. The paper contained several clippings on Duchamp from his wife's scrapbook and his obituary from a 1968 edition of the *New York Times*. Eighty thousand copies of the paper were distributed at the three museums.

MOMA's own education activities for the show centered on an information kit for schools and universities, casual talks by graduate students, four lectures by internationally known scholars, and a student evening sponsored by the Junior Council (see preceding section), planned with the help of the education office.

## Education programs within curatorial departments

As MOMA, according to its director, is structured along collegiate lines, its six curatorial departments are relatively autonomous. As a result, much of the educational activity at the museum is left to the various initiatives of the individual curatorial departments.

**Study centers.** Although not all departments are equally active in education, each has its own study center, an idea that was developed under the International Study Center and administratively decentralized into individual curatorial departments in 1972. Access and facilities in these centers vary: some departments allow students and classes to use the rooms—which are essentially open storage areas—whereas others restrict their services to scholars and professionals.

The freest and most flexible study centers are in the photography and print departments. Both are open to anyone who wants to use them three afternoons a week, although appointments are necessary in each case—a month in advance for photography, just a day for prints and illustrated books. Of all the study centers, the photography department's programs are the most elaborate: it has held workshops for public schoolteachers who wanted to learn how to start photography courses in the high schools, shown teachers how to do photograms (once known as Rayograms, for artist Man Ray), helped instructors from community centers prepare slide series for children, and given special orientation sessions for teachers who were bringing their classes to special exhibitions. The center also allows small groups of college students to spend two days on special projects and to make use of its photo and reference libraries and its biographical files.

The prints and illustrated books center, too, works with teachers from local high schools and colleges. Teachers are invited to come for a visit before they bring their classes; then each teacher may give the class talk himself or ask a staff member from the study center to do it. Other regular visitors are book designers, studio classes in printmaking, library science classes, and art historians.

Less accessible are the architecture and design and painting and sculpture centers, though both try to admit classes that have good reason to come. The architecture and design center has spacious quarters in what was once the People's Art Center. Objects are clearly visible in vitrines or open racks. Because the department's staff has been cut almost in half in the last six or seven years, its study center is open only one day a week to an average of six persons, mainly professionals and students with specific projects.

The painting and sculpture study center is in a large storeroom. Paintings are hung on 11-by-13-feet-high aluminum pull-out racks, and heavy sculpture on wooden pallets can be moved by a hydraulic lift machine. The center is open every afternoon and averages two or three appointments a day made one week in advance.

The centers are given little publicity because the departments fear overcrowding and a demand that their limited staffs may not be able to meet. Nevertheless, most curators consider the study center an important educational service. Riva Castleman, curator of the department of prints and illustrated books—a collection she calls the best in the hemisphere and the most accessible in the world—finds that it is easier for a class of students to "get in touch with" Toulouse Lautrec, for example, if they can handle original works of art and if they can be away from the distractions of the gallery. The problem, she agrees, "is that most print collections tend to be curated by people who are *extremely* careful about their prints." But she argues for making use of the collection:

> If you can police the situation well enough so that nobody has the opportunity to do the wrong thing, when you are a facility like we are, why do you want people to come? I mean, that's what you are there for. We are not a treasury, we are not a vault in some bank.

**Architecture and design: a sample of one department's activities.** If the department of architecture and design is not as free as some of the others with its study center, it has been particularly active in other educational directions.

One was an exhibition of African textiles and decorative arts in the fall of 1972, whose educational components—written into the grant proposals to the National Endowment for the Arts and the Exxon Corporation—were developed and carried out by the department and the only staff member of the education office then, Joan Rabenau. Ms. Rabenau sent suggestions to the curator, Arthur Drexler, who chose the most feasible: 500 packages of slide sets for distribution to public schools, with texts written by the guest director of exhibition, Roy Sieber from Indiana University; posters; a catalog of the show; tours arranged for junior and senior public school classes before the museum opened in the morning and conducted by specially trained guides from a variety of disciplines.

Forty-five classes, a total of about 1,500 students, took the tours. So that he could get a sense of the audience and the guides who led them, Drexler even conducted a few of the groups himself.

About a year later, in the winter of 1973/74, at the urging of the education staff and trustees on the committee, Drexler took on another educational program. This was to be an "intentionally elitist" seminar on architecture and design for ten or twelve public high school students who, as Drexler wrote in his letter of invitation to teachers, have "some demonstrated skill in *any* area," making model airplanes, performing scientific experiments, or "being very good at athle-

tics." The class was to be a revival of one in the history and theory of modern art that Drexler, along with two or three others who are also now MOMA curators, attended in 1938 under Victor D'Amico.

For the 1973/74 seminar, Drexler ended up with 12 students who stayed in the seminar to the end. There were six planned sessions, each lasting two hours and often longer. They were all intended "to make the student aware, in Drexler's words, "of how man-made artifacts from teaspoons to cities are designed, and how the world of 'useful' objects relates to such 'useless' objects as paintings and sculpture."[39] When the seminar was over, four or five students asked for and got three more sessions with Drexler, in which they worked out studio problems to find out what it is like to design a house or a small-town library. Drexler would like to do the seminar again, as soon, he says, "as I muster up the energy."

In spite of the drain this class placed on Drexler's time, he is making plans for the use of a new seminar room assigned to the department, with a separate entrance to the street. Among other ideas, he hopes to bring the brightest architecture students from schools around the Northeast for discussions on the state of the profession with practicing architects—partly to introduce the latter to promising newcomers.

One spinoff from some of the activities in Drexler's department that the MOMA administration and trustees are especially proud of is the Institute for Architecture and Urban Studies. It grew out of a 1967 MOMA exhibition called "The New City: Architecture and Urban Renewal," organized in collaboration with four teams of architects. The idea of the institute, which was proposed by chairman of the trustee education committee June Larkin, was to teach urban planning by assigning real projects to graduate students from schools of architecture on the Eastern seaboard. MOMA's interest in the institute stemmed not only from its sympathy with teaching in this Bauhaus tradition but also from a desire to have more of an effect on public housing policy in the city than its exhibitions seemed to be making.

Co-sponsored by MOMA and the Cornell University School of Architecture, the institute was chartered as an independent educational institution by the New York State Board of Regents in 1967. Drexler helped raise funds for the institute and served as chairman of the board until November 1974; he was succeeded by the husband of a MOMA trustee, Armand Bartos. Although the museum now has no official connection with the institute, it has the right of first refusal to exhibit and publish the students' projects. (So far, it has held just one exhibition, "Low Rise, High Density," which showed designs students and young professionals had made for an Urban Development Corporation project in 1973.)

The idea seems to have been a success: students have produced designs under contracts from the U.S. Department of Housing and Urban Development, the New York State Housing Agency, and the Urban Development Corporation, as well as private organizations. In fall 1974 the institute started an undergraduate program in introductory architecture for a group of five Eastern seaboard liberal arts colleges, each of which wanted a program but could not afford to undertake it separately.

## After zeal, realism

In discussions about its educational activities in the 1970s, MOMA staff and trustees are inclined to speak defensively. They point to past successes, sometimes to repetition and revivals of old programs, to the spinoffs and borrowed ideas from the period when MOMA was the source of almost every imaginative program in the museum world. When an institution has been as successful in its mission as MOMA has, it is perhaps a natural temptation for members of MOMA's critical public to ask, as MOMA Director Dick Oldenburg noted recently, "But what have you done for me lately?" MOMA is not the only museum in the country that built up a staff and plant in the 1960s that the economics of the seventies could not maintain. Nor is it the only museum that had satisfied its missionary zeal. But it is a museum whose spectacular past is an especially hard act to follow.[40]

And it is also a museum that may exemplify better than any other the indivisibility of the museum's educational role. MOMA's educational activities under Victor D'Amico were, at their peak, a reflection of MOMA's educational mission; they seemed not a thing apart until quite late in D'Amico's day. Now, in the seventies, MOMA's new education office seems to be a reflection, too, of the way the museum's administration sees its role—working with what it has rather than what it wants to attain, trying to fuse and appease rather than energize an internally disparate and decentralized organization, accepting the institutions around it (the schools, the teachers' union, the board of education, the colleges and universities) on their terms rather than trying to change them to fit the museum's.

But it may be that MOMA, in its acceptance of the way things are, has devised the more realistic approach. Working slowly and carefully with teachers, many with limited imagination and experience, who do not always respond to the museum's most energetic attempts to reach them, is not very exciting, and many museum educators have neither the energy nor patience to stick with the job. Yet if teachers are to become the educational levers museums want them to be, there may be no substitute for the MOMA way—finding the open few and building on small but visible gains. For many museum educators, too, cooperative relations with curators are much to be desired, yet if MOMA's experience is any lesson, forging ties often requires an accommodation to curatorial ideas and prerogatives that museum educators are not always willing to stand for.

There is no question that MOMA has taken on two of the tasks that have been professed and pursued by museum educators for the better part of a century in this country—teaching the teachers and closing ranks with the curators. The methods may be quiet and unspectacular; but they may also

be as educationally successful as any art museum has the right to expect.—*F.G.O/B.Y.N.*

## Notes

[1] Russell Lynes, *Good Old Modern* (New York: Atheneum, 1973), pp. 127, 156, and 141.

[2] Ibid., p. 352.

[3] For sources of quotations without footnote references, see list of interviews at the end of this report.

[4] At its peak in 1969, when John Hightower took over as director, there were 539 persons on the MOMA staff; the painting and sculpture department alone employed 24 persons, three times the number that had operated the whole museum in 1929 (Lynes, pp. 422 and 419). As museums go, MOMA's still seems a relatively luxurious operation. In 1974, there were 365 full-time members on the staff at MOMA, as opposed to 230 at the Cleveland Museum and 852 at the Metropolitan (into whose Great Hall, Arthur Drexler once said, would fit all of MOMA's gallery space [Lynes, p. 433]). In its six departments MOMA has roughly 40,000 objects, including films, posters, photographs, but not counting its architectural drawings; the Metropolitan has an estimated one million items in 13 curatorial departments. The Metropolitan's operating budget is $14 million, MOMA's $6.3 million, Cleveland's $3.3 million.

[5] Lynes, *Good Old Modern*, p. 83.

[6] Ibid., p. 354.

[7] Barbara Rose, "Oldies But Goodies: Modern Reinstallations, II," *New York Magazine*, May 14, 1973, pp. 84–85.

[8] Lynes, *Good Old Modern*, p. 88.

[9] "The Museum of Modern Art Educational Activities, 1929–1960," p. 5.

[10] Lynes, *Good Old Modern*, p. 386.

[11] "MOMA Educational Activities, 1929–1960," p. 5.

[12] Lynes, *Good Old Modern*, p. 169.

[13] Ibid., p. 161.

[14] For more details on all these programs, see Museum of Modern Art, *Experiments in Creative Art Teaching: A Progress Report on the Department of Education, 1937–1960* (Garden City: Doubleday, 1960).

[15] Ibid., p. 9.

[16] Ibid., p. 15.

[17] Ibid., p. 9.

[18] Ibid., pp. 10–11.

[19] Ibid., pp. 62–63.

[20] "MOMA Educational Activities, 1929–1960," p. 2, and *Creative Art Teaching*, p. 42.

[21] *Creative Art Teaching*, p. 48.

[22] Ibid., p. 46, and interview, December 14, 1971. (The price the board paid in 1975 was about $13,000.)

[23] "MOMA Educational Activities, 1929–1960," p. 2.

[24] *Creative Art Teaching*, p. 46.

[25] Ibid.

[26] Ibid., p. 22.

[27] Ibid., p. 34.

[28] Ibid., p. 35.

[29] Ibid., p. 40.

[30] "The Children's Art Carnival," brochure on the St. Nicholas Avenue program.

[31] Interview, December 14, 1971.

[32] *Creative Art Teaching*, p. 51.

[33] Ibid., p. 52.

[34] Lynes, *Good Old Modern*, p. 171.

[35] Ibid., p. 169.

[36] The Museum of Modern Art, "The Lillie P. Bliss International Study Center," May 27, 1968.

[37] Through its Art Lending Service, the council rents and sells the work of about 700 artists it has on consignment.

Related to the lending service is the Art Advisory Service, begun in 1972 and aimed at creating what the council's chairman describes as "closer relationships with corporations that may use a part of their resources to support museum programs." Through this service, the council buys, installs, and catalogs art for large corporations, giving them better informed choices than they could get from a decorator.

Penthouse Exhibitions are the third component of the council's art services. Primarily for the members of the museum, the exhibitions are planned by both MOMA and freelance curators to further the work of younger artists.

The three programs earned a total income in 1973/74 of $39,000 and a profit of about $1,400.

[38] Bill Burback to Liz Shaw, September 11, 1974.

[39] Letter to teachers, June 4, 1973.

[40] Writing of the "agony," as the headline called it, of the Museum of Modern Art in 1967, *New York Times* art critic John Canaday described the dilemma the museum has faced at least since the mid-1960s:

". . . Without any question at all, the Museum of Modern Art has been so powerful, and on the whole so beneficial a force in American cultural life, that it could coast for a long time before anybody realized that it was approaching a standstill. But it has been coasting. And when you are middle-aged, you coast a lot more slowly than you used to. . . .

The trouble is that since its organization in 1929—that was a long time ago—the museum has achieved its goals so consummately that it has worked itself out of a job. . . .

[The museum] not only seems to have lost the capacity to do anything more than imitate itself, but also must compete with museums that have learned to imitate it. . . .

When the museum first opened, Mr. Barr had great territories to explore for his public, and his success is apparent in the general knowledge of those territories today. . . . With the exhaustion of this material—or, rather, with the gap closed between it and the public—the decline of the Museum of Modern Art from its position as the most valuable educational force in the art world toward a position now in sight—that of a hothouse for preciosities—began." (Sunday, June 4, 1967.)

## Interviews

(All titles refer to Museum of Modern Art unless otherwise indicated.)

Alexander, Grace George. Acting Assistant Director for the Bureau of Art, New York City Board of Education. October 12, 1974.

Bowen, Jerry. Custodian, Department of Architecture and Design. December 11, 1974.

Burback, William J. Director's Special Assistant for Education. December 2, 6, 1974; telephone, March 25, 1975.

Castleman, Riva. Curator of Prints and Illustrated Books. December 6, 1974.

Chisholm, Michael. Administrator, Black Emergency Cultural Coalition. Telephone, March 25, 1975.

D'Amico, Victor. Former Director of Education. December 14, 1971; January 12, 1972.

Drexler, Arthur. Director, Department of Architecture and Design. December 11, 1974.

Edkins, Diana. Director of Research, Photography Study Center. December 6, 1974.

Green, Herman. Program Specialist, New York City Department of Corrections. Telephone, March 25, 1975.

Hanson, Anne. Chairman, Department of the History of Art, Yale University; former Director, International Study Center, Museum of Modern Art. Telephone, May 21, 1976.

Heckel, Inge. Member, Junior Council, and Manager, Development and Promotion, Metropolitan Museum of Art. February 12, 1975.

Jakobson, Barbara. Chairman, Junior Council. December 6, 1974; telephone, March 25, 1975.

Kainz, Louise. Former Chairman, Art Department, Washington Irving High School, New York City. Telephone, March 20, 1975.

Kossoff, Alice. Associate Director, Museums Collaborative. Telephone, April 25, 1975.

Larkin, June. President, Edward John Noble Foundation, and Trustee, Museum of Modern Art. December 10, 1971; November 14, 1974.

Levy, Howard. Poet. Telephone, April 18, 1975.

Mazo, Sarah. Assistant Curator, Department of Paintings and Sculpture. December 6, 1974.

Milgram, Sylvia. Teacher-Coordinator, Bureau of Art, New York City Board of Education. December 6, 1974.

Morgan, Joan Rabenau. Administrative Assistant, Education Office. December 6, 12, 1974.

Morning, John. Designer; former member, Junior Council. Telephone, March 25, 1975.

Norman, Jane. Senior Rockefeller Fellow, Metropolitan Museum of Art, and former teacher of art. July 9, 1974; March 22, 1975.

Oldenburg, Richard E. Director. July 13, 1972; November 14, 1974.

Parkinson, Eliza Bliss. Trustee. January 19, 1972.

Rockefeller, Mrs. John D., 3rd. President. November 14, 1974.

Rose, Stanley. Acting Director, Bureau of Art, New York City Board of Education. December 16, 1974.

Rubin, William. Curator of Paintings and Sculpture. Telephone, December 12, 1975.

Schimmel, Julie. New York State Council on the Arts Intern, Coordinator for the New York City Public High School Program. December 6, 1974.

Schroedter, Howard C. Professor of Art, Department of Art, School of Fine Arts, University of Wisconsin-Milwaukee. Telephone, March 22, 1975.

Shaw, Liz. Director, Public Information. Telephone, March 1, 1976.

Volkmer, Jean. Chief Conservator. December 6, 1974.

# The Individual Visitor and Exhibitions Designed to Teach

# Introduction

One of the more interesting mysteries of the art museum world—not only for professionals in it but for many observers outside it as well (proposals for audience studies abound)—is the "average" museum visitor. Who is he? Why does he come? What happens to him when he gets there? Perhaps museums should leave well enough alone, or at least leave the "average" visitor alone, but the presence of a relative stranger in the house inevitably creates anxieties among the hosts—and for most museum staffs, no matter how many surveys are conducted and questionnaires passed out, the "average" visitor is still a stranger. So in their desire to reach (and reaching, perhaps to please), museums continue to mount exhibitions, produce flyers, record tours, publish catalogs, and add more prose to their labels, hoping one day to learn from someone who responds visibly and gratefully that the mix is just right.

In the meantime, there is no definitive profile of the art museum audience. Only two things are certain about the self-selected, self-directed individuals who come to art museums on their own: one, they do so voluntarily, and, two, no one can predict at what level of learning and sophistication they will be.

A number of museums have undertaken surveys of their visitors, and their results suggest that the variations fall within a fairly narrow range. A study for the Metropolitan Museum in New York in 1973 revealed that its audience is "distinguished by its youthfulness, high degree of education, and affluence." Sixty-nine percent were under the age of 40, 54 percent were college graduates; a third of the visitors had family income of at least $20,000 a year. Few visitors had no college education (18 percent), or family income of less than $8,000 a year (18 percent), or held blue-collar jobs (3 percent). Only 8 percent were from minority groups.[1]

A similar visitor survey conducted for the Boston Museum of Fine Arts in 1973 indicated comparable economic and educational circumstances. Contrasting museum visitors to the general population, the authors noted that two-thirds of the museum visits were made by the youngest 40 percent of the adult population; that a third of Boston's graduate degree holders visited the museum but only a thirtieth of high-school graduates; that 83 percent of the museum's visitors were "college educated" (those now in college or graduated), compared with 28 percent of the larger population.[2]

Many observers see the art museum's audience as an "unplanned consequence of the free time created by industrial development" rather than a new segment of the population that the museum has "successfully captured."[3] Though shifting economic and industrial patterns have indeed bestowed "free" time on many, psychiatrist Robert Coles points out that free and easy leisure is "by no means available to millions of Americans, perhaps to the overwhelming majority of them. Consequently, most museums are places

frequented (with any degree of regularity, familiarity, and relaxation) by upper-middle-class educated people—no surprising conclusion, I suspect.''[4]

No, it is not surprising to most people who work in museums. They may even acknowledge, albeit uncomfortably, the picture of a museum visit drawn for Coles by one of his unleisured former patients. As a young boy he often had visited museums with Coles, who remembered how he had ''fairly glowed with delight'' on those childhood visits, ''when he saw that there was a long tradition to keep him company and give him sanction: artists and what they had managed to create, and an audience of people, both old and young, who kept coming to look, to be moved and taught.'' He described to Coles his adult feelings in a Boston museum:

It's not for me—for us. You can't persuade me. I admit it: when I was a kid, I liked going there. But that was something special; if I hadn't been in all the trouble I was, I never would have got near the place, it's for people with money, or people who are going to get money later on—the college kids. I saw them marching some colored children through, telling them to look here and there and everywhere. It was as if they were saying: see all you've been missing; here it is! I know, it's probably good for them, to go and look at pictures. . . . But then they have to leave and go back home; and it's not easy, when you land in your backyard, to remind yourself that life is no picnic along a river, the way it shows some of those people having in the paintings, pleasant picnics. Maybe for some it's a picnic, but not for the colored, and not for us around here, either.[5]

According to *Museums USA,* few art museums make a special effort to attract visitors like that young working-class man—and not much more to attract old people, or minority groups. If statistical studies, visitor surveys, random observations, or a sensitive physician's inquiries cannot precisely define the art museum's audience, they do support the general assumption among museum professionals that their audience consists primarily, though not entirely, of college-educated persons of, at the very least, middle-class economic status.

What *is* surprising is that museum workers invariably speak of that audience as ''untutored,'' of its individual members as ''uninstructed'' or sometimes as the ''lay'' visitor, as if some great and sacred gap separated museum worker and the educated middle-class visitor. How accurate these adjectives are, given the specialized nature of contemporary knowledge and the sophistication that many visitors bring to the museum, one can only guess.

A curator quoted in one of the reports in this chapter advises that the very next step after conceiving the idea of an exhibition is ''to define the exhibition's audience.'' Others reverse that process, counseling that the museum *begin* with the audience's needs—as the museum perceives them. Most

museum definitions of even the customary audience and its needs assume a low level of art historical knowledge and an even lower level of visual understanding: there lies the mysterious gap. It is for such an audience that most art museums mount their most aggressively ''educational'' exhibitions, write their booklets, labels, and guides, and record their explanations.

Some form of learning is required to recognize and ''read'' works of art. Rudolf Arnheim has defined vision as ''a truly creative grasp of reality . . . not a mechanical recording of elements but the grasping of significant structural patterns.''[6] As this study has been forced to recognize, visual learning is the form of education least likely to be taught in America's schools, and even in its colleges, though undergraduate art history survey courses appear to be making an impact. Some art museum educators and curators have accepted, as part of their professional responsibility, the task of helping museum visitors relearn to use their eyes, to *see,* as well as the more accustomed task of conveying art historical information.

Relatively narrow though its educational and economic range seems to be, the art museum's traditional adult audience is still a heterogeneous and unpredictable mix. It is several publics, and most require some bridge between scholarship and popular education. This chapter is devoted to an examination of how art museums try to provide those bridges, what they hope to accomplish, and how effectively they realize their hopes.

**The museum's intentions for the individual visitor.** One statistic cited in an earlier essay bears repeating, because against it the programs in this chapter must be measured. Of art museum directors surveyed for the National Endowment for the Arts, 94 percent responded that ''providing educational experiences for the public'' was a ''very important'' purpose of their institutions; a few less, 92 percent, listed ''aesthetic experiences for the public'' in the same category.[7]

However curious it may seem that educational experiences take a slight edge over aesthetic ones among art museum directors' expressed purposes, readers will note the caution from consultants to the Endowment study that the responses undoubtedly reflect widely varied definitions of ''educational experiences.'' (And no consultants are necessary to remind the reader, again, that the 1969 tax laws and the readier availability of money for educational purposes than for aesthetic ones may also have influenced those answers.)

Art museum directors gave highest priority to two functions: (1) exhibiting the cultural heritage, and (2) providing instruction *to the young.*[8] When these priorities are translated into programs, it becomes clear that museums ''teach'' the young through a variety of classes and programs, but that educational or didactic exhibitions are the principal device art museums use to catch the attention of the individual adult visitor. The disparate exhibitions and accompanying aids assembled in this chapter fairly reflect not only that priority but

also the heterogeneous mix of audience interest and need, as perceived by museum curators and educators.

## The education of the individual adult visitor

Just as there is no definitive profile of the museum's publics, so there is no single or consistent art museum view of how best to ''educate'' them. Assuming that museum educators know what museum curators are trying to convey in an exhibition, shall they provide extra doses of *that* information, or another layer of information? How can museum educators keep teaching in the galleries from becoming what one museum director has called ''something to do while looking at art''?

Even without sure answers to these questions, still the educational activities multiply. Some exhibitions and their surrounding programs are thoughtfully conceived, some are merely ''crowd-pleasers,'' others are heavy with instruction, as if their planners secretly believe that art is, after all, such sheer pleasure that it must be stiffened, so to speak, with education, the most popular morality of all. If the visitor is to benefit from any of the museum's activities—if he is, as Robert Coles has said, ''to look, to be moved and taught''— the museum must help him first to see the works of art and pay attention to them, and help him understand that both will require his time and his effort.

**Installations.** An early researcher in the behavior of adult visitors in an art museum, A.W. Melton, ascribed this theory to the conventional display of works of art: that the works ''are capable of affecting the beholder through some inherent, given relations between art forms and human reactions.'' On the basis of nearly a decade of observing visitors to permanent collections, Melton concluded that some traditional display emphases were misplaced. Specifically, he said, it is not true that the intrinsic interest of the art object determines visitor attention and response, and that ''the factor called aesthetic quality is not very significant to the average adult visitor.'' He cited other factors that he found more significant in determining what a visitor looked at and for how long. Among them were the location of the work in relation to the gallery entrance (he found that 75 percent of the visitors instinctively turned to the right); the pull of the gallery exit as a rival for the visitor's attention; the position of the object in a group of similar objects; the object's distance from the museum entrance, a factor of ''museum fatigue.''[9]

Behavioral psychologists studying museum visitors more recently have offered other insights, some no more comforting to museum curators or congenial to museum designers. One can, with trepidation, summarize the two current extreme conflicting views. The first argues that what is in an art museum is precious, or at least unique; that the museum's first responsibility is toward its objects and that any exhibition and explication that simplifies them will also, and inevitably, compromise or trivialize them. Exhibitions that reflect these convictions generally center on works of art and look

much like traditional or scholarly installations, unmistakably akin to the installations of the permanent collection. To such didactic exhibitions a staff may add long explanatory labels and a variety of educational aids—booklets of toned-down scholarship, recorded tours, gallery demonstrations, maps, and diagrams. But the appearance of the exhibition and the tone of its supporting material will be generally unbending toward any light-hearted approach to popular education.

At the other extreme is the argument that however precious or unique the objects in the museum, the public cannot be expected to understand and appreciate them without the familiar trappings of popular culture. Exhibitions that reflect this conviction may be based on conventional or unconventional subject matter; what distinguishes them is the ''packaging'': the installations may, and have, run the gamut from a department store display to a fun-house labyrinth, and the accompanying material may range from imaginative to arch. The look and tone of such an exhibition will be geared primarily to ''getting its message across.''

Like the majority of didactic exhibitions and their accompaniments in American art museums, those included here fall somewhere between the two extremes. Neither stuffy nor ''far-out,'' all include some of the elements of both. Taken together, they represent the dominant trends in didactic exhibitions in the early 1970s.

**Subject matter.** Art is no longer the subject of all art museum exhibitions. From sociology to school architecture, topical issues and polemics have crept into museum exhibitions. The Walker Art Center's ''New Learning Spaces and Places'' used no precious works of art in its effort to generate interest in the application of new technology and new architectural and educational ideas to the community's schools. Philadelphia's ''Invisible Artist'' used works of art, among other things, to convey a message that was not specifically focused on those works.

In recent decades art history has expanded to include once-neglected cultures. ''African Art and Motion,'' exhibited at both the Wight Gallery at the University of California, Los Angeles, and at the National Gallery in Washington, D.C., reflected not only that expansion but the emphatic new trend toward exhibitions that explore the cultural contexts of works of art and veer away from treating art as objects isolated from economics, technology, politics, or social structures.

As art historical studies multiply and, perhaps more important, as works of art become more difficult to obtain than documentation and ''supporting material,'' some museum workers predict that ''contextual'' temporary exhibitions will become increasingly numerous. No one, yet, has predicted the demise of the temporary exhibition itself, which has been called the ''museum equivalent of inflation.'' But high travel and insurance costs now conspire to prompt museums to search through their own collections for new ways to look at—and to induce the audience to look at—

familiar pieces with fresh eyes. A small exhibition, "Dutch Couples," drew primarily from the Metropolitan's holdings and borrowed only two works of art. Each of the exhibitions reported here—with one exception, the Heard Museum's permanent reinstallation—was a temporary exhibition, and none was an educational auxiliary to a scholarly exhibition elsewhere in the museum.

Exhibitions designed specifically to help visitors use their eyes with discrimination are another, and most welcome, trend. The Minneapolis Institute's "Fakes, Forgeries, and Other Deceptions" took a novel approach to that subject. And an interview here with Katherine Kuh, art critic of *Saturday Review* who has long been admired for the Gallery of Interpretation she installed when she was a curator at the Art Institute of Chicago in the 1940s and early 1950s, provides one of the historical antecedents of the trend. Kuh's belief that "art could be taught in terms of art rather than in terms of words" and her use of reproductions, natural objects, diagrams, and visual comparisons of literally anything that would help the visitor recognize the capacities of his visual and emotional equipment, attracted the attention of many museum curators, though few have followed one Kuh formula: "I believe in asking questions—and not always answering them."

**A plethora of words.** Long ago Benjamin Gilman argued that any label beside a work of art was "unsightly . . . impertinent . . . fatiguing . . . unsatisfactory . . . atrophying to the perception . . . misleading."[10] Ever since, museum workers have debated whether and what kinds of labels should be used. Melton found an "appalling lack of verbal guidance for the museum visitor" when he did his studies in the 1930s,[11] but its abundance in the 1970s appalls many others. Curators eager to get into the act of educating the public sometimes write what one consultant calls "hand-waving" labels, designed more to show off the writer's erudition than to illuminate the subject. Earnest museum educators are not fault-free either; their labels can sometimes be as tedious and long-winded as the Ancient Mariner.

Some labels, to be sure, are helpful. But more than one museum worker has pointed out that the "nuts and bolts" of labels—their size, color, typeface, length, as well as their content—seem to be indifferently studied, if at all, by anyone in an art museum other than the museum designer. An encouraging exception is the label and its stand carefully designed by curator John Walsh for his "Dutch Couples" exhibition.

The proliferation of written materials, especially of labels, troubles many experienced museum-goers, who feel that anything that fills the walls or distracts the visitor from works of art is wrong in an exhibition, even an avowedly didactic one. In a review of the Metropolitan's popular exhibition, "The Impressionist Epoch," *New York Times* art critic Hilton Kramer described it as a "radically revised notion of the best way to exhibit works of visual art to the museum public." Kramer found its "didactic apparatus" distasteful: "Rarely, if ever," he wrote, "have so many pictures in a great museum been so forcibly and so ubiquitously chaperoned by so many words."[12]

"The Impressionist Epoch" was one of the more conspicuous results of the entry into the support of museum exhibitions by the National Endowment for the Humanities, which has encouraged the growing use of words in art shows. Critics argue that, however fascinating, nonart information belongs in the classroom and not in the museum gallery. Others are sympathetic and even delighted, because they believe that art history has been taught for too long as if separate from the history of ideas, and works of art for too long exhibited without context; they contend that the NEH is correct to try to pull curators out of their preoccupation with stylistic concerns.[13]

**Video, slides, films, and other visual aids.** Technology, the alchemy of our modern world, is susceptible to some of the same ills as the written word—and to a few of its own. If overused in an exhibition, technological aids can inflict the same sense of disruption and distraction as a plethora of words; that was a frequent reaction to the use of video in UCLA's installation of "African Art in Motion." Furthermore, as those familiar with video know, any exhibition heavily dependent on electronic equipment is probably bound to have maintenance problems; Philadelphia staff responsible for "The Invisible Artist" caution that any museum using video had better court a good repair shop.

Despite the difficulties of using video well, an increasing number of museums apparently believe it is worth the effort. An AAM survey in 1972 found that 100 museums (of 120 responding) used video in some way, though only a few then used it for "exhibition reinforcement or display enhancement."[14] A random survey taken by the International Council of Museums in 1974 indicated that 50 percent of the responding museums used video, which they found especially versatile in providing information about artists and exhibitions to visitors.[15] At least one art museum educator offers a reason for the growing interest in video: in our society, she believes, for museum-goers who think themselves superior to television as well as for the "average uninstructed" visitor, television validates personality and experience. At the very least, it is familiar technology providing familiar images. (The century's other familiar technology, film, is used in several of these exhibitons; see "Fakes, Forgeries, and Other Deceptions" and "New Learning Spaces and Places.")

By comparison with video, color slides—which once gave notoriously unfaithful reproductions and still can, if not carefully controlled, "overglamourize" objects—seem like old reliable friends. Slide-tape programs such as those offered by the Cleveland Museum of Art are not entirely new to art museum visitors; they are short, automated versions of the slide lectures long given in art history courses in colleges and

museums but designed for a general audience with little knowledge of art history or techniques, though an occasional tape is made for a more scholarly audience with specific interests. Cleveland staff chose slide-tape programs because they are cheaper than any other visual aid and help the visitor focus on a still image, which that museum believes the best preparation for contemplating works of art. All the programs are shown away from the galleries, keeping their noise and "didactic apparatus" separate from works of art.

**Starting where the audience is.** Museums that try to discern what their audiences know and what ideas or talents they bring to the museum are likely to change what they customarily provide to those audiences. A staff member at the Philadelphia Museum of Art explained that in taking visitors through exhibitions, "we may learn that the questions which the exhibition poses are not really important to the people who see it." Based on such experiences and on a careful visitor survey, the museum's education division mounted a journalistic show, "The Invisible Artist," one of a series designed to challenge stereotypes visitors bring to the museum.

The audience of Minnesota's small Red River Art Center helped turn the sudden cancellation of a traveling exhibition from a calamity to a modest triumph. The replacement was a participatory exhibition built on the energy and ingenuity of the director and the center's audience.

New staff members at the Heard Museum in Phoenix recognized that most residents and tourists flocked to the museum to admire its collection of Southwest Indian art but ignored the dilemma of the modern Indians; they reorganized the installations to serve as a source of encouragement to present-day Indian artists and craftsmen and as a source of information and understanding for the white community.

**Most important of all: helping the audience to look.** If works of art do indeed speak for themselves, and museum curators and educators have enough faith in them to let them simply *be,* then just putting out the material with sympathy and skill ought to do the trick. Two temporary exhibitions and one "orientation" room (in a natural history museum) come closest to that approach. A small show at the Metropolitan, "Dutch Couples," exhibited portraits of married couples with special attention to the psychological and formal relationships of each pair; the curator deliberately chose an idea and a visual presentation he believed—correctly, as it turned out—would attract and please the general public, without forfeiting a scholarly audience that might be intrigued to study the subject.

"Fakes, Forgeries, and Other Deceptions" at the Minneapolis Institute took particular pains to induce visitors to examine visual elements in works of art. Applying the idea of a game or puzzle to its exhibition, the institute juxtaposed "real" works with copies, forgeries, or fakes. The success of the exhibition was at least in part derived from its emphasis

on distinctions of quality, the aspect of museum-going that gives connoisseurs their greatest pleasure and that the "average" museum visitor recognized, perhaps unexpectedly, as a pleasure for him too.

The Discovery Room at the National Museum of Natural History, the Smithsonian, is not unlike a good library. A pleasant quiet welcoming room, it offers objects to touch; it trusts the curiosity of its visitors (many of them children) to assert itself and gives each visitor enough time to study and examine at leisure. Visitors to the Discovery Room tend to agree with the research that prompted its establishment: "Touching and handling appeared to stimulate new perceptions and insights." (Staff members at the Heard Museum believe this, too, and allow visitors to touch some objects.) The report here suggests aspects of the Discovery Room that might be useful to art museums, even those wary of letting visitors touch anything.

**Finally, what constitutes success?** If even a fraction of the energy that goes into planning and mounting exhibitions could be spent on assessing their impact on visitors, museum professionals might know a little more than they now appear to about the effectiveness of their ideas and installations. What do they want the stranger in their house to learn, how do they choose to help him, how observant are they of his responses?

Some museum educators claim that establishing "educational goals" is the first step in judging exhibitions, which all museum workers—curators and directors, as well as educators—call the primary education work of an art museum. Chandler Screven, a behavioral psychologist who has tested some of his ideas at the Milwaukee Art Center and at the Renwick Gallery of the Smithsonian, urges that museums try to be clear about their objectives and at least open-minded about ways to achieve and measure them.[16] Screven acknowledged that setting certain goals can produce neglect of others, and suggests that museum workers can design programs that alert the visitor to some specific aspects of the works of art without confining him to those. "In no other part of your life is your life directionless," he points out, and suggests that a visitor does not come to a museum for no purpose at all. "As soon as you really admit, yes, I want my institution to have some kind of impact [on that visitor], you can clarify objectives and find ways of measuring them."[17]

Research on objectives, Eric Larrabee once pointed out, has as its "real power . . . to clarify the minds of the people who asked for it."[18] This seems to be the plea educators and psychologists are making to museum workers when they talk about evaluation and measuring effectiveness. They suspect that the reason so few museum staffs hire, even for occasional consultation, anyone qualified to evaluate their programs is because museums are "scared of finding out how wrong they have been."[19]

Experienced museum-goers who have participated in

some of the "learning games" and other efforts designed to measure how successfully an exhibition is teaching have registered mixed reactions. Some say, as did one CMEVA reporter, that they "remember almost everything . . . but disliked the method . . . resented having to work for the information and [were] anxious to leave the museum after completing the questionnaire." Others say they may answer all the questions correctly "but without much feeling of accomplishment . . . and curiously embarrassed." Many visitors, including well-educated ones who feel inadequate in the face of a museum's certainties about its offerings and the way it presents them, have admitted to embarrassment when the educational approaches are esoteric and parochial, to irritation when they are elementary.

In the temporary exhibition that declares itself to be educational, and that therefore by definition has at least implicit objectives, arguments for setting goals and measuring effectiveness merit consideration—and, increasingly, grants for "educational exhibitions" require them. But even museum educators who advocate such evaluation schemes recognize the danger of offering too narrow an approach—"tunnel vision"—to an exhibition from which each individual visitor will, and should always be free to, take whatever he needs or wishes. Respect for "random access," the freedom of movement and choice that characterize the museum as a learning environment, mandates that setting goals and measuring them not intrude on the special and private pleasures of visiting an art museum.

But anyone watching visitors in the galleries can use one simple measure: How long does the visitor look at the work on exhibit? Surveys suggest that the average visitor spends less than 30 seconds in front of a work and rarely longer than two minutes. Samuel Sachs, director of the Minneapolis Institute of Arts, thinks that people want the visual arts to be direct and immediate and will not spend the time "to let them soak in"; his exhibition, "Fakes, Forgeries, and Other Deceptions," effectively countered that visitor tendency to dart from object to object. "It's a curiosity," he observed, "that it would take fakes to make them do that."

Attendance is an uncertain, though often cited, measure of success. The Walker's "issue-oriented" exhibition of school technology and architectural ideas drew the institution's third largest crowd, probably because of the timeliness of the issue. But many adult visitors expressed bewilderment, anxiety, even anger at the focus on hardware and technology. What the show effectively did was to emphasize the Walker's stance as a contemporary art museum that can play an active role in the community.

Many visitors express particular satisfaction with those aspects of exhibitions that encourage freedom of movement and choice and that treat visitors as intelligent individuals capable of paying careful attention without explicit instruction and of moving through an exhibition at the pace and pattern they wish. Indeed, any success enjoyed by the exhibitions discussed here can be traced at least in part to the chal-

lenge they offered the individual visitor to make visual connections, see parallels and contrasts, and generally teach himself through what he saw. It is an argument against overprograming that museums might well consider.

Even the most informal visitor survey can turn up perceptive comments and appraisals. What any museum curator or educator responsible for an educational exhibition would probably like to hear is the kind of comment one experienced museum-goer made on leaving the National Gallery's "African Art and Motion" exhibition: "Terribly well done," she said, and reported that she had learned two things—"which is pretty good for 30 minutes."—*A.Z.S.*

## Notes

[1] "The Metropolitan Museum and Its Public: Highlights of the Yankelovich Survey," Metropolitan Museum of Art *Annual Report 1973/74* (New York, 1974), p. 18.

[2] Michael O'Hare, "The Audience of the Museum of Fine Arts," *Curator,* vol. 17, no. 2 (June 1974), pp. 130–131.

[3] Cesar Grana, "The Museum and the Public," *Museums' Annual* (International Council of Museums), vol. 3 (1971), n.p.

[4] Robert Coles, "The Art Museum and the Pressures of Society," *On Understanding Art Museums,* (Englewood Cliffs, N.J.: Prentice-Hall, 1975), p. 201.

[5] Ibid., pp. 189–190.

[6] *Art and Visual Perception* (Berkeley and Los Angeles: University of California Press, 1954), p. viii.

[7] *Museums USA* (Washington, D.C.: National Endowment for the Arts, 1974), pp. 25, 26.

[8] Ibid., p. 28, fig. 19, and p. 33, fig. 21.

[9] Arthur W. Melton, "Problems of Installation in Museums of Art," *Studies in Museum Education,* ed. Edward S. Robinson, in *Museums Journal,* new series, no. 14 (Washington, D.C.: American Association of Museums, 1935), pp. 2, 254, 256.

[10] Ibid., p. 11 (quoting Gilman, "The Problem of the Label," *Proceedings of the American Association of Museums* 5:15–25 [1911]).

[11] Ibid., p. 2.

[12] Hilton Kramer, "An Odd Way to Honor the Impressionists," *New York Times,* December 1974.

[13] The debate seems in no danger of abating. *ARTnews* carried an article that focused on the NEH's interest in "interpreting" exhibitions through "installations and accessories—labels, brochures, films, tapes—[that] occasionally overpower the art." Linda Charlton, "The Humanities Endowment: 'Ballast' on the Ship of Culture?" *ARTnews,* January 1976, p. 37.

[14] Rebecca Moore Clary, "Video in Museum Gagedtry [sic] or Imagery?" *TeleVISIONS,* vol. 3, no. 1 (January/February 1975), p. 4. Formerly *Community Video Report,* published by Washington Community Video Center, P.O. Box 21068, Washington, D.C. 20009.

[15] Mary Elizabeth Osher, "A Progress Report on the Use of Videotape by Some American Museum Educators," prepared for the International Council of Museums, Committee for Education and Cultural Action, Working Party on Communication, June 1974, Copenhagen.

[16] See C. G. Screven, *The Measurement and Facilitation of Learning in the Museum Environment: An Experimental Analysis* (Washington, D.C.: Smithsonian Institution Press, 1974). Also, "Instructional Design," *Museum News,* January–February 1974, pp. 67–75.

[17] Interview with Sue Hoth, May 1974.

[18] *Museums and Education,* ed. Eric Larrabee (Washington, D.C.: Smithsonian Institution Press, 1968).

[19] See Scarvia B. Anderson, "Noseprints on the Glass," ibid.

## Bibliography

The two lists of books and articles here, one on visitor behavior and the other on aesthetic perception, were prepared for this study by Sue Hoth and Daniel Nadaner, respectively. Hoth, who is research instructor in the M.A.T. program in museum education at George Washington University (see chapter 14) and a reporter for this study, has taken a particular interest in evaluation of museum experiences; Nadaner, a Rockefeller Foundation Fellow at the Metropolitan Museum of Art in 1975/76, has done his work there primarily in the field of visitor perception as it is affected by architectural environment, developmental psychology, and social and economic background.

### I. Museum Behavior and Evaluation

Borun, Minda. "Museum Effectiveness Study, A Bibliographic Review." Philadelphia: Franklin Institute, 1975, unpublished. Lists such issues as awareness of the museum, demographic characteristics and interest profiles, orientation, visit process.

Elliot-Van Erp, Pamela, and Ross J. Loomis. *Annotated Bibliography of Museum Behavior Papers.* Washington, D.C.: Smithsonian Institution Press, 1975. "Probably the most comprehensive first source for anyone interested in the subject." Focus is on museum visitor studies, including sociological surveys, educational evaluation, environmental psychology, formal learning systems, children's experiences in museums.

Loomis, Ross J. "Please, Not Another Visitor Survey," *Museum News,* October 1973, pp. 21–26.

———. "Social Learning Potentials of Museums." Unpublished manuscript presented at a symposium, "The Museum as a Learning Environment," at a meeting of the American Educational Research Association, April 16, 1974, Chicago, Illinois. Discussion of museum visitor attitudes toward museums.

Mager, Robert F. *Preparing Instructional Objectives.* Belmont, Ca.: Fearon Press, 1962.

———. *Goal Analysis.* Belmont, Ca.: Fearon Press, 1972. According to Chandler Screven, "an amusing and useful treatment of how to get from goals to behavioral statements of objectives."

———. *Measuring Instructional Intent.* Belmont, Ca.: Fearon Press, 1973.

Melton, Arthur W. "Visitor Behavior in Museums: Some Early Research in Environmental Design," *Human Factors,* vol. 14, no. 5 (1972), pp. 383–403. Studies in an art museum and a science museum illustrate "that we have barely begun to act on the findings of behavioral studies done in the thirties."

Schutz, Richard, Robert Baker, and Vernon Gerlach. *Stating Educational Outcomes.* New York: Van Nostrand, 1971. Leads the beginner through the process of writing learning objectives step by step.

Screven, Chandler G. "The Museum as a Responsive Learning Environment," *Museum News,* June 1969, pp. 7–10.

———. *The Measurement and Facilitation of Learning in the Museum Environment: An Experimental Analysis.* Washington, D.C.: Smithsonian Institution Press, 1974. Includes much of Screven's early work in the Milwaukee Public Museum.

Shettel, Harris. H. "Exhibits: Art Form or Educational Medium?" *Museum News,* September 1973, pp. 32–41. Highlights the general lack of agreement among museum professionals on what makes for a "good" exhibit.

### II. Perception and the Museum Environment

#### A. Aesthetic perception and the work of art

Arnheim, Rudolf. *Art and Visual Perception,* rev. ed. Berkeley and Los Angeles: University of California Press, 1974.

———. *Visual Thinking.* Berkeley and Los Angeles: University of California Press, 1969.

Behrens, Roy. "Perception in the Visual Arts," *Art Education,* vol. 22, no. 3 (March 1969), pp. 12–15.

Dewey, John. *Art as Experience.* New York: Capricorn Books, 1958.

Ehrenzweig, Anton. *The Hidden Order of Art.* Berkeley and Los Angeles: University of California Press, 1971. A psychoanalytic view of perception and creativity. Ehrenzweig describes the activity of the unconscious in perception, the stages of the creative process, and the manifestation of the unconscious life in works of art.

———. *The Psychoanalysis of Artistic Vision and Hearing.* New York: George Braziller, 1965.

Gombrich, E. H. *Art and Illusion.* London: Phaidon, 1960.

———. *Art, Perception, and Reality.* Baltimore: Johns Hopkins University Press, 1972.

Kepes, Gyorgy, ed. *Education of Vision.* New York: George Braziller, 1966. A collection of essays by Arnheim, Ehrenzweig, Johannes Itten, Bartlett Hayes, Paul Rand, on educational approaches to problems of visual perception.

Klee, Paul. *The Thinking Eye.* London: Lund Humphries, 1961.

#### B. The impact of the museum environment

Borhegyi, Stephen F. de, and Irene A. Hanson, eds. *The Museum Visitor: Selected Essays and Survey of Visitor Reaction to Exhibits in the Milwaukee Public Museum.* Milwaukee Public Museum, 1968.

Ittelson, W. H. *Visual Space Perception.* New York: Springer, 1960.

———. *An Introduction to Environmental Psychology.* New York: Holt, Rinehart and Winston, 1974. Discusses problems of perception in an environment as a system of information processing, interwoven with experience and serving as a prognosis for future action.

Lehmbruck, Manfred. "Perception and Behavior in Museum Architecture," *Museum,* vol. 26, nos. 3/4 (1974). A statement of the need to consider perceptual experience in architectural planning. All aspects of space, light, and form will have an effect on how one feels and behaves in a museum, and these aspects must be planned for with the viewer in mind.

#### C. Developmental considerations

Arnheim, Rudolf. "Growth," in *Art and Visual Perception.*

Ehrenzweig, Anton. "The Child's Vision of the World," in *The Hidden Order of Art*.

Gardner, Howard. *The Arts and Human Development*. New York: Wiley, 1973.

———. "Children's Sensitivity to Painting Styles," *Child Development*, vol. 41, no. 3 (September 1970), pp. 813–821.

Piaget, Jean. *The Child's Conception of Space*. London: Routledge, 1956.

———. *Six Psychological Studies*. New York: Random House, 1967.

### D. Social and cultural influences

Coles, Robert. "The Art Museum and The Pressures of Society," Sherman E. Lee, ed. *On Understanding Art Museums*. Englewood Cliffs, N.J.: Prentice-Hall, 1975.

Deregowski, J. B. "Picture Recognition in Subjects from a Relatively Pictureless Environment," *African Social Research* 5:350–364 (1968).

Dorfles, Gilo. *Kitsch*. Milan: Gabriele Mazzotta Publishers, 1968. A survey of common, imitative art forms throughout various cultures, and their meanings.

Kennedy, John M. *A Psychology of Picture Perception*. San Francisco: Jossey-Bass, 1974. Explores the visual forces which make pictures informative and recognizable; considers pictures as seen by nonpictorial cultures.

### E. General works on visual perception

Bruner, J. S. "On Perceptual Readiness," *Psychology Review* 64:123–152.

——— and A. L. Mintern. "Perceptual Identification and Perceptual Organization," *Journal of General Psychology* 53:21–28 (1955).

Gibson, J. J. *The Perception of the Visual World*. Boston: Houghton-Mifflin, 1950.

Gregory, R. L. *Eye and Brain: The Psychology of Seeing*. London: World University Library, 1966.

———. *Concepts and Mechanisms of Perception*. London: Duckworth, 1974.

———. *The Intelligent Eye*. London: Weidenfeld and Nicolson, 1970. Explores our ability to recognize objects and spaces and the deceptions that occur; the relation of our biological-perceptual system to new systems of information and our ability to cope with them.

Jonas, Hans. "The Nobility of Sight," *The Phenomenon of Life*. New York: Dell, 1968.

Vernon, M.D. *The Psychology of Perception*. Harmondsworth, Middlesex: Penguin Books, 1952.

In addition to the preceding bibliographies, see also the following articles:

Gombrich, E. H. "The Visual Image," *Scientific American*, September 1972, pp. 82–96.

Rock, Irvin. "The Perception of Disoriented Figures," *Scientific American*, January 1974, pp. 78–85.

## METROPOLITAN MUSEUM OF ART "DUTCH COUPLES: PAIR PORTRAITS BY REMBRANDT AND HIS CONTEMPORARIES"

The Metropolitan Museum of Art
Fifth Avenue and 82nd Street
New York, New York 10028

**The making of a temporary didactic curatorial exhibition for the general public, from inspiration to completion. Careful planning, painstaking design, ingenious labels, and a short, free catalog turned a difficult subject—Dutch pair portraits—into a rewarding and popular show for museum visitors. CMEVA interview: May 15, 1974.**

**Some Facts About the Exhibition**

**Title:** "Dutch Couples: Pair Portraits by Rembrandt and His Contemporaries."

**Audience:** General public, between 60,000–80,000 visitors.

**Objective:** To show selected examples of Dutch husband-wife pair portraits from the Metropolitan's collections and to reunite two other important pairs—Rembrandt's *Portrait of a Man* from the Taft Museum with *Portrait of a Woman* from the Metropolitan, and Hans Memling's *Portrait of an Old Woman* from the Museum of Fine Arts, Houston, with *Portrait of an Old Man* from the Metropolitan—while enriching the audience's appreciation with visual and verbal information.

**Funding:** Under $2,000, from the museum's exhibition budget.

**Staff:** Curator of European paintings and the Metropolitan's exhibition staff.

**Location:** European paintings gallery of the Metropolitan Museum of Art.

**Time:** Six weeks, from January 23 to March 5, 1973.

**Information and documentation available from the institution:** A catalog, *Dutch Couples: Pair Portraits by Rembrandt and His Contemporaries*, New York: Metropolitan Museum of Art, 1973.

On a visit to the Taft Museum in Cincinnati in 1972, John Walsh, curator of European paintings at the Metropolitan Museum, realized that an early Rembrandt there, *Portrait of a Man*, was painted as a companion piece to another Rembrandt, *Portrait of a Woman*, owned by the Metropolitan. The two portraits, painted in 1633, were originally conceived as a single work of art, and they worked together psychologically and formally. Walsh felt that splitting them up was a kind of vandalism, and he decided that they had to be reunited.

Although it was well known that pair portraits were often painted in seventeenth-century Holland, this genre of portraiture had never been systematically studied. Walsh also realized that the Metropolitan owned a good many other important pair portraits by Rembrandt, his contemporaries, and his predecessors, that needed to be reunited, too, in order to be properly seen. The situation was ripe for a major scholarly exhibition. The material was plentiful, it was important, and it had not yet received the critical attention it deserved.

But Walsh was struck by something more than an historical interest in these pair portraits, and that was the way they revealed the basic human theme of husbands and wives. He saw in them an intrinsic interest in how marriage is visualized, and he believed that this interest could be used to attract the general public to portraiture and Dutch painting in general. From among his several options, Walsh chose to present these portraits as a didactic exhibition.

**Designing the show**

''Once you have an idea,'' says Walsh, ''the next step is to define the exhibition's audience.''[1] He decided to aim this show at an untutored but responsive general public that would come to the museum on its own but was not necessarily sophisticated enough to appreciate the material without some help. To reach more than one kind of audience with a single exhibition is often difficult, he says. If the show were to be aimed at scholars, it would have to be more elaborate than Walsh intended. It would call for many examples, and the catalog would require a good deal of very specific documentary information. Although the show was not intended for specialists, Walsh felt it should present hypotheses, suggestions, and ideas that were neither scholarly nor popular, but novel and true, and that would open the subject to scholarly study.

The third step in the preparation of a show, according to Walsh, is the clear formulation of its function. He feels too many shows are accidental hybrids of several ideas or reflect the personal interests of the curator rather than the needs of the audience: exhibitions can become uselessly overspecialized simply to satisfy the curator's own self-respect. Walsh decided that he would design this show to please and intrigue the general public by presenting the poses, expressions, and psychological interaction of gestures between figures in pair portraits. Seventeenth-century Dutch portraitists usually showed men as active and women as passive—sometimes very subtly, sometimes dramatically. Walsh thought that the symbolic and formal devices these pictures used to portray relationships between men and women could serve as a useful handle in helping his audience look at them more receptively and understand the normative or ideal marriage relationship of the seventeenth century.

Walsh feels strongly that the function and the form of an exhibition must be closely connected, and in preparing the show he was concerned initially about the feasibility of linking the two. The material he had chosen was perhaps visually unstimulating—too specialized and repetitive to capture the interest of the audience. Walsh realized that if this show were to fulfill its purpose of enticing a general public, the visual presentation had to be perfect. A straight line of pictures on a flat wall he knew would not work in this case. Each pair had to be singled out; every picture had to stand on its own.

One of his first decisions was to keep the show small, only 14 pairs. As work on the show progressed, three of these pairs were eliminated because Walsh felt that they were redundant or simply did not advance the precept of the show.

In order to give the pictures maximum impact, the installation was clean and spare. The main ideas were to come across visually. The single gallery for the show—a large, square room—was painted a chocolate brown that would act as a foil to the pictures. Although the walls were warm and dark, the room was full of light. The space itself was broken up by two devices—a nearly ceiling-high cube set in the center of the room at a 45-degree angle (see photo) and large door blocks placed at intervals against the walls. Using the walls and these extra exhibition spaces, Walsh was able to give each of the 12 pairs of portraits its own unique place. At the same time, vantage points and sight lines were carefully chosen so comparisons could be easily made. Every detail of the presentation was looked after scrupulously. In several cases heavy gilt frames were taken off the pictures and replaced with dark wood frames of the period. The pictures that needed to be were cleaned or revarnished.

The pairs were arranged in rough chronological order, from donor-worshipper portraits on fifteenth-century altarpiece wings to the fully secular portraits of the seventeenth century. The Rembrandt pair that inspired the show was placed in the center, physically and chronologically. It was the impact of these two pictures that was to lead the visitor into the rest of the exhibition.

**Educating the exhibition's audience**

In addition to enticing his public visually, Walsh also wanted to slip it some information. He concluded that a large catalog would not be read by many of the people who came to the show both because of the energy required and the fact that it would have to be bought, and he was strongly opposed to long didactic labels that ''compete with the pictures.'' He also felt that printed material is more familiar than visual information and that people therefore trust it more, inevitably picking it over visual material. So his solution was to use modified forms of both these basic means of conveying information.

For the specific remarks about each pair that he wanted made to all who visited the gallery, Walsh had an invention: information in the form of brief ''talk'' labels was printed on the slanted tops of free-standing pedestals. The labels were not intended to interpret the pictures, but rather to direct people's attention to things they could see with their own eyes. Each was a maximum of ten lines in length, designed to be read in a maximum of one minute. Because the pictures hung vertically on the walls and the written information lay obliquely on the tops of the pedestals, they both could not easily be seen from the same vantage point. The pedestals were a clear visual cue that reading was a different order of experience from looking—the labels were obviously not another two-dimensional thing that could be thought of as

equal in importance to the paintings. Says Walsh, "A visitor could not fool himself that it was possible to read and look at the same time; he had to choose." In addition, the print was large and the labels convenient to get to; visitors were not forced to walk close to the label to read and then step back to see the picture. And, because the labels, like the paintings, were given their own distinct space, they were not easy to avoid; Walsh observed that most visitors read them.

A free four-page catalog supplemented the labels.[2] It contained a 600-word introduction to the subject, an overview, and a checklist and bibliographical note designed primarily for the reference of scholars and students.

## "Dutch Couples": the completed exhibition and some conclusions

Six months after John Walsh first decided to do a show of Dutch pair portraits, "Dutch Couples" (January 23 to March 5, 1973) opened in the European Paintings galleries of the Metropolitan Museum. Its cost was under $2,000: chief

**The exhibition space for "Dutch Couples" was broken up by a nearly ceiling-high central cube, *left,* set at a 45-degree angle to the room, and by door blocks placed at intervals along the walls, *right.* Labels were printed on the slanted tops of free-standing pedestals placed so that the visitor could not read and look at the same time. Portraits at left are Mierevelt's *Jacob van Dalen* and *Margaretha van Clootwijk.***

expenses were for the catalog, silkscreens, labels, and painting the walls. (Because there were only two loans, insurance and transportation costs were minimal.)

Too often all the energy that is expended on an exhibition is poured into its preparation. As soon as the show is open and has been reviewed, everyone who worked on it disappears; rarely does anyone bother to discover whether all the ingenious devices designed into the show to serve the public are in fact doing the job. According to Walsh, this failure to study a show after it is hung is one of the biggest problems of museum temporary exhibitions. He himself carefully observes his shows with several questions in mind: Is the

catalog being picked up and used? Is the organization of the show lucid or do visitors get confused? Do they seem to understand the theme and intention of the show? For some of his shows he assigns projects in which students systematically study public behavior in the galleries.

In the case of "Dutch Couples," Walsh estimates that between 60,000 and 80,000 people visited the show during its six-week life. Feedback from the public allowed him to make some minor changes in the presentation while the show was still up. On the basis of his observations, Walsh came to several conclusions about "Dutch Couples." He thought audience reaction to the show was generally positive. Visitors were clearly interested enough to read the labels and catalog. As an exhibition it was perhaps visually less exciting and didactically less methodical than many others he had done, but it was, he felt, his best in terms of careful integration of ideas, content, presentation, and information.

Walsh is probably more modest about "Dutch Couples" than he should be. The well-thought-out presentation of this little exhibition allowed its very specificity to have an impact much broader than intended. The way in which symbols and gestures were used by Dutch painters to unify a pair of portraits into a single composition exposed an important but as yet largely unstudied aspect of Dutch painting for scholars; it has since become the subject of a doctoral dissertation. The striking visual presentation combined with novel and carefully selected comments about pair portraits gave the visitor who normally would not look closely at portraits a handle by which he could enter into an experience of them.

Just before "Dutch Couples" opened, John Walsh had a sinking feeling that perhaps he had laid a bomb in the galleries. Portraits are often the last thing most visitors look at in a museum. His fears were ungrounded. The show came closer to fireworks than a bomb.—*F.G.O.*

## Notes

1 All quotations from Walsh are taken from an interview, May 15, 1974, and two telephone conversations about editorial changes thereafter.

2 Walsh advocates small, free catalogs such as the one produced for this show. He says that his experience shows that many people who do not buy catalogs do pick up and read these handouts. For this kind of didactic show, which in reality has little permanent value, he states, curators should swallow their vanity and produce something that, although it may be ephemeral, is vastly more useful to the general visitor than an expensive—and pretentious—catalog.

*Photograph courtesy of the Metropolitan Museum of Art.*

## THE MINNEAPOLIS INSTITUTE OF ARTS: "FAKES, FORGERIES, AND OTHER DECEPTIONS," AN EXHIBITION

The Minneapolis Institute of Arts
201 East 24th Street
Minneapolis, Minnesota 55404

**Humor, intrigue, and a touch of scandal attracted 40,000 visitors to a 1973 exhibition designed to develop audience understanding of "the essence of quality" in art. Fakes and forgeries juxtaposed with the real thing challenged viewers to analyze differences; didactic labels rescued the perplexed. CMEVA interviews and observations: September 1973; July, August 1974.**

### Some Facts About the Exhibition

**Title:** "Fakes, Forgeries, and Other Deceptions."
**Audience:** The general public; about 40,000 visitors attended. (The exhibition was not installed at the museum, where visitors to the permanent collection might drop in; those who came did so specifically to see the exhibition.)
**Objective:** To provide an opportunity for visitors to view specific kinds of fraudulent art along with genuine masterpieces in order to stimulate them to look more carefully and to develop an understanding of what constitutes quality.
**Funding:** From the museum's exhibition budget. Approximately $40,000 was raised through a $1 admission charge to help defray expenses.
**Staff:** The director of the institute spent four years planning and assembling the exhibition; institute exhibition staff installed it; docents gave tours.
**Location:** The eleventh floor of the I.D.S. Building in downtown Minneapolis (the institute was closed for renovations at the time).
**Time:** Eight weeks during summer 1973.
**Information and documentation available from the institution:** Catalog of the exhibition, *Fakes, Forgeries, and Other Deceptions.*

I think this exhibition . . . proved that patience in looking at art really pays off. . . . People spend a great deal of time on the other arts. They will spend a lot of time reading a book, or looking at a play, or listening to a symphony, but they want the visual arts to be direct and immediate and they won't spend the time to let them soak in. Exactly how museums can encourage this I don't know, but certainly we found people spending a lot of time looking at works of art in the fakes exhibition. It's a curiosity that it would take fakes to make them do that.—*Samuel Sachs II, Director of the Minneapolis Institute of Arts*[1]

Most museum educators are dedicated to helping their audiences look more carefully at works of art. An exhibition that forces people to compare one work with another, and thus to look at the art objects more carefully, could be considered an educator's dream—and such a show was "Fakes, Forgeries, and Other Deceptions," an eight-week exhibition mounted during summer 1973 by the Minneapolis Institute of Arts. It was one of the largest exhibitions of fake and forged art pieces ever to be held in America. (The institute's buildings

were being renovated at the time, so the exhibition was on the eleventh floor of the tallest building in downtown Minneapolis. About 40,000 visitors saw the show, and it was estimated there might have been as many as 80,000 if the show had been held at the institute and kept open on Sundays.)

Samuel Sachs II, director of the Minneapolis Institute and someone long intrigued by fakes, spent four years assembling the exhibition. "To study fakes is to understand what the essence of quality really is," he said. He wanted to install the show in a way that would encourage the museum visitor to look more carefully at the art, to decide which works were of better quality, and thus to understand how museum professionals judge the value of art. As finally assembled, the exhibition included paintings, drawings, prints, sculpture, jewelry, and ceramics.

The result was that "Fakes, Forgeries, and Other Deceptions" was one exhibition Minneapolis will long remember. There was a touch of humor, a sense of intrigue, and an aura of scandal about the show. One observer, Harvard psychologist Howard Gardner, wrote of the exhibition,

Confronted by two drawings, one an original, the other a skilled copy, the viewer is virtually compelled to compare the two, to search for significant as well as insignificant differences, and to take a stab at which is the original, and which is better. Instructions are unnecessary; a young child is likely to detect the tacit message: look, compare, choose, evaluate.[2]

The show recorded the history of fakes, the money that collectors have paid for them, the various forms of fraud, the artistry involved in producing a good copy, biographies of renowned forgers, and methods of detection currently used by dealers and museum professionals.

## How the show tested the viewer

"Every work in the show had to have fooled one good person once," explained Sachs. Obviously inferior fakes were, therefore, not used. Neither were works that had been misattributed and later proved wrong, or pictures "painted perfectly honestly" that later had dishonest signatures or flourishes added. All had been meant to deceive (and had succeeded in doing so) museum curators, dealers, or knowledgeable collectors.

A number of dealers and collectors lent pieces to the show. Some were eager to display a fake that had fooled them, but not everyone was enthusiastic. One museum professional was unalterably opposed to the exhibition as it was being assembled, in the belief that it would shake the public's faith in the museum "expert." (Sachs says this expert changed his mind once the show opened.)

The exhibition presented to visitors pairs or small groups of apparently identical or markedly similar works. The choices required care; as noted, fakes of obviously inferior quality would pose no challenge, and comparisons that were too difficult would frustrate the viewer. Fakes and genuine works were not uniformly arranged; had the originals always been in the same relationship to the fake, the game would have been too easy to play. Comparisons were often intentionally misleading: some authentic works were displayed in plain wooden frames while the copies were in ornate gold-painted frames; sometimes it was the other way around. Two "look-alikes" were hung separately in distant parts of the gallery, so the visitor had to remember one piece while he was studying the other—the kind of visual memory task that curators and collectors face every time they walk into a gallery. Several pairs included an original of no special distinction by a famous artist, placed next to a forger's copy of a better work by the same artist, an illustration of what Sachs calls the unthinkable popular notion that Renoir and Degas might have had "a bad day, just like anybody else." And some comparisons consisted of a cluster of fakes with no original.

Two paintings in the exhibition were partially cleaned to show how a forger attempts to change original works. In one, a section of the surface of a would-be El Greco was removed to reveal the face of a small figure. Though the surface quality alone made the painting a dubious El Greco, the presence of another painting underneath and the easily soluble surface pigments suggested a forgery. A painting once attributed to Holbein used a portrait of a Dutch burgher (by an unknown painter) as the basis of a purported portrait of the King of England, copying only the hands and face of the original painting and adding a costume of Holbein's time. (The exhibition featured several works by a single forger, as evidence that the artist-forger's style comes through in copies of different periods and masters.)

At the entrance to the show hung a pair of Modigliani drawings so similar that many professionals could not tell which was the fake and which the real thing. It was an introduction designed, in Sachs's words, "so the public would not get the idea this was going to be easy." Even attributions were omitted from the labels for these two drawings.

## Labeling

But labels were generously sprinkled around the rest of the show. A visitor could read those parts of the label copy that directed his attention to important differences between the works without reading the attribution (if he could keep his eyes from straying to the attribution) or could choose to read the whole label. Because the labels were usually long, it took hard work and concentration to read all their material—eye work and time better spent on looking at pictures, some observers believed—but many visitors did it.

Howard Gardner thought some labels too erudite, others just plain showing off, what Gardner called "hand waving":

. . . There was a fair amount of technical material—recondite references to the styles of paintings, characters from mythology, and methods of production and detection, which are sure to be meaningless to many viewers. Such references can only intimidate them. . . . Hand waving shows off the writer's knowledge while embarrassing

the uninformed reader: it is also unnecessary for the connoisseur who should already know the point to which the hand waver is alluding. A good label is one which points to a difference which can then be seen by the viewer . . . a hand-waving label "swoons" or "enthuses" without calling attention to relevant details.

### Other help for the visitor

The movie *Eye to Eye,* produced by public television station WGBH in Boston, was shown about five times during the day. It explained many of the issues illustrated in the show and yet was a more passive and less demanding "learning experience" for visitors challenged everywhere in the exhibition to compare works of art. It also provided a rest for the feet as well as for the eye; seating was near a main path of gallery traffic, and many visitors gratefully sat down, but few watched the whole film.

Docent tours, lasting about 50 minutes, started off about six times a day. At the beginning of each tour, a docent usually had a large audience, but part way through many followers deserted. The groups were often too large to allow every member to examine closely, or even see, the piece the docent was discussing. Nobody minded the dispersion, for the show was designed to entice the individual visitor to get close to the works and look, alone and untroubled by anything but his own responses to what he was seeing.

### Pulling them in

An ambitious publicity campaign to tell citizens about the unusual attraction on the eleventh floor of the I.D.S. Building relied on posters in every transit bus in the Twin Cities ("Will the real Mona Lisa please stand up?" read the line under two photographs of the famous lady)[3] and on short "spots" on three major television stations. Three 30-second tapes, written by a local ad agency, narrated by a television professional, and produced in the studios of the local public television station, cost the institute less than $100; nearly all services were provided without cost to the MIA, and the stations ran the spots free of charge under FCC regulations. Here is an approximate tapescript of one spot:

Two apparently identical portraits appear side by side.
A voice speaks, slightly hesitant, as the camera focuses on one of the paintings:
"The picture on the left is a portrait by Fragonard of Marie-Catherine Columbe painted in 1793."
The camera then pans to the other picture.
"Now the picture on the right is a copy. This was made by a forger in 1957. And . . . (pause) . . . no . . . This is the original and the other is . . ."
The camera abruptly shifts back to the other picture.
"No, this is the . . ."
The voice begins to fade out.
"Could I see that other one again please?"
The screen goes to black, and the exhibition logo appears.

### Did the show educate anyone?

Touches of humor and trickery may have drawn large crowds throughout the eight-week run, but the question still remains—was it more than fun and games for visitors once they got there? The institute's staff did not devise tests to determine what or how much people learned from the exhibition, but Sachs is convinced of its educational value:

Education in a museum is anything that causes the viewer to interpret what he has seen differently than when he first came into the museum—that is to say, he leaves an exhibition or leaves the museum somehow touched or changed. Many people look at works of art but don't see them. Here we had pairs of works of art that were seemingly identical, and the public was challenged to tell where the difference lay.

Gardner, too, believes that looking for "the difference" was an instructive experience for the museum visitor, who was allowed (for a change, he implies) to move through a show "as an intelligent individual, freed from constricting defenses" and encouraged to "initiate comparisons, to recognize that there are degrees of goodness, and even to learn that an original can be poorer, in various ways, than a copy." The exercise does a "great deal," Gardner believes, "to reduce ignorance and demystify art."

Some museum curators, however, are uneasy about endorsing the idea that fakes and forgeries can instruct the general public about quality. At a gathering of museum directors and curators where the exhibition was discussed, one participant described the idea as a particularly "complicated and sophisticated" lesson in looking at art. Some believed it might mislead and misinform, where it strives to do the opposite, because it may oversimplify questions of quality. For all these reasons, some curators have suggested that such an educational exhibition is more suitable for a university art museum than for a general art museum. In fact, Sachs based the exhibition on the practice of the Fogg Museum at Harvard, which encourages students to use its extensive collection of fakes as an exercise in distinguishing quality. (The Fogg never displays its copies and "look-alikes" to the public.)

Sachs and his colleagues at the Minneapolis Institute designed the exhibition as a teaching show for the general public and treated all who chose to come as students. Some visitors were encouraged and enthusiastic: "I thought it was easy to see the differences," reported one young woman who attends museums regularly but had no art history training. Another veteran museum-goer found it hard to "believe that almost any of the works was fake . . . [but] if you paid careful attention and studied each, then you could definitely see quality." Many visitors complained that they could not "see" the "differences" pointed out by the labels and were frustrated by the connoisseur's "game." That game is played behind the museum scenes all the time but rarely in museum galleries, where every object is treated with the same loving

care as every other (with the rare exceptions highlighted in rooms of their own), without distinctions of quality mentioned in label copy or anywhere else.

Sachs believes that comparisons in looking are as useful for the visitor as for the museum professional, and cites one example outside his museum:

The Metropolitan Museum owns a large number of Rembrandts; they're not all of the same quality. I'd love to see them hang two Rembrandts side by side and compare them to each other and say this one's good and this one isn't, and [see] why.

Few museums will do this with their own collections or with works they borrow, for fear of offending donors or lenders. Yet such distinctions of quality are the essence of connoisseurship and of any art museum enterprise. Howard Gardner cites the public response to this instance of the connoisseur's game as evidence that the general public can learn to play it, with pleasure and purpose:

I have never attended an exhibit where people spent as much time in front of a canvas, looked back and forth between two or more canvases, oscillating between label and picture, and remaining physically close to the brush strokes. Indeed their intimacy with the work is good evidence that some discrimination is going on: there are very few reasons why an individual would place his eye within a few millimeters of the canvas.

He concludes,

. . . An exhibit of this sort is ideal for educational purposes. If the purpose of a museum, and of museum education, is to stimulate viewers to look more carefully at works of art, an exhibition featuring originals, fakes, forgeries, etc., is ideally suited to achieve that goal.

—*J.A.H.*

## Notes

[1] For sources of quotations without footnote references, see list of interviews at the end of this report.

[2] All quotations from Howard Gardner are from his "Notes Inspired by the Exhibit, 'Fakes, Forgeries, and Other Deceptions,'" written for CMEVA, September 1973.

[3] The transit system charged only $40 to put posters in all of the buses for eight weeks.

## Interviews

Sachs, Samuel, II. Director, Minneapolis Institute of Arts. July 31, August 26, 1974.
Visitors at the exhibition.

# WALKER ART CENTER: "NEW LEARNING SPACES AND PLACES"

Walker Art Center
Vineland Place
Minneapolis, Minnesota 55403

**One way an art center or museum can educate is to choose a public issue and offer a variety of aesthetic or architectural solutions for the citizenry to consider. The Walker Art Center in Minneapolis built this exhibition around the issue of new school construction and, with the help of an imaginative group of architects, produced such provocative results that "New Learning Spaces and Places" became one of the most heavily trafficked shows in its history. CMEVA interviews and observations: January, March, June, October 1974.**

### Some Facts About the Exhibition

**Title:** "New Learning Spaces and Places."
**Audience:** General public; 61,000 visited the galleries during the six weeks of the show (maximum number of visitors on one day was 4,200).
**Objective:** To study the effects of environment on the learning process, and to determine potentials for making the learning experience more responsive to individual needs.
**Funding:** The exhibition cost $78,000 and was funded by grants from the Graham Foundation for Advanced Studies in the Fine Arts in Chicago ($7,500), the National Endowment for the Humanities ($36,427), and the T. B. Walker Foundation ($34,073).
**Staff:** Mildred Friedman, editor of *Design Quarterly,* coordinated the exhibition, which was designed by the New York firm, Hardy Holzman Pfeiffer Associates, architects. The exhibition catalog was prepared by the Walker design staff. The director and a curator served as consultants on the installation and the catalog. A University of Minnesota intern developed research materials and assisted in installation. Film programs and education programs related to the exhibition were arranged by members of the film staff and education staffs respectively. One teacher from the Minneapolis school system was assigned to the Walker full time for six weeks to work with the high school student interpreter-guides. Walker staff ran several education programs in the galleries.
**Location:** In the galleries.
**Time:** January 27–March 10, 1974; Tuesdays and Thursdays, 10 A.M. to 8 P.M.; Wednesdays, Fridays, and Saturdays, 10–5; Sundays, noon to 6 P.M. Most films and performances related to the exhibition started at 8 P.M.
**Information and documentation available from the institution:** "New Learning Spaces and Places," *Design Quarterly,* vol. 90/91, exhibition catalog, Walker Art Center, 1974.

Few museum exhibitions include sewer pipe, computers, Butler grain bins, plastic Mobil gas signs, fiber-glass cubes, or automobile belly-pans. The Walker Art Center's "New Learning Spaces and Places" did—and it was not a show about pop art or found objects or industrial design. It was an "issue-oriented" exhibition intended to examine how learning, especially in school, can be affected by architectural structures, by new technology, and by urban resources.

At the time of the exhibition in early 1974, Minneapolis was in the middle of a vast building and renovation program for its schools. With the cooperation of the Minneapolis schools and with the help of the architectural firm of Hardy Holzman Pfeiffer Associates, the Walker mounted the show to give the Twin Cities public a chance to inspect and think about new ways to build, furnish, and use schools. Architect Hugh Hardy said, ''We hoped we could encourage people here to think about the expenditure of all these vast sums of money. . . . That is quite different than the typical exhibition in a museum!''[1] And the Walker's coordinator of the show, Mildred Friedman, echoed that hope:

This show was making people aware of what's available in schools, not only in architecture but in new kinds of equipment and communication techniques. . . . I would be lying if I told you we didn't have a point of view about this subject; we should have. We try to be inclusive. We're not saying there's only one way to design a school, or teach a class. We're saying that there are many things available; we're trying to make people aware of what was, what is, and what will be possible. Then people can make decisions.

The central idea of the exhibition was not only that there are many ways and places in which learning can and does take place, but also that, desirable as some of the new technology of education may be, new schools and new hardware do not necessarily make schools better. The show also tried to encourage the adult viewer to consider the way he was educated himself and to compare the latest technology on display in the show with his own experience. Explained Mrs. Friedman, ''The show makes people aware of their past because the past affects the way they are now.'' Architect Hugh Hardy underscored her point—and the point of the first two exhibits the visitors would see, ''the wall'' and a video work by artist Frank Gillette—when he said, ''We believe the future is nothing more than the present being influenced by the past.''

### What does a decision-making show look like?

The axis of the exhibition was a 90-foot-long, 20-foot-high ''wall'' that zig-zagged through the two galleries the show occupied. It was a massive accretion, almost a collage, of paraphernalia used to educate Americans over the last hundred years. Much of it was shelves stuffed with books, 7,000 of them borrowed from a library at the University of Minnesota: books stacked, folded, falling open in disordered and yet enormously appealing array to any book-taught visitor (one commented happily that it ''even smelled like an old classroom''). Clinging to the wall like barnacles were geography charts, basketball hoops, school furniture, water bubblers, a stereopticon, football trophies, class pictures. There was no chronological or alphabetical order; it was an intentional mix of old and new, bookish and unbookish, formal and informal learning tools. As the ''metaphorical and literal spine of the exhibition,'' the catalog explained, the

wall ''represents a store of factual information—the effective core of learning.''[2]

Stuck into open spots in the wall were three television monitors. One showed a tape of newsreel events from the 1950s, another a tape of major events of the sixties, a third of recent events of the seventies. When the 1960s tape replayed the assassinations that plagued that decade, a sober mood generally fell on the adult visitors around the wall—but younger people, who knew those events only as ''history,'' seemed unaffected by the images on the television screen and continued to wander through other parts of the exhibition, playing with computers.

The second thing the visitors saw was a bank of video monitors, a work by video artist Frank Gillette called *Tracks/Trace*. Mrs. Friedman chose it partly to ''involve'' the viewer and to tell him that ''this show is about you.'' But the work also made the point that the past is always visible in the present (whether or not the young who have not experienced ''history'' are always aware of it) and forms the basis of what we do next.

The Gillette work consisted of 15 television monitors arranged in a pyramid. Three television cameras, spotted in different nearby locations and shooting at 12-second intervals, recorded activity in the area in front of the pyramid. One camera recorded the visitors in front of the bank and simultaneously played back their pictures on the monitor at the top of the pyramid. After three seconds, this image, already three seconds ''old,'' moved down to the two monitors in the second row, and at the same time the top monitor began playing another live ''real time'' image of the same visitors and new ones wandering in. Another three seconds and the original image, now six seconds old, moved down to the three monitors in the next row, followed immediately by the image behind it. This cascading effect continued through the five rows of monitors in the pyramid and became a continuous cycle of 15 images, each three seconds apart in time from those before and after it.

### The presentation of architectural alternatives

Dramatizing individual experience as one way we learn, most of the installations were ''action-rich'' and centered on the individual visitor. Around the two galleries were nine self-contained ''experience areas.'' Patterns of movement through the exhibition were dictated by the shape of the ''wall'' and by the entrance to each of these nine areas; visitors moved from one to the next in the order the designers had determined.

Noises came from all areas, some of which were brightly lit, others almost completely dark. Each area was devoted to a method of learning or a kind of learning-machine or learning environment, indirectly suggesting alternatives to current architectural formulas for schools.

• One ''experience area'' built of cube-shaped, hollow fiber-glass forms normally used in construction of reinforced concrete ceilings; recesses in the forms served as

shelves, and their amber color created pleasant lighting effects.

- Two areas were housed in Butler grain bins, round, corrugated metal buildings that cost $800 each, can be put up quickly, and are suitable for outdoor use or for subdividing large interior spaces.
- Two sewer culvers, seven feet in diameter and thus high enough to stand—and "learn"—in, formed two sides of an installation that held a computer toy-game.
- Four walls of automobile parts and gas signs defined another area, a metaphor the architects used to drive home their point that educational spaces can be made out of practically anything, anywhere.

## The "experience" exhibits

It was what went on inside these "experience areas" that really mattered. Early in the planning stages, the Walker's design staff decided that the exhibition must draw on and illustrate different kinds of education and learning, in order to demonstrate how architecture reflects the activity that goes on inside the spaces architecture provides; indeed, the staff's intention throughout the exhibition was to show how architecture complements learning.

One of the action-rich exhibits, which followed directly after Gillette's *Tracks/Trace* video work, was a "cybernetic toy" called Turtle that speaks a language called Logo. Developed at the Massachusetts Institute of Technology to teach math to first and second graders, Turtle is a dome-covered disc that moves across a table top in response to commands typed in Logo on a teletype machine. A computer translated the commands into signals for Turtle, which drew its own path on the table with a pencil fixed in its center. The challenge for a child playing with Turtle was to require that the "toy" do what he wanted it to do—but to make a particular design, the child had to understand geometric concepts and transmit the proper message to Turtle.

After Turtle, the visitor confronted one of the Butler grain bins. Stepping over a door-sill two feet above the floor, he entered a small chamber containing two teletype machines and two monitors. Three simulation games that might be used in math, history, or science classes were set up there. BUFLO was a "resource management program" trying to solve the problem of how to control a buffalo herd's annual harvest of adult males and females. CIVIL was a game about the U.S. Civil War, in which a player "allocates money for food, salaries, ammunition, and makes a decision on battle strategies." And the third, POLUTE, was designed to "study the effect of pollution on various types of bodies of water."

One of the simplest games—and according to one teacher who is instructional consultant in data processing for the Minneapolis Schools, also the most practical for education—was Plotter, which can draw charts, graphs, designs, and even a graphic game of billiards. Plotter requires three technical parts: a telephone, a television set, and a Digilog Telecomputer (priced at the time of the exhibition at about $1,000). When the computer gives information over the phone to the Telecomputer, it can translate these signals and display the information in written form on any television screen. As the teacher pointed out, most American families already own at least a phone and a television set; when—or if—the price of the Digilog Telecomputer comes down, this three-way system could give students anywhere, no matter how remote from established learning centers, access to computer information banks.

One of the most popular games was PLATO TV, designed by D. L. Bitzer of the University of Illinois as an answer to the increasing demands for individualized instruction in the schools. "Students" could respond to literal and pictorial images on PLATO's 8½-inch-square screen by typing answers on a standard typewriter connected to PLATO, or by touching a portion of the screen to answer multiple-choice questions.

Inside one dark enclosed "experience area" were displayed three holograms, whose three-dimensional images were illuminated by three laser beams; the purpose of the holograms was to suggest the potential of this highly accurate form of visual reproduction as a learning device. Another area contained two soundproof booths, each with a monitor and video playback machine; on it the interpreter-guides (see below) continually showed tapes made by students and community groups, some documenting community issues, others instructing the viewer in a particular activity. And a 16-mm film, *The Urban Classroom,* made specifically for the exhibition, documented two school programs that used the city as a learning resource.[3]

Demonstrating how cities can be resources for education was an important goal of the exhibition. The final installation was a "Learning Resources Bank," which consisted of a keyboard and remote terminal connected to a computer in a nearby city and pointed visitors to resources all over the Twin Cities area. The terminal automatically typed out a message—and most visitors responded by typing an answer to the first question, "What is your name?" Then asked by the terminal to state a field of interest—options included science, the arts, the occult, and social science—a visitor could select a category. Once he had done so, the computer posed increasingly specific questions, always offering him options that might further focus the "conversation" between computer and visitor. The final exchange was a computer printout of a list of local institutions where a visitor might pursue his interests; to a visitor interested in "museum/art centers/galleries," for instance, the computer presented a list of 26 locations. This final "experience area" was a kind of summation of the vast amount of information available and the speed with which it could be provided even to a visitor idly "talking" with a typewriter.

Children from preschool to high school age appeared relaxed in the presence of the technology and readily played the computer games. Many adults surveyed the terminals and monitors with skeptical curiosity, but few operated the

machines. Even though parents commonly encouraged their children to participate, they rarely played the games themselves.

**The philosophy and planning behind the exhibition**

The designers of "New Learning Spaces" wanted to make sure that the liberal use of computers would not encourage visitors to regard the exhibition as a "hardware show." Computers were simply used as one device among many available to the schools to help them implement humane, personalized programs—in effect, to carry out their real task of teaching people how to educate themselves. Because the designers believe that most high schools, whose students are fast becoming adult members of society, are not preparing young people for responsible adult life, they focused the exhibition mainly on high school learning, though all levels of education were included in the format.

The exhibition suggested four basic premises for a more "relevant" education:
1. Cities should be used as educational resources.
2. School architecture should not be standardized but should be planned with the specific activity of a particular school in mind.
3. School systems should use new technology and media as resources for delivering information.
4. All efforts should be made to construct "humane" learning programs geared to the individual learner.

Despite such clearly stated points of view, the architects and museum staff contended that the show made no conscious value judgments in comparing past and present methods of education. They explained that the show evoked the past to try to encourage visitors to think about the differences between a technology-rich education and the book-centered classroom of the past. Their aim was to "ventilate issues," as Walker Director Martin Friedman put it, and to investigate "the expanding possibilities of certain well-used technology." The designers were concerned, they said, with the process of education, not its content.

Nevertheless, the thesis of the exhibition, as it was laid out in the planning sessions and as Mildred Friedman described it later, did grow from the sense that any changes in the school buildings would have to be derived from a change in the curriculum. Said Mrs. Friedman, "Any kind of school architecture is going to have to grow out of a program, and a program is going to have to grow out of needs, and needs today are not necessarily the needs of ten or twenty-five years ago."

The groundwork for this thinking, as for the exhibition itself, was laid in a two-day planning conference in March 1973, conducted by the Walker design staff. Fifteen educators, designers, architects, and media experts gathered then to discuss the topic "Physical Facilities and Learning." They agreed at the end not only that there is no single perfect learning environment—a conclusion that determined the exhibition's emphasis on diversity—but also that "learning

is a process of interaction between the learner and a system of resources—the total cultural context. "Consequently," as the report in *Design Quarterly* noted, "it is not possible to examine the physical resources (classrooms, buildings, cities) of the learning environment without also considering the human and information resources that activate architectural spaces."[4]

**How the message got across: aids to education in and around the exhibition**

To amplify the philosophy of the show and to make sure people could understand the principles of the educational hardware in it, the museum turned the 90/91 volume of *Design Quarterly,* which is published by the Walker, into a catalog devoted to the exhibition. The center also hired interpreter-guides from the local high schools, who stationed themselves in galleries to help explain the exhibits to visitors.

**The catalog.** The *Design Quarterly* issue that constituted the show's catalog served both to describe the exhibition to those who could not see it at the Walker and to give the reader an idea of the state of American education in the 1970s. The foreword was written by Superintendent John Davis of the Minneapolis public schools; together with statements by Mrs. Friedman and the architect's staff, it introduced 85 pages of detailed descriptions and photos of each of the exhibition's learning environments and ancillary material. There was a series of charts and statistics on American education during the last hundred years: changes in occupations, literacy rates, percentage of citizens graduating from high school.

A brief history of American education and a two-page curriculum profile of the Minneapolis public schools from 1880 to 1970 added some illuminating fragments of information: for instance, the first swimming pool in a Minneapolis school was built in 1910, and the first music and art programs were inserted into the curriculum about ten years later. At the end of the catalog was a bibliography of almost 100 books, periodicals, reports, and pamphlets on modern trends in education.

**The interpreter-guides.** The student guides were recruited with the help of the Urban Arts program of the Minneapolis public schools (see report in chapter 10). There were 65 high school students in all, about 11 on duty in the galleries at any one time.

Because the show required student guides who were capable math students and could talk simply about abstract ideas to the general public, recruitment was an important first step. A joint letter from the center and Urban Arts to all math department chairmen and all high school principals in the greater Twin Cities area asked them to recommend students who enjoyed using computers, could handle the responsibility of independent study, could afford to miss four days of school each week for six weeks, and had a "strong interest"

in technology and its effects on learning. Recommended students had to get parental permission and apply for an interview at the Walker. In one two-day period, Wallace Kennedy, director of Urban Arts, and Sally Sloan, chairman of a junior high math department on loan from the schools as guest instructor for the student guides, interviewed 116 students. Besides computers, technology, and education, each student was asked to talk about a reproduction of a painting hanging in the interview room. Fifty-four students, most of them male, were chosen; 11 more were recruited later to augment the guide staff. All agreed to work four school days plus a minimum of 40 additional hours in the galleries; they received course credit for the time they would normally have been in school and were paid (at the rate of $1.80 per hour) for the time they spent in the galleries beyond regular school hours.

Walker staff members say it would have been far more difficult to recruit and work with the students without the help of the schools, which paid for Kennedy's and Sloan's time, and for the substitute teacher who replaced Sloan in the classroom while she spent full time in the galleries throughout the exhibition.

The Walker's total cost for the interpreter–guides came to about $400; the school system obviously invested much more. Most of the guides' training took place in the galleries the day before the show opened; it was a full day of instruction by technicians and museum and school staff in how the equipment worked, what to expect in the gallery, and how work would be organized and scheduled. About a week after the opening, all guides met with Mrs. Friedman, Kennedy, and Sloan to talk over and correct the few problems that had come up.

**Extra offerings.** As part of their usual schedule of programs related to exhibitions, the Walker presented lectures, performances, and films while ''New Learning Spaces and Places'' was up. (The three most popular movies were Truffaut's *The Wild Child,* Robinson's *Asylum,* and Wiseman's *High School*.) Teachers and principals from local schools met several times in the galleries, as did other groups of educators.

### And what did a show on learning spaces have to do with art?

For the Walker Art Center, ''New Learning Spaces'' was no novelty. The center has long had an interest in the community, and ''New Learning Spaces'' was preceded by an exhibition, also developed by Mrs. Friedman, called ''Making the City Observable,'' which depicted cities as learning centers (and included photographs of the city taken by local schoolchildren).

The Walker, furthermore, has demonstrated over the years a special attitude toward the visual arts and an art center's role in helping its audience understand them. The first art gallery in the Midwest, the Walker was founded by Thomas B.

Walker ''to promote educational, artistic, and scientific interests.''[5] In the mid-1940s, Thomas Walker's collection was gradually de-accessioned and replaced by twentieth-century pieces. At about the same time, the design staff of the center began producing *Design Quarterly,* a journal for professional designers. In the 30 ensuing years, the Walker has become one of the most respected avant-garde museums in the country. Its schedule of visual arts exhibitions includes film, photography, and video art—''the media of our time,'' the Walker's director, Martin Friedman, has said—as readily as painting and sculpture. Performances of music, dance, and poetry that take place alongside the exhibitions (encouraged by the fact that since 1971 the Walker has been part of an arts complex in which the famed Guthrie Theater is also housed), in Director Friedman's view, serve to reinforce and establish a context for contemporary visual arts and to ''stress the continuum that binds the arts.''

The Walker's programs have taken place throughout the community: in schools, where the Walker has sponsored art workshops, master classes, and performances of modern dance groups; in prisons, where the center's staff members have arranged for classes in music, dance, drama, poetry, as well as art, and have staged folk and rock music concerts; and in department stores, banks, shopping centers, and parks, where the Walker has held special exhibitions. Said Mrs. Friedman of the shows,

[Although] not all of Walker's exhibitions focus on issues . . . [when we do] we try to deal with the important issues that people are asking about . . . and we hope we are selecting something that will in some way affect the community. . . . These shows are saying, ''Look around at what you see every day and be aware of what you are looking at.'' . . . If people see an exhibition that makes them mad or makes them glad, then we hope they will follow through on their own and read more about the subject.

In such an environment—where the artistic ideas and the issues of art are centered as a matter of policy and conviction in the real life of the community—''New Learning Spaces'' had a natural place. The Walker staff's belief that architecture affects and is affected by what goes on inside it led the center to choose as a partner in the exhibition a group of architects whose work clearly demonstrated the same attitude. The group was Hardy Holzman Pfeiffer Associates, a firm of young architects in New York that had made a reputation for itself as imaginative, trendy, humorous, and flexible. It had designed two museums based on the concept of ''architecture as environment''—MUSE, a one-time pool hall and auto showroom in Brooklyn, New York, and the Brooklyn Children's Museum, a partially buried ''strong-box'' that visitors enter through a large sewer culvert, stopping off at several exhibition levels as they descend to the main floor.

In the ''New Learning Spaces'' catalog the architects wrote, ''It is our conviction that the nature of education is changing, and architecture because it irrevocably affects the

life it contains, can make a constructive contribution to new learning process."[6] The Hardy Holzman Pfeiffer group felt that the advances in the technology of information and in mobility had had a deep effect on the development of American young people of this decade and, further, that there was evident in the architecture of the schools a clash of ideas and learning styles between the students who inhabit the schools and the politicians and school administrators who are too imprisoned by the rules of education to be able to look at school architecture with a fresh eye and who determine the uniform, "sterile" way schools are built. A more constructive answer, according to the architects, is a pluralistic one: in Hugh Hardy's words, "We are not literally proposing anything in those galleries as an architectural solution, but we are saying that the world is full of ways to organize space. . . . We are attempting to act as a prod, and I think that was the social purpose of the exhibition."

## Reactions and responses

The exhibition drew the third largest attendance of any show the Walker ever had, proof that the center had hit on a timely issue.

Perhaps predictably, not everyone who came got the point. Schoolchildren of all ages responded more readily and enthusiastically to the "hardware" than did adults, many of whom seemed either intimidated or simply bewildered. Some were angry. A science teacher from a local "free" school thought that the exhibition mystified science and technology; he resented the "magical aura" bestowed on the machines and the lack of adequate explanation of the equipment. An informal survey of teachers who visited the galleries suggested that most were supportive of the show and of the use of computers as teaching devices. Few teachers interviewed were using computers in their instruction, but many said they were "considering" the possibility.

The news media displayed mixed feelings. The art columnist for the *Minneapolis Tribune* was perplexed but still enthusiastic: "The show itself is a bit confusing as it scurries through two galleries trying to touch a huge number of topics, but as a starting point for a discussion of learning it's excellent."[7]

A writer on the University of Minnesota paper supported the Walker's attempt to look into the future but was put off by the installations. Arguing that the small enclosures went against current trends in "open education," he wrote,

. . . The exhibit takes on the flavor of a "boat, sports, and travel show," a bazaar containing the latest in educational computer toys. The casual visitor is left to roam about, dumbfounded, gawking curiously at the novel inventions while they tick, whir, or flash words on their plasma-gel screens.[8]

And an ex-schoolteacher turned staff writer for the *Minneapolis Star* was disturbed by the exhibition.

I am skeptical . . . about the Walker show, which seems to me to imply that technical and architectural gimmickry is

the answer—or even part of the answer—for the malaise that grips our public schools. Far more radical (and less expensive) solutions are needed, I think, than carpeted classrooms, flexible partitions, and electrically enhanced lectures.[9]

Obviously, the exhibition did not allay the questions and uncertainties that confront the public about either schools or the education of the young. Nor was it clear when this study was completed how much influence the show had had on the decisions Minneapolis ultimately made about school construction, educational hardware, and new learning spaces. But there is no doubt that the Walker found and perhaps even helped to create an interested audience with its attempt to stimulate new ways of looking at schools. And because fresh perceptions are, after all, one of the artist's many salutary contributions to everyday life, the Walker's exhibition of "New Learning Spaces and Places" was an appropriate reminder of the integral part the visual arts play in shaping and reflecting the common environment and of the educative powers of an institution that is devoted to helping people see.—*J.A.H.*

## Notes

[1] For sources of quotations without footnote references, see list of interviews at the end of this report.

[2] "New Learning Spaces and Places," *Design Quarterly*, vols. 90/91 (Minneapolis: Walker Art Center, 1974), p. 10.

[3] Most of the videotapes were produced by Film in the Cities, a program of the St. Paul Council of Arts and Sciences; Public Service Video, a student-operated video network that offers tape production and distribution to the public; and the Urban Arts Program Film and Photography Workshop. The 16-mm film was narrated by the chief curator of the Walker Art Center.

[4] "New Learning Spaces and Places," p. 9.

[5] *History, Collection, Activities* (Minneapolis: Walker Art Center, 1971), p. 9.

[6] "New Learning Spaces and Places," p. 12.

[7] Mike Steele, *Minneapolis Tribune*, Sunday, February 3, 1974.

[8] Martin Schendel, *The Daily*, University of Minnesota, February 22, 1974.

[9] Roy M. Close, *Minneapolis Star*, Tuesday, February 12, 1974.

## Interviews

Althofer, Gerd. Hardy Holzman Pfeiffer Associates. January 4, 1974.

Barnes, David. Educational Industry Office, Control Data Corporation, Minneapolis, Minnesota. January 12, 1974.

Davis, John. Then Superintendent, Minneapolis Public Schools. January 31, 1974.

Friedman, Martin. Director, Walker Art Center. January 30, October 31, 1974.

Friedman, Mildred S. Editor, *Design Quarterly*, Design Department, Walker Art Center; Manager of Exhibition, "New Learning Spaces and Places." March 25 and June 20, 1974.

Hanhardt, John. Film Staff, Walker Art Center. March 6, 1974.

Hardy, Hugh. Hardy Holzman Pfeiffer Associates. January 15, 1974.

Holzman, Malcolm. Hardy Holzman Pfeiffer Associates. January 15, 1974.

Hoos, Judith. Museology Intern, University of Minnesota. March 6, 1974.

Kennedy, Wallace. Director, Urban Arts Program, Minneapolis Public Schools. January 26, 1974.

Nord, Mary Ann. Education Department, Walker Art Center. February 12, 1974.

Sloan, Sally A. Chairman of Math Department, Southwest Junior High School, and Guest Instructor. March 5, 1974.

Thompson, Norman. Instructional Consultant, Minneapolis School District Data Processing Joint Board. January 26, 1974.

Weil, Suzanne. Coordinator, Performing Arts, Walker Art Center. March 7, 1974.

## THE PHILADELPHIA MUSEUM OF ART: "THE INVISIBLE ARTIST"

The Philadelphia Museum of Art
Parkway at 26th Street
Philadelphia, Pennsylvania 19101
**This educational exhibition—centered on videotaped interviews with artists surrounded by examples of their work and even some of their common, everyday possessions—sought to dispel popular myths about artists as "freaks." It was the fourth in a series of shows by the education division to clear up mistaken ideas about art that visitors bring into the museum. CMEVA interviews and observations December 1973; January–April 1974.**

### Some Facts About the Exhibition

**Title:** "The Invisible Artist."
**Audience:** The general public and school groups.
**Objective:** To dispel popular myths and misconceptions about artists.
**Funding:** $20,000 from the Wintersteen Fund, an endowment to the museum available for educational programs. Of this, $6,200 was spent on video presentations, including $3,500 for video hardware.
**Staff:** The entire staff of the education division planned and installed the show; a part-time video technician helped tape and edit the interviews and maintained equipment.
**Location:** In the museum's Wintersteen Student Center.
**Time:** From October 31, 1973 to January 1, 1975. The show was open during regular museum hours.
**Information and documentation available from the institution:** A short videotape prepared by the education division, available on ½" reel-to-reel tape, or ¾" cassette.

The television set is on, its picture flickering in the small gallery. Off-camera, a voice is asking: "What does an artist wear?" "How does an artist act?" "What would it be like to go to a party where the other guests are artists?" One by one, people on the street—a policeman, a student, a construction worker in a hard hat—are stopped by a roving reporter and a cameraman. They answer: artists are "freaky," political dissidents, and long-haired hippies; artists are poor young men who wear berets or jeans, discuss issues other people cannot understand. (One young man looked into the camera, puzzled, when he was asked: "Would you like to marry an artist?" After an embarrassed pause, he answered: "Oh—a FEMALE artist!")

The questions were posed by a staff member of the division of education at the Philadelphia Museum of Art to men, women, and children picked at random in three Philadelphia neighborhoods—Center City, South Philadelphia, and the Main Line. Center City is a combination of new buildings and old used by a mix of Philadelphians; South Philly is Italian and black, an old, poor neighborhood that those who love find rich in community feeling and those who do not feel is dangerous; the Main Line is one of Philadelphia's well-tailored upper- and upper-middle-class suburbs, remote from the city's problems.

Yet the answers from these three disparate areas of Philadelphia were not markedly different. That did not surprise the staff members; they had previously conducted a survey within the museum, interviewing as a control group an audience they assumed would be more informed, or at least more sympathetic, than the general public—and their survey had turned up the same stereotypes.

Challenging those stereotypes about artists was the purpose of the education division's exhibition titled "The Invisible Artist." It examined stereotypes by offering information about the lives and works of famous artists, introducing Philadelphia artists through their work, their surroundings, and videotaped interviews, and leaving conclusions to the audience.

### Design and content of the exhibition

An archway, capped by a red neon sign, "The Invisible Artist," led to a semicircle of graduated carpeted platforms facing a large television monitor. Big enough to hold only one school class, the theater's carpeted platforms kept noise down and allowed visitors to sprawl in front of the television set, to feel and behave as comfortable and relaxed as they do in front of their television sets at home.

They could switch channels as they wished to watch one or another of the man-on-the-street interviews the staff had conducted all over Philadelphia. Three channels fed into the monitor, each running a continuous 10-minute loop of video tape. Most visitors stayed in this "orientation" theater about 15 minutes, though many returned after seeing the rest of the exhibition to catch interviews they might have missed. (The telecast could be discontinued by changing to a fourth neutral channel, and when the theater was empty, the guards often did this to lower the noise level.)

Openings from either side of the theater led to two small darkened rooms where slides and taped narratives presented images and information about four artists—Leonardo da Vinci, Vincent van Gogh, Pablo Picasso, and Peter Paul

Rubens. Three of the four were chosen in an informal popularity contest that education staff members conducted while they were planning the show. Students had most often mentioned Leonardo, whose *Mona Lisa* received heavy press during its visit to the United States; Picasso, as well known for his politics and longevity as for his art; and van Gogh, identified principally as the man who "cut off his ear." Rubens was unknown to most of those questioned in the museum, an obscurity education staff suspected was due to his solidly bourgeois life, unremarkable and unremarked by historians, novelists, journalists, movie script-writers, and other chroniclers.

Each slide-tape presentation documented the artist through his works and, where possible, his own words. Picasso was pictured in his studio; the accompanying script included statements by him and by his contemporaries. Passages from van Gogh's letters revealed the intensity with which he worked, and some even mentioned the unfortunate ear. The *Mona Lisa* and its imitations were the focus of slides in the Leonardo presentation, which was accompanied by a Nat King Cole recording on the famous smile. The Rubens slide-tape emphasized the happiness and placidity of a family whose head was a popular and prosperous artist engaged in civic activities.

In the galleries beyond these small slide-tape rooms were displays of cartoons and photographs. The cartoons portrayed the artist with smock and beret, long-haired, poorly dressed, at work in his messy studio, where he was either seducing his nude model or feeling alienated from his family, preoccupied, and absent-minded—all the stereotypes turned into jokes. The photographs of museum staff planning and installing the exhibition treated the staff as artists working together and at the same time described what goes on behind the scenes of a museum exhibition.

And beyond all this, with labels to point the way, was the heart of the exhibition: a large space divided into six areas devoted to Philadelphia artists at work. Though each area was self-contained, each allowed a glimpse of adjacent areas, encouraging visitors to wander back and forth. "Vital" statistics about each artist included dates, education, military service, people and events the artist felt most important (parents, spouse, children, helpful friends, even pets), and turning points in their lives. In each area there were objects the artist especially liked or had been influenced by, plus tools and drawings, large photographs of the artist's studio, and a life-sized photo of the artist, cut out and mounted in relief on the wall. The material chosen by each artist—and some had sifted through old school yearbooks and family albums—might deny or reinforce the stereotypes of the man-in-the-street interviews or of the cartoons, but the visitor was challenged throughout the exhibition to revise the notion that all artists are white, male, untidy, inarticulate, "freaky." There was abundant evidence that artists marry, support families, celebrate birthdays, teach, work hard, travel, walk dogs—in short, lead lives not much more exotic than everyone else's.

For the most part, this main section of the exhibition presented material in ways familiar to museum visitors: labels, objects in cases, photographs, and paintings on the walls. If, as the earlier informal survey had suggested, the usual museum visitor is no more convinced than the general public of the artist's "real life," then these relics of that life, however interesting and appealing in a chatty way, might not by themselves serve to convince him. The real difference in the way "The Invisible Artist" made its case rested on five-minute videotaped interviews with each artist. In each artist's exhibition area, a television monitor was set up to play the interview; some tapes were lively, some subdued, some showed the artist at work, others displayed finished work, introduced the artist talking, demonstrating work, laughing, being serious or shy. In each interview, the voice, hands, movement, personality, and "chemistry" of the individual artist gave weight and emphasis and a sense of contemporary reality to the facts, photos, and works of art spread out around the television set.

- Edna Andrade talked about her daily schedule, the way she prepares for her work, the simple pleasures she finds in a productive day in the studio. Her graphics and "hardedge" acrylic paintings, and one ethereal still life, hung on the walls around the monitor.
- Rafael Ferrer, conceptual artist, created for the exhibition a small house made of rowboats, corrugated metal, rope, and branches. In his interview he explained the influences of his Puerto Rican heritage—which he described as not indulging in responsibility or guilt—and talked of his alienation from his family.
- Venturi and Rausch, a Philadelphia architectural firm, had asked that no individual member of the firm be emphasized but that all be portrayed as artists working together. Though the firm's members talked about their individual attitudes and lives, they presented in their display area only jointly-owned possessions and jointly-designed work, and they emphasized in the joint interview their common belief that individual artists cooperating can produce a single artistic style.
- Harry Bertoia, Italian-born, spoke proudly of his close family, several members represented in snapshots. Wandering through his studio, the camera always following him, he fondled and beat his sculptures (which are made of flexible rods or metal discs), clearly delighted by the sounds of cymbals and gongs they make; he said he considers himself as much musician as sculptor.
- Louise Todd, weaver, spoke thoughtfully, gently, of the hours she spends preparing and executing her work, its exacting nature, the incidental backache it gives her.
- Charles Searles, high school dropout, paratrooper, one-time street-gang member, told of encouragement from other artists to study and travel, of his response to the colors and designs of Nigerian artisans. Asked in his interview what it is like to be an artist, his face lit up with wonder and joy—he had no ready answer and explained that he thinks

of his work as simply a major part of his life, that he has never thought to label himself "artist."

## The purpose of the exhibition, as part of the Division of Education's purposes

"The Invisible Artist" was the fourth exhibition staged by the Division of Education specifically to challenge the popular misconceptions about art and art history that its staff has encountered in gallery teaching. Because all of the staff members either teach or have other assignments in which they meet the museum public, they feel they are "on the firing line," as one put it, forced to recognize what the public thinks and wonders about. Taking visitors through exhibitions, another said, "We may learn that the questions which the exhibition poses are not really important to the people who see it."[1]

So its own exhibitions are important to the education staff as ways to clear up mistaken ideas visitors bring into the museum. The first exhibition in the division's gallery, "Impact Africa," challenged the stereotypes of that continent as primitive and unsophisticated. It illustrated the influence of African art and culture on Western art, especially on certain types of twentieth-century French painting and sculpture and on American music and dance. "The Mind's Eye," the second exhibition, used such objects as a Lucas Samaras mirrored tunnel and *trompe l'oeil* paintings to approach the subjects of illusion and deception. The third show, "1492," described seven cities which in that year had achieved great heights of civilization and commerce, and where Columbus's voyage, so momentous to Western Europe and America, was unknown or unmarked.

"The Invisible Artist" was the first of the four exhibitions to use television as an integral part of the show. It was also the first that all members of the division helped to plan and install; until "The Invisible Artist," education staff had only chosen the theme and the objects, leaving installation design to consultants hired outside the museum. (The look and content of this exhibition—the "funky" neon title, glossy dark gray walls, television sets, pop culture material—suggested trendiness to some observers, to others a welcome sense of humor and healthy desire to communicate with a broad audience.)

All four exhibitions took place in the Wintersteen Student Center, a recently installed facility for school groups located on the floor below the education offices. Though only school groups with reservations enter the center through its reception hall (which is adjacent to the bus parking area), other museum visitors can reach it easily from the museum restaurant and cafeteria. In addition to the reception hall, the student center includes a lunch room, rest rooms, and the gallery—and it is always open. Like many other museums, Philadelphia does not have enough money to pay a full complement of security guards and therefore closes some galleries on specified days, but the center is always open, well-staffed with guards, clean, and very busy.

## Technical and financial aspects of the video exhibition

Of a total budget of $20,000 for "The Invisible Artist," $6,200, or 32 percent, was spent on the television presentations. The major expense was the purchase of three Concord CV solenoid-operated tape decks at $600 each; new equipment that had been discontinued and superseded by even newer models, they were no longer on the market. These three new decks supplemented three second-hand decks the Division of Education had previously bought: a Sony 2600, a Sony 3600 CV, and a Panasonic AV. (The video technician employed by the division reported that the new consoles gave a better signal but needed repair more often than the older models.)

Ten-minute Sony cartridge loops were used on all consoles, each running continuously during the museum's operating hours; each tape cost $30. Total hardware costs for the exhibition, including purchase of monitors as well as of the three new tape decks, and the original tape supply (which cost $300), was $3,500. David Katzive, chief of the Division of Education, said that "shopping around" kept these costs to a minimum, far below the then-current market value of comparable equipment, which he estimated at about $7,800. The only salary expense in the exhibition's budget was for a part-time video technician, whose camera work, editing (on equipment the division owned), and maintenance help cost $1,900.

Maintenance was the chief problem of this video exhibition. The video hardware was carefully placed in the exhibition areas for easy access for minor repairs and adjustment; however, major repairs requiring removal of the equipment from the exhibition area meant that back-up machinery was necessary. So was a competent local commercial repair company, which the museum staff "courted" to establish and keep as a reliable resource. Unless such a company exists and is willing to work with the museum, cautioned Katzive and his staff, a museum ought not undertake a video program. Only a skilled professional can maintain video hardware, they said, though museum education staff can learn to operate it and take care of minor service problems. (And they did, despite scheduled duties that took priority.)

The program schedule was heavy. The three Concord tape decks operated the three simultaneous telecasts of man-in-the-street interviews. The three old decks carried the five-minute artist interviews, which were "paired"—two to a tape loop—and cued to broadcast alternately on two of the monitors. Thus three of the six monitors carrying artist interviews were playing at any one time, and three remained silent. (The silent monitors remained blank but did not turn off.) It was possible to hear, often simultaneously though indistinctly, any of the seven (including the theater set) television monitors in the exhibition, but all were set at a noise level that did not interfere with any presentation a viewer chose to watch. Staff members reported that the quality of the

different decks was apparent: the Panasonic unit on which the Venturi-Rausch and Searles interviews were paired gave the least satisfactory signal, whereas the Concord decks showing the man-in-the-street interviews gave the clearest.

After three months of continuous operation, the inevitable technical difficulties began. Slippage developed on the tape in some of the slide-tape presentations; a malfunction in the tape signal on one console reversed two artist interviews; there was "snow," or carbon build-up, on the videotape. Between the part-time technician and education staff, most of these minor problems were corrected, but not always as quickly as desirable.

Legal permission to use interview material was requested of each artist as the first interview question. The recorded assent, edited out of the final tape, remained on file with the Division of Education.

**The audience's response**

Reactions to the exhibition were mixed, but not uninterested, staff observers reported. School groups began in the orientation theater, watched some of the man-in-the-street interviews, were alerted by museum instructors to the slide-tapes, displays, and major exhibition space, and then were set free to explore the show on their own, with a lecturer always available to answer questions. Older children spent most of their time looking at the cartoons before returning to the carpeted theater; very few saw the full sequence of artist interviews or stayed through a single complete five-minute interview. Whether this behavior derived from their television habits at home, where they combine watching television with doing other things, or whether they simply enjoyed the freedom to move and talk at a normal pace in a museum, or whether the interviews bored them, no one can say. Few children had questions for the lecturer. If the lecturer took the initiative and started a conversation, some students responded, but others behaved as if such talk encroached on their freedom to move around in the exhibition.

What did they move around to do and see? They paused often to play with the Bertoia sculpture, much as the artist himself did in his taped interview, or to sit in small cozy groups within the Ferrer "house." In the slide-tape area, van Gogh's ear proved to be almost endlessly fascinating; black children seemed especially pleased to hear Nat King Cole's recording and were drawn from other parts of the exhibition to listen to it, sitting through the entire Leonardo slide-tape to hear the song a second time.

Individual visitors—mostly adults, but also teenagers who came without school supervision—spent more time at the artists' video sets, often retracing their steps to make sure they had seen each interview. Many chose an aspect of each artist, often the memorabilia, and moved back and forth to compare data. Visiting families seemed especially to enjoy the freedom to see the exhibition at different levels of interest and different speeds, parents and children often wandering separately through adjacent areas. (Home television habits

apparently flourish everywhere; some parents seemed to use the exhibition as a babysitter, letting the children watch whatever flickered across the screens and retrieving them only when it was time to leave.)

Guards in the exhibition changed as their gallery schedules varied, but all seemed to relax in "The Invisible Artist" area. Besides tending to routine chores, they adjusted channels on the orientation monitor, instructed visitors in aspects of the show they thought interesting, relayed problems, comments, and incidents to the education staff. One black guard was excited that the exhibition intrigued black children, who could discover, earlier than he said he had, that a museum is "a library for the senses." Describing how his education in music had helped him understand patterns of creativity, he spoke with feeling of his belief that young people, "especially emerging peoples, should learn from all things, not just books," that are part of the culture around them.

All of the guards seemed to enjoy the young peoples' responses to the exhibition, especially to Harry Bertoia's sculptures, which made a good bit of noise when several children played with them. Though there were times when the guards were subjected to large doses of Bertoia "music", they generally agreed that it was not bothersome and was, in fact, a good thing, because it meant people were enjoying the show. Watching an adult visitor tentatively tap one of the Bertoia sculptures, the guard remarked that it was "too bad she can't loosen up like the kids." As encouragement, he walked over to the piece and gave it a good whack himself.

Whether "The Invisible Artist" changed the audience's attitudes toward artists is impossible to judge. The amount of time adult visitors spent considering the material, watching the interviews, talking with each other (and with the guards), suggests their willingness to examine their own stereotypes. Children may have been more actively involved with the objects, but probably were less involved with the lesson. One boy, perhaps ten years old, whacking his way through the Bertoia sculpture with a group of friends, shouted happily over the din, "I still say they're crazy."—*B.C.F.*

**Notes**

[1] For sources of quotations, see list of interviews at the end of this report.

**Interviews and observations**

Anderson, Elizabeth. Staff Lecturer, Division of Education, Philadelphia Museum of Art. January 8, 1974.
Balkin-Bach, Penny. Coordinator, Department of Urban Outreach, Philadelphia Museum of Art. February 14, 1974.
A guard at the exhibition. January 11, 1974.
Katzive, David. Chief, Division of Education, Philadelphia Museum of Art. January 7 and 9, February 11, 1974.

Robinson, Tara. Exhibition Coordinator, Division of Education, Philadelphia Museum of Art. February 11, 1974.

Seiger, Marjorie. Staff Lecturer, Division of Education, Philadelphia Museum of Art. January 8, 1974.

Sewell, Darrell. Curator of American Art, Philadelphia Museum of Art. April 11, 1974.

Stapp, Carol. Staff Lecturer, Division of Education, Philadelphia Museum of Art. January 8, 1974.

Turner, Evan. Director, Philadelphia Museum of Art. January 10, March 26, 1974.

Williams, Patterson. Staff Lecturer, Division of Education, Philadelphia Museum of Art. January 7–10, February 12 and 13, April 10, 1974.

Williams, William. Assistant Chief, Division of Education, Philadelphia Museum of Art. January 10, 1974.

Observation of the exhibition. December 17 and 18, 1973; January 10 and 11, April 12, 1974.

## TWO INSTALLATIONS, ONE PURPOSE: "AFRICAN ART IN/AND MOTION"

The Frederick S. Wight Gallery
University of California
Los Angeles, California 90024

The National Gallery of Art
Constitution Avenue at 6th Street
Washington, D.C. 20565

**Two museums took the same materials—objects from a private collection of African art, photographs, and films of tribal rituals—and designed two quite different didactic exhibitions, one learning from the other about how not to handle film in the galleries. An art historian from Yale set the theme, chose the objects, and wrote a scholarly catalog. CMEVA interviews and observations: March and May 1974.**

### Some Facts About the Exhibition

**Title:** "African Art in Motion" (at the Wight Gallery); "African Art and Motion" (at the National Gallery).
**Audience:** The general public; 20,619 at the Wight, 315,000 at the National Gallery.
**Objective:** To demonstrate the relation between art and life in African cultures.
**Funding:** The exhibition was sponsored by the University of California, Los Angeles, Art Council and supported by $14,600 from the National Endowment for the Arts for installation at the Wight Gallery, plus an additional amount (figure not available) for the catalog. Brochure for the exhibition at both museums was paid for by the Ahmanson Foundation in Los Angeles. Total cost for both installations was about $110,000. The films produced by Robert Farris Thompson to accompany the exhibition were made under private grants to him.
**Staff:** Art historian Robert Farris Thompson chose the objects and wrote the catalog; exhibition staff at the two museums installed the show.
**Location:** Frederick S. Wight Gallery, University of California at Los Angeles, and the National Gallery, Washington, D.C.
**Time:** At the Wight, January 21–March 17, 1974; at the National Gallery, May 5–September 22, 1974.

**Information and documentation available from the institutions:** "African Art in Motion," an illustrated guide to the exhibition.

Two exhibitions of a private collection of African art began with the same purpose—and ended up looking very different. On the premise that in Africa "art" and life are intimately related, each exhibition proposed to explain that relationship and to interpret its meaning in the forms of African dance, costume, sculpture, and ceremonial objects.

Perhaps the first clue to the exhibitions' differences was a change of name. At the Wight Gallery of the University of California, Los Angeles, the show was titled "African Art in Motion"; at the National Gallery in Washington, the title was "African Art and Motion." UCLA's installations put objects, films, and photographs side by side; the National Gallery separated them.

The collection on which the two shows were based is large and personal, gathered boldly by Katherine Coryton White, a collector whose passionate interest in the art of Africa is matched by her interest in African life. In Robert Farris Thompson, an art historian in the Afro-American Studies department of Yale University and the author of the catalog, the White collection found a scholar with the same interest. Thompson's catalog established the governing idea of both installations: that all the objects are icons (its subtitle: "Icon and Act") for the beliefs, rituals, attitudes, and values of traditional African life and that to see the objects at rest, motionless, is to miss their meaning.

The explanation of African art offered by each installation was the same: that all African art is a continuum, a unity within which words, music, dance, bearing, sculpture, mask, dress, ornament, all live with the same force and express the same ideas. Thompson organized his catalog around themes of physical posture as it reflects specific states of mind and spirit, and it was around these themes that both installations were designed.

Thompson contended that standing, sitting, riding, kneeling, supporting, balancing—all the deliberate compositions of the body in African life, sculpture, and dance—reflect emotional and psychological postures and attitudes. The way a person composes his body communicates personality and his relation to the world. Balance often signifies composure: physical balance reflects the presence of an emotional or spiritual balance. Sitting communicates permanence, calm, authority; riding is an active form of sitting, connoting superiority and mobility. Kneeling suggests relation to a higher moral force, a sense of respect and humility.

Pointing out the various symbolic meanings African societies give to specific postures, Thompson read each sculpture, costume, dance, or ritual for its meaning. ("The meaning is the beauty," as one critic noted.)[1] For instance, the Ngbe people of southeastern Nigeria and western Cameroon dance out the same symbols in their steps and body movements that appear in their textiles, carvings,

tatoos, and other decorations. Thompson called their movements "action writing" and defined some of their mimed gesture-language signs.

Thompson's judgment that the balance between "physical vitality and mental calm" is the most highly prized value in African art and life was borne out by most of the objects exhibited and by all of the films of dance and ceremony, which Thompson made in Africa. He stressed the contrasting but equally essential halves of the African spirit: the immobile face or mask, displaying detachment or control, and vigorous body movements and supple limbs, expressing vitality and power. The combination of controlled facial expression, which indicates seriousness and discipline, with rhythmic vibrations of the body, which connote life and energy, are taken together—in dance, sculpture, and all other African arts—as symbolizing the ideal balance of controlled power. Even the brillant colors and complex patterns of the costumes are seen as a kind of visual force set beneath the silence of the masks or the dancer's lips. Fusing the motionless face and the active body is the highest sign of artistic power, or as Thompson used contemporary slang to explain, detachment is "cool," energy is "getting down," and their balance is "getting it all together."

### The Frederick S. Wight Gallery, University of California, Los Angeles: January 21–March 17, 1974

Putting objects, films, and photographs side by side, UCLA darkened its galleries so that visitors could see the films clearly; according to Gerald Nordland, director of the Wight Gallery, in order to achieve a brilliant image on a rear projection screen, the balance of light had to be in favor of the screen. Spotlights picked out and accentuated individual objects, many of them placed on low platforms or mounted on wall brackets against photographs, others in cases.

Life-size photomurals of dancers, village scenes, tribal elders, vegetation, served as backdrops for objects and other display elements that were intended to make the objects vivid and accessible by showing how they were used. In front of large photographs of Africans carrying kindling, bowls, and children, for example, was mounted a cut-out figure supporting a heavy object, adding another dimension to the concept of *supporting*. A life-size mural of Ngbe society members sitting in their house had a batik fabric stretched above it as an awning and a fabric-covered table set in front of it.

Tribal costumes were displayed on poles with arms extended like a scarecrow to enable visitors to see the costume's construction and functional design for the African climate. A form dressed in the Egungun costume of the Yoruba of Nigeria and Dahomey revolved slowly, its moving fabric panels implying the whirling motion of the dance.

UCLA's efforts to help the visitor understand connections between the "icon" and African attitudes toward life and art did not satisfy all visitors; some found that the installations

distracted them from the individual objects, that the spotlights made it difficult to see works of art, that the absence of seats or any place to relax in front of the films made it difficult to absorb their content and to study the objects alongside them. Drums and chants from the films resounded through the gallery, creating for some visitors the festive atmosphere of an African village on special ritual occasions—and disturbing other visitors. Many viewers reported that they felt the exhibition often ignored the object to concentrate on its function.

### National Gallery of Art, Washington: May 5–September 22, 1974

The National Gallery's designer, Gaillard F. Ravenal, heard and saw for himself many of the criticisms leveled against the UCLA installation. Spending ten days at UCLA, he reported he found visitors "becoming hostile . . . to darkness and crowding in small spaces." On the basis of his observations and the National Gallery's different possibilities and requirements, he designed an installation that used only 160 of the 210 objects on display at UCLA and spread them among 14 galleries with a consequent and deliberate sense of spaciousness and calm.

Five minitheaters were placed among the galleries, separated from them by raffia hanging curtains; it was only in these darkened theaters that the films were shown, leaving the galleries to works of art against cool white walls with brilliant light levels. In the theaters the floors were covered with mats, and there were banks of built-in seating, some covered with African textiles. Alongside the movie screens were life-size figures wearing costumes exactly like those the tribal performers were wearing in the demonstration films. The sound track's noise of drums, other music, and voices was generally confined to the minitheaters and muffled or barely noticeable in the galleries.

Ravenal explained his use of stark white walls and bright light in terms of the African experience—"Many African dances are performed in bright sun at 11 A.M."[2] But some visitors criticized the installation for its "chic-boutique" atmosphere that displayed each object as an isolated, albeit vivid, fragment of a culture, in direct contradiction of the catalog's premise that African sculpture is an integral part of all African art and life.

### The critics: private and public

Visitor reactions and comments on both installations have suggested how difficult it is for any museum exhibition to satisfy, educate, and delight every visitor: what pleases one visitor irritates another. An experienced museum-goer who spent about 30 minutes in the Washington show thought it "terribly well done" and noted she had learned two things from it—"which is pretty good for 30 minutes." (Those two things: the significance of physical stance and posture in African sculpture and the new idea that at least one African

civilization had used geometric patterns as writing.) She commented on the ''competition between'' the handsome and striking gallery installation and the objects, and especially liked those objects next to the films in the minitheaters, because ''I was a witness—and could see more human involvement with the maker of the object, and the user. . . .''

It was precisely that sense of human involvement that the UCLA installation was designed to convey. ''African sculpture does not make complete sense,'' said critic John Russell, ''until we have seen it in motion.'' He felt that the exhibition derived ''its special character . . . from the audio-visual element in its presentation.''[3] Fellow *New York Times* critic John Canaday, in his column of June 16, 1974, wrote that the National Gallery's installation ''climaxes the current back-to-anthropology movement that began about 10 years ago as a reaction against the pure estheticism that dominated our response to African art for a full 50 years. . . .'' Canaday did not see the UCLA installation, which was even more clearly a climactic anthropological interpretation, but he accurately notes that art museums have gradually recognized ''the incompleteness of a purely esthetic approach.'' Yet, he continued, the parts of the National Gallery show he enjoyed most ''were the quiet galleries where the finest pieces were displayed as art.''

That ambivalence about African art—as anthropology or aesthetic experience—characterized the installation designs as well as viewers' responses. Both exhibitions were trying to help the visitor understand how intimately African art is part of traditional African life: UCLA stressed the anthropological approach; the National Gallery tried to strike a balance, focusing on the objects as art in a way that UCLA did not.

Neither museum did a careful study of the educational impact of its installation. When museums share exhibitions and can choose to install them differently but do not trouble to study and compare their achievements, they miss an opportunity to inform themselves about what elements in an educational exhibition really educate the public. And all museum designers and educators are denied the chance to learn from their colleagues' experiences.—*A.Z.S./E.S.C., with supplemental interviews by S.R.H.*

## Notes

[1] John Russell, ''Films and Music Portray African Art,'' *New York Times,* May 4, 1974.

[2] For sources of quotations without footnote references, see list of interviews at the end of this report.

[3] Russell, ''Films and Music.''

## Interviews

Bowman, Ruth. Director of Education, Los Angeles County Museum. March 15, 1974.

Chin, Michael. Rockefeller Fellow, Fine Arts Museums of San Francisco. March 16, 1974.

Dowell, Shelley. Rockefeller Fellow, Fine Arts Museums of San Francisco. March 9, 1974.

Deussen, Claire Isaacs. Director, Junior Art Center, Los Angeles. March 12, 1974.

Houlihan, Patrick. Director, Heard Museum. March 22, 1974.

Nordland, Gerald. Director, Frederick S. Wight Gallery, University of California, Los Angeles. March 15, April 29, 1974; telephone, March 5 and 14, 1974.

Ravenal, Gaillard F. Designer, National Gallery of Art. May 28, 1974.

Tamura, Ruth. Director, Gallery, California College of Arts and Crafts, Oakland. March 9, 1974.

Ziady, Jonathan. Senior Rockefeller Fellow, Fine Arts Museums of San Francisco. March 16, 1974.

Unidentified visitors to the National Gallery exhibition. May 25, 1974.

## Bibliography

'''African Art in Motion': Evoking a Unity beyond Art,'' by Paul Richard, *The Washington Post,* May 2, 1974.

''Esthetics versus Anthropology in the Art of Africa,'' by John Canaday, *New York Times,* June 16, 1974.

''Films and Music Portray African Art,'' by John Russell, *New York Times,* May 4, 1974.

Thompson, Robert Farris. *African Art in Motion—Icon and Act in the Collection of Katherine Coryton White.* Berkeley and Los Angeles, California: University of California Press, 1974.

## THE HEARD MUSEUM: EDUCATING INDIANS AND OTHER AMERICANS

The Heard Museum
22 East Monte Vista
Phoenix, Arizona 85004

**A famous tourist attraction and beneficiary of wealthy Phoenix patronage is dedicated to the Indians of the Southwest, both their ancestral arts and crafts and their present-day expression and social betterment. New directions since 1972 have transmuted the Heard's exhibits into instant education—fakes, raw materials, tools, *retablos*, and *santos*. CMEVA interviews and observations: 1972–1974.**

### Some Facts About the Program

**Title:** Education Exhibitions.

**Audience:** Indian schools bring their students to see their heritage; Indian artists come to study the old designs; collectors and scholars with an interest in Southwest Indian art come to study the collection; in addition, the Heard is a must to the many tourists who visit Phoenix annually.

**Objective:** To emphasize the arts and crafts of the Southwest Indian; to preserve this heritage; to encourage new forms of artistic expression.

**Funding:** Private funding amounted to $40,000 for reinstallation of the exhibitions in 1973 and 1974.

**Staff:** Regular museum staff.
**Location:** In the museum.
**Time:** All year.
**Information and documentation available from the institution:**
Color postcards. Patrick Houlihan, "Museums and American Indian Education," *Journal of American Indian Education,* vol. 13, no. 1 (October 1973).

According to the *Official Museum Directory,* the Heard is an anthropology and primitive art museum, its specialty the American Indian. To Patrick Houlihan, who became the Heard's director in 1972, these two concerns are of equal importance and often inseparable. For the somewhat condescending word "primitive" he substitutes "ethnic." And he believes that such museums as the Heard can no longer confine themselves to what he calls the three traditional museum functions: collection, exhibition, and research. They must add "new and different services" that will more effectively share the museum resources with ethnic audiences. In other words, the Heard Museum is trying to expand its program to provide more opportunities for American Indians—"the people whose heritage it has helped to preserve."[1]

It is worth noting that Houlihan excluded "education" as such from his roster of the traditional functions of museums. The most casual visitor to the Heard can see why. For the museum's installations, both permanent and temporary, bear witness to the philosophy that exhibition *is* education. All Heard exhibitions lead the viewer—tourist, Phoenix social-ite, Pima from the reservation—through a series of experiences, a "cognitive map" designed to change and inform his understanding of Indian silverwork, weaving, masks, or whatever the exhibit's theme.

### On visiting the Heard

I sometimes think of the Heard as the Mother Church. Someone once described it to me as that, and I think it is true. In Phoenix, there are not a lot of old institutions. The Heard is one of them. It is tied to a pioneer family that was very influential in developing the water and power resources of all of Arizona. And so it has an aura about it of legitimatizing things. If it is at the Heard, it must be all right.[2]

This comment by Patrick Houlihan reflects the prevailing attitude in Phoenix and throughout the Southwest. Tourists feel that they must visit the Heard Museum. Indian potters, jewelers, and weavers want to see the old designs. Indian schools bring students to see their heritage. Collectors and scholars come to study the vast offerings of the Heard collection, the Fred Harvey collection, and the Barry Goldwater Kachina collection.

Phoenix, founded in 1867 and incorporated in 1881, is a wealthy town laid out in a grid pattern. Date palms, cactus plants, spacious lawns, pale stucco buildings, and shopping centers characterize this desert community. The Heard Museum blends in, a Spanish-style arcaded structure in an upper-middle-class residential neighborhood near the center of the city, built around a courtyard fragrant with orange

---

## How to Create a Participatory Exhibition on Short Notice

Red River of the North Art Center
521 Main Avenue
Moorhead, Minnesota 56560

Like many art centers, the Red River of the North Art Center that serves Fargo, North Dakota and Moorhead, Minnesota—sister cities sharing the Red River and the state line—has a small staff, an inadequate budget, and virtually no permanent collection. To fill its galleries, it relies on traveling shows and displays of work by local artists.*

Like other art centers, too, the Red River Center is sometimes faced with scheduling foul-ups and last-minute cancellations. Six weeks before a traveling show was to open at the center, Claudia Baker, the director, received word that the show had been canceled. What to do?

### From John Dewey to "Essence"

Ms. Baker turned to a favorite quote from John Dewey's *Art as Experience,* in which he describes the work of the artist:

The artist has his problems and thinks as he works, but his thought is more immediately embodied in the project. . . . The artist is compelled to be an experimenter because he has to express intense individualistic experiences through means and materials that belong to the common and public world. His problems cannot be solved once and for all.

For years, Ms. Baker had felt that the artist was unnecessarily misunderstood and the artistic process isolated from everyday life. She wanted to conduct a program that would help people learn about the problem-solving nature of the artist's activity. The result was "Essence: Simulation of the Artistic Process as Problem Solving," an exhibition of works constructed by a cross-section of local people, planned, designed, and installed in time for the previously scheduled opening.

### How the community got involved

The center's first advantage was its 230 members, many of whom Ms. Baker had learned to count on to help hang exhibitions and to attend functions at the center. Its second advantage was the city itself. Considering its size, Fargo-Moorhead is culturally rich: its 100,000 inhabitants support a symphony, a civic theater, and an opera. The three local colleges—North Dakota State University, Moorhead State College, and Concordia College—employ the majority of the working population. Ms. Baker felt she could readily find people who would participate in "Essence."

First, she publicized the center on the radio and in the local papers. Then she spent several days on the phone, calling both members and nonmembers to work on the exhibition. By the time she was through, 18 people had agreed to take part: a university professor, a construction worker, the executive director of the musicians' union, two automobile mechanics, several students, a high school football coach, an architect, a psychiatrist, and two local city

blossoms. A string of chiles hangs from the courtyard walls, and stone grinders with corn kernels waiting to be ground are placed around the arcade. Both help to create a warm atmosphere of welcome. Heavy wooden doors opening off the courtyard reveal the first gallery and the Goldwater Kachina collection—spirits of the Hopi religion represented by painted wood carvings, dressed in traditional costumes, and used to instruct Hopi children.

This superb collection, which Senator Barry Goldwater gave to the Heard in 1964, launched the museum on an unprecedented program of building and expansion. Despite all the changes that Houlihan and his staff are making at the Heard, the Kachina collection will continue to occupy the first gallery, partly because it provides such a spectacular introduction, partly because of the senator's local and national prominence. But it will be reinstalled to tell part of the story of the Pueblo people, of which the Hopis are one group.

Ideally, Houlihan would like the Heard to embrace "two great galleries," so that visitors would more readily grasp the broad historical and cultural framework of the installations:

I would like the visitors to enter the building and walk into a prehistory area that would bring them up to a point in early European-Spanish contact. Then you take them through tribally in this ecological framework. Then you let them loose on the arts and crafts.

"Living with the political realities of the situation" makes the job of directing the Heard distinctive from that of most museum directors who also serve diverse audiences. On the one hand are the Phoenix patrons and the swarming tourists, all interested in Indian art. On the other hand are the Indians, even more interested in Indian art, for sharply different reasons.

The wealthy Phoenix patrons and collectors of Indian art, for example, may have scant concern for the welfare and art of the contemporary Indian, including their Indian neighbors. On the outskirts of the city live the Pima Indians in dry, desolate country. Since their water supply was diverted in 1820, they are no longer farmers or basket-makers. The willows cannot grow in their now-dry river-beds. It is easy to forget the condition of the present-day Indians in the enchantment of the Heard Museum, for here is a shrinelike institution, dedicated to the art of the Southwest, particularly the Southwest Indian. The silver and turquoise, the baskets, the shiny black pots, and the tightly woven rugs and blankets are the statements of artists skilled in their craft, who have perpetuated it through time.

The director of the Heard Museum is well aware of the plight of the American Indian. He knows their teenage suicide rate is more than 400 times the national average. He knows that alcoholism, prostitution, and poverty prevail among urban Indians. He also knows that some Indian artists are keeping the traditional art forms alive, that others are finding new ways of expression, and that an institution like the Heard has a unique opportunity to serve an Indian public. One of the "political realities" is to maintain the Heard as a nonpolitical showcase that will help make Indian arts and crafts known to an ever wider non-Indian audience—and market.

mayors. A student from North Dakota State helped Ms. Baker run the show and received credit for her work from the university.

### The project

Ms. Baker and the 18 participants met for the first time in the empty galleries on Monday evening, four nights before the scheduled opening. To ensure diversity in the working teams, participants were grouped in three categories and their names placed in empty coffee cans designated as follows:

1. People with art experience.
2. People professionally involved in education.
3. Miscellaneous.

Six persons drew two names each from categories other than their own, forming six three-member teams. A representative from each group then selected at random a problem that was to be his team's assignment. Sample problems:

• Select labor-saving devices commonly used in or around the home. Present each object out of context so that its original purpose or use is altered.
• Create a power structure using tangible objects and materials.
• Give complete directions for five activities; use no words in the directions.
• Construct an environment designed to produce or invoke frustration.

Ms. Baker then presented participants with raw materials donated by local businesses and asked each group to pick an area of the gallery in which to work. For the next three nights, the six teams constructed their exhibitions, the center's staff acting as facilitators rather than teachers. Because the show was planned as a study of the problem-solving process, a video cameraman documented each night's work. His edited tape was shown regularly while the exhibition was open to the public.

### The results

When the exhibition opened, each visitor was handed a paper that explained the project, listed the members of the project teams, and asked him to match the exhibits with the problems described on the sheet. The exhibits themselves were identified only by a number. In addition, from piles of raw materials in one corner of the gallery and a new list of problems on a nearby wall, visitors were encouraged to construct their own solutions, and by the center's count, 953 did. What Ms. Baker was able to do with $143 (all from the center's program budget), six weeks' lead time, a telephone, and a willing public, any arts institution can do. The result was not only low cost, but it presented no security problems, required few trained staff members, drew the intense involvement of 18 people, and just may have taught some lessons about art and the artist to several hundreds more.—*J.A.H.*

*Information for this report was drawn from interviews with Claudia Baker, director of the center, and others who worked on the show in January and March 1974; and from observation of the show, January 1974.

## The Heard credo

Patrick Houlihan reveals no uncertainty about the Heard's nature and mission. When he took over as director, the vigorous program of gallery reinstallation and exhibits he inaugurated represented no mere shift in techniques and audience-building. To him the Heard could not rest content as a "cultural shrine," nor continue with what he considered a stale and unenlightening exhibition scheme—"a tribal orientation with a little bit of ethnology" thrown in. True, the Heard still builds on its reputation as a national tourist attraction; such fame is one of its reasons for being.

But Houlihan wanted not only to dazzle the tourist and local non-Indian patrons: he wanted to *educate* them. At the same time he wanted to restore and strengthen the museum's regional role as preserver and protector of the Indian arts and artists of the Southwest. And, in a way appropriate to a museum run not by Indians but by whites, he wanted to respond to the needs of the Heard's Indian public. "Museums," he says, "can't do much other than educate the public to the facts."

In keeping with this mix of concerns, the Heard presents Indian art as *art*. Works are shown to bring out their aesthetic qualities rather than their ethnological significance. The artifacts are arranged, however, in ways that make ethnological sense rather than the old familiar tribe-by-tribe arrangement. Houlihan thinks that, properly installed, the art can convey even to the layman the tribal differences, while conveying ideas and sensations of greater moment.

The major consideration is always the aesthetic quality of the silverwork, baskets, pottery, and blankets the Heard displays. To Houlihan this focus is consistent with the primary function of Southwest Indian art during the twentieth century—to provide a living for its creators.

A corollary of the aesthetic-economic purpose of the displays is the museum's sense of responsibility toward the Indians of the Southwest in helping them to revive lost crafts and encouraging them to explore new ways to make art and to find employment. Conscious as he may be of the Indians' present-day plight, however, Houlihan is wary of the Heard's assuming or even seeming to assume the role of spokesman for the Indians' social, political, and economic problems—and not, it would appear, for fear of offending the museum's important Phoenix patrons or even Senator Goldwater. On occasion the Heard does use its space to make a point about contemporary Indians that the galleries do not usually convey. One 1974 exhibition is illustrative.

As a cultural anthropoligist Houlihan wanted to say something about Indians and about Phoenix. So he hired a photographer to document the life of the urban Indian. The results were exhibited as "Reservation-Phoenix." The powerful photograph of a prostitute in downtown Phoenix or of a drunk Indian lying in the gutter in front of the Mission of Hope told a story very different from the vision of an Indian making a basket in front of her adobe home—so different, in fact, that

the Heard's board of directors requested the removal of one of the photographs. Although anyone driving on a Saturday afternoon along Highway 66 through Gallup, New Mexico, say, or some other well-traveled route sees drunken Indians by the dozens, most Southwesterners apparently prefer to ignore the problems of the urban Indian. So do the tourists who flock to the Southwest to buy Indian crafts, and probably think of the craftsman living in a quaint pueblo house, hogan, or ramada. "Reservation-Phoenix" was a strong antidote to such picture-book notions. Nonetheless, Houlihan considered it no harbinger of a new trend for the Heard, for several reasons:

I'm not sure that Indians want white organizations to talk for them. I'm not sure that I want to say things for Indians. They have tremendous tools available to do this. They have more access to the press than we do. . . . So they have to articulate their own demands in this political sphere, I think.

And the museum should not usurp that role from Indians. Their own museums can do that. I don't think we can.

Besides trying to serve its very different audiences as effectively as possible, the Heard—like any museum specializing in Indian art and culture—has to consider another and quite delicate relationship: its role vis-à-vis Indian, or tribal, museums. What, for instance, should be the Heard's stance in response to demands for the return of objects to such museums? Some time ago, when Hopi elders demanded the return of *kiva* masks the museum had on exhibit, Houlihan's predecessor complied. (These masks are sacred, not to be seen outside the *kiva,* or ceremonial chamber.) Houlihan is inclined to think that, although he would certainly have removed the pieces from display, he might have put them on long-term loan to the Hopis rather than giving them back. In general, he thinks an off-reservation agency like the Heard may be best equipped to collect, save, and display artifacts that might otherwise be lost, and in the process to help the Indians of today and tomorrow.

## The working assumption: exhibitions

According to Houlihan, the basis of his "working assumption in exhibits" was his experience at the celebrated Milwaukee Public Museum (of natural history), where both he and Jon Erickson, the Heard's curator of collections, were trained. From Wisconsin to Arizona there has passed along a potent museum mix of aesthetics, education, and drama. Says Houlihan,

I wish I could say that I changed the exhibits because they were not educational, but my gut reaction was because they were professionally embarrassing. That may mean that they were not educational, but it also means that they were not aesthetically pleasing, and there was no organization to them.

As both temporary exhibits and permanent installations use very few words, it is risky to try to verbalize the essential principles of a Heard installation. What Houlihan calls a

"cognitive map" comprises an arrangement that in itself conveys continuity, influences, dispersion, and history, puts selected objects in context (of daily life, fabrication, time in history, tribal origin), and brings the visitor into an immediate sense of what he is seeing and its connection with sights behind or ahead.

**Southwest Silver Room.** The first of the reinstallations tells in a glance the history of silverwork in the Southwest. Closer inspection reveals exceptional works by Indian artists. Against matte black walls, in well-lighted cases, each piece of silver stars. The work is displayed with all the respect museums extend to the work of Fabergé, ancient Chinese jade carvings, or pre-Columbian cast gold. But the gallery's message to the visitor goes well beyond the instant assurance that he is seeing real art.

He is also learning through displays the artist's techniques, his tools, and the role of jewelry as "pawn"[3]—wealth—as well as for adornment. Through photographs, actual work tables and tools, and deft juxtaposition of raw materials and finished objects, the gallery tells the story of Indian silverware. A visitor reacts: "I stood around the gallery waiting for a jeweler to start working. . . . I learned a lot up there. I didn't realize that they did sand-casting like that."

Displays devoted to individual tribes make clear the artistic and technical differences among the Navajo, the Hopi, and the Zuni. After these displays, a case labeled with one word, "Modern," delights visitors with stunning pieces of contemporary jewelry and demonstrates the continuity of Indian art. (In response to an observation by a visitor, Houlihan agreed that the artist's name should be added.)

The final case is a shocker to tourist and scholar alike: imitations of Indian jewelry, varying in quality but all stamped by machine and imported from Mexico or Japan. By daring to display fakes, the Heard makes the viewer see for himself the inimitable excellence of the real thing. (For another lesson in the original versus the imitation, see report on "Fakes, Forgeries, and Other Deceptions" in this chapter.) One visitor who saw the Japanese jewelry just as he entered the gallery was "really shocked"; he said, "If you don't follow the exhibit in order, it's very confusing."

**Navajo weaving.** The recently installed galleries devoted to the art of Navajo weaving display raw materials to similar purpose in telling the story of how blankets and baskets are made. Indigenous plants, the red shale of Arizona, maps, and an actual hogan provide a context for the art exhibited. In the weaving exhibit, the Heard also uses fakes to teach. A display of Mexican blankets next to contemporary Navajo weaving shows the weft separated to reveal that the Navajo piece has a continuous warp edge unlike the Mexican pieces with their broken warp edge. "Oh, so that is how I can tell the difference," said a visitor. "Look at how it is woven."

Again visitors sometimes misunderstand the lesson of the fakes, and the point backfires. Thus Houlihan got word back from a museum in Flagstaff that the Heard "had Mexican rugs for sale." A garbled account had placed the cautionary display, not in the gallery, but in the museum shop as purportedly genuine.

**Spanish Colonial Room.** This gallery has been transformed into a religious shrine, with *santos* behind glass along with other religious artifacts. At the end of the room, behind an altar complete with fresh flowers and the sacramentals of the mass, *retablos*—religious paintings on wood—are displayed. The intimate space and low lighting may make it hard to see the works of art, but the churchlike atmosphere is authentic and, Houlihan thinks, well suited to the objects on display. There is even a collection box on the wall that accepts donations for the museum.

**Temporary exhibitions.** As in the permanent installations, the Heard's temporary exhibitions are built around single art forms or concepts. "Mask Art around the World," through the placement of objects and label headings, tried to raise and answer questions about the worldwide meaning of mask art, the mask's literal and spiritual uses, the mask as aesthetic object.

"Music of the Pueblos" combined musical instruments and costumes with sculptures and paintings that showed the instruments in use. The visitor was invited to discover sound differences for himself by tapping on the drums. Integral to the exhibit was an audiovisual presentation. Finding the cost of film almost prohibitive, Houlihan uses less expensive substitutes such as slides. He describes the arrangements for the music exhibit:

I did something here with a light show. I had three large lithographs—one was a buffalo dancer, one was an eagle dancer, and one was a deer dancer. There was a quadraphonic sound system, one over each dancer and one over the sitting area. The gallery was divided. Half was open, displaying ceremonial arts, costumes, and drums, and the other half was a dark area where you could sit and listen to an 11-minute program.

The lights were coordinated with the tapes to light the eagle dancer from Taos Pueblo. The music would play and then go soft, and a voice would come on to explain the eagle dance. This was repeated with the deer dancer from San Juan Pueblo and the buffalo dancer.

Then it would go on again. This time I would talk not about the ethnology but about the music and then about the dance. So I went through it with just light. It was in effect three static graphics. . . . What I wanted to do was to introduce music and information to what would otherwise have been merely a visual experience.

**The Heard technique, in essence.** Throughout the Heard's exhibits, Houlihan tries to invent ways to involve the audience actively, to compare one Indian culture with another or Indian with Western, to show the evolution from raw mate-

rial to art, and to bring in art forms other than the visual. Thus, for example, a Peruvian exhibit interspersed compositions of Indian flute with contemporary Western music. Prints might be displayed pinned to wire clotheslines as though drying in the printmaker's studio, or screens and squeegees might be included in an exhibition of serigraphy.

As much as possible, both Houlihan and Erickson want to call on other senses to enhance the visual (in the weaving exhibit, for instance, a blanket hangs on the hogan for visitors to touch), and to make the visual experience itself as direct as possible. Labels, then, are always short and simple. Houlihan displays primitive art—a term he uses "with qualifications"—as art, not as curious artifacts. By curtailing verbiage he feels the museum can give this art and its viewers "the same kind of validating experience as you do for the *Mona Lisa*: That's it on the wall! You don't see a big label that it is the *Mona Lisa*. O.K., this is a Dan Mask, and that's it."

As he installs exhibitions, the director keeps in mind the results of an unobtrusive visitor survey conducted by his students in a museum training program in 1972 at the University of Arizona. Findings: the average visitor devoted 30 seconds or less to a display case; two minutes was the longest time a visitor spent before a case in any exhibit or gallery area.

### Responding to the Indian artist and craftsman

In pleasing Phoenix patrons and tourists from afar, the Heard is also responding to its very special audience—the Indian artist—by popularizing and boosting the market for Indian arts and crafts, educating the Indian about his heritage, and recognizing contemporary Indian art forms. The museum's response goes further, however.

Three instances from 1973 exemplify the policy. The Navajo wanted information on painting; the Institute of American Indian Arts in Santa Fe (see chapter 14) asked for videotapes of the museum collection; the Apache wanted to learn beadwork. The Heard complied with all of these requests. It lent the Navajo Community College in Many Farms, Arizona, paintings and artifacts by Plains, Southwest, and contemporary Indian artists for exhibits in the college library. Photography students from the Institute of American Indian Arts videotaped an exhibit of contemporary Indian sculpture to be shared with the institute's other students.

The traditional museum functions of collecting and preserving art objects can, with an institution like the Heard, take on a highly practical immediacy. In 1973 a recently established Apache reservation near Payson, Arizona, was struggling to develop an income-producing home craft. A health education assistant brought some of the women from the reservation to the Heard for a series of visits so that they could examine traditional Apache beadwork and basketry from the reserve collection in an effort to improve the quality and authenticity of their own work.

Besides such specific services, the museum all year round provides a source of ideas and inspiration for the Indian potters, jewelers, and weavers of Arizona and New Mexico. Moreover, the Heard holds an annual Indian fair that attracts 30,000 persons—a major opportunity for Indian artists to sell their work to a receptive audience in a museum environment. The fair also highlights another of the Heard's unusual and delicate problems: striking an acceptable balance between the traditionalists and the avant garde *within* the Indian art community. Of Indian painting and sculpture, Houlihan has written,

> For the most part, subject matter is confined to the scenes and symbols of the artist's own tribal background. However, a small group of Indian artists, whose product has been called the "new Indian art," are exploring non-Indian design statements and social commentary in their work. The leader of this movement is Fritz Scholder, of California Mission Indian heritage.[4]

In 1972 and 1973, in response to demands by Indian artists, the Heard selected an all-Indian jury for its annual arts and crafts exhibit. As one of the 1972 judges, Scholder sparked what Houlihan has called "a terrible controversy," for this leader of the new Indian art "was looking for social comment in the art, whether it was pottery, beadwork, or whatever." To Houlihan this concern may be legitimately applied to painting . . . but crafts? The Indians whose work was being judged would have none of the Scholder position; they wanted their crafts judged for excellence in design based on tradition. As Houlihan said, "They didn't feel that in beadwork or in basketry they had to make a social statement." The Indians in general share his own view that the criterion for a good basket is its aesthetic quality "and the number of coils you pack into an inch."

So the Heard continues to perpetuate traditional Indian art while also encouraging the Indian artists who want to break away from the old boundaries. In 1974 the museum received a grant from the National Endowment for the Arts to purchase contemporary works, including illustrative paintings, minimal sculptures, and abstract line drawing. Says Houlihan, "I want Sister Leona's kids at St. John's Indian Mission to see these are Indian paintings, and there is not a teepee among them."

But aside from the "non-Indian design statements and social commentary" of Scholder and his school, the mainstream of American Indian art builds on a long cultural tradition. And here the Heard is carrying on a mission that has become increasingly common among ethnic and third-world museums—what one observer has called "the salvaging of ethnology." In the social and cultural turmoil of the late nineteenth and twentieth centuries, many Indian groups such as the Apaches described here literally lost their crafts heritage—the design and techniques of weaving, pottery, jewelry-making, basketry. By collecting and preserving original, traditional pieces and making them available to present-day Indian artists and craftsmen, the Heard provides

an important service to those seeking to regain an ancient heritage and an ethnic identity.

## The meaning of "education" at the Heard

In a sense perhaps truer of the Heard than of many more traditional art museums, the Heard Museum's entire operation is educational; the exhibitions are the heart of the enterprise. There is no separate education department. Those aspects of the museum's work that are specifically "educational"—tours, classes, traveling exhibits—are handled by the curators of Indian arts, of anthropology, and of collections, who report to the director. In 1973 the cost of these services came to $15,000, or 6 percent of the total budget.

Over 15,000 schoolchildren a year tour the museum with docents called *Las Guías*. The docents' speakers bureau also brings slides and objects to Phoenix classrooms for lecture presentations in the schools. Altogether there are four full-time professional and fifty part-time volunteer docents guiding tours or helping to run the gift shop. The Heard's director, conscious of the guides' importance in interpreting the museum's collection to the public, sees to it that the curator of collections works with them every morning and evaluates their tours. Their role, Houlihan feels, is particularly important because the Heard relies for its educational impact so much on the exhibits and so little on formal education programs. He thinks that the Heard should hold classes and seminars, "as they do at other museums." (He also feels that the museum should have better than "a relatively inactive research program.") Among the circulating exhibits are the "Try-On Museum of Indian Footwear," which goes to elementary schools, and the "Kachina as a Data-Retrieval System" for the business community (an interpretive exhibit of Hopi *kachinas* that tours Phoenix electronic plants).

Sympathetic Heard-watchers, who recognize the value of the museum's exhibits and other modes of educating its disparate audiences, believe that there is need for classroom space and for a full-time person to work with docents. One problem—and this is one the Heard shares with museums everywhere—is that the docents represent a single sector of local society: women who can volunteer time and do not need money. Someone from St. John's Indian School made the point succinctly:

> I am afraid to bring the kids into the [Phoenix Art] Museum because all of the rich Phoenix ladies are there. We never bring them to the art museum, but we like to go to the Heard. We just wait until the ladies leave and then go in.

One formal educational effort was a seminar for teenagers, in the summer of 1973, on basic anthropology. Here students dug in a sandpit that had been salted with objects to simulate an archaeological site. The class had nothing to do with studio art, nor with training junior anthropologists; rather, it was a way of using the Heard's resources to demonstrate the scientific method. The students formulated a hypothesis, gathered data, and tested the hypothesis against the excavated evidence.

The Heard under Houlihan is a transformed museum. It would seem impossible for its varied audiences and clients to greet all the changes with favor. The director cites, for instance, the testimony of one of the museum's "most knowledgeable guides." Harking back to the days when the collection was installed in tribal order rather than by art form or concepts, she told him that some of the kids she was guiding around missed the Plains exhibit. It turned out that the docent used to enhance the experience by telling the students "about the scalp that was up there, how a young Plains girl took a husband, and how a young brave did this and did that." To which Houlihan responded,

> "Fine, but the Plains Indians don't do that any more, so stop telling them about that." And I wanted to say, "If you want to tell them anything, tell them about the suicide rate." So I'm not sure whether there was great approval in changing the galleries.

—*E.S.C.*

## References

[1] Patrick Houlihan, "Museums and American Indian Education," *Journal of American Indian Education,* vol. 13, no. 1 (October 1973).

[2] For the sources of quotations without footnote references, see list of interviews at the end of this report.

[3] Throughout the Southwest, Indians exchange jewelry for money or merchandise at the trading posts. Pawn that is not redeemed by the specified deadline is displayed at the post and sold. Old pawn is sought after by dealers in Indian art.

[4] Houlihan, "Indian Art: Fads and Paradoxes," *ARTnews,* February 1975.

## Interviews and observations

*The author of this report made frequent visits to the Heard Museum during the period noted here, both before and after becoming a member of the CMEVA staff; the nonspecific dates in this list of interviews reflect that continued contact.

Chino, Marie. Potter, Acoma Pueblo, New Mexico. 1972–1974.

Chino, Rose. Potter, Acoma Pueblo, New Mexico. 1972–1974.

Chiu, John. Visitor to the Heard Museum. September 1973.

Erickson, Jon. Curator of Collections, Heard Museum. March 22, 1974.

Hanson, Anne Lewis. *Indian Voice,* San Jose, California. 1973–1974.

Hooee, Daisy. Potter, Zuni, New Mexico. September–October 1973.

Hooee, Sydney. Jeweler, Zuni, New Mexico. September–October 1973.

Houlihan, Patrick. Director, Heard Museum. September 24–25, 1973; March 22, June 2, August 14, 1974. Telephone: March 8, 15, 26, 1974.

Kanioke, Bob. San Francisco, California. 1972–1974.

Lewis, Al. San Francisco, California. 1972–1974.

Navajo Museum Administrators. AAM Conference, Fort Worth, Texas. June 1974.

Nordwall, Adam. Bay Area Indian leader, Chippewa Tribe. 1973–1974.

Parker, James. Curator of Art, Heard Museum. September 23–24, 1973; March 2, 1974. Telephone: February 17, 1974.

Rush, Larry and Maria. St. John's Mission, Laveen, Arizona. September 19, 1973.

St. Martin, Elaine. San Francisco, California. June 1973–June 1974.

Sanchez, Santana. Acoma Head Start Program, Acoma Pueblo, New Mexico. 1973.

Sister Leona. Art Director, St. John's Indian Mission, Laveen, Arizona. September 23, 1973.

Stevenson, James L. Senior Curatorial Assistant, de Young Museum Art School, San Francisco, California. October 1973.

Students. Institute of American Indian Arts, Santa Fe, New Mexico. 1972–1974.

Students. St. John's Indian Mission School, Laveen, Arizona. September 19, 1973.

Students and elders at Zuni, New Mexico.

Visitor response to exhibitions. Observed September 25, October 31, 1973; March 2, 22, 1974, in collaboration with James L. Stevenson, Senior Curatorial Assistant, de Young Museum Art School, and Ruth Tamura, Director, Gallery, California College of Arts and Crafts, Oakland, California.

Wells, Helen Pinon. Curator of the Fred Harvey Collection, Heard Museum. September 25, October 30, 1973; August 14, 1974.

## NATIONAL MUSEUM OF NATURAL HISTORY: THE DISCOVERY ROOM

National Museum of Natural History
The Smithsonian Institution
Constitution Avenue at 10th Street, N.W.
Washington, D.C. 20560

**A natural history museum encourages the discovery method of learning with a room where visitors can examine, touch, smell, and taste natural objects. In addition, a variety of puzzles, games, film loops, labels that pose questions, and reference materials supplements the exhibits. The application of this approach to art museums is the subject of this report. CMEVA interviews and observations: October 1973; May, June, and September 1974.**

### Some Facts About the Program

**Title:** The Discovery Room.

**Audience:** The general public and some school groups (about 25 visitors can use the room at one time, 30 on weekends with a half-hour limit on each visit); attendance was 80,000 in 1974.

**Objective:** To provide a place within the museum where visitors can touch and examine natural objects, a process that, the museum feels, stimulates their curiosity and leads to new perceptions and insights.

**Funding:** Development funds from the National Science Foundation, $50,000. Operational funds from the museum's budget: $10,000 from the education department for supplies and two half-time salaries; $12,000 from the exhibits office for replacement of equipment, including the Discovery Boxes.

**Staff:** 2 part-time professionals; 60 volunteers (6 volunteers work exclusively with school groups).

**Location:** On the first floor of the Museum of Natural History.
**Time:** Opened March 1974. Hours: Monday to Thursday, noon to 2:30 P.M.; Friday to Sunday, 10:30 A.M. to 3:30 P.M.; school groups Monday to Thursday, 10 to 11:30 A.M.
**Information and documentation available from the institution:** "The Yes Room," mimeographed brochure.

In the National Museum of Natural History's Discovery Room, a 36-by-28-foot space tucked away at the end of the mammal corridor, curious visitors are finding out what it is like to sit down at a table and pick up, examine, feel, smell, listen to, and even taste a museum exhibition. Most of the objects offered for this scrutiny are sturdy and replaceable—seashells, fossils, bits of minerals and wood, bones, herbs, seeds. A few more delicate or uncommon items, such as freeze-dried insects and Eskimo toys, are glass covered, but still movable and available for close inspection. The room also contains a saltwater fish tank, movie loops, reference books and materials, identification games, labels in the form of flip cards, and photographic enlargements.

At first glance, it may be difficult to see what the concept of the Discovery Room can offer to administrators and curators of art museums. Most feel, with good reason, that handling of objects is the very antithesis of their mandate to preserve unique and valuable works. Yet the sensory experience is one that its supporters believe is not only helpful but necessary to complete understanding of what one sees—in a work of art no less than in an object of nature. To those who have visited it, the Discovery Room holds several interesting possibilities for art museums.

The idea for the Discovery Room began when the Anacostia Neighborhood Museum (see chapter 4), like the Museum of Natural History a branch of the Smithsonian Institution, tried a smaller-scale version as an experiment in the late 1960s. Caryl Marsh, a psychologist who helped plan and launch the Anacostia branch, had noted that handling objects seemed to stimulate visitors to ask questions, and she decided to investigate what happens to learning in a museum setting when touch is added to the visual experience. Her plan called for a three-year research project, which the National Science Foundation eventually funded through the National Museum of Natural History. In it Marsh would study visitor reactions to touching and not touching in three of the Smithsonian's branches—Anacostia, the Museum of Natural History, and the National Museum of Design in New York. Also part of the proposal was to be the design and construction of the Discovery Room itself, an idea particularly favored by the Smithsonian's secretary, S. Dillon Ripley.

As it turned out, the research was never undertaken. To the new director, who was appointed to the Museum of Natural History in 1973, the idea of the room was more appealing than the research, and as the grant recipient and administrative home for the project was the museum, its agreement was crucial. Thus the research lost and the Discovery Room won.

## Exploring: the raison d'être of the Discovery Room

The central question that was to be answered by Ms. Marsh's research was, according to the proposal,

> Does the guided handling of real objects lead the visitor to experience curiosity, learning, insights, or other consequences that do not occur as readily when touching the exhibit is prohibited?[1]

Even though the research Ms. Marsh hoped to carry out had to be abandoned, there was an indication from the Anacostia study that the handling of objects would indeed make a difference to visitors. Marsh found that not only did people who touched specimens spend more time observing them and ask more questions about them, but children who were allowed to handle materials while on a museum visit produced significantly more detailed, complex, and rich drawings of their visit than did those children on the traditional museum tour trip.

It is on this finding that the Discovery Room was built. But even the originators of the Discovery Room agree that touching alone does not account for all the excitement and enthusiasm that visitors feel there. They consider touch merely a starting point from which people can develop new perceptions of an object—''a mind-stretching experience.''[2]

Although the volunteers in the Discovery Room wear white lab aprons, the room has the atmosphere of a library rather than a laboratory. The floor and the seating platforms are carpeted; tables and chairs invite study; objects are placed in boxes and small cabinets that can be taken to study tables like books from shelves.

These Discovery Boxes are what one volunteer has called ''the heart of the Discovery Room.''[3] Most of them are actually compartmentalized trays with lids, 6 inches deep, 18 inches wide, 24 inches long, into which each object is fitted. They are meant to encourage visitors to make discoveries on their own. Labels come in a variety of styles: some simply give the name of each object; others suggest games or methods of identifying differences between similar examples; still others contain excerpts from books in the Discovery Room library and anticipate questions visitors might have about particular specimens. Sometimes objects are organized around several themes: mollusks, for example, have been arranged by pattern, color, and growth. Magnifying glasses on leather thongs are easily borrowed for use throughout the room. Photographic blow-ups encourage careful comparisons (Does Queen Anne's lace really look like that close up?). Reference books are close at hand, and postcards offer visitors the chance to ask questions to which curators may respond by mail.

## Maintenance and staff

Judy White, the project assistant at the museum who is in charge of the room, was warned to expect the loss of many small objects in such an open situation as the Discovery Room. Yet she has found very little damage and no theft. One reason, Ms. White feels, is that people are more careful, less likely to drop things when they are seated than when they are standing up and moving around. Too, the system of checking boxes as they are returned to the shelves discourages visitors from pocketing small items. And because the items are compartmentalized, missing pieces are easy to spot. Expecting damage, Ms. White miscalculated on the number of replacements to have on hand: she began with far more than were actually needed.

Nevertheless, the room and its exhibits require constant care. Objects, boxes, and other materials in the room must be cleaned, checked, repaired, and sometimes replaced, jobs that take about an hour and a half of staff time each day. In addition, the room is staffed mainly by volunteers, whose work requires supervision and coordination by museum personnel.

At the same time, the Discovery Room makes exceptionally rewarding use of volunteer time. As most of the boxes are self-explanatory, volunteers are not required to have a scientific background or to take special courses. They serve instead chiefly as hosts and facilitators, greeting visitors, pointing out the various study opportunities in the room, and checking Discovery Boxes in and out. Working in the same space with much of the same material each day, volunteers become familiar with the content of the boxes and learn from visitors' questions how to use the room and help others use it.

## Application to the art museum

To art museum aficionados who have visited the Discovery Room, the idea of such a place raises interesting possibilities for translation into visual arts terms.

*The boxes,* for example, might hold natural artifacts, just as they do at the Natural History Museum. As Janet Moore notes in her book, *The Many Ways of Seeing,* natural objects studied closely are an excellent stimulus to visual training. ''You . . . will probably never see the shape of a leaf, a bone, a shell,'' she writes, ''more clearly than when you are drawing. The effort to set down shape, texture, and structure makes . . . a little track in the brain; it leaves a mark like that made by a needle cutting a record, long after the drawing is forgotten.''[4]

But the boxes in an art discovery room might also contain reproductions, photographs of the details of art works, tools of the artist, samples of the media in which artists work, or small duplicate artifacts—such as clay or terracotta figures, coins, scarabs, or seals—encased in plexiglass, that can be examined under a magnifying lens. Perceptual games might be devised for the boxes: visitors might be asked to feel nuggets of bronze, marble, plaster, steel, or plastic without seeing them and then match the feeling with photographs of finished works. A small window of cardboard or paper could be offered to visitors to help them find pleasing compositions in a box containing several prints and photographs.

*Film loops* could show artists working in their studios, take viewers through the steps in an art process such as silkscreening or silversmithing, document the damage that handling can do to works of art, and demonstrate techniques of conservation.

*Labels* in an art discovery room, like those in the natural history room, could lead the visitor on a step-by-step investigation of the contents of the box in his chosen subject, sometimes posing questions instead of giving facts. More important, they could make the connection for him between the material in the exhibits and objects in the museum collection.

*Reference materials* can be made available, both on shelves and in file drawers, to visitors who want to expand their investigation of an exhibition or a subject area. Books, articles, catalogs, and reproductions might be set aside here, to be used in connection with special exhibitions or the Discovery Boxes.

### Some pros and cons

Obviously, there is still much to be learned about the educational value of touching in a museum. In fact, not all staff members at the National Museum of Natural History agree that this value has been proved. Designer Harry Hart has said that he feels the Discovery Room is educational only in the sense that all life experience is educational. He has cited the room's lack of structure and pointed out that a conventional exhibition not only allows close examination of an object without touching, but it can accommodate many more people.

Yet this argument has been countered by those who feel that many museum visitors have never been taught how they might use the museum collections—how they might discover new aspects of things they have looked at before, or how they might see for the first time natural objects or works of art that are unfamiliar to them. Perhaps for such visitors an art discovery room would not be just a chance to touch with their hands but might suggest specific ideas and devices that would help visitors see things for themselves when they go back into the museum galleries.—*S.R.H.*

### Notes

1 Caryl Marsh, "A Proposal to Develop an Experimental Touch Exhibit in the National Museum of Natural History," p. 4.
2 For sources of quotations without footnote references, see list of interviews at the end of this report.
3 Judy White, "Hey, Look What I Found!" *Museum News*, December 1974, p. 32.
4 Cleveland and New York: World Publishing, 1968, p. 14.

### Interviews and observations

Hart, Harry. Chief, Office of Exhibits, National Museum of Natural History. September 18, 1975.
Marsh, Caryl. Former Project Director of Touch Exhibit, National Museum of Natural History. October 30, 1973.
White, Judith. Former Project Assistant, National Museum of Natural History. May 9, 1974.
Observations, May 5, June 7, and October 8, 1974.

### Bibliography

Gabianelli, Vincent J., and Munyet, Edward A. "A Place to Learn," *Museum News*, December 1974, pp. 228–233. "Hey, Look What I Found!" is appended to the lead article and reports on the Discovery Room.
Marsh, Caryl. "A Proposal to Develop an Experimental Touch Exhibit in the National Museum of Natural History." Submitted to the National Science Foundation.
———. "Progress Report to the National Science Foundation Pre-College Education in Science, Grant #GW-7623," Experimental Touch Exhibit (Discovery Room), National Museum of Natural History, Smithsonian Institution, Progress Report on Phase I, July 1972–March 1973.
Moore, Janet. *The Many Ways of Seeing*. Cleveland and New York: World Publishing, 1968.
National Science Foundation. "Doing What Classrooms Can't," *Mosaic*, vol. 4, no. 2 (1973), pp. 16–21.
Reece, Carolyn. "Exploring Art and Science," *Children Today*, vol. 3, no. 4 (1974), pp. 18–21.
Thompson, Peggy. "Please *Do* Touch These Exhibits," *Smithsonian*, May 1974, pp. 93–95.
White, Judith. "The *Yes* Room." Unpublished essay.

## The Audio-Guide at the Metropolitan: "The Impressionist Epoch"

The Metropolitan Museum of Art
Fifth Avenue and 82nd Street
New York, New York 10028

Billed as a "self-contained multi-media kit," the audio-guide was a three-piece home-study package sold at the Metropolitan Museum during its popular exhibition, "The Impressionist Epoch." Marketed in a see-through plastic bag, it consisted of
1. A 48-page booklet on Impressionism, with black-and-white and color illustrations and text by Associate Curator Margaretta Salinger.

2. A 20-minute cassette of Salinger discussing the exhibition in the galleries, keyed to the booklet.
3. A 35-mm color filmstrip of nine paintings mounted in a folding cardboard viewer (flat in the package, it easily became three-dimensional with a push of the hand) that could be held up to light. The filmstrip could also be removed and used in a filmstrip projector.

For the individual visitor—and the shut-in or out-of-towner who could not get to the show—it was an ingenious, if slightly expensive, auxiliary: $7.50. Discounts for teachers or larger purchase orders brought the price down a little.

# AN INTERVIEW WITH KATHERINE KUH

**In the annals of American art museum education, one of the best remembered programs was the Gallery of Art Interpretation at the Art Institute of Chicago, 1942–1953. Here its originator, Katharine Kuh, talks about how and why she conceived it and about what she thinks of the state of museum education today.** CMEVA **interview: May 22, 1975, New York City.**

*Katharine Kuh is the author of several books on art and art museums; she is also art critic of the* Saturday Review *and former curator of painting at the Art Institute of Chicago.*

**Q:** When did you start the Gallery of Art Interpretation at the Art Institute of Chicago?

**Kuh:** It was about five or six years after Mies Van der Rohe came to America, because it was he who designed the gallery and installed the first show. It must have been 33 years ago [about 1942].

**Q:** What sort of exhibitions did you do in the gallery?

**Kuh:** Most of my shows were based entirely on visual experiences, on contrasts and parallels. I thought that art could be taught in terms of art rather than in terms of words. For instance, I did a show called "Constable and Turner, the Road to Impressionism," when the Art Institute was having an exhibition of Constable and Turner. The idea was to demonstrate how Impressionism developed, using only a few terse questions. The explanatory show was based on original works of art and on all manner of other material that related to the movement's dependence on light and color. No technical words were included. Diagrams, photographs, dramatizations, visual comparisons were basic. Words were kept to a minimum, and were usually couched as questions for the visitor to answer.

I also did a show called "The Artist Transforms Nature." (I used "transforms" because in those days the word "distorts" seemed disturbing.) There were many different approaches. One exhibition stressed the difference between nineteenth-century French and American art. Usually American art is, of course, simpler, drier, more realistic, less sensuous, more forthright. And, to be sure, we investigated the reasons for this, again with as few words as possible. Questions and their answers (supplied by the visitor) were based on direct visual confrontations. Works of art are never illustrations; they are experiences in their own right and only in their own right.

**Q:** Did you use only original art?

**Kuh:** I used all kinds of visual material; whenever I could include originals, I did. For instance, in one exhibition we used an original Spanish seventeenth-century painting and along with it variations done by a young artist showing how changes or omissions in design, color, tone changed the meaning of the picture. Another exhibit demonstrated how sculpture differs from painting. We used such devices as mirrors and actual ambulatory space. People were not asked to discuss the difference—they experienced it.

**Q:** Was the Gallery of Art Interpretation located in the midst of the permanent collection?

**Kuh:** No. I usually did the exhibitions downstairs in the gallery that Mies designed; it was a wonderful, flexible space, and it was not far from our exhibition galleries.

**Q:** Who was your audience for the Gallery of Art Interpretation?

**Kuh:** There seemed to be more men than women, and we were amazed by this. We found that more businessmen than schoolteachers wanted to know about the various questions proposed in the gallery—about the difference between space and distance, why artists distort, why we accepted Botticelli's liberties and rejected Picasso's. We don't reject them now, but we did then.

**Q:** Was your work concerned, then, with trying to explain Abstract Expressionism, and was it similar to Victor D'Amico's?

**Kuh:** No relationship. My theory wasn't confined to Abstract Expressionism, which, by the way, was scarcely in its infancy then. I always felt that Victor was experimenting with, and more directly interested in, young children. They were usually rather rich children, interspersed with a few "prize" poor children, and his method (and most important contribution) was working directly with the children and allowing them to experiment and so forth. I wasn't as much interested in children learning through making art. . . . That's fine, I think they should. My interest has always been not in the education of children but in that of their teachers. I feel I can't reach thousands of children directly, but through their teachers we possibly can. I wish I could stop everything I'm doing and go back to teaching teachers. I know it's important, I know it should be done by people who have some imagination about what they are doing.

**Q:** People like Martin Friedman [director of the Walker Art Center in Minneapolis] often visited your gallery. Can you speculate on why this was so important to them?

**Kuh:** Well, I think that they were interested in the techniques of the gallery; they certainly didn't learn anything about the substance of art there.

**Q:** What inspired the Gallery of Art Interpretation?

**Kuh:** Before I went to work at the Art Institute, I had my own gallery in Chicago and taught there from the paintings on view, never using slides. I feel that one must have contact with the original work of art. When I closed my gallery at the start of the war and went to work at the Art Institute, this just gradually evolved.

One way in which it evolved was that we had an education department—a regulation, standard education department—and one day [the head of it] called me and said that there was a representative of the International Ladies Garment Workers Union who wanted someone who could talk to the women about art. The woman from the ILGWU immediately started calling me "teacher," so I said, "I'll

try.'' I suppose it was one of the most revealing experiences I've ever had. I went to their meetings, over on the west side of Chicago, at night. Here were about 30 women who had worked all day; they spoke very poor English—they were mostly Polish and Russian—and here I was, about as fit to teach them as the man in the moon, because I was still thinking in old-fashioned terms about art history.

After three meetings they said, ''Teacher, we don't like.'' I was shocked and asked why. They said, ''We want to know what color to make our curtains; we want to know where to get a rug cheap.'' I had sense enough to realize that what I was giving them was meaningless and that what I should do was persuade them to look at the world around them. I told them, ''I can't help you to choose the color of your curtains; I don't care what color you put in your house; you should put just what you want in your houses. Maybe what we should do is stop learning about art and just go out and look at the city together, and begin to learn how to look at things.''

At first they were dubious. I worked with them for some time, meeting once a week. Some came, others didn't; some would bring their friends. We always had a group of at least 30. I got so interested in them that we gave them memberships in the Art Institute, and they came religiously to our openings. They got to the point where they would come to the museum on their own; I'd see them on Saturdays, bringing their kids. They didn't turn out to be art professionals, they didn't turn out to be aesthetes, but they had some joy in looking at art. They began to understand.

One couldn't approach them with conventional methods. After we had gone around the city and talked about our experiences, we would sometimes visit just one room at the Art Institute, sometimes to look at just one picture. (I never bothered them with dates or routine facts.) For instance, I remember once taking them to see van Gogh's *Bedroom at Arles,* and I said, ''I wish you'd look at this picture carefully, for a long time, and then tell me what kind of man painted it, what is he telling us about himself.'' They began to tell me he was lonely and poor, and then slowly pulled new meaning out of this picture for themselves. They were interested in why he used so much yellow, which is an important point. They began to understand other things that helped explain the other van Goghs in the room. So that time we skipped everything else and just looked at the van Goghs in the museum. And, thank goodness, I never once mentioned that he had cut off his ear. And also, thank goodness, the Art Institute is well supplied with van Goghs.

**Q:** I'm interested that, although there have been many recent types of orientation or interpretive galleries, they are not patterned after yours.

**Kuh:** I don't like most of them. The reason they fail for me is because they depend on wall labels or earphones; people either read or listen, and that's literature, you see, all verbal. I watched people at the Scythian Gold exhibition [at the Metropolitan Museum in spring 1975]. Here were the most marvelous objects—with endless wall labels. People were spending most of their time reading. It's a tragedy. They were having no emotional reaction to the objects, at least that I could see. I don't believe in wall labels. I believe in asking questions—and not always answering them.

**Q:** Why did your work in the Gallery of Art Interpretation stop? Did the institute want you to stop?

**Kuh:** Oh, no, they didn't want me to stop. I stopped because I was promoted to curator of painting. When I was an associate curator, I had time to handle the gallery, but when I took on the whole department, I just didn't have the time. The Gallery of Art Interpretation was much more work than doing regular shows. I spent my nights working on it, and finally I just couldn't do it any more. After that, I was allowed to use the gallery for anything I thought was important: we gave Mark Rothko his first museum show there, and we gave Mark Tobey a marvelous show, but it was never again a Gallery of Interpretation.

**Q:** Do you feel that curators make good teachers?

**Kuh:** I think that some curators make splendid teachers but that most curators tend to be dull, narrow teachers. Yet over and over again, the great curators are apt to be thoughtful teachers. The most unsuccessful curatorial teachers are the ones who only talk to each other, who want to keep up with each other, and who never have the courage to think beyond accepted practices. They lecture, but I really think they should all go and teach the Ladies Garment Workers.

**Q:** The National Endowment for the Humanities says that museum people don't know enough about the background of objects in their collections and therefore should be developing programs in cooperation with academic humanists.

**Kuh:** They certainly should, particularly now that the day of the gentleman connoisseur, who did know literature and history, is over. A man like Kenneth Clark makes these subtle connections, but most museum people today seem to lack knowledge of the whole ambience of a work of art. They know certain facts about it, but not its relationship to a larger world.

I feel strongly that art education departments in universities should be abolished. I think they are a menace. I see no reason for three different kinds of art departments competing in one institution: the history of art, the making of art, and the teaching of art are often three separate departments, squabbling over funds. They all belong together. The most insidious department is always the art education department, which, as a rule, trains prospective teachers how to make papier maché sculpture, to paint little watercolors, to draw a bit, to make a ceramic—and in the end, they learn only superficialities. They have a smattering of art history, of theory, and they are let loose on our children. They have developed no philosophy. Even worse are superficially trained volunteer teachers who, due to dwindling funds, are proliferating in art museums.

**Q:** What would you like to see instead of this?

**Kuh:** It seems to me that if you could teach a child, or better yet, his teacher, how to see, how, for instance, to look at the light changing on a building from hour to hour, you'd have something. Art is a visual experience, and can't be expressed in words, except for a highly sophisticated audience. Only the most accomplished professional thinking should be let loose on our children and their teachers.

When I taught in the New York state school system, I worked with ordinary teachers as well as with art teachers. My hope was to get them to communicate to their classes some strong emotion about art *without talking*. They developed certain marvelous techniques. Once they realized there was nothing to be afraid of, and broke down their habit of saying ''It's beautiful,'' they came up with one experiment after another.

**Q:** What about education in museums?

**Kuh:** Museums should banish tours, and do away with well-bred docents. We need museums that are ready to pioneer in visual education. In our discussions of museum practices, we don't even approximate what teaching means. Read John Walker's book, *Self-Portrait with Donors*. Both he and Kenneth Clark (in his autobiography) talk at length about the rich and powerful, the donors. Neither mentions anything to do with public education, or anything that seems an extension of what a museum could be. I agree with both of them that museums must acquire the best possible art, but to spend one's whole life courting the rich, instead of thinking in terms of a serious educational use of art—that's sad.

I think the Museum of Modern Art has missed the boat, at least recently. It used to be in the lead when Alfred [Barr], with his revolutionary ideas, included photography, design, architecture, films in his program. He was a true pioneer. Now the museum seems occupied with conventional afterthoughts. I would think the next step, after René [d'Harnoncourt] set up that wonderful study gallery, would have been to use it in a new way; but this hasn't happened. The museum is spending thousands of dollars filling gaps in its collections, which is all to the good. I want it to have that missing Matisse, but if it's a *modern* museum, it must do more than fill it. I don't see why it wants to repeat what has already been done. The museum had a golden opportunity to pioneer in education, in *visual* education. I once suggested this to a trustee, and he looked at me as if I had taken leave of my senses. He said, ''Where do you think the money's coming from?'' ''Oh,'' I said, ''if you really had an excellent program it would come from the best foundations.''

I think that the most important thing about art education in museums is to reach the teachers of our children. And museums are not reaching them.

I've always wanted to look into prisons, too. One could start with something the inmates experience in their own awful environment that yet goes beyond their environment. Again, the change of light against a wall, perhaps. If you're a good teacher, your students eventually lead you.—*B.C.F.*

## Bibliography

Books by Katharine Kuh:

*Art Has Many Faces: The Nature of Art Presented Visually.* New York: Harper & Row, 1951. ''A book with pictures . . . designed to explain art in terms of art,'' says Kuh. ''My hope is to *show* rather than tell. . . .''

*Leger.* Urbana: University of Illinois Press, 1953.

*The Artist's Voice: Talks with Seventeen Artists.* New York: Harper & Row, 1962.

*Break-Up: The Core of Modern Art.* New York: Harper & Row, 1969.

*The Open Eye: In Pursuit of Art.* New York: Harper & Row, 1971. A collection of essays about people, places, and opinions, almost all of them from Kuh's columns in the *Saturday Review.*

## THE CLEVELAND MUSEUM OF ART SLIDE-TAPES

Cleveland Museum of Art
11150 East Boulevard
Cleveland, Ohio 44106

**Teaching tools in the form of slide-tapes that cover every period of the collections and many aspects of art are available for museum visitors—individuals or groups—to use in a special viewing room at the Cleveland Museum. Any museum staff member is free to prepare a program in any area of interest, and the personalities of the 120-plus tapes are as various as their subjects. CMEVA interviews and observations: throughout 1974; February, March 1976.**

### Some Facts About the Program

**Title:** The Audiovisual Program.

**Audience:** General audience, including organized school groups, random visitors, scholars, first-time visitors.

**Objective:** ''To inform and enrich the museum visitor's experience in the galleries.''

**Funding:** Original investment of about $10,000 required to set up control room, mirrors, recording equipment. (Screens and viewing equipment not included.) Annual cost of supplies: $1,000, including three new projectors purchased each year. Each tape costs an estimated $500 in materials and salaries of regular museum staff.

**Staff:** One technician, one utility man, one professional in museum's education department, all part-time. All department staff and some curatorial staff make slide-tape programs.

**Location:** In the museum.

**Time:** 10:30–4:00 (or 4:30) Tuesdays through Saturdays; 1:30 to closing on Sundays.

**Information and documentation available from the institution:** List of available slide-tapes.

---

With a little perseverance, a visitor to the Cleveland Museum of Art can find the audio-visual center on the classroom level, one floor below the museum lobby and far removed from the galleries. Notices leading to it are modest in size, color, and

wording; directional signs are barely visible. This discretion, like the location itself, is a clue to the museum's attitude toward the slide-tape programs available in the center: they do not provide an experience that can substitute for, or compete with, the experience of looking at works of art.

Education department staff members agree on a basic philosophical approach to the slide-tapes they make: they are designed not for "splashy creativity" but "to make a simple direct statement," to be a teaching tool rather than a "show," as Janet Mack, assistant curator responsible for the center, describes them.[1] The catalog of over 120 slide-tapes is as comprehensive as the museum's collection, covering all periods from ancient to twentieth century, all major art-producing areas, and all media. Most last about 10 minutes. A few, for very young children, are shorter, and some "survey" tapes run as long as 20 minutes.

### The catalog of slide-tape programs

There are tapes on formal elements (on space, or color, or line); tapes designed especially for children (focusing on works of art, or process, or museum behavior, like one that features a Marcel Marceau-like dancer slithering around the galleries acting out some do's and don'ts of museum-visiting); tapes on individual artists or works of art. Tapes in French, Spanish, and German are available on request, but they are not widely publicized and are rarely used.

Some slide-tape programs draw parallels between the visual arts and literature or examine works of art in relation to the place where they were made—one on three Cézanne paintings and Provence, another on motifs from nature found in Chinese and Japanese paintings—and still others deal with technique and process. Only one slide-tape is without sound, a brief vivid program that relies entirely on visual images; exquisite photography concentrates on details generally overlooked by even skillful museum-goers. (Miss Mack reports that invariably a visitor comes out of the audiovisual room to complain that the sound has gone off.)

Art historical information usually concentrates on objects in the museum collection, but a slide-tape program prepared for a special exhibition often includes both loan objects and objects not included in the exhibition, for purposes of comparison and explanation. Slide-tapes made for loan exhibitions have proved not to be very useful once the show is dismantled.

On the other hand, slide-tapes that offer ways to look at works of art are never outdated. Among the most continually serviceable tapes, if not always the most imaginative, are those that stand in place of a lecture. Miss Mack finds it "encouraging that requests for repeats are for information tapes, not for entertainment. . . . Some [that] are enjoyable [are] not re-requested as often." Though she takes this request rate as a sign that the programs are being used as intended, for education, she recognizes that the quality of the tapes requested is uneven and observes, "The general public is grateful for anything you give them—even if the product is not always as good as we might wish."

### The product and the process

The uneven quality of the slide-tape programs accurately reflects the informal process by which they are made. Any member of the museum staff may prepare a script, choose slides, and record the presentation. Most of the authors have been members of the Department of Art History and Education, though curators (and the director) have also made programs.

Within the education department there are no assignments to make tapes; everyone is expected to contribute, and nearly everyone does manage to steal time away from other duties. Many of the tapes have been prepared as necessary introductions to exhibitions, whereas others are born of a staff member's special interest or particular need.

The assortment of approaches and vocal qualities offered to the viewer results, therefore, not in one consistent style or point of view that represents "the museum" but rather in what one staff member likened to a selection of "everyone's best jar of homemade preserves." This absence of uniformity, which charms some visitors and irritates others, reveals the staff as individuals with varying degrees of talent, scholarship, and desire to communicate with the public. There appears to be no attempt to gloss over individual eccentricities for the sake of "production values."

The variability of the slide-tape contrasts with the tidy professionalism of the center itself, where the programs are shown and where all of the technical work is done. The center comprises two areas; one for projection, one for production. (Its layout is roughly based on the audiovisual center at Phillips Academy, Andover, Massachusetts.) In the small (dimensions: 8-by-20 feet) projection room are housed tape decks, projectors, and the entire library of slide-tape programs. Equipment is within easy reach; one person can program and monitor all three viewing rooms at once. The number of persons who can operate the equipment is purposely limited (to two) so that responsibility is assigned and taken seriously. There is usually—but not always—someone available to make minor repairs or to run special programs on request. In the production area, museum staff members record and edit their presentations, with the help of Miss Mack and Fred Janesch of the technical staff. (A complete list of equipment is appended to this report.)

### What the visitor finds

**The projection area.** A central projection booth serves three viewing rooms with rearview projectors. In the largest room, which can seat 40 persons, run the daily programs for the general public and for school classes. On the other side of the projection area are two smaller rooms—one seating about 20, the other no more than 8 without crowding—for seminar groups or individual visitors who request tapes. The largest viewing room opens into the educational exhibition area. (Slide-tapes are also shown in museum auditoriums and classrooms; no programs go outside the museum.)

**The schedule.** Slide-tape programs run continuously in the two larger viewing rooms from 10:30 A.M. to 4:00 or 4:30 P.M., Tuesday through Saturday, and from 1:30 to closing on Sunday (shortly before 6:00). The schedule of Sunday slide-tape programs for the largest room is made up a year in advance for a local newspaper, which publishes a brief notice every week. That schedule is based on special exhibitions, gallery talks, and other events in the museum. Programs for the second room are arranged from week to week to permit flexibility.

**Crowds and no crowds.** Attendance at the Cleveland Museum of Art is heaviest on the weekends, when there is sometimes (but not always) standing-room-only in the viewing rooms. They may be nearly empty on weekdays when school groups or scheduled adult groups, who dominate the weekday audience, are not using the rooms. Attendance figures for slide-tape audiences are kept only for scheduled groups. From 1971 through 1975 a total of nearly 33,000 persons in over 1,200 groups used the facility.[2]

### Observations, evaluations, appraisals

**Use of the slide-tapes.** The staff calls general use disappointing. It had hoped that classroom teachers who bring their students for "self-guided" tours of the galleries would use the slide-tapes to prepare themselves and their students for the museum visit. Though some teachers may come to see the programs without identifying themselves, department statistics indicate that in the first year of operation fewer than 100 such classes, out of a total of 688 who came to the museum, asked for and watched the slide-tapes.

Museum instructors use the programs more frequently, probably because, as one pointed out, "we know exactly what they are and what we can use them for." The comment suggests that—as in so many other areas of museum education services for that special adult audience, teachers—communication has failed, or at least faltered.

Staff members would like more visitors to use the center and believe that more publicity, better signs, and higher visibility would help. Evidence for their belief is offered by the consistent requests for those programs mentioned on labels in the galleries, which alert visitors to related slide-tapes.

**The equipment.** Expensive and elaborate audiovisual equipment arouses contradictory feelings among art museum educators: some are suspicious, skeptical of technology and the mysterious skills required to run machines; others are eager to try new technology, convinced that museum education falls another step behind with each invention it refuses to try. Like many museums that have attempted to make prudent use of the new technology, the Cleveland Museum made some mistakes and some happy discoveries about audiovisual equipment. If one thinks about recording by magnetic tape as a long chain of pieces of equipment and space linked together—from the microphone and pream-

plifier to the speaker and the viewing room—one cannot escape the old saw: a chain is only as strong as its weakest link.

The museum's staff, recognizing some weak links and technical flaws in its audiovisual programs, asked an independent engineering company to evaluate the equipment. The report judged the speaker system and the equipment for making the working tapes from the master tapes woefully inadequate, the recording equipment and tapes of the highest quality: "There was no speaker system of any quality, even remotely comparable with the capability of the recording equipment. . . . The monitored speakers were of the less than a dollar variety, and mounted without enclosure merely on the face of the recorder. I say again, there was no point in listening to master tapes through this kind of a speaker system since the play back speaker link would probably be less than ½ on a scale of 10 to 1."[3]

Despite disappointing performances of some pieces of equipment, the total adds up to a sound system that is adequate, even excellent, for the spoken word and inadequate-to-poor for music sound tracks. As most of the slide-tapes use text rather than music as background for the slides, the inadequacies of the equipment do not seem especially significant to most staff or to visitors interviewed at random. The few tapes that use music continue to be scheduled and run, though some music-lovers among the museum's visitors complain of the distortions.

The visual aspect of the slide-tapes is, as one might expect in an art museum, more consistent. A staff member of the education department, who also serves as photographer for the department, makes or duplicates slides for all slide-tapes, always with an eye to the most faithful possible reproduction of works of art.

One of the engineer's recommendations was to tear out all three viewing rooms and replace them with rooms "carefully fitted with the proper speaker systems and perhaps designed so as to create more of the idealistic audiovisual concept of being able to 'lose the person in the picture.' The ultra of audiovisual seduces the person out of himself and creates a genuine illusion with the observer-listener becoming a part of an experience."[4]

Aside from its prose, this suggestion got nowhere at the Cleveland Museum of Art. What the museum precisely intends *not* to do with its slide-tape programs is to seduce visitors or create a "genuine illusion." At the museum, only works of art are proper seducers.

**The value of slide-tape programs.** Some observers equate the programs with the printed handout or the interpretive label. Their most enthusiastic supporters believe that slide-tapes have a flexibility of length, approach, tone, and sophistication built into them that written materials cannot have; it is their variety that especially pleases some staff members who make them. But all agree that "there are things that could be done to make [the program] more creative, more useful, more fully used, better known to the general public."

In choosing slide-tapes over film or video as audiovisual aids to the individual visitor, the museum director and staff considered cost (slides are cheaper than any other) and, much more important, their purpose. James Johnson, curator of the Department of Art History and Education when the audiovisual center was designed, has explained: "Good color slides afford . . . concentrated study of art objects, especially in detail . . . [and] moreover, can be employed as exercises in fixing attention, an appropriate prelude to an encounter with original works of art." The museum chose to concentrate primarily on its own collection: "The overriding purpose of this audiovisual program is to direct the visitor's attention to original works of art in the galleries."[5] Their character, as much as their location, places them firmly subsidiary to the museum collection.—*A.Z.S.*

## Notes

[1] For sources of quotations without footnote references, see list of interviews at the end of this report.

[2] The following are the attendance figures for persons in scheduled groups between 1971 and 1975 (the drops in 1974 and 1975 are attributed to the effects of the fuel crisis):

| Year | Number of Groups |
|------|------------------|
| 1971 | 243 (7,023 individuals) |
| 1972 | 286 (7,340 individuals) |
| 1973 | 323 (8,847 individuals) |
| 1974 | 211 (5,249 individuals) |
| 1975 | 195 (4,399 individuals) |

[3] Undated memorandum from Electrical and Mechanical Design, Richfield, Ohio.

[4] Ibid.

[5] *The Educational Program of The Cleveland Museum of Art,* 1971, p. 24.

## Interviews

Hoffman, Jay. Instructor, Department of Art History and Education, Cleveland Museum of Art. February 26, 1976.

Janesch, Fred. Technical staff, Department of Art History and Education, Cleveland Museum of Art. March 9, 1976.

Mack, Janet. Assistant Curator, Department of Art History and Education, Cleveland Museum of Art. August 1 (with Norma Roberts), September 17, 1974; telephone, March 3, 1976.

Weisberg, Gabriel. Curator, Department of Art History and Education, Cleveland Museum of Art. May 29, 1974.

Museum staff and visitors. Throughout 1974.

### Recording equipment

† 1 - Stereo tape recorder (Model 1024 Telex Magnecord)
† 1 - Manual recorder (Model 1021 Telex Magnecord)
† 2 - Pre-amplifier sound mixing stages or units
† 2 - Sound mixing amplifiers (Model McMartin)
† 1 - Record player (Precision type Model 1209)
† * 1 - Cartridge Stereo recorder (Model Telex 36, used for final stage of recording)
† 2 - Variable frequency oscillators (used for recording pulses on tape so that synchronizer can advance slide projector)
† 2 - Dynamic microphones (Model AKG)
† * - Tape Cartridges are standard broadcast station type (Model Fidelipac #4039) which utilize standard ¼-inch lubricated recording tape. Maximum play time of this cartridge is 30 minutes. It also has a very high reliability record when in heavy or constant use.

### Editing equipment

† 1 - Stereo reel-to-reel tape player with easy editing features
† 2 - Standard 12-inch speakers
† 2 - Standard 15-watt amplifiers
† Various splicing and cutting materials

### Viewing equipment in AV rooms

† 4 - Slide projectors (Kodak Carousel Model 760)
† 3 - Tape players (Telex Model #36)
† 8 - Standard 12-inch speakers
† 3 - Sound amplifiers (Telex Model # P94 A)
† * 3 - Pulse amplifiers (operates at 400 Hertz)
† ** 1 - Pulse amplifier (operates at 1000 Hertz)
† 4 - Synchronizers
2 - Dissolve programers (Kodak)

† Denotes equipment needed to set up similar operations elsewhere.

* Needed for operating single-projected programs.

** Needed for double-projected program when random slide comparison is desired.

## Museum and Community

prototypes for a welter of museum outreach efforts. Some distinguishing features: a network of volunteers in the towns visited, a traveling curator, and supplementary interpretive materials.

158 **Dougherty Carr Arts Foundation: South Texas Artmobile.** One exhibition a year, borrowed from museums around the country, makes the rounds of rural South Texas towns in a tractor-trailer bought and equipped by a single donor and staffed by a curator and volunteers.

160 **The University of Kansas Mini-Van.** A simple, inexpensive, one-axle trailer, specially designed for the purpose, carries original art for one- or two-week stays in libraries, community colleges, and banks throughout Kansas. (Box)

### SPECIAL AUDIENCES

159 **The Metropolitan Museum of Art Department of Community Programs: Senior Citizen Slide-Lecture Program.** The museum provides training, slides, and equipment, and elderly volunteers do the rest in a program to serve the city's senior centers. One result is a psychological boost for the volunteers; another is good community relations for the museum.

164 **The Wadsworth Atheneum Tactile Gallery.** Both blind and sighted visitors are given nonvisual sensory experiences in the exhibitions of this gallery with its own curator and staff of volunteers. It also serves as an orientation to the rest of the museum.

167 **Albright-Knox Art Gallery: "Matter at Hand."** Clay workshops were combined with a touch exhibition of sculpture, accompanied by large-type and Braille labels, for the blind and handicapped. The volunteers who made it work called the program "a great human experience."

170 **The Addision Gallery of American Art: Video for Special Audiences.** A museum in a cloistered setting—a prep school in the New England hills—reaches out to two untraditional museum audiences with a participatory video program: patients in a state mental hospital and residents of nearby working-class towns.

## Introduction

Most American art museums were founded by "men of fortune and estate," as Calvin Tomkins describes them,[1] for what one of those men of fortune called "the vital and practical interest of the working millions."[2] A popular cartoon of the 1870s showed one art museum's august trustees pulling members of the working class out of the local bar rooms and hauling them off to "humanize, educate, and refine" them at the feet of high art.

If the fond dreams of these moralists have not always come to pass, if not everyone has been humanized and refined at the behest of the art museums of the country, it may be, say the critics, the museums' own fault for paying too much attention to men of fortune and estate and not enough to the working millions. The reports in this chapter describe some of this generation's attempt to correct that fault.

### The art museum's proper "community"

Although these attempts speak for themselves, one or two points might be made about the art museum's responsibilities to the community to help place these efforts in perspective.

First, the art museum has a self-selected audience, well defined by a variety of audience studies as highly educated, affluent, and professional. The problem has long been the expansion of that audience to include other segments of society—the less well educated, blue-collar workers, the poor, the elderly, the handicapped—any identifiable group that might harbor art-responsive members to whom the art museum could issue a special appeal.

Second, in spite of the charges commonly laid against them, many art museums have earnestly tried over the years to attract new audiences among the working classes, the poor, and other publics, as one observer put it, "that have not traditionally been courted by the museum." As with other American social and educational movements, there have been several swings of the pendulum toward and away from more alienated members of "the community"; at some times, usually depending on the mood of the rest of society, museums have been more aggressively egalitarian than at others. But as a reading of the annual reports will attest, mobile units, branch museums, loan exhibitions in libraries and settlement houses are not new in this country, nor is the interest of museum educators in the blind, the unemployed, or immigrants recently arrived in the cities. Katharine Kuh describes in chapter 2 some of the classes she held for members of the garment workers' union in Chicago during the forties. Museum annual reports recount special lectures in the 'teens for salespeople and buyers in retail stores, the deaf and the blind, off-duty soldiers and sailors; and in the 1930s there were weekend gallery talks for workers, courses for foreign-born adults, and circulating "neighborhood exhibitions."

For the better part of the last century, in fact, art museums have served alongside the great urban libraries as surrogate universities and centers of acculturation for successive immigrant groups as they made their way through the ports of the Eastern seaboard to the interior of the United States. The museums were free then, open to anyone with the interest to come. Although they may have been more intimidating than they are now (66 percent of the people who responded to the 1973 survey for the Associated Councils of the Arts, for example, felt that museums in the 1970s were doing "imaginative things to make them interesting places to visit"),[3] still people used them, and there were many on museum staffs who took seriously their educational responsibilities to their changing communities.

What has always been an open question, however, is whether art museums should focus their relatively limited resources in one segment or another of their communities and if so, which. Are they basically universities, and can they thus expect their visitors to make some of the educational effort themselves? Or are they schools, obliged to teach the necessary visual literacy from the bottom up? How much recruitment of new students should museums be required to do? Unlike libraries, art museums have had to draw largely from private sources for support, even those whose buildings are guarded and maintained, and sometimes owned, by the public. Yet most art institutions owe their existence and survival to their exemption from taxes, and those dollars, after all, could have helped to reduce local or state budgets. That exemption is meant to benefit the public; it should give people the sense, as one art museum trustee has put it, that those institutions "belong to us." Even so, other tax-exempt institutions—universities, hospitals, private foundations, churches, social welfare organizations—though they may be available to everyone, in reality serve only parts of the public, not all of it. Furthermore, there are those who point out that it is the art museum's mission to collect, conserve, and exhibit works of art, not to correct society's injustices or serve as a catch-all community center. Should art museums, then, be free to choose what parts of the community they will serve? And if the art museum is not to decide for itself, whose responsibility shall it be?

During the late 1960s, some of the decisions about whom art museums should serve were made by government and private funders, pressed along by the social upheaval of the time. The National Endowment for the Arts' "wider availability" funds encouraged art institutions to redefine and enlarge their community focus to include the poor and the underserved in particular. Many art museums bit that carrot, and many followed with programs funded by other money. In the Endowment's 1971/72 survey, among all kinds of museums, art museums had made the most efforts to attract blacks (49 percent of all art museums reported special programs here) and the "economically disadvantaged" (33 percent).[4] But for some museums community programs have not proved to be all that digestible. "To carry on a revolution in a bank," the Metropolitan Museum's director, Thomas P.F.

Hoving, says later in this book (see chapter 10), "you have to dress like a banker." That disguise may work very well inside the art museum, but on ghetto streets the banker may not be the happiest image an art museum can project.

Even some of those museums that stuck with the job have not always been successful. Part of the problem has been the quality of the commitment. Unused to thinking in egalitarian terms—and almost always assuming a certain degree of literacy among its clientele—art museums tend to offer one set of standards for the rich and the "enlightened" and another for the poor and untutored. Sometimes imagination and sensitivity are missing. Sometimes it is consistency: often museums have to be reminded of their wider responsibilities, and the "commitment" ends up as a series of short-term responses to intermittent waves of any given community's self-assertion.

One audience the art museum has trouble with is the poor, a mutual alienation that has been tellingly described by psychologist Robert Coles. It is evident from Coles's essay, written for *On Understanding Art Museums,* that to the poor, as to anyone else, "money and power have their effect inside as well as outside museum walls," and that all one museum's attempts to attract a broader public have not hit the mark.[5] But it is not clear that the average art museum can hit the mark with this audience. John Dewey is only one of many observers, including Coles, who have deplored the gap between the aesthetics espoused by the art museums and the "aesthetics" of the public environment in which so many of the "working millions" live out their lives. Writing in 1930, Dewey said,

> I can think of nothing more childishly futile . . . than the attempt to bring "art" and esthetic enjoyment externally to the multitudes who work in the ugliest surroundings and who leave their ugly factories only to go through depressing streets to eat, sleep, and carry on their domestic occupations in grimy, sordid homes. The interest of the younger generation in art and esthetic matters is a hopeful sign of the growth of culture in its narrow sense. But it will readily turn into an escape mechanism unless it develops into an alert interest in the conditions which determine the esthetic environment of the vast multitudes who now live, work, and play in surroundings that perforce degrade their tastes and that unconsciously educate them into desire for any kind of enjoyment as long as it is cheap and "exciting."[6]

Such an assignment to the purveyors of high culture does involve the larger mission to correct society's injustices, and it is one that most art museums have assumed with questionable success. Those few times when they have tried—through architectural and social exhibitions, for example, that can be considered only marginally aesthetic—they have been roundly criticized for stepping out of their appointed role. For traditional museums, the social crusade does not come naturally.

So there are difficulties here. Some of the programs described in this chapter have tried to meet the difficulties by attacking them head on: the Everson Museum went directly to its city's black population, Indians, and prisoners; the Philadelphia Museum's Department of Urban Outreach took its programs into the surrounding Hispanic-populated streets; the Addison Gallery went into mental institutions and centers for lower-class teenagers. For other museums, expansion of the audience may have required no less adjustment, and populations may have been in their way no less culturally deprived, but the job that Dewey and Coles have described is far larger. It is barely begun by some of the institutions that have emerged in urban neighborhoods in recent years (see chapter 4), and hardly understood by most museums of art.

## Some operating definitions of community and some operating approaches to it

Obviously, the choices art museums make to expand their publics are determined partly by what kind of institutions they are and where they are located. Some museums—Virginia and Greenville County, for example—are their area's only visual arts centers, and their public mandate is to serve the wider community. Others—the Philadelphia, Metropolitan, and Whitney museums, among them—are part of a relatively crowded cultural landscape, and they are thus somewhat freer to pick and choose which publics they will serve. But in one way or another, all of them have had to make changes in educational style and substance, and in at least one case, administrative pattern, to fit the audiences on which they have set their sights.

The Everson Museum under Director James Harithas decided that the museum was focusing too much on what he called "an old definition for that community" at the expense of "people who are in jazz, people who live in ghettos, people who live outside of the traditional context." Harithas was determined to "break that down." He went to the prisons and mental institutions; held exhibitions for the city's Indians, Haitians, blacks, Ukrainians, students, and office workers; visited churches; offered the museum's auditorium to any group that wanted to use it, including the American Legion and the Daughters of the American Revolution. "My commitment is to art," said Harithas, "which I believe elevates the individual." And clearly, for Harithas, if not for the many museum directors who do not agree with him, art is the means, the individual the end. As for the Everson's relatively small but not undistinguished collection, much of it was dispersed around the city to hang in schools and corporate offices. Harithas was more interested in establishing new roots for the American attitude toward art: "I just don't think we're going to have a real culture," he said, "until we accept the rest of the world on a parity with Western Europe. . . . We have to begin dealing with our own context."

One of Everson's devices for "dealing with our own context" was video, "the medium of our time." Harithas's purpose was not only to present video art, which the Everson was one of the first U.S. art museums to do, but "to expand the range and breadth of the museum's involvement in the community through the direct use of public media." For three

other art museums in this chapter—the Addison Gallery, the Philadelphia Museum, and the Greenville County Museum—the motive in using video was the same, to attract and communicate with new audiences who have become accustomed to getting their information through television. Greenville's task is especially "awesome," as the museum's curator of education points out: nearly half of its target audience has not finished high school. Like Everson, both Greenville County and Philadelphia have used video to introduce artists and let them explain their work directly to museum visitors. Greenville has also made its video presentations something of a special event by adding pop music to videotaped slide presentations for high school audiences. Addison has given children the chance to create their own video shows at the gallery, an experience that has helped them to feel it is "their museum." All four have taught people to use video equipment, but in the Addison and Philadelphia programs there has been a particular emphasis on the use of the camera to let people express themselves and look critically at their communities. Each museum has tried to integrate art and the visual experience into "the mainstream of life" and to "provide a context for understanding works of art."

Although all four museums have been trying to bring new groups into the museum community, Addison has made a special effort toward mentally disturbed or handicapped people who live both inside and outside institutions. So have two other museums here—the Albright-Knox Art Gallery in Buffalo, New York, and the Wadsworth Atheneum in Hartford, which created special galleries for the blind and physically handicapped. In the process of trying to make their museums more accessible to these particular groups, they made other discoveries. The Atheneum found that its Tactile Gallery was popular with its sighted visitors as well—and began planning to use it as both a sensory laboratory and an orientation center for their museum. The Albright-Knox staff and the volunteers who set up the gallery's "Matter at Hand" exhibition discovered that the exercise of learning about the specific needs of handicapped visitors—what kinds of experiences they are often given too much of, what physical problems have to be accommodated in the design of an exhibition, and what administrative arrangements are required to handle the tours—brought new life and purpose to their work as a whole. It also holds lessons usefully applied to other audiences. For what is required, as one observer has noted, in any attempt to attract a new public, is an "imaginative understanding of individual circumstances and needs,"[7] and that has turned out to be an important part of all the efforts reported here—one that it would seem could have an effect on museum educational programs for any kind of audience.

For other museums the handicapped and the poor are not the only culturally deprived audiences in this country. The Metropolitan Museum found one constituency waiting in senior citizen centers—and tapped a pool of senior-citizen volunteers to serve it. The Virginia Museum and South Texas artmobiles and the University of Kansas portable exhibitions

travel deep into rural territory where their appearance and the rare presence of real works of art are "a major social, intellectual, and aesthetic event." The Whitney and Baltimore museums found that the downtown business communities were just as cut off from cultural stimulation and had just as much need to "broaden their tastes and expand their cultural horizons." The Whitney's David Hupert extracted a contribution out of one businessman for a satellite museum in New York's Wall Street area by making the point that "you try to get the most out of your workers, and you don't get very much out of them if they're going to be starving. There are many ways to starve," he said, "including culturally." The Baltimore Museum has helped stimulate the weekday population of a downtown renewal area with its branch museum, which, like the Whitney's branch, sometimes draws a larger attendance than the mother institution.

Both the branch museums and the mobile units have tried to gear their exhibitions and attendant activities to the particular circumstances of the sites they inhabit. The branches are designed for lunch-hour traffic and office-workers' tastes (the most egregious bid being the Whitney's exhibition of John De Andrea fiberglass nudes), the mobile exhibitions for easy transportation and topical interest (art from a cowboy museum in west Texas, for example; quilts and the work of some of the state's photographers on the Kansas van).

But few museums have gone quite as far in tailoring themselves to fit their audiences as the Children's Museum in Boston. Rather than organize itself by collections and activities, as most traditional museums have done, the Children's Museum revamped its administrative structure in 1972 by client needs: teachers are one audience, mobile middle-class parents and their children another, and less mobile, underserved community populations are the third. Division heads, who are all but autonomous, design their programs and schedules and hire their staffs with an eye to the audiences they have decided to serve. If the people in the low-income communities of Boston cannot get to the museum and yet respond to the kind of stimulation the Children's Museum can give, the community services division trains program leaders to bring visual arts, crafts, music, and science activities to the communities. It is director Michael Spock's opinion that branch museums for institutions like his are "expensive and unrealistic." Rather than compete for money and attention with local organizations, the Children's Museum, he thinks, does better to give community organizations access to its resources. The administrative design may not fit large, traditional museums, but it does offer an alternative pattern for education and community affairs departments that are usually structured more by age group than by lifestyle, mobility, and educational privilege.

## What is left to do

During the 1960s one of the most influential social changes affecting the arts and the institutions that support them was movement of the population. Between 1960 and 1970 the

white population of the central cities in the United States declined by 644,000; the nonwhite population increased by 3.8 million.[8] As the U.S. census makes no ethnic breakdowns, these figures do not take into account the influx of Puerto Ricans, Mexicans, and other minorities who are classified as white. But by almost every measure available to them, population experts agree that the central cities are becoming increasingly nonwhite and that it has fallen to urban centers—as it has throughout recent American history—to educate and "upgrade" this expanding minority (which in several central cities has now become the majority). As one report puts it, "The population flowing into cities . . . tends to be—relative to the host population—undereducated, less skilled, and more impoverished. The responsibility and cost of upgrading inmigrants falls upon institutions in destination areas. National problems of poverty and discrimination—not necessarily problems *of* cities—come to be located *in* them."[9]

Most of these changes took place in the cities where the private wealth so abundant in the nineteenth century and the first half of the twentieth was invested in many of the country's greatest art museums—New York, Boston, Philadelphia, Cleveland, Detroit, Toledo, St. Louis, for example. The complexion of these populations changed dramatically during those decades; in New York City alone between 1950 and 1970 two million middle-class whites were replaced by two million nonwhites, many of whom were economically disadvantaged.

To judge from available statistics, it would seem that in very few of these cities, however, has the composition of the art museum audience changed to match the composition of the population. Studies in the early 1970s showed that the people who visited art museums were still overwhelmingly white, well educated, and well employed. A 1975 survey by the National Research Center of the Arts found that whites who had visited art museums or galleries four or more times in the previous 12 months outnumbered nonwhites two-and-a-half to one. In the income group below $15,000 average attendance was 12.3 percent, and among those who had not finished high school the figure was 5 percent.[10]

Surveys taken by the Metropolitan Museum in New York and the Museum of Fine Arts, Boston, in 1973 produced similar results. As noted in the introduction to chapter 2, only 8 percent of the Metropolitan's audience belonged to a minority group, 18 percent had no college education (probably including students), 18 percent (also probably including students) earned less than $8,000, and a mere 3 percent held blue-collar jobs.[11] Although the Boston Museum's statistics were not strictly comparable with the Metropolitan's, the results of its survey were much the same: about 17 percent of the MFA's visitors had a high school education or less, 3 percent had blue-collar jobs, and less than 2 percent were members of a racial minority.[12]

What these figures seem to suggest is that to enlarge their definition of community (especially if it is to include minority groups, the poor, and the less educated), art museums—already making proportionately more efforts in behalf of these audiences than other kinds of museums—will have to do a good deal more than they are doing. Art museums may not be able to correct society's injustices, but with a more sustained and focused commitment, they can perform a useful role by casting their nets to find the art-sensitive members of every economic class, age, and race and offering them their special gifts.

Money for community programs is scarcer in museums now. But out of the welter of attempts to expand the art museum audience in the last decade, there have emerged in some institutions notes of hope—a new sensitivity to unserved audiences of all kinds, the addition of minority-group members to some museum staffs, an effort to look more carefully at the old assumptions in building museum collections. Perhaps the most hopeful signs of all are the new arts organizations that have grown up outside the traditional museum, a few of which have been strengthened and even made possible in the first place by the steps that museums took in the late 1960s to extend their resources. Some of these organizations and their alliances with traditional museums are described in the chapter that follows this one.—*B.Y.N.*

## Notes

[1]*Merchants and Masterpieces, The Story of the Metropolitan Museum of Art* (New York: E. P. Dutton, 1970), title of part 1.

[2]Ibid., p. 17.

[3]*Americans and the Arts,* A Survey of Public Opinion, conducted by the National Research Center of the Arts, (New York: Associated Councils of the Arts, 1975), p. 31.

[4]*Museums USA* (Washington, D.C.: National Endowment for the Arts, 1974), p. 58.

[5]"The Art Museum and the Pressures of Society," *On Understanding Art Museums,* ed. Sherman E. Lee (Englewood Cliffs, N.J.: Prentice-Hall, 1975), p. 199.

[6]"The Crisis in Culture," *Individualism Old and New* (New York: Minton, Balch, 1930), pp. 130–131.

[7]Renée Marcousé, "Changing Museums in a Changing World," *Museums, Imagination and Education* (Paris: UNESCO, 1973), p. 21.

[8]*Statistical Abstract of the United States, 1971* (Washington, D.C.: U.S. Department of Commerce, Bureau of the Census), p. 16.

[9]*Population, Distribution, and Policy,* ed. Sara Mills Mazie, vol. 5, Research Reports of the Commission on Population Growth and the American Future (Washington, D.C.: Government Printing Office, 1972).

[10]*Americans and the Arts II, A Survey of the Attitudes toward and Participation in the Arts and Culture of the United States Public,* conducted for the National Committee for Cultural Resources (New York: National Research Center of the Arts, August 1975), p. 84.

[11]"A Study of Visitors to the Metropolitan Museum of Art," presentation charts, March 1974, chart #1, "Who Comes to the Museum."

[12] Memorandum from John Coolidge, president of the Museum of Fine Arts, to members of the program committee, January 23, 1975, pp. 1, 19, 20. See also Michael O'Hare, "The Audience of the Museum of Fine Arts," *Curator,* vol. 17, no. 2 (June 1974), pp. 126–158.

# THE CLIENT-CENTERED STRUCTURE OF THE CHILDREN'S MUSEUM, BOSTON

The Children's Museum
Jamaicaway
Boston, Massachusetts 02130

**Searching for ways to solve its financial problems, reach "new audiences" in the low-income communities of Boston, and serve its middle-class visitors better, the Children's Museum, with the help of management consultants, reorganized its administration to provide for three divisions and a client-centered hierarchical structure. The result has been a happier, more efficient staff and an operating budget in the black. CMEVA interviews and observations: July, August, October, December 1973; January–March, October 1974; April 1975; March 1976.**

## Some Facts About the Museum

### 1. General Information

Founding: 1913 by the Science Teachers' Bureau in Boston, which installed the museum's small nature study collection in a city-owned building in Olmstead Park. The museum was chartered as a separate organization in July 1914.

Collections: Natural history objects (birds, shells, rocks, insects); cultural artifacts (primarily Japanese and Native American); nineteenth- and twentieth-century Americana (household furnishings, utensils, clothing, dolls, games, books, magazines)—over 50,000 cataloged artifacts.

Number of paid staff: 52.

Number of volunteers: 20 teenagers, who serve as junior curators; 30 preadolescents, who are called museum helpers; 15 volunteers; 60 work-study students, who serve three-month internships (the museum pays 20 percent of the salaries for students in funded programs).

Operating budget: $630,213 in fiscal year 1974 ($739,917 in fiscal 1975).

Expenditures for education: $414,000 (FY 1974) for the programs of the visitor center, the resource center, and the community services division. In all, about 69 percent of the museum's budget is allocated to direct educational services.

Source of funding: Earned income from admissions, kit circulation and course fees, sales and royalties ($326,693 in fiscal year 1974, or about 50 percent of the museum's operating budget); research and development project grants and contracts ($167,037); unrestricted gifts and investment income ($142,900). Grants have come mainly from the National Endowments for the Arts and Humanities, the U.S. Office of Education, and private foundations.

### 2. Location/Setting

Size and character of city: The population of Boston proper in 1970 was 641,071, and the standard metropolitan statistical area was 2.7 million. The city is multicultural, diverse in its socioeconomic mix, and heavily populated by college and university students (there are 47 degree-granting institutions in Boston's metropolitan area).

Climate: New England seasonal.

Specific location of institution: In two old mansions, a converted auditorium, and several outbuildings in a transition area of mixed-income (welfare, blue-collar, and professional) families and ethnic background (Hispanic, Irish Catholic, black). The area is situated between predominantly black Roxbury and predominantly white, suburban, middle-class Brookline.

Access to public transportation: Although the museum is only two blocks from bus and trolley lines, they are far out on one of the spokes of a radial transit system, and the museum is therefore especially difficult to reach without a car.

### 3. Audience

Membership: 2,000. Families living within the City of Boston pay $8 a year; others, $16. Privileges of membership: free admission to the visitor center, 10 percent discount on sales shop purchases, and monthly newsletter. (In 1972, the membership structure was changed to encourage more sustained use of museum resources and provide a "lower access threshold" for low-income clients.)

Attendance: Visitor center, 185,000 (1974); resource center, 10,000-15,000 adults who work with 200,000–300,000 children; community services division workshops, 750 adults who work with 5,000 children.

### 4. Educational Services

Organizational structure: No separate education department; the entire operation of the museum is organized to serve its clients' educational needs.

Size of the staff: Visitor center, 17 (5 part-time); resource center, 13 (one part-time); community services division, 9 (5 full-time and 4 part-time).

Budget: $414,000 (1974).

Source of funds: Admissions, fees, contracts, and grants.

Range of services: Exhibitions, workshops for teachers and community workers, programs for visiting school groups, circulating collections and teaching kits, a recycled materials shop, and an extensive resource center that allows classroom teachers and other adults to try out published and homemade educational materials.

Audience: Visitor center—school groups and their teachers, families, children on their own, the general public. Resource center—teachers, students of education, museum educators, and other adults working with children. Community services—community-based groups working with children (day-care centers, camps, settlement houses, recreation centers, kindergarten and nursery schools), individual children from the neighborhoods, and families.

When the Children's Museum in Boston opened its new visitor center in 1968, the museum was in the middle of what many people looked on as a boom. A popular and widely regarded young director, Michael Spock, had been at the helm for nearly six years, and in that time he and his staff had managed to turn a half-century-old science and cultural institution into a new kind of museum.

Under the new regime, the museum went through what one

of its documents describes as an "explosive increase in program"[1]: it added new property, developed a resource center for teachers, revamped its exhibits and its teaching materials, doubled the size of the staff (and raised salaries by 52 percent), and more than quadrupled the operating budget (it went from $85,000 in 1962 to $377,000 in 1969), as the museum attracted grant moneys from a widening circle of federal and local funders.

As for the public, with the opening of the visitor center, the museum seemed to have become all a modern children's museum should be. Families and school groups came from all over the Boston area—and museum workers from all over the country—to take part in and pick up ideas from the new hands-on activities the museum had devised. In what had been a 500-seat auditorium, where children were asked to sit passively, the architects (Cambridge Seven Associates) designed an ingenious three-tiered exhibition space that had more the markings of a large tree house than a museum. In the new center, instead of filing past exhibits carefully arranged behind glass, young visitors could now handle, poke, try on, stroke, smell, and even crawl inside them. There were electronic calculators, a giant aerial photo map of the metropolitan area in which a young visitor could locate his own home, a life-size, authentically furnished wigwam, and simple animation equipment that a child could use to make a 13-frame film. Exhibit props were either unbreakable or so inexpensive (the Children's Museum was one of the pioneers in the use of tri-wall cardboard, for instance) that they could be easily replaced if they were damaged or destroyed.

It was all designed, as one museum staff member put it, to be "open, inviting, and intimate rather than fortified, forbidding and cavernous; active and experiential rather than passive and pedantic; innovative and risk-taking rather than conservative and protective."[2]

### But on the Jamaicaway major problems remained

The accomplishments might have been grounds for rejoicing, except for two disturbing facts: the museum was running sizable deficits each year, and at a time when young people all over the country were joining forces with the poor and discriminated-against, the "new" Children's Museum seemed to be attracting the same kind of audience as the old Children's Museum. What the museum's young and idealistic staff had hoped for was that it could at last begin to draw more family visitors from Boston's low-income neighborhoods—that at last they would not be intimidated by a museum's "forbidding" front.

But that did not happen. As Community Services Director Jim Zien noted, "While our attendance skyrocketed, our individual and family audience profiles remained substantially unchanged: middle class, suburban, and overwhelmingly white."[3]

The museum's problem was not helped by the fact that, in spite of its burgeoning budget, Children's was just poor enough itself to need the income the visitor center and other services attracted from its middle-class audience. Between 1962 and 1967, for example, user fees, including admission charges, had gone from $2,000 to $32,500. By fiscal year 1969, user fees and other earned income were bringing the museum $80,273. The low-income families whom growing numbers of the staff wanted the museum to serve were not—to judge from those who used its services—the museum's primary "clients."

For one thing, the museum, located in a kind of buffer zone between predominantly black Roxbury and predominantly middle-class white suburban Brookline, was not easy to get to from many of Boston's low-income and minority communities without a car. Most poor people, too, as Zien and others have pointed out, have no habit of using cultural institutions, and nothing Children's was doing seemed to change that pattern. The several kinds of community programs the museum had tried with low-income families—a mobile workshop circulating objects and curriculum materials (see brief report on the MATCH units in chapter 11), traveling exhibits, and special Community Days—did not amount to more than "a series of disjunct 'outreach' projects," as Zien said of them. In fact, he noted, they only made the staff more dissatisfied:

> Each of these approaches suffered one or more of the problems of ephemeral-ness, inflexibility with regard to audience interests and needs, limited reach, narrow use of resources, high cost, and, most important, lack of any implied direction for fundamentally changing the operating structure of the Museum to incorporate a coherent program of Community Services. . . .[4]

### The Director's Project

By 1970, the museum staff—and especially Spock—had decided that more than new programing was required. They were persuaded that if the museum's audience were to be broadened, as opposed to simply enlarged, the museum itself would have to be fundamentally reorganized. They arrived at the solution in a unique way.

In the summer of 1970, prodded by both the staff's and his own frustrations about the museum's audience and by financial and administrative problems that the museum seemed unable to solve, Spock asked for time off to think through the possibilities. He turned the day-to-day museum administration over to Phyllis O'Connell as the museum's acting director and took an office at the Institute of Contemporary Art, half the city away from the Jamaica Plains site where the museum had been located ever since its "new" quarters were opened there in 1936. Every day for the better part of nine months, from July 1970 to March 1971, he worked on what was known as "the Director's Project." During that time he found an "organizational development" consulting firm, McBer and Company, formed by a group of former professors and students from the Sloan School of Management at the Massachusetts Institute of Technology. The McBer help was to prove invaluable to the project.

**The project objectives.** The exercise had several purposes—not the least of which was to analyze and project the museum's fiscal future. A 1968 report had noted that in its "pell-mell pace" of expansion, the museum had relied heavily on grants from government and foundations for special projects. "Too often," the report admitted, "the project tail has seemed to wag the service dog. . . . The staff had difficulty finding the time or money to respond to community and school requests."[5] A way had to be found to finance the museum's services to all parts of the community.

But aside from, or perhaps more accurately, in relation to, money, Spock's basic task was to try to answer this question: "How can the Children's Museum provide valid educational experiences to a larger and broader audience, including suburban and inner-city folks?"[6] Put another way, the museum was trying to "break out from the limitations of our old definition as a children's museum in order to become a really constructive force in the education and lives of children."[7]

For Spock himself, the questions were personal as well as institutional. After seven years "at the grindstone," as he put it in a memo to the trustees in October 1970, he had gotten to the point where he was "having trouble keeping track of the real issues before us."

There were several specific things bothering Spock. He pointed out the "awkward stage" the museum had reached: too large to be as intimate and informally organized as the staff would like, but too small to carry on many of the programs it wanted to undertake ("For example," said Spock, "any attempt at an effectively decentralized neighborhood program demands a much deeper array of human and financial resources than we presently have available").[8] The setting and location of the museum was a problem: it suffers, Spock wrote, "from a certain 'preciousness' that makes the Museum appear remote from the real world and the concerns of many of the people we hope to serve. . . . We must eventually find a more open-ended, rough-hewn, adaptable, economical envelope to wrap around our ideas, people, and things."[9]

In addition, the collections needed to be made more accessible ("a tragic waste of an immense resource that gives a distorted and superficial emphasis to the Museum's services"); the board needed more effective, harder working members who could "establish policy guidelines responsive to broad community needs"; money was scarce, and no one knew just where it was going to come from; the museum's "history, organization, size, and our clientele's expectations all conspire to inhibit our responsiveness"; and yet both Spock and the staff felt "the intense challenge to be relevant and effective":

> In these times it seems frivolous at best and criminal at worst to apply scarce human and financial resources simply to the business of protecting and maintaining old expectations, structures, and relationships. The Museum *must* decide what things it can do to help the world survive and get on with doing them.[10]

In all of this, Spock felt strongly the need to spend time "looking at the world . . . talk with thoughtful people; watch children, teachers, parents at work and at play; but most particularly, to think."

**The project method.** Spock was looking for an organizational model that would allow the staff and the museum board to match realities with needs and provide a more satisfying, effective role for Spock himself. He was convinced the model could not be constructed without the help of outside consultants, yet there was no money to spend on them, and his project committee (made up of members of the board) was against the idea, partly because, as Spock noted in a memo in May 1971, he was "unable to articulate the tasks we would ask them to undertake."[11]

Nevertheless, Spock had begun his talks with the McBer group to see whether some way might be found to get its help without paying the $30,000 McBer estimated the job would cost. By February, Spock got the "reluctant permission" of a key board member to use the consultants if the costs could be kept within the year's operating budget. The result was that Spock and his staff collected most of the necessary data themselves and used McBer only when they "absolutely had to."[12]

One of the first tasks was to conduct a staff climate survey to find out how staff members felt about the museum—the constraints it did or did not place on them, the responsibilities they were given, the standards management set for them, the recognition they received for good work, the "clarity" of the organization, and the museum's *esprit de corps*.

In a two-month period, Spock—and from time to time, other members of the staff—met every other week for a half-day with David Berlew and one of his McBer associates to learn organizational development techniques. Each meeting was carefully planned: the first third of the time went to analysis of the homework that Spock had done between meetings; the second third of the time to decisions about the analyses (clarifying needs, definitions, and relationships, and posing possible solutions); and the final third to planning and learning how to conduct the next piece of work.

The tools were standard for the "O.D." method: decision matrixes and "trees," "force-field" and functional analyses, meetings "to define personal and institutional goals, alternative methods of achieving those goals, and forces that might impede or support the attainment of those goals."[13] Homework between meetings generated "lists, tables, graphs, definitions, [and] models."

In the end, Spock became his own "consultant," with McBer as trainers and guides. Instead of $30,000, the original estimate, the project cost the museum about $8,000.

**The organizational result.** By spring, the project had reached some preliminary conclusions, which Spock presented in a document to the staff at a retreat in May 1971. The paper set forth two "general" goals:

1. To develop a strong, flexible nucleus around which new and existing community resources can organize to become more responsive and effective in meeting people's real educational needs.
2. To develop a clearer sense of the specific role(s) the Museum will play in facilitating and exploring new forms of life-long, learner-directed education.[14]

What was being proposed was a new administrative structure organized around client needs. Spock charged the staff at the retreat with the job of analyzing the document "thoroughly," "testing its assumptions, negotiating revisions, fleshing out details, developing implementation plans, and taking on individual assignments so that the objectives will be successfully reached."[15]

Under the new plan, there were to be one administrative division (called support services) and three program divisions—the visitor center, community services, and the resource center. Each was to have a quasi-independent manager, responsible for developing the division's program (though the objectives of each were outlined in Spock's April 1971 paper) and raising the necessary funds to support it. At the top of the organizational pyramid was a corporation with "community representation." Next came the board, with policy and fund-raising responsibilities; an executive committee, charged with review of the program and the museum's finances; under it, the executive director, who was to plan, raise money, and handle board and community relations; and an associate director in charge of day-to-day operations, coordination among divisions, personnel, and finances.

The heart of the museum's work was to be carried on by the three program divisions, and it was these divisions that Spock and his consultants had structured around the client.

### The clients and their needs

The aim in the new administrative structure of Children's was to bring the museum closer to the client so that it would not be "media specific" but would instead be a sort of broker, dealing with a variety of "potential" education resources. Spock was less concerned that the Children's Museum collect and display objects than he was that it bring "the child [or other kind of client] and real materials together in provocative and revealing encounters—experiences that will give him the confidence to deal directly with, make choices about, and have some impact on what happens to his world, his people, and himself."[16]

In large museums, Spock has said, the "main educative area, the galleries, are organized by curators and not the department of education staff. . . . Most galleries do not lend themselves readily to interpretation because it is not especially the concern of curators. . . . Education functions are an after-thought." It may be, he thinks, that "this is really the way we want these institutions to be. Indeed, the notion that these institutions can and should be nimble and responsive may be contrary to the other important functions they have." What we may need, Spock says, are more intermediary institutions that are located outside the museum itself, nearer the client in terms of geography, function, and attitude, but manned by people who are trained to understand museums and talk the curatorial language and are able to make reasonable requests of them in behalf of the clients they serve.

Although Spock did not go so far as to suggest that the Children's Museum become such a "broker" or "intermediary institution," at a staff retreat to discuss the new organizational structure in May 1971, he and his staff did define two key words, "brokerage" and "resources," with the idea that they should apply directly to the museum:

*Brokerage*
1. Links one-shot programs to resources for continued learning.
2. Sets up [a] human guide system to lead kids to existing resources.
3. Finds and establishes contact with existing resources in community.
4. Responds to requests to be/become resource.
5. Finds and establishes contact with institution(s) which can be developed into resources.
6. Brokers with educational system (teachers) and trains teachers to be effective brokers in their schools and communities.

*Resources*
1. Trains others to develop/find/use resources.
2. Focuses on teachers/educational system.[17]

As the organizational table developed, it was closely tied to the provision of brokerage and resource services to three client groups—mobile middle-class families and organized groups; schoolteachers; and low-income communities unaccustomed to using major cultural institutions and served more directly by other agencies.

**The mobile middle class.** The museum designed its main exhibition area, the visitor center, and its related services for the families who had long been the Children's Museum's natural clientele. Though this audience also included some ethnic, social, and economic diversity in the school and community visitors that came from metropolitan Boston, it continued to be "heavily middle class and suburban,"[18] and the museum made no pretense that it was otherwise. Exhibits in "Grandmother's Attic," for example, tended to depict "environments or times that the visiting audience can identify with."[19]

Within the center are several "components," as the displays and exhibits are called, each meant to accommodate a few individuals or a relatively small family or school group at a time. There is a living things component, for example, a computer component, a television-studio-audiovisual component, an Indian and Japanese component, and Grandmother's Attic. It is the philosophy of the visitor center's

manager, Elaine Gurian, that the business of a museum is "the single, in-depth pivotal experience." She feels that "kids need permission to try grown-up roles, to try stuff that is dangerous or naughty, and they need to do it on their own time"; thus, she says, "the visitor center does lots of interceding" on behalf of such self-exploration.

As for the content of the exhibits, the museum has moved from what was primarily nature and science education before the Spock regime began in 1962, to themes that address children's needs and interests, with particular emphasis on contemporary life in the city. One exhibit, "Me," tried to help children understand their bodies (hospitals was one exhibition, dentists and handicaps have been the focus of others). Other exhibits have dealt with scale, size, dimension. Another theme had the objective of helping children understand such cultures as those of Japan, Algonquin Indians, and turn-of-the-century and 1930s America. Another theme explored the manmade world with such things as mapping, the use of the city as an educational environment, the world of the office, and even the world under the streets.[20]

Although the visitor center is designed for people who know how or are learning to use cultural institutions, and do so as a matter of course, and although it was not a major goal to expand visitor center attendance by minority and low-income people,[21] the center has made some efforts to attract a wider community. For its free Friday nights, it advertises in the city's underground press and distributes flyers, some of them in Spanish, in little City Halls around Boston. The center also gives "One Kid Free" cards to members of school tours and trades passes one month a year with all the city's major museums (866 persons came in on such passes in January 1974).

One morning a week the visitor center is reserved for two groups of 20 children in special education programs; the center provides 20 staff members on these days so that the ratio for each group is literally one-to-one, and as there is no one else in the museum, the children do not have to compare themselves unfavorably with others or compete for use of the exhibits. "This is a great service," says Gurian, "for enormously disadvantaged kids."

**Schoolteachers.** From the time the Children's Museum was founded—actually as an adjunct to the Science Teachers' Bureau in Boston—classroom teachers have been one of the museum's primary constituencies. So it was natural that the second client audience under the reorganization be teachers and that the resource center, one of the museum's three program divisions, cater to their needs.

Although teachers all over the Boston area regularly bring their classes to Children's, the basic service of the resource center has been to provide curriculum materials and loan exhibits—something the museum has done since 1936—and to conduct workshops for teachers in service and, under contract with universities, for teachers in training.

In 1963, soon after Spock came to the museum, he and the staff proposed a reworking of the school loan program. Convinced by a 1961 report on the use of the loan exhibits that the service was important to schools (the museum was then circulating 641 boxes on 113 different subjects in answer to nearly 4,300 orders a year), the staff decided to try a different approach by assembling materials children could handle and even some they could keep. Instead of a box of rather tired "exhibits" with labels that "tell" children about the Plains Indians, for instance, the staff proposed a box full of such things as tape recordings of Indian speech, songs, and camp noises with a small tape recorder to play them on; a portable movie projector and film loops on hunting, preparing food, making arrowheads, and playing games; face paint for the children to put on themselves; materials to construct a teepee in class; books for further reading; projects for the teachers.

With an $80,000 grant from the U.S. Office of Education in 1964, the museum developed new themes and a wholly new concept for the boxes, which became what are now the museum's famous MATCH units (see chapter 11). When it saw the first four MATCH units the museum had produced, the Office of Education extended the contract for another three years (four and a half years, in all) and granted the museum just under $500,000 to create 12 more units.

Another grant to the museum that was important to the evolution of the resource center was a four-year contribution, beginning in 1968, from the Carnegie Corporation for the Workshop of Things, what Spock calls a "modest" effort to collect educational materials from curriculum designers that could be reviewed by the museum staff and especially that could be tried out by teachers.

As the resource center has developed, it now offers a library of curriculum materials, from commercial as well as other kinds of educational developers, which teachers, parents, and other adults who work with children can browse through, and work areas where they can experiment with the participatory packages. In the last few years, the center has added Recycle, a shop where industrial surplus materials (such things as gears, shoe lasts, and camera lenses) are sold for use in education and art projects. The museum also offers regular Recycle workshops and publishes "Recycle Notes," a compendium of offset sheets (added to irregularly, the "Notes" were up to about 70 pages by spring 1976) that suggests uses for the materials. (Jim Zien says "Recycle Notes" cost $1, and "thousands" have been sold.)

Under the new administrative structure, the resource center was expected to be self-supporting from fees and contracts with universities, schools, and school systems—and thus fulfill Spock's plan that the clients should determine the policies of the museum by buying services they need. Though the museum is breaking even on its materials, its workshops have been gradually reduced. Since the Children's Museum started them, teacher centers have sprouted all over Boston. The service that had once been attractive to

teachers because almost no other place offered it has now lost its appeal: for one thing, some teachers are "workshopped out"; for another, budget cuts in the schools have meant that there is almost no money for teachers to take advantage of such programs.

**The inner-city audience.** The thorniest client problem the museum faced was an "audience" Children's Museum felt it had touched only superficially—low-income and minority families in Boston's inner city. When the museum staff realized how little it could do on its premises, and how little it did off them, to serve this group, it began to analyze some of the reasons why.

The first such analysis was made by Jim Zien, then a student at the Harvard graduate school of education, who had read about the museum and dropped by one day in the summer of 1969 to see it. At just that time the museum was running a program known as Community Days, which offered free bus service to the museum from various parts of Boston, as part of its effort to draw visitors from working-class neighborhoods. The service, paid for by a Sears-Roebuck grant, aimed primarily at community organizations with summer programs for children between six and twelve years old. The program allowed for just one visit per group, which seemed to the staff too unsatisfying to continue; it wanted a more formal, continuing relationship with community organizations.

Zien and a colleague, Robin Stumpf, were hired to evaluate Community Days and to come up with a better idea. They surveyed two dozen community centers over a two-month period to find out how these centers could use the museum's resources. Most, it turned out, had no idea that a museum might offer anything more than a place to visit—and in any case, the Children's Museum had no money to offer them anything else.

But the next summer, 1970, the city's Office of Cultural Affairs, through a program called Summerthing, gave the museum enough money to design activities for a traveling unit, the "Earthmobile," that was funded, as Community Days were, by Sears-Roebuck. Zien was asked to run the program, and for the first time the museum was providing the inner-city neighborhoods with services, rather than simply free trips to its central headquarters. Furthermore, by making special arrangements with Summerthing, the Earthmobile was able to stay in each of eight neighborhoods for a week, getting to know the children and the leaders of organizations and building bases for later projects with them.

The Earthmobile activities were divided loosely into ecology, manmade structures, and crafts. Children would explore plant and animal life in vacant lots, collect specimens, examine them under microscopes, and mount them for their own nascent collections. A "structures" group would tour the neighborhood to look at buildings and demolition sites, then return to the truck to build models of their own. Crafts instructors taught children how to weave with simple

materials—yarn, newspaper, grass, soda straws—and adults began coming around for ideas and lessons too. Zien felt that the week-long programs made it possible for the Earthmobile staff to reach the children "not just physically . . . but intellectually and emotionally. The value of each successive visit [by the children]," he reported, "is multiplied by the experiences built on from the days before."[22]

Although the museum repeated the Earthmobile program in 1971, this time visiting four neighborhoods for two half-days a week each throughout the summer, the Earthmobile ultimately led to not more of the same, but to a conviction that the best thing the community services department (later to become a division) could do for community organizations was to serve their leaders, not to try to design programs directly for the children those organizations were already reaching.

In the fall of 1970, Zien and one of his Summerthing contacts, a multiservice center in South Boston, tried a pilot project in science, which mushroomed into a drop-in center for 20 to 30 curious children a day. In the next months, as the restructuring of the museum fell into place, Zien was given a budget for the community services division and began hiring staff—primarily people with teaching experience and experience in neighborhood projects who could bring their community contacts to the museum with them.

From the pilot project in South Boston, the community services division moved on to environmental education: the question for the staff had become, in Zien's words, "how neighborhood environments and districts in a city can incorporate opportunities for people to learn things directly about what happens in that environment or to learn things indirectly, [for example], to learn science through investigating something in the environment."

Zien believed that this kind of learning could not take place in school. For one thing, most schools resisted discovery learning; parents, teachers, and administrators alike could not see how job-oriented skills could be learned that way. But even more to the point for Zien, schools were not in touch with the interests and needs of children in the same direct way community centers were. Community centers, said Zien, "are friendly"; furthermore, they have begun to see their role as not simply "glorified babysitters" but as places that can fill an educational vacuum. They are a more "natural setting for exploration, discovery, and active involvement with the environment." They can inspire children to look on the arts, for example, as "a good time," not something that is primarily "culturally enriching."

So the community services division came to focus almost all its energy on workshops, ideas, materials, the designing of spaces and programs—and, to a degree, brokerage with other institutions—for a wide variety of neighborhood houses, community centers, multiservice agencies, day-care and Head Start programs, youth clubs, and community-controlled alternative schools. By 1974 the division had a staff of ten—artists, craftspeople, musicians, a scientist, an

early childhood educator, a media specialist, and an architect-designer; its annual operating budget was "stabilized" at $100,000; and the roster of its clients over the five years since the division began listed more than 150 community organizations throughout the city.

## Funding and client power

Community services, Spock had hoped, might become self-supporting like the other divisions, through a combination of user fees (though workshops at first had been offered free, the division eventually began asking for $3 from each participant who could afford to pay), grants, special memberships, and fund-raising events.

Between 1972 and 1975, what Zien calls "the most critical support" for the division came from the National Endowment for the Arts' "Wider Availability of Museums" program and the museum's annual Haunted House benefit. Together they accounted for 60 to 75 percent of the division's annual budget. Other sources have been contracts for such services as Head Start teacher training; contributions from individuals, corporations, and foundations; special grants for specific projects; and the minimal fees charged for workshops.

Although the National Endowment was a faithful supporter of the division for several years, the 1975 application to the Endowment was turned down. The result is that Spock sees a more and more difficult job to keep community services going. The museum's best hope is a doubled attendance at the annual Haunted House benefit, increased contributions from local foundations and corporations, state education funds for "racial de-isolation," and more project grants and contracts.

In spite of this optimistic projection, Spock and Zien admit that their community services clients represent a shaky audience for the museum. The withdrawal of federal funding has meant that most community organizations, in Spock's words, have had a "terrible time staying alive." They have become "less loose," more institutionalized, and less able to pay for the "extras" that the division's workshops represent.

In 1974, the museum began to merge the resource center and community services division, a merger dictated by a combination of financial circumstances and philosophical consideration—the loss of NEA Wider Availability funding; a shrinking market for teacher workshops; program cutbacks in community agencies facing severe financial problems; a desire on the museum's part to effect closer contact between schoolteachers, community program leaders, and other adults who work with children; and a need to develop a more coherent public image for the museum's other education programs not directly connected with visitor center exhibits.

Beginning in July 1976, therefore, a consolidated resource center division, under Zien's direction, would administer all educational programs and services outside the visitor center, and would manage the circulation and sale of materials from the museum's loan department, library, Children's and

Teachers' Shops, and Recycle. Thus, the resource center would be identified, physically and pragmatically, as the part of the museum from which educational materials, training, and program assistance are available.

For the future, Spock feels that funding will have to be based on earned income from the sale of materials, in particular, a forecast he is able to make because the museum's activities here are now breaking even. What is needed then, says Spock, is to find a way to convert this income into a surplus.

What this all means about client power is not quite clear. In the "Great Society" decade, poor people were given power to "buy" some services with federal funds, which were far more generously shared then than they have been during the first half of the 1970s. Except for the money still granted by the National Endowments and some remnants of preschool education programs, there is almost no way that low-income clients can lever power by providing a source of funds. Although the museum has experimented with forms of the cultural voucher (an idea Spock promoted as a member of the White House Conference on Children in 1970), for the Children's Museum, like other cultural institutions, the middle-class's ability to pay may be the soundest fiscal policy to pursue and the museum's own conscience the surest way to serve all its clients' needs.

## The results of the new structure

A clearer measure of the restructuring at the Children's Museum may be reactions to it from the staff. Although nearly everyone, from the board on down, was suspicious of the Director's Project when Spock proposed it in 1970, the tests show that the change has been remarkably successful.

The "staff climate survey"—taken the first time in March 1971 before the reorganization went into effect and the second in 1973 when it had been in operation for two years—was designed as part of the Director's Project to see how staff members felt about six aspects of the organization. There were two answers to each question in the survey: how people thought the organization actually behaved, and now they felt it ought to operate. The spread between their descriptions (the "actual") and their expectations (the "should be") gave the museum its score.[23]

The difference between the two tests was almost total. In the March 1971 survey, the widest spread showed up on the question of organizational clarity ("the feeling that things are pretty well organized rather than disorderly, confused or chaotic"): the "actual" score was lowest of all on the organizational profile, the "should be" score was the highest, and the spread between them was almost 60 points. On the 1973 test, the "actuals" and the "should be's" on organizational clarity were less than 15 points apart; only under the rewards category ("the degree to which employees feel that they are being recognized and rewarded for good work, rather than being criticized and punished when something goes wrong") was there any significant spread, about 30 points, and that,

said Spock, was largely because the support services division—responsible for such things as the business office, public relations and development, maintenance and security, sales and product development—felt it was not sufficiently appreciated. Overall, the results showed not only that the organization was functioning better for the staff than it had in 1971, but that the staff's expectations of it had become more realistic.

For Spock, the scores proved that the Director's Project had been, on the whole, worthwhile for staff morale. But it had been especially instructive for Spock himself. During the 1960s, he said, he really believed that creative people needed to be involved in all the decisions that affected them—and a lot of those that did not. He created teams to design programs, and the staff held almost constant meetings to figure out ways to make the museum more responsive to the community. The Director's Project and the staff retreat that grew from it gave evidence that the staff's commitment to the museum was "very high." But the retreat also brought some gripes to the surface. In answer to one question, "What could increase your commitment to the Museum?" the staff wrote such answers as these:

Proper working load.

Fair managing.

Recognition of what our work load is..

General improvement of executive management.

Knowing where one stands.

Strong middle management.

To the question "What could decrease your level of commitment?" staff members answered,

Repetition of fruitless meetings.

Vacillation in administrative matters.

Too many Museum commitments.

Semiannual reorganization.

Finding out that people are still getting their way by a temper tantrum with Mike.

Stasis—in budget and program.

Trend toward inner-orientation by Museum.

Trends toward commercialism.

For Spock, the lesson of the Director's Project was that creative people, no matter how nonconformist they seemed to be, needed more structure, not less. The staff wanted to be free to do its work; it did not want to manage and decide. "There is *much* decision-making now at the managerial level," says Spock, and although that has meant that "tasks have to be matched to managerial styles," it has also meant that the museum's structure has become more hierarchical. Managers do their own hiring, as they have long done much of their own fund-raising. Their staffs report to them; there is no more going around the managers to the boss.

Perhaps the most dramatic proof of the success of the Director's Project has been that in each of the four years following the reorganization the museum operated in the black, something that had happened only once, in 1964, since Spock took over the directorship in 1962. Spock attributes the accomplishment almost entirely to the fact that the structure of the museum has been stabilized: the staff has taken on more responsibility both for management and fund raising; the managers have had information in sufficient detail and early enough to be able to make personal and program decisions that fit the realities of the available money; the staff spends less energy trying to cope with internal communication and daily problems that the structure was inadequate to handle, and more energy running programs.

In the fall of 1975, the museum also found the "more open-ended, rough-hewn, adaptable, economical envelope" it has looked for almost since the day Spock became its director. It is a nineteenth-century brick-and-timber wool warehouse near the South Boston wharf, which the Children's Museum will share with Boston's Museum of Transportation. A bare-bones structure that will allow the two museums to develop almost any floor plans they want, it is also centrally located: bus and subway routes serve the area from all parts of Boston and its suburbs. By the end of 1975, the museum had raised $800,000 in gifts and pledges toward the Wharf Project, and the papers had been signed transferring ownership of the property to the two museums.

When the renovation is completed and the museum has moved from Jamaicaway to South Boston, the Children's Museum will at last have its less "precious," "rougher-hewn" home and the organizational structure to manage it.—*E.H./B.Y.N.*

## Notes

1 "Bringing the Dead Circus Back to Life: New Directions for Boston's Children's Museum," June 1968, p. 5.

2 Jim Zien, Director of Community Services, Children's Museum, letter to CMEVA, June 19, 1974, p. 3.

3 Ibid.

4 Ibid., p. 4.

5 "Bringing the Dead Circus Back to Life," p. 7.

6 Memorandum from Michael Spock to several members of the staff, November 16, 1971.

7 "Fiscal 1972 Goals and Objectives," Children's Museum, April 30, 1971, p. 1.

8 Report on the Director's Project for the Annual Meeting of the Corporation, October 19, 1970, p. 2.

9 Ibid., p. 4.

10 Ibid., pp. 4–6.

11 Memorandum to the members of the Director's Project Committee, Management Group, and McBer Staff, May 25, 1971, p. 2.

12 For sources of quotations without footnote references, see list of interviews at the end of this report.

13 Memo to Director's Project Committee, p. 3.

14 Ibid., p. 2.

15 Ibid., p. 1.

16 "Bringing the Dead Circus Back to Life," p. 8.

17 Retreat Record, Children's Museum, May 1, 1971, p. 3.

18 Zien, letter to CMEVA, June 19, 1974, p. 4.

19 Notes from members of the Children's Museum Staff, August 7, 1973, p. 2.

20 "City Slice" derives from one of the first of the museum's participatory exhibitions. Called "What's Inside," it explored the

mechanics, properties, and chemistry of things common to children's environments—cross-sections of household utensils, a cross-section of a house, a "slice" of what's under a city street, a view of what's inside a pregnant mother, and a drop of water.

[21] Zien, letter to CMEVA, June 19, 1974, p. 5.

[22] Memorandum on the Earthmobile, July 29, 1970, p. 2.

[23] The staff climate survey covered six scale definitions:

1. Conformity. The feeling employees have about constraints in the work organization; the degree to which they feel there are many rules, procedures, policies, and practices to which they have to conform rather than being able to do their work as they see fit.

2. Responsibility. The feeling that employees have a lot of responsibility delegated to them; the degree with which they can run their jobs on their own without having to check with the boss constantly.

3. Standards. The emphasis that employees feel management puts on doing a good job; includes the degree to which people feel that challenging goals are set.

4. Rewards. The degree to which employees feel that they are being recognized and rewarded for good work, rather than being criticized and punished when something goes wrong.

5. Organizational clarity. The feeling that things are pretty well organized rather than being disorderly, confused, or chaotic.

6. Team spirit. The feeling that "good relationships" prevail in the work environment, that management and fellow employees are warm and trusting, and that the organization is one to which people are proud to belong.

On a scale of 0–100, the members of the Children's Museum staff (24 in 1971, 33 in 1973) scored each category this way:

|  | March 1971 | | 1973 | |
|  | Actual | Should Be | Actual | Should Be |
|---|---|---|---|---|
| 1. Conformity | 30 | 10 | 11 | 10 |
| 2. Responsibility | 40 | 70 | 70 | 80 |
| 3. Standards | 49 | 70 | 64 | 50 |
| 4. Rewards | 37 | 70 | 45 | 78 |
| 5. Clarity | 12 | 79 | 46 | 60 |
| 6. Team Spirit | 60 | 70 | 75 | 56 |

## Interviews

Except where the institutional affiliation is otherwise noted, all the persons on this list are members of the Children's Museum staff.

Davis, Melvin. Assistant Supervisor, Child-Care Program, Denison House, Dorchester, Mass. April 16, 1975.

Dolinich, Nancy. Community Services Staff. January 18, 1974.

Garfield, Thomas. Community Services Staff, January 4, 1974.

Gurian, Elaine. Director, Visitor Center. February 8, 1974.

Hastie, Elizabeth. Community Services Staff. January 25, 1974.

Hirsch, Elizabeth. Early Childhood Educator, Boston Region Office of Children. April 16, 1975.

Holley, Charles. Community Services Staff. January 4, 1974.

Merriel, Andrew. Community Services Staff. January 18, 1974.

Merril, Dorothy. Community Services Staff. January 11, 1974.

O'Connell, Phyllis. Director of Support Services. July 31, 1973; February 19, 1974.

Robinson, Jerri. Community Services Staff. January 11, 1974.

Sage, Richard. Community Services Staff. January 4, 1974.

Spock, Michael. Director. August 8, October 9, 1973; March 18, 1974. Telephone, March 23, 1976.

Zabrowskie, Bernard. Community Services Staff. January 25, 1974.

Zien, James. Director, Community Services. August 9, December 15, 1973; February 13, March 14, October 24, 1974.

## THE EVERSON MUSEUM IN "PHASE FOUR"

The Everson Museum
401 Harrison Street
Syracuse, New York 13202

**A small-city museum reaches out to attract all segments of the community with a prodigious schedule of exhibitions, programs, and events, many of them controversial. The result is a rebirth of community pride, support, and enthusiasm for the museum, mixed with questions about institutional purpose and artistic integrity. CMEVA interviews and observations: November 1973; January, April, May, August, and September 1974.**

### Some Facts About the Museum

**1. General Information**

Founding: The Syracuse Museum of Fine Arts was founded in 1896; in 1960 became Everson Museum of Art of Syracuse and Onondaga County.

Collections: Contemporary American paintings and sculpture; traditional American paintings; nineteenth-century American paintings on loan from the Onondaga Historical Association; Cloud Wampler collection of Oriental art; seventeenth-, eighteenth-, nineteenth-century English porcelain; contemporary American ceramics.

Number of paid staff: 20.

Number of volunteers: 50.

Operating budget: $474,000 (1974).

Education budget: $50,000 (1974).

Source of funding: City, county, state, National Endowment for the Arts, membership, contributions.

**2. Location/Setting**

Size and character of city: Syracuse, with a population of 197,297 (1970 census), is part of a standard metropolitan statistical area with a population of 635,946 (1970 census). An industrial city, home to some 500 manufacturing plants that turn out products from air conditioners to china and candles, Syracuse is known nationally for its ceramics competitions. It is politically and culturally conservative, a significant factor in museum-community relations.

Climate: Seasonal. Heavy snowfall and blizzards in winter months curtail participation in cultural events.

Specific location of institution: In a commercial area.

Access to public transportation: Excellent.

**3. Audience**

Membership: 2,290 (1974). Cost: $25. In addition, 110 corporate members pay from $100 to $5,000 annually for membership.

Attendance: 200,000 (1974), including school tours.

**4. Educational Services**

Organizational structure: A separate education department is

headed by a curator of education who reports to director of museum.

Size of staff: The curator of education and 38 docents.

Budget: $50,000.

Source of funds: Operating budget.

Range of services: Art classes for children, teenagers, and adults; Auburn Prison art workshop; Jamesville Penitentiary art workshop; Hutchings Psychiatric Hospital workshop; docent program; volunteer program; traveling exhibitions; in-service class for city school teachers; poetry readings; preschool deaf classes; programs for senior citizens; lecture series; artist-in-residence program.

Audience: In addition to the traditional museum audience, the Everson reaches out to those with special needs—prisoners, mentally disturbed, deaf, and elderly.

Objective: ". . . To teach people how art affects their life . . . to continue to provide a wide variety of programs and activities for all the members of the community: the young, the old, the rich, the poor."

Time: Educational programs are offered year round.

Information and documentation available from the institution: Joan Watrous, "Community Opinion of a Regional Museum: Views on the Everson Museum of Art, Syracuse, New York," *MetrOpinion,* vol. 1, no. 1 (January 1973); museum newsletters.

---

James Harithas and Gussie Will Alex sat drinking coffee at a table in the staff kitchen of the Everson Museum in Syracuse. It was the early fall of 1973, and they were discussing the installation of a new exhibition, Elaine Sturtevant's "Duchamp, Beuys, and Warhol." The installation was complicated, requiring a rigger to bring the large steel beams into the museum and lift them to the upper galleries, and Alex was the only one who knew how much weight the floors of the Everson structure would take or who could devise the simplest method of stabilizing the sculpture so that pieces of it could not fall on a clumsy or too-curious visitor.

The talk shifted to astrology, a regular topic between the two men, and then to Alex's own painting, and finally to Alex's church, where Harithas went often on Sunday mornings to take part in the service and once or twice to tell the black parishioners about the Everson and to ask what they thought the museum might do to help them.

Harithas was the Everson's director, and Alex the building's superintendent. For three years, up until he left Everson in June 1974 for the Museum of Contemporary Art in Houston, Harithas took time nearly every working day to think with Alex about their museum, art, and themselves. For Harithas, learning to know his staff in the way he came to know Gus Alex was of a piece with learning to know the community. "This attitude," Harithas told an interviewer, "that goes along with our involvement in the community is that . . . [the museum] should be a place where every point of view can become visible. But the first thing is to relate to the people closest to you, the staff. I don't believe in outside involvement if it doesn't exist inside."[1]

So the kitchen where the maintenance men gathered for their 9 A.M. coffee break was always Harithas's first stop when he started the day. It was also one place where he began his research into the Syracuse community, an assignment he gave himself when he became the Everson's director in 1971, fresh from a job as associate professor of art history at Hunter College in New York and before that for two years as a revolving-door director of the Corcoran Gallery in Washington, D.C.

"The first thing," Harithas decided, "was to go around and see how the city was structured. I found out where the different ethnic groups lived; where the hospitals, schools, churches, restaurants, and social service agencies were; and I used that information as part of the basis for what was going to happen."

What was to happen over the next three years was to turn the Everson Museum from what one member of the board has called "just an art preservation institution" into a building opened up "to be used by all segments of the community." Along the way the people of Syracuse were exposed to experiences that alternately stimulated and enraged them but, according to Syracuse's mayor, Lee Alexander, that propelled the museum "deep into community existence—which is where the museum should be."[2]

What happened, and how did Harithas and the Everson trustees bring it off? And what does the Everson experience mean to the idea of a museum and the educational function it serves within its community?

**The trustees' view**

When Helen S. Everson died in 1941, she left $1 million "to found, erect, and maintain a museum of art to be known as the Everson Museum of Art to be located in Syracuse, N.Y." As the city of Syracuse already had two art museums and Miss Everson's will did not specify that either was to get the money, executors of the estate decided to charter the Everson Museum as a separate entity. Court tests and negotiations followed. In the end, the Syracuse Museum of Fine Arts—founded in 1896 by George Fiske Comfort, who was also a founder of the Metropolitan Museum in New York—was merged with the Everson under a new charter and a doubled board of trustees.

The Syracuse Museum, although not exactly a community center in the sense the Everson came to be, had a history of serving the community. It conducted art classes for the unemployed during the Depression, sponsored daily classes for the children of women workers during the war, and rented the auditorium in one of its early buildings to any group that needed a place to meet.

By the time the Everson trustees were ready to erect a permanent building in 1960, the precedents for the museum as a center of community activity were already established. Instead of accepting an offer from Syracuse University to house the museum on university land, the trustees chose a site in downtown Syracuse, part of an urban renewal area that had

been designed by city planner Victor Gruen. The museum thus became the first element of what was meant to be a new cultural plaza, eventually to include a theater, a library, and several government offices.

The first permanent director under the merger, Max Sullivan, helped the board select I. M. Pei to design the building. Together, he and the trustees raised $1.4 million to add to Miss Everson's legacy for construction of the new museum. It was no small feat for a museum with no endowment and no inherently wealthy group to support it. In the eleven years of Sullivan's tenure, from 1960 to 1971, the museum expanded its collection of ceramics (the Syracuse Museum, and after the merger, the Everson, had enjoyed a national reputation for its biennial ceramics competitions),[3] graphic arts, and American paintings, and acquired major works by such contemporary artists as Al Held, Barbara Hepworth, Ernest Trova, Henry Moore, Helen Frankenthaler, and Morris Louis, whose *Alpha Delta* the museum's trustees consider one of Louis's finest works.

In the brochure published at the dedication of the new Everson building, architect I. M. Pei wrote of the structure, "This building is less a repository of art than an educational center for the community." There were several attempts to fulfill that promise—a nonjuried regional art show on the Community Plaza outside the museum, in which 148 local artists participated and which drew, according to a museum newsletter, 8,500 visitors in two days; concerts in the auditorium sponsored by local musical groups; art classes for children, 10 percent of them on scholarships awarded to Title I schools; and a communitywide membership drive.[4] The rest of the program was built around seminars, lectures on ceramics, studio courses for adults, and art films.

According to most observers, this traditional museum fare appealed to only a small coterie of art-loving supporters. "No one came," said Lucy Kostelanetz, director of the Visual Arts Program at the New York State Council on the Arts. According to trustee August Freundlich, Everson was "a mausoleum."

When Sullivan resigned in 1971, the trustees felt the museum was at a turning point. Richard Montmeat, a longtime Syracuse resident and a member of the Everson board for the last seven years (he was elected in 1967), describes the "phases of Everson": first "the formation phase, when the museum was an art preservation and education institution; then the building phase of becoming a place where people could find you in a permanent [structure]; then getting enough money to assemble an adequate and more permanent installation in a key part of the physical community; and then the phase of really opening the building up to be used by the community—which was the Harithas phase. . . . [This] phase was a key one, but not the final one."

According to Montmeat, Harithas's "opening up of the museum to all segments of the community helped the board realize what new [options] were available to us. The museum didn't have an extensive collection, and therefore the concept of a collection-oriented museum was really not viable to us in the pattern of current [prices in the art market]. . . . Shipping and insurance costs are so astronomical that bringing in traditional-type exhibits also presented a very limited alternative. We really had no immediate choice but to become a community-oriented museum with innovative programing that could be generated within our resources and that had broad appeal. From that perspective, it was a natural tie with Jim's interests."

So the trustees hired James Harithas, a man with a reputation as a maverick and a community-minded administrator, and Everson entered Phase Four.

**The Harithas view**

As Harithas saw the situation when he arrived in 1971, the relationship between the Everson and the people of Syracuse—the community—was not only distant but bordered on apartheid. The problem, he felt, was "how to break that down." What he has said on the subject of the museum and the community is familiar to many museum people who were raising questions about the role of the museum and other established institutions in the 1960s:

I think that for a more traditional institution, sitting in a traditional relationship to a large community, the process is essentially one of breaking down what the traditional institution has been doing, its orientations or its objects, primarily, and expanding that orientation so that it involves the people who live there. That's number one. Number two . . . [is] the whole question of community definition; I think that, unfortunately, what happens in most communities—essentially what I found in Syracuse—is that there is an old definition for [the] community . . . and that idea . . . was exclusive of a great portion of that community. . . . A museum's definition . . . tends to be exclusive of people who are in jazz, people who live in ghettoes, people who live outside of the traditional context. So the problem then becomes . . . how do you get information into that context from outside its traditional audience? How do you get to know that audience? That's what I think I've been engaged in.[5]

Harithas's first moves were designed to shock the community. "We did a lot of things," he has said, "simply to get attention and let people know we were here." But behind the shock were two basic goals, as Harithas has described them, which the museum was to pursue during his tenure: to open the museum up to all segments of the Syracuse community and to all persuasions, and to develop a first-rate video department.

Clearly, Harithas was not out to build a collection when he came to Everson, nor to raise money, nor even to bring high or traditional art to the people of Syracuse. He did want the museum's resources, whatever they were, to be made available to a wide range of communities and interest groups. "The museum," he said in an interview, "is primarily involved in interacting with the community at all levels. . . .

The museum should be a place where every point of view becomes visible . . . whether he's a way-out radical or a way-out conservative, it really doesn't matter. The important thing is to get him up there to tell the truth about something.''

''We live in a culture,'' he continued, ''which has no structure for bringing people together . . . so part of these interaction programs is just to get people together to examine an activity within an art museum . . . whether it's raising chickens or listening to the most far-out political statement or seeing the most advanced video material. . . . We are not passing these activities as art, but all of this should be part of the museum's statement.''

To make contact with the community, Harithas used a wide variety of issues and devices—exhibitions built around local talent, community improvement, sociology, biology mixed with economics, as well as events that outsiders viewed as essentially political but that the Everson staff, if not Harithas himself, regarded as ''all part of the artistic experience.'' But the medium Harithas chose as the heart of the communications process was the most popular of all in the early seventies, television. It was the museum's ''educational tool and extending device,'' as trustee Richard Montmeat describes it, and by the time Harithas was through, Everson had become what *Museum News* called ''the video museum of the East.''[6]

It also, by most accounts, became a source of pride for many members of the Syracuse community. Says Mayor Lee Alexander, ''Jim Harithas has given a new vitality to our museum. In a hurricane of innovation, he has translated 'culture' from an empty concept into terms of substance and dynamic relevance. He has made us aware that a museum can be more than a warehouse of the pious and traditional. He has shown us that it can be a stimulant, an adventure.''[7]

### The director and the trustees: a shared sense of purpose

As Harithas's programs and policies developed, it became more important, board members felt, that the executive committee meet frequently to keep the lines of communication open between the director and those legally responsible for the operation of the museum. To a large extent, the trustees were in favor of community involvement, but they were concerned about the methods being used.

Said Board President Virginia Small in an interview, ''There are many ethnic and other interest groups who for the first time have really gotten involved in the museum. We've tried very hard to appeal to all kinds of people and all kinds of tastes by offering the greatest variety of aesthetic experiences we can.'' Mrs. Small noted that in the controversy over the American flag (see below), the board ''stepped in and convinced'' the county legislature that ''the museum was not being run by an irresponsible maverick with no direction from the trustees.''

According to August Freundlich, dean of the College of Visual and Performing Arts at Syracuse University and a member of the trustee search committee that hired Harithas,

Everson had become isolated from all but a very small portion of the Syracuse community, and the trustees were anxious to bring ''life and action'' to the museum. They wanted the museum to be ''a center of community activity.'' In all the controversy that resulted from the Harithas events, Freundlich said, ''the board has closed around him.''

Another trustee agreed, even though he admitted that not all the director's programs were the board's idea and, indeed, sometimes took the trustees by surprise. ''I'm not sure we gave Jim the scope and authority to do what he did,'' he remarked. ''I think he kind of took it, and we were in the position of deciding whether he was going too far or not. As long as his programs were within our resources and our general perception of community needs, we were with him 100 percent—and that was 90 percent of the time.''

Phase Four, then, seems to have suited both ends of the Everson board table. Over time, it seems to have suited the Syracuse community as well. Whether the art museum universe beyond Onondaga County, New York, can swallow the Everson program for community involvement is debatable.

### The communications devices

James Harithas sought out the Syracuse community in a variety of ways—by visiting people in their places of business and assembly, drawing a barrage of publicity, showing art and the making of it on public television, offering video workshops, and even playing the part of what he called ''information lady'' at the museum's information desk, a favorite occupation on weekends so he could ''rap with people.'' In the first two years of Phase Four the attention-getting, community-embracing Everson blitz involved, by the museum's count, 83 exhibitions, 128 events, and 25 educational programs.

**Exhibitions.** During the Phase Four period, Everson did not earn its notoriety from its exhibitions so much as from the events and programs it sponsored. Yet its prodigious exhibition schedule (''Eighty-three exhibitions in two years is in itself way too many for any serious art museum,'' growled one art museum traditionalist when he heard the figure) included several with ''very fine catalogs,'' according to Thomas W. Leavitt, director of Cornell University's Herbert F. Johnson Museum in nearby Ithaca. There were one-man shows, including an exhibition of Joan Mitchell works that drew praise from even the more conservative museum directors in upstate New York (trustee August Freundlich thought it looked especially ''traditional'' in the Everson context); exhibitions based on social history; and, in a tradition that long preceded Harithas, a string of shows by local and regional artists.

A sample of the exhibitions and some of their consequences:

*''Three in One,''* an exhibition of the works of Amos, Richmond, and Truman Johnson, three black artist-brothers from Syracuse, all of them largely self-taught. The show

consisted of 25 pastel and pencil works on the Afro-American experience. One of the works, a large mural of Martin Luther King, Jr., was permanently installed at a local elementary school when the show closed.

*Ukrainian arts and crafts,* organized by the Syracuse branch of the Ukrainian Congress Committee of America. Nearly all the material on exhibit—embroidery, painting, ceramics, and costumes—came from the homes of Ukrainians living in the Syracuse area. The museum staged a festival around the exhibition that included the performance of traditional folk dances and demonstrations of the Ukrainian art of decorating Easter eggs.

*Canals and canal towns,* a scholarly and definitive exhibition mounted with the help of the Canal Society of New York State. Maps, paintings, lithographs, and scale models of bridges and canal boats depicted the development of cities and towns along New York State's manmade water routes during the 1800s.

*A nonjuried regional show.* The 1970 exhibition had been cosponsored by two local artists' groups. This time anyone could submit a painting, drawing, collage, or photograph. "All they had to do was haul it in and hang it," said the director, and more than 400 upstate residents did.

*Iroquois Indian exhibition.* One of the more publicized and widely attended events of the museum, the show was open to "any Iroquois who creates art." The arts and crafts submitted for exhibition consisted of both historical and modern works of the six tribes of the Iroquois confederacy—the Onondaga, Cayuga, Seneca, Tuscarora, Mohawk, and Oneida. Materials were drawn together from other museums and private collections, as well as from the hands of the 175 individual Indian artists, who kept bringing their pieces to the museum even after the exhibition was closed.

The exhibition was assembled largely by the artists themselves, and many of them were present during the exhibition to interpret their works, give lectures, and talk to schoolchildren and other members of the audience. A special sales desk was set up to accommodate hundreds of people who wanted to purchase items from the exhibition. Native American singer Buffy Sainte-Marie gave a concert. There were daily films on the social plight of the contemporary Indian and demonstrations of beadwork, moccasin-making, and basket-weaving.

The exhibition was so popular that it was extended nearly a month beyond its scheduled four weeks. Museum figures record 20,000 school-age visitors who came for group tours.

*"Ai Haiti,"* an exhibition about the Voodoo religion as it is practiced in Haiti. Built around ritual objects and photographs by ethnologists and photographer Odette Mennesson-Rigaud, the exhibition was organized with the help of the National Center for Afro-American Artists in Boston. It was particularly popular with school groups for its relation to black studies in local classrooms.

*"Video: Process and Meta-Process,"* an exhibition by video artist Frank Gillette. Housed in all four of the Everson's upper galleries, the exhibition consisted of eight separate works and a series of information environments. One of the works was called *Gestation/Growth,* which Gillette described in the show's catalog this way:

An incubator housing chicken eggs and an 18-foot diameter geodesic dome. . . . Each day a row of eggs hatch and the chicks enter the dome to grow. The environment continues for 21 days, the gestation period of a chicken.

Two scanning television cameras translate the birth/growth process into information via closed circuit television. The images are displayed on a matrix of monitors in an adjacent gallery. The processes inside [the] environment are both discontinuous and continuous; i.e., eggs evolving into chickens, and the growth of chicken into maturity.[8]

A group of local chicken farmers provided the eggs and also constructed the dome. Unity Acres, a nearby home for alcoholic men, became the ultimate recipient of the more than 100 chickens that resulted from the exhibition. (Not only were Unity Acres residents eating chicken for months after the show closed, but the offspring of the Gillette birds are reportedly still reproducing and feeding the men.)[9]

*Yoko Ono's "This Is Not Here,"* Harithas's first major exhibition and easily the most memorable event of the period. It brought the Everson notoriety well beyond the community's borders; in Syracuse, say the trustees, the shock waves are still being felt three years later.

The exhibition itself consisted of about 80 works with such titles as *Painting to Let the Evening Light Go Through, Cloud Piece, Acorn Piece,* and *Apple,* the last a real apple on a pedestal that every visitor was invited to bite as an act of artistic participation. In her comments on the event, Ms. Ono said, "This show proves you don't need talent to be an artist. Being an artist is a frame of mind."[10]

The show was put together with the help, according to Harithas, of 400 Syracuse youngsters. To keep the overflow moving through the exhibition, 200 Syracuse University student volunteers—"peace" marshals, as they were called—patrolled the galleries. During the weekend opening of the show, over 5,000 visitors came, a record crowd for the Everson. There were dozens of representatives from the press on hand, along with the chic of Syracuse, such visiting luminaries as former Beatles John Lennon and Ringo Starr, political activist Jerry Rubin, and nude cellist Charlotte Moorman, and, all told, two or three thousand young people from kindergarten through graduate school.

The opening coincided with Lennon's thirty-first birthday, which was roundly celebrated in the museum. Daily film showings in the museum's auditorium were a retrospective of Yoko Ono films. The museum staff kept busy videotaping

some of the activity generated by the show. And a videotape entitled, *Water Piece for Yoko,* produced by Andy Warhol and the Factory (a half-hour fixed camera shot of a water cooler in the Factory and the conversations that revolved around it), became the first videotape in the Everson collection.

Reactions to the show were diverse and swift in coming. One critic recalls that students from nearby colleges and universities were "furious" that they had been charged an admission to a show that was "a put-on and a hoax." "Ono and Lennon weren't even there when the public came," he said. Six members of the museum turned in their cards, and "numerous others," according to Board President Virginia Small, "let membership lapse." On the other side, 380 people joined the museum who supported its new open policies. One local newspaper carried an article that speculated, "The Yoko Ono art exhibition may go into local legends alongside the aprocryphal tale of how the Cardiff Giant was dug up back in 1869 on Stub Newell's farm near Cardiff."[11] Another local paper simply said it this way: "New Creative Atmosphere at Everson."[12]

*In summary.* The relation of such exhibitions to "art" as most museums interpret the word is undoubtedly tenuous. Phase-Four Everson was the product of a time when conceptual artists saw almost every human or natural activity as an aesthetic expression. Beyond that, however, Harithas felt, as many of his contemporaries did, that exhibitions like the Indian art show were important in establishing new roots for the American attitude toward art. "I just don't think we're going to have a real culture," he said, "until we accept the rest of the world on a parity with Western Europe. . . . The crucial thing is to find a basis in native American culture for ourselves . . . to become part of a culture that's been here thousands of years. . . . We have to begin dealing with our own context."

For the museum's trustees, the crowds of all ages, colors, and classes more than made up for the controversy and the questions of aesthetic standards that would roil the waters around a more traditional institution. They saw, above all, young people in the museum for the first time, and that was good.

**Events.** Even more controversial than the vagaries of the exhibition schedule were some of the programs the museum sponsored and allowed other groups to stage in its 320-seat auditorium. As the result of the museum's determination to become an educational center for the community, the doors were thrown open to nearly every organization that asked for space. During a three-month period, January to March in 1974, a total of 44 different groups used the auditorium. They included the district attorney's office of Syracuse, Brotherlove Church of God and Christ, the Onondaga Historical Association, the Syracuse Opera and Theater Group, the New Music Ensemble, the Onondaga Library System, the Coalition Advocating Protection of the Environment, the Junior League of Syracuse, the Daughters of the American Revolution, Lesbians Incorporated, the American Legion, the Council for Negro Women, the Syracuse Latvian Society, the Jewish Welfare Federation, and the International Meditation Society.

Nothing these or other organizations sponsored at the museum, however, quite rivaled the cultural "Freedom Festival" that the Everson cosponsored with the Syracuse Peace Council in 1972. Two of the participants were attorney William Kunstler and activist-clergyman Daniel Berrigan, a native of Syracuse. Kunstler addressed the overflow audience on such topics as government censorship and the rights of the oppressed in society. Berrigan discussed the Vietnam War and read some of his poetry. For those unable to get into the auditorium, the staff videotaped the event and showed it live on monitors in the museum lobby.

The event gave rise to more controversy, exacerbated by the famous flag episode, which surfaced after Kunstler and Berrigan had appeared at the museum. When the new Everson building was erected, the first of several cultural and educational facilities in the proposed downtown cultural plaza, there was no flagpole installed on the grounds and therefore no flag on display outside the museum. Confronted with the antiwar Freedom Festival, the American Legion's protest burst into outrage.

Even before the flag issue had become headlines, several county legislators had come into the museum, accompanied by television news cameramen, for a confrontation with Harithas over the De Andrea sculpture of two nude boys playing soccer. The county annually contributed $100,000 toward the museum's operation, and it was these legislators who were eventually to force an inquiry into the museum's "political and obscene" activity. Said Mrs. Small, "These combined events were too good an issue for some of the publicity-oriented persons involved with challenging our policies to leave alone until some rational discussion of our position was able to convince them otherwise."[13]

The controversy continued for nearly a month and abated only after the trustees of the museum "stepped in and convinced [the legislature] that the museum was not being run by an irresponsible maverick with no direction from the trustees."[14] The trustees issued a statement that finally seemed to bring clarity to the situation:

The original architectural plans for the cultural plaza include numerous flagpoles, but these were never installed because the remainder of the plaza is still to be completed. Furthermore, not all the ground around the museum is museum property, and the installation of flagpoles is a matter for joint effort by the museum . . . the city . . . and county, and one which the museum would be happy to participate in.[15]

In the end, the American Legion presented the museum

with a pole and a flag that can now be seen flying daily. In return, the museum issued a standing invitation to the Legion to exhibit its own flags, trophies, medals, uniforms, and other military memorabilia in the galleries. The exhibition is not yet scheduled, but indications at this writing (October 1974) are that the Legion will soon accept the invitation.

As for the county legislature, it has increased its allocation to the museum and, in the face of outspoken public support for the museum's right to freedom of expression, relaxed its criticism.

Of these and other "events" at the museum, Assistant Director Sandra Trop-Blumberg, a long-time resident of Syracuse, has observed,

We've been criticized a lot for being too liberal politically. People say that we only have the Berrigan types here. That's not true. . . . It's been equal. . . . Anybody who's asked for the auditorium has been given it. Just because someone rents our auditorium does not mean that we espouse their political philosophy. What we've tried to do is to open up the building and the programs to all kinds of thinking. [We] feel that this is all part of the artistic experience. It goes beyond painting and sculpture to philosophy and thought as well.

Whether the community understood the "artistic experience" implied in the expression of political thought, not to mention the raising of chickens and participation in the eating of an apple, is not quite clear. Trustee Richard Montmeat is one who does not think most of the Syracuse public did accept the message. "Most of our controversy," he said, "was along the line of political rather than artistic controversy. . . . The prime concern [of the American Legion and various other groups] was political and never artistic. . . . Jim really didn't bother to explain the reasoning and content of the art in shows [with a political bent]. He kind of let it happen and left people to react accordingly; so in effect he forced people to test themselves, and not too many of them wanted that challenge."

But the events did achieve one Harithas goal—getting attention. When that was won and the director settled into the Syracuse scene, the consensus of some board and staff members is that he was less flashy and aggressive, less of a "culture hustler," as one journalist called him. He had done what every successful rebel and mould-breaker does, so shocked his audience that change could be looked at fresh. Fortunately, his trustees understood. Again, Richard Montmeat: "Jim probably decided to leave [Everson] because his skills are best suited to a changing situation, and moving on at this point was probably good for him and good for us."

Meanwhile, the Phase Four story is not yet complete.

**Programs.** Besides exhibitions and events to draw new audiences, Harithas constructed several educational programs (25 in the first two years, by a method of accounting that is not entirely clear). Some of them are described here.

*Prison Arts.* One of the first major programs the new director initiated when he came to Syracuse was the Prison Arts Program with Auburn State Prison, about 20 miles outside Syracuse. Two nights a week for more than two years, Harithas taught art history and led painting workshops with 50 Auburn inmates each term.

To pay for the program, which was not at first supported from museum funds, every Sunday morning Harithas would visit a different church in central New York State, talking with parishioners about the program and "passing the hat," as he puts it. In all, he raised $4,000 this way, enough to keep the program going for a year. Later others, including the museum's trustees, added their contributions.[16]

The efforts paid off. The program survived, and by the end of June 1974 more than 200 men had gone through the program. In addition, several former inmates who enrolled in the program have been employed by the museum. They have conducted tours, given lectures, worked in the departments of education, video, and design, and served, two of them, as artists-in-residence. They also set up the first store-front museum in Syracuse: it was located in a housing project and lasted nine months.

The inmates' work resulted in several local exhibitions and one major traveling show, called "From Within." Paid for largely by foundation money, the exhibition has visited more than a dozen museums, including the National Collection of Fine Arts in Washington; still pending is a European tour in 1975. More than half the works from the exhibition have been sold, some to other museums and private collectors and three to the Everson Museum itself. Program costs are now partly covered by the museum, and under the direction of Jack White, the Everson's only black trustee, the program has expanded to include another penal institution, Jamesville, and another 100 inmates.

Why did Harithas choose the prisons? "An art course is about helping individuals make the best art they can," he said. "This program aims for quality; we talk about everything from craft to the realization of an image. . . . My commitment is to art, which I believe elevates the individual."

*Art for psychiatric outpatients.* Shortly after the Prison Arts Program was initiated, the Everson set up an arts program for outpatients of the Hutchings Psychiatric Center, a nearby mental institution. Art teachers, museum staff members, therapists from Hutchings, and college students from Syracuse University were recruited to conduct twice-weekly painting workshops for about 50 outpatients. In the fall of 1974, the program entered its third year.

*Visiting artists.* The practice at the museum whenever a show by a living artist was scheduled, was not only to get his help in hanging the exhibition but to conduct classes on his work for schoolchildren and to help the docents become familiar with his work. An artist would often stay around the

museum for a week at a time after the opening of his show (one stayed for two months), talking to visitors in the galleries and performing, often without pay, educational tasks with the staff.

*Docent training.* "We could not operate on the scale we do without the help of the members' council and other volunteer groups," says Mrs. Virginia Small. "The president of the docents is a volunteer who gives five days a week to this job. . . . Many volunteers . . . give tremendous amounts of their time and energy to the museum, which supplements our small staff."[17] As in many other small museums, most of the volunteers are middle- to upper-middle-income women. The Everson also has two male docents (a college professor and a semiretired businessman) and between eight and twelve college students. The students, most of them enrolled in the Syracuse University museology program or art history department, receive three course credits for their semester's work at the museum. Video is both a resource and a training device for the docents: they tape each other's tours and play the tapes back to analyze faults and virtues; they use video to learn from artists who have been taped on visits to the museum; and they have helped instruct students from the local schools in the use of video equipment.

*Programs for schoolchildren.* Educational offerings for young people, arranged and conducted by a one-woman education staff and about 40 volunteers, include the usual group tours, lectures, slide shows, loans to the schools, and art classes. The museum, following a longstanding practice, is reserved four mornings a week for organized school groups, which constitute 30 percent of the museum's visitors. Docents visit the schools and give special tours to classroom teachers, who often come, according to the museum's assistant director, to visit new exhibitions on their own before bringing their classes.

*Lunch-hour program, "On My Own Time."* Among the industries that employ Syracuse workers are General Electric, Crouse Hinds, Chrysler, Carrier Corporation, and a few craft-based family firms. The Everson staff reasoned that the employees, who could not take advantage of most daytime events at the museum, represented a largely untapped audience. That reasoning resulted in a program in 1974 called "On My Own Time." Principally during the lunch hour, five members of the staff paid an average of three visits to each firm, giving talks on the museum and on art and conducting painting workshops at a few. Ten participating firms helped the museum staff organize a series of two-week exhibitions of employees' art work. With both money and assistance from the Cultural Resource Council of Syracuse (together, the museum and the council contributed $2,500 for the program), the firms exhibited the paintings and photographs of a total of 200 workers. The entries were juried, and the best of them then exhibited at the museum.

*Use of the collection.* In most traditional art museums, programs are built around the collections. In the case of the Everson, with its relatively small store of art works and its slim acquisitions budget ($20,000 a year, including matching funds from the National Endowment for the Arts), the collection still must take second place to the program. Although some part of the museum's possessions is always on view in the galleries, much of it is circulated to school and corporate offices in the community, as well as to other museums. Harithas acquisitions have been largely focused on the development of the video archive at Everson (there are now about 200 tapes in it by 85 artists). In addition, a few works by contemporary artists (the De Andrea soccer players, mentioned earlier, were bought under Harithas, and only recently returned to the museum after a six-month loan to the Museum of Contemporary Art in Chicago)[18] and several by prison artists were purchased for the permanent collection.

**The video department**

Harithas's second goal when he came to Everson had been to develop a first-rate video department. It would, in his words, be organized for several purposes:

1. To expand the range and breadth of the museum's involvement in the community through the direct use of public media.
2. To provide artists with an opportunity to explore the aesthetic potentials of television tools and systems.
3. To provide the public with a view of the work being produced by the increasingly sophisticated group of artists exploring the aesthetic potentials of this misunderstood and often misused medium.
4. To produce a model for the future development of direct museum involvement with public media and for the future development of related use by other educational institutions.[19]

To head the new department, the museum appointed a 22-year-old, David Ross, a graduate of the school of communications at Syracuse University and the first curator of a department of video anywhere in the country. Ross was given a gallery off the main entrance for his daily exhibitions but no separate budget to buy tapes. In Ross's three years at Everson (he left the same time Harithas did, for a job at the Long Beach Museum in California), the department acquired 200 works by 85 video artists; set up special shows that involved several of the museum's upper galleries and on two occasions the local public education television station;[20] created several local documentary programs; taped lectures and workshops given by visiting artists at the museum for repeated later use; and helped the staff to use video for a variety of job-related purposes—primarily as a training and evaluative tool for the education department and as a recorder of the movements of objects and exhibits by curators and conservation staff for insurance.

Although most of the video department's activities were curatorial—exhibiting video art and encouraging the de-

velopment of new works—there was an educational motive behind the creation of the department. To repeat Harithas's purposes, he wanted "to expand the range and breadth of the museum's involvement in the community through the direct use of public media" and "to produce a model for the future development of direct museum involvement with public media and for the future development of related use by other educational institutions." The Everson became the video center of the country by opening the museum up to experiment with and exhibition of this medium without waiting for other institutions—art galleries, schools, university departments, for example, not to mention the commercial and public networks themselves—to sift out or establish standards of quality.

Whether such experiment is the proper role for a museum of art is subject to debate (the traditionalists will debate it, though it is not clear that they will be able to control the direction the experiment will take). But the Everson use of video to reach the local community has interested several other museums and arts organizations. And it has caused the Everson trustees themselves to ponder the future that video presents to the museum. Said Richard Montmeat,

> There are two ways of looking at video. It's an art form in itself or it's a communication device to reach a broader audience. The latter is the one I tend to favor. I think we're pushing into the future a little bit too hard to dig into video as an art form; I think we're just on the fringe. . . . It's a very difficult medium because it gobbles up material at an incredible rate, and I don't think [our museum has] the resources to probe it too far. However, using video as an educational tool or extending device is wide open.

For Cornell's Tom Leavitt, the extending device is the most appealing aspect of video, too. "What is most exciting about the Everson program is that it has opened the museum to instantaneous communication with the community. . . . If this is the proper course for museums, it gives us a new idea of a museum." Lucy Kostelanetz, director of the Visual Arts Program of the New York State Council on the Arts, which cosponsored with the Rockefeller Foundation a major video conference at the Everson in April 1974, credits the Everson video program with helping to show other museums the way to use video to reach into the community. The council has tried to attract more proposals for video programs that would begin to develop more expertise and would ultimately result in television shows on art for general audiences throughout the state.

## Roundup

If Everson has any lessons for other museums that are trying to extend themselves into the community, they are probably both pro and con. As guardians of aesthetic standards, art museums have problems to resolve in trying to appeal to or even lead popular taste. For some, Harithas was too much "with it," too caught up with the new and fashionable. In his eagerness to be up to date, said one critic, he did not always follow through. Was Harithas too "trendy"? The question, for August Freundlich, was whether Harithas followed the trend or made it; Freundlich thinks Harithas got to know the community in his own way and dragged people along with him. "A museum," said Freundlich, "must choose a good man and let him do his thing."

Like many museums, the Everson under Harithas moved in the direction its strongest personality took it, and the community seems to have come along—often kicking and screaming—behind. It was Harithas's own opinion that if someone squawks or protests it is because he is not involved, and the chances are that his frustration will subside if he is somehow drawn into the action. Not all museums see their audiences this way; perhaps it is the particular problem of the museum in a small city, where its visibility as a cultural center makes it particularly sensitive to the push and tug of community factions.

In any case, the Harithas methods were often extreme: upstate New York, which gave Conservative Party candidate James Buckley a resounding Senate victory in 1970, and where a symphony orchestra conductor, according to Freundlich, was criticized because, among other things, he played too much Mahler, was not likely soil for the political-cum-aesthetic seeds Harithas dropped upon it. Yet, according to Montmeat, it was the steady museum-goer of Syracuse, the art patron, the well-heeled representative of the community—and the one most resentful of what Harithas did—who changed and learned the most. It is Freundlich's impression that as a result of the Harithas phase, there is now more involvement in the visual arts by wider segments of the community than anyone thought possible. Said Lucy Kostelanetz, "It's good for the museum to move left. Now it will stabilize."

Another observer was not so sure:

> There is a danger to the field in the espousal of a kind of hustling attitude toward art regardless of the integrity of the program, and the Everson program under Harithas did not have integrity. Some of the concepts were fascinating, and the publicity was good, but often projects weren't realized and there were many let-downs. Even though Harithas added some good nineteenth-century paintings to the collection, [on the whole, his performance] was not consistent and solid. In the end, the net effect on the community was positive. But one serious objection is the use of art as a means of enhancing the institution—the museum-as-circus syndrome. This violates the integrity of art and degrades it. What did some of these activities really accomplish for the sake of art?

Perhaps Trustee Richard Montmeat should have the last word. As he talked about the Harithas experience nearly three months after Harithas left the museum, he said,

> I think we're leaning in the direction of an innovative museum rather than going back to a conservative . . . type of institution. . . . We don't have the resources or the huge inventory that a Cleveland or Metropolitan Museum does.

. . . We've been particularly pleased with the way local government people have stood up for the museum and come to be friends and supporters of it with a sense of pride and a feeling that [the museum] is one of the things that Syracuse has going for it that not too many other cities do. So I think there is a kind of rebirth of pride, support, interest, and enthusiasm for the museum. . . .

We have to be more of a window to what's happening in the rest of the country and the rest of the world, so we can provide the Syracuse community a place to look at how art is moving and how it's interpreting social change. . . . The musum is not an arts and crafts center for the community. . . . So then the real question becomes what standards should be established for showing both the outside-world art and local art.

With Jim Harithas moving to Houston, the board is now face-to-face with these decisions. We can opt toward a more traditional position, continue the innovative community thrust, stress education—or all of them if we find the resources. Everson has suddenly reached Phase Four.
—*E.H./B.Y.N.*

## Notes

[1] For sources of quotations without footnote references, see list of interviews at the end of this report.

[2] Quoted by Joan Watrous in ''Community Opinion of a Regional Museum: Views on the Everson Museum of Art, Syracuse, New York,'' *MetrOpinion*, vol. 1, no. 1 (January 1973).

[3] Russell Lynes, ''Museums: Playing the Cultural Odds,'' *Harper's Magazine*, November 1968.

[4] *Newsletter*, summer 1970, Everson Museum of Art.

[5] Transcript of a meeting on community museums held in New York City, May 13, 1974, by members of the staff of CMEVA.

[6] September 1974, p. 51.

[7] ''Community Opinion of a Regional Museum.''

[8] Judson Rosebush, ed., (Syracuse: Everson Museum of Art, 1973), p. 9.

[9] Letter from David Ross to CMEVA, July 31, 1974.

[10] Ben Gerson, ''Plastic Ononism,'' *Boston after Dark*, October 26, 1971.

[11] *Syracuse New Times*, October 7, 1971, p. 15.

[12] *Syracuse Post Standard*, October 12, 1971.

[13] Letter to CMEVA.

[14] Ibid.

[15] ''Museum Would Accept Flag,'' *Syracuse Post-Standard*, November 21, 1972, p. 10.

[16] One woman sent $5 a month regularly for three years, and another individual a total of $800 in monthly checks.

[17] Letter to CMEVA.

[18] In spite of the furor the work caused, Sandy Blumberg reported that ''people missed it, and were glad to have it back—except for two old ladies who declared they thought the Art Institute ought to keep it on permanent loan.''

[19] Letter to CMEVA, March 15, 1974.

[20] The main obstacles to the airing of museum-produced shows have been access and the Everson's own limited expertise. Although

Syracuse is on the list for a cable television station, while Ross was at the Everson, there was no channel to work with, and the Everson staff was too small to develop shows of broadcast quality.

## Interviews

Beckos, Barbara. Curator of Education, Everson Museum. November 8, 1973; January 30 and 31, 1974.

Dryansky, Leonard. Theater Department, Syracuse University. April 2 and 4, 1974.

Freundlich, August. Dean, College of Visual and Performing Arts, Syracuse University, April 4 and September 30, 1974.

Harithas, James. Director, Everson Museum. November 8 and 9, 1973; January 30 and 31, April 4 and 6, 1974. CMEVA meeting, May 13, 1974.

Kostelanetz, Lucy. Director of Visual Arts Program, New York State Council on the Arts. Telephone, August 26, 1974.

Leavitt, Thomas W. Director, Herbert F. Johnson Museum of Art, Cornell University, Ithaca, New York. Telephone, August 26, 1974.

Montmeat, Richard. Trustee, Everson Museum, and Director, Design Department, General Electric, Syracuse, New York. August 20, 1974.

Ross, David. Video Curator, Everson Museum. November 9, 1973; January 30 and 31, April 4, 1974.

Small, Virginia. President, Board of Trustees, Everson Museum. January 30, 1974.

Trop-Blumberg, Sandra. Assistant Director, Everson Museum. November 8 and 9, 1973; January 30 and 31, April 5, 1974; telephone, September 19, 23, and 27, 1974.

White, Jack. Trustee, Everson Museum. January 31, April 5, 1974.

Williams, Herbert. Director, Folk Art Gallery, Syracuse, New York. January 30, 1974.

## GREENVILLE COUNTY MUSEUM OF ART: ELECTRAGRAPHICS

Greenville County Museum of Art
420 College Street
Greenville, South Carolina 29601

**A wide range of multimedia programs are produced in-house by this public museum to serve school groups, adults (half of whom do not have a high school education), and the museum itself. Some examples of video productions: interviews with artists to supplement exhibitions, illustrations of art techniques to accompany the Student Art Mobile, interviews with museum members and patrons to document the history of the museum. CMEVA interviews and observations: September, November 1973; September 1974.**

### Some Facts About the Program

**Title:** Electragraphics.

**Audience:** General public (including television audience), school groups, and the museum itself.

**Objective:** To produce educational materials for the museum and to promote video as an art.

**Funding:** Electragraphics is a separate, full department in the

museum, established with the financial assistance of the South Carolina Arts Commission; sustaining funds come from the county, state, and federal grants, local foundations, private gifts, and income derived from assisting county agencies in the production of video programs. Equipment cost $60,000 to $70,000 over a five-year period. The department budget for 1974 was $33,254, including staff salaries and services (the production of multimedia software for education department programs, orientation information to accompany gallery exhibits, as well as graphic design work for museum publications).

**Staff:** 2 full-time.

**Location:** Programs are produced in-house and presented in the museum's theater and, on occasion, in the gallery entrances. Some are filmed outside the museum and edited later in the production studio. Programs have been shown in the schools, in the Student Art Mobile, and on local educational television.

**Time:** Daily showings as part of the education program. A videotape on an artist in his home or studio may be run continuously in the galleries during an exhibition of his works.

**Information and documentation available from the institution:** Sample schedules and budgets.

At first glance, the small city of Greenville, South Carolina, may seem an unlikely place to find an adventurous contemporary art museum. The city sits at the edge of Appalachia within sight of the Great Smoky and Blue Ridge Mountains. It is surrounded by some 328 industrial plants, mostly textile, that employ over 40,000 local residents. Few skyscrapers disturb its horizon, though Greenville is home to one of the tallest buildings in the South Carolina Piedmont. There is evidence of growth (a new airport designed by Skidmore, Owings, and Merrill) and of decay (many closed-down buildings in the few city blocks on the main street).

The new Greenville County Museum, which opened in March 1974, stands in the Heritage Center, a few blocks from the city's main street.[1] Its opening completed the plan for a cultural center composed of the museum (which also houses an art school), a library, and a theater. A departure from the usual blocky contemporary construction, the museum's trapezoidal form generates more than its share of excitement and curiosity among the residents of Greenville and surrounding counties, many of them baffled by the "scrawls" of modern art.

The community is, as Curator of Education Sylvia Marchant says of it, an especially challenging one for the museum. Of the 240,000 people in the museum's "target" area, nearly half, 48 percent, have not finished high school. It is "a predominantly textile community," says Marchant, "undergoing phenomenal socioeconomic change. This picture presents an awesome view to a tax-supported county art museum; its responsibilities to the community it serves are tremendous." She goes on to point out that "less than 5 percent of the total curriculum in area schools has been devoted to the visual arts. Accordingly, [the] adults charged with the upbringing and education of the young are . . . visually illiterate."[2]

## The purpose of the department

When the Electragraphics department was first created in 1970, in the old Greenville Museum, it was conceived as a multimedia production arm of the museum that would help the education department develop programs related to temporary and permanent exhibitions. According to an early proposal for Electragraphics, the education department wanted to be able to assemble a presentation on short notice for students who had never been to the museum before. "The first impression," said the proposal, "has to be exciting."[3] Thus electronic techniques, especially video, were introduced by James Howard, Electragraphics director and himself a video artist, as a way of drawing Greenville County's "visually illiterate" population into the museum and keeping it there.

Over the next four years the Electragraphics department's purposes expanded to include:
- Support for the museum as a whole, including graphics work and visual materials for catalogs, announcements, brochures, and other publications.
- Production of audiovisual materials to supplement education department programs.
- Creation of a video center to promote video as art, support for a video network of museums in the Southeast, and a video facility for artists.

Although Electragraphics has "separate and equal" departmental status in the museum, in practice its staff and facilities have been used primarily to serve the education department, which in turn concentrates most, though not all, of its energies on the local school-age population.

## Programs of the Electragraphics department

As the museum studied the socioeconomic and cultural levels the county contained and analyzed museum attendance figures, it decided that its only educational course would be programs custom-designed for each audience.[4] For schoolchildren those "custom-designed" programs have included the production of four 20-minute color videocassettes that traveled with the museum's Student Art Mobile. Each explained an art technique—painting, printmaking, sculpture, and ceramics—in varying formats. One, for example, showed an artist at work as he was being interviewed by the museum director. A video cassette playback system was built into the accompanying exhibitions.

As the museum also discovered, the public school system was moving toward "child-centered," as opposed to teacher- and subject-centered, education. That meant, says Marchant, more possibility for the children to move out into the community and, especially for grades 6–8, more chances for the museum to become "part of the total educational process."[5] One example of the way the museum has taken advantage of its chances was an early production of Electragraphics, a 35-mm slide transparency montage called "The

Map.'' Designed for junior and senior high school students as an orientation to the museum's tricentennial exhibition on the state of South Carolina, the 26-minute slide montage was a fast-paced series of images dissolving into one another, thus eliminating the usual jerkiness of a slide presentation. It was set to contemporary music and used only minimal narration as it traced the history and art history of the state. Slides of objects in the museum's collections (which are limited to the visual arts of North America with emphasis on contemporary regional artists) were included.

"This system continues to offer its unique feature: relevancy," says Marchant. "Revisions or editing of the visuals can be rendered periodically to keep the program abreast of changes in society. . . . 'The Map' is in constant demand, since continued exhibitions of South Carolina art work make the program a natural complement."[6]

In an outgrowth of the same idea, Electragraphics has also tailored packaged educational materials to fit its student audience. For example, a recording and set of slides sent as orientation materials with a loan exhibition from the Metropolitan Museum, "Protest and Hope" (see chapter 11), were, according to Howard and Marchant, "like an academic college lecture, devoid of the human emotions expressed in the finished paintings."[7] Howard put the slides on videotape, used a local high school art instructor to present the material, and added songs by pop artists Judy Collins, Neil Young, and Cat Stevens. The production, in the words of one observer, "really grabbed the audience."

The department also produces a television show for youngsters, *Scrunch,* which is broadcast weekly on local public television. Portable video equipment is taken out of the museum for a series of "man on the street" interviews with local children on topics that interest them—school cafeteria food, for one.

Not all of the Electragraphics productions for students are visual. For the education department's puppet show on the theme of texture in art for K–5th graders, Howard created a sound track "to add as much professionalism as possible [to] the dialogues, music, and special effects"[8] and to free the docent-puppeteers to concentrate on stage blocking and choreography during performances.

**Programs for the general audience.**  Most Electragraphics programs for the museum's general audience are based on videotaped interviews with artists, which are shown in the museum's auditorium in connection with exhibitions. The point of these productions, says Marchant, is to provoke questions that lead the visitor to make his own discoveries in the museum.[9]

One such interview was a 30-minute tape on the life and works of artist William M. Halsey to supplement a retrospective exhibition of his work (the department also did photography, layout, and printing supervision for a 100-page monograph *raisonné* for the show).

The department has also videotaped an interview with Sam

Wang for an exhibition of his photographs, another with artist Sam Gilliam, and one with A. Graham Collier, a juror in the annual Greenville Artists Guild exhibition, who explained how he makes his selections—a tape that was of interest to the artist entrants in the show as well as to museum visitors. Other tapes showed Greenville Museum Art School artist-in-residence Phil Whitely constructing a sculpture and sculptor-in-residence Bud Wertheim doing a first casting in the art school foundry.

Videotape screenings have been incorporated into the museum's film series, and a traveling video exhibition, "Circuit: A Video Invitational," was included in the 1973 exhibition schedule. In mid-1974, the department was planning a permanent collection of video art works and a video screening facility for visitors within the museum.[10]

**Programs to serve the museum.**  For the opening of the new museum building, just before the usual speeches and ribbon-cutting, the Electragraphics staff presented a 15-minute speeded-up videotape record of the construction of the new building, shown on six television monitors. Accompanied only by music, the construction, from groundbreaking through completion, flashed by while the minutes and seconds up to 10 A.M. on opening day ticked away at the bottom of the screen. At exactly ten o'clock, the presentation switched to a narrated history of the museum as an institution and ended with the potential the new building held out to the residents of Greenville County.

In another production that coincided with the opening, the Electragraphics staff videotaped the guests at a "nostalgia tea" for people who had been members and patrons of the Greenville County Art Association and the museum over the years. During the tea, selected guests were taken one by one to the video studio and asked what they remembered about the old museum. The result was eight hours of tapes documenting the museum's history, including the reminiscences of people who have since died.

The fact that in video there is no delay between making the picture and seeing the produced image has led the Greenville Museum staff to use it as a tool for training and evaluation. The docents who perform the educational puppet shows for children, for example, set the camera at child's-eye level during rehearsals so that individual docents can study the tapes to improve the way they play their parts.

The Electragraphics studio is connected by conduit to rooms throughout the museum building, and monitors can be placed wherever they are needed, so the museum uses video for security (cameras in each gallery play back to a monitor at the rear entrance of the museum). The conduit system serves the education department as well: a monitor in the education curator's office allows her to follow the progress of tour groups through the museum.

**Facilities and equipment**

The space for Electragraphics, planned and developed in

consultation with the architects of the new museum building, received as much careful attention as the galleries themselves. The facilities—control room, auditorium, stage, puppet theater, production studio, small studio for taping interviews, and screens for film (including 35-mm cinemascope) or multiple 35-mm projections—are all next to each other; they are also near a lounge on the ground floor, easily accessible to school groups as they first enter the building. The auditorium has a flat floor and removable seats so that video equipment can be used to tape large productions that the studios cannot accommodate. The stage itself is angled to provide two points of focus—straight ahead or about 45 degrees to the right.

From the inception of the department, both Howard and Marchant felt it was important that the museum purchase sophisticated equipment—not least because one of the main purposes of the Electragraphics educational software, as Marchant says, is to reach young people "brought up on the sophisticated presentation techniques of commercial television," who may not recognize quality but are turned off by the usual "deadly dull" educational slide programs and filmstrips.[11] It does not "snow" in Electragraphics video productions.

The equipment the museum bought between 1970 and 1974, at a cost of about $70,000, includes a Spindler and Sauppe control system, Ektagraphic projectors, inch and half-inch videotape recorders, monochrome and color cameras and monitors, a special effects generator, processing amplifier, oscilloscope, and a video-cassette playback system.

## Rationale

The staff at Greenville is aware of what have been called the "dangers" of video and other electronics in an institution set aside primarily for the quiet contemplation of works of art. As one critic has said, "The museum's indispensable role is as a zone of silence in the midst of the insistent yammering of audiovisual trivia."[12] The Greenville County Museum agrees that the museum is and should be centered on its collections and that audiovisuals should not be a substitute for them. The "exception," says Howard, is video art, which is "not an exception, but rather an inclusion."[13] (Video monitors are never placed in the galleries except for exhibitions of video art.)

For that reason, with every program the Electragraphics department takes on, the museum staff asks itself, first, whether it is necessary to supplement the original works and, second, how audiovisual materials can most appropriately be used. Decisions on both those points start with the needs of the community—adults and children—that the museum is mandated to serve.—*S.R.H./A.V.B.*

## Notes

[1] The old museum was housed in a local historic mansion, Isaqueena, that had been purchased by the Greenville County Art Association in 1959, largely with the contributions of local private citizens. It lacked adequate gallery, storage, and office space, and security was poor. In the late 1960s local textile manufacturers Mr. and Mrs. Arthur F. Magill donated $750,000 toward the construction of a new facility; the Greenville County Foundation then gave a piece of downtown property for the building of a cultural center; and the Greenville County Council matched the Magill gift with a bond issue.

[2] James Howard and Sylvia Lanford Marchant, "Electragraphics," *Museum News,* vol. 52, no. 5 (January–February 1974), p. 41.

[3] "Projected Use of the Equipment," unpublished Video-Tape System Proposal/Museum Network Video-Tape Proposal, Greenville County Museum of Art, undated, p. 11.

[4] Howard and Marchant, "Electragraphics," p. 43.

[5] Ibid., p. 41.

[6] Ibid., p. 43.

[7] "Electragraphics at the Greenville County Museum of Art," *SEMC Notes,* vol. 13 (1972), p. 23.

[8] Ibid., p. 20.

[9] Howard and Marchant, "Electragraphics," p. 44.

[10] James Howard's goals for Electragraphics had included the establishment of an experimental video workshop for regional artists: he wanted the museum to place a higher priority on developing the screening facility and on opening the department's production center to artists who were either already working with video or interested in trying it. The postponement of this activity in favor of day-to-day work on educational programing was one of the major reasons why Howard left the Greenville staff.

[11] Howard and Marchant, "Electragraphics," p. 41.

[12] Robert Hughes, *New York Times Magazine,* September 9, 1973, quoted by Joseph Shannon in "The Icing is Good, But the Cake Is Rotten," *Museum News,* vol. 52, no. 5 (January–February 1974), p. 30.

[13] For sources of quotations without footnote references, see list of interviews at the end of this report.

## Interviews and observations

Conversations with museum members at the opening of the new building. Greenville County Museum of Art. March 9, 1974.

Howard, James. Director, Electragraphics Department, Greenville County Museum of Art. November 5, 1973; September 25 and 26, 1974.

Marchant, Sylvia Lanford. Curator of Education, Greenville County Museum of Art. September 28, 1973; September 25 and 26, 1974.

Morris, Jack. Director, Greenville County Museum of Art. September 28, 1973; September 25 and 26, 1974.

Observation of Electragraphics productions. November 5, 1973.

Ritts, Edwin. Chief Curator, Greenville County Museum of Art. September 26, 1974.

# THE PHILADELPHIA MUSEUM OF ART'S DEPARTMENT OF URBAN OUTREACH

Philadelphia Museum of Art
Parkway at 26th Street
Philadelphia, Pennsylvania 19101
**Responding only to the expressed needs of community residents, this museum outreach program seeks to help people become "independent, energetic learners" and to encourage "creative thinking" about the arts. In a neighborhood video project at a satellite cultural center, participants develop skills, and the museum gains a foothold in the community.** CMEVA **interviews and observations: December 1973; January–March, September 1974; March 1976.**

### Some Facts About the Program

**Title:** Department of Urban Outreach (DUO).
**Audience:** Residents of Philadelphia, primarily those in poor neighborhoods.
**Objective:** To serve the expressed needs of neighborhoods of the city through activities, including video projects that take place in a community cultural center (the Thomas Eakins House in Spring Garden), environmental art programs, a summer mobile program, community exhibitions, special events (among them, an inner-city cultural arts festival of performing arts), and an information and resource exchange center for local arts groups.
**Funding:** DUO's operating budget in 1973/74 was $112,360, of which the museum and the City of Philadelphia together contributed more than 75 percent. Other sources included the National Endowment for the Arts, the Pennsylvania Council on the Arts, and local foundations, businesses, and other agencies.

Of the budget, $63,000 was used for programs, maintenance, supplies, salaries, and administrative costs of the Eakins House; the city gave most of this money, supplemented in part by two small grants from Hanneman and St. Christopher's hospitals specifically for community video projects, which alone took up about $15,000 of the Eakins House budget.

DUO's budget in 1974/75 was $153,155.
**Staff:** Usually about 6 full-time, including the director. Number of part-time staff and consultants hired for specific project ranges between 8 and 24.
**Location:** An office in the museum; the Eakins House, which is in the Spring Garden area of Philadelphia; and other neighborhoods throughout the city. Some of DUO's special events take place in the museum.
**Time:** The department began in 1970. Programs run year-round.
**Information and documentation available from the institution:** None.

The Department of Urban Outreach (DUO) of the Philadelphia Museum of Art was created in 1970. It was an acknowledgement of certain community needs the museum had identified and of the museum's growing number of activities designed to serve those needs, activities that could not, as one observer put it, "logically be assigned to departments then in existence."[1]

The Philadelphia Museum's outreach efforts go back to the 1930s, when it established several satellite museums to which selections from the permanent collections were circulated for audiences unlikely to visit the parent building. Fiske Kimball, then director of the museum, wrote in a 1931 museum bulletin of his belief that the future of museums lay in their extension, in the manner of branch libraries, to various parts of the city.

In 1930 the museum inherited the Fleisher Art Memorial, a free art school in downtown Philadelphia that still, in the 1970s, serves approximately a thousand persons a week from all over the city and its suburbs. Fleisher has its own private endowment and staff but is administered by the museum's division of education. (One DUO staff member is an artist-in-residence at Fleisher.)

In 1968 an anonymous donor purchased the Thomas Eakins House and gave it to the City of Philadelphia, with the request that programs held in it be administered by the museum. As the house had been both home and workshop to the great Philadelphia artist, the first plans for the house proposed that it be restored to the condition it had been in during the artist's lifetime. After discussions of this tentative idea and study of neighborhood museums, Philadelphia Museum Director Evan H. Turner concluded that the predominantly black and Puerto Rican residents of the Spring Garden neighborhood, where the Eakins house is located and which is adjacent to the museum, would neither befriend nor be served by such a museum. With the agreement of the museum trustees, Turner recommended that the Eakins House be "restored" as a community cultural center that would respond to the needs and resources of the neighborhood.

### The beginnings of DUO

Turner's resolve encouraged the museum to look for ways to serve the city and its disparate communities. In 1970 he brought David Katzive, then acting director of the Museum of Contemporary Art in Chicago, to Philadelphia as the museum's first director of urban outreach.

Together with a number of nonmuseum agencies and individuals, the museum staff mounted an exhibition the following year, titled "City/2." Focusing on the fact that half the city is in the public domain and the other half private, the show explored the urban environment. Inside the museum, neighborhood residents, architects, students from the Parkway schools, and others built units on the balcony of the Great Hall displaying their ideas about community involvement in city planning. Outside the museum, the DUO staff—then Katzive and one assistant—went into neighborhoods with a mobile video unit staffed by local media students (see below).

The new department set to work researching programs in other cities that operated through neighborhood art centers, store-front museums, recreation departments, or studio workshops. Eager to understand the hazards and benefits of such programs before embarking on their own, that first year the DUO staff tried many experiments that other museums

had launched, dropping those that seemed not to fit Philadelphia's character and modifying those that seemed feasible. One such idea, sidewalk chalk-drawing competitions, had worked well in Los Angeles and proved popular in Philadelphia, too; their principal virtue was to introduce DUO staff to individuals in various neighborhoods. Another experiment with wall murals was immediately successful.

Cooperating with the city recreation department to stage an exhibition of black artists' work in a cultural center and with the American Institute of Architects in neighborhood architecture workshops, Katzive and his assistant made contacts throughout the city and established the pattern they have since tried to follow: taking energy from a community, helping to direct it, and channeling it back into that community.

## The Spring Garden videotape project

One example of this circular pattern can stand for all that DUO does. During the summer of 1971, in conjunction with the "City/2" exhibition, DUO went into six Philadelphia neighborhoods with a mobile video unit. The purpose was to instruct young people to record the images of their own communities, each of which represented a different ethnic background and cultural interest. Making contact with an established community group in each neighborhood, the DUO staff worked with residents to develop a program that would serve their needs.

**Summer in Spring Garden.** In the Spring Garden section, the location of the proposed Eakins center, DUO's contact was with a group called the "Potentials." Sponsored by Smith, Kline and French, a pharmaceutical company with its main office in the Spring Garden area, the "Potentials" were young people, many of them former street-gang members, whom the company was trying to help prepare for jobs.

About 50 of these young people worked with the mobile unit at first, but their number gradually dwindled to those who took a serious interest in the project. Because the DUO staff was so small, the museum added a team of students from the Annenberg School of Communications at the University of Pennsylvania to the project; primary responsibility for supervision and for liaison with DUO lay with graduate student Peter Cuozzo.

As the project developed during the summer, Cuozzo came to believe that an ongoing video program could be useful to an urban community. He wanted to combat what he saw as a trend toward television as a "cloistered" medium, accessible only to those who have the confidence and take the initiative to seek out training. Cuozzo discussed with museum staff his idea for a video project permanently based in a neighborhood so that people there could learn to use video equipment to document their community's experiences. The museum agreed. David Katzive has said that "central to the museum's involvement in these programs is the idea that the quality of life, awareness and control of the environment, survival, mind expansion and communication are vital issues and something of concern for museums."[2]

At summer's end, the department used a grant from the Pennsylvania Council on the Arts, originally given for film showings in Spring Garden, to screen not only professional films, but the films and videotapes that had been made during the summer community project. Though the staff members had intended to edit these tapes into finished products, they decided that the "product" was less important than the "process" that had created them, and the time and energy that might have gone into editing should be channeled instead into future work within the community.

**Setting down roots.** Spring Garden posed, as they say, a challenge and an opportunity. The neighborhood is viewed as "difficult" by most outsiders and by many who live within it. Its population is 40 percent Spanish-speaking, 40 percent black, and 20 percent white, all reacting on different levels of fear and anger. But there also existed the possibility of a connection with the proposed Eakins center, further work with the "Potentials," and some activity with another group of neighborhood young people who were engaged in a silk-screening workshop sponsored by an independent print club.

Neighborhood residents had already found that using video equipment is relatively easy, but they had not acquired the more demanding ability to maintain the equipment or to design a script and coordinate a production. The developing project was designed to attract members of the neighborhood, from all groups, who wanted to learn more elaborate and specific television skills. Museum staff saw instruction in those skills as consistent with the spirit of an art museum, for it brought a concept of the arts to people and involved them not in the simple mechanics but in a progressively more creative enterprise.

DUO hired Cuozzo as a consultant in Spring Garden and began a word-of-mouth campaign to enlist people to work with him. Deliberately avoiding any other publicity or contacts that might impose a structure or goal on the project, the DUO staff and Cuozzo were determined to let it develop in response to community needs and inquiries. As Cuozzo met with community organizations, he tried to identify individuals with a sense of independence and to avoid those advanced by any particular interest group. The usual mix of curious and interested people began to come around; as those without serious interest disappeared, Cuozzo was left with a core of young people who really wanted to learn what he felt he had to teach them.

Until the Eakins house was ready, headquarters for the video project—along with the silkscreen workshop and classes in music and dance that DUO sponsored—was the Spring Garden Community Information Services Center, which also housed a small library, recreation facilities, a day-care center, and a medical referral service.

One of the video project's first decisions was to tape a billiards competition held in the center and billed as an "athletic" event. Both the competition and the videotaping gen-

erated enthusiasm in the neighborhood. Project members who were adept at wiring and had begun to understand the video system connected a camera in the poolroom with the television set in the main lobby so that people unable to crowd into the poolroom could watch the event. For the community it was an exciting time; the museum, which might have logically viewed the event as "very lightweight," according to one sympathetic observer, chose not to think in such terms but to see the effort as a step toward gaining a welcome foothold in the community.

**Local skills and leaders develop.** From the beginning of the project, Cuozzo had figured that he could measure his success by working himself out of a job. He wanted to train neighborhood people to operate the equipment, administer the program, and, most important, understand what they might accomplish for themselves and their community. At some point, he hoped, community residents would be ready to take over and would confront him with the argument that they could do his work better than he could.

One of the young men in Spring Garden did just that. Luis Parilla had at first seemed shy and reluctant, but as his skills developed, he became more interested and more assertive. DUO arranged for him to attend technical workshops. With refined skills and increased confidence, Parrilla began to express concern for the content of the work in the video project. Arguing that his community needed information on "survival skills," he proposed to search for ideas and ways to use video to communicate necessary information to the area's residents. Because Parrilla's intentions were consistent with the museum's hopes for the project and with Cuozzo's expectations, Parrilla was hired and sent out to do his own research.

He located services in the neighborhood and established contacts with people who could help his neighbors. One of these was Elsa Alvarez, a nutritionist working with the children and youth program at Hanneman Hospital. The hospital and museum staffs, brought together by Parrilla, drew up grant proposals, all to be channeled directly through the hospital.

Their first effort was a videotape, *Twenty-Four Hours in the Life of a Baby.* It follows a young woman and her baby through the daily routine of bath, feeding (and burping), formula preparation, play, and relations with an older sibling. Community artists, "actors," and technical assistants were hired to work on the tape, which was shown in the hospital clinic waiting room and in other neighborhood gathering places.

**Cordial confrontation.** That tape was only the beginning for Parrilla. He began to find out more about the mysterious ways communities exchange information; he established contact with a group in South Philadelphia that wanted to learn his skills; and he located young people in Spring Garden schools who wanted instruction from him.

As information about the Hanneman project began to cir-

culate, Dr. John Levitt, director of the Children and Youth Program at St. Christopher's Hospital in another section of Philadelphia, asked DUO for help on a tape about dental hygiene. There was clearly going to be more work than Parrilla or Cuozzo could handle alone. They decided to form a team, Parrilla as a contact with neighborhood people, Cuozzo with administrators. Cuozzo recalled the "confrontation" over who would do what:

> We flipped a coin and decided that I would do [the dental hygiene tape] and he would do the Hanneman tapes. That was the moment when my role was clearly in jeopardy . . . the confrontation I talked about. That was great. It wasn't that I nursed him along but that we worked together as colleagues, and at this point he decided he knew where he was going.

Cuozzo acted as producer of the dental hygiene tape, calling on a number of people DUO had identified. A young Philadelphia artist who had previously worked with the museum on a project for the blind created the major props—a puppet stage in the form of an open mouth with a proscenium of large red lips, and an enormous toothbrush with floppy yarn "bristles." Children from one of the museum's summer mobile programs, the Children's Improvisational Workshop, manipulated hand-puppet "teeth." The director of that workshop directed the tape, for which other workshop artists wrote the script and composed the music.

In the puppet theater section a live segment featured a dentist explaining hygiene to a young patient, his mother, and a Spanish-speaking friend, to whom the doctor's nurse translates. Four students from four different Latin American countries did the translations, dubbed so that the tape could be used for English- or Spanish-speaking audiences. The DUO staff took particular satisfaction in this project's use of the talents of young Philadelphia artists.

**A new temporary location.** As the videotape project flourished, it outgrew its headquarters in the Spring Garden Center and had to move into a commercial garage with a spacious loft, four blocks from the center and only a few blocks from the Eakins House. The move allowed programs that had been spread among various neighborhood facilities to be brought together under one roof, as they would eventually be at the Eakins House.

But the move also meant the loss of some participants, especially young children whose parents were reluctant to have them travel a few blocks farther from home into other areas of Spring Garden that the parents saw as threatening. Neighborhoods create their own boundaries, even if only a few blocks apart, and so the new temporary location changed the project's constituency—not dramatically, but noticeably. First priority was given to those residents who lived around the new location and all areas of the Spring Garden neighborhood. Philadelphia residents from other neighborhoods were accepted only if there were class or workshop openings that were not filled by Spring Garden residents.

**Home, at last.** Restoration of the Eakins House was completed in spring 1975, and it opened for business in May. During the spring the new program coordinator, Hediberto Rodriguez, met with community leaders and residents, listening to their assessments of past projects and planning future programs.

With Parrilla as full-time communications coordinator, with part-time artists and staff offering workshops in the visual arts, music, dance, and Afro-American and Puerto Rican culture, and with a secretarial assistant, the Eakins House has completely absorbed the original Spring Garden project that began modestly in the summer of 1971. Peter Cuozzo remains as a consultant and part-time staff member of DUO, working with Eakins House and on other projects. Funds for Eakins House activities are provided by the City of Philadelphia and administered by DUO.

### Other activities of DUO

Early in the development of DUO, an architects' workshop had asked for help with a mural the architects wanted to commission from a community artist as part of a "Tot Lot" they were designing in north Philadelphia. DUO turned to a community cultural center near the proposed "Tot Lot" and asked the art instructor there for names of artists living in the neighborhood. The artist he suggested was one of those who had exhibited in the show of black artists sponsored by DUO; the artist was invited to submit sketches to the landscape architect designing the playground, and one sketch was accepted. With the assistance of DUO, the artist hired some young people in his neighborhood to help him, and together they executed the mural.

The role of broker among neighborhoods, artists, and agencies has become a special one for DUO. Publicity about that early wall mural brought further requests, enough to prompt the department to add two environmental artists to its staff in the summer of 1972. DUO staff members are quick to point out that they operate in response to needs the community expresses and do not impose their own goals on a project. If plans proposed by the residents of Spring Garden materialize, it will be because they, not the museum staff, want them. Those plans include one for a library of tapes, another for shared personnel and resources (both are beginning), and a third for cable television in public housing, which at this writing looked nearly hopeless.

Other projects have included annual exhibitions of winning string-band costumes from the Mummers' Parade, a Philadelphia institution that can draw half a million people on New Year's Day. The costumes were exhibited on the museum's Grand Staircase as part of a cooperative venture between the department of textiles and costumes and DUO. That exhibition is still viewed by some Philadelphians as controversial, probably because, as Penny Bach, Katzive's successor, once said, "You don't place feathers and plastic pearls in a sacred temple. The gods reject them." But the exhibition brought to the museum people who do not customarily come and encouraged others to think about what audience—or audiences—the museum is intended for.

Controversy over the Mummers' exhibition centered on the quality of the art in it. Some museum staff felt that there was no difference between this exhibition and any other where museum standards are involved, and they point out, further, that not everything in a museum is of the highest quality.

But most of DUO's work has not been controversial. The department has grown quietly, from a staff of two in 1971 to a staff that ranges between eight and nearly two dozen, depending on the number of part-timers and consultants hired for specific projects that are funded by special grants.

The museum is kept aware of DUO's work through quarterly reports from the head of the department to the museum director and outreach committee, which consists of three museum trustees (one of whom is chairman) and representatives of agencies and constituencies related to DUO's activities. The outreach committee acts as a source of advice and guidance but does not determine the direction DUO programs take. DUO staff members believe that the museum board of trustees and other museum staff can accept the department's autonomy and its involvement in some unpromotable and almost "underground" activities because so many of its other community activities receive broad and enthusiastic publicity throughout the city.

### A change at the top—but not in philosophy

In the summer of 1972, Katzive became director of the Philadelphia Museum's Division of Education. The Department of Urban Outreach, a separate entity from that division, has been headed since January 1973 by Penny Bach, former coordinator of art for the Parkway Program and a member of the original developing staff for that famous experimental high school in Philadelphia.

She sees as one of DUO's goals holding out opportunities for aesthetic experiences to people who do not usually look to a museum for them: "What I think we're doing is providing a context for understanding works of art." She went on,

To make the artistic experience *and* the museum experience a more familiar encounter doesn't necessarily mean a visit to the museum, but I'm a firm believer that certain things happen to a person when one enters a museum that are very, very exciting. I have always found it exciting, but it is because my predetermined interest gives me the ability to gain entrance. I've tried to determine if what happens to me in a museum can be matched in another way. Maybe we don't do the same things; for example, we don't take a work of art out into the community, but we try to match the kind of experience one has in museums.

Though to many museum traditionalists the "experience one has in museums" may seem unmatchable, Bach explains that the goal of the department's work is to help people become "independent, energetic learners" and to encourage "the sort of creative thinking that happens when you look at

something." Further, she believes, if the department can "generate more positive thinking out there, wherever there is," then the experience can be transferred to the museum.

We don't leave it to people's own consciousness to make the first step; we do something with them that they can begin to understand. That makes the first big step. I feel that is the responsibility of the museum towards its public.

. . . You provide an initial stimulus to cause a change in attitude that may lead them to rediscover something or to discover for the first time, which is often the case.

A case in point, she feels, are the children who worked on the wall murals; they were involved in the production of a work of art from the first aesthetic decision: choosing the design, looking at the site, projecting changes in scale, joining with other people to execute it, handling materials, working with an artist.

Many of those children have been brought to the museum to look at contemporary art, and Bach says their "association is incredible." Students who worked on a wall mural, she believes, "can begin to understand, say, what Stella had to go through to stretch a large canvas, or perhaps the difficulties an Indian sculptor has to overcome in hacking out a huge piece of stone. They have a sense of what the insurmountable is, what the artist or the person working with the artist has to deal with in order to produce something. All that creates a sympathy for the artist, the artifact, preservation."

The impact on a community of a joint venture, like the wall murals or the video projects, is considerable, Bach thinks. Believing that most people living in a city feel they have the ability to change very little, she trusts that their perception of themselves and of the city changes through such ventures.

. . . In the society in which we live, people are conditioned to think that either one creates radical change, like the SLA, or is politicized, or paralyzed. All three options, for the majority of the people living in the urban community, are unappealing. They don't want to be revolutionaries because they are afraid of destroying what little they have; they don't want to be politicians because they're afraid of not understanding the political games. They don't feel that they can do anything. The mural, in a way, is a symbol for what can be done. . . . What will often happen in a community after the wall is produced is that other city agencies respond to the community's desire to have some playground equipment installed or, in one instance, the community raised money to install better lighting facilities around a playground adjacent to the wall mural. It wasn't just to see the wall mural, certainly, but it was to create a better quality of life. I think that this, historically, has been one of the goals of the artist, too: to try to create a better way of life.

—B.C.F.

## Notes

[1]For sources of quotations without footnote references, see list of interviews at the end of this report.
[2]David Katzive, "Museums Enter the Video Generation," *Museum News*, January 1973, p. 23.

## Interviews

Bach, Penny. Coordinator, Department of Urban Outreach, Philadelphia Museum of Art. December 1, 1973; January 8, February 14, March 26 and 27, and September 15, 1974. Telephone, March 16, 1976.

Caruthers, Samuel Jr. Administrative Assistant, Eakins Center, Philadelphia. March 27, 1974.

Cuozzo, Peter. Consultant and Staff Member, Department of Urban Outreach, Philadelphia Museum of Art. February 14, March 27, 1974.

Katzive, David. Chief, Division of Education, Philadelphia Museum of Art. November 19, 1973; January 7, 8, and 9, February 11, 1974.

Parrilla, Luis. Communications Coordinator, Eakins Center, Philadelphia. February 14, 1974.

Searles, Charles. Artist, Philadelphia. March 7, 1974.

Turner, Evan. Director, Philadelphia Museum of Art. January 10, March 26, 1974.

Wilson, H. German. Program Coordinator, Eakins Center, Philadelphia. March 27, 1974.

Wood, Clarence. Environmental Artist, Eakins Center, Philadelphia. March 27, 1974.

# WHITNEY MUSEUM OF AMERICAN ART: THE DOWNTOWN BRANCH

Whitney Downtown Branch Museum
55 Water Street
New York, New York 10041
**Some of Manhattan's art riches are moved out of midtown to Wall Street, a "culturally deprived" area where about half a million people, few of them affluent, work every day. Subsidized by business and landlord, the branch attracts lunch-hour crowds with shows from both loans and the best of the Whitney's collection.** CMEVA **interviews and observations: January, March, April, November 1974.**

## Some Facts About the Institution

**Title:** Downtown Branch Museum.

**Audience:** Workers in downtown Manhattan, about 400 daily.

**Objective:** To help change the anonymity of the Wall Street area into a more meaningful community by reaching a neglected and culturally deprived population with works of art formerly available only to uptown audiences.

**Funding:** $53,000, contributed by 29 businesses in the Wall Street area.

**Staff:** Museum studies students in the Independent Study Program, under the guidance of the head of the education department.

**Location:** 4,800 square feet on the Plaza level of 55 Water Street, a recently opened 53-story office building.

**Time:** Open to the public from 11:00 A.M. to 3:00 P.M. (lunch hours) on business days; closed holidays and weekends. The Branch opened in September 1973.

**Information and documentation available from the institution:** None.

---

In the 50 blocks north of 53rd Street in Manhattan are 20 museums, most of them with collections so rich that only a small portion can be shown at any one time. By contrast, no major museum exists in Queens, the Bronx, or Staten Island. Brooklyn, New York City's remaining borough—three times the size of Manhattan with a million more people—has only one major museum.

It is no wonder, then, that with the rise of community feeling and community organizations in the late 1960s, Manhattan's museums became the object of increasing pressure to decentralize their collections. The argument of the local groups is simple: art is as necessary to the poor as to the wealthy; the surfeit of cultural resources concentrated in mid-Manhattan, already one of New York's plushest areas, should be moved to those areas that need it most.

The Whitney was the first museum to respond seriously to this demand. But why did the Whitney reach out from one overly-endowed neighborhood to, of all places, Wall Street? The museum's answer is that Lower Manhattan is, in fact, one of New York's most culturally deprived communities. The Whitney's research at the time showed that every day 480,000 workers commuted to this neighborhood, the heaviest concentration of office workers in the country. They came from all five boroughs and suburban counties in New York, New Jersey, and Connecticut. Eighty-five percent of them earned $12,000 a year or less. Turnover was high: the average employee stayed on a job 14 months. Obviously, it was a tremendous potential audience, with nowhere to go.

The neighborhood offers these thousands of workers scant relief from a nine-to-five routine in glass and steel cages. In deciding to bring its form of relief, the Whitney faced two basic realities: first, as museum hours are usually the same as business hours, the working person is one of museum's most neglected audiences; second, most New Yorkers like to combine museum trips with shopping or eating out.

Except for those workers who may return to Manhattan on weekends, when museums are overcrowded, the downtown audience has no museum habit. The Whitney decided to reach for this new audience by adjusting a branch museum to Lower Manhattan's timetable and adapting its shows to the community.

The Whitney's branch museum opened September 18, 1973, an escalator flight up in one of New York City's largest and fanciest new skyscrapers. The space is large (4,800 square feet), open, airy, but because it is also long and narrow it conveys an intimacy in pleasant contrast to the monstrous structures of the neighborhood. A revolving glass door opens onto a large plaza. On the other side of the building is newly renovated Jeannette Park. The museum is open only from 11 A.M. to 3 P.M. on weekdays, a time specifically designed for lunch-hour visits.

**Exhibitions**

The exhibitions, many of them major, have included some of the best objects from the Whitney collection and important loans as well. The shows have been designed not only to break up the office-workers' daily routine but also "to broaden their taste and expand their cultural horizons."

The opening ten-day show, "Beginnings: Directions in Twentieth-Century American Painting," first greeted the new audience with pictures that would be familiar either in subject matter (Raphael Soyer's office girls and a painting of the Brooklyn Bridge by Joseph Stella) or style (Grant Wood and John Sloan). Then the show moved on through more openly Modernist pictures, such as Max Weber's *Chinese Restaurant,* to contemporary pieces like those of Rothko and de Kooning. The exhibition was meant to show a range of twentieth-century styles and to offer something to everyone who came to see it.

The second show, "Watch the Closing Doors" (October 31–November 30, 1973) was on mosaics done during the first three decades of this century in New York City subway stations. The show included photographs, plans, and maps of the expanding subway system, but only two actual mosaics. The idea was that subway riders could see many of the other mosaics as they passed through one station after another on their way home.

The best clue to the Whitney's new audience is perhaps its reaction to a single object—undoubtedly the most popular and controversial piece the branch has exhibited so far. It was *Brunette Woman Sitting on a Table,* a polychromed polyester and fiberglass sculpture by John De Andrea, part of a diverse 1974 show called, innocently enough, "People and Places." His exceptionally realistic sculptures of nude young girls with their glass eyes and real hair had been exhibited the year before in a downtown gallery without much more notice than a photograph in the *Village Voice.*

At the branch, however, it was a different story. Daily attendance at most previous shows ran somewhere between 200 and 400. But the day this show opened, there were 900 visitors, the second day 1,100, the third 1,600. Attendance stabilized at between 900 and 1,100 persons for the show's duration—the maximum number the space can comfortably accommodate. Crowds around the De Andrea nude became so thick that the piece had to be assigned its own full-time guard.

Reactions to this phenomenon varied. Some staff members objected strongly to the work and felt that, because such a show-biz presentation was totally at odds with the purposes of the museum, the piece should be removed. (The *New York Times's* James Mellow thought the lady was out of place in this "irrepressibly oddball" exhibit.) The Independent Study Program students, who were responsible for the exhibition (and who comprise the entire staff of the branch; see

report in chapter 12), defended the piece's aesthetic value and wanted the museum to stick to its guns. In addition, the students argued that if people came to the museum once for whatever reason, they might come again—and perhaps find more lasting rewards.

The work in the show that followed, "Illuminations and Reflections," was unfamiliar and difficult for most of the audience. Attendance, however, reached 700–800 people a day, gradually tapering off to about 400 by the time the show closed. As the branch's audience appears to be growing—some days, in fact, attendance exceeds the uptown count—the ISP students' hope seems partially vindicated.

## Money and the future

The Whitney's premises about the need for a museum in downtown Manhattan have received the enthusiastic and practical endorsement of the local business community. The Uris Buildings Corporation has given the Whitney a five-year lease on the branch's space at $1 a year, and 29 other businesses have contributed $53,000 to make up the first year's expenses.

In the meantime, the branch with its adjoining plaza added dance, music, and poetry to the schedule of events. There were eight performances in the spring of 1974; more were planned for the fall.

• • •

The story of the Whitney's three-year efforts to bring the branch museum to reality follows in an interview with David Hupert. The branch's operation and some of its other exhibitions are described in the report on the Independent Study Program in chapter 12.—*F.G.O.*

## Story of the Branch

**An interview with David Hupert, Head, Museum Education Programs, Whitney Museum of American Art, March 22, 1974.**

**Hupert:** I wasn't thinking about a branch museum when it all started. I was looking for additional space for the studio phase of the Independent Study Program. Cherry Street was just getting too small for us. We couldn't enlarge the studios, and we didn't have room for everybody who wanted to work there. . . .

I happened to do a TV program on Channel 31, and walking down Chambers Street I noticed the old Emigrant Savings Bank where I used to bank when I was a city planner. It was vacant. It's a beautiful Beaux Arts interior with high ceilings. I said, "My God, man, what's going on here?" And I made some inquiries. This was back in 1970. I found that the city had condemned it because that building overlaps by about two feet the location of a new municipal building they're supposed to build on Reade Street. All right, with the financial problems [Mayor] Lindsay was having, I knew that the municipal building wouldn't be built for ages, and I im-

mediately ran off to City Hall and said, "How do I get that space? I want to make a museum." I thought it would be a fabulous place to show big sculpture.

**Q:** Tell me what it means to go to City Hall. You've got to know somebody down there, don't you?

**Hupert:** No. I saw the space. I walked a block. Actually I made some phone calls first to some friends. I called the city-planning department, and I said what's happening to 51 Chambers Street? And they said, "Well, it's condemned and it's going to be torn down."

**Q:** And you'd worked in that department?

**Hupert:** Yeah. Then I literally went to City Hall. . . . I walked in and said, "Who's got information on this thing?"—just asking questions. I got led on a tremendous goose chase. Nobody seemed to know anything about that space. Turns out, ironically enough, that the space was allocated to the Municipal Broadcasting System, which was where I was coming from in the first place when I saw it, to be used as a TV studio. That struck me as very strange because it would be terribly expensive to transform space that big, and I knew the Budget Bureau would never approve money to be spent on a building that was going to be torn down. I mean *I* could do that—I could run a slipshod physical facility and turn it into a first-rate organization because it's relatively small scale, but you can't do that with a big-time broadcast TV studio. You'd have to spend literally hundreds of thousands of dollars just in soundproofing, lighting, electrical work, and so on. And if the building is going to be torn down, they wouldn't do it. Turned out I was right and they were wrong.

I did another TV program, and just at that time I saw the director, Seymour N. Segal. He used to be director of the Municipal Broadcasting System (that's WNYC—Channel 31 and WNYC radio). I told him it would be a great museum; don't turn it into a studio. Make a recording studio down in the basement. There are 18-foot ceilings in the basement. He said, "No—contracts are let, you'll see. In February of this year, '71, it will be under construction." Nothing came of it. Had to do another program on WNYC-FM in March or maybe April, and I walked by the building and sure enough nothing was happening, so I said, "Aha! This is my chance."

So I started working to get the building. I first went to the city-planning department to see what plans were made and what the potential date of the new construction was. That was off in the indefinite future, and I had just read in the *Times* that the Board of Estimate had refused funds for the final engineering study of the new municipal building. That put it off many years, because if they didn't know what they were going to build, they certainly weren't going to start demolishing this building. The Lindsay administration was using it as kind of an additional executive office building. As people were being moved out, they were moving in various agencies. So I knew the building was around. I went to the Office of Lower Manhattan Planning, telling them what I wanted for a

museum. They came back after they did some investigation saying, you can't get it. Instead they came up with this map of potential Lower Manhattan sites. In the meantime I got to know a number of people working in the mayor's office, especially Ed Skloot, who was pretty helpful.

**Q:** How'd you get to know people in the mayor's office?

**Hupert:** By offering a very reasonable proposal to them. I said, "Look, there's a space going to waste. I want to do something. I want to make this place more exciting. I want to put a small museum there. It won't cost you a nickel—we'll pick up all the costs of it."

**Q:** So originally you wanted the Emigrant Savings Bank not for the Independent Study Program, but for a museum?

**Hupert:** Yes, but let's go back three steps. I wasn't even looking for a museum. I was walking in the neighborhood. I was always keeping my eyes open for a loft space or some kind of space because I wanted to move the college program. I said, "Aha! What a great space for a museum." And that was the birth of the Downtown Museum. So then I got hot after that building. I went to Local Planning Board #1, which is Lower Manhattan, made an appeal before them, and they thought that was the greatest idea. Got unanimous support from them. Went to Percy Sutton [borough president of Manhattan] and got a very strong letter of support from his office. Then the only stumbling block left was the Department of Real Estate, and they have their own interest, which is not to get involved with all kinds of outside groups using their buildings. I can understand that. I can also understand that they're not necessarily sensitive to what it was that we were really trying to do. But I couldn't get through to the Department of Real Estate, which refused to budge on it.

**Q:** Why don't they want outside groups in their buildings?

**Hupert:** Because the Department of Real Estate is responsible for the maintenance, they have to carry the insurance, they have to know that we're reliable and all that. And also their main aim is to get the new buildings up. If there's another group in and it comes time to tear it down, how do they know we're going to move out? Then they're going to have a law-suit on their hands. It gets really hairy. So I had part of the executive branch of the government lined up and the planning departments behind me. I had to get some support from another area, and I went to the City Council, and [Councilman] Carter Burden gave me some very valuable support.

At the last minute Howard Samuels came trotting in and wanted that space to make the largest off-track betting parlor in the city. In the meantime I'd already been there on a couple of inspection tours and saw the downstairs place and decided that if I could get the downstairs at least I'd solve another problem, which was the ISP. And so a deal was made whereby OTB got the whole thing, and Howard Samuels gave the basement to me. That's how ISP moved in downstairs.

That still left me with a funny idea—a little museum—and as I was going around people were saying, "Don't worry

about that building. You can't get it—why don't you look at this building or that building?"—and so I did.

At some point along the way the whole idea of opening a downtown museum became very important, because I realized that everybody was interested in it—they thought it was a marvelous idea. The more time I spent in Lower Manhattan, the more I realized that there was just nothing to do in the middle of the day—nothing—that the place really doesn't have any cultural institutions, that there's no community that takes an interest in people, no major community centers, no Henry Street Settlement House. We started investigating a possible museum at Pace College, but then Pace College had its own requirements, and the space they offered wasn't really suitable—too tied down. Now we're getting on into later in 1971.

**Q:** So you finally got Reade Street early in '71?

**Hupert:** Well, this is later in '71. It took a long time to get the Reade Street space, and we moved in during the summer of '71.

Then the office building situation in New York changed from a seller's market to a buyer's market. There was a tremendous excess of buildings popping up all along Water Street. It was suggested that since I'd been looking so eagerly for some space for the downtown museum, I might as well look at some new space. This was suggested by the Office of Lower Manhattan Planning. I asked for this map. I was interested in the old ferry building, which was a space I had looked at. I was thinking of what open space was available, and they also put in the new buildings and they made a suggestion that we look into some of these newer ones going up. The Uris building was an obvious one. . . .

And so we went to Uris. Percy Uris had been a corporate member of the Whitney, a $1,000-a-year (there are a number of corporations that do that). First I went to see one of his vice-presidents, who was strongly enthusiastic about the whole thing, and then I went with [Whitney Director] Jack Baur to see Percy Uris. You see up to this time the Whitney Board of Trustees wasn't involved—this was all my idea. Somewhere along the way I had talked to Jack Baur about it—I'd said I would like to open a downtown museum, and his approach was, "Well, look, if you can really get it going so it won't cost the Whitney any money, fine." So he liked the idea. So after we talked to Uris, I went to the renting agent, and the renting agent talked to Percy Sutton. Percy called Jack and said yes!

I had told him what I wanted: 5,000 square feet on a really accessible level. It turned out that he gave us that main floor with the highest ceiling in the building—open to the plaza, with use of the plaza. Uris went even a step further and said not only will we give you the space for five years, but we'll pay for the basic architectural installation: they gave us our own revolving door to the plaza, which was really nice. We were somewhat restricted in what we could do in terms of color and floor tiles. We didn't want the dropped ceiling, but it's necessary because the dropped ceiling acts as a plenum

for the air-conditioner, and so on. It wasn't as if we would be building our own space, but they were awfully nice about supplying basic lighting and equipment.

In any case, that whole deal was set early in 1972—and then came the teamsters' strike, then the cement workers' strike, then the elevator operators' strike, then the lathers' strike. So it wasn't until a year and a half later that the building was finished. It was fully a year and a half after we expected to move in that we were able to. We were told the space would be available to us in June of '73. But that was just when I was expecting to leave for our summer program in Albuquerque. When I got back in August we got to work organizing our first show, which opened on September 18.

Then comes the next important aspect of the thing, right after Uris said yes. That was the first major hurdle. (That space could have been rented by Uris for a minimum of $100,000 a year—probably more.) Then we had to go out and find the money for it. I had written a proposal before we went to Uris, and I gave that to Uris to describe what we were going to do. I went to a number of businesses in the area, partly suggested by Uris, people who would seem to benefit most.

We got a list of the prospective tenants in the building itself and went to those tenants. They included Chemical Bank first, because Chemical was the prime tenant, and a number of major brokerage houses. We—Jack Baur and I—asked the Whitney trustees to help, and they did. We explained the idea to them, and they liked it very much since they saw it was going to work. A number of trustees had friends in these various places and were able to recommend others. The Chemical Bank came along with a very helpful contribution, $5,000. A number of places gave that much, but the guy who's now the president of the bank said that he would send out my proposal to other businessmen recommending that they support it. And that made life a lot easier, because the door was open.

I would come in and give my little song and dance explaining how I was offering them a service—I didn't want them to contribute to a charity—to make Lower Manhattan a more useful place for them and their employees, to make a better climate. And we raised the money.

**Q:** How much?

**Hupert:** $53,000 from 29 contributors.

**Q:** I was talking with Anne Wadsworth from ACA (Associated Councils of the Arts), and she said that you got some money from the Tugboat Union or something like that?

**Hupert:** Moran Towing. That was incredible—Joseph Moran. I walked in there. He has a very lush desk, you know, office, wood paneled, big desk—and he's sitting there. He says, "Sit down." Okay. He looks me straight in the eye and says, "What the hell do you want me to give money to a museum for? The people that work for me work hard, and I pay them well. I don't have to entertain them."

I explained that it's not entertainment. I asked him about

the carpet on his floor. I asked him about the cafeteria (I assumed they had one, and sure enough, they do). Just went on talking about the fact that money is the central element to trade, but that there's a lot more and you try to get the most out of your workers and you don't get very much out of them if they're going to be starving. There are many ways to starve, including culturally.

It was a long talk. And at the end he said, "You know, if you ever want a job just come see me." And he gave $500. He was tough, but he was good. I liked him. He was the most honest. He said, look, tell me why the hell you want me to give you money. The others were all into—a lot of them— "Oh yes. I think it's a marvelous idea. Art, yes. When the people have nothing to do they can go to the museum."

No! That's not what it's about—when they have nothing to do! I say I want to give them something extra to do. I want to make them work harder at the museum. And then they'll come back, they'll talk about Lower Manhattan a little. They won't just shudder when they think about it.

I did a little homework before I went to see them. At that time there were 480,000 workers in Lower Manhattan; 85 percent of them earn $12,000 a year or less; the average stay of an employee was 14 months—three months of training, 11 months of use, and he's gone.

I said, "If I can add one week onto that, you'll be getting your money back ten times over because the biggest expense you've got is training those employees who are going to be leaving. They're not doing any damn good for you those first few months anyway until they know what they're supposed to be doing." Apparently enough of them bought the idea. We even got some money out of the Stock Exchange, and the Stock Exchange never supports anybody.

**Q:** There's a factor in getting the space that has to do with zoning regulations, doesn't it? A certain amount of space in these new buildings has to be public space or has to be service space?

**Hupert:** No. Sometimes builders will make those kinds of deals. They'll say, "I'll put in—I'll give you a certain kind of public function. We need the zoning variance." That wasn't the case here. There was a different kind of deal here: Uris agreed to rebuild Jeannette Park. We came in after the whole Uris thing was finished. They weren't looking for us. We came asking them for some of their space.

**Q:** So what was the advantage of this thing to Uris?

**Hupert:** The most important is that a thing like the Whitney Museum branch going strong in a building makes it a lot more attractive. You can say to somebody who wants to open a store, "Look, you've got the Whitney Museum here, and now I can say there are a thousand people a day coming to that Whitney Museum. That means traffic. Traffic helps business."

**Q:** And if there's a store in there that sells art books?

**Hupert:** If it sells *anything*—I mean if you've just got people walking by. If there's a cafeteria, a restaurant, or

anything, it gets help. Also with the people actually working there it makes the building that much more interesting. It also adds to the whole glamour of Lower Manhattan.

Another thing is that we're a starting point. Now other people are thinking about it. The *New York Times* had that editorial praising the Whitney Museum for going down there and gently chiding the Met, saying why didn't you get down there? The Whitney isn't the largest museum. It's far from the largest.

So we started. The Whitney has been the first major cultural institution in Lower Manhattan, and it's doing very nicely. It shows that there's an audience that really wants to see this kind of stuff, that wants to be engaged. It's not an unsophisticated audience—it's not a hostile audience, it's a very interesting one. We have less trouble downtown with people touching works of art than we have up here at the Whitney. Very rarely do you have to tell somebody to move away. Those first few weeks we were open, so many people came over to us saying "Thank you. Thank you for opening it. So glad you're here." There's something really nice about that.

We're starting our second-year fund-raising drive again to make more money. We had to cut back on the exhibition schedule because we were running out. Trucking and things like that are fantastically expensive. It started out to be a great strain on the Whitney—just a whole other set of exhibitions that the art handlers have to pull from the stacks and put on the trucks. So we wanted to help the Whitney pay for a part of another art handler to help cover the load. Other things like that cost money. We're starting a big program of outdoor performances as soon as the weather gets nice—on that big plaza we've got. We put one piece of sculpture out, and we'll be putting more there as time goes on.

But in order to stress that this is a service provided by the businesses I won't allow any admission charge. That's very important. I won't allow even a contribution box. I just feel that you don't have to pay to look at the East River, it's there; you don't have to pay to look at paintings on the wall of a bank when you're cashing your money. Why should you pay to look at art anywhere else if in fact you're in a business situation and the businesses do have enough money to support this thing? So I see it as kind of obligation—I'm allowing the businesses to fulfill one of the obligations they've got to their workers. And I think they see it that way too a little bit.

**Q:** And you think the business community is satisfied with this thing and is going to continue supporting it?

**Hupert:** I think that we're going to have no difficulty getting the money the second time around. Everybody is very pleased. You know, we've just gotten started sending out the first letter saying we're going to be asking for money and asking them to recommend other businesses that haven't contributed. I think that will be the easiest part of my job.

—*F.G.O.*

## Interviews

Chisholm, Nan. I.S.P., Junior in Art History, Mills College. March 27, 1974.

Clark, Ronald D. Instructor, I.S.P. January 15, 1974, March 27, 1974.

Diao, David. Instructor, I.S.P. January 15, 1974.

Hupert, David. Head, Museum Education Programs, Whitney Museum of American Art. November 7, 1973, March 8, 22, 1974, April 5, 1974.

Kleinberg, Jane. I.S.P., Junior in Art History, Oberlin College. March 27, 1974.

Marshall, Richard. I.S.P., Graduate in Art History, University of California at Long Beach. March 27, 1974.

Schoonmaker, John. I.S.P., Junior in Art History, University of Rochester. March 27, 1974.

Tobias, Richard. I.S.P., Junior in Painting, Pennsylvania College of Art. March 27, 1974.

## THE BALTIMORE MUSEUM'S DOWNTOWN GALLERY: EXTENSION SERVICE IN THE MARKETPLACE

Baltimore Museum of Art Downtown Gallery
2 East Redwood Street
Baltimore, Maryland 21202

**A museum's branch gallery attracts a "new audience"—over 30,000 office workers yearly—in the revitalized waterfront business district of downtown Baltimore. Its most popular offering: changing exhibitions supplemented with foods, films, guest speakers. CMEVA interviews and observations: February, March, May, and August 1974.**

**Some Facts About the Gallery**
**Title:** Downtown Gallery.
**Audience:** Adults—workers, bankers, business people—whose occupations center in downtown Baltimore; 36,611 (1974).
**Objective:** To create a new audience for the museum.
**Funding:** Over $25,500 annually, allocated as follows: $15,000 for salaries, $8,000 for exhibitions, $2,000 for exhibition installation, $500 for printed materials, plus honoraria for speakers at $25 each. Sources: private and corporate donors, grant from National Endowment for the Arts, plus funds and in-kind services from the Baltimore Museum itself.
**Staff:** One full-time guard, one part-time administrator.
**Location:** In Baltimore's waterfront business district.
**Time:** 10:00 A.M.–4:30 P.M. weekdays. The gallery was opened in 1972.
**Information and documentation available from the institution:** Printed materials such as handouts and the museum calendar.

Baltimore reveals itself slowly to the visitor. Its most publicized aspects seem to be "The Star Spangled Banner," a high crime rate, political corruption, a notorious "entertainment" quarter called "The Strip," and a large ghetto.

Its residents know that it is also the home of the Baltimore

Symphony, the Lexington Market—where meat, fish, and produce are sold from stalls by independent vendors as they have been for over 100 years—and a summer-long ethnic festival by the waterfront with the food and entertainment of one of the city's ethnic groups featured each weekend.

In the eighteenth century Baltimore looked to the sea for its wealth and its character. Trade, shipbuilding, and fishing, the economic foundation of the city, began to blight the harbor area in the nineteenth century, and those who could afford to turned their backs to the harbor and amused themselves on the heights, where they built parks, squares, monuments, and mansions. The inner ring of residences grew: sturdy brick row houses with austere façades.

At the outer edge of this ring is the Baltimore Museum of Art, with its pleasant park, adjacent to college campuses, and an area of in-town estates. At the inner edge the Walters Gallery, the Maryland Institute College of Art, and the earlier site of the Baltimore Museum lie just up the hill from the commercial district.

Now, in the second half of the twentieth century, Baltimore, once more a major East Coast seaport, is turning again to the harbor. Around the waterfront, new buildings are rising, old ones are being revitalized, and people are returning to the heart of the city to shop and spend their leisure time. The new buildings are not only business facilities but restaurants and theaters as well.

Charles Street, which starts at the waterfront and runs through the financial district on up to the heights, is a focal point for Baltimore's reorientation. One Charles Center, an earth-colored cast-concrete complex of shops and theater, and its contemporary neighbors border a multilevel plaza with fountains, flags, and comfortable, shady little parks full of people. The older structures, ranging in style from Louis Quinze to Louis Sullivan, rest easily beside the new. Most of the buildings around Charles Center are banks and bank-offices. Close by are two hotels, the seedily elegant Lord Baltimore and the glossy new Hilton.

The street floors of the surrounding buildings house an almost endless number of smart men's stores, both clothing and sporting goods, punctuated by carry-out sandwich shops. It is Baltimore's Wall Street, and its nine-to-five occupants are evidently predominantly male. A few blocks away are the department stores and boutiques; together they comprise a different sort of urban ghetto, populated largely by money-makers and spenders too busy to travel uptown to the museum.

### The downtown branch: an oasis for the lunch-hour crowd

In the midst of this commerce and concrete, the Baltimore Museum of Arts' Downtown Gallery is serendipity incarnate. The building, barely three stories high, is known as the Hansa House for its North German architectural style and the 39 coats of arms of Hanseatic cities set into its stucco walls. Owned and formerly used by the neighboring Savings Bank of Baltimore, it was built in 1912 for a German shipping line.

**The Downtown Gallery is in the old Hansa House (built 1912), an architectural anomaly among the old and new stone and concrete buildings in the revitalized Baltimore harbor area. (Drawing by B. C. F.)**

Now its low arched windows are filled with red geraniums, and the sign above them spells out "DOWNTOWN" in rainbow-striped letters.

The Downtown Gallery, in its first year at this location in 1973, began across the street at One Charles Center in 1972, where in its first twelve months it drew 34,000 visitors. Much of this audience was generated by contact with the major corporations located in surrounding buildings—mailings to their personnel lists and publicity in their house publications—as well as by notices in the museum calendar sent to members. Visits center on the lunch hour, although the gallery is open from 10:00 A.M. to 4:30 P.M., Monday through Friday; during "off" hours visitors may number from two to twenty.

The gallery's main appeal to downtowners lies in its busy noontime schedule on Tuesdays, Wednesdays, and Thursdays, related thematically to the current exhibition and accompanied by just enough esoteric food to make the trip to the sandwich shop unnecessary. Lunchers may be served grapes, apples, cheese, and wine, or perhaps French pastry; the offerings are always sympathetic to the theme of the exhibition. Gallery Manager Brenda Edelson greets noon-hour visitors as though they were guests at a private salon.

One February noon, for example, a group assembles to hear a short talk by a theater lawyer about his book of celebrity photographs. The exhibition is titled "Faces," and the gallery is filled with a pleasant selection of portraits—paintings, photographs, caricatures, sculptures, and both theatrical and ritual masks. (Other programs for this exhibition included a lecture by a makeup artist and a member of the Baltimore police department, who demonstrated how identification portraits are created through eyewitness descriptions.) The audience for this particular talk could have been

lifted from a random sample of the Charles Street passersby, plus a few aficionados from the Morris Mechanic Theater across the street. They stand about, eating and sipping their wine in a small room to the rear of the gallery. Beyond the abundant serving table about 50 folding chairs face a podium. The speaker is so absorbed in these amenities that the program begins a little late. It will end even more tardily; no one wants to leave.

"Behind the Great Wall of China," a loan exhibition of photographs taken during the last 75 years of Chinese history, was accompanied by a lecture on Chinese politics, a film about acupuncture, and a three-week course in Chinese cooking. "Posters by Toulouse-Lautrec" featured a sidewalk cafe where coffee and dessert were served on Tuesdays, films and lectures on other days.

If the gimmickry seems foreign to the concept of a museum, it does serve to attract an audience that habitually skims the surface of culture and might well not choose to cross the street on the promise of a sensitive, intellectual lunch hour. Once in the gallery, however, the visitor is neither razzled nor dazzled. The exhibition and curatorial staff that serves the museum does not compromise its standards in the gallery. If the choice of exhibitions from the museum's collection is limited by security restrictions, the results are not second-rate art. Nor does the gallery use sensationalism as a come-on. Like that musical institution, the pops concert, the Downtown Gallery offers light classics by gifted artists and program notes by scholars who do not seek to confound.

### Attendance and funding

The combination of exhibition-and-program, location, and charm has kept attendance on the rise. As with the Whitney's Downtown Branch in New York (reported in this chapter), which inspired the gallery, attendance at the branch sometimes exceeds the number at the museum proper. This was particularly true in the 1974 summer months: although visits dropped at the museum itself, they held their own downtown. Air-conditioning, which the gallery has and the museum does not, may account for some of this difference, but museum officials think a gallery visit is only one of several reasons why people now come downtown; the gallery's prospering neighbors in the business community tend to agree.

Funding for the first year's operation was provided by corporate and private donors in Baltimore. A grant from the National Endowment for the Arts, matched by funds and in-kind services from the museum and the community, has made the second year possible. Chief among the gallery's benefactors are the Savings Bank of Baltimore, which has provided the gallery's new home for "at least one year," and a variety of other local businesses that sponsor individual exhibitions. Thirty percent of the museum's contribution is given in the form of services by the curatorial staff and the public relations and community-related services departments.

Salaries for the gallery director and one guard are budgeted at $15,000, eight exhibitions at $1,000 each, installation for the exhibitions at $2,000 for the year, and printed materials such as handouts and additional copies of the museum calendar at $500. Honoraria for speakers are kept to $25 each.

### A need identified and met

Outside the entrance to the Downtown Gallery is a sign that gives a brief history of the project. Written when the present quarters were first opened to downtowners, it says,

> The decision to continue the program at this new location is based on the recognition that the downtown extension of the Museum has created a new audience, and fulfills the objective to broaden Baltimore's growing awareness of the Fine Arts.

True. The Downtown Gallery has sought, developed, and held the attention of an audience that may seldom, if ever, cross the threshold of the museum on the heights. There are other forces at work, however, and recognition of the city's recreation of downtown as the center of its activities is a part of the story. The Baltimore Museum's contribution might be said to lie not in "creating an audience" but in identifying and filling a need.—*B.C.F.*

### Interviews

Edelson, Brenda. Gallery Administrator. February 19, March 14, and May 29, 1974.

Freudenheim, Tom. Director, Baltimore Museum of Art. Telephone, August 7, 1974.

"Manolo." A passerby. May 29, 1974.

Payne, Phillip. Gallery Guard. May 29, 1974.

Thompson, Carolyn. Gallery Volunteer. May 29, 1974.

## VIRGINIA MUSEUM OF FINE ARTS ARTMOBILES: THE ORIGIN OF THE SPECIES

Virginia Museum of Fine Arts
Boulevard and Grove Avenue
Richmond, Virginia 23221

**A mandate to promote art education throughout the state and a philosophy that art is most apprehensible in small, self-contained galleries prompted the Virginia Museum to create four Artmobiles, considered the prototypes for mobile unit programs. On the community circuits, Artmobiles are staffed with curators who give lectures and presentations and who prove, once more, that human contact is essential to the success of mobile programs. CMEVA interviews and observations: March and April 1974.**

### Some Facts About the Program

**Title:** Artmobile.

**Audience:** Schools, colleges, clubs, museums, and libraries in 75 communities throughout the State of Virginia.

**Objective:** To bring art to the people of Virginia along with interpretive materials that make it meaningful and enjoyable.

**Funding:** Repairs, supplies, alarm systems, and insurance on the four Artmobiles runs about $25,000 per year; printing of brochures, posters, and labels, plus miscellaneous expenses reaches about $9,000 per year; travel expenses and salaries for curator and driver total about $23,000 for each of three vans; the fourth van, the Collegiate Artmobile, requires a driver only, starting salary of $7,032, plus $4,300 for travel expenses.

**Staff:** Artmobile coordinator and a part-time secretary, 3 curators, 4 drivers, and volunteer coordinators throughout the state. ("Curatorial" functions for the Collegiate Artmobile are provided by the faculties of the host institutions.) Exhibitions are originated by museum staff and guest exhibition directors; installations are designed by the museum's exhibition designer.

**Location:** Program is statewide.

**Time:** The program began in 1953 with one Artmobile, now includes four. The Artmobiles operate throughout the year.

**Information and documentation available from the institution:** Charles C. Mark, *The Mark Report: A Survey and Evaluation of the Virginia Museum's Statewide Programs,* Virginia Museum, 1974; brochures and flyers.

"To promote throughout the Commonwealth education in the realm of art,"[1] the Virginia Museum of Fine Arts has dedicated the whole of its energy and resources for nearly 40 years. Significantly, there is no department of education for the museum: the entire programs division has educational responsibilities, a reflection of the museum's philosophy, which, according to one staff member, "has never included the 'exclusive repository concept.'"[2] The staff is divided into functional categories, each of which has its own responsibility to the people of Virginia to see to their education in the arts.

The museum has two major divisions: collections, which are global in provenance, beginning with ancient Near Eastern cultures and continuing to the present; and programs, which are further divided into headquarters (the museum) and state services. It should be understood that the State of Virginia owns the museum, its collections are held in trust for the people of the state, and the museum's overriding purpose is to disseminate both the knowledge and the pleasure implicit in the collections. Since 1955, the museum has also had a theater arts division, with responsibility for the Virginia Museum Theater in the headquarters building and for a statewide performing arts schedule.

Since 1961 the museum has had a statewide network of chapters (arts organizations generated by local interest, but begun as branches of the museum) and affiliates (existing organizations that chose to associate themselves with the museum). The network provides the museum with an increased membership, better communication with its state audience, and a well-established organization on the receiving end of its programs. Chapter and affiliate members are members of the museum as well and are offered a variety of special activities, such as dinner and theater at the museum, through their organizations.

From 1948 to 1968 the director of the Virginia Museum was Leslie Cheek, Jr. The programs begun during his administration, as well as policies of administration and exhibition, all bear the stamp of his philosophy and personal taste. His flair for drama, in visual as well as performing arts, has influenced installations that attract almost as much attention as the objects they exhibit. His determination to serve the state with earnestly conceived and implemented programs is perhaps nowhere better represented nor better known than in the Artmobiles, the first of which he designed and put on the road in 1953. Three more Artmobiles, quite similar to the first, were added to the program by 1966. All four now tirelessly travel the state, bringing the collections to the audience.

The Virginia Museum Artmobiles are galleries on wheels, which have become models for other museum mobile programs. They represent a philosophy of education which suggests that a work of art is more apprehensible within this particular context and setting and that the "museum experience" is more than just an interaction between the object and the viewer.

**The units and their schedules**

The art is carried and exhibited in tractor-trailer units whose interiors are carefully designed not only to enhance the objects but to protect them against the rigors of weekly moving and a one- to two-year absence from the climate of the museum. The 45-foot vans were built in Richmond under the direction of Fruehauf Company; the cost of the two most recent Artmobiles was $85,000 each, including tractor components. Three tractors are used for the four Artmobiles; with deft scheduling, it is possible to have one tractor free to hop around the countryside picking up the extra van while the others are on location.

There are two circuits for each Artmobile during the academic year. One begins in September, the other in late January. Artmobile I, sponsored by the Virginia Federation of Women's Clubs, has an itinerary that the museum designates on the basis of requests from clubs in 30 communities throughout the state. The unit was given to the museum by Miller and Rhoads Department Store in Richmond. Artmobiles II and III, sponsored by the museum's Confederation of Art Organizations (chapters and affiliates), visit the 30 communities in which their organizations are located, and are the gifts of the Old Dominion Foundation and Miller and Rhoads. Artmobile IV is sponsored cooperatively by several colleges and universities throughout the state working with the University Center and the Virginia Community College System. In 1973/74, Artmobile IV visited 33 colleges, all of which received the visits free (the charges to the schools were eliminated in 1972/73, along with the slides and photographs that used to accompany the exhibition). A gift of E.

Claiborne Robins, Artmobile IV operates with funds given for a three-year period by the Carnegie Corporation. During summer months, unless scheduled for reinstallation, Artmobiles visit fairs and other functions around the state.

The units are equipped with burglar warning devices, none of which has been put to use in the 18 years since the first unit took to the road. Successive destinations are scheduled so that not more than an hour elapses between disconnection of power in one location and connection in the next, keeping temperature and humidity relatively constant.

Two local hostesses assist the traveling curator in each of the communities on circuits I, II, and III. On the first day of each community visit, the Artmobile driver stays with the unit so that the curator is free to lecture to school classes or local organizations. No curator travels with unit IV on the college circuit; art department faculty and students are responsible for education and security.

While in transit, the objects are protected by cushioned frames, foam padding, and even special "seat belts" for three-dimensional objects. The staff members characterize the damage that has occurred as "very minor" in relation to the scope of the project. They are confident enough of the safeguards built into the program to have begun planning an Artmobile exhibition of the museum's excellent collection of gold objects.

The operation of the Artmobile program is a model of efficiency. Information and instruction distributed to sponsoring and host organizations, in whose hands the ultimate success of the program rests, is on color-coded sheets of paper; Artmobile schedule on gray, hostess schedule on pink, visit report sheet on yellow, all packaged in a convenient folder. At specified intervals before a visit, sheets are returned to the Artmobile coordinator in Richmond relating arrangements made by the sponsors for police protection, power hookups, hostess duties. The coordinator thus knows in detail that the community is ready for the Artmobile to arrive.

## Design

The settings within the Artmobiles are dramatic. The environment is self-contained—not only the environment that engineers build into the van, but also the one the designer has created to convince the eye and the mind of the visitor that he has left the parking lot of, say, Stonewall Jackson High School and entered the temple of the muse. Inside is an impressive array of valuable objects, well lit, carefully mounted. (With characteristic forethought, the museum has built a special loading dock in a secure part of the Richmond building where Artmobile exhibitions can be mounted and dismounted with minimal danger to the objects.)

The exhibition designer for all three-dimensional projects in the museum also designs the installation for the Artmobiles. As he was also once a set designer for the museum theater, it is not surprising that the effect he has achieved in the Artmobile is like the curtain rise on an especially lush set. If this provides distraction from the objects, it also serves to distract from the tunnel-like interiors of the vans.

## The staff

The Artmobile curators are three young men hired from outside the museum staff. The job was established with recent college graduates in mind, especially those with B.A.'s in art history, art education, or studio art who want museum experience and also money for further education. The curators work for nine months a year, do their own research on the collection with which they will travel, and spend six to eight months with their charge, visiting places they would probably not otherwise see. Food is sometimes indigestible, lodgings difficult to find, and loneliness is a factor in their lives. "I don't think anybody has lasted in this job for over three years" (the museum points out that no one is expected to last more than *two*), says one curator who enjoys the work and who finds that in rural areas, where conditions are more difficult for him personally, there is also a particularly enthusiastic reception for the Artmobile.

Another young curator, weary and disenchanted as he neared the end of a circuit, chooses not to enter the van, in which he has been giving as many as 15 lectures a day. He will not be returning for another year and gives as reasons for his disenchantment the political maneuverings among hostesses, the spartan working conditions, and the concepts of the particular exhibition to which he is currently assigned and which he has found impossible to make understandable to his audiences. Nevertheless he believes that there is no substitute for the one-to-one relationship between person and object that the Artmobile provides for people with no other access to works of art.

Inside the van an elderly hostess with a hearing problem is loudly complaining about her elastic stockings and sharing a bag of cookies with visitors. Asked a question about the exhibition she says, "You'll have to ask the young man outside, I don't know anything about art. But don't tell him about the cookies; he's very fussy."

The Artmobile curator stands between the mission of the Virginia Museum and those who receive its services. Despite the work of many people, the years of thinking and practice that lie behind each circulating exhibition, it depends on a single person to coax a meeting of minds and objects "out there" on the Virginia circuit.—*B.C.F.*

## Notes

1 Mandate to the Virginia Museum of Fine Arts, Virginia General Assembly, 1934.

2 Phyllis Houser, Assistant Programs Director, Virginia Museum, written comments to CMEVA, September 25, 1974.

## Interviews

Alberti, L. Robert. Assistant Head, Programs Division/State Services, Virginia Museum of Fine Arts. March 10, 1974.

Fitzgerald, Jay. Artmobile Traveling Curator, Virginia Museum of Fine Arts. April 1, 1974.

Houser, Phyllis. Assistant Programs Director/State Services, Virginia Museum of Fine Arts. March 10, 1974.

Pittman, David. Artmobile Coordinator, Virginia Museum of Fine Arts. March 10, 1974.

## DOUGHERTY CARR ARTS FOUNDATION: SOUTH TEXAS ARTMOBILE

Dougherty Carr Arts Foundation
P.O. Box 8183
Corpus Christi, Texas 78412
**A mobile unit, initiated and funded by a single patron and unaffiliated with any museum, brings high quality original art works to children and adults in small towns throughout south Texas. Exhibitions designed to teach and enrich are drawn from museums around the country. CMEVA interviews and observations: June, October, November 1973; May 1974.**

### Some Facts About the Program

**Title:** The South Texas Artmobile.

**Audience:** The general public, including schoolchildren, in small communities throughout south Texas. In 1973/74, 32,799 persons attended the exhibition, about two-thirds of whom were students on prearranged tours.

**Objective:** To bring a museum on wheels to the small communities of south Texas and to contribute to their art education and cultural enrichment by providing an opportunity for residents to view high quality, original works of art presented in an historical context.

**Funding:** In 1973/74, $36,794.37, of which $2,000 came from the Texas Arts and Humanities Commission and the remainder from the Dougherty Carr Arts Foundation. Expenses included salaries of curator and driver ($14,638.67), truck maintenance, including insurance ($5,405.70), exhibits ($6,600), and administration, including director's salary ($10,150). The trailer itself was built at a cost of about $100,000 in 1969.

**Staff:** A full-time curator, full-time driver, and half-time director. About 30 volunteers, plus an area chairman, are recruited in each community the Artmobile visits.

**Location:** The program is administered from a central office in Corpus Christi. The Artmobile visits small towns throughout south Texas; in 1973/74, these included 27 communities in 20 counties.

**Time:** From September to May each year. The Artmobile spends a week in smaller communities, two weeks in larger ones. The program began in fall 1969.

**Information and documentation available from the institution:** *South Texas Artmobile Workbook,* a preparation manual for volunteers.

The small towns of south Texas are basically like small towns everywhere but with the special stamp of the Southwest's geography and ethnic mix. It is a land of benign climate, open space, and an expanding economy, most of whose inhabitants—ranchers and farmers, among them blacks, Chicanos, and whites—share a prevailing life style: hard-headed pragmatism focused on work, family, and church. Art is scarcely an educational, social, or economic priority.

Even so, May Dougherty King wondered if art might not find a welcome there. Mrs. King is a native of Beeville, Texas (population: 16,458) and president of the Dougherty Carr Arts Foundation. In 1969 she learned of the Artmobile of the Virginia Museum of Fine Arts (see report in this chapter) and determined to duplicate it as a gift to the people of south Texas.

Modeled on the Virginia Museum's traveling units, the Texas tractor and trailer together measure about 62 feet x 10½ feet. Inside the trailer are 81 feet of exhibition wall space. The trailer is air-conditioned and humidity-controlled; the art works are mounted so that there can be no damage due to vibration. Since its inception in 1969, the Artmobile has circulated one exhibition a year, each unified by theme, period, or style. Because the traveling program is not affiliated with any museum, it borrows its exhibitions from museums and other sources: the National Cowboy Hall of Fame, the Republic of Mexico, the National Gallery of Art, the Dallas Museum of Fine Arts.

Between September 1973 and May 1974, the Artmobile traveled to 27 communities in 20 counties; its home base is Corpus Christi, and it goes as far north as Kenedy, east to Victoria, west to Laredo, and south to the Rio Grande valley. About 50 miles separate each weekly stop. The schedule goes like this: the unit arrives in a community on a Monday, opens for a volunteers' preview that evening and to the general public Tuesday through Friday. In bigger towns, like Laredo, it stays for two weeks. Tours scheduled for schools and community groups begin with a brief talk by Artmobile Curator Raymond Hetzel; he is also available on request for workshops and lectures in the evenings to interested groups and can give them in either Spanish or English. As no more than 20 persons are permitted in the van at a time, informality flourishes.

The Artmobile program is governed by a board of directors: two nominees of the foundation, two representatives of the Junior League, the Artmobile's part-time director, and two members-at-large. Day-to-day administration is the responsibility of the director. The curator and the driver travel with the van from city to city; in each community, they find a band of volunteers (recruited through the Junior League or a comparable organization) who serve as hostesses, publicity agents, and school coordinators. These volunteers rely on the ''Workbook,'' a preparation manual that covers every detail: how to organize and schedule tours, how to publicize and coordinate the Artmobile's visit.

Most visitors (two-thirds of them students, from elementary level through college) come for prearranged tours. Three weeks before the Artmobile arrives in town, school classes

scheduled to visit it receive slide-lecture packages including slides of all works in the exhibition, general background about the period or culture covered, and a commentary on each work. Casual visitors are attracted by advance publicity, by the unit's reputation from previous stops, or by the imposing presence of the trailer parked in a schoolyard, convention center, or shopping center parking lot.

According to Hetzel, the audience's response is simple: awe. "People are amazed to be seeing real paintings. They ask, 'Is this the *original,* the real thing?'"[1] He has expressed surprise at how much students tend to remember from previous visits; they ask for comparisons with paintings they have seen before in the Artmobile and return after school or at night with parents or friends. Plainly, the Artmobile's appearance is a major social, intellectual, and aesthetic event in the lives of these south Texas towns.

There are other responses: some secondary and college art teachers have asked for more didactic shows; other teachers have asked for a broader representation of media; one man—whom Hetzel hesitantly described as "a young Chicano militant"—found the exhibit of American primitive paintings "irrelevant," asked why the Artmobile showed no Mexican or socially conscious art, and left, appeased, when told that the previous year's exhibit, which he had missed, had been "Mexico: Art through the Ages." Few visitors have requested more contemporary or avant-garde works.

The only "evaluation" is based on the hundreds of thank-you letters that come into the foundation every year. Most of them laud the quality and importance of the Artmobile's exhibits and urge the van to return; as the Artmobile's director, Mrs. Maudmae Eldridge, said, "They like exactly what they're getting." One packet of letters came with a note from the principal of a junior high school:

These letters from our students are our attempt to thank you for coming our way. The students at George West are the most culturally disadvantaged students I've ever worked around. Live Oak County is about 50 years behind in their thinking and acting. This is why outside sources of information are so very valuable to us.[2]
—*B.K.B.*

## Notes

[1] For sources of quotations without footnote references, see list of interviews at the end of this report.
[2] Eli Casey, principal, George West Junior High School, Live Oak County, Texas.

## Interviews and observations

Eldridge, Mrs. Maudmae. Director, South Texas Artmobile. June 27, October 30, 1973; telephone, May 29, 1974.
Hetzel, Raymond. Curator, South Texas Artmobile. November 16, 1973; telephone, May 28, 1974.
Morrison, Mrs. Ralph W. Junior League Representative to the

South Texas Artmobile Board of Directors. Telephone, May 28, 1974.
Children from Victoria, Texas, schools while visiting the Artmobile.

# THE METROPOLITAN MUSEUM OF ART DEPARTMENT OF COMMUNITY PROGRAMS: SENIOR CITIZEN SLIDE-LECTURE PROGRAM

Metropolitan Museum of Art
1000 Fifth Avenue
New York, New York 10028

**A happy congruence of needs—those of a senior citizen volunteer group to find work for its clients and a museum to supply the demand from senior citizen centers for "art appreciation" lectures—produced this response to a special audience. The program's major problem is tricky slide projectors; its major rewards, a service to the elderly community and the satisfaction and sense of purpose it gives the volunteers. CMEVA interviews and observations: January–March 1974.**

**Some Facts About the Program**
**Title:** Senior Citizen Slide-Lecture Program.
**Audience:** Members of New York City senior citizen centers who request the service, as well as the senior citizen volunteer lecturers themselves (there were 53 in 1974). Although they have a range of backgrounds, the volunteers tend to be upper middle class, white, female, Jewish; many are retired schoolteachers.
**Objective:** To bring some of the Metropolitan Museum's resources to senior citizens unable or unwilling to come to the museum and to involve the volunteers in a useful and revitalizing activity that draws on their experience and background as senior members of the community.
**Funding:** About $3,500 annually, almost entirely from the operating budget of the museum's department of community programs. This department is financed entirely by the National Endowment for the Arts and the New York State Council on the Arts.
**Staff:** One coordinator and one instructor, assisted by the staff of the museum's photography and slide library.
**Location:** Training for volunteers takes place in the museum; lectures are given in senior citizen centers throughout New York City.
**Time:** September–June; the program averages one lecture every other day, booked two to three months in advance.
**Information and documentation available from the institution:** None.

In January 1973 the Metropolitan Museum began a program in which senior citizen volunteers are trained to give lectures to their peers in New York City senior citizen centers. The most noticeable result of this program has been the involvement and enthusiasm that have developed in the senior volunteers as a result of their responsibilities.

## Birth of the program

In its first five years of operation, the Metropolitan Museum's department of community programs learned a good deal

about the resentment that communities can often feel toward high-powered culture brokers who try to forcefeed "high art" to those designated needy of it. The department's most successful and long-lived programs have been those initiated not by the museum but by the community itself and designed around community-defined needs. Many of the department's activities are simple get-togethers at the museum to help various local interest groups learn about museum resources that may be useful to them.

The senior volunteers lecture program is an example of a community-initiated program. It is the result of the happy merging of two needs; one was the demand from senior citizen centers for lecture programs; the other was a request from the Retired Senior Volunteer Program (RSVP) to the Metropolitan for work that senior citizen volunteers might do. The solution to both requests became apparent to the community programs staff, and the program was on its way.

## Training and recruitment

Before volunteers can become lecturers, they must meet weekly for ten to twelve weeks for basic instruction in the principles and history of art by art historian and sculptor Robert Friedman. At the same time, the volunteers are introduced to the Metropolitan's collections and taught techniques of lecturing, the operation of the slide projector, and the use of the museum's slide library. Before the training session is completed, each volunteer gives a ten-minute lecture to the other trainees. There is no pass or fail system, but those volunteers who cannot meet the demands of the training period also generally lose the desire for the job and drop out of the program.

After the training period, there is a graduation ceremony in which the volunteers receive a certificate designating them qualified community lecturers. They also receive a museum identification card that entitles them to regular staff privileges, such as museum restaurant and bookstore discounts.

Between January 1973 and March 1974 there were three training sessions, which graduated 53 senior volunteer lecturers. The primary sources for participants have been RSVP, word of mouth, a July 1973 article in *New York* magazine, and the National Retired Teachers Association of the American Association of Retired Persons. This last organization has produced the largest number of senior volun-

## The University of Kansas Mini-Van

University of Kansas Museum of Art
University of Kansas
Lawrence, Kansas 66045

When the staff of the University of Kansas Museum of Art constructed its mobile unit to display two-dimensional works of art throughout Kansas, it considered several requirements. The vehicle had to be uncomplicated, easy to operate, and secure against theft and vandalism. The installation design had to be adaptable to various settings and simple enough for anyone to set up and dismantle. Finally, the entire operation had to be low cost.*

### The unit

The museum staff decided on a trailer rather than a self-propelled unit for two reasons. First, the trailer posed fewer logistical problems. The driver could pull it with his own car; should that break down, the exhibition schedule need not suffer, he could simply use another car. And second, it is less expensive, they found, to build a trailer to specifications than it is to buy and remodel a truck.

The trailer they built cost $3,500 for design and construction. About 8-by-7-feet, it weighed 1½ tons when loaded and thus required heavy-duty tires. It had a single axle, a distinct disadvantage, as this caused the trailer, which must travel great distances, to weave at speeds of over 45 miles per hour. In spring 1974 the designers were planning to add electric brakes.

### The installation

The art works are transported and exhibited in six pairs of freestanding wood and aluminum panels that provide a total of 12 4-by-5-feet display areas. Built by the museum's cabinetmaker, O. B. Shipman, the panels cost only the price of the materials. To install an exhibit, staff members remove six Allen screws from the top of each panel and take off the aluminum sheet closure (see A in drawing). Pictures are fastened to the units by driving screws through the now-exposed back of the panel into the frames, which are covered by plexiglass to protect the art. The closure is then fitted back into place. (Assembling or dismantling an entire show takes two persons about three hours.)

On location, the driver simply adds three legs to each pair of

**Mini-Van exhibition panel. The legs are removable for shipping.**

teers and, because of the backgrounds of its members, has sent those individuals best equipped to function as public lecturers.

## Who the senior volunteers are

The majority of the volunteers are upper middle class, white, female, and Jewish—although this description is far from inclusive. The spread of personalities and abilities within the group is wide: some volunteers have difficulty following the art historical training lecturers, whereas others are able to break into the lectures with additional pertinent information when an area in which they are knowledgeable is being discussed. One confessed that although he loves telling the stories of pictures, he has no understanding of the "art part" and has picked up the "isms" from an art book of his daughter's.[1] Many of the lecturers are retired schoolteachers who traveled widely during summer vacations and now use this experience to advantage. One woman regularly includes in her Gauguin lectures slides she took in Paris and Tahiti.

## The lectures: topics and format

Most of the senior volunteers stick closely to the basic infor-

mation they were given in the training sessions. They say that their favorite subjects are van Gogh, Gauguin, Toulouse-Lautrec, and Chagall. As they become more experienced, the volunteers are encouraged to branch out in the exploration of new topics, and many of them do, adding such subjects as Chinese, early Mesopotamian, and Egyptian art; Flemish and Dutch painters; fashion in art; the "Ash Can" school; and African art. Although some lecturers develop expertise in a single area, others are able to talk on a variety of subjects. One volunteer gives thematic talks—the nude, hats, animals, flowers—and prepares a new one virtually every time she speaks.

The volunteers' lecturing techniques vary as widely as the lecture topics, but the basic format is a seven- to ten-minute talk followed by a slide show. Some volunteers are highly "audience conscious," able to adapt a single lecture to various groups. When speaking about Chagall to a Jewish group, one lecturer stresses the Jewish symbolism and representations of ghetto life in his paintings; this same lecture before a Puerto Rican group becomes the story of a poor boy who made good. Some volunteers divide their lectures into distinct units and place accompanying slides in three separate

panels, two at the ends and one at the central hinge. The panels can then be arranged in a variety of ways to conform to available space. In one location this might be a six-pointed star, for an exhibition-in-the-round; in another, four pairs may be set in a central group with two others standing free.

Art work cannot be removed from the panels without disassembling them, a process that requires special tools, though not special skills. Each pair of panels weighs over 250 pounds and thus is virtually theftproof.

Wallace May, director of classes for continuing education at the

**A Mini-Van photography show holds the attention of a visitor at one of the Kansas sites where it remains for one or two weeks. The panels in which the art is displayed also protect it in transit.**

university—the department that arranges the van's schedule—estimates that the unit costs about $1,000 a year for vehicle and van maintenance and gas. Labels, which the museum has decided are more useful than catalogs, fabric to cover the panels, and plexiglass cost another $200–$300. In addition to the labels, the museum and the Division of Continuing Education have experimented with a device called an Audiscan, which contains a tape recorder and a rear-screen projector that can be used to show slide transparencies as part of the exhibition.

## Scheduling and audience

Although each exhibition is usually scheduled to stay in each location for one week, many institutions try to keep it for at least two weeks. The van travels extensively in the western part of the state where the towns are small and the rural areas sparsely populated, so an average audience is 150–200 persons a week. University officials estimate that somewhere between 3,000 and 10,000 persons visit the exhibitions each year, most of them in libraries (often one room in a downtown building), banks, and community colleges (the latter, says May, full of people interested in the arts and in education)—though the exhibitions can be set up in any building that can provide the security and special lighting they require.

For the modest sum the van and its portable exhibitions cost, the museum and the university are satisfied that people who may have no other contact with art are receiving a "high-quality" exhibition program. Furthermore, says May, the show "looks good no matter where it is put."—*J.A.H.*

*Photograph courtesy of the University of Kansas; drawing by J. A. H.*
*This report is based on interviews with Wallace R. May, Director of classes for continuing education; O. B. Shipman, Cabinetmaker, Museum of Art; and Dolo Brooking, Curator of Museum Education, Museum of Art—all at the University of Kansas, Lawrence, January 21 and March 25–27, 1974.

trays so that the talk can be cut short if the audience starts to fidget, or certain points expanded on if they arouse special interest. This flexibility is valuable, say the lecturers who use it: people in a nursing home are usually not interested in the same things as are those bustling around the Central Presbyterian Church.

Other volunteers emphasize content rather than presentation in their lectures and like to think of themselves as experts in a given specialty. One volunteer says she has read the entire Bible so that she can answer questions about the discrepancies between science and religion that are provoked by her archaeological talks. If some of this lecturer's scholarly interests are lost on her audience, another lecturer is able to keep his audience actively involved with speculations about why some of Leonardo's paintings are unfinished, the creative impulses of Marc Chagall, the undue credit de Gaulle received for the liberation of Paris, and blind fish that inhabit caves.

### The senior citizen audience

Card-playing and dancing are favorite activities in New York's senior citizen centers; cultural programs usually run a poor third in popularity, say some observers, functioning chiefly to give the "fun" activities respectability and legitimacy. Nevertheless, arts and crafts classes are well-attended in the centers, so the volunteers, at this writing, were planning a series of craft-oriented lectures to be given together with studio classes conducted by Elder Craftsmen, Inc.

If audiences do not always share the senior volunteers' enthusiasm for art, they are usually responsive to the fact that the program is being presented by one of their peers. Post-lecture questions as often revolve around the senior volunteer program itself as around the art the volunteers present. After one lecture four members of an audience of fewer than thirty asked for the name and phone number at the Metropolitan to call about a volunteer job.

### Problems

Volunteers and museum staff agree that the program's biggest problems are getting and organizing the slides and operating often recalcitrant projectors. The Metropolitan slide library has been an important partner in the program's success: each month 600 or more additional slides are in circulation as a result of this program, all of which have to be reserved, charged out, returned, and refiled. When several borrowers are using slides from the same period, there is competition for basic material. Accustomed to serving a professional public, the library has had to adapt its procedures to these new borrowers. Slide librarians have found the senior volunteers eager and conscientious in the preparation of their lectures, but inclined to forgetfulness afterward. Some volunteers are uneasy about asking necessary questions that have been asked before; others ask too many questions. To help ease the way for the volunteers, the slide library staff has prepared mimeographed sheets on the use of the library and

the operation of projectors. Published slide sets with scripts have also been helpful to volunteers so that they do not always have to depend on their own initiative and organization of complicated material.

Operating the projectors is another problem. Outwardly simple, they can be tricky and obstinate. In the middle of one lecture a volunteer looked down at her projector and exclaimed, "It's going by itself! Why is it going by itself? I can't talk that fast! What am I going to do?" Somehow the button on the Carousel projector had switched to automatic, and the lecture was thrown into five minutes of chaos before the error could be corrected. Another lecturer consistently projected all his slides either upside down or sideways. Often the senior citizen centers do not have the proper equipment, so the Metropolitan has tried to solve the projector problem by sending a department member to the lecture with a projector from the museum and asking him to run the machine and help with mechanical problems as they arise.

### Scheduling

Lectures are given every other day on the average—the heaviest schedule the department feels it can handle. Because of an announcement that has gone to most senior citizen centers, the demand is heavy, and lectures are scheduled two to three months in advance. Although volunteers were at first apprehensive about moving around the city, they now serve senior citizen organizations in all New York neighborhoods, from Park Avenue to Bedford-Stuyvesant to Flushing.

Senior citizen centers in New York are notorious for their disorganization. In one case a bingo game was scheduled at the same time as the lecture; in another, it was a doctor's visit. In addition, audiences are not always told about an upcoming lecture, or the room is not set up in time or cannot be darkened or lacks a screen.

When these things happen, volunteers feel their program is just part of the center's "busy work" rather than an important activity. To make the lectures mean more to the centers, the museum has considered instituting a small charge. It has also planned a luncheon at the Metropolitan for directors of the centers and the volunteers, both as an orientation to opportunities for senior citizens in the Metropolitan and as a forum where volunteers and directors can share their needs and problems.

To safeguard lecturers against such day-to-day difficulties as strange neighborhoods and runaway projectors, senior volunteers usually travel in pairs, one as the lecturer and the other as the backup person. Training staff emphasize that every plan should have an alternate: thus, lecturers who plan to have a projector sent from the Metropolitan often bring their own as well.

When one lecturer discovered all his slides were projecting wrong way up, his partner came forward and gave a short talk until everything could be straightened out. Senior volunteers travel in pairs, too, because they like to keep abreast of each other's lectures. Two women, one of whom talks on Egypt

and the other on Mesopotamia, attend each other's lectures so they can maintain a running debate on which civilization invented writing.

To help the senior volunteers move ahead in their knowledge of the field and the techniques of lecturing, the department in 1974 instituted bimonthly meetings. In the morning there is an art lecture and in the afternoon the volunteers meet with a museum staff member to plan and schedule the coming lectures, discuss problems, and share experiences and ideas. In a recent session one volunteer, an actress, spoke to the group about eye contact and voice projection.

## Other activities

In their visits the senior volunteers have discovered that their audiences hardly knew the Metropolitan Museum existed. Although the lecture program was originally designed to reach audiences neither mobile enough to travel to the museum nor hardy enough to make their way through its long corridors, increased attempts have been made to encourage follow-up visits to the museum. By spring 1974 one museum tour had been given to senior citizens by the volunteers, and others were planned.

The senior volunteers, some of whom come to the museum several days a week, are active in the museum in other ways, too. They visit exhibitions, partly to help prepare their lectures; attend gallery talks and auditorium events; help with paper work in the community programs office. Two volunteers spend one day a week filing slides for the slide library.

A big annual event is the Senior Citizens' Holiday Party, now staged mostly by the volunteers themselves, which takes place in December in the Metropolitan's Medieval Sculpture Hall around the museum's Christmas tree. The 1973 party featured a concert by the Sirovich Senior Center Orchestra and a welcome for the nearly 400 guests by the museum's director, Thomas Hoving. To accommodate an impossibly large potential audience in the fairest way, the museum sends invitations to senior citizen centers on a rotating basis. But so socially prestigious has the event become in the senior citizen community that political pressure has been exerted for an invitation.

## Funding

Almost all senior citizen activities at the Metropolitan are paid for out of the operating budget of the department of community programs; those funds, in turn, come from the National Endowment for the Arts and the New York State Council on the Arts, not the museum. Expenses for the program run about $3,500 annually, including the party, which got extra funds from the New York Telephone Company in 1973.

## What the program means to volunteers

To judge from their bright eyes and eager interest, senior volunteers are well served by the program. As the slide lectures are an open-ended activity, preparation of a talk can become an all-consuming occupation. One volunteer speaks of the heavy load of free time she was faced with before she came to work at the museum. Another tells of friends who upon retirement have simply dropped dead because they have no interest to replace their jobs.

The volunteers seem to find their new roles at the Metropolitan exciting and useful. The nature of the Metropolitan Museum itself is a factor here. Intimate association with a prestigious public institution is a source of pride to the volunteers and an affirmation of their worth to society. Small touches—the official I.D. cards and behind-the-scenes visits to places like the Arms and Armour workshop—are important psychologically in the success of the program.

Few of the volunteers had any background in art before coming to the Metropolitan. One signed up for the program in the belief that it was a course in photography, but she has stayed on to become deeply involved in her museum activities. A woman who had been an accountant helps senior citizens in another program fill out their tax forms; for her, both programs have similar meaning. It would seem that it is not a love of art that has created the bubbling enthusiasm of these senior citizens, but rather the new focus the program has given their lives. One volunteer speaks eloquently about the vast resource of experience and expertise that senior citizens represent. The Metropolitan Museum is starting to tap this resource.—*F.G.O.*

## Note

[1] For sources of quotations, see list of interviews at the end of this report.

## Interviews

Bellaire, Cheryl. Senior Library Assistant, Photograph and Slide Library, Metropolitan Museum of Art. March 6, 1974.

Feigenheimer, Aviva. Art Instructor, Bland Senior Citizens Center. February 26, 1974.

Friedman, Robert. Instructor, Senior Citizens Slide-Lecture Training Program and Seminars, Metropolitan Museum of Art. February 28, 1974.

Leone, Clara. Coordinator, Central Presbyterian Church Senior Group. February 1, 1974.

Nolan, Margaret P. Chief Librarian, Photograph and Slide Library, Metropolitan Museum of Art. March 6, 1974.

Sims, Lowery S. Education Assistant for Community Programs, Coordinator, Senior Citizens Slide-Lecture Program, Metropolitan Museum of Art. January 11 and February 28, 1974.

And the following senior volunteers:

Alexander, Bertie. February 28, 1974.

Alexander, Edith. February 28, 1974.

Alexander, Herbert. February 28, 1974.

Bruney, Joseph. February 26, 1974.

Bucode, Reatta. February 28, 1974.

Herman, Jean. February 28, 1974.

Isenberg, Marion. February 28, 1974.

Lederer, Hilda. February 1, 1974.
Miller, Frances. January 16, 1974.
Morel, Dorothy. February 28, 1974.
Payne, Ruby. February 26 and 28, 1974.
Sokoloff, Nekha. February 28, 1974.
Wachtel, Rebecca. February 1, 1974.

# THE WADSWORTH ATHENEUM TACTILE GALLERY

Wadsworth Atheneum
600 Main Street
Hartford, Connecticut 06103
**Museum visitors, both sighted and blind, gain nonvisual aesthetic experiences in a special gallery that emphasizes textures, smells, sounds. Museum staff hoped someday to use the gallery as a laboratory for the study of nonvisual perception and the relationships among the senses. CMEVA interviews and observations: October, November 1973; February, May 1974.**

### Some Facts About the Gallery

**Title:** The Tactile Gallery.
**Audience:** General public, including the blind. Average monthly attendance is 1,400, about 10 percent blind persons.
**Objective:** To provide visitors with nonvisual aesthetic experiences.
**Funding:** $29,000 for installation and $16,000 to $20,000 annually for operation. Sources: Lions Clubs of Greater Hartford; Ladies Visiting Committee of the Connecticut Institute for the Blind; Concordia Foundation; Howard and Bush Foundation.
**Staff:** One full-time curator of the gallery; 18 specially trained volunteer guides. Education director assists in planning and installing the exhibits; consulting architects and artists hired for some shows.
**Location:** At the Avery entrance of the museum.
**Time:** Regular museum hours; 11 months a year. Gallery opened in May 1972.
**Information and documentation available from the institution:** None.

From September to November 1973, the Wadsworth Atheneum sponsored an exhibition called "Fibers." Designed to provide visitors with experiences in nonvisual perception, the exhibit was contained in the museum's 20 feet x 29 feet Tactile Gallery.[1] In seemingly random arrangement, the gallery was hung with strips of rubber, steel, and plastic; pieces of alpaca, raffia, and natural jute; woven yarn and macramé; and straw, ribbon, and feathers—all selected for their texture, sound, and smell.

Just outside and to the left of the gallery was an "orientation space" containing large cupboards whose inviting portholes were lined with various fibers. Visitors could put their hands into the holes and sense by touch contrasting materials—thick and thin, soft and hard, rough and smooth.

One November afternoon eight visitors (all of them sighted) gathered to tour the exhibition. A specially trained guide asked them to put on blindfolds and take off their shoes, then led them single file into the gallery. For the next half hour, touch, sound, and smell became the only means by which they negotiated and experienced their environment.

The group entered the gallery through a doorway perceptible only by a curtain of feathers that brushed lightly over the face and body. Inside, the next tactile encounter was with tall, smooth cardboard tubes. Then there were large knotted-rope wall hangings that formed strange and unexpected shapes. Still following the guide, visitors next found themselves in the midst of hanging rubber and plastic strips separated by lengths of ribbon and, just beyond, dangling metal coils. Then another confrontation with rope—a mobile sculpture—and more smooth rubber strips juxtaposed with macramé hangings and rough braided jute.

When the tour was completed, the visitors were invited to go back inside the gallery without blindfolds and "rediscover" the objects visually.

"Fibers" was one of a series of exhibitions organized by the Education Division of the Atheneum after the opening of the Tactile Gallery in 1972. The shows, which were well received by the public—the average monthly attendance was 1,400—had a decidedly educational purpose: literature on "Fibers" explained to visitors that weaving has been historically regarded as a craft but that contemporary weavers have developed it as an art, producing fiber sculptures for aesthetic rather than functional reasons. The objects in the show included works that demonstrated techniques used in weaving, knitting, wrapping, braiding, and knotting and thus provided visitors with a heightened awareness of both the visual and nonvisual aspects of these art forms.

### The development of the gallery

The Tactile Gallery was originally conceived as a gallery for the blind and partially sighted. The proposal for it was made in 1967 by members of the Ladies Visiting Committee of the Connecticut Institute for the Blind. During that year, several members of the committee visited the Mary Duke Biddle Gallery for the Blind in Raleigh, North Carolina, and returned to Hartford feeling the Atheneum should consider establishing a similar facility.

Within a few months Roger Selby, then education director for the Atheneum, was put in charge of a feasibility study funded by the Lions Clubs of Greater Hartford. He and his staff conferred with authorities on blindness throughout New England and came to the conclusion that, although blind people should be considered and served, they should be made to feel part of, not isolated from, the world of sighted people. So the emphasis was shifted from a "gallery for the blind" to a "tactile gallery" for both the sighted and blind who, the staff felt, could learn from each other.

Selby drew some further conclusions from the results of the study that influenced the development of the gallery. They included the following:

1. The blind and partially sighted rely primarily on sound rather than touch to negotiate and gain a sense of space.

Therefore, to be as aesthetically and functionally rewarding for the blind and partially sighted as possible, exhibitions should be designed to stimulate perceptual inquiry by nonvisual senses other than touch—and especially by hearing.

2. Sighted people would be attracted by an opportunity to explore and develop the nonvisual senses and thus should be encouraged to visit the gallery.

3. The purpose of such a gallery should not be to cause the sighted to sympathize with the blind (though this may happen). Rather, the focus should be on exploring and engaging the nonvisual experiences of the visiting public.

4. A gallery set up along experimental lines (in which distance, time, touch, sound, smell, and objects could be combined) would lend itself to research into nonvisual aesthetic experiences of both the blind and sighted.

The study was completed in 1969 and put forth the recommendation, approved by the museum's board of trustees, that the Atheneum install a permanent nonvisual gallery for both blind and sighted visitors. Because of their strong interest in the blind and their belief in the concept of the proposed gallery, the 43 Lions Clubs in Hartford and Litchfield counties (district 23B) guaranteed funds for installation and the bulk of the operating expenses for three years ($29,000 for installation and $16,000 to $20,000 a year for operation). Some of this money was given to the Lions Clubs by the Ladies Visiting Committee, the Concordia Foundation, and the Howard and Bush Foundation. A local architectural firm was hired to design the gallery, and a curator was hired by the education division to supervise its operation.

### The gallery in operation

It was not until May 1972 that the Tactile Gallery opened and its first exhibition mounted. The Center for Advanced Visual Studies at the Massachusetts Institute of Technology, headed by Gyorgy Kepes, agreed to design and set up the first show, "Dialogue for the Senses."[2] Selby described the exhibition as "an attempt to prompt visitors to discover connections between the senses by presenting analogous and contrasting elements and objects."[3] Included in the show was a relief panel, nearly 30 feet long, of sand, gravel, and glue on canvas; a series of textured columns; a curvilinear maze of 8-foot-high peg board; a row of goblets upon which drops of water fell in syncopation; and a modular sound-producing floor.

After "Dialogue," the education division brought to the public a variety of tactile and other kinds of participatory exhibitions. They have included "Forms for Dance," a combined event and exhibit at which participants were invited to expand their awareness of the variables of space, movement, and composition through dance, free association, and other interactions with geometric sculptured forms; "Chair," an exhibition of a dozen chairs (ranging from astronaut Scott Carpenter's contoured seat from a space capsule to a seventeenth-century piece from the museum collection), selected for their contrast in style, shape, and material; "Fi-

bers"; and "Faces," an exhibition of sculptured heads—portrait busts, low reliefs, and masks, which, when touched, conveyed the subtleties of contour, texture, and temperature. The gallery also housed "The Shape of Sound," which consisted of three auditory pieces—*Waterfall, Seascape,* and *Afternoon Rain.* Its attraction, according to artist-composer Howard Jones, was that "sounds experienced through the passage of time alter the visitor's perception of space. The sounds . . . have been selected, manipulated, altered and juxtapositioned [sic] in order to achieve a super-real experience in time."[4]

The exhibitions were planned by Selby and Curator of the Tactile Gallery Bette Leicach and installed by the education staff, sometimes with the help of consulting artists. The shows changed four times a year and cost between $2,000 and $8,000 each.

Guides for the exhibitions were a group separate from the Atheneum's regular docents: more than half were full-time students from nearby colleges and universities; several members of the Lions Clubs volunteered their services on the weekends. However, Selby planned gradually to involve the regular docents in the Tactile Gallery. In early 1974 he was preparing a special training program for them on the techniques of guiding visitors through the gallery, sensory perception and dynamics, environmental art, and museum education. (For a report on the Atheneum's docent program, see chapter 5.)

Most visitors to the gallery were casual museum-goers with varying levels of art experience. Said Ms. Leicach, "We believe that many people coming to the gallery are new to the museum and that the gallery serves as an introduction to the rest of the museum for them."

School groups constituted another major audience for the gallery. In the case of one group from a local elementary school, their tour of "Dialogue" led to the construction of their own 6 foot x 6 foot classroom version of the gallery, complete with plastic pipes, fabric- and fur-enclosed tubing, and on the floor, a yellow plastic duck that squawked when stepped on.

### Assessing the Tactile Gallery

An advisory committee of educators, individuals representing the blind, members of the Lions International, and museum staff has closely observed the activity of the Tactile Gallery since its inception. In that time the committee, and indeed many others involved in the operation of the gallery, has come to better understand its strengths, limitations, and potential. By her own observations and surveys, Bette Leicach has concluded that a majority of visitors came away from the exhibitions feeling "aesthetically enriched"; she noted that for many of those visitors the spatial and logistical layout of an exhibition offered an aesthetic experience apart from the objects. Selby and Leicach agreed that orientation devices proved useful but were sometimes difficult to mount and maintain. They cited the "touch cupboards" used for

"Fibers" as an example: after several weeks of being squeezed, pulled, and otherwise manipulated, the pieces of rope, macramé, and plastic were loosened and altered. (There was apparently no carry-over effect into the gallery, however. In the three months "Fibers" was open to the public, none of the exhibits was damaged.)

Asked what he felt the limitations of the gallery were, Selby responded,

> I don't believe that permitting people to touch art will concomitantly provide them with an art experience. . . . People can feel faces but generally cannot detect the subtle moods in them. There have been indications that people mistake a ponytail for a handle, a soft hat for a helmet, a young child's head for that of an old man. Two portraits of the same man go undetected. The point is that if a person cannot perceive the emotional and visual components of a work by touch, can he hope to have the artistic experience inherent in the work of art?

Of some disappointment, too, for both the Atheneum and the Lions Clubs is the fact that relatively few blind people toured the gallery. Selby estimated that no more than 10 percent of the visitors were blind. However, in an article about the gallery, "On the Edge of Vision," Sallie Calhoun points out that "50 percent of the adult blind population is over 65 and many are thereby otherwise handicapped."[5] Clearly these handicaps were a significant factor in the low attendance by blind people. To increase the number of blind visitors, Ms. Leicach began working through agencies in Connecticut serving the blind and sending letters to more than a thousand blind people in the Greater Hartford area to inform them about the facility and offer free transportation to and from the museum. In addition, funds were sought to provide loan materials to those unable to visit the gallery.

The small size of the gallery also caused some concern. On weekends it was common to find visitors lined up, sometimes for more than a half-hour, waiting to tour the gallery. Even with a system whereby fully 75 percent of all tours were prearranged, drop-in visitors still presented a problem.

To accommodate more visitors and reduce the waiting time, the advisory committee considered enlarging the gallery to allow for duplicates of exhibitions or several concurrent exhibitions—a move it saw as preferable to relocating the gallery: easy access for blind and handicapped visitors is critical, and that is what the present location affords them.

As a further measure to accommodate blind visitors, the study space next to the gallery was turned into an exhibition area for the exclusive use of the blind. It consists mainly of works from "Faces" that are on permanent exhibition.

### The gallery as research laboratory: plans for the future

In 1975 the advisory committee planned to begin looking for funds to conduct research into nonvisual perception and the aesthetic experience. The museum staff and Selby in particular looked on the gallery as a laboratory that could yield valuable insights and data here. Indeed, Selby's own skepticism about the ability of people to "have the artistic experience inherent in the work of art [by touching it]" probably requires probing, as does the question of how information imparted before and after a tour of the gallery might bias the experience. (Recalling the "Chair" exhibition, Selby observed, "Many visitors found Scott Carpenter's chair uncomfortable and unsettling; yet once blindfolds were removed, they 'saw' the chair and were 'told' what it was; many of those same people were not only anxious to rediscover it, but did so with great satisfaction.")

Ms. Leicach, who has guided many blind and partially sighted visitors through the gallery, has found that for a majority of the congenitally blind, it is difficult to abstract from a work of art the concepts of form, shape, and composition. If the gallery is to serve its congenitally blind audience, she feels, certain questions must be asked: for instance, what combination of objects, techniques, and symbols can give this audience the aesthetic experience? How, if at all, does that experience differ from that of the partially sighted visitor, or the sighted adult or child?

Selby has suggested further areas he thinks need to be investigated: what can be determined by touch; what correlations exist among the senses; how can visual works in a museum be enhanced by nonvisual means; what insights can the blind and sighted share with each other; is the object or the experience the more crucial aspect of the human encounter with art?

Provided that funds can be found, the museum staff hoped to hire an educational or experimental psychologist to investigate these and related questions, using the Tactile Gallery as the laboratory. The findings of such research would no doubt be of value to any museum interested in setting up a tactile or, perhaps more correctly, a multisensory gallery serving both a general and specific public.—*E.H.*

### Notes

[1] In September 1974, the name of the gallery was changed to "Lions Gallery of the Senses."

[2] The center was established in 1967 as an organization to further collaboration among artists, scientists, and engineers. Kepes describes its aims in an exhibition catalog:

> ". . . to investigate the possibilities of creative work on a civic scale that could give new artistic dimensions to our urban environment, and thus revitalize civic awareness to environmental values . . . to develop participatory art forms; spectacles, events and pageantry that might bring a new sense of community to isolated individual lives . . . [and] to learn to utilize new techniques of communications media to develop our sensibilities as well as our consciousness of our present ecological and social situation."

[3] For sources of quotations without footnote references, see list of interviews at the end of this report.

[4] "The Shape of Sound," exhibition catalog, p. 1.

[5] Sallie Calhoun, "On the Edge of Vision," *Museum News,* vol. 52, no. 7 (April 1974), p. 38.

## Interviews

Leicach, Bette. Curator, Tactile Gallery, Wadsworth Atheneum. November 1973; February 14, 1974.

Selby, Roger. Education Director, Wadsworth Atheneum. October, November 1973; February 14, May 20, 1974.

## ALBRIGHT-KNOX ART GALLERY: "MATTER AT HAND"

Albright-Knox Art Gallery
1285 Elmwood Avenue
Buffalo, New York 14222

**With an exhibition for the blind and handicapped, the Albright-Knox Gallery discovers the rewards and complexities of serving this special audience: most visits are institutional, not individual; scheduling must be worked out carefully with the appropriate agencies; the volunteers must be reliable; repeat visits are important for workshops, and workshops are an important part of the experience. CMEVA interviews and observations: October and December 1973; June 1974.**

### Some Facts About the Program

**Title:** "Matter at Hand."

**Audience:** 560 blind and handicapped persons attended the exhibition.

**Objective:** To serve the blind and handicapped by providing them the opportunity to touch sculpture and to participate in clay sculpture workshops.

**Funding:** $1,212.36 (itemized: $100, honorarium; $690, teacher fees; $406, workshop supplies; miscellaneous, $16.36). Source: Members' Advisory Council. Cost per person: about $2.15.

**Staff:** Junior Group (21 members) plus 55 outside volunteers.

**Location:** Education department exhibition corridor and gallery studios.

**Time:** "Matter at Hand" was open for three weeks, May 15–25 and May 29–June 3, 1973. Regular and rigid visiting times were scheduled in the morning and afternoon every day the gallery was open; some of those times went unused.

**Information and documentation available from institution:** None.

"Matter at Hand," an exhibition for the blind and handicapped, was conceived as an experiment to serve that special audience by inviting them to a sculpture exhibition they could touch and to workshops where they could do simple sculpting in clay. Curator of Education Charlotte B. Johnson suggested it to members of the Junior Group, an auxiliary of the Albright-Knox Art Gallery. They called associations serving the blind to ask if the idea would be welcomed. Their telephone survey indicated not only that it would be, enthusiastically, but that other handicapped persons should be invited, too, and so "Matter at Hand" came to life.[1]

The Junior Group is a committee of young women (who must be under 35 when elected) interested primarily in children and what the gallery's education department can do for them.[2] The group sponsors children's movies and the children's room; it also started an inner-city mobile art studio (for a report on this program, Color Wheels, see chapter 6) and the Art to the Schools project. As one docent put it, the group's members "basically come up with ideas."[3] They also come up with money, or persuade others to: the Members Advisory Council agreed to underwrite the expenses of "Matter at Hand" up to a limit of $2,000.

### The volunteer staff

Though members of the Junior Group sponsored the program, they could not sustain it alone. To solve the problem of additional volunteers, they turned to established volunteer groups: the Members Council and the docent training courses at the Albright-Knox, the Junior League of Buffalo, Temple Beth Zion's Service to the Sightless, the YWCA, and their friends. The response: "fantastic." Two men were among the volunteers, a college student and an optician who spent his free Wednesdays at the exhibition.

Volunteers attended a single training session. The first half of the two-and-a-half-hour session was devoted to comments on the sculpture chosen for the exhibition by Miss Johnson. Most of the selected sculptures were set up in the auditorium, where the session took place. At that session volunteers received a map of the education department (in whose gallery the exhibition would be mounted), a list of the sculptures with background information on each, job descriptions and the names of responsible volunteer personnel, and an "inspirational message" on the values of sculpture.

The second half of the session was handled by Dr. and Mrs. Kenneth Cross. Dr. Cross, research director at the Research and Development Complex, State University of New York at Buffalo, is totally blind. He and his wife, who is also blind, spoke about blindness and ways to approach handicapped persons. Talk just as if they were sighted, Dr. Cross recommended. Don't shy away from saying "look at this" or from color, because "color means something to each of us."

### The audience

The original audience of blind persons was considerably broadened to include all handicapped persons: the telephone survey had indicated that the blind constitute a very small part of the handicapped audience and that agencies serving other handicapped persons would willingly participate in the program. The decision to exclude the general public was made on the basis of two considerations: (1) to admit the general public during "off-hours" would cause security problems, and (2) to admit the general public while the special public was at the exhibition would be at cross-purposes with the intent of the exhibit.[4]

In the end, the audience consisted of 560 persons in 16 different groups, who attended 23 sessions during the 15 days the exhibit was on. Thirteen of those days were set up to provide three separate visiting times; two of the days (both

Sundays) were scheduled for only two visiting periods. Had all the visiting sessions been used, there could have been 43 different visiting sessions instead of the 23 that were actually offered. Of the 560 visitors, 235 were blind. The others were handicapped in various ways, not only by physical infirmities; particular "social infirmities" qualified some groups for admission, such as groups coming from vocational rehabilitation services.

The State of New York forbids the disclosure of a handicapped person's name to the public. The only way to reach handicapped persons, therefore, is anonymously or through the agencies that serve them. The agencies contacted by the Junior Group provided transportation and their own volunteers and took complete charge of inviting and arranging the visits at times specified by the gallery volunteers, who scheduled reservations in definite time slots: 10–12 in the morning, 1–3 in the afternoon.

## Costs and objectives

The first effort to schedule volunteers proved excessively difficult; a single "master" schedule apparently confused all the volunteers. Clarity and order were restored by the appointment of a receptionist, a member of the Junior Group who served as coordinator for each time slot and was responsible for the volunteers assigned to that slot. Four or five group members kept themselves available to fill in for any volunteer who could not meet her obligation.[5]

Each volunteer docent was assigned up to four clients and stayed with them for their entire two-hour visit, in the workshop as well as in the exhibition area. The receptionist remained free to coordinate the groups, to help press and television, and to fill in as docent when needed.

The cost was kept well below the Members Council limit of $2,000. Two fees, totaling $100, were paid to Dr. and Mrs. Cross. Two teachers were paid $15 each for 23 workshop sessions, at a cost of $690. Workshop supplies cost $406, and setting-up expenses came to only $16.36. Total costs out of pocket were, therefore, $1,212.36. Free services included Braille and large-type labels written and mounted by an assistant curator, Braille typing and typesetting by the Buffalo Association for the Blind, and all work by the gallery itself.

The stated objective of "Matter at Hand" was, according to the Junior Group's report, to "service the blind by allowing them to touch the sculpture and then involve themselves in simple sculpturing in a workshop with clay."[6] A press release stated, "Appreciation of sculpture is beyond the visual. On the same parallel the service of a museum must also reach beyond its traditional audience."[7]

A member of the Junior Group talked about another objective:

I think we were honest with ourselves. . . . We were looking for something that volunteers were going to enjoy doing and get satisfaction out of. It's becoming more and more difficult for volunteers, for women who are well

trained, to feel that what they are doing has been a worthwhile venture . . . and here we have an A double-plus for a project that possibly the volunteers got more out of than the people who came.

The curator of education demurs: "I would hesitate to say the volunteers got more out of it than the audience. . . . These are two different kinds of responses, and there's no way to measure them precisely. But we can only conclude on the basis of returned questionnaires that the audience got something, too." One of the chairmen felt "it had unlimited value—for the people who came and had experiences they'd never had, on the institutional level where it brought some agencies into contact with the gallery for the first time, and, speaking very selfishly, it was the most memorable experience I've had."

## The exhibition and workshop

Participating institutions included the Buffalo Association for the Blind, two public schools, West Seneca State School for the Mentally Retarded, Niagara Frontier Vocational Rehabilitation Center, Buffalo State Hospital, Chautauqua County Association for Retarded, Goodwill, Salvation Army, School for the Blind in Batavia, the Rochester Association for the Blind, and others. Most were called during the exploratory phone survey—as were others who did not use the exhibition—and indicated interest. Some expressed enthusiasm, others caution (like the art teacher at one school who suggested the exhibit be on the ground floor and the works very stable because the children's muscular control was a problem), and still others anxiety about transportation or costs. One commented that the idea was "great and long overdue."

Each visiting group was split when it arrived at the gallery, half going into the workshop, half into the exhibition. Lenore Godin, a group member, observed,

Some of the people resented coming in and doing clay work. Their response was, I do that all the time. When that was the case, we just didn't push them to do it at all. Others—a few really—were too uncomfortable looking at the exhibits. They just didn't know how to relate to it so they spent the whole time in the workshop. We set it up in a flexible enough manner so that they were not forced to go to the workshop or were not forced to go to the exhibit. They could do either. We did find that two hours is too long a time, and that an hour is too long in each place. We only needed a half hour . . . and as the week went on they spent more time in waiting to take their coats off and socializing.

Both workshop teachers reported satisfactory experiences and expressed particular pleasure at some of the work done by blind visitors. But as Caroline Hassett, a cochairman, reported, the workshop teachers felt frustrated because they could work only once with each group of this special and unfamiliar audience; they recommended repeat visits for any future workshops for the handicapped.

A visitor who made something in the workshop could have

it wrapped to take home. Blind visitors were offered, as a gift, a Braille booklet on the exhibition, which contained information gathered by several members of the Junior Group with the help of education department staff. The same basic information was offered by labels and in the docents' talks.

Information was not, however, the primary purpose of "Matter at Hand," as a segment of the "inspirational message" suggests:

Each visitor could tactily [sic] experience each sculpture and communicate with that spiritual message of the arts. The visitor could glean factual information from the volunteer guide as well as from Braille labels, large-type labels and Braille booklets. The visitor could express his own creativity in the workshop under professional guidance. The exhibition was held in the Education Department wing; as a result the sighted also enjoyed viewing exhibited work done by children in the Creative Art Classes. To a few the day proved to be only an outing while to others it was truly an artistic awakening.[8]

The 19 sculptures were chosen by the curator of collections and an assistant curator for their tactile value and for their sturdiness: they could be touched over and over without undue risk or damage. The sculptures included a variety of materials and sizes, from an Egyptian piece to a Jaacov Agam sculpture that makes music when touched.

## Characteristics and reactions of the visitors

In the exhibition gallery, each group of visitors was accompanied by its own agency volunteers ("some good, some not very good," observed an Albright-Knox volunteer). About 20 persons were considered the maximum number who could be in the exhibition area at one time, and there were usually fewer.

The gallery volunteers learned an unexpected fact during the exhibition, that only 2 to 3 percent of "blind" persons cannot see at all. Most see light and shadow, and, as one of the group reported, "when they stand in front of a piece of art work, they can see the shape, maybe not the details but certainly the shape . . . and a good number of them could see enough big color that we found it was a waste not to take them into the gallery itself. And we found that if we took it upon ourselves to walk them into the gallery and show them some of the things there that they were fascinated. And in the workshop, when they were working with clay, it was obvious to us how much they could see and the fact that they were not the way we were picturing blind people."

But even those few who were totally blind reacted to the experience. As one volunteer described a scene, "When they started to feel the Braille, they were reading it to each other out loud. One girl got so excited, the volunteers with her said they hadn't seen her like that about anything. Just those two or three people made the whole thing worthwhile."

Although the Albright-Knox Gallery set aside certain sessions for drop-in visitors and advertised them, the Junior Group report indicates that only five individuals took advantage of the sessions. Serving the handicapped seems to be almost entirely an institutional enterprise. That fact solved a scheduling problem the volunteers had worried about: "We found that as concerned as we were about having enough volunteers on weekends, weekends were not heavily attended either, because you are working through institutions and they tend to plan their [activities] during the week. We had only one heavy group coming on Saturday afternoon. There was nobody on Sunday at all."

Public response to the program was good, the group believes. There was considerable press coverage, though certain aspects of the coverage troubled the gallery. At least one reporter was annoyed to find only handicapped—palsied, crippled, and others—visitors and not blind persons when she came and would not have them photographed. Reporter and photographer were persistent; they came back later to take pictures and do a story on blind visitors.

## Evaluation of "Matter at Hand" by volunteers, staff, and audience

The final report by the volunteers concludes that the experimental exhibition was "a great deal of work" but "a great human experience."[9] A volunteer who thought the experience a fine one nevertheless believes the exhibition was "dealing with a minority of people, and . . . if we tried to justify space here" for a permanent installation for blind and handicapped, "we certainly wouldn't be getting per hour the visitation you want for the space in the gallery."

Between a single experimental exhibition and a permanent installation, such as the Tactile Gallery at the Wadsworth Atheneum in Hartford (see report in this chapter), there is considerable ground to be explored. The curator of education always looked on "Matter at Hand" as "far from a 'one-shot' performance" and believed "that the gallery should offer other opportunities to the same groups for those who wanted more and for those who somehow never made it the first time."[10] One of the cochairmen said that the first time "had to be a step-one, a one-shot single involvement" because the exhibition concept and the audience were so unfamiliar to the gallery staff and to most of the volunteer docents.

Some of the same recommendations came from the docent evaluations as from the representatives of agencies and institutions serving the blind—whose 100 percent return on the Junior Group's questionnaire demonstrates the need felt by those agencies. Primary among those recommendations were shorter visits, return visits, and more opportunities to visit the gallery. The docents, in addition, recommended that color be freely used in future exhibitions and that jewelry not be worn by anyone touching sculpture.[11]

But would they recommend that other art institutions try this sort of exhibition? One group member said,

I think they should try it only if they are aware of how large an undertaking it is. I think the biggest problem is the

volunteering: you had to work with a large group of volunteers and you had to work with people that you could count on . . . and ours were very reliable. They must also have the cooperation, which we had, of the association for the blind or other institutions like that, because they do all the work as far as sending out invitations and getting in touch with their membership.

She did not question the value of the experience for the docents or for the gallery: "I think that a lot of us become very calloused about what we are doing as far as giving tours or going to Art to the Schools, but this was something that gave us a new spark, that made you look at everything else you do a little bit differently." As for the Albright-Knox Gallery, the program and the large group of previously unaffiliated volunteers were "great P.R." The report notes that the museum's image shifted to "more a service level" of operation than it had seemed before. The volunteers invited to help and (in several instances) to give expert guidance were seen as a new source of support in the community.[12]

On the basis of the returned questionnaires and the evaluations by docents and staff, another experiment is being planned. It is to include three short separate workshops, two weeks each of sculpture, painting, and mixed media, and small exhibitions to accompany them. Agencies will be given a choice of exhibitions for their clients. "We're viewing this new project also as a 'pilot,'" says a cochairman of the original "Matter at Hand," because "evaluations of it will help get federal funds for a citywide project involving other museums." The new project will stress workshop experiences, largely because those were preferred by the agency representatives answering the questionnaires. Estimated costs of the new pilot project are higher than those for "Matter at Hand": between $4,800 and $5,000, of which the Members Advisory Council has already promised $3,000.

How does one measure the effectiveness of such a program? In financial terms the outlay was insignificant: a per-capita cost of about $2.15 per person, though only about $1,200 was spent. In public relations terms, it seems significant to a cochairman that people see that "the gallery is reaching out to the community and trying to reach new audiences," and, almost as important, that volunteers who had never before been involved with the gallery enthusiastically worked on the project. ("Very honestly," reports the volunteer leader, "one reason for holding a reception six months after the exhibition was to call these same volunteers back, to [have them] come back to the gallery six months later and still feel welcome and needed.")

And though it has not been "scientifically" measured, the impact on the blind and handicapped audience may have been significant, too. "We do realistically know that we'll have to have people doing evaluation and put it into intelligent form," said Caroline Hassett, one of the volunteers. But no scientific evaluation will persuade or dissuade Lenore Godin, another volunteer, who recalled,

I go back to this one girl who was reading the Braille, who

hadn't been as excited about anything in a long time. So if you are reaching only one or two a day, you feel you are accomplishing more than you usually accomplish in a day. One blind woman said to me, "Isn't this a shame. I've only been blind for five years, and I've always lived right around the gallery before that, and I never came to the gallery when I wasn't blind. Why did I wait until now?"
—A.Z.S.

## Notes

[1] Final Report to Junior Group, "Matter at Hand," by Barbara Herndon and Caroline Hassett, p. 1.

[2] A note on the Junior Group: its board is self-perpetuating, seven members going off each year and seven new members elected. According to a group member, "The only requirements are that they must be a member of the Buffalo Fine Arts Academy, which of course they will join at the time they are elected. . . . When elected, their credentials should show that they have some interest in art, possibly some background, but basically interest and desire to serve. The electing is a sore spot, because it's exclusive. Fortunately it's not exclusive in the way that exclusive usually denotes, but rather exclusive for those who really want to spend time here. It's just a volunteer group who are extremely active."

[3] For sources of quotations without footnote references, see list of interviews at the end of this report.

[4] Final Report, p. 1.

[5] Ibid., pp. 2–3.

[6] Ibid., p. 5.

[7] Press release.

[8] Junior Group "inspiration sheet," unsigned, p. 2.

[9] Final Report, p. 5.

[10] Letter from Charlotte Johnson, December 4, 1973.

[11] Final Report, p. 5.

[12] Ibid., pp. 4–5.

## Interviews

Freudenheim, Mrs. Robert. Volunteer Docent, Albright-Knox Art Gallery, Buffalo, N.Y. Telephone, December 10, 1973.

Godin, Lenore (Mrs. William). Volunteer Docent, Albright-Knox Art Gallery, Buffalo, N.Y., December 17, 1973.

Hassett, Caroline (Mrs. William). Volunteer Docent, Albright-Knox Art Gallery, Buffalo, N.Y. Telephone, June 21, 1974.

Johnson, Charlotte Buel, Curator of Education, Albright-Knox Art Gallery, Buffalo, N.Y. October 24 and December 17, 1973; June 18, 1974.

## THE ADDISON GALLERY OF AMERICAN ART: VIDEO FOR SPECIAL AUDIENCES

The Addison Gallery of American Art
Phillips Academy
Andover, Massachusetts 01810
**The philosophy that art has a "fundamental integrating capacity to make people function better whether they're disturbed or normal" undergirds this museum program that combines video art therapy or training for people in their own settings—mental hospital, city streets, community center—**

with visits to the museum. CMEVA interviews and observations: September, November 1974; May 1975.

**Some Facts About the Program**

**Title:** Addison Gallery Television (AGTV).
**Audience:** The program has two parts: (1) video art therapy for mentally and emotionally disturbed children and adults, both in-patients and out-patients, about 150 persons in all; and (2) video art education and training for black and Hispanic children, teenagers, and adults in communities near the museum, about 50 persons.
**Objective:** To provide video art therapy as a service to in-patients and out-patients of several local mental health institutions and organizations; to offer the museum's traditional resources to groups and individuals—"some of the most seriously deprived people in the area"—who do not usually come to the museum.
**Funding:** About $21,000 in 1974.
**Staff:** 5 part-time professionals; 6 to 10 graduate and undergraduate student interns from Boston colleges.
**Location:** In the museum, at Danvers State Hospital, and in nearby communities.
**Time:** Six days a week, September through May.
**Information and documentation available from the institution:** "AGTV—A Video Art Therapy Project for People with Special Needs," program prospectus; materials listed in the bibliography at the end of this report may also be obtained from the museum.

The Addison Gallery of American Art was established in 1930 on the campus of Phillips Academy in Andover, Massachusetts. A private secondary school founded in 1778, Phillips Academy is now coeducational and comprises 200 buildings on over 400 acres. Theodore Sizer, the school's current headmaster, whose father was director of the Yale Art Gallery from 1927 to 1967, describes the school's founders as "Hamiltonian politically, Jeffersonian educationally."[1] In the academic year 1974/75, the academy enrolled 1,178 students from all parts of the United States and several foreign countries. Most boarded and paid tuition and fees of $3,700 a year.[2] Nearly 100 percent of the academy's graduates go on to college.

Andover and the academy are about 20 miles north of Boston in a region known as the Merrimack Valley. Unlike Andover, a middle- and upper-middle-class community, most of the towns and cities in the region are predominantly working class. Unemployment is chronic; since the large textile manufacturers started leaving the area about 15 years ago, the term "depressed" has often been used to describe the region's social and economic situation.

There is another kind of community in the valley, made up largely of the thousand or so patients at Danvers State Hospital, a mental institution in Hawthorne. Some of Danvers' patients constituted a "special audience" for the Addison Gallery in a program that prompted the gallery's staff to extend its work to other special audiences.

**The Danvers project**

In 1972 Shaun McNiff was director of art therapy at Danvers

and looking for places—museums, for instance—that would exhibit the art work of some of the long- and short-term residential patients he had been working with. Christopher Cook, director of the Addison Gallery and an artist, remembers 1972 as a time when he "really wanted to get something happening between the museum and the community" and when he began to think of ways the gallery might use videotape.

It did not take long for McNiff to convince Cook to have the exhibition at Addison. "Art Therapy at Danvers" was held there in December 1972 and subsequently traveled to several other locations in and around New England.[3] While it was on view at the Boston Museum School, a *Boston Globe* art critic wrote, "The images of drawings and paintings . . . testify . . . eloquently to the degree in which practicing an art can temper and affect the chaos of experience."[4]

After the exhibition left the Addison Gallery, Cook and McNiff decided to produce a videotape of the patients working in their maintenance-room-converted-to-art-studio at Danvers and show it wherever the exhibition went. While Cook was making that tape, moving about the studio with the camera, the patients took a lively interest in his work. Some stopped painting, looked into the camera, and started to talk about what they were doing and why; others asked if they could operate the camera for a few seconds; still others simply smiled or waved at the camera and then went on working. When the tape—the "movie," as several patients called it—was played back, the patients were captivated by what they heard and saw. Encouraged by McNiff, they began to discuss the art they saw themselves making, their social interaction, and their feelings about both of those processes. Thus began the Addison Gallery-Danvers State Hospital Video Art Therapy Program.

It took several sessions before Cook, McNiff, and some volunteers were convinced that the videotape was more than just a "sexy prop." Cook's skepticism—he suspected the novelty would wear off after a few weeks—faded as he saw that the recording and playback of the videotape proved to have a positive effect on the patients and their work.

By fall 1973 the videotape recorder and the small playback monitor had become part of each weekly art session at Danvers. Although drawing, painting, and sculpture were the principal art activities, mime, movement, improvisation, poetry readings, and plays written and performed by the patients were also captured by the camera. Patients also began operating the camera; McNiff recalls that one patient chose using the camera as his weekly activity.

**Museum visits.** Although the program was still in a formative state, Cook decided it was time to add a new dimension: visits to the museum. Few if any of the patients ever talked about going to the museum, but their enthusiasm for their own art work and for the video that permitted them to discuss it encouraged Cook to introduce them to the museum environment. Groups of patients began visiting the gallery, generally about once a month, to see the changing exhibitions.

"The stimulation of the changing exhibitions and the sheer beauty of the museum had some very noticeable effects on them," said McNiff. "By coming here they began to feel a certain dignity that they didn't feel in most other environments. They got the idea that the place really cared about them and that it was for their enjoyment and pleasure."

**The program's purposes.** McNiff has pointed out that there is no one definition of art therapy:

Emotional disturbances are generally described as stages in which the perceptions are confused. . . . What we try to do in the context of art-making is to reorganize visual perception. We've discovered over and over that when you can get a person tuning in to objective structures and relationships—color, shape, form, etc.—he can establish a certain equilibrium and awareness which has a precipitous effect on his total personality.

McNiff's views on art therapy represent only one of several schools of thought on the subject. He is primarily concerned with the development of an individual's cognitive and perceptual abilities and expressive skills through art, not its diagnostic use to analyze unconscious conflicts and psychopathologies.

The following excerpt of a videotaped interview between McNiff and one patient illustrates the kind of discussion generated in the playback sessions and the way perceptual awareness stimulated thought in some patients. The respondent is a woman in her early thirties who has been institutionalized since childhood and working in Danvers' art therapy program since 1970.

Q: Why do you do your art?
A: It's an escape from this cruel wicked world of destruction that you hear about on TV all the time. . . .
Q: Are there other reasons why you make art?
A: To express creation—it's a part of an alliance with the Lord, a part of unity with God.
Q: So you make your art for escape and you make it for spiritual reasons. Are there any other reasons?
A: For pleasure, for the pleasure of sharing it with other people.
Q: How do you feel when people enjoy your art?
A: I feel I can enjoy it with them, and we can talk about the professionals. . . . I like to brag about the famous artists, and when I see somebody paint better than me I smile at their work and say, "That's a real professional!"
Q: What does the Addison Gallery mean to you?
A: Freedom. Freedom from the locked doors of the hospital, from the chaos that goes on there and the constant commands and tensions.
Q: What happens here at the gallery?
A: People enjoy. They look up and laugh. They do unto others as you would have them do unto you.
Q: Is it important to you to come to an art environment like the gallery?
A: Very. It makes me forget things that are depressing.

. . . I love to look at the art work in the gallery. There's so much in art that I don't know about. But sometimes I can learn by just observing the art.
Q: Do you learn more about your art by looking at the work of other artists?
A: Yes . . . Gauguin has colors that stand out against each other and yet they're blended in beautifully. The colors are smooth and neat. I also love Matisse, but I haven't looked at him enough to learn much about him. I've learned a little bit from Paul Klee. He did squares, angles, and different colors. He was very original and very unique. . . . I arrive at my own style by looking at children's art and the works of great masters. The French Impressionists are my favorite.
Q: So, art plays an important role in your life.
A: Yes, it does.[5]

**Ideas about the use of video.** The Addison Gallery's use of video seems far removed from the traditional applications of film by art museums. But its staff members eagerly defend the video program and assert their growing conviction of its value. Fordie Sargent, an Addison art therapist and elementary educator, believes video's greatest benefit is that "it enables clients to see themselves in a postive way." To Judith Grunbaum, an artist who worked in parts of the gallery's developing program, "video helps to bridge the gap between the internal construct of oneself and objective reality." Christopher Cook sees videotape as "the people's art medium. It's the least traditional, least elitist art medium we've got," he said. "The museum can bring it to people without the psychological load of other more traditional art forms."

### Building on the Danvers project

Though Cook, McNiff, and—by spring 1974—a score of art therapists, psychologists, and psychiatric workers had given the Danvers project high marks, Cook was curious whether good timing and sheer novelty alone might have accounted for the program's apparent success. One way to find out, he reasoned, was to continue the gallery's videotape program and invite other groups to participate.

Midway through 1974 Cook decided to extend the gallery's service to some of the numerous community-based mental health facilities in the area and to try to establish relationships with other kinds of community agencies. With the aid of James Keller of the Greater Lawrence Ecumenical Area Ministry (GLEAM), Cook and his staff talked with representatives of over a dozen organizations and enlisted five.

**Hispanos Unidos.** The only social agency in Greater Lawrence serving Spanish-speaking youth, Hispanos Unidos is located in a former church in a section of Lawrence that is low income and working class, a mix of Hispanic, black, and white. Although the agency's services are available to all

area residents, Manager Oscar Rodriguez estimates that 90 percent of its clientele is Hispanic and between the ages of 6 and 16. It is a young organization, too; Hispanos Unidos was organized in 1972 and was without a full-time salaried administrator until Rodriguez's appointment in 1974.

Chess classes, karate lessons, language tutoring, cultural discussions, even a table tennis tournament and a clean-up committee are among activities the agency has offered its clients. When some of them heard about the gallery's plans to work with community groups, they asked Rodriguez to include Hispanos Unidos. Two groups, one of young people and one of adults, began working with gallery staff.

Twelve adults signed up to learn video skills, and six successfully completed the program. "They really wanted to learn the technical aspects of video—how to operate the camera, how to edit, how to produce quality tapes," Rodriguez said. "The therapy format was not what the adults were looking for." The six who finished the program had had some previous experience in their native lands with electronic media, primarily as radio announcers and technicians. For all of them a major goal was to learn to use video as a way to get back into broadcasting professionally, according to Rodriguez: "They saw video as a means of improving their English and learning a profession."

A report on those once-a-week adult sessions describes how they went:

> Each class began with a discussion of one aspect of camera work (framing, long shots, medium shots, close-ups), and members were then asked to practice the various approaches. At the end of each session, the work would be reviewed on the monitor and a critical discussion would follow. Various approaches included dialogue shooting, following focus, shooting rapid action.[6]

Participants went into Spanish-speaking neighborhoods of Lawrence to videotape meetings, they taped classes and events at Hispanos Unidos, and they made short documentaries of various facets of Hispanic life in the Merrimack Valley. These experiences, plus the reviews and critiques that followed each playback, had by 1975 paid off for some members of the group; two worked behind the camera on several productions of a local cable televison station, and a third was negotiating for a nightly 15-minute news program aimed at the Hispanic community.

"When the adults started taping at the Hispanos center, some of the kids became interested in what they were doing and asked if a program could be started for them," reported Julie Cook, one of the two Addison Gallery staff members who worked with children at Hispanos Unidos (the other is Susan Clark). About a dozen children, between the ages of 6 and 12, met with the staff once a week. As the children were encouraged to decide what they wanted to do at those meetings, and as there were often art classes going on simultaneously, the children's art-making often became the subject for taping, playback, and discussion. They also visited the museum, staged small dramas, played games, and vid-

eotaped activities stimulated by or related to all of their experiences. A half-hour of each two-hour session was devoted to reviewing the day's tape. For Julie Cook, "seeing themselves be themselves has been the most rewarding part of the program for the kids and for us."

**The Methuen Storefront.** Taking its name from the town in which it is located, the Methuen Storefront is a drop-in center that offers counseling and social services to adolescents and their parents. According to Rod Walsh, its director, "Many of our kids are one-parent, acting-out kinds of kids. Generally speaking, they're not too verbal and not accustomed to being creative. . . . The video has touched both the playful and the creative elements within them, has given them a chance to get their feelings out. It provides a structure which justifies getting those feelings out."

At the storefront and at the gallery, Walsh and his students—whose number varied from two to eight—usually concentrated on group experiences in creative movement, dramatic improvisation, role-playing, and pantomime. Fordie Sargent, the Addison staff member who spent the most time with this group, found the warm-up exercises for these activities particularly helpful because they encouraged the teenagers to "loosen up" by creating "an atmosphere conducive to more free, more verbal, and more spontaneous self-expression." Sometimes the warm-up as well as the activity was videotaped and played back for review and discussion; Sargent was convinced that the whole cycle broke down "certain barriers and inhibitions, thus enabling the teenagers to discuss more freely inner feelings about themselves and others."

Rod Walsh believes that visiting the museum was as useful to the students as the "insight" therapy that Sargent described. Though they came originally "because they enjoyed running around looking for pornographic connotations," he said, "I think they've really started to view art with some seriousness; now they'll walk through [the gallery] and make comments to each other about the exhibits without joking and laughing. . . . Coming to the museum is a big thing for the kids; it's important to them."

**The Day Treatment Center.** A community-based mental health facility in downtown Lawrence, the Day Treatment Center provides an alternative to residential care at Danvers State Hospital. A staff of 11 occupational therapists, psychiatric social workers, and psychologists work with 90 clients, most of whom are in their twenties and thirties. (The center also takes clients referred from physicians in private practice and from other institutions.)

Margot Porter, a staff member of the center, is an occupational therapist, a former secondary school art teacher, and a volunteer (in 1973) with McNiff in the Danvers art therapy program. She defines the center's principal function: "to help clients resettle into the community."

Between ten and twelve center clients worked in each

video session. As many as four staff members from Addison and three from the center participated in each session. The two staffs concentrated on two goals: encouraging individual art-making with a range of art materials and developing group experiences through mime, movement, and dramatic improvisation. The clients worked at the center and visited the gallery. Of those museum visits, Porter said,

> Even though most of our clients had never been to a museum before, they all felt very much at home in the gallery. Even the new ones who have joined the group at different times of the year take to the environment in no time. Without a doubt, I would say that for some of them the trip to the gallery was the highlight of the week.

Yet, she believes, "without the video and the playback the program would have been half as valuable. I'm sure there'd be just as much participation, and the clients would be just as enthusiastic about the museum visits and get a lot out of them. But the video added a whole new, exciting dimension to the experience."

**St. Ann's Home.** St. Ann's in Methuen offers both residential and day treatment programs for children with moderate to severe behavioral and emotional disabilities. A staff of more than 80 persons works year-round with 60 boys and girls, ranging in age from 6 to 15. One goal of the program is to help the children acquire the social and academic skills required to enable them to reenter the public school system.

Two separate groups from St. Ann's, one of six children between the ages of 9 and 14 and the other of seven children aged 7 to 11, took part in the Addison Gallery video project. Like the children from Hispanos Unidos, they helped determine their own activities, most of them based on art; special favorites were puppet-making, photography, and drawing. One child wrote and directed a play that the group decided to perform and videotape at the gallery.

Elizabeth Doyle, a special education teacher at St. Ann's who worked with the children in the video project, found the program unsettling for the children at the outset:

> At first the children were very threatened, not only by the video but the gallery, too. Also, when we first started, there were too many adults involved—eight including the gallery staff. It was really quite chaotic for a few weeks. . . . I did some things in the classroom which helped to ease the children a bit. I got them used to hearing their voices on audio tape, for instance. . . . As time went on, things worked out very well.

She has observed growth in her students that she attributes to the video project:

> In the beginning, the kids teased one another a lot when they saw themselves on video. They'd say things like, "Look at Billy; he hasn't combed his hair in three weeks." That sort of thing has phased out completely. Now they watch the tape intensely, comment on the activity, and are much more supportive of each other. . . . In terms of socialization, there has definitely been some observable

growth. The children have transferred the kind of behavior expected of them at the gallery to other nonschool social settings.

> The children have also become more creative. They will now try new projects and activities that were previously threatening to them. . . . The program has been a very positive experience for the children. It's been particularly good for their ego-building, which I think is an important part of anyone's education.

One of the gallery staff, Julie Cook, believes that the children came to look on the gallery as "their museum, a place which has a special meaning for them." And one of the children chose not to take his art work home but to present it to the museum to add to the collection.

**John Crowder and friends.** The fifth group may be more accurately described as an "alliance." It is not a community agency but the creation of one man, John Crowder, who teaches at the private Shady Hill School in Cambridge. He lives in Boston and drives the 20 miles or so to Lawrence every Saturday to spend most of the day with nearly 20 black teenagers, friends he had made in the town's small black community. "The kids really didn't have an outlet in the community for self-expression," said Crowder. "Through a minister I know, I contacted some of them and began to work with them in the gallery's video program."

Accustomed to using videotape—he has used it for four of the thirteen years he has been teaching—Crowder believes one of its most rewarding uses is to encourage kids "to develop a 'television' program on a subject of interest to them. Children are at their creative best when they can find resources that are adaptable to the medium of television. This kind of activity often brings the child into direct contact with his community."[7]

Working along with his young friends, usually in their own community, Crowder has chosen two activities for these 13- to 16-year-olds. The first concentrates on documentaries: they travel around Lawrence's black community, videotaping whatever appeals to them, and then review their production. (In May 1975 they produced and performed in what Crowder considers their best effort to date, a half-hour tape of a local church choir, to which some of the teenagers belong.)

The second kind of video activity is what Crowder calls "value clarification games," which he describes as:

> Activities designed to help children look at, examine, and clarify their values for themselves. Basically, it involves role-playing. For instance, I use pictures depicting various problematical situations. The activity asks that the student place himself in one of those situations, define what he thinks the problem is in the picture, then work through the problem and try to bring it to some resolution. The technique enables the student to look at himself and talk about alternatives to solving problems. . . . This is the great thing about video. It affords instant replay and analysis. It allows the kids to see themselves right away doing an ac-

tivity and that helps them get in touch with themselves.

Though most of the young people have grown comfortable with the video machine (which they initially found a little frightening), Crowder reports "there are still a few who haven't gotten accustomed to it yet." By contrast, he found most of them quickly at ease in the museum environment on those few occasions when they visited the Addison. The gallery staff takes part in Crowder's program only when he and his companions visit the gallery, which was a secondary goal for Crowder. His main purpose was to help these teenagers express themselves and look at their community through the critical eye of the camera. "I think we've made some progress," he said, "and I think the kids feel that way, too."

### Lessons and questions suggested by the program

From the evidence gathered so far by the Addison staff's experiences with video, two conclusions present themselves. First, what happened at Danvers State Hospital in 1972 was more than just good fortune. There seems little doubt to the staffs involved that the instant playback feature of videotape, if properly used, does have an inherent therapeutic value. Moreover, when that value is wedded to an art-based activity, and when the documentary use of video is itself seen as a kind of art, the cumulative effect can be a profound and rewarding experience for all participants.

Second, the program has shown that, for a museum administration so inclined, video can be a legitimate and effective way to make the acquaintance of, and to serve, audiences rarely served by museums. Whether that acquaintance develops around the museum as resource center or an art therapy facility for community groups, video is an educational device that enables a museum to take on many meanings for many people.

Not all museum professionals—or psychotherapists, for that matter—would necessarily agree that the Addison Gallery's videotape program is an appropriate enterprise for an art museum. Even those who admire it, including the men and women who have worked in it, do not claim it is without flaws or weaknesses. They point to transportation and scheduling problems, to the museum's desire to have group leaders bring essentially the same group each week (a fairly difficult task for agencies working with unstable clients), and, most important, to an absence during the formative stages of the program of "two-way feedback": no structure was built into the program to allow gallery staff and client staff to share ideas and information. The director of only one of the client agencies, and to a lesser degree a second, met with gallery staff on a regular basis to discuss, plan, and evaluate activities.

The program continues at Addison, adding clients and volunteers, exploring the potential of videotape in a museum and with audiences most museums never notice. Even to museum professionals who have never considered it their responsibility to seek out such audiences, the Addison Gal-

lery's efforts to be useful to people neglected by society, not just by museums, are persuasive. Christopher Cook has the last word:

I'm for the idea of art being useful. And by useful, I don't mean reducing quality. I mean that art shouldn't just be for fun and titillation, but that art has some kind of fundamental integrating capacity to make people function better whether they're disturbed or normal.

I certainly have an interest in a museum being a beautiful place. But the primary significance of a museum should be to help art get into the mainstream of life.
—E.H.

### Notes

[1] For sources of quotations without footnote references, see list of interviews at the end of this report.
[2] *Andover,* Andover, Mass., Phillips Academy, 1974. p. 40.
[3] The exhibition subsequently traveled to the Office of the Lieutenant Governor of Massachusetts, Boston; the Center for the Arts, Wesleyan University, Middletown, Conn.; Hampshire College Gallery, Amherst, Mass.; the Carpenter Center for the Visual Arts, Harvard University; Gallery One, Carnegie Hall, University of Maine, Orono, Maine; the Currier Gallery of Art, Manchester, N.H.; Fordham University at Lincoln Center, New York City; and Worcester Art Museum, Worcester, Mass.
[4] *Boston Globe,* May 21, 1974.
[5] Partial transcript of a videotaped interview, March 1974.
[6] Judith Grunbaum, Program Summary, May 16, 1975.
[7] John Crowder, "Toward Humanism through Electrography," unpublished, August 1974, p. 27.

### Interviews

Clark, Susan. Curator of Painting, Addison Gallery of American Art. May 16, 1975.

Cook, Christopher. Director, Addison Gallery of American Art. September 24, November 12, 1974; May 15, 19, and 21, 1975.

Cook, Julie. Art therapist, Addison Gallery of American Art. May 16, 19, 1975.

Crowder, John. Teacher, Shady Hill School, Cambridge, Massachusetts. May 15, 1975.

Doyle, Elizabeth. Teacher, St. Ann's Home, Methuen, Massachusetts. May 20, 1975.

Grunbaum, Judith. Art therapist, Addison Gallery of American Art. May 15, 16, 19, and 21, 1975.

Maio, Andrew. Administrator, St. Ann's Home, Methuen, Massachusetts. May 19, 1975.

McNiff, Shaun. Director, Institute for the Arts and Human Development, Lesley College, Cambridge, Massachusetts. November 12, 1974; May 16, 19, and 21, 1975.

Porter, Margot. Director, Day Treatment Center, Lawrence, Massachusetts. May 14, 19, 1975.

Rodriguez, Oscar. Manager, Hispanos Unidos, Lawrence, Massachusetts. May 16, 1975.

Sargent, Fordie. Art therapist, Addison Gallery of American Art. May 16, 19, and 21, 1975.

Sizer, Theodore. Headmaster, Phillips Academy, Andover, Massachusetts. May 19, 22, 1975.

Thiras, Nicki. Registrar, Addison Gallery of American Art. May 15, 16, 19, 20, and 21, and June 2, 3, 1975.

Walsh, Rod. Director, Methuen Storefront, Methuen, Massachusetts. May 21, 1975.

## Bibliography

**Publications:**

McNiff, Shaun. "New Perspective in Group Art Therapy," *Art Psychotherapy,* 1973.

———. "The Myth of Schizophrenic Art," *Schizophrenia Bulletin,* 1974.

———. "Re-Organizing Visual Perception through Art," *Academic Therapy,* 1974.

———. *Art Psychotherapy at Danvers*, a catalog of the special exhibition of work by patients at Danvers State Hospital, originally held in 1972. It includes three case histories of patients involved in the program.

——— and Paul Knill. "Art and Music Therapy for the Learning Disabled," *New Ways,* 1975.

——— and Christopher Cook. "Video Art Therapy," *Art Psychotherapy,* 1975.

**Videotapes:**

*On Art Therapy: A Conversation with Rudolph Arnheim,* Addison Gallery of American Art, 1975.

# Community-Based Museums and Umbrella Agencies

## Introduction

Throughout the history of America, ethnic and racial minorities have tried to preserve the cultural and religious traditions they either brought with them when they came to this country or created in the enclaves where they settled after they arrived. Blacks, Jews, Irish, Italians, Asians, American Indians, Latin Americans, and a host of other ethnic groups have expressed themselves and sought to give meaning to their lives through the songs, stories, festivals, costumes, and dances passed along from one generation to the next. Some of these traditions have found their way into the general American culture; others have flowered beyond the attention of the rest of society.

In the last 25 years, two quite uncultural events have had an unexpected effect on the role of minority cultures in American life. One was the Supreme Court decision on school desegregation in 1954, the other was the Civil Rights Act of 1964. These decisions and the public programs that followed them brought a rising public consciousness of discrimination and disadvantage and a new appreciation of the wealth of cultural expression that had made itself felt for many generations in ethnic communities in all parts of the country.

Black poets, playwrights, authors, and artists, the law of the land behind them and hope ahead, were among the first to publish their works and create their own theaters as an expression of their need to grow, not simply as artists but as people. Soon they found a larger public, and minority arts became "legitimate." The movement began to have its impact on other minorities as well—Puerto Ricans, American Indians, Asian and Mexican Americans—and by the early 1970s there were minority or "community" arts organizations in nearly every major city in the North, on the West Coast, and in the South.

So deeply ingrained have these organizations become in their communities that most of them have managed to find ways to support themselves and to become increasingly professional as they have done so. One reason they have survived is that their communities will not let them die. In response to that determination, in 1970 the National Endowment for the Arts added a new program called Expansion Arts. It was designed, according to the Endowment's annual report for 1971/72, "to help the growing numbers of professionally directed community arts groups with activities involving ethnic and rural minorities whose cultures had been inadequately supported in the past." Between 1972 (the program's first full year of operation) and 1975, the Expansion Arts budget rose from $1.1 million to $5.2 million—from 4 to 7 percent of the Endowment's total program budget.

Although community arts organizations have also benefited from programs of other federal and state agencies, the Endowment grants have been crucial to the community arts movement and will undoubtedly continue to be. For these groups, more than most cultural organizations, are almost totally dependent on public funds. Barry Gaither, curator of the museum of the National Center of Afro-American Artists in Boston (see report in chapter 8), has said that because community arts organizations are defined by the fact that "they originate in the communities they serve, . . . they have a great problem of how to find money, because they are, almost without exception, in communities that cannot generate the money to support [them]."[1]

At the same time, what one observer has called the "fantastic resilience" of community arts groups derives something, too, from the inventive ways these organizations have found to stay alive. One of those inventions is the alliances community arts groups have formed both with traditional institutions and with one another. It is some of those alliances that the reports in this chapter describe.

### The community arts mission

To understand why communities are so determined to keep their arts groups in existence, it is useful to know what these groups are and how they conceive their role. When members of community arts organizations speak of the difference between their groups and traditional institutions, they tend to define "traditional" or "establishment," as Anacostia Museum Director John Kinard has here, as "self-originating institutions that decide what is good for other people." Kinard describes a community or neighborhood organization, in contrast, as one that "has a responsibility . . . to understand and appreciate its surrounding geographical interest environment." Where a "self-directed," traditional institution is distant emotionally, physically, and psychologically from all but the people who run it and who are "involved" with it, a community organization has a close relation with "the ground on which it is standing"; it has "body contact" with what the community around it "is about, has been about, and could be about."[2] These organizations are created inside their communities, in Gaither's words, by "groups of people who decide, of their own necessity, to create an institution."[3]

Such institutions are needed because, as Gaither says, "this is white country."

> I think that the fundamental problem of the minority publics in this country . . . whether they're black or Puerto Rican or Chicano or whatever . . . is the absence of institutions that preserve the interest of these people. . . . Every community must have some pegs around which its identity exists. And it's an institutional function to provide that. . . .[4]

Gaither points out, furthermore, that in "white country" traditional museums cannot and have not served the minorities who want not only to have their cultures represented but to maintain control over the interpretation of them:

> The Metropolitan [Museum] cannot become a Puerto Rican museum or a black museum. So black people and Puerto Ricans demanded that the Metropolitan do for them

what it says it does for the whole public. But you know the Metropolitan is clear who its central audience is. It would like to have a larger audience. It is willing to do something, but it is not willing to fundamentally change itself. Moreover, it has not the option to change itself. It has a hundred years of inertia, and a direction that is like the Presidency. It veers a few inches here or a few there, but it does not reverse.

And the reality of our lives is if we want to have a participation that is valid, we have to structure an institution that rings true to, and does in fact contain, our experience. That will be radical in the culture at large, but it will be conservative in our own interest, because its design is to preserve the reality of our experience. The other option is always to be the beggar with nothing of your own and always asking somebody else to take you in and to represent your interests, because if you don't create an institutional base that becomes the vested statement of your position, then you have no position.[5]

In the community arts organizations that are described here, another need is expressed, too, beyond building and protecting cultural identity. It has to do with establishing a sense of community—not only within an ethnic group but among several groups that share a part of an urban environment—and doing this by infusing art into the life of the streets rather than setting it apart in museums, galleries, theaters, and symphony halls.

"A welfare mother," a director of one community organization points out, "has to hustle for every dime. She doesn't have the time to go to a museum. . . . We are bringing the art out of the museum into the street." Often this art of the streets has political overtones, even on occasion a political mission. Community arts organizations have taken up the cause of Puerto Rican independence, rent strikes, school reform, urban renewal protests, and school board elections. "It's the politics of life," said one organizer, "the basic needs—people, clothing, shelter, and food."

But the basic objective is to try to improve the community. Those who man community arts organizations find their excitement in seeing "what could happen and what's going to happen to me and the people around me. . . . Working here, running this place, we have people that touch one another. . . . I'm part of the community." It is a struggle that joins people to each other: "The future of the community is our future." For John Kinard, a community museum "has a social responsibility" to help people understand their common problems and try to deal with them:

You can't do too much with a problem unless you understand it, you know, and this is one of the difficulties in urban complexes like here in Anacostia. People are feeling hurt by housing. We've got raunchy, run-down houses, management is no-account, and people are hollering, but they don't know what to do. Consequently, people get involved in all kinds of socially unbecoming behavior because they are frustrated with jobs, housing, these things.

They act in a confused, moribund, demoralized way. I think understanding will help it, so that people will no longer need to lash out at children and at other people in the society in socially unbecoming ways. Once we understand the problem and how to look at problems, then the average Joe, who may not have more than a 4th-grade education, if it's bent toward that level of understanding, can say, well, I think that we should do this, or that, or the other.

The museum's responsibility . . . as I see it, is to draw straight, analytical solutions to the problem. . . .

For many community arts organizations there is no limit to the areas of life they might touch, both in the name of art and in behalf of the community. Says Carolyn Curran, coordinator of Seven Loaves in New York (see report in this chapter),

I think the community arts movement is trying to revive the idea that art is an expression of people's lives and being integrated into lives. It's not just something you put in a museum vault and lock up; it's something you use every day, and it's part of everything else.

The staff here doesn't have a policy on how the arts should be used for community action. On the other hand, when we see possibilities for linking up what members are doing with other projects and elements in the community, we try to reinforce that relationship.

To those who believe in the power of art in any community, it is important that there be, in Gaither's words, "a tremendous variety of institutions"—children's museums, auto museums, museums of antiquities, museums committed to different cultures, and museums that "one can call community, depending on whether one wants to locate it vis-à-vis a particular identifiable public." Gaither would like to see them all "co-equal, across the board":

Ideally, all of those should exist on an equal basis. It should not be a put-down to say "community." It should not mean, *a priori*, something that is smaller and ragged, which is, in fact, how the word is used. . . . When people say "community," they generally mean something that is somehow on the side of, rather than is central to. I would rather see a situation of co-equality where a Studio Museum [in Harlem] is not seen as a community museum when the Whitney is seen as an American museum. Those should be co-equal, across the board. They should provide . . . the same quality of service.[6]

Marta Vega, a founder and former director of El Museo del Barrio in New York, agrees with Gaither. As one who has organized exhibitions that traveled as loan shows to the Metropolitan Museum and the American Museum of Natural History and back to El Museo, she feels strongly that community arts organizations are not only "co-equal" with establishment institutions but that the two sides have equally important things to learn from and give each other:

. . . We will tap whatever resources are necessary to do an effective job. If those resources exist in the corner, we will use those resources that are in the corner. If those resources

they exist at the Natural History, we will use them. . . . We would [co-sponsor an exhibition] with any established institution that has what we want. Originally, when the Met contacted us, they said do you want an armor exhibition, and we said no. And then, a year later, we went to the Met with what we wanted. So that, all I can say is, whatever we need, and wherever it exists, we will go after it. The Met now has nothing particular in its collection that we feel we want. But it certainly has the mechanism to bring about an exhibition that we do want. So . . . we'll explore it with them at that level. We're doing that with the Natural History now, where they have a collection of pre-Columbian pieces that has not been exhibited for 20 years. We would like to tap it and use it, because it is a resource. So we will explore those possibilities there, but we are also going into people's homes and saying, you have certain needlework that we would like to exhibit, and [we tap that resource].[7]

It is Barry Gaither's hope that one day there will be "a full spectrum of institutions" within a community as well as within the city as a whole, equal in kind and quality for dominant and minority cultures alike:

> If you take a community like the American black community, within that community there is the need for a full spectrum of institutions in every area—not just visual arts. . . . Those range from informal institutions, which are essentially activity-oriented, to formal institutions, which are essentially repositories of collective value. And there must be that spectrum if that community would have a way to participate in some equality in the total community of other groups that make up the city. . . . Just as other people have a full spectrum of things, so ought we. And just as they have formal and informal institutions, so ought we. And there ought to be no implicit put-down in the identification of a program with a particular public and with its commitment to that public. . . .
>
> The issue is, finally, people and their survival, and what they structure as tools for their survival. The legitimacy of things that people make radiates from the fact that they made it. These things are self-validating. Culture is validated by the people who live it. . . . Our competition is to gain some control of the apparatus. So I want to have everything that everybody else has, the whole spectrum.[8]

**The nature of the alliances**

If community arts organizations in their early years had legitimacy in their neighborhoods with their particular clientele, few of them had it with the establishment—and that meant especially the funders. Most organizations had to scrape up money wherever they could find it: sometimes it came from better recognized antipoverty groups, sometimes through local churches or settlement houses, and in a few cases from school districts out of federal education programs. In the late sixties private foundations, state arts councils, and the National Endowment for the Arts began to give some support to community organizations, too. But with some exceptions, such as El Museo del Barrio and the Studio Museum in New York, untried independent community organizations had trouble attracting foundation grants; some groups had failed, and in a few cases the administrators were too inexperienced to hold them together. Foundations looked for a performance record and management skills, something few community groups could readily supply.

The exceptions were those that were formed partly by organizers who not only had managerial experience but could serve as interpreters between the community and the society at large. Often they were people who had long lived in the community, were a part of it and understood its needs, and yet were able to communicate with the establishment world as well. Even with such help, however, community groups often found themselves competing with each other for funds and occasionally for turf.

So a pattern of alliances began to emerge. The Anacostia Neighborhood Museum in Washington, D.C., was one of the first. Anacostia was a community museum from the beginning: board, staff, program, and location have been determined by the people who live in the Anacostia neighborhood. But it was conceived by and is a part of the Smithsonian Institution, and that has given the museum stability, an assured source of funds, and access to professional services of the Institution.

Another tie to an established institution, described elsewhere in this study (see chapter 8), is one between the museum of the National Center of Afro-American Artists and the Museum of Fine Arts in Boston. Instead of creating a separate program for the city's black community in the late 1960s, the MFA was persuaded to ally itself with the center, which needed no introduction to that audience. Under the arrangement, the MFA contributes about a third of the NCAAA museum budget and allows the center museum to use its conservation and storage facilities. Barry Gaither, curator of the NCAAA museum, also serves on the MFA staff organizing exhibitions of African and black American art and advising the MFA on purchases and personnel.

The Neighborhood Arts Program, started in San Francisco in 1967, represents a different kind of alliance. It was formed before the communities knew that they either wanted or needed cultural activity; NAP's job was to find out what the city's neighborhoods could use. With its district organizers, NAP stimulated the development of neighborhood art galleries, workshops, and street festivals, offering funds and equipment and sometimes lessons in how to make the best use of both. The program has now spawned several arts organizations around the city, many of which raise their funds independently from NAP and use the NAP umbrella only for expensive equipment and the publicity services the program's offices provide.

The origin of Seven Loaves in New York City is the reverse of NAP's. A coalition of community arts groups on Manhattan's Lower East Side, Seven Loaves was organized

to serve as a center for pooled resources, to encourage communication among the groups, and to provide administrative training for programs that had existed independently and wanted to stay that way. By the time the coalition was in its second year, grants to the members were four times what they had been before Seven Loaves was formed. Just as important to the members as their newly won financial respectability, however, was the network itself and the psychological support and sense of community it has brought to their work.

In the case of Museums Collaborative in New York, the alliance is meant to bring three kinds of constituents together—establishment museums, community organizations, and public schools. Although the Collaborative raises money that goes into the programs and thus benefits all three participants, its goal is not so much the financial health of the institutions as their educational effectiveness. An outgrowth, too, of the community movement of the 1960s, the Collaborative was meant to help and encourage museums to broaden their audiences and to provide a forum where museum professionals could learn from one another in that process.

One example of the Collaborative's incentives to traditional museums to work more closely with community organizations is its experiment with the cultural voucher. The plan puts community groups in the position of negotiating with the establishment museums for offerings that will be attractive to a new kind of "customer." With this and other programs, the Collaborative is beginning to create a community of interest among many of the city's diverse cultural organizations and to place them, large and small alike, on a more nearly equal footing—one step, perhaps, along the way to the spectrum of institutions Barry Gaither hopes will one day belong to every community.

## Community art and the future

Art museums have been built in this country in large part because their founders were intent on establishing cultural roots and finding the cultural continuum in which the American experience could be placed. A sense of community and of self-respect was a motivating force for those people, too. As the nation has developed, the acculturation process, with its dominant Western European orientation, has been acceptable to some; it has succeeded only in alienating others, and the assimilation of new cultures has obviously taken place too slowly within most establishment institutions to solve the problem. To the degree that traditional museums can quicken the expansion of their audiences at all—and their collecting universe alongside—a strong community arts movement in this country could surely help them.

As for the job of integrating art with life, perhaps no traditional institution will be able to get close enough to the streets to become the "artistic salesmen" Robert Coles has asked for "to help give sanction to the thoughtful reveries of many millions of people" who need what art can give.[9] That job may belong uniquely to the artists and the community arts

organizations that are, as one community arts director has said, "down here with the workers." But for the health of the art museum and the society it serves, understanding this job, supporting it, and drawing sustenance from the results are a necessary part of its responsibility. One long-time member of the community arts movement has found it "alarming" that the large institutions are imitating the community arts programs "because somehow this is fashionable now." The greatest problem, she feels, is that these institutions do not always have "trained and sensitive and knowing people in the key positions"; the programs simply become an excuse to get more funding. The knowing people are needed in art museums to bridge the gap between the community and the establishment in the interests of both.[10]

Great art of all ages has found its roots in the myths, the images, the songs, and the daily lives of "ordinary" people—the folk, if you will. They are the roots from which all our cultures have sprung. If our great institutions of art in this country are to remain so, they, too, will learn to draw spiritual and cultural energy from the lives and needs of the mass of people of all races and walks of life. They can only become sterile by remaining aloof. American art museums have much to offer the community, but as their knowledge of the community grows, they will also find, perhaps, that they have much to learn from it.—B.Y.N.

## Notes

[1] Transcript of a meeting on community programs called by the CMEVA staff, New York City, May 13, 1974, p. 6.*

[2] Ibid., pp. 7–10.

[3] Ibid., p. 27.

[4] Ibid., p. 14.

[5] Ibid., p. 40.

[6] Ibid., p. 55.

[7] Ibid., pp. 72–73.

[8] Ibid., pp. 56–57.

[9] "The Art Museum and the Pressures of Society," *On Understanding Art Museums,* ed. Sherman E. Lee (Englewood Cliffs, N.J.: Prentice-Hall, 1975), p. 202.

[10] Miriam Colon, artistic director, Puerto Rican Traveling Theatre, New York, CMEVA transcript, May 13, 1974, p. 71.

*A note about the meeting on community programs:

The content of this introduction is drawn largely from a meeting held in New York City on May 13, 1974, to which 13 persons, all of them experienced in helping to develop and administer community arts organizations, were invited by the CMEVA staff. Its purpose was to give the staff the benefit of their knowledge about the community arts movement so that our coverage of these programs would be better informed.

The guests were:

Cleveland Bellow, artist; organizer of the Third World Artists Conference, Contemporary Arts Council, Oakland, California; Art Consultant, Bay Area Rapid Transit.

Miriam Colon, Artistic Director, Puerto Rican Traveling Theatre, New York.

Carolyn Curran, Coordinator, Seven Loaves, New York.

Richard Fong, Associate Curator, de Young Art School, Fine Arts Museums of San Francisco.

James Harithas, then Director, Everson Museum, Syracuse, New York.

John Kinard, Director, Anacostia Museum, Washington, D.C.

Adal Maldonado, Director, Little Photo Gallery, Staten Island, New York.

Luis Santana, Curator, Galeria de la Raza, San Francisco.

Edward Spriggs, Director, Studio Museum in Harlem, New York.

Ruth Tamura, Assistant Director, Alameda Neighborhood Arts Program, San Francisco; Curator, Third World Artists exhibition, San Francisco Museum.

Marta Vega, then Director, El Museo del Barrio, New York.

Vantile Whitfield, Director, Expansion Arts Program, National Endowment for the Arts, Washington, D.C.

Edmund Barry Gaither, Visual Arts Director, Elma Lewis School of Fine Arts, and curator of the museum of the National Center of Afro-American Artists, Roxbury, Massachusetts, attended for CMEVA, of which he is a member.

Hosts for the meeting were five members of the CMEVA staff.

## ANACOSTIA NEIGHBORHOOD MUSEUM: A MODEL OF COMMUNITY CONTROL

Anacostia Neighborhood Museum
Smithsonian Institution
2405 Martin Luther King Jr. Avenue, S.E.
Washington, D.C. 20020

**As a museum whose primary purpose is to help its community move toward a better life, Anacostia bases its exhibitions and activities in the expressed wishes, interests, and needs of the community. In an interview that accompanies this report, the museum's director, John Kinard, describes Anacostia's educational role and method and lays out a path to a new kind of community museum that will, in his words, "espouse" the opportunity for the museum's audience to develop and grow. CMEVA interviews and observations: July, August 1974.**

### Some Facts About the Institution

1. **General Information**

    Founding: 1967.

    Collection: The museum maintains no formal collection of its own; most of its exhibits are drawn from various Smithsonian collections.

    Number of paid staff: 16 full-time (no part-time).

    Number of volunteers: Casual; number varies.

    Operating budget: $327,000 (1973/74).

    Education budget: About $10,000 (1974), not including salaries.

    Source of funding: Smithsonian (federal).

2. **Location/Setting**

    Size and character of city: Washington, D.C. (population 756,510 in a standard metropolitan statistical area of nearly 2.9 million, according to the 1970 census) has the largest concentration of museums, nature centers, parks, botanical gardens, and historic sites in the country. It is the center for federal administra-

tion, headquarters for innumerable national organizations, and one of the country's leading tourist attractions. Its cultural facilities serve a mixed audience of visitors, short-term residents, and an indigenous population that is 72 percent black (public school enrollments are nearly 96 percent black). Educational resources include five universities: American, Catholic, Howard, Georgetown, and George Washington.

    Climate: Cold winters, little snow; hot, muggy summers.

    Specific location of the institution: On a main avenue in the center of the area of southeast Washington, D.C., called Anacostia. It is predominantly black and is a mixture of middle-class neighborhoods, extensive public housing, and impoverished areas. Anacostia is somewhat isolated from the rest of Washington by the Anacostia River, but is easily accessible by public transportation. The home of Frederick Douglass, now open to the public, is in the heart of Anacostia.

    Access to public transportation: Very good; several bus routes serve the area.

3. **Audience**

    Membership: No formal membership maintained.

    Attendance: 69,467 (1974). Audience is primarily young people in the immediate community. Special events attract an audience from the full spectrum of the Anacostia population.

4. **Educational Services**

    Organizational structure: Supervisory program manager heads the education and development department and works under the director of the museum.

    Size of staff: 2—including the supervisory program manager and the program manager, mobile division (responsible for development and implementation of mobile services and programs, under the director of the museum).

    Budget: About $10,000 (1974), not including salaries.

    Source of funds: Smithsonian (federal).

    Range of services: Exhibitions; special programs related to exhibitions, with a comprehensive cultural approach, including music, dance, and food; tours; lectures; and films. The Anacostia Studies Project provides the community with information about its most immediate heritage and the history of the area. A mobile program takes small portable exhibitions and "shoeboxes" (small resource kits full of objects and ideas) to the schools, provides lecturers, conducts workshops and demonstrations out of a van. The van also transports the museum's portable library, which contains school textbooks by black authors and other books of special interest to Anacostia's children. A training program in exhibition techniques for minority people was scheduled to begin in 1975.

    Audience: School groups, residents of the community. Special events draw a wider representation from the community, whereas exhibitions and programs primarily attract youth.

    Objective: To bring to a low-income minority community, whose residents seldom come in contact with existing cultural resources, exhibits of objects from various Smithsonian collections, and to offer opportunities for open, nondirected learning in relation to the exhibits.

    Time: The museum is open 10 A.M.–6 P.M. six days a week; 1 P.M.–5 P.M. on Sundays; plus additional times in response to community needs.

    Information and documentation available from the institution: Fifth anniversary commemorative booklet.

Except for a raucous parrot named George, who sometimes has to be muffled and sent to the washroom, the Anacostia Neighborhood Museum has few "tangible objects, animate or inanimate."[1] For strict constructionists in the museum field, Anacostia is thus not properly a museum at all. It has no curators. Nor does it attract significant numbers of casual visitors like the other museums in the Smithsonian Institution, of which Anacostia is a part. It does not have a membership, in the sense of a fee-paying, structured patronage. The museum is also not widely used by the Smithsonian Associates, whose Resident Program provides the museums on the Mall with something that approximates a cadre of regular supporters.

In many ways, what the Anacostia Neighborhood Museum lacks in a conventional sense it makes up for by a commitment between institution and audience that is strongly emotional and effectively fulfilling for both.

## The museum and the community: a developing relationship

Naturally, not everyone in the community of Anacostia feels this commitment. There are, and always have been, various points of view about the museum. From the moment the Smithsonian announced its intention to establish what it first referred to as a "storefront" museum, there has been support for, distrust of, and apathy toward the project and the institution that has developed from it. It is characteristic of Anacostia's museum, as it is not for other museums with the same range of public regard, that all this was discussed at open meetings in the community by all the factions who wished to have a voice before a decision was made to accept the museum into the community. And it is important to understanding the concept of the museum to note that the Smithsonian did not arbitrarily place a museum in Anacostia: the community determined that it wanted and would use such a service. The community and the Institution further determined that such a service would continue to be valuable only as it responded to the changing needs of the community; therefore, control of the museum was placed in the hands of the community, or in the hands of those people who wanted and would accept control of it.

Much of the original opposition to locating the Smithsonian's neighborhood museum in Anacostia was economic. There was a question not only of whether a museum would provide jobs for the residents—new jobs for the unemployed and advancement for the employed—but also whether this sort of spending by a government agency should take place in Anacostia when many other needs there were not being met. The neighborhood, located in the southeast sector of the District, is predominantly black and predominantly poor. Its most notable physical characteristics are huge tracts of public housing and its semi-isolation from the rest of the city by the Anacostia River.

This was 1967, a time when the Johnson administration's poverty programs were making some impact on Anacostia.

The flaws in these programs had made the residents suspicious of ideas "laid on" them; the benefits had made them aware of possibilities for growth and change and impatient to have these possibilities touch their own lives. According to Alton Jones, chairperson of the museum's board of directors, the competition for jobs in the poverty programs was intense. Understandably, the new museum being offered to the community was interpreted in terms of personal advancement. But although the intention of the Smithsonian Institution was to hire as many residents as possible, there were in reality very few openings. Jones says that the community saw the museum "primarily as an institution where jobs were made available to certain people but not to the average guy: you need training for this type of job."[2]

To Jones it was a moving experience to witness the community's gradual acceptance of an institution that "would be an opportunity for them to broaden their experiences and make life more meaningful" rather than financially rewarding. "One thing that I think the poverty programs did in addition to motivating people toward more opportunity economically," says Jones, "was to motivate them in terms of their participation in deciding what they really wanted, other than jobs, for a better life."

## The people behind the museum: director, advisory committee, and board of directors

To Almore Dale, who, like Jones, has been an adviser and supporter of the museum from the beginning, it was the appointment of John Kinard as director that gave reality to the ideas being negotiated between the Smithsonian and the community. Kinard's background as a lifelong resident of Anacostia, a professional in community work (Kinard left a position as program analyst with the Office of Economic Opportunity to become director of the museum), and a Bachelor of Theology, no more fits the usual *curriculum vitae* of a museum director than Anacostia fits the usual description of a museum. What is important is that the needs of the museum are well met in the qualifications of its director and in his attitudes. If John Kinard seems doctrinaire to those who do not know him, members of his staff, his board, and his community describe him as sensitive and flexible, always offering choices, always in touch with the alternatives.

The growth of the Anacostia Neighborhood Museum—from a single sentence in an address by Smithsonian Secretary Dillon Ripley to a practical reality—has been accompanied by an uninterrupted consultation with and guidance from the community as it is represented on the board of directors. This body, whose roots lie in a fellowship of residents variously involved in projects to improve the quality of life in Anacostia, first assembled in response to a call from Stanley Anderson, community worker and former city councilman. Anderson's belief in the possibilities of the museum was shared by Jones and Dale.

The first formally titled advisory committee, which was to be the responsible body for the community and later to be-

come the board of directors, began to function before either the museum or the director had been chosen. Numbering 90 persons and including many names still associated with the museum staff and board, it selected and has consistently supported Kinard as director of the museum. The advisory committee chose to remain flexible in attitude and process, paring itself down to approximately 30 members, but keeping access to membership open to anyone in the community who was interested. In addition, the committee made conscious efforts to reach into the community and draw out its feelings. Indicative of this was the inclusion of two young people as full committee members, one a high school student and the other just entering the business world in Anacostia.

According to Jones, the advisory committee was organized in 1972 in order to provide the museum with "some perpetual kind of responsibility" and free it from the hazards of personalities with a "great degree of power or concern or charisma" whose loss can disrupt informal structures. Primarily, he adds, all the nonprofit organizations of any stature are required to maintain a supervisory body to which they are responsible. Clearly, then, the Anacostia Museum is unlike other bureaus of the Smithsonian, which have a responsibility first to the Institution and then to Congress. Instead, with the transition of the advisory committee into a board of directors, Anacostia has legally committed itself to the community-museum relationship.

### The museum in operation: policies and activities

Some of the museum's activities are those of a community cultural center; the facility is open to the neighborhood for community group meetings, for performances, and even for weddings. Programs connected with exhibitions often take a comprehensive cultural approach: they include music, dance, and food, as well as tours, lectures, and films. It would be impossible to dismiss any of these activities as just entertainment. They are an introduction to the community of the intellect, talent, and wit of outstanding black people and of the style and quality of life that black people have developed in various parts of the world. They also help the Anacostia audience integrate its heritage with contemporary developments in the community.

**Exhibitions.** Many exhibitions for the Anacostia Neighborhood Museum place less emphasis on objects than on the written word, strongly didactic and frequently heavily politicized. In one exhibition, "The Message Makers," whole walls of expository labels, slogans, and symbols are remindful of the hortatory massing of posters that accompany political controversy in many countries. It is possible that all the words are read: as Louise Hutchinson, director of the Anacostia Studies Project (see below), says, "People in Anacostia have always had an insatiable appetite for education." Perhaps, as with the political poster walls, people do not so much read the words as recognize the symbols, including the word symbols, and feel a kinship with the creators and

their causes. The symbols and, indeed, the creation of the wall are in each case a demonstration of mutual goals that are meant to banish despair and provide the energy to go on.

Early exhibitions included "This is Africa," a display of traditional and contemporary African art objects, fabrics, tools, and native dress (African students served as docents); "This Thing Called Jazz," originated by the young people on the advisory committee, which traced the history of jazz through films, slides, graphics, an "environmental room," and musical demonstrations by leading artists; and "Moments," a juried display of photographs by Smithsonian personnel, Anacostia museum staff, and local neighborhood residents.

Others have centered on black patriots of the American revolution, the contributions of black scientists, the civil rights movement, the role of blacks in the westward movement, Jamaican art and culture, and local painters and other artists. At this writing, an exhibition on consumerism for the poor, "Buy Now, Pay Later," is planned. Its basic message: how to avoid being bilked by merchants.

**The Anacostia Studies Project.** Providing the Anacostia community with a knowledge of its most immediate heritage—the history of the place in which they live—has given rise to the Anacostia Studies Project. To Louise Hutchinson, project director, the Anacostia of the past is as visible from her office as the Anacostia of the present. Her research will contribute to the *Anacostia Story,* which the museum intends to publish and which will present a view of Washington as a "hometown" rather than as national seat of government.

The history of Anacostia begins with the settlement of Prince Georges County, Maryland, from which the land that is now Anacostia was ceded to the Federal City in 1791. Sifting through records in the Library of Congress and the National Archives has provided much documentation for the Anacostia Studies Project. The project has recorded the purchase of the Barry Farm by the Freedman's Bureau in 1867 and the settlement of this tract by black people who purchased one-acre plots from the bureau and built on them, receiving a salary of 50 cents a day for their labor.

With this and further settlements, a lifestyle developed, limited in many ways, as Kinard points out, but rich in others, and the Anacostia Studies Project has tapped this in a doubly rewarding way. It collects oral histories from its older residents, using, whenever possible, the young people of Anacostia as recorders. This legitimate function of the museum's research department thus takes on the additional importance of strengthening the relationship between the museum and community.

**Mobile program.** Another aspect of the museum's relationship with the community is the museum's recognition of the particular qualities that Anacostia shares with other poor and economically isolated neighborhoods. One of these is lack of

mobility. Poor people seem to feel that going places involves a physical danger, a threat to self-esteem, or, at best, a challenge that is not worth the effort.

Therefore, with a grant from the Junior League, the museum purchased what Fletcher Smith, the program manager of the mobile division, calls "the jitney bus, which looks like a bread truck."[3] With it, the museum began to take its resources into the community, and the "bus"—actually a van—has become part of an outreach program that includes small portable exhibitions for the schools, a speakers' bureau (which can deliver not only lecturers but also people who conduct workshops and do demonstrations), and "shoeboxes," small educational resource kits full of objects and ideas on subjects such as black scientists or the history of Anacostia that reflect either curriculum needs or a relation to museum programs. The museum has also identified a need in the Anacostia and other District schools for textbooks written by black authors on subjects familiar to inner-city children, and has collected a portable library to be shared by the schools.

The Anacostia van is about the size of a United Parcel truck and originally held removable bench seats for visitors who came to view its exhibitions inside the van. In 1971 the van was altered to carry free-standing exhibits, which are set up in such places as schools, churches, recreation centers, colleges, and universities for stays of anywhere from three to ten days. Themes of the exhibits tend to follow the shows designed for the museum itself, and increasingly the mobile exhibition is created at the same time as the museum's main show.

**Exhibition laboratory and training program.** The most ambitious project for the Anacostia Neighborhood Museum is the concurrent building of an exhibition design and production laboratory and the development of a training program in exhibition techniques for minority people. The laboratory building, erected with the museum's Smithsonian Bicentennial funds, removes all exhibition design and preparation from the cramped quarters previously shared with the Anacostia Studies Project. Before the new laboratory was built, exhibitions were assembled on the floor of the museum, and the museum doors were often closed to the public for days at a time while staff members constructed new shows.

The second use for the new laboratory is to house the Exhibits Training Program for minority people, funded by the Ford Foundation. The first year's program, in 1975, concentrated on design of the program and thus gave the museum time to solve the administrative problems of housing and placement before students began to arrive. Actual training was to begin in 1976 and to include trainees drawn from the United States and possibly Africa, as well as Washington itself.

The program is designed to use not only the facilities of the museum's exhibition lab but other resources in the Washington area that have sophisticated production methods and equipment (the Naval Research Laboratory, also in Anacostia, is frequently cited as an example). The focus of the training is mainly on exhibition techniques for community museums, though trainees are supposed to learn to deal with other exhibition concepts as well. Supervisor of the program, James Mayo, is exhibits specialist for the museum and an advocate and practitioner of specialized exhibition design for community museums. (Mayo is, incidentally, responsible for one of the most elegant installations in Washington, the Robert Woods Bliss pre-Columbian collection at Dumbarton Oaks.)

**A new breed of educational museum.** John Kinard considers Anacostia the first step in providing "a model of how a museum is developed." It is, in his words, an opportunity for exposure, "for expansion of the mind, for involvement and understanding and associations with others . . . an opportunity to bring folks together" (see interview in following paragraphs). He wants a museum to teach the community about itself and about the world outside; its research should feed back immediately into the daily lives of the people who need information in order to solve social problems—in education, transportation, health, sanitation, housing, jobs.

Few museums in the country have taken on an educational assignment of the scope Anacostia has laid out for itself. Few, either, have made such a primary commitment to the needs of their communities. Anacostia may not point the way that large traditional art museums will or can follow, but as an educational institution intent on understanding, reaching, and providing opportunities for a deprived audience, Anacostia may indeed come close to offering the model of the new breed of museum Kinard has in mind.

• • •

The following interview with Director John Kinard explores in more detail the history and philosophy behind the Anacostia Neighborhood Museum, its role in and relation to its community, and some possible directions for its future.—*B.C.F.*

## The Kinard Philosophy

**An interview with John Kinard, director of the museum, July 17, 1974.**

Q: Do you work for the people of Anacostia or the Smithsonian Institution? Who hired you?

**Kinard:** The people were looking for a director, and they contacted me. I live here and had worked here at Southeast Neighborhood House in the antipoverty program at the local level, just working on the streets with people and their problems. At the time, in 1967, I was working at the Office of Economic Opportunity for the Eastern Shore of Maryland. I wasn't involved here in Anacostia at all, but I'd only been away for nine or ten months. The lady[4] who was looking

didn't know me, but after we talked she said, "We'd like for you to go down and talk to [Charles] Blitzer[5] about this job." That was how I got involved, so when you say "Who hired you?" I feel a commitment and a responsibility to the people here and on the board, part of that first group, who said, we want you, and directed me on the path I was to go. It was a joint relationship between the people in this community and the Smithsonian.

Now that occurred before this building was ever opened. I was just a staff of one in 1967. Charles Blitzer had the responsibility, for the Secretary of the Smithsonian, to get this thing going. He and I worked on what it is we're trying to do and dealt with the budget and personnel, getting something started. That's the way it went initially.

**Q:** How do people in your community feel about your being part of an institution like the Smithsonian?

**Kinard:** I think people here, even the board of directors who first worked to start the museum, were suspicious. That's why they said, "We'll choose the director." When you're suspicious to begin with, there are two avenues you can follow. One, you can say, hey, Mr. Charlie, what is it that we can and can't do? Two, you can say, do what you want to do, and what they don't understand, or what they do understand and want to applaud, just do that. So there may have been some suspicion at first, but the community took the bull by the horns and said, we are going to *do,* and let whoever differs, differ. That was a very positive step, taken for the first time in this community.

The fact that this museum exists after seven years is noteworthy. It says to this community, if you can do this, you can do a whole lot of other things to help yourself. The mentality among black people has been that somehow if we cooperate and are nice and civic-minded, the white man, who's in control, will do what's best by us; he'll be fair. That's a big lie, but that's what we have believed. We have, consequently, not done very much for ourselves, because we've always had what I call a slave mentality—that we belong to him; he's in charge, and he will treat us fairly. That hasn't occurred. So when people come to the conclusion that you've got to row your boat for yourself, then it turns the whole mental thing around. For better or for worse, you're in charge, you see, so you take charge.

**Q:** Aren't there people at the Smithsonian who enjoy your dissenting role as an education for themselves?

**Kinard:** Absolutely, many people. And they would like to work over here, too. They say, man, I'd sure like to work in that place, because it seems to be such a creative thing. And those of us here, I would suggest, by and large, enjoy it. Whatever decisions are made, are made jointly between the board of directors and the staff. Staff does all of the staff work, and the board does all the agreeing and disagreeing. We agree and disagree among ourselves about the point of view, about the mood, and there's total staff involvement, you see. Then we immerse the board in it. We don't ask the board to tell us what exhibits to do. We say here are some

alternatives which we designed, what do you think? We tell them as much as we know about it. And they'll say, this way, that way, we think that would be best for us. But we don't lay it on them . . . and take it away from them, which is traditionally what museums do.

I think there's a science to it that traditional museum people are not in possession of. I call traditional museums "self-originating institutions," in that they decide what is good for other people in this country—and that is bad. It's that whole orientation, you see. I can't, in order to keep something going here, just go out grabbing for straws. [I can't] say, "Smithsonian! Bring me an exhibit so I got something in here." I'd rather close the museum down and just have meetings. "Come on in the office, it's cool in here, let's talk, let's rap, you know." And I have done it. And then to have a schedule so long, and "Who suggested you-all do that?" You know what I mean? What's your base of reference?

I'm convinced that whatever we do ought to be an expression of Anacostia. I use that geographical boundary, not because I'm tied to it, but there's a community of interest there, and we need to represent the ideas and aspirations of some of the people—maybe not all of them at the same time, but at least some of those people, even if what the people suggest is very controversial. They might . . . want to have an exhibit on prostitution, or communism, or black history. Okay. That's what the people are interested in. . . . We do it to let them know it can be done; we can work together and do it. It's a Socratic method, you know. We come to a conclusion, for today. It'll be different tomorrow. And I'm not confused by that.

One example: the next exhibit to come here is on communications; it's called "The Message Makers." You know the folk downtown would do it much different from the way we do it, but it's an effort to help people understand what's happening to their minds when they watch that boob-tube. We want to draw attention to that, how much time is spent on TV, how attitudes are developed from it, what the economics of it are, what job opportunities are involved in it. This thing's something laid on them. Most of them don't even understand how a television set works, how it operates, technically. And that *can* be understood, you know, so that they can dream, and think technically about ideas, about their own development and growth.

**Q:** Are you providing an alternative education system to the school system for your people, here, in Anacostia?

**Kinard:** In the formal sense, no, but in a very informal sense, [yes]. Youngsters and adults can come here and see a number of things that are an expression of their own interest [and will help them] expand upon their original thinking. I think that's what "The Message Makers" will do.

We're doing another one, called "Buy Now, Pay Later," about consumer problems. What are the problems of the purchaser in this particular community? We've done some research on over 200 census tracts to get an idea of what

people buy and where they buy it, how much they pay for it, how they're ripped off in the marketplace, what a thing really costs and what all the add-ons are. What are the gimmicks to get you to buy, because most things that you see advertised you don't want and you don't need. A friend of mine who was head of the Peace Corps in Nigeria said one thing he learned in Africa is how little it takes to really live on in terms of the things about you. We think we need every damn thing we see, which is just a way of thinking. One is sacrificing, prostituting his values, as well as his economics, when he does that. You really can't live like that. You never have anything. But that's a very significant statement he made, in terms of how you are compelled to buy, and to get involved in things that are worthless in this society.

**Q:** Can you tell me something about the education system here in Anacostia?

**Kinard:** You know we have a decentralized unit here in Anacostia. It's called the REP Program—response to educational needs, sometimes called the Anacostia Project. There are 26 schools involved, all the schools in Anacostia. Here in Anacostia we've had a problem of just structures for kids who go to school, just the physical buildings. You'll see next to a little four-room school house another embellishment. Then you see an extension, and now you see this big new monster that they have put up; and there's still not enough space for the kids here in Anacostia. More than 50 percent of our population is under 18 years of age, you see. In addition to that, when the Southwest section of the District was cut up, people were sent to the four winds, and public housing was built out here in Anacostia, so we have more public housing out here in Anacostia than in any other part of the city.

**Q:** Was it a covert move to send people to Anacostia?

**Kinard:** Well, not Anacostia in particular, I don't think. You see the politics of the city was that there was decision-making without representation. So people could do anything in the city they wanted to—the city fathers, the speculators, the zoning people. So Anacostia has all this open land out here. [The decision-makers could say], "We don't want them over in Northwest where we live, so let's put them out there."

That happened 100 years ago. When the freed slaves came up from the South, they sought solace near the Capitol and built their little shanties and shacks around there. A thing was instituted called Freedman's Bureau by General O. O. Howard, and there was a whole lot of cry to get those people away from here. [Howard] came out here and bought some farms—the Talbert Farm and up above it the Barry Farm and the Garfield Farm. These farms were purchased to relieve Southwest and bring the people over here 100 years ago; it was 1867, as a matter of fact. In 1957 there was a re-enactment of the same thing. Southwest had built up again with blacks, so they just bulldozed everything and built more public housing up here, in these same Freedman's Bureau tracts. Other folks went to the Northwest corridors.

They really couldn't afford it, but they were told they'd be able to come back to Southwest. If you know anything about Southwest, you know that you can't get into Southwest. They have no public housing down there.

At any rate, President Johnson wanted to give some money to some area in the country for an experiment in education, and this area got it. So we've had this program since he was president. [The point of it is] to try to experiment with new teaching methods in a deprived area, [to find out] how you can instruct and deal with a variety of children. When we get ready to do an exhibition, we go talk to the school people. [We ask] what ideas they have that we could use to meet their needs. Where are they in the curriculum? What kind of things could we do at the museum that you couldn't do in the school? What films would you like to show that we can get? What kind of educational materials can we help you develop? It has been a very informal kind of a thing, but I hope the day comes when we can look at the curriculum critically, across the board, at all levels, and criticize it from a practical vantage point. Then we can bring teachers in and say to them, look, here's what we're doing, here's what you're supposed to do, here are some other ways of doing that, here is a critical examination of it, and here's what we recommend.

**Q:** When kids get all the way through the Anacostia Project, do they then have to face the same standard as other D.C. public school students?

**Kinard:** Yes sirree. That's the standard of acceptability; it says, you need to be here, and that's where we want you. As you certainly must know, many of them drop out in between. I heard a figure once that out of every 100 kids who start off in the first grade together in this community, by the time they get to the 10th grade, 60 of them are gone; they're in the streets. And the system's designed to weed them out. One ought not to be shocked at that figure. One should be shocked that it isn't higher. So those who can acculturate and adopt the standard more easily are the ones that move on. Those who can't are the trash heap—yet they may really be the smart folks, you know.

**Q:** Tell me about your training program.

**Kinard:** We here don't have a lab to produce our exhibits. That was our number one problem, so about four years ago we started thinking, how can we get a lab to produce our exhibits? Our view is that the way exhibits are done ought to reflect the circumstances of your environment. If you are doing an art show, it's not just stuff slapped up on the walls in a traditional way. If you understand the interests of people in your particular geographical area, there certainly must be a way of doing exhibits that is consistent with your understanding of their mentality—which means a new way of doing it, because it hasn't been done that way before. We think we need to try our hands at exhibits that technically are so woven into the fabric of the interests of people that one cannot help think, well that's interesting, but the way that it was done is even more interesting. And that opens up a whole new creative avenue. We want to provide an opportunity for people in

this community and around the city to try learning how to design exhibits that are an expression of their own creativity, done in a way that is consistent with their interests. We supply the technical know-how of all the different ways you can design something. Once they understand lines, measurements, and all that sort of thing, and once they have seen it done in a traditional way quite a bit, things pop up in their minds.

In addition to that, museums—and the Smithsonian is no exception—say, we want more minorities, but we can't train them, we don't have a training program. We got some money through the Bicentennial. The Smithsonian's doing a whole lot of things for the Bicentennial, so we decided that's the avenue we would take in the development of this institution. We took our $200,000 and built a building. We went to the Ford Foundation and said, "Here's what we want to do. We want to train people, Anacostia people." They said they would not give us a dime to train people just from Anacostia. "If we give you the money," they said, "it will be to train minority people from across the country—Indians, Puerto Ricans, Spanish-speaking Americans from the Southwest, poor whites up in West Virginia who don't have any opportunity either, Japanese, Chinese. You go out to California and you look in the museums there and you see Chinese and Japanese out there, but they ain't workin' in no museums." The Ford Foundation is also interested in training Africans. We have decided the way to do all that is first to train people from the [D.C.] metropolitan area. [That means] we don't have a problem [looking for housing] the first year, and [we can] learn how to run a program like this. Once we learn how to do it, then we'll take minority groups from elsewhere. But we have to work through museums. For example, we'll go to the Brooklyn Museum and say, "You want to hire some Spanish-speaking people here? We will train them if you assure them of a job in your place when they come back."

We are starting off at the technical level, which is easiest to broach. Then we'll move into paraprofessionals at curatorial levels and on up into administration. The curators are much more obstinate than the people in exhibits. You've got to have a Ph.D. But there are a lot of things that a guy could do. You don't have to have a Ph.D. or a Master's, or even a B.A. If you're exposed to the work by people whose life's breath is involved in it, you pick that up, you see; you become interested. You may discover an interest you really didn't know was there. We want to provide an opportunity for the exploration and exploitation of that in the museum. And maybe we can get museums to start concentrating on the environment of which they are a part. [Maybe they'll start to think about] the nature of the problems and the aspirations of people in their environment, too. The training lab is an opportunity for us to produce our own exhibits and train people at the same time.

**Q:** When you take people from Anacostia into the training program and they develop the skills to make good exhibits in Anacostia, you are also going to be training people to go into major museums that already have set ideas about what a museum should be. Are you training those people, then, to be strong enough to effect a change in the attitude?

**Kinard:** To understand it you would have to understand the traditional museum and those problems, so that you don't immediately get frustrated and die. I have to do this every day. There are a number of traditional museum people among my colleagues; I must [say to myself], their ideas aren't so completely asinine and mine so virtuous that we fail to open up channels of communication where we can respect each other's ideas. That [attitude] has to be imbedded in people. Just because you think what they're doing is all bad and what you're doing is all good, it doesn't mean you can't deal with these people. Each of us could be wrong. If we can get together and talk and have a substantive discussion, both of us will benefit. What we come up with may be a hybrid, which is good.

So we have to provide a unique historical understanding of museums and of the way different national groups are reflected in their own museums. In America you've got a variety of expressions of what the museum traditionally has been from its European origin. Why a museum? What are the economics of it? [We have to understand] how the Smithsonian, in what it does daily, undergirds and supports a vicious system of cultural supremacy. That's the reason it exists. You know that, man. So when you look at an exhibition you know exactly what you're looking at, why it's put there, and what all aspects of it are.

**Q:** Can you do an exhibit here on your relationship with the Smithsonian and the differences between you and the Smithsonian?

**Kinard:** Yes, we have no aversion to that, certainly no fear of that at all, but you see it must be done in a way that is not a John Kinard expression, but a unique expression of the board of directors. How would it help us? How would it help the Smithsonian? It must be done in a way like if you beat a man, you also have the medicine kit there so you can put him back together. You don't just want to be vengeful. You're sick, he's sick, and nothing happens. The board and the community [must be able to] say, "This is the direction we're moving in now. We understand what it does for others and what it does for us to do this exhibit, and we're standing behind it." You have to understand the economics of such a move; it needs to be thoroughly investigated before you do it. Maybe someday . . .

I read in the paper once where at the Guggenheim [Museum] this artist was doing an exhibition; he was doing paintings of all these old, run-down, rackle-shackle buildings in New York. And who owns [those buildings]? Some of the people on the board of directors of the Guggenheim. That exhibit, as you must know, was never shown, when they became hip to what he was trying to do. I would see us someday doing that here, in Anacostia. Who owns all the stuff out here? Names and addresses of interest. So you find out who your exploiters are. Who's helping, who's hindering. Conceivably a whole lot of stuff could occur. When the

fur flies on the Secretary [of the Smithsonian], he gives me a piece of it. But he would have a difficult time giving me a piece of it if the need came from these local people. So that's part of the politics.

I proclaim that we aren't involved in politics. We're involved in the exploration of the truth about whatever it is, and we expose what is, what could be, what was, so that the truth becomes the object to be dealt with and not personalities. That sort of a mentality is what I would call the community museum. It has a social responsibility, and here's how it goes about carrying it out. It must be well thought out by a variety of people [who understand] that these are their interests and understand their interests better, and then you try to [translate] their interests into an exhibit. The Smithsonian's view was that the Anacostia Museum would act as a boardwalk into the halls of the Smithsonian. But that [Anacostia] river is a tremendous barrier. We have youngsters in this community who grow up to be 16 and 17 years old who've never been across the river.

**Q:** They don't know what's there, or they don't want to go?

**Kinard:** I think it's more somebody taking them who's interested. You can't say that they don't know because they must know. They're watching television all the time, and people they know who may live over across the river come to see the family. It's just the opportunity to be ushered around. When I was growing up, for example, my parents were great parents, but nobody who had ever traveled a thousand miles ever came to my house. Nobody who was engaged in any significant kind of work, different from lawyer, preacher, doctor, teacher, ever came. So I'm sitting there listening to them talking about whatever they're talking about—the Bible, school, health, the job, whatever. It was insignificant, maybe. [In a situation like that] the mind doesn't have a chance to expand. You look at professions among people in communities like Anacostia, and it's just an embellishment on what it is. Nobody's talking about going to China, nobody's been there, nobody knows what the hell it is. Nobody's talking about going to Africa, or Europe. You just don't get that. Consequently, a youngster's image of himself and of his world is very, very narrow. Not that he doesn't want to go; the opportunity never arises in his mind. He can look at the television and see something happening somewhere; it may arouse aspirations in his mind, but he's confused because they cannot be fulfilled once he understands what his situation is with his family.

**Q:** Tell me about Museum for the City of Washington. Will it affect Anacostia? Will it be connected with this museum?

**Kinard:** We're doing some research with oral histories to document our way of life here in Anacostia. In our discoveries we're finding so much that pushes us into Washington proper, as well as Prince Georges County, because this was part of the land ceded from the State of Maryland. So there's an indivisible line of history between Maryland and the District that goes back to the founding of the city. Since we've been pushing into this area and further

mention ourselves in the city of Washington historically, we are seeing the need for a unique entity that every city ought to have—a museum that affirms its existence through documents, objects, whatever. Nothing like that exists here in Washington. You can't go to a museum to learn anything about the founding, or talk about the history of Washington, D.C. Unless you read a book on it, unless you studied it in school or talked to somebody who knows, you don't know anything about the city of Washington.

Now I'm particularly interested, based on the experience here in Anacostia, in a museum that looks at urban problems, aside from the history. Because we have so many people here from around the world and around the country who are interested in the problems of education, urban transportation, service delivery systems in health, sanitation, etcetera, I think Washington could be looked at as a microcosm of cities all around this country. Here we might see an accurate identification of the problems with regard to health care. A visitor might analyze all the kinds of things that people in his town suffer from, which are no different from other towns.

But maybe they are! Maybe there's something significant here that people suffer from. We don't know because we haven't looked at it. [We haven't looked at] what's being done, what has been done to analyze this problem in the past, what conclusions were drawn, what solutions or recommendations were made that were or were not put into effect. So what we are talking about doing in this museum is [trying to look at] what *is*, what *is* today, what *is* ten years ago, and back as far as we can go, so that people can see and understand.

You can't do too much with a problem unless you understand it, you know, and this is one of the difficulties in urban complexes like here in Anacostia. People are feeling hurt by housing. We've got raunchy, run-down houses, management is no-account, and people are hollering, but they don't know what to do. Consequently, people get involved in all kinds of socially unbecoming behavior because they are frustrated with jobs, housing, these things. They act in a confused, moribund, demoralized way. I think understanding will help it, so that people will no longer need to lash out at children and at other people in the society in socially unbecoming ways. Once we understand the problem and how to look at problems, then the average Joe, who may not have more than a 4th-grade education, if it's bent toward that level of understanding, can say, well, I think that we should do this, or that, or the other.

The museum's responsibility, instead of playing politics, as I see it, is to draw straight, analytical solutions to the problem—not just to identify what the problems are, but to say, from what we have discovered here, this is what we recommend, what we suggest. People can criticize it and shoot holes in it, but at least they aren't acting in that demoralized way any longer. They're operating from a more informed point of view.

People from Chicago, or wherever, will say, "Wow, I

never before got involved because I never understood the problem, but here is a way that I can understand the problem.'' The city museum will consequently have another aspect—training people to man jobs in this unique institution, which is, I suggest, a museum of the future in its commitment to social responsibility. You just don't do some research and put it on a shelf; you're also forced to promulgate what you have discovered, broadly and widely, through this museum and in other halls of academia. The social institutions—the churches and the schools, in particular—have a commitment to say, here's what we have discovered.

The new museum must also be engaged in every aspect or discipline of life that we know. Consequently, we're talking about the graphic arts and the performing arts. If you have an auditorium, not only do you have a place for people to come and perform, but you actually *espouse,* maybe by having a theater company, the opportunity to develop and grow. You help people live, or at least approach, something called "the good life." This has nothing to do with economics, with how much money you're drawing in. [It has to do with] opportunities for exposure, for expansion of the mind, for involvement and understanding and associations with others, whatever their education and social class background. Here is an opportunity to bring folks together. So that's what I see as a museum for the city of Washington, and according to anything I've ever seen, that would be unique.

It ought to be a model of how a museum is developed, so that other folk in other towns who are developing a museum can look at a case study of how this thing was put together. It must be put together loosely, so that you can switch on and, where there is no interest, switch off. That decision is arrived at through hearings, through discussions with people. It's not just me sitting down, saying, well, we're going to do urban studies, and here's why we're going to do that. I must state my idea, open to the public, and have it attacked or embellished, whatever the case may be. So that's another aspect of the model technique. In traditional museums the [managers] say, "We know what's right for people, what's just for people, and we'll set up an art gallery, and if people don't come, well fair enough. If they do come, well fair enough."

Whether we're talking about a unique, separate institution, or whether we're talking about meshing with what Anacostia is as it grows and expands, I haven't solved that problem yet. My own allegiance, based on the tremendous dedication of the people on this board who got this whole thing started with the Smithsonian, is to having it here in Anacostia. And the politics of that is changing the center of things. This is really a deprived area; [there are very few] opportunities for exposure of this kind. We need to put something like that here, something that espouses dignity and involvement on the part of people here and that is open to people from around the world. Then it becomes a dynamic community, always changing, to the benefit of those who live here.—*B.C.F.*

## Notes

[1] Definition of a collection for the purpose of accreditation by the American Association of Museums.

[2] For sources of quotations without footnote references, see list of interviews at the end of this report.

[3] Quoted from a presentation on mobile units made to a meeting of the Museum Education Roundtable, April 1974.

[4] Caryl Marsh, consultant to the District of Columbia Department of Recreation and to the Smithsonian Institution.

[5] Then director of the Smithsonian Office of Education and Training.

## Interviews

Archer, Audrey. Administrative Assistant, Anacostia Neighborhood Museum. July 23, 1974.

Blake, John. Secretary and Corresponding Secretary, Board of Directors, Anacostia Neighborhood Museum. August 8, 1974.

Dale, Almore M. Treasurer, Board of Directors, Anacostia Neighborhood Museum. July 18, 1974.

Hutchinson, Louise. Director, Anacostia Studies Project, Anacostia Neighborhood Museum. July 22, 1974.

Jones, Alton M. Chairperson, Board of Directors, Anacostia Neighborhood Museum. August 6, 1974.

Kinard, John. Director, Anacostia Neighborhood Museum. July 17, 1974.

Martin, Zora B. Supervisory Program Manager, Education and Development, Anacostia Neighborhood Museum. July 22, 1974.

Mayo, James E. Exhibits Specialist, Anacostia Neighborhood Museum. July 22, 1974.

Smith, Fletcher A. Program Manager, Mobile Division, Anacostia Neighborhood Museum. July 22, 1974.

Thomas, Larry Erskine. Supervisory Program Manager, Research and Design, Anacostia Neighborhood Museum. July 22, 1974.

## THE SAN FRANCISCO ART COMMISSION'S NEIGHBORHOOD ARTS PROGRAM

San Francisco Art Commission
165 Grove Street
San Francisco, California 94102

**A history of the struggles, successes, and failures of a city-sponsored program to nurture the arts in the neighborhoods of San Francisco. Its goal: to encourage and support arts programs that are required and, increasingly, devised by the residents of San Francisco's diverse communities. Two of the emerging ethnic art institutions nurtured by NAP are also described here to show how their combined gallery and workshop programs serve their special audiences. CMEVA interviews and observations: June 1972–September 1974.**

### Some Facts About the Program

1. **General Information**

   Founding: The Neighborhood Arts Program (NAP) was started in 1967.

   Number of paid staff: The San Francisco Art Commission is

staffed by 10 professionals in the arts plus a director and an executive secretary. The Neighborhood Arts Program has 8 to 35 part-time employees, hired as needed.

Number of volunteers: Volunteers are used sparingly as instructors, and only when they can be relied on to keep a commitment to teach for a semester. Only about a dozen are involved at any one time in the program.

Annual operating budget: For the Neighborhood Arts Program, about $300,000 per year.

Annual education budget: About $60,000 (representing about 20 percent of the total budget) supports the workshops program. Of this, $36,000 goes for salaries, and the remaining $24,000 supports eight neighborhood workshops at $225 per month plus special workshop projects.

Source of funding: City and county of San Francisco, National Endowment for the Arts, Zellerbach Family Fund (Zellerbach funds sustained NAP in 1968 and 1969 and now amount to $30,000 a year). New and expanded programs are funded by separate grants and donations, mostly from the San Francisco Foundation and the California Art Commission.

## 2. Location/Setting

Size and character of city: San Francisco, with a population of 715,674, is second only to Manhattan Island in population density. Thirty-two percent of the population is nonwhite; the enrollment in San Francisco schools, 77 percent nonwhite. Set among high hills, San Francisco is one of the most picturesque cities in the country. The city is known for many other things as well—cable cars, Fisherman's Wharf, Chinatown, and much more—and it is easy to see how civic pride comes naturally to San Franciscans.

Climate: Temperate.

Specific location of program: Citywide.

## 3. Audience

Memberships: No formal memberships.

Attendance: About 50,000 persons attended free performances, classes, and workshops sponsored or cosponsored by NAP. Through its services to artists, art organizations, and performing companies, however, NAP indirectly reaches 300,000 persons.

## 4. Educational Services

Organizational structure: The San Francisco Art Commission is a division of the city government. The commission's director of cultural affairs oversees the Neighborhood Arts Program, which is administered by a director.

Range of services: In addition to NAP, the art commission sponsors an annual city art festival, a pop concert series, and a gallery that exhibits the work of local artists. The commission also oversees the design quality of city structures and assigns 2 percent of the cost of these buildings to art enrichment—graphics, sculpture, murals, or other forms. The NAP sponsors or cosponsors about 100 performances each year, about 120 classes, workshops, and master classes yearly; designs and prints leaflets for about 600 art groups and organizations, distributes free booklet on basics of art publicity (*How to Manipulate the Media*); offers consultation on publicity needs, free use of lighting and design equipment and film projectors, stage truck, and Neighborhood Arts Theater for performances, rehearsals, and classes; provides assistance in proposal writing and grantsmanship. District organizers help arts groups set up community programs.

Audience: NAP workshops attract about 1,500 children, teen-agers, and adults to about 150 workshops and classes per year. The audience for NAP performances raises the attendance to a total of about 50,000 per year.

Objective: To encourage grassroots arts programs in the neighborhoods, to establish liaison with community groups, and to increase support for neighborhood artists and cultural organizations.

Time: Throughout the year.

Information and documentation available: *How to Manipulate the Media* and annual reports, 1970/71, 1971/72.

---

San Francisco enjoys the reputation of being almost everybody's favorite city. It boasts one of the country's oldest opera companies, a symphony, a ballet company, and four major West Coast museums; it is also home to the Beat Generation of the fifties and the Flower Children of the sixties. It was the late sixties, too, that gave birth to the phenomenon that is the San Francisco Art Commission's Neighborhood Arts Program.

If San Francisco has seemed to outsiders to be supportive of the arts, it should be understood that for many years the support went largely to the opera, the symphony, and the museums. It did not reach the city's community artists or its many diverse ethnic neighborhoods. Of the 750,000 persons who live in San Francisco, 43 percent are nonwhite, and in the schools the figure is 77 percent.[1] As is common in America, the lower- and middle-class minority populations in San Francisco have not been well served by the established art institutions, and until 1968 there were few community-oriented art events.

By 1974, community arts groups were thriving in storefront art centers and neighborhood theaters. There were festivals throughout the city, made possible every month of the year by the temperate California climate. Muralists were decorating walls in schools, miniparks, and at many intersections throughout the Mission district.

This burgeoning activity owes much of its vitality to a small group of people who operate out of an unobtrusive two-story, grey stucco Federal style building located in San Francisco's Civic Center. Here all phases of the arts can find a helping hand. Free posters, publicity assistance, sound systems, Xerox service, and fund-raising and proposal-writing expertise are dispensed, along with carefully apportioned chunks of the city's cultural funds. Either directly or indirectly, 300,000 persons, nearly half the city, are affected each year by the work of the Neighborhood Arts Program, budgeted in 1974 at about $300,000 a year.

Why did San Francisco decide to support the arts of its neighborhoods? And how did the city do it?

## The setting: San Francisco 1967

There are no defined formulas for convincing a city that it should nurture arts in its neighborhoods. The decision to create such an arts program was influenced by several unrelated factors, among them the drive of a few dedicated indi-

viduals and the support of others for political or benevolent reasons.

Whatever the reasons, the result was that the cultural activity of the sixties—not all of it well received by the city fathers—had made its point. In a few years before 1967 when NAP was born, San Francisco had witnessed a spectacular revival of the arts in light shows, decorated vans, rock concerts, and psychedelic posters that circumvented the establishment arts and brought international recognition to Bay Area artists. The San Francisco Mime Troupe had been playing the city's parks since 1963: the group's history of professional performances, arrests, and finally banishment from the parks had publicized the potential of art in the neighborhoods. The 1966 "summer of love" gave further evidence: such future stars as Janis Joplin, the Grateful Dead, and Jefferson Airplane, performing in the Panhandle of Golden Gate Park, drew down a law against amplified music and roused the police to hire tactical squad experts to control the hippies; but they also made the city officials aware that the arts were alive in the residential enclaves where the voters lived.

At the same time, the ferment in the arts convinced local artists that they should be able to live and work in the city. There had to be a way to make a living in the Bay Area: "I'd rather sell my art out the front door," said one, "than go to New York and scratch around cocktail parties for 15 years to see if I can make my connection."[2] In an effort to survive economically in San Francisco, artists formed the Artists Liberation Front of 1965–1966. They held mass meetings that defined downtown business interests and the concentration of art support in the city's center as "the enemy."

It was the artists' contention that the city's cultural budget had room for both downtown and the neighborhoods. Allying themselves with first the philosophy and, later, the creative arts departments of San Francisco State College (now San Francisco State University), they moved into politics. Their sights were set on improving the quality of life in the neighborhoods. Symposia on the issue of community arts were held at the college, generating further support for the idea of a citywide community arts program. Said Rod Lundquist, the first director of the Neighborhood Arts Program and an early member of the Artists Liberation Front,

> We had reached a point in city politics generally where there was a reawakening of the neighborhoods to some degree. People recognized that the quality of life in the neighborhoods was important to the health of life in the whole city. The tendency in many areas, in addition to the arts, was to ignore the quality of life in the neighborhoods, build freeways through them, and build developments that were incompatible with previously existing residential areas. So the Neighborhood Arts thrust reached sympathetic ears among people who were not particularly absorbed in the arts. It also reached sympathetic ears among the artists because they had become disenchanted with the idea of going to New York and making it, which had been

the basic illusion on the horizon for artists for the last 40 years.

The city fathers and the business community had been thinking of a different kind of art program for San Francisco. They envisioned a cultural complex in the civic center that would attract major performing groups—and tourists—to the city. A bond issue to finance this undertaking went before the voters in 1965 and was defeated two to one. As Lundquist pointed out, the business community realized that it must give something to the neighborhoods in order to gain approval:

> Downtown interests wanted to sink a great deal of the taxpayers' money into this big new cultural center downtown. Well, the neighbors didn't like the sound of that too much because it all goes for the tourist industry, and they can't even afford a ticket to the stuff. So it was pretty well spelled out. . . . The supervisors became more sympathetic for the neighborhoods because that's where the votes are. A number of neighborhood issues were emerging that made it clear that if the neighbors didn't get something, there wasn't going to be any downtown cultural center. So the neighborhood arts program was virtually levered into existence on that basis.

The stage was set to bring the Neighborhood Arts Program into being.

### The main characters, 1966–1967: establishing NAP

**Art Bierman.** Member of the College Committee for Arts in the Neighborhood; founder of a nonprofit organization devoted to implementing community arts, the Neighborhood Arts Alliance, which acted as a lobbyist for NAP. Also helped found "Arts in the City" class at San Francisco State and recruited Richard Reineccius as instructor. Friends and colleagues of Lundquist, they worked together to conceive NAP.

**Rod Lundquist.** Helped originate the idea of NAP on the basis of eight years' experience with foundations and his perceptions of San Francisco as an artist living there for 20-odd years. He knew what foundations wanted and designed a program to meet their requirements.

**Martin Snipper.** Executive Secretary of the San Francisco Art Commission since 1966 (now Director of Cultural Affairs); for 15 years director of the San Francisco Art Festival. In 1964 entered a $2,500 line item into his budget for the involvement of the neighborhoods in the annual art festival. The money was approved, but then Snipper realized it was too little for all neighborhoods, nor could all the neighborhoods provide entertainment for the art festival: some were culture producers, others were culture consumers. Snipper picked one, the Mission district. According to Snipper, the idea was not successful, but he had been thinking about the neighborhoods. So Lundquist and Bierman found a sympathetic ear.

**Harold Zellerbach.** President of the San Francisco Art Commission, trustee of the California Palace of the Legion of Honor (now the Fine Arts Museums of San Francisco), board member of the symphony and the opera, president of the Zellerbach Family Fund, and advocate of a performing arts center in San Francisco's Civic Center.

**The supporting cast**

**Mayor John F. Shelley.** Had run for mayor of San Francisco in 1962 on a platform that advocated neighborhood arts programs. As Snipper recalls, he and an art commissioner had drafted this as one of his proposals:

> . . . I remember Al Frankenstein [art critic for the *San Francisco Chronicle*] was in the audience, and the mayor announced as part of his program that he favored neighborhood arts programs. I remember Al asking questions, but after Shelley was elected, nothing happened.

When Lundquist and Bierman approached Snipper about a neighborhood arts program in 1966, the three of them reactivated interest in city support of a neighborhood arts program. Said Snipper,

> We saw this as a three-way partnership. San Francisco State would establish courses and provide personnel to work in the community. The private sector would take on the responsibility for programing; the art commission would only be a service agency. The private sector would simply make its needs known. So I put in for a budget request, and I think we got $25,000 the first year. Shelley's immediate response was, "Oh, yes, that was my platform." When I asked him, I was hoping to get the $3,000 for the art festival, but the minute I put it in, it was accepted by Shelley. State College started a course, but there was no place for the students to work out in the neighborhoods. Rod Lundquist, since he and Art and I had evolved the program, was the first director.

**Richard Reineccius.** Director of the Julian Theater; instructor in the Creative Arts Division of San Francisco State College and eventually instructor of "Arts in the City"; and program coordinator of NAP, 1968–1970. In 1972 Reineccius formed the Community Coalition for the Arts to seek revenue-sharing money for the neighborhoods. He said of the episode,

> I was interested in getting college kids off campus. This was the time of the whole myth of college without walls (1967). The Julian Theater had started in a church basement in the Mission in 1965. Things were moving very fast. All kinds of EOC programs were getting started; we wrote our first proposal for community arts in 1965. The Mission Rebels and Casa de Hispaña got angry, as we were coming in from the outside. They got organized. We were naive to think we could organize a thing in a district that was predominantly Spanish-speaking.

**Jack Morrison.** Member of the Board of Supervisors, the governing unit of San Francisco. Supervisors are elected representatives of the city's districts. The support of this body, led by Morrison, was partly responsible for the establishment of the Neighborhood Arts Program under the wing of the San Francisco Art Commission. In 1967 Morrison sponsored legislation to create the Neighborhood Arts Program, not by taking it to the voters of the Board of Supervisors, but by placing it under an existing department, the art commission.

So on July 1, 1967, the Neighborhood Arts Program came into existence as a project of the San Francisco Art Commission with a budget of $25,000. NAP was designed "to improve the quality of urban life through encouragement and support of an active interest in the arts on a local, or neighborhood level, and to establish liaison between community groups, and increase support for neighborhood artists and cultural organizations."[3]

**The San Francisco Art Commission**

Established in 1932, the art commission functions like any other city commission, such as police, fire, or port, which governs major city departments in San Francisco. The commission selects the chief administrative staff members of its department. Each commission is appointed by the mayor and operates autonomously. The Board of Supervisors does not have the authority to interfere in commission decisions, though it must approve the budgets and implement any law, ordinance, or regulation that results from a commission's proposal.

The art commission came into being primarily to save the San Francisco symphony during the Depression, when it initiated a series of low-priced concerts in order to keep the musicians at work. One of the art commission's major programs has been a series of low-priced pops concerts under the direction of Arthur Fiedler, which have been virtually sold out for several seasons. Members of the art commission are predominantly professionals in the arts. There are two architects, a landscape architect, a musician, a writer, a painter, a sculptor, and three lay members. Ex-officio members with full voting rights are the president of the board of trustees of the Fine Arts Museums of San Francisco, the chairman of the Planning Commission, the chairman of the Library Commission, and the president of the Park and Recreation Commission.

Martin Snipper and his executive secretary are the paid administrative staff for the art commission. Snipper is designated the Director of Cultural Affairs for the City of San Francisco and is responsible for all of the activities of the commission. Like most of its members, he comes from the artist ranks, with some administrative experience as director of the San Francisco outdoor art festival. Snipper said of his early political activity,

> Essentially I lived by teaching and painting. I was very active in some of the art groups. At that time, the art commission only presented musical programs. They had no programs whatsoever in the visual arts. So I was part of

a group of artists that pressured for the establishment of a visual arts program. That was about 1948.

Besides NAP, the art commission sponsors the annual city art festival, the pops concert series, and a gallery that exhibits the work of local artists. The art commission is given the authority to approve the design of any structure the city plans to build. In addition, it oversees the city's assignment of up to 2 percent of the cost of these buildings to "art enrichment," a phrase that covers the commission or selection of graphics, murals, and sculpture for civic buildings. Under these terms, according to Snipper, the city also purchases works of art selected by a jury from the San Francisco Art Festival entries and is responsible for this collection.

### The original concept of NAP

The author of the Neighborhood Arts Program, Rod Lundquist, envisioned an organization that would respond to the needs of the community and to the needs of its artists. "My idea in inventing the NAP apparatus in the first place," he said, "was that it seemed to me that in an egalitarian democracy there is little justification for using public funds to provide entertainment for the rich, which is regrettably the way it turns out." He went on to say,

> Originally, we were not thinking of ethnic groups, but we weren't eliminating ethnic groups either. It had nothing to do with ethnic groups one way or another. It had to do with the recognition that elitist art and downtown art and New York art were not the only kinds of art that were feasible, and in fact in many ways they are becoming unfeasible. There is a growing audience in the United States for art, but the downtown stuff and the high-brow stuff is not necessarily more intelligent, more relevant, or of better quality than what could be made elsewhere.

The concept was that neighborhood art councils would determine what kinds of art programs they wanted for their communities and that they would handle the financing of these programs and events. NAP would provide and coordinate facilities and facilitating mechanisms, and college students would act as the staff to assist the neighborhood in implementing its programs. There was no intention to buy art or art programs to give to the neighborhoods. According to Lundquist,

> If you buy art, then you are going to have a downtown character, whether he is a bureaucrat or an ethnic frontman or a highfalutin manipulator, sitting there deciding who are the favorite artists and who are the less favorite artists and giving out free money for artists. The line would be endless unless you develop a very carefully protected inner circle.

In order to avoid pandemonium or the development of a clique of artists, Lundquist wanted neighborhood arts councils to create a market for artists by sponsoring programs and finding places for them; the public itself would then select and support the art. He felt that the role of NAP was to locate buildings and provide stages, sound systems, publicity assis-

tance, and space where the artist could perform, teach classes, or exhibit his work. It would be the role of the private sector of the economy to support the artist, like any other producer, through gate receipts for performances, fees for classes, and payment for his graphics, painting, and sculpture. The public would be, in the end, the patron and would decide who succeeded and who failed. In Lundquist's words,

> You may be investing some organizational help; you may be investing some equipment and some publicity that may be wasted in some cases because a guy comes in [to NAP] and says he wants to put on that show or whatever, and nobody comes. He may come back several times. Eventually people who can't draw are going to be embarrassed toward an appropriate modesty.

### Testing the idea: early problems

Lundquist was committed to laying the groundwork for neighborhood arts councils carefully in order to test his premise of community-supported art programs. But his plans did not get off the ground with the speed demanded by city officials. Snipper and Art Commission President Zellerbach needed immediate results. The result, as Lundquist described it, was an inevitable confrontation:

> What ultimately occurred was total cooptation of the whole idea. Once I was in there, I was immediately under pressure to produce: I should go out and buy some artists to put on some shows. I was very reluctant to do that, but I was also cornered because the neighborhoods were not alert and ready for the kind of sponsoring that I looked forward to, so I was playing both ends against the middle. On the other side, downtown, I was under pressure to prove that this thing works. They wanted me to do some central programing, giving art to the neighborhoods. I resisted this and ran as hard as I could on the neighborhoods. I ran that course out. It was fairly evident to me at the end of my brief tenure that the neighborhoods were not ready immediately to do what I was hoping to do.

Thus, Lundquist's idea of a grassroots marketplace for the arts turned out to be idealistic and premature. Beyond the fact that the neighborhood was to handle the programing, no one was informed about community arts or had any idea what to expect from the art commission for neighborhood organizations. People did not know what to request. The art commission mailed a newsletter and questionnaire to community groups announcing NAP and the availability of a staff from San Francisco State and a bank of equipment ready for use. To the 80-odd questionnaires distributed, there was only one response. Community arts was too new an idea.

The commission itself had trouble deciding which organizations should receive the questionnaire. When organizations like the Lions Club or the Kiwanis got the questionnaire, they had no idea what the art commission meant. Ethnic groups, such as the Italian-American Social Club, Slovak Folk Dancers, or Chinese classic music clubs either

were left off the list or were too suspicious of a city agency to reply. The administrators of the program realized finally that if NAP was to succeed, there would have to be education and publicity about it throughout the city.

Meanwhile, the students enrolled in San Francisco State College's field studies class were eager to work, but there was no place for them, and the nature of the semester system was not compatible with real life. Besides, students were not enough; NAP needed a staff. As Snipper described the situation,

> State College had started its program, but number one, they started their program too soon—before we could make use of anybody. Number two, the disadvantage in State College is that there is constant changeover in students so almost after the first year, they drop out. There is nothing for them to do.

But the major hurdle for NAP remained the demands of city government: there had to be a product to demonstrate the worth of the program or there would be no program. NAP could not be left to evolve naturally. Snipper was getting nervous; he needed evidence of a program. While Lundquist was researching a procedure to develop popular arts for the people of the city, the politics of city government demanded an artificial injection from program headquarters. Said Snipper,

> Rod was always three steps ahead of me. He would be out in the community making contacts, and I could never see him. It was like a pot that was constantly boiling with steam coming out, and you would lift the lid and somehow nothing was in there. We had money earmarked for a secretary, and I refused to hire a secretary unless she knew what she was going to do.

The art commission members did not want to release money and invest in staff and equipment until they knew what NAP was going to do. NAP could not function without money and equipment. All this, coupled with the necessity for programing in the neighborhoods, determined the direction of the NAP activities. As Lundquist remembers the period, it was not an easy time:

> When I went into the whole business, I was prepared to fight over budgets, but I did not think there would be people who would want to repress the whole program. But there are people who are into repression and do not like certain ideas given expression and, in fact, from time to time exerted negative force on this program. . . . I had some sense of neighborhood politics, city politics, and foundation politics, so I should have known what to expect, but it was the most unhappy six months of my life.

## NAP gets off the ground

Lundquist resigned as director of NAP toward the end of 1967, recommending as his successor June Dunn, an experienced political organizer whose commitment to the concept of the program was as deep as his own. Their positions overlapped for one month while they worked with students from San Francisco State to produce the first major NAP event, an Afro-American art festival. Lundquist realized that he would have to demonstrate to the neighborhoods what he meant by community arts. Mrs. Dunn knew how to conduct a political campaign and immediately identified the need for NAP to campaign in the neighborhoods. Using the Afro-American festival as a vehicle for making community contacts and for showing the city fathers that the voters wanted grassroots arts, she and Lundquist initiated a program that was to become a national model. According to Lundquist,

> NAP was beginning to gain some momentum, but it would take time, so it seemed reasonable enough to prime the pump by putting on some shows and to go carefully into neighborhood programing to show people what was possible in their neighborhoods. We could then go ahead to organize neighborhood-based groups, whether they were wings of existing groups like churches, Boy Scouts, ethnic organizations, neighborhood associations, or a group that had just come into existence called the Sunset Art Association, or whatever—just like a downtown group would be the museum association. Only the allegiance of these groups was to their neighborhood and to all the arts they could get going in their neighborhood.

The Afro-American festival, held during Negro History Week, February 1968, was essentially a performing arts program repeated at five community locations. It was staged in existing facilities—libraries, park and recreation centers, and schools. NAP provided the entertainers, the sound system, the publicity, and the organizational skills necessary to the production of such an event.

Mrs. Dunn described the festival as a "huge success":
> It was a huge success because no one had ever done anything before, and it was free. There was a newspaper strike at the time so we leafleted. We had to turn away crowds. It was an old-time variety show that played for three weeks to various communities. Zellerbach was thrilled. He saw thousands of people standing around and was really happy. It was immediately after that that we went to the supervisors for $78,000, and I hired organizers. Before that, there were only three people working with me.

The success of the Afro-American festival brought new demands for NAP's services, and the $25,000 budgeted for NAP by the art commission quickly disappeared. Zellerbach, who was not only president of the San Francisco Art Commission but also president of the Zellerbach Family Fund, had become by this time sufficiently supportive of NAP so that his foundation granted it $70,000 to pick up the slack for the remainder of the year.

The work involved in the festival set the pattern for the type of programing NAP would follow in the next three years—concert series, film series, theater all over town, programs on trucks, events in parks. However, Mrs. Dunn had no intention of continuing such programing indefinitely. Like her predecessor, she believed that the neighborhoods should become responsible for their own art programs:

It was always our goal that those neighborhood councils be real and that they eventually take over all the functions. My feeling was that what centralization remained would maybe be some equipment stuff and maybe some key people, some technicians for big stuff, mainly in an advisory capacity. The initial programing we did was not educational per se. The goal always was to get viable organizations in the neighborhoods. We had no idea how to do that, and it was purely luck. We did find people who combined the necessary political skills with the ability to identify or find people with the art skills.

The basic question was how to proceed. The art commission had made a contract with Mrs. Dunn for a given number of dollars each year. With this money, she was to hire staff and create a program. The city demonstrated flexibility by establishing this loose procedure, but it was not the ideal solution in the view of the art commission, which felt that it did not have proper control over the program. Commission members also felt that the NAP staff was underpaid, without job security or the benefits of city employees. Snipper himself disapproved of the arrangement:

In order to avoid civil service, June Dunn was put under contract, and she was allowed to hire staff. So as the program evolved, we had community organizers, not by district and not by ethnic group but simply at large. She employed them, and that was rare for a city. This was one of the most difficult things to control in terms of a program. To consider how far a city will lean over backwards to accommodate itself to a situation, we gave her $1,500 a month in advance, and then she accounted for the money after she spent it. Have you ever heard of a city operating that way? She hired the entire staff and had strict control over the money.

### The working procedure: organizing the neighborhoods

June Dunn's definition of her role as director was to raise money for the program, get the program well documented, and keep the organizers working. Her first official acts were to request a supplemental budget from the Board of Supervisors to continue the program and to ask for additional money from Zellerbach for a badly needed sound and stage truck. She later began appeals to local foundations. The budget went primarily toward staff, services, and programing.

The initial staff consisted of the NAP director, a workshop coordinator, a program coordinator, a publicist-poster artist, an equipment specialist, and five community organizers. The organizers were black, Asian, and Spanish-speaking, and they were responsible for the arts of specific ethnic groups for the city at large. Mrs. Dunn thought of the organizer as someone who would make grassroots contacts, identifying community groups and responding to program needs; he would have his own budget for programs but would be able to rely on the central office for additional funds. Her aim was to avoid central programing as much as possible.

The unique geography of San Francisco helped determine the structure of the program. That the city is small, bounded by water, and divided into clear-cut neighborhoods and ethnic communities, was an asset to the organization of NAP. A further asset was NAP's emphasis on ethnicity, then becoming politically popular. Said June Dunn,

All I did was capitalize on the times. We have this idea, and the way to develop it is to tie it to what is happening in the rest of the community and what is happening with social problems generally. . . . The only way I could perceive that program was to do it on a political basis. You go where the community is. The city is divided ethnically. The first grant we received from the [National Endowment for the Arts] came out of the Office of Education and from the Vice-President—not for art, but for riot control.

NAP thus came to emphasize the arts of ethnic communities. There were two parts to the program: one was staging festivals and performances, and the other sponsoring workshops. Programs and festivals flourished in the summer of 1968. They were designed for the San Franciscans who could not afford a weekend away from the city. The NAP staff developed a particular style in the way it carried off its programs. As one staff member put it,

Chaos and people getting involved was one of the program's standards for success. . . . We found that existing groups often don't respond to needs, but we could get diverse people together around a special event in the arts, something open that could be carried off within a workable span of time.

The workshops were directed to a specific group of patrons, young people who were dropping out of the junior and senior high schools. There was no attempt to move into art education for children or special classes for adults. Mrs. Dunn saw the workshops as unique to the function of NAP. They were to provide a place for kids to hang out—off the streets—and to learn a skill. She defined the audience as "kids in Chinatown and the Mission whom the schools did not have any influence on, who had dropped out or were on the verge of dropping out."

Meanwhile, in an effort to make NAP known, Mrs. Dunn pushed for quantity. During the year 1968/69, NAP put on over 400 events with the participation of half a million people; it sponsored workshops and paid artists to mount exhibits for community centers and libraries. Foundations and government agencies were sufficiently interested so that NAP began to plan for a budget of $500,000 by the fiscal year 1971/72.

Between 1968 and 1970, there were hundreds of street fairs, carnivals, free concerts, and film programs. Community art centers and small theater groups sprang up around the city, and with them came general confidence in grassroots art activities. NAP had created a network of communication between ethnic communities and a central agency. As the direction of the program moved from developing programs for the communities to assisting the emerging groups in the

community develop their own, the district organizer's role became one of coordinator as well as implementer. NAP provided technical and consultant assistance to those who wanted it. Its major purpose was to activate community arts by showing people how to put on a festival or by providing art instruction in the community. In NAP's 1970 report, the director of the San Francisco Mime Troupe wrote,

What is more difficult to appreciate without experiencing it is the service the program provides. . . . No one else in the city can tell a neighborhood association planning a festival, for example, what else is happening that week or where to get a band; no one else can tell a band or a theater group planning an outdoor performance what would be the best place or how to arrange the permits. The program contributes to a far larger number of events than it directly pays for. It is a bargain, and its disappearance or curtailment would leave a very noticeable vacuum in the grassroots cultural life of this city.

### The 1970 crisis: NAP comes to a temporary halt

That writer's remarks were not made casually. Conflicts between the art commission and Mrs. Dunn and her staff, which had surfaced before, were coming to a head in early 1970. A major source of contention was money, including money for staff salaries. Said Mrs. Dunn, "Something was wrong in a city program where half the staff was on food stamps. I just could not stand it."

Too, the staff members felt frustrated in their desire to create a decentralized organization that would encourage self-determination in the neighborhoods. They began a movement to take NAP out of the art commission's control, recommending that the program be governed instead by a nonprofit corporation. Richard Reineccius, then NAP's program coordinator, described the battle that followed:

We investigated trying to find another department or commission to assume the program. A lot of people, including the art commissioners, were saying at the time that it was a recreation program, not an art program. We had tried to move it under the park and recreation commission, but that became impossible very quickly. We wanted to move anywhere else—planning, the libraries. I had always thought the libraries were a logical extension. You take the books off the shelves and perform their words or their music.

It wasn't June that was put out. The reform she was trying to put through was the recommendation of the whole staff. She was trying to move NAP from a single contractor to a nonprofit corporation that would operate with district councils. These councils would have autonomy and their own good-sized operating budgets. It would be a lot more than Zellerbach's pet project. We were trying to take it out of the single control of the commission, which we thought was totally unrepresentative of the neighborhoods. A separate nonprofit corporation would become fiscal agent having the contract with the art commission to receive the money. It would be actually composed of district councils that would run their own programs.

The first thing that happened was not against June. It was an order from Martin Snipper to eliminate two jobs and the printing and publicity operation of NAP. That was when we knew something was going to happen.

It was our contention in 1970 that they [the art commission] were trying to wipe out the program [NAP].

The fever of activity abruptly ended in June 1970 when the art commission did not renew Mrs. Dunn's contract. Mrs. Dunn recalled,

When my contract ended in June 1970, no one had a job. I was contracted by the fiscal year; we had fought about changes in the contract. Snipper got mad at us primarily because he was afraid of the program growing so fast. The budget was to exceed his by far. The art commission had $200,000; NAP had $250,000. I was planning on continued money from the city, money from Rosenberg Foundation, money from the San Francisco Foundation, and Zellerbach. I had every reason to think that I was going to get Ford money and Model Cities money. I was not being unrealistic in anticipating $500,000 in three or four years, and at that time reducing the program and having the money handled elsewhere.

As she noted, the unusual nature of the contractual arrangement between Mrs. Dunn and the art commission meant that the entire staff was eventually fired, too. In the meantime, however, the art commission retained the NAP staff for one month after Mrs. Dunn left the program. But it was not long before the staff and the commission again collided; and because NAP was now simply a project of the art commission, the commission won the battle. Roberto Vargas, one of NAP's district organizers at the time, recalled,

The fight all happened at the top. The community organizers who were going to be affected had nothing to say, as we were not part of the administration. We were in agreement with June about the issue that NAP should have autonomy from art commission rule. I'm just saying that the third-world staff who were representing the community were not in administrative positions. Although there were important issues, it came down to being a fight between two personalities, June Dunn and Martin Snipper.

So NAP stopped as it had started, with a hullabaloo between those who felt they represented the neighborhoods and those who, in the NAP staff's estimation, represented the downtown interests, this time the art commission.

**The other side, from Martin Snipper.** Popular and powerful as Mrs. Dunn's program had become, it did raise some hackles, and from the art commission's view was moving too far too fast. This is how Snipper saw the battle from his side of the desk:

. . . Sitting here I am responsible for things. I was always in the position of saying, "June, you should not have done this." She'd say, "That's right. I won't do it again." But I

was always closing the door after the horse got out, because she was getting the money in advance. We began to develop friction, and I moved NAP into another building. They began to consider themselves as a completely separate organization from the art commission. I was not afraid of the program growing, but some of the friction began as the program expanded in a massive way; when you build it up on a response basis, you find you are doing the same thing endlessly. . . . So we started having discussions about it. I would say that I would like to have some indication of where the hell the program is going. I don't want a blueprint, but are we just going to do more of what we are doing or are we going to try to move people from here to there or open them up to new experiences or something of this order?

. . . The reasons for the weakness of NAP were apparent, and I said that one of the things that occurs in neighborhood programing is a repetition of amateur productions. This has a validity, a place, a role and everything else, but at the same time the neighborhoods ought to have the opportunity of experiencing periodically a professional. Now the problem is when we put on a rock concert, we can pick up that band for $25. When we bring in a string trio, we are in for $400. So the minute you get into professional programs you are into a lot of money, and this is where we drop off, as we don't have the money for this type of activity. I consider this a weakness in the program, and yet I don't know how to solve it.

June just ripped me up and down about how any of our productions in that neighborhood are just as good as anything that occurs in the opera house. Now this is from a gal who had no background in the arts and was telling me where art is. At least I thought I was far more open about it than she was, so that was where the frictions began. Finally it got to the point where she submitted a budget, and it was a deficit budget, more than we could reasonably expect from the city. I couldn't accept it. I am not a private organization like the symphony. The symphony can put on concerts knowing it is going into debt and knowing it can raise money privately to cover the debt. When you work within a city, you work within your budget. Well, she was adamant: this was going to be her budget.

Then I said I would also like to have some indication of where the program is going to go, where we are going to be a year from now, and where you think we ought to be two years from now. She refused, and said, "My staff is my program." . . . At that point, I couldn't cope with June Dunn, and so I let her confront Zellerbach. Then we decided we would have to let her go. Well, June had effectively wrapped up the program in her personality so that if you fired her, you were eliminating the program. We were firing a whole staff. . . . Then we said we would employ all of them.

At this point, we decided the staff would have to be employed by the art commission. The art commission would hire a director. We would hire staff, and then the director runs the staff. So if we ever had a contretemps again and had to get rid of a director, the program would remain intact.

I am in the position of being asked why I'm firing her, and if I say she comes in with a deficit budget or she refuses to give me a program, it sounds as though I'm tying her up in red tape, this free spirit. We never argued the point. You know, there is no sense. You come out the loser in that type of an argument. So we finally fired her and the staff, and we announced that we would hire new staff.

Snipper also pointed out that two surveys in 1969 and 1970 indicated that not only was NAP not generating community interest in the downtown performing arts centers, but also there was some neighborhood dissatisfaction with the program on the grounds that the same groups were being serviced over and over. The art commission felt strongly that art programs such as the symphony and ballet should go to the neighborhoods. It voiced a desire to implement such a program, introducing at the same time a new organizational structure for NAP. The commission also indicated it was willing to retain the entire NAP staff, except for Mrs. Dunn.

It was an honest disagreement: the commission wanted to raise the communities' cultural standards; many of the communities apparently did not want them raised, at least in the commission's direction. Said then-district organizer Vargas,

I think Zellerbach had ideas of bringing his concept of what art was to the community. It was like what they are doing now essentially. The Threepenny Opera or Brown Bag Opera in Dolores Park, that kind of stuff. I guess he thought [that] by bringing the stage truck to the community we would be bringing the art commission's concept of what art was to the communities.

## NAP starts anew, fall 1970

The temporary suspension of NAP shocked the city's system of neighborhood programs: it had seemed impossible that the city government would stop a program that so successfully celebrated its neighborhoods. Community groups that had recently responded to this city program now distrusted both government funding and government employees. Artists and performers who were once friends of NAP had grown to resent the art commission's control of the program. But the city wanted neighborhood arts, and the art commission expressed no intention of stopping the program. Community groups needed the assistance that NAP offered, and artists needed jobs and money. It was clear, therefore, that any intended boycott of a reorganized NAP could not sustain itself. Furthermore, because neighborhood needs are diverse and vast, not all groups had been satisfied with the old NAP.

So the San Francisco Art Commission's Neighborhood Arts Program began again in fall 1970, this time with a new director at the helm, Stephen Goldstine. It was a complex job. As June Dunn has described the situation, "Stephen Goldstine took over a program that was wounded and kind of

in shock. That is why you see arrested growth. Stephen thought of himself as someone to pick up the pieces.''

Goldstine arrived at NAP with a strong art background, several years of university teaching, and very little experience in community politics. He had been a patron of the Mime Troupe and the Julian Theater, appreciating their performances in parks and church theaters, and was anxious to encourage all forms of art in the city. Goldstine's job was to direct NAP's program; Eric Reuther, an experienced political worker, was appointed administrative director in February 1971 to help Goldstine with organizational responsibilities. One of their first assignments, as the NAP's 1970/71 annual report pointed out, was ''to prove that the concept of neighborhood arts support is still alive in San Francisco, and . . . to reestablish contact between the program and the neighborhood arts groups.''

The new staff included only two district organizers from the former administration. The wounds from the battle had gone deep, and there was little exchange of information between the old staff and the new—and virtually no contact between Goldstine and his predecessors, Lundquist and Dunn. The original NAP concept, the goal of the program to establish neighborhood arts councils, and the pending grants, all fell by the wayside. Snipper, the commission, and the new program administrators were determined not to repeat past mistakes.

In choosing a new director, the commission established that he would be an employee, not an independent contractor. Both he and his community organizers would have to be loyal to the program and its concept, at least as the commission saw it. Snipper wanted, furthermore, the NAP staff to be committed to ''a higher artistic level,'' a point on which he and June Dunn had disagreed. Said Snipper,

> It becomes a job, and how do you maintain an enthusiasm and a drive for a higher artistic level. I am saying that this is a built-in problem. Without this sort of commitment on the part of the neighborhood organizers, they don't have the drive, but having been given that commitment, then it is a question of making sure that it is broad and does not narrow down to their own very, very personal commitment. You don't have enough money to spread around.

On the question of money, there will never be enough to provide art for 750,000 San Franciscans, plus the commuters and tourists who pour into the city. Goldstine assumed directorship of a citywide program with a budget of $164,000, a decrease of $23,000 from the previous year.[4] By 1972 the budget was up to $190,000 and in 1974 to $300,000. Nevertheless, one of the major problems of NAP continues to be insufficient money. As Snipper has pointed out, every community is underserved:

> You are trying to achieve a sort of equitable distribution. . . . You have this problem with the ethnic groups. I was picketed by the Philippine community who said NAP is fine, but what are you doing for Pilipinos?[5]
>
> Well, we weren't doing anything really. We started, but

they came late on board after the program had already made its commitments to the black community, the Chicano, and others. You know the big unserviced community in NAP is the white middle class out in the Sunset district. We have very little going on there.

Goldstine inherited many of the same problems that confronted Mrs. Dunn, including a minority-oriented art program dominated by a white leadership in both the NAP administration and the commission. Greer Morton, an urban education adviser at the San Francisco Art Institute, wrote about this in 1968:

> Earlier, when I spoke of the old-line charity complexion of the program [NAP], I meant simply that the program had been conceived and formulated outside the communities they were to serve. This problem has never been satisfactorily resolved. White, middle-class people were hired to administrate. Minority personnel work chiefly at the community level. The result has been a split between the staff and the administrators. Until there is a reevaluation, and hopefully a reformation of the NAP, things will continue to limp along.[6]

Although Goldstine has been able to heal the schism between the program and the commission that had opened up in the previous administration, and has been sensitive to the problem of white domination from the beginning of his administration, it was not until 1974 that he was able to bring a former district organizer, Roberto Vargas, into the NAP administration. Vargas's appointment as an associate director of NAP was a major breakthrough for the minority people who had been working in the neighborhoods but had not been close to the commission and its center of power.

### The operation of NAP, 1970–1974

How did NAP presume to support community arts in an entire city, mending the wounds from the early stages of the program and avoiding the inherent problems? According to Goldstine,

> Part of the model consisted of convincing the city to undertake this activity and to care about what went on in nonestablishment institutions, and the other part of the model was designing a kind of delivery system which would work and keep the city from tearing its arts groups apart politically over the question of whether they were getting a fair share.

**Funding.** It is significant that NAP, which was started primarily by large sums from a private foundation, the Zellerbach Family Fund, was inside of four years drawing half its annual income from the city budget. By 1972/73, the Zellerbach contribution was down to 10 percent, about $30,000 a year; 25 percent came from the National Endowment for the Arts (Expansion Arts Program). New projects are funded by separate grants and donations, particularly from the San Francisco Foundation and, more recently, the California Art Commission.

Martin Snipper credits Zellerbach for much of NAP's success with the city budget. "What he has done," said Snipper, "is to build up the city's contribution [a recommendation to the city that, as president of the art commission, he has the authority to make]. And while each year the Family Fund contribution has not been reduced in absolute terms, it has become a smaller percentage of the total because he has felt that the city should basically underwrite [the program]."

For Goldstine, too, the city's support was essential:

As long as you couldn't depend on a regular source of money for a program which charges no tuitions and which charges no admissions for any of the festivals, performances, or direct responses, and which continues to offer services of equipment, printing, and so forth without charge to the community, you could not see a future unless the city thought this should be a regular part of its operations.

A program in which 300,000 persons are served at an annual cost of under $300,000 is a bargain for any city. The results are achieved because very little money goes into administrative overhead. NAP does not pay rent or utilities, and the city controller does all NAP's accounting. However, NAP does pay its $3,000 a year phone bill and the cost of a Xerox machine that is often available to community art groups. The budget is also low because the director does many jobs himself. He prepares budgets and program proposals, sometimes for neighborhood organizations as well as NAP itself, seeks funding, hires staff, and acts as both liaison with the art commission and, often, consultant to community groups. He also serves as a community organizer for those areas of the city that do not have a regular staff person or budget assigned to them. He has a discretionary fund of just $1,000 per month to support programs.

Says Goldstine of the NAP staff costs,

In an absolute administrative capacity, there are myself, an associate director who is largely responsible for reorganizing a lot of the workshops and making sure that they are operating efficiently, a half-time bookkeeper . . . an administrative assistant, and just one secretary. . . . The secretary is an organizer in a sense because oftentimes people call up, and they want a certain kind of information. She is able to connect them up with a group or find them a certain sort of placement or accept a resumé and pass it on to another organization with a job result. Although the absolute administrative costs in terms of salaries accounts for 15 percent of the budget, that is not a very accurate assessment of the administration overhead because it is somewhat less than that.

**District organizers and workshop coordinators.** NAP operates a decentralized administration for the support of diverse community programs. This functions through the district organizer system, which was structured in the fall of 1970 to focus on specific geographic districts rather than different ethnic arts in the city at large.

This decentralized district organizer system is the crux of the entire program. In 1974 there were six districts: Western Addition, Sunset-Richmond-Marina, Chinatown-North Beach, Mission, Bayview-Hunter's Point-Ocean Merced-Ingleside (added in 1972), and South of Market (Pilipino community, added in 1973). Each district has an organizer and a workshop coordinator who are artists (or "artist-entrepreneurs") known and respected in their neighborhoods. Each organizer is given a budget of $500 a month and each workshop coordinator $225 a month, sums that they are free to spend without hierarchical red tape on the assumption that they know their own neighborhoods' wants and needs best.

Organizers are paid between $450 and $700 per month for their work, which requires a sense of community politics, a feeling for the arts, and a 24-hour-a-day, seven-day-a-week commitment to a particular community. Coordinators teach in, as well as organize, community workshops in their neighborhoods. There are no retirement, sick leave, vacation, unemployment, or social security benefits for a district organizer or, for that matter, any employee of NAP. Goldstine himself gets no fringe benefits and is paid a comparatively meager salary for an administrator of a major city program.

**Geography and ethnicity.** As noted earlier, the geographical boundaries that determine the territories of the district organizers conveniently define ethnic communities within the city. Goldstine, like Dunn, feels that ethnicity is the essence of NAP's appeal:

I indicated that although community arts in an ideal sense do not necessarily mean ethnic art, in San Francisco it is simply a fact that among middle-American communities there is very little response to our program. . . .

Very few organizations have been created as a result of NAP. Those organizations have to occur themselves. It is in ethnic communities that those organizations have been most prevalent. NAP wasn't designed to be an ethnic program, but it is to the extent that our program is in response to a real need that has grown up over the past decade.

The majority of NAP district organizers are third-world persons of the same ethnic background as the majority of the population in their districts. The district organizers in fall 1974 included one Hispanic woman, two black males, one male Chicano, one male Chinese, and one male Pilipino. (NAP plans to add a Japanese and a Samoan program through grants from the San Francisco Foundation.)

NAP staff members explained some of the fine points and problems of ethnic matching and district size. Said Goldstine,

It is a simple fact that although there are some Caucasians, some Pilipinos, and some other groups living in the Bayview, it is essentially a black neighborhood. To have a white representative or to pretend you are dealing with Bayview and not with black American culture is just to be

an ostrich. The same situation exists if you have 100,000 Spanish-speaking or Spanish-surname people in the Mission. In the central Mission to have an organizer who doesn't respond to Latino, a South American kind of classic Spanish culture, on the one hand, and Chicano, a middle American-Mexican culture, on the other, is to ignore a fact of life about a neighborhood of San Francisco.

Added Cleveland Bellow, one of the district organizers,

[The district made up of] Bayview, Hunter's Point, Ocean Merced, and Ingleside is huge. Although all are black communities, they are really three distinct areas. Hunter's Point, separated by the freeway, is almost a separate city. There was no way that a single individual with a $500 budget could respond to the requests of the people in that area or even cover the physical territory.

And, from René Yanez, one of the workshop coordinators,

In the community, you are trapped between the people and the downtown administration. I have a budget that I have to spread to the whole community. There is $200 a month to share with ten groups. NAP provides no safeguards or specific guidelines for their community staff.

### What does NAP do for the citizens of San Francisco?

Essentially NAP has two functions: one is organizing community programs and responding to requests for help in the implementation of arts programs; the other is developing a workshop program of free classes in such diverse subjects as the martial arts, creative writing, photography, arts and crafts, dance, and theater.

**NAP workshops.** As noted here, the pre-1970 workshops were an auxiliary program designed for teenage dropouts. In his report Greer Morton criticized NAP's handling of them: he found "confusion over goals of the workshops" and felt they ought to be serving "the educational needs of the radical portion of the ghetto community" rather than "mostly children and middle-class kids."[7] But June Dunn herself did not take workshops seriously. "I always thought that the workshops were merely a part of the program," she said. "Arts education should be in the schools or another agency, not run by an art commission."

Under Goldstine, however, the workshops have grown substantially. They now encourage the development of skills and art appreciation as part of everyday life for all members of the community. Goldstine, in fact, considers the workshops the foundation for the expansion of art in the neighborhoods. The workshops are also an opportunity for interested local artists to obtain sustained instruction in art, tuition-free and within easy reach.

Although NAP sponsors workshops throughout the city, they are meant to supplement existing community programs, not to impose anything on a community. There has been some unevenness in the program—prestigious artists conduct some workshops, whereas ill-equipped instructors are put in charge of others—and critics complain that the workshops are almost too popular. Yet the workshops have been sufficiently effective so that there has been discussion about bringing them into the city schools, and NAP has given thought to opening the schools on Saturdays and evenings for art workshops as part of its goal to make art programs more accessible in the neighborhoods.

**Organizing and technical assistance.** Through both the district organizer and the central office facilities, NAP responds to community requests for a variety of art services. These are in every case available to organizations; NAP policy does not allow assistance to individual artists. The services are what one district organizer sees as part of NAP's "pyramid":

NAP [has two directions]. One is education in the arts. The other is promoting community groups to develop their art form. . . . Essentially the goals are the same. It is like a pyramid. Community arts is at the top; the base is these two points, the workshops and the services. The approach might take on a diagonal. Both can be done.

The services are delivered mainly at headquarters. Up a narrow wooden staircase in a complex of offices furnished with second-hand couches and discards from other city offices, an NAP client will find a clanking Gestetner press, ringing phones, and bustling people. Goldstine, who believes in the open-door policy, is easily accessible to artists and community groups.

Printing posters is the most apparent service that NAP provides. Throughout the community, multicolor Gestetner flyers announcing a play, a workshop, an art show, or a festival, are posted in laundromats, in coffee houses, on telephone poles; they can be picked up in head shops, museums, or churches. Any community agency active in the arts can benefit from the designs of the NAP staff artists. Stationery, posters, and a variety of business forms are printed by this process and used by organizations as diverse as the Galeria de la Raza, the de Young Museum for its Trip-out Truck, and a children's center for a fund-raising festival.

In the NAP reception office, the walls are covered with flyers announcing events in each of the city's districts. Bulletin boards are organized by district so that anyone in the city can walk into the NAP office and see what art activities are scheduled in his community during a particular month.

These flyers are only one kind of publicity service offered by NAP. Another is help with press releases and contacts with newspapers and television and radio stations. NAP employs a part-time publicist for this work, but as he cannot possibly help everyone, NAP has published a paperback book called *Manipulating the Media,* which gives instructions on how to approach the press and write releases. This is continually updated and offered free to arts groups.

NAP also has two stage trucks, video equipment, sound systems, lighting, and a theater for practice and performances, available to any group that requests them in advance. NAP arranges street permits, provides the assistance

of a technician and crew, gives advice, helps coordinate schedules, and offers general moral support. NAP, in short, is a place where a group with an idea or a vision can come for encouragement and direction in the pursuit of its artistic goal.

Another magnet drawing people to NAP's central office is its two IBM typewriters and its Xerox machine, equipment that has become essential to administration but something most groups cannot afford; and even if they could afford such overhead, most do not want their creative energies sapped by the administrative hassle that machines and maintenance represent. NAP literally makes it possible for these groups to function. As for the wear and tear on NAP's supplies, Goldstine has found it minimal: "We have been lending equipment now for seven years. No community group has ever failed to return the equipment it has borrowed or has severely damaged any of it."

**Money.** But the major request from every group in every community is, of course, money. It is also the one request NAP is least able to fulfill. The monthly $500 program money that each organizer can spend in his district is not enough to go around, and the director's $1,000 for the remainder of the city does not help much either. Groups can thus expect only limited financial assistance.

NAP's help with proposals and fund-raising is important, but it does not solve the problem. As groups learn to write proposals, they end up applying to the same foundations, competing with one another for the same monies. The sources soon run dry. The California Art Commission, perhaps the most popular grantor, is inundated with requests for the meager $1 million it must divide up among art groups throughout the state. Clearly, new answers are needed here.

**Training.** In all this activity, NAP has given invaluable administrative training to community people as well as its own staff. The small size of the city and ingrown nature of its established institutions, however, make it difficult for them to use such training. Few of the city's cultural institutions realize the advantages of hiring someone who is experienced in dealing with the urban community. Although Goldstine is in steady communication with other city agencies, only one of his district organizers has been hired as an executive in another city institution. Yet NAP has several employees who would like to move on to other jobs. Said one district organizer of the situation,

> I think that NAP should make a policy that no one stays more than four or five years in order to give young kids a chance. Until NAP . . . gets city employment status, there is no chance of working out [such] a system. There is nowhere else to go. The pay is rotten. The benefits are nowhere. Perhaps this is good, too. If you make everybody civil service, it would kill the program. Everybody would hang on.

**Fostering a network.** Isolation in a city the size of San Francisco is virtually impossible. Goldstine has used his position to develop a close working relationship with other city agencies and Bay Area arts organizations that has been advantageous to community groups. The city's museums, the parks and recreation department, the library, and the planning commission cooperate with NAP in many projects and benefit from the existence of the program. A phone call or visit to NAP headquarters can put a program in touch with the entire city. Every racial group and every art form is represented in the NAP network. The de Young Museum has made space available for NAP performances, and its art school has hired staff identified by NAP district organizers. The museum has lent exhibition hardware to community art groups, and in turn NAP has advised the museum in initiating community-oriented programs, from the scheduling and cooperative projects of the Trip-out Truck (for a report on this program, see chapter 7) to the creation of an exhibition program of Bay Area artists. Said Goldstine,

> I think when it comes to the city, NAP is an umbrella agency in more areas than just community arts because of the kind of ethnic and cultural diversity it has. In every staff meeting, there is a lot of acquaintance with everything that is going on in the community—its education, crime, health, or whatever. Sometimes we find ourselves sharing information with various city agencies . . . because we are informed on a wide range of issues. When it comes to the arts, I can't imagine any urban organization that would have anything like the input of NAP.

It all happens because of the people who keep it going. "All in all," Goldstine concluded, "the staff is creative, talented, diverse, and representative of the city's population. The staff's experience and energies make this program what it is."

## Emerging Institutions in San Francisco

The climate so sympathetic to the arts in the sixties—increased enrollment in college art departments, thriving art schools, new art complexes in the suburbs, the plethora of new museums throughout the United States—affected urban ghettos as well. But unlike the renaissance in the rest of society, the revival of the arts in the ghettos of most cities came only after discontent had been expressed by protest and political action. In Los Angeles, Studio Watts was created to improve the life in that neighborhood only after the Watts riot of 1964. The creation of San Francisco's NAP followed along behind such organizations, as the idea not of the communities but of sympathetic people outside them.

It was not until 1969 and 1970, fully two or three years after NAP was founded, that art centers began to develop in this Bay Area community. Michael Chin, a cofounder of one of the Chinatown workshops, has attributed the community

arts movement in San Francisco not so much to economic conditions as to ethnic identity—a phenomenon for which the political divisiveness of the Nixon era is probably more responsible than all the emphasis on art, culture, and economic quality of the Kennedy and Johnson years. He said,

There was a new surge in the seventies. A lot has to do with the emphasis on education first: do better than your parents. In the late sixties, during Vietnam, there was a tremendous radicalism in the community and the schools. There was a mature questioning of the type of education available and a search for cultural identity. The term "third world" was popularized in the United States through the San Francisco State strike in '68, which paralleled the same questions and issues that were raised in the community.

The first of these grassroots, ethnically oriented art programs in San Francisco was the Black Man's Art Gallery, privately owned and operated by Jublo Solo, who founded the gallery in 1968. This gallery exhibited both African and local black art. As a showcase for black artists, it was often visited by school groups from the black community seeking their own ethnic identity. Although it was a popular gallery, it could not conquer San Franciscans' traditional disinterest in buying art, and it closed in 1972.

More successful were two art centers that emerged in San Francisco in the early seventies. Both were service-oriented and functioned as art workshops as well as galleries: the Galeria de la Raza (founded in 1969) and the Kearny Street Workshop (1971). Each sprang into being because of the initiative of a group of ethnic artists who decided to go back and work in their communities. Said one, "When you get out of high school . . . you get a car and acquire mobility outside the community. A lot has to do with going back to the community and showing what's outside."

Although the NAP framework was an asset to the development of these centers, in some ways it also deterred their growth toward independence. Because of their attachment to NAP, neither group applied for nonprofit status at the beginning and both were denied initial funding by foundations, which not only questioned their credibility, but also rationalized that NAP was taking care of the communities. Most foundations preferred to fund community programs conducted by more established organizations.

But directors of these community-based organizations argue that centralized art programs are not enough: they have to be complemented by centers in the neighborhoods. Said one of the founders of Chinatown's Kearny Street Workshop,

When Kearny Street Workshop went to the San Francisco Foundation, the guy at the desk said, "Well, I'll talk to Bill Wu, the director at the Chinese Cultural Center, to see what he thinks of your organization." In terms of the arts, they think the Cultural Center, because of its massive structure, is an established institution. That place . . . is modeled after a museum; it's a showplace not a workshop.

Our workshop goal and the Cultural Center's goal are almost the same in writing, but not in method. They think they can do it by just exhibits. We are saying no, people have to get into it. They can create themselves.

In the view of community arts proponents, institutions that emerge from the neighborhood and are easily accessible to the people who live, work, play, and shop there are essential to the growth of the arts in this country. The arts must become a comfortable and integral part of everyday life. "Old ladies with shopping bags and little children with schoolbooks and ice cream cones ought to be able to peer through the windows to see their neighbors making art," said one San Francisco arts program organizer. She went on,

They can walk in and talk to someone they have seen around the neighborhood in their native language and look at works of art without being made to feel ill at ease in a foreign environment or compelled to dress up and check parcels at a security desk. These centers do not compete with museums or professional art schools, although they may be of equal quality in some instances. Their role is unique to their community by making art available and teaching people about art, aesthetics, and their environment. They can also encourage people to visit museums, improve their surroundings, and express themselves through the arts. We will all reap the benefits from these indigenous centers and must encourage their growth. The National Endowment for the Arts is funding these projects under their Expansion Arts Program, but these monies are eaten up by rent. The projects only survive and grow because artists and community residents care about the program, volunteer their time, work without any financial remuneration, and invest their own money to keep their project together.

Richard Reineccius, now with the Community Coalition for the Arts, put it this way:

We wanted ten to twelve neighborhood centers that people could easily move into off the street. One of the great barriers of a cultural palace is that you have somebody collecting money for tickets at the door. Even if you are not collecting tickets, there are big doors you have to go through and you are trapped inside with a bunch of people and you are embarrassed to walk out.

Inspired by the success of such groups as the Galeria de la Raza and the Kearny Street Workshop in San Francisco, the Mechicano and Compton Communicative Arts Academy in Los Angeles, and the Museo del Barrio in New York, new grassroots arts centers continue to spring up throughout California. The Pilipino community launched an art center in 1973–1974 in the South of Market district in San Francisco, using a building slated for redevelopment. The Western Addition United Projects sought to develop a mural project and visual arts program in a renovated brewery made available by revenue-sharing funds.

Because the Galeria and the Kearny Street Workshop have

been models for other groups, it is worth seeing how they are put together.

### The Galeria de la Raza[8]

It has been said that NAP does not plant seeds; it acts as fertilizer and watering can for programs. NAP's associate director, Roberto Vargas, describes how the fertilizing process began for the Galeria:

> In 1968, the Mission had a couple of groups, including the Casa de Hispaña de Bellas Artes. It was small then and dealt with a small segment of the traditional Spanish community. NAP did a lot of workshops. From these, a lot of new organizations came out. We encouraged people to do their own things. Mission Media Arts became a successful operation for awhile until money got them down, and then the Galeria de la Raza formed with the help of René Yanez. Rolando Castellon started Artistes Seis under the Casa de Hispaña at one time. Then he and René teamed up. We tried to find people from the community to envision their own programs.

René Yanez, codirector of the Galeria de la Raza, had such a vision. He and Rolando Castellon created the Galeria in late 1969. During the first years of its existence, the Galeria was located on the border of the San Francisco Mission district, a community rich in ethnic and cultural traditions, composed of Latin, non-Latin, Native American, Pilipino, and Samoan residents.[9]

The concept of a gallery dedicated to exhibiting the work of Raza artists grew out of Yanez's successful experience in Oakland, California, where he established a storefront art center in an educational clearinghouse. When the Oakland Museum opened in 1969, he was assured by the original staff of that museum that Chicano and Latino art programs would be initiated in this East Bay community and so decided to move his efforts to San Francisco. The original Oakland Museum staff was subsequently fired. By that time, however, Yanez was well on his way to establishing the Galeria. As Yanez told the story,

> At La Causa, an education clearinghouse, I had a one-man show. I was thinking about the concept of a community art center. We got space there and started classes. I got together with several Raza artists, and we formed the Mexican-American Artists' Liberation Front. This was before the word Chicano was even around. It was a dead-end street in Oakland. I came over and talked to the people at Casa de Hispaña who were doing art festivals. Rolando was then at 14th Street. He got the building. Then I was working at NAP and giving half my salary for the rent because I really believed in it. It went on, but there was not enough foot traffic. It was an off-the-wall place.

The Galeria was first publicly recognized in 1971 when it organized an exhibit of Latino children's art at the local library. STEP, a local employment program, then made seven positions available to the Galeria through NAP. This enabled Raza artists to form a team, which started a project to beautify the Mission district. They painted murals, took on commercial art projects, and taught silkscreening in day-care centers and schools. With the $3,000 it was paid by STEP, the mural team began looking in the Latino business district for new space for the Galeria de la Raza, which had been evicted from an earlier location. They found a former laundromat and turned it into a gallery that soon became a center for community-oriented projects, professional exhibits, and art workshops.

Yanez, an NAP workshop coordinator, assumed the directorship of the gallery as a volunteer. His NAP position gave him a salary and a minimum budget; it also gave him access to equipment, office facilities, and citywide contracts that helped the Galeria program. In addition to this help, NAP found funds through the Emergency Employment Act for the salary of a codirector, Ralph Maradiaga, who was responsible for organizing art exhibits, designing and printing the exhibit posters, and coordinating a silkscreen calendar produced each year by the Galeria artists. For nearly three years, from September 1971 to June 1974, while Yanez was organizing the administrative structure of the Galeria, NAP also provided money for exhibitions and general upkeep. Much of Yanez's efforts went into building the audience for the Galeria. He explained,

> You have to build an audience and get it going. I was looking at the art critics, the museums, and the other galleries. The Galeria had to be a new concept. It was at first a showcase of Chicano and Latino thought. There were other groups in Sacramento and Fresno; we communicated with them. We measured audience reaction. We're not commercial, so we don't worry about sales. We are mostly concerned with communicating with the audience.

**NAP and the Galeria.** The NAP money for the Galeria came the long way around. After the Galeria's own appeal to the San Francisco Foundation was rejected in 1972, it turned to Goldstine, who managed to get the decision reversed. But though this money was earmarked for the Galeria, it was granted directly to NAP, not as fiscal agent but as project administrator.

The Galeria's relation to NAP is thus a convenience, primarily for purposes of financial aid. But there are some program connections, too. NAP workshops have been conducted at the Galeria, and NAP films are shown each summer to neighborhood children. Otherwise, the Galeria program centers mostly on exhibitions and the production of the kind of art that visitors can take back to their homes. Because the Galeria is on the corner of a busy area—it nestles amid Mexican and Chinese restaurants, panaderias, a Chinese bookstore, a bank—and within walking distance of schools, a church, a community swimming pool, a minipark, and a housing project, it draws an audience easily. And that is Yanez's purpose: "If the young children here are exposed to enough good art things, they grow up to know what excellence in art is. The Galeria is for all levels. A lot depends on

the exhibit. High school kids like the murals. The Santos exhibit was for the older set."

**Galeria's activities.** The Galeria's program is generated mainly by the creative energies of three people—Yanez, Maradiaga, and Curator Luis Santana. They have produced calendars with original silkscreen prints by Galeria artists for every month of the year and a coloring book of line drawings. But it is in its exhibitions that the Galeria makes its mark. They attract city school classes, families after Sunday mass, artists for Friday night openings, and a variety of residents from San Francisco's Mission community. They have included the work of contemporary Chicano artists (including a special show of women artists) and Latino photographers, Mexican folk art, Guatemalan textiles, children's art, and the prints of José Posada, a well-known Mexican artist. Yanez was determined to show what the Galeria considers good work:

It really had to be a quality program because it was in the barrio, the so-called ghetto, and we didn't want it to take a back seat. We had to prove ourselves not only to the community at large but to our local community. Then people, the Galeria artists, volunteer all their time and money; everybody pitches in because they want to.

The Galeria de la Raza conducts art workshops as part of the exhibition schedule. It also tries to make the exhibitions as educational as possible. For an exhibition of mural painting techniques, the working drawings of the muralists and photographs of community murals were supplemented with a map that located the murals around the Mission area. The exhibit was meant to teach the people of San Francisco about the Mission and to help them see the worth of wall beautification and the process of creation. The Galeria also wanted the exhibit to generate mural painting projects in other Raza communities throughout the state and encourage businesses to commission such projects.

For the exhibition of José Posada prints, a loan show from the national Galeria Bellas Artes de Mexico, the Galeria created an environment of paper cutouts and papier maché skeletons derived from the imagery of Posada. Children would run into the Galeria on their way home from school to touch the cutouts and see the etchings of skeletons and legendary heroes hung on bright magenta and yellow wall panels.

The Posada exhibition is an example of something more than supplementary activity. It is the kind of exhibition that perhaps only an organization like the Galeria could do. Though it could have been sponsored by a museum and thus have drawn a wider audience, a museum would not have been located where schoolchildren and housewives could drop in. Leaders of the Chicano community as well as Chicano artists from various communities in the state of California who came to the show would not have felt as welcome in an establishment museum. At the Galeria there are no guards. The directors, a curator, or an artist are on hand to greet the visitor in English or Spanish and to talk about the exhibit.

Free posters and catalogs are available; a silkscreen T-shirt or calendar can be purchased for a minimal price.

**Money and the future.** It is in this sense that Yanez and Maradiaga direct an art center that suits its community and, as a result, receives the community's support. The trouble is that the barrio does not have the financial base to perpetuate this project. Art critics from the city's papers do not review the Galeria exhibits often, so many San Franciscans are not familiar with the work of the Galeria or the neighborhood where it is located. Art works exhibited at the Galeria, economically priced for young collectors and the low-income residents of the immediate neighborhood, sell well there. So do the posters, calendars, and T-shirts. Unfortunately, these sales do not sustain the artists or pay the rent. Programs continue even as the grants expire. Yanez is philosophical about, if not reconciled to, the situation:

I feel the Galeria is particularly important because it is visible, and we get the cooperation of a lot of people. It's kind of hard, the money situation, but it exists all over in the arts. In Sacramento people do a lot of murals for free because they just want to get it on. That's the art history of the Chicano. They get paid very little or not at all. What can you say? . . .

People respond to whoever shouts the loudest and makes threats, those sixties tactics. I felt my work at the Galeria would speak for itself.

NAP can provide assistance, but it cannot assume the position of patron, nor can it absorb the Galeria as a project. The Galeria wants to be independent and exercise self-determination. During the winter and spring of 1974, when the Galeria experienced a financial crisis, NAP paid the Galeria's rent until June when emergency funding of $10,000 came to the Galeria from the National Endowment for the Arts' Expansion Arts Program. (Ironically, however, although the Galeria received this grant, NAP was cut back in its NEA funds.) In the fall of 1974 Yanez resigned as a workshop coordinator for NAP in order to devote himself full time to the Galeria. With Maradiaga he plans to publish a bilingual textbook and a catalog of the work of contemporary Chicano artists and to investigate state manpower programs to employ artists as muralists.

As a result of its tenacity, the Galeria is slowly gaining a foothold in the West Coast cultural community. It acts as agent for the San Francisco Museum of Art in the circulation of an exhibit of the prints of Siqueiros, Rivera, and Orozco to community art centers, libraries, and university galleries. It also serves as consultant to and colleague of Chicano and Latino art groups throughout the state of California. Both Fresno and San Diego have initiated community art centers through the print exhibition. Recently, too, the Galeria put on an exhibition at Stanford University.

The ideas and enthusiasm for art programs continue at the Galeria de la Raza. Nevertheless, the question of who will support these projects hovers over the program. So, too, do

the Latino community's problems. As is characteristic of many low-income areas, San Francisco's Latino residents are aliens and speak a language other than English. Many are not U.S. citizens and are thus unable to qualify for jobs that require citizenship status. Yanez himself is not a citizen. A capable curator with sensitivity to the community who has acted as a consultant to the Fine Arts Museums of San Francisco and the Oakland Museum, he cannot find employment in government-funded museums or art programs. Like many of his fellow Latinos, Yanez is too proud to subject himself to the citizenship process:

> The citizenship thing has hindered me in a lot of things. I'm a little uptight. That shouldn't really matter. What should matter is my record, not where I was born. I'm a universal citizen. The kind of changes they make you go through when you apply—they belittle you. If there was a dignified way, I'd do it.

### Organizing community arts in Chinatown: Kearny Street Workshop emerges[10]

Chinatown, the nation's most popular ghetto, accommodates 12 million tourists a year and houses a resident population of 32,000 persons, most of whom derive their income from working in sewing factories, laundries, and restaurants. Seventy-three percent of the Chinatown residents have incomes below the poverty level. Immigrants from Hong Kong, Taiwan, and Mainland China live in close quarters with American-born Chinese. Friction between the old traditions and the younger generation, tension between the immigrants and the American-born Chinese, and the deterioration of the close-knit family unit have resulted in a neighborhood of old people isolated in their small apartments, street gangs of teenagers, and young children playing in their families' places of business amidst narrow hillside streets crowded with tourists, traffic, and noise. The social problems are those of any American ghetto—violence, gambling, slum housing, inadequate social services—compounded by the language barrier and cultural isolation from the mainstream of Western society.

That Chinese culture and arts were flourishing long before Western civilization is a fact that Chinatown leaders use to rationalize what seems to their critics a willful ignorance of the new kinds of expression of contemporary Chinese youth. Traditions of connoisseurship, calligraphy, brush painting, kitemaking, music, *tai-chi*, dance, and the artistic expressions associated with Chinese festivals exist in Chinatown side by side with the social problems.

During the sixties, the ills became still further complicated by the growing—and unprecedented—rift between the youth and the established leadership of Chinatown. Even when some of the young people tried to take the neighborhood problems in hand, they were thwarted by the community. One group of teenagers, for example, rented a former billiard parlor where they established the Leeway Program, whose purpose was to assist the community with its delinquency problems. The police harrassed the project, and the established community refused to support it.[11]

**Seeds of the Workshop.** If the Neighborhood Arts Program could not solve the problems of ghetto youth, it had a staff that would respond to them and would not impose outside ideas on the community. In 1968, Loni Ding, an NAP district organizer for the Chinese community, appraised the Chinatown situation and decided that a community festival might help bring the factions of Chinatown together. The 1968 festival was successful enough to be repeated in the summer of 1969. It has become an annual tradition. The character of the fairs, however, has changed to emphasize education as well as art. The Hop Jok Fair of 1974 was an art event, but it also introduced Chinatown residents to available social and health services. Loni Ding describes the festival method:

> First we got well-known professional artists like Win Ng and Nong to participate. Then we got a youth group to display their motorcycles and drawings of motorcycles. . . . The business community and Chinatown Six Companies also participated. By indicating the extreme ends of the spectrum, we let people know there is room for everyone to participate.

The NAP workshop concept was also tested in Chinatown, first in 1968, later in 1970, both times by NAP staff member Bernice Bing. Not a native of Chinatown, she found it difficult to win over the local residents. "When I [made] contact with some of the groups there," she said, "I was confronted with tremendous hostility because I represented the city." Her 1970 workshops in the Chinatown library drew fire from James Dong, a local artist and cofounder of the Kearny Street Center, modeled in part on the Galeria de la Raza. He charged that the workshops were ineffective—just drop-in art classes for young children—and insisted that more NAP money had to be channeled into Chinatown, but only to fund programs that came from within the community.

But in 1971 he and Ms. Bing decided to get together. She told Dong she had a dream for Chinatown: a community-oriented graphics workshop, for which she already had money from the National Endowment for the Arts through NAP. All she needed was a place for the project. Persuading Dong to open his Kearny Street Center to the workshop took some doing:

> Then I had to deal with Kearny Street because they did not want anything to do with NAP. They said NAP is going to be telling us what to do. I said we don't tell you what to do. It is all yours. You structure the policy. You have autonomy. Here is the money, do what you want with it. There was hostility about NAP using Kearny Street as one of their workshops, but I told them you can't avoid that. It is a cosponsorship. NAP is the fiscal agent for that grant. They calmed down.

**The Workshop blooms.** So just $2,000 from the National Endowment for the Arts launched the graphic portion of a visual arts center that has struggled without funding and salaries and lived under the threat of eviction notices for three years. The project of Dong and Michael Chin, Kearny Street Workshop, was started in the summer of 1971. Its founders regarded it as a summer program that would not survive the year and immediately used up the NEA's $2,000 on rent and equipment, leaving nothing for salaries.

The Kearny Street Workshop began by sharing space with a dry goods store, whose owner allowed Chin and Dong to set up their silkscreen production behind the shelves and displays. The professional silkscreened prints and attractively designed posters that came out of Kearny Street soon attracted fellow Asian art students and other Chinatown agencies. The workshop survived, and when the dry goods store went out of business, it expanded into the entire storefront space, adding photography, sewing, and eventually ceramics.

Chin and Dong credit their existence to an ability to make do with what they had, not with early assistance from NAP. Said Dong,

The Kearny Street Workshop lasts without NAP because we know how to scrape. It would be another paper organization if it was just people from NAP. NAP can provide the money, but they can't provide the resource, the people.

A lot of Kearny Street's initial hostility to NAP has to do with credibility. Some outside organization like NAP gets credit, but the work is put in by the people that are there, and they don't get paid. They do it because they want to do it. NAP gives $2,000, and they want the credit. The $2,000 was just for a graphics workshop. We set up Kearny Street Workshop, and it includes a lot more than just a graphics workshop. NAP can't take credit for that!

Starting at 4 P.M. young Asians crowd Kearny Street Workshop, working until past midnight, printing serigraphs, drymounting photos, working on one of the two ceramic wheels (a kiln and one of the wheels are on loan from the de Young Museum Art School) or simply gathering for a community meeting. The core participants in the workshop are Cantonese-speaking, although equipment is shared with groups from Nitomachi (Japanese), and occasionally Caucasian friends visit the workshop. But, as Dong asserted, it is specifically designed for Chinese participation:

It's mainly Chinese; geographically that's how it worked out. We discourage other participation only because the immediate obstacles they would have to go through would set us back. The reaction of the people at the workshop is as though you are going to someone's home. People don't feel comfortable with a white person there because either they're not part of day-to-day living or because they remind us of an experience that was very unpleasant. The workshop is somewhere to hide out for the time being. I'm talking about the core group because of what we deal with.

An older person comes in and starts rapping in Cantonese. We want him to feel comfortable. You are welcome here, not an outsider. A lot of elderly people had a lot of bad experiences with outside agencies. Chinatown is a ghetto because the Chinese have to isolate themselves, maybe not economically but socially . . . even from other third-world people.

Kearny Street Workshop produced work of exceptional quality, some of which Goldstine himself has purchased and hung in his home. A series of prints by Michael Chin, which documents four working-class families, formed the basis of an exhibition at one of the Fine Arts Museums of San Francisco. Ceramic forms that range from traditional to ''Bay Area funk'' are made at the workshop and exhibited in the storefront windows.

Besides its studio and art center activity for young people, the Kearny Street Workshop provides other services to the community. Its artists have painted murals in the city schools (for fees that barely covered the cost of materials); they teach local children and take them on field trips out of Chinatown; and they silkscreen posters for other community agencies.

**Once again, money.** Funds for these efforts are, of course, scarce. As one of several groups without nonprofit status, the Workshop must apply for grants through NAP and thus compete with other groups from Chinatown as well as the rest of the city. A recent $17,000 grant from the National Endowment for the Arts' Expansion Arts Program was a breakthrough for Kearny Street, but the bulk of the money will be absorbed in rent. Kearny Street has expanded its space into a former bistro, partly so it can hold more workshops and exhibitions, but partly, too, because the location might bring the workshop some income through sales. The workshop's directors are beginning to look to NAP to help them develop administrative skills and learn fund-raising procedures.

The workshop has emerged as an institution in San Francisco's Chinatown. But survival is still uphill. To the outside world, Kearny Street Workshop is small, new, ethnic, and not yet recognized or respected by established institutions. Dong reported,

Someone from [the National Endowment for the Arts] came to a meeting at the workshop. He was looking around. At the time, we didn't have any exhibits or display. The space is a workshop environment, not a showcase. The place was messy. We had been working, and there was a lot of stuff the younger kids had made. One comment he made was that NEA was looking for a place that did professional work. We felt that all the stuff from Kearny Street has been up to snuff. But I guess they are looking for one or two people to emerge from the workshop that will give NEA credit.

**The Chinese Council for the Arts.** There are over 300 organizations in Chinatown. Among these are classical

music clubs, dance clubs, the Chinese chamber orchestra, the Chinese Cultural Center, and Kearny Street Workshop. In 1974, 15 of these groups joined together expressly to lobby for revenue-sharing monies for their community. Ms. Bing, who led the move, explained why:

> Because of the whole social movement in Chinatown, a younger generation of people who have been educated in the universities and are in highly professional careers are coming back into Chinatown to establish service agencies. There is a tremendous amount of enthusiasm to work for the community. This is why the time was right to form a council. The council was formed because revenue-sharing money was coming into the area, and I wanted to see Chinatown get its share.

This group formed a council and received an $11,000 grant through NAP from the California Art Commission. A portion of the money was used to sponsor the Hop Jok Fair of 1974. The rest is earmarked for the formation of a nonprofit organization that its organizers hope will be able to act as a fiscal agent for small arts groups that develop in Chinatown. Although the relation between this council and NAP is yet to be determined, once a community arts council is firmly established it could take on many of NAP's functions. NAP might then expand its service role and leave programing and organizing to community councils. The district organizer might simply serve as a liaison between the community and NAP.

No matter what direction the new council takes, what is exciting to long-term observers of NAP's development is that after seven years of neighborhood arts activities, a community formed an arts council, just as Lundquist hoped when he conceived of the Neighborhood Arts Program. In her eight years with NAP, Bernice Bing not only brought money into the area but managed to pull art groups together. When she resigned in the fall of 1974 to return to her painting, she and the council worked together to find a new organizer from Chinatown who knew the area and could carry on with the council.

## Revenue Sharing and the Future of NAP

For Martin Snipper, NAP's next step is the development of community centers:

> In terms of the future, I think the biggest change is the centers. All of our organizers have been sort of floating in the neighborhoods. With community cultural centers, they will have a base of operation. . . . These will become almost ethnic centers. I like the idea of establishing it like a Chautauqua circuit. If the black community out in Western Addition develops a program that is effective, then it would go over to the Mission community center and on to the Chinatown center.

Snipper wants these centers to have space for workshops, rehearsals, and a well-equipped small theater, not only for the use of community groups but for professional performances that can be booked at the community centers and play to the various neighborhoods of the city. Snipper thinks these dreams will be achieved because revenue-sharing funds have been made available to the art commission for the purpose of establishing community art centers.

That revenue sharing go to the communities for art centers was not the city's first idea for the money that came down from the federal government in 1972. The plans for a performing art center rose up again, and the Neighborhood Arts Alliance, the group that lobbied the NAP into being in 1967, reconvened to form the Community Coalition for the Arts and demand revenue sharing for the neighborhoods. Said Reineccius, who was a leader of the movement,

> The information was printed in the paper that any city department and others could request that revenue-sharing funds go into special kinds of projects. This was a whole new thrust of federal monies for the cities, a whole new way for the city to open up to the people, and it would hold hearings. Naturally, I went to the art commission. Martin Snipper indicated this money wouldn't go to the arts. Then the city announced its intention to use revenue sharing for a performing arts center. Well, that was for art, so we formed the Community Coalition for the Arts. My initial interest was to make places [such as the Julian Theater and other community art facilities] safe for the people.

After numerous hearings and much publicity about the issue, the city voted $500,000 in revenue-sharing funds for community arts programs. The money was to come through the San Francisco Art Commission specifically for the creation of neighborhood art facilities or the upgrading of those that already existed.

It may be significant that it was Reineccius and the Community Coalition, not NAP, that led the opposition to the performing arts center. Goldstine explains,

> Initially, we were culpable of perhaps not acting with as much foresight as we might have. When they began to propose the money for the performing arts center, I was critical of it, but it never occurred to me that we could really force them out of the revenue sharing to get money for buildings. The reason it didn't occur to me was that it has never happened in any other community in the United States. Meanwhile, people in these various communities, as they were forming coalitions, began not only to object to the buildings downtown but also to demand money for neighborhood buildings. At that point, I began to realize that a request should be made for buildings. The fear of the commission was that if we asked for some money from revenue sharing and it went for our regular operation, then if the revenue went down the drain in five years, our operation could be wiped out because the city should do it out of its regular tax support.

The revenue-sharing controversy has generated the formation of other neighborhood arts councils like the one in Chinatown. Between 1967 and 1974, neighborhood arts have matured. Communities are generating their own programs and demanding more money for the arts. NAP has initiated

this revival; now some of its supporters think it must seek a new kind of response to this very active community arts climate in San Francisco.

NAP assists groups to achieve their goals and to grow toward complete independence. A poster or two, some Xeroxing or the loan of equipment will continue to be available, but more and more, neighborhood groups want to be self-sufficient and independent. Because money and resources available to the arts are limited, NAP and the emerging community groups will eventually be competing for the same dollar. Should NAP's role change as the community arts programs mature? How will the organizational structure of NAP adjust in response to the independence sought by these emerging community arts institutions?

NAP's associate director, Roberto Vargas, thinks the program will have to help more with fund-raising:

> One of the biggest problems with NAP is money. We've gotten into the position now where most of the communities are pretty well organized. We were out promoting the idea of developing your own art in your own communities in 1968. So what happens now seven to eight years later, the communities are aware that we are here. They themselves are pretty well organized. They no longer require a lot of organizers coming in. They already have their own workshops. A lot of visual artists don't need to go to the workshops. They need money for materials and supplies. Also, communities are putting together their own festivals. The district organizer acts as a liaison with the city, but most of the calls are for money. We provide services, but then again people need money to pay musicians, to provide materials. That is one area we must investigate.

Goldstine's response is that NAP should expand its services to the community and get out of financial assistance altogether:

> The NAP organizers might provide only services in the future. We would have four stages, five sound systems, and a bank of equipment. There would be no money, only services, spaces, and a staff of consultants. NAP would deal with the demand on a rational basis. . . . As long as we can offer services so community people don't flounder, we have a viable program. This makes NAP a much more painless operation because we could give straight answers. We can offer this but not that; we do this but not that.

As he looks back on NAP's growth, Goldstine finds these services and the program's flexibility its crucial assets. In a recent interview, he concluded,

> Now that the Neighborhood Arts Program is in its eighth year of operation I often wonder about the reasons for its status as the only comprehensive urban community arts program. What did San Francisco have to offer that other cities lack? Its moderate size surely helped. Its extensive and diverse community of artists was also a very important factor. But in addition to these considerations, there were two essential economic and political ingredients that made

this program a reality. One was the support, both fiscal and political, of Harold Zellerbach, who as president of the San Francisco Art Commission and as a private philanthropist has gained national prominence as a generous patron of the arts. The annual grant of the Zellerbach Family Fund has helped to stimulate increased support from the city, the NEA, and various local foundations.

> The second crucial factor is the remarkable flexibility of our program. This is in a large measure the result of our ease in dispensing our monies. This comparative lack of red tape is necessary, especially when dealing with artists who cannot afford the delays of weeks or months that would not disturb most vendors and large corporations. This flexibility was only possible because the Board of Supervisors, the mayor, the art commission, the chief administrative officer, and the controller all understood and supported our need to respond as painlessly and immediately as we could to the needs of art and community groups throughout the city. I constantly hear from colleagues in other institutions about the difficulty they encounter producing a festival or mounting a show, their need to obtain city council approval for a $6 voucher or a $22 performer's payment. I realize that with similar constraints there would be no NAP. It may seem to others rather astonishing that such a mundane matter should loom so large, but nonetheless it does.

Looking back in 1974 on the program he helped conceive, Rod Lundquist, too, expressed satisfaction with the way the Neighborhood Arts Program worked out: "I am convinced more than ever now that it was not just a good idea, it was a great idea because it has lived through these years. I watch the bodies go in and out, and the idea goes on—not happy or fulfilled, but alive."—*E. S. C.*

## Notes

[1] 1970 San Francisco census, 1974 San Francisco School District enrollment.

[2] For sources of quotations without footnote references, see list of interviews at the end of this report.

[3] *"Origin of NAP,"* February 1970, p. 2.

[4] NAP annual report, 1970/71.

[5] "Pilipino" is a spelling invented, and insisted upon, by the community.

[6] "A Study in Chaos," mimeographed report, California State University at San Francisco.

[7] Ibid.

[8] For information about the Galeria's staff, budget, funding sources, audience, and educational services, see the checklist appended to this report.

[9] Ralph Maradiaga, *"Galeria de la Raza History."*

[10] For information about the Workshop's staff, budget, funding sources, audience, and educational services, see the checklist appended to this report.

[11] *"Unity Leeway, Inc.,"* pamphlet, 1968.

## Interviews and observations

Bellow, Cleveland. Former District Organizer, NAP. May 23, September 10, 1974.

Bing, Bernice. District Organizer, NAP. January 13, May 16, April 5, June 12, August 31, 1974.

Castellon, Rolando. Director, M.I.X., San Francisco Museum. July 12, 1974.

Catlett, Michael. District Organizer, NAP. July 15, September 29, 1974.

Chin, Michael. Founder, Kearny Street Workshop. November 22, 1973; June 3, July 13, September 22, 1974.

Clay, Beryl. Black Writers Workshop. June 14, 1974.

Concha, Jerry. Galeria de la Raza artist. June 8, September 23, 1974.

Dere, H. Director, Chinese for Affirmative Action. September 22, 1974.

Dong, James. Founder, Kearny Street Workshop. July 13, September 22, 1974.

Dunn, June (also, June Dunn Gutfleisch). Former Director, NAP. September 5, 1974; correspondence, September 21, 1974.

Ebey, George. Actor. July 14, 1974.

Goldstine, Stephen. Director, NAP. January–September 1974, weekly.

Kleyman, Paul. Publicist, NAP. January 5, March 15, April 8, June 11, September 20, 1974.

Lundquist, Rod. Former Director, NAP. August 23, September 18, 1974.

Maradiaga, Ralph. Director, Galeria de la Raza. September 4, 1974.

Mills, Chuck. Former District Organizer, NAP. September 15, 1974.

Oliva, Kathy. Former Administrative Assistant, NAP. March 15, April 8, September 21 and 29, 1974.

Reineccius, Richard. Former Program Coordinator, NAP; Community Coalition for the Arts. September 21 and 23, 1974.

Reuther, Eric. Administrator, NAP. January 18, 1974.

Rios, Tom. Galeria de la Raza artist. July 10, 1974.

Robeles, Russell. District Organizer, NAP. September 13, 1974.

Salinsky, Helene. Administrative Assistant, NAP. July 14, September 13 and 22, 1974.

San Francisco Census Bureau Representative. June 8, September 22, 1974.

Santana, Luis. Curator, Galeria de la Raza. May 31, June 1, 2, and 13, September 21, 1974.

Silverberg, Leonard. Artist. July 14, 1974.

Snipper, Martin. Director, Cultural Affairs, City and County of San Francisco. July 22, 1974.

Vargas, Roberto. Associate Director, NAP. September 13 and 28, 1974.

Walker, Becky Jenkins. Former Workshop Coordinator, NAP. October 8, 1973.

Yanez, René. Director, Galeria de la Raza. June 13, August 28 and 30, September 22, 1974.

Galeria de la Raza, Hop Jok Fair, Kearny Street Workshop, and NAP programs, June 1972–September 1974.

## Galeria de la Raza and Kearny Street Workshop checklists

Galeria de la Raza
2851 24th Street
San Francisco, California 94110

1. **General Information**

   Founding: 1969.

   Number of paid staff: One (paid by Emergency Employment Act).

   Number of volunteers: One director, one curator, 15–20 artists.

   Annual operating budget: $10,000.

   Source of funding: National Endowment for the Arts.

2. **Location/Setting**

   Specific location: Mission district, a community of Spanish-speaking residents.

3. **Audience**

   Attendance: Approximately 150 attend workshops; 2,500–3,000, including school groups, attend exhibits.

4. **Educational Services**

   Organizational structure: Galeria de la Raza is an independent organization, for which the Neighborhood Arts Program serves as an umbrella agency, providing assistance in acquiring funding and making the Galeria eligible for Emergency Employment Act funds. One of the cofounders of Galeria de la Raza was a workshop coordinator for NAP and is now volunteer director of the Galeria.

   Range of services: Classes, exhibits, posters and catalogs, traveling exhibits, tours of Mission district murals by Raza artists. In addition the Galeria offers consultation to Raza art centers and seeks ways to help and employ Raza artists.

   Objective: To bring art to the community and to provide a showcase for the art of the community.

   Time: Throughout the year.

   Information and documentation available: Silkscreened calendar 1972–73, posters documenting exhibits, Galeria de la Raza artists coloring book, catalog of Posada prints (1974), "History of the Galeria de la Raza," a leaflet by Ralph Maradiaga.

Kearny Street Workshop
854 Kearny Street
San Francisco, California 94108

1. **General Information**

   Founding: In 1971, NAP district organizer Bernice Bing applied for and received funds from the National Endowment for the Arts, which James Dong and Michael Chin used to purchase equipment and to rent space for the Kearny Street Workshop.

   Number of paid staff: None.

   Number of volunteers: 20–30 workshop members.

   Annual operating budget: $17,000 (1974/75 only).

   Source of funding: National Endowment for the Arts.

2. **Location/Setting**

   Size and character of city: Chinatown is a city within a city, comprising over 9 percent of San Francisco's population. A popular tourist attraction (12 million tourists a year), Chinatown is home to 32,000 persons of working-class origins, 73 percent of whose incomes are below poverty level.

   Specific location: Kearny Street, in the heart of the tourist/business district of Chinatown.

**3. Audience**

Attendance: 600–800 attend studio classes; 800–2,000 attend exhibits. The audience is composed of a cross-section of the Cantonese-speaking residents of the community, from children to senior citizens.

**4. Educational Services**

Organizational structure: Nourished in its early stages by NAP district organizer Bernice Bing, Kearny Street Workshop is sustained by its founders, Michael Chin and James Dong, and a collective of Asian artists.

Range of services: Classes in jewelry, ceramics, silkscreen, sewing, and photography; studio for young Asian adults; summer classes and field trips for children; community-oriented exhibits; silkscreen poster service for community agencies.

Objective: To make available to community residents the opportunity to develop skills in the visual arts.

Time: Throughout the year.

Information and documentation available: Silkscreen prints and posters by Kearny Street Workshop artists.

# SEVEN LOAVES:
# A NETWORK FOR SURVIVAL

Seven Loaves, Inc.
177 East 3rd Street
New York, New York 10009

**Seven community arts groups with concerns that went well beyond art as aesthetics formed a coalition in 1972 so they could share resources, raise funds jointly, and learn the nuts and bolts of running a stable organization. The idea worked: when this report was written there were nine groups in Seven Loaves, and they had discovered some other benefits of alliance, among them moral support in "hard times" and cooperative programs to reach more people. CMEVA interviews and observations: July, November 1975; March 1976.**

**Some Facts About the Organization**

**1. General Information**

Founding: In October 1972, when seven community arts programs on New York City's Lower East Side banded together to share administrative, fund-raising, and public relations resources. It received its first grant in December 1972.

Number of paid staff: 3 full-time—a coordinator, an assistant, and a secretary—who act as consultants and trainers to the member groups. (Member programs employ about 60 staff members, not including Neighborhood Youth Corps, Urban Corps, and other workers who are paid by outside sources.)

Number of volunteers: 50. In addition, people from all the member groups give time to the coalition's activities; the number varies widely depending on tasks to be done and time of year. (About 400 volunteers serve the member programs.)

Budget: $55,000 in calendar 1974; $58,000 in 1975.

Sources of funding: The National Endowment for the Arts, the New York City Department of Cultural Affairs, five local foundations (the Fund for the City of New York, the Robert Sterling Clark Foundation, the Rockefeller Brothers Fund, the Edward John Noble Foundation, and the New York Foundation), Banker's Trust, and miscellaneous contributors.

**2. Location/Setting**

Size and character of the city: New York's 7,895,563 (1970 census) residents are spread over five boroughs: Manhattan, the Bronx, Brooklyn, Queens, and Staten Island. Not only are these boroughs significantly different from one another in their ethnic and income mix and in the dispersal of cultural and educational institutions, but neighborhoods within each borough vary widely. Between 1950 and 1970, two million predominantly white middle-class residents left the city (New York's standard metropolitan statistical area was 11,528,649 in the 1970 census) and were replaced by two million black and Puerto Rican immigrants.

Climate: Seasonal.

Specific location of the organization: A storefront on Manhattan's Lower East Side (population: 182,000, according to the 1970 census), an area about 16 miles square, bounded by Lafayette Street, City Hall, the East River, and East 14th Street. There are a number of smaller neighborhoods within this large one, among them Chinatown and the East Village. The area is mixed residential and commercial, deteriorated, and predominantly minority and poor.

Access to public transportation: Most people walk to program sites; several bus and subway routes serve the area.

**3. Audience**

Membership: This has fluctuated since the coalition's founding. In mid-1975 there were six full-fledged Loaves and three affiliates. The full members were Basement Workshop, Lower East Side Printshop, Cityarts Workshop, Charas, La Semilla, and El Teatro Ambulante-El Coco que Habla. The affiliates were the 4th Street i, Los Hispanos Co-op, and Media Workshop.

Attendance: Together the members directly served about 5,400 local residents with a combined income (including central office) of $360,000 in 1974. It was estimated that in 1975 this had increased to over 7,000 persons on a combined income of about $592,000. (Member program budgets include about 5 percent earned income from sale of products and services.)

**4. Educational Services**

Organizational structure: Seven Loaves is governed by a board made up of the autonomous member groups, to which the coalition's staff acts as consultant and trainer. Operational procedures and membership standards are set out in bylaws. All decisions are reached by majority vote. Each member group has a coordinator or director who is its administrative head, and each sends one representative to Seven Loaves board meetings.

Range of services: Administrative training for staffs of member groups, joint fund-raising, opportunities for sharing of resources, assistance in economic development projects, program coordination, information and referral, publicity.

Audience: the chief audience for Seven Loaves is the member groups; occasionally other neighborhood and nonprofit organizations also participate in the training and other services. The member groups themselves work mainly within the Lower East Side community, though most engage in projects that have a citywide or national audience as well.

Objectives: To ensure the survival of local community arts programs by providing a center through which they can learn administrative and fund-raising techniques, raise money jointly, share resources, and become more visible and credible to both funders and residents of the community they serve.

Time: Seven Loaves operates year-round.
Information and documentation available from the organization: Brochures.

New York City's Lower East Side, a neighborhood of immigrants from Europe, Asia, the Mideast, and Puerto Rico, was once predominantly a Jewish ghetto. The shops, restaurants, and bakeries remain, but they now show the influence of a mix of ethnic groups: Puerto Rican bodegas sit side by side with Italian pizza parlors and "soft goods" outlets managed by the sons of Jewish refugees from all parts of Europe.

As one observer has described it, "The Lower East Side isn't just a New York neighborhood, it's an international village with roots going all around the world."[1] The streets and cold-water flats are populated by artists, craftsmen, and young activists, as well as aging rabbis and burgeoning families of ethnic minorities. The Lower East Side is the home of New York's Chinatown and some of the city's most colorful Italian street festivals. The area, about 16 square miles of lower Manhattan, is characterized by light industry, shops, schools, abandoned storefronts, tenement housing, boarded-up buildings, a few vacant lots strewn with cans and bottles, and even fewer parks or green spaces. It is a neighborhood of commotion: noise, buses, people, traffic.

A microcosm of our nation of immigrants, the Lower East Side was traditionally a melting pot of diverse cultures, a stopping-off place for the newly arrived poor who were striving toward both assimilation and affluence. Within the last decade or two this pattern has changed markedly. For one thing, social pressure and a tightening economy have restricted the economic and geographic mobility that attracted earlier immigrants to America. For another, the ethnic consciousness of the 1960s affirmed for many the value of retaining and preserving their special heritage.

The result is that more and more residents of the Lower East Side have come to see their neighborhood as home—a place in which they have a stake. This sense of community and ethnic pride has given birth to a grassroots artistic movement that has turned vacated storefronts and warehouses into "factories" of culture, promoting and celebrating arts unique to the neighborhood.

Many of the people who run and take part in these programs have done so partly to express themselves in ways they felt the established cultural institutions neither understood nor responded to. But they have also seen the Lower East Side arts movement as a way of becoming closer to the life and problems of their communities. Art is not divorced from life, they reasoned, and life in a place like the Lower East Side is plagued by social problems; money, jobs, food, housing, health, crime, alienation, and education are far more immediate concerns to the people there than aesthetics. Thus, these community arts groups found themselves using art to help people deal with first things first, and they were soon caught up in the search for solutions to the community's problems. Carolyn Curran, coordinator of Seven Loaves, put it this way: "I think the community arts movement is trying to revive the idea that art is an expression of people's lives and should be integrated into their lives. It's not just something you put in a museum vault and lock up; it's something you use every day, and it's part of everything else."[2]

For some of those early arts groups the burdens of sustaining an organization were too much, and they quickly went out of existence. But in 1972 seven of them, tired of the instability of going it alone, formed a coalition that they hoped would help them avoid wasting scarce resources on administration, public relations, and fund-raising—those bugaboos of small grassroots organizations run largely on the energy and commitment of volunteers or low- and irregularly-paid staff.

The coalition's founding groups were Cityarts, Los Hispanos Co-op, Charas, Basement Workshop, Children's Art Workshop, the Printshop, and the 4th Street i. They chose the name Seven Loaves, an allusion to the New Testament miracle that multiplied the loaves and fishes, because, as they said, they all needed "bread."[3] "This is the ideal," said Curran. "Community artists want to nourish as many people as possible with their few resources—and a lot of spirit."

With an initial grant in 1972, Seven Loaves hired two staff members and borrowed its first office. After several moves it settled into a long, narrow storefront on East 3rd Street near Avenue B, a place that has become the home of what its members call "a community arts family."

### The beginnings

What brought these seven community arts groups into being in the first place goes back into the dim reaches of the early 1960s. In the summer of 1964 Monsignor Robert J. Fox, as part of his job as coordinator of Spanish-speaking services for the Catholic archdiocese of New York, helped organize a casual summer arts program at the Lillian Wald Houses, a huge public housing project on the Lower East Side. He explained how the program worked:

There was no money, no staff, not even a name, just a lot of people—80 or so—interested in volunteering. The Lillian Wald Houses had a large central plaza that was very threatening to the people who lived there. The blacks, whites, and Puerto Ricans would cross it, and they were afraid of one another; they wouldn't talk to one another.

We wanted to try to get people together, and we chose the plaza as the place to do it. So each day all that summer we would get something going on out there, often something to do with the arts. It was very unstructured: someone would start singing and get others to join in. Or there was a nun who was very skilled in puppetry who would do shows and plays, and the kids would start doing it with her. What we were about was creating something alive out in the public forum.

Response to the project was "tremendous," Fox said. During the fall and winter he applied for War on Poverty

funds from the U.S. Office of Economic Opportunity to expand the idea and take it to other neighborhoods in Manhattan and the Bronx the following summer. The program was given a name (''Summer in the City''), staff, and some 40 storefront centers in the two boroughs. More activities were added to the singing and puppetry: mural painting, costuming, acting, photography, instrumental music. The philosophy of the program, said Fox, had three elements:

> First, the idea of the public forum: you get people out of the insularity of their homes and into the streets where they can begin to interact with one another. Second, creativity: you free up the creativity in people as a way of getting them in touch with themselves, stretching their perceptions. And third, relationships: you use the energy and awareness that the creativity releases to encourage and stimulate relationships among people, getting them to be more vulnerable and therefore more open to one another.
>
> We were trying to seduce people into seeing, touching, tasting, feeling their blocks, their environment, what was going on around them.

Neighborhood organizers on the Lower East Side believe that ''Summer in the City'' and Fox's later programs that grew out of it planted the seeds for the emerging arts organizations still alive in the seventies.[4]

If the general ideals and philosophical direction of these groups were set, the cumbersome processes of running the nuts and bolts of their organizations often were not. As Fay Chiang, director of Basement Workshop, said,

> A lot of people came into the community arts thing with the idea that we're alternative institutions and why should we have to deal with a lot of administrative stuff. But my personal feeling is that although we don't have to get superadministrative or superbureaucratic, we do need a certain amount of administration and so-called bureaucracy just to keep the systems running, so we can have our reports together and keep our programs consistent.
>
> We are building alternatives to traditional institutions. We look at traditional institutions and see that their strength lies in their continuity and stability—that's how they perpetuate their values. So my personal feeling is that we had to set up alternative structures which have a certain amount of stability and continuity [in order to] perpetuate the values of community arts—the alternative political, social, and cultural values.

**A coalition is proposed.** By 1970 not only had the concept of community arts become popular with the constituents of small grassroots arts groups but it had also become fashionable: the large traditional cultural institutions were starting their own community outreach programs and beginning to compete with the small groups for available government and foundation money. Although some applauded this new interest by the big institutions, others saw it as a clear threat to the existence of the small ones. In the race for money, many of the little guys felt they did not stand a chance.

Two of the early supporters of community arts in the city, the New York State Council on the Arts and the Rockefeller Brothers Fund, recognized the problem and commissioned a study of it by then freelance journalist Priscilla Dunhill (later director of Museums Collaborative; see report in this chapter). She interviewed representatives of thirteen active community arts groups throughout the city (four of them were later to be members of Seven Loaves) and found they had at least one need in common: help with fund raising and administration. ''All thirteen of the arts organizations placed longrange financial stability as their most urgent and pressing problem,'' Dunhill wrote in her 1971 report.[5] She also reported that the small volunteer staffs on which most of them depended were bogged down in paperwork.

While affirming the value and unique contributions of community arts, Dunhill pointed out that the very attributes that made the small programs successful in the community—their open and casual style, their loose structure, their readiness to respond to the needs of the moment—raised questions in the minds of potential funders about their administrative stability and their capacity for survival. She proposed a coalition through which community arts groups could pool their resources and energies to establish a firm administrative base, collaborate on fund raising, and form a pressure group for community arts. She was careful to note that the integrity of the individual groups did not have to be compromised by such an alliance:

> Initially, the coalition structure should be fairly loose and informal, making minimal demands upon its members. If the coalition serves its members well in this initial joint effort, other joint projects will develop out of mutual trust. . . . First the organizations should meet to establish criteria for inclusion in the coalition, establish requirements for continuing participation, and then determine priorities in the first year of operation.[6]

On paper, the idea was simple, logical, and practical. But although 11 of the 13 groups met twice in 1971 to discuss the feasibility of the coalition, nothing came of it. A later Seven Loaves report on the effort pointed out that ''no common plan for solving [the] problems was reached because the programs covered very different geographic and philosophical areas.''[7]

### Seven Loaves is formed

In 1972 Carolyn Curran, a friendly, energetic neighborhood resident, was doing most of the proposal writing and fund raising for Cityarts, a community arts program on the Lower East Side, and acting as volunteer consultant in the same areas for three of the eleven groups that Dunhill had studied—Children's Art Workshop (also known as CAW Collect), the Printshop, and SHOW (which later became Los Hispanos Co-op), all of them located on the Lower East Side too. The sharing idea appealed to still another group, Charas, which was also feeling the need for fund-raising help. The primary motivation of all five at that point was to

seek administrative training so they could stabilize their organizations but at the same time retain their independence.

By October the five groups were meeting regularly. In November they invited two other local organizations, Basement Workshop and the 4th Street i, to join them. Seven Loaves was born, and Curran became its full-time coordinator. Its first act was to prepare a funding proposal to pay for staff, an office, and minimal operating expenses, and the first grant came at the end of December from the Edward John Noble Foundation—$10,000 to cover expenses through March 1973 and to help two of the programs that were in financial trouble. In February, when a request for full first-year administrative support at $37,000 was approved by the Fund for the City of New York, that grant was given some flexibility: the Fund permitted $10,000 of its money to go for support of the programs when Seven Loaves received a later administrative grant of $10,000 from the National Endowment for the Arts Expansion Arts Program.

The small groups were unsure of one another and uncertain about how to proceed, and the first few months were marked by dissension as representatives from each group tried to establish priorities and operating guidelines. Full written records were kept of each meeting and the minutes distributed to make sure the decisions, which were always reached by majority vote, would stick. Bylaws that would give cohesiveness to the alliance, without compromising the autonomy that each Loaf cherishes, were hashed out on a trial-and-error basis (excerpts from them are appended to this report).

Gradually the early distrust waned, and by the summer of 1973 the Loaves had become comfortable enough together to sponsor a joint program—a combination block party and arts festival. As Edgard Rivera, program coordinator of Charas, later said about this period, "It doesn't matter what boat you came in on. We're all in the same boat now."

Besides administrative stability, two primary goals of the alliance were to raise the level of funding to the members and to increase their earned income through sale of products and services. During 1973 Seven Loaves raised $100,000 from foundations, corporations, and government. Most of the money was distributed among the member groups to bring them to a more equal level of operation, and some was used to support the central office.

The fund-raising method developed that year has continued ever since: each member of the coalition has a representative on a joint fund-raising committee that meets about every two weeks (with Curran, who acts as consultant). The groups write short descriptions of their programs, attaching price tags to each. The descriptions are presented to funders, who may choose to make a block grant that the committee can then distribute to the programs—the amounts are always decided by vote, and the money is usually divided equally among the members—or to fund one or more programs separately (nearly all have taken the former course). By mid-1974 all the member groups had operating budgets over $35,000, and they averaged around $50,000, according to Curran.

During the first two years of the coalition, the members continued to develop the independent income-producing projects that most of them had been running before: exhibitions, festivals, benefits, and sale of publications such as the 4th Street i's "cultural magazines"—collections of poetry, short stories, recipes, photographs, home remedies, all contributed by neighborhood residents. "Seven Loaves helped in these only indirectly, because the increased funding had made the programs more visible, in the community and around the city," said Curran. "The more sophisticated projects came later" (see below).

All through this early period Seven Loaves was building toward what its members regard as a fourth, and equally important, goal: a true "family" of organizations, "sharing moral support about similar problems, challenging members to correct problems in a positive way, sharing advice and resources."

Finally, Seven Loaves also began a campaign to publicize the activities of the member groups throughout the Lower East Side neighborhood.

### The members of Seven Loaves

Membership in the coalition has fluctuated since its founding. Early in 1974, for instance, one of the founding members—Children's Art Workshop—was voted out, an action that a 1975 Seven Loaves proposal pointed to as an example of its membership standards. (The reason: internal disputes among the Workshop's three codirectors made it impossible for them, in the view of the other Loaves, to have a unified representation in the coalition.) That same year an "affiliated" status was created for some groups that wanted to be part of the alliance but did not or could not meet all the requirements of membership. (Affiliates have been organizations that take part in the administrative training and services but not the joint fund-raising efforts.)

In mid-1975, when this report was researched, there were six full-fledged Loaves and three affiliates. First, the Loaves:

**Basement Workshop,** located in Chinatown, was founded in 1969 and concentrates on bridging what it calls the "communication gap" between Asian-Americans and the larger society and on bringing Asian-Americans together for "dialogue and creative expression." Its programs include creative arts workshops in graphics, photography, dance, and crafts for community artists, art students, and Chinatown residents of all ages. It has also established a resource center and library for people who want to learn about Asian culture in the United States, initiated an oral history project for elderly residents of Chinatown, and developed educational materials about Asian identity, including *Bridge* magazine, which has a national circulation. Its "community planning" arm sponsors language classes in Chinatown, most in English, but some in Mandarin and Cantonese too.

**Charas** is a spin-off from "The Real Great Society," a poverty-program organization begun in the mid-sixties by a

"rehabilitated" street gang called The Assassins. Charas aims to offer residents of the Lower East Side alternative lifestyles and alternative methods of housing. In 1968 some of its members invited Buckminster Fuller to speak at the Real Great Society's University of the Streets and, as Curran put it, "They fell in love with him." Since then the group has been developing new methods and materials for the construction of geodesic domes for urban recreational use and rural housing. Charas domes have sprouted in vacant lots all over the area; several of the group's members, in fact, have lived in a dome built on the top floor of an empty loft and furnished with cast-off furniture rescued from city streets. (The group has had a branch active in housing development in Puerto Rico since 1974.)

Charas also offers education and recreation programs for young people, including mathematics training, and provides technical assistance for street fairs and other community events.

**Cityarts Workshop,** better known simply as Cityarts, is dedicated to getting people in the community to express themselves through public art, particularly murals. It was originally a project of the city's Parks, Recreation, and Cultural Affairs Administration under Cityarts' founder, Susan Shapiro Kiok. According to its present director, Susan Caruso-Green, Cityarts uses the walls of the neighborhood "for statements . . . to give a wider sense of community." The techniques its artist-staff uses—polaroid cameras, projectors, and scaled mock-ups—enable any community residents, including children, to participate in the design and execution of the murals.

The group also has organized the construction of community-participation cement sculptures: still-wet concrete in molds is brought to a site, and everyone is invited to create art by imbedding pieces of mosaic tile and colored glass in the concrete. Two of the most successful of these projects have been a large, flat plaza in Washington Square Park (on which over 700 persons left their marks) and the mosaic benches at Grant's Tomb on the Upper West Side.

**The Lower East Side Printshop** began during the New York City school strike in 1968. It became involved in Lower East Side community affairs largely through the efforts of Eleanor Magid, a professional printmaker, artist, and teacher. She brought her small daughter's neighborhood friends and then their parents into the studio and began to teach them printmaking techniques.

Now the Printshop offers people of all ages a range of free workshops in fine arts printmaking: intaglio, silkscreen, relief printing, prototechnical processes, fabric printing, photography, and portfolio and book production. Although anyone can walk in off the street and participate, most of the daytime activities are with children from the local public schools. Evening classes are chiefly for adults, who either pay if they can afford to or donate work toward the group's poster- and print-making services. The Printshop also spon-

sors a "keyholders' program": for a monthly fee of $10, local artists receive a key and may use the printing facilities at any time.

**La Semilla** (The Seed) is a group reconstituted in 1975 from the earlier Children's Art Workshop, one of the founding members of Seven Loaves and the first to be voted out. (After its expulsion, the Workshop split into two parts, and La Semilla incorporated itself separately; it is the offshoot that has carried on the original Children's Art Workshop activities.) La Semilla holds photography and silkscreen classes, primarily for junior-high-school-age children; six such groups, in fact, come to the La Semilla storefront during school hours and receive credit from the nearby public schools for what they do there. Exhibitions of student work are mounted about every two months.

La Semilla also makes posters on order for neighborhood and nonprofit groups and runs a photography service for community events.

**El Teatro Ambulante-El Coco que Habla** is a Puerto Rican performing arts group, a former Seven Loaves affiliate raised to full membership status in 1975. Its artistic director, Bimbo Rivas, described the organization as "a collection of poets, musicians, artists, actors, and community people from all walks of life—from the barbershop man to the grocery man, from the kid on the street to the community worker and small-time politico."

It was begun as the Elephant Theater in 1972, and that name is still used for the teenaged branch of the group. El Teatro has put on about six productions and a hundred performances; its members also emcee block parties and festivals and write and publish poetry, some of which ends up on posters produced by other Seven Loaves groups.

The affiliates:

**The 4th Street i,** one of the founding members of Seven Loaves. It was set up originally to publish community newsletters and magazines as a way of improving communication among the neighborhoods of the Lower East Side; among the Loaves, it is the only one that was directly linked to the "Summer in the City" program. The program conducts workshops in photography, creative writing, and layout and editing to train community people to produce publications.

**Los Hispanos Co-op,** also a founding member, which focuses on self-help and trains community people in sewing skills so that they can create products that are then sold in the co-op's stores or find jobs in the garment industry.

**Media Workshop** (an arm of a larger and long-lived organization called Young Filmmakers), which teaches filmmaking to young people throughout the city, emphasizing the medium as a discipline and a creative tool.

### Administrative training and joint fund raising

The major work of the Seven Loaves administrative training service is done by its staff of three. Curran, the coordinator,

helps individuals in the member groups with managerial tasks, at the same time teaching them the skills that will make them administratively self-sufficient. An assistant administrator helps the groups get their books audited and works with volunteer lawyers who assist members in incorporating and obtaining tax-exempt status. A secretary keeps the coalition office running and does some clerical work for member groups.

Administrative workshops—primarily for members, but open to other community groups as well—take up about 40 hours a month of the coalition's time in all but the summer months when members' program schedules are heaviest. The participants have learned, within organizational structures that are loose and horizontal rather than rigid and vertical, how to become incorporated, write proposals, approach and follow up openings with funders, outline and develop programs, set up bookkeeping systems, and plan and stay within budgets. (This training is always given with the idea that participants will pass on what they learn to others in the community; Curran hopes that one result of the workshops will be production of a manual on grassroots administration.)

Because the needs and structures of community arts organizations are different from those of establishment institutions, their administrative styles are also somewhat different. Thus, the workshops are what Curran calls a "forum for ideas" about new methods for developing administrative systems that will satisfy the groups' desire to keep their structures "open" without scaring off the funders. As Curran has pointed out, the community groups also need an administrative system that untrained newcomers can learn to operate:

> In our programs we believe that everyone possesses some kind of administrative skill. Therefore everyone should be included in it. But if you decentralize all of the decision making, everybody has to be educated as to what these administrative things are. There always are new people coming into it, and the training process is continuous. You don't just hire somebody who has skills, and they just do the job. Everybody is learning all the time they are doing it. This inclusiveness means the administration is often done by youth, by people without college-level reading skills, and by people without standard credentials.

Though the style may be radical, the procedures themselves are not. As Curran describes them,

> A lot of what we do is simplifying standard management procedures so that the groups can easily adapt them to their needs. For example, out of the Loaves' experiences, we've developed a simple 11-step "accountability method" for programing, broken down by long-range goals, program plans, and the job roles. There's also a 16-step "fundraising method." You could say that in one sense we're miniforms of establishment administrative structures.

Basement Workshop's Fay Chiang, a participant in the training, explained what she felt it had done for her and her group:

> One of the things that is coming out of Seven Loaves is that administration, program planning, trying to meet deadlines, don't have to be like an albatross. And [that's because] there have been workshop sessions and training periods to teach people how to go about these things in a systematic way. [They are taught] not only in terms of administration or arts or education, [but] how you approach them all. And if there is somebody there to give you the skills to do it yourself, it's only a matter of time and practice until you [learn how].

The National Endowment for the Arts regards the Loaves' self-help administrative training as a model for community arts groups and has helped spread the concepts nationally through its Expansion Arts Program, whose staff members have followed the progress of Seven Loaves. According to Curran, "the members are conscious of their heavy responsibility as a pioneering coalition to help create administrative solutions and long-term goals for community arts."

**Fund raising and self-support.** The training bore early fruits: in 1974, Seven Loaves' second year, the coalition raised about $360,000, four times more than the members had received among them before banding together. More money and collective action also brought increased visibility and recognition: in the summer of 1974, for instance, all the groups received Neighborhood Youth Corps slots and summer program money from the city's Department of Cultural Affairs; the local school district, too, began to become more interested in their programs. For example, the Lower East Side Printshop has increased its daytime school programs to three times a week, during and after school. Said its coordinator, Murad Jones,

> We have art classes that come [to the Printshop] from elementary, junior high, and some high schools. The kids can come back after school and learn more if they want to. So we are working more and more with the schools in terms of alternative teaching situations, and we've just applied to the school district for money.

The number of community residents participating in the member group programs doubled from the previous year to an estimated total of 7,500.

Another aim of the training has been to help members expand their self-support projects so that they can eventually survive without private foundation—if not without public—financial support. The groups have continued to run their benefits and special events and have begun some new projects. The five members that produce publications—Basement Workshop, 4th Street i, the Printshop, Cityarts, and Charas—are working on a joint distribution system; Charas, the Printshop, and Cityarts are producing teacher manuals on the arts; Basement Workshop has set up a speakers bureau; 4th Street i plans to open a community press and will charge for its services; in 1975 the Printshop published a limited-edition calendar that was sold through the Metropolitan Museum. "The idea," said Curran, "is to get these projects to a point where they will be a stable, reliable source of

income to the groups—money that can be counted on.''

The self-help aspect of the coalition is one of the most important to its members. Said Murad Jones, ''Seven Loaves is a way for us to become independent.''

## Sharing and community action

Though they are clearly pleased with the administrative and fund-raising successes of Seven Loaves, representatives of the member groups reserve some of their highest praise for the chance the coalition has given them to find out about and share in one another's programs, to offer and receive the moral support that ''gives us the strength to keep going.'' Said Elsa Gonzalez, coordinator of the 4th Street i,

The Lower East Side is so big, so many things are happening. Groups didn't know each other well. We decided to get together. Basically, though, I like Seven Loaves, not for the funding aspects but for getting to know other programs. We get to know other people. It's good. I like the communication. . . . Together is the only way we can do it!

Fay Chiang agreed, adding that the ''personal aspect'' of the sharing is also vitally important to her:

. . . I feel good about the people in [Seven Loaves]. For myself, I'm learning from people who have more experience, more life experience. They give me the spirit to carry on through the muddle—the hard times, the bad times—by being supportive and being there. . . . You see that other people have gone through it and are still going through it. It's that whole supportive thing, that struggling and keeping to the values they believe in.

For Bimbo Rivas of El Teatro Ambulante, Seven Loaves has created a ''family'' structure for the members, ''not only in our art endeavors, but in a human kind of way. A lot of people are really down together to do something. That's a good feeling, and you start getting the positives. You start to think that there is nothing you cannot do.''

The major cooperative program of the Loaves has been an annual summer arts festival, a continuation and expansion of the first joint block party-festival in 1973. ''By 1975 it had gotten so big we had to move it off the block and into Tompkins Square Park,'' Curran said. The festivals feature music by members of the Loaves groups and others, free food, exhibitions of the groups' art (including domes by Charas), banners, balloons, do-it-yourself silkscreen workshops, booths where members sell their products, and displays by neighborhood service organizations.

There are other, less flashy cooperative efforts in which two or more members with a common interest develop a project. For instance, La Semilla, Cityarts, the Printshop, and Charas are sharing resources and advice on their school programs, for which they are also seeking joint funding. Often the groups simply chip in and help each other, as Charas did when it built a dome for one of the 4th Street i's benefits.

The coalition is important to the members, too, as a way of keeping in touch with community issues, for the Loaves see themselves, individually and together, as community action groups. (The idea is not a new one. During the summer-1967 riots in East Harlem, the by then year-round storefront arts centers that grew out of Monsignor Fox's ''Summer in the City'' program organized ''peace processions.'' These brought thousands of neighborhood people out into the streets to demonstrate nonviolently their commitment to their community and to help ease the tension between the community and the police. More recently, the Elma Lewis School of Fine Arts, a black cultural center in Boston, was an arbiter in the 1973 school busing controversy there; see chapter 8 for a report on the school.) Curran explained the process:

The staff here [at Seven Loaves] doesn't have a policy on how the arts should be used for community action. On the other hand, when we see possibilities for linking up what members are doing with other projects and elements in the community, we try to reinforce that relationship.

For instance, if people from one of the block associations or food co-ops or tenant co-ops down here [on the Lower East Side] come into the office looking for any kind of art service or workshop training for their people, we try to make the link.

The Seven Loaves community involvements do not stop short of political action. For example, all the groups took part in—and the Lower East Side Printshop made posters and banners for—a ''culture parade'' to get voters registered for a hotly contested local school board election. Said Murad Jones, ''I think that's the first time arts groups gathered around [such] an issue; we were a brave band that day. . . . We haven't had much experience dealing with things like that, but we're committed to try.''

**Some problems of sharing.** Seven Loaves is an organization in process, and not all of its problems have yet found happy endings. The major one, which may be unresolvable, is that cooperation is hard work and thus saps energy that members of the groups might otherwise invest in their own programs. El Teatro's Bimbo Rivas is one who has complained about the time the coalition takes:

When we were writing our first proposals, Seven Loaves helped us a lot . . . and a rapport was formed. It was supposed to be a fund-raising thing so that we could get our programs off the ground. . . . We said, ''out of sight!'' and decided to join . . . and it's been good because we've been able to achieve more in terms of finding sources for funding. By doing it and getting it taken care of, it gives us more time artistically to do theater.

But what has happened lately is that we have become so involved [in the coalition] that we had to tell [Seven Loaves] to cut out all this shit because we are wasting too much time in meetings. So that's the negative aspect.

To Susan Zeig of Media Workshop, the advantage of being a Loaf was not worth the cost. In 1975 her group moved to affiliate status because ''the Seven Loaves meetings were taking too much of our time and not addressing our needs.''

She continued, "We weren't interested in the administration and fund raising particularly—it was more to get our kids involved [in what the other groups were doing] and to get the feedback. . . . I don't have time any more for the administrative things." So for Media Workshop, Seven Loaves is "a connection in the community . . . a base from which to get around there."

Murad Jones is another who sometimes finds the process of keeping the coalition together tedious: "There are a tremendous number of meetings and a lot of time required, which is a negative. . . . And there are a few other things that need changing." But, she added, "that's all part of being a member of a group."

## Seven Loaves and the future

In fall 1975 Seven Loaves and the local Coalition for Human Housing together received a $25,000 planning grant from the City Spirit Program of the National Endowment for the Arts (the point of the program, said Curran, is "to get nonart people involved in the cultural life of the community"). It was the beginning of an effort, she added, "literally to help rebuild the Lower East Side, to stem the increasing decay by convincing the people who live here that this community can be saved. Call it image-building."

With about a dozen other groups, Seven Loaves has formed a steering committee that, during 1976, is investigating ways to reclaim the community. "A lot of the work will be with vacant lots, which were multiplying very fast because so many abandoned buildings were being torn down before local housing groups had it stopped," said Curran. "We're thinking about gardens, domes for recreation and storage of tools, small murals. There will be a lot of organizing for new block associations, too, and that means posters, brochures, publicity. There's a role for everyone."

This project, which has been dubbed "Loisida" in a play on the Spanish pronunciation of "Lower East Side," points the direction for Seven Loaves beyond 1976. The administrative training services will be phased out by the end of that year because, said Curran, "it will by then be self-perpetuating among the members."

This "new form of community action," as she calls it, is seen as a natural evolution from the coalition's previous work. Seven Loaves is about community arts, and Fay Chiang spoke for its Lower East Side adherents when she defined community arts this way:

> It's not the mechanics of providing exhibits or putting out a magazine or doing a mural. It's the process behind all that, leading to that point: working with the people, teaching the people, learning from the people. . . . And with the people process there is the spirit, the feelings, the emotions of struggling, supporting and moving forward.

—*E. S. C./A. V. B.*

## Notes

1 *Of Hands and Heart,* exhibition catalog, American Crafts Council, introduction.

2 For sources of quotations without footnote references, see list of interviews at the end of this report.

3 In Matthew 15:34–38, Jesus fed 4,000 men plus women and children with seven loaves and "a few small fishes." There were seven baskets left over.

4 "Summer in the City" was funded by the federal government again for summer 1966. In fall that year, Monsignor Fox and his associates formed an umbrella coordinating agency, the New York Institute for Human Development, to support the storefronts year-round. Administrative and start-up monies were given by the local Grace Foundation, and the centers, known collectively as "Project Engage," each sought their own operating money from their local OEO (Office of Economic Opportunity) community boards and other sources, ran their own programs, and had their own names.

The institute, which was linked to the archdiocese, also published a series of poster-books called "Full Circle" (which had national circulation) and sponsored discussion groups (some just of people in the neighborhoods around the storefronts, some that brought city and suburban dwellers together) called "Mansight."

In early 1968 Fox resigned from the institute because of ideological disputes between him and the staff, on one hand, and the institute's director and board, on the other. He and the staff formed a new organization, Full Circle Associates, and continued to work with the centers, produce the publications, and sponsor programs to bring suburbanites into the city neighborhoods for festivals, discussions, and weekend block clean-ups (the most famous was "A Thing in the Spring" in April 1968, when over 5,000 out-of-towners helped community people clean up and beautify the neighborhoods around the Engage centers).

In 1969/70, as the poverty program began to be dismantled, most of the centers lost their federal funding and dissolved. Full Circle continues to do some publications, holds forums for discussions of social issues, and has been helping community people to reclaim and rehabilitate small apartment buildings in East Harlem. Throughout, the philosophy of "Summer in the City" has remained the organization's base.

5 "Community Arts Report to the Rockefeller Brothers Fund," 1972, p. 5.

6 Ibid., p. 10.

7 *Seven Loaves Annual Report,* 1974.

## Interviews and observations

Brandon, Jorge. President, El Teatro Ambulante-El Coco que Habla, New York City. July 10, 1975.

Caruso-Green, Susan. Director, Cityarts Workshop, New York City. July 16, 1975.

Chiang, Fay. Coordinator, Basement Workshop, New York City. July 15, 1975.

Corchado, David. Coordinator, La Semilla, New York City. July 10, 1975.

Curran, Carolyn. Coordinator, Seven Loaves, New York City. July 8, 1975; telephone, March 18, 22, and 23, 1976.

Fox, Monsignor Robert J. Director, Full Circle Associates, New York City. November 5, 1975.

Garcia, T.C. Member, El Teatro Ambulante-El Coco que Habla, New York City. July 10, 1975.

Gonzalez, Elsa. Coordinator, 4th Street i, New York City. July 15, 1975.

Jones, Murad. Coordinator, Lower East Side Printshop, New York City. July 16, 1975.

Ortiz, Diego. Member, El Teatro Ambulante-El Coco que Habla, New York City. July 10, 1975.

Perez, Eddie Conde. Member, El Teatro Ambulante-El Coco que Habla, New York City. July 10, 1975.

Rivas, Bimbo. Artistic Director, El Teatro Ambulante-El Coco que Habla, New York City. July 10, 1975.

Rivera, Edgard. Program Coordinator, Charas, New York City. July 9, 1975.

Zeig, Susan. Media Workshop, Young Filmmakers, New York City. July 14, 1975.

## Excerpts from the Bylaws for Seven Loaves, Inc.

### Article 1—Goals

Seven Loaves was formed in 1972 by existing community arts groups on the Lower East Side of Manhattan in New York City.

Current members are Basement Workshop, Inc.; Cityarts Workshop, Inc.; Charas, Inc.; El Teatro Ambulante; La Semilla, Inc.; and Lower East Side Printshop, Inc. Affiliate members are 4th Street i, Inc.; Media Workshop of Young Filmmakers Foundation; and Los Hispanos Co-op.

We have come together to join forces to meet the community's spiritual and physical needs.

By spiritual needs, we mean self-confidence, self-respect, and pride, respect for heritage, need for self-expression, and education.

By physical needs, we mean food, clothing, housing, health, education, and employment.

Seven Loaves meets the spiritual needs primarily through art. Through art, we build a positive sense of identity, self-pride, and community spirit, by encouraging individuals to grow and change through creative expression.

We believe that the result of meeting the spiritual needs is the reinforcement of the feeling that people have the power to take hold of their lives and to better their lives for themselves and their community.

Although we are mostly an arts group, we also lend our support and resources to organizations and people dealing with housing, education, communication, jobs, and working on community issues.

We have also come together to join forces to (a) ensure the survival of our groups and the continuation of our services in the community; (b) help clarify the direction each program is leading in, so that all can work more effectively; (c) share resources; and (d) support each other.

In addition to the above general goals are these specific goals:

1. To maintain a central office as a focus for the corporation, which is independent of any member program. The office is a resource for the member programs and for the general public as determined by the members from time to time.

2. To engage in joint fund raising in specified ways as determined by the members from time to time.

3. To function as a local arts council, which shall be defined as a service organization fostering the development of multi-media arts in the area.

4. To actively seek long-term solutions to the need for self-sufficiency by providing training and assistance primarily for staff people of member programs and in some cases for the general public as determined by the members from time to time.

5. [To phase out] training for each program . . . once these goals are met: (a) all management skills are present—that is, fiscal, legal, personnel, production of income, and public relations; (b) new staff can be trained by existing staff; (c) program has an economic plan and skills to carry it out; (d) program has effective evaluation system.

6. [To provide] training [in which] (a) members identify workshop topics to be given by corporation staff and members to one another; (b) individual consulting work is done by corporation staff and members to one another; (c) aggressive development of outside resources [is] directly linked to member programs with corporation staff as temporary liaison.

7. To develop cooperative programs such as festivals, exhibitions, and workshops, which will improve members' effectiveness in the community.

### Article II—Membership

Section I: Criteria for Membership

1. Membership is open solely to any organization which is a not-for-profit corporation or nonprofit association. . . .

2. Membership is open to any community service organization meeting other membership criteria, but 60 percent of the membership must be community arts groups.

Membership privileges shall be extended to nonarts groups with the understanding that Seven Loaves itself shall not undertake any non-art-related functions.

We want to extend membership privileges to nonarts groups in the belief that the coalescing of arts and other agencies who are working to create social alternatives can create a more powerful force in changing the lives of the people of the Lower East Side when we meet frequently and work together.

3. Members should believe in the goals of the corporation as described in the bylaws. Members should help to carry out the goals and should help to promote a good image of the corporation to others.

4. Members must be financially accountable and all books and records of every member shall be made reasonably available to Seven Loaves, Inc., or its representatives.

5. Eighty percent of the people affected by the member programs must be residents of the Lower East Side, the geographic area classified as Planning District 3, Lafayette Street to the East River and 14th Street to Center Street.

6. There are attendance requirements for the members' meetings and permanent committees that shall be determined from time to time by the members.

Section 2: Termination of Membership

1. Any member program may terminate its membership at any time by (a) fully accounting for funds received through Seven Loaves, Inc., and (b) written statement of termination.

2. Membership of any program in Seven Loaves, Inc., may be terminated by a majority vote of the other members for violation of bylaws.

**Section 3:** Selection of New Members

1. Application may be made at any time of year by an applicant who obtains sponsorship of one member.
2. Prior to discussion by the members, the applicant must have already visited with a majority of members so that there is adequate information on which to vote.
3. Application for new membership must not be made through the corporation staff. Staff may not sponsor a new applicant.
4. Applicants must meet the criteria for membership as described in Article II, Section 1.
5. Applicants must have been in existence long enough to have established a track record for community service, preferably two years. The track record must be for the program, not for an individual.
6. Community programs may be invited to apply by any member group.

**Section 4:** Membership Categories and Rights of Members

1. Categories
   There shall be two categories of membership: (a) general membership; (b) affiliate membership.
2. Rights and duties of general membership
   Service: Members may obtain from Seven Loaves, Inc., services as determined in each year's budget for Seven Loaves, Inc., as determined by the members.
   Fund raising: Members must cooperate in corporation fund raising to produce the paid services and must participate in joint fund raising because general membership means the commitment to collective action at all levels for mutual survival.
   Policy: To the maximum extent permissible under the New York state not-for-profit corporation law, the membership shall be responsible for all policy decisions of Seven Loaves, Inc.
   Personnel: Members are responsible for hiring and termination of employment for all staff of the corporation. This will be handled by an ad hoc personnel committee composed of not less than two members and including existing staff of the corporation. The committee will make recommendations to members for approval. . . .
   Meetings: Members must maintain minimum standards of attendance at membership meetings as determined from time to time by the membership. Failure to attend two consecutive membership meetings may be cause for termination of membership. If a member misses two consecutive meetings, there will automatically be a grievance committee meeting to discuss the problem.
   Each general member shall have one vote at membership meetings on all matters voted upon by the membership. In cases where a member program sends more than one representative to a member meeting, the people from this program will caucus before a vote so they are in agreement but will cast only one vote.
   . . .
3. Rights and Duties of Affiliate Members
   All new members of the corporation shall be affiliate members for one year before being accepted to general membership. They will be invited to all membership meetings but have a limited attendance requirement—two meetings per year. They have no vote in membership meetings and may not participate in joint fund raising. They may obtain "free" services of the corporation such as workshops, staff consulting time, and shared resources with members, but they may not obtain "cost" services of the corporation such as printing, Xeroxing, or paid outside consultants. . . .

# MUSEUMS COLLABORATIVE, INC.

830 Fifth Avenue
New York, New York 10021

**The story of how a small organization helped to break through New York's institutional apartheid by devising incentives for museums, schools, and community arts groups to work together. From its trials, mistakes, and a steady stream of evaluations, Museums Collaborative has learned lessons that it continually applies to new programs—and that can be useful in a variety of ways in other cities, large and small, where cultural and educational institutions might have more to gain by sharing their efforts and learning from each other than by trying to go it alone. Interviews and observations used in preparing this report were made throughout the years 1971–1975.**

**Some Facts About the Organization**

1. **General Information**
   Founding: Established in 1970 by the New York City Parks, Recreation, and Cultural Affairs Administration (PRCA), with a $50,000 program grant from the New York State Council on the Arts; incorporated as a separate not-for-profit educational institution in July 1972 (though it has retained its affiliation with PRCA).
   Number of paid staff: 3 full-time administrators and a secretary; cultural voucher program, a three-year project begun in 1974, employs a separate staff of 2 full-time administrators and a secretary. Consultants hired as needed for special projects.
   Number of volunteers: Schoolteachers, museum educators, curators, trustees, and scores of specialists—from artists to botanists and deep-sea divers—have donated time to projects sponsored by the Collaborative.
   Operating budget: In 1974/75, $294,543, including $60,000 for staff salaries (see below); $6,500 for the Education Forum; $218,717 for the cultural voucher program. Operating expenditures for the first four years: $114,692 (1970/71), $132,967 (1971/72), $138,884 (1972/73), $241,349 (1973/74).
   Administrative budget: In 1974/75, $60,000, plus rent, telephone, and duplicating services from the city. Administrative expenses for the first four years were roughly the same.
   Education budget: All of the Collaborative's programs are educational.
   Sources of funding: The New York State Council on the Arts, the National Endowments for the Arts and Humanities, the National Museum Act, private foundations, and the sale of exhibition portfolios. About half the budget for the 1974/75 cultural voucher program came from the Fund for the Improvement of Post-Secondary Education of the U.S. Department of Health, Education and Welfare. The Department of Cultural Affairs of the Parks, Recreation, and Cultural Affairs Administration gives the Collaborative office space, phones, supplies, and other services.

2. **Location/Setting**
   Size and character of city: New York's 7,895,563 (1970 census) residents are spread over five boroughs: Manhattan, the Bronx, Brooklyn, Queens, and Staten Island. Not only are these boroughs significantly different from one another in their ethnic and income mix and in the dispersal of cultural and educational

institutions, but neighborhoods within each borough vary widely. Between 1950 and 1970, two million predominantly white middle-class residents left the city (New York's standard metropolitan statistical area was 11,528,649 in the 1970 census) and were replaced by two million black and Puerto Rican immigrants. This is a significant part of the population the Collaborative is designed to help museums serve.

Climate: Seasonal.

Specific location of the organization: The Collaborative's administrative offices are in a commercial building at the upper edge of Manhattan's midtown business district. However, its seminars, workshops, and other events are held at museums and other sites throughout the city.

Access to public transportation: Excellent to poor, depending on the neighborhoods in which the activities are held.

### 3. Audience

Membership: None. Twenty-five New York City cultural institutions are listed as official participants in the Collaborative, but the organization works with a wide variety of agencies and institutions all over the city: not only museums, but community arts organizations, public schools, and human welfare agencies take part in Collaborative programs and events.

Attendance: Participation in Collaborative programs varies; a single event such as "Art Swap Day" may draw several hundred people, whereas workshops may be limited to as few as ten.

### 4. Educational Services

Organizational structure: The Collaborative is governed by a 15-member board of directors, drawn from museums, schools, business, and the New York community.

Range of services: Workshops, seminars, conferences; joint educational programs for museums and schools and museums and community organizations; services to museum professionals through the Education Forum (see below); a cultural voucher program, under which ten community organizations (in 1974/75) purchased services from seven cultural institutions; administration of a network of five school-based or -oriented cultural resource centers, which serve as experimental learning laboratories; the Education Forum, which sponsors week-long workshops, all-day seminars, and open meetings for educators from the city's museums, zoos, and botanic gardens. Publications: *Annual Manual* (a directory of museum education programs), "The Inside Track" (a column in the teachers' union newspaper), and *Newsletter* (information for staff members of museums and community arts organizations).

Audience: The Collaborative's primary direct audience in its first years was museum educators through New York City; increasingly the Collaborative has designed its programs for other museum professionals. Its indirect audience is students, teachers, and adults, especially those in the culturally underserved neighborhoods of the city.

Objectives: (1) to develop a structure by which New York museums can jointly decentralize their goods and services, and (2) to support museum educators and other museum professionals who are attempting to deliver museum services to new audiences.

Time: Programs operate year-round.

Information and documentation available from the organization: A wide variety of newsletters, posters, program announcements.

Among the several museum organizations and activities that were spawned by the urban community arts movement of the 1960s, perhaps none is more ambitious than Museums Collaborative in New York City. Its small staff has managed in its first five years to set in motion a bewildering variety of programs, contacts, new ideas, and people, all of them aimed at two basic goals: (1) "to develop a structure or mechanism by which New York museums could jointly decentralize their goods and services," and (2) "to provide support services to those museum educators who were attempting to deliver [these] services to new audiences."[1]

The creation of Museums Collaborative in 1970 came at a time when the political air was filled with pressures to bring government, education, and cultural services closer to the people. The New York City school system was broken up into 31 community school districts that year, Mayor John Lindsay was plumping for his "little city halls," and museums were being bombarded with cries of "decentralization" by militant community organizations around the city.

In late 1969, after a conference in Brooklyn on small and community museums,[2] staff members of the New York State Council on the Arts and the Cultural Affairs Department of the city's Parks, Recreation, and Cultural Affairs Administration developed several ideas about what these demands from the communities meant to museums. They believed that the survival of the museums depended on broadening their audiences and that as recipients both of tax benefits and of tax dollars, museums were accountable to the public. For three of these staff members—Emily Dennis, Allon Schoerner, and Arthur Rashap—not only was decentralization desirable, but some cooperative framework was needed to help the decentralization process along and to keep museum decentralizers from stumbling over one another in the communities.

In July 1970, with a grant from the Rockefeller Brothers Fund, the State Council commissioned Priscilla Dunhill, a journalist who had been working on a study of museums for the Twentieth Century Fund, to survey 13 New York City museum directors to find out (a) what their most pressing institutional priorities were, (b) what educational services their museums were offering the general public, and (c) which of their operations they thought might benefit most from cooperative action with other museums. The answers: public interpretation had priority over collection and preservation, museum directors were dissatisfied with their educational materials, and expansion of the museum audience would gain the most from cooperation.[3]

Museums Collaborative was formed in the fall of 1970 with five staff positions from the Department of Cultural Affairs and $50,000 in program money from the New York State Council. Emily Dennis, an artist with experience in museum "creation" (she was the originator of Brooklyn's MUSE; see below) and administration, was named director and Priscilla Dunhill associate director. When a city budget cut in May 1971 left the Collaborative with the program

money and no staff, the State Council agreed to let the Collaborative use its initial grant to pay the salaries of Dennis and Dunhill, and the Department of Cultural Affairs agreed to give the two office space. The pattern has remained much the same: operating and program funds (about $200,000 a year) from public sources, a small staff (three principals and a secretary in 1975) and housing from the Department of Cultural Affairs.

With the help of a small board of trustees and a larger body of advisers, Dennis and Dunhill began to coax local museum educators, schools, and community groups into new patterns of cooperation. By 1975, the Collaborative had become both broker and politician in the complex world of 60 or more New York museums, 950 public schools, and an untold number of community and cultural organizations, artists, and specialists such as botanists and deep-sea divers the Collaborative has put to work on behalf of its various educational purposes.

At the same time, the Collaborative had clearly learned its way around the world of foundation and federal finance. In its first five years it had extracted the better part of $1 million for its various causes from local, state, and federal sources, a sum that does not count the office space, phone, and supplies the Collaborative has received from the city, or the numberless hours of free services it has cajoled out of a host of experts—from museums, universities, schools, corporations, and community centers—or the array of museum materials it has helped recycle for use by community groups.

The Collaborative's activities are divided here into three parts: efforts to help museums decentralize their services, programs for museum professionals, and fund raising.

## Museum Decentralization, New Audiences, and the Voucher Plan

The Collaborative staff started its work from scratch, for there was almost nothing in the history of the New York museum world to guide them. Emily Dennis, who had been the creator and acting director of MUSE, a children's museum in Brooklyn, decided that one place to begin was the schools.

### The cultural resource center, where museums meet the schools halfway

When the Collaborative was founded, the idea of object-centered, resource-rich, activity-oriented education had come to life again in the form of open education. Open-classroom teachers' centers were springing up around the country, several of them in New York, and local teachers and teacher trainers were among the many pilgrims who returned from trips to British infant schools determined to convert their barren, "joyless" classrooms into lush (plants, live animals, carpets) and stimulating (games, home-made musical instruments, a myriad of found objects and activity centers) environments.

MUSE, along with the Anacostia Neighborhood Museum in Washington, D.C., and the Children's Museum in Boston, was not unlike such places of learning. A combination science, natural history, and art museum, MUSE was fitted into a former automobile showroom a few blocks from the Brooklyn Museum. Its live-animal and hands-on exhibits and its relaxed atmosphere had special appeal for children and teachers from nearby schools. MUSE was in fact all but taken over on weekdays by the schools, whose classes came by foot and bus by the hundreds every year. On weekends it was a popular gathering spot for the rest of the community as well. To the Collaborative's founders, the popularity of MUSE was testimony to the need for more facilities like it in other parts of town.

The Collaborative had its own twist on the resource center idea: not only should it be activity- and object-oriented, but it should be a place that stood halfway between the classroom and the museum, where children and their teachers could be connected to the outside world—and particularly the centers of culture—on terms that would be specifically and closely related to what they were doing in school. Those who advocated the cultural resource center saw many advantages in it. A committee assembled in 1972 to design the prototype described those advantages this way:

- It would bring the museum experience and "confrontation with the original object" closer to the school, allowing more children to take part in activities related to the object (making another object like it, learning about its origins, practicing the visual and artistic language that makes objects comprehensible).

- By calling on the talents of artists and craftsmen it would introduce teachers to people many of them do not meet in their daily lives and would thus enlarge their approach to their work: ceramics could be combined with earth science, weaving with numbers, poetry with vocabulary, photography with social studies or chemistry and physics, painting and color mixing with behavior of the eye and brain.

- The center would also give teachers a chance to experiment in a neutral setting with new subjects and new ways of teaching them without fear of messing up their classes.

- Because it would not be tied to a single cultural institution, users of the center—not only schoolchildren but adults from the neighborhood who would be part of the program after school hours—could draw on the resources of a variety of New York museums. The riches of these museums would thus be broadly understood, and the community linked effectively with centralized institutions it might otherwise never come to know.[4]

**First tries.** With the experience of MUSE behind it, the Collaborative began to explore the possibilities for establishing cultural—that is, art and science—resource centers in school districts throughout the city. One of the first allies it encountered was the New York City Board of Education's Learning Cooperative, established in 1971 by Chancellor Harvey Scribner as the school board's vehicle to improve

education at the elementary level in the city's 31 (there are now 32) community school districts. The Learning Cooperative was new and open to ideas, and the resource center fit the cooperative's own vision of a "linkage" system that would put the school in touch with a network of social and cultural resources—hospitals, banks, insurance companies, doctors, and mathematicians, as well as museums, zoos, botanical gardens, theaters, artists, dancers, and musicians.[5]

So the Learning Cooperative and Museums Collaborative agreed to collaborate, or cooperate, on the development of two centers, one for art and the other for science, that could serve as prototypes of others to come. The terms of the agreement were simple enough: the Cooperative would find a school district that was sufficiently interested in the idea to bear the ultimate cost of staffing and operating the center; the Collaborative would raise the planning money, coordinate the planning, and identify the appropriate museum resources; and a team of museum staff members, teachers, and community representatives would design the program.[6]

The first project was the Heritage Museum, on which the Collaborative had done some work before its alliance was formed with the Learning Cooperative. Sponsored by a school district in the Bronx and located in an abandoned movie theater, the museum was patterned after MUSE in Brooklyn, though its focus was more ethnic (African) than MUSE's.

At the same time that the Heritage Museum was being brought to life, the Collaborative and the Learning Cooperative set in motion a second project, the Theodore Roosevelt Environment Education Center (TREE) at the Roosevelt birthplace in Manhattan (the name was later changed, as was the location, but the acronym stayed the same). In many ways it was not typical of the Collaborative's model: the product of 18 months of negotiation with the National Park Service, the center was designed to serve ten school districts, not just one, and although the Collaborative paid the salary of a full-time person the first year and the schools have since supplied the transportation for the students and released time for the teachers, the National Park Service rather than the schools provided space and paid for most of the operating costs.

The center nevertheless demonstrated the basic idea of an out-of-classroom place from which teachers and their students (in this case, 5th graders) could explore the urban environment using the resources of local cultural institutions. Classes came for a day a week for the entire year. With the help of the TREE coordinator to set up courses and workshops and make connections with the relevant museums, zoos, or environmental centers, the school groups would investigate such urban phenomena as incinerators and supermarkets and learn—for example, from an ornithologist, coordinated visits to museums and science centers, and sessions with a group like Young Filmmakers—to identify and photograph birds in the streets, parks, bays, and marshes around the city.

The art resource center was another story. The Learning

Cooperative did find a school district (#9 in the Bronx), the Collaborative did raise the money ($33,695 from the Fund for the City of New York), and the planning committee did turn out a program design (see the preceding outline for the prototype). But soon the timetable began to lose its meaning. The school district had elaborate plans for not only educational but physical renewal, of which the resource center became a smaller and smaller part as the renewal plans grew. It looked like years instead of months before a site would be offered to the Collaborative-Cooperative and longer still before district funds would be committed to the center. There were political problems in the offing as well: a new school board election, charges of fiscal mismanagement against the superintendent, and inevitable conflicts among community groups about both the details and the scope of the grandiose renewal scheme. The Learning Cooperative, which had originally, like the Collaborative, expected to devote 90 percent of its work to the "linkage" center idea, was now becoming attracted to other ideas. The alliance was loosening.

Relations became especially strained in the winter of 1972/73. By this time the project was nine months behind schedule, the district's commitment was still vague, and the Collaborative's grant money was dribbling away in the development of a center that was clearly going nowhere. Negotiations with the district finally collapsed in May 1973, one year after they began and four months after the center was to begin operating.[7]

**A new network.** With what was left of the grant money, the Collaborative was given permission by its funding source to work with three centers that had already been started elsewhere in the city. One was GAME (Growth through Art and Museum Experience), a storefront resource center serving three schools on Manhattan's Upper West Side (see report in chapter 8). There were four others—for art, culture, or environmental studies—in school districts in Manhattan and Brooklyn. The remaining grant money was divided among the five centers and the salary of the new coordinator, Jennifer Lander, who was hired in the spring of 1973.

Although no two centers were quite the same, the pattern of school support was similar:

- All but GAME were part of the school system and had space within a school.
- All were allotted some equipment, materials, and teaching time by the participating schools.
- All had to rely on outside funds, most from a National Endowment for the Arts grant to the Collaborative, which provided about $3,000 for each center for planning, consultants, artists, and instructors and materials from cultural institutions.
- All needed, but could not always count on, the assignment of regular staff positions for teacher-coordinators to run the programs, organize appropriate curriculum materials, and train and support teachers in arts processes, audiovisual techniques, and the use of cultural institutions.

The Collaborative's role with the five centers (a sixth was added in 1974/75) was primarily brokerage: the Collaborative coordinator moved around among them, met regularly with the center staffs and teachers who used the centers, and helped scout the outside talent and materials they needed. At one, for example, the Collaborative put the center in touch with the Museum of Contemporary Crafts, which trained students in health careers to teach art skills to hospital patients; the museum also gave workshops to students in decorating and furnishing their resource center. In a silkscreen workshop conducted jointly by staff members of the Metropolitan Museum and the Malcolm X Art Center, a nearby community organization, students built their own silkscreen studio. An exhibition workshop given by the Metropolitan culminated in an exhibition of prison art.

Through the same center, the school has given courses for its students at the American Museum of Natural History, the Wave Hill Center for Environmental Studies, Jamaica Wildlife Center, and the Audubon Society. It has also developed an environmental curriculum with the help of the New York Zoological Society, the New York Aquarium, Wave Hill, and the New York Botanical Gardens. In another project, the Collaborative's coordinator helped get a grant for the center to use local museums and historical societies for a social studies segment on immigration: students studied records and exhibitions, then prepared a slide presentation, based on photographs they had taken themselves, that compared Jewish, black, and other ethnic and racial immigrations with the histories of their own families.

Another center, sponsored by a school district in Queens (a district that is particularly barren of cultural resources and even materials: "The center serves an entire district in which crayons and scissors are a rarity"[8]), has had help from a variety of institutions—among them, the Metropolitan Museum, a community-based teacher-oriented organization called ARTS, Inc., and Pratt Institute's Center for Environmental and Community Development. But the Collaborative's special relation has been with the Brooklyn Museum, which joined the school district in January 1974 as a sponsor of the center by donating a museum staff member two days a week. Together with two full-time teachers from the district, the Brooklyn staff member became part of a team that conducted teacher training sessions, led ten school classes a week, and worked on curriculum development. As the result of their investigation of African and Oceanic cultures at the museum, three pilot social studies classes purchased objects from museum shops for the center's permanent collection and staged a festival for their parents at the center, comparing their social customs and beliefs with those of the cultures they had studied. For the Brooklyn Museum's education staff, the center has provided a laboratory for testing museum-school programs.[9]

Whatever their activities or layout, the centers have had one common problem: money. The original Collaborative-Cooperative idea had been based on a small amount of planning money from outside sources, particularly foundations or government, and a commitment from the school district to provide space, personnel, and permanent maintenance of each center. But as the Collaborative and the centers themselves were soon to be reminded, school budgets change from year to year, and classroom programs tend to take precedence over out-of-school projects; thus long-term commitments for the centers from the school districts were likely to be uncertain.

At the end of the 1973/74 school year, the five centers submitted a proposal to the central board of education asking for salaries to staff the centers, a total cost of $91,000. The result was that each of the five was assigned a full-time staff member for 1974/75, paid from tax-levy funds to the school districts.

**The lessons of the centers.** Although the funding question was far from settled when this study was made, the Collaborative felt it had learned several things from organizing the centers. The first attempts to create a model districtwide resource center, said Jennifer Lander, were unrealistic. "The concept was not workable," she pointed out, "[because] it was too big. Too many people, too highly placed were involved in the planning. We hadn't gotten down to the level of the working teacher. Art programs are like guerilla warfare—you can't talk it, you have to do it." More than ever by early 1975, she was convinced that change could only begin to take place at the "grassroots level" and from there "bubble to the top."[10]

The Collaborative had also become convinced that schools must be able to make use of outside resources without outside help. Said Priscilla Dunhill,

The centers must grow and become independent; they must raise their own money. We don't want the Collaborative to be forever involved. The centers should be tax-exempt organizations able to bargain for funds with their own school districts. New school centers will need help, and we must be free to work with them.

The difficulty still not solved, however, was that the centers often required one-to-one arrangements, in every case a time-consuming task. Many of the teachers who wanted these services were far removed from the city's cultural hub: one district, for example was at least a 90-minute subway ride from Manhattan. Distance alone made it hard for teachers in such situations to learn to know the major New York museums well enough to negotiate with them for services or even to take students on the customary field trip. To find a well-trained botanist or deep-sea explorer or silkscreen artist to help with curriculum themes was often just as hard. And yet, as one director, Thelma King, noted, the searching out of knowledgeable experts in several fields is important to schools. "We need these resource people for special projects," she noted, "and we need the Collaborative to help us find them. Our school philosophy is based on external experience in the life of the student. [In many cases] we turn to

Jennifer [Lander] for the necessary brokerage.''

In 1975 the National Endowment for the Arts renewed its grant to the Collaborative for the $3,000 each center is given for the use of museum resources, and the board of education (until spring 1975, at least) continued to provide the basic services. The Collaborative itself, Director Dunhill has said, would rather turn the program into a voucher plan (see below) and let the centers buy museum services on the open market, thus forcing museums to tailor their services more closely to their clients' demands. Without such a device, it is not clear that if the Collaborative does move out of its brokerage role, the resource centers and the museums can go it alone.

## The museum-school-community arts program

One thing the Collaborative learned from its experience with the resource centers, and particularly its abortive attempt in District 9, was that it was far more productive to work with a center already in place than to try to interest a school district or community in creating one. For both the board and the Collaborative staff the question was not the idea of the intermediate institution itself, for clearly the existing centers were proving to be a success; rather the question was whether the effort and money it took to establish new centers constituted the wisest investment the Collaborative could make.

At a meeting in spring 1972, Emily Dennis and the Collaborative's first board president, then vice-director of education at the Metropolitan Harry S. Parker III, suggested that instead of trying to decentralize museum resources through resource centers alone, the Collaborative work with community arts groups—many of which already had extensive programs with the schools—to devise ways of serving the schools. These small community-based museums and art centers—the Studio Museum in Harlem, El Museo del Barrio, the Children's Art Carnival, the Children's Art Workshop, the Bronx Museum, for example—knew their communities and local schools far better than either the museums or the Collaborative ever would. They were also struggling for money that was increasingly hard to get. In effect, through these community centers, museums could begin to decentralize their educational services and strengthen the centers at the same time.

The recommendation was based partly on the Metropolitan's own experience. As the museum assembled its department of community programs in the late 1960s, the staff discovered that a large museum like the Metropolitan could not successfully respond to every community request that came to it, nor could the museum design programs from on high to fit the city's myriad neighborhoods. They had learned, too, that sending exhibitions around the city was not the answer to decentralization. Valuable works of art require security and a modicum of atmospheric control, and most of ''the people'' do not pass through the libraries and courthouses that provide such a safe environment.

It turned out, furthermore, that many arts organizations were interested in promoting their local artists and in offering the people in their communities the chance to do things themselves. What many community organizations wanted was lessons in how to hang exhibitions, how to manage small museums, how to silkscreen posters, how to conduct art classes, how to find materials, how to raise money. The Metropolitan's community staff found itself brokers not between the community groups and the museum's collections, but between those groups and the curators, conservators, exhibition designers, and registrar.

The Collaborative staff outlined a program in response to the Dennis-Parker plan. Twenty community arts groups would be invited to submit proposals that would match the resources of the large central museums to local school needs. The money for carrying out the projects would come from foundation grants; schools would be asked to contribute funds, space, or staff.

**Year 1 (1972/73).** Of the 20 organizations invited to turn in proposals, eight were chosen for the program the first year. With $80,000 contributed by two foundations, the Collaborative gave grants to the eight community organizations ranging between $7,500 and $12,500 each. The organizations were expected to follow nine guidelines, spelled out in a memo to the community groups in August 1972. Each project would

1. Be jointly planned by the sponsoring community arts organization, the museums it proposes to work with, and the local school district; and the school district must commit funds or services to the project.
2. Use museum resources, which should be reimbursed with the Collaborative grant, and the project should offer new directions and program components.
3. Provide for teacher training within the project.
4. Offer community residents paraprofessional or intern training.
5. Serve students directly or offer consultation to schools and teachers.
6. Be based on art, science, or cultural heritage and draw on both large central museums and local resources.
7. Involve visual and performing artists and craftsmen from the community.
8. Be carried out in adequate space either on the organization's own premises or the school district's.
9. Be undertaken by a sponsor that has a demonstrated history of cooperation with a school or school district.
The projects were varied:
- One proposed to develop three traveling exhibition kits based on the cultures of China, Puerto Rico, and the American Indian, using the resources of the Brooklyn Museum, Museo del Barrio (a Puerto Rican museum), the Metropolitan Museum, and the American Crafts Council. The kits would be used in schools on the Lower East Side of Manhattan.
- Another organization proposed borrowing selected art objects related to the traditions, customs, and cultures of the

community's various ethnic groups, and training local residents in exhibition techniques.
- Still another wanted to hold demonstrations and workshops for teachers, paraprofessionals in the schools, and children at the Metropolitan's Cloisters, using artists in the community wherever possible, to teach about the life, crafts, systems, and customs of the Middle Ages.

Others hoped to get museum staff members to help them organize a film and slide library, document community customs, hold workshops for teachers in multimedia techniques, and produce a traveling collection on a specific culture for use in classrooms.

**How it worked.** Most of the projects, chosen in late fall 1972, got under way after the first of the year in 1973 and continued as scheduled throughout the spring. For an initial foray into new territory, the Collaborative probably did better with this complicated program than it had any right to expect. Perhaps most important, it got the program started. Few of these community organizations had ever tried to work with large museums, and this program did mark the beginning of some kind of relation between them. The Collaborative learned how the community groups operated and where their assets and weaknesses were. The experiment also gave the Collaborative an education in the museum world: by the end of the first year, it was a good deal clearer to the Collaborative staff what museums could and could not do than it had been when the program began. In a few instances, too, the museums learned something about the community arts groups in New York, and in one case the program led to a cooperative exhibition between a midtown museum and one of the community groups on the Lower East Side.

Measured by the Collaborative's own guidelines and the community organizations' proposals—and certainly by the expectations of the scheme—however, in its first year the program probably scored around 30 percent. One organization lost two key staff members just as the project was about to start and never did take part in the program. Three of the eight grants involved groups that did not strictly qualify as ''community arts organizations''—a parent-run private school, an environmental conservation center, and an activity originated by a community group but administered by an established institution (the Cloisters workshop). The group that had proposed creating three kits completed two with difficulty, and in the process its staff developed such antipathy toward the museums it had expected to work with that the Collaborative decided not to fund its project a second year. Involvement of board of education personnel and other relevant school organizations was almost nonexistent.

The shortcomings of the program were summed up in a report submitted to the Collaborative in fall 1973:

Good will is apparent nearly everywhere in the project. All the participants—community arts centers, the Collaborative, funding agencies, and museums—gave evidence of their desire to reach a young audience that might not otherwise participate in art-enriched activities. The program's promise and potential live in this desire. . . .

Even with the best will in the world, however, bold ventures like the Collaborative's effort to act as liaison among dramatically different groups—community arts organizations, museums, funding agencies, and schools—require careful planning, resourceful leadership, tactful intervention, and a firm sense of purpose and value. These requirements were not met in this first attempt. It must be said that throughout the experimental project, the Collaborative's role and purpose were ambiguous. If there is a lesson to be drawn from the mistakes in this project, it can be found . . . in the Collaborative's misplaced sense of mission.

According to the Collaborative's own literature, that mission was to serve museums and —through the decentralized use of museum services—schools and communities. The organizations chosen to try to deliver those services—the community arts groups—were supposed to pioneer new approaches to, and uses of, museum collections.

Yet these have been little understood or appreciated by many of their clients. Community arts groups, many in their infancy as institutions in New York City, have tremendous drive and resourcefulness, but they do not have the expertise that such a role requires. How much direction the community arts organizations would take was a major consideration for the Collaborative. Such arts groups have battled individually to reach their present status. Often they now fear that supervision and guidance might blur or submerge their individual identities. Sensitive to the history of such groups, the Collaborative made every effort not to impose its will or its being on them. . . . The result was that the Collaborative left all the organizations too much on their own to research and investigate resources that were unfamiliar, indeed alien, to them.

Certain predictable weaknesses in all of the projects developed from this fundamentally awkward posture rooted in good will. Lack of structure often meant that well-conceived programs were carried out in an offhand manner or that programs were too casually conceived in the first place. Teacher-training efforts were superficial. Rich resources in the city lay untapped, uninvestigated, or even overlooked by the Collaborative and grant recipients to whom the Collaborative offered little guidance and few suggestions. Leaders and workers in the community arts centers did not learn as much about using the city's museums and other cultural institutions for their own purpose as the Collaborative wished. Staff and participants at the community arts centers often did not have enough information to be able to form questions or make requests.

In its excess of faith—or excessive desire to demonstrate good faith—the Collaborative failed to make clear to the recipients of its funds that the grant's primary goal was to find ways to decentralize and use museum resources. In

short, the Collaborative gradually shifted its goals from the grant purpose—decentralization—toward meeting the pressing financial and other needs of the community arts centers. It is possible that the Collaborative was caught in a position in which it had the funds for a specific purpose, but the purpose was premature and there were no agencies to carry it out.[11]

**Year 2 (1973/74).** As the result of the evaluation, in the second year of the program the Collaborative made several useful changes. Since it was apparent that community organizations needed help in designing their programs and in approaching large museums, the Collaborative staff became more aggressive in monitoring the goals, planning, and progress of each project. It also raised money to pay for an extra staff member (two were part-time) at each of three museums—the American Museum of Natural History, the Brooklyn Museum, and the Museum of Contemporary Crafts—whose job was to act as a go-between within the museum on behalf of the community groups, helping them develop their projects and channeling requests for services and loan materials to the appropriate curators and other specialists in the museum.

In other changes, to make sure that the money would go directly to the project and not to general operating expenses, the Collaborative allotted each community group smaller sums and required that at least half be spent in museums. And in an effort to strengthen the commitments of museums and schools to the program, the Collaborative required (1) that proposals be ''jointly planned and submitted'' by the museum and community group and (2) that schools ''specifically detail the nature of their contribution to the program.''[12] It also required that the beginning and ending date of each program be established at the outset, and that the community arts groups agree to at least three evaluation visits during the life of the project.

Proposals came from the same seven groups that completed projects the first year, plus eleven new groups. Twelve were chosen in all, six of the new applicants, six of the old. As no two of the projects were the same, it is not possible to give a typical example, but two might suffice to suggest the range of objectives and methods the community groups pursued.

*El Museo del Barrio.* Founded in 1969 and located in Manhattan's East or Spanish Harlem, El Museo is a storefront museum of Puerto Rican culture, designed particularly for schoolchildren (it is actually housed in a building that closely resembles a supermarket, though it was built as a Head Start center).

When El Museo applied for Collaborative funds in the first year of the museum-school-community arts program, 1972/73, its primary source of support was the community school district that serves East Harlem. That year, with money from the Collaborative, El Museo developed ten traveling kits on Puerto Rican crafts and craftsmen for use in the district and subsequently for distribution in schools throughout the city. Artifacts, slides, and research came from three institutions in Puerto Rico; the American Museum of Natural History helped Museo staff members go through some of its storage collections; and the Metropolitan Museum of Art lent slides.

The second year, El Museo proposed a joint project with the American Museum of Natural History to investigate the possibilities for long-term display at El Museo of the museum's pre-Columbian Taino Indian collection, which had been closed to the public for ten years for lack of funds. El Museo not only wanted to arrange for exhibition of the collection—some of which had already been on display at El Museo—but also for cataloging and photographing it and for designing teaching materials around it.

Although Museo had planned to create the teaching materials for use by the public schools, the requirement for some kind of commitment by the schools was waived because in 1973 El Museo declared its independence from the school district to be free to serve all schoolchildren in the city (Museo was also protesting the district's pressure on it to help lift reading scores by directing the art experiences it offered toward verbal, rather than cultural or visual, literacy—a move that also would have allowed the district to support El Museo through federal funds).

The Collaborative granted $6,300 to El Museo to pay members of its staff and two guest curators to organize an exhibition that would appear first at El Museo, then at the American Museum of Natural History. The Museo staff members also built a considerable slide archive on Taino Indians both from photographs they took of the natural history museum collection and from slides purchased from the Instituto de Cultura, the Santo Domingo Museum, Yale University, and the Museum of the University of Puerto Rico.

The exhibition, an ambitious project for which the Collaborative funds were only the beginning, was still some way off at the end of the period of the grant (August 1974), and an evaluation report on the second year of the Collaborative program noted that ''progress . . . seems to be slower than is justified.''[13] But by January 1975 El Museo and the Museum of Natural History had submitted a joint proposal to the National Endowment for the Humanities to pay for the exhibition, and Museo director Marta Vega had been awarded a senior Rockefeller Fellowship at the Metropolitan Museum (see chapter 14) ''to pursue research in the United States and the Caribbean on Taino Indian culture.''[14]

*Upper Manhattan Artists' Cooperative, Inc. (UMAC).* In an attempt to encourage artists and art-making in the upper Manhattan area, a group of artists, teachers, and other local residents formed the Upper Manhattan Artists Cooperative in 1971. One of its first projects was to set up an art media center where artists could do their own work and help aspiring artists do theirs. In its search for a site, UMAC approached the

Metropolitan Museum about space at its uptown branch, the Cloisters, that had been used for a workshop the summer before. The museum's trustees studied the project and agreed, as part of its program to respond to decentralization interests in various New York communities, to accept the UMAC proposal to allocate $15,000 toward program costs and renovation of the Cloisters garage.

The result of the Metropolitan's contribution and UMAC's energies was something called Project Turn-On, developed with the help of the local Community School District 6, another arts group called Community Environments, Inc., the New York State Council on the Arts, and ultimately Museums Collaborative.[15] The purpose of the project was to "connect" the children and the community "with their neighborhood museum and with art in a live, exciting way," as UMAC's proposal to the Collaborative put it.[16] The first year of the Collaborative program, UMAC developed workshops for District 6 schoolchildren in medieval crafts—weaving, ceramic sculpture, stained-glass, bread baking, glass blowing, and banner making—all of them with master craftsmen, several from the Cloisters, who took the children on visits to the Cloisters galleries for inspiration at each workshop session. The grant from the Collaborative ($10,000) paid for a research assistant, who drew up bibliographies and helped with slide presentations in the schools, thus freeing the instructors for planning and teaching; the grant also paid the salary of the guard so the workshop could stay open after school hours and adults from the community could take part.[17]

In the second year, UMAC expanded the program. It included community arts activities in public places for upper Manhattan residents (a quilt-in, a crafts fair, and a paint-in); a Title I program called Reading through the Arts for 120 District 6 children (five sessions in each workshop on calligraphy and bookbinding, tapestry and weaving, metalsmithing, and puppetry); and after-school workshops for children from 14 public and 14 parochial schools, 45 a day in each of two ten-week sessions. The program called for workshop supplies, museum materials (slides, maps, brochures, artifacts), a person to assemble a slide collection for the reading teachers and coordinate museum resources, the salaries of two UMAC members to register participants and schedule the after-school workshops, and also the salaries of the workshop instructors. Of the total cost of the program, $74,700, the Collaborative provided $4,900, earmarked for community coordinators and craftspeople for the after-school program. The rest of the money came from the National Endowment for the Arts and federal education funds; the Metropolitan supplied a full-time staff member and guards.

**Lessons of the Collaborative program.** As is usual with any plan, not all the projects turned out the way they were proposed in either year: some produced less than they promised, a few produced more. But both the Collaborative and the participating museums learned several things, which have been incorporated into the Collaborative's policies and guidelines for subsequent programs, especially the cultural voucher program outlined later in this report.

For the Collaborative's part, the experience demonstrated that

- What community arts groups wanted most from museums was not material and artifacts but the help of skilled people.

- Museums, especially large ones, are too complex for community arts groups to use successfully without help, and thus the addition of staff members to provide the necessary liaison between the community groups and the museum resources was crucial in the three institutions where they were hired.

- Schools proved in most instances to be such unreliable partners ("principals change, teachers shift within a school district, and biannual community school board elections play havoc with budget support of special programs")[18] that the Collaborative decided to confine its school-directed programs to the five cultural resource centers already in place (see below).

- Large amounts of money are not the answer to successful use of museum resources, and money by itself does not buy commitment from either schools or museums.

- What is more important is fiscal and administrative stability, professionalism, and clear definition of educational goals on the part of the community arts group. Organizations constantly struggling for money are unable to do much other than try to survive: of the twelve community groups that participated in the Collaborative program over the two years it was in operation, three died for lack of funds, and in at least two cases administrative problems seriously interfered with the carrying out of the projects. Where organizations are stable, small amounts of extra money provide flexibility and, in the Collaborative's words, "when sustained over a period of two or three years, allow a program to grow slowly and empirically."[19]

- Community groups and museums need time to learn to know each other and to build trust. In the second year of the program, according to the Collaborative, "the level of sophistication of program planning between museums and community groups rose substantially." Where these groups had tended to use obvious museum resources in the first year (existing courses, museum-prepared materials, and preconceived museum ideas), in the second year the programs were what the Collaborative considers "far more substantive [and] inventive."[20]

- The Collaborative staff should have assumed a much more active role as broker and hand-holder than it had originally planned. The staff found itself in the second year following programs closely to find the right resources, match the interests of the community groups and the museums, soothe "ruffled nerves," "bridge the gap between the different and, at times, antithetical goals, values, and mind sets of

the participants,"[21] and develop alternatives when one avenue failed.

There were lessons in the experiment about, if not for, museums too:

- The fact that large museums are basically object- rather than client-oriented makes it difficult for them to think in terms of "the community." In this program, at least during the first year, museum priorities tended to obliterate the sense of importance that community groups attached to their projects; many museum staff members had either not heard of the program at all or regarded it as so peripheral to their own work that they often greeted the requests of community groups with excessively bureaucratic barriers or just plain inertia.

- The idea that the museum is a repository not only of objects and information about them but of skills and other intangible resources is a relatively new one. Although several large urban museums have been asked to help establish new museums abroad, training personnel in the process, this program made it apparent that museums have not been organized to offer their expertise to small community groups close to home. At the same time, although this program provided money for community groups to buy materials and other tangible museum products, in practice it often required that museums give advice and technical help free. The Collaborative's voucher program is designed to change that: its guidelines include, in fact emphasize, the exchange of people and skills as much as loans of objects and the purchase of kits, reproductions, and other material.

- Community arts organizers have a far less professional, in the museum sense of the word, attitude toward the product of their work than museums have come to expect. In one cooperative exhibition undertaken between a community group and a midtown New York museum, for example, the standards of public performance were so different that the frustrated museum staff finally decided to take over the management of the exhibition itself. The casual, loving-hands-at-home style of many community groups may be acceptable in the storefront, but museums will not stand for it in their galleries.

- Like their counterparts in Washington, D.C., and perhaps elsewhere in the country, New York art museums tend to regard their primary audience as art aficionados who transcend national and international boundaries, and they focus their sights on local community groups only with difficulty. Even though several museums tried to respond to community pressures during the height of the decentralization battles during the late 1960s, museum trustees and administrators do not often give ethnic or community interests a high priority in formulating policy, except as those interests may be reflected in support from city funds. The Collaborative is one of the few organizations in New York keeping the idea of decentralization alive—and thus forcing museums to take a more generous attitude toward the cul-

turally underserved areas of the city and, indeed, even to visit these areas to try to understand them firsthand. It is doubtful if many art museums and even their education staffs would be as active as they are in behalf of "the community" without the Collaborative's constant prodding. Community art centers, as one observer has noted, "are an important source of cultural enrichment in the community . . . an oasis in a socioeconomic desert."[22] It is a lesson that the large, wealthy, centralized museums in New York may be learning reluctantly.

### Decentralization and the cultural voucher

For large and small museums alike, one obstacle to change is not just attitude; it is also money. Experimenting with new programs and new audiences can be costly; it requires turn-around and research time, tests of pilot designs, evaluation. Few institutions are flexible enough to stop what they are doing and divert their staff energies to untried programs.

As part of its prodding of museums toward new community audiences, the Collaborative also has helped to raise the necessary funds. For three years, from 1971 to 1973, under a program called Museum Summer, the Collaborative assembled both federal and foundation money to help support summertime community activities of first five, then ten, and in the third year twelve New York museums. In 1973, the last year of the program, the Collaborative tried out a version of the cultural voucher, a method of payment for cultural services advocated by at least one Congressman (James Delaney in 1969) and spelled out in detail in the *Report to the President* from the White House Conference on Children in 1970.[23]

Under the Collaborative's 1973 plan, the prospective museum participants submitted their program designs to an advisory panel, which chose the 12 finalists on the basis of guidelines that had been announced to the museums in advance. These 12 community organizations, representing "a broad range of age, ethnic, and socioeconomic backgrounds,"[24] were then sent bulk mailings of a brochure that described the programs and included an application to be filled out by individuals or groups who wanted to take part in the program. These filled-out applications were, in effect, the vouchers: returned by the participating museums to the Collaborative, these vouchers testified that the applicants had indeed been served by each museum, and the museum was then reimbursed by the Collaborative on the basis of the per-capita cost of the program—a cost that had been projected by the museum at the beginning of the negotiation with the Collaborative and approved by the advisory panel.

The Collaborative's new cultural voucher program, for which fund raising and planning began in July 1974, has a different base, although it derives many of its guidelines and "lessons" from the Collaborative's earlier programs. Under the new plan, vouchers for museum services are given not to individuals but to community groups.[25]

The vouchers, worth an average of $3,500 each, allow the ten community groups in the program to work with seven cultural institutions chosen by a special advisory council. The vouchers are then redeemed by the cultural institutions from the Collaborative.

The Collaborative's ambition for the three-year demonstration project is to provide an incentive for cultural institutions and community organizations to work together to produce new programs—and, as is the Collaborative's custom, to prod the large, centralized institutions to open themselves up to new audiences. In its May 1975 proposal to private foundations, the Collaborative describes the voucher program's purpose this way:

. . . Museums Collaborative has established a series of innovative programs designed to make the cultural and educational resources of the City's museums, zoos, and botanic gardens available to a more broadly based public.

The Cultural Voucher Program will apply this experience in a three-year demonstration project developing an on-going partnership between a group of seven cultural institutions and ten community organizations with constituencies not reached by existing museum programs. It is expected that the Cultural Voucher Program will introduce people to cultural resources, but more importantly it will result in the creation of new educational programs with community organizations and cultural institutions collaborating in their design. These programs will be conducted in local communities and incorporate local traditions and skills. Reflecting community priorities, they will help community organizations to implement their own cultural or environmental programs.

With their principle [sic] activities focused on maintaining collections and preparing informational and educational resources, no single museum is equipped to make a comprehensive effort to resolve the problem of community outreach. Yet there are organizations in every community with direct and established networks of communication reaching exactly those segments of the community who do not use the resources of cultural institutions. Their principle [sic] activities may be drug rehabilitation, community planning, ethnic identification, senior citizens activities, etc. But secondarily, all of these organizations are committed to programs of adult education, activities which enrich the lives of their constituency.

As an incentive for an on-going partnership between such diverse groups—cultural institutions and community organizations—the Cultural Voucher Program will, in effect, provide them each with funds restricted to the purpose of working together.[26]

Even though the client was to be the community group, however, the Collaborative hoped that the program would be a true exchange between the two: it saw "a working agreement to trade goods and services" and "a mutual education process" as the result of the exchange, "through which community organizations gain a clearer understanding of the nature and value of museums, and cultural institutions gain a deeper understanding of the public they serve."[27]

Building on its experiences with other programs—especially the Museum Summer and the two-year museum-school-community group project—the Collaborative drew up far more formal guidelines for the cultural voucher program than it had done for the earlier efforts. For example,

• Where the Collaborative had in earlier programs been trusting and even casual about the cultural institutions' commitments to work with community groups—only to find that poor internal communications left important staff members ignorant of the program—now it asked for agreement about the institution's participation from the trustees or director and from all appropriate professional, service, or administrative departments.

• Having learned that community groups could not find their own way into large institutions, the Collaborative agreed to pay the salary of a staff member to serve as liaison between the institution and the community organization.

• Because it had turned out that the services of professionals were more important to community groups than materials and preconceived programs, the Collaborative built into the budget fees for consultants from museum staffs who agreed to work with community groups.

• In earlier programs, some participants refused to allow projects to be evaluated, and others found the needs of the evaluators distracting and time-consuming. This time, the Collaborative guidelines required prior agreement from all participants on evaluation and the criteria it should follow. And because evaluators often had been able to start their work only some time after the projects were under way, thus missing important stages in their development, under the cultural voucher program the evaluation team was chosen even before all the participants had been picked.

• From the community organizations, the Collaborative demanded a stable organizational history and fiscal responsibility to avoid the problems it had encountered before with organizations in such fiscal flux that they could not carry out their projects successfully.

• To make sure community groups understood the institutions they elected to work with, the Collaborative required an orientation period with each institution—a long step ahead from the first year of the community arts-museum-school program when the participants were left to find each other on their own.

• Where the Collaborative once had chosen to stay out of the picture almost entirely so that community organizations could work without interference, under the cultural voucher program the Collaborative has agreed to monitor relations between the museums and community groups and to help with fiscal administration. "It is mandatory," say the guidelines, "that each community organization [or institution] discuss concerns and problems about the Cultural Voucher Program with Museums Collaborative as they arise."[28]

**Who participates.** To find the cultural institutions and community groups for the voucher program, the Collaborative and its voucher staff (three persons: a director, Susan Bertram; an assistant director, Cheryl McClenney; and a secretary [see section on the Collaborative staff, below]) invited application from 65 museums, zoos, botanical gardens, and historical societies in the city and sent a mailing on the program to 2,400 community agencies—from drug rehabilitation centers to senior citizen programs (by the terms of the initial grant, the emphasis was on adult audiences).

From the cultural institutions there were thirty-five applications, which were then sifted by an advisory council appointed to the job by the Collaborative. The council picked seven: the American Museum of Natural History, the Brooklyn Museum, El Museo del Barrio, the Museum of Modern Art, the New Muse Community Museum in Brooklyn, the New York Zoological Society (the Bronx Zoo and the New York Aquarium), and the Queens Botanical Garden.

Community applicants were required to answer a one-page questionnaire about themselves and, in subsequent stages of selection, to submit a general profile and finally a proposal outlining the project each group wanted to develop. Of the 162 community agencies that were declared eligible, 48 submitted proposals. To help them decide what to ask for in their proposals, the Collaborative held a day-long workshop in June 1975, at which representatives of the 7 cultural institutions made their pitch and community representatives asked questions. Each institution described the kinds of services it was able to provide—jazz concerts, galleries for local exhibitions, contemporary artists to talk about art, all manner of workshops, libraries and study collections, speakers on everything from animals to grave robbing, tools, plants, trees, stakes, fertilizer, wheelbarrows, slides and films, scientists, teachers, designers, and technicians. Community groups asked about transportation (public transportation to and from museums is included in the budget), training programs for prisoners and ex-offenders, help with exhibitions, arrangements for after-hours tours, the purchase of artifacts in museum shops, not to mention the working of the voucher system itself.

By July 1975, the Collaborative had chosen all ten community groups, whose constituents included American Indians living in New York, adolescents living in group homes, senior citizens, Greek-Americans, ex-offenders, emotionally disturbed children and their families.

Some of the projects:

• The American Indian Community House, the first central meeting place for New York's native American population, is "buying" training in exhibition display techniques from the Brooklyn Museum and, from the American Museum of Natural History, several sessions on the use of educational materials based on the museum's American Indian collection.

• The Manhood Foundation, which counsels ex-offenders and sponsors programs for children of inmates in seven New

York prisons, bought a series of workshops from the Brooklyn Museum to teach children how to make animated films. The films they produced were to be screened in the prisons for their parents.

• A crisis intervention center that provides group homes for adolescents used its voucher funds for three projects: courses on African culture, photography, and jewelry making given by the American Museum of Natural History; music instruction from musicians found for the center by the New Muse Community Museum in Brooklyn; and courses in fluorescent-light gardening and carpentry from the Queens Botanical Garden to help the youths improve the way the residences look.

**Funding.** The base money for the program is what is known as a noncompetitive renewal grant from the Fund for the Improvement of Post-Secondary Education (FIPSE), a division of the U.S. Department of Health, Education, and Welfare. The grant, which is renewable annually for three years, pays roughly half of the annual operating budget—$106,000 of the 1974/75 budget of $218,717. The rest of the money must be raised from local sources. The FIPSE money is earmarked for administrative costs, salary stipends for four of the seven participating cultural institutions, and a portion of the evaluation.

That the Collaborative has been able to interest HEW in museums is in itself a significant step. According to the Collaborative, HEW is a source of funds that few museums have tapped before. Although there have been some signs that other funders look upon the HEW grant as an excuse to hold back on their own contributions to museum projects, the Collaborative continues to point out that the voucher project should serve to increase rather than substitute for the pool of funds available for museum programs.

The Collaborative hopes that the costs of a cultural voucher program in New York eventually can be picked up by the city, the New York State Council on the Arts, and the museums themselves, though it has no specific plans to seek funding after the three-year pilot ends. The city's fiscal crisis in 1975, in any case, would seem to bode ill for such a scheme. In the meantime, the Collaborative has some time to find out just how well the voucher idea stands up against more traditional methods of funding museum-community programs.

## Services to Museum Professionals

The Collaborative's second goal has been to support museum educators who were trying to "reach new audiences in new ways" by devising joint programs (Museum Summer, workshops, Art Swap Day, conferences), bringing educators together for regular meetings (the Education Forum), and publishing information about programs ("The Inside Track" and the *Annual Manual*), jobs, and fund raising (*Newsletter*). More about these activities follows.

But, first a word about the Collaborative staff and its approach to museums.

Although the Collaborative has concentrated on two basic goals, when it was founded, it was actually given three assignments: to develop structures by which museums could jointly decentralize their goods and services; to develop a mechanism by which museums could jointly produce and distribute educational materials; and to provide support services to museum educators who were trying to deliver these services to new audiences.[29] In each of these directives, the emphasis was on museums and the provision of services to them. Yet even those who have come to be the Collaborative's most ardent fans agree that at first its interests and sympathies were a good deal more on the side of the schools and the community than the museums.

The Collaborative did make a try at the services. The joint fund raising for Museum Summer was one attempt, and it was by and large a success. As for more substantive services to museums, in spite of regular meetings of an advisory council composed largely of curators of education, it took nearly four years from the time of its founding before the Collaborative could get its museum constituency to schedule the kind of session for museum educators that the Museum Education Roundtable in Washington—a group started by museum educators themselves (see report in chapter 15) regarded as the Roundtable's own primary reason for being.

**Backgrounds of staff.** The Collaborative got off to a "bad start," one local museum educator, Philip Yenawine, has noted, "because it was established by people not working in museums." Whether or not the start was all that bad, the Collaborative was perhaps slower in coming around to an appreciation of museums than it might have been had any member of the Collaborative's small staff been an integral part of a traditional museum. Emily Dennis had planned and administered MUSE but was primarily an artist; Priscilla Dunhill's experience was mainly in journalism. As the staff grew, the Collaborative continued to hire people without museum experience—an urban planner and two ex-teachers, one of English, the other biology.

The result was that the Collaborative tended at first to plan its programs without enough spadework in and with the museums themselves, and it was sometimes regarded early in its life as more of a threat to museum educators than a help to them. They watched the Collaborative raise significant amounts of money from a pool of foundation funds that seemed increasingly finite for museum education projects; the more the Collaborative took, the less museum educators thought would be left for them. Several supplicants did, in fact, encounter such "we gave to the Collaborative" responses from foundations. Said Yenawine of the Collaborative's reaction to the educators' complaints, "The Collaborative showed some insensitivity at the beginning. It is difficult to counteract the natural paranoia of museum educators, who are the paranoids of paranoids."

But both Yenawine and Bill Burback, the director's special assistant for education at the Museum of Modern Art, agree that the Collaborative's attitude toward museums has improved. "They're coming around to really liking museums," said Burback. "There was a little bit of hostility at first. Then we started working very closely, and now it's like having another ally." According to Yenawine, "Museums Collaborative is an absolutely essential operation. . . . [It] lacks focus sometimes, but it has continued to grow. . . . I'm personally convinced that museum education wouldn't have gotten as far as it has in this city without the Collaborative's encouragement."

One evidence of the change is that in staffing the cultural voucher program the Collaborative looked for people who understood museums and had experience in them. The director of the voucher program, Susan Bertram, and the assistant director, Cheryl McClenney, have had 11 years of museum work between them—Ms. Bertram in exhibitions and film at the Museum of Modern Art and Ms. McClenney on the curatorial staff at the Guggenheim Museum and in a teaching program at the Art Institute of Chicago.

Certainly the Collaborative's firsthand experience with museums has helped change its attitude toward them, as Burback has pointed out. But it has also been goaded and pushed by at least one member of the staff, Marilyn Josephson, whose constant question has been, "What are you giving museums?" The developer and director of the Collaborative's first resource center, TREE (The Resource Center for Environmental Education; see above), "Jo" Josephson moved to the Collaborative staff in 1973. She felt then that the Collaborative's programs were "weighted in favor of community groups" to the detriment of museums ("The Collaborative sometimes gets its priorities and its audience mixed up," she noted) and that the organization had an obligation to help museums reach the community.

Ms. Josephson also realized from her life as a teacher that educators of all kinds need help. "I really felt alone [when I was teaching] in the South Bronx," she recalled. "I wanted to see what others were doing. You can't be good alone." From this experience grew the Education Forum and other services to museum educators in which she has had a part. That her colleagues on the Collaborative staff have come to understand the needs of the museums, to devise a growing number of programs specifically for them, and to encourage and support staff efforts directly on museum educators' behalf is, in Jo Josephson's words, "a healthy change."

**The Education Forum**

Bringing New York Museum educators together for regular discussions and trading of ideas had its origins in expressed interest among the educators themselves and, too, in the example of the Museum Education Roundtable in Washington. Although the Collaborative had held meetings of local educators before, the Education Forum as a formal organization began in February 1974 with a paper-bag supper

meeting at the Museum of Modern Art. Since then, under the chairmanship of Linda Sweet, then coordinator of school services at the Brooklyn Museum, and the careful planning of Ms. Josephson, the forum has offered its members workshops and meetings on a wide variety of subjects.

During one week in April 1974, for example, the forum sponsored a "Paper-Bag Workshop Week in Museum Education." It was designed to give museum educators a chance to take part in programs that seven institutions felt were their most successful experiments. In the half-day workshops at each museum (for which registrants paid $2 each), participants were taken through the usual paces of each program; then over paper-bag lunches, they attempted, says Josephson ("they were just getting to know each other"), to discuss the theory, logistics, and problems of each program with its author, who also passed out evaluation sheets that asked the visiting educators to write brief critiques on several aspects of the program.

In the fall of 1974, the forum began a new series called "Museum Education in Focus." Open to educators and other professionals from the city's museums, zoos, and botanical gardens, the series, according to the announcement cards, promised to deal with subjects that museum educators themselves had picked to broaden "their knowledge of contemporary educational, social and political issues" and to further "their technical skills as educators." Some of the subjects: the mayor's cultural policies, program evaluation communications, perception, museum-school partnership, improvisational theater techniques, and environmental education.

For all of these meetings and workshops, advance registration and limited attendance were the rules. Attendance at the open meetings averaged about 70, and the workshops, said Jo Josephson, "were always filled to the limit," usually a maximum of 25 (though some called for no more than 10 participants). As space was commonly donated by the museums where each meeting took place, the cost of the program for 1974/75, exclusive of Ms. Josephson's salary, was about $2,800, a sum that was taken out of a grant to the Collaborative from the National Endowment for the Arts.

For the 1975/76 series, the Collaborative received a $14,000 grant from the National Museum Act, the first that would be applied specifically to activities of the forum. The new series was planned to interest museum exhibition designers, curators, and development officers as well as educators, and early responses indicate that local curators welcomed the invitation. To accommodate a wider audience, the Education Forum changed its name to the Museum Forum.

## Publications

**Annual Manual.** As part of its campaign to educate the educators about one another's work, the Education Forum published in 1974/75 what was to be the first edition of the *Annual Manual.* It is a looseleaf directory of education programs in 30 New York City museums, zoos, and botanical gardens, complete with names, phone numbers, and ad-

dresses. The *Manual,* produced at a cost of $2,000 for 700 copies, was sent free to about 600 museums, foundations, local community arts groups, and national art organizations. Single copies sold for $3 apiece.

Plans, as laid out in fall 1975, were made to assemble such directories for audiences other than museum educators. One manual was compiled specifically for teachers, giving information about how to use museums and including other departments and services as well as education programs. Entries were cross-referenced by subject: under "Indians," for example, teachers were given suggestions for using the collections at both the American Museum of Natural History and the Museum of the American Indian. Two of the cultural resource centers helped with the subject entries, and the board of education agreed to print and distribute 3,000 copies of the manual to the schools.

**"The Inside Track."** A kind of template for the *Annual Manual* for the schools has been a monthly (before 1974/75, semimonthly) column, called "The Inside Track," that the Collaborative has prepared for *The New York Teacher,* the newspaper of the city's teachers union (circulation 70,000). The column usually has a theme—gardening, music, creating an exhibition with slides and photographs from little-known collections in the city's major museums, studying French history and art through current museum shows—with which the reader is led through "current and choice" school-related programs and services offered at local museums, zoos, and botanical gardens.

Each program entry includes, along with a description of the program, the address of the institution, costs and reservation requirements, the name and telephone number of the person to call for more information, and public transportation routes to the museum. Each entry also gives specific examples of how a teacher can best use a particular exhibition or curatorial department. Jo Josephson, author of the column, made it a point to see each program before writing about it. She was not content simply to draw up lists and work from press releases but tried to uncover facts "teachers don't normally know about."

After the column was begun in 1972, museums reported a noticeable increase in responses for their special programs from teachers who read the column. Courses suddenly began to fill up; slide libraries received as many as five times more requests from schools; and one museum that had had trouble drumming up interest in a teaching portfolio was inundated with calls. According to Jo Josephson, the column has been particularly helpful to small museums that have not been well known to the schools, and they have now begun to seek publicity for their programs through "The Inside Track."

**Newsletter.** Four times a year the Collaborative produces a mimeographed *Newsletter* containing information of interest to staff members in museum education departments and community arts organizations. It covers such subjects as ways to get money, job openings, training programs and

fellowships, news of local events and national conferences, free services, and more ways to get money. The Collaborative is both successful at raising money itself and shameless about reminding others in the museum business of the necessity for doing so, and its recommendations in the *Newsletter* are invariably to the point. Every issue carries information about the next deadlines for proposals to the New York State Council and the two National Endowments. One special issue was devoted to a three-page article on "Weaving Your Way through the Bicentennial: What's in It for You," plus a checklist of fall 1974 funding deadlines at the National Endowment for the Arts and the National Endowment for the Humanities, and a list of requirements for CAPS (Creative Artists Public Service Program) funds for New York artists.

### Meetings, trade-offs, workshops

**"3 for the Arts."** In the spring of 1973, soon after the Collaborative had launched its museum-school-community arts group program, the staff began planning a conference that would bring museum and foundation representatives together to learn to know the community arts world in New York.

The idea for such an event had been carried back East by several people who had attended the June 1972 Artsworth conference in Los Angeles, actually the eleventh annual meeting of the American Council for the Arts in Education. That conference, cosponsored by the Los Angeles Community Arts Alliance and the Department of Arts and Humanities, University Extension, UCLA (University of California at Los Angeles), had taken busloads of participants into several Los Angeles communities where local groups staged a kind of running street festival of the performing arts. The experience had so impressed the New Yorkers who took part that there had been talk for most of the next year about staging a similar affair for people on the East Coast, particularly funders of art programs and administrators and trustees of established cultural institutions.

The Collaborative's conference was ultimately not so ambitious as the Artsworth meeting had been. Though there had been some thought of inviting trustees and curators from museums in Boston and Philadelphia, in the end almost all the participants were New Yorkers. But the registration list managed to encompass the range of organizations and positions in them that the Collaborative had in mind. There were over a hundred museum trustees, museum educators, foundation officers, university evaluators, community arts organizers, and miscellaneous fund-raisers at the two-day meeting, all of them focusing on the community arts movement in the city and the possibilities for "greater sharing," as the conference report put it, "of ideas and resources."[30]

**Art Swap.** One of the ideas that came out of the "3 for the Arts" conference was put forth by the Museum of Modern Art, whose trustees had been represented in force at the meeting. Urged to find ways to share resources, MOMA par-

ticipants suggested, for a start, that instead of throwing away the remaindered books from its museum shop, it might give them away to community arts groups for their own use. The result was the Collaborative's first "swap"—a total of 40,000 books that 200 community groups and museums received for the asking one day in the summer of 1973. The only stipulation MOMA made was that the books not be resold or used for raising money.

That first swap day led to a second in 1974. Museums were encouraged to bring anything they wanted to "recycle"; community arts groups, in turn, contributed their talents. At the 79th Street Boat Basin in Riverside Park, Art Swap Day became a kind of cultural bazaar. The Puerto Rican Cultural Center supplied the music, the Children's Art Workshop silkscreened T-shirts, and the Children's Art Carnival of Harlem demonstrated the art of face painting. Meanwhile, the "customers" picked over samples of the merchandise: surplus exhibition catalogs, postcards, snakeskins, books, reproductions, toys, antlers, picture frames, albums of sea chanties, tulip bulbs, wildflower calendars of yesteryear, live rabbits, notecards, and posters—93,000 items in all, donated by 56 organizations. The cost for the day was $6,000 ("a lot," Dunhill commented; too much, she implied) for handling the logistics of moving and packing the material and offering food and drink the day of the swap; grants from the New York State Council on the Arts and the National Endowment for the Arts covered those expenses.

In 1975 Swap Day turned into Swap Sheets. Now the Collaborative publishes two call-and-get-it lists of recycled museum materials a year. Offered on a first-come-first-served basis, items in the March 1975 sheet ranged from parts of tape decks and film projectors to wooden frames, pedestals, and columns, and ten sheets of plexiglass. Interested recipients are asked to call the Collaborative for information on where and when to pick up the materials.

**The Spock workshop.** In early 1974, Ms. Dunhill and Alice Kossoff approached Michael Spock, director of the Children's Museum in Boston, about conducting a two-day seminar on the development of museum materials, having in mind the Children's Museum work with teachers and with its famous MATCH boxes (see chapter 11). To describe the process of developing anything, Spock said, would take more like two years than two days. After further discussion, Spock and the Collaborative settled for 18 months. And thus was born the Spock workshop—or the Program for Training Museum Personnel in a Systematic Process for Developing Effective Educational Programs.

Funded with a $21,471 grant from the National Endowment for the Humanities, the program began with an invitation to 45 New York museums to attend a presentation of the idea at a meeting in June 1974. Of the 35 institutions that sent representatives to the introductory sessions, five submitted projects they wanted to be developed during the 18 months—the Brooklyn Museum, the Queens and New York

botanical gardens, the Queens Museum, and High Rock Park Conservation Center on Staten Island. The Queens Museum ultimately dropped out when it lost its director. But the rest stayed on through a program that various members of the group felt was an "inspiring" and instructive exchange among their colleagues.

In its first year the group met just once every six weeks on the average, each time at one of the institutions, where a phase of the project under study was assessed. The workshops were conducted by Spock with the active participation of two Columbia University evaluators assigned to document the program. The discussions were built around basic management techniques: for each project the participants were required to set goals, analyze the tasks necessary to meet them, create time lines, and along the way, try out various methods to see whether they did in fact move the project toward its desired end.

Perhaps the most complex project was that of the Brooklyn Museum. It proposed nothing less than the revision of its entire education program, expressing dissatisfaction particularly with the teacher training aspect of it, the one-shot school visits, and the In-Depth Series (see report in chapter 6). As Spock's emphasis was on developing a project from the beginning with the team of people who must ultimately assume responsibility for the results, the Brooklyn Museum was represented at the workshops by five members of the education staff. One of the first things the five discovered when they were asked to set down their goals was that they did not agree on them. "It took several months," said Alice Kossoff, who managed the workshops for the Collaborative, "before the Brooklyn staff set goals everyone could live with." During the brainstorming period that followed, the Brooklyn team threw out its original ideas and began to experiment with other ways to meet their goals.

A persistent problem with the In-Depth Series, for example, had been lack of teacher interest; in one trial the teachers were separated from their classes, which were taken over by museum staff while the teachers were set to work on something else. The staff decided, with the help of the analysis done for the workshop, that such separation was too complicated. "It's better to have them with their classes," said Linda Sweet, coordinator of school services at the Brooklyn Museum; "otherwise it's a problem to try to get them caught up with what the class has been doing. Each class comes with a different topic, such as Africa or colonial America, and we have to work through that topic with each group." The solution, or at least the next step, was to require that the teachers come for a two-and-a-half-hour session in advance of the class visit and that they then stay with their classes throughout the museum lesson.

Ms. Kossoff feels that the Spock workshop was one of the most useful programs the Collaborative has sponsored. "It is exciting," she said in discussing the workshops, "to see everyone participating, four institutions working together and helping each other with their projects. There is new information for them each time, and the fact that everyone is learning from the experience has created a bond among them. In other institutions—hospitals, schools, business—these management training techniques may be taken for granted, but for museum educators they are brand new."

In spite of its value to those who have participated, the Collaborative will probably not repeat the workshop—a decision that is consistent with its policy not to institutionalize such pilot projects. But if a similar program were arranged again, Ms. Kossoff would try to make sure (A) that the projects were very specific—exhibitions, kits, something that led to a physical product; (B) that the group was kept small ("The institutions," she emphasized, "must be stable enough to release staff members for the workshops regularly and to stay with them all the way to the end"); and (C) that the Collaborative was more aggressive in promoting the workshop with museums in town so they would realize "what the management techniques could do for them."

## Money and Money Raising

The Collaborative's success at raising money has been formidable almost from the start. For one thing, proposal writing is a skill that Priscilla Dunhill and her staff have managed—"with difficulty," according to Dunhill—to master. For another, the Collaborative has a healthy respect for money and what it can do. Staff members are not coy in their approaches to sources of funds.

As for the sources, they have so far found the Collaborative an attractive idea. Beginning with a $50,000 grant that established the Collaborative in 1970, the New York State Council on the Arts has been a steadfast supporter. Between 1971 and 1975, the Council made annual grants, primarily for administration, that totaled about $250,000. The National Endowment for the Arts was also an early funder—its first grant from a category known as the "wider availability of museums" was $55,855. Subsequent Endowment grants have paid for stipends to cultural resource centers to buy museum services and the salary of the Collaborative staff member to work with the centers; conferences, workshops, and seminars for museum professionals; and some of the salaries for museum liaison staffs in the cultural voucher program.

Almost all the money the Collaborative has raised, beyond the $60,000 needed for annual administrative expenses, has gone directly to institutions that participate in Collaborative programs. Though it can be argued that the Collaborative, not the institutions, is determining how this money is to be spent and thus is subtracting from the funds that allow them independence, there seems to be a growing acceptance of the Collaborative's role as mover and pusher of people and institutions toward more cooperation. Furthermore, the Collaborative may have helped to generate more interest in its field and thereby to extract more rather than less money for it

from both public and private sources. The Collaborative has also given a hand-up to organizations that lacked fund-raising sophistication; through the Collaborative's good offices, several of these organizations have established relations with foundations that have led to grants they might otherwise not have had.

## The Now and Future Collaborative

There is no question that in its first five years Museums Collaborative has moved fast. If one advantage of its small staff stands out above others, it is the Collaborative's ability to move fearlessly into territory where many museum educators have been loath to tread. As one museum educator has noted, the Collaborative's "lack of familiarity with the traditions and ways of museums lends a kind of courageous craziness" to what the Collaborative does; "we have often learned things by accidents." True, it has taken the Collaborative staff of journalists, urban planners, and teachers more time to learn its way around the museum world than a museum-trained staff might have needed. But it is also likely that a group of museum educators in charge of the Collaborative would have moved much more slowly and cautiously to develop the range of contacts and programs the Collaborative has managed in these first few years.

So the question is not how fast but how *far* the Collaborative has moved toward its goals—to help museums jointly decentralize their resources and to support museum professionals in that process. At a time when many of New York City's major museums are hard pressed to keep their centralized resources intact—indeed, to keep their doors open at all—the idea of decentralization might seem, without the Collaborative's persistence, a romantic throwback to another richer, more liberal decade. But the Collaborative continues to provide the necessary goad to keep the idea alive. That the Collaborative is figuratively, if not literally, out in the streets a large part of the time, actively seeking the unserved museum audience, represents a healthy and necessary contribution to the museum world, and museum staffs in New York have clearly grown to welcome it. Said the director of one conservation center,

The Collaborative has made us work, and the fact that in the [first] cultural voucher program, for instance, we were all competing for a buck influenced how we tried to reach our audience in a way that would mean something to them. It was a kind of validation of our programs, a way of keeping us honest with our public. In an unbalanced museum situation like the one we have in New York, the Collaborative helps small museums compete against the big ones. Sometimes the large museums get left out of programs, because all they have done is to submit stock proposals. They tend to be self-satisfied. The Collaborative, I would say, has caused a reduction of undue confidence.

To some observers, the Collaborative has bent over backward for the community at the expense of the museums. "The Collaborative's real achievement," said one critic, "is brokering for small struggling community arts groups." But there are signs that some of the Collaborative's orientation is changing, and they are perhaps nowhere clearer than in the response the Collaborative has received in the pursuit of its second goal, to help museum educators in their decentralization efforts. The Collaborative's attempts to bring museum educators out of their basements and attics into productive contact with one another are what many members of the Collaborative's museum constituency value most. Said one museum educator,

Many of us are involved with the same public, but we never have had a chance to sit down and discuss this audience in any depth and to trade criticisms and feedback. Whether it's the Botanical Gardens or High Rock Conservation Center, we all deal with audiences that face the same kinds of barriers, the same kind of façade as a museum. We have learned a lot from each other through the Collaborative.

According to another museum director and educator, "The best thing the Collaborative does is the Education Forum. It sets the tone for educators; we get a chance to talk about common problems, and I am impressed with the Collaborative's ability to respond to them. In some of the meetings, we have learned to see what we are doing right and how we can set goals. And by bringing in important people to talk to us—from MIT [the Massachusetts Institute of Technology] or the Mayor's Committee on Cultural Policy—the Collaborative has given us a sense of worth."

There are, on the other side, some drawbacks to the Collaborative's methods of operation. Its tendency to take action has sometimes made it look like the staff has moved first and finished planning later: program descriptions and guidelines are not always the same at the end of a project as they were at the beginning, as sympathies and circumstances change along the way.

For one particularly critical art teacher, the fact that programs change after they are in operation is an indication not that the Collaborative staff has not done its planning, but that it does not know how to think through a program carefully:

The Collaborative has no foundation for understanding the arts and thus can only create superficial programs. Someone must be responsible for the content, the philosphy, the tone of the projects. You can't come out bang with a program. You have to lay a foundation for it with the children.

The Collaborative, furthermore, is not tapping the basic resource, the craftsman artist-teacher. Such people must be given a lab situation, and there must be careful, solid in-service teacher training. I think the Collaborative is at fault here, because museums don't exist to do basic art education. If good programs are to be designed, you must look more carefully at the background of the children and fill in what is missing. The Collaborative doesn't do that,

and neither do the museums. Everyone wants to do programs and come out with a finished product. But it is not enough to produce gimmicks—and the Collaborative's programs are essentially gimmicks.

Another criticism of the Collaborative's programs came from a museum educator who said,

> With the exception of the Forum, which keeps getting better, I don't have a sense of continuity in the Collaborative's programs. The resource centers, for example, have a lot of potential, but the Collaborative could be offering more to them. It could really help schools establish a dialogue with museums and thus help museums. There could be some continuity in a process evaluation of the way the centers work with museums.

She also had mixed feelings about the voucher program: "It's a gimmick in some ways. Our museum doesn't really need it, and many of the proposals were traditional and predictable. The one thing that might help is the addition of the liaison people in the museums."

**The future.** Where the Collaborative moves next in its work with community groups and museums may be determined partly by the outcome of the cultural voucher program. But the staff is sufficiently interested in self-analysis and evaluation—in learning from action as well as taking it—to be asking some of the next questions now. The Collaborative staff is convinced that pump-priming programs are necessary to encourage museums and community arts organizations to work together. Some of these will clearly continue. The staff is impressed with the effect that the liaison people in museums have had on programs with community groups and would like to see them absorbed into museum payrolls.

Beyond such programs, however, Ms. Dunhill sees forums, workshops, and conferences occupying as much as 60 to 70 percent of the Collaborative staff time in the next years, community programs taking up no more than 20 percent. There is a possibility, too, that the Collaborative will begin to broaden participation in its programs to include curators, exhibition designers, and members of publicity and publications staffs, especially those who have been helpful in the Collaborative's programs with community arts organizations. As Ms. Dunhill points out, "Some of the schools we have been working with have gotten so sophisticated that their needs nowadays go beyond what museum education departments can provide. They want to get to the curators. But look at the curators. Nobody's talking to them. Five years ago it was the museum educators." Now the Collaborative is trying to understand the curator and *his* problems.

And what about the schools? In several cases, the Collaborative's resource centers, limited as their access to the large school population has been, have created the kind of relations museum educators have long hoped for in their work with schools. The Collaborative may be frustrated by its experience with the local school district and central board of education leadership, but it would seem that the Collaborative's brokerage role between schools and museums is only beginning. The "real world" of the public schools is even more complex than the world of museums and community organizations, and it is a full-time, long-term job to establish patterns of museum use that could make a permanent difference in the way teachers and schools regard this rich educational resource.

What is perhaps most certain to the Collaborative staff is that it wants to remain small. "The value of the Collaborative," Priscilla Dunhill has said, "is its catalytic role. By bringing museums together through conferences, workshops, and experimental programs, the Collaborative helps museums sustain a continuing process of self-examination: what do we do well, what should we be doing, what can we do better, and how? The answers form a collaborative basis for realistic cooperative ventures, the sharing of programs, resources, and personnel." That kind of brokerage probably does require precisely the kind of staff the Collaborative has now—small, mobile, and, increasingly, knowledgeable and accountable to the institutions that have come to expect the impetus to collaboration they could not draw solely from themselves.—*B. Y. N. with supplementary research by I. R. T. and A. G.*

## Notes

[1] Priscilla Dunhill, "Museums Collaborative Documentation, a Chronological Narrative History," draft #1, November 18, 1974, p. 2.

The Collaborative's purposes are stated in several ways. Another version, from Alice Kossoff, "Museums Collaborative Final Report on the Community Arts/School/Museum Program, 1972–1974," April 1975, p. 1:

> "(1) to develop mechanisms by which New York museums could jointly decentralize their services, and (2) to develop programs which would increase the professional skills, horizons and effectiveness of professional museum staff members."

In still another Collaborative circular, *Background Information and Current Programs* (spring 1973), the goals are stated this way:

> "(1) to decentralize museum resources and to use them in new ways with new audiences, and (2) to ease the individual burdens of the education departments of museums through collective services such as joint fund raising and information exchange."

A third goal, since dropped by the Collaborative for reasons described later in this report, was originally "to develop some mechanism by which museums could jointly produce and distribute educational materials" (Dunhill, p. 2).

[2] For a summary of the conference, see Emily Dennis Harvey and Bernard Friedberg, eds., *A Museum for the People* (New York: Arno Press, 1971).

[3] Dunhill, "Documentation," pp. 1–2.

[4] Philip Yenawine, draft proposal, "Cultural Resource Center: Initial Description" (with excerpts from the ARTS, Inc., model for a community-based Resource and Training Center for Inner-City

Public School Teachers and the Community School District 6 program description of Project Turn-On by Cecile Davis), February 24, 1972, pp. 1–2.

[5] Council on Museum Education, New York, Study Report #1 (March 1972), pp. 11 and 29.

[6] "Museums Collaborative: Program for Decentralized Museum Services," a proposal, March 1, 1972, pp. 1 and 8.

[7] The planning schedule (Museums Collaborative, May 31, 1972) under the terms of the grant from the Fund for the City of New York called for final selection of the project coordinator "in consultation with Learning Cooperative" in June 1972. Detailed program planning was to begin in September, and by February 1973 the center was to be in full swing. In June 1973 the Learning Cooperative and Museums Collaborative were then to publicize the center to other districts and try to raise planning funds for additional centers.

[8] "Proposal to Provide Museum Services for Six Museum/School Resource Centers," n.d., pp. 22–23.

[9] "Proposal to the Central Board of Education from a Coalition of Five Cultural Resource Centers," May 1974, pp. 18–19, 8–10; also "A Proposal to Provide Museum Services for Six [a District 8 program is added to this proposal] Museum/School Resource Centers," n.d. (probably late 1974).

[10] For sources of quotations without footnote references, see list of interviews at the end of this report.

[11] This evaluation was made for the Collaborative by CMEVA staff member Ida Talalla in the summer of 1973, just after the CMEVA study began. The 145-page report, plus appendices, describes each project in detail and makes recommendations for improving the program, several of which the Collaborative later incorporated into this and succeeding programs. This extract comes from pp. iii–vi.

[12] Kossoff, "Final Report," p. 9.

[13] William J. Finneran and Katherine Rosenbloom, "An Evaluation of the Community Arts/School/Museum Program, 1973/74, for Museums Collaborative, Inc." (New York University Center for Educational Research and Field Services, School of Education, October 31, 1974), pp. 29–30.

[14] Kossoff, "Final Report," p. 22.

[15] Community Environments was organized in 1968 to use the skills of artists, photographers, craftsmen, environmentalists, and city planners to help communities build playgrounds and vest pocket parks, plan and stage environmental street festivals and exhibitions, put up wall murals, and organize workshops in filmmaking, theater, weaving, printmaking, and other media. (Talalla, CMEVA report, p. 55; Priscilla Dunhill, report to the Rockefeller Brothers Fund on 13 community arts organizations recommending a community arts coalition, October 1971, p. 19.)

[16] Talalla, CMEVA report, p. 105.

[17] Ibid., p. 109; Kossoff, "Final Report," p. 6.

[18] Kossoff, p. 19.

[19] Ibid.

[20] Ibid., p. 20.

[21] Ibid.

[22] Talalla, CMEVA report, p. 33.

[23] Council on Museum Education, Study Report #1, p. 19.

[24] "Museum Summer 73, a Cultural Voucher Plan for 22 Community-Oriented Museum Programs," submitted by Museums Collaborative, March 1973, p. 5. (The total of 22 programs is accounted for by the fact that several of the 12 participating museums offered more than one program.)

[25] "An integrated Program of Community Education at the Metropolitan Museum of Art," 1972, p. 13. It is an idea promoted in 1972 by Collaborative Board President Harry Parker, who saw the voucher system as a way of financing museum-community programs for both sides. Not only would community groups buy services, materials, and talent from the museums, but the museums would be able to buy certain kinds of know-how from the community groups too—their knowledge of ethnic and racial interests and customs; their understanding of local sociology and of particular kinds of clients; their ability to move easily around a neighborhood, to stage street festivals, or to lead groups on tours.

[26] "A Cultural Voucher Program for New York City," Museums Collaborative, May 1975, pp. 2–3.

[27] Ibid., p. 14.

[28] Ibid., p. 41.

[29] Dunhill, "Documentation," p. 2.

[30] Bernard Friedberg, report on "3 for the Arts, 1973: A Conference for Museums, Foundations, and Community Arts Groups," p. 1.

## Interviews and observations

Where specific dates are lacking, researchers failed to keep records.

Arth, Malcolm. Chairman, Department of Education, American Museum of Natural History, New York City. April 24, 1973.

Behrman, George. Teacher, Clinton Program, New York City Board of Education. February 6, 1975.

Beil, Carlton. Instructor, "Sealed Worlds," High Rock Park Conservation Center, Staten Island, New York. May 3, 1973.

Beirne, Elizabeth. Director, Bronx Museum of the Arts. June 13, 1973.

Bertram, Susan. Director, Cultural Voucher Program, Museums Collaborative, Inc., New York City. May 21, 1975. Other interviews between March and September 1974 not recorded by CMEVA reporter.

Bryant, Gregory. Student, Junior High School 71, Manhattan, New York City. April 5, 1973.

Buckman, Arlette. Instructor, "Found Objects," High Rock Park Conservation Center, Staten Island, New York. May 3, 1973.

Burback, William J. Director's Special Assistant for Education, Museum of Modern Art, New York City. N.d.

Chance, Cathy. Associate Museum Educator in Charge of Community Programs, Metropolitan Museum of Art, New York City. April 18, 1973.

Ciniglio, Ada. Coordinator, Rockefeller Fellows Program, Metropolitan Museum of Art, New York City. N.d.

Cohen, Barry. Director, Community Environments, Inc., New York City. May 2, 1973.

Coleman, Edith. Art Therapist, Kelly Street Creative Art Center, Bronx, New York. June 14, 1973.

Corchado, David. Codirector, Children's Art Workshop, New York City. April 5, 1973.

Curran, Carolyn. Coordinator, Seven Loaves, New York City. April 21, 1973.

Dagness, Dan. Education Assistant, Community Programs, Metropolitan Museum of Art, New York City. April 27, 1973.

Darwin, Davis. Reading Instructor, Children's Community Workshop School, New York City. April 6, 1973.

Davis, Cecille. Director, Project Turn-on, and Art Supervisor, Community School District 6, New York City. May 2, 1973.

Dennis, Emily. Former Director, Museums Collaborative, Inc., New York City. January 14, February 8, March 2, 9, 14, and May 4, 1972; January 31, 1973.

Drake, Robert. Teacher, Children's Community Workshop School, New York City. April 6 and 9, 1973.

Dunhill, Priscilla. Director, Museums Collaborative, Inc., New York City. December 22, 1971; January 14, February 8 and 29, April 17, September 25, November 30, 1972; August 27, 1974; January 8, 1975; telephone, March 17, 1972 and August 7, 1975. Other interviews between March and September 1974 not recorded by CMEVA reporter.

Frey, Gary. Teacher, District 22 Ecology Center, Brooklyn, New York. February 7, 1975.

Greenberg, Robin. Teacher, District 22 Ecology Center, Brooklyn, New York. February 7, 1975.

Hardney, Florence. Education Assistant, Community Programs, Metropolitan Museum of Art, New York City. April 18, 1973.

Hazelcorn, Doris. Director, District 22 Ecology Center, Brooklyn, New York. February 7, 1975.

Hotton, Julia. Assistant Director, Interpretation, Brooklyn Museum, Brooklyn, New York. N.d.

Hupert, David. Head, Education Department, Whitney Museum of American Art, New York City. N.d.

Josephson, Marilyn. Program Associate (until September 1975), Museums Collaborative, Inc., New York City. April 30, May 9, August 22, 1974; March 11, 1975; telephone, August 28, 1975. Other interviews between March and September 1974 not recorded by CMEVA reporter.

Kallop, Edward L., Jr. Curator, American Museum of Immigration, New York City, N.d.

Kasper, Jane. Teacher, Charles Sumner Junior High School 65 Annex, Manhattan, New York City. June 15, 1973.

Kaufman, Anna. Photography Instructor, "Worlds To Shape," High Rock Park Conservation Center, Staten Island, New York. May 3, 1973.

Kelly, Elizabeth. Staff Member, Children's Art Workshop, New York City. April 5, 1973.

King, Thelma. Director, Park East Cultural Resource Center, New York City Board of Education. Telephone, August 5, 1975. Other interviews between March and September 1974 not recorded by by CMEVA reporter.

Kitchel, Nancy. Codirector, ARTS, Inc., New York City. April 12, June 8 and 15, 1973.

Kitt, Sandra. Educational Assistant, Project Turn-on, The Cloisters, Metropolitan Museum of Art, New York City. May 2, 1973.

Klinger, Marilyn. Instructor, Mixed Media, Project Turn-on, The Cloisters, Metropolitan Museum of Art, New York City. May 2, 1973.

Korman, Bette. Director, GAME, Inc., New York City. February 25, 1975. Other interviews between March and September 1974 not recorded by CMEVA reporter.

Kossoff, Alice. Associate Director, Museums Collaborative, Inc., New York City. Telephone, April 25 and August 28, 1975. Other interviews between March and September 1974 not recorded by CMEVA reporter.

Kueffner, Nancy. Assistant Museum Educator, The Cloisters, Metropolitan Museum of Art, New York City. June 14, 1973.

Kurek, Scott. Program Coordinator, Kelly Street Creative Art Center, Bronx, New York. April 26, 1973.

Lacey, Dolores. Art Instructor, Kelly Street Creative Art Center, Bronx, New York. April 26, 1973.

Lander, Jennifer MacLiesh. Project Director (until summer 1975), Cultural Resource Centers, Museums Collaborative, Inc., New York City. January 14 and May 14, 1974. Other interviews between March and September 1974 not recorded by CMEVA reporter.

Larkin, June. Chairman, Edward John Noble Foundation, New York City. N.d.

Levy, Howard. Coauthor of "Beginning a Community Museum," and former staff member, Metropolitan Museum of Art, New York City. N.d.

Lewis, Frederick. Assistant Director, Studio Museum in Harlem, New York City. April 25, 1973.

McClenney, Cheryl. Assistant Director, Cultural Voucher Program, Museums Collaborative, Inc., New York City. May 21, 1975. Other interviews between March and September 1974 not recorded by CMEVA reporter.

McGinnis, Patrick. Deputy Commissioner, Department of Cultural Affairs, Parks, Recreation, and Cultural Affairs Administration, City of New York. February 24, 1975.

Moran, Lois. Director, Research and Education Department, American Crafts Council. April 24, 1973.

Norman, Jane. Senior Rockefeller Fellow, Metropolitan Museum of Art, New York City. Telephone, August 5, 1975.

Oster, Jacqueline. District Art Coordinator, Community School District 19, Brooklyn, New York; also Director, District 19 Art Resource Center. Telephone, February 4, 1975.

Overby, Steve. Head Science Teacher, Intermediate School 61, Staten Island, New York. May 3, 1973.

Parker, Harry S., III. Former President of the Board, Museums Collaborative, Inc., New York City. January 6, March 14, April 12, and May 12, 1972.

Patane, Paul. New York City Board of Education staff member assigned to the Junior Museum, Metropolitan Museum of Art, New York City. May 4, 1973.

Pleet, Sally. Instructor, High Rock Park Conservation Center, Staten Island, New York. May 3, 1973.

Ribaudo, Madeline. Assistant Project Director, "Worlds to Shape," High Rock Park Conservation Center, Staten Island, New York. May 3, 1973.

Robinson, Joshua. Teacher, Bank Street School, New York City. N.d.

Sandberg, Barbara. Drama Teacher, Cloisters After-School Program, Metropolitan Museum of Art, New York City. May 2, 1973.

Sapp, Allen. Former President (until February 1975) of the Board, Museums Collaborative, Inc., New York City. September 6, 1974.

Scherbatskoy, Mary. Codirector, ARTS, Inc., New York City. April 12, June 8 and 15, 1973.

Sciolla, Juliana. Program Assistant, Museums Collaborative, Inc., New York City. N.d.

Seeley, Mae. Assistant to Director, High Rock Park Conservation Center, Staten Island, New York. May 3, 1973.

Segal, Gerald. Director, Clinton Program, New York City Board of Education. February 6, 1975.

Simon, Sybil C. Executive Director, Arts and Business Council of New York City, Inc. April 24, 1974.

Singletary, Mike. Artist-in-Residence, Kelly Street Creative Art Center, Bronx, New York. April 26, 1973.

Sinisi, Randy. Art Teacher, Public School 16, Staten Island, New York. May 3, 1973.

Steinfeld, Jacob. Principal, Public School 16, Staten Island, New York. May 3, 1973.

Sweet, Linda. Coordinator of School Services, Brooklyn Museum, Brooklyn, New York. Telephone, September 3, 1975. Other interviews between March and September 1974 not recorded by CMEVA reporter.

Taylor, Betty Blayton. Executive Director, Children's Art Carnival, New York City. N.d.

Tiefenbacher, Lynn. Codirector, Children's Art Workshop, New York City. April 5, 1973.

Tilley, Mark. Executive Director, Cultural Council Foundation, New York City. N.d.

Vega, Marta. Rockefeller Fellow, Metropolitan Museum of Art; formerly Director, El Museo del Barrio, New York City. April 10, 1973; March 14 and 27, April 3, May 17, July 9 and 19, 1974 (with other members of the Museo staff).

Watson, Frederick. Director, Children's Community Workshop, New York City. April 6, 1973.

Whittall, Liza. Volunteer Cataloger, American Museum of Natural History, New York City. June 8, 1973.

Willensky, Elliot. Director, High Rock Park Conservation Center, Staten Island, New York. May 3, 1973; telephone, September 9, 1975.

Wray, Alicia. Seventh-Grade Student, Children's Community Workshop School, New York City. April 6, 1973.

Yenawine, Philip. Then Director of Museum Operations, South Street Seaport Museum (formerly Associate in Museum Education in Charge of High School Programs, Metropolitan Museum of Art), New York City. January 17 and August 3, 1972; February 24, 1975. Other interviews between March and September 1974 not recorded by CMEVA reporter.

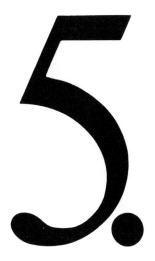

# The Museum Volunteer

# Introduction

Docent and museum were joined together early in this century at the Museum of Fine Arts, Boston. Benjamin Ives Gilman, secretary of the museum, credits the Boston Museum's bulletin with resurrecting the "forgotten English adjective 'docent'" for the position of museum guide and teacher, which became official at the MFA in 1907. Gilman proposed that this "new function of museum officials and other interested persons" should not be a full-time profession: "The education given by a museum of art should always be the partial occupation of persons engaged also in productive labor in competition with equals."[1]

With Gilman as spokesman, his museum became the chief proponent of mobilizing staff and volunteers to instruct visitors about museum objects. The Boston Museum had already welcomed members of the Twentieth Century Club as lecturers (the project was announced formally in 1906), and from various American and European museums, including the Louvre, came reports of volunteer instructors. At the very outset, the volunteers became the subject of controversy. The December 1901 *Chronique des arts* suggested that the Louvre replace its volunteers with staff members. In reporting this, Gilman took no stand on volunteer versus staff, choosing instead to warn museums against indulging their *docent* function to the exclusion of their *guardant,* or preserving, and *monstrant,* or exhibiting, responsibilities.

In 1974, a topic of major concern was still the competition, against which Gilman had warned, between museum education and the museum's other obligations. Indeed, it has become almost axiomatic among museum directors and scholars that as museums respond to demands for education, their attention to research and care of their collections decreases.

At the annual meeting of the American Association of Museums in Fort Worth in 1974, it seemed to one observer there that the prevailing view among museum people relegated docents, in the words of the report here, "to the bottom of the pecking order, with even education directors several chickens above." Volunteers were treated, thought Deborah Franklin, director of education at the University of Texas Art Museum, like "museum lepers."

Can it be that what Gilman joined together museums now wish to put asunder?

## The place of the volunteer in the museum

According to the National Endowment for the Arts study, *Museums' USA,* in 1971/72 volunteers made up over two-thirds—67 percent—of the total art museum work force. Seventy-four percent of America's art museums were served by a total of 23,900 volunteers, of whom 30 percent worked in education programs—that is, as docents or in a similar teaching capacity.[2] It is clear that museums are grateful for this service; many a director has acknowledged that without the volunteers his museum's education programs would be financially impossible. Some directors, in fact, feel that without volunteers they could not open their doors.

Most educational programs for which volunteers are responsible center on the group tour: only because volunteers are available have so many museums been able to welcome such legions of schoolchildren and to deal with them in the small groups that some teachers feel are especially conducive to learning. For example, the Museum of Fine Arts, Boston, reports (in this chapter) that it serves about 60,000 children a year; the Rochester Memorial Art Gallery (chapter 1),

13,000; and Atlanta's High Museum and Hartford's Wadsworth Atheneum (both in this chapter), about 10,000 each. It is these schoolchildren who provide the museum with the resounding statistics often cited to document its worth to the community. As the High's director, Gudmund Vigtel, has pointed out, "Trustees love to see those buses parked outside the building."[3]

Although not many museums have calculated it, the dollar equivalent of volunteer service is enormous. The Museum of Fine Arts, Boston, estimates that its docents save the education department more than $100,000 in salaries annually. These figures do not touch on the income that volunteers help generate. Many education program volunteers engage in museum fund-raising activities as well, from benefits and cocktail parties to membership drives. Too, the high economic status that characterizes museum volunteers as a group makes them a logical source and catalyst for private donations and for grants from such organizations as the Junior League—itself the spawning ground for untold numbers of volunteers. One former museum director has estimated that if the Junior League had withdrawn from or been "pushed out" of his museum, it would have produced a 30 percent budget loss. (For a sample of the many art museum activities the Junior League has devised and helped to finance across the country, see the Index.)

For Vigtel, his 1,000-plus volunteer force is a "key link" between the museum and a city that has "no tradition of interest in the visual arts" or history of support from wealthy patrons and collectors. "The volunteers are the public face of the museum," Vigtel has said, "and they are our captive audience. They have had a remarkable effect on fund raising and can communicate to the trustees, better than anyone else could, enthusiasm for our programs."[4]

**What the volunteers do.** The work of museum volunteers in education programs is often as varied as the programs themselves. As noted here, group tours for schoolchildren are the staple, but even these range from the conventional lecture as at the Wadsworth Atheneum, to the school visit combined with tour as at the Boston Museum, to some of the more elaborate programs like those found at the High Museum, where volunteers engage children in games, acting, musical performances, and art-making in school classrooms and at the museum. Docents also go out of the museum to schools and community centers, and in some places they help to design programs as well as carry them out. Depending on the institution, they may be given a good deal of responsibility. (The reports in chapters 6 and 7 describe a number of programs for children that not only rely heavily on docents and other volunteers but in many cases have been created by them.)

In all of this, for the adult as well as the child audience, the volunteer docent is, as she (and it is almost always a she) is described in one report here, "a translator, a person who speaks lay language to the public on its own terms. Standing in the middle ground between audience and object, the docent must find ways to make art personally meaningful to visitors by raising questions prompted by her own enthusiasms and, in turn, eliciting and affirming those of the public."

Finally, the volunteer often brings warmth, enthusiasm, and a fresh attitude into the museum that can counter institutional inertia and revive staff members who might otherwise be overwhelmed by the demands that group tours place on them.

**What the volunteer receives**

Perhaps the most obvious benefit of being a museum volunteer—especially in a museum that stresses the art historical approach in its tours and other education programs—is the training. For without a doubt, volunteers are often the museum's single most intensively served audience. In this sense, their services do not come free: professional museum staffs are engaged in a continual cycle of educating one museum audience in order to educate another. Long—and expensive—staff hours are spent in training, retraining, and refreshing docents: up to eight weeks almost daily at the High Museum, once a week for a year at the Memorial Art Gallery in Rochester, half a year for three years at the Wadsworth Atheneum, 24 sessions over seven months at the Fort Worth museums (of which half in 1973/74 were led by outside experts who were paid from a Junior League grant; see this chapter), and five years of intensive weekly work for full-competency educational aides at the Boston Museum of Fine Arts, where the training program cost the museum over $70,000 in 1974/75. (The Fine Arts Museums of San Francisco estimate that docent training costs $17,000 a year, a sum that includes the coordinator's salary, fees for lecturers, overhead, and administration. For the High Museum, out-of-pocket costs are still less: Vigtel estimates no more than $10,000, which covers the salaries of a part-time secretary and a staff lecturer.)

More important than the intellectual stimulation to many volunteers are the less tangible rewards—the chance to "get out and meet people," the satisfaction of service to the community. Then, too, in many places the role of museum volunteer attracts members of a community's social elite, a status symbol that tends to reinforce itself each time a new volunteer is welcomed into the ranks. In addition, most museums try to add to the appeal of volunteerism through ceremonial dinners, pins and badges, volunteer-of-the-year awards. Some museums hold out the lure of eventual paid jobs for their best volunteers. At the 1973 triennial conference of the Volunteer Committees of Art Museums, where one topic was "creative training to the paraprofessional level," Mrs. Lucius Battle, a volunteer at the Corcoran Gallery, recounted several instances of volunteers reaching professional status in museums. It is not a status, however, that all museums offer. Martha Wright, supervisor of volunteer training in the Boston program, tells her docents that their position is not a

stepping-stone to a paid job: "It's a dead end, and the aides understand this."

## Problems in volunteer programs— from the museum's point of view

For all the benefits volunteers bring museums, there are tensions in most volunteer programs, many of them in the relations between the volunteers and the professional education staff. Some of these center on the issue of volunteerism itself, and many professional educators, already conscious of their relegation to the bottom of the museum hierarchy, are further offended by the fact that theirs—not the curators' or the conservators'—should be singled out as the province of amateurs. They feel that the deployment of volunteers in their territory is yet another example of the low esteem in which museum trustees and administrators hold education. One critic has noted that "in no other field" are volunteers allowed to do such responsible work.[5]

At the same time, museum educators are often the first to praise and defend a "professional" volunteer and to lean gratefully on her talents. What bothers them is not so much that the volunteers are taking jobs that someone might be paid to do—although it has been suggested that money for additional professionals could be raised by most museums "if they paid more attention to legislators and businessmen"— but rather the casual irresponsibility of volunteers who do not behave and perform like professionals. One professional in public television spoke for many who supervise volunteers when she said, "Volunteers make this little joke that drives me wild. Whenever you complain that something wasn't done properly, they say, 'Take it out of my salary.'"[6]

Another burr for paid museum staff is the volunteer who exploits her position, who takes unfair advantage of her access to the trustees and administrators, who puts down and undermines the staff and works to impose her ideas and will, all without being subject to administrative sanction. As more than one observer has pointed out, volunteers can be the most powerful group in a museum. Their access to power has been demonstrated often enough so that a number of museums have resorted to specific schemes to "control" their docents.

When Roger Selby was education director at the Wadsworth Atheneum, he devised a set of bylaws to govern all the volunteer and affiliated organizations of the museum. These set out formal procedures for application, selection, and expulsion of volunteers. Even more important to Selby, they explicitly placed the docents under the authority of the education director and his staff liaison—not the trustees— and established the point that any funds raised by the volunteer organizations belonged to the museum. The major purpose of the bylaws, according to Selby, was to "stabilize" relations between docents and staff and prevent volunteers from becoming involved in a "power situation."

The Fort Worth Museums' Docent Council is not really an organization at all but an office with a part-time paid staff member who coordinates tour schedules. The docents are not allowed an independent association of their own or meetings other than training sessions and are strictly accountable to the education director of the museum in which they serve. Says the education curator of the Kimbell, one of the Fort Worth museums that cooperate in docent training, "Docents function as *unpaid staff members* of their respective museums, [and their role] is . . . educational, not social."[7] The Rochester Memorial Art Gallery's volunteer supervisor, Jacquie Adams (a former volunteer promoted to a paid job), too, advocates a "tight rein" over volunteers to ensure their responsibility to the museum and to overcome what she calls the "social aspects" of docent organizations.

**Accountability and evaluation.** Nearly all museums that have volunteer programs, including those reported here, have established some kind of system for expelling volunteers who do not meet attendance requirements for training and tour duties. What none seems to have come up with, however, is a method of qualitative evaluation through which the on-the-job performance of volunteers can be judged— and through which they can be "fired" if necessary.

For example, Boston's Martha Wright admits readily that evaluation is the weakest point of her program. Although schoolteachers fill out evaluation forms after their classes' tours, Wright feels that this is not a reliable guide: it is her impression that the teachers themselves are rarely well enough versed in art history to spot mistakes, and they have low expectations of art museum programs anyway. Further, the refresher courses for active docents at the MFA are voluntary, and—inevitably—it is often those who need the most help who do not show up for the training.

Wright, along with other museum professionals, gloomily acknowledges that evaluation, let alone dismissal, of volunteers is a delicate issue for the institution, enough so that a docent can perform poorly for years and never be corrected. For smaller museums that cannot afford to pay a supervisor of volunteers or find a volunteer willing to manage the program, the problem can be even more difficult; staff members who already have many other duties find themselves saddled with an additional time-consuming and frustrating task, and one not designed to ease staff-volunteer tensions.

**The problem of who the docents are.** A final charge that has been leveled at volunteer programs by critics both in and out of the museum is one that is by no means the docents' "fault." It concerns the characteristics of museum volunteers as a group: they are overwhelmingly white, female, and well-to-do. How, the critics ask, can these Ladies Bountiful hope to "relate" to the poor, inner-city, and minority audiences that museums are now trying so hard to reach? Though one answer is that it is unfair to assume that all volunteers lack the sensitivity and human skills to overcome the barriers, the question is often raised, and it may not have a solution; the inescapable fact is that, for the present at least, it is the women—and most especially those of the monied and

educated classes, some of them unwilling to accept pay they and their families do not need—who have the interest and leisure to volunteer in art museums. Poor people and many members of minority groups cannot afford to give their time in this way, however useful they might be to the museum in its attempt to reach a broader audience. Some museums, including the Wadsworth Atheneum, the Portland Museum, and the Memorial Art Gallery in Rochester, have recruited male docents, but few that the CMEVA studied had yet broken the color-class lines. The nature of the art museum may be that recruitment of minorities—and males—for volunteer work may still be a way down the road.

What bothers some observers even more is the effect volunteers have on the content of the museum's program. San Francisco artist and teacher Ruth Asawa Lanier feels strongly that the middle-class museum docent teaches a concept of art that militates against art: "Art is not neat and clean," she points out. Far better as teachers than middle-class volunteers or museum educators, Lanier argues, are artists. "Children should see artists in the day-to-day, grubby, thankless task of working on projects that are yet to be accepted. . . . The artist is key to conveying what art is to children and adults." Lanier would like to see museums "get out of the volunteer concept." There should rather be, she feels, "direct funding to artists whose studios are incorporated into museum-art-education."[8]

Another issue that museums seem not to have considered sufficiently in their attempts to study volunteer programs is the matter of costs and the uses to which the money and effort now devoted to volunteers might otherwise be directed. If it is true that the Boston Museum of Fine Arts spends $70,000 a year to gain $100,000 of volunteer help—and the difference is only $30,000—it might be fair to ask whether the balance is worth the investment and whether some other audience could make better use of the instruction. If the same $70,000 were spent on schoolteachers, for example, whose full-time career is educating young people—and whose daily influence in the classroom may be far more powerful than the brief exposure the museum visit allows—might the museum staff's energies be better rewarded? And might volunteers be as well fulfilled in other kinds of service to the public?

To judge from the sample of museums studied here, few administrators seem to have developed hard cost-accounting of their volunteer programs. In particular, they have not looked carefully at the educational effect—for better or worse. It may turn out that assigning volunteers to conduct group tours for children is the best educational program an art museum can devise, particularly if its educational energies are to be focused primarily on children. The point here is that no one knows for sure, because so few museums, it appears, have tried to find out.

## And now for the docents' side

For their part, volunteers have several legitimate complaints against museums. Deborah Franklin, director of education at the art museum of the University of Texas, points out here that docents are neither ersatz art historians nor art teachers and that museum staff attempts to mold them into one or the other account for much of the frustration among volunteers and professionals alike. Some museum directors have suggested that there be more careful screening of volunteers for teaching jobs. Not all volunteers are gifted teachers, and in spite of a museum's best efforts to train them, it is not clear that all volunteers can become as professional as museums and the subject matter should demand.

Too, many docents feel they are not treated as professionals, a condition not likely to encourage them to become so. Those interviewed at the Wadsworth Atheneum, for instance, said they felt keenly their low status. The professional staff, they reported, tended to be "snobbish," to denigrate the volunteers' work because it is unpaid. Relations between the two were "always helpful, but never friendly." Another minor, but telling, instance: according to a survey of 114 docent volunteer programs made in spring 1973 by Gretchen Sibley, director of docent programs at the Natural History Museum, Los Angeles, only 31 percent of museums surveyed provide insurance against injury or other mishaps incurred while serving the museum.[9] To add insult to injury, where staff members receive not only pay but also titles, promotions, seniority, and periodic reviews of their work, docent recognition is primarily ceremonial. Moderate feminists suggest not that such voluntary services be abolished but that the volunteer at least receive tax credit, promotion from volunteer to professional status (and back) with a *curriculum vitae,* and a contract that spells out both parties' obligations. "The volunteer professional would be hired and fired—trained, supervised, promoted, and given written job references," says volunteer advocate Ellen Straus, who points out further that increased responsibility is a partner to increased respect.[10]

## Toward an "imaginative use" of volunteers

When Gilman advanced the idea that there should be docents in the Boston Museum of Fine Arts who were actively employed elsewhere, he had in mind outsiders "to whom the work speaks in a mother tongue, and who can to practical effect speak of it to others." But Gilman did not have in mind that these docents should be speaking to children. Works of art, he points out, "were not made by children, nor, unless by exception, for children; and no aid can enable children to comprehend them fully. . . . The museum that treats its docent office as a duty chiefly owed to youth," he writes, deprives others capable of "a larger growth who could best profit by its instruction."[11]

Gilman joined together volunteers and art museums, in other words, for quite different purposes than the museums have since designed for their docents. What he undoubtedly did not foresee was the interest museums would hold for women, in particular, who were free to do the docent work, nor the emphasis museums would place on docentry aimed

primarily at the young. It is pointed out elsewhere in this study that museums like to fill their galleries during daytime hours when the only audiences free to visit are schoolchildren and people who do not work in 9-to-5 jobs. The result is that the museum often puts the two audiences together, one to learn and the other to teach—and the volunteer group to receive the most instruction of all.

For some museums this use of volunteers has been highly successful. Says the High Museum's Gudmund Vigtel, "Much depends on how the museum approaches and handles volunteers. We never create work for them; we use volunteers only if we need them." Vigtel feels strongly that his museum's volunteers, "used creatively," make an enormous contribution to its programs and its relations with the community, and he is willing to spend a large portion of his time to make sure the volunteers are brought actively into the museum's work. For other museums, their experiences have raised questions about whether they have found the best use of volunteers and whether the considerable investment they have made in training, scheduling, evaluating, and serving their volunteers, as they are being served by them, is the best way to carry out their educational mission.

Perhaps the key to mutual satisfaction between a museum and its volunteers is Vigtel's stress on "imaginative use" and the close understanding an interested director can bring about by his personal leadership of the volunteer as well as professional staffs. Clearly, museums will continue to need and rely on volunteers in their educational programs; equally clearly, that educational work is of sufficient importance to museums so that the task of directing those who perform it, paid or volunteer, is one that cannot be left to chance. —*B.C.F./A.V.B.*

## Notes

[1] Benjamin Ives Gilman, *Museum Ideals of Purpose and Method* (Cambridge, Mass.: Riverside Press, 1918), chap. 4, part 1, "The Museum Docent," p. 285.

[2] *Museums USA* (Washington, D.C.: National Endowment for the Arts, 1974), pp. 85, 87, 92. "Education" accounts for the second highest percentage of volunteer use; only in "operations and support" are more volunteers, 40 percent, employed.

[3] Notes from a meeting of CMEVA, Minneapolis, Minnesota, November 18, 1974.

[4] Ibid.

[5] Hilton Kramer, interview, September 17, 1975.

[6] Ceci Sommers, director of special events at WQED in Pittsburgh, quoted by Eugenie Bolger in "Take It Out of My Salary: Volunteers on the Prestige Circuit," *Ms.*, vol. 3, no. 8 (February 1975), p. 73.

[7] Ruth S. Wilkins, report to CMEVA, July 25, 1974, p. 23.

[8] Undated notes to CMEVA, received January 27, 1976.

[9] "Report on a Survey of Docent/Volunteer Programs in the United States," Xeroxed, n.d., pp. 2–3.

[10] Quoted by Enid Nemy in "NOW Attacks Volunteerism—But Others Rally to Its Defense," *New York Times*, June 7, 1974, p. 41.

[11] *Museum Ideals*, p. 285.

## University of Texas Art Museum: Function, Care, and Training of Docents

University Art Museum
University of Texas
23rd at San Jacinto
Austin, Texas 78712

Deborah Franklin, art curator and director of education at the art museum of the University of Texas, is not naive. She did not have to attend the 1974 American Association of Museums meeting to discover that for most professionals, docents are the museum lepers, relegated to the bottom of the pecking order, with even education directors several chickens above. But she also readily acknowledges that pecking orders arise existentially and, alas, are frequently justified.

"Docents," she admits, "are not for everybody."* But to discover whether docents may have a viable and creative function in the museum hierarchy is to look again at what they *can* do. For Franklin, docents are not ersatz art historians, art teachers, nor dispensers of aesthetic value judgments, and the attempt to mold them into any of these roles accounts in part for the frustration they seem to inspire among professional museum educators. Rather, she feels, the docent is a translator, a person who speaks lay language to the public on its own terms. Standing in the middle ground between audience and object, the docent must find ways to make art personally meaningful to the audience by raising questions prompted by her own enthusiasm and sensitivities and, in turn, by eliciting and affirming those of the public.

The skills do not come naturally to all who wish to serve in a museum. Franklin admits that much of the satisfaction she receives from working with volunteer women (and men and students) is watching them grow in skills and understanding. "We all feel inadequate to perceive," she says, and even volunteers drawn to the museum feel this. Although offering neither instant adequacy nor instant expertise, Franklin adds, "to get anybody to do a good job in doing anything, he has to have a sense of self-worth. . . . There isn't a person alive who can't reach inside himself and find some well of talent or understanding he hasn't tapped. The purpose of the docent is to help the members of the art audience delve into the wells within them as they confront art objects."

For Franklin, the museum is a bastion of individuality and uniqueness in an impersonal, automated world—a place where one individual can make contact with a unique object and where one's response can be affirmed.

And she herself does a lot of affirming. She is enthusiastic and supportive—and, as she admits, motherly—challenging and goad-

## Bibliography

Bay, Ann. "Getting Decent Docents," *Museum News,* vol. 52, no. 7 (April 1974), pp. 25–29.

Gilman, Benjamin Ives. *Museum Ideals of Purpose and Method* (Cambridge, Mass.: Riverside Press, 1918).

## THE HIGH MUSEUM OF ART: VOLUNTEER OPPORTUNITIES

High Museum of Art
Atlanta Memorial Arts Center
1280 Peachtree Street, N.E.
Atlanta, Georgia 30309

**An atmosphere of cooperation and attention to detail mark this training program for volunteers, who are carefully supervised both by the museum education staff and by their own volunteer chairmen. Each recruit joins a specific program and takes part in special workshops for it. CMEVA interviews and observations: June, October 1973; April, May 1974.**

### Some Facts About the Program

**Title:** Members' Guild.

**Audience:** Over 1,000 volunteers and, indirectly, the museum's visitors, including schoolchildren.

**Objective:** To develop an active, vital link between the museum and the people of Atlanta; to increase the size of the city's "visually oriented" community; to provide unpaid staff to help conduct the museum's programs.

**Funding:** No specific breakdown available. All volunteers belong to the Members' Guild, which comprises 1,200 persons who pay annual dues of $5 each. Thus, about $6,000 per year is generated to pay overhead for guild programs (including a lecture series) conducted largely by the volunteers. Salary for a full-time docent trainer is paid from the museum's operating budget.

**Staff:** One full-time docent trainer. Other professional museum staff give time, as needed, to supervise and work with volunteers.

**Location:** Training takes place in the museum; volunteers work throughout the museum and in school classrooms.

**Time:** Most volunteers work from September through June.

**Information and documentation available from the institution:** Members' Guild invitation; brochure describing museum's programs for children.

Given the choice, one of the museums that would take a corps of volunteers no matter how many professional staff members it might be able to hire is the High Museum in Atlanta. For the High staff, volunteers are a necessary part of the operation of the museum: there are over 1,000 of them, and they offer a direct link with the part of the Atlanta community that is, admittedly, white and middle class.[1]

The director, Gudmund Vigtel, points out that Atlanta has no tradition of the visual arts or of support from wealthy patrons and collectors. Income for the museum must therefore derive in large measure from the cumulative effort of many people: nearly 40 percent of the operating budget was generated by the membership in 1974.

ing the 52 volunteers who work with her to deepen and broaden their knowledge of art and cultural history.

### Training for an individual approach

For their part, docents agree that the approach forces them to "work hard." They choose from among the changing exhibitions, of which there may be as many as 35 in a year, and read from bibliographies, attend lectures, and prepare sample tours. For example, just before the opening of a pair of 1974 shows on German Expressionist painting and Käthe Kollwitz prints, a university professor of philosophy lectured the docents on the philosophical roots of Expressionism; an art history scholar gave them a two-hour slide-lecture on the development of Expressionism in Germany; and Franklin prepared and sent out a reading list on H. H. Arnason and others who wrote about the painters of the period.

Two days after the opening, the director of the collections gave the volunteers a gallery tour, and several days after that the more experienced docents presented their sample tours, illustrating approaches to specific audiences—school groups, transplanted Germanic patriots, history students. The newer docents met with Franklin to assess what they had seen and read and to develop their own tour plans. (Each docent must prepare and present an outline to Franklin before conducting any group through an exhibition.)

The emphasis on individual preparation reflects the education director's philosophy that tour content depends on two significant variables—the background and interests of any given group visiting the museum and the specialization and talents of individual docents. What she wants to preserve and nurture, she said, is the "electric exchanges" that happen when art, docent, and visitor make contact. She maintains that the techniques uniquely the province of docents in the museum are elsewhere so common that "there is nothing special about them": just as an interesting conversationalist is one who draws upon his partner's ideas, so too does the skillful docent draw out and assist members of a generally "visually illiterate" public to trust their ability to perceive works of art. Franklin cautions the docents that getting a visual and verbal "dialogue" going during a tour "is more important than commenting on all the paintings on your list." (She also advises them to "give up your pearls and your jewels.")

Although the fast and continual turnover in exhibitions at the University Art Museum can be frustrating, Franklin said—"they never anchor long enough for docents really to perfect a tour"—the constant change puts a priority on individual discovery and mutual support among the volunteers and between the volunteers and the education director. If the absence of a permanent collection is a drawback in some ways for the docents, Franklin concludes, "the eureka quality is there with almost every new show."—*B. K. B.*

*Quotations and other information were drawn from interviews in September and October 1974 with Mrs. Franklin and Donald B. Goodall, director of the University Art Museum.

In addition to financial backing, Vigtel feels, volunteer participation is important in establishing a visually oriented community. "You can't count on casual visitors to do this," he says.[2] He elaborated on the role of these supporters in a four-year report in 1968:

> An energetic drive for an increasing membership—for a broader base of support in the community—was part of a conscious effort on the part of our working corps of members, the Members' Guild. . . . Membership is the most important single source of income for the Museum. . . . When a community institution such as the High Museum depends on the interest and support of many citizens rather than a few patrons, it is only natural that the institution reflect, to some degree, the qualities of the community and the aspirations of the active supporters.[3]

## Selecting the volunteers

The High Museum provides a variety of service activities for volunteers, so that their interests and abilities can be carefully matched to the museum's needs and the requirements set by the staff. It is the staff's position that making clear what a museum expects of a volunteer sets a self-selecting process in motion.

At the High Museum, the process starts when each new museum member receives an invitation to join the Members' Guild. The invitation describes what membership offers and what the volunteer may offer in return—to be specific, 28 different possibilities for volunteer service. These guild privileges are open to all regular museum members for an additional $5 per year. Active service is not required, but the invitation booklet makes participation attractive. Volunteers are asked to plan and act as hostesses for special daytime and evening events, including meeting receptions, the Christmas Weekend, exhibition openings, the spring party. Some forms of service are strictly clerical, some have more social responsibilities, and others emphasize education.

## Volunteers in education programs

Two groups of volunteers work with the education programs—the Department of Children's Education (also known as the Junior Activities Center) volunteers and the docent committee. Docentry, however, is only one of many services in education. What is important about the High Museum education department volunteer activity, as with all voluntary work in the museum, is that a range of activities is offered and that the staff spells out the requirements for participation in each activity. Some examples:

- *Elementary-Art to the Schools,* a three-part series designed for 6th graders. This program consists of a school visit by museum volunteers, followed by two trips to the museum, also led by volunteers. (See chapter 6, for a report on this and the Discovery program.)
- *Student tours.* Three dialogues in the museum galleries are conducted by volunteers for grades 1–12.

- *Discovery,* a six-part program for inner-city 4th graders. It combines visual and performing arts, professional artists, and workshop experiences.
- *Adventures in looking,* an annual subscription series for members' children from ages 4 to 15. Volunteers in this program are often employed during the week (the program is staffed by professionals as well).
- Volunteers who do not choose to work closely with children but who still wish to provide service to the education department may select the *Artventures* program, where "volunteers package creative materials for children, [and] explore new design ideas."[4] Items thus packaged are then sold through the Junior Art Shop and the Art Cart.

In all these activities, volunteers are expected to follow the education department's design that involves "making art, looking at it, teaching it, investigating its labyrinthine past [as] varied facets of one integrated experience."[5]

## Cooperation between volunteers and paid staff

The amount of professional staff time dedicated to a volunteer program is a critical factor in its success. The High Museum's education staff is active not only in volunteer training but also in the programs that the volunteers carry out. A program initiated by a museum staff member and then turned over to a volunteer group is one in which the volunteer may have little at stake and the staff can pass on the responsibility for failure to the volunteers.

At the High communications between the Junior Activities Center volunteers and the education staff are kept open by volunteer day chairmen, who relay to the paid staff suggestions, complaints, and ideas. Part of volunteer training is done in small groups that provide a close relationship between staff and volunteers. This encourages a sense of working together toward a goal with the staff and reduces the chances that staff members might behave as lecturers addressing a class.

## Volunteer training: Department of Children's Education (Junior Activities Center)

Volunteers for the Junior Activities Center are given six sessions of art historical introduction to the collection, classes in visual analysis, and workshops in their particular program, after which they must pass a "conference" tour with the staff. Training focuses on dialogue and game techniques, for the staff wants the volunteers to learn ways to encourage children to notice, enjoy, and return for further enjoyment of the visual arts.

The Junior Activities Center training schedule has several elements worth noting:

- Instructions to the volunteers are spelled out in detail, and they are adhered to by the staff throughout the training period: "Pick up your name tags from your program chairman at the place scheduled for your program's training session." "Please contact your program chairman if

you must be absent; she will assist you in scheduling a make-up session." "Training sessions . . . begin . . . promptly at 10:00 and will last approximately one and one-half hours."[6]

- General training sessions bring all volunteers together, but separate sessions for smaller groups are held for each program to encourage the commitment to the program and to help them develop the specialized skills required for it.
- Within a program, volunteers are assigned to workshops according to the weekday they will serve—an arrangement that means the staff repeats each workshop until each volunteer has participated in it.
- Training for most programs lasts two months, each volunteer coming one day a week. There is additional training for new museum exhibitions during the year.
- Most training is by example, not lecture, so that volunteers can learn techniques for giving the tours.

### Volunteer training manual

A volunteer training manual, written by the staff, serves as a reference and as a further means of sharing ideas among both new and seasoned volunteers. The manual lists names and phone numbers of volunteer chairmen, titles and extension numbers for museum staff. It reviews dialogue techniques, gives instructions for theater games and notes about where they may be appropriately used, and provides art history and media information on each section of the museum's collections. Space is also provided where volunteers can make notes on temporary exhibitions and particular paintings.

Volunteers are encouraged to develop their own dialogue techniques, patterned after those suggested in the manual.

### The docent committee

An activity of the Members' Guild, the docent committee provides public tours for adult visitors to the museum and staffs the information desk in the museum lobby. Training for admission to the committee in the past has consisted of a basic course in art history, "Learning to Look" (also open to the public), taught by a museum lecturer. In September 1974, the curator of education made a number of changes in the course, including a shift in emphasis from straight art history to "study of the visual elements and expressive content" of paintings and sculpture, and the media and methods used in creating works of art, as well as "the history of art within a broad cultural matrix."[7]

Volunteers taking the course meet for two hours, twice a week, using facilities throughout the museum. Students must make an oral presentation in class and take a mid-term and a final exam. The course is open to all museum members for a fee. Potential docents must pass with a grade of B or above, submit a paper, and present a sample tour for the curator of education and the museum director. Docent committee membership has "status" among volunteers because its requirements are so exacting.

### A new trend

Partly because the docent committee was established before there was a curator of education at the High, both the prerequisite course and the regular weekly meetings are separate from the volunteer programs in the Department of Children's Education. Although these two groups rarely overlapped before, in the early 1970s they began to forge closer ties. Some docents participate in the Junior Activities Center programs, even though they must take the JAC volunteer training in addition to their own preparation. Other docents have asked for media workshops such as those given to JAC trainees: during the spring of 1974, for example, a workshop in weaving was arranged to supplement docent training, and the docent training course as it was revised in 1974 requires workshop experience in various media such as woodcutting, egg tempera, etching, and engraving.

The new course is an attempt on the part of the curator of education to offer docents an approach to their work that goes beyond a reliance on art historical information. As Janet Gaylord Moore puts it,

There are many ways of seeing: with scientific observation, with intellectual detachment, with emotional involvement. Indeed, it is hardly possible to separate these three. . . . It is important that looking should not be altogether passive. . . . Your own experience of life can . . . broaden and deepen your understanding of this language of the arts.[8]

A belief in many active approaches through which people may "broaden and deepen" their understanding of the language of the arts informs both the volunteer training and the programs that are staffed largely by volunteers at the High Museum.—*S. R. H.*

### Notes

1 A *New York Times Magazine* article of April 7, 1974, "Capital of Black-is-Bountiful" by Peter Range, describes the large and established black middle class of Atlanta. "If the growing middle-class community did not intrude much upon the white consciousness, it was probably because the middle class blacks remained relatively self-contained, both in their institutions and in their residential patterns" (p. 29). This does not seem to be a community that the museum is reaching in any large number.

2 For sources of quotations without footnote references, see list of interviews at the end of this report.

3 Gudmund Vigtel, "A Report Covering the Period July 1, 1964, to June 30, 1968, for the High Museum of Art."

4 Brochure of the Department of Children's Education, "Share Our Adventure," used for recruitment purposes, February 1974.

5 Katharine Kuh, *The Open Eye* (New York: Harper & Row, 1971), p. 198.

6 Junior Activities Center Training Schedule, fall 1973, and Junior Activities Center Training Announcement. This kind of detail, which lets volunteers know how long something will last, is

helpful and indicates the careful planning that is necessary for volunteer programs to run smoothly.

[7] Draft of proposed changes in syllabus for course entitled "Looking at Art," spring 1974.

[8] *The Many Ways of Seeing* (Cleveland and New York: World Publishing, 1968), p. 12.

## Interviews and observations

Hancock, Paula. Curator of Education. June 13, October 15–17, 1973; April 3–5, 16, and 17, May 16, 1974.

Scheidt, Monica. Junior Activities Center Program Coordinator, Department of Children's Education. June 13, 1973; April 4, 1974.

Vigtel, Gudmund. Director, High Museum of Art. October 16, 1973; May 16, 1974.

Adventures in Doing Program for Docents: textile workshop. April 5, 1974.

Creative Packaging Program. April 3, 1974.

Elementary-Art to the Schools Program. In museum, April 16 and May 16, 1974; at Anderson Park Elementary School, April 4, 1974.

First-grade tour, part of student tour program. April 16, 1974.

Junior Activities Center volunteer training session. October 15, 1973.

## WADSWORTH ATHENEUM: THE DOCENT PROGRAM

Wadsworth Atheneum
600 Main Street
Hartford, Connecticut 06103

**The distinctive feature of this fairly typical volunteer docent program was a set of administrative bylaws, meant to formalize relations between docents and staff. The bylaws spelled out procedures for selection and expulsion of the volunteers and tried to prevent the development of "a power situation." What they could not do, however, was monitor the quality of volunteer performance, perhaps the most important administrative responsibility of all. CMEVA interviews and observations: September, November 1973; January, February, May, August, and September 1974.**

### Some Facts About the Program

**Title:** The Docent Program.

**Audience:** About 50 active docents, whose primary duty was to conduct tours for 10,000–11,000 schoolchildren per year.

**Objective:** To train volunteers to conduct museum tours for schoolchildren as well as special programs and presentations for adult groups.

**Funding:** For the first three years of the program, docent candidates and others who attended training lectures paid fees that covered all costs—about $8,000 per year. After 1971, program was paid for from museum's operating budget.

**Staff:** One member of the professional staff, who served as liaison between volunteers and the director of the museum; education director, who conducted training; one full-time secretary.

**Location:** Most docent activities take place in the museum; some slide presentations given at other locations.

**Time:** Program began in 1968. Training period spanned three years, during which each volunteer attended courses for one-half of each year.

**Information and documentation available from the institution:** Mimeographed copy of bylaws governing volunteer and affiliated organizations of the Wadsworth Atheneum.

One of Roger Selby's first acts after he was appointed education director of the Wadsworth Atheneum in 1968 was to start a docent program. What came to distinguish his program from those in most other museums was an unusual method of financing the training and the establishment of a set of bylaws strictly defining the functions, activities, and position of the volunteers.

### Docent training and activities

The first class of docent candidates, about 60 women, was divided into two groups, one that began training in the fall "semester," the other in the spring. Selby planned a three-year course, in which each candidate spent one semester each year in training, an arrangement that proved sufficiently practical so that it was maintained throughout Selby's six-year tenure at the Atheneum.

At the start, the docents studied art history, for the most part, and that almost entirely through lectures. It was the lecture format, in fact, that led to Selby's idea for financing the program. The cost of the program had been estimated at $8,000 a year for three years, including a half-time staff coordinator, a full-time secretary, supplies, printing, and postage. The Junior League of Hartford had offered to meet most of the cost, and the Women's Committee of the museum was to make up the difference. As it turned out, the museum never spent a penny for the first three-year course. Selby charged admission to his art history lectures ($20 for docents who did not belong to the Junior League; $25 for museum members; $30 for nonmembers; and $5 to $6 for an individual lecture), and so raised about $4,000 a semester, enough to cover all initial costs. After the first three years, the museum itself assumed the cost of the docent programs.

Selby later regretted the original emphasis on art history, because he found that the docents had become too dependent on the academic approach, which then needed undoing. He came to feel that, ideally, first-year training should focus exclusively on perception and cited as an example an exercise he sometimes used with the Atheneum docents: he asked them to list adjectives that describe a refrigerator without reference to its function. One group of docents developed a list of 50 words, such as "cool," "hard," "rectangular," and "hollow." With some satisfaction, he reported overhearing a docent use this same kind of analysis with a group of schoolchildren who were examining a minimal sculpture.[1]

The focus of docent training thus changed, Selby esti-

mated that the 1973/74 program consisted of 35 percent art history, 25 percent discussion of the museum and its collection, 20 percent preparation of specific tours (there are eight), and 20 percent on ways to help volunteers communicate with children.[2] Once the training was completed, each docent gave two or three tours per week. She also spent about one hour per week in a review course.

In 1974 there were about 50 docents conducting tours for 10,000–11,000 students per year. Nearly all were college-educated women in their early thirties. One was a graduate student in art history, another a professional artist. Ten of them had had some teaching experience.

Besides the tours for schoolchildren, Wadsworth docents gave a series of slide presentations on various themes, such as flowers in art or Christmas in art, developed in conjunction with the museum staff. The fee for these presentations, whose major audience was women's clubs, was $25. In addition, when a group requested a special night tour of the Atheneum, it was charged a fee of $25 per docent. The money went to the docent organization and was used to buy such supplies for its activities as a tape recorder for evaluating tours and a slide projector for the women's club presentations.

### The bylaw structure—and some conclusions

Another distinguishing feature of the Atheneum's docent program was its structure. Selby was determined not only to have a structure but to make that structure explicit. So early in his tenure he developed a set of bylaws to govern all volunteer and affiliated organizations at the museum. Although they were fairly strict, Selby believed that these bylaws stabilized relationships between the volunteers and the museum by establishing the position of the volunteers in the museum's hierarchy and preventing their involvement in what he called "a power situation."[3] The bylaws explained the formal procedures for application, selection, and expulsion of volunteers, the museum's expectations during the training period, and the substance of the training. They also established an executive committee, elected by the volunteers, and explained its structure and function.

For Selby, the most important features of the bylaws were their specific organization of the volunteers under the command of the director and his staff liaison, not the trustees; their clear statement that any money earned by volunteer organizations belonged to the museum and that any unusual expenditure must have staff approval; and their framework for dealing with problems.

Were these bylaws as effective as Roger Selby wished them to be? Docents interviewed for this report said they did not know; they pointed out that the program had never been governed another way, and, to their knowledge, cases that might test the bylaws had not arisen. But they characterized their relations with the museum's professional staff, in spite of the bylaws, as "uneasy," "always helpful but never

friendly." They felt that the professionals tended to be "snobbish," to denigrate the docents' work because it was unpaid. So the bylaws had not, in fact, solved the perennial problems of staff-volunteer relations. And, although Selby intended the structure to inhibit contact between the docents and trustees, the docents, when asked if there were any males in their group, responded, "Why yes. At the moment, two of our male trustees are docents."

Perhaps the major limitation of the Atheneum's volunteer structure—and the reason that it was not the cure-all that Selby had hoped—was its focus: the bylaws constituted no more, and no less, than a useful administrative tool. If a docent missed assigned tours or failed to attend required classes, the procedure by which she could be expelled was clearly defined. However, if the docent showed up for all appointments but performed poorly, however faithfully, the bylaws stood by, mute and helpless. One of the biggest problems of museum volunteer programs, judging *quality* of performance, was not solved by the establishment of rules and committees.—*E. H./B. N. S.*

### Notes

[1] Roger Selby, talk at New England Regional Meeting, American Association of Museums, Nashua, New Hampshire, September 29, 1973.

[2] Information taken from a questionnaire from a professor at North Texas State University, completed by Roger Selby on June 20, 1974.

[3] For sources of quotations without footnote references, see list of interviews at the end of this report.

### Interviews

Docents at the Wadsworth Atheneum. May 20, August 13, and September 20, 1974.

Eliot, James. Director, Wadsworth Atheneum. May 20, 1974.

Leicach, Bette. Curator, Tactile Gallery, Wadsworth Atheneum. February 14 and May 20, 1974.

Selby, Roger. Education Director, Wadsworth Atheneum. September 4 and November 2, 1973; January 24, February 14, May 20, and September 20, 1974.

## MUSEUM OF FINE ARTS, BOSTON: THE DOCENT PROGRAM

Museum of Fine Arts
465 Huntington Avenue
Boston, Massachusetts 02115

**Intensively trained docents work with nearly 60,000 schoolchildren a year in museum galleries and school classrooms. The program's problems, not solved here, are practically universal: evaluation, accountability, coordination between school and museum visits, length of the tours. CMEVA interviews and observations: February, May, and July 1974.**

## Some Facts About the Program

**Title:** The Docent Program—School Volunteers and Educational Aides.

**Audience:** About 75 docents who work with nearly 60,000 schoolchildren a year in both classrooms and the museum.

**Objective:** To train volunteers who will give children an introduction to art and the museum collection through classroom visits, gallery tours, and for special programs, courses and discussions on art and art history.

**Funding:** $82,245 (1973/74), $71,350 (1974/75); from operating budget.

**Staff:** 3 full-time, 2 part-time; 53 educational aides; 20 school volunteers.

**Location:** In the museum and 5th-grade classrooms throughout Boston.

**Time:** During the school year. The program has been in existence for 11 years.

**Information and documentation available from the institution:** None.

---

At Boston's Museum of Fine Arts most of the teaching of schoolchildren (grades 1–12) is done by volunteers. Each year these volunteers introduce nearly 60,000 young people to the museum.

The school program is staffed by women, most of whom are recruited through the museum's Ladies Committee. In fact, the program began as an activity of the committee. In 1963, in anticipation of the opening of the Tutankhamun show[1] and its expected audience of busloads of children, the head of the division of education and public relations (predecessor to the present department of public education) asked the members of the Ladies Committee to act as guides. The arrangement turned out to be a good one for the divisions, and the program has continued ever since.

All potential volunteers are interviewed by the supervisor of volunteer training, Martha Wright, and by the head of the school and youth program, Dell Macomber, a former teacher. Both are interested in lively and energetic people who have had previous contact with museums, some work experience, and, of course, an interest in art. Ms. Wright feels that these qualities are more important than a college degree or professional experience. Ms. Macomber finds that women who returned to school after rearing children are particularly good candidates for the program.

As a result of the flexible requirements, the present group of more than 70 volunteers is relatively diversified, within the limits of an economic background that allows them to do unpaid work. (There are no black or other minority docents.) The group includes one Ph.D. in physics, one Ph.D. candidate in Near Eastern Languages, a lawyer, a state representative, an art teacher, a number of studio artists (mainly potters and painters), a collector of prints and another of Persian ceramics, a graduate student in education, and many housewives. Many are former teachers, especially the younger members of the group. Although most of the volunteers are middle-aged, the work tends to be done by younger volunteers (those around age 35), said Ms. Wright, who noted that these women have the highest energy level and contribute the most enthusiasm to the program. In the past, all volunteers were asked to sign on for three years, a commitment that discouraged many young women, including students or wives of students in the Boston area, for whom relocation is a regularity. The three-year requirement was finally waived for college students, who were accepted as docents beginning in September 1974.

### Training: two levels of docentry

At the Museum of Fine Arts there are two levels of docents, distinguished by the work each can perform. The first group, the school volunteers, is recruited largely through an outside agency, School Volunteers for Boston, Inc.[2] As part of the Boston 5th-grade visit program, these volunteers visit classrooms both before and after the children's museum tour, first to give an orientation lecture and then to give a follow-up talk called "Environment and Response." Both lectures are designed to encourage the students to become more sensitive to their visual environment. In 1972/73, school volunteers from the museum gave 566 talks to 7,033 children in 283 classrooms.

The school volunteers are trained in a six-month course that gives them a general background in visual awareness, in art history, and in the ways children learn, as well as familiarity with the museum's collections in the four subject areas in which the school tours are given—American, Asiatic, Classical, and Egyptian.[3] If a volunteer gives a satisfactory sample talk, she is free to prepare her own talks and is scheduled to visit the classrooms.

The other group of docents, the educational aides, conduct the children's tours in the museum. Many aides have already been school volunteers. (In 1972 it became a requirement that anyone who wanted to become an aide had first to serve as a school volunteer; those who already were aides at that time were encouraged to become school volunteers as well.) Aides are trained in intensive and sophisticated courses on each of the four tour subject areas, which are planned and taught by Martha Wright[4] and by a former head of the school and youth program. Each course, with the exception of Asiatic, takes a year; the Asiatic course takes two years. Only one course is given each year. They are run like seminars: there is one three-hour lecture with slides per week, as well as gallery work, assigned readings, reports, papers, and exams. Ms. Wright characterized the courses as "a little lecture and a lot of discussion, a little bit of slide viewing and a lot of time in the galleries."[5] The courses provide the docent with sufficient information so that she need not give a canned talk, and they are intentionally demanding; performance in them is the principal method used to evaluate a docent's competence.

Attendance at the training classes is expected, though not required. This typifies the museum's approach to its docents: they perform a valuable function and are treated seriously.

What is expected of them, however, is nowhere codified by a set of rules and bylaws.

After having completed a course successfully, the aide can begin to give tours in that subject area only. Thus, it takes five years to become qualified in all subject areas, and only 11 of the present 53 aides are thus qualified.

In 1972/73, nearly 60,000 students were taken through the Museum of Fine Arts on tours, and the aides worked 7,150 hours in the museum. At the rate earned by adjunct lecturers ($15 per hour per group), the department of public education would have to pay more than $100,000 per year for the aides' services.

## Additional opportunities for docents

The Boston 5th-grade visit program, in which every 5th-grade class in the city school system visits the museum,

accounts for about half of the tours given by aides. There are other special programs available for docents who show particular ability and initiative. For example, two aides designed a program that brings a group of ten- and eleven-year-olds from a Montessori school in Cambridge to the museum once a week during the school year for an art history course. The aides teach mostly in the galleries; slides are used only occasionally. Other aides are involved in a similar shorter program with another private school. A religion class from Brookline High School meets in the galleries over a four-week period with its teacher and a few aides to discuss art and religion.

Ms. Wright characterizes the attitude of the department toward these special programs as "the more the better." A measure of its attitude toward the aides is the department's willingness to give them as much responsibility as they can

## Fort Worth Docent Council:
## Cooperative Volunteer Training

Fort Worth Art Museums' Docent Council
1309 Montgomery Street
Fort Worth, Texas 76107

For the three art museums situated on "the Acropolis" in Fort Worth, Texas—the Amon Carter Museum of Western Art, the Fort Worth Art Center Museum, and the Kimbell Art Museum—the key to training volunteer docents is sophisticated art history instruction, and the key to providing such instruction is cooperation both in planning and in the use of resources, including funds.

This policy was begun in 1968 by the directors of the three museums in response to what they saw as their common need for docents qualified in art history and museum methods who could conduct tours for school and adult groups. They decided on a twofold program: docent training in the form of a one-year art history course and a docent council staffed by a paid tour coordinator who would schedule all guided tours for the three museums.

By 1973/74 the program had attracted 150 recruits who formed the docent council, and the course had been refined into a seven-month evening series of lectures presented by both local museum staff and visiting scholars. By that time, too, the docent council had been given an office in the Fort Worth Art Center Museum and a yearly budget of $8,000, with which its staff member administered the program and scheduled tours for nearly 23,000 children, college students, and adults.

Under the plan, the tour coordinator works directly with the museum's education officers and is familiar with both the local public school bureaucracy and the docents themselves. The council is not an independent organization; it has no officers or bylaws. Each docent is directly responsible to the education officer of the museum in which she volunteers.

**The art history course.** The fourth partner in the cooperative training program has been the Junior League of Fort Worth, which has contributed both money and candidates since 1968. In 1973 it gave

$18,000 to be used over a three-year period "to expand the educational role of the three museums." Five thousand dollars of the 1973/74 allocation was put into the training program: 24 lectures on Tuesday evenings for 80 docent candidates, for whom it was free, and 100 auditors, who paid $35 each for the series.

Planning of the course content was done by a committee composed of the director of the Fort Worth Art Center Museum and the program director and education curator of the Kimbell. The outline, lecture topics, and guest lecturers were approved by the directors of the three museums. (The Junior League kept in touch with the program through evaluation of the grant expenditures.)

The lectures covered prehistoric through contemporary art. Ten were given by staff members of the sponsoring museums, two by other museum curators, six by faculty from area universities, and six by art scholars. The latter included Robert Rosenblum on Cubism, Jean Boggs on Degas and the Impressionists, Lorenz Eitner on neoclassicism, and Kurt Foster on Mantegna and the Northern Italian Renaissance.

After each session there was a coffee hour, held to encourage informal discussions among the students and between the students and lecturers. At the end of the series the candidates took a final examination (which all 80 passed), and the new docents chose which museum they wished to serve in the following year.

**The fruits of cooperation.** According to the curator of education at the Kimbell, the training program was successful because of the cooperation among the museums, and that cooperation exists because "it is mutually beneficial to share programs such as docent training . . . [and] it is mutually beneficial *not* to duplicate efforts. . . ." She adds, "If there is a lesson to be drawn by other institutions, it is just exactly this."*—*A. V. B. from reports submitted by R. S. W.*

*Interviews for this report were conducted during spring and summer 1974 with directors and staff members of the participating museums and with Ann H. Bass, community arts chairman, Junior League of Fort Worth.

handle. In fall 1974 the department approached school systems outside of Boston with an offer of similar docent programs; if these are arranged, the docents will incorporate still more visits into present programs.

There are further opportunities for the ambitious docent. Aides who have special expertise are used to teach other aides. For example, the collector of Persian ceramics lectured about her field for four weeks during the Asiatic course. The aide who is getting a degree in Near Eastern languages gave a course in hieroglyphics during the Egyptian course. And many of the more experienced aides help train docents at the Brockton Art Center in nearby Brockton.[6]

Martha Wright stresses that being an aide is not a "stepping stone" to a professional position at the museum. In spite of the fact that a few former aides hold staff positions in the department (one runs the education gallery), she states firmly, "It's a dead end, and the aides understand this."

### The visit program in operation

Following a group of children through the museum visit program clarifies both its virtues and its failings.

At the Robert Treat Paine School in Dorchester, the 5th-grade classroom is actually a "portable" room set in the playground. Some of the children hang out of the door waiting for the school volunteer to arrive. Inside, the room, decorated with crayon drawings of Easter bunnies, lacks most of its acoustical ceiling tile, window shades, and a screen. The volunteer sets up her projector, focusing her slides on the blackboard. The teacher had requested an American art tour,[7] and the volunteer's half-hour "orientation talk"—using slides of American paintings from the museum's collection—encourages the students to think about what the artist was trying to accomplish. She stresses the fact that in this situation there are no right answers, that one can say whatever one feels.

Beginning with some early American portraits, the volunteer asks the students to search for clues about the artist's conception of the character of the sitter, having them look at faces, hands, and poses. The volunteer then emphasizes similarities between paintings, in this case between two Copleys. After that, she shows a slide of an American primitive painting. A small boy (actually a 3rd grader visiting from another classroom) shouts across the room, "That ain't no Copley!" The other students are less articulate and more guarded in their reactions, and interest declines noticeably when the volunteer shows modern paintings (Louis and Olitski).

The following day the group goes to the museum for its tour. There the class is divided in half (standard operating procedure at the museum; groups are divided into sections of ten or fewer to enable freer participation and to ensure closer supervision for the protection of objects), and each group is assigned an aide. The children pass portraits they had seen the day before on slides, greeting them like old friends. In the American silver corridor the students show little interest. After looking at a painting by Copley, who was, they are told, an expert in chiaroscuro (the guide mispronounces the term), the children proceed through a period room, exhibitions of ship models and Egyptian mummies, and the special gift store for children, where no one buys a souvenir. All this takes place in an hour and amounts to little more than a dash through various parts of the collection—a fact reflected in the evaluation form filled out by the teacher after the visit.

The next day the school volunteer returns to the classroom for her "Environment and Response" talk to help the students become aware of design elements in their own environments. She compares a slide of the surface of a manhole cover to that of a Mondrian, and another of a stop sign to a D'Arcangelo highway painting. Again the children seem interested but do not articulate their feelings about the things they are being shown. The paintings used for this talk are totally unfamiliar; the children had been shown no modern paintings at the museum.

### Some questions about the program

One of the issues here is the relationship between the two parts of the program, the classroom visits and the museum tour. The museum education staff suggests that the school volunteer be present for the museum tour, but this does not always happen. As the children are obviously delighted when they recognize paintings in the museum that they have seen on slides during the classroom visit, it would seem possible, indeed sensible, to correlate the two aspects of the program: if the school volunteer and the aide covered the same ground, it would reinforce the efforts of both.

Another issue is accountability. How does the department ensure the quality of work done by volunteers? Martha Wright is frank in declaring that evaluation is the weakest point of the program. The teachers fill out evaluation sheets at the end of their tours, and the department has access to these sheets, but Boston schoolteachers are not highly trained in art history, nor do they have high expectations about what an art museum's programs could or should do. They may not be able to judge the quality of a tour nor catch errors of misinformation or mispronunciation.

How then should unsuccessful aides be identified and corrected? This is, as the department recognizes, a delicate problem for the institution. Every year the training course being offered is accompanied by a review course in the same subject for veteran aides. Ms. Wright characterizes the review course as informal sessions in which aides discuss the problems they have had in presenting the material. Attendance at these courses is voluntary. And, not surprisingly, they are well attended by those docents who are most enthusiastic and successful; docents who really need help rarely come. Thus, an aide may perform poorly for years and not be corrected.

The third issue is the length of the tour. How much can be

expected in an hour's tour of any museum? Dell Macomber says the reason for the hour tour is the shortness of children's attention span, but longer tours are available on request.

## Conclusion

Some of the problems this program raises, such as the question of who is responsible for the docents' performance, are nearly universal and have caused difficulty for many museums. Other problems—the lack of coordination, for example, between the school volunteers' and the educational aides' activities with the same group of children—are, says Martha Wright, relatively easy to solve. She cites a particular aide who has become a school volunteer for the specific purpose of taking responsibility for all three days' experiences with each group of children she sees, not as a possible solution for the whole body of docents, but as an acknowledgment of an awareness of the problem. This docent's own efforts to resolve a particular issue for herself does indicate, however, that the general question of accountability may be inseparable from the individual issues that plague both docents and the people who rely on their services.—*B. N. S.*

## Notes

[1] "Tutankhamun Treasures," a traveling exhibition circulated under the auspices of the Smithsonian Institution, at the Museum of Fine Arts, February 1–March 3, 1963.

[2] The School Volunteers for Boston, Inc., is primarily concerned with teacher-aide placement. The organization recruits through the public media and provides one orientation session for all new volunteers designed to reinforce their positive feelings about vol-unteerism. Prospective school volunteers who apply directly to the museum are referred to the organization for the orientation session.

[3] The limitations of such a structure seem obvious. Yet the subject areas were originally chosen to correlate the museum's special strengths with the grade-school curriculum.

[4] A B.A. in art history from Smith, Ms. Wright has worked in the department of public education in various capacities since her graduation in 1960, first as a slide librarian, then as a full-time lecturer, and, since 1965, as supervisor of volunteer training.

[5] For sources of quotations without footnote references, see list of interviews at the end of this report.

[6] Part of a more extensive collaboration between the Museum of Fine Arts and the Brockton Art Center Fuller Memorial, Brockton, Massachusetts.

[7] Teachers choose which of the four subject areas they would like for the tour.

## Interviews and observations

Antonellis, ——. Teacher with 5th-grade students from the Robert Treat Paine School, Dorchester, Massachusetts. May 21–24, 1974.

Brownstein, Joan. Coordinator, Education Gallery, Museum of Fine Arts. July 24, 1974.

Dane, Grace. Docent, Museum of Fine Arts. May 21 and 24, 1974.

Lillys, William. Dean, Department of Public Education, Museum of Fine Arts. February 1974.

Macomber, Dell. Head, School and Youth Programs, Museum of Fine Arts. May 9, 1974; telephone, July 12, 1974.

Smith, Nancy. Docent, Museum of Fine Arts. May 23, 1974.

Wright, Martha. Supervisor, Volunteer Training, Museum of Fine Arts. July 23, 1974.

# A Good Idea from the Portland Art Museum

The Portland Art Museum
1219 S.W. Park Avenue
Portland, Oregon 97205

In 1973 the board of trustees of the Portland Art Museum decided to train a group of volunteer guards and got more than it bargained for. The Chamberlains, as they are called, did indeed begin as unpaid guards, but as they pursued their security duties, they began to learn about the museum collections, form study groups, and respond to questions from visitors. By spring 1974 the Chamberlains —about 75 persons, most of them employed in full-time jobs and two-thirds of them active volunteers—had evolved into a group whose primary function was "to make the museum and the exhibits more accessible to the public."*

Each Chamberlain signs up for duty one day a week either on the weekend or a weekday evening after work. Once a month they all meet with the museum director and the education coordinator for required training sessions on the collections and temporary exhibitions. The weekly study groups, which are optional, deal with specific areas of the collections. While they are on duty the Chamberlains sit in the galleries, answer questions, and give short tours.

At first the museum staff was afraid that the regular guards would be hostile to the program, for the Chamberlains have similar duties and are even authorized to open the museum. But when one guard asked a staff member what time the Chamberlains were coming because he wanted to go on his dinner break, the museum knew that these unusual volunteers had been accepted.—*E.S.C.*

*Information and quotations in this report were drawn from interviews on March 25, 1974, with Polly Eyerly, coordinator of education, and Francis Newton, director, Portland Art Museum.

# The Art Museum and the Young, Their Teachers, and Their Schools

# Part II
# The Art Museum and the Young, Their Teachers, and Their Schools

Of all the institutions in the United States that are not schools—and that are not paid to be—few try harder than museums to educate the young. They conduct classes, often for credit; they deliver lectures, train classroom teachers, design teaching materials for classroom use, provide a home base for teachers on board of education payrolls, often send their own instructors into schoolrooms to teach; and they create numberless programs—mobile units, special exhibitions, studio classes, even didactic dramas—that go out to schools to "enrich" the curricula. Among art museums, nine out of ten offer some kind of program for school classes, most of them (70 percent) on a regular basis.[1]

The programs that are described in the following pages may reflect circumstances peculiar to the schools, museums, and communities concerned. Yet, since they have also grown from impulses and ideas common to art museums everywhere, these programs raise questions fundamental to any inquiry about the American art museum's educational purposes.

## The issues, if not all the answers

The generosity of museums toward young visitors (never mind the complaints about overzealous guards and crowded lunchrooms), and the schools that send them in unceasing flow, is one of the unsung stories of this antiheroic age. The 47 museums whose programs are described in this study have reported education budgets that total more than $8 million, much of it spent on programs for children. Very little of this money has come from funds offered to museums through the schools; almost all of it has been either allocated from the museums' operating budgets or contributed by private donors, foundations, and state or federal government. In addition, volunteers donate countless hours just to prepare themselves to conduct these programs, not to mention the time they spend each week on the job. One museum estimates

that its volunteers are equal to an annual contribution of $100,000, or at least $10 million worth of endowment.

Why do museums do all this? Furthermore, should they? Is the very substantial investment they make in programs for young people worth the effort and the money? Museums looking for ways to do better might consider four issues that are raised in the reports that follow:

1. What is the art museum trying to do in its education programs for the young?
2. Should young people come to the museum; if so, why and at what age?
3. In dealing with schools, what realities do museums face?
4. How can museums best focus their energies in helping young people to use and understand their collections?

## 1. What is the art museum trying to do in its education programs for the young?

Almost all the purposes museums have listed in describing their programs here fall into these three categories:

- Helping young people feel at home in an art museum and understand its value.
- Introducing them to visual experiences that will sharpen their perceptions.
- Giving children richer opportunities to make art, important for itself and for understanding and enjoying the art of others.

Undoubtedly, hidden behind such objectives are motives not so altruistic, and the less charitable among the museum's critics will regularly hold them up to public view. Children, some of the charges go, like the leisured housewives who are recruited to help teach them, constitute the only substantial audience available to museum staffs determined to end their working day at a gentlemanly hour instead of the late nights when orchestra members, actors, and dancers—more dependent on the reality of the marketplace—end theirs. The

"gratifying statistics," in the words of Benjamin Ives Gilman, that result from drawing on large numbers of schoolchildren are thus sufficient justification for the existence of the museum (which, in the view of the cynics, really exists for the gratification of the curators and the wealthy patrons who find permanent memorials in the purchases they leave behind) and for its support from public funds. In this view, the work that goes into mobile units, one-time group tours, and similar programs designed to bring more children to the museum—and maybe to turn them into understanding, public-spirited supporters of it in later life—has less to do with educational reality than with public relations.

Scratch a museum administrator or trustee and some of this kind of thinking is easily exposed, for there is truth in all these charges. Most museum educators and curators encountered here, however, do genuinely care that the children who come to the museum gain as much as they can from their visits. What is not always so clear, as Richard Grove once put it, is "*why* they do what they do, what principles guide, what theories inform. . . . Meetings," he continued, "are not organized around issues and the shadows are filled with problems waiting for someone to speak their names."[2]

Many museum educators, for example, have long defended the one-time group tour as the only fair way to make sure that all children in the schools are exposed at least once in their lives to the inside of an art museum. But some of them go further: their argument holds that group tours, by helping children to establish a pattern of museum-going, constitute a legitimate form of audience-building. After nearly 100 years of experience, there exists almost no evidence to support such claims. The survey conducted in New York State in 1972 by the National Research Center of the Arts is one of the few that has even asked the question. The answer: among frequent art museum goers school trips were a factor in stimulating the interests of only 3 percent, the same percentage given for those who "favor but don't use cultural facilities."[3] If the group tour is a justifiable investment for art museums, the research to prove it is still to be done.

Museum educators talk, too, about making children feel at home in the museum. But many museum practices belie such hospitable intentions. Guards *do* often intimidate children, particularly minority children, and few museums studied here make any apparent attempt to sensitize their guards. Upper-class docents *can* give children the impression that art is the province primarily of the rich. And—in a museum trying hard to break with tradition—being asked to lie down on a cold marble floor pretending to be a purple triangle may not always be a small child's happiest introduction to high art.

Sometimes, in short, museums do what they do in their programs for the young *without* carefully examining the reasons why or asking the hard questions that might lead to quite different answers than the tried and (not necessarily) true. Not all the programs described in this section give evidence of careful thought and planning. But each has some element, again, that begins to step beyond museum-business-as-usual into new and promising territory.

## 2. Should young people come to the museum? If so, why and at what age?

Should young people come to an art museum at all? If such a thought now seems heretical, it was not always so. According to the very quotable Benjamin Ives Gilman—and, one suspects, an occasional fanatic today—young people do not belong in art museums. "To attempt to put within adolescent grasp," he wrote in 1918, "masterpieces embodying the utmost reaches of thought and refinements of expression, the fruits of the richest experience, is treachery to art as in the class in literature. . . . There is solid psychological ground," Gilman added, "for the objection, intemperately voiced from time to time by a few fanatics, to indiscriminate museum visits by school classes."[4]

Beyond the instinctive objections of those who are either annoyed by children in the museum or skeptical of the value of their visits, there seems to be no Piaget of the museum education world. Some institutions believe that the sooner children come to the museum the better. At the Cleveland Museum, leaders of the East Cleveland project, described in chapter 6, feel instinctively—in the face of statistics that show more tangible results among upper elementary classes—that 1st and 2nd graders should come to the museum, too, if only to "walk through the museum ga-ga." A few museums have devised programs that begin with three- and four-year-olds, although the psychological rationale for such programs has not been made clear. These programs are most often devoted to studio work, the kind of doing and manipulating that educational theorists from Pestalozzi and Froebel to Dewey and Piaget have long known children at that age need. Just why it is the art museum, rather than nursery schools or day-care centers, that should provide this activity may have something to do with a dearth of such services in any particular geographical area; but there are many people who are prepared to argue that the museum does not have to move into every educational vacuum.

The idea that children should come to a museum at an early age in order to get the museum habit is more persuasive—but only on certain conditions. When Edouard Vuillard, Degas, Dillon Ripley, Louis Finkelstein (see chapter 13), and the many others who speak in adulthood of their visits to museums as children and the influence such visits had on them, they almost invariably remember being brought to museums by their parents—not once but almost weekly. And even then, the visits did not always take. As Vuillard answered once when asked how he became a painter, "I can say with Degas, 'my parents took us to the Louvre on Sunday afternoons. My brother slid on the polished floors, and I looked at the pictures.'"[5]

The other ingredient of a museum habit besides the com-

panionship of parents (which is undoubtedly only the symptom of a cultural life at home that goes much deeper than visits to the museum) is regularity. In the 1973 survey of American attitudes toward the arts for the Associated Councils of the Arts, researchers found that people who attend cultural events frequently were "*consistently* [emphasis added] exposed to all kinds of cultural activities at an earlier age than were nonattenders."[6]

In the absence of any more solid base, then, we are left with conjecture. Joshua Taylor, director of the National Collection of Fine Arts, is one who argues that seeing great works of art is a necessary stage in the development of the child's eye. He urges in an article on art in education that young people begin their eye training by experimenting with color of all hues, "never dissociated from preference or emotional overtones," and that at the second stage they be exposed to experiences beyond their capacities to create. It is at this point that Taylor feels the child should come to the museum, not to be force-fed "the unexamined clichés of art history," but to be given the chance to discover "how the painting makes him feel or what it makes him think about, and what this has to do with what the painting looks like." Taylor thinks the child should "be encouraged to expand on the differences in feeling [stimulated by different painters], both in speaking and writing," with the ultimate goal of "the expansion of self in the understanding of works of art."[7]

Art historian Erwin Panofsky, though he expresses a particular interest in the high school years, feels that humanistic education, of which the visual arts and art history are for him an integral part, "should begin as early as possible, when minds are more retentive than ever after."

I do not believe that a child or an adolescent should be taught only that which he can fully understand. It is, on the contrary, the half-digested phrase, the half-placed proper name, the half-understood verse, remembered for sound and rhythm rather than meaning, which persists in the memory, captures the imagination, and suddenly emerges, thirty or forty years later, when one encounters a picture based on Ovid's *Fasti* or a print exhibiting a motif suggested by the *Iliad*—much as a saturated solution of hyposulphite suddenly crystallizes when stirred.[8]

Janet Moore, a former art teacher and for 12 years associate curator of art history and education at the Cleveland Museum, writes in her book for "youthful beginners"—a book directed, however, primarily at teenagers—about the need for young people to practice visiting museums of all kinds in order to sharpen visual awareness. In art museums, she tells them to "make notes or sketches, jot down questions to look up in a library, study and compare . . . discover [their] favorites and proceed to enlarge [their] horizons." The reward is "the opportunity of seeing through the eyes of many artists and so eventually we may come to our own way of seeing."[9]

To veteran museum educators the most successful young audience for museums is 4th to 6th graders, the upper elementary years when children are learning about myths, geography, the history of other civilizations and the connections with their own, the point where objects and pictures in an art museum begin to have some meaning. In many school systems, it is also a point, coincidentally, just before junior high, when school-day scheduling has not become so complex and museum visits so difficult that young people in school groups are lost to the museum for several years to come—or lost for good.

There may be no one right answer to the question of *when*. But one alternative to running with the latest educational fad may be for museum educators to spend less time keeping up with their own newest inventions and more time examining the results not only of their last inventions but those of others, too. Educational theorists like Piaget may be helpful; so might the perceptual studies of an R.L. Gregory (see bibliography following the introduction to chapter 2), or the real theories and practices of the open classroom, not just the ones described in the newspapers. A gifted teacher may be able to get by on his instincts; for most of us, instincts are not enough.

## 3. In dealing with schools, what realities do museums face?

Although most art museums try to organize programs for children who come on their own or with their parents—studio classes for members' children are perhaps still the most typical—the child in a group with his schoolmates and teacher is by far the most common arrangement the museum must deal with. And by far the most common solution is the docent-led group tour.

But there are easily recognized complications in the relationship—the different agendas that separate museums and schools; the museum educator's unfamiliarity with the reality of the classroom; his superficial relationship to the children; the problems of discipline and, for children, the strangeness of a new place; the classroom teacher's own aesthetic deficits; and perhaps above all, the elusiveness, especially for the schools, of the subject matter. These are some of the challenges of museum education. The programs devised to tackle them make this a subject of unexpected fascination for observers as well as practitioners.

In spite of the many claims made for them by their founders, museums are not schools, and museum education is not the same as schooling.[10] What are they, then? Frank Oppenheimer calls museums "a parallel educational system," neither extensions of schools nor supplements to them. They are not, says Oppenheimer, "and probably never should be certifying institutions." What museums do best, he feels is to "provide real experiences," a "quite separate" kind of education that "should be supported separately but with many interwoven threads." Oppenheimer would like to see a

museum district in each city, financed much like a school district as part of the educational system. (See interview in chapter 6.)

As it is, and until the recognition of museums as equal members of the education community comes to pass, museums will continue to be dependent on schools for large segments of their audiences and for help in driving home their message. This means close work with administrators and teachers. As one museum educator points out in a program report here, it means that museum people have to "get off their duffs and into the schools" (see Taft Museum's in-school program, chapter 7).

For there is much about schools and the life within them that museum educators must understand: the curriculum and its lacks; the limits of the teacher's knowledge and experience and, sometimes, imagination; the pressures on teachers and schools to wrest measurable "cognitive" progress from the children; the threat that another figure of authority or foreign subject matter often poses to an insecure classroom teacher; and the difference between the rhetoric of education and the practices in the classroom, between what principals and teachers themselves say they are doing in the school and what actually happens there—sometimes even what can possibly happen there.

There is another issue here, in the relation between art museums and schools and their expectations of each other. It is the matter of their attitudes toward the place of art in education. Clearly, the museum believes in it, whatever "it" is, and quite clearly the school generally does not. In their efforts to close that particular gap, art museums everywhere have worked hard to make art's point, even assuming the responsibility for all instruction in it themselves. But few museums have really taken sides on how art should be used in education. Some have themselves been used—in Title I programs to help children read and write better, for example, or in enrichment programs designed to help integrate schools or make them more attractive to the middle class. It does not follow that a coherent museum philosophy has been advocated or developed from such experiences.

Perhaps the question is, *should* museums take part in the debate? Should they have a position on art in education? Do they know enough—have they studied the learning process, have they tried to find out what children learn in an art museum and how it fits with what else they are learning? Furthermore, can museums study such things? If museums are educational institutions, in any way a part of the American educational system, why is it that they are so rarely represented at education conferences or on education commissions? Decisions of considerable importance, many of them affecting museums themselves, are often made by such bodies—yet museums have long been passive about the educational questions that involve them, silently acquiescing to any new source of funds or attention that may come their way. Philip N. Youtz, the director of the Brooklyn Museum

in the 1930s, made the charge nearly half a century ago: "We are out of touch," he wrote in a *Museum News* article quoted by Theodore Low, "with the latest psychological studies of the learning process. For the most part we are unacquainted with the experiments of the progressive schools here and abroad. We have no well thought out theory of education, no grasp of the relation between museum and school education."[11] It is not clear that the situation has changed.

And what about the school's responsibility to understand the museum? Much has been written in the last decade about the use of the museum and other institutions—social, industrial, political, and cultural—to broaden the education of the young. In the last three years, seven separate panels have issued reports on secondary education, all of them advocating some form of community participation in adolescent learning. Art museums, at first glance, may applaud the prediction of one commission that "in the years ahead . . . students who are artistically inclined will learn in art museums, studios, and conservatories."[12] But how would the average art museum respond if it were suddenly confronted with the responsibility for even a part of the education of 400 or 500—or in the big cities, 14,000 or 15,000—artistically inclined high school students every day? Who has asked the museums if such an idea is realistic?

More directly, what about the schools' specific knowledge of the art museum? Museums are often linked in partnership with libraries to form "the two halves of the public's memory of the past." The library has developed a Dewey decimal system, taught, along with the ability to read, to every student and teacher in the country. The museum, unfortunately, can provide no such simple key to its treasures. That is all the more reason why the colleges of education and the schools should make special efforts not only to try to understand the art museum but to help their students find and "read" the museum's rich testimony to the past.

The relation between museums and schools must be, then, the familiar two-way street. Each has much to learn from the other, as the evidence of several of the studies presented here suggests. If museum and school educators are either too comfortable or too pressed to make the necessary approaches to each other—visiting each other's territory, studying each other's attitudes, sharing each other's knowledge and ideas—then it may be time to make the incentives for such efforts higher and the rewards more visible. Both sides can help, but the students and funders of educational programs probably can help even more.

### 4. How can museums best focus their energies in helping young people to use and understand their collections?

From the programs described in this section and the observations we have made in museums and schools around the country, several lessons have emerged.

One is the importance of cooperative planning between museums and the schools. Museums have clearly demon-

strated their ability to create useful and interesting programs, for which the teachers and schools have often expressed their gratitude. But for the museum that aims to have an effect on the way schools regard art, the way they teach it, and the way they make use of art museums, those programs seem to be most successful that are based on close and continuing relations between the two institutions. In the process, as several programs in this section have demonstrated, what museum educators learn from the schools can have a constructive influence on the way museums approach education, too.

A second conclusion these programs suggest is that one museum experience is not comparable to several: it is a rare museum that can make young people feel "at home" during a single visit. For students to learn about art in that visit or establish a "habit" of museum-going, a good deal more is required of museum educators than they should be expected to deliver in a one-time tour. Museums have always had to deal with the question of whether they should try to offer their services to as many young people as possible or concentrate on those they can reach more often—exposure or real results. Again, museums seem not to have tried to measure the effects of their programs over time. Even the simple device of asking adult visitors about their childhood experiences in museums could help to inform museum educational policies. If the National Research Center of the Arts survey in New York State is at all accurate, the long-term effect of the school tour is negligible.

Third, although young children are inevitably an attractive audience for museums—they are available and their ready reactions obviously appeal to museum teachers—there is evidence here that high school students may be an even more appropriate audience for art museums and one which art museum staffs may be especially well qualified to help. Students of high school age are able to understand, better than elementary-school-age children, the relatively sophisticated subject matter of high art; museum staffs well grounded in art history and theory are able, in turn, to offer high school students an approach to the study not only of art but of academic subjects related to it that most high school faculty members, who are required in virtually no colleges of education to take courses in art history, are not equipped to give them. Panofsky laid down the challenge long ago on this subject:

> . . .Nothing short of a miracle can reach what I consider the root of our troubles, the lack of adequate preparation at the high school stage. Our public high schools—and even an increasing number of the fashionable and expensive private schools—dismiss the future humanist with deficiencies which in many cases can never be completely cured and can be relieved only at the expense of more time and energy than can reasonably be spared in college and graduate schools.[13]

For art museum staffs willing to help schools make up for the deficiencies in their art instruction, high school students may not always be the easiest or most readily available, but they may be one of the best places to start.

Finally, if the subject of art and the resources of the art museum are to be welded into the school curriculum and the learning processes of the young, the most important audience of all for the museum educator may well be the classroom teacher. A teacher has charge of a school class several hours a day for months on end, and a good teacher often has a lifelong effect on his students. No museum can hope to counteract that steady influence. Among art museum goers who answered the National Research Center's New York State survey, 77 percent cited the importance of family friends or teachers in creating cultural interests; the role of such adults was even more influential than the family, which was a factor in laying cultural groundwork for 60 percent of the art museum goers.[14] The art museum may be content to provide the "enrichment" of a few visits to young people who come in school groups; to offer more than enrichment requires the partnership of teachers who have become convinced of the importance of the art museum as an educational resource and who have learned how to use it.

In its attempts to reach the young, it would seem the wise art museum may want to be increasingly selective in the way it constructs its educational programs. Precisely because the art museum has such singular control over its subject matter —because the content of the visual arts is still so alien to most schools, universities, and teacher-training institutions —art museum education staffs have a special responsibility to choose their audiences and their teaching methods with care. The programs in this section should give the museums not only ideas but a basis for making some of those decisions.—B. Y. N.

---

## Notes

[1] *Museums USA* (Washington, D.C.: National Endowment for the Arts, 1974), p. 38.

[2] "Problems in Museum Education," *Museums and Education*, ed. Eric Larrabee (Washington, D.C.: Smithsonian Institution Press, 1968), pp. 80–81.

[3] *Arts and the People*, a Survey of Public Attitudes and Participation in the Arts and Culture in New York State (New York: American Council for the Arts in Education, 1973), p. A73.

[4] *Museum Ideals of Purpose and Method* (Boston: Museum of Fine Arts, 1918), p. 287.

[5] Quoted by Janet Moore in *The Many Ways of Seeing* (Cleveland and New York: World Publishing, 1968), p. 115.

[6] *Americans and the Arts* (New York: Associated Councils of the Arts, 1975), p. 67.

[7] "History of Art in Education," published in a report of a seminar in Art Education for Research and Curriculum Development, Pennsylvania State University, 1966.

[8] *Meaning in the Visual Arts* (Garden City, N.Y.: Doubleday Anchor Books, 1955), p. 344.

[9] Moore, *Many Ways of Seeing*, pp. 115–116.

[10] Theodore Low, for example, quotes Samuel Eliot's remarks at the

opening of the Museum of Fine Arts, Boston: ''Every museum, every museum of fine arts particularly, is not only a museum but a school.'' *The Educational Philosophy and Practice of Art Museums in the United States* (New York: Teachers College, Columbia University, 1948), p. 21.

[11] Ibid., p. 85. Youtz quote from *Museum News,* September 15, 1933.

[12] *The Reform of Secondary Education: A Report to the Public and the Profession,* National Commission on the Reform of Secondary Education, B. Frank Brown, chairman, established by the Charles F. Kettering Foundation (New York: McGraw-Hill, 1973), pp. 11–12.

[13] *Meaning in the Visual Arts,* p. 342.

[14] Table 28, *Arts and the People,* pp. A71–A72.

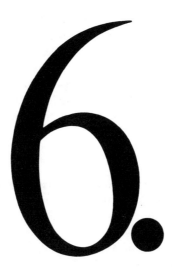

# Programs for Schoolchildren in Museums

## Introduction

Many school people, and nearly all art museum educators, believe that art education in schools, no matter how good it might sometimes be, is inadequate. One veteran museum educator has said it this way:

It is . . . widely recognized that the teaching of art in our schools has always suffered almost everywhere from neglect, inadequate financial support, and a shortage of qualified teachers. . . . Art is still normally taught by the general teacher who is often unequipped for the job. . . .[1]

Not only are schools hard-pressed to provide supplies, space, and time—to say nothing of trained art teachers in many places—but few schools offer an environment that prizes art and the aesthetic experience. The conviction that most schools do not understand and cannot minister to the emotional and aesthetic needs of children is basic to the work of most art museum educators. The desire to "reform" the schools is explicit in very few of the programs reported here, but the desire to supplement and enrich the school curriculum, the school environment, and the lives of schoolchildren is implicit in all of them.

These reports also reveal that museum education departments have been as much affected by the growing emphasis

on the schools' responsibility to the emotional and aesthetic needs of children as they would like to believe they affect that movement themselves. The "reform" of educational methods is under way in museums in many cases along the same lines followed by the schools, as museum educators have become increasingly dissatisfied with the group tour and other conventional museum programs for schoolchildren.

## The ideas behind change

What has been called the "Education Decade"—roughly from 1957 to 1967 (the years of particularly large expenditures by the federal government and national foundations)—began with the confidence that the ills of education could be cured. It ended with renewed and widespread criticism of the schools. The failure of the learner was increasingly seen as a failure of the system to draw on the learner's capacity, interests, and needs—regarded, in turn, as better keys to his learning than curriculum and structure, into which so much money and effort were poured in the 1960s. The net effect in both schools and museums has been to prompt educators to find ways to relate their ideas and, in the case of museums, their objects to the curiosity and experience of the learning child.

This view of learning and teaching revives ideas that John Dewey advocated decades ago. Learning through experience has become respectable again among many educators; in museums, for example, elementary-age children have learned to bake bread like New England farmers, to play African drums, to write, illustrate, and edit their own newspaper about the arts, or to dance and sketch and play-act in museum galleries and studios. (See chapter 10 for elaborations on the theme for high school students.) Dewey's theory suggested that not all experiences are "genuinely or equally educative," that some "land [the learner] in a groove or rut," that others are "so disconnected from one another that, while each is agreeable or even exciting in itself, they are not linked cumulatively to one another." He insisted that "the central problem of an education based upon experience is to select the kind of present experiences that live fruitfully and creatively in subsequent experiences."[2]

Dewey's concern for the quality of the experience may or may not always be considered carefully by the educators who, like him, advocate such learning. To be sure, recent trends in primary and elementary education have pushed toward "freer, less-structured educational environments" and "more emphasis on learning than on teaching."[3] Museums have pushed in the same directions. Says the Victoria and Albert Museum's Renée Marcousé,

> . . . Less emphasis is placed on the formal concept of learning in the museum, about objects as such. It is now assumed that children are not taken round galleries in large numbers, that they work individually or in small groups, that they do not merely listen to the expert but learn, by looking, how to distinguish differences in styles, in periods, and so on. . . .

This emphasis on direct involvement, on personal discovery, on creative activity—music, dance, drama, as well as related interests (archaeology, history, geology)—is characteristic of the open-ended approach to education which is now encouraged in the museum as in the school. . . .[4]

Indeed, "hands-on" museums "that are experience-oriented rather than object-oriented," on the premise that "the visitor can learn the most through an experience in which he is an active participant,"[5] are beginning to dot the American museum landscape. A recent report on these museums notes that they "require no trained eye," that they "are concerned less with high culture than they are with popular culture."[6] Even traditional art museums—which do require a trained eye, do concern themselves with high culture, and are certainly object-oriented (believing as art museums do that the valid art museum experience is precisely that derived from objects)—are beginning to show signs of these changes. In the report from the Brooklyn Museum included here, the staff notes, "Our approach is now less formal, more personal; less object-oriented, more people-centered; less dominated by the instructor, more experiential on the part of the audience."

But the question raised by these reports is: do these changes satisfy Dewey's criteria for "present experiences that live fruitfully and creatively in subsequent experiences"?

## The basic change: the group tour

The group tour has long been the most widely used teaching technique in museums. It is also the closest museum approximation of the conventional classroom situation, except that in the museum the teacher walks instead of standing in front of the class, and the class marches two by two through the galleries instead of sitting in neat rows of desks in the classroom.

Dissatisfaction with the traditional group tour, in which docents herd children through the museum, lecturing all the way, is not new, but increasing numbers of art museum educators have begun to despair of it. To many museum educators interviewed in this study, the traditional tour often seems to impose a passive learning situation on children, to give them irrelevant information, and, even in the hands of the most sympathetic and stimulating lecturer or docent, to be antithetical to the idea that children learn best through participation, discovery, and the stimulation of their natural curiosity. Yet the group tour remains the backbone of most museum education programs, partly because changing the status quo requires more energy than preserving it, but more important, because there is no guarantee that current substitutions for the traditional one-time lecture tour will be more effective. They may even antagonize schools by reducing the numbers of schoolchildren the museum education department can serve, antagonize museum education staff and docents by requiring new and sometimes alien or faddish ap-

proaches, and antagonize curators by introducing into museum galleries activities that seem unwarranted or, at the very least, distracting.

Every effort reported here to ring changes on the conventional tour—to devise what one reporter calls "antitours" —relies on the encouragement or acquiescence of schools, docents, curators, and sometimes museum directors. These changes range from simple variations on the theme—a single visit focused on a concept and reinforced by some physical activity, as at Sturbridge, Clark, or New Orleans (reports in this chapter; see also the Taft Museum program, in chapter 7)—to elaborate series of visits.

**Series of visits.** To many museum educators, the idea of a series of visits now seems crucial as a way not only of grabbing and holding the children's interest, but also making possible sequence and reinforcement, what Dewey meant by experiences "linked cumulatively to one another." The series allow museum instructors to get to know students and their teachers and thus to establish the relationship considered central to teaching, as distinguished from lecturing. (By bringing in groups in series, some museums here report, they also manage to keep their best docents interested.) All of the programs reported in the first section of this chapter try to give some children repeated experiences inside the museum, so they will come to feel comfortable with its objects, its resources, and its people.

But "some" is the word in that sentence that scares many museum workers. Does providing more intensive and longer experiences for a relatively small number of students inevitably deny to others any contact at all? It does not have to. Most of the series programs reported here deal with numbers small enough not to upset entirely the balance of the education department's traditional programs for schoolchildren.

The Brooklyn Museum, for example, suspended all one-time visits led by museum staff, accepting only school classes willing to come for four hours one day a week for a number of weeks. But to make up for some of the visits that might have been prevented by its decision, the museum also offers after-school workshops to teachers who want to take their classes through the museum—and the teacher's participation in a workshop is required before the museum will schedule the do-it-yourself visit.

The Cleveland Museum of Art hired, largely with funds paid to it by the school out of federal grants, extra teachers to conduct its East Cleveland Project; its intention was not only to assemble a staff especially designated for the program but to ensure that the program's presence in the museum would not deprive other schools of their regular visits. Without some such auxiliary staff or special teacher workshops, however, it seems impossible for museums interested in series visits to avoid a sharp reduction of the numbers of children who can visit the museum.

And what do these programs suggest about how to construct a series of visits? For some architects of serial pro-

grams described here, what happens between visits is as important as how many visits the children make. Frank Oppenheimer, director of the Exploratorium (see the School in the Exploratorium report in this chapter), believes in a schedule that provides a week of school between each of the six or eight museum visits. Such a program "stretches learning out in time" and allows the classroom teacher to reinforce what has happened in the museum. The East Cleveland program, on the other hand, constructed by a school administrator, has the children spend each morning or afternoon for a whole week at the museum (or at another cultural institution), leaving the other half of the day for the schoolteacher's reinforcement. At the Art Institute of Chicago (see the "Focus" and "Perception" programs reported here), the series stretches over six months of the school year, a visit a month as the students complete each literature unit correlated with their museum visit.[7]

How do schools feel about the series of visits? The Indianapolis schools arranged for their 8th-grade students' work at the museum to satisfy state requirements (24 hours) for art at that grade level (see report on Search, this chapter). The most comprehensive program and report included here, the East Cleveland Project at the Cleveland Museum of Art, demonstrates that a school administration committed to active learning, broad use of community resources, and experimentation is more than eager to use the museum in a series of visits planned by the museum staff. That program's architect, Dr. Lawrence Perney, says he never saw much value in just "making the rounds" of museums and believes that the children and teachers "had to get involved in the institution if [they] were to be able to take away something meaningful."

**In defense of the one-shot tour.** Though many museums may feel, as the High Museum in Atlanta did, that "once over lightly" (or what Victor D'Amico called "the service-station approach") is not enough to do anything for a child, schools have generally been grateful for the outing that a single museum trip provides—especially in the spring when the "real" work required by the curriculum is completed. And there are museum educators who stoutly defend the one-time guided tour. In part, they are troubled by the notion that, for more intensive programs, a museum must choose a few out of the many. One museum educator points out that a policy to serve the broadest spectrum of the school public is in line with the way museums serve the general public: most people, she notes, rarely choose to visit a museum more than once a year, and she reminds the profession that having only an hour to work with the children before they disappear for another year forces museum educators to try to provide an experience the children "can have *only* in the museum—[to be turned] on to the perception of museum objects."[8] Though Frank Oppenheimer believes that the quality of learning provided by one-time visits "is not much to talk about," he compares them to sightseeing: "Individual sights

combine to form patterns, which constitute a simple form of understanding.'' He points out that one never knows whose sightseeing will provoke exceptional imagining or insights and cites Marco Polo and Charles Darwin as master sightseers.

Other museum educators argue that the one-shot visit can be as educational and allow for as much active participation as any series of visits, that the quality of the exposure rather than quantity of the visits is the key. All the programs reported here must be examined for evidence that the series of classes is necessarily more useful than the one-time visit, that it really provides and connects "present experiences that live fruitfully and creatively in subsequent experiences.'' After three years of their In-Depth Series, Brooklyn Museum educators now believe that unless a museum program relates to the work that goes on in the school and actively involves the classroom teacher, a series of four or six long visits may not be more significant than a single short one.

## Why go? Goals set by schools

The belief that art and culture are "good" for children used to prompt schools and museums to say, in effect, why not go to the museum, even if only once a year? Nowadays that question is likely to be phrased more sharply by school people—why go?—and to be taken seriously by thoughtful museum educators.

Drawing up a code of guidelines in 1972, a task force of art educators urged that school art teachers use art museums in certain ways:

A visit by the class is, of course, the most valuable use of the art museum, since students can thus directly experience original works of art. Class visits should usually be prepared for in advance, so that students have some previous idea of works they are to see, the cultures these works represent, or perhaps how they might approach the experience of visiting a museum's collections. However, there is also the possibility of making the visit a purely exploratory, intuitive, surprize [sic] experience, without previous preparation. It is best to concentrate upon only one small part of a museum's total collection—to emphasize only a few works of art, rather than try to expose students superficially to a vast number of works. Every effort should be made to see that the museum visit is an occasion for a sensitive, personal engagement between an individual and an art object. The teacher's sincere involvement with a painting, sculpture, or other art form can do much toward guiding and inspiring students to experience deeply.[9]

It is a noble goal, the "sensitive, personal engagement between an individual and an art object,'' and one many school art teachers ardently work toward. But the requests that generally come from classroom teachers to museum education departments are for visits that will relate to social studies curricula ("the cultures those works represent'') or to other academic subjects. The New Orleans program, "Museum Experience—Africa,'' is the plainest example here of an art museum visit geared to a social studies unit; Chicago's "Focus'' and "Perception'' series are geared to literature courses. The School in the Exploratorium is carefully designed to enlarge and enrich the science curriculum, because many schoolteachers have had to ignore science under the pressure of teaching reading and math, a situation museum educators recognize only too well. More flexibly related to the school curriculum are programs at Brooklyn and at the Elvehjem Art Center, the museum of the University of Wisconsin at Madison.

At Indianapolis, however, the school art supervisor specifically asked the museum to put its emphasis not on art as an adjunct to social studies but on "man as an image maker.'' Lawrence Perney of the East Cleveland Schools consistently argued against correlations between school curricula and museum experiences; convinced that no public school "at the present time'' is capable of providing good art instruction, he requested the Cleveland museum staff to concentrate on what it knew best, art.

Indeed, Perney's inventive plans to use cultural institutions focus the issue of how schools want to *use* museums. Recognizing that the museum has its own educational goals, which do not necessarily parallel the school's, Perney nevertheless confidently expected that the children's art experiences at the museum would indirectly improve their verbal, cognitive, and emotional learning (an expectation that was borne out in later testing of the children). Indianapolis schools initially wanted to use the museum as a "neutral'' space where children from segregated schools could meet and work in an integrated class—a not uncommon use of museums and other cultural institutions in very recent years.

## Why come? Goals set by museums

Cultural history, awareness of the larger world, pleasure—these are among the goals museums share with schools for school class visits to the art museum. But museums in the 1970s have as perhaps their most popular, or most often stated, goal that of teaching visual awareness or perception: how to *see*. There was a time when art history was the sole focus of museum visits even for elementary-level schoolchildren. But one school supervisor's throwaway comment—"So you tell somebody this was painted in 1892, so what?''—is echoed by many museum educators today. If the programs selected for this study are any indication of the state of art museum education in the early 1970s, museum staffs have apparently come to distrust art history as the primary subject for students below high school age: not one program reported here concentrates on the history of art.[10]

What they focus on, in one way or another, is sensory education. It is the sensory experience that is at the heart of the High Museum's series, of New Orleans's "museum experience,'' of Clark's multi-arts visits, of Brooklyn's "Art Focus'' series, of East Cleveland's classes. Indeed, everywhere the effort to teach children to see and respond, to draw pleasure and instruction from the work of art itself

independent of its maker or its place in the history of art, has become the central museum goal.

Other goals are mentioned in some of these reports. A few museums—notably Kimbell, the Exploratorium, and Cleveland—are consciously reaching out to the parents and families of the children who come in school groups. Some museums are trying to find ways to serve school classes that cannot come to the museum: the Elvehjem with its student newspaper, Sturbridge Village with its Data-Resource Packets, and the Exploratorium with its portable exhibits and materials for teachers. (For more on this subject of instructional materials for the classroom, see chapter 11.)

Though few of these museums come right out and say so, they also hope to change what happens in the school. The Museum of South Texas's "Art in Action" project, in which each 3rd grader spent only an hour, was aimed at alerting parents and teachers (and taxpayers) to the kind of art program that could go into a school system without regular arts teachers in the elementary grades. Frank Oppenheimer says it neatly: "If people spend a little more of their lives in a museum, it will change what happens in the classroom."

### What happens in the museum and who comes

For anyone who is familiar with the "usual" museum tour—and for those who have long criticized its routines— many of the programs described here will defy the stereotype. It is true that observers who chose programs for this study were looking for ideas that promised something more, or at least something other, than the standard tour. Yet it may also be true that the stereotype is all but dead. Gone from many museums are two long-cherished methods of teaching schoolchildren: the art history lecture diluted to schoolchild strength and the introductory slide-lecture in a large auditorium (what one museum educator here calls the "enormous, impersonal background hour").

**Content of the tour.** What has taken their place? One old idea that has proved to hold up well and to take on new prominence here is the thematic tour. It is particularly useful in science and history museums. Sturbridge's tours, for example, give students a way to look through "a magnifying lens" at one or a few elements in a vast and potentially overwhelming environment. Because each exhibit at the Exploratorium puts an idea on display, school classes there can also take a thematic approach.

But how to adapt this approach to works of art? Peter Floud of the Victoria and Albert Museum feels it is something of a travesty to try:

> . . . The value of the objects in art museums, by contrast with those in all other museums, lies primarily in their own intrinsic merit and beauty, and only secondarily in their function as illustration and evidence.[11]

Art museum educators uneasy about the thematic or curricular approach are more comfortable with the "themes" of visual awareness—line, texture, weight, balance—that con-

stitute the High Museum's projects, Bill Ruffer's "Structure" class for East Cleveland children, or Brooklyn's "Art Focus" series.

Closely related to such visual "themes" is the traditional art museum practice of introducing studio activity—helping the children learn to see by doing, making something with their hands. Lately, art museum educators have taken this idea a step further and incorporated more than art-making into their "hands-on" experiences. Though few art museums have yet devised the kind of hands-on environments now fairly common in science, history, and children's museums (the Exploratorium, Sturbridge, and the famous Children's Museum in Boston [see chapter 3] are only three excellent examples), some are trying—New Orleans with its African "environment" and the High Museum with its special exhibitions (see also the "Shapes" report in chapter 9).

Yet more than one art museum educator has questioned the value of learning by touching, for in an art museum only "objects of little value" can be handled. An artist, watching a school group make prints with cut potatoes after a tour of a drypoint etching exhibition, exploded, "Would you teach a kid about jazz with a plastic horn?" Rather than fall into the hands-on trap, some art museum educators have reasoned, as staff at Philadelphia did, that the purpose of coming to an art museum is to focus on the collection, and they have therefore tried to devise "games of seeing and understanding [that] could be just as exciting as those of handling."

Many museums are adding role-playing, dramatizations, dance and movement,[12] creative writing, all the arts. The East Cleveland project may be the most comprehensive example of this approach in any museum program for elementary-level schoolchildren, but it is a path many are taking. No one can yet "prove" that it "works."

**Who should visit.** Not quite so clear as content of the program is the question of what age child museum educators prefer to work with. Though most of these programs are aimed at the traditional upper-elementary grades (4th, 5th, and 6th), there is some crumbling of that long-established pattern. Not that the pattern is without its reasons: Virginia Merriman at Elvehjem chose 5th grade as an age level "where children can be stimulated and where they have enough skills to communicate their ideas." Many museum educators point to the practical matter that 6th grade is generally the last year when children are taught by a single teacher who can bring them to the museum without upsetting the school schedule.

But note that the Indianapolis program is for 8th graders and that Chicago's is for 7th and 8th graders, both in school systems that retain the 8-4 division between grade school and high school. One is moved to wonder if grades 7 and 8, instead of grades 5 and 6, might be the most popular ones to bring to the museum, had more school systems kept the old 8-4 schedule instead of changing to 6-3-3, or some other step midway between "grade" school and "high" school. (See

the Chicago report for observations by a school supervisor.)

Corpus Christi, Clark, and East Cleveland include younger children. The East Cleveland inclusion is based on the museum staff's conviction that it is never too early to offer children a wide and affectionate exposure to a larger world, to art, to unfamiliar places and new personalities. If delight remains a goal of art museums, it is therefore also a goal of art museum education efforts, no matter what the age of the audience.

## Money, staff, responsibility, evaluation, and other anxieties

**Money.** A survey of art museum educators in 1971 prompted this assessment: ''Indeed, it may even be argued that [art museum educators] are needed only because the schools are not doing their job in art education at all levels.''[13] If museums do the job of art education that schools are supposed to do, should they be paid for it? By whom?

Louise Condit has pointed out that American museums ''hardly ever have formal, official relationships with schools, covering educational policy, standards, budget, and division of responsibility,''[14] even when they devise and offer extensive programs to schools. A few partial exceptions appear here: the Corpus Christi school district pays the Museum of South Texas $24,000 a year—or half the museum's annual education budget—for a regular program of docent-led tours for all 5th- and 6th-grade students; the Philadelphia Museum receives about $75,000 a year (the figure changes with economic circumstances) from the Pennsylvania State Board of Education for support of its school programs; and some big-city boards of education—New York, Philadelphia, and Cleveland among them—pay their own art liaison teachers to serve their classes in the museum, which usually provides office services to the teachers.

But most public or private museums rarely insist on being paid anything for the educational services they continue to render, perhaps believing that providing those services is the most appropriate way they can earn (or justify) their tax support or their tax-exempt status. When federal monies became rather widely available at the end of the 1960s, museums hoped the day had finally come when schools would become clients who paid for at least some services; the hope of that ''patronage'' has now pretty much dried up, along with the funds.

One of the most provocative suggestions about this subject of money and service is Oppenheimer's call for a ''museum district financed through tax money and treated independently, much like a school district.'' He believes that these parallel cultural and educational systems could form many ties while maintaining their differences.

**Evaluation.** Among the virtues of such a museum district would be its independence of the school district. But like schools, museums receiving public monies (or private grants, for that matter) increasingly must face the question of accountability. Accountability procedures in the mid-seventies tend to rely on student academic achievement as a more useful measure of educational quality than facilities, teacher-training, or the racial-social-economic mix of the student population, all of which were ideas of primary concern in the 1960s. (A close reading of the East Cleveland program suggests that though schools must juggle academic achievement scores and accountability reports, museums contracting their services out to schools are not yet forced to confront that problem.)

Indeed, what kind of evaluations do help museum educators know how effective their work is and how wisely or well they are spending money? A number of the programs reported here tried informal evaluations, but it is clear that their guidelines and standards of measurement are fuzzy. What does the children's retention of images and facts—as reported, for instance, by Kimbell and Elvehjem—mean? Is visual memory an art museum's equivalent of the school's measure of academic achievement? Or is it enough to record the children's evident pleasure in the museum and the activities offered to them there? The programs described here, some modest and some ambitious, suggest that evaluation based on what goes *into* a program and how it is conducted may very well be more helpful for art museum educators than a hopeless effort to measure what comes *out* of it. Learning in an art museum is not quantifiable, and once art museum educators convince themselves it is all right to acknowledge that, the more realistic can be their approaches to funders and to accountability requirements.

**Staff.** Professional classroom or art teachers and professional or volunteer museum instructors bring at least four different kinds of training, credentials, and emphases to their teaching. Some people in museums and schools distrust these differences; others celebrate them.

But the differences are crucial to working relationships between art museums and schools. Most art museum educators know little about learning theories, the development of children, the specifics of school curricula; many do not know what really happens inside the average classroom, or, as one school art supervisor put it, ''they haven't walked that mile in our teacher's moccasins.'' (He was talking specifically of the fact that most museums divide their visiting classes into groups of about 15—a genuine necessity for looking at works of art but a practice that looks like sheer luxury to the classroom or art teacher who daily faces classes of 30 to 35 children.) Despite their ignorance of the school, art museum educators generally feel they have more to *teach* the schoolteacher than learn from him; given the ignorance of art the average classroom teacher brings to the museum, it would seem that each has much to learn from the other.

And who shall teach *in* the museum? Seven of these thirteen programs rely primarily on docents or other volunteers; one hires ''escorts'' whose credentials and training are, in most instances, comparable to those of volunteers in other

institutions; only one (Indianapolis) tried to use the school art teacher in the museum but gave that up in favor of museum staff and docents; and four (Brooklyn, the Exploratorium, Philadelphia, and Cleveland) depend primarily on paid museum educators. This question is explored at length in chapter 5 (which concerns museum volunteers), but it is an essential element in the planning and execution of most museum programs with schoolchildren.

**Responsibility.** It is clear from all these reports and the issues they raise that cooperation between school personnel and museum staff is a vital, if elusive, element in programs for schoolchildren. Like many art and education people, Kathryn Bloom, director of the Arts-in-Education program of the JDR 3rd Fund, has said that art museums are wrong to devise programs and present them as "products" to the schools, ready to be accepted and used: "School faculty must assume the responsibility for the organization and objectives of the education program, and the function of community organizations must be coordinated and related to this program."[15]

But several of these reports—notably East Cleveland, Brooklyn, and the Exploratorium—suggest that the issue is subtler. The East Cleveland schools organized the program and asked the museum only to "do its thing" as it saw fit. Brooklyn and the Exploratorium devised programs and offered them to schools, which eagerly accepted them. It appears from these and other reports that it may not matter so much whether the school or the museum initiates the program; more important is how the two institutions see each other and what kind of spirit and intelligence they bring to their work together.

**And what of the children?**

It is the children for whom all these programs are devised, for whom responsibility must be accepted by someone. More than one museum educator (and, for that matter, school administrator) has warned that museums must not take the ultimate responsibility for arts education; unless the arts are built right into the school system, they are likely to go down the drain—and that would mean a failure of the society's responsibility to its children.

The basic question, then, is what should the museum's responsibility to the children be? Compared with libraries as cultural resources, as they often are, museums find themselves faced with a task libraries are not asked to perform: to teach the basic skill that enables people to use them. No one expects libraries to teach children to read. Why, then, should it be left to art museums to teach children to see?

Perhaps the simple and inevitable answer is that art museums are among the few institutions *able* to teach children how to see—and certainly to teach from and toward works of art. Left to their own devices, without the constant prodding of museums and those who care about the visual arts and art education, the nation's elementary schools,

reflecting the society around them, will forever ignore the nonverbal world.

More important for the art museum may be the question of how it should teach children to see. What is the best use of the museum's limited energy, time, and financial resources? Should the museum be the primary agent of art education— and in the face of educational resistance and public priorities, can it be?

Frank Oppenheimer's answer to those questions: the public must begin to support parallel systems of education. As the public school, reinforced and supplemented by the public library system, has proved that it can handle only one kind of education at a time—the kind that deals in words and numbers—the visual and experiential education so necessary to the health of both individual and society may have to be assumed by another set of institutions, among which the museum system could be a major force.—*A. Z. S.*

## Notes

[1] Louise Condit, "Children and Art," *Museums, Imagination and Education* (Paris: UNESCO, 1973), p. 63.

[2] John Dewey, *Experience & Education* (New York: Collier, 1963, copyright 1938), pp. 25–28. The passage preceding the last quote reads: "Just as no man lives or dies to himself, so no experience lives and dies to itself. Wholly independent of desire or intent, every experience lives on in further experiences. Hence the central problem. . . ."

[3] Condit, "Children and Art," p. 80.

[4] "Changing Museums in a Changing World," *Museums, Imagination and Education*, p. 18.

[5] Bob Feild, *Hands-On Museums: Partners in Learning* (New York: Educational Facilities Laboratories, 1975), p. 5.

[6] Ibid., p. 6.

[7] In 1944, when the New York City board of education asked a group of museum educators to report on the schools' use of museum visits, they noted that "by far the most popular with the schools" is the museum-school-planned full-day program, "because it makes possible best use of museum facilities." *Use of Museums and Museum Materials by the New York City Schools*, undertaken and written by representatives of seven New York museums, 1944, unpaged.

[8] Patterson B. Williams, "Find Out Who Donny Is," *Museum News*, April 1974, p. 45.

[9] *Art Education: Middle/Junior High School*, written by a Task Force of Art Educators under Task Force Chairman Walter Hathaway (Washington, D.C.: National Art Education Association, 1972), p. 116.

[10] A recent state-by-state study of history teaching in the nation's schools, conducted by the Organization of American Historians, reported that recent trends in the teaching of history have caused a significant drop in students' "confidence and interest in history." Those trends have promoted a teaching approach that stresses issues, not facts, and tries to bring history into present perspective. Results: "relevance" has overwhelmed rigorous research and has distorted inquiry into the past, and students have trouble dealing with concrete names, dates, and events. Traditional historians argue that history must be taught chronologically, because

that is the way it happened. Art historians have voiced the same objection to the increasing unconcern with art history in museum education programs for schoolchildren. —Based on an article in the *Journal of American History*, reported in *Newsweek*, November 10, 1975.

[11] Germaine Cart, Molly Harrison, and Charles Russell, *Museums and Young People, Three Reports* (Paris: International Council of Museums, 1952), p. 26.

[12] The growth of "movement" classes in schools and museums deserves mention. Originated by Rudolf Laban, who had become interested in movements of the human body while doing time-and-motion studies in a German factory, "movement" was introduced into English education by Laban when he fled Nazi Germany. To quote John Blackie, England's former chief inspector for primary education, it "begins by being an exploration of the body's capacities for movement, heavy and light, large and small, fast and slow, with the whole body involved. . . . As time goes on control of the body develops and the children are able to perform a very wide range of movements with confidence and grace, both singly, in pairs and in groups." Blackie notes that "those teachers who are the most dedicated followers of Laban believe that all dramatic work with young children should derive from the movement of the body and that appeals to the imagination, such as would be made at a school of dramatic art, are mistaken. . . ." (*Inside the Primary School*, New York: Schocken, 1971, pp. 125–126, 128). Museum educators, knowingly or not, use both approaches in museum galleries.

[13] *Education in the Art Museum*, published by the Association of Art Museum Directors, 1972, p. 37.

[14] "Children and Art," p. 66.

[15] "Arts Organizations and Their Services to Schools: Patrons or Partners?" one chapter of a manuscript titled *An Emerging Pattern for Educational Change—The Arts in General Education*, for the Arts-in-Education Program, JDR 3rd Fund, p. 7.

# THE CLEVELAND MUSEUM OF ART: EAST CLEVELAND PROJECT

Cleveland Museum of Art
11150 East Boulevard
Cleveland, Ohio 44106

**Intensive work for two week-long periods in the Cleveland Museum of Art's galleries and studios is an integral part of an enriched and extended (eleven-month) school year for 1,500 East Cleveland children. Overall program was planned and funded by the school system; museum component planned and conducted by the museum staff. On balance: a success from diverse points of view with some surprises for participants along the way—and significance for educators in both museums and schools. CMEVA interviews and observations: 1971–1974, concentrated in 1973/74.**

### Some Facts About the Program

**Title:** The East Cleveland Project.

**Audience:** 1971/72: one elementary school, 300 students (spring). 1972/73: three elementary schools, 900 students (fall); plus one junior high, for total of 1,200 students (spring). 1973/74: five elementary schools, 1,500 students. 1974/75: same as 1973/74.

**Objective:** To provide support and a friendly atmosphere for studio projects and classes in creative writing, movement, and dramatization, so that the museum and its collections can contribute in a special way to the education of children whose opportunities otherwise would be limited; and also to prove beneficial to the teachers of these children by providing them the opportunity to observe their students in a new situation and to observe another teacher's methods.

**Funding:** $19,000 (1972/73) and $28,500 (1973/74) paid to museum by East Cleveland Board of Education. Cost per person, 1972/73: $15 (or about $3 per instruction day); 1973/74: $19 (or about $4 per instruction day).

**Staff:** 7 full-time (hired only for the project), 3 substitutes (museum staff), one part-time; number of volunteers—sporadic.

**Location:** In the museum.

**Time:** During the school year, including the summer. An eleven-month school year is central to the program; each participating class visits the museum for two separate weeks of five consecutive half days during the school year.

**Information and documentation available from the institution:** A brief report from the associate curator responsible for the program.

## I. East Cleveland: Its Schools and the Program Called EESY

East Cleveland, an independent municipality, is three miles square, bordered on three sides by the City of Cleveland. With approximately 40,000 residents, it is the most densely populated municipality in Ohio. An old community—conservative, white, middle class for most of its history—East Cleveland has a long tradition of careful city management and good schools. Its character and ethnic composition changed dramatically in a single decade.

- In 1960, blacks constituted 2.4 percent of the city's population, and a mere 1 percent of school enrollment.
- By 1970, the city's black population had risen to 59 percent and the school enrollment to 92.5 percent black (96.5 percent by 1974).

These figures, of course, echo recent urban transformations all over the country. Some other East Cleveland statistics:

- From 1960 to 1970, the percentage of home owners dropped from highest in the county to lowest.
- From 1967 to 1974, the city's collectible tax duplicate declined from $124 million to about $100 million.
- In the same period, the number of schoolchildren from welfare families rose from 29 to 4,023.
- By 1970, the schools' dropout rate had increased, and the performance on standard achievement tests had dropped.
- By the early 1970s, the annual teacher turnover rate was running close to 30 percent.

But East Cleveland's new residents, for the most part emigrants from Cleveland's inner city, came there seeking a better life for themselves and their children—including, notably, better education. Thus in 1972, despite the prevailing poverty—the city ranked second lowest in the county in per

capita and family income—East Clevelanders continued to approve incremental and school levies, and paid the fourth highest total school-district tax in the county. (School-district general revenue, including taxes, accounted for about 70 percent of the 1973 budget of $11.3 million, the rest coming from state, federal, and foundation sources.)

## Schools and university take steps

A changed but still proud community, East Cleveland was not ready to give up its reputation and traditions without a struggle. The board of education and the administration of the East Cleveland City Schools set out to stem the decline that sets in when middle-class families flee a community and poor families replace them. In January 1970, they took the first steps toward developing the program known as the Extended and Enriched School Year, commonly called EESY or E&E for short.

The East Cleveland City Schools, together with the department of education at Cleveland's Case Western Reserve University, obtained a $60,000 grant from the U.S. Office of Education for a joint program in "staff and program development." (These funds were available under the Education Professions Development Act.)

A Joint Community Council that was named to establish overall direction for the program included school representatives, university staff, and East Cleveland citizens. The initial project was a seven-week summer school: 320 students drawn at random from all six East Cleveland elementary schools, 64 teachers drawn from the schools and the university. Good as the teachers found the program, they and the council felt it was too short and too separate from the normal school experience to benefit the students directly.

Therefore, in the second year, 1971/72, the East Cleveland school system decided to integrate those extra weeks into the regular school year. The new year consisted of the 182 days of instruction required by Ohio plus six weeks added and spaced over nearly an eleven-month period from September 1, 1971 to July 21, 1972.

In an evaluation report for the 1971/72 school year, the East Cleveland schools administration described the use of the extra weeks this way: The extended year would not mean simply adding six weeks of instruction to the regular school program. Instead it would mean that both students and teachers would have time spotted throughout the year "to reflect their psychological needs, their motivational and physiological rhythms, and their interests and learning styles."[1] (The decision to extend the school year reflected sentiments expressed in an Ohio state commission report.[2])

In East Cleveland the *extended* year also became an *enriched* year. The plan proposed

1. Periodic short holidays throughout the eleven-month school year as a tradeoff for the six weeks of summer vacation "lost." (In 1971/72, for example, the extended year included five one-week holidays besides the traditional Christmas and Easter vacations.)

2. Six weeks of instruction at cultural institutions, scheduled throughout the entire period as "enrichment."

This was the beginning of EESY, and of the East Cleveland Project in which the Cleveland Museum of Art would soon take part.

## The residency

In general the plan provided for four or five weeks of classroom work, one week away from school for instruction in a major cultural institution (called a "residency"), and one week off. The residency experience, considered crucial, gave the children five straight days at a time in each institution, and accounted altogether for between six and ten weeks of the eleven-month school year. In general, children spent half the day in the institution, the other half in school, a pattern devised to allow the classroom teacher to tie in the experience with school work.

In the children's two separate weeks at the art museum, a similar pattern of three to six weeks between visits permitted the classroom teacher to build on the first museum experience and prepare for the second. It also permitted the museum instructor, relying on the children's memories to span six weeks, to connect the two residency experiences. (Scheduling problems sometimes got in the way of this ideal pattern.) The week "off" was a holiday for the children but a week of planning, tutoring, and studying for the East Cleveland classroom teachers, who were paid for an 11-month work year.

Teachers volunteered for the first year of the program, as did the students (or rather, parents on their behalf). Guidelines for accepting students required them to be below grade-level achievement. Despite this nominal requirement, both Dr. Lawrence Perney, the assistant superintendent for instruction and curriculum, and Sheryl King, the 1973/74 supervisor, acknowledge that there are children in the program who do not test below grade level; both declare that the schools' primary consideration was the parents' *desire* for their children to be in the program. "Besides," says Perney, "almost 90 percent of the kids in our system would have qualified as being below grade level."[3]

To Dr. Perney the voluntary aspect of the program is all-important:

I have kept the program limited, and I make the parents and children ask to be in it. . . . And I think if we had gone and said you have to be in the program, it might not have had the aura of being something special. . . . Because you know in inner cities . . . most programs are viewed as remedial, and automatically that gives them a connotation which is negative. . . . This way there's an aura of "it's something special," and we really did not pick out, to be perfectly honest with you, only the slow students.

The East Cleveland schools selected and invited a number of cultural institutions to offer residencies. At one time or another the following institutions participated: the Cleveland Health Museum and Education Center, the Cleveland Museum of Art, the Cleveland Museum of Natural History,

the Cleveland Music School Settlement, the East Cleveland Public Library, the Fairmount Center for Creative and Performing Arts, Karamu House, Red Raider Camp, and the Western Reserve Historical Society. The schools' requirements for residency institutions were that they

1. designate a staff member as supervisor of the program;
2. share the program planning with East Cleveland teachers and supervisors, but take the *entire* responsibility for instruction at the residency;
3. make the necessary space and equipment available;
4. be willing to accommodate *student* needs—or, as one schoolteacher put it, "know how to treat first graders as first graders";
5. work within a budget for instruction of $10 per student for the five full days of residency instruction.

In the spring of 1971, the Cleveland Museum of Art accepted the East Cleveland Board of Education's invitation to participate in EESY. With the steady encouragement of the then-curator of education, Dr. James R. Johnson, the museum's education staff began planning in May and that fall observed East Cleveland classes in other cultural institutions where the project had already begun. In October staff members met with the twelve participating schoolteachers and administrators from the East Cleveland school system.

## II. Money and Other Numbers

The East Cleveland project at the Cleveland Museum of Art got under way on January 3, 1972, beginning what the museum expected to be a two-year commitment to East Cleveland's Extended and Enriched School Year. During the first semester of operation, museum instructors worked with 300 students from 1st through 6th grades at Chambers Elementary School, 50 children from each grade.[4] The museum was paid $3,000 ($10 per student) as a subcontractor under Title III (the "innovation" title of the Elementary and Secondary Education Act).[5]

The staff that first semester included regular staff members, newly hired studio specialists, and volunteer college students working on senior field projects. (Volunteers were strictly limited to helping with set-up, clean-up, class control, and other minor nonteaching duties. They were invited, however, to attend and contribute ideas "to any luncheon session or informal meeting" to evaluate the program.)

The program began again on September 18, 1972, bigger and more expensive. Three elementary schools—Prospect and Mayfair, in addition to Chambers—sent a total of 900 students. Besides Title III, funds came from Title IV-A of the 1967 amendments to the Social Security Act. In late fall, the East Cleveland Board of Education received approval and funds from the same sources to extend the program to junior high students—480 of them—during the spring semester of 1973. Altogether, in 1972/73, 1,200 students came to the museum as part of EESY. As the fee by then had risen to $15 per student, the total cost was $19,000, including $1,000 for supplies. In 1973-74, 1,500 students took part in the project at the museum, for a total cost of $28,500, or $19 per student including supplies.

The staff was enlarged to handle the larger number of students, and further enlarged—to seven regular teachers, four substitutes, and one part-time teacher—in 1973/74 when, besides the 1,500 students, 60 teachers from five of the city's six elementary schools were involved in the Cleveland Museum's part of EESY. (The junior high program had been dropped by the decision of the school, and against the judgment of the museum instructors.)

The two newest schools—Superior and Rozelle—were funded under Title VII, "Project Learn," in the first year of a three-year project designed to allow "longitudinal study." (Though Title IV-A had folded by this time, Title I money was taking up some of the slack. The bookkeeping is so inventive that, according to the assistant superintendent, even the General Accounting Office people who check the books marvel at the intricacy of the funding arrangements.)

Of nine institutions in the program during the first three years, the museum was the only one to deal with all the students. This ambitious undertaking was made possible, in the judgment of James A. Birch, then assistant and later associate curator, by "excellent physical facilities, a staff that can adjust its teaching level from first through sixth grades, and, most importantly, because of the interest and dedication of the Education Department and the East Cleveland staff to the value of this project."[6] It should be noted that Birch, who was directly responsible for the project, and his secretary each gave one full day a week to the project.

As for the overall cost of EESY, Dr. Perney estimates that the extra six weeks of schooling—including "teacher cost, secretary cost, travel cost, contract with the institutions, and everything else"—runs about $95 per student per year.[7] With the per student cost for the regular school year running at about $1,000, he considers this increase of barely 10 percent minimal: "There's always enough fat in any school program that if you were to cut back you could save 10 percent. It could be done quite easily."

One of the curious episodes in the unfolding of the East Cleveland project—at least from the museum staff's perspective—was that when the East Cleveland schools had to make some budget cuts, four of the five art specialists in the schools were let go. "We teach the value of the visual arts," one museum instructor said wearily, "but not to the school board."

Asked by a museum staff member how he felt about the release of the art specialists, Assistant Superintendent Perney replied, "Not bad at all, because I had received numerous complaints from teachers who said that [the specialists] were not providing adequate art instruction. So what were they providing? We were paying five teachers approximately . . . $60,000, plus fringe benefits to 15 percent—$69,000 a year. That's more than what it would cost to send each and every child in our elementary school program to your institution for

one week, grades one through six—a total of 25 hours of special instruction. And in the school what do they get? They get a 35-minute lesson once every two weeks—half as much approximately. Now that's a comparison.''

## III. Goals for the East Cleveland Project

What goals have the East Cleveland schools sought in E&E, specifically in that part of the program centering in the Cleveland Museum of Art? What have been the museum's goals—with respect to the children, their parents, their teachers, the school system, the museum itself? And, more broadly, what lessons can other art museums draw from this collaboration between a museum and a city's elementary schools?

Elementary schoolchildren and teachers come into the Cleveland Museum with the hopes of their school system invested in them and in what will happen to them at the museum. What were East Cleveland's hopes?

1. For the children: increased academic achievement, as the result of a richer and more diversified environment for learning.
2. For the East Cleveland teachers: new skills and attitudes.
3. For the parents and the community: new awareness of resources outside the schools, new pride in themselves and their children.

The schools' goals are more easily stated than those of the museum, for—a point worth emphasizing—EESY was initiated by the schools, not by the museum or any one of the other residency institutions. To secure funding and also to mobilize a constituency, it was up to the East Cleveland City Schools to announce quite specific goals.

The museum, on the other hand, having had no part in the original conception or funding of the Extended and Enriched School Year, had no occasion to set forth a formal statement of *its* goals for the East Cleveland Project. In accepting the schools' invitation to play an active part, the museum administration tacitly accepted the schools' nominal goals. This is not to say, however, that the museum did not have, or as time went on, did not develop, its own ideas of what the project might accomplish.

A fair statement of the museum's goals would go something like this (paraphrasing a 1974 memorandum by Birch[8]):

1. The wish to create a friendly, welcoming, and creative atmosphere so that the museum and its collections could become a part of the students' education through classes in creative writing, movement, and dramatization, and studio projects.
2. The hope that the East Cleveland Project would disprove the statement once made of the Cleveland Museum that ''it isn't really doing anything in relationship to the community that is right at its doors.''[9]
3. The hope that having the East Cleveland teachers observe their students in a new situation, and observe other

teachers' methods, would prove beneficial to them.
4. The hope that through the students' intensive participation in museum classes and through their familiarity with the collections, their parents might come to know the museum too.

That the program originated with the East Cleveland school system, rather than the museum, is judged critical by administrators in both institutions. That the Cleveland Museum staff accepted the idea without entirely accepting the East Cleveland school board's goals has puzzled a few people in both institutions. Others, however—including notably Lawrence Perney, who initiated the plan—regard the disparity between the museum's goals and the schools' as not only good but essential.

### A choice among goals

Whatever the official or unofficial stance of the institutional sponsors of the East Cleveland Project, participating individuals—schoolteachers, school administrators, museum instructors, university representatives—could and did emphasize different aspects of the program. (Also, the program itself shifted somewhat over time from prime concern with teaching to prime concern with learning.) And this was a program of sufficient diversity and scope to lend itself to varying emphases. In broad outline, the project was designed to meet four kinds of goals, and each of these won unpredictable adherents:

1. *To expose children to the city's cultural institutions and help them feel at home there.* Thus, Dr. Bert Masia, of Case Western Reserve, speaks of giving youngsters a ''sense of the place itself''; James Birch, of the museum, of enriching the students ''by making these institutions an integral part of their educational experiences'';[10] the East Cleveland Board of Education, of exposing students to the ''many educational opportunities in Greater Cleveland.''
2. *To shake up the schoolteachers and bring them together with their students in a more informal setting.* The schools' own evaluation report for 1971/72 included as one purpose of EESY, ''To try to shake up the neatly arranged and controlled world of the teacher and to introduce some untidiness into it.''[11]
3. *To help students acquire specific skills.* The same evaluation report stated as EESY's broad objective helping both student (and teacher) acquire ''new cognitive and and affective skills.'' All funding sources have insisted on improved language skills as the primary goal. And Lawrence Perney speaks of East Cleveland's interest in ''achievement orientation.'' Marlo Coleman, a museum instructor, frames the expectation diffidently: ''I'd say I'm trying to make a child be able to see and maybe to think.''
4. *To enliven and stimulate aesthetic responses and help children to be creative.* Though the 1971/72 evaluation

report speaks of "affective skills," this aspect of the East Cleveland Project receives relatively little stress from the schools, much more from the museum. Speaking of the project, museum instructor Celeste Adams says, "you are really teaching students to be creative."

Clearly these goals are not mutually exclusive, and individuals from the institutions concerned shared them in different combinations. Elizabeth Swenson, for instance, a Case Reserve graduate student who worked on evaluation, is cautious in her own summation of the project's potential: "To feel at home in the museum; perhaps to enliven the children's aesthetic responses; to heighten creativity"—that is, she endorses two kinds of goals. But she demurs on the achievement emphasis: "Could a week, or even two, in a museum legitimately be expected to affect cognitive learning?"

### Schools and museum: complementarity at work

To their credit, administrators in the East Cleveland schools did not expect the museum to perform the same way the schools do, nor to share the schools' specific objectives. In an interview about the program, Lawrence Perney was saying in effect "Vive la différence!" If the museum were not a different kind of institution, the residency would lose its point:

> Remember you do not have the same kind of climate or environment the schools do, and you have to adhere to yours strictly; you cannot conform to the school, you must make the school conform to you. . . . We have other goals we want fulfilled.

For him the museum's primary goal was different:

> You are trying to [teach] art forms that you are trying to get [the students] to appreciate. Now, they might someday develop . . . and they might not. [But] that's your goal. Your secondary goal will be assisting the schools in teaching academic matters. . . . We can come to you and say, "If you are dealing with children in the first grade, [they] have difficulty with certain words: *in front of, behind, in, on,* and so on."

It is important, he continued, that the museum not be "viewed by the public as an extension of the schooling process."

For all this understanding between the two institutions, and the schools' appreciation of the different world of the museum, it was always clear that the East Cleveland schools' primary goal for EESY was to increase student achievement—in actual performance, as measured by standard tests. If this sounds like the immemorial goal of schools everywhere, what distinguishes the EESY project has been the indirect means by which East Cleveland sought this primary goal; (1) by increasing family participation and support, especially through the Joint Community Council; (2) by increasing students' acceptance of the school process, through the sense of special privilege; and (3) by tapping extraordinary educational resources in order to increase students' ability and desire to learn, through the cultural residency weeks.

### On balance

So the two institutions went their complementary ways in the East Cleveland Project. For all the contrasts in emphasis and purpose among the many individuals involved and a certain amount of inevitable if minor conflict, the differences do not seem to have caused operational difficulties. One reason must surely be the open-minded, give-and-take attitude that has marked the administrators responsible for the project in both schools and museum. Another is that both institutions shared enough general assumptions about the project to make it work—that, for instance, the museum experience would be good in many ways for the children, and perhaps their teachers, and that through the children the museum might reach their parents and other East Cleveland adults.

It would appear that no harm came to the project as the result of certain assumptions the institutional partners did *not* share. And two of these were substantial: (1) the museum did not share the schools' assumption that the program would improve testable academic achievement; (2) the East Cleveland schools did not share, at least explicitly, the museum's assumption that the visual arts have a special value per se.

## IV. On Achieving Goals

In trying to assay the value of the Cleveland Museum's East Cleveland Project, it will be useful to examine its effects, direct and indirect, measurable or not, first on the schoolteachers (they were the first concern as E&E started) and then on the children.

### For EESY's teachers

Are museum instructors more "creative," more flexible, and freer than classroom teachers and therefore able to serve as models to classroom teachers?—an important consideration as EESY began. In talking with museum instructors, one readily learns that most of them believe so; it is equally plain that most East Cleveland teachers either do not believe or will not acknowledge it.

**Schoolteachers look at museum instructors.** Every East Cleveland teacher interviewed—perhaps 20 of the 60 involved in the 1973/74 program—spoke of the superior quality of one museum instructor's teaching, commenting on her "feel for the children," her ability to "inspire" them to joy in learning. But few gave such unstinting praise to other museum instructors, though there was general respect and occasional admiration for them expressed in written evaluations by the East Cleveland teachers. Here are selected excerpts:

- [One staff member of the museum] displayed such a wealth of knowledge on many subjects that his enthusiasm carried over to the children who in turn brought it back to the classroom with them.

- The personnel were all pleasant and interested in children. . . . The children enjoyed the visit and benefited by the concepts introduced. The trip motivated slow learners, and the children showed more interest in coming to school. . . . Even though museum rules were stressed, the instructors were often not firm enough with children, and the children took advantage of this.
- There was one excellent lesson on the city, I don't know the teacher's name, but it was an excellent lesson. The students have come back with a positive attitude toward the museum.
- Lesson ideas were appropriate for 1st grade. Museum teachers' motivation and enthusiasm were contagious. All museum teachers seemed very knowledgeable and had much to offer the children. . . . Many times a museum teacher "pressed onward," resulting in management problems which interfered with the impact of the lesson. . . . It would be valuable for all museum people involved with 1st graders to know about the need for structure when moving large groups within a space or from one area to another. . . . Museum teachers need to phrase rules as do's rather than don'ts.
- Most of the teachers had a good rapport with the children. . . . The planning aspect was commendable.
- Most of the instructors appeared to have the know-how necessary for working with children, but several did not. They talked above the children's understanding and moved too quickly from one activity to another without adequate explanation.
- The extensive use of the galleries was a distinct improvement over last year. The choice of galleries was excellent, and the discussions introduced vocabulary and new concepts in ways six-year-olds could learn from. [One instructor's] discussion with them about sarcophagi and [another's] visit to the Japanese gallery were particularly vivid and enriching.[12]

What emerges from these comments is emphatically not a picture of teachers traveling to an art museum to be "instructed" by "freer and more flexible" model teachers. Rather, there is a sense of professionals appraising their colleagues. Whether or not the appraisals are complimentary (and the majority are), the central fact is the East Cleveland teachers' unanimous failure to comment on what *they*, as distinct from their children, learned from the museum instructors.

Trying to discover precisely what the East Cleveland teachers believed to be their role at the residency institutions is difficult. The 1973/74 school supervisor for the project, Sheryl King, was admittedly unfamiliar with it when she assumed responsibility in the summer of 1973. She likens the administration's explanation to the teachers of the program and its goals to the official explanation to the students entering the program: "Well, just like if you say to kids, this is a remediation program, it's going to be, 'Oh, no, not this

again!' The same with teachers. I think that maybe—and this is conjecture on my part—they weren't given that feeling because it was quote unquote supposed to go naturally, not forced from the bud."

The prime mover and supervisor of the program since its inception disagrees. Said Lawrence Perney,

Every one of the teachers has been told that their role there is one where, even though they are not conducting the instruction, they have to learn what's going on and reinforce it when they get back in the classroom. . . . They might say they haven't been told, but they have, because I myself have told every one of them. I talk to each school separately once a year, at the beginning of the year; I tell them the objectives of the program, and I tell them what their roles are. And then I give each one of them a copy of the proposal. So they know that in there they are the ones who are supposed to be the supervisors of the program, although they are not conducting the instruction.

Dr. Perney believes, and says, that they should be learning along with the children, and they should find ways back in the classroom to repeat or reinforce what has happened in the institution.

A member of the university evaluation team reports that her efforts to learn from the East Cleveland teachers what they felt they had learned aroused "hostility"; a frequent response was that "they weren't supposed to have learned anything, the program was for the children." A 1st-grade teacher commented to an observer in the museum: "I haven't learned anything new, but I have enjoyed it."

**Museum instructors look at schoolteachers.** Museum instructors differ widely in their opinions of teachers, of their own usefulness as "models," and of the program's effectiveness as "teacher training." Here is a sampling:

- From a regular Cleveland Museum of Art teacher: "You could say that they were trained in that they see how a child is taught to be creative. Perhaps they, as a result, become more creative in their teaching. I think in that sense it's a kind of training. Certainly if we had a teacher workshop for the East Cleveland teachers . . . what do we do at teacher workshops? We stage a class demonstration. . . . So in that sense I wouldn't say that there is no teacher training or teacher benefit. Certainly there is."
- From an experienced school art teacher working on the museum's East Cleveland project staff: "I really get the feel of the students the first five minutes and the relationship of them to their teacher, and then just by verbalizing things allow the teacher to either assume or diminish responsibility."
- From another museum instructor, writing of her relation to the classroom teachers: "I use the classroom teacher as much as I can, when she is able and willing. I count on the teacher to handle flagrant discipline problems, and I ignore small ones. . . . I often use the teacher's advice in dividing

or grouping her class and hope that she will gain by observing her children in a creatively freer situation than the classroom provides. In many cases, I have gained tremendously from the teachers. Other times, the teacher's attitude has been a terrific hindrance to free and playful working."[13]

The instructor just quoted, who has "gained tremendously from the teachers," is as it happens the museum instructor whose work and attitude the East Cleveland schoolteachers most warmly praise. Perhaps her own openness to learning from the schoolteachers and her lack of stress on the "model" role has something to do with it. On the other hand, a museum administrator-teacher who is also admired by many classroom teachers believes the residency would work well for everybody if classroom teachers served as model students:

We made it clear to the teachers that their role was to be as a student in the class, with the class; a special member of the class, yes, but nevertheless a member of the class. And they did not have a discipline role, they did not have an organizational role of any kind. That worked pretty well.

He doesn't claim it is the best system, only "that it is good, and I'd say it worked."

Another museum teacher says, "Most of the time I would prefer the classroom teacher to work as the children are doing or not remain in the room."[14] Striking a different note, a third studio teacher writes that "some of the best results on return visits have come from involving the class teacher in planning."[15]

At the request of James Birch, Sheryl King sent the following memo to East Cleveland teachers:

The Art Museum staff informs me that it would be helpful, to our program with them, if teachers are aware of the following points regarding their role in Art Museum classes: (1) Teachers are participants (along with students) in Art Museum classes. Children react better when they see their teacher as a student. (2) Teaching and discipline in Art Museum classes are the responsibility of the museum instructor, unless the instructor requests your assistance. I have found in my visits to the museum that when these points are adhered to the experience is more exciting for both student and teacher.[16]

Although she agreed to send the memo, the supervisor did not agree with or approve of the "model student" role for the East Cleveland teachers because she believes it too limited:

The skills of the East Cleveland teacher should be utilized. . . . That teacher should be a participant in the class, an active participant. If that means they can do some team-teaching type of thing, then they can work together. . . . When she's in a class she should be participating, helping the residency teacher if necessary.

The assistant superintendent, although wanting his teachers to gain from the experience, agrees that the role of "model student" is not quite right: "I'd rather not put them in that position because many of them have been embarrassed by their ineptitude with respect to some of the [studio] skills involved."

**EESY as teacher training.** Neither of the school administrators just quoted wishes to make an issue of role definition. In fact, King says,

I think the key is for [both sets of teachers] to get to know each other. For instance, if you're coming from school and three kids had a fight this morning, and you go to the art museum, and because you don't have a working, talking, communicating relationship with that staff member, you don't say, "These three kids were really at it so today let's keep them separated." Simple problem. You could do it and work your program or your lesson plan or whatever you're going to do that day, fine, but because that communication hasn't been established those three kids could ruin it for twenty-two other people in that class.

She goes on with the minidrama:

And the instructor is saying, "My God, what's happening? Is it me? That teacher's a poor teacher." And the teacher is saying, "My God, look at that instructor. He doesn't know anything about teaching these kids." They really didn't know each other, feel comfortable with each other, or really understand what that person had to offer. And it created some problems. I don't think they were massive problems, but it would have been a lot easier had this been done day one, week one. At least you set up that liaison time, so we can talk to each other.

The 1971/72 evaluation of EESY found it "moderately successful" as a teacher training program. That success was measured by lower absence rates; significant shifts to self-sufficiency, sophistication, and self-discipline; and moderate shifts to more warmth and flexibility—and toward some increased tension too. On this point the report observed, "The serenity that was discarded was unrealistic and . . . the concern and apprehensiveness adopted is consistent with being an effective professional."[17] On a happier note, Perney expresses the belief that the EESY teachers "have loosened up" and have learned from the methods and approaches of the residency instructors. He also observes that "the children have established a new kind of rapport knowing that the teacher is 'just another one of us.'"

What do the East Cleveland teachers themselves say? Their commonest request is for a closer working relationship with the "residency" instructors. They ask for more in-service workshops, demonstrations, explanations, and conferences—that is, more time and intimacy with their colleagues in the cultural institutions. Supervisor King agreed with the classroom teachers' clamor for more workshops and planned the 1974/75 year (though she would not be supervising it) to include workshops at every cultural institution.[18] She said,

All the institutions I talked to said they would be willing to

do that, . . . and they thought it was needed—not only for new but for old [teachers]. . . . So that this year the vacations will all be at the same time and at least three days of those vacations they are going to spend in retraining with institutions. They are going to actually be able to talk about what's been done, how you can carry over in a classroom.

### EESY children and parents: attitudes

In general, the East Cleveland schools and the museum shared the belief that the children's experiences in the museum (and in other residency institutions) would improve their attitudes toward themselves and toward learning in and out of school.

**The museum's view.** Most museum instructors believe that the program has been "effective" in achieving this goal, by which they mean that some of the children come back with their families and some sign up for museum Saturday classes, and that all the children seem more alert and more self-confident and "are generally enthusiastic and well-behaved. More importantly, they appear at ease and happy to be in the museum."[19]

A museum instructor who has worked in the program from the beginning described a 3rd-grade class in its third year of visits: "I have never seen any group of children as relaxed or ready to cooperate and become totally absorbed in the work at hand. . . . Both coming into the museum and leaving the museum, the children had outstretched hands for touching and many happy looking-around-again smiles."[20]

A senior high school intern, new to the museum and to the project, reported on a 6th-grade class at the museum for the first time:

[They] really came in with a chip on their shoulder the beginning of the week, but by the end . . . like I was really frustrated after the first day because I'd been working with the 2nd graders for two weeks previous to that, and they really appreciated being there, and they really liked you to help them, and it was really just great—and then these guys came in and they just, you know, didn't want to be there and they didn't want you to be there or anything. And by the end of the week—I think on Friday—really I enjoyed that class more than my 2nd graders because they had progressed so much. . . . It was really evident in just that one short week.

Only one or two museum instructors regularly question the value of "attitudinal" change. One asked, "What [possible] difference can it make when it scarcely touches the real problems these kids have—poverty, race, class?" There was weary acquiescence from other staff members, though occasionally one would say that "you have to start somewhere." The doubt nips at all their heels, from time to time, and makes them unhappy.

**The schools' view.** Most East Cleveland teachers expressed the belief, in interviews or in written evaluations, that

EESY's good effect on the children's outlook and behavior is manifest. According to the 1971/72 evaluation, both teachers and parents noted that the children talked more, and more effectively, were enthusiastic about school, and were much more adaptable and self-confident than they were before the project began.[21] An interim evaluation, covering the six-month period from October 15, 1972 to April 15, 1973, makes the following points: that students' favorable reactions to the residencies are reflected by low student absenteeism during residency weeks, and that "all teachers commented that their active participation with their classes at the cultural institutions has resulted in enhanced feelings of closeness and comradeship between teacher and students."[22]

The 1972/73 evaluation speaks of "the tremendous improvement of the participating students' self-concepts, self-esteems, and attitudes toward school."[23] All evaluations report a striking reduction in absenteeism—both student and staff—as the result of participating in the program. Dr. Perney reports an absenteeism rate among E&E students of about 2.4 percent, compared to a 5.6 percent rate among the rest of the elementary school population, and a university evaluator believes that the most dramatic statistic in the mountain of statistics gathered for the evaluation reports is "the abrupt drop in truancy."

Even those East Cleveland teachers who doubt the efficacy of the project for academic achievement—and there are some—acknowledge its impact on the children's feelings about themselves and about learning. A 5th-grade teacher who withdrew from the program ("personally tired and professionally frustrated," she says) reports she found the children in the program more disciplined than non-EESY students, and she found their major improvement to be in increased attention span and broader experience. A 6th-grade teacher acknowledges that she stayed on to be a "gadfly" and improve the program if she can because she believes it has so much promise. She believes the biggest "spillover" for the kids to be in behavior and self-esteem. She specifically mentions that the participating students became "more discriminating about what was offered" after the museum series.

Although statistically significant academic improvements are claimed by the East Cleveland schools, the school people generally agree with the museum staff that the project's clearest and most vivid, if least measurable, result has been its positive effect on children's attitudes and feelings. Perhaps a chronicle of one class can document the museum's efforts to encourage students to work well together, to think well of themselves and one another, and to recognize the link between attitude and accomplishment.

**An example: "Structure" may be the name, but . . .** In his class in "Structure," museum instructor Bill Ruffer tries to point out to 5th graders from Mayfair School the relation between the problem they have to solve and the way they organize themselves to study and solve the problem.[24] The problem: to make a structure 10 feet high that will support

itself. The materials: string and 18-by-24-inch sheets of white drawing paper. The instructions: to roll each sheet, tightly on the diagonal, into a "spindle"; to put three spindles together, by running a string through each, to form a triangle; to add triangles to each other to form a free-standing, three-dimensional triangle called a module; then to join together as many modules as necessary to build a single structure that can touch the ceiling. As Ruffer has written,

> I view my role as requiring me to carefully structure the class, motivate the child, supply all proper and needed materials, and then not interfere too much. I try to orient my classes around the task of problem solving, and sometimes also of group organization. . . . [For the structure class] I suggest they might be wise if they decide that certain people will perform specific tasks, such as the making of spindles, triangles, or modules, or the construction of the main structure . . . [and I recommend] prefabrication . . . since the final structure is too delicate to be worked on directly.

> Once the goal is clearly outlined, the means for attaining it are thoroughly explained, and all questions are answered, the class is left completely on its own. . . . Always too many spindles are made, probably because they are the easiest to make. As modules are completed the structure lurches vertically in fits and starts. By the time it is a few feet off the ground a lucky class will recognize its leaders, those who intuitively understand how the structure must be built, and they will supervise the building. Meanwhile, spindles are created as if they alone could bring success while triangle production lags. No class has been able to fully coordinate this effort. When time is called the structure generally reaches a height of seven to nine feet. No matter if the height is less, the students are always swelled with pride since each thinks of the structure as his/hers and it is larger than they are.[25]

An observer watching the class spend one of its ten museum days building this ambitious structure notices several things. The instructor has set two sophisticated problems: how to construct something out of almost nothing, and how to work in a group. Most of the children do not readily see either the relation between the two problems or how to approach them separately. Those who do make an impact on the others by the end of the two-hour class. The spindles pile up; there is a considerable amount of scurrying and order-giving; and, as the final structure begins to take shape out in the corridor, the level of excitement rises.

The tallest girls and boys are hustled to the structure and helped up on chairs so they can try to attach new modules. An assembly line somehow gets set up—with no help from either schoolteacher or museum instructor—and new modules are brought out from the classroom studio. The wobbly ones are impatiently rejected, the firm ones handed up to the student standing on a chair. The student adds them, carefully, slowly. The children assembled in the corridor hold their breath, give sighs of relief when a module stays in place, and gasp with dismay when one tips over and threatens the precarious structure. One child industriously making spindles in the studio refuses to leave the task he has set himself; the spindles pile up relentlessly behind him.

In the corridor the excitement rises to near-fever pitch; Ruffer's major responsibility becomes restraining the class from a kind of mob frustration/mob ecstasy—only two minutes to bus time. The tall, heavy-limbed girl who has accepted the responsibility for the delicate task of attaching the last modules to the now immense structure leans over, and, tense with emotion like a new mother putting the angel on the top of her family's first Christmas tree, places the final module. It holds.

The class roars with approval, the students applaud themselves and each other. The heavy girl steps down, carefully, from her chair and steps back. She is radiant. Even the diligent spindle-maker ventures out to see the fruit of his labors and smiles. One module slips, then another; the children suddenly quiet down; a few gasp. One rushes to the structure as if to hold it together by sheer will power, but the modules at the top slowly slide sideways. The structure no longer touches the ceiling but it stops trembling; nothing else slips. The children sigh with relief and leave for the bus.

Watching his students that morning, the East Cleveland schoolteacher called the basic value of the class "teaching the kids to solve problems." He believed it was good "therapy" for the troubled kids and good training for all of them. Writing his evaluation of the entire week inside the museum, he said,

> Teaching students how to go about solving problems (whether it be in math, English, or in life) is a paramount task of a teacher, or any educational program. These activities also forced the students, at times, to work together, constructively, to achieve a common goal. Learning [sic] students how to cooperate and work within a group is another important task for educators. . . . The Art Museum experience, in general, served to educate and enrich the students' understanding of themselves, of others, and the world around them, and the relations between these. Their Art Museum experience will undoubtedly carry over to their school work and home life in positive and constructive ways.[26]

**And the parents.** One of EESY's goals has been from the start to encourage the parents of East Cleveland schoolchildren to take an interest in the schools and to foster their confidence that the schools can provide their children with ways to improve their lives. In the interim 1972/73 evaluation, teachers reported that the periodic week-long vacations were especially useful in encouraging relations with parents, and that parent conferences, in which "parents seemed more relaxed and asked more questions," could be "more leisurely, with more time for a real conversation."[27]

One aspect of the original effort to encourage parents' interest was the schools' desire to have parents assist as vol-

unteers. A principal at one school says that parental involvement, though visibly more intense, rarely results in volunteer help. On the other hand, a 1st-grade teacher says the program has involved many parents intimately who *do* volunteer to help, taking home work they can do for the teacher and the classroom.

The 1973/74 EESY coordinator says that when Title I evaluators descended unexpectedly in fall 1973, they wanted to meet with parents. "So the parents were called, just to show up at the meeting and talk about it, because," she explains, "they just wanted to hear what parents had to say about the program." Expecting no more than 30 parents on such short notice, King and the other school people were startled when 200 showed up:

There was no written notification, nothing. And the parents became very upset when one of the evaluators described this as a remediation program and "your child isn't reading at this grade level." "What do you mean?" the parent said, you know—because the parents don't even view it as "I know that Johnny is having problems in school" but as "I know now that he's happy about being in school."

Most of the parental involvement, and all of the work with parents, is outside the museum's ken. The only regular meeting between the museum and the parents of East Cleveland students takes place once a year when the museum holds an open house—a combination reception and opening of the exhibition of students' work. The first year there was a small reception for the children from Chambers School; the children acted as guides to their parents, showing off favorite objects and displaying every sign of being at home in the museum—a distinct contrast, as one university visitor observed, to "some feelings of alienation on the part of their parents in this rather formidable and impressive building."

The largest and most successful open house was held during the second year: on a rainy weekday evening in March 1973 more than 700 parents came to the museum. Many were there for the first time in their lives. One small boy pulled his father over to a Buddha, a plump white marble T'ang figure of ineffable complacency. The father, a dark heavyset man in a damp denim jacket, dutifully admired it and listened to his son's rattling commentary. His hand on the boy's head, as if to restrain the sound for a brief minute, he said to the museum instructor in the gallery, "Willy just said I had to come and see this where he's been at this year. Works my second job at night and I had to take off tonight, or Willy would have never give me no peace." He smiled and nodded, the instructor smiled and nodded, and Willy dragged him off to look at the Chinese paintings.

### For EESY's children: academic record

In its strong support for EESY, the East Cleveland school system banked heavily on the program's effectiveness in raising students' achievement scores. The museum staff generally regarded this goal as far beyond what its own part of the program might accomplish, and took no public position in the matter. (A few staff members privately dismissed the goal of higher academic achievement as "bureaucratic" justification for the grants; a few others, who esteem academia, questioned the program's pretensions to solid academic achievement.)

**What testing showed.** The official evaluation report of EESY, issued in 1974, reported statistically significant gain scores for the EESY children, based on the Stanford Achievement Test (SAT)—a "very stringent test of any educational program's effectiveness."[28] The report declared,

At each grade level for each subtest of the Stanford Achievement Test,[29] the E&E students were compared with all other students in the East Cleveland elementary population as well as with non-E&E program peers within their same elementary school. In both types of comparison, the academic gains of the E&E participants significantly exceed those of nonprogram participants, varying with the specific grade levels and the specific SAT subtests.[30]

For the 1971/72 school year, the official evaluation showed
• For 2nd graders, "highly significant, positive effect" on achievements in language and reading.
• For 3rd graders, much more modest effects.
• For 4th graders, "a most startling unsurpassed effect." On virtually all subtests, E&E 4th graders ranked significantly higher than 4th graders in all six East Cleveland elementary schools and non-E&E 4th graders in their own schools.
• For 5th graders, almost the same pattern of gain.

For 1972/73, the evaluation showed
• For 2nd graders, no statistically significant growth in comparison with control groups.
• For 3rd graders, several areas of significant growth, greater than the preceding year.
• For 4th graders, several areas of significant growth.
• For 5th graders, significant gains in more academic areas than any other E&E participants, paralleling the 1971/72 gains.

More specifically, according to the East Cleveland schools' own 1971/72 evaluation, EESY students in grades 3 through 6 averaged a 40 percent improvement in their rate of learning over that of the general elementary school population during the given year. Instead of testing out at a six- to seven-month annual learning rate, the E&E children tested out uniformly higher: at an eight-month annual learning rate in 2nd, 3rd, and 5th grades; at one full year in 4th grade, and at 1.3 years of learning growth in the 6th grade. When the 1971/72 report says that "project students . . . have made a notable departure from the pattern which characterizes the system and have shown a strong effort to move toward national norms,"[31] it is more modestly translating the astonishing 40 percent improvement in learning rate. Results obtained by evaluators in 1972/73 gave E&E students in grades 2 through 6 an edge of 37 percent over the rest of the system's

elementary school population in average rate of learning.

The fact remains, to be sure, that the EESY students are still below grade, but not so far below as the rest of the East Cleveland students or children around the country in similar situations.[32] The national norm for a child completing 6th grade is 6.9 or just a month shy of 7.0 (or 7th-grade work). The East Cleveland norm, however, is 5.0, or nearly two full years below grade level. So when in the East Cleveland schools' evaluation for 1971/72 the E&E 6th graders tested at 6.0, they were still one academic year—or nine months—below the national norm but a full academic year above their peers throughout the school system.

**A surprise for educators.** Of patterns emerging from these statistics, the one that aroused particular interest in both 1971/72 and 1972/73 was that EESY apparently produced the greatest positive advances for children in the upper elementary grades. As the official report stated, this effect was

rather unexpected and, frankly, quite exciting. Most educational programs yield their largest results at the lower elementary, primary grades, when students are still relatively "turned on" toward school, when students have not yet "missed out" on much academic learning [and] the cumulative academic deficit has not yet reached its highest toll, and when students have not yet experienced repeated failure.

These findings contradict the widespread belief that educational patterns are pretty well set by the end of the 3rd grade and that no efforts—however costly, imaginative, or diligent—at the upper elementary level can achieve much. But it was precisely in those grades, where success has been believed unlikely, that the East Cleveland project made its most dramatic gains. It was largely to refine these findings in 1971/72 that the 1972/73 evaluation report was undertaken for, according to a member of the university evaluation staff, "they knew something was happening, but knew the first evaluation had not shown what."

In contrast to the surprising achievement the tests showed for the older children, much more modest advances were noted for the 1st and 2nd graders; the 1971/72 evaluation claimed only a 12 percent improvement in their rate of learning. The East Cleveland staff was disappointed in this apparent discrepancy. But the museum staff, untroubled by statistical findings, urged that 1st and 2nd graders continue in the program, and some did come during 1972/73 and 1973/74. The reason for the museum staff's interest in the earliest grades is consistent with its general goal for the program: that it is never too early to offer children a wide and affectionate exposure to a larger world, art, unfamiliar places, and new personalities.

**Qualifiers and reservations.** Everybody is scared to death of claiming too much for the East Cleveland City Schools' primary objective: higher academic achievement. In the first place, "as with all federal programs, once those students are at grade level—that's your goal—then they are no longer qualified to be in that program," in the words of one administrator. Until the federal government risks funding successful programs beyond the point of no further return, the East Cleveland administration is going to be very modest about its official claims—despite the bursting pride it makes little effort to hide. Even Dr. Perney, who relishes the success of his idea, cautions,

Now I don't want to claim that there's any one panacea that is going to solve all problems, and therefore I'm not saying that this program is going to make all children achieve better. What I'm saying is that the results do indicate that the majority do improve. . . . But there are about 10 percent of the children who are in the program who do not seem to show any progress.

As for the evaluation procedures themselves, who can be certain what they prove? A member of the university evaluation team—which used the Purdue Teacher Opinionaire (Form A) and "Thinking Creatively with Pictures" by Paul Torrance (Booklet 1)—notes, "If teachers rate creativity, it appears to correlate with competence—that is, with SAT results and maturity tests; but children who rate high on the Torrance Creativity test appear to rate low on those other tests." She raises a question to which she has no answer: whether teachers see as "creative" those children who are competent, and cannot believe that immaturity and incompetence might go hand in hand with creativity.[33]

A schoolteacher sharply questioned the evaluation statistics because "the best teachers chose to go into the program in 1972/73. Therefore the program seemed very effective as the kids' scores went up briskly." Another teacher, the one who characterizes herself as a "gadfly" and is admired by the museum instructors as "dynamite," says she can give a specific example of "cognitive" learning: "Art is a primary way for kids to learn about things like cuneiform, arabesques—you can talk till you're blue in the face, but when you *see* them, you don't have to talk any more." But, she adds, cocking her head to one side, "any testable educational benefits were incidental."

## V. Museum Program in Action: The Visual and the Verbal

Another way of looking at the East Cleveland Project is to examine the museum's way of handling such basic elements of the residency as the visual arts and language skills.

### Visual arts

Only the museum has taken a significant interest in what the children learn about the visual arts. Consequently, there are no statistics, no verifiable measures; not even the "creativity" tests administered by the university evaluators have been shown to the museum staff. The only real sense of any impact the museum's visual arts program may have had on

the children's art work at school, or on the classroom teachers, comes from the enthusiastic assistant superintendent:

> Our teachers the first day they were here came back, and they were absolutely flabbergasted. They said they didn't believe it possible to have an art lesson where the child was allowed to be creative in what he wanted to use as a medium and what he wanted to develop. Usually what we do is say we're going to draw a snow man, now show how creative you can be in drawing a snow man, but we would never dream of saying here are four or five different kinds of things you can use, some are arts that you can draw, some are things that you can paste together, some are things you can cut up—now I want you to go ahead and do something with it, to come up with an idea. . . .

> Our teachers just never believed that students could do it in an orderly way. And when they came back the first time they said, they have all these art supplies out and they told the children what to do and they all went about doing it, and we thought it would be absolutely chaos! And it was absolutely the most orderly lesson they've ever had. And they said, that's true creativity when you come in and say here's the materials, here's the subject, and here's what you have to do—how can you be creative?

The museum instructors are in general and devout agreement that the collection is at the heart of their teaching. Some comments from museum instructors document what the East Cleveland Project includes in "education in the visual arts."

From a sculptor and experienced art teacher, Gerry Karlovec:

> An effort to relate the [print] collection, the majority of [which] are sophisticated in technique, [and] coordinate a lesson that would at least contain an analogous learning experience was difficult. . . . For some of the younger primary grades, I used a painting (Rousseau's *Tiger Attacking Water Buffalo*) stressing the shapes of the leaves and the repetition of the shapes of the leaves and the repetition of the shape on a single plant. I then attempted to relate the shape concept and repetition through printmaking. Individual leaves were cut from cardboard, then "inked" and pressed onto a background of construction paper. . . .

> As far as the clay classes went . . . I seemed to rely heavily on both the ancient Oriental section and pre-Columbian for relation of gallery and studio work. The early clay bowls, jars, and funerary offerings of the Oriental seemed to be a good kicking-off point for form, whereas the pre-Columbian collection (especially the two incense burners) was terrific for decorative application of the additive process. When the spirit so moved me I would base a lesson on some two-dimensional work if the subject matter seemed especially good to use for motivation; for example, having the students react to city planning and cityscape paintings in order to get them to clarify their thinking on subjects appropriate to their clay cities. Techniques I used were coil pot, pinch pot, slab construction,

relief-type sculpture with both additive and subtractive methods. . . .

> I also believe in giving the class sufficient motivation, be it verbal or visual or both, before they begin working. Also because of a strong Art Ed background I usually always base a lesson on a specific art concept—as simple as "blue is a cool color" or complicated like "textures can be created on a two-dimensional surface by using various kinds of lines."[34]

A teacher especially interested in painting and weaving, Sue Kaesgen, reports on several different class projects in the museum:

> First visits centered around process, handling materials used in actual studio production; we've made paint with eggs and oils, earth and dried pigments, we've dyed wool with elderberries, goldenrod, walnut husks, and an entire year's supply of onion skins. When we looked at the African textile exhibition, the children could easily tell aniline dyes from natural ones.[35]

Ms. Kaesgen set one class to making pigments by grinding up moss, pounding together rocks containing yellow ocher or other mineral ores, and crushing charcoal, then to mixing their pigments with beeswax, bacon grease, egg yolk, or other vehicles to make their own paints. The following day she took them to the galleries to look at different techniques: Greek encaustic painting on shrouds, medieval egg tempera miniatures on illuminated manuscripts, a Rembrandt portrait in oil, and a Degas chalk drawing.

With very young children, 1st and 2nd graders, in one of the "Art, Words, and Movement" classes, Marlo Coleman works on shape:

> We begin in the classroom talking about shapes in the world. We draw them in the air and find them in the room. It's like a game. Soon everyone has found a shape they want to share. "Using your fingers, can you make any shapes? Who can put their whole body in a circle? A triangle? To the beat of the drum, who can walk across the floor in a circular pattern? What feels different about a square and round movement? Which seems busier?" We discuss abstract shapes: blobs, drips, clouds. "Who can be an abstract shape?" As we move through the galleries, I have them notice shapes in the ceiling, out the windows, and in the paintings. We talk about abstract paintings, how these feel, what they suggest. The children come alive as lines, shapes, movements, congestions, and explosions. In groups they choreograph the movement or mood of pictures to my music.[36]

Bill Ruffer relates his lesson on structure to the sculpture collection and the students' ability to look at and understand sculpture:

> I have found that some understanding of almost any piece of three-dimensional art is available to the students if they answer this initial question: "How does it get up off the ground?" Having just built something in the studio which got up off the ground, they are prepared to recognize other

questions which follow. . . . "How much does it weigh? How much of it is air? Where is the weight? Is it balanced?"[37]

## Language skills

Under grants awarded to the East Cleveland schools in 1973/74, as part of the federal "Project Learn," a major goal is the improvement of the children's language skills. Besides "Art, Words, Movement," the museum offers a special course dealing with language— "Creative Writing." Most of the museum instructors also try to incorporate word games, new words, verbal instruction, and plenty of conversation into their lessons.[38]

Take, for example, a 4th-grade class in the museum, as described by a high school intern in her journal. The museum instructor decided to teach three difficult words, "transparent," "translucent," and "opaque." (This triad is a favorite among teachers in the upper elementary grades; to explain the distinctions, most use a simple classroom example like the clear window pane, the ordinary window shade, and the room-darkening shade.) The journal continues,

[In both classes,] "transparent" was familiar, the other two were not. We handed out pieces of clear, heavy plastic to which the children pasted (with a glue that dries clear) different colored shapes cut out of cellophane, crepe paper, and construction paper. . . . [The next day] we took them through the galleries, showing them different things that were made of glass, enamel, or that were glazed (transparent, translucent, and opaque). These included the small rock-crystal goblets, the gold-glass Alexander plate, the medieval stained glass windows, the Greek blue glass vase, and the Tiffany stained glass window . . . and since a lot of them live in late nineteenth early twentieth century houses where stained glass was used a great deal . . . they all had to tell me about their house, or their cousin's house, or the house belonging to the rich people next door, who subsequently moved, etc., and about the stained glass inside. They were all just dying to have someone listen to them.[39]

Another class, as described by its instructor, fully demonstrates all the words in its title:

"Art, Words, and Movement" in the galleries is a lot of talking (exclaiming), a lot of movement (occasional frenzy), and some joyous moments of perception/communication, the *real* art. The class might really be called improvisational gallery work. My aim is to make the art objects of a museum seem alive, interesting, and useful to children. I would like them to learn to really *look* at objects, in both the gallery and the world at large, perhaps *seeing* the shapes, subtle colors, story, and other secrets hiding there. . . .

I often begin with free and open conversation about certain works of art and then throw it out to the realms of the body. "Who can really be a hunk of wet clay? Who can be inside of a square? How does it feel to be gray? To be red?

Who can show me the way *that* shape would act if it came *alive*? Can three people show me the *before* and *after* of this painting? Who can act out this character?" . . . [Then] I can divide them into groups and have them act out or write about a particular object. During this time I talk with them, asking questions, giving some information about artists or specific art works, encouraging wildly imaginative responses. I usually give a studio art project at the peak of class involvement and enthusiasm. They are ready to apply what they have imagined or absorbed, and I can talk quietly with each child and with the teacher.[40]

Museum instructors who teach 1st and 2nd graders resort to all kinds of devices and lures. One, pointing out the difficulty of creative *writing* for such young children, makes use of what she calls word collages—"quick verbal exchanges of descriptive words."[41] Another uses rebus puzzles and word games.

It was fun, and it was rewarding because we didn't have to deal with the traditional way of writing. . . . We were doing sign writing, and they liked this. . . . They were really thinking, because they had to figure out a way to say something without the use of letters, and I think it was better than working with letters.

As for older children and their "creative writing," one museum instructor revealed discouragement with what she found and what she was able to accomplish:

Maybe in 3rd or 4th grade they're charming and innocent, but by 5th or 6th you can already see how common are their ideas, their languages, their poems. I take what will happen to them later seriously—it's not enough to amuse or entertain them. . . . They care so little about words— when we tried to "write" a play, using two paintings as the actions and thinking up lines for them, their lines showed no compassion or kindness or sensitivity to feelings or words.

By the end of the year, the same instructor found her initial discouragement reinforced:

[Maybe] our expectations exceed the reality of the situation. But I think that writing, creative writing, is something that requires certain basic skills and certain basic vocabulary, command of the language—skills which we assumed that the students in 5th and 6th grades had acquired before they got to us. And I think we were disappointed in that. There are . . . lots of ways to communicate and lots of ways to be creative, physically or visually. I think that . . . writing . . . is probably the weakest area in which these kids can be creative. Even discarding spelling, discarding punctuation and things like that.

Another museum instructor meets with her 5th graders in the classroom and talks about landscape—how our senses register the details of light, time of day, what we see—then goes to Frederic Church's *Twilight in the Wilderness* in the American gallery. In front of it, with the children sitting cross-legged on the floor, she talks about the sunset and asks them to "go into" the picture, think what sounds they'd hear

and what it would feel or smell like. "How would you get into this picture?" The children are responsive verbally, but when paper and pencils are handed out they are shy. She encourages: "Choose how you might feel, short words, you don't have to have sentences, you can draw after you write, don't worry about how it's spelled." She uses ideas behind words, almost as illustration for the pictures, rather than focusing on sounds of words (or nonsense sounds). A sample piece of writing from the class: "The Sun Raise—One morning I got up before the sun raise and I went down by the shore to watch the sun come up."

One instructor takes a 2nd-grade class into the galleries and, sitting down with them before a Hans Hofmann, *Smaragd Red and Germinating Yellow,* and a Mark Rothko, *Red Maroons No. 2,* talks about contrasts in sounds. Guess, he suggests, guess which painting would be noisy and which quiet. "Maybe you'd like to think about real words, or make-believe words, fast or slow words that you could hear those paintings saying." And the children, spread on their stomachs across the gallery floor, paper and pencil at the ready, devise: Pummp. Uvolcomendock. Pasooca. Ploco. Big-labuylamoomoomoom. All of this satisfies, indeed delights, Lawrence Perney:

> A child has to grow in his ability to write, speak, and read simultaneously, in all three areas, or he doesn't really develop the skill properly. . . . And when they come here [to the museum] they are learning vocabulary. The [classroom] teachers are asking them to keep diaries. Now they don't view this as a language lesson; they view this as part of the report that is associated with coming to the institution so they can take home and show their parents, or the teacher can keep a record of what they're doing.

> But in effect what we're really doing is we're teaching children to write. That's our goal. Now they don't know this. That's a hidden objective. The teachers know it. The teachers are told, get them to speak as much as possible with as many adults as possible, on a one-to-one basis between themselves as peers, or in groups, or with adults. . . . With increase in spoken facility comes increased fluency in writing, and when they develop their ability to write they improve their reading skills automatically.

## VI. Meanwhile, Back in the East Cleveland Classroom . . .

Presumably, if the museum experience is to bear fruit, the classroom teacher will somehow build on it when she brings her children back to school.

### Three classroom vignettes

**October 1973:** 5th graders, most in their second year of the program, have already completed the two separate weeks of morning classes in the museum. There they greeted last year's instructors (wriggling with pleasure when the instructors call them by name—"She remembers us from last year"—forgetting that each child wears a name tag), tried to act out strong feelings without words, to draw their dreams or abstract shapes and lines that look like their feelings or the movements of their bodies, tried to build a structure that reached to the ceiling, looked at big paintings and small clay bowls, walked through the empty spaces in huge sculptures and around all the sides of little metal figures, visited the museum's greenhouse.

Now they are back in the classroom. It is a second-floor room, as befits 5th graders who can take the steps a half-dozen times a day and leave the first-floor rooms for the little kids. The room is large, sunny; dust dances in the afternoon light. Desks are in straight, orderly rows; the children sit according to reading ability. The teacher confides to a visitor that they read at 3rd, 4th, nearly 5th-grade levels; one student, out of twenty-three, reads at 5th/6th-grade level. A beginner who did her student teaching at this school last year and requested placement here, and in the E&E program, the teacher is a little flustered by the visitor's presence, even after several days of visiting back and forth in the museum and classroom. She controls the orderly classroom: "Don't get out of your seat without the teacher's permission." She makes assignments with specific deadlines, spells out the punishments for failing to meet them. She reassures the children that they are "not behind in anything because of the field trip."

On the blackboard are pictures of the moon and planets, neatly mounted on bright paper, carefully arranged. (These children have just had the "Structure" class at the museum and have talked about being stranded on a strange planet; no one comments on the pictures when they return to class.) On one counter—the "art area"—are straw triangles; the teacher has tried to work out an art project based on the museum class on shapes. The boys in the class say it's "easy"; they groan when she announces it's time for them to finish that project and another which involves winding yarn. The children have more freedom during the art project time than at any other time. Usually the teacher allows very little talking, group work, or activity, but when it's time for the art project, she announces, "You can talk a little, because it's supposed to be free."

**January 1974:** 1st-grade classes, first-time museum visitors, first month of a new year, the freshest of fresh beginnings. Two teachers arrive, one young, casual, relaxed but reserved; the other, an older teacher, seems very conscious of the noise her students make, interrupts quietly and often to hush them. The children, who had been so tired that some had reverted to thumb-sucking, have grown hardier by the end of their first several mornings, but all still wilt perceptibly between arriving and leaving time.

One of their ten mornings: The young teacher's class sits in a circle, talks with the museum instructor, and the talk turns to color. The instructor asks, "What do you like because of its color? Food? Flowers?" One white boy (the only one) in

the class says his favorite color is black. Chorus from the class, "No-o-o." And then one black boy says, "black is beautiful," and everybody cheers. She turns to shapes: they see doorknobs, patterns in ceiling tile, and in the wooden floor; the children are inventive and excited to discover shapes around them. Then to the gallery: to a Morris Louis, then an Albers painting. "Do you think these colors are friends?" she asks. "No," says one boy, "they're a family." Back in the studio (by 10:40, with plenty of time left), children set to work, quickly absorbed. The volunteer aide (a mother) who has accompanied them thinks they are allowed to make only one picture each; the museum instructor assures her there are extra pieces of paper.

Back at school, in the younger teacher's room: The children put their heads down, resting in a darkened room. When the bell signals the end of rest period, she plays a record and asks why they think she has chosen it. Many know the words, sing along—they must know it, or must listen very carefully, for the words are not entirely clear. It is about a greenhouse, deals with solar rays, heat, glass: she is making a science use of their first day's trip to the museum. She asks the children to come around her in a circle and talk about the trip, so they can write a letter to their parents: "We didn't *just* look around!" Children remember *in order* as she coaches them to think in order: getting off the bus, seeing the guards, getting in the huge freight elevators ("Big enough for the jolly green giant," one boy chortles), seeing the sculptures ("A statue, that's why it's not a painting," ventures one child), seeing stratus clouds and the museum building's striped grey walls, hearing a story about a knight (which she reminds them of), seeing a sword, seeing a movie (slide-tape) of a mime who acts out rules about museum behavior. They repeat the rules: no sliding, just walking; touch with eyes, not hands; be polite to others; no gum, no food.

The older teacher's room: The teacher seems flustered at the visitor's arrival (though the appointment has been arranged days earlier through the principal), so the visit is brief. The room is not well-provisioned; no art area, no record player, a small stack of books. The children are noisy, restless, keenly conscious of a visitor in the room. All work on math papers, but those who finish early rarely occupy themselves, as there are few resources available. The teacher is kind, helpful to individual students as she moves from desk to desk. Noting several students unoccupied and restless, she says to them, "We do one thing at a time here."

Both of these 1st-grade teachers cover all subjects for their children; the school has no art or gym teacher. Otherwise, they seem to have little in common. The one teacher so pressed, harassed, feeling each child in her room so dependent on her for ideas, motivations, assignments. The younger teacher already training her children to be independent— they are quiet, occupied singly or in groups, able to use the many resources she has furnished her room with. They clean up in teams, know precisely what is expected of them by their quiet firm young teacher.

## What's the answer?

Who is supposed to help these classroom teachers, once they are locked into their rooms with their students, use the experiences of the mornings spent out in the city? Is it the "model" instructors in the museum? Is it someone in the school building? Is it someone assigned to the job by the E&E supervisor? And whoever it is, where is he or she?

Perney says that responsibility belongs to the E&E coordinator, that it is a "full-time job," inadequately done in 1973/74, for the coordinator "was not in close enough contact during the year with the individual activities in the classroom." King herself says "the principal is really responsible for teacher supervision. There is no one person per se who can go in and say you should be doing these types of things." One of the few East Cleveland teachers who have harsh things to say about the program believes that its greatest weakness is that there was "little or no correlation between institution and classroom lesson." A more cheerful teacher said she thought her class was "just lucky that the art museum visits related to the social studies curriculum," but she notes that the "commonest complaint" among EESY teachers was "that the school administration didn't consult with them." A former 1st-grade EESY teacher believes that workshops for the teachers "would have been useful—but there were none." And a new teacher struggling to make something of her 5th-grade classroom? She says, wistfully, that she wishes the residency teachers might have come to EESY staff meetings.

Is it the responsibility of the residency teachers—that is, the museum instructors and their counterparts around the city—to go into the classroom or in some other way to work with the classroom teachers? As designed, the project depends entirely on school staff to do that job. As executed, the school person assigned to the task found no time to do it adequately: 60 teachers in five schools were just too much. Asking that the residency teachers help with that job, Sheryl King cites an institution that joined the program in 1973/74 and sent one of its own staff to each school to talk with the children and the teachers and prepare them for the new experience. This seems to her ideal.

Does it seem so to museum staff? Some of them are unwilling to accept the responsibility for going out into the schools, convinced as they are that what they have to offer is primarily inside the museum with its collections and studio rooms—for the children, a new environment. Others are willing to go out into the schools, at least to establish contact with the teachers.

A teacher of teachers observing the East Cleveland program in the Cleveland Museum is pessimistic "about the long-term effect of the program on the kids if the classroom teacher doesn't build on the museum experience." Obviously there is need to forge stronger bonds between what goes on at institutions out in the community and what goes on in the schools. Many hopes hang on the success of the 1974/75

workshops for schoolteachers and residency instructors scheduled for several days of the week-long intervals when the children are on holiday.

## VII. The Project's Impact on the Museum's Education Staff

Unintended consequences follow on every human enterprise. Perhaps the most unexpected consequences of the East Cleveland Project in the Cleveland Museum of Art are the changes wrought in the education department itself. A wise observer might have predicted such changes. The museum education staff did not, although, by the testimony of the instructors involved, the changes are substantial, salutary, and welcome.

Associate Curator Birch says, "What the East Cleveland Project has brought in [is] a different kind of staff member, and a different mentality within the department." A staff member—who watched the program develop without her, asked to join it, and is now one of its mainstays—speaks of the value for teachers of participating in many different kinds of teaching:

You can't expect a teacher who's creative and bright to do eight one-hour tours a week, four of which may be intros. But give that teacher a variety of different kinds of teaching—it makes the work more interesting, and they grow. Everyone here, I think, has said that they felt they grew.

It was challenging, I think, from the point of view of the teaching staff and the kind of enthusiasm you want in a department, the kind of ideas you want generated. . . . Look at this department even before the project, five years ago. I don't think there were the ideas, new ideas, being generated, people really being thoughtful about teaching and reaching the kids. There was much more emphasis on learning your information. Now there's a different kind of thrust, so I would say that this kind of program has done a tremendous good within our department, the quality of our staff.

A dancer and art history B.A. who worked only during the 1973/74 year agrees that, from the museum instructor's point of view, the program is worthwhile: "It really forces you to think in many different ways about galleries, and that's one of the excitements of it." A more seasoned teacher, almost as young but with some experience in a Montessori school and two years in the East Cleveland program, argues that for a teacher the excitement of such a challenge is not selfish but part of "getting high on teaching"—the chance to experiment and work with other people.

### Effect on hiring

Clearly, the East Cleveland staff at the Cleveland Museum of Art has experienced some of those intense feelings that develop in any group of people absorbed in working toward a shared goal. They cherish one another and the work they have done. But the seven staff members hired especially for the project are scattering now—most are young, still searching for things to learn and try, for other experiences. The staff left behind has rather decided ideas about hiring replacements. According to one museum instructor, it is possible for a department that opts for both kinds of teaching—lectures and the East Cleveland type of teaching—to hire people with the requisite qualifications for the two different categories. For the second category, the experience and recommendations count more than academic credentials. He says,

It just has an awful lot to do, I suppose, with the person who does the hiring just having enough insight to know when somebody extraordinary walks in the door. It's just somebody with a great feel for people, an ability to see a lot in people, not just something mechanical on paper.

The "person who does the hiring" is Associate Curator Birch. His ideas on who should belong to a museum education department reflect his double background as a painter and as a school art teacher:

A great problem of museum education is that we don't have enough educators, just teachers [who are] not art historians, you know. They didn't have their Wellesley art history degree, and want to work in a museum, and end up teaching kids. [But] you *can* get a person who adores art history *and* lecturing and all of that, you can get them all wrapped together; they're not that hard to find.

For anyone undertaking something like the East Cleveland program, he adds a warning note about hiring: "The institution has to recognize that from the beginning they have to go out and get a staff to do this project. If they think they're going to take the staff they've got that's set up for other things, . . . then it's going to fail." By his own admission, he trusts his instincts and is partial to hiring artists and teachers who have had real day-to-day school experiences with children; he insists there is no substitute for that, even in a museum education department. (Quite clearly, his major field of responsibility is young people's classes; another curator is responsible for adult education.)

Teachers he has hired say they share his intuitive approach to hiring and supervising teachers: "First of all," says his assistant in the East Cleveland program, "it's important to hire teachers who are very individual." Another: "I think the strength here has been the fact that every person hired is an individual, and this has been where the great fun for me has been. Nobody has asked me about what I have to do. I can do what I want and feel free."

### Effect on traditional program

Any museum educator or administrator will wonder about the impact of the ambitious East Cleveland program on other school services rendered by the museum's Department of Art History and Education. Figures for 1971/72, 1972/73, and 1973/74 indicate that the number of school classes coming to the museum has dropped a little, although there is no evi-

dence to link the 5.5 percent from 1971/72 to 1972/73 or the more dramatic 18 percent drop in 1973/74 with the East Cleveland Project. As additional staff was hired for the project (and paid out of the special grant), and no cuts were made in regular staff, the drop cannot be attributed to any drain on the education department by East Cleveland's requirements. The first and smaller drop remains unexplained, although the second and more dramatic drop seems closely related to the large numbers of classes canceled because of the gas shortage. (Despite all assurances to the contrary, by the energy office and various arts offices in Washington, many art museums experienced abrupt cancellations of scheduled school bus trips in 1973/74.)

**Effect on new programing**

In his evaluation for a university team, Bill Ruffer, an assistant supervisor of the East Cleveland project at the museum, wrote,

> We are encouraged to begin new programs based on our East Cleveland experience; for example, the University Circle program (see below). Also, our belief in the desirability of offering programs of intense involvement for visiting groups is supported.[42]

Education is no longer considered by the staff to be primarily lecturing, nor just for one hour, nor just working with suburban schools,[43] nor the one visit a year, nor even the social studies adjunct that it has previously been. Though the museum has not yet actively sought clients for its new ideas, department staff welcomes opportunities to try out their newly developed skills and new free-wheeling approaches.

Perhaps the most systematic application has been in the University Circle Project, which serves students from Title I schools in the immediate area—an area of low- to lower-middle-income blacks and ethnic whites—including Cleveland public schools and Catholic parochial schools, grades one through twelve. Though money for transportation and lunches is provided by a local foundation, the museum pays for materials, instruction, and other services out of the education department budget.

The idea was initiated by the arts program director of the University Circle Center for Community Programs, a group organized "to provide to school children, their parents and teachers, the opportunity to visit the many institutions in the University Circle area and introduce them to all areas open not only to themselves but to everyone in the surrounding communities."[44]

The Cleveland Museum's part in the University Circle program began modestly with six two-hour classes in the spring of 1973, in which the museum instructors, as the museum's report on the project says, "chose to do classes related to their special talents . . . often projects that our teachers had wanted to try but hadn't had a previous chance to try." Judging these first classes a success, the education staff set up an enlarged program for 1973/74. The report continues wistfully, "As this is our only special project that deals with

Cleveland schools, we hope that this will be an on-going project."[45]

Less successful was another new undertaking with some of the elements of the East Cleveland Project. It was proposed to the museum, and to two other Circle institutions which participated in E&E, by the Cleveland Council of Independent Schools. Called EPIC (Educational Partnership in Cleveland), its stated objective was to provide quality education for students in independent schools and children in an East Cleveland school. Implicit in EPIC was a desire to integrate white and highly privileged students with poorer and largely black kids. Now it happens that the East Cleveland school participating in EPIC was the *only* East Cleveland elementary school not included in E&E; by East Cleveland standards, that school is better, or luckier, or whatever word one chooses in the interests of tact, than all other East Cleveland schools:

> This one school . . . consists of less minority children as well as less children of lower socioeconomic family background. This school has a higher mean I.Q. level among its student body, has far less turnover among members of the teaching staff, has less turnover and transiency within its student body, and produces notably higher levels of academic achievement in its students than has been true of all other East Cleveland schools.[46]

A cruel irony. The children in that school, so far superior to the children in other East Cleveland elementary schools that they did not qualify for E&E funds, were the poor and culturally deprived factor in the EPIC equation. So 100 white children from an independent suburban school and 100 mostly black children from East Cleveland's best elementary school, all 3rd to 6th graders, spent a couple of hours a day together for a week or several weeks at a time in cultural institutions.

Togetherness was timidly approached. One judgment: that the program was more successful in the lower grades, where "children weren't so conscious of their differences and mixed more easily." Museum staff noted that the time allotment was "too brief for much to happen," though the time (9:30 to 11:30 A.M.) is the same as that allotted in the East Cleveland Project. Museum staff further noted that group activities worked better than individual projects, which tended to split the students up and deprive them of their reason for being at the museum at the same time in the same class. One classroom teacher was quoted by a museum instructor: "The classes are great, the kids are great, and the concept is terrible. The CMA is not a social-work center."

## VIII. Summary: Assessments, Findings, Lessons

It is hard to find anyone in the East Cleveland City Schools who does not believe the Extended and Enriched School Year is at least a partial success. Children, parents, teachers, ad-

ministrators, all have found substantial benefits in it and promise of more. As if to confirm local judgments, an evaluation team hired by the federal government has recommended East Cleveland's EESY to the Department of Health, Education, and Welfare as one of ten national "model programs" in the Right to Read Project. That project was mounted "to try to eliminate illiteracy in the seventies," according to Perney.[47] The East Cleveland program is the only one of the model programs that approaches reading improvement "indirectly," he continues, explaining,

> Rather than teaching reading as reading, we have gone through the use of the cultural institutions, whereby we have children developing skills in language arts by speaking, by developing vocabulary, by writing, and in this way improving reading skills.

Other than academic achievement gain scores, the East Cleveland schools point to the sharp drop in absenteeism among E&E children, which came abruptly at the very outset of the program, and has stayed ever since at about half the rate for elementary students in general. Teacher turnover has dropped from the 1970 high of 30 percent: "We have 165 teachers in the elementary schools who are regular classroom teachers, and this year [1974/75] we hired less than 10," the assistant superintendent notes, though he readily acknowledges that the tight job market for teachers must have had some influence on the dramatically lower turnover rate.

There have been unexpected consequences in the East Cleveland schools, just as in the museum's education department. The 1973/74 coordinator has observed a "spillover" effect on the non-E&E teachers who are "not able to do the same things as those in the institutions are. That means they try harder. They try to do a lot more with what they have." The assistant superintendent adds that there's been a spillover with non-E&E students too: "Our evidence is that the baseline data before there was any program showed the average growth rate was four or five months. . . . [It's] increased now by about a month to between six and seven months" throughout the elementary school population. He believes the program has demonstrated an "undeniable value to the entire school system," now only to those enrolled in the E&E.[48]

**Is the extended year necessary for success?**

As Dr. Perney consistently reminds colleagues, the EESY program is two separate things: enriched and extended. "It need not be both. It is not only possible but in most cases probably more feasible [in a nine-month calendar year because] I don't think most parents would go along with an eleven-month school year." A teacher of teachers agrees that the "structure is applicable even for a nonextended school year, as 'day-to-day' learning, . . . [and] the children get a lot out of it as far as *art* goes."

The 1971/72 and 1972/73 evaluations do not distinguish between the extended year and enrichment as factors in the equation. The 1971/72 evaluations tested the project children at the end of their eleven-month year and claimed tentatively that "urban students [who] lose anywhere from zero to two-and-a-half months during the summer . . . have been turned around," in Dr. Perney's words.

Now, in our situation, they lose from zero to gaining sometimes as high as a year, but I would say on the average from one to three months [gain]. . . . In almost every instance, the child comes in September with higher achievement scores than when he left at the end of school—and that doesn't occur anywhere except in suburban schools.

He makes "a calculated guess" that the same was true for 1972/73 but laments that the outside team hired to do the evaluation ("$8,000," he groans) failed to provide, in their computer, an analysis based on pre- and post-testing. They provided him with September/May/September growth rates, but failed to give him the growth rate at the end of the eleven-month year (that is, the rate in July, when the EESY year ends).[49]

Although the tests may disappoint the assistant superintendent in East Cleveland, their very limitation may yield provocative data to other schools: that enrichment even without extension substantially boosted achievement scores.

**The art museum's place in EESY**

If one looks not at the schools but at the art museum in an effort to summarize, assess, and learn from the East Cleveland experience, what emerges? An art museum educator can read this report from two contradictory perspectives:

1. One reading might be that the extended school year in and of itself is the prime cause for any good effects attributed to EESY; that the extended year requires breaks, lest the children and their teachers rebel; that as these breaks cannot always be vacations (lest the children end up spending just as much time as during a normal 182-day school year in the "chaotic" life of their neighborhood), other places must be found for them; that such places—including the art museum—are elegant time-fillers or highly refined babysitting services.

2. On the other side, one could speculate that week-long visits to nonschool institutions, specifically "cultural" institutions, are in and of themselves the true value of the program; that they enlarge the children's horizons, welcome them into a world larger than any they have known, introduce them to places, people, ideas, words, manners, habits, beliefs that they might not otherwise meet, all of which are expressions of the "culture" the children need to make their way out of the world that is now theirs. (A pejorative version of the same reading might be that the project scatters tasty, nourishing, middle-class experiences into their working-class or welfare-class lives, like still-plump raisins in day-old bread.)

Both the Cleveland Museum education staff and the East Cleveland school staff have tried to steer a middle course between such extreme positions. A middle course, however undramatic, has seemed to the two institutions, and to their

separate staffs, both prudent and generous, in the light of all that can be (and sometimes is) claimed for the program. An extended school year appears to provide a useful structure to fragmented lives. Week-long visits to the art museum (and other cultural institutions) appear to provide the children a welcome variety of experiences and adult acquaintances.

Debating—sometimes endlessly and often, it seemed, to no conclusive end—the nature of the "ideal" relationship between school and museum, both staffs have recognized the need to balance shared goals and separate goals. The debate in the schools sounded like this, according to an EESY administrator:

> Some teachers felt it should correlate very closely to what they're doing in school, in fact build up or at least introduce what will be happening in school. [Others thought] that this will be an enriching experience, this is something different, something that will excite kids, something that the teacher in EC will be able to hopefully utilize in the classroom, give her some new insights into ways of handling things.

In the museum, the debate was more muted and more one-sided. Few education staff members argued for lesson plans and close curricular connections. Although several of them gave the children informal assignments for their return visits, none provided classroom teachers with followup work plans. Several, however, discussed with teachers possible class activities related to museum visits. Whatever the individual preference of museum instructors, their collective judgment was that relations between museum and school should proceed slowly and cautiously toward more intimacy and structure.

This judgment seemed to spring from a wariness about turning the museum session into an extension of the classroom or "using" it exclusively for the school's goals. The wariness betrays an uneasiness familiar to many museum educators who cannot precisely define or measure what they teach, or how. There was general relieved agreement at a staff meeting when an instructor who had been a school art teacher said, "But we are simply offering a different type of structure," and—insistently—"we *are* structured."

Certainly the museum has been used. A portion of its time, space, and energy has been hired out to the East Cleveland schools; the museum's collections and staff skills have been employed to help the school system achieve school goals. Is this sinister or hopeful? The answer given by the Cleveland Museum education staff is that such use of the museum has been hopeful, healthy, even invigorating.

Certainly the museum and the school have retained their separate views of shared assumptions—perhaps too much so, as witness the still unsatisfactory teacher-training aspects of the project in *both* teaching staffs. Certainly the museum and the school have retained their separate assumptions about the prime purpose and value of the project—though less so than at the outset. Museum staff has gradually come to understand the desperate verbal needs of the East Cleveland children, and East Cleveland teachers have begun, some more readily than others, to sense what the visual experiences in the museum collection can mean to them and to the children.

## One finding, different lessons

A single example may help reveal how one finding yielded up by the program evaluations can teach more than one lesson to each institution, and can teach conflicting lessons. Take the high rate of learning growth among children in the upper-elementary grades. This finding took the school people by surprise: it's "contrary to any other research," says Assistant Superintendent Perney, though he excepts Kagan's intriguing work in Guatemala. which demonstrated that profoundly deprived children could be "turned back on" after everyone had given up on their ability to learn.[50] He speculates that perhaps the enrichment—the visits to the museum, for example—was what turned the trick for 4th, 5th, and 6th graders and that, consequently, the E&E program ought to concentrate on them.

The "finding," however, comes as no surprise to museum instructors. Many Cleveland Museum instructors, like art museum staff elsewhere, have long observed that at those upper-elementary grades children begin to make historical and conceptual connections, that their "learning" is more visible, more specific. (Art museum educators who have observed this and have tailored their programs accordingly are, among others, Barbara Wriston at the Art Institute of Chicago and Louise Condit at the Metropolitan Museum in New York.)

But the Cleveland staff steadfastly insisted that the program was valuable for 1st and 2nd grades: "I think the older kids learn more," said Ruffer, "but that doesn't mean that 1st graders shouldn't come here and, you know, just walk through the museum ga-ga. You know, that's fine, and it serves a purpose." James Birch argues that what happens in the early grades "may help it all fit together later. . . . And besides," he adds, "I don't trust tests for 1st and 2nd graders." Dr. Perney concedes the point: "There's just no way of measuring how well [1st and 2nd graders] comprehend what they're doing on tests," and he grants that tests are "probably invalid" for such young children.

The museum staff is convinced that even without measurable "learning," the experience of being out in the world, welcomed into the museum, acquainted with art and artists has a value all its own. It is the museum education staff's way of making a point that art museum educators frequently fail to make: an art museum "teaches"—refreshes, delights, informs, welcomes its visitors into the experiences of all men—by its very existence. If the children in 1st and 2nd grade learn nothing else, they can learn to relish the museum just because it is there.

## What next?

What has the museum learned from that lesson about the youngest scholars? That maybe it ought to hire someone

especially equipped to teach them and "find out what really happens to them in an art museum." And the school? It acquiesces in the museum's insistence that it be allowed to teach whom and how it thinks best. The 1st and 2nd graders continue to come to the art museum; their rate of learning continues to grow more slowly than that of older elementary schoolchildren; Dr. Perney remains unconvinced.

But he is as good as his word: he trusts the museum to know its business and to establish its own goals. His own long-range goals for cooperation with the art museum transcend whether 1st and 2nd graders come or do not come. "It has always been my wish that . . . instead of having a curriculum director for each school, . . . I'd love to have the resources of a [museum] staff who have the facilities, who have the personnel to sit down and say, 'Let's develop something really worthwhile.'"

How should an art museum respond to that? And how shall an art museum respond to this statement from the same inventive, experienced school administrator?

First of all let me say that I know of no public school at the present time that is capable of providing a very good art course. We can't replicate your facilities, we can't replicate your staff, and we cannot do anything other than a very rudimentary job in teaching art. . . . So I think the art curriculum and art form direction, what is taught, has to come from the art institutions, the artists themselves. And what is to be taught and what our teachers are to learn—and I don't want our teachers learning about it from teacher training schools. They fail. I want them learning about it from the real artists and the real places where it is.

The final "evaluation" of the East Cleveland program in the Cleveland Museum of Art comes from the two professionals who have shepherded it through the three years of its life there. From Dr. Perney:

I have this absolute guarantee: The East Cleveland Extended and Enriched School Year will not be curtailed. If everything else could go, that program—I have an absolute command from the board of education—is to remain in effect. We will not eliminate it. It must become a permanent fixture of the system.

And from Associate Curator James Birch of the museum, who agrees with Dr. Perney that such a program cannot be duplicated in the schools:

It's a program I believe in. If the school stopped paying for it, I'd find money in my budget for it. I'd cut it down—it's too big anyway, too many children from one school—but I'd never cut it out.

—*A. Z. S.*

## Notes

[1] Evaluation for 1971/72 by Edward Armon for East Cleveland City Schools.

[2] In June 1972, the Commission on Public School Personnel Policies in Ohio published *Time and Opportunity: The School Year,* the fifth in a series of statewide studies on improving the education of students. Excerpts from the Commission's conclusions follow:

"The present school calendar rests solely on the assumption that the traditional 180-day school 'year,' together with a 90-day summer vacation and the usual seasonal vacations, is the best way for most students to experience public school education.

"The Commission seriously questions this assumption. It believes that the perpetuation of such a calendar is based not upon a sound analysis of what children need educationally, but rather upon a social phenomenon that has assumed the status of a tradition. . . .

"There is no evidence . . . that children need any more than the much shorter vacations that usually provide sufficient periods of change and relaxation for adults.

"Educators are also concerned about indications that students do not 'stand still' during the summer months in terms of acquired skills and concepts but rather regress to some point below the plateaus reached during the previous school year. . . .

"In addition to limiting the professional aspects of teaching, the typical school calendar limits the financial rewards possible in a situation with more . . . employment options. . . .

"The Commission concludes that neither the educational needs of children nor the professional needs of teachers are being adequately met by continued adherence to the traditional school calendar with its inflexible constraints and attendant problems. . . ." (From pp. 1–13.)

[3] For sources of quotations without footnote references, see list of interviews at the end of this report.

[4] East Cleveland's school population is about evenly divided between elementary and secondary education. In 1973/74, out of an enrollment of 8,300, 4,300 were in elementary schools.

[5] James A. Birch, Cleveland Museum of Art, supervisor, East Cleveland Project. Memo to James Johnson, December 10, 1971; East Cleveland Project report, 1972, by Birch and Ann K. Chadbourne, assistant supervisor.

[6] Annual report from James A. Birch to Cleveland Museum of Art's curator of art history and education, 1973.

[7] The $95 figure includes what the assistant superintendent calls "some very expensive activities," including a residential program at a local camp (at $36 per student, the highest fee).

[8] February 28, 1974.

[9] *A Museum for the People* (Cleveland: Acanthus Press), p. 4.

[10] Birch, memorandum, December 10, 1971.

[11] Armon, 1971/72 report, p. 82.

[12] The teachers, in order quoted, are

Lucille Winston, Chambers School, grade 4, December 17, 1973.

Faye Bradley and Betty Lott, Rozelle School, grade 1, February 8, 1974.

Cain and Jacobson, Superior School, grade 6, February 19–22, 1974.

Diane Boyer and Tennie Smith, Superior School, grade 1, February 11, 1974.

Bell and MocZulski, Rozelle School, grade 5, March 1, 1974.

Halasz and Dussing, Rozelle School, grade 3, March 4, 1974.

Armine Cuber and Giaramita, Chambers School, grade 1, February 28, 1974.

[13] Marlo Coleman, 1973/74 report to CMA supervisor.

[14] Gerry Karlovec, 1973/74 report.

[15] Sue Kaesgen, 1973/74 report.

[16] Sheryl King, September 19, 1973.

[17] 1971/72 evaluation report, p. 30.

[18] Teacher retraining is included in Title VII funding and specifically not allowed in Title I funding. But as three of the five schools are funded for 1974/75 by Title VII, there is, at last, money for sustained teacher training.

[19] William Ruffer, evaluation memorandum, October 1973.

[20] Ann Chadbourne, memorandum, October 24, 1973.

[21] 1971/72 evaluation report, pp. 62–64, 68.

[22] First Interim Report, East Cleveland City Schools, East Cleveland Community Classroom Program, Title IV-A, by team from Case Western Reserve University, pp. 2–3.

[23] 1972/73 evaluation, p. 1.

[24] The instructor uses a NASA exercise which encourages students to imagine themselves lost on another planet. To get back to the mother ship in time for the last trip to Earth, they must choose what items they really need and justify the selection. Choices can be made either unanimously or by a student's persuasion of the group; in any event, the group must agree on its goals and needs and then agree on ways to satisfy them. See George I. Brown, *Human Teaching for Human Learning* (New York: Viking, 1971), for a full description of the exercise, though the museum instructor says he does not know the book and believes he must have gotten the idea somewhere else.

[25] Ruffer, 1973/74 report.

[26] J. Fagan, Mayfair School, 5th grade, evaluation report, October 8, 1973.

[27] 1972/73 interim evaluation, p. 4.

[28] EESY Program, ECCS, *Data Analyses,* submitted by Leonard Visci and Lawrence Perney, Ph.D., March 1974, p. 2.

[29] Ibid., p. 4. The precise number of subtests used in the SAT varies from four to ten, depending on grade level. They include word meaning, paragraph meaning, spelling, word study skills, language, arithmetic computations, arithmetic concepts, arithmetic applications, social studies, and science.

[30] Unless otherwise attributed, all the evaluation data in this section, including the direct quotes, are drawn from the official 1974 report *Data Analyses* (see note 28). As readers will have gathered from the preceding section on attitudes, there have been several evaluations of EESY, the first, for 1971/72 by Edward Armon of the East Cleveland City Schools (see footnote 1). Wanting independent verification and refinement of the 1971/72 findings (some of them quite remarkable), the East Cleveland schools called on Case Western Reserve University to execute the 1972/73 evaluation, study the schools' own earlier evaluation, and draw comparisons and conclusions. For technical reasons of moment chiefly to statisticians, the university evaluators dealt only with grades 2 through 5 in *Data Analyses.*

[31] 1971/72 report, p. 29.

[32] The similarity of the situation is this: "The typical pattern for poor urban schoolchildren is that they fall behind with each year in school and fall behind each summer. . . . The typical urban child with nine months' schooling operates at 65 percent efficiency. If growing at six months' level, they're falling back three months each year. . . . The EC child falls back over the summer while the suburban child continues to grow." Perney, May 7, 1973.

[33] The university evaluators also issued certain cautions about interpreting their findings: (1) attrition is about 30 percent in East Cleveland's elementary school population; (2) there was no way to know the gains of E&E students who had left the school system after one year; and (3) there was no provision for testing E&E two-year veterans.

[34] Karlovec, 1973/74 report to CMA supervisor.

[35] Kaesgen, 1973/74 report.

[36] Coleman, 1973/74 report.

[37] Ruffer, 1973/74 report.

[38] One museum instructor even corrects diction and teaches verbal manners ("please," "thank you," "may I," and such) to the dismay of certain colleagues but to the distinct (and expressed) satisfaction of Lawrence Perney. The delicate issue of what constitutes "proper" language is at the heart of a mild internecine dispute: some staff members believe that "street language" is not only acceptable for East Cleveland's black kids, but that it is more appropriate, suitable, and proper than "white" English. That this dispute, which has engaged sociologists, black militants, employers, and government wisemen, should have crept into the East Cleveland Project at the Cleveland Museum of Art is no surprise.

[39] Rose-Anne Moore, journal, January–March 1973.

[40] Coleman, 1973/74 report.

[41] Chadbourne, 1973/74 report.

[42] Ruffer, evaluation sheet for Case Western Reserve University, October 1973.

[43] A note of explanation: "Suburban" in this context does not necessarily connote prosperous bedroom communities; it simply reflects the division of labor prevailing in the Cleveland Museum of Art education programs for the past quarter of a century. The Cleveland Board of Education, which supervises the city school system (the largest in the area, but only one of 33 school systems serving Greater Cleveland), pays the salaries of its own certified art teachers, who have offices in the museum and are solely responsible for teaching City of Cleveland classes in the museum.

Though many cities and museums look on this arrangement with admiration and even envy—because it demonstrates a major board of education commitment to museum education—they overlook, or are unaware of, the net result: City of Cleveland school classes have a pupil-teacher ratio of anywhere from 25 to one to 40 to one when they visit the museum. Regular staff members of the education department are not scheduled to teach these classes. Consequently, about ten museum-paid teachers handle all non-Cleveland—that is, "suburban"—classes, and two (though once, in lusher days, four) Cleveland Board of Education teachers handle all City of Cleveland classes.

[44] Board minutes, Enrichment Committee, Cleveland Music School Settlement, May 11, 1973, p. 3. The University Circle Center for Community Programs grew in part out of the Community Schools Program, funded by a local foundation and private gifts, which provides selective exposure of neighborhood students to the various institutions in University Circle. In 1972, the program reached over 7,000 students. A variation on this theme focuses on the arts—more specifically, an effort to make the community more aware of the arts institutions and programs in the Circle through a program with selected elementary, junior high, and senior high schools. That program is designed at varying levels to reach the student of "above average *interest* or *talent*," the student with a "general" interest, and all residents of the neighboring community through performances (modern dance groups, short operas) in their schools, churches, and neighborhood centers.

All of these programs probably reflect the growing consciousness of the Circle art institutions—not all of them upper class and insular, though many fit that description—that their immediate neighbors are poor or working class people who have generally felt left out of the Circle and its doings. (The impressive buildings and institutions that ring the university make Cleveland's University Circle a substantial example of the American "cultural center" left behind by its patrons and supporters in their relentless move to exurbia.) Efforts to bring neighboring schools into the Circle have that "Catch 22" ring familiar to many who deal with federally funded programs: according to Mrs. Annie Toney, principal of one of the schools involved, all free field trips once available to her school ended when the school came under Title I funding, as buses "used for Title I schools [are] only used to transport the children from the school to home and home to school and nowhere else."

[45] University Circle Project report, undated, p. 1.

[46] *Data Analyses,* p. 6.

[47] The assistant superintendent notes that the Right to Read Project was a "nice public relations effort . . . but no new money was behind it, so existing monies were channeled into reading programs." A realistic man, he consequently geared up his enriched and extended program to concentrate on reading achievements.

[48] Dr. Perney cites as a minor example of spillover the increased number of field trips for non-E&E students. The subject might not have come up had he not been questioned about the complaints made by several non-E&E teachers to interviewers that, as one said, "we're lucky to get one bus for classes if it's not an E&E class." Perney responds: "We had no field trip program to mention before the program. . . . I didn't feel by making the rounds and observing things you were really benefiting a great deal. . . . I felt you had to get involved in the institution if you were to be able to take away something meaningful. . . .

"[Besides] prior to the E&E we didn't have any buses. . . . We went out and received grants, and in the grants we received money to purchase buses for purposes of going to these institutions. Now these children are being bused to these institutions, and through a process of collective ownership, teachers feel they're 'our' buses, not the E&E's buses." He believes even the one or two field trips now possible for non-E&E kids are part of the spillover benefit, though he places, as he says, little faith in just "making the rounds."

[49] In trying to untangle the statistics that had been gathered for him and force them to yield up the information he was searching for, Dr. Perney recognized that he did not have enough E&E children for the September "post-tests." After detailed record-searching, he and his staff learned, "We are losing the top third of every class every year, as their parents make it up and out to Shaker Heights, Cleveland Heights . . . and the children who are coming in to replace them are coming in from the central city. We're a way station for upward-mobile blacks . . . and that has a terrible effect upon overall achievement results."

[50] See Jerome Kagan (Harvard) and Robert Klein (INCAP), "Cross-Cultural Perspectives on Early Development," *American Psychologist,* vol. 28, no. 11 (November 1973).

## Interviews and observations

Adams, Celeste. Instructor, East Cleveland Project, Cleveland Museum of Art; Assistant Curator, Department of Art History and Education, Cleveland Museum of Art. October 1, 1973; May 29, 1974.

Armon, Edward F. Formerly East Cleveland City Schools Administration, Extended and Enriched School Year Coordinator (1972/73). September 26, 1972.

Atwater, Henry. Teacher, EESY, Mayfair School. May 7, 1973.

Birch, James A. Associate Curator, Department of Art History and Education, Cleveland Museum of Art; Supervisor, EC Project. Interviews throughout 1971–1974.

Boyer, Diane. 1st-Grade EESY Teacher, Superior School. Interviews and observations: January 28–February 1, 1974.

Brescia, Dee. 6th-Grade EESY Teacher, Mayfair School. January 25, 1974.

Buchanan, Penny. Director, Greater Cleveland Teacher Center. Shared observations of EC classes: January 28–February 1, 1974. Conversations during 1974.

Carroll, Wayne. Head of Secondary Teachers, EC City Schools Administration. October 31, 1973.

Chadbourne, Ann K. Assistant Supervisor, EC Project, Cleveland Museum of Art. Interviews and observations: October 1, 1973; January 21, May 31, 1974. Conversations throughout 1971–74.

Clements, Bridget. Teacher, Prospect School. May 7, 1973.

Coleman, Marlo. Instructor, EC Project, Cleveland Museum of Art (1973/74). Interviews and observations: September 10, 1973; May 31, 1974, others during year.

Cuber, Armine. 1st-Grade EESY Teacher, Chambers School (1972–1974); 4th-Grade non-EESY (1974/75). July 30, 1974.

DeFiore, Michael. Principal, Mayfair School. October 1, 1973.

Fagan, Joseph. 5th-Grade EESY Teacher, Mayfair School. Observation: September 10, October 3 and 5, 1973.

Hammer, Paul. Business Manager, East Cleveland City Schools. Telephone interview: September 6, 1974.

Hyde, Betty. Evaluation, EC City Schools. Telephone interview: September 9, 1974.

Jirus, John. Director, Elementary Education, School Community Development and Educational Media, EC City Schools Administration. Interview: August 20, 1974. Telephone interview: September 6, 1974.

Jones, Tim. High School (University School) Senior Intern (spring 1974) assisting EC Project. May 29, 1974.

Kaesgen, Sue. Instructor, EC Project, Cleveland Museum of Art. Interviews and observations throughout 1973–1974.

Karlovec, Gerry. Instructor, EC Project, Cleveland Museum of Art (fall 1972); sculptor. Interviews and observations: January 25, May 7 and 31, 1974, and others throughout the year.

King, Sheryl. Coordinator, EESY, EC City Schools (1973–74). October 2, 1973; August 20, 1974.

Koontz, Ted. High School (University School) Senior Intern (spring 1974) assisting EC Project. May 29, 1974.

Kuhlman, Patricia. Teacher, Mayfair School. May 7, 1973.

Lathe, Tim. High School (University School) Senior Intern (spring 1974) assisting EC project. May 21, 1974.

Moore, Janet. Formerly Curator, Department of Art History and Education, Cleveland Museum of Art. Interviews throughout 1972–1973.

Moore, Rose-Anne. High School (St. Paul's) Senior Intern (January to March 1973) assisting EC Project.

Osmond, Mark. High School (University School) Senior Intern (spring 1974) assisting EC Project. May 29, 1974.

Owens, Wayne. Principal, Superior School. January 28, 1974.

Perney, Lawrence. Assistant Superintendent, Instruction and Curriculum, EC City Schools. May 7, 1973; August 20 and September 13, 1974. Telephone interview: September 25, 1974.

Polita, Linda. Teacher, Chambers School. May 7, 1973.

Retino, Linda. 5th-Grade Teacher, Mayfair School (EESY, 1972–73; non-EESY, 1973/74). October 1, 1973.

Robins, Mary Louise. Instructor, EC Project, Cleveland Museum of Art (1972–1974). Interviews and observations: May 7, 1973; January 31, 1974, others throughout the year.

Rose, Katherine. 5th-Grade EESY Teacher, Mayfair School. Observations and interview: September 10 and 12, and October 5, 1973.

Ruffer, William. Assistant Supervisor, EC Project, Cleveland Museum of Art. Interviews and observations: May 7, September 10, October 1, 3, 15, 25, 1973; January 21, May 21, 1974, and others throughout the year.

Silverman, Lanny. Instructor, EC Project, Cleveland Museum of Art (spring 1974). Interview and observation: March 13, 1974.

Smith, Tennie. 1st-Grade Teacher, Superior School. Interviews and observations: January 28–February 1, 1974.

Swenson, Elizabeth. Ph.D. Student (1971–1974), Case Western Reserve University, Department of Education. November 20, 1973, and during January 1974.

Walker, Vishakha. Instructor, EC Project, Cleveland Museum of Art (1971/72). Interviews and observations throughout 1971/72.

Weaver, Diane. Instructor, EC Project, Cleveland Museum of Art. May 11, 1972.

Weisberg, Gabriel. Curator, Department of Art History and Education, Cleveland Museum of Art. May 29, 1974.

Whelan, John. Principal, Chambers School. May 7, 1973.

Whitmore, Dorothy. 3rd-Grade EESY Teacher, Chambers School. October 25, 1973.

Woideck, George. Instructor, EC Project, Cleveland Museum of Art (fall 1972). Interviews and observations: May 7, 1973, and others during 1972/73.

## Bibliography

*Time and Opportunity—The School Year.* The Fifth Report of the Commission on Public School Personnel Policies in Ohio. June, 1972.

"First Interim Report." East Cleveland City Schools. East Cleveland Community Classroom Program. Title IV-A. April 12, 1973.

Evaluation for 1971/72 by Edward Armon for East Cleveland City Schools.

*Data Analyses*, Extended and Enriched School Year Program, East Cleveland City Schools, East Cleveland, Ohio. Submitted by Leonard Visci and Lawrence Perney, Ph.D. March, 1974.

An evaluation of the 1972/73 Guggenheim Museum Children's Program, "Learning to Read through the Arts," ESEA Title I Program, by Howard Conant (Evaluation Director, Center for Educational Research and Field Services, School of Education, New York University), July 1973.

This program resembles the East Cleveland Project in some ways. The Guggenheim Museum and the New York Board of Education together mounted a reading-through-the-arts program. Their audience, about 100 10- to 12-year-olds, qualified for inclusion in the program because they read two years below grade level. From November through May, the children spent two afternoons after school and every Saturday in workshops with professional teachers, school personnel, reading specialists, and evaluators. Their reading scores went up, or as the report says, "an exceptionally significant reading score gain . . . was determined" (p. 2).

The Guggenheim program was much smaller than the East Cleveland Project and more directly aimed at reading (though it also used indirect means), and regularly met at an artist's studio complex as well as at the museum. The evaluation report recommended that the Guggenheim program be "expanded into a five day per week venture" and that it be "emulated by other museums, by schools, and by other types of cultural and educational institutions throughout the world" (p. 3).

## THE BROOKLYN MUSEUM: IN-DEPTH SERIES

Brooklyn Museum
Eastern Parkway and Washington Avenue
Brooklyn, New York 11238

**A decision to "serve only as many children as we can serve well" has led the Brooklyn Museum to design a program of weekly four-hour sessions for school classes. The total number of children is down, but the quality of the museum experience is decidedly up, and so, increasingly, are the museum's relations with teachers. CMEVA interviews and observations: April, May, September, November 1974; January and April 1975.**

### Some Facts About the Program

**Title:** In-Depth Series.

**Audience:** Mostly elementary schoolchildren from New York City (the education staff would give no figures for 1973/74, but 1972/73 total was 1,710 children).

**Objective:** To provide intensive (and longer) experiences and to raise the quality of the one-time museum tour.

**Funding:** Instructors' salaries are included in the museum's general support from the City of New York. Fees from the schools to cover the cost of materials averaged about 41 cents per child per visit (in 1972/73, a total of $2,850).

**Staff:** 4 instructors, each taking a class two or three times a week.

**Location:** The galleries and workshop and studio space in the museum.

**Time:** 4 hours one day a week for 4 or 6 consecutive weeks during the school year.

**Information and documentation available from the institution:** Written reports about the program.

Once upon a time there was a program at the Brooklyn Museum called "The Background Hour." Hordes of children, 300 at a clip, barreled into the museum's auditorium, where they were hushed into row upon row of collapsible

chairs. Lights out, slides on. Great art. Lecture over, lights on. "Let's go."

The recollection makes Linda Sweet shudder. Ms. Sweet, coordinator of the museum's school services, says that "in those days many of the classes returned to school without ever visiting the galleries."[1] She adds with a sigh of relief, "The enormous, impersonal background hour was disbanded altogether in 1971."

What the museum's education department came up with in 1972 was something quite different. Every principal in New York City received the announcement of a new program called the In-Depth Series, which would welcome classes to the museum not for just an hour, but for four hours one day a week for four or six consecutive weeks. Within a month the program was booked for the entire school year.

This new venture entailed two major decisions, one far more difficult than the other. The first was to resist the temptation to give the children a taste of all the glories the museum had to offer, but instead to focus the visits on selected elements of the collections. One reason beyond the obvious wish to avoid superficiality was the hope that a schoolteacher, in consultation with a museum instructor, could choose exhibits that related directly to his lesson plans and were best suited to his particular children.

The choice in the series is wide: the cultures of Africa, Egypt, the Middle East, India, China, and Japan. The visits can also revolve around the museum's pre-Columbian collection, or the arts of the North American Indian, or colonial America. Teachers are encouraged to include their students in making choices. For example, with the help of her students, a teacher from Public School 249 in Brooklyn decided on an in-depth study of China because the children's interest had been piqued by the news accounts of President Nixon's visit there in 1972. Another option is "Art Focus," a series dealing strictly with visual awareness—how to see line, texture, form, composition in any work of art, regardless of the particular cultural area—and a theme that has come more and more to permeate the museum's programs for children.

The second and perhaps more painful decision was, as Ms. Sweet puts it, to "serve only as many children as we can serve well." It meant that the museum would try to provide more intensive and longer experiences for fewer students and to raise the quality of the one-time tour. The result of the decision was that in the first year after the policy was initiated (1973/74), the number of children who came to the museum in tour groups dropped by 10,000 from the previous year (1972/73)—but the total number of student hours in the museum increased by 30,000.

Classes for the In-Depth Series are usually booked on a first-come-first-served basis, though the museum makes an effort to give each Brooklyn school district an equal number of appointments. The visitors are almost all from the elementary schools. Much as the education department would like to work intensively with high schools, departmentalization and rigid schedules make it nearly impossible for groups to leave school for big blocks of time. The education department has, however, been able to work out special series with some of Brooklyn's "alternate" high school programs.

## Money and milieu

The In-Depth Series has operated during its first two years on practically no budget. The instructors' salaries are charged to the museum's general support from the City of New York. Starting the program entailed no major investment on the part of the museum, or even an overhaul of the education department itself, though the department would like to increase its staff and inaugurate other experiments. Four teachers comprise the core group, each of them taking a series class two or three times a week.

Fees from the schools cover the cost of all materials. In most cases, the museum bills the schools $50 per class for the four-week series and $75 for the six-week series (the cost per child comes to about 41 cents for each class hour). The schools, in turn, may draw this fee from a variety of sources—the PTA, the principal's discretionary fund, the children themselves, or even, on occasion, a generous teacher.

From the start the museum had decided that any school in a poverty area could substitute supplies for money payments, thus covering the series' only out-of-pocket expenses—paint, brushes, glue, paper, clay, and other materials. However, such schools were slow to respond to the opportunity, so the museum in 1974 secured a grant from the New York State Council on the Arts that enabled the museum educators to approach four school districts with an offer of a subsidy for 12 classes per district. Each district sent a minimum of 12 classes; three asked for additional slots. For the second year, the districts were asked to take over the costs, and by spring 1975, three of the four had agreed to do so.

The fact that the facilities are not ideal is no deterrent to either the staff or the children, says Ms. Sweet. The workshop and studio space is cramped, lacking sinks and windows. As there is no special lunchroom for series children, they must eat in the workshop itself, and often in the afternoons the smell of oranges hovers in the air, mingling with the bittersweet smells of paint and paste. There are no toilet facilities nearby, so young artists must walk or ride the elevator from the sixth to the first floor. That they can do this on their own after just one visit is to the staff a sign that they have become comfortable in the museum.

Since the In-Depth Series began, members of the education department have become experienced child-watchers, knowing the importance of making their point of departure a child's special interests and personality. As they often remark, they want the children "to see"; they make the best use they can of the galleries. Instructors have learned to drop information into the proceedings casually, whenever children seem to need it, and to impart it through the senses rather than through words. This they do in a variety of ways: they might encourage nine-year-olds to sit quietly in the lotus

position before a statue of Buddha, place one hand over the other palms upward, close their eyes and take ten deep breaths, and "feel inside of you . . . think about yourself inside of you"; or they might suggest using clay and wood to make a flat boat inspired by one the children saw in the galleries. (The staff would never suggest, says Ms. Sweet, that the children reproduce what they have seen: "We take off from what they've seen, as well as from their responses and experiences, and bring their imagination into play so that their creations are quite personal."[2])

Playing musical instruments, children explore the rhythms of an African mask. "Do we all wear masks?" the teacher asks them. "How would you alter yourself, if you could? If you wanted me to know you were strong or rich, what would your mask look like?" Children may spend time in the museum's studio making puppets of "people in a myth" or acting out the story in dance and drama. A visitor to the galleries may stumble on a child lying on his stomach and munching on the end of a pencil, absorbed in his attempt to draw the curved arm of a statue. As a museum instructor expressed one of the program's premises, "You can't learn unless there's pleasure involved, the satisfaction of having accomplished something."

In one series, an instructor leads a group of children into the gallery of colonial American portraits—a shadowy place, whose quiet somberness might please an adult but might well inhibit a youngster. Each child gets pencil and paper, with these instructions:

1. Pick a picture. (A mad scampering about and giggling until each child is standing before a portrait.)
2. Quickly write down the first word that comes to mind.
3. Write four words starting with the same letter that relate to the picture. Or (if that step seems too hard) write four other words.
4. Take a pose like the figure in the picture; become the picture.
5. Make the next move the person in the portrait might make.
6. What would the person say? (Each child makes a statement, sometimes silly at first, but gradually more serious as the group falls into the spirit of the exercise.)
7. Now that you are the person in the painting, how would you answer if someone said to you, "The latest fashions from Paris have arrived"?
8. If the man next to you met you in the street and told you, "The British are coming," what would you say? Talk to each other.

By this time the children have thawed considerably. They sit on the floor, close their eyes, and try to imagine themselves on a ship coming to America centuries ago. Then with eyes open they begin studying the backgrounds of the pictures. What kinds of houses did people live in? Were rich people the only ones who had their portraits painted?

The instructor succeeds in provoking a general discussion about portraits. "Is having your portrait painted a major oc-

casion? If there could be only one picture of you your whole life long, what would you like it to be? Why do we take photographs? Why do we have pictures of ourselves and our friends and family?" Children are asked to bring in snapshots of themselves next time, which are then tacked up on the studio walls. Perhaps the children do a full-length portrait of a classmate by having him lie down on a large piece of paper and tracing the outline of his body.

One method of helping the children to *see* Egyptian artifacts, perhaps during the third visit in the series, is to ask them to list all the animals on the mummy cases and other objects in a particular room. There are about 30 animals, the instructor says. Slowly the children begin to comb the objects with their eyes, writing down their discoveries—monkey, dog, duck, tiger, snake, cat, goat, beetle. Some names are picked from labels—jackal, ibis, hippopotamus. This census leads to a discussion of habitats—air, water, land. "Is there an animal you would want to protect you? Think of an animal. How does it sleep? eat? move?" A child becomes an animal and the others try to guess what kind. Two child-animals come together, an eagle and a snake. "Freeze," says the instructor and starts to talk about gesture drawing, frontal and profile views, negative space. "I never do Egypt the same way twice," comments one instructor.

Although the series called "Art Focus" might seem too abstract or technical to enliven, the museum instructors have found ways to draw children actively into the study, for example, of "the line"—or many kinds of lines: angry lines, happy lines. For homework, students are to bring in a line. It can be practically anything: a strand of hair, a rubber band, even the finger of a small outstretched hand. One day a child was upset because he had forgotten to bring in his line. Calmly, the instructor said all he had to do was to stretch his chewing gum out of his mouth; *that* was a line.

Or the class may visit the galleries and stop off to look at Chinese calligraphy. Perhaps the children become symbols and characters in calligraphy. A child may choose to become a character related to a landscape image, recalling a previous discussion of the Chinese concept of nature. Back in the workshop they draw their own landscapes or go outdoors to sketch. They make up stories, they play charades and guessing games, they invent their own symbols. In one class a child drew a diagonal followed by a dot and then a line curving down. It meant, he said, climbing up a mountain and then jumping into a pool of water.

### Trying to forge bonds with the classroom teacher

"A major concern during these first years of the program has been to establish a solid relationship with the teacher," says Linda Sweet, echoing many another museum educator who works with the public schools. The education staff tries to elicit the schoolteacher's active cooperation by such means as invitations by phone to visit the museum and staff before the first class session, letters suggesting ways to introduce the children to the In-Depth sessions, further suggestions for

follow-up activities after each visit and at the close of the series.

Besides the contact made with teachers during the course of the series, in the 1974/75 school year the education department set up after-school workshops to give schoolteachers a chance to work with art objects and to help them and the museum instructors better understand each other and each others' institutions. These workshops are intended primarily for teachers who want to take their classes around the museum on their own; the teacher's participation in a workshop is a prerequisite to scheduling such a do-it-yourself tour. So the on-own class visit still takes place, but with a difference. The day of the unprepared teacher coming into the museum, perhaps for the first time, and leading her class through the galleries has gone the way of "The Background Hour."

The museum educators bring the ubiquitous questionnaire into play, too. As each class ends its series, the teacher is asked to answer 17 questions covering many aspects of the experience.[3] The questions range from requests to compare it with one-shot museum visits and other field trips to probes of the teacher's reactions to the extent and content of the series, its relation to his or her expectations, and its impact "if any" on the students. The final open-ended question invites suggestions and overall criticism.

A random sampling of questionnaires and unsolicited letters shows that the response provides the education staff with useful pointers. It is clear, for instance, that some teachers at least would like to be part of an In-Depth Series teaching team. (The staff admits that the program has not yet worked out adequately the role of the classroom teacher.) Despite the museum efforts, moreover, teachers also indicated the need for preparatory and follow-up material. The staff prizes all such feedback, which helps it plan more intelligently for the future. A good deal of the museum instructors' strength comes from an apparent clarity about what they know, what they do not know, and what they hope to achieve. They have noted that the child, in general, presents fewer problems to them than does the teacher, who in many ways remains a mystery.

The instructors have begun to realize how little they know about life in the schools from which the children come and how much they have ignored the teachers by focusing on the children. More important, their experience indicates that no matter how good or how intensive the museum program may be, unless it somehow relates to the work that goes on at the school and brings in the teacher more actively, a series of four or six long visits can be hardly more significant than a single short one. (For more on how the staff has worked on relations with teachers, see report on Museums Collaborative, chapter 4.)

### Lessons from the past; plans for the future

At the close of its second year of operation, the In-Depth Series seemed firmly established at the Brooklyn Museum.

The education staff was full of plans for improving and expanding the program, many of them in response to admitted shortcomings in this evolving experiment. Nor were the plans by any means limited to the series.

According to Linda Sweet, "The development of this program, the working out of the balance between workshop and gallery experience, has occupied the staff to the exclusion of almost everything else." She hastens to add, however, that what her department has learned has been applied successfully to other programs. One Sunday a month, for example, adults who drop into the museum find themselves in the workshop doing their own artwork in response to an informal gallery discussion. "Our approach is now less formal, more personal; less object-oriented, more people-centered; less dominated by the instructor, more experiential on the part of the audience."

The response to the format and procedure of the series has been, on the whole, positive, though too little is known as yet about its real impact on its young audience or on classroom education. It is unclear, for instance, how well "Art Focus," perhaps the most experimental part of the series, is going over. The museum expected it to be particularly valuable to schools that have no art specialists. But the heavier demand for "Art Focus" in the spring than in the fall suggests that teachers are chiefly interested in it when basic curriculum requirements have been more or less fulfilled and they need extra things to do with their classes. Ms. Sweet reports that the resistance of schools in poverty areas to "Art Focus" melted when subsidy money became available. "The change has been wonderful," she says.

Central to present plans is strengthening the bond between museum staff and classroom teachers. As Linda Sweet puts it, "We are now ready to direct our attention to teacher training, though we are aware that we must be trained by the teachers at the same time that we train them." Plans are afoot, for instance, to hold an In-Depth Series strictly for the teachers themselves. One objective would be to develop materials jointly with the teachers and to mesh their expectations more closely with the museum's.

The museum might become, in the broadest sense, a resource center for teachers, providing information about programs, books, art materials, and objects. The staff also feels that it is "very important" to work more directly in close cooperation with district art supervisors to give them the opportunity to make decisions for their districts about participating schools, classes, and teachers. One idea, which the museum has never tried before, is to hold a weekly or biweekly open house for teachers.

The museum is gradually becoming, in fact, a teacher-training center. In response to demand, the education department staff has begun to work with university and college education departments, offering one-shot workshops and internships for students studying to be teachers, as well as courses for paraprofessionals and teaching opportunities for student teachers. Cultural resource centers, such as GAME

(Growth through Art and Museum Experience; see chapter 8), have called on the museum to offer special teacher training that can supplement their own programs.

The Brooklyn Museum's staffers are searching for learning opportunities such as Lillian Weber's Center for Open Education at City College. The staff is also interested in developing joint programs with other museums. Linda Sweet was instrumental in forming the Education Committee of the American Association of Museums and the Education Forum of Museums Collaborative. The education department would like to help establish cultural resource centers—''linkage'' houses—in the community. This idea of a place where teachers and students can come together with the Brooklyn Museum's staff and resources (thus, among other things, relieving the pressure on the museum itself) is just getting off the ground with the aid of Museums Collaborative.

Meantime the department continues to ask itself questions about the In-Depth Series and to look for standards that will test its effectiveness. When the program began, the museum teachers found it taxing to be with the same group of students over a much longer period of time than they had been used to. It was a teaching stretch for them in every sense of the term. It was also, however, a stimulating relief from the boredom and frustration that, Ms. Sweet says, instructors had felt in the past. It is her opinion that not too long ago educators at the Brooklyn Museum voiced no complaints because they viewed their positions as way stations to graduate degrees or curatorial careers. But the museum's education programs are different now, and so is the staff. In Linda Sweet's words, ''It was only when the teaching staff at Brooklyn suddenly found itself made up of individuals concerned about education, who sought out positions in that field, that change took place.''—*A.G./J.M.*

## Notes

[1] For the source of quotations without footnote references, see list of interviews at the end of this report.

[2] Letter to CMEVA, May 21, 1975.

[3] The children are also given a questionnaire to fill out—much shorter, only seven questions.

## Interviews and observations

Dunhill, Priscilla. Director, Museums Collaborative, New York City. Interviews between March and September 1974 not recorded by CMEVA reporter.

Geschwer, Steven. 5th-Grade Teacher, Public School 213, Brooklyn, New York. January 5, 1975.

Hotton, Julia. Assistant Director, Interpretation, Brooklyn Museum, Brooklyn, New York. May 23, 1974.

Korman, Bette. Director, GAME, Inc., New York City. Interviews between March and September 1974 not recorded by CMEVA reporter.

Oster, Jacqueline. Art Supervisor, School District 19, Brooklyn, New York. February 1975.

Sweet, Linda. Coordinator of School Services, Brooklyn Museum, Brooklyn, New York. Telephone, April 14, 1975. Other interviews between March and September 1974 not recorded by CMEVA reporter.

Talalla, Ida. Instructor, Brooklyn Museum, Brooklyn, New York. November 1, 1974.

Schoolchildren taking part in series programs. April 9 and November 1, 1974.

## THE SCHOOL IN THE EXPLORATORIUM

The Exploratorium
3601 Lyon Street
San Francisco, California 94123

**A now-famous science-art museum runs a school for 4th–6th graders and their teachers, who make a series of lengthy visits to learn about perceptual phenomena among an array of ''must touch'' exhibits in the museum; follow-up activities tie the museum experience to the regular classroom curriculum. The school demonstrates what Exploratorium Director Frank Oppenheimer considers the museum's unique role in education and the way he feels the ''museum system'' should be related to the school system. CMEVA interviews (including an extended conversation with Oppenheimer excerpted here) and observations: May and June 1974; July 1975.**

**Some Facts About the Program**

**Title:** School in the Exploratorium (SITE).

**Audience:** 4th, 5th, and 6th graders from San Francisco and Marin County public schools; 600 students, 1974/75 school year.

**Objective:** To acquaint children with scientific phenomena and to stimulate their perceptual awareness through the use of exhibits in the museum.

**Funding:** 1972–1974 costs were covered from general budget of museum (amount and breakdown not available), with some assistance ($16,650) from the Rockefeller Brothers Fund in 1973/74. The Ford Foundation has funded the program at $75,000 per year for three years beginning in 1974/75. In all years, schools paid a fee of $1 for each participating child to cover cost of materials.

**Staff:** 4 full-time teachers and 4 half-time aides.

**Location:** In the museum classrooms and exhibition area; follow-up activities take place in the schools between Exploratorium sessions.

**Time:** Either once a week for five all-day sessions or once a week for eight two-hour sessions, throughout the school year. Program began in fall 1972.

**Information and documentation available from the institution:** Announcements, course descriptions, memos, staff reports, and other material from the Exploratorium.

Monday, November 25, 1974: The thing in the middle of the low blue table was a cow's eye. As the teacher cut into it with a razor blade, several of the 4th graders turned away, giggling or squealing: ''I can't look.'' ''That's icky.'' Two boys sat on a bench holding their stomachs. Nancy, the teacher, kept on cutting. Eight children clustered around her, kneeling or standing, trying to identify each part of the eye as she uncovered it.

At a second table, another dissection began, under the supervision of an assistant, Yaye. When Yaye offered the razor to one boy, he took it unhesitantly and began searching for the optic nerve: "Look, I found it! That's it, isn't it?" It looked enough like the cross-section diagram Nancy had handed around that he seemed confident, even as he asked, that he had found the real thing.

"Real" things are only part of what this unconventional museum class in an unconventional museum is about. The Exploratorium is a science-art museum devoted to perception: how we see, taste, hear, feel, and how our brains understand—or garble—the messages our senses send. Studying the eye is part of a course the museum offers to some schools (but not as many as request the course) in an ambitious program called SITE—School in the Exploratorium.

Nancy had already spent nearly an hour this morning with the children in the museum's cavernous (90,000 square feet) exhibition area, looking at displays that directly relate to vision, and another half-hour in the museum classroom with the diagram of the cow's eye and passing around lenses ("You're upside down!" shrieked each child with his first squint through his lens). This was the second of five full school days these 4th graders from San Francisco's Madison School spent at the Exploratorium; in succeeding weeks they studied more about visual perception and moved on to sound and touch.

Monday, December 9, 1974: At the fourth of five sessions for 5th and 6th graders from the same school, Madison, the children worked with prisms, magnifying glasses, light angles, filters. The teacher, Terry, kept them busy selecting and blocking out colors, and experimenting with light movements until about 11:30, when they headed for another class.

On the way, an observer asked Curtis, a bouncy good-humored black boy, fully a foot taller than the others in his class, what he liked about his Exploratorium classes. "Missing school—I have to do too much work there." What about this, isn't it work, too? "This isn't work," Curtis answered. "This is fun!"

By 1:20, the same children were settled into a quiet classroom with Nancy, watching her mix colors for a tie-dyeing project. The children dipped paper towels, then rice paper, into the colors, and looked so happy and absorbed that the two public schoolteachers with them decided to join in.

Tuesday, December 17, 1974: The same 5th and 6th graders, back with one of their teachers, Bill Crawford, were out on the floor of the Exploratorium. The exhibition area is 1,000 feet long, 40 feet high, with steel girders bridging the 120-foot width—and the whole area is given over to these and other children in SITE classes, who test exhibits. Two girls led a third, blindfolded and giggling, up to Crawford and asked her to identify what "it" was. Two boys, Kenny and William, took turns blindfolding each other, wandering through the exhibit area making a game out of identifying exhibits they were both already familiar with.

A neatly dressed boy, Marty, was experimenting with an exhibit called Sidebands, turning dials and creating different images. An observer read aloud the written description of Sidebands (all Exploratorium exhibits have simply written explanations of the phenomena they demonstrate), and once he discovered that the upper row of knobs controlled the design and the lower row the movement, he moved ahead with dispatch. He explained it to a classmate, Daphne, who came up to watch him: "I've got it. See that knob? That controls the master pattern. It's like math. You just get the different patterns, then it changes the base of the pattern. I guess that's all for me. My eyes are tired."[1]

### The philosophy of the Exploratorium and its exhibits

Frank Oppenheimer, the founder and director of the Exploratorium, talks of his collection of about 300 exhibits as a "library of props" that visitors can handle, study, watch, push, pull, walk into, talk to, ask questions about, and learn from. Each exhibit puts an idea on display, and the visitor can investigate that idea by playing with the exhibit.

Each exhibit challenges the perceptions and the intellect of the visitor, who is allowed in this science-art museum to do what a scientist does as a matter of course: to go sightseeing among natural phenomena normally inaccessible to the public. The versatile and unifying theme for all exhibits is perception. Some have come from professional artists, some were made by Exploratorium staff or by local high school students or teachers or craftsmen, some come from industry or from federal agencies. Giant lenses and parabolic mirrors came from the warehouse of the Atomic Energy Commission. At the entrance is a Tesla Coil, a high-frequency oscillator-transformer that sends out 300,000 volts of purple light and ignites three fluorescent tubes, sizzles, and thanks every visitor who drops a coin into the donation barrel. (A donation is not required, but some visitors drop in another coin just to see the Coil flash into action again.)

Experiments and demonstrations in the exhibit area include lasers, a synthetic-order display, stroboscopes, holography, computer-poetry, models of spacecraft. *All* are to be touched: visitors can operate a large gyroscope or manipulate a bar magnet to affect a cathode-ray-tube image. Most are three-dimensional and manipulative, rather than two-dimensional and unresponsive to the visitor; indeed most of the exhibits do nothing at all without some action by the visitor. Oppenheimer is convinced that "only a limited amount of understanding comes from watching something behave; one must also watch what happens as one varies the parameters that alter the behavior."[2] So, the visitor himself experiments and discovers the scientific idea of the exhibit.

Oppenheimer has noted that the so-called "discovery method" of teaching often leads students to "'discover' only what the instructor had in mind,"[3] and he especially relishes the "flexibility that allows exhibits to be used for play," for visitors to find in each exhibit something that the artist or designer might not have thought of. Visitors spontaneously

use a large screen, which was designed to show the effect of retinal disparity using red and green shadows, as a backdrop for shadow dancing and pantomime, imprinting their shadows on the screen and watching with pleasure as the after-image slowly fades. A harp, which illustrates a photo-feedback process and sings in the light as an aeolian harp sings in the wind, has become a favorite device for visitors who produce rhythmic modulations by graceful or vigorous hand waving.

A number of Exploratorium exhibits are art objects. There is the giant *Checkerboard* of colored lights, whose squares change color as visitors "shoot" a light "gun" at them; different squares are affected by the red and green guns, and other squares are affected if the guns are held horizontally or vertically (a polarization phenomenon not everybody catches on to right away). Another is the sculpture called *Light Form,* made of rapidly revolving metal plates delicately carved to reflect light so that what the visitor sees appears to be a "sculpture" or an "object," but is really the "image" of the reflected light. And a lovely lively one is titled *Pin Ball Machine,* which uses polarization to turn apparently white circles into brilliant colored designs.

Oppenheimer's approach to science is that of a man committed to the democratic notion that people can choose what to learn; as he puts it, the Exploratorium is not designed to "glorify" anything or anybody:

We don't tell people what they are supposed to get out of a particular exhibit or make them feel silly or stupid because they enjoyed it in a way that was perhaps not intended. In this sense the Exploratorium is a playful place, and people are aware that they are not being pushed around. Our one firm rule prohibits riding a bicycle among the exhibits.[4]

### How it all began

As a university professor of physics, Frank Oppenheimer had developed a "library of experiments" for his students ("It was small, about 4,000 square feet. It had a lot of experiments set up and students had a free choice."[5]). A man who has used museums all his life ("I enjoy them, and I've used them for study as well as for simply going through. I've gone back over and over again to the same museum learning some particular history or whatever I wanted to learn"), he began to plan a science museum in the mid-sixties after spending a year visiting English and other European museums.

Returning to the United States, talking about and mulling over his ideas of a new kind of museum, it occurred to him that explaining science and technology without props is like trying to teach someone to swim without ever letting him near the water. In September 1969, he established the Exploratorium in San Francisco. It is like no other museum in existence, though many museum people have begun to lift ideas from it, to Oppenheimer's delight.

He believes that most museums—science, art, or whatever—do not respond to the needs of individual visitors, setting up instead a "fairly rigid pattern" that determines what every visitor will see and how he will see it. In contrast, Oppenheimer has set up what could be called a random or autonomous exhibit area; he calls it "trying to organize experience into ideas" and believes that this free-access teaching "is a role that museums can play that no classroom or television show can."

One of the things that has always scared people away from science is that they have been taught that the only thing that mattered was the right answer, and if you didn't know what all of the scientists at that particular moment thought was the right answer, you didn't have any business even thinking about it. This place dispels that fear. The right answer isn't pushed on people as the only possible answer. People make up their own answers and feel relaxed about it.

The study of perception interested physicists and others in the nineteenth century, according to Oppenheimer, but until scientists learned more about nervous organization, feedback and inhibition, and until they devised better instruments for looking at perception, the field went relatively unexplored. He believes it has become a lively study in the last 15 or 20 years, richer and more amenable to some sort of demonstration and understanding, but it's still "a very young field, with a long way to go before people understand it." His own interest began in the early 1960s when he was working on elementary school science curricula and recognized that depth perception was "a nice way" of teaching young students.

### The School in the Exploratorium

Though Oppenheimer believes the quality of learning in one-shot field trips "is not much to talk about," the Exploratorium continues to provide them to nearly 50,000 students a year. He compares them to sightseeing—"individual sights combine to form patterns, which constitute a simple form of understanding"—and notes that you never know whose sightseeing will prove valuable: he cites Marco Polo and Charles Darwin as master sightseers. But he distinguishes between passive and "participative" sightseeing:

In fact, it is impossible to lead a group through [the Exploratorium] on a guided tour. If one starts off with a group, one soon finds oneself alone, other people have stayed behind to play with or investigate one or another of the displays on the intended tour.[6]

The central focus of the Exploratorium's work with schools is with those classes that come for sessions once a week for five or eight consecutive weeks. "This pattern is good," Oppenheimer believes, "because it stretches learning out in time. Five consecutive days would be much less valuable because less would happen in the school in between visits. The program uses our museum to structure a curriculum, and I think that is possible in any museum."

A class, with its teacher, meets in the museum either once a week for five all-day sessions (10 A.M. to 3 P.M. with a lunch break) or once a week for eight two-hour sessions. All-day classes are held Monday and Tuesday, when the Exploratorium is closed to the public; on Wednesday, Thurs-

day, and Friday—the days when single-visit field trip classes fill the museum between 10 A.M. and 2 P.M.—SITE classes are held after these tour groups have left the exhibit area. The sessions are led by Exploratorium teachers and assistants; if a class exceeds 15 children it will be divided into two groups, each taught by an Exploratorium teacher and an assistant. Children in these classes are encouraged to keep journals of their experiences, and their teachers get from the Exploratorium staff suggestions for classroom follow-up.

The students come from the 4th, 5th, and 6th grades of the San Francisco and Marin County public schools. To allow teachers and students to share their experiences with their colleagues at school, the staff likes to work with several classes from a school over a period of time. (For example, between October 1, 1973 and April 1, 1974, they worked with eight classes and eight teachers from a single San Francisco school, with three classes from a parent-participatory school in the San Francisco public system, and with three classes from one Marin County public school.)

The curriculum is based on the concepts of light and sound and the processes of seeing and hearing. Before a class begins its SITE program, it takes a field trip to explore the museum, and Exploratorium staff who will work with the class pay a visit to the school to meet the students and talk with participating teachers and the principal.

**A typical SITE course.** Then the course and the "serious business of discovery," as one staff member puts it, begin. The course described here is a five-week course, but the eight-week sessions cover much of the same material and are conducted in the same way.

On the first day, one staff teacher explains the day's program to the classroom teacher while another introduces the children to their senses: they play one-eyed tag; taste "green" peanut butter (which looks terrible but tastes normal) and compare it with peanut butter that looks normal but has been heavily salted; close their eyes and try to distinguish sounds (light switches, camera shutters, cap pistols, staplers); sift through their hands salt, flour, baking powder. The first lesson is devoted to light, especially to refraction (one child insisted on calling it "infraction," but he got the idea), using concave and convex lenses, and flashlights and laser beams hitting opaque, transparent, and translucent surfaces (mirrors, water, and lenses).

The second session, a week later, builds on the first, turning to the eye—how it uses and adjusts to light (beginning with a camera with an open shutter) and how the two eyes work together, each seeing a different picture and requiring the brain to put them together into a single three-dimensional picture. That day the children spend a good bit of the morning looking at three-dimensional exhibits; each child goes on a scavenger hunt with a partner and a list of questions or statements for which he must find the pertinent exhibits (each is flagged). Sometimes a child will become fascinated with one or two exhibits, and the staff encourages him to stick with those displays and forego the rest of the hunt.

This is the day the children dissect an eye, and they quickly get over their first queasiness when they see the clear flexible lens and the open pupil. (One child wrote in his journal: "We all said they were ugly. Then we saw inside. There is a lens inside your eye. And behind that it's clear and behind that it's black.") The children test their blind spots and see what causes them in the optic nerve they have found in the dissected eye. Staff members say that the "most spontaneous and extensive follow-up" comes after this session.

Session three focuses on color and reflection, using prisms, mirrors, and about two dozen of the floor exhibits. Session four introduces sound and the sense of hearing, and Exploratorium staff observes in one report that the "children don't seem as tuned in to their hearing world as they are to their seeing world." During this session, the class breaks into five small groups, each with at least two adults (an Exploratorium teacher plus a classroom teacher or an assistant) to work with musical instruments, tuning forks, rhythm games, exhibits that look and work like musical instruments, and records; in the afternoon, the children make ear harps to take home.[7]

Session five continues the exploration of sound and vibration (everything from rubber bands and bell jars to sophisticated exhibits) and ends with the great tour de force of the Exploratorium, the Tactile Gallery. Designed by an artist, this 30-foot-diameter dome is a sculpture and an experience in exploration; children enter the dark labyrinth, unable to use their eyes at all and dependent on their senses of touch and sound (and their trust in friends in front of them and behind them) and snake their way through soft, bristly, rubbery paths that go up and suddenly down. Some are scared, some exultant, but all do it with great excitement—and the most adventurous do it over and over until they are finally hauled home.

### Follow-up in the schools

In order to flesh out the SITE experience and make it more lasting, the museum staff has prepared outlines of material covered in each session and a number of suggestions for follow-up activities—projects, experiments, homework assignments—for teachers and students to do between their SITE visits. For example, one activities list for use after the first visit suggests,

Do a class project on shadows: Pick a spot on the school yard for each child. Stand on the spot at the beginning of school, recess, lunch, before going home, etc. Have another child draw the shadow and mark the time. Have them talk about the position of the sun and varying shadows. Make shadow drawings and see if someone looking at them can tell what time of day it is. . . .

Another, for use after the second visit, recommends that children "try spending an hour with one eye covered up . . . moving around, trying to pick things up, playing tag, etc." Others contain diagrams and instructions for other experi-

ments with sound, light, water, perspective, and movement.

Some of the follow-up has been spontaneous. One teacher told the SITE staff the following story:

I have two experiments in my class right now that I attribute to the kids' participation in the Exploratorium classes. It was the kids' idea to set them up. One is on color and the other illustrates a chemical reaction. . . . The kids just came to me and said they had a "scientific experiment" they wanted to try. It's terrific because I'm just not the sort of person that would have initiated something like that. They got the things started and attracted the attention of a number of other kids. I just let them go with it, and it's been a really nice addition to the classroom.

According to a SITE staff report, "the impact of the program seemed much stronger on teachers and students who did some follow-up work between sessions, and so we wanted to find a way to make it an integral part of our program." Part of this effort is a plan for a more formal "teachers' notebook" for the 1975/76 school year—a comprehensive collection of outlines and suggestions that will be given to every teacher whose class participates in the five-week program.

The Exploratorium staff is also investigating another kind of follow-up, one that involves teachers the year *after* their participation in the five-week program. (Because of demand, each teacher can participate in SITE only once.) In meetings with teachers during 1974/75 the staff found that most teachers, much as they valued the SITE experience and felt that its elements should be integrated into the regular curriculum, were reluctant or hesitant to initiate attempts to carry over parts of the course with future classes. The staff's conclusion: follow-up would require "a vast amount of prodding and hand-holding from us."

So for 1975/76, this "prodding and hand-holding" will take two forms: a lending library of props, portable exhibits, and material that will be available to teachers, and a letter that outlines the specific ways in which a teacher can take advantage of the museum even though his class cannot participate in the SITE program. Among the planned offerings are regular meetings with all teachers in a school who brought children to SITE the previous year, to discuss the portable exhibits and accompanying material; individual curriculum planning conferences with Exploratorium instructors; visits to the museum; and workshops for teachers on specific themes, held at either the museum or the school.

### How do teachers, parents, and Exploratorium staff feel about SITE?

Parents' responses might be summed up by an episode at the Old Mill School in suburban Mill Valley: when it ran out of funds for the elective program at the Exploratorium, the parents of children who had already taken the SITE course gave money so that other children could have the same experience. Teachers' responses are nothing short of ecstatic. A teacher of a gifted class wrote,

I think that the Exploratorium experience is just marvelous

for the teachers as well as the children. The kids of course are full of curiosity about how things work and your particular setting provides materials and stimulation they just simply couldn't get anywhere else. . . . As for the teachers, it's fantastic inservice training for us. We have the opportunity to see other teachers with an expertise in science working with our children—this is very good. I could be the best teacher in the world in a structured classroom, but the more informal setting at the museum is a whole different thing. I've learned a great deal from watching the kind of learning that goes on in this kind of more informal environment.[8]

Museum staff noted in one report that teachers "get as much out of the School in the Exploratorium as do the children" and that because many have had to ignore science under the pressure of teaching reading and math, the Exploratorium course introduces them to some new concepts as well as some new ways to teach them.

Since SITE's beginning in 1972, the course has changed and refined its approaches to individual children. (Staff noticed that 4th graders from a prosperous neighborhood understood much more readily than 4th graders from a poor neighborhood the idea that water is a good conductor of sound; it turned out the "advanced" children had spent a lot of time banging stones together under water in their backyard swimming pools.) Some "take-home" projects have been too simple, others too complex for certain children. But parents, teachers, and staff seem agreed that all the children who come to SITE find, as staff at San Francisco's Rooftop School wrote, "that learning is exciting and knowledge is accessible."

### Oppenheimer's hopes for a museum district as a parallel educational system

A dedicated advocate and successful demonstrator of the idea that effective learning can go on in a museum, Oppenheimer has been talking about and pushing for a "museum district" set up for educational purposes. He believes that a city "should establish a museum district financed through tax money and treated independently, much like a school district." These two parallel cultural and educational systems then could form many internal and external ties, he believes, while maintaining their differences.

If one has other structured institutions within the community, then the school system can make use of them, but they are not just for the schools. They are for the general public, for extension divisions, for college classes and for preschool as well as for senior citizens, so that they cover a much wider audience.

Museums are not and probably never should be certifying institutions. That is, you do not get a job or learn a trade (except the museum trade) by going to a museum. If you do work there, you might acquire some skill, but museums are not prerequisites for commerce. They are resources which can stimulate a kind of inventiveness with and fa-

miliarity with the roots in the culture. The schools have difficulty doing that. Museums can provide real experiences, while the schools inevitably are oriented toward the classroom. These quite separate kinds of education should be supported separately but developed with many interwoven threads.

Oppenheimer's conviction that museums of all kinds offer a rich variety of alternatives to classroom education leads him to hope that all kinds of museums would cooperate within such a "museum district":

> That is what I mean by a museum system—not just the financial support, but that the museums of a town or community or a county think of themselves as sort of a unit that could interact.

**What's here for art museums?**

Art museums depend, perhaps naively, on schoolchildren's eyes to give them the information that experienced art museum visitors have learned to decode. Somewhere in the exciting labyrinth of the Exploratorium, there are ways to help people understand what their eyes can do, what they can see that they do not know they are seeing and have not seen before.

Frank Oppenheimer believes there are some experiences and approaches at the Exploratorium that art museums might use. He says "a lot of art museum people" come to watch and ask mostly about the SITE and the Explainer programs (for a report on the Explainers, see chapter 10). He notes, "They are very sanguine about converting their art museum into a place where the galleries themselves are thought of as part of a pedagogy. That is going to take a lot of doing. I do not know how it will get done."

But he has some ideas. The prudent use of reproductions seems sensible to him:

> If they [museum people] want to show the development of a certain kind of painting, they're perfectly willing, if they don't own that kind of painting, to leave big gaps, which make their themes impossible to follow because they don't want to use reproduction material to fill in with the real material. It's important that the museum does have real material, but I think there's no reason it can't add things that are needed to instruct.

Handling of the exhibits by visitors is one of the prime pleasures and purposes of the Exploratorium, which immediately sets it apart from the traditional art museum. Oppenheimer readily acknowledges the difference: "We don't have many of the standard conservation and curatorial and preservation problems here, since we don't have priceless or historical objects. We have valuable things that people want to steal, but [nothing] that's irreplaceable."

Yet, he observes, the Exploratorium has suffered no vandalism and "very little willful destruction," a fact he says "astounds people, especially as there are no guards in the museum." (Maintenance accounts for a little over 10 percent of the museum's operating budget.) He attributes the care

with which most people handle the exhibits to several factors, primarily a lot of space, access to information from labels and willing staff, and the fact that "people are not bored."

> . . . The exhibits are built in a way that there are many things to do with each. An exhibit does not just do what it is supposed to do, but it does other things, too. As long as people can invent something to do with the exhibits, they do not feel that they have to destroy them.

> Also, the same exhibit is interesting on a lot of different levels. I am against designing something as a children's museum or a museum for a certain age group or a certain professional group. I think one can design each exhibit in this kind of place to do more than one thing and appeal to a variety of audiences. To translate these design principles may be difficult in an art museum.

Though Oppenheimer has some casual ideas about how art exhibitions might "mix up" things to provide the diversity found in his museum, an art museum educator might find in his Exploratorium several solid ideas:

- An orientation gallery separate from the collections, where objects like some of Oppenheimer's could be available (for manipulation or not, depending on the nerves of the reigning director) to help visitors use their eyes and prepare for the galleries.
- Simple labels that "make knowledge accessible."
- The kind of tour that provides no "right answer" and that gives the children freedom to search for the objects that interest them.
- Museum classrooms and exhibition areas for a specific course in one or another principle of science or art or history.
- A philosophy of education that promulgates "two essential elements of any sort of teaching . . . to make people want to learn something; and then when they've started to learn, to get them unstuck" if they run into trouble.

Frank Oppenheimer is enough of an optimist, a visionary, and a stubborn fighter that he may even succeed in persuading the general public—from school boards and legislators to taxpayers—as well as his fellow museum educators, of his basic belief about museum education: "If people spend a little more of their lives in a museum, it will change what happens in the classroom."—A. Z. S.

---

**Notes**

[1] All episodes reported here are taken from observations by Joan Smith of the Exploratorium staff during fall 1974.
[2] Frank Oppenheimer, "The Exploratorium: A Playful Museum Combines Perception and Art in Science Education," *American Journal of Physics,* vol. 40 (July 1972), p. 982.
[3] Ibid.
[4] Ibid.
[5] For sources of quotations without footnote references, see list of interviews at the end of this report.
[6] Ibid., pp. 979–980.

[7] The ear harp the SITE children construct is a musical instrument made of a 4-by-8-inch piece of plywood strung with three pieces of nylon fishing line of varying lengths. Each child hammers three tacks in a row along a narrow edge of his piece of plywood. He attaches eye screws along the opposite end of the board, placing each a different distance from the tacks. After tightly securing the fishing line to the tacks, the child threads the line through the eye screws, and ties it to the screws. With a nail, called a "tuner," he turns the screws to tighten each line. When he has tuned it to satisfaction, the child holds the harp against his ear and plucks the strings to produce a delicate, tinkling sound.

[8] M. Heller, teacher quoted in an Exloratorium staff report.

## Interviews

The following persons were interviewed for this report by CMEVA staff during May and June 1974:

Grinell, Sheila. Assistant Director, Exploratorium.

Isaacs, Lenni. Exploratorium Staff Member.

McMillan, Michael. Artist-Teacher, de Young Museum Art School, San Francisco.

Miller, Bob. Artist-in-Residence, Exploratorium.

Oppenheimer, Frank. Director, Exploratorium. Interview conducted by Paul Kleyman, June 21, 1974; also July 9, 1975.

## Bibliography

Albright, Thomas. "From Electric Music Boxes to Solar Energy Art," *San Francisco Chronicle,* October 22, 1970.

Cole, K. C. "The Art of Discovery in San Francisco—Exploratorium," *Saturday Review,* October 14, 1972.

Doss, Margot Patterson. "A Place Full of Wonders," *San Francisco Examiner and Chronicle,* June 21, 1970.

Evans, Gwendolyn. "An Explorer's Reward," *San Francisco Chronicle,* August 28, 1974.

"Hands-On Policy." *Newsweek,* December 3, 1973, p. 82.

Oppenheimer, Frank. "Teaching and Learning," *American Journal of Physics,* vol. 41 (December 1973), pp. 1310–1313.

———. "The Study of Perception as a Part of Teaching Physics," *American Journal of Physics,* vol. 42 (July 1974), pp. 531–537. (Both the preceding are reprinted from the Robert A. Millikan lecture, which Oppenheimer delivered at the 1973 meeting of the American Association of Physics Teachers, on the occasion of his receiving the Millikan Award in recognition of his concern with the teaching of physics.)

———. "The Exploratorium: A Playful Museum Combines Perception and Art in Science Education," *American Journal of Physics,* vol. 40 (July 1972), pp. 978–984.

———. "A Rationale for a Science Museum," *Curator,* November 1968 (unpaged).

"San Francisco Museum Stresses Involvement," *Physics Today,* June 1971, p. 62.

## INDIANAPOLIS MUSEUM OF ART: SEARCH

Indianapolis Museum of Art
1200 West 38th Street
Indianapolis, Indiana 46208

**An art museum satisfies the state's art-instruction requirements for the 8th grade with an inexpensive program that brings the students to the museum and teaches school and museum educators something about each other. CMEVA interviews and observations: November 1973 and May 1974.**

### Some Facts About the Program

**Title:** Search.

**Audience:** 8th-grade students, about 60 each semester, 120 per year.

**Objective:** To provide studio art experiences in the museum classroom, under the direction of schoolteachers, that are related to gallery visits and other art experiences.

**Funding:** Paid for out of regular museum and school funds; about $200–$300 for supplies, plus bus costs, are paid by the schools.

**Staff:** 4 school art teachers per year, plus school art consultants; 2 museum education staff, and about 6 to 8 selected volunteer docents.

**Location:** In museum; occasionally at sites around the city.

**Time:** Program began in 1971/72; runs twice a year, once each school semester. During the semester, there are two two-hour morning sessions per week for six weeks. The time allocation of 1,440 minutes constitutes the total scheduled art education for the participating students for the entire semester.

**Information and documentation available from the institution:** Folders and brochures announcing and describing the program.

---

The modest project called Search provides an instructive example of a school-museum experiment born of politics but transformed by events into something else. It was originally designed in 1971/72 by the Indianapolis Public Schools and the Indianapolis Museum of Art to "provide mutual multi-ethnic experiences"—that is, to take black and white students from their segregated schools to an integrated museum experience. The museum was to provide neutral territory where the young people might meet with a minimum of tension and awkwardness.

When a court order required all Indianapolis public schools to integrate, the "multi-ethnic" aspect of Search was suddenly obsolete. It was, "anyway, a lever to get the job done," says Ted Moore, the art supervisor of the city schools.[1] This job was another goal listed in the original proposal: "To provide unique art experiences related to the Museum collection."[2]

"I think it holds up better as a cultural experience than as an interracial one," comments an experienced docent. Several docents observed that mixing classes in an effort to integrate them for a couple of hours a day made the schoolteachers feel they had to compete for the affection and

respect of one another's students. It also failed, inevitably, to provide the students with any real opportunities to make friends with new students.

Search '73/'74 was much the same as the original Search, but with race a forgotten factor. Each semester about 60 8th graders from two schools—30 to a class—spent two mornings a week for six weeks in the museum. Each session lasted two hours. The total time, 24 hours, satisfied the state art-instruction requirements for the 8th grade.

The 12 Search sessions followed the same general pattern: a half-hour visit with docents to one or two galleries or some other museum area, then an hour-and-a-half session in the museum studio directed by the school art teacher, with a visiting school art consultant and museum docents assisting. A typical session might include a talk with the museum conservator followed by a studio project where students see slides of cave paintings, make brushes and mix pigments, and do "cave paintings"; or a tour of the sculpture galleries emphasizing modeling, carving, and positive and negative space might be followed by a studio lesson in firebrick and wire sculpture. Music, dance, and field trips to architectural landmarks are also part of Search.

Part of the museum's impetus for the Search program was to get school groups to come more than once and to keep the best volunteers interested. The key phrase is "more than once." From the schools' point of view, there was a desire to put the emphasis not so much on social studies as on "man as an image maker, so kids will feel, 'I can do it too,'" as the art supervisor puts it. He sees "a conflict between the self-contained-classroom teachers, who see art as a historical phenomenon, and art teachers who see art as objects creative men have made."

### How the museum and the school system cooperate

Perhaps because the project was inexpensive and small (fewer than 150 students a year), cooperation was fairly easy—that is, with no more than the usual communications gap between two institutions, two staffs, two perspectives. The Indianapolis Public Schools provided all basic supplies, transportation, and the studio art teachers; Moore estimates school costs at no more than bus expenses and "maybe $200–$300 for extra supplies." The museum, which provided work space and professional and volunteer assistance, set aside no funds for Search.

The program was planned by the schools' art supervisor, two art consultants on his staff, and the museum education staff. School and museum staff met twice before the six-week units began. The museum staff discussed exhibitions for the coming year, the permanent collections, the museum facilities available, including a nature area, theaters, and kilns and jewelry-making equipment. The second meeting, about two weeks later, decided programs and schedules: "It's at that meeting that the teachers, after thinking about the hard work that their first phenomenal ideas will require, settle on what they can really expect to do in the museum," ob-

served Sue Moreland, a former schoolteacher and the museum's supervisor for Search.

The museum sees itself as "a resource, and the teachers choose from our list of over 30 suggestions," says Mrs. Moreland. She reports that "during the first year we found that giving the teacher the semblance of authority encouraged her to take it on more and more." The position consistently taken by museum staff is that the school art teacher is "responsible for discipline and provides stability for the kids."

If in 1973/74 the schools seemed to some museum staff less enthusiastic than before, it may be, as a docent observed, that "the teachers are so pressed for time they just don't want to do the planning." Time is a problem, acknowledges Ted Moore, who also sees Search as primarily a school project that uses the museum as resource. "The principal has to be willing and flexible," he says, "and the teaching staff sympathetic . . . because the biggest headache for us is pulling a teacher out of school, since somebody else has to plug that hole. I wouldn't want to cajole or force teachers. The whole success of the project depends on the art teachers."

Museum staff and docents, in contrast, doubt that art teachers always volunteer. The assistant curator of education, Marla Dankert, believes that "the school system chooses the classes that will come; proximity to the museum and the willingness of the principal are probably significant factors in the choice."

"Proximity" is no minor problem. The Indianapolis museum's new building is set in a handsome former estate, across the road from a country club and five miles from the center of town, with no access to public transportation.

### The fruits of cooperation

Whenever museum and school people anywhere try to work together a difficult problem surfaces. Museum educators nowadays generally pride themselves on their flexibility, inventiveness, and conception of the student as a potentially creative being. Most school people find this attitude a sloppy premise for the business of teaching, priding themselves on their ability to undertake and complete a project in which their students achieve some of their potential. Most museum educators in turn find this emphasis on achievement rigid and narrow.

Given these uncomfortable facts of life, the museum and school people who work on Search have learned from each other some useful lessons. Art Supervisor Moore believes that many museum people find it difficult to deal with 25 or 30 children at a time, as schoolteachers must, and notes that the Indianapolis Museum limits gallery groups to 15: "Some don't understand the tactics school art teachers feel they must use. Museum educators take a more laissez-faire attitude and emphasize freedom more. But they haven't walked that mile in our teachers' moccasins."

On the other hand, one docent wryly observed, "Some teachers believe any lady who's a volunteer at a museum is just automatically too far removed from kids." "A little

storm-trooperish at first, more interested in order in the classroom," was another docent's first impression of a school art teacher. "But we've gotten to know each other, and she encourages us to help, and we've worked it out."

A staff member explained the museum perspective on dealing with 8th graders: "When we get them real loose after a visit to the gallery, we're sorry to see them get nervous in the studio when the teacher starts giving instructions and then maybe they get too tight to enjoy their work."[3]

Working hard at working it out, Indianapolis Museum and school staff believe they have put together a good program that will get better with practice. Museum staff learned to recognize that a school art teacher's abilities often determine the lesson plan. Though one docent saw the visiting school art consultant as the pipeline to the highest authorities ("from her mouth to the board of education's ears"), the docents acquired a deep respect and affection for those consultants who pitched in and helped the school art teacher in the museum studio, encouraging both teacher and students. Museum staff and docents agreed the school art teacher had a difficult job to do, in unfamiliar surroundings and under time pressures.

According to the art supervisor, most of the participating teachers considered Search "a fine program but a heck of a lot of work." He says the teachers had to worry about teaching in two far-distant points, "and they aren't just pulled out of school and out of pattern; their time is compressed, and they do this additional work without additional pay."

As for the students, responses to the museum's questionnaire indicate that most liked the program. The number who wanted to sketch outside again, and to use the outdoors more often, may be expressing an adolescent urge to be unconfined, or responding to the exceptionally pleasant park where the Indianapolis Museum sits.

Mrs. Dankert says the program has been very gratifying to the museum on several levels: "It's raised the general level of awareness of the kids, and the art teachers get better work out of their students—more diverse, freer." A Search docent agrees:

The kids are beginning to look at the museum as a place for them, not just for old people. I try to bring this out; I think it's the most important thing I can do. The kids begin to relax as times goes on, they begin to use their eyes, to look a little more. And I see some later in the museum, giving Search tours to their friends.

### Postscript

At the start of the 1974/75 school year, the program underwent certain changes. The most important is that the museum staff has taken charge of the program; school art teachers no longer conduct the studio sessions. "Staff" means not just museum professionals, but also docents (including two with degrees in education, one accredited as an English teacher, the other as an elementary schoolteacher), who work under the supervision of the professional staff. Not only the school art teacher but subject teachers accompany their classes to the museum, as observers, helpers, and presumably ultimate arbiters. The schools' art supervisor gave as one reason for the shift his feeling that, with no release time for his teachers to prepare for the museum visit or to cover their working time in the museum, the quality of Search would decline. The museum staff member in charge believes that the new approach gets more teachers involved and supplements the school curriculum more broadly. Because the students now come for one day rather than two days a week for six weeks, the program no longer satisfies the state's time requirement for 8th-grade art, and the state gives no credit. The schools pay $2 per student to cover the museum's cost of materials.

The museum offers six different packages or sequential series of visits, which include more art history than before. The schoolteacher chooses among them or asks for the mix best suited to a particular class. Six schools work in the 1975/76 program: two city public schools, two parochial schools, and two country schools.—*A.Z.S.*

### Notes

[1] For sources of quotations without footnote references, see list of interviews at the end of this report.

[2] Search outline, 1973/74.

[3] One outsider's report of what went on in a museum classroom, with the school art teacher and two docents on hand: Some 8th graders impatiently waited their turn at the video machines, others were absorbed in drawing self-portraits (one boy with bad skin punched black marks all over his drawing of his face), and the adults wandered from table to table, murmuring encouragement, asking or answering questions. Toward the end of the lesson, the art teacher called out, almost caricaturing herself: "I want your feelings. Come on, class, get some colors in there, and some self-expression." At the very end, in a loud flat voice, she said: "I want a title." One boy demurred, saying he didn't have one in mind. She repeated, "Give me a title anyway."

### Interviews and observations

Adney, Carol. Department of Education, Indianapolis Museum of Art. May 9, 1974.

Dankert, Marla. Assistant Curator of Education, Indianapolis Museum of Art. November 13, 1973; May 9, 1974.

Frick, Don. Department of Education, Indianapolis Museum of Art. May 9, 1974.

Leviton, Florie. Volunteer Docent, Search, Indianapolis Museum of Art. Observed May 9, 1974; telephone interview, May 23, 1974.

Loar, Peggy. Curator of Education, Indianapolis Museum of Art. November 14, 1973; May 9, 1974.

Marshall, Ray. Department of Education, Indianapolis Museum of Art. May 9, 1974.

Moore, Ted. Art Supervisor, Indianapolis City Schools. Telephone interview, May 22, 1974.

Moreland, Sue. Curatorial Assistant for Special Education Programs, in charge of Search for the Indianapolis Museum of Art. May 9, 1974.

# HIGH MUSEUM OF ART: DISCOVERY AND ELEMENTARY-ART TO THE SCHOOLS

High Museum of Art
1280 Peachtree Street, N.E.
Atlanta, Georgia 30309

**In two programs for inner-city 4th and 6th graders, volunteers work closely with museum staff members to lead a series of classes, starting in the schoolroom and moving on to several sessions at the museum. Both series aim to give children the handles for looking at art and at the forms of art everywhere around them. CMEVA interviews and observations: June and October 1973; April and May 1974.**

### Some Facts About the Program

**Title:** Discovery and Elementary-Art to the Schools.
**Audience:** Discovery: six 4th grades of the Atlanta Public Schools, all from the inner city. Elementary-Art to the Schools: 3,000 6th graders from throughout the city.
**Objective:** To develop "each child's perception of the elements of art as they exist in his environment."
**Funding:** Discovery cost $2,669.16, including bus transportation, guest artists, doughnuts, supplies. For Elementary-Art to the Schools, supplies cost $1,013.35. For both programs private donations paid transportation costs, and the museum paid for staff time and materials.
**Staff:** Professional staff contact the schools, schedule visits, train volunteers, and sometimes act as lead teachers. Volunteers: 16 for Discovery and 42 for Elementary-Art to the Schools. Professional dancers and musicians also participate in Discovery.
**Location:** One session is conducted in the school. Others take place in the Junior Activities Center, special exhibitions, and museum galleries.
**Time:** Discovery: two 4th grades each school quarter; each class comes to museum for six hour-and-a-half sessions. Elementary-Art to the Schools: each group of 60 children (two classes) takes part in three sessions spread over three or four weeks.
**Information and documentation available from the institution:** Junior Activities Center training manual and volunteer training manual (mimeographed), Guild membership invitation, museum monthly calendars.

In her book, *The Open Eye,* Katharine Kuh writes that "only a genius could reach children in more than routine measure" in the usual regimen of the 40-minute art class or museum tour.[1] She found disciples in the education department of the High Museum. Convinced that it was not enough to reach each child "once over lightly," the staff decided in 1972 to expand the boundaries of the museum's traditional programs for schoolchildren. Working with museum volunteers, they devised two programs that combine classroom exercises and a series of museum visits. One is called Discovery, a six-part program for inner-city 4th graders; the other is Elementary-Art to the Schools, a three-part program for 6th graders. Both are conducted largely by trained volunteers and are keyed to a special exhibition built around selected elements of art.[2]

### The Discovery program

Designed to develop "each child's perception of the elements of art and his environment,"[3] the program begins with basic concepts and vocabulary in a preliminary session at school, conducted by a High staff member and a volunteer for each class. Six sessions in the museum follow, each lasting at least an hour and a half. The themes are equally basic: line, movement, and rhythm; two-dimensional shape and space; three-dimensional shape, form, and space; texture and sound; color and mood; composition and rhythm.

Every museum visit explores the collection through dialogue, improvisational games, and some workshop activities. The lead teacher for each session may be either a museum staff member or an experienced volunteer, assisted by other volunteers responsible for the same three or four children on each visit. (They use the buddy system, two volunteers and their charges visiting the galleries together; that way, if a volunteer misses one trip, her partner feels equally at home with both groups of children and they with her.)

One of the six basic themes is used to focus the children's attention at the beginning of each museum visit. In an effort not to isolate each theme from all the others—thereby making art less than the sum of its parts—the volunteers try to follow the advice of their training manual: "Each week we will emphasize a specific element of art and strive to create continuity by building on discussion and experiences of previous weeks."[4] In addition to the customary questions and answers ("Which color do you see first in this painting?" "Do the lines and shapes in this painting make your eye want to move in a particular direction?"), the volunteers have a wide repertory of teaching methods. To teach about texture, they invite the children to touch a stretched canvas painted with various techniques. An assignment the children seem to find especially stimulating is to do rubbings of surfaces inside and outside the art center. Theater games, such as "Slomo" (a play on the words "slow motion"), involve the children in discussions of mood and movement.[5] And the volunteers sometimes carry "busy baskets" full of pipe cleaners, newsprint, crayon, yarn, and other materials the children can use to make their own compositions. (For a report on how volunteers are trained at the High Museum, see chapter 5.)

**The museum visits.** Four of the six museum visits combine gallery tours with a workshop project, either in the galleries or in the Junior Activities Center. One features a workshop on three-dimensional form conducted by two dancers. Another includes a musical performance in the galleries by a professional trio. That session, on color and mood, illustrates the approach of the Discovery Program.

The volunteer begins the session by encouraging the children to respond to moods they find in works in the galleries. To a Blakelock painting, one group responded almost as a group, sad and thoughtful; to a sharp red in another painting,

their responses varied widely, and the volunteer observed to them how personal reactions to colors can be, asking them to think about the colors of favorite clothes or places or things. When the children and their volunteer leaders returned from their gallery tour to a large open gallery of Impressionist paintings, they found waiting for them a member of the Department of Children's Education and three musicians, ready to lead a lively workshop on color and mood.

The children began with warm-up exercises to music, then listened—with obvious delight, calling out familiar words and events—to a musical rendition of the "Three Little Pigs." Posted on an easel in the gallery was a list of words: angry, sad, quiet, calm, explode, all words of feelings and mood. Each child would silently choose a word to act out, using a colored cape one of the adults had ready, the movements of his body, and music; he would confide his choice to the musicians, who then helped him along in his mood-creation. His classmates would try to guess the child's word, usually successfully, though even sympathetic adults might concede that it was sometimes the music rather than the child's movements that revealed his secret word.

In the typical final Discovery session, each group constructs a terrarium, using what they have learned about composition, line, texture, and dimension, and proudly carries it back to the classroom.

## The Elementary-Art to the Schools program

Designed for 6th graders, this series uses many of the same techniques as Discovery but is very highly structured; in some instances the sequence of events is specifically prescribed. In the first session at the school, volunteers show a filmstrip of natural objects and works in the museum collection, interrupting from time to time with questions, games, and suggestions that the students look around for shapes similar to those on the filmstrip. By the end of the morning, the volunteers (four of them, two in each classroom) have the students enthusiastically making their own small wire-and-wood sculptures, incorporating what they have learned about line and shape.

At the museum the following week both classes spend an hour and a half in the galleries and the special exhibition—in this case, "Shapes"—guided by the same four volunteers who had worked with them in the classroom. Some theater games may be used at the guide's discretion, but others—"Blackout" and "Slomo"—are required immediately before or after visiting the "Shapes" exhibition, to prepare the children for the filmmaking session the next week.

During that final session—conducted in the Junior Activities Center by the same volunteers, who are now fast friends with all the children—the students use magic markers and clear leaderstrip to produce their own film of many-colored shapes. That film is shown, with musical accompaniment, at the end of the session along with several animated films made by the same process by local college students.

## Reactions and outcome: children and volunteers

After only a couple of visits, the children in both programs are so comfortable, reported one volunteer, that they feel as though they "own the place." Especially the younger children respond with affection, eager to do every activity that is offered, vying for the privilege of carrying the guide's materials or busy basket. One schoolteacher whose children took part in the Discovery program noted that some of them had taken books on dance out of the library before coming to the museum session that featured dancers.

Volunteers have stressed that the continuity of the programs—the chance to work repeatedly with the same children and learn something about their individual responses—is important to them. And they add that tackling one issue at a time allows them the luxury of not having to "cover the waterfront" in one tour. How do they know when they have been successful in communicating something to the children? For one volunteer, the answer to that is, the moment when the children offer comments that are all their own rather than guessing at answers to her questions.—*S. R. H.*

## Notes

[1] (New York: Harper & Row, 1971), p. 197.

[2] From 1971 to 1974 the special exhibition was "Shapes" (see report in chapter 9); it was followed by "The City" (briefly described in the "Shapes" report).

[3] "Share Our Adventure," a brochure for recruiting new volunteers. February 1974.

[4] The volunteer training manual has several sections: dialogue guidelines that can be used in many of the department's programs, as well as specific scenarios that can be followed for particular programs. Studying the entire manual may give volunteers a number of approaches to the same issue: "Does your eye travel from one part of this picture to another? What devices has the artist used to do this? (color? shapes? texture?)." And elsewhere in the manual: "Do you have the feeling that the subject continues beyond the limits of the picture? Does the action 'move out' from the center? Do some lines give you the feeling of movement? Which ones? How did the artist make you feel there was movement here? (In the Ricci, lots of curved lines give a feeling of movement. How does a snake move?)."

The manual also includes a section on the permanent collection. Each painting is included on a separate page with space for the volunteer's notes. The painting is described by name of artist, title, medium, a few lines on the time in which the artist worked, something about the artist and his goals, a line about the subject, and some suggested questions and dialogue ideas or a reference to another section of the manual.

[5] In the special scenario section of the volunteer training manual, a number of theater games are described, together with simple instructions and observations on their use. "Slomo" is "physical concentration on analysis of action. Everything is done in super slow-motion, and it is good for use in discussion of line, movement, mood, etcetera, and is an effective physical activity with a particularly active group."

## Interviews and observations

Hancock, Paula. Curator of Education, High Museum of Art. June 13, October 15–17, 1973; April 3–5, 16, and 17, May 16, 1974.

Scheidt, Monica. Junior Activities Center Program Coordinator, Department of Children's Education. June 13, 1973; April 4, 1974.

Vigtel, Gudmund. Director, High Museum of Art. October 16, 1973; May 16, 1974.

Junior Activities Center Volunteer training session, October 15, 1973. (Guest speakers: Dr. Dennis White, Georgia State University; Alma Simmons, Arts Coordinator for Atlanta Public Schools.)

Adventures in Doing program for docents: textile workshop session on card weaving. April 5, 1974.

Creative Packaging program. April 3, 1974.

First-grade tour, part of the student tour program. April 16, 1974.

Elementary-Art to the Schools program in the museum, April 16 and May 16, 1974, and at Anderson Park Elementary School, April 4, 1974.

## ART INSTITUTE OF CHICAGO: FOCUS AND PERCEPTION

Art Institute of Chicago
Michigan Avenue at Adams Street
Chicago, Illinois 60603

**A large urban museum bases a program for 7th and 8th graders on literature texts for good readers, illustrated by reproductions of art works on the books' themes. Students who make the monthly museum visits and volunteers who lead them carry on their discussion at a high plane, to the delight of teachers, parents, and museum staff. CMEVA interviews and observations: November 1973, March 1974.**

### Some Facts About the Program

**Title:** Focus and Perception.

**Audience:** 7th- and 8th-grade classes from six schools in District 1 of the Chicago Public School System.

**Objective:** To complement thematic literature classes with a series of six museum visits, during which the children study the same themes in works of visual art.

**Funding:** No specific funding. The schools (or the children) pay for bus transportation; the museum contributes considerable staff time.

**Staff:** Supervised by the assistant director of museum education in charge of the Junior Museum of the Art Institute, the program is conducted by the individual classroom teachers and by 12 volunteer staff assistants, each of whom is assigned to a particular class for the entire year. (The language arts consultant of the school district serves as adviser.)

**Location:** In the museum galleries.

**Time:** Classes visit the museum once a month between October and March of the school year. Each visit lasts at least an hour and a half.

**Information and documentation available from the institution:** None.

"People come up to me and they say, 'Who are those children? Where do they come from? I haven't heard kids talk like this in a gallery in my whole life. I'm from out of town and I want to know what goes on in this town.'"[1] Rita Hansen was clearly delighted to have had the question asked and to have a chance to repeat it, because she thinks that what goes on in this town, Chicago, in a school program at the Art Institute, *is* remarkable.

Mrs. Hansen is language arts consultant for District 1, one of 28 school districts in Chicago's city school system. District 1 takes in the far northwest corner of the city: 26,000 children of many backgrounds but mostly white, in 26 different schools, including 3 high schools. Mrs. Hansen meets with all of the schools; the work at the Art Institute that so delights her is a small program serving only 12 classes, the 7th and 8th grades in six schools of District 1. The program takes its name from two 7th- and 8th-grade literature texts for good readers, *Focus* and *Perception*.

It began with one school class of "gifted" children. By its third year, 1973/74, the program was considered a success for average students, too, by school personnel and by the Department of Museum Education at the Art Institute of Chicago. Lois Raasch, assistant director of museum education, supervises the Focus and Perception project and the 12 volunteer staff assistants who work with District 1 classes.

### The textbooks

The books are part of the Themes and Writers Series published by the Webster Division of McGraw-Hill. Primarily literature texts, they are divided into thematic units—"The Unexpected," "Survival," "When It's Your Own"— illustrated with reproductions of paintings, sculptures, and graphics on the same theme. (Other textbooks illustrated with works of art are on the market, as are thematic curricula, like UNESCO's.)

Literary selections range from Biblical passages and Aesop's fables to stories by little-known writers and by such well-known ones as James Thurber, Budd Schulberg, Washington Irving, Edgar Allen Poe, and Shirley Jackson. Poetry includes work by Robert Frost, Carl Sandburg, John Updike, and Stephen Vincent Benet, and a translation of a Goethe poem by Sir Walter Scott. And there are nearly-novel-length stories by Thomas Hardy, Mark Twain, Charles Dickens, and Jack London; a play by Gore Vidal; and versions of Greek myths, Beowulf, and other classics. The teacher's guides contain, in addition, books recommended for further reading.

The choice of visual arts is as catholic—Hopper, Chagall, Turner, Sassetta, Schongauer, Morris Graves, Persian miniatures, John Steuart Curry, Sir John Tenniel, Klee, Daumier, Le Nain. These reproductions—usually several pages in each unit—are called "Galleries."

The teacher's guides explain their purpose: "Each gallery, through direct visual impact, illuminates the literary theme . . . [and] adds a new dimension to the student's experience

of the theme. Line, color, mass, stone, wood, etc., like words, convey the theme in their own unique terms.'' The reproductions "play an important but secondary role: they are to complement and extend the literature."[2]

The teacher is advised to "keep the approach to the gallery simple. In short, do not let it become 'arty.'" The simplest approach, recommends the guide, is to

> give the students 15 to 20 minutes to examine the fine art and read the captions on their own. . . . The captions provide sufficient information to make each painting or sculpture interesting and relatively intelligible. Moreover, they help the student see that the painter (sculptor) is dealing with the same human concerns as the writer.[3]

The 8th-grade teacher's guide (*Perception*) suggests questions that might occupy the class after the simplest exercise is completed: which painting best suits the theme, or appeals to the students, and why, or "what different effects the different styles achieve."[4]

More ambitious 8th-grade approaches suggest that students write papers "comparing the writer's and the painter's ways of doing things: characterization, imagery, organization, tone, style, and purpose. . . . Encourage students to discuss how this is done, noting as they do the close similarities to vivid writing." Students might make a "gallery of their own," at least half of which should be composed of fine arts reproductions; the "remainder may be any other types of illustrations." And the guide warns, "The problems of finding really suitable illustrations to fit a particular theme are considerable. . . . Local art museums have catalogues of their collections, and larger libraries have art books as well as xerox machines to reproduce a particularly good find which cannot be cut out." Installing the collection will require the students to decide what goes next to what and why, the guide observes. It also suggests that the brightest students might write papers relating one painting to another and analyzing various styles of painting, "regardless of subject. If some of your students reach this level of sophistication, they will find an almost endless supply of topics for composition projects."[5]

Captions accompanying these reproductions are not written to gladden the hearts of artists or museum educators. Daumier is called "one of the great people-watchers of all times." The Le Nain *Landscape with Peasants*—a painting that is exactly what its name says, a pastoral landscape with figures—is included in a unit titled "Trapped" and labeled with this questionable interpretation:

> For some people the way of life they have inherited is the trap in which they spend their lives. Three hundred years ago, Le Nain painted the peasants of his age to show the hopelessness of their lives.[6]

Other captions are sensible enough and even note visual elements. For Chagall's *Green Violinist*, which introduces a unit called "The Unexpected," the caption reads,

> The green violinist floating in space with one white and one green hand is one of many deliberately humorous fantasies created by Marc Chagall. Many of his paintings start with a reference to his native Russia and its folklore, but what he makes of them is always unexpected. What aspects of the painting strike you as unexpected?[7]

But most are very simple. Accompanying the unit on "Fighting Dragons," a lovely Persian painting—*Rustam and Rakhsh Slay a Dragon,* in the Fogg collection—is reproduced, its colors distorted, of course, by the textbook printing; but the powerful curve of the dragon's body, the dappled horse, the field of flowers, all are there and unmarked. The caption reads,

> The slaying of the evil dragon is the crowning achievement of heroes. The great hero of Persian legend, Rustam, fought successfully against dragons and various demons. This Persian miniature is over 600 years old.[8]

The uneven quality of the captions is bound to puzzle any school or museum educator, who welcomes the use of works of art in textbooks.

## The schools

What does a language teacher do with these visual elements in a literary text? The teacher's guides make *no* suggestion that the students might be encouraged to visit the local museum to *look at* works of art. Rita Hansen reacted this way:

> I opened it, and I saw all those paintings. And here was Tovatt from Indiana and Carlson from Iowa [the authors of the texts], and neither had chosen any paintings from the Art Institute except for one . . . and I was furious. How dare those Midwesterners do that! I couldn't fight with them, so I called up the Art Institute, and that's how the program started.

She is enthusiastic about the textbooks for 7th and 8th graders, who "don't have any really neat reading to do." "You know," she continues, "Willa Cather said one day to English teachers, 'Why is it you are always about the trappings of literature instead of what really happens to people?'" Mrs. Hansen trusts these textbooks to reach the students on an emotional level where life "really happens to people." She believes the anthologists "carefully thought out things that would work, were universal, and it seemed to me that some of the models in those pictures are as valid as the stories."

The emotional needs of 7th and 8th graders are, in Mrs. Hansen's judgment, ill-served by the now-conventional junior high school that sets them apart ("It's not valid," she insists) and are better served by the school that goes from kindergarten through 8th grade, as do Chicago's public schools:

> Being upperclassmen means they have to act like good kids, because they have to watch the little kids. They have to be the hall guards, do some tutoring. So they have some sense of being the big shots, of being important. . . . They have some sense of responsibility for little children. . . . They are thinking about growing up, about the kind of

people they are and are going to be, they are trying to find sex relationships. . . . [What they need] is really Aristotelian catharsis, and I think anything less than this for children at this age is wrong. I think it has to be a piece of art that's good enough. . . .

Other literature teachers share Mrs. Hansen's admiration for the textbooks and the guides. "I think the book is exceptional," said one, ". . . [and] the teacher's guide is just about the best I've ever used." Teachers disagree about the level of the literary selections; one says, "You need top kids," and another, who has taught both gifted and average students, says, "I find that [the average] children don't get as much in the reading . . . but the kid who hasn't read it all can come along. They don't get the meat of the story necessarily, but they can use what they get."

"We have some children who really didn't read those stories, but they know them from all the talk; that shouldn't keep them from the great ideas of the world. We've had kids paired and they read it aloud, and some teachers put it on tape," Mrs. Hansen explains. A 7th-grade teacher observes that sometimes it is the poor readers who have the best insights about visual ideas, in class as well as in the museum, and Mrs. Hansen agrees: "That was a surprise. The teachers have all independently found this out for themselves."

After a trial year with one class and one volunteer staff assistant at the institute, Mrs. Hansen and Ms. Raasch agreed that the program should be expanded. Neither wanted it to be an "elitist program"; consequently, average as well as gifted students are included in it.

**The museum**

Each volunteer lecturer is chosen for the program on the basis of her experience (several have lived in other large cities and have volunteered at other major American art museums), her interest, and her ability. The same volunteer serves as friend, hostess, and instructor for a school class on each of its six visits. Visits begin in October and end in March ("and we'll tell you why it ends in March," says one of a group of teachers: "It's because nobody else pays any attention to the

### The Pad, Pencil, and Child on His Own

Some museums offer activities for the independent school-age child who comes alone or with a friend. The Art Institute of Chicago provides "I Spy" games in its Junior Museum, the Metropolitan Museum offers periodic Treasure Hunts, and the Jewish Museum in New York has a "Show and Search" program.

But what of other possibilities for the child who does not come as part of a school group? Do any American museums offer a child, as the London Natural History Museum has offered, the chance to sketch alone in the galleries? The idea is that, for a penny, a child can pick up at that museum's desk a pad of paper, a pencil, and a stool; when he leaves, he may keep the paper he has drawn on but returns the pencil, the rest of the pad, and the stool, and gets his penny back.

institute . . ." ". . . Until spring and the field trips," another chimes in. "We come in blizzards and never have a kid absent," says a third firmly, and the assembled teachers nod agreement).

Teachers spend a month on the thematic unit in the classroom, discussing the reproductions and stories and working on projects. Each museum volunteer in the program has a copy of the textbook, reads what the children are reading (with occasional slip-ups), and plans their museum visits around a very few objects that can be related to the themes—emotional, stylistic, and narrative—of the literary selections. Toward the end of the month, the class visits the institute.

Effective work with the children in the institute galleries, the volunteers say, depends primarily on the children. One observes that "you get a completely different reaction with two different classes, even with the same teacher," and another says, more emphatically, the program "makes or breaks" on the class chosen to go into it. Volunteers do not rely on systematic or even steady communication with the teachers. One even notes that the classroom teacher of the children for whom she is responsible "resists" her efforts to establish continuing communication: "He wants me to do it my own way," she says.

Her way looks good enough to explain why the teacher does not want to tamper with it. An attractive suburban mother of five, she looks the "typical" upper-middle-class docent; the 7th graders from Volta School, which serves a mixed blue- and white-collar area of Chicago, greet her with eager affection. She and they have finished reading Steinbeck's *The Red Pony,* and they head for a large T'ang horse in the Chinese galleries. She begins by talking about how artists always start with a blank canvas, or paper, or piece of clay, and must—or can—choose any form, size, mood; about how the artist works, how he makes his point, and how we analyze his finished work. The children chime in: about animals and why people love them, about lines in the horse, about expressive power, about emotional feelings artists can put into *things*. It is clear, even to a first-time observer, that the children are talking with her about issues they have discussed before, that lines, shapes, colors, feelings, and ideas are by now, at the sixth visit, familiar topics.

Later, the volunteer voiced her occasional desire to change the format, perhaps to spend the whole time in one gallery and maybe not see so many things. (The children that morning spent time with her in front of eight different works of art.) She noted that "the book changes pace, and I think we should more, too." Some classroom teachers extend the visit beyond the hour and a half with the volunteer staff assistant, and others say they would welcome the volunteers into their classrooms, because they establish "just an astonishing rapport." One volunteer believes that "sometimes it's hard to tell how much they're getting," but the teachers assure her that the children are getting something "even if it doesn't always show."

## The results: unscientific but heartfelt evaluation

What does show? First, the obvious pleasure and ease with which these 7th and 8th graders come every month to the Art Institute. A few volunteer staff assistants have turned the tables on their students and asked them to serve as "leaders" Giving out postcards of works of art to the children, the volunteers asked the children to bring them back the following month and "do the talking." And they did, marveled a teacher: "The stone-faced children were the ones who grabbed the postcards and said I'll do it and stood up there and gave forth!" The students also talk to younger classes at their schools, and write and perform plays for the younger children.

According to teachers and volunteers, the children's talk in the galleries *is* unusual, as the out-of-town visitor noticed. Their talk about Turner's swirling *Snowstorm* swiftly got to the sense of being overpowered, of shifting movement in space. Before Delacroix's *The Lion Hunt,* the volunteer led them to talk of romantic subject matter and the way certain colors—in this case, red—can force people to look at certain places in the painting.

School corridors, principals' offices, and classrooms are lined with drawings and paintings done by students in the program. One teacher who has the children for both art and English says, "I *do* think it has affected the kind of detailed attention they pay to their work. They don't care if they hurry up and finish. They are more concerned with producing quality." Mrs. Hansen adds, "I think the people who are in this program awhile do something that many teachers do not do. They concern themselves, as we do in the writing program now, with the details. Somehow or other, if you pay attention to all the details, the overall structure seems to take care of itself and you don't ask the kids to say the main theme—you keep having them get pictures in their minds."

## On Sketching in the Gallery

In my experience, one does not create visual awareness or aesthetic enjoyment by talking too much about the exhibit before the students have themselves looked at it, for this can blunt their visual awareness. In the gallery my first concern is, therefore, to give them the experience of looking; to devise ways to keep them occupied with the object so that they too discover for themselves a design, a colour, a meaning, which otherwise they may not see. . . .

I think use of the pencil to make visual notes in the gallery could well be encouraged in museums today. It is not intended, as with art students, to teach drawing, perspective, and skilled copying, often thereby distracting the attention and diminishing immediacy in appreciation of the object; its purpose is to hold them longer in the presence, to make them look more attentively and with greater understanding. —Renée Marcousé, "Animation and Information," *Museums and Adult Education,* ed. Hans Zetterberg (UNESCO, 1968), pp. 59–61.

Enthusiastic letters from the teachers are not uncommon. A sample:

You are to be complimented on [a staff assistant working with an 8th-grade class]. . . . Her rapport with young people, her creative approach, her warm personality and friendliness made her contributions an experience that these students will long associate with the Art Institute.

A testimonial to her success was hearing eighth-grade boys regret that the year's trips had ended and then listening to their plans to visit there this summer. Comparing this enthusiasm with the resistance encountered from these same boys earlier this year was truly rewarding.[9]

Some children have told their teachers that their families have joined the institute because of the program. Teachers agree that mothers clamor to accompany the children on the institute visits: "When you take a trip, usually, you'll have one set of mothers one time and a different set the next time. *These* mothers stick like glue—the same ones!" reports one teacher. And the teachers say they have been influenced, too; some now have institute reproductions in their classrooms (few did, before), and the children notice them.

One result that several teachers hope for is that the program will be greatly expanded so that it can reach many more children. Money is not the problem. The program costs nothing to either the school or the institute; the only cost to the children is bus fare. (And in poor neighborhoods, says Mrs. Hansen, even the buses might be paid for out of government funds.)

One student evaluation went this way:

I think the trips we had were very educational. I began to notice the changes in everybody's paintings after the trips. And I have become more artistic and I feel I can express my feelings on a painting as well as the artist. Now everybody in our room knows a lot more about art and the help we got from our guide helped us a great deal and I wish we had the trip continuously.

—*A.Z.S.*

## Notes

[1] For sources of quotations without footnote references, see list of interviews at the end of this report.

[2] *Focus,* teacher's guide, pp. 178–179.

[3] Ibid., p. 180.

[4] *Perception,* teacher's guide, p. 204.

[5] Ibid., pp. 205–207.

[6] Ibid., pp. 142–143. The Daumier is *The Beggars,* in the Chester Dale Collection, the Le Nain in the Kress Collection, both in the National Gallery of Art.

[7] Ibid., facing p. 1. The Chagall painting is in the Guggenheim Museum.

[8] Ibid., p. 330. The painting is part of the bequest of Meta and Paul J. Sachs to the Fogg Art Museum, Harvard University.

[9] A letter to the Art Institute from Christine Savoy, assistant principal and grade 8 teacher, Onahan School, Chicago, March 29, 1975.

## Interviews and observations

Alexander, Karen. Volunteer Lecturer, Art Institute of Chicago. March 20 and 21, 1974.

Chalmers, E. Laurence, Jr. President, Art Institute of Chicago. November 1, 1973.

Frank, Bobby. Teacher, Haugan School, Chicago Public Schools. March 21, 1974.

Hansen, Rita. Language Arts Consultant, District 1, Chicago Public Schools. March 21, 1974.

Linder, John. Teacher, Volta School, Chicago Public Schools. March 21, 1974.

Nash, Marian. Teacher, Haugan School, Chicago Public Schools. March 21, 1974.

Raasch, Lois, Assistant Director, Junior Museum, Art Institute of Chicago. November 1, 1973; March 20 and 21, 1974.

Simon, Eleanor. Teacher, Volta School, Chicago Public Schools. March 21, 1974.

Thomas, Virginia. Volunteer Lecturer, Art Institute of Chicago. Telephone, March 20, 1974.

Wriston, Barbara. Director of Museum Education, Art Institute of Chicago. November 1, 1973.

And 7th- and 8th-grade students of Volta School, at the Art Institute of Chicago, March 21, 1974.

## Bibliography

Carlsen, G. Robert, and Anthony Tovatt, with Ruth Christoffer Carlsen and Patricia O. Tovatt. *Focus, Themes in Literature* and *Perception, Themes in Literature,* and teacher's resource guides for both. Both the textbooks and guides are part of the Themes and Writers Series, Webster Division, McGraw-Hill Book Company, St. Louis (New York, San Francisco, Dallas), 1969.

## ELVEHJEM ART CENTER: CHILDREN'S NEWSPAPER PROJECT

Elvehjem Art Center
University of Wisconsin
800 University Avenue
Madison, Wisconsin 53706

**A university museum with a commitment to a wider audience develops a program that gives an intensive experience to a few children and uses their work to reach other children throughout the state. Newspapers, with drawings and articles exclusively by children, relate to museum collection and school curricula. CMEVA interviews and observations: October 1973, February 1974, July 1975.**

### Some Facts About the Program

**Title:** Children's Newspaper Project.

**Audience:** 39 children, mostly 5th graders, in 1973/74.

**Objectives:** To create a publication about the museum collection for children by children; to provide a museum-generated teaching tool related to upper-elementary curricula; to provide a rich experience in the museum for children and docents; to inform Wisconsin schools about the museum and its facilities.

**Funding:** Total cost for one year, about $450, including printing, mailing, initial publicity, and photographic reduction of drawings. Newspapers generated about $95 income; remainder was paid from fees for adult tours.

**Staff:** Curator of education, 4 docents, and a music education student from the University of Wisconsin.

**Location:** In museum classroom and galleries.

**Time:** For the first newspaper, three sessions per week during summer vacation; for the other three, two after-school sessions on weekdays and occasional Saturday mornings. Each session lasted from an hour and a half to two hours. Each group met for a period of four to five weeks.

**Information and documentation available from the institution:** "Special Report: Elvehjem Art Center Children's Newspaper Project, July 1973 through May 1974"; copies of newspapers: *Ancient News, Asian Indian Times, Face to Face,* and *Journal of Art and Music.*

---

Hercules looks tough with rocks all around him. It seems like his muscles make him look like the strongest man alive. His bow makes it seem like he is shooting at the sun or at Geryon. His hair looks like a cap and his legs like they are going to break the stone. Mr. Frank Hood gave us this sculpture.[1]

The 6th grader who wrote this was a reporter for a newspaper on the arts, a journal written and illustrated entirely by elementary schoolchildren at the Elvehjem Art Center, the University of Wisconsin's Madison-campus museum.

On any given visit to the center, it is common to find a youngster sitting cross-legged on the floor, straining to see a statue or painting in front of him, head bobbing up and down from the work of art to the paper on his lap. The results of such close observation since Virginia Merriman, tour coordinator at the Elvehjem, started this project in the summer of 1973 are four newspapers that have been bought for use in several school classrooms.

To produce the papers, the education staff of the Elvehjem Art Center (the curator, four volunteers, and a student) work with groups of about ten children at a time in the galleries. Their objective is to encourage and inspire the children both to write and to draw their impressions about the works in the collection. Every child does some writing and some sketching. After each session, the education staff collects the work, and during the last two sessions the staff and the children edit all the material. The staff helps them correct spelling and punctuation, but leaves word usage and grammar in its original form. The drawings and brief commentary are printed on inexpensive paper (newsprint folded in quarters), and copies are circulated on a subscription basis to elementary schools around the state.

Ms. Merriman initially intended the project to help prepare schoolchildren for a trip to the museum, reasoning that "they will have direction and a very special interest if they have already read a paper on the subject, which was written and

illustrated by their peers.''[2] If the paper has a special message for elementary schoolchildren because it communicates the excitement of the museum in their own style of language and art, it also provides schoolteachers with an original teaching aid that they can use in the classroom without bringing their students to the museum. In the paper focused on the art of India, chosen because there was an exhibition of Indian miniature painting in the galleries at the time, the children made specific references to Hinduism and Indian culture, and their drawings accurately depicted Indian dress and artistic style, all of which gave a sense of Indian life that readers could grasp without seeing the exhibition. In another issue centered on ancient art that the young authors had studied in the Elvehjem's collection, the writing made constant allusions to mythology, and the pictures distinguished different kinds of vases. After reading this edition, one 4th-grade class asked its teacher to start a unit on mythology.

## Background

Located on the campus of the University of Wisconsin at Madison, the Elvehjem Art Center is officially a department within the university. But it is also the only major institution in the region that exhibits art work for educational purposes, and partly because of this the director and staff feel a commitment to serve a much larger audience, including the local public schools. The newspaper project was begun in the wake of a failed studio class program for schoolchildren in the museum. As Ms. Merriman explained, ''There wasn't much we could do with [the children] except talk about the paintings, because we couldn't use messy finger paints or clay in the galleries.'' The children were neither interested nor responsive.

She remembered that the Wisconsin State Historical Society, located across the street from the Elvehjem, had once tried a newspaper project: schoolchildren were encouraged to write about what they saw when they visited the society's collection; the staff then organized and edited the reports, incorporating them into a journal that was, however, largely written by the professionals. Ms. Merriman liked the idea of children writing about their experiences and perceptions in a museum, but rejected the notion of a final product so heavily influenced by adults.

From its inception, the children's newspaper project at the Elvehjem has had a dual purpose: to provide an intensive and satisfying museum experience over time to a small number of children and to offer a broader educational service to elementary schools both in the surrounding area and throughout the state. For classes in nearby schools, the newspapers can be a direct introduction to the museum, preparing students for tours of the collection. For students in more distant schools, unable to visit the center, they can be purely instructional, used by teachers to supplement regular curriculum material in such classes as ancient history, world religions, art, science, or mythology.[3]

## The operation of the program

After some experimenting, Ms. Merriman and her staff decided to confine the program to groups of ten or fewer 5th-grade students, supervised by no more than three docents. Fifth graders were chosen, she said, ''because we wanted to focus on an age level where children can be stimulated and where they have enough skill to communicate their ideas.'' Students for each project are selected on the recommendations of their teachers; the criteria are that they like art and enjoy writing.

The children come to the museum (usually driven by parents) two or three times a week for four or five weeks. Each session takes about an hour and a half to two hours. Scheduling is flexible, depending on the difficulty of the theme chosen for each paper. In a typical week, two sessions are held after school and one on Saturday morning. Four newspapers were produced in 1973/74; four more were planned for the following year.

Each newspaper revolves around a clearly defined topic that relates to the museum collection and, usually, the upper-elementary school curriculum. Besides the editions on the art of India and ancient art, students have produced papers on faces in art, music and art, and (for 1974/75) nature, birds and animals, signs and symbols, and sculpture.

During the first five or six sessions, the children are primarily engaged in sketching and writing about particular objects in the galleries. Before and during this process, docents may read or tell stories from mythology or some other appropriate literature. Then all the work is collected, typed (without authors' signatures), and copied for distribution to the entire group.

The children edit their own material and discuss with the docents how the final report will look. The adults consciously refrain from influencing decisions or even giving definitive answers to children's questions on anything from spelling to the quality of individual sketches; the children are encouraged to find or figure out their own answers.

Each young reporter then votes for the articles and sketches he thinks should be included. When these—and a name for the newspaper—have been decided on, the students prepare a camera-ready layout of the paper. Printing is done on 11-by-17-inch sheets of newsprint, folded into quarters to make eight pages. The final cost of each paper is two cents.

When the newspapers come back from the printer, docents and children gather for a final meeting during which they count papers, stuff envelopes, and carry packages to the post office. This session marks the end of the program for each group.

## Judging the program

The Elvehjem's education staff feels that the newspaper project has been successful in its goal to give an enjoyable and educational experience to the participating students. Some

newspapers, they agree, were probably more valuable to the children than others, but all had their strong points. For example, the project on Asian Indian art took a scholarly approach: students did not inject their personal opinions into the articles, which stressed hard information about Indian culture and art; the first page of the paper included a glossary of words such as "reincarnation" and names such as Brahma and Vishnu. Thus, this paper was seen as a particularly good teaching aid.

On the other hand, for the next paper, *Face to Face,* the docents encouraged the children to "react directly" to the art objects. Students looked carefully at faces in portraits and sculpture and sketched from a live model. Their writing emphasized personal reactions. Elvehjem staff felt that this was, overall, a more successful project because these children responded more readily and became more involved in the topic than did those who worked on the Indian paper.

The education staff is not so pleased, however, with the project's ability to meet its goal of providing an educational service to Wisconsin schools. When the first paper, *Ancient News,* was printed, the Elvehjem sent copies of it to the principals of all the elementary schools (about 2,400) in Wisconsin, along with a brochure about the museum's tour program. Response to the publicity was poor; different schools subscribed for different editions of the paper, but the greatest number of schools to buy any one edition was only 16. During the first year, 1973/74, the art center sold fewer than 2,000 copies at four cents each. As each copy cost two cents to print, it was obvious that the project could not support itself on sales. Total cost for the first year came to $442, whereas the income (including that for some papers sold over the museum sales desk at 15 cents each) was only $95. Money from fees which adult groups pay for guided tours of the Elvehjem paid for most of the difference.

Nevertheless, there has been some encouraging response from the subscribers. Ms. Merriman telephoned the teachers who had bought the newspapers to ask how they had been used. One, from a distant part of the state, said that her children had enjoyed the papers enormously and that she intended to engage them in a similar project after a visit to a museum closer to her school. Another said she had used the journal to teach reading to lower-level 6th and 7th graders. In

## Sterling and Francine Clark Art Institute: The Children's Program

Williamstown, Massachusetts 01267

> What we set out to do is to help direct and assist children in becoming more aware of different art forms, how they relate to one another, and some of the elements common to all. . . . We don't try to teach art history.*

Thus John Brooks, associate director of the Sterling and Francine Clark Art Institute in rural Williamstown, Massachusetts, explains the rationale behind a typical children's program—this one devised by a museum whose basic ingredients are a superior collection of European and American paintings, prints, drawings, and sculpture; a supply of well-educated women from an urbane liberal arts college environment to serve as docents; and schoolchildren from widely scattered hill towns for whom the institute represents a special, all-day cultural trip.

The institute has put all this together in a series of thematic tours for 2nd, 4th, and 6th graders. Most of the students who take part in the program are bused in from schools throughout the western part of Massachusetts, eastern New York, and southern Vermont. Each year since the program began in 1970, each class has been offered three tours spaced several months apart. One revolves around visual arts, another around performing arts, and the third around literary arts. In the full program cycle (the museum has chosen to skip grades 3 and 5 so that the tour format and content for grades 4 and 6 need be changed only every other year), the tours are offered three times to the same children over a five-year period, but each time in a different version so that the children will study a variety of works in the collection on their visits.

**Some tour samples.** The visual arts tour—which is laid out precisely for docents in a seven-page outline that includes suggested questions, props, and reading assignments—has three sections: architecture, painting, and sculpture. On each of the visual arts tours, the children are introduced to architecture by noting specific details about the institute's own classic building. On one visit, for example, they are asked to look for moldings, overdoors, flooring and window patterns, materials, even leaks in the ceiling. They may also be asked to react to the size of different gallery spaces.

In the painting part of the tour, in which younger children study light, docents may set up a "matching" plastic-fruit arrangement in front of a Sisley still life and ask the students to move a spotlight around the arrangement to observe the changes in light and shadow and to try to discover the effect the artist achieved. Later in the tour, the children look for the effect of light on sculpture: reflections off bronze, stone, even their own skin. Older children compare materials for sculpting—soap, wood, stone, plaster, clay—or examine with a flashlight the ways various sculptors have represented the human eye.

On the performing arts tour, which is offered in the winter, music, dance, and drama are explored in relation to painting, sculpture, and architecture. Through body movement and improvised performances, children might "act out" to music the wind, the sea, volcanic smoke in Renoir's *Bay of Naples with Vesuvius in the Background.* They might pose Carpeaux's three-figure group *The Dance* and put it in motion, or demonstrate to their classmates how *they* would like to be painted after looking at a roomful of Sargent portraits.

In one exercise the docent divides the class into two groups and shows one group a card upon which is written a single word or phrase that expresses a mood, feeling, or emotion (desperate, victorious, haughty, content, amazed, in love). Through body language "with or without facial expressions," the "informed" group

some schools, only the art teacher has used the papers, whereas in others, teachers from a variety of disciplines had shared them.

The Elvehjem staff members remain confident that the newspaper is a solid and valuable program for school-children. They base this in part on the conviction that if museums are to become useful educational resources, they must investigate ways to make themselves more accessible to schools that cannot actually come for visits or tours. Traveling exhibitions and slide programs are complicated, expensive methods for an art institution to reach geographically removed school audiences. Because it is run primarily by docents and does not involve complicated equipment, the Elvehjem's Children's Newspaper Program is, they feel, an inexpensive as well as realistic alternative.

### Postscript: 1974/75

At the end of the newspaper project's second year, Ms. Merriman, now promoted from tour coordinator to curator of education at Elvehjem, reported this progress:

During the spring 1975, several classes from out-of-town schools that had subscribed to the newspapers came to the art center for tours. Docents who supervised these groups noted that the children recognized a number of objects in the collection from reading about them in the papers. A local class that came for a tour was actually guided by two of its members, both boys, who had worked on one of the papers over a year before. Ms. Merriman said that the boys' retention of what they had learned was "simply amazing."

Subscription sales to the newspapers were not up significantly from the previous year. But Ms. Merriman is working on a possible arrangement with the Madison School District whereby the school system will help defray some of the cost for the 1975/76 program and distribute the papers throughout the local elementary schools.—*J. A. H./ A. V. B.*

### Notes

[1] *Ancient Art,* summer 1973, p. 4.
[2] For sources of quotations without footnote references, see list of interviews at the end of this report.

tries to communicate to the other group what the word is. The principles of communicating emotions are then applied to works of art in the galleries. Another tie to drama on this tour is to have the young children, dressed in costumes made by the docents, assume the roles of the figures in a given painting (Piero della Francesca's *Virgin and Child Enthroned with Four Angels* is often used for this exercise). In the music part of the tour, the docent plays tape-recorded selections to set various moods and asks the children to associate each piece with a specific painting or sculpture. Rhythms in music, in architectural fenestration, and in certain paintings are also examined.

The literary arts tour given in the spring focuses on verbal expression. Sometimes children, having looked at various artists' choices of colors, are encouraged to write poems about how those colors make them feel; or they may be asked to develop a five-line poem inspired by a painting. Docents tell the stories represented in some works of art, then encourage children to make up their own tales based on one or several paintings.

Limited props are an important part of all the tours—sample building materials, writing pads, pieces of cardboard to help define spaces, examples of classical print-making tools, and colored scarves, hats, and shawls to help bring a painting to life.

**Numbers, preparations, plans.** In 1973/74 the program served nearly 3,000 children from 46 schools in Massachusetts, New York, and Vermont (not every class returned for the second and third tours: the number of children dropped from 2,929 for Visit 1 in the fall to 1,776 for the winter visit and 1,893 for Visit 3 in the spring). The same tours are offered to the 4th and 6th grades, a practice that, Brooks says, does two things: "It illustrates the fact that the interrelationships of the arts are basic enough to be presented at any age level . . . and it prevents me from going mad constructing endless tours for each grade level throughout the year."

Before each class visit, the institute sends the teacher a letter explaining the tour's content and purpose; she is asked to review with the children beforehand "what the arts are and how each communicates." Normally docents do not visit the classroom either before or after the visit, although a visit may be arranged at the request of a teacher (a rare occurrence, noted Brooks). Instead of following the usual museum practice of sending slides and other classroom material to prepare children for their visit, the Clark staff tries consciously to bring the children in fresh, undistracted by the previews they might carry in their heads. Slides of the collection may be borrowed by teachers for follow-up to the tours, but as Mrs. Willard Dickerson, one of the docents, explained, preparation is not one of the Clark's aims:

We [used to] send slides to the schools before children's visits, but often the children would arrive at the museum and want to go immediately to those works of art shown on the slides. . . . Their anxiousness made it difficult to carry through the tours, so we decided it would be better to save the slides until after the tour when they'd seen all of the collection.

Future plans for the program include recruitment of more docents (in 1973/74, 20 conducted 437 tours), a longer and more comprehensive training period for the docents (the training period in 1974 was only one month, supplemented by sporadic lectures and presentations), and the development of more formal working relations with schoolteachers. Brooks is also considering the possibility of offering similar thematic tours to junior and senior high school students.—*E.H.*

*Quotations and other information in this report were drawn from interviews in December 1971, October 1973, and February and April 1974 with John Brooks, associate director of the institute; Mrs. Willard Dickerson, a docent; Cindy Nystrom, art facilitator with Williamstown's Integrated Arts Program; Richard Steege and Janet Wheeler, local public school teachers; and from documents provided by the institute.

[3] The idea of using material written by children to teach—or entertain, inspire, or stimulate—other children is not unique to this project. The Teachers and Writers Collaborative in New York City, which places writers and visual artists in several elementary schools, regularly publishes children's work (mostly written) for use by other children as well as teachers. The collaborative's director, Steve Schrader, said in July 1975 that research into the effects on reading level, attendance, and grades of students who used a reader and other material prepared by their contemporaries is under way, but no results are yet available. He did note, however, that adults working with and observing the children have a strong sense that they learn from and are excited by other children's writing.

### Interviews and observations

Bownds, Marilyn. Docent, Elvehjem Art Center. February 9, 1974.

Merriman, Virginia. Tour Coordinator, Elvehjem Art Center. October 12, 1973; February 9, 1974; telephone, July 21, 1975.

Rogers, Millard F., Jr. Director, Elvehjem Art Center. October 12, 1973.

Schrader, Steve. Director, Teachers and Writers Collaborative, New York, N.Y. Telephone, July 18, 1975.

Walker, Margaret. Docent, Elvehjem Art Center. February 9, 1974.

### Bibliography

Merriman, Virginia. "Special Report: Elvehjem Art Center Children's Newspaper Project, July 1973 through May 1974," 1974.

Newspaper article, *Wisconsin State Journal,* December 9, 1973.

The following newspapers, produced by children in the Newspaper Project in 1973/74: *Ancient News, Asian Indian Times, Face to Face, Journal of Art and Music.*

## KIMBELL ART MUSEUM: KIMBELL CLUES

Kimbell Art Museum
Will Rogers Road West
Fort Worth, Texas 76107

**Color-coded "clues"—photo blow-ups of details—lead 6th graders on a hunt for specific paintings, sculptures, and other objects in the museum galleries, followed by discussions with docents. Evaluation tests of participating children show surprising retention of, and interest in, the art works. CMEVA interviews and observations: throughout 1973/74.**

#### Some Facts About the Program

**Title:** Kimbell Clues.

**Audience:** Fort Worth 6th graders; about 500 students of mixed social and racial backgrounds from two 6th-grade "cluster schools" participated in 1973/74.

**Objective:** To encourage visual awareness and actively involve children in expressing their thoughts and feelings about art; to motivate children to return to the museum on their own.

**Funding:** Cost to the museum was about $2,000 in 1973/74; school system provided transportation.

**Staff:** The curator of education, with the assistance of 21 volunteer docents, who conducted the tours (docent-child ratio was one to nine). The school system's art consultant and an art teacher helped plan the program. A psychologist was used by the museum to evaluate the first year's experience.

**Location:** The children were bused from the schools to the museum; tours were held in the museum galleries.

**Time:** Program began as a pilot project with one school (Forest Oak) in October 1973. Students from another school (William James Middle School) were included when the program officially began in February 1974. Expansion to a third school was planned for 1974/75.

**Information and documentation available from the institution:** "Kimbell Clues—A Pilot Project in Visual Awareness," report on the operation and goals of the program; docents' tour reports; "Evaluation—Kimbell Clues, Sixth-Grade Pilot Project" by Billie Keith Arnoult.

Children like to know how things are made, what materials are used. . . . Don't use dates, but tell them how old a thing is: that will impress them. . . . They like mythology, outrageous stories about the gods. They love gossip; the bullfighter should be a favorite subject. . . .

Yes, you can use the word "courtesan." They know what it means. . . . They love new words. Some will know what a kimono is.[1]

These were among the useful suggestions that Carol Marrs, an art teacher from the Forest Oak School, made during the planning sessions for Kimbell Clues, a program devised by the Kimbell Art Museum in cooperation with the Fort Worth Independent School District, and one of several education programs offered by the museum. Like other variations on the treasure hunt, Clues exemplified one more effort on the part of museums to enliven the group tour and, conceivably, spark enough interest in the touring children to bring them and perhaps their relatives to the museum on their own. The goal is particularly compelling for museums that, like the Kimbell, have few loan shows and keep their permanent collections on continual view.

### Finding art by following the clues

The program, in essence, presents small groups of 6th graders with clues to the Kimbell's collection in the form of photographic blow-ups of details taken from a variety of paintings, sculpture, and decorative objects, in the hope of making the child an active participant rather than part of a large captive audience. As each 6th grade (about 36 children) arrives at the museum for the 55- to 60-minute tour, the teacher divides it into four groups. A docent armed with a packet of nine clues is assigned to each group. She introduces the first clue, an 8-by-10-inch black-and-white photograph, mounted on a gray mat board, for all the children to see and discuss; perhaps it shows Christ's right hand, pierced by a nail (Bellini's *Christ Blessing*). A docent who has been assigned, say, the color blue to designate one of four sequences in the portraiture tour, uses a packet of clues color-

coded correspondingly. As the hunt proceeds, her children view nine portraits ranging from a 3½-inch-high clay figurine of an Olmec *Seated Woman* to a massive *Buddha Enthroned* from Cambodia.

Once the children have taken in the first clue, the docent leads them to the proper location and lets them find the Bellini. There is further discussion—about the time of day, the rabbits, bird, tower, or background figures. Each child then gets to study his own clue, perhaps the pale bare foot of a Japanese courtesan of the Edo period.

As each child finds his picture or other object, the docent tries to engage the whole group in discussion, following as best she can indoctrination that teaches her not to be doctrinaire: thinking up her own questions, avoiding those with built-in answers, responding to evidence of these particular children's interests and reactions.

Meantime the three other small groups of children with their color-coded docents have been viewing and discussing other sequences of portraits. Part of the planning of Kimbell Clues went into ensuring an equitable flow of traffic, to avoid confusion and congestion in the galleries.

The Kimbell's participatory tour is built around two themes: the one on portraits, whose formal title is "Portraiture, 'What is a Man?'" and the second called simply "Details." Both tours follow the same small-group, four-track, color-coded procedure, and both are organized to exploit all the variety of subject, material, technique, time, and geography the Kimbell collection affords. "Details" offers an even wider range than "Portraiture": for example, the incised fish on a Tz'u-chou vase; two tiny figures lost in the landscape of a Chinese scroll; a goat from Boucher's *Birth of Bacchus.*

The program is set up so that each class visits the museum twice, first for the "Portraiture" tour and the following week for "Details." In class during the interval, each child is assigned by his teacher to do a portrait, usually in pastel or watercolor, either of himself or of a friend.

The Kimbell education staff lays much stress on combining careful preparation with the greatest possible latitude. Docents are enjoined to work out their own procedures and to think up new ways of presenting material and involving the children. The museum counted on developing good procedures out of actual experience, trial and error; to this end, docents are asked to write brief reports after each tour, recording successful techniques and illuminating responses from the children as well as negative findings.

### Early findings; plans

In addition to evaluations carried on throughout the first year by the Kimbell education department, the museum retained psychologist Billie Keith Arnoult to conduct an overall evaluation at year's end. Mrs. Arnoult's tests were devised chiefly to determine the children's ability to recall the art they had found and seen through Clues. The children were also asked to volunteer comments on the art objects and to list specific details they remembered and new words they had learned. The tests showed that the several hundred children specifically remembered over 80 percent of the objects they had seen, even up to ten weeks later. The children also displayed a surprising propensity to remember and discuss an assortment of objects they had seen rather than hewing, as the testing instrument provided, to the clues (red or whatever) that their particular group had followed.

Though sensitive written comments were few (most of the children were not very verbal, had what one observer called "abominable handwriting," and were poor spellers), their teachers were impressed that they had made any effort at all to write comments. One major disappointment was that, despite the evident enthusiasm and good feeling, only two students as of the test date had returned to the museum on their own initiative.

On balance, the adults involved in Kimbell Clues were heartened by these early results. Most important, perhaps, was docent reaction to Clues. They acquired increased confidence in both their abilities as tour guides and their own responses to art; some emerged as leaders capable of training other docents and eager to help plan the next year's program.

In 1974/75, the museum planned to add another cluster of 6th graders during the second semester, with the first two schools continuing throughout the year. The Kimbell's educators and their opposite numbers in the schools were working out a new sequence of clues, one revolving around sculpture, the other around pictorial space.—*J. M. from report submitted by R. S. W.*

### Note

[1] For sources of quotations, see list of interviews at the end of this report.

### Interviews and observations

The following persons were interviewed by R. S. W. throughout 1973/74:

Arnoult, Billie Keith. Psychologist and Consultant to the Kimbell Art Museum.

Couch, Ted. Art Consultant. Fort Worth Independent School District.

Marrs, Carol. Art Teacher, Forest Oak School, Fort Worth.

And docents and children in the program.

## THE NEW ORLEANS MUSEUM OF ART: "A MUSEUM EXPERIENCE—AFRICA"

New Orleans Museum of Art
City Park
P.O. Box 19123
New Orleans, Louisiana 70179

**A jointly planned program on Africa for 4th graders comes out of a public school system's commitment to the arts, a museum's contribution of volunteers, space, money, and access to its col-**

lection, and a professional rapport between school and museum educators that, although it is "extraordinary," does not save this program from the usual problems that beset museum visits. A workshop and workbook for teachers are part of the program, and so is touching for the children. CMEVA interviews and observations: September 1973; January and May 1974.

**Some Facts About the Program**

**Title:** "A Museum Experience—Africa."
**Audience:** 780 4th-grade students and their teachers, selected by the school administration of the Orleans Parish Schools.
**Objective:** To develop the visual awareness of both students and teachers and to introduce them to a specific collection of the museum through a series of related art experiences.
**Funding:** $2,000 for workbook, films, art materials, African materials, insurance. All funds come from the museum's education budget. Cost: $1.10 per child per session.
**Staff:** The curator of education, a half-time assistant to the curator, a secretary, and 29 volunteers.
**Location:** Wisner Wing, gallery, and Stern Auditorium.
**Time:** Each participating class came two mornings, for an hour and a half each visit, once in the fall and once in the winter. The program was carried out during the 1973/74 academic year.
**Information and documentation available from the institution:** *Teacher Workbook for a Museum Experience;* evaluations conducted by the museum from docents, teachers, children, and the assistant to the curator of education. A slide-tape program is being developed.

---

The New Orleans Museum of Art stands in the center of City Park. The approach through a tree-lined alley offers glimpses of a small lake to one side. Large plate glass windows of the City Wing reflect water, majestic trees, and the men and women who wander through the park looking for a shaded bench to temper the omnipresent humidity of the Louisiana lowlands.

Some distance away, in the center of the city, the administration building of the Orleans Parish School Board stands solid as a warehouse, in a neighborhood of random-sized buildings and parking lots, concrete and gravel, blowing paper and heavy air. The interior is a honeycomb of corridors and cubicles with books—on shelves, in boxes, on boxes—crowding every niche.

The institutions share three priorities: art, education, and children, though not necessarily in that order. The museum provides a range of educational services for adults and children, to which it devotes about 20 percent of the total annual budget, or (in 1974) over $92,000. Altogether, during the 1973/74 school year, it reached about 19,000 children. But until 1969, aside from a museum field trip at the option of classroom teachers, interchange between the museum and the schools was symbolized by the buildings that housed them: solid but distant. Now the two institutions are working closely together in a jointly planned program called "A Museum Experience—Africa," for 4th graders, and have been organizing a sequel for 5th graders, centering on pre-Columbian and colonial Latin American cultures.

## Background

What brought the two together? Shirley Trusty, the supervisor of cultural resources for the schools (a post created in 1969), put it this way:

> Our previous experiences with the museum had been random, purely at the discretion of the classroom teacher. We felt there was a need for school staff and museum staff to work together to make the museum visit a more educational one. We wanted to find a way to mesh the resources and objectives of the schools with the museum's objects in a way more related to our lives and to mankind. If somebody takes you through the museum and says, "This was painted in 1892," who cares?[1]

The museum's senior curator of education, Dode Platou (whose post was also created in 1969), agrees: "It was the school board that got us rumbling. They knew about the success of the Wisner Wing tour experiences.[2] They said let's develop something for the 4th grade." Such development was a chronological if not a logical next step, as the Wisner Wing tour program was available only to the kindergarten through 3rd-grade age group. Although other gallery tours were a part of the museum's educational program for older children and adults, the K–3 program, which combined sensory games with a gallery visit and an art project, offered the schools greater opportunities to correlate curricula with the museum experience. Ms. Trusty felt the sensory emphasis important, not only because of its prominence in the 4th-grade English and science curricula, but because "the senses are a part of every curriculum."

The museum said, "We have African objects that children can touch." The schools said, "Our children study Africa in 4th-grade social studies; let's extend." The museum suggested an art project, related to what children have seen in the galleries, that classroom teachers could undertake. The schools agreed, urging the museum to develop additional projects.

Ms. Platou stresses the evolution since 1969 of parallel arts-education goals in school system and museum. At this time, for instance, the museum began sensory-perception training for its docents. And the school system was not only bringing live performances to the schools but also supporting an extensive artists-in-residence program. Schools and museum have often shared talent and specialists. Moreover, the museum hired an additional curator of education, Bonnie Pitman, who has worked directly with the school system's supervisor of cultural resources in workshops organized to advance the schools' experimental arts programs.

Cooperation between institutions, however alike their goals, is anything but inevitable. Three additional conditions helped make it possible in New Orleans: an established in-school support system, the museum's willingness to budget money for the program, and an extraordinary interinstitutional professional rapport. In New Orleans, two in-house revolutionaries squinted at each other across the space be-

tween their institutions and discovered that they were carrying the same flag.

Within the Orleans Parish schools, the support system is three-pronged: supervisory, artistic, and vehicular. The creation of the post of cultural resources supervisor, equal in status to other curricular supervisors, underlines the schools' commitment to the arts.[3]

Of particular moment to the new museum-school program has been the artists-in-the-schools project. In 1973 the black jazz artist-in-residence, already known to many 4th- through 6th-grade classrooms through his two-day residences, brought back to New Orleans recorded tribal music from several African countries and a collection of musical instruments and artifacts. He also served as consultant to Dode Platou, adding his understanding of African culture, New Orleans jazz, and elementary schoolchildren to the planning and thinking going on inside the museum's education department.

As for bus transportation to and from the museum, participating principals agreed to give the pilot museum-school program priority in the two annual school-supported field trips each class is permitted.

For its part, the museum was also ready, designating the children's room in the Wisner Wing as core space. It set aside $500 to buy contemporary African crafts—wooden masks and figures, batiks, and musical instruments—around which to build an African "environment," and added other objects from the African collection.

### Putting the program together

Choosing the topic was the first of the decisions made jointly by the school and museum staffs. It had been a relatively simple one: Africa was a part of the regular 4th-grade curriculum and therefore a choice calculated to win over even the least art-conscious classroom teacher; the museum's African collection was touchable, capable of satisfying the schools' desire to let students learn by handling objects; the jazz artist-teacher with his treasures was a rich resource for both institutions.

The museum, in short, was doing something *for* teachers. But the broader objective was to build programs *with* teachers. Without delay, therefore, Ms. Pitman studied 4th-grade materials and enlisted four teachers to help compose the *Teacher Notebook*.

The workbook was designed to provide a clear statement of the program's objectives ("to develop visual awareness of students and teachers . . . [and to give] an opportunity to focus on the sensory experience and cultural origin of an art work"); to offer useful suggestions for bulwarking the museum experience and the standard textbook materials; and to provide background information relating African art to its context plus details on the specific artifacts in the exhibit. The "orientation" section, for instance, recommends that teachers prepare their classes for the museum visit with map work, vocabulary, slides on Africa, or discussion of popular misconceptions about Africa (Good-bye, Tarzan; so long, Jane). The "culture" section briefly explains the meaning and use of masks, for the first museum visit, and of ancestor figures, for the second, with specific examples identified under each heading. Topics suggested for classroom discussion range from the importance of fire in many African ceremonies to the qualities invested in different animals. The idea, besides informing the teacher, is to introduce the children to the ritual connotations of the objects they will see, and if possible connect the ceremonial, religious aspects to their own lives. "The senses" section suggests ways to spark the sensory mode of learning, a key aspect of the program. (For an excerpt, see the accompanying box.)

The workbook concludes with six projects using art, music, and movement for classroom follow-up, and a list of related books for children available in the New Orleans public libraries. (The revised edition contains a list of audiovisual materials available through the school system.)

### Experiencing the "Museum Experience": the best-laid plans . . .

Museums cope with real children whose response to a program may be colored not only by its appropriateness and flexibility, but by the psychosocial baggage (along with the gum and candy wrappers) that children bring with them. The description of a particular encounter that follows, although reflecting in part the limited time for on-location observations by CMEVA staff, is instructive in pointing to challenges museum volunteers sometimes must meet and the resources that a museum experience puts at their disposal. It asks, as

---

### Helping Children Use All Their Senses

**Seeing:** Make a fist with your hand and describe your entire hand in as much detail as possible. How many lines do you count? Slowly open your hand. Count the lines—then examine the texture of your skin. How many lines do you count now?

What are three favorite things you like to look at in your own house? Think about the ancestor figures and masks the Africans own.

**Smelling:** African art works have been smoked to create the dark coloring of the wood. Can you relate this process to something the children are familiar with?

**Touching:** Close your eyes and stretch out your hands and touch the chair and desk. What sensations can you feel? The African masks are made from wood and other materials that can be found in your classroom; examine them.

**Hearing:** Listen to the sounds outside the room. Identify as many as possible. The African dancers make the sound of the animal spirit they have become. What "spirits" would you become after listening to the sounds of your environment?

**Tasting:** The foods of Africa are especially hot and spicy. Why? Also much of their meat and fish is "dried" for trade reasons. Why?
—*from* A Teacher Workbook for a Museum Experience, *Bonnie L. Pitman, New Orleans Museum of Art, 1973.*

Whether reacting to left-over home and school tensions, a stuffy bus ride, or the barometer, the group of children we observed exploded from the school bus in a bubble of noise, frenetic glances, and a jumble of steps and jumps. The 4th graders bounced up the front steps and through the door of the New Orleans Museum into the two-story sculpture court, which is surrounded by a balcony opening to the galleries of the original building. They stood for a moment before the broad central staircase until several red-smocked docents escorted them to the auditorium just beyond. The cool, darkened room was a calm contrast to the humid glare outside.

Snuggling down, the children were soon engrossed in a short film entitled *The Elephant*.[4] Without narration, and with only the music of elephants moving through the African landscape, the film dwells on the texture of wrinkled skin, on the ripples of muscle beneath, on the peculiar flexibility of an elephant's foot as it settles on the ground.

When the lights came on, a docent asked, "Did you like the film?" Enthusiastic response. As she attempted to extract comparisons between episodes in the film and the children's experience, the response became less sure. Working very hard, though smiling and gracious, she urged the children to recount, to compare, to remember their previous museum visit. Reasonably attentive to the questioning, but mute, the children perked up only when they sensed their imminent release: half were to go to the gallery and half to the African "environment" in the Wisner Wing. Two docents accompanied each group of 25 children and their teacher.

In the gallery the group split again, and a dozen or so children joined each docent. One grabbed her group's attention when a child asked about a very pregnant female figure; her answer was explicit, and the children did not miss a word. But the going got rough for the other docent. She tried a combination of stories and questioning, relating the objects to what the children had seen previously. Some children remembered the fire-spitter mask and pointed it out, but part of the group wandered away. The docent asked a group of boys on the periphery not to lean against a platform covered with volcanic rocks on which a number of masks were mounted. They ignored her; the teacher, standing next to them, said nothing. No guard was in sight. Then one boy picked up a rock and tossed it in the air; another followed suit. Blocking a potential scuffle with military efficiency, the docent stopped the boys and herded the group back to the Wisner Wing, ending the brief drama.

Enticed by the several activity areas in the open space of the Wisner Wing, the children moved freely and tensions eased. Some looked at objects and handled them, or played with drums and other musical instruments. The accessibility of the objects captured the children: fingers explored textures, cool metal, warm woods. One sculpture was passed among three boys, who compared its visual and actual weight. Encouraged by a docent, one child placed a wooden duck bowl near his face, inhaling its smoky odor.

Another group clustered around a docent with a projector, who showed how masks and ancestor figures are used in African villages. Interested children asked questions, but excess light in the room made the slides hard to see. Meanwhile, the rock-tossers gathered on one of the large rugs, and with scissors, paper, and bright paper tape began the art project that had been set up for the visit. The children's teacher took a docent aside, "These children tune you out. They live in an environment that is so noisy; the only way they can cope is to tune people out."

At the end of the hour-and-a-half visit the children returned to their bus, each holding, with varying degrees of pride, his paper sculpture "ancestor figure." The docents sat down together to analyze the morning's events. To the teacher's comment, one added,

They did more than tune us out. I felt it was a disaster; what these children needed was not to listen, but to do. When we left the gallery it was all right. They *did*—with musical instruments, with the paper. But some started one project after another; they were devastated. . . . This is the hardest group I've had. I heard two threats with scissors.

Leaving the Wisner Wing, the child from the non-rock-tossing contingent confided, "My class is much better than that one. That class is bad!" As the young moralist perceived, much of the "disaster" element was inherent in the class, rather than in the museum or its program.

Although a museum staff and volunteers cannot know everything about a class in advance, they *can* be prepared for eventualities. That the docent was able to rescue the tour by changing her approach is a tribute to her and to her training; for this is a program in which flexibility and openness are watchwords.

### A few observations

**Teacher preparation and rapport.** Teachers learned about the "Museum Experience" by attending an advance afternoon workshop planned by the four teachers who helped write the workbook. There they were introduced to the workbook and the correlation between the social studies unit they would teach and the enrichment resources of the museum. According to evaluation forms filed with the museum, all teachers felt the session was "necessary and useful," particularly in helping them know what to expect from the museum and to get excited about it.[5] Thus, some used the museum visit to initiate the school unit on Africa.

Workshop notwithstanding—and with notable exceptions —for many teachers the partnership with the museum was an uneasy alliance. Like the children, they were off home turf. Perhaps in a program built so squarely on school-museum cooperation, more than a few selected teachers should be expected to play, and might welcome playing, a more active role. Such sharing might mesh teachers' strengths with those of the docents.

**Tour structure.** The "Museum Experience" offers qualitatively varied but thematically unified experiences: film,

slides, gallery objects, objects to touch, art-making. Even with difficult groups, if one approach fails, another may not. The deliberate flexibility of the program permits docents to adapt the sequence and selection according to the needs of the group. Further, the informal activity areas in the Wisner Wing as a place apart are an antidote to the touch-me-not galleries and serve as alternate border-crossings into the sometimes foreign ground of the museum.

**The role of the docent.** Volunteer time given by docents makes the "Museum Experience" financially possible. As a committed group especially trained to facilitate this program, their challenge is clear: to attune themselves to children as individuals, to elicit from each expressions of feeling or understanding, to affirm their mutual purpose. One way museum and school staff hope to achieve this tutorial rapport is by cutting in half the child-docent ratio, allowing each docent to work with only seven or eight children.

• • •

One docent tells of meeting a group at the museum's front door with the cheery question, "Do you know who this museum belongs to?" An unhesitating if somewhat cynical reply came from a boy at the back of the group, "Yeah, you!" Somewhat taken aback, she managed to reply, "But it belongs to *you,* too." The "Museum Experience—Africa" gives credibility to that answer.—*B. K. B.*

## Notes

[1] For sources of quotations without footnote references, see list of interviews at the end of this report.

[2] The New Orleans Museum of Art's recent expansion program culminated in the addition of three new wings to the original Delgado Museum, including the Wisner Education Wing, which opened in 1970.

[3] One result has been a creative arts center, offering qualified 10th-, 11th-, and 12th-year students a concentrated arts major. The museum provided space for the first semester of the visual arts class until the school system arranged its own housing.

[4] Other films (all from Encyclopedia Britannica Films) used show the cheetah, the giraffe, and the zebra in their African habitat.

[5] The museum gets written evaluations from both teachers and docents and taped interviews with the children. According to the curator of education, these reactions have helped them to make fruitful changes in the museum's "perceptions of the program."

## Interviews and observations

Boasberg, Judy. Docent, New Orleans Museum of Art. January 31, 1974.

Bodenheimer, Nina. Docent, New Orleans Museum of Art. January 31, 1974.

Fox, Martha. Docent, New Orleans Museum of Art. January 31 and May 8, 1974.

Gatto, Jean. Docent, New Orleans Museum of Art. January 31, 1974.

Hamuel, Elaine. Docent, New Orleans Museum of Art. January 31, 1974.

Hanemann, Ann. Docent, New Orleans Museum of Art. January 31, 1974.

Johnson, Susan. Assistant to Curator of Education, New Orleans Museum of Art. January 31, 1974.

Pitman, Bonnie. Curator of Education, New Orleans Museum of Art. September 13, 1973; February 1 and May 8, 1974.

Platou, Dode. Senior Curator of Education, New Orleans Museum of Art. September 13, 1973; January 31 and May 8, 1974.

Rice, Charles. Teacher, Dwight D. Eisenhower School. May 9, 1974.

Silbernagel, Marilyn. Teacher, McDonough School. May 9, 1974.

Trusty, Shirley. Supervisor of Cultural Resources, Orleans Parish Schools. September 14, 1973; May 22, 1974.

Fourth-grade students taking part in program. January 31, 1974.

# THE PHILADELPHIA MUSEUM OF ART: SCHOOL PROGRAMS

Philadelphia Museum of Art
Parkway at 26th Street
Philadelphia, Pennsylvania 19101

**Museum educators who do not believe that "the museum should become a school" create new programs for local schools. Most emphasize perception and some require more than one visit. All demonstrate the value of independent ideas from the museum staff. CMEVA interviews and observations: November 1973; January, March, April 1974.**

### Some Facts About the Program

**Title:** School Programs.

**Audience:** School systems in the Philadelphia area; some 3,000 museum experiences are provided annually and serve an average of 80,000 to 90,000 children. Students from the city's public schools participate through the board of education; for students from other communities, activities are conducted by museum staff lecturers.

**Objective:** To provide museum experiences in art that emphasize perception, rather than art history alone, to students who participate in both one-shot and serial visits to the museum.

**Funding:** From the museum's operating budget.

**Staff:** 2 full-time coordinators, under direction of the chief of the division; 6 full-time lecturers; 7 part-time lecturers; 2 staff members paid by the board of education.

**Location:** In the galleries and sometimes in the audiovisual facilities of the museum. Pre-trip and post-trip programs are conducted in the schools at the discretion of the staff and are designed to fill specific needs of the teacher and students.

**Time:** School programs are offered during the school year.

**Information and documentation available from the institution:** School mailings (lists of offered programs and events), teacher fact sheets on current and proposed programs, special publications offered in conjunction with another institution (such as *Italy,* sponsored jointly by the World Affairs Council and the Philadelphia Museum of Art for Philadelphia's public and parochial schools).

A French class would ask for nineteenth-century French painting or French interiors, 1500–1800, and that wasn't what the class really needed. What the class really needed was one Impressionist painting, one gorgeous room, one beautiful piece of silver, one smashing picture with a

bunch of nudes in it. They needed to get turned on by French civilization and culture.[1]

That is how Patterson Williams illustrated the reasons behind the revamping, in 1973, of the Philadelphia Museum of Art's school programs, the largest enterprise of the division of education, drawing the greatest audience and requiring the most staff time. Mrs. Williams and her colleague, Carol Stapp, who coordinate the school programs, were becoming increasingly dissatisfied with the group tours and other conventional offerings for the schools.

They decided to reassess the museum's programs for schoolchildren and came up with a reduced but, they believed, refined schedule of ten one-visit lessons. Eight deal with the Philadelphia's collection in general categories of art history; for the most part, these are the lessons requested by upper-elementary and secondary schools. The other two are visits based on visual themes: Perception Games is a lesson for young children, kindergarten through 5th grade, and Museum Treasures is a general tour for students of any age except perhaps the very youngest.

Besides these ten one-visit lessons, Mrs. Williams and Mrs. Stapp have developed a pilot program called Museum Journeys that brings students to the museum for a series of four visits. In addition, the museum's education department has undertaken collaborative ventures with a Jesuit high school and with the Academy for Career Education, an alternative program of the Philadelphia school system. (For brief descriptions of these high school programs, see box in chapter 10.)

Central to most of these revisions was the conviction that the traditional emphasis on art history should give ground to the *perception* of art. Carol Stapp has said, "We want to offer the same kind of experience to everybody, regardless of what area of the museum they visit." Patterson Williams, who like all staff lecturers at the museum has a master's degree in art history, believes that teaching from a purely art historical vantage point may overemphasize sheer information. Shifting the emphasis to perception forces the museum teacher to incorporate his art historical background into a lesson that "would no longer be second-rate art history [but] first-rate education and communication."

## Perception Games

The lesson grew out of earlier attempts to give lessons that interested children and used their energy but did not endanger the collection. Though the children and their adult escorts seemed to enjoy these "touch" lessons, Stapp and Williams recognized that the lessons focused the children's attention on objects of little value, the only objects in an art museum that can be handled. As the children had made the effort to come to the museum, they reasoned, the museum lesson should focus on its collection; games of seeing and understanding could be just as exciting as those of handling. The title, "Perception Games," is meant to suggest to schoolteachers that the lesson is designed to appeal to children—like the improvisational theater games used at some museums—but also that it takes a specific educational point of view: the phenomenon of perception.

Perception Games work on three levels. First, they are really games the children take part in and seem to enjoy.[2] Second, they challenge the children, posing problems the lecturer helps them solve. Though they may look like play, the games provide an intellectual puzzle. Say the children's efforts to balance like a nineteenth-century bronze goddess prompts a discussion of the problems of weight and balance the artist had to think through; then the lecturer helps the children apply that discussion to a mobile sculpture—and the sheer difficulty of acting out *its* balance makes a point the children can feel in their own bodies. And that kind of activity leads to the third level: the lecturer helps the children recognize that they already have the resources for greater perception and that they can learn more about how to identify and use them.

Central to the success of Perception Games is the lecturer's ready response to the children's responses in the galleries while the games are being played and afterward. Of the 12 to 15 children generally in a Perception Game tour, usually one or two choose not to participate but to observe, with the lecturer, what the others are doing. Throughout the tour the lecturer carefully keeps open the options every child has. He may "become" sculpture or be a critic of the sculpture or simply watch. (At every turn, the lecturer asks, "Who *wants* to . . .," and tries to make clear that all choices are equally acceptable.) When some children assume the posture of a sculpture and others check its "accuracy," the whole group may end up talking about distortion and other artist's conventions that take liberties with the human body, or about a work of art's emotional impact on a person's ability to register technically precise information about it.

Most children who play the games get more excited as the tour progresses. More and more of them volunteer guesses about each new problem and pay ever closer attention to the activity and the talk about it. Carol Stapp reports, "The kids are 'up' at the end of the hour and don't want to stop. I think that means they're getting something out of it."

After the tours are over and the children have reluctantly left, the lecturers meet to analyze what happened in the galleries—what worked, what did not work, what the children saw and why, how they responded. Day-to-day consultation is important to Stapp and Williams. "People who devise programs but don't go out and teach them miss out on the greater part of the evaluation," argues Carol Stapp. "I'm a great believer that the person who can do the program best is the person who developed it. Even more important is the reverse: you can't develop programs unless you teach and try them out." Patterson Williams adds, "We have developed a direct sort of working situation, which is where most of our ideas come from. We could do even a better job if we had more people who were intensely interested in teaching." Every staff lecturer now conducts the Perception Games tour

and is familiar enough with this new way of teaching to move on to apply the idea to other lessons.

## Museum Journeys

All of the ten redesigned lessons, including Perception Games, are for students making one-time visits to the museum, and they account for the major part of the education division's school program. In 1974 Williams and Stapp developed a pilot program as an alternative to the single visit. Like Perception Games, Museum Journeys uses techniques to awaken perception, but is aimed especially at high school students. In four successive visits a class is introduced to various parts of the collection and to various ways of thinking about art. In the first visit the class explores perception; in the second, art as communication; in the third, aspects of the art produced during a given period and that art's meaning for civilization; and in the fourth visit, the artist as an individual.

## Summary

According to Mrs. Williams, all staff lecturers responded favorably to teaching perception as they became familiar with the new techniques. Through this pilot program she hoped gradually to change the whole scheme of museum lessons. Because her observations have suggested that the curriculum in many schools is increasingly interdisciplinary, she has come to feel that visits organized to reinforce a single subject are no longer relevant. And she believes museum education should reflect those changes in the schools:

> The basic thing about using methods of perception is to forget the necessity of giving historical information. What people do when they come to a museum that they can't do anywhere else is to look, but people don't look. . . . The only way you can get them to look at things is to make them do the work themselves. This is a very difficult role for the art historian, who has been subjected to years of being lectured at and has finally attained a position in which he can do to others what his professors have been doing to him. Except that now he is doing it to a group of people who are three feet high. The most dangerous thing about the verbal approach [is that] you're depriving people of their right to make their own intellectual assumptions under the guise that you're afraid that they can't do it for themselves.

—B.C.F.

## Notes

[1] For sources of quotations without footnote references, see list of interviews at the end of this report.

[2] Of the 12 to 15 children in a Perception Game tour, usually only one or two decline to participate; rarely does a child choose to stay out of a physical activity. As the children are given the opportunity to participate only if they choose to do so, the child who is inhibited is not singled out, nor is he prevented from learning what his classmates are learning by his lack of active participation. The evidence of children acting out, speaking out, and responding to the lecturer overtly is the basis for assuming that they enjoy the participatory games.

## Interviews

Katzive, David H. Chief, Division of Education, Philadelphia Museum of Art. November 19, 1973; January 8 and March 26, 1974.

Stapp, Carol B. Developer of Special Projects, Philadelphia Museum of Art. March 27 and April 8, 9, 10, 1974.

Turner, Evan H. Director, Philadelphia Museum of Art. January 30 and March 26, 1974.

Williams, Patterson B. Administrator of School Programs, Philadelphia Museum of Art. April 8, 9, 10, 1974.

# MUSEUM OF SOUTH TEXAS: "ART IN ACTION"

Museum of South Texas
1902 North Shoreline Drive
P.O. 1010
Corpus Christi, Texas 78403

**A one-time demonstration of inventive ways to involve young children in art, this was a cooperative venture of local arts council, Junior League, school system, and a brand new museum. Cost: $6,800. Planning time: two years. Duration: ten days. Audience: 6,800 3rd graders and many of their teachers. Volunteers on hand: 15. Outcome: general enthusiasm, potential long-term enhancement of children's art-making in Corpus Christi. CMEVA interviews and observations: June 1973 and April 1974.**

### Some Facts About the Program

**Title:** "Art in Action."

**Audience:** 6,800 3rd-grade students from Corpus Christi public, private, and parochial schools and from surrounding municipalities; others from civic groups; general public.

**Objective:** To provide a creative learning experience for all 3rd-grade children in the Corpus Christi area by providing a stimulating environment and making available recycled materials for individual creative projects; to assist development of imaginative art programs; and to make known the availability of resource materials.

**Funding:** $6,800. Sources: $3,400, Junior League of Corpus Christi; $1,000, Corpus Christi Arts Council; $500, Burger Chef; $1,900, City of Corpus Christi, Parks and Recreation Department. Cost per person: $1.

**Staff:** 4 paid staff, including curator of education; director, Corpus Christi Arts Council; curator of exhibitions; and a custodian. In addition, 315 volunteers served in the program: 70 from Hadassah, 15 from Corpus Christi Arts Council, 100 from Junior League of Corpus Christi, 130 from AIA, PTA, AAUW, and others.

**Location:** Three main-floor gallery areas, Museum of South Texas.

**Time:** April 1–10, 1974, Monday–Friday, 9 A.M.–5 P.M.; Saturday, 10 A.M.–5 P.M.; Sunday, 1 P.M.–5 P.M.

**Information and documentation available from the institution:** Newspaper articles, black-and-white photographs, and slides are available from the Museum of South Texas, Corpus Christi. An evaluation and manual is available from Junior League of Corpus

Christi, Room 301, United Savings Building, Alameda, Corpus Christi, Texas 78412.

The Corpus Christi public schools assign no art specialists to elementary classrooms on a regular basis. Arts instruction, outlined in curriculum guides, is the responsibility of the classroom teacher, whose yearly series of in-service workshops includes one in art methods and materials. Teachers seeking further guidance may call on a reading specialist who also serves as "art and music consultant."

As one attempt to enrich the children's art experiences, the Corpus Christi Arts Council and the Junior League agreed to work with Superintendent of Schools Dana Williams to bring Kaleidoscope—a touring participatory art exhibit for children sponsored by Hallmark, Inc.—to Corpus on its swing through Texas in 1973. Although that initial effort failed when the exhibit was unable to include the southern tip of the state, community leaders had grown committed to the potential of such a program. Thus, when James E. Seidelman, who had designed the original Kaleidoscope and was now director of the Living Arts and Science Center in Lexington, Kentucky, suggested that Corpus Christi create its own program, the community was ready. "Art in Action" was born. It was an ingenious, carefully planned, one-shot demonstration of imaginative ways to stimulate young children to make art.

In April 1974, for a period of ten days, 6,800 3rd graders from public, private, and parochial schools in Corpus Christi and five surrounding municipalities were scheduled for a single one-hour session during school hours. After-school and weekend sessions were reserved for six- to twelve-year-olds from such organizations and institutions as the Scouts, Campfire Girls, and Corpus Christi State School. Lecture-studio workshops during the evening hours explained to classroom teachers "how they could encourage creativity in the classroom on a limited budget."[1]

Budgeting for art is a real problem for most schools; art materials can be costly. Seidelman followed the Kaleidoscope format and designed the program around recyclable resources—the wastes and leftovers of local businesses and industries, free materials that required the purchase of no more than a roll of tape or a can of glue.

**The role of the museum**

Once it had been decided to include all the children from a single grade (a stipulation of Junior League commitment to the project), the next step was to find a place to accommodate these thousands of children. Possible choices included a church recreation center, a vacant clothing and shoe store in the center of town, and the Museum of South Texas. Working with Seidelman, Junior League and arts council representatives selected the museum.

Under the terms of the museum's contract with the "Art in Action" committee, Katina Simmons, curator of education, shared the chairmanship with representatives of the two other organizations. The arts council and the league took responsibility for obtaining chairmen for local committees. The museum provided the space, plus the services of Mrs. Simmons and the custodial staff. Responsibility for selecting materials, staging the program, and training the volunteer day chairmen lay with Seidelman.

Many of Seidelman's exhibit-workshops, which he and his Lexington staff bring to small communities in Kentucky and other parts of the country, take place in recreation centers, basements, gymnasiums. Setting up a do-it-yourself exhibit for children in the Museum of South Texas (brand new, designed by Philip Johnson) provided a different and stimulating setting that Seidelman felt demanded a more sophisticated treatment. "We couldn't use folding chairs and tables here. We had to construct tables that were clean, well designed.[2] So he created round tables that can seat ten children each from two 4-by-8-foot pieces of plywood, spray-painted them white, and encircled them with white Scandinavian plastic stools. The museum space available comprised three areas—two high-ceilinged and open to the entrance hall, the third more intimate, with a lower ceiling. All containers for materials were painted blue, yellow, or orange; clusters of children's art displayed against bright panels added the only other color to the white museum environment.

Selection of the museum for "Art in Action" comported well with the museum's policy, as expressed in its "statement of purpose":

The closest liaison shall be developed with the public and private schools and the colleges and universities of the area to assure the broadest program with minimum duplication of effort, especially in the area of creative art instruction.[3]

To Museum of South Texas Director Kathleen Gallander, "Art in Action" provided an opportunity for the museum to demonstrate fresh potentials in art education by sponsoring "a pilot program capable of exerting leverage to change the schools"—a lively extension of the institution's regular program of group tours for all 5th- and 6th-grade students.

This regular program is conducted by 56 volunteer docents, trained by the curator of education, who take children on "perceptual-improvisational tours" of current exhibitions. In return, the school district pays the education department $24,000, almost half the department's yearly operating budget. Slide lectures keyed to art history are also available to the schools. The lectures are given by 16 docents or by the librarian, who, with the curator of education, constitutes the entire education staff.

**Community involvement**

Augmented by the museum's curator of education, the planning committee moved ahead. The school district agreed to provide bus transportation to and from the museum. Various after-school sessions were arranged. On the weekend, "Art in Action" was to be open to the general public.

The resource committee collected 300 different kinds of scrap materials, many as the result of leads and ideas de-

veloped by Seidelman. Committees of the Junior League and arts council readied materials for workshop use while others prepared publicity or found the more than 300 volunteers needed to help make the program run smoothly. These volunteers were a varied group. They included members of the Junior League, Hadassah, the Corpus Christi Arts Council, the American Institute of Architects (about 30 architects gave lunch-hour time for the ten days), PTA's, the American Association of University Women, and students from local colleges.

The 20 volunteers required for each hour of actual operation received a half-hour orientation from their day chairman before the first busload of children arrived. The day chairmen themselves were trained by Seidelman, who emphasized that their attitude toward the children and the volunteers manning each table would tend to set the tone for the day. Although volunteers were primarily dispensers of materials, Seidelman hoped that, through friendly talk with the children, they could encourage them to exploit the possibilities inherent in the materials around them, without telling them what to do. Creativity, not gimmicks, was the order of the day: "We may be working with trash, but we want to end up with something each child can treasure," Seidelman said.

Funding for "Art in Action" came from a number of local sources: the Junior League, the arts council, the City of Corpus Christi, and Burger Chef, Inc., with the Museum of South Texas and the Corpus Christi Independent School District providing in-kind services. The $6,800 budget brought the cost to approximately $1 per child.

**An hour at "Art in Action"**

With so many children, materials, and adults being processed through an hour of planned creativity, one might reasonably envisage an assembly line rather than a studio-museum. Such premonitions, however, would have been wrong. For one thing, care was taken *not* to set up materials in a way that would predetermine the completed object. And although children were overwhelmed, stimulated, and involved in turn, the volunteers succeeded in maintaining an atmosphere of adventure, enjoyment, and helpfulness.

The program could accommodate about 100 children for each session. Leaving the school bus at the front door, they romped up the museum's broad, terraced steps, and melted into the auditorium for a brief introduction and welcome by the day chairman (for many it was their first visit). The children learned that, after looking around at the variety of materials laid out on the different tables, they could sit down at the table that enticed them and have at it.

## Art Project Tables for Gallery Use: A Design that's Attractive, Efficient—and Cheap

The work tables for the "Art in Action" project had to meet several requirements: they had to be sleek enough to harmonize with the museum galleries; large enough to seat up to ten children with ample work space for each, leaving a center supply area within easy reach of seated children; easy to clean and stack. And, perhaps most important, they had to meet the demands of a limited budget.

To solve this design and economic problem, Seidelman and his son Joel joined forces to create round plywood tables, in which cross-braced legs and additional square undergirding support a round top. Legs and undersupport fit together by means of a slot construction. The semicircular plywood pieces that form the top are joined by a piano hinge. Because the precision construction requires neither nails nor screws, it is easy to assemble and take apart. It folds flat for storage. (See accompanying illustrations.)

Cost is minimal, as the design uses almost every inch of two 4-by-8-foot sheets of ¾-inch plywood. White paint, a long piano hinge, and labor need be the only other expenses. Danish-designed Kalmen (or hour-glass) stools of white polystyrol provided the seating.

**Pattern for the Seidelman art table. Materials: two 4-by-8-foot plywood boards.**

**Undersupport for art table, shown here assembled.**

Filing out of the auditorium, some children seemed to notice their surroundings for the first time—the balloons and ferns hanging from the balconies, the pillow sculptures billowing in the air above the tables, figures made of miniature bottles hanging clustered in front of a bright orange panel, a mass of paper-bag puppets in a corner, box sculptures mounted on dowels coming up out of a container full of brightly colored boxes, and in a far corner a sculptured canopy of paper drinking straws over a table. In one area, animals made from tightly rolled newspaper pages hung from a wire grid near the ceiling; to one side, the smell of melting crayon was a guide to the "melt-art" table, where pieces of Venetian blinds lay ready to be painted. On another wall, frames covered with newspaper set off curling and angular designs made of half-inch rolled and flattened newspaper sheets. Painted cartons on the floor and in grocery-store carts overflowed with paper, yarn, tissue, and bouquets of drinking straws.

The architects who served as noon-time volunteers expressed unqualified enjoyment of the program ("Nope, no frustrations. I got 20 years younger!"). They agreed that the environment, while exciting, was overwhelming to some children. Rather than being stimulated to create, a few of them froze, unable to leap the chasm between thought and hand. Most "jumped right in," however, confident in their choice of materials and design.

### Scorecard

There seems little doubt that "Art in Action" was a success as far as it went, and that it effectively carried out its mission. There was, to be sure, nothing revolutionary about its methods, variations of which have been practiced for decades here and abroad.

The kind of freedom-within-limits and extravagance of unconventional and inexpensive materials exemplified by "Art in Action," however, is still far from standard practice in U.S. public schools, especially those, like Corpus Christi's, where classroom teachers are responsible for all subjects including the arts in the lower grades. So beyond the immediate value of that one-time experience for the city's 3rd graders, it was probably useful for the teachers to get a fresh vantage point on children and art.

In his teachers' workshops, Seidelman analyzed the principles implicit in "Art in Action." He put major emphasis on motivating the child to make something on his own by conveying without words that there is no single "correct" solution. This can be done visually, by displaying many different ways of carrying out a given project. Stimulation through the ears can help too (music playing in the background), and through the nose (cut Ivory soap, fresh wallpaper books, those melting crayons). From ample, varied materials appropriate for the particular project—carefully prepared and arranged—the child can choose what appeals to him cafeteria-style. At this point, if all goes well, he should be ready and unafraid to make something.

A Seidelman-designed art project table in action: nine Corpus Christi 3rd graders who chose the doll-making area find they have plenty of work space and easy access to materials in the center of the table. The simple, efficient plywood construction, painted white and encircled by Scandinavian plastic stools, harmonizes with museum galleries, folds flat for storage.

For Seidelman, the teacher's role throughout is not so simplistic as standing back and letting self-expression reign. Besides setting the stage by providing and deftly arranging the displays and materials, she or he should move about, ask provocative questions, offer advice when asked. Finally, he says, without ever comparing one child's work with another's, the teachers should make their own judgment of the results and help the children to see what they have created. One of his ideas was to move children and finished objects to a different area, perhaps the gym. By placing their work on one of the painted perimeter lines, the young art-makers created an instant exhibition.

### Some questions

Museums constantly seek ways to meet the needs of their communities. Relatively new ones like the Museum of South Texas must rely on temporary exhibitions, trying to mesh their own standards with the needs and expectations of their audience. The by-products of events such as "Art in Action" are seductive: thousands of small children who come away with a "product," financial support from seven local sources, and 315 volunteers from diverse community groups.

But planning took two years; even committed volunteers tire, and, although the program certainly shocked some parents and teachers into a new awareness of what art education can be, awareness is only a first step.

A number of "Art in Action" leaders indicated that the focus of the program changed for them as they took part and saw the results. Rather than seeing it as a single spectacular, they began to view it as a catalyst for change in Corpus Christi. To effect real change, however, was not some kind of organized effort required?

Several next steps were being considered in mid-1974: (1) a school administrator suggested that representatives of sponsoring institutions meet to evaluate the program and to propose ways to improve art education; (2) one organization suggested carrying the program forward on a smaller scale by using a van to bring teachers and materials from school to school; (3) one volunteer, a teacher who knew of two empty rooms in her school, planned to convert them to a miniature "Art in Action" studio and resource center.

At the very least, "Art in Action" established a network of communications: the museum, the school system, community organizations, and over 300 citizens came together for a common experience in art education.—*B. K. B.*

## Notes

[1] Fact sheet on "Art in Action."

[2] For sources of quotations without footnote references, see list of interviews at the end of this report.

[3] "Statement of Purpose," Corpus Christi Art Foundation.

## Interviews and observations

Alaniz, Terri. Elementary Consultant. April 3, 1974.

Avant, Sally. Cochairman, Resource Committee. April 3 and 5, 1974.

Barth, Jean. Cochairman, Public Relations Committee. April 5, 1974.

Carrol, Garth. Cochairman, Staging Committee. April 5, 1974.

DeShane, Connie. Project Administrator for Creative Staff Development, Corpus Christi Independent School District. April 5, 1974.

Edwards, Mary Lee. Cochairman, Production Committee. April 5, 1974.

Gallander, Kathleen. Director, Museum of South Texas, Corpus Christi. June 14 and 27, 1973; April 3 and 5, 1974.

Hausman, Renee. Project Cochairman and Director, Corpus Christi Arts Council. April 3 and 5, 1974.

Kennedy, Susan. Cochairman, Resource Committee. April 3 and 5, 1974.

Lee, Mary. Day Chairman. April 3, 1974 (observed).

Marks, Sue. Cochairman, Production Committee. April 5, 1974.

Merkle, Jennifer. Cochairman, Staging Committee. April 5, 1974.

Morrison, Diana. Project Cochairman. April 3, 4, and 5, 1974.

Seidelman, James A. Director, Living Arts and Science Center, Lexington, Kentucky. June 14 and 27, 1973; April 3 and 5, 1974.

Simmons, Katina. Curator of Education, Museum of South Texas, Corpus Christi. June 27, 1973; April 3 and 5, 1974.

Wollock, Clarise. Volunteer. April 3, 1974 (observed).

Group interview with the following architects, April 5, 1974: Carlos Alexander, Johnny Cotten, Bert Haas, Bill Holland, Gordon Landreth and Larry Money.

## Bibliography

Articles from the *Corpus Christi Caller*, March–April, 1974.

The following books by James E. Seidelman and Grace Mintonye

published by Crowell-Collier Press were available as resources during the in-service workshops:

*Shopping Cart Art*, 1970.

*The Rub Book*, 1968.

*Creating with Papier Maché*, 1971.

*Creating Mosaics*, 1967.

*Creating with Clay*, 1967.

*Creating with Paper*, 1967.

*Creating with Paint*, 1967.

*Creating with Wood*, 1969.

*Photograph:* Blackwell Photography, Corpus Christi, Texas.

# OLD STURBRIDGE VILLAGE: MUSEUM FIELD STUDY PROGRAM

Old Sturbridge Village
Sturbridge, Massachusetts 01566

**An elaborate re-creation of an old New England village, stocked with original artifacts, gives children a chance to project themselves back into the nineteenth century. Tours, supplemented by studio work (mostly with reproductions) and dramatizations, center on a specific theme—work, community, or family—all of the activities adaptable for use in art museums as well. CMEVA interviews and observations: November 1973; February and May 1974.**

### Some Facts About the Program

**Title:** Museum Field Study Program.

**Audience:** Children in school groups, of whom about 50 percent are from grades 3–6, 25 percent from grades 7–9, 10 percent from grades 10–12, and 7 percent from college. The remaining 8 percent are from primary grades, recreational organizations, or special education classes. About 82,000 children in school groups were served in 1972.

**Objective:** To structure learning experiences in the village and in the new museum education building through a variety of approaches: using primary sources, objects (both originals and reproductions), and visual materials; encouraging role-playing and dramatization; and developing teaching strategies.

**Funding:** There are no separate budgets for Sturbridge Village programs; however, an estimated two-thirds of the $370,000 budgeted for educational programs goes for school and college programs, including the Museum Field Study Program. (The remaining third goes for teacher training and material.)

**Staff:** About 20 full- and part-time paid escorts, 7 professional staff members, 3 program and administrative assistants, and 3 clerical staff members.

**Location:** In the village.

**Time:** Tours are evenly spaced throughout the school year, from October to May. Escorted thematic tours have been given since 1971.

**Information and documentation available from the institution:** *The Almanac,* the program announcement of the museum education department, describes all its activities. The "Thematic Guides" to the village are available from the museum education department.

Old Sturbridge Village is a re-creation of a New England rural community of 1790–1840. Spread over more than 200

acres are nearly 40 major buildings including houses, shops, mills, a store, a tavern, a meeting house, all laid out on the typical village plan with a commons and neat main roads. Like Colonial Williamsburg and other reproductions of a past time and place, it is a kind of dream-come-true for historians of daily life and a challenge—or, at its best, an inspiration—to the imagination of visitors who wander among its buildings and along its paths. To those who work in more conventional museum galleries, Sturbridge Village is like the biggest period room of them all.

### The Museum Field Study tours

Since 1971, the central program of the village's museum education department has been thematic tours for groups of schoolchildren.[1] Each tour is keyed to a theme that is an organizing principle, a kind of magnifying lens that helps the children concentrate on one aspect of the rich but potentially overwhelming environment.

Three basic themes were chosen for the 1973/74 program: work, family, and community. In small groups (usually about 10 or 12), students tour the village with an escort who alerts them to the specific problems and ideas that their "theme" raises and takes them to places where costumed interpreters demonstrate the daily activities of an early nineteenth-century New England village. The escort's major responsibility is to help the children consider—look at, respond to, work with, think about—all the diverse exhibits and activities from a single perspective. The escort's principal teaching method is to help the children imagine themselves ("role-play" is the inescapable word in modern education jargon) living in the village, using its tools, facing and solving its problems. A tour's theme is reinforced, usually after the tour of the grounds, by "studio experiences"—when the children work at role-playing in the village's new education building. In its several open teaching areas, each equipped for a different theme, students can husk corn, spin wool, bake over an open hearth, or play at being actual New Englanders of the early nineteenth century, using information from tax lists and demographic records.

A "community" tour group might explore the village to find problems that required community decisions. Then, pretending to be householders, they might hold a make-believe town meeting where they could debate the merits of building a new road or a textile mill, considering all the attendant effects of industrialization on an agricultural community. A "family" tour group might visit the Pliny Freeman farm or struggle with arithmetic sums and penmanship in a simulated schoolroom to understand how children were educated, informally and formally, in early New England. To a "work" tour group, the same Freeman farm could suggest the way chores were assigned in a family or how a family's work changed according to the season.[2] One work tour group of 4th and 5th graders began its day by making batter cakes for tea, which required the children to grease the pans with lard,

stand over the fireplace watching the cakes, fetch and heat the water to do the dishes. (Original tools are displayed in each studio space in the education building for the children to examine and touch, but they actually use accurate reproductions of pots, furniture, spinning wheels, or whatever in their "studio experiences.")

**Escorts.** During the season (which corresponds to the school year), about 20 full-time or part-time escorts join the village staff. Perhaps half of them live in the neighborhood and are wives and mothers returning to work. The rest are young people working at Sturbridge for a year as an alternative to a more conventional teaching job.

The Sturbridge education staff chooses escorts not for their background in history but for intelligence, sensitivity, and an interest in children. Their training is brief: two weeks before the season opens, three or four more weeks during the season. It plays down information in favor of skills to entice children with small group-teaching techniques, simulation and role-playing, ways to "mediate" between the children and the collection.

**A tour observed.** Well planned as they are, the museum field study tours are not immune to the usual hazards of dealing with clumps of children free from school for a whole day. (The tours last four or five hours, and what with transportation from school to the village and back, take up an entire school day.) Jack Larkin, acting director for museum education, says the thematic tour can have "a range of outcomes, from the extraordinarily rich to the acceptably good through the flat and stale—with occasional real disasters."[3]

A work tour group of 13 Spanish-speaking 4th and 5th graders from an inner-city school in Springfield, Massachusetts, in spring 1974, would probably fall somewhere close to "flat" on Larkin's range. The escort introduced the village and the day's theme: "We are now going to see a village of about 1800, the time of your great-great-great-great-great grandparents. We would like you to think about the kinds of work they did. This period was a time when most people did farm work." Counting the generations back on their fingers, the children showed a lively interest in that way of getting a handle on history. But when a horse-drawn wagon passed by, the children's attention was lured away from the tour; no matter what the escort or the costumed interpreters did (and no matter how hard the children sporadically tried to listen politely), their chief interest from that point on was getting a ride in the wagon.

Touring the village, the children saw people splitting rails, making barrels, cooking, weaving. The point of all they were shown and told was, as one observer put it, to demonstrate to them "the critical necessity for self-sufficiency" and "the real meaning of work in the early nineteenth century." But when they finally came, at the tour's end, to the village's country store—the only place where farmers could buy the

tools and supplies they needed to grow their own food, raise their own animals, fashion their own necessities—and were asked, "What might an early nineteenth-century New England farm family need to buy at the store?", they chorused enthusiastically, "Food!" (This experience is not unlike that of another school group taken to the nineteenth-century cemetery and encouraged to look over the tombstones; noticing that some of the children had found three markers with the same family name and the same death date, an alert escort asked what they thought might have carried off several members of the same family at the exact same time. Another enthusiastic chorus: "A car accident!")

**The schoolteachers.** Advance information from the teacher determines the choice of theme and tour for each class that will visit the village with an escort. But the escort staff can work with only 150 of the 400 children who come to the village every day. Guides for the rest—that is, for more than half the school visitors—are their own teachers, some of whom prefer it that way. Because the museum education department cannot double its staff to serve all visiting school groups, it is trying to work out ways to help schoolteachers who will escort their own classes. Some staff members may offer suggestions about role-playing, the collections, and other topics before the teachers begin their tours—a step that could also encourage closer cooperation between staff and visiting teachers.

**Resource packets**

Sturbridge's education program with school groups is not devoted only to the real and re-created relics of the past. Direct *written* evidence of the past is equally useful to students and to teachers, museum staff believe, and since 1974 they have made copies of the village's historical resources available to teachers. Diaries, autobiographies, account books, apprenticeship records, tax lists, and family and school records are gathered into data-resource packets. There are 13 such packets, each on a different theme, each containing suggestions for using the documents and additional background papers (which may be reproduced for classroom use). For the teacher planning a museum field study tour, the packet is both introduction and follow-up; for teachers who cannot bring their classes to the village, the data-bank resource packet is a comprehensive curriculum unit. (The data bank also provides a slide set and script as introduction to the village for teachers to use in their classrooms before a visit.)

Sturbridge staff believe that the best use of resource materials depends on consultation and joint planning between teachers and museum staff. The staffs of both the education department and of the teacher center are available one Saturday a month for group or individual consultations, to discuss proposed class visits to the village. (For further information on the teacher center and its programs, see box in chapter 11.)

**The Museum Field Study Program, in summary**

What distinguishes the program's work with elementary school students is (1) the thematic organization of the tours—a "magnifying lens" that helps children focus on one aspect of a complex museum collection; (2) the combination of the museum visit with a studio or "hands-on" experience that tries to compare homely familiar actions (eating, getting dressed, going to school) with their nineteenth-century equivalents and appropriately uses both original objects and reproductions to do it; and (3) a staff member trained not in subject matter but in specific teaching methods to guide small groups of children through the "museum."

These are principles a museum of any kind might apply to its group tours, just as any art museum educator can see in Sturbridge's experience some of his familiar problems: how to spread staff around, how to establish cooperative programs with teachers, how to improve the "strategies" for making a tour among objects of another time and place seem real, even memorable, to children who do not yet know that cars and packaged food have not always been the staples of life.
—*B. N. S.*

**Notes**

[1] In addition to the tours for elementary schoolchildren, the village offers programs for high school students, handicapped children, and college students in such fields as history, literature, sociology, engineering, and museology, and one-visit and serial programs, at the village and in classrooms, for inner-city 5th graders.

[2] Additional examples of the thematic approach are given in the new "Thematic Guides to Old Sturbridge Village." These parallel the methods used by the escorts. They are distributed to adult and family visitors, who do not receive escorted tours, so that they may approximate this special experience for themselves. The "Guide about Food" suggests that the visitor think about how members of an early nineteenth-century New England farm family satisfied its needs for food. It points out a way one might answer this question by stating that the process of preserving food begins with the necessary utensils. Thus, one might start one's exploration at the store or the pottery to investigate the availability of inexpensive food storage containers. The guide includes a map that locates the other important areas in the village related to food.

The "Guide to Farmers and Farming" was designed to explore some of the working relationships between the early nineteenth-century farmer's management of his resources and the shaping power of the natural environment. Here the map picks out the farming or farm-related exhibits in the village. Another guide explores the question of the use and the sources of energy 150 years ago. Each guide offers a way of considering all the diverse exhibits in the village from a single important point. The experimental guides were developed with the support of the National Endowment for the Humanities.

[3] For sources of quotations without footnote references, see list of interviews at the end of this report.

### Interviews and observations

Endter, Ellen. Escort, Old Sturbridge Village. May 17, 1974.

Forrest, Marian. Escort, Old Sturbridge Village. May 17, 1974.

Larkin, Jack. Acting Director for Museum Education, Old Sturbridge Village. November 9, 1973; February 5, 1974.

Sebolt, Alberta. Director, Teacher Center, Old Sturbridge Village. February 5, 1974.

Sidford, Holly. Program Coordinator, Old Sturbridge Village. February 5, 1974.

A group of 4th and 5th graders from Springfield, Massachusetts. May 17, 1974.

# Museum Programs for Schoolchildren at Other Sites

## Introduction

Taking art to where children are is an almost irresistible impulse for nearly every art museum with a modicum of energy and interest in its school-age constituency. With the zeal of the missionary that an art museum often regards itself, it might send docents or staff into school classrooms to make presentations, devise circulating exhibitions for school hallways and libraries, or sponsor workshops and mobile units for parks, playgrounds, and city streets—all to bring light into philistine darkness.

Specific objectives vary, and so do the resources and methods the seven programs described in this chapter employ to reach their objectives. But all serve the cause of art—its creation, appreciation, or infiltration—and most serve the cause of the museum as well. Four of these programs—the In-School Program of the Taft Museum in Cincinnati, the Artmobile of the Birmingham Museum in Alabama, the Trip-out Trucks of the de Young Museum Art School in San Francisco, and the Color Wheels bus of Albright-Knox Gallery in Buffalo—set out, with varying degrees of determination, to interest young audiences in visiting the museum itself, although only one program (Taft's) always integrates a museum visit with its off-site activity. Two—the High Museum's Georgia Art Bus and the Ringling Museum's Art Caravan in Florida—are statewide in scope, designed to bring art objects as well as instruction to children who cannot come to the museum. And one, the Houston Museum of Contemporary Arts program, Art after School, seeks to do no more than provide studio classes that emphasize "organic" art experiences. Not surprisingly, five of the seven programs have as one explicit or implicit objective to substitute for, or at best supplement, art instruction in the schools, generally described by its mildest critics as "inadequate."

### Content of the programs

Each of the off-site programs described here and in other chapters in this study tends to draw its major strength from one of three elements: (1) the artists or teachers who conduct the activities; (2) the activities themselves—what the children do, why, and how; or (3) the use of art objects as a teaching tool and a means of attracting children to the museum.

**People.** The quality of the artist-teachers clearly makes or breaks a program such as Trip-out Trucks. Bearing almost total responsibility, they must drive the trucks, scavenge and recycle supplies, cook up inventive project ideas that relate to school curricula, plan with, help, and try to serve as models for schoolteachers, train volunteer assistants, lead museum tours, and be "marvelous with children," all the while teaching art.

The success of the Georgia Art Bus program, too, depends almost entirely on the artists-in-residence who travel to the state's hinterlands with the bus's exhibition of contemporary art. As they make presentations, lead discussions about the exhibition, teach new techniques, and try to pique their audience's curiosity about art, their personalities and presence become as important as their talents; they are the sole connectors between the students (most of whom have never before seen original art) and the paintings, prints, and drawings that hang for two or three weeks in their school hallways, cafeterias, and libraries.

In the second year of the Urban Arts program of the Minneapolis public schools (see chapter 10), its planners decided that bringing artists into the schools for repeated visits would constitute a stronger program than sending students out to studios, museums, theaters, and concert halls, as the program had done the first year. Not only did this new policy ease some of the dissatisfaction of schoolteachers who resented the artist-instructors "out there," but it gave many more students the chance for exposure to the artists and helped to integrate the arts into the overall curriculum and the life of the school. The approach has been judged generally successful by inside and outside observers, not least because of the artists selected: the prime criterion besides talent was their capacity to stimulate youngsters and to reflect the energy and special quality of "the great world of art."

**Activity.** What the children do with their hands, eyes, or minds is the emphasis of several other off-site programs in this and other chapters. In two of them, what takes place in the classroom is a direct prelude to and preparation for a museum visit. Docents from the Taft Museum go out to 2nd-through 5th-grade classrooms with suitcases and workboxes of materials that give children something to do—make their own paint or prepare an enamel glaze—as a hand-hold with which to apprehend Old Master paintings or French Rennaissance enamels on a later visit to the museum itself. The National Portrait Gallery staff in Washington, D.C., prepares high school students for a museum tour by staging a drama, "The Trial of John Brown," in classrooms (see chapter 10). Acting as the trial jury, students are steeped in the social issues of the times and the personalities of the famous charac-

ters whose portraits they will later see, thus enhancing their enjoyment and appreciation of the art.

Teaching students how art is made and how to make it themselves is at least one element of most visual arts museum off-site programs. For some it *is* the program. Houston's Art after School was organized because parents were dissatisfied with the level of art instruction in the schools. They turned to the museum to represent the visual arts interests of the community. The program, 12 weeks devoted entirely to studio art for elementary schoolchildren, is backed by an explicit philosophy: "individual creative and perceptual growth through organic experiences and personal contact with artist-teachers." In small classes that take place in the schools after hours, the children explore the elements of art and experiment with a range of media.

The Albright-Knox Art Gallery, too, began its mobile studio program, Color Wheels, in part because of what the staff felt was inadequate art instruction in the schools. In visits to schools and community centers around Buffalo, New York, instructors on the bus make some effort to tie studio instruction—drawing, printmaking, painting, sculpture—to the museum's collections, but they insist this is not the primary purpose. In the words of the program coordinator, "We just want [the children] to know that there is an art—it exists, and they can participate in it and maybe find something that would brighten their lives."

Participation in an "art experience" is also the focus of the Ringling Museum Art Caravan. Three museum educators (two of them artists as well) visit selected elementary schools throughout the state of Florida, offering a carefully structured three-hour program that engages children in a variety of activities: body movement, discussion of art objects, and studio work in which the students fashion their own clay pots, masks, or other objects.

The Art Resources Center, an extension service of the Whitney Museum in New York City (see chapter 10), exists solely to provide studio space and materials for any interested teenagers. A small staff of professional artists gives guidance and advice, if asked, but virtually no supervision. For a time, the staff let some of the regular participants have their own keys to the studio so they could come in whenever they felt like it. (In 1975 the museum began to impose some restrictions on access to the program and the building itself.)

GAME, one of New York City's cultural resource centers and a half-way point between school and museum (see chapter 8), emphasizes art-making activities that tie into academic subjects the children study in school and exhibitions they visit at various museums around the city.

**Objects.** Original works of art from the collections are the pull of the Birmingham Museum's Artmobile. The van parks in the yards of local public and parochial schools, and children from grades 3–7 pour out, one class at a time, to stand around the vehicle for a half-hour lecture by the driver-teacher, who shows and leads discussions about the pieces.

The message he most wants to get across is repeated to every class and amplified in a brochure given to each child: the treasures in the van are only a sampling; there is much more in the museum itself, which is open to the children free of charge.

Original artifacts are also the major attraction of the mobile unit of the Museum of the National Center of Afro-American Artists (see report on the Elma Lewis School, chapter 8). Here, objects from the collection of black and African art are taken to schools in Boston suburbs as part of a cross-cultural program "to reduce minority group isolation." The Memorial Art Gallery in Rochester, New York (see chapter 1), sends museum objects to elementary schools that have exhibit cases in their hallways. Docents called Art Ambassadors change the shows regularly and meet with classes, bringing the children to the case or the objects to the classrooms so that children can handle and discuss the material before it is arranged in the case.

A few museum objects are also used in the Trip-out Trucks program. They are packed in suitcases aptly called Trip-out Trunks and taken to school classrooms to enhance art projects on such themes as puppets and masks. The in-school part of the Taft program makes some use of reproductions of objects from the collections, as does Color Wheels. Although the Georgia Art Bus exhibits only original art, the pieces are not from the High Museum's collections, but were bought expressly for the traveling show.

### Relations with the schools

Every outreach program described here has reached children mainly through the schools—logically enough since schools are the largest and most dependable sources of young, educable minds. To varying degrees, depending on the nature of each program, the relationships between museum and school and between museum educators and schoolteachers can determine the success or failure of the effort.

Several programs set out, in consultation with teachers, to meld their offerings into the class curriculum. The Ringling Art Caravan has eight canned programs, related to such topics as the art of American Indians or black Americans, from which teachers can choose one or a mix. Trip-out Trucks staff members meet with the teacher before each series of visits and will gamely take on almost any curriculum-based art project he wants. (In the not-uncommon event that teachers, especially those in the lower grades, are at a loss for an idea, the staff makes suggestions, a bit of flexibility that is much appreciated.) Most of Rochester's Art Ambassadors also meet with teachers beforehand to seek their advice on appropriate loan exhibits. The administrators of the Urban Arts program, by bringing the artist-instructors into the schools, have negotiated a twist on this theme: they want art instruction to seep into (though not dominate) every academic discipline.

The delicate issue of turf crops up in most programs that involve use of school space and time. How a regular teacher

responds to an outside expert who swoops into his classroom, or worse, lures his students out of it, is a function partly of his personality but partly, too, of the sensitivity of the museum staff. The extra effort that the Ringling and Trip-out staffs put into involving teachers apparently pays off: both report almost uniformly positive feedback, and requests for the programs from individual teachers far exceed the museums' ability to meet them. The Ringling program, in fact, styles itself as a "model for art instruction" and brings in outside teachers to observe the action and spread the good word to other schools and school systems in the surrounding area. (In some cases the very existence of an outreach program may have a positive effect on teachers. The CMEVA reporter who studied the Georgia Art Bus observed that, far from being threatening, the exhibition and artist-in-residence provided a boost to the morale and status of the isolated rural art teacher, "often a lonely sentinel in school and community.")

Observers of the Urban Arts program and of the Institute of Contemporary Arts' VALUE program in Boston (see chapter 10), which took high school students out of the classroom four days a week for six or seven weeks, noted feelings of rivalry, resentment, and even hostility among home-school teachers. The VALUE staff acknowledged that this could have been due mostly to its own failure to communicate to the teachers about what the students were doing. The problem in Urban Arts was largely, though not entirely, vitiated when the program began to import artists into the schools rather than export students out of them. The GAME cultural resource center neatly sidesteps the turf issue by conducting its activities on neutral territory where schoolteachers, artists, and museum staff can come together with children.

In most of these programs there has been little discernible resistance from the schools to the museums' outreach programs. In fact, the opposite is generally the case. In Birmingham, for example, the board of education pays not only the salary of the Artmobile's driver-lecturer but most of the van's operating costs as well. VALUE employed as coordinators two teachers, both paid by the school district, and used for its headquarters space in a school administration building. Recruitment of students for Houston's Art after School is done through the system, and public school classrooms are used for most of the studio workshops. For the Whitney Museum's Art Resources Center, which also leans heavily on the schools for recruitment, the relationship has been uneven. Although allowing some students to receive academic credit for work done at the center, the board of education has balked at giving the fund-raising help that the Whitney's head of education feels is most crucial to the program's survival.

### Logistics

**Spaces and places.** The ways in which museums take their resources to other sites are as various as their teaching techniques once they get there. Four of the programs described in this chapter make use of a specially designed vehicle. The Georgia Art Bus is a converted school bus that carries the art works, the artist-in-residence, and the supplies he uses in his workshops and demonstrations. Color Wheels is a converted mobile classroom, fitted so that children—about a dozen at a time—and instructors can work inside. The two Trip-out Trucks, bulky one-ton vans that look like paddy wagons, were designed to carry supplies and staff, though in 1974 one of them was turned into a mobile darkroom for a film program. Birmingham's Artmobile is a half-ton van that carries exhibits in glass cases built into the sides of the interior and mounted on pull-out pegboard panels in the rear. (Despite its name the Ringling Art Caravan until fall 1974 was a single ordinary station wagon that simply carried the staff, some art objects, films, and other supplies.)

The Taft Museum's program arrives in ingeniously designed suitcases and workboxes, small enough to be carried by the docents and equipped with all the materials needed for the classroom work. The workbox for the French Renaissance enamels lesson, for example, contains a small kiln so that docents can fire the children's own enamel work on the spot.

Each of the mobile programs except Birmingham's, which is conducted entirely around the van itself, uses school space for all or part of its activities. Color Wheels and the Trip-out Trucks can also be parked in playgrounds, parks, and vacant lots while activities take place in and around the vehicles. Art after School, which has no vehicles, uses community centers and churches for studio classes where school rooms are unavailable.

Of the other off-site programs, two occupy permanent quarters in which activities take place. The Art Resources Center is housed in a three-story converted warehouse rescued by the Whitney Museum from the wrecker's ball and partitioned into small studios, and GAME in a 2,500-foot-square basement storefront neatly divided into specialized workshop areas. VALUE used some office space in a school administration building but scattered its students to all corners of metropolitan Boston to pursue their projects.

Security for works of art is a factor in two of the mobile programs. The Birmingham Museum chose an exhibit-van with objects secured in cases so that it could show valuable pieces it is unwilling to have carried into classrooms (although each exhibition does include a few less valuable or especially durable items that children can handle). One reason why the organizers of the Georgia program decided to buy art expressly for the traveling exhibition was to avoid the security problems inherent in exhibiting costly or borrowed works in public areas. As it turned out, by 1974, the fourth year of operation, there had not been a single instance of theft, vandalism, or other damage.

**Money and other numbers.** Inevitably the scope of an off-site program—what it seeks to accomplish and how large an audience it reaches—is tied not only to the educational vision

of the museum, but also to the financial resources on which it can draw. Indeed the question of which comes first—money or program—may often be one of chicken or egg. In this light the programs observed for this study are hardly comparable. Granted, some are more flashy and energetic than others; some are expensive and some relatively cheap; some "reach" tens of thousands of persons in a year, some only a few hundred, if that many. But each must be taken on its own terms.

The Birmingham Artmobile, for example, which costs less than $10,000 a year (or 40 cents per child), does not pretend that its modest program provides an intensive art experience for the more than 25,000 schoolchildren per year to whom it exhibits museum objects. By contrast, the Whitney Museum's Art Resources Center gives studio space, supplies, and staff support to about 300 teenagers a year at a cost of $60,000, or $200 per person, and, even at that, the center's staff acknowledges that only 25 to 35 young people are served "intensively."

The number of persons reached by an off-site program can, of course, be misleading. The Ringling Art Caravan, whose staff actually came into contact with about 1,000 children in 1973/74, claims, perhaps pretentiously, that it has provided "entire school systems with fresh, open, and original art instruction methods," because of its policies of broadening participation at each stop to include teachers from other schools—"so they can take the techniques back to other students"—and of videotaping some caravan visits for use throughout school districts. The Trip-out Trucks reach an estimated 110,000 persons each year in school and community programs, but this figure includes those who may do no more than make a paper airplane in a park as well as children in an elementary school classroom the staff visits four times.

Money, allocated and spent, does not tell the whole story either. The National Center of Afro-American Artists (see chapter 8) bought and outfitted a sophisticated 10-by-35-foot trailer for its mobile museum with a single federal grant, and fees for upkeep and staff time (over $500 per week) are paid by the suburban school districts that the trailer visits. The Trip-out Trucks, in contrast, depend heavily for their shoestring survival on found and recycled materials, volunteer assistants to the professional staff, and in-kind contributions from staff and city agencies.

Interestingly, of all the off-site programs in this study, only one—the National Portrait Gallery's—is paid for entirely from the museum's operating budget. The schools contribute to six others, ranging from almost total support for the Birmingham Artmobile to donation of space for Art after School. Most of the money for outreach programs comes from sources such as the federal government, state arts councils, the National Endowment for the Arts, private groups like the Junior League, foundations, and businesses. (Only Art after School makes a direct charge to participants; some tuition-free classes in poor neighborhoods are subsidized by grants from the state arts commission and an insurance company.) It would seem, then, that the commitment of public agencies and the generosity of private donors play a large role in determining how far a museum can travel beyond its doors.

**Scheduling.** For programs such as the Art Resources Center scheduling is not an issue: the teenagers can drop by to work whenever the center is open. For others it is a simple matter. As the Birmingham program is unencumbered by tie-ins to school curricula, the Artmobile is assigned to each school (depending on size) for one to three days, and the principals are notified of the assignments at the beginning of the school year. The exhibitions are changed once a year in five-year cycles so that no child sees the same one twice.

Color Wheels makes a series of scheduled stops in specific locations—parks, community centers, schools—at which children sign up for classes in advance. It returns to each location for two-hour sessions one day a week for eight weeks, a schedule determined by the large demand for the bus, not the coordinator's preference: "Kids need more than one day a week," he feels. The Trip-out Trucks' summer community program is a mix of scheduled stops once a week at fixed locations and special one-time visits preceded by intensive advance publicity that includes contacting community leaders, posting flyers, and visiting churches and neighborhood centers.

Scheduling problems become most difficult in those programs that draw students, especially high school students, out of classes during school hours. This created friction with teachers in both the VALUE and Urban Arts programs, as noted earlier. Urban Arts solved the problem at least partially by moving the artists into the schools and setting up an advisory committee that determined where and for how long each artist should teach and trying to match the artist to a particular school activity already in progress. The schedules were publicized in each school and the teachers signed up for the various time slots.

**Staff.** One of the first questions a museum must resolve in designing an off-site program is whether to use artists as teachers. Most of the programs described here have come down on the *yes* side and, it seems, have been extraordinarily blessed in their ability to find artists who can also teach. An almost inevitable problem, however, is high staff turnover. Because the jobs are nearly always part-time and often seasonal or dependent on the vagaries of funding, many of the museums find themselves having to recruit quickly and frequently. The director of Art after School, for example, reports that about half of her program staff of 29 is new each year. An obvious pitfall here is the temptation to hire whoever is available regardless of artistic or teaching talent.

In several programs the "artist" half of the artist-teacher is crucial. The High Museum feels that the Georgia Art Bus exhibition draws its credibility from the artists-in-residence,

who not only teach technique but also, by their very presence, make the art works "real" to a particularly unsophisticated audience. Urban Arts and the Art Resources Center, too, are predicated on the interaction between students and people who create art as a profession.

Among the programs that offer some kind of studio instruction nearly all use artists as staff, though for some this is a higher priority than for others. The coordinator of Color Wheels is adamant in his conviction that artists should teach art, no matter how young the students. The Trip-out Trucks program, which has easy access to practicing artists because of its affiliation with the de Young Museum Art School, is nevertheless hampered by budget constrictions and must supplement its professional staff of six part-time artist-teachers with volunteer "art apprentices."

The Taft Museum's In-School Program and the Memorial Art Gallery's Art Ambassadors are the only programs described here that put the entire burden of off-site instruction on volunteers—in both cases docents. In the Taft program, because the studio work in school classrooms is fairly circumscribed—45 minutes of mixing paints or glazing cups—and the volunteers carefully trained, there is clearly no need for often costly professional artist-instructors. The docents' knowledge of the collections and their availability to lead the follow-up museum tours with each class are more important to the program's goals than dexterity with a paint brush or potter's wheel. The Art Ambassadors are also well trained, and all have previous art or education experience. The program depends almost entirely on the individual volunteer's initiative; each is assigned her own school and schedules her own visits and work load.

The National Portrait Gallery turned to college students to supplement its own staff in presentations of the "Trial of John Brown." Paid by the hour and trained for roles in the drama, the student aides are also available to help conduct the follow-up tours at the museum.

### In summary

Although the programs described here are so different from one another as to defy outright comparison, taken as a group they do raise a few basic issues that should be considered by museum educators planning or assessing an outreach program.

- Regardless of a program's intent or content, the people who conduct it—artists, educators, or volunteers—are crucial to its success. The ability of the outreach staff to establish rapport with youngsters, to "turn them on" to art, seems consistently to have more impact on both teachers and children than the size or shape of vehicle, abundance of supplies, or even frequency of contact.
- If a program contains some element of reinforcement, it is more likely to leave something lasting behind. The reinforcement can take the shape of a tie-in with school curriculum (like the Trip-out Trucks and Urban Arts), relating art-making technique to art objects (like the Georgia Art

Bus and the Taft In-School Program), scheduling activities in a series (like Color Wheels and Art after School), or follow-up visits to the museum (like the "Trial of John Brown" and the Taft program).
- The museum that goes into the schools must tread carefully. An extra effort to plan ahead with individual teachers not only virtually ensures a warm welcome but increases the possibility that classroom teachers will build on the experience when the program has moved on.
- Logistics—the where, when, who, how, how much, how often, and how many—inevitably dominate the off-site program, and failure to plan carefully can defeat a program before it starts, or at best make for endless headaches for its staff. Some lessons and guidelines can be drawn from the individual program reports here (note especially the "how-to" hints on mobile studio units offered by the Color Wheels coordinator in the report on that project), but two constants remain throughout: the museum must know its audience, and it must realistically tailor the scope of its program to available resources.
- More is doubtless better, but once is better than nothing at all. The outreach program that touches its audience briefly and then moves on—the Ringling Art Caravan or Birmingham Artmobile, for instance—has been pejoratively termed a "circus" or a "tease" by some critics who feel that one-shot exposure to museum objects or an art experience, like the one-shot museum tour, is virtually worthless. Yet there is a case to be made that, well done, such efforts have at the very least the value of making children and teachers aware of art and the resources of the art museum, an awareness that they may get no other way. And if the schools or even the children themselves are encouraged to follow up on their own, so much the better. For the museum that is small, operating under a tight budget, or mandated to serve a farflung audience, the one-time outreach may be the only alternative to staying within its own four walls.

—*A. V. B.*

## THE TAFT MUSEUM: IN-SCHOOL PROGRAM AND SUITCASES

The Taft Museum
316 Pike Street
Cincinnati, Ohio 45202

**A specialized museum with a small, closed collection—mostly seventeenth- and eighteenth-century porcelains, enamels, glass, crystal, and paintings—reaches out to local 2nd–5th graders with a "do, then see" approach. Docents teach children in their classrooms to make paints, enamels, and porcelains, later meet them at museum to study art objects in the same media. CMEVA interviews and observations: November 1973; April, June 1974.**

### Some Facts About the Program

**Title:** In-School Program.

**Audience:** Focus is grades 2–5 in four schools—one suburban, one inner-city, one experimental and arts-centered, and one enrolling some handicapped students. The In-School Program in 1973/74 totaled 53 visits and served 762 children.

**Objective:** Special classroom demonstrations and related museum visits designed to acquaint Cincinnati schoolchildren with an aspect of the city's traditions and to "determine the value of specialized visits to the Taft."

**Funding:** Ohio Arts Council grants: first year (1971/72), $1,250; second year (1972/73), $1,500; third year (1973/74), $2,250; fourth year (1974/75), $2,000. Ohio Arts Council grants are matched from museum budget, mostly by in-kind services. The grants provide disposable materials but do not pay for slides, hardware, or other permanent equipment.

**Staff:** 15 volunteers, supervised in part by the museum professionals.

**Location:** The museum and schools.

**Time:** The school year.

**Information and documentation available from the institution:** Docent background material only.

Being a Taft in Cincinnati should be a bed of roses. Maybe it is for a political Taft, but for the art-museum Taft it has proved a trifle thorny. The Federal house that Mr. and Mrs. Charles P. Taft gave to Cincinnati for use as a museum had, like many such lovely old houses in downtown America, seen the surrounding city grow seedier. But this house escaped the wrecker's ball; nor was it sentenced to a withered old age as boarding house or funeral home. It has been restored to its original condition, furnished with Duncan Phyfe pieces and Regency and Empire fabrics and hangings, and regularly painted a crisp white—all thanks to the organization established, commissioned, and largely funded by the Tafts.

Toward the end of the 1920s, Charles P. Taft, a half-brother of former President William Howard Taft and a man of great wealth, helped organize a public endowment of more than $3.5 million to support the Cincinnati Institute of Fine Arts. This nonprofit corporation was to support the symphony and the art museum, and, after the death of Mr. Taft in 1929 and his widow in 1931, to turn their home into the Taft Museum.

The gift, Charles Taft's nephew Robert wrote to another uncle, "is the greatest thing for Cincinnati which has ever happened."[1] It may have seemed so to a Taft, who treasured the house's share of history—after all, famous poets and politicians had gathered round its table, strolled in its formal garden, lived and visited there—but the rest of the city showed scant appreciation of the gift for the next four decades.

By the 1960s, urban renewal and a revived interest in the downtown economy, in historical landmarks, and in notable architecture prompted Cincinnati to dig in its heels against the flight from the inner city. Perhaps no cultural institution has benefited from this revival as much as the Taft Museum in downtown Cincinnati. Its site and character are now readily identified by many Cincinnatians who as late as ten years ago might not have known it even existed.

Attendance soared to 67,000 during 1972/73, a dramatic 50 percent increase over the previous year, and the second year in a row to register a similar rise in attendance. Such a sharp increase presents problems; 67,000 is "many too many," says Katherine Hanna, the Taft's director. The Taft may be a mansion among houses, but it is a tiny museum. Its works of art were collected by the Tafts—a few Rembrandts, Corots, Goyas, quantities of European enamels and Chinese porcelains: 580 objects in all. The small objects are displayed in small cabinet-cases; the paintings hang on living room, drawing room, dining room, and bedroom walls.

## The development of an education program

With its closed collection and two-woman staff, the Taft for many years provided a modest educational program. The two professionals—Miss Hanna and the designer, Jan Weigel—conducted tours through the house, sometimes as many as three or four times a day each, until in 1967 "that was about all we did, it seemed."[2] A first effort to enlarge the museum's educational program brought in four volunteers—an inadequate response to the growing requests for tours of the Taft. Consequently, in 1970 the Taft hired a part-time education staff member, Jayne Merkel, and undertook its first organized docent program.

Volunteers were recruited by newspaper articles, letters, and word of mouth. Of 80 women who signed up for eight lectures in art history and for research seminars, 40 survived, passed the examination, and began work as all-purpose volunteers. Their on-the-job training, under the supervision of the three professionals, included everything: exhibitions, errands, hospitality, tours through the historic house and its collections.

"It had always seemed to us a good idea to try to go into the schools, but we needed trained docents for that," Miss Weigel says. "For the first time, we had them." Out of the first school visits, docents and museum staff developed a pilot program to test the impact of a small and fairly specialized museum on children returning to it every year for four years. In these circumstances, knowing the children would not have to see everything at once, could they design narrow but effective programs focused on specific collections? That was the question the museum has tried to answer. Miss Hanna was also eager to test whether "doing as learning"—some kind of classroom activity—was the most effective way to prepare children for an exciting and valuable visit.

Going to the supervisors of art and social studies, to elementary schools and secondary schools, the two women arranged with the board of education to undertake a pilot program for grades 2 through 5 in four different schools chosen by the board. With supervisors, they went to the principals of these schools to explain the project and invite them to take part in it.

Each year the In-School classes study one of the Taft collections: 2nd grade, Old Master paintings; 3rd grade, French sixteenth-century enamels; 4th grade, Chinese porcelains; 5th grade, nineteenth-century American architecture and furniture. The classroom activity centers on a portable studio. "Since children visiting the museum express interest in the process by which objects are made, the classroom discussion focuses on techniques and refers to reproductions of art they will study in the museum," Miss Hanna reports.

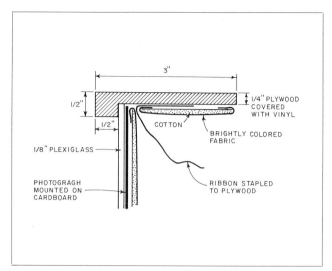

**Cross-section of a suitcase corner.**

**How the suitcase is constructed.**

Jan Weigel designed an ingeniously outfitted suitcase. Each suitcase and accompanying workbox is equipped with materials, reproductions, and information; everything relates to the works of art the children will see on their museum visit the week after their classroom meeting with the volunteer docent, who also conducts the visit.

The suitcases are kept at the museum, carefully checked in and out, and kept clean by the docents. The same few objects constitute the focus of both the 45-minute classroom visit and the one-hour tour. (The instructions to the docent stress: "Do not feel they must see everything in their first visit.")

**How the suitcases are used in the classroom**

The painting kit, designed for 2nd-grade children, contains rocks and flowers, as well as mortars and pestles. Each child gets to grind, delighting as green emerges from malachite rock or parsley leaves. To these colors the children have made themselves, they add linseed oil—"the sensuous smell of the oil is important!" They then mix prepared paints, also from the kit, on disposable palettes. The docent helps them look carefully at the colors in the reproductions—which are excellent (and expensive, about $35 each)—always making clear

## The Taft Museum's Suitcases and Workboxes for Classroom Use: A Look Inside

**1. Painting Kit**
**Suitcase:** two large reproductions (Sargent portrait of Stevenson, Goya portrait of Queen Maria Luisa), stretched canvas, pad of paper palettes.
**Workbox:** six tubes of assorted colors oil paint, minerals (limonite, hematite, lapis lazuli, malachite, cinnabar, murex brandaris), streak plate, mortar and pestle, dried natural materials (flowers, leaves), turpentine, linseed oil, mixing cups. The workbox is a one-tier metal tackle box, standard size.

**2. French Renaissance Enamels Kit**
**Suitcase:** three large reproductions (Duc de Nevers portrait, Monvaerni triptych, grisaille wine ewer), large asbestos sheet.
**Workbox:** kiln and kiln plug, trivet for top of kiln, asbestos shelf, hammer, spatula, mitt, three pyrex cups, two mortars and pestles, chunks of glass, gum tragacanth, tongs, jars of powdered enamel and glass, jars of overglaze enamels, sample painted disc, plain copper disc, white enameled disc (to paint

on), small asbestos sheet, extension cord, paper towels. Workbox is metal, with carrying handle and lock; dimensions are 12½" x 9" x 10".

**3. Chinese Porcelain Kit**
**Suitcase:** calligraphy scroll, three large photographs (Shou Lao figurine, miniature horses, Battle of K'un-yang City vase), several pads of newsprint.
**Workbox:** bag of china clay, ink slab, ink stick, two Chinese brushes, bottle India ink, porcelain ladle, plastic-coated sheet for kneading clay, sample glazed cup, pieces of greenware, three cups (one bisque, one underglazed and fired, one underglazed, glazed, and fired), one-half of a terra-cotta plate, one-half of a porcelain bowl, two jars of opaque underglaze, one bottle transparent glaze, scotch tape, assorted clay modeling tools, assorted brushes. This workbox is metal, with a carrying handle and lock; it contains an interior center division. Dimensions are 12¾" × 10" × 10".

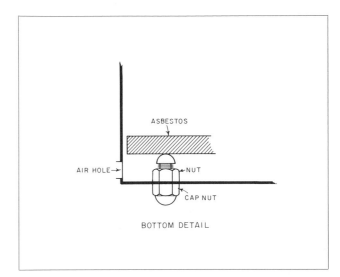

**Construction of the workbox, which holds trinket kiln for the enamels kit.**

that they will see the *real* painting in the museum. The object is to help them at least approximate the colors of the reproduction.

The 3rd-grade lesson, which focuses on the Taft's collection of French Renaissance enamels, is more intricate. A kiln is taken into the schoolroom, where the children can grind colors and make the enamel "paint," though they are not allowed to use the kiln. Two adults are required, for safety, during this classroom visit; they help the children with the grinding and painting and then fire the enamels while the children watch.

The porcelain kit does not include a kiln. Instead, the children paint sake cups, or some other bisque objects the docents have brought, using different glazes, including a final opaque glaze that goes over their designs. The docents take the cups back to the museum. When the children arrive the following week, they see the fired objects. No artist was ever more delighted with the work of his hands than these children appear to be when the shining little cups are handed out. (The fourth and final suitcase, outfitted for the 5th-grade lesson in architecture and furniture, was to be used for the first time in February 1975.)

As each suitcase contains some materials common to all—photos of the museum itself, for instance, and of some objects—the docents refer to past lessons and visits. In addition, each suitcase bears the message: "The Taft Museum was a gift to the people of Cincinnati. It is your museum." The docents repeatedly stress each child's personal stake in all that the museum holds.

**The program at the museum**

That a 4th-grade class seems more eager to see the docent than the works of art says something about the value to children of familiar, friendly faces in a museum. One class arriving for a porcelain lesson received cards showing details of

**Top: Cross-section of a bottom corner of the enamels workbox. Bottom: French Renaissance enamels kit. Everything the docents need to teach children about the museum's enamels is ingeniously squeezed into this suitcase and workbox, from a trinket kiln and reproductions to copper discs and chunks of glass.**

objects and set out to find the porcelains with the matching details. Watching them, their young teacher, Dave Gaskell, described his class: Appalachian whites, poor blacks, most reading at between 3.2 and 4.1 level—"the kind of kids who need exposure and rarely get it: this is a great way to tap their creativity." (He found no correlation between classroom skills and attentiveness in the museum.)

Wasting no time between the classroom and museum visits, Gaskell had worked out a creative-writing assignment based on the reproduction of two porcelain horses, had "done a unit" on Japan including a filmstrip, had talked over

with the children the docent's explanation of the Chinese calligraphic symbol of longevity which they had painted on a clay vase.

He wasted no time in the museum either: noting the children's interest in a continuous narrative battle scene on a large vase, he asked each of them to remember parts of it so that the whole class could do a follow-up session. His opinion of the program? "Great enrichment: it's a wonderful way to get kids involved in a museum, to have somebody come out to them."

Some children are more interested in the building itself than in the objects or the docent. One 4th grader looked up at a visitor and exclaimed, "I bet there's no roaches here." A class of "slow learners" from a pilot school remembered most vividly from the classroom visit that the museum belonged to them. The docent asked them: "Whose museum is it?" "Ours." "Who'll take care of it?" "We will."

Children learn unexpected bits of information. A docent passing around a piece of silk chiffon so the children could touch it while looking at a painting of a woman in a filmy dress reported that several children expressed pleased surprise that "chiffon" meant something other than pie or margarine.

### Consensus: The program enhances museum visits

The program is relatively inexpensive; half of the 1973/74 budget of $5,000 came from an Ohio Arts Council grant, the other half in services provided by the museum. By that time over 750 students, in four quite different elementary schools, were taking part.

Evaluations are made by each docent and each classroom teacher after every class or museum visit, filling out brief questionnaires designed to elicit the pros and cons of the experience plus suggestions for improvement. The docents agree that "details help the kids to look, especially with the porcelains that they normally find hard to look at." Teachers agree that the "kids really knew what to look for at the museum." All note the children's pleasure in the classroom work: "They like using their hands"; "the hands-on experience really fires them up."

Drawbacks noted by both docents and classroom teachers include the shortness of the 45-minute classroom period and the difficulty technical language sometimes poses for young children, especially if the docent cannot explain processes in simple terms.[3]

Jayne Merkel reports, "Some docents feel that each of the programs might be more effective at a higher level. We did the painting with high school seniors and they loved it." Yet some question the usefulness of, say, the painting suitcase and lesson, as now designed, for older or more sophisticated children. An experienced docent had a few rough moments in an upper-elementary classroom in an arts-oriented "alternative school"; though the kids enjoyed grinding colors, they found fresh white canvas and the "sensuous smell of oil" old hat—what worked for them was studying details of the re-

production and trying to approximate color, testing their eyes against each other's visual acuteness.

Both staff and docents believe that such experiences—if realistically and candidly appraised—are essential to proper revision of the lessons and suitcases in expanding the program beyond its original elementary-school bounds.

The most significant findings of the program, according to the museum professionals, are (1) it works to relate the lessons to each other—painting first, then painting with glass (enamels), then painting with glazes (porcelains)—though they wonder if the second and third lessons may be too similar, and (2) it works to relate lessons specifically to the Taft's collections; few art museums would risk devoting an entire museum visit to such specialties as porcelains and enamels, particularly for 3rd- or 4th-grade visitors.

Underlying this experiment is the conviction, in Jan Weigel's words, that "you can't just drag bodies through a museum and expect anything to happen." As the project seems to be working very well, Miss Hanna's explanation may be useful to other museums: "Kids like that basic stuff, and the secret of the success of their museum visits lies in the demonstration lesson first, the doing. . . . They also get a sense that the original is in the museum. They want to see 'their friends, the paintings,' even on a later trip." Miss Weigel emphatically recommends the program: "I kind of feel like getting on a soapbox," she says, "and telling museum people to get off their duffs and into the schools."

**Postscript.** In fall 1974, the In-School program expanded from four to six pilot schools, and would soon include 5th graders and a new lesson. The Taft, therefore, hired a part-time educator.—*A. Z. S.*

### Notes

[1] Letter to Horace D. Taft from Robert A. Taft, June 3, 1927, quoted in James T. Patterson, *Mr. Republican* (Boston: Houghton-Mifflin, 1972), p. 112.

[2] For sources of quotations without footnote references, see list of interviews at the end of this report.

[3] Quotations and generalizations based on questionnaire responses filed at museum.

### Interviews and observations

Gaskell, Dave. Teacher, Washington Park School, Cincinnati, Ohio. April 2, 1974.

Hati, Jean. Volunteer Docent. Taft Museum. April 2, 1974.

Hanna, Katherine. Director, Taft Museum. April 2, 1974.

Merkel, Jayne. Part-Time Education Staff, 1970–1974, Taft Museum. November 13, 1973; April 2, 1974.

Roberts, Peggy. Volunteer Docent, Taft Museum. Observation and interview, April 2, 1974.

Weigel, Jan. Designer, Taft Museum. November 13, 1973; April 2, 1974; telephone, June 28, 1974.

Other volunteer docents, Taft Museum. November 13, 1973; April 2, 1974.

Students from Mt. Adams and Washington Park Schools. April 2, 1974.

## Bibliography

Findsen, Owen. "These Will Want To Go Back," *Enquirer Magazine* (Cincinnati), April 15, 1973, pp. 29–32.

Patterson, James T. *Mr. Republican, A Biography of Robert A. Taft.* Boston: Houghton-Mifflin, 1972.

Taft Museum annual report, 1972/73.

Docent packages, brochures, and related material. Taft Museum, Cincinnati, Ohio.

## FINE ARTS MUSEUMS OF SAN FRANCISCO: DE YOUNG MUSEUM ART SCHOOL TRIP-OUT TRUCKS

Fine Arts Museums of San Francisco
M. H. de Young Memorial Museum
Golden Gate Park
San Francisco, California 94118

**A versatile and popular mobile arts program brightens the schools and parks of San Francisco. Emissaries of the city's Fine Arts Museums, two Trip-out Trucks carry visual and performing artists and assorted improvised art materials, reaching thousands of children and grown-ups with their own special blend of instruction and entertainment. CMEVA interviews and observations: throughout 1972–1974; supplemental interviews, September 1975.**

### Some Facts About the Program

**Title:** Trip-out Trucks.

**Audience:** Schoolchildren, community residents, classroom teachers—about 110,000 persons in 1973/74.

**Objective:** To bring art and artists to the city's schools and communities.

**Funding:** Of the estimated $50,000 it costs to operate the program, in 1973/74 $33,000 came from these sources: Junior League of San Francisco ($14,000), Gensler-Lee Diamonds ($5,000), Bothin Helping Fund ($6,000), Museum Society ($6,000), Flax Artist Supply ($2,000). The rest, $17,000, was made up by contributions of supplies and staff time.

**Staff:** 2 administrators, 6 part-time teachers, 161 volunteers.

**Location:** In schools and other locations in the community.

**Time:** Summer, four days a week, 12 noon–6 P.M.; school year three days a week, 9 A.M.–3 P.M. The program began in 1970.

**Information and documentation available from the institution:** Evaluations from Rockefeller interns and participants; videotapes; flyers announcing programs.

"There is no doubt that the trucks are a valuable program. They are like Mom and apple pie. Everyone loves them."[1]
So said Ian McKibbin White, director of San Francisco's Fine Arts Museums, early in 1974. He was talking about the Trip-out Trucks (TOT), which had become plural only the previous year. At that time a second truck joined the original one-ton van the de Young's director made available to the museum's art school in 1970, the better to carry out a popular outreach program.

The program costs about $50,000 a year to run. As the regular Fine Arts Museums budget makes no provision for the Trip-out Trucks, they depend financially on grants from private donors, including the Junior League. In a "good" year, like 1973/74, the deficit—made up largely by contributions in kind and time—may be only $17,000. If there is not enough money to operate the trucks, the program continues somehow, improvising mobility.

Conducted by the de Young Art School (see report in chapter 13), the program brings artists and the arts to schools and communities in San Francisco. Obviously, two vehicles can reach only a fraction of the city's more than 77,000 schoolchildren and 750,000 residents. Each semester the trucks regularly visit about 50 classrooms in 30 schools (K through 12), and each summer about 15 parks—sometimes more, sometimes less. The program expands or contracts as funding comes or goes. Fueled by talent, enthusiasm, and hard work, the Trip-out Trucks have reached thousands and left behind such permanent records as murals and plantings. Beyond its own impact, the program hopes to set a model for community programs and to encourage other agencies to break out of their institutional walls.

The trucks are also an emissary of the city's Fine Arts Museums. Tax-supported city agencies, the museums have a responsibility to the people of San Francisco, many of whom know the museums only from what they read on the society pages. Addressing the Docent Council in 1972 on the need for museums to create "linkage systems," Director White said,

The Trip-out Truck is one such link with the outside world, but it is a fragile link, which relies on renewed foundation funding each year. When we don't have the money, the truck stays in the garage. Besides, I don't think we need a Trip-out Truck. We need a fleet of them.[2]

The two, painted with rainbows, drive around the city announcing, "We are Trip-out Trucks from the de Young Museum." The vans themselves are works of art, designed and painted by a Bay Area custom-car artist. They are fitted with shelves for paint and supplies, paper rolls, a bulletin board, and such essentials as a broom, garbage can, and first-aid kit.

Each truck is usually staffed by two artists—one skilled in the visual arts, the other in music, dance, or drama—plus assorted volunteers. Altogether, about ten persons, including program administrators, work the trucks and alternate with one another. Like everything else about Trip-out Trucks, assignments are fluid. Two teachers plus a volunteer or teenage museum intern constitute the usual pattern, but on a given day the crew might consist of one teacher and six employees of the Neighborhood Youth Corps (in a pinch the art school's curator-in-charge, who also directs the mobile program, may

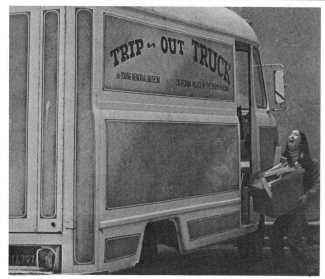

A Trip-out artist-teacher loads a box of typical Trip-out Truck art materials—wood scraps—into the one-ton van just before it leaves on a school visit. The wood will be used by children in a lesson on shape and composition.

take the truck out herself). The art school makes an effort to recruit teachers for the school and the trucks who reflect the city's population (43 percent nonwhite) and to mix and match assignments appropriately.

Three mornings a week during the school year, the trucks back out of the de Young's parking lot to begin their day in the city schools. Four days a week in the summer, they go out into the community from noon to 6 P.M. The Trip-out Trucks actually carry out two distinct programs: the school program and the community program, which differ in both concept and method. It all began with the schools, but soon spilled over into the community at large.

### How it all began

There was a program before there was a truck. In 1968, at the invitation of the San Francisco Educational Auxiliary, an organization of volunteers working in the city schools, the art school agreed to provide artists to teach ceramics in elementary schools. The artists (who soon branched out into many other art forms) discovered that students "had" art once a month and that materials were scarce and often unusable, though hard clay and dried-up tempera could be reclaimed by someone with enough time and expertise. As the response to these initial visits was positive—from teachers and administrators, children and parents—the museum teachers wanted to organize their efforts to greater effect. First, the program needed a well-stocked, dependable vehicle. So during the following school year, the museum allowed the art school to use one of its busy vans two afternoons a week.

This worked for a time, but the nameless program's unpredictability made it hard to keep the van on schedule to meet its regular museum duties. One day the van got back to the museum at 6:30, an hour and a half past closing time. It

seems that a 5th-grade class became so absorbed with making kites that when school let out, the truck moved to a nearby playground so the kids could fly them. The 5th graders were soon joined by brothers and sisters and friends, and everybody was making kites, and painting too. As one of the truck teachers said later, "I was exhausted, but there were lots of happy kids bringing big paintings home to hang on their walls. If a museum doesn't promote interest in art, who will?"[3]

Clearly, the program had community as well as school possibilities; equally clearly, it was taking on a life of its own. So in March 1970, the museum director gave the art school permanent use of a one-ton van. After needed repairs were made, the truck was painted navy blue with gold circus-style letters announcing "Trip-out Truck." Its resemblance to a police wagon ("Hey, are you guys from the police?") was an advantage. Returning from school visits, the truck could park practically anywhere and start an art program—vacant lots, housing projects, street corners, and parks.

As for staff, materials, and funding, the Trip-out Truck's arrangements were as informal as the program itself. Staff was any de Young Art School teacher with a few hours free time. There was no funding at the start, so the teachers volunteered to work on the truck. Materials consisted of whatever could be salvaged from school supplies, solicited from industry, or devised from next to nothing by the artist-teachers. Often the classroom projects were no more than chalk drawings on the blackboard or paper airplanes. The teachers all studied the *Paper Airplane Book* and origami. ("We had to know every fold, as sometimes all we had to use was the daily newspaper," one truck teacher recalls.)

### Growing pains

Throughout 1970 and 1971 the TOT staff experimented with ideas and actions, consulting city officials and school and museum people in order to develop a program that would respond to diverse needs. In one experiment in 1971 the TOT had what its director terms "disastrous" results in trying to link the mobile program with both school curriculum and museum collection. It was jointly sponsored by the TOT and the Asian Museum In-School Docent Program. (The Fine Arts Museums encompass the M. H. de Young, the Asian Museum, and the Palace of Fine Arts.)

**A pilot project in the schools.** The basic idea of the experiment, conducted in one elementary school for 14 weeks, was, in the words of a classroom teacher's evaluation,

to provide children with a pragmatic working awareness that art is a real, a tangible medium, not an isolated, cloistered function taking place in a rarefied, no-touch atmosphere. The docents [who made classroom presentations related to the museum collections] would acquaint the children with antiquity, and the truck's teachers would attempt to make the experience pertinent to the *now* of their

lives, making the museum a more vital institution in the community.[4]

The pitfalls awaiting this worthy endeavor may seem by hindsight obvious, but some of the fallout surprised even the skeptics.

From the standpoint of the truck's staff, several things went wrong. Once the truck was subjected to interrelated planning by school people, docents, and truck teachers, the program began to lose the spontaneity and excitement of the children's initial contact with the truck, which the staff considered so important to the total experience. Furthermore, truck teachers, who were essentially artists, were now expected to know enough about art history and the museum collections to work with the docents. In addition, the divergent backgrounds and life styles of docents and truck teachers made it difficult for them to work together, and soon they were competing with each other for the children's attention. Docents and classroom teachers, too, developed some rivalries: justified or not, the typical schoolteacher viewed the docent as Lady Bountiful and felt that the docents were ineffective with their slide-lecture presentation and their inexperience in reaching ghetto children. And the truck teachers were appalled to discover that most of the boys had tuned out of the program: the docents had made art seem "sissy."

For all the program's faults, however, the TOT director insists that everyone learned from the experience. The docents learned that it took more than a few planning sessions to deal with ghetto kids and the classroom setting. The truck teachers learned from the more gifted docents the uses of museum objects in teaching. One truck teacher, for instance, found one of the docent presentations so lively and relevant to the children's interests that he began to design new elements of the program around it. From observing this docent's methods he found that young children became interested in ancient pots not by wordy explanations of types and history, but by being allowed to blow into and listen to and feel the objects. The lesson contributed to the creation, two years later, of the Trip-out Trunks (see following paragraphs) and other important features of the in-school program.

**Summer programs in the community.** Meantime, the TOT entrepreneurs had been working out new directions for the community work of the mobile unit. The 1971 summer program was to set the pattern. A special staff was hired, their primary responsibility to work on the Trip-out Truck. Their talents were more diverse than the earlier staff's had been: there was an actor, a musician, and a dancer, in addition to two visual artists. Now performing artists, experienced in community work, could, with little equipment beyond themselves, engage large numbers of people in song, dance, and theater, as well as visual arts.

A prototype of the new direction was the 1971 summer program the staff put on in the area of San Francisco known as South of Market. Slated for redevelopment, this area was a challenge, with its bulldozed dusty blocks, dingy hotels, and mix of blacks, East Indians, Chicanos, and poor whites. In line with regular TOT policy, the truck staff worked out the particulars of the program in consultation not only with city agencies but also with the residents themselves, especially the kids hanging around in need of something to do. The plan that emerged was an all-day visit from the truck every Monday all summer long, stressing the visual arts mornings at South Park, the performing arts afternoons at South of Market Minipark.

A lovely circular park surrounded by once regal Victorian houses, South Park is in a cul-de-sac close to the commerce and industry of downtown San Francisco. The truck would arrive in this predominantly black neighborhood to find teenagers and adults playing bongo and conga drums, clusters of unemployed adults drinking, and children playing without a playground.

Tumbling mats and two conga drums first helped the truck make friends. The truck musician would jam with the resident drummers and tape sessions. Another truck artist brought bamboo and a wood burner so that he and the people in the park could make flutes. (A housewife ran an extension cord out of her window for plugging in the wood burner.) Before long the street musicians brought their children to the park. The younger ones danced on tumbling mats; other children expressed a desire to learn embroidery. All the while the musicians kept jamming and taping their concerts. A block from South Park, the teachers found a carpentry shop that donated wood scraps and an appliance store with an oversupply of large cardboard cartons. Result: wood sculpture, puppet shows, and cardboard cities. And, most important, the people in South Park saw where their "art supplies" came from and what working together could produce.

Although the staff has changed since 1971, South Park is still a regular summer stop for the Trip-out Truck. Dialogue, September 1971:

*Teenager:* "It was a good summer. When are you guys coming back?"

*Teacher:* "We don't have funding, but we will be back next summer."

*Teenager:* "I'm on the Businessmen's Youth Council. Maybe I can get you money."

*Teacher:* "Great, then we could come this fall."

*Teenagers:* "Yeah, we blacks have to work together."

*Teacher:* "I'm not black. I'm Chinese-Hawaiian."

*Teenager:* "Oh, yeah. I forgot."

### Trip-out to the community

In a 1971 report the program's director wrote,

We are "turning people on" to what is around them and available at little or no cost. Abandoned vacuum cleaner parts become musical instruments at Dolores Park; a cyclone fence was woven with weeds and flowers at Bessie Carmichael School. The residents of Banakar Homes wanted to see a play so the children made paper costumes and practiced for a skit about neighborhood life. The teens

at South Park wanted to learn photography; the museum photographer helped them set up a darkroom in the Recreation Department building and taught them basic darkroom procedure. . . . In essence the truck is stimulating ideas between the old folks, teens, young parents, and children in the neighborhood, helping them to communicate with each other. The Trip-out Truck assists each neighborhood in the creative projects that they want to have happen. In addition, we want to establish a continuous program in each community and to develop lines of communication between the neighborhoods and the museum.[5]

"Sometimes all we can do is give them a fun-shot," as a truck teacher has said. The Trip-out Truck may pay one visit to a community festival or work out a full summer program like that in South of Market with a particular neighborhood. The community program is concerned not only with the arts but also with activating people to do something about their environment.

Working on street corners, in housing projects, or in the parks, the truck artists are swamped with children and try to help each child communicate something about his life through painting, drawing, dance, or music. Hard work, not magic, brings the crowd on the appointed day. Several weeks in advance, the truck staff talks to teachers and leaders in the community, posts flyers announcing the visit, and calls schools, churches, and child-care centers within walking distance of the site.

At the playground the truck teachers sometimes start by playing ball with the kids or by letting them climb in the truck and honk the horn. If a child has never painted and is afraid to try, the truck teacher may ask him if he wants to be traced. The child lies down on a rolled-out length of paper and chooses

the color he wants to be outlined in. The truck staff complies, and then hands the child small juice cans filled with tempera paint and tells him to fill himself and his clothes in.

Suddenly, like the early kite-making scene, everyone wants to be traced: a young mother traces her four-month-old baby; kids trace each other. Painting has started. Kids are mixing colors in the cans and on the paper. Someone discovers that yellow and blue make green, or that red and white make pink.

Face painting is something else that brings out scores of kids, their parents, and their grandparents. They paint each other to look like mimes, and a Trip-out Truck performer gets them to dance and pantomime. A painted face is not museum art, says the program's director, but it is someone's creation, a step toward making art.

The truck programs vary widely; even when a project is repeated, the response differs. A clear warm day at San Francisco's Civic Center produces kids wearing cardboard ice

San Francisco children get into the Trip-out act by painting their own and one another's faces. One of the trucks' performing artist-teachers leads them in an impromptu pantomime.

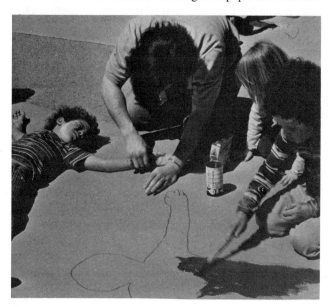

On a summer park visit, a Trip-out Truck artist-teacher warms up shy children by tracing them on rolled-out paper. The kids pick the outline color, then "fill themselves in" with tempera paint mixed in juice cans.

cream cones, huge cardboard clown shoes, and cardboard flower petals around their faces. A music cart with instruments made from plastic bottles, water-filled jars, bells, pitch-pipes, and tightened skins sets the tone at another location. Children experiment with sounds and with making musical instruments, though the truck's horn remains the favorite instrument.

The truck's community program must adapt on the spot to many variables, from the weather to the number and variety of participants—infants through great-grandparents. "What do you do with one hundred kids, only fifteen brushes, and a staff of two persons?" a truck coordinator asked the staff. Answer: You start a chalk drawing on the blacktop and get all the parents to help; or you start weaving crepe paper strips in the cyclone fence and call the art school's hot line to send

reinforcements; or you try body sounds: everyone can be a musical instrument or do pantomime. The truck staff always tries to come equipped with materials for several art projects, and to give every participant the opportunity to do them all.

## Trip-out to the schools

The education budget squeeze, of which art teachers and art materials are an inevitable victim, is being felt in San Francisco as in other parts of the country. But the fact that the program is free is apparently only one of many reasons for the Trip-out Trucks' popularity among local teachers. The response of those interviewed for this report who have had the truck staff in their classrooms was uniformly favorable: they cited the continuity of the program (the truck comes to the same class at least three and often four times), the preplanning (TOT staff meet with the teacher beforehand to map out activities), and the immediate and obvious rapport that the artist-teachers establish with the children.

Increasingly the truck staff is trying to plan with teachers art projects that relate to the museum collections and special exhibitions as well as the school curriculum and age level of the students. One way this is done is through Trip-out Trunks, of which two were available in 1973/74.[6] One exhibited masks from the collection, the other puppets. (For a glimpse of how the trunk on masks fits into the curriculum, see accompanying box.)

William Crawford, a 4th-grade teacher at the Madison School, has had the truck staff visit his classroom three consecutive years, each time for a project related to the study of Africa, a regular part of his social studies curriculum. In one series of visits the TOT teachers helped the students make clay masks, after which the children went to the de Young

Museum Art School to fire them; in another, paper masks; and in the third, African jewelry. Crawford was impressed by the interest and care the truck staff showed in the projects. He reported,

For one class the Trip-out teachers invited the kids over [to the de Young Museum]—it's within walking distance for us—when they [the teachers] had a break and, on their own time, took the kids for a tour of the Oceania exhibits. It was really great, far better than having a docent come to the class and just talk about such things.

The enthusiasm of the children for the whole art project and related activities was for me the best part of the program; and this experience became associated with the de Young Museum itself. Whenever we took a trip to the museum, the children asked about Tad and Calvin; so a trip to the art museum, for whatever reason, was associated with something very positive and fun (instead of the usual ''shushing'' trip through museums we often must take).

Other teachers see the Trip-out Truck more as classroom ''relief'' than as a substantial contribution to the curriculum, but are not the less enthusiastic about the experience for that. A teacher of 2nd graders at the Sutro School, Mrs. Rose Fradon, chose the theme for her class's 1974 Trip-out project on the basis of a chance question one of her students asked about totem poles. She described the first TOT visit:

The truck teachers came in, covered the floor with a big tarp, passed out paint, scrap materials, and gallons of glue, and proceeded to help the kids build floor-to-ceiling totem poles. . . . They emphasized design, trying to get the kids to be more sophisticated about how the faces should look.

It was a great experience because it was something the kids could do with their hands, something they could relate

## The Trunks of the Trip-out Truck

One of the two trunks, or suitcase exhibits, prepared for the Trip-out Truck to use in its school visits, contains masks from many cultures: an African Gio River mask, a Gajesa cornhusk-face mask, Japanese No masks, Balinese puppet masks, and festival masks from South America and India. The truck teacher places these objects in the classroom along with photographs and such items as a hockey goalie's mask, a catcher's mask, a bridal veil, and sunglasses. The classroom teacher then uses these familiar contemporary objects to elucidate the concept of a mask. With the exhibit providing a minimuseum, the children can see, feel, and touch actual examples of what they are studying.

One 3rd grade, for instance, was studying the Philippine Islands when the truck visits were scheduled. In addition to the Trip-out Trunk exhibit, the teachers brought along a woven raffia mask from an Oceanic culture, and books about Oceania to show the classroom teacher.

What do the students do with a mask? They study it; they look at the form, the texture, and the materials used. They talk about the vegetation of the area, about weaving, about the mask's colors that come from the earth, and about masks in primitive cultures. Hallo-

ween masks and catchers' masks enter the discussion.

The trunk, the masks, and the artists in the classroom produce excitement, which generates talk and movement. The students make faces and then trace the contours with their fingers. They make mask forms by cutting a large piece of paper, and folding and stapling it into a face form—a simple introduction to sculptural forms.

On a second visit children weave natural materials around a wire construction. The class might talk about the differences between the materials and make sculptural hangings and table pieces.

The third visit might deal with making paint from ochre, red iron oxide, and cobalt for painting bark, followed by painting watercolor and tempera murals on rolls of paper. The last visit might be the start of an acrylic mural on an outside wall of the school, or it might concentrate on making masks for use in a skit.

How the trunk exhibits and the Trip-out visit develop depends on what the teacher and students want. The truck introduces ideas and, on its last visit, leaves a project to be continued. If it is as complex as a stained-glass window or a mural, art apprentices riding the truck may assist the classroom teacher in seeing the project to its end.

to, and something we normally just wouldn't get a chance to do. . . . And the [Trip-out teachers] are marvelous with children—kids really responded to them.

Because her school, too, is within walking distance of the museum, Mrs. Fradon was able to take the class there for a follow-up visit. (But she and Crawford both emphasized that there is simply no money available from the schools for such field trips.)

That the trucks and their artist-teachers generate a great deal of good feeling in the San Francisco education community is clear: the TOT director reports that she receives many more requests from schools than the staff can possibly fill. (One observer of a TOT school visit mused enviously, "It made me reflect on my days in elementary school when we didn't have such things.") But whether the Trip-out projects have a genuinely lasting effect on the children is a little less clear. Inevitably this is, at least in part, a function of the children's age, the way the project fits into their regular curriculum, and the teacher's follow-up in the classroom or the museum after the TOT visits end.

Even William Crawford, who had what might be considered a model Trip-out experience, admitted, "It's extremely difficult to measure what the kids get out of one art experience like this: you can't test them, it's not like spelling or math." He thinks that the "social effects" of the Trip-out activities are perhaps the most important—"the interaction between the students and artist-teachers, the chance for the kids to do something new and different." And he firmly believes in the value of the experience: "I would choose [the Trip-out Truck] over any other field trip or activity, [including] a museum visit."

Whether the TOT approach to art education rubs off on schoolteachers is also difficult to pin down. Artist Michael Nolan, whose organization, Optic Nerves, videotaped several Trip-out school visits, reported, "I saw two kinds of teacher reactions. The sharper ones participated and paid attention. [But there was] one who was clearly threatened and went off into a corner." Mrs. Eleanore de Paoli, principal of Glen Park, a K–3 school that the truck has visited several times, said that she thought her teachers did learn "indirectly" from the truck staff. She noted that because of budget cuts her school no longer has access to art supervisors and that therefore the regular teachers have the full burden of art instruction. "[They] don't feel adequate to teach the arts," she said. "They're insecure about their background, and so they carefully watch and work with the Trip-out people."

### Volunteers: one answer to limited funding

Despite many tributes and the high demand for the trucks' services, the program can never depend from one year to the next on adequate funding, and it became clear that the trucks' paid teachers would have to be augmented with competent volunteer help. As the museum owned the vehicles and the materials used for art projects were largely scrap, the program could thus keep going even when no operating funds were available.

So in early 1973, the Junior League of San Francisco funded the Art Apprentice Program to train Trip-out Truck and community arts volunteers. A 12-week curriculum in studio art includes on-the-job training on the trucks for the apprentices, who range in age from 14 to 60 and in occupation from clerk to architect. The curriculum, planned by the Trip-out teachers, comprises work with various art materials, concepts of teaching children, and field trips to community arts programs.

A year later over 160 of these art apprentices were working in community arts programs and in art programs in the San Francisco public schools. Positive as these results are, however, the program has not diminished the need for professional staff on the Trip-out Truck, says its director:

Volunteers have neither the time nor the commitment to work on the truck for six hours every week; mostly they want to work just one two-hour class. Yet a mobile unit cannot succeed if it depends only on professional artists with painting skills: your teachers have to play basketball, volleyball, clean up classrooms, have charisma, and see a scrap box and stop the truck to find supplies.

Nonetheless, the art apprentices have helped the truck teachers and allowed the truck to work with greater numbers of people than before. In summer 1973 apprentices acted as community organizers by recruiting children and planning programs for the trucks' park visits. One apprentice, for example, worked with four others to plan a continuing program in the Panhandle of Golden Gate Park. She also met with the playground director and community agencies to plan a summer art program for the children of the Haight-Ashbury district. The apprentice suggested projects, arranged a storytelling day and a puppet festival, and made the flyers announcing the program. The Trip-out Truck simply brought the supplies to the playground where two artists assisted the apprentices. There were similar summer programs at four other locations. One truck teacher remarked,

The art apprentices are a lot of help, but they also add to the complexity of our job. Not only are we teaching the kids and assisting the classroom teacher or playground director, we are teaching the art apprentices. We are teaching about art, and we are teaching how to teach art. It's like being a one-man band.

### What lies ahead for Trip-out?

In fall 1974, funding prospects for the Trip-out program were bleak. But the program's staff and administrators said they had faced worse prospects before and had kept going.[7] (In 1972, for instance, the TOT received no funding for the in-school program; so the curators went, with a docent or two, to one of the city's "alternative" schools one day a week, working with two classes for the year.)

By September the Trip-out Truck had received requests from over 300 teachers. So popular, indeed, is the program

that the staff hopes demands from San Francisco's community arts organizations and from other satisfied customers may stimulate a fresh spurt of grants, perhaps even support from the museum.[8]

The Trip-out Truck expects to reach even more people in the future, through a film program added in summer 1974. Truck II was converted into a mobile darkroom that visited two locations twice each week. The idea—increasingly popular in and out of schools across the country—was to introduce children to new tools for making statements about their lives and environments. The Trip-out Truck staff planned to follow a simple procedure, beginning with photograms and working up through pinhole cameras and Polaroid cameras to films with Super-8s.

The staff was pleased with the results, though it recognizes certain flaws in the plan. The basic flaw was trying to do too much in too short a time. "We had only begun to establish relationships and work with individual kids when the program ended," reported Jonathan Ziady, who ran the project. In one location the truck staff skipped the intermediate steps and started film work. One of the best productions of this brief exploration of plot and serious camera work was a film the kids shot of a bank robbery, using the darkroom-theater-truck as the getaway car.

On the basis of the 1974 experience, the truck staff is working on improvements, deciding whether to start at once with filmmaking or to take the whole sequence more slowly. One useful lesson for mobile units was the necessity to have an alternative program—painting, mask-making—ready for the kids who show up at each location. As Ziady observed, "One cannot have a coherent filmmaking session with 50 kids and three movie cameras." Ultimately, the staff hopes to continue the photo-film program during the school year; students at schools within walking distance of the museum would take part and would include the museum collections among their subjects. One by-product of this endeavor, the staff hopes, would be some help for the docents in finding out what interests children at the museum.

This hope points up a continuing concern among the TOT staff: creating and maintaining continuity between the outreach program and the museum itself. The program's director admitted that on balance the Trip-out Trucks, for all their popularity, have not succeeded in doing this. Though beginning efforts such as the Trip-out Trunks have been made, Ms. Cameron pointed out that "if someone who has been turned on by the truck and its doings comes to the de Young Museum, he is likely to encounter a conventional docent or guard, not one of the congenial artists he has worked with at school or in a park." She feels that the TOT's efforts to develop a new audience for art must be matched by a commitment by in-museum staff to sensitize themselves to the interests and needs of that new audience.

Meanwhile, the Trip-out Trucks continue on their rounds. Projects change in response to clients, but the concept remains constant: to bring art and artists to the schools and communities of San Francisco. As one truck teacher said, the program wants to provide its audience "with enough media and skills so that they can communicate to the people who are supposedly educating them what they can see, what they know, what they want, and what they need."—*J. M. from reports submitted by E.S.C., with additional interviews by B. Y. N. and A. V. B.*

## Notes

[1] Ian McKibbin White, director, Fine Arts Museums of San Francisco, education committee meeting, April 1974.

[2] White, address to Docent Council, June 1972.

[3] For sources of quotations without footnote references, see list of interviews at the end of this report.

[4] Evaluation report: Helen Gray, classroom teacher, Buena Vista Elementary School, February 1, 1972.

[5] Report: Elsa Cameron, "The de Young Museum Art School and Trip-out Truck," August 1971.

[6] By spring 1975, five more had been added. The themes are textiles, ceramics, printmaking, calligraphy, and the art of paper.

[7] The TOT program received some relief, in the form of staff artist-teachers, in early 1975 when 18 new artists were hired and paid by the de Young Art School under the Comprehensive Employment and Training Act (CETA). The stated purpose of the hirings was to serve the San Francisco community. The artists ranged in age from 19 to 70 and included a muralist, actor, dancer, clown, rock gardener, sculptor, poet, writer, musician, and stage technician.

[8] Staff members, like their counterparts in education programs elsewhere, tend to be critical of museum priorities. They find it hard, they say, to reconcile official acclaim of the Trip-out Truck with failure to give it financial stability within the over-all museum budget.

## Interviews and sources

Persons listed here without specific interview dates are those with whom Elsa S. Cameron, the Trip-out Trucks director and primary source for this report, had continual contact during the report period, 1972–1974.

Andino, Barbara. Metal Arts Teacher, de Young Museum Art School.

Bellow, Cleveland. Art Apprentice Instructor; Trip-out Truck Teacher.

Chiu, John. Coordinator, Art Apprentice Program; Trip-out Truck Teacher.

Concha, Jerry. Trip-out Truck Teacher.

Crawford, William. Teacher, Madison School, San Francisco. Telephone, September 10, 1975.

de Paoli, Eleanore. Principal, Green Park School, San Francisco. Telephone, September 10, 1975.

Ebey, George. Trip-out Truck Teacher. February 18, 1972.

Fong, Richard. Assistant Curator, de Young Museum Art School.

Fradon, Rose. Teacher, Sutro School, San Francisco. Telephone, September 9, 1975.

Fukuyama, David. Trip-out Truck Teacher. February 18, 1972.

Goldstine, Stephen. Director, Neighborhood Arts Program, San Francisco.

Kessinger, Kent. Former Registrar, M. H. de Young Memorial Museum.

Krenkle, Noel. Former Curatorial Assistant, de Young Museum Art School; Evaluator, San Francisco Unified School District.

McMillan, Michael. Trip-out Truck Teacher. February 18, 1972.

Nolan, Michael. Staff Member, Optic Nerves, San Francisco. Telephone, September 12, 1975.

Pursley, Karen Apana. Former Coordinator, Trip-out Truck. Summers 1971–1972.

Seligman, Thomas K. Curator-in-Charge, Africa, Oceania and Americas Collection; Vice-Director of Education, M. H. de Young Memorial Museum.

Silverberg, Leonard. Chairman, Painting and Drawing, de Young Museum Art School.

South Park residents. Taped interview conducted by Karen Apana and Suzanne Helmuth, August 1971.

Stevenson, James. Senior Curatorial Assistant, de Young Museum Art School.

Tamura, Ruth. Coordinator, Trip-out Truck I.

Young, Diana. Teacher, Andrew Jackson School, San Francisco. Telephone, September 9, 1975.

Ziady, Jonathan. Art Apprentice Instructor.

Zied, Ted. Guard, de Young Museum.

## Bibliography

Cameron, Elsa. Report: "The de Young Museum Art School and Trip-out Truck." August 1971.

Patridge, Janet. "Report to the Docent Council." February 18, 1972.

Tamura, Ruth. "Report on Museum/School Interaction." San Francisco: Rockefeller Intern Project.

Simon, Herb. "Report on Museum/School Interaction."

Trip-out Truck brochure. January 1973.

*Photographs by Ruth Tamura.*

## ALBRIGHT-KNOX ART GALLERY: COLOR WHEELS

Albright-Knox Art Gallery
1285 Elmwood Avenue
Buffalo, New York 14222

**A shabby but cheerful remodeled mobile classroom brings art classes and museum teachers to Buffalo schools and neighborhood centers, year-round, seven days a week. Participants—mostly children—make prints, view slides, create art from found materials. Albright-Knox exhibits work several times yearly. Program helps to compensate for schools' skimpy art instruction. CMEVA interviews and observations: June and October 1974.**

### Some Facts About the Program

**Title:** Color Wheels, Neighborhood Creative Art Classes.

**Audience:** Mostly children, average age 8 to 12 years, plus two or three senior citizens groups during a year; 910 classes attended by 18,096 persons (July 1, 1973–June 30, 1974).

**Objective:** To bring varied art experiences to neighborhoods in the city which are particularly in need of cultural advantages and enrichment.

**Funding:** New York State Council on the Arts, $25,000 (1974). A special grant of $4,000 from the local Cummings Foundation for 1973/74 for capital expenditures. Cost of program: $1.25 per capita, which is the same as the fee charged for tuition in studio classes in the gallery studios.

**Staff:** A full-time coordinator and teacher, 4 part-time teachers, and 4 part-time assistants (figures vary, however). No volunteers.

**Location:** Throughout the city, at or near community centers, schools, parks, and churches.

**Time:** Usually two hours in the mornings and afternoons during July and August; on Saturdays and Sundays all year, and after school during the school year. The program began in December 1967 as Neighborhood Creative Art Classes (no vehicle); no classes during 1969/70; in July 1971, following acquisition of the vehicle, Color Wheels, from the Western New York Foundation, the program resumed in new guise.

**Information and documentation available from institution:** Reports, photographs.

The bus needs a coat of paint. Its white body is turning gray, a few names are scrawled across the fenders, last winter's road salts have eaten rust spots into the steel. The blue-and-purple stripe painted across the bus is dimmed a little by dust, but the small blue-and-purple letters next to it are still clear enough to read: "Color Wheels, Albright-Knox Art Gallery."

Pulled up under a tree in the parking lot of the John F. Kennedy Center, the bus is shabbier than the public housing development across the street. There flowers bloom along neatly trimmed paths, one woman washes her living-room windows, two others stand outside looking across the parking lot at the children going in and out of the bus.

One or two at a time, the children jump out, run to the tree next to the bus, pull off some leaves, stoop down to rummage in the dirt at the base of the tree, scatter to other parts of the JFK playground, and return to the bus, their hands and pockets stuffed with leaves, broken glass, rocks, flowers. One girl has found an old Yale lock and holds it carefully as she climbs back up the steep bus steps.

Inside, about a dozen children, who range in age from 5 to 12, stand at counters set under the windows. Four instructors move through the side center aisle, helping the children fill flat cardboard supermarket boxes with wet sand, which one of the instructors dug up at a Lake Ontario beach early this morning. The sand is wetted down with water from buckets or igloo water-coolers; there are no sinks on the bus. Each child is trying to decide, sometimes in silent deliberation, sometimes in noisy conference with a friend or teacher, which of the found treasures to put into his box of wet sand and whether to believe the teacher's promise that they will, within the hour, turn into a kind of "art," a permanent memory embedded in plaster of a pleasant, sunny, breezy day when the Color Wheels bus parked under a leafy maple tree at JFK playground.

## A decade of work in the neighborhoods

The bus has been coming to JFK since 1971. Before that, art teachers from the Albright-Knox Art Gallery took materials into JFK Center and helped children work with them as part of the gallery's Neighborhood Creative Art Classes. The classes, offered free to Buffalo neighborhoods, resulted from the Albright-Knox education department's search for ways to

Inside the Color Wheels Bus, two children pensively mix colors for their paintings while a third consults with their instructor, an art educator from Buffalo's Albright-Knox Art Gallery. The mobile studio-classroom unit is parked outside a city housing project.

get out into the community. The museum made the search partly because of cramped studio space inside the gallery, partly because it is the gallery's philosophy, first declared in its founding charter in 1862, "to sponsor art in the community,"[1] and probably partly because it was the early 1960s and doing good for "the community" was in the air. Those early classes met in housing projects, neighborhood PAL centers, and other social agencies; JFK was among the first, in 1964.

A private museum group, the Members' Advisory Council, paid for the program during its first two years; the New York State Council on the Arts picked up the tab for the next three years. At the end of that time—three years is the conventional limit for "seed" or "pilot" projects—state council funding ended. Another private organization associated with the museum, the Junior Group, set out to find a way to continue the neighborhood studio classes. The education department wanted to continue providing instruction and materials but thought, on the basis of the first five years' experience, that some kind of traveling studio might circumvent the problems of borrowed facilities and occasional fouled-up schedules with cooperating agencies.

A mobile classroom that had been used by the county as a reading lab was available. A local organization, the Western

New York Foundation, agreed to purchase it for $7,200; it was already a few years old and had seen a lot of service. Turning it into a mobile studio cost another $3,000. Says Charles Munday, the coordinator of the Neighborhood Creative Art Classes,

> We took all the insides out, put in shelves and storage space. We kept that down to a minimum so we could get more kids in. The only thing we had to buy for the inside was wood; the labor was ours. We added a generator on the back for lights and heat, put in new wiring, an air-conditioner, and then took off. We painted it white with a big purple-and-blue stripe around, and you'd sure recognize it. . . ."[2]

A lot of places must recognize it by this time. The Color Wheels bus now operates all year long, seven days a week. In 1973/74 it visited 53 different locations or centers in 13 different parts of the city. "The schedule is generally set up to work with the same material three weeks in a row. . . . It's like a course—two-hour sessions one day a week for eight weeks. . . . But," says Munday firmly, "kids need more than once a week."

The bus goes to schools now as well as to neighborhood centers. In the schools, says the coordinator, "we start with a slide presentation of different kinds of work from the gallery and from other places. Just art that I want them to start off with. First we do drawing and stuff like that, advance to printmaking. . . . The more things they can do with their hands, the better they get. . . . But I always take something into class first: large plates, prints of art work, reproductions." All of the Color Wheels school-related activities can take place in either the classrooms or the bus, except printmaking, which can be done only on the bus. For those studio sessions held inside the classroom or inside a neighborhood agency, the bus itself is not necessary; instructors simply pile materials into their own cars and drive to the school or center. The Color Wheels bus is thus free to go into and serve areas that have no facilities.

## A substitute for the school art class?

Why does the bus go to schools? Should it be an art museum's job to teach art in the schools? Some Buffalo schools sorely lack art teachers, supplies, programs. "Most of the time these schools do not have an art curriculum. The most the kids get a week is half an hour," says Munday. Further, he argues,

> I really think the way we go out to schools—I think that's best . . . because the people who work at the gallery here, the people we have on our own staff, are mostly artists. I'm an artist, and I do my best. I'm not a psychologist as far as kids go. I'm a simple printmaker, and I go out there and I try to take that to the kids in a manner they can work with. I think people who know art are the ones to teach the classes, and I know that some of the teachers we have been up against are really . . . they do such . . . I don't know how to explain it, but it's just not real art. . . . So letting the

kids do something, a subject they want to do, and helping them do it in a manner they'll remember and try to do it again—I think that's a real challenge.

One of the limitations of a traveling studio is that it is not always there whenever a youngster feels like dropping in to work, as he might in an art room in a school. "Well, it's a disadvantage," agrees the coordinator, "but the places we go, it's worked out to where we go in the mornings because it's when the young kids first go in, and they are ready to go when we get there. And then when school's out, we're ready for the kids to come out of school. And we work that way so that really the kids don't have to go and wait for us."

Throughout the week, especially after school and on weekends, the Color Wheels bus runs, and art teachers from Albright-Knox travel around the city. Munday estimates there are about 15 to 18 classes a week, in schools and centers. The audience of about 18,500 during 1973 was mostly children of school age, but senior citizens groups, hospitals, and varied other audiences complete the constituency of the Neighborhood Creative Art Classes. All classes are full.

### Efforts to tie the classes to the gallery

Color Wheels classes sometimes come to the museum, either in school groups or as individuals, to see their work exhibited. A Color Wheels show goes up about every three months. Beyond those exhibitions of work done in the neighborhood classes, however, and some slides of works of art shown in classrooms, there is no formal relationship between the Neighborhood program and the gallery collection, events, or tours. "I really hesitate to say it," says Munday, "but they [the lecturers and docents in the gallery] would probably not know if one of the groups coming in was one of my groups. It's very difficult, because we have so many groups coming in. We're not coordinated in that sense."

Yet he is convinced that more people come to the gallery as the result of Color Wheels and its work. "We have had quite a lot of people come in to see the exhibitions," he says. "Some of them had never been here before. . . . Believe it or not, half of the kids we go out to haven't been to the gallery here, or don't even know that it exists." He notes that his purpose is not to teach the students (or other audiences) anything specifically about the Albright-Knox collection, nor is it to turn kids into artists—a disclaimer the gallery itself publishes in its announcements of tuition studio classes inside the gallery. "We just want them to know that there is an art—it exists, and they can participate in it, and maybe find something that would brighten their lives."

### Community reaction to Color Wheels

The program is judged a success by the gallery staff, partly on the basis of the waiting list of schools and centers requesting classes. "People from one place see it announced in the paper or hear about it and come in to see what happens and ask would you come to our place," reports Munday. "Except maybe for one elderly group that I called, I haven't called anybody. They call me." The waiting list is eventually served. "We haven't turned anybody down yet."

The reaction of the audience suggests the impact of the program: "It's really great to see 60 or 70 kids [on a playground], which is what I've had, standing and working. And they stand and work the whole time, and we have to take the stuff away from them to get ready to go." Munday reports that "in a lot of places, people are understanding what happens, and they can see the changes that are happening to the kids. We've got some absolutely beautiful letters from places that have never had anything like that before, and they write and tell us how the kids have worked out, and how their minds have changed toward art."

### Color Wheels how-to's

For any museum or art center thinking about such a bus, the man who runs one has some down-to-earth suggestions:

1. Before you do anything else, find out who and what places want it. Without an audience, there is no point.
2. Find out, right away, who can pay for it, how much, and for how long.
3. Scrounge around for free supplies. Failing that, bargain for the lowest price you can get on wood, Plexiglas, and anything else you can use.
4. Any bus will do. An ordinary school bus would be easy to transform, because all you have to do is take out the seats before you put in what you need.[3]
5. Be satisfied if the bus is clean *enough* and in good working order. Don't be fastidious. Don't carpet the bus, for goodness' sake. Make everything in the bus movable, so it can be lifted out and the whole bus hosed down inside and out.
6. Get insurance that covers the kids or anybody else when they're working in the parked bus, but don't drive any kids anywhere, ever.
7. Take good care of the bus, garage it, and check it annually at least; be sure it has exit safety doors.
8. Hire the best people, not first-apply, first-hired. Don't simply choose them on the basis of race. Ask for resumés and references. *Hire artists.*

### Funding and the future

The education department budget for 1973/74 was $29,000: of that, $25,000 came from the New York State Council on the Arts and went to pay for staff salaries, supplies, and all office costs; the remaining $4,000 was a grant from the local Cummings Foundation, specifically for the maintenance of the Color Wheels bus. For the audience of about 18,500, the per-capita cost is thus about $1.25—by pure chance, exactly the fee charged per student per class for the creative art classes held in the Albright-Knox studios.

The education department has asked for a budget of about $150,000 for 1974/75. That portion of the proposed budget

earmarked for the Neighborhood Creative Art Classes would go for more staff and for two panel trucks to carry supplies to neighborhood centers. The department also hopes to purchase a new Color Wheels designed and constructed to meet its specific needs.—*A. Z. S.*

## Notes

[1] Robert Buck, director, Albright-Knox Art Gallery, interview.

[2] For sources of quotations without footnote references, see list of interviews at the end of this report.

[3] For custom-built traveling studio buses, which do not come cheap, Charles Munday recommends the following sources:

Children's Caravan, Inc. (see **Note** below)
Weston, Connecticut 06880
Attention: Liz Beardow
203-226-3355

The Gerstenslager Company
Bowman Street
Wooster, Ohio 44691
Attention: A. W. Baehr
216-262-2015

New York office:
The Gerstenslager Company
P.O. Box 235
Northport, Long Island, New York 11768
Attention: Richard Donovan
516-261-6333

**Note:** Anyone in the New York vicinity who is interested in seeing one of this company's buses may get in touch with New York City School District 16 (Brooklyn), which has one on lease.

## Interviews

Buck, Robert. Director, Albright-Knox Art Gallery, Buffalo, N.Y. June 18, 1974.

Burback, Bill. Director of Education, Museum of Modern Art, New York, New York. Formerly of Albright-Knox Art Gallery, Buffalo, N.Y. Telephone, September 1973.

Cole, Lucille. Instructor, Color Wheels, Albright-Knox Art Gallery, Buffalo, N.Y. June 18, 1974.

Crosman, Chris. Instructor, Education Department, Albright-Knox Art Gallery, Buffalo, N.Y. June 18, 1974.

Flemming, Phebe. Coordinator, Arts in the Schools, Albright-Knox Art Gallery, Buffalo, N.Y. October 24, 1973; June 18, 1974.

Johnson, Charlotte Buel. Curator of Education, Albright-Knox Art Gallery, Buffalo, N.Y. October 24, December 17, 1973; June 18, 1974.

Mache, Jerry. Instructor, Color Wheels, Albright-Knox Art Gallery, Buffalo, N.Y. June 18, 1974.

Moore, Ed. Instructor, Color Wheels, Albright-Knox Art Gallery, Buffalo, N.Y. June 18, 1974.

Munday, Charles. Director, Color Wheels, and Coordinator, Neighborhood Creative Art Classes, Albright-Knox Art Gallery, Buffalo, N.Y. December 17, 1973; June 18, 1974.

O'Hern, John D. Coordinator, Public Relations and Publications, Albright-Knox Art Gallery, Buffalo, N.Y. June 18, 1974.

Rohrer, Barbara. Instructor, Color Wheels, Albright-Knox Art Gallery, Buffalo, N.Y. June 18, 1974.

Wood, Jim. Assistant Director, Albright-Knox Art Gallery, Buffalo, N.Y. October 24, December 16, 1973.

*Photograph: Courtesy of the Education Department, Albright-Knox Art Gallery.*

## CONTEMPORARY ARTS MUSEUM: ART AFTER SCHOOL

Contemporary Arts Museum
5216 Montrose Avenue
Houston, Texas 77006
**A museum's studio classes for elementary schoolchildren, taught by artists and art educators. Started in 1964 to meet demands of parents dissatisfied with art instruction in schools and to put museum's theories into practice. Widely dispersed throughout Greater Houston in 39 rent-free schools or other community buildings. CMEVA interviews and observations: June, September, and October 1973; February 1974.**

### Some Facts About the Program

**Title:** Art after School.

**Audience:** Focus is elementary children in two groups: grades 1 and 2, and 3–6. During the 1973/74 academic year 2,100 students from 39 schools and centers participated in the program.

**Objective:** To provide studio art classes for elementary schoolchildren in their own neighborhoods, emphasizing individual creative and perceptual growth through organic experiences with art elements and personal contact with artist-teachers.

**Funding:** Largely self-supporting through tuition, $22 for 12 weekly one-hour sessions ($18 for museum members). During spring 1974 a $5,000 matching grant from the Texas Commission on the Arts and Humanities and the Prudential Life Insurance Company supported 25 tuition-free classes in areas of the city where it is difficult or impossible for students to pay tuition.

**Staff:** 29 part-time teachers; a full-time curator of education.

**Location:** 39 schools in the Houston Independent School District and five other districts in the Greater Houston area (Clear Creek, LaPorte, Ailief, Spring, and Klein) provide rent-free space, subject to local principal's approval. Church or community organizations' space is used where schools are not available.

**Time:** Fall semester beginning in September; spring semester beginning in February. In each, 12 one-hour classes meet once a week, either from 2 to 3 P.M. or from 3 to 4 P.M.

**Information and documentation available from the institution:** Brochures; newspaper articles in *Houston Chronicle, Houston Post,* and *Christian Science Monitor* (August 8, 1973); project director's report for subsidized classes.

The Art after School program of the Contemporary Arts Museum puts that institution in the enviable position of doing well by doing good. Established by the museum board in 1964, these largely tuition-supported studio classes for elementary schoolchildren in their own school buildings or

nearby space not only pay for themselves but provide the funds to pay the salary of the curator of education, who supervises Art after School as well as the museum's other education programs.

### Rationale for the program

In the ten years since its inception, Art after School has been molded by three forces: public need, the geography of Houston, and the museum's philosophy. Although the need appeared more pressing ten years ago, the program's steady growth indicates that it is still vital. According to the museum's curator of education, "parents are no longer looking for a fun art class after school."[1] Now they seek an environment for the individual child's creative experience and growth.

To some observers Art after School stands in marked contrast to the general level of art education in the public schools. Throughout the city's 170 elementary schools there are no art specialists; the 200 teachers with an art major or minor must teach all subjects as regular classroom teachers. The board of education's regularly scheduled in-service workshops include art among the many options competing for teacher attention. A curriculum resource book outlines projects that teachers may include in the 100 minutes per week the state *suggests* for art. By and large, the art activities, however well intentioned, tend to be illustrational rather than exploratory, mechanical and craft oriented (follow steps 1, 2, 3 to produce product X) rather than organically developed.

In about 30 schools parent VIPs (Volunteers in the Public Schools), trained in part by the Contemporary Arts Museum's curator of education, assist classroom teachers with art instruction. Although VIPs are not professionals, like the museum's instructors they view art as a process with many potential outcomes. And like the museum, they work with fewer students, not an entire class, permitting the classroom teacher to work with a smaller group as well.

Art after School derives, at least in part, from Houston geography. Like other Southwestern cities, Houston stretched rather than compressed to accommodate the post–World War II population boom. The downtown business and commercial center remains the city's hub, but Houston's 38-mile span from east to west includes many smaller commercial, business, and residential centers. Although this sprawling metropolis is liberally laced by freeways, Houston's tribute to its petrochemical industry, the Art after School classes dispersed around the community spare parents the inconvenience of rush-hour trips downtown to bring their youngsters and art together.

Rather than seeking to provoke change in the schools' art curriculum, Art after School has remained an extension program of the Contemporary Arts Museum, reaching out to the larger community by extending not only a service but a philosophy of art education as well: individual creative experience and growth through organic experiences. In classes limited to 15, students explore the elements of art—line,

shape, color, texture, and three-dimensional form—and participate in corollary experiences to heighten sensory awareness. Instructors try to offer children opportunities to repeat projects if they wish, to give them experience in a broad range of media, and to challenge them to discover alternatives to trite and easy statements. By their own example as professionals, these artist-teachers show students that modern art did not stop with Picasso, that what students seek to express directly relates to contemporary art.

### Staff

Watching Art after School classes suggests that such objectives, however lofty, are not wholly beyond reach. They are made accessible by the artists' skill and devotion, by the curator's judicious selection of materials, and by a curriculum guide that stresses elements of art while leaving teachers free to design problems suitable for their particular children.

Many of the program's faculty are young; about half have a Bachelor of Fine Arts degree and are practicing artists with diverse part-time teaching commitments. Of the remainder, several are certified teachers. Those who have stayed at the same location for a number of semesters have managed to develop community support for the program, as shown by the higher percentage of returning students. Yet, perhaps because of the part-time nature of the commitment, teacher turnover is high; about half of the faculty is new each year.

### Curriculum

Mrs. Ann Bunn, the museum's curator of education and director of the program, provides for the students' exploration of such media as dry drawing, paint, paper, fabric, acetate, clay. In addition, many teachers incorporate recycled materials from local industry for additional projects.

The curriculum guide, which outlines the 12-week course, includes two class sessions devoted to line, using pencil, ink, or crayon; experimenting with paint and brush strokes; relating paper strips, wire, straw, or kinetic sculpture to body or mechanical motion. Instructors are asked to spend two classes on shape, two on color, two on solid form (clay, claycrete, box sculpture), and one or two on texture. At least one session is left open for a field trip of the teacher's choice.

In its ten years of life, Art after School has developed a more concrete and detailed curriculum as the size of the program has increased. Until 1967 there was no formal curriculum, and the program was run by a part-time volunteer coordinator; since that time the director has been a professional. Feedback from parents and principals has been positive. The demand for classes exceeds the museum's ability to find qualified part-time teachers. At the same time, repeaters are few, although some students find their way to the museum for the more specialized courses offered there. Like the single visit to Houston's Museum of Fine Arts included in the 6th-grade curriculum, Art after School is an appetizer. But where does the interested student go for the main course? One op-

tion available since 1971 is Houston's High School for Performing and Visual Arts, discussed in chapter 10.

## Program administration

Administering a program that enrolls, as in 1973/74, 2,100 students at 39 sites spread over considerable distance requires a sensitive hand and a graph-paper brain. Through prior arrangement with the Houston Independent School District and others in Greater Houston, Art after School is allowed to distribute flyers announcing the program in any elementary school with the principal's permission. Early in the fall students receive registration forms; parents mail tuition ($22 for 12 one-hour sessions; $18 for museum members) directly to the museum. Each principal determines the day or days classes can be conducted in his building; usually two successive classes are held on the same day to accommodate different dismissal times.

The program teachers are responsible for whatever set-up and clean-up their classes require. Mrs. Bunn makes unannounced visits to ensure that the quality of the classes meets museum standards. For their part, instructors meet twice each semester to discuss examples of student art, to compare approaches and projects that have worked well, to learn new techniques, occasionally to participate in workshops with other professionals, and—not incidentally—to get back in touch with the fact that they are part of a museum outreach program.

## Program growth: Expanding the opportunities

In spring 1974, a matching grant from the Texas Commission on the Arts and Humanities and the Prudential Insurance Company subsidized 25 classes at 12 additional schools and one neighborhood center, and thus expanded the program, in the words of the project report, to "areas of the city where it is a hardship or impossible for students to pay tuition." Six area superintendents each selected two schools; students, in turn, were chosen by individual principals and classroom teachers. Although the Contemporary Arts Museum suggested that participation be based on a child's "interest" rather than his "demonstrated talent," the curator of education noted in her summary report that some principals used the classes as a reward for good behavior, or selected students on the basis of draftsmanship.[2] At the first class meeting a number of teachers were confronted by twice as many students as they could handle. Teachers and school staff joined forces to reduce classes to manageable size.

In the subsidized classes, a core group of ten out of a class of fifteen attended regularly, with extra spaces filled from the cadre of "interested observers who hung around the door, hoping to participate." Although parents were involved to the extent of signing a permission slip that allowed children to remain in school for an extra hour, erratic attendance could well be attributed to the lack of parental commitment to the classes. Like other public education ventures, organization came from the top down: area superintendents to school principals, to teachers, to students and their parents. Attendance might be better, Mrs. Bunn observed, if it were generally advertised throughout the district and requested by interested schools. Another alternative would be to hold classes in central locations such as neighborhood centers or branch libraries, drawing students from several schools.

Teachers in the subsidy program, all experienced in working with tuition-funded classes, noted that children who came regularly tended to "appreciate the experience" more than the middle-class children on tuition.[3] However the two kinds of classes differed, instructors' sensitivity to individuals and groups was a common theme of principals discussing Art after School. Of his teacher one child in a subsidized school remarked, "He's the greatest man I ever met with long hair."

Generally children take work home after each class, as lack of storage space in the schools prevents accumulating a class portfolio. In one public school where enrollment has declined, however, a room has been set aside for Art after School. There the instructor displays all children's work after each class, usually for several weeks at a time. Students and teachers regularly visit the room, thus helping to establish the program as a permanent, valued addition to the school's activities. If elementary school enrollment continues to decline, more such supplemental programs may acquire both a time slot and a home as well—but not without raising thorny questions of broad availability, finances, control, and basic educational philosophy.—*B. K. B.*

## Notes

[1] For sources of quotations without footnote references, see list of interviews at the end of this report.

[2] "Art after School Expanded to Areas Needing Subsidy," project report, July 10, 1974, p. 6.

[3] Ibid., p. 9.

## Interviews

Bunn, Mrs. Ann. Curator of Education, Contemporary Arts Museum. June 18, September 27, 1973; February 27–28, October 25, 1974.

Dahl, Ms. Carolyn. Art after School Teacher. February 27, 1974.

Golightly, Harry. Art after School Teacher. February 27, 1974.

Lecorgne, Mrs. Laura. Parent of Art after School Student. October 25, 1974.

Mackey, Fletcher. Art after School Teacher. February 28, 1974.

McClure, Mrs. Neil. Art after School Teacher. February 27, 1974.

Stringfellow, Floyd. Principal, McDude Elementary School. February 27, 1974.

Temple, Mrs. Mary Pearl. Director of Elementary and Secondary School Art, Houston Independent School District. Telephone, October 23, 1974.

## THREE MOBILE UNITS: GEORGIA ART BUS, RINGLING ART CARAVAN, AND BIRMINGHAM MUSEUM ARTMOBILE

**These three mobile units, all designed primarily for schools and schoolchildren, vary in their program, staffing, choice of vehicles, and educational style. But all three have the virtue of making a connection between a dispersed audience (two of the programs serve entire states) and the museums' ways of teaching art.** CMEVA interviews and observations: July, September, October 1973; March, April, May, August 1974.

### Some Facts About the Three Programs

**Titles:** Georgia Art Bus
   Ringling Art Caravan
   Birmingham Museum Artmobile

**Vehicles:** The Georgia Art Bus is a tricolored converted school bus that carries art works meant to be hung in the schools.

The Ringling Art Caravan, until a new Econoline van was purchased in 1974, consisted of one modest station wagon, which carried audiovisual and other equipment and supplies and a small exhibition of artifacts and reproductions.

The Birmingham Museum Artmobile is a 1966 Dodge van, about 10 feet long, designed to hold many objects and to open up in sections as the driver-lecturer leads children around it.

**Audience:** The Georgia Art Bus brings the works of contemporary Georgia artists to people who might not otherwise be able to see original art.

The Ringling Art Caravan aims to integrate art with other classroom studies and to provide schools with a model for art instruction.

The Birmingham Artmobile tries to interest local schoolchildren in visiting the museum by bringing original works from its collections.

**Funding:** For the Georgia Art Bus, the $18,000 budget in 1974 came from the National Endowment for the Arts and the Georgia Council for the Arts.

Ringling Art Caravan's budget was $5,500 in 1973/74, including prorated staff salaries. Sources were the National Endowment for the Arts through the Florida Fine Arts Council, the Ringling Museums' Members Council, and the Women's Exchange of Sarasota. The museum provides the exhibits, station wagon, and gasoline. In 1974 new grants increased the budget to $9,200.

The Birmingham van, begun with federal Title III and later Title I funds, is now a joint project of the museum and the Birmingham Board of Education: the board paid for the purchase and remodeling of the vehicle ($3,000) and also pays the salary of the driver-lecturer ($8,500 for nine months), printing costs of brochures ($500 a year), repairs and insurance for the bus; the museum provides the objects and their insurance.

**Staff:** Georgia Art Bus has a half-time coordinator, who arranges visits, inspects the exhibition space, distributes interpretive materials, helps with installation and packing, provides publicity; 2 bus drivers, who deliver and install the exhibition; and 4 part-time artists-in-residence, who conduct workshops, classes, demonstrations.

Ringling Art Caravan requires 2 artist-instructors and a member of the museum education staff, who travel with the station wagon and share the teaching.

Birmingham Artmobile is staffed by a driver-lecturer (a requirement is a B.A. in art) who chooses the exhibition, writes the children's brochure, and gives the talks to school groups.

**Location:** The Georgia Art Bus takes its exhibitions into high school classrooms, cafeterias, and libraries.

The Ringling Art Caravan staff gives its demonstrations in elementary school classrooms.

The Birmingham Artmobile is a self-contained exhibition, which children usually visit on the school playground.

**Time:** Georgia Art Bus travels between January and May, remaining at each school for two or three weeks and often carrying exhibits that can be installed in two neighboring communities at the same time. During the summer the Art Bus is used for inner-city community programs.

The Ringling Art Caravan makes 10 or 11 trips a year, visiting each school for three hours (in 1974, after the CMEVA report period ended, the museum trebled the scope of the program, bought a new Econoline van, and now visits nearly 30 schools a year).

The Birmingham Museum Artmobile stays for one to three days at each school; each class gets a half-hour program.

For many museums mobile units have long been an attractive alternative and, in some cases, supplement to the museum visit. Though no two programs are ever alike, the three described here are typical of the museum roadshow designed for schoolchildren.

### Georgia Art Bus
**High Museum of Art**
**Atlanta Memorial Arts Center**
**1280 Peachtree Street, N.E.**
**Atlanta, Georgia 30309**

Created in 1970 by the Georgia Council on the Arts, the Georgia Art Bus has been administered since 1972 by the High Museum in Atlanta. Its purpose, to bring original art to young people throughout the state, is controlled by two policies: to confine the exhibits to contemporary works, primarily by Georgia artists, and to show the works for two- to three-week periods in the public schools so that the art can be part of the students' environment over time.

Like most states, Georgia has few art teachers, most of them shared by several schools and some of them spread thin across several counties. When the High Museum took over administration of the bus, it added to the program an artist-in-residence, who spends a week in each school while an exhibition is on view, conducting workshops, classes, and demonstrations. The Art Bus program usually operates simultaneously in two neighboring communities, and the artists move back and forth between them.

**The artist's job.** In 1973/74 the artists were a painter-printmaker who also worked in film and photography, a

painter especially interested in helping students with color problems, another printmaker, and a potter. The role of each artist depended on his talent, the needs of the community and the school, and the presence or absence of a school art teacher. In some places, the artist might arrange to give demonstrations to everyone in the school; in others, he might concentrate on the school's art classes and lead discussions of the exhibition with teachers or community groups.

The artists bring something exotic into the classroom. Teaching methods in the schools change for the week, at least. Students have the chance to make the connection between the unfamiliar art hanging on the cafeteria and library walls and the real person who is an artist himself. Many students want to know whether the artist's work is in the exhibition (it is not—an obvious promotional problem for the museum), where he does his art-making, what else he does for a living. Teachers are exposed to new techniques (one art teacher expressed his pleasure that the artist-in-residence in his school happened to be a printmaker and could teach him something about a medium in which he had little experience), and some welcome the disruption in the steady course of things.

**What are the effects?** Not every community makes use of the Art Bus resources or takes advantage of the two or three evenings a week the artists set aside for meetings or demonstrations. Too, according to the Art Bus coordinator in 1973/74, teachers tend not to use the suggestions developed by the museum's education department in its "Notes for Teachers," which gives ideas for engaging and holding young people's interest in the works on exhibition. One art teacher was disappointed that the students' first exposure to original works of art was strictly contemporary; others regretted the absence of weavings and sculpture.

But there is little question that the Art Bus and its creative staff bring a breath of new life into the communities they visit—boosting the spirit and status of the art teacher and often generating new programs in the schools. To one energetic school arts coordinator, whose territory covered four counties, the bus provided the impetus to purchase a kiln, and in at least three communities, classes built their own silkscreens after the Art Bus left, success enough for the bus's staff and its sponsors.

## Ringling Art Caravan
**John and Mable Ringling Museum of Art**
**P.O. Box 1838**
**Sarasota, Florida 33578**

The Ringling Art Caravan has some of the same objectives as the Georgia Art Bus, but its program is slightly more prescribed. As Florida's only major, state-supported art museum, the Ringling feels responsible to a statewide audience, so its single modest station wagon in 1973/74 (an Econoline van added in 1974 considerably expanded the program) traveled throughout Florida, bringing its brief but intense program to about 1,300 children and 100 educators.

The caravan was created in 1972 by Leslie Ahlander, then the museum's director of education, in response "to the lack (or curtailment) of art education within the Florida public school system." The aim of the caravan was to "provide entire school systems with fresh, open, and original art instruction methods."[1]

In 1972 a school could choose from among five programs keyed to such basic concepts as color or form, but teachers then as now had the option of mixing programs or requesting one to suit their individual school's requirements. By 1973/74 the Art Caravan was offering eight programs. Added to the original five (on form, color, line, Baroque art, and "Art Today") were three on black American, Latin American, and American Indian art. (The most popular that year were those on art today, Florida Indians, and black art.) Each program includes a film, two or three workshops, an exhibit, a slide-talk, a seminar, and exhibition and discussion of student work.

To qualify for a visit, a school chooses a program and fills out a form specifying whether the caravan is to be part of a larger program, whether artists and community educators will also take part, and what tie-in the school wants made with its regular curriculum. In addition, the school must be able to provide at least three spaces for the caravan—one room for films and slides and two for the art workshops—and all must have electrical outlets and space to display exhibitions of sculpture or paintings. The Ringling furnishes films and other materials, but the schools are asked to provide, if possible, a 16-mm film projector, a screen, a Wollensak AV 2550, a Kodak Carousel, and a record player.

Because the museum receives at least six times as many requests as it can fill, schools are chosen each year on the basis of need (they have no regular art program) and location (the caravan does not usually visit the same county in successive years); among equally deserving candidates, it is first-come, first-served.

**Staff and budget.** In 1973/74 the caravan's programs were carried out, with whatever variations the schools requested, by three museum staff members—two of them practicing artists—who traveled in the station wagon with audiovisual equipment and other supplies and a small exhibition of artifacts and reproductions. Their work was paid for out of a $5,500 budget that covered prorated salaries, the station wagon and its operating expenses, and the exhibits. Sources of the funds were two Sarasota membership organizations and the National Endowment for the Arts through the Florida Fine Arts Council. No contribution from the school was required, although occasionally local groups have raised money to bring the caravan to a community not among the scheduled ten stops.

Staff members in 1973/74 were Betty Lou Curry, assistant director of education at the museum; Ralph Hyams, a sculptor and graphic artist; and his wife, Martha Hyams, a painter and dancer. In a typical program, the three would lead children in a variety of exercises, each carefully designed to build on the other. A program on form, for example, would start with a black-and-white animated film by Elliot Noyes, *Clay, Origin of the Species*.[2] Children would then be divided into three groups, each under the charge of a caravan staff member (the schedule was always arranged so that each group took part seriatim in each of the three 45-minute caravan sessions, which were joined by the day's theme or themes). One session might focus on movement exercises, another on a clay workshop, and the third—designed to relate art to the school curriculum—on the exhibit arranged in a classroom or the school library. To help reinforce this third session, teachers would have received in advance such material as a vocabulary list, an article on the day's topic, and suggestions for classroom work both before and after the caravan visit.

**The results.** Like the Georgia Art Bus, the Ringling Art Caravan brings something out of the ordinary into the lives of teachers and students. Whether this single injection of art, restricted in any given year to three hours in a limited number of locations, can hope to have a ponderable effect on art instruction in Florida's schools is a question that perhaps only the schools themselves can answer.

But the Ringling pins its own hopes not so much on the single caravan visit as on the multiplier effect of yearly visits over time. The museum staff offers the program as a model for art educators in the elementary schools and tries to broaden participation at each stop to include teachers from other schools in the county and school administrators and local artists as well. In a state that, like so many others, does not require instruction by art specialists and allows local districts to fulfill art instruction mandates as they will, the caravan gives the teachers a chance to step back and see how their students respond to special talents and a different approach.

Through feedback supplied by the forms that participating teachers fill out and from other evidence, the museum can point to some lasting effects. Teachers from various schools have reported that students remained interested in the concepts and specific techniques of the workshops long after the caravan had departed. "Since your visit," wrote one teacher, "we have been able to build on the concepts you presented by visiting a local exhibit in sculpture and developing lessons in sculpture ourselves."[3]

In the end, the success of the program has seemed to rely almost wholly on the three people who man the caravan and the relations they have developed with the schools. Whatever the virtues or distinctive differences of this mobile program, the indispensable ingredient, once again, is the staff's talent, intelligence, and love for the work at hand and for the children who share it.

## Birmingham Museum Artmobile
**The Birmingham Museum of Art**
**2000 8th Avenue, North**
**Birmingham, Alabama 35203**

The Birmingham Museum's Artmobile is less a program than a self-contained exhibition. The van, a 1966 Dodge, brings original works of art from the museum's collections to local schools. It parks in school playgrounds, and children come out of the classrooms to look at exhibits that the van's driver—a teacher employed by the Birmingham Board of Education, who is required to have a B.A. in art—shows them in the course of his half-hour discussion. The children regard the van as a treasure chest, and the museum regards it as an invitation to visit the building itself.

The van stays for one to three days, depending on the size of the school, and concentrates its visit on 3rd and 7th graders. It visits all public and parochial elementary schools within the city limits. In 1973/74 the Artmobile traveled to 85 schools, holding sessions for more than 25,000 children in 138 days.

A schedule informs each school at the beginning of the year when to expect the Artmobile; as a further reminder, the driver-lecturer calls each school a week before the visit. Within a school, the registrar schedules the group visit, trying to restrict the number to 25 students at a time (more tends to overload both the van's and the driver's capacities).

The objects from the Birmingham Museum's collections are chosen for their appeal to elementary schoolchildren and always include several items sturdy enough for the children to handle—a Samurai helmet, say, or a mask. Exhibition themes for spring 1974 dealt with the art of North and South American Indians, Eskimos, Africans, and New Guineans. The fall 1973 program, chosen from the museum's Oriental collection, included porcelain snuff bottles, lacquer bowls, ivory figures, terra-cotta pieces, a bronze vessel, scrolls on silk, woodcuts, clothing, a Samurai sword and helmet, a jade incense burner, a mirror of bronze, a statue of Shiva, and even a Chinese picnic basket and lantern.

**Funding.** The Artmobile is one of the few instances uncovered in this study where the local board of education sought the collaboration of the museum. Spurred by the prospect of federal funding in 1966, the Birmingham Board of Education and the Birmingham Museum applied for and received a Title III grant (later continued under Title I) for the Artmobile. When the federal funds ran out, the board of education assumed responsibility for operating the Artmobile and paying the driver-lecturer. Under the continuing arrangement, the museum provides and insures the art objects, which the

driver-lecturer chooses from the museum's collections.

For the museum, the Artmobile has so far proved to be the best way to bring the children in touch with original artifacts from the Birmingham's collections and to make them aware of the museum. Because the school system operates no buses and hiring city buses for field trips is expensive, the Artmobile is a particular bargain for the city of Birmingham: the Artmobile costs no more than $10,000 a year to operate, and the museum's outlay for insurance is minimal. Scheduling has been simplified (the Artmobile does not try to adapt its programs to special school needs) and requires no extra staff for either the museum or the school board.

**On balance.** The Birmingham Museum's Artmobile is a modest and disarming program. One of its virtues—and, at the same time, one of its defects—is that it does not call for much initiative on the part of individual teachers, nor does it insist that teachers mesh specific lesson plans with its programs.

On the other hand, the Artmobile's wholesale approach to the schools does mean that every teacher and every student in the grades it covers has access to its offerings. Students of teachers who may never have heard of the museum's programs or considered taking a field trip have the same chance to see the Artmobile's exhibits as those classes led by teachers who make a point of arranging field trips or booking special exhibits.

Bringing treasures once a year to a child, if only for half an hour, is not a great deal, but it is something. Most people who work with children would not dismiss the value of this experience, and certainly no one who had watched the enthusiastic response of children in a Birmingham schoolyard to the Artmobile and its talented driver-teacher.—*S. R. H.*

## Notes

[1] *Ringling Museums Newsletter,* March 1974.

[2] Other films were *The Loon's Necklace; Buma; Little Blue, Little Yellow; Why Man Creates; Caravaggio and the Baroque; Richard Hunt, Sculptor;* and *Arts and Crafts of Mexico.*

[3] From written forms submitted by teachers in the Manatee County and Lake Como (Orlando) schools.

## Interviews and observations

### Georgia Art Bus

Benning, Margee. Artist-in-Residence, Washington, Georgia. May 15, 1974.

Bright, Harold. Artist-in-Residence, Sparta, Georgia. May 15, 1974.

Delaney, Jack. Art Teacher, Washington, Georgia. May 15, 1974.

Donahue, Sharon. Art Bus Coordinator, High Museum of Art, Atlanta, Georgia. April 4 and May 15, 1974.

Grant, Marena. Curator of Education, Loch Haven Art Center, Orlando, Florida, at the site of the Art Bus exhibition in Washington, Georgia. May 15, 1974.

Hancock, Paula. Curator of Education, High Museum of Art, Atlanta, Georgia. October 16, 1973.

### Ringling Art Caravan

Ahlander, Leslie Judd. Curator of Contemporary Art (then Director of Education), Ringling Museum of Art. July 13 and 14, 1973.

Carroll, Richard. Director, Ringling Museum of Art. July 13, 1973.

Curry, Betty Lou. Assistant to the Director of Education, Ringling Museum of Art. July 13 and 14, 1973; March 13, 1974.

Davison, Richard. Curriculum Specialist, Chiaramonte Elementary School. March 13, 1974.

England, Ken. Assistant Director, Florida Fine Arts Council. Telephone, August 20, 1974.

Gilmore, Florence. Public Relations Director, Ringling Museum of Art. July 13, 1973.

Hines, Nancy. Assistant Director of Education, Ringling Museum of Art. July 13 and 14, 1973.

Hyams, Martha. Artist-Teacher. July 13 and 14, 1973; March 13, 1974.

Hyams, Ralph. Artist-Teacher. July 13 and 14, 1973; March 13, 1974.

Llich, Jane. Office of the State Art Consultant. Telephone interview, August 15, 1974.

### Birmingham Museum Artmobile

Black, Rebecca. Artmobile Driver-Lecturer since 1972. September 27, 1973.

Howard, Richard F. Director, Birmingham Museum of Art. September 27, 1973.

Powell, Mary L. Artmobile Driver-Lecturer, 1967/68 and 1971/72. September 27, 1973.

Smith, Mrs. Nelson. Coordinator for Museum Art Education Council. September 27, 1973; telephone, August 21, 1974.

Weeks, Edward. Curator, Birmingham Museum of Art. September 27, 1973.

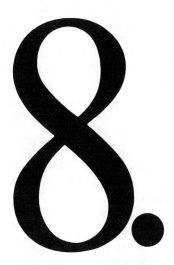

# Nonmuseum Visual Arts Programs

## Introduction

The programs described in this chapter are all for children, they all focus, in whole or in part, on visual arts education, and they all take place outside the museum. They are included here to demonstrate three points: first, that it is possible to give children intelligent, substantive instruction in the visual arts; second, that there are other institutions besides the art museum capable of providing such instruction; and third, that museums, public schools, and arts centers operating outside the museums and the schools have much to teach and to learn from one another—that they should, indeed, strive to exchange ideas and divide responsibilities to their common advantage and for the good of the children they serve.

Most museum educators believe that children should receive their visual arts instruction in the public school. They believe this despite their conviction, shared by a surprising number of public school administrators and teachers, that very few schools are able to provide adequate art education. Yet many museums, their instructional and financial resources already stretched too thin, can hardly assume still greater responsibility for children's art education than they do now—and in any case, no matter what the art museum

offers, it can be no match for the day-in, day-out influence of institutions whose primary function is the education of the young.

Certainly art museums will always be essential partners in visual arts education. But the programs described here are proof that the art museum is not the only supplement—or even alternative—to visual arts instruction in the public schools.

The Junior Arts Center in Los Angeles is one kind of answer. Supported entirely by municipal funds, it focuses exclusively on visual arts education, which is given free to any Los Angeles child who can be squeezed in. The annual $200,000 budget supplied by the municipal arts department to the center is, in effect, a kind of supplemental education appropriation. But the fact that this money goes to the Junior Arts Center and not to the schools guarantees that these funds will not get lost in the system and that the art education the money pays for will not be twisted out of shape by bureaucratic regulations from the schools.

GAME (Growth through Art and Museum Experience), on the other hand, draws its major financial support from four New York City public schools and the district's local school board. GAME serves as a resource for teachers from these schools, offering them an out-of-school space where they can develop new curriculum ideas with their children, learn about and build on the resources of several kinds of local museums without having to research these formidable institutions themselves, and get help in preparing their classes for museum visits that are meant to fit usefully and naturally into the classroom sequences they have planned. As a kind of intermediary institution between the museums and the schools, it is able to stay closely tuned to its constituents—its "clients," as one museum educator calls them—and to make sure that museums, along with other kinds of cultural centers in the community, are wisely rather than randomly used.

The Elma Lewis School of Fine Arts in Boston, part of an independent, privately funded arts complex, provides highly disciplined instruction in all the arts, both visual and performing, and is building up its own museum and slide collection. Administrators of the school are convinced that the black children and their parents who are the school's primary constituents should value this instruction enough to pay for it, even at a reduced monthly rate if they cannot afford the full fee.

In each case, these programs provide imaginative answers to the problem of visual arts education for children. Their authors—in every instance an energetic and dedicated individual—have not simply stood on the sidelines criticizing the schools but have taken matters into their own hands. These programs have other things in common, too: artists as teachers, involvement of local citizenry, and the use of the community as classroom. And each program abounds in specific projects and ideas that both museums and schools might use in their own educational work—the children's exhibitions at the Junior Arts Center, GAME's ingenious

transformation of found space and found objects, Elma Lewis's emphasis on giving children the critical tools to judge their own art and the art of others.

Most of all, however, these programs make clear that museums do have allies in their communities, whose efforts can effectively serve the art museum's purposes in education as these supporters of the visual arts pursue purposes of their own.—*J. M./B. Y. N.*

# THE JUNIOR ARTS CENTER, LOS ANGELES

Junior Arts Center
Barnsdall Park
4814 Hollywood Boulevard
Los Angeles, California 90027

**A city-funded art center, created in the bountiful sixties, survives in the tight-budget seventies and continues to offer disciplined art instruction to Los Angeles youngsters, who find the experience both serious and enjoyable. Meanwhile, increasing cooperation between center board and staff helps to solve funding and administrative problems. CMEVA interviews and observations: 1967–1974, concentrated in 1974.**

**Some Facts About the Program**

**Title:** Junior Arts Center.

**Audience:** About 3,200 children and teenagers make roughly 30,000 visits annually for classes; some attend for an entire school semester, others for as few as one or two sessions. A gallery program and special events attract another 23,000 visitors a year. There are occasional workshops and training sessions for adults who work with children.

**Objective:** To offer young people in Los Angeles the fullest opportunity to develop their creative capacities through participation in the arts.

**Funding:** Development cost of $450,000 was paid mainly by the City of Los Angeles (the Junior League contributed about 5 percent). Annual operating cost averages around $200,000, paid by the city's municipal arts department, of which the Junior Arts Center is a division. In addition, the Friends of the Junior Arts Center try to raise at least $10,000 a year to be used mainly for art supplies and equipment. Cost per person: $35 for classes, $1 for gallery programs and special events. There is no charge to participants.

**Staff:** 9 full-time, 13 part-time instructors; approximately 25 volunteers.

**Location:** In Barnsdall Park, in what is known as the Los Feliz district—also called East Hollywood. Adjacent to the center is the Hollyhock House, designed by Frank Lloyd Wright in 1920, the Municipal Art Gallery, and the Arts and Crafts Center, operated by the recreation and parks department for adults.

**Time:** Open year-round.

**Information and documentation available from the center:** Brochure, Junior Arts Center, 1968; announcements of classes each semester, 1968–present; postcards of drawings by students; slide presentations.

Three million persons live in Los Angeles, a city that extends from the foothills of the Sierra Madres west to the Pacific Ocean. Freeways wind their tentacles around the city connecting the pockets of business, industry, homes, and culture. L.A. is the paradigm of mobile America, a town of gasoline stations, drive-through car washes, and drive-in restaurants. Amidst this twentieth-century plastic culture, freedom of expression reigns in flashy cars, colorful costumes, large-scale art, and architectural wonders. But the city is more than a product of man; it has canyons and beaches and parks. The Junior Arts Center is located in one such oasis, Barnsdall Park, a hill covered with grass and olive trees in the Los Feliz district, often referred to as East Hollywood, an area considered one of the most culturally and ethnically varied in metropolitan Los Angeles. Barnsdall Park provides a welcome escape from the glaring California sunshine and the prevailing Los Angeles smog. A winding road leads up the hill to the complex of buildings devoted to the arts.

Aline Barnsdall, who gave this 11-acre summit to the City of Los Angeles in 1926, spent the next 20 years trying to persuade the city to buy the hill's remaining 36 acres. Believing that Los Angeles was destined to be the cultural center of the United States, Miss Barnsdall had purchased Mount Olive (Barnsdall Park) in 1919 for a reported $300,000 and had commissioned Frank Lloyd Wright as her architect. The two envisioned a residence for Miss Barnsdall, a theater complex, and residences for artists. Wright completed two structures—a home for Miss Barnsdall called Hollyhock House, now a cultural heritage landmark, and a guest house for the theater director, now replaced by apartments.

By the 1970s Barnsdall Park had become the art complex Miss Barnsdall wished. In May 1964, the municipal arts department and the recreation and parks department announced a development plan for the park. Its first element, the Junior Arts Center, was dedicated in May 1967; the cost of $450,000 was paid mainly by the city and partly by the Junior League of Los Angeles. In fall 1970 a second structure was added to the park, the imposing Municipal Art Gallery, which is both a gallery and an auditorium.

## How it happened

Why should the City of Los Angeles create a children's arts center? Passing the question off lightly in 1974, Kenneth Ross, general manager of the municipal arts department, replied, "I have four kids, and I have always gotten along well with kids and dogs."[1] But obviously there was more to this municipal decision, in which Ross was so influential, than a desire to please children. In his career as arts administrator, Ross had often thought about the place of Los Angeles in the national arts arena, and particularly about the city's role in children's art education: "New York has always been the leader in this field with Victor D'Amico at the Museum of Modern Art," he said in 1967. "What can California do? This is a question I have always asked, because there is so much happening here now."[2]

In 1947, when Ross was director of the Pasadena Art Institute, he started a children's program. In 1950, wanting to create a separate space for children rather than relegating them to the basement or the back of the gallery, he approached the Junior League. But not until more than a dozen years later, in 1963, was Ross's proposal accepted— overwhelmingly—by the league. The Junior Arts Center became a reality because of Ross's vision and tenacious faith, the support of the Junior League, and the potent if intangible influence of a new climate for the arts set by a new president of the United States, John F. Kennedy. "People were beginning to realize that the arts were important," the director of the center recalled in 1974. "They were receiving more support and recognition for their value in society."

Although the Junior League contributed only about 5 percent of the project's total cost, the organization's support provided the essential impetus for the establishment of the Junior Arts Center. As Ross has said, without the league's backing he could never have gone to the City Council and "asked for half a million dollars for children rather than policemen."

So in 1967 a glass and concrete cantilevered structure, dedicated to children and art, was opened. (Construction was expedited by the designation of Barnsdall Park as an art complex, and also by surplus funds, earmarked for a building, that the recreation and parks department made available.) The Junior League paid the director's salary for four years, and half of it for the next two years; after that the City of Los Angeles assumed total responsibility for this outlay. The entire operating budget, which averages about $200,000 a year, is paid by the city. An additional sum of about $10,000 a year, that pays for supplies and certain other expenses, is raised by a newly formed group, the Friends of the Junior Arts Center.

The center is a division of the city's municipal arts department and is administered by an 11-member board of trustees, which includes community representatives, the general managers of the municipal arts and the recreation and parks departments, and a voting teenaged student member.

## The dream

Here was a handsome building in the park ready for a program. Robert O. White, a biochemist, painter, and former director of the Junior Art Gallery in Louisville, Kentucky, became the man who would determine the direction of the Junior Arts Center.

> They asked me what a center was, and I told them it was where the ballad could be passed on from generation to generation. It really does not make any difference how you do it just so it is important. I was rather poetic. . . . I was talking about urban problems also. . . . It is hard to remember, but it had to do with the importance of art and the contrast between a gray and a colorful society.

With this dream in mind, White started to recruit a staff of artists devoted to youth and art. (He interviewed over 150

persons who responded to articles about the Junior Arts Center in the *Los Angeles Times*.) The search was for artists, not schoolteachers; resumés were less important than experience, energy, and ideas. As White wrote in 1967,

> The artist is trained to see, interpret, and express the function and structure of things, to be satisfied only with the most intimate and truthful reality, to base his solutions on what is and not what seems to be. His training and his concern with original, uncensored seeing may help him maintain a clear sense of his own identity and value in a society where individuals may well feel themselves powerless, miniscule atoms in a massive, impersonal, immutable system.
>
> I believe that artistic attitudes properly communicated can be of great value to any child, whatever his talents. Our ultimate concern is not the production of accomplished and impressive objects but the encouragement of growth, the fostering of creative ways of dealing directly with any reality.[3]

So White gathered a diverse staff. It included artists of national stature who had little experience teaching children but a great interest in art and technology; three printmakers trained by Sisters Corita Kent and Mary Magdalene at Immaculate Heart College, women experienced in the Mary festivals and in producing the famous *Irregular Bulletins*[4]; a skilled ceramist with a unique style of expression; two artists concerned with nature and ecology who had taught children for years and experimented with bread sculpture, art, and cooking; a photographer with an extraordinary knowledge of Los Angeles, who was gathering slides of urban and folk art; and an artist-administrator from the Pasadena Museum. Many of these artists were still with the center in 1974, eight years later. The dream, in White's words, was "an exciting, open, thought-provoking exchange, an experience using materials and the arts as a vehicle to exchange the ideas. We were not trying to make a whole bunch of artists. We were trying to add to society. That, plus some kind of real feeling for a discipline. I still feel this."

The Junior Arts Center was an evolving art form in itself. The staff wanted to present every child with a rich environment and expanding experiences. As White wrote,

> We would be sitting around and wondering where to go. What are we going to do now or how do we even solve the damn problem? How do we get kids even to come?
>
> The first class programing was the magic stuff. How do you program that stuff in? But people just brought it to the building of the classes themselves. If the idea was valid, let's try it. I would present the idea to the board and try to keep as much of it as possible. My biggest job was seeing that things were not diluted by bureaucracy . . . the city government. I came away saying art and municipal governments just cannot mix. It is just like oil and water. It is impossible. We did it though.[5]

They did indeed do it, despite problems that were complicated by the improbable yoking of art and bureaucracy.

One had to do with space; another with money. For all its grandeur, the Junior Arts Center presented an unyielding physical barrier to the vitality and vision of the artist-teachers. With its tile floors and partitions, the center's four classrooms, gallery, and downstairs work area were—then, as now—inflexible. Almost at once, the center was too small. There was need of a darkroom, administrative offices, a library, and wooden—rather than tile—floors in the gallery to admit panels and pylons. (Notwithstanding the difficulties, a darkroom and film space were eventually carved out.)

Originally it was thought that a budget of about $65,000 from the city and the Junior League would do, but soon it became clear that even a jump to $185,000 would not be enough. To carry out their ideas, the artists wanted an extensive slide library, printmaking equipment, books, more and more art supplies, and the materials necessary to experiment with art and technology.

The spirit was adventurous, and the results were flamboyant. Probably most of the children who came to the JAC in those days would never forget the experience, and the artists working there would talk about it for years to come. Ingenuity and brashness compensated for short funds. Artists would call IBM, Hughes, Lockheed, Bell & Howell, and other companies and ask for donations. Through perseverance and palpable sincerity, they obtained mylar, sound systems, movie cameras, and more. For one festival, "The No Snow Snow Show," the Los Angeles Fire Department covered the park with foam so children could get an idea of what snow was like. Another time, the Golden State Freeway was jammed for hours, and the citizens of Los Angeles were convinced the sky was filled with UFOs. The phenomenon was, in fact, floating mylar constructions created and set free by the JAC. Wanting above all to reach their kids, the center's artists tended to act without asking first. As White has said, "if we had asked the city, we would have never gotten off the ground."

### The reality, 1967–1969

The Junior Arts Center was flying. Classes were full; publicity in print and on the air reached north to San Francisco and east to New York City. More important than the classes in ceramics, printmaking, drawing, painting, dance, drama, cooking, and building were the concepts explored by the artists and their students.

> We work with ideas and present problems which give birth to ideas. The Junior Arts Center wonders about the astronaut who preferred space to being inside the Gemini capsule. Maybe the space around an object is more important than the object. We want astronauts and scientists to talk with students at the Junior Arts Center about environmental space . . . how it affects them and us.[6]

The emphasis on mating art and technology resulted in the UFO experiment, the foam snow, and another enterprise: the sound tunnel, a long, dark tunnel equipped with speakers, built by teenaged students and artist-teachers to

dominate the gallery area in order to explore electronics, sound, and space.

Students were continually experimenting with lasers, light, sound, and space, committing such absurdities as unfurling a roll of toilet paper on Hollywood Boulevard to measure distance, or crowding into a room and blowing up a weather balloon until there was no space left. In White's words, "we must speak to young people in media and methods that are contemporary to them, while at the same time never losing sight of what history and their heritage mean."[7]

One summer became a summer of film. (Hollywood, the film capital of the world, extended east to the Junior Arts Center.) Bell & Howell lent the center enough cameras so that each student could produce his own films. Five hundred students made films. Screenings 12 hours a day provided contest and inspiration for the student filmmaker to see and study many different films and their techniques: zooming, dollies, and special effects. The shows spanned film from the classics of Buster Keaton to *Blowup*.

The director and his staff believed that the Junior Arts Center could serve as a model to Los Angeles and to the nation. Here things could happen that could not happen in the public schools. Here artists could experiment with materials, ideas, and concepts. In planning the project, the Junior League, in general agreement with the City of Los Angeles, stressed this goal: "to develop through art the creative power of the child to the greatest extent possible, encouraging the development of the imagination, invention, individuality, exploration, and awareness."[8]

White extended this philosophy further: "To realize this potential for national leadership, the center must become a focus of new ideas, a 'center' of things actually, as well as in name; it must be willing to take chances and risk occasional failures in its search for excellence."[9]

White took chances, aware that he would soon run into a brick wall. An artist, a dreamer, and an innovator, he was no city administrator. As the program and the center flourished, expenditures were escalating, and the board of trustees grew concerned about the center's focus and structure. White was dismissed as director of the Junior Arts Center in fall 1969. Five years later he saw it all in this perspective:

In a sense, we have been over the dream thing. It came close, and also it was during the Kennedy years. I think all over the country in a way it was the beginning of a Camelot for the arts. It really changed an awful lot of things. Finally, when [Jack and then] Bobby Kennedy [were] assassinated and then Martin Luther King, Jr., there was a change. It was like those three guys gave a lot of energy to where I was. Maybe you really could change things.

And as White has said, "He who experiments has the right to fail. You learn by failure. . . . We could perhaps do things and break some new ground where schoolteachers were not able to." Though the right to fail is an important premise of the center's way of life, White himself did not fail in his dream for the center. His dream and his work laid the foundation for the present program.

## A new director and a new focus

Like Robert White, Claire Isaacs Deussen, the present director, believes in the importance of artists interacting with children, in having young people see art as a growing kind of experience and not simply a series of exercises. Mrs. Deussen faced a different kind of challenge, almost inevitable in the growth of an organization like the Junior Arts Center. She had to reorder the center's administrative procedures, bring the city government and the Junior League into a better understanding of the center's purposes, and at the same time nurture the artists' energies that White had generated. "We had to become more alert to all the public, not just the advanced art community," she says. "I loved the magic— that's what brought me to JAC. I tried to retain the magic, but administratively I had to put the brakes on if we were to survive."

Arriving at the JAC after it had been without a director for nine months, she discovered a conflict of goals between the center's staff of artists and its board, which was essentially representative of the Junior League and of the city government. Mrs. Deussen, an experienced museum curator and educator with a graduate degree in art history, had a long record of working with art programs in the schools and communities of the San Francisco Bay Area and San Bernardino County. The combination of White's dream and Mrs. Deussen's experience, administrative abilities, sensitivity to artists, and concern with urban problems combined to shape the Junior Arts Center into a workable program that would stimulate young people while sustaining rapport with city government and the board of trustees. As she has reported,

When I came to the center, the center had already established its form and its image, but it was deeply troubled at that time. . . . I realized that the reason the center had become such an exciting, vital place that many people in the arts looked to, and many nonart people found a delightful place to be, was because the instructors and staff were something special. . . . When I came to the center, naturally I had a lot of personal ideas . . . [but] in time I had to realize that trying to impose my ideas, or "direct" in the usual sense, was just not in the best interests of the center.

Even in the area of a philosophy of art, and of teaching, I had to let go. I had to give the staff a lot of freedom but with a guiding hand and let them take responsibility for the basic direction of the classes, and for basic attitudes about art. This was all hard on the ego at first. . . . Of course, I have my own areas of interest. I am stronger in art history and museum background than most of the staff. . . . [but] I do not function as a director in the sense of leading but function much as the coordinator of a very lively staff of individuals, creating an atmosphere of trust in which everyone feels he is contributing and has a potential for growth. . . .

I am really trying to let the teachers have their own aesthetic directions. I am an eclectic. I enjoy the diversity. . . . I think that, basically, Bob White is an innovator and me, I'm a catalyst. He was excited by the new ideas in art the staff could create, and I'm excited by the human yeast, the interaction, and enjoy seeing the creative ideas rise from it.

The Junior Arts Center would seem to offer more than enough diversity and interaction to satisfy the director, evident even in the sheer statistics of services offered and audience served. Free of charge to the young people of Los Angeles, the center provides about 100 hours of highly diversified instruction weekly for 40 weeks of the year. Weekly enrollment ranges from 650 to 700 youngsters, about 550 of them—evenly divided between teenagers and younger children—in after-school and Saturday classes. The rest are bused to the center through arrangement with the Los Angeles public schools. The school groups, about two-thirds of them from elementary schools, generally come once a week for ten or twelve weeks; the Friday program offers one-time visits only.

The children represent a wide variety of social and economic backgrounds, reflecting in part the ethnic variety of the Los Feliz, or East Hollywood, district. Besides these 3,000 or so students who attend classes in the course of a year, the gallery program attracts another 23,000 each year, including adults.

**The artist as teacher**

Every teacher at the center is an artist with his own way of teaching. Some days he will be ''up''; others he will not feel like teaching. Occasionally he will be late to class because he has been up all night doing his own work; then again he may come very early in order to create an environment for his students.

Such are the hazards of hiring artists. The students—especially the teenagers—seem to understand because they, too, are seriously involved in what they are doing. (Younger students come accompanied by parents who tend to worry about time schedules.) Instructor Eric Orr states the case for the artist-teacher as contrasted to the professional teacher:

After the third class you are probably ad-libbing the situation. Maybe driving into work that day you don't have any idea what you are going to do. If you have had enough experience at it, you have no anxiety about that, which is a very important aspect.

The center's architectural rigidity inhibits the exchange of ideas between students, and the melding of one medium with another. It also limits the influence of young students on teenagers and vice versa. But teachers get around this structural impasse by creating classes that will encourage communication. Mrs. Deussen taught a class of adolescents that prepared a treasure hunt for a group of younger children; each of her students made up clues, hid objects, and presented his conceptual piece to the five- and six-year-olds as a gift. Because the City of Los Angeles owns minivans that can be borrowed by city employees (the Junior Arts Center artists), teenagers can explore such wonders as the J. Paul Getty Museum, an elaborate marble palace at Malibu Beach, and the mosaic spiral towers of Simon Rodia in Watts (see accompanying box).

Students at the Junior Arts Center create art. The production of art is not the only emphasis, however; communication about art, ideas, and the environment is of equal importance. One artist-teacher has said,

The place which I feel sets up the tone for the whole class is the beginning of the class. . . . Maybe when you walk into the class, you will see something in the classroom. Your eye will pick up on a piece of paper that will trigger a whole information structure that you will apply to that kind of

---

## A Visit to Simon Rodia's Towers

It was hot and mucky in Watts. The students arrived, looked around the famous garden of tall spirals with their mosaics of tile and glass, and sat to rest on a cement bench.

**Deussen:** Why do you suppose Simon Rodia created these towers?
**Students:** He was lonely. He wanted to keep busy. He wanted to express himself.
**Deussen:** Those are probably all correct reasons. Rodia's wife had left him, and he was trying to fight alcoholism. See all the pieces of 7-Up bottles!
**Students:** Oh, he drank 7-Up instead of whiskey. How did he find all of those tiles?
**Deussen:** Rodia was a tilesetter. These were probably pieces from jobs he was on.
**Student:** How did he build so high?
**Student:** He would let one layer dry and then construct on it.
**Student:** Look where he pressed hammers into the cement.

**Deussen:** And cornbread pans and objects we find in every home. Do you see any other shapes you recognize? Look at the shapes of the towers.
**Student:** It is like a ship's tower.
**Student:** Or the power lines.
**Deussen:** Yes, most people say it was the influence of the power lines. There was an architect in Spain whose buildings are very similar to this—Antonio Gaudi. No one knows if Rodia ever saw Gaudi's work. I will show you a film of Gaudi's Sacrada Familia Cathedral when we return to the center.
**Student:** Why is it so full of designs? There is no space.
**Deussen:** This is called fear of vacuum. We often see this tendency among untrained or primitive artists. Do you remember something called psychedelic art, posters from the Filmore Ballroom in San Francisco?

situation. Or maybe a kid will make a comment when you come in the door, and you will say that is a great idea. We will do that today. It is being able to handle those situations on an immediate basis that I think differentiates an artist as a teacher from a person who has gone through teacher training. The structure gets in the way. Teaching is a dynamic situation where you have to be able to involve all kinds of subtle things.

The artist-as-teacher is essential to the purpose and work of the Junior Arts Center. The artist's sharing with his students his own creative spirit and the influence of the Los Angeles environment on his perceptions is all-important, as Robert White and Claire Deussen recognized. (White: ''I think back on my own education; although you remember some formulas that you use all the time and some books, God, the people were the most significant things.'') One artist-teacher commented,

The most important ingredient of the art experience is the tone or the attitude that the teacher sets up or the person who is ostensibly in the room to guide the students. Let's say those shepherds or guides can make all the difference in the world. The main thing to me is if a kid ends up really hating art or falls in love with it. So what you are doing in art is setting up a romance. Setting up a romance, like in all things, is a very tenuous affair and has to be done very delicately. In that kind of respect, someone who has never had that romance or is viewing it as a job does not have a vision or is not working on their own vision. It is very hard for that kind of person to impart that kind of feeling to a group of kids. That may be one of the big differences between the artist and the ordinary teacher.

## Teaching the visual arts:
### different teachers, different ways

The one-time visit always poses a problem. Take those school groups that are bused to the center from the Los Angeles city schools for a single two-hour art lesson (the Friday program). To achieve anything of lasting value, the teacher must establish an immediate and illuminating rapport. ''What do you do with a group of elementary-school children for two hours once in their life span?'' Claire Deussen asks, and then gives one answer:

The children come in and sit down very quietly around the table. Each one has a pencil and a piece of paper about two inches square in front of his seat. [Cathy] Herman talks to her class in a very quiet voice: ''How many of you remember what it was like to be a baby? What are babies like? Let's go back to our beginning when we were all born.''

The class giggles; no one remembers when they were born, but they remember their baby brothers or sisters. ''What do babies do?'' ''They cry; they pee; they take a lot of mother's time; they just lie on the mattress.'' After this initial exchange, each child is asked to draw himself as a baby. The drawings are usually a stick figure or an organic

turtle shape. The teacher looks at each child's drawing as she walks around the room. She asks each child his name and the age, which she writes on the drawing. The teacher is making contact with her student. This is repeated with various sizes of paper; and each time the drawing gets larger as the child gains more confidence.

The third drawing is of the child when he started school, and the medium has been changed to charcoal. As the age and paper size progresses, the concept of negative and positive space is introduced. Here they might look at the shape under the arm or between the legs and begin to work from light to dark. Each age results in a bigger and more sophisticated drawing ending with a large sheet of paper (24'' x 18'') on which the child pictures himself as a grown-up, using watercolor. As the children leave the Junior Arts Center, they are carrying a portfolio of two hours' work in pencil, charcoal, and watercolor. No one said that they couldn't draw because anyone can make a mark on a teeny piece of paper.

This artist has been teaching children for 30 years. She believes that unless children make connections between their own lives and their art, between art and nature, art will be an empty exercise. How can a teacher help forge these connections? For one thing, Cathy Herman teaches drawing classes at Pierce Agricultural College so that children can see, touch, and smell the animal that they are drawing.

She also teaches a series of classes called Drawing and Cooking. Children draw a still life of vegetables, dissect the vegetables for a soup or stew, make a recipe book, and sometimes draw pictures of the cooked food. The food is shared with other classes at the center. In an age when children have little to do with preparing family meals, these classes provide a novel experience. And for children from poor communities they connect art with something as basic as food. The students do not play with the food. They study the shapes of the raw vegetables, draw these forms, copy a recipe, and work together to combine these raw ingredients into a meal for themselves and their friends. Beets become borscht; flour, salt, sugar, eggs, and milk become a cake; carrots, celery, and rice become minestrone. This is a lesson in nutrition and ethnic cultures, as well as drawing and cooking.

At the Junior Arts Center, students learn to see and to think as they draw and paint. A teenage class was invited to sit among some trees by the creek that runs through Barnsdall Park, and to think about themselves in the landscape. They breathed deeply, closed their eyes, and considered such questions as

What kind of landscape is this?
How does it feel?
How does it smell?
How do you feel in it?
What do you want to say about it?
Can a landscape say something?
Then, after studying reproductions of Wyeth, Constable,

van Gogh, Utrillo, Cézanne, Vlaminck, and Boudin, they talked about their response to these landscapes and about what the artist was communicating. Closing their eyes again, they imagined themselves walking around inside the pictures. Next they examined them to determine how each artist had used brush strokes, colors, design, to project his feelings and thoughts. Finally they took Polaroid photos of aspects of their own landscape that interested them. Back at the center, the students began to draw and paint landscapes, aware of the subjective quality of their work and of the many ways to convey their own responses.

Ideas are exchanged and expanded by the Junior Arts Center teachers, ideas that worked and ideas that did not work. The classrooms exhibit the evidence—exciting ideas like huge collage murals using billboard paper, giant scissors, and structures of sponge rubber, or a floating city constructed of styrofoam bales and popsicle sticks as well as such routine projects as cardboard boxes decorated with felt-pen designs.

Can you measure the experience of making art by the product? One day brown tubes were walking around the center. These were, in fact, cylinders of corrugated cardboard wrapped around young children. What is the value of wrapping a kid in cardboard? If it is not a work of art, it is a means of discussing space, of understanding sculpture as a three-dimensional form standing in space. The children experience themselves as objects contained in a defined area; they love becoming sculptures.

Clay has been a medium of creation since the beginning of time, a link between twentieth-century artists and prehistory. The Junior Arts Center still wonders about clay in the computer age, especially the magic in taking a hunk of anything and transforming it into an image of the mind. A child tends to flatten clay into a pancake. But clay is a sculptural medium. If the artist-teacher wants his students to build up forms, what does he do? One teacher at the center solved this problem by getting a class of five- and six-year-olds to concentrate on animals. He talked with them about circuses and zoos and pets, with the single but precise goal of getting them to make pieces that would stand up. Cookies are flat, yes. Are animals flat? No. Ultimately the children got their quondam cookies into the third dimension.

Another teacher capitalized on the predictable flat shape, and had each student fit it into a paper plate. Then she had them all roll out coils and construct slab forms to build on this base. If the plate remained a plate, the child might build a hamburger on it, or a chicken leg, peas, and mashed potatoes, or tacos. Others, however, using the flat clay shape as the Dodger Stadium, a space station, a freeway interchange, or Barnsdall Park, created landscapes.

Printmaking and photography—art forms that require exacting discipline and technical proficiency—exemplify a Robert White dictum about one value of the arts: "The hardest thing for young people today is to know that something really good takes a hell of a lot of work. It does not come out of a cellophane bag ready-packaged." The Junior

Arts Center's etching department is fully as professional as any college's; preschoolers through teenagers learn to etch using a zinc or plexiglass plate. Photographs by teenagers—excellent silver-image prints distinguished by strong imagery—are often exhibited in the JAC gallery or reproduced in the center's brochures.

In the busy etching studio teenage students are drawing, etching, wiping, and printing plates. Their exchange of ideas and techniques sounds like a discussion among professional artists, as well it might. Some have been studying at the center for five years; some have exhibited in Los Angeles galleries; others have sold their work.

What has led to this interest in printmaking? Libby Chaney, a printmaker whose life is devoted to her art, has taught printmaking at the center since it opened and communicates her devotion and standards to her students. In teaching students the steps to follow in etching and the qualities of a good print, she emphasizes technique ("I sneak in the aesthetics").

One successful printmaking class combined a wide range of ages—eight- to fourteen-year-olds. Teenagers are usually hesitant to start a plate and self-conscious about what to draw. Eight-year-olds, in contrast, will jump right in but lack the attention span and discipline to follow through. Learning from each other, the young children encouraged the teenagers to start a plate and to try an idea, and the teenagers set the young ones a model to emulate so that they completed their prints or tried again.

## Out of the park and into the schools

The Junior Arts Center conducts limited operations away from home base, chiefly at the public schools. (An experimental hospital project and others focusing in the parks did not, for various reasons, work out very successfully.) With 640 schools in Los Angeles and little funding available for in-school activities, the JAC must be highly selective in the schools it visits. The chief criterion is clear evidence of ability and enthusiasm to carry on an art program beyond the one-time experience offered by the center artist-teacher.

Not surprisingly, working in the schools presents problems. Mrs. Deussen believes that a great deal of energy goes to waste unless both institutions back up the program "administratively and morally." Often the situation is awkward for both the public schoolteacher and the JAC artist-teacher. One solution has been to undertake something fairly dramatic, such as a mural painting, a project popular in California schools. Children like to paint murals, and their elders, at home and in school, are usually glad to see an old school building brightened up.

Sometimes the Junior Arts Center encounters unexpected complications when it agrees to mount a mural-painting enterprise. Claire Deussen describes one such occasion:

There were some wonderful spinoffs. When they first started painting, some of the youngsters said they would like to paint the pavement around a tree planted in the

patio, and they selected red, white, and green, and it looked very delightful. This is a school where a lot of parents and grandmothers tend to spend their time sitting in the playground of the school during school hours, and these old Chicano ladies were quite upset because they felt the children had desecrated the Mexican flag—you see, red, white, and green.

The children were very understanding and decided maybe that wasn't the thing to do, and rather than offend these older people they changed the color scheme, and then they decided it was also an improvement. This particular school ended up with murals, each one of which is very reflective of the age level and art ability of that grade level. It is almost a manual of a development of their skills in art, which is quite delightful.

We ran into some problems with the kindergarten children because they got very turned on and they kept going and going for two hours. They were rolling paint and painting in this very beautiful kind of five-year-old abstract expressionist painting that they did, and some of the people in the community wandered by and felt that the school board should have painted their school, and we shouldn't have sent five-year-olds in to do it, and we were really insulting them and their children.

There was quite a to-do about this. We lost on the school ground, but we won in the coffee room as we talked more and more to the teachers. [We talked] about what [happens to] the child when he himself creates something, what is real direction with the child, and what is real censorship of what he attempts to do. [We reminded them] that nothing is permanent, and they don't have to feel that somehow it is a reflection on them when the child does what he is ready to do at a certain age. [We said] there is no difference between kids painting on a paper and painting on a school building, no matter what they seemed to think. . . . [We also pointed out] that art is not necessarily only valuable because it develops social cooperation.

We feel that we not only left the school with some beautiful murals, but we did change attitudes among the teachers, the principal, and the community about what art in a school could be. As a result of this, the art coordinator for this particular area in Los Angeles also realized that he has to come and do a lot of follow-up work with the teachers and parents in terms of what art education is and what the value of art is in the child's life, so we stimulated a lot of activity there.

Murals are not the only answer, of course, and it is possible for an artist to make himself *persona grata* even to a suspicious or hostile schoolteacher. Here is the way one JAC artist-teacher, who was not sure he would "last ten minutes in a public school," describes his technique:

I've done these kinds of nomadic gestures. The first thing the teacher finds out is that you get along with the kids real good, and they get real upset because maybe they are not doing such a good job with the kids. So you have a little jealousy going on with the teachers. When I go into the public schools, I usually try to work out a good relationship with the teacher first so I get all my bases covered. And then going along with that, simultaneously, is working with the kids—because if I estrange the teacher she is going to badmouth me when I leave or badmouth the situation, which will set up a negative influence, and that gets back to setting up the proper tone, ambience, milieu. So I become very aware, if I go into the public school, that all lines are set out. I'll say whatever they want to hear to set them at ease. I say that I'm taking all responsibility for the situation so that they aren't responsible. That will usually work out.

This particular artist devised a program called "Kite Day." First off, on an appointed day before school started, he would meet with a number of the schoolteachers and teach them how to make a tetrahedron kite—simply and inexpensively with tissue paper, straws, and string. Then he would go into each classroom for a half-hour at a time, where he and the teacher together would teach the children this skill. Returning a week or two later, the artist would find the children with their kites ready to fly. Lo, Kite Day could start. As the JAC's director has said, all this may not make "a long-range change in terms of 'art education,'" but it is a memorable event.

### The gallery program

The center's policy is, in general, to mount exhibitions done with, for, or about children. JAC's art curator feels that the gallery program should involve the students in some sort of excitement that will bring them back to the center. "We create our own museum because we are not a museum," says Claire Deussen. (Not that more conventional exhibits are excluded: in 1973/74 there were exhibits of staff work, student work, Chicano painters, Los Angeles photographers, and American Indian art.)

Exhibits have included "Tube City," an environment built of Sonoco tubes (cardboard cylinders used as storage tubes and for construction forms). Children could climb, play, and create their own cities. During White's directorship, many spectacular exhibits were put on, including the sound tunnel, the anechoic chamber, and "COLA" (Coherent Light Art, with Lasers). The schedule, however, was erratic. These days 13 exhibitions a year are organized by the Junior Arts Center gallery.

"The Word Show," January through March 1974, was a cooperative venture of the staff artists and the gallery's curator. The result was a wild and educational exhibit based on the origin, form, perversity, and delight of words. It was full of verbal and visual puns, jokes, riddles, and images. For example, from Groucho Marx,

Outside of a dog, a book is man's best friend because inside of a dog is too dark to read.

The exhibit's organizers wanted to make children aware of language, of words in combination, and of the sound and

shape of words and letters. If skywriting was impossible, a scarlet letter slide was not. Children could become part of the letter A as they climbed up one side and slid down the other. Ideas to engage children's enthusiasm ranged from a giant scrabble board to a large photomural of an ear to whisper into and a mouth equipped with a playback echo chamber so you could hear YOURSELF, Yourself, yourself. There were exhibits to play with and exhibits to learn from.

Word-vending machines responded with a noun, a verb, an adverb, a number, an adjective, and a preposition that were magnetized to become sentences and poems on a wall board. Visitors could hear onomatopoeia through earphones, or they could use a printing press to emboss words and letters. Special visitors even received a fortune cookie with a poem hidden inside; classes formed letters from bread so they could eat their words. Enhancing the exhibit were all kinds of displays—the evolution of alphabets, Oriental calligraphy, pictographs, hieroglyphics, Morse code, Braille, hand language, and word art by Ruscha and Corita. Entering the gallery, the visitor was confronted with a giant YES saying

**Trying on a "Q" for size, a small visitor to the Junior Art Center gallery's "Word Show" discovers the delights of the soft-letter corner. One purpose of the 1974 exhibition was to make children aware of the shapes of letters and words.**

welcome and have fun at the Junior Arts Center gallery.

"Wallnuts," which followed "The Word Show" in spring 1974, was a quite different but also unusual exhibit, responding to the schools' fondness for murals. As the JAC could bring its excitement and expertise to so few schools, perhaps it could mount an exhibit-demonstration that would tell schoolteachers and their students about historical and contemporary murals, and about media, composition, and aesthetics. The center's sensible position is that you do not just stand children, any more than adults, in front of a blank wall and say "Paint it." Whence, "Wallnuts." The center's gallery became at once an artist's studio and an exhibit. Whereas "The Word Show" in its two-month run had an audience of some 12,000, including school tours and adult week-end visitors, "Wallnuts" played to a much smaller number, but all of them participants. Over a month's time, 10 to 15 youngsters per day from selected schools came to the gallery to study the exhibit and develop a full-sized mural cartoon for their own schools.

The gallery displayed art books and slides of murals to inspire the students. They could watch an artist-teacher paint a fresco, using the ancient techniques of Pompeii and of Michelangelo. The gallery curator executed a mosaic mural. A local ceramic company supplied tiles, both unglazed and glazed.

What do you need to create a mural? Paint, either acrylic or fresco, mosaics of tile and wood, a collage, a construction. Gallery visitors could see all these possibilities as they wandered through "Wallnuts." On hand were three bins of wood scraps that could be combined to create a wood mosaic wall panel, and four-sided easels with paint and drawing materials ready so that the children could paint or sketch pictures that would become part of a mural (see accompanying box).

"Fifty Inches Off the Ground" began by having children in six geographically diverse schools look at their environment and produce art about it. The results—demographic studies, maps, stories about walking to school, and sculptures of neighborhoods in paper and other materials— were displayed at the Junior Arts Center gallery and circulated to the participating schools. The original idea for the project, as its title suggests, was to encourage the child to express his world as he perceived it, and to show teachers and other adults what the world looks like if you are 50 inches tall. It turned out, however, to be less an exercise in perception than a demonstration of what elements of his environment a child chooses to depict. Thus, the kids from a housing project refused to make models of their homes, whereas all the other kids did. Some students revealed their fascination with the high-rise buildings of the Wilshire corridor, some with sleazy motels and guard dogs, some with oddly shaped swimming pools and with dump trucks. *All* the children included fast-food purveyors in their constructions.

The next exhibit for 1974 was to be about artists, with Ron Cooper, Dewain Valentine, and Eric Orr sharing their ideas and their childhoods with the Junior Arts Center students.

The idea is to establish a level of empathy and communication between professional artist and student artist, to relate what artists experienced as children, and what they do as internationally recognized artists today. In the curator's words,

> Everyone figures that an artist springs fully armed ready to be an artist at any age, but it is not true. You have to go through a learning process. You have to go through a system of doing things and not knowing why you are doing them and not even thinking about being an artist or possibly a system where decisions are made to do art as a career and act in accordance with their early decisions.

> Ron Cooper cleaned out his closet at [age] 14 and made it into a studio and spent the next five years there. Dewain Valentine did art as a kid. His grandmother saved all of his work. He'll make slides of it, talk about it, and relate it to the whole system of when he decided to be an artist. What were the things that prompted him to become an artist?

> These things are essentially no different than when a kid takes a course at the Junior Arts Center. Eric Orr just lives out of his pocket. He is going back to re-create the ideas he had growing up, because he did not even think about art until he was in high school.

### The now and future center

"The Junior Arts Center has gotten a lot tighter with materials," a student observed in 1974. But he added, "I still think it is probably one of the best things around." This would seem to be a fair judgment of the center after seven evolutionary years.

The Robert White years were the first phase—"the dream"—and the administrative and other organizational reforms of Claire Deussen, from 1970 on, the second phase.

Phase one reflected the expansion that liberal funding made possible, as well as high expectations for experiments in art and programing in the Los Angeles community. Phase two reflected the gradual but inexorable cutting back of funding for the arts and education, the growing tendency of city officials to see the center as a luxury, and also the realization by the seasoned staff that not everything they tried, however exciting, worked.

There is seemingly no end to the improvements and expansion that the center's well-wishers, both insiders and outsiders, would like to see in Barnsdall Park. More original works of art, for instance, including some major sculptures. More circulating exhibits ("The Word Show," for instance: schools and libraries throughout the Los Angeles area might have welcomed this exhibit, or components of it, in suitcases that the institutions could borrow). Wider distribution across the country of the center's good ideas ("Wallnuts," for instance: might not museums everywhere be interested in the concepts of this studio-exhibit program in the making of murals?). Greater efforts to work with the public schools, more intensive interchange between the JAC artists and the students and teachers in the schools. Should the hardworking artist-teachers have sabbaticals so they can make their own art? Should they be given time to see people and programs elsewhere in the country, and time just to brainstorm at the center? What about inviting a guest artist to the center each semester to bring in fresh ideas about combining children and the arts? And could the JAC staff better reflect the ethnic diversity of Los Angeles?

Perhaps the most perplexing questions arise from the basic problem of how the Junior Arts Center can sustain its reputation as an exciting place for children to make art and at the same time fulfill what some see as its responsibilities to the

### Wallnuts—Learning to Make Murals

After visiting the Junior Arts Center and seeing the exhibits and demonstrations, the children taking part in this project to make their schools more beautiful returned to school.

At each one they recorded the dimensions of the wall to be painted. A Polaroid photograph was taken of the wall in order to remind the students of the shape and size of the area they were going to paint.

Back at the center, each class group was divided into two so that only 10 or 15 children would be working on the mural project at one time. Children painted on small pieces of paper while standing at the easels. In some cases, the school had an idea for a mural theme. In others the children were free to paint all kinds of images—flowers, figures, sun and stars, anchors, hearts, and Snoopy dogs.

Showing these drawings on a screen by means of an opaque projector gave an idea of the scale necessary to cover a wall. As each image was projected, it became dramatic. The mural was composed by projecting images on the wall. Children outlined their drawings and assisted each other with the drawing and composition of the

mural. Some made shadows of themselves that were outlined to become part of the mural. When completed, the outlines were filled in with watercolor and tempera, often changed in the painting process. Collage elements were introduced to some of the murals with billboard paper.

As the mural began to take final form, all this experience at the Junior Arts Center gallery prepared the students to start the mural at their school. It showed their teachers and parents a method for starting a mural, convinced administrators of the mural's importance, and gave everyone involved ideas about murals.

So with various tools—pencil, paint, collage, slides, and projectors—they started the picture. Together with JAC staff, they looked, thought, and talked about the mural. Did they like it? How should they change it? They mixed colors, moved from line drawing to form and considered the importance of the background and negative space. "This was really an education those kids will never forget," says Mrs. Deussen.

children and teachers in the schools of Los Angeles. (The problem, obviously, has analogies in questions facing museum educators.) On this matter, as might be expected, there is strong conflict among the center's artists. Should they extend beyond the center, or should they concentrate their energies on programs at the center? What *is* the Junior Arts Center's responsibility to the City of Los Angeles? Is the center too confining? Or if it tries to serve more of Los Angeles, does it not risk spreading its artistic energies too thin? There are no clear-cut answers on the best use of the center's limited funds and resources. City budget analysts question whether the JAC should play *any* role beyond its doors, and stress the need to use the building to its maximum. Yet most staff members feel the need both to strengthen their home base and to reach out into the community.

Mrs. Deussen recognizes the center's multiple problems, and is trying (in conjunction with the steering committee, composed of staff members and trustees) to clarify the JAC's role and decide where it should go from here. Even if budgetary constraints were relaxed, there seems to be a working consensus to this effect: drastic expansion would destroy the very qualities that distinguish the Junior Arts Center, and so the best course is constant improvement of the Barnsdall Park programs and greater dissemination of the center's imaginative and successful experience in art education. One practical and not too costly application would be the addition of a mobile art van, a plan under study in fall 1974. Without sapping the vitality of the center itself, such a project could enhance essential two-way interchange between staff and community.

Probably the only adequate (if decidedly unrealistic) solution to the basic problem underlying all the questions that beset the JAC is for Los Angeles to set up additional junior arts centers to serve more of its far-flung communities. Short of that ideal, the JAC is trying to work out its own destiny and strike the best balance among the options available. The center seems to be entering phase three, according to Mrs. Deussen. In her words,

> It is a phase of regenerating its strengths to make it viable and relevant as well as accountable in the tight-budget 1970s. The increasing closeness of staff and board of trustees was exemplified by a retreat at Del Mar. Finally, out of a long list of both improbable and realistic ideas, a few major goals were determined to be worth really fighting for.
>
> The board began to see its greater role in community contacts for funding, and the staff for working on realistic programs which could find noncity funding. New horizons have begun to appear as foundations, corporations, and private donors are being approached. The values as well as the problems of matching local, federal, and state funding are better appreciated. The responsibility for finding outside help is no longer seen as something which can be put off until tomorrow while city funds come in.

A mutual respect between staff and board (along with the Friends of the Junior Arts Center fund-raising group) has gradually replaced a long-standing distrust. The board and FOJAC have declared that it is not their place to create the center's programs, but to assist in sustaining them, while the staff turns with greater assurance to the board for meaningful support of all kinds. If this atmosphere can be maintained, the center will present a strong face in gaining the much greater outside help it requires to continue the kind of program for which it is known.

—*E.S.C.*

## Notes

[1] For sources of quotations without footnote references, see list of interviews at the end of this report.

[2] Kenneth Ross to Claire Isaacs Deussen in 1967, from interview with Mrs. Deussen, August 8, 1974.

[3] Robert O. White, *Junior Arts Center at Barnsdall Park* (County of Los Angeles, 1967), p. 5.

[4] The *Irregular Bulletins*, which can be found in the files of most U.S. art museums, were published by the two nuns beginning in the early 1950s—first in anticipation of, and later on the crest of, the liberalizing spirit of Pope John XXIII. The bulletins were early precursors of the *Whole Earth* catalogs, appearing first as a collection of cutouts meant to turn Catholic girls on to the visual arts. Issued sporadically, they became popular underground literature and soon had bulged out to as many as 100 pages.

The two women worked out of space they had "liberated" in the basement of a Los Angeles fire department, which, as one museum director described it, they turned into "a fairyland of junk." From these headquarters they launched a mission on behalf of the arts and humanities that took them all over the world and that attracted back to their basement lair such artists as Henry Miller, Robert Motherwell, and Ben Shahn. One of their causes was Watts Towers, which they helped to save from the wrecker's ball. Another was the art of silk screen, which their admirers credit them with giving an enormous boost in this country.

[5] White, *Junior Arts Center*, p. 5.

[6] Ibid.

[7] Ibid.

[8] "History of the Junior Arts Center" (mimeo. 1970), p. 3.

[9] *Junior Arts Center*, p. 6.

## Interviews

The author of this report, having followed the organization since its inception, has talked to a number of staff members and participants and observed many of the center's activities over the years. Those persons listed here were interviewed specifically for this publication.

Deussen, Claire Isaacs. Director, Junior Arts Center. August 8, 19, and 29, 1974.

Labyorteaux, Ron. Art Curator, Junior Arts Center. August 19, 1974.

Orr, Eric. Art Instructor, Junior Arts Center. August 14, 1974.

Ross, Kenneth. General Manager, Municipal Arts Department, City of Los Angeles. August 30, 1974.

Silberman, Sabin. Student, Junior Arts Center. August 28, 1974.

White, Robert O. Former Director, Junior Arts Center. August 28, 1974.

Wyles, Libby Chaney. Printmaking Instructor, Junior Arts Center. August 28, 1974.

## Bibliography

Deussen, Claire Isaacs. "Report on Junior Arts Center," June 29, 1974.

Johnson, Beverly Edna. "Playing with Words," *Los Angeles Times Home Magazine,* March 3, 1974.

Sutherland, Henry. "The Strange Saga of Barnsdall Park," *Los Angeles Times,* March 15, 1970.

White, Robert O. *Junior Arts Center at Barnsdall Park.* County of Los Angeles, 1967.

"History of the Junior Arts Center" (mimeo), 1970.

Grant application, *Fifty Inches Off the Ground,* California Arts Commission, February 2, 1974.

# GAME,
# A CULTURAL RESOURCE CENTER

GAME, Inc.
260 West 86th Street
New York, New York 10024

**A resource center that operates out of a basement storefront on Manhattan's Upper West Side was ingeniously transformed into a functional multifaceted workshop for children, teachers, and community. GAME links some 2,000 schoolchildren and their teachers to city museums in extensive and intensive programs. CMEVA interviews and observations: April 1974 through June 1975.**

## Some Facts About the Center

### 1. General Information

Founding: Incorporated in July 1973 as GAME (Growth through Art and Museum Experience), Inc.

Collections: Natural artifacts (fossils, bones, geodes, shells) from the American Museum of Natural History and artifacts from the museum shops of the Brooklyn Museum, the American Museum of Natural History, and the Metropolitan Museum of Art.

Number of paid staff: 3 full-time, 12 part-time.

Number of volunteers: 28.

Operating budget: $100,000 in direct support and in-kind services (1974/75).

Education budget: All of GAME's activities are educational.

Sources of funding: Rockefeller Brothers Fund, New York State Council on the Arts, New York Community Trust, Museums Collaborative, National Endowment for the Arts, the Edward John Noble and other foundations, New York City Board of Education, Manhattan School District 3, and Manhattan Public Schools 9, 166, 84, and 75.

### 2. Location/Setting

Size and character of the city: New York City, with a population of 7.9 million in a standard metropolitan statistical area of about 15.5 million, is the nation's leading industrial and commercial center. Its five boroughs boast 42 museums, plus many parks, zoos, botanical gardens, theaters, and concert halls. Its educational facilities include 6 universities, 23 colleges, 976 public schools, over 1,000 private schools, and 199 public libraries. Climate: Seasonal.

Specific location of the center: A double storefront basement on Manhattan's Upper West Side. (GAME staff members sometimes work in the public schools and give workshops for teachers and other professionals at colleges, museums, and other locations. Some special events are held in city parks.)

Access to public transportation: Excellent. The center is close to the IRT Seventh Avenue subway and the 86th Street crosstown and Broadway bus routes.

### 3. Audience

Membership: A membership program, open to the public, was being planned when this report was researched. Fees were to be graduated from $10 to $25 a year.

Attendance: In 1974/75, formal programs served about 2,200 schoolchildren, 100 school professionals and paraprofessionals, and 100 adults. Several thousand more children and adults participated in community projects and special events.

### 4. Educational Services

Organizational structure: GAME is governed by a board of directors (three principals from local public schools) assisted by a board of advisers (heads of parents' organizations, educators, artists, community leaders). The director is responsible to the board of directors, and other staff members to the director.

Size of staff: 3 full-time, 12 part-time, 28 volunteers.

Budget: $100,000 (1974/75).

Range of services: Publications—*Art and the Integrated Day* (50 pages, biannual), documentation evaluation, curricula folders, calendars of events, newsletter (published three times a year), books by children for children *(Song of Myself; Signs Symbols and Alphabets)*—day program, after-school program, adult evening center, whole school programs (banner-making workshops, quilting bees), free Saturday afternoon films for children, in-service and pre-service courses for teachers, museum visits, cosponsorship of museum special events, community projects.

Audience: In 1974/75, the day program served some 2,000 schoolchildren (grades 1–6) and over 100 teachers, student teachers, and school paraprofessionals; after-school program, about 200 children from local schools and community; adult evening program, about 100 neighborhood residents; community projects and special events, several thousand children and adults, mostly from surrounding community.

Objective: GAME's primary focus is as an arts, media, and cultural resource center for students and teachers at four local elementary schools. Workshops and programs at the center are designed to tie into school curricula and collections and programs in New York City museums.

Time: All programs run from September to June. Day program, Monday–Thursday, 9 A.M.–5 P.M.; after-school program, Wednesday, 3–5 P.M.; adult program, Wednesday, 7–9 P.M.; community projects and special events, no specific schedule.

Information and documentation available from the center: *Art and the Integrated Day,* biannual magazine; newsletter (published three times a year); curricula folders; *Song of Myself* and *Signs, Symbols and Alphabets* (books by children for children); Super-8 films.

Unlike many snappy acronyms that are tortured into being, "GAME" is not only an expressive nickname for the enterprise in question but a short form that explains the enterprise quite precisely: Growth through Art and Museum Experience. It was to foster such growth that GAME was founded in 1972. The children who form its major constituency appear to find the project a game that is fun as well as serious and rewarding; so, it appears, do most participating schoolteachers, interns, student teachers, museum educators, and community adults.

Broadly considered, GAME embodies the diverse efforts that have been made down the years to engage children actively in art and, one way or another, to connect their own work with the arts and crafts of museums—to do something, in other words, to give the world of museums a meaning and interest for children that the assembly-line group tour so signally fails to do. (GAME, incidentally, though it stresses arts and crafts, also is concerned with nature, history, and science, using then the resources of appropriate museums.)

Brought into sharper focus, GAME is one of a dozen or more so-called cultural resource centers in New York City, five of which began life loosely linked through a protean, quasi-public organization known as Museums Collaborative (see chapter 4 for a report on the Collaborative and a fuller discussion of its role with respect to the resource centers). All five put special stress on the museum connection.

## Background: GAME's tie to the schools

The other four centers are part of the school system, housed in board of education buildings and staffed primarily by schoolteachers. GAME, on the other hand, operates out of commercial premises—the basement of a double storefront on Manhattan's Upper West Side. And although the school system provides some support for the center's activities (in-kind services in 1972–1974 and about 15 percent of the $100,000 budget in 1974/75), the bulk of GAME's funding comes from foundations and other sources. Nor are all of the center's clients public schoolteachers and children: there are adult evening programs, an after-school program for any and all neighborhood youngsters, and special events, often co-sponsored with museums, that are open to the public.

GAME is unique among the cultural resource centers in other ways. From the beginning, classroom teachers, parents, school administrators, and community leaders have been involved in preparing and developing the project. In 1972 its founder, director, and moving spirit, Bette Korman, approached her principal at Public School 75 with a simple question: "What about sponsoring a center?"[1] She was by then a six-year kindergarten and 1st-grade teaching veteran who has described the "weight of her life" as "developing creative work with children"—and she was tired of "dragging art materials" in and out of her classrooms.

The principal, Luis Mercado, not only agreed that it was a good idea but also offered to write on her behalf to other principals in nearby schools. By 1973, GAME had incorpo-

rated, found its space, formed a board of directors (three principals from local schools) and a board of advisers (heads of parent organizations, educators, artists, community leaders). In mid-1975 the staff, besides Ms. Korman, included 2 full-time, 12 part-time, and about 30 volunteer members.

The day program, which serves children and teachers from four elementary schools in the local district,[2] is at the heart of GAME, comprising three 12-week sessions (or trimesters) over the school year. A total of 18 classes from the four schools took part in 1974/75, 8 classes during each cycle. Working with museum educators and the classroom teachers, GAME's staff has conducted sessions on a range of themes, all reinforcing the school curriculum and drawing on museum resources—colonial America, for instance, a theme that produced among other things a six-foot cardboard boat inspired by workshops at the South Street Seaport Museum; ancient Egypt, which generated books, plays, masks, a pyramid and shrine, all made after explorations of the Metropolitan Museum's extensive Egyptian collection; New York City, which augmented close study of an Upper West Side block with visits to the New York Historical Society and the South Street Seaport Museum and led to scale-model drawings, photographs, and taped interviews.

GAME perceives teacher training as an integral component of all its work. The projects that the children undertake at the resource center are not only planned cooperatively but also—in principle, at any rate—carried over into their classrooms after the GAME session ends. Occasionally during the course of the session, one of the regular weekly workshops takes place in the school, with GAME carting staff and materials right into the classroom.

## The world of GAME

Once down the nine steps to the basement on 86th Street near Broadway, the visitor finds himself through the looking-glass and into a wonderland—a kind of Santa Claus's workshop, to mix the metaphor. Here, in a space of roughly 25-by-100-feet, are, for starters, a small amphitheater (four tiers high, curving around the corner near the entrance) and several "activity" centers, appropriately equipped, decorated, and labeled—"Weaving Center," "Printing," "Clay Works," "Nature and Design," "Non-Darkroom Photography," "Photography," "The Ocean Cradle," and "Treasures of the Earth." Each unit is self-contained; it includes tools, work and exhibit space, books, and even storage.

All of this and more occupies the larger of the two converted storefronts, which was previously a florist shop. The narrower one to the west, once a Chinese laundry, now houses a minute office at the rear, and in front a gallery wall, a coatrack that is also a mural, and a small homemade fountain. The checkerboard floor was found under layers of grime and restored. The walls are shiny white, with accents of light blue, green, and orange. Despite the profusion of mobiles, maps, charts, botanical drawings, children's art work hanging from walls and ceilings—to say nothing of ferns, stuffed

A Santa Claus Workshop: GAME's 25-by-100-foot space is built around a small wooden amphitheater on which children gather before and after each workshop session—first to hear the program plan, later for "sharing time." The checkerboard floor of the basement storefront was found under layers of grime and restored.

birds, giant shells, and fossils on pedestals and shelves—there is a remarkable absence of clutter.

**A class visit.** Then the children arrive. As GAME deals with a different group each morning and afternoon, four days a week, it would be idle to characterize any single session as typical. But here is what went on, from one visitor's view, on a February morning in 1975.

The weaving center contains looms, materials, examples of textiles and baskets, instruction charts, and vocabulary guides. Clutter is kept to a minimum, and several children may use the work area at the same time.

Twenty-nine children—a bilingual, combined 1st and 2nd grade—arrive with their teacher and her aide. The GAME staff—Director Korman, an assistant, two student interns, an "executive high school intern," a "resource person" (textiles)—awaits them. These children are fair veterans: it is the sixth of their 12 weekly sessions, and the 2nd graders had been to GAME the year before.

First they range themselves among the cushions on the little grandstand, listen to a soft-spoken greeting and program plan from Ms. Korman, and then head for their particular projects. This class is building its various works on the subject of Venezuela. (In general, the children are allowed to float around for the first visit or two, then by the third visit are introduced to a theme.) By this sixth meeting the class had already visited two museums to enrich its knowledge and understanding of Latin American life and culture—the Museum of Natural History, which runs a bilingual work-

The printing area contains equipment with which children can print and bind books they have written themselves in GAME sessions. This activity is often used in conjunction with the study of words, writing, and alphabets.

shop, for specifics on such aspects of daily life as dwellings and utensils; the Brooklyn Museum for an examination of Taino masks and other pre-Columbian artifacts and a demonstration of weaving techniques. There would be additional museum vists before the GAME trimester ended.

At this session, the children are divided into five groups—one marbleizing paper to make covers for books they had composed and printed about Venezuela; a second building clay components of a village; another weaving in appropriate colors and patterns, and still another making belts, shoes, and various other leather accessories. The fifth group is ready for a wholly new experience—silkscreening. All of this work proceeds with seeming informality but considerable order, even the messiest processes.

Notable also is the care on the part of the classroom teacher and the resident staff to shield or draw out shy children, and

some deliberate effort to relate the goings-on to academic subjects (''Now, we've folded six pages for our book—how many more do we need?''). Indeed, learning through art is a theme dear to Bette Korman, who likes to stress the relation of weaving to geometry and social studies, or of sketching from nature to biology and botany.

Whatever they are doing and learning, the young children almost without exception work with pleasure and concentration and are sorry when they have to stop, clean up, and put away work and equipment. They then spend some time writing in the individual logs they keep—a recipe, a how-to, or a description of a picture perhaps. The session closes with the children back once more in the amphitheater for ''sharing'' time, which prompts considerable competition as to which pair from each task force can get to show and tell. (From the clay work area: ''Now this is what you call a Venezuelan pyramid. And here's a Teflon fireplace.'')

**Teaching workshops.** Teachers from the participating schools not only attend the center along with their classes, but also take part in weekly afterschool workshops, as well as special workshops from time to time. Strewn with cushions, the amphitheater makes a comfortable, informal setting for the give-and-take of ideas. One week, for example, a teacher expressed an interest in setting up a program to study cross-cultural alphabets with her students. Her colleagues began exploring the ways children grasp the meaning of signs and symbols. Why not have the children develop their own alphabets, their own iconography? Why not look at gestures that people make in the street and record them? What media should be used—ink, photography, film? Why not ask the kids what they think? Wouldn't it be a good idea to follow up the work in the Egyptian collection at the Brooklyn Museum? How can the results be related to the curriculum of the participating school?[3]

''Nobody ever asks teachers what they want,'' says Grace George Alexander, of the Bureau of Art of New York City's Board of Education. ''The programs that work are the ones in which the teachers are not recipients, but participants.''

Participation and planning go hand-in-hand at GAME. In preparation for the 1974/75 school year, teachers gathered in the amphitheater and developed likely themes to coordinate with museum and GAME resources, looking always for opportunities to relate themes to a variety of school subjects. Hitting upon such connections is one reason most classroom teachers seem to find the GAME experience so refreshing. ''It's not like one of those art classes where they teach you to stick a feather into a mound of clay,'' said one.

In addition to these regular workshops at headquarters, GAME staff members sometimes go on location. They have given sessions, for example, at Bryn Mawr College (before a graduate class in art and museum education), Queens College (for the School-within-a-School program), the Staten Island Children's Museum, the local School District 3 Learning Center, the Junior League, the New Orleans Arts in Educa-

tion Conference, and the City College Workshop Center for Open Education.

**Dream to reality**

To suggest that GAME sprang full-blown from the head of Bette Korman would be hyperbole, but nearer to the truth than not. An intense young woman, her ideas and the way she carries them out have provoked the range of reactions from hostility to adulation. What she—and GAME—have never provoked is indifference. Having studied, made, and taught art for years, she became increasingly convinced of the need for a neighborhood center that would engage children in making and understanding art as the schools do not and perhaps cannot. Her obliging principal at P.S. 75 was himself committed to open-corridor learning, bilingual education, and innovation generally. So GAME started life as just a pilot arts and media project in the school, funded by a small grant from the New York State Council on the Arts. What made the neighborhood resource center financially possible was a grant from the Rockefeller Brothers Fund, which, as Ms. Korman says, ''took the chance.''

For a supposedly impractical dreamer, the director-to-be rather quickly learned her way through the maze of school bureaucracy (known in New York as ''Livingston Street''), potential funding sources both public and private, and local politics. Equally important, she knew how to win friends in the community, in the museums, and elsewhere who were willing to help her, often as unpaid volunteers. She found out, for instance, that through Educational Facilities Laboratories she could get free technical assistance from an architect knowledgeable in the uses of found space.

So with architect Clark Neuringer's help, she chose the double basement on 86th Street and got some general admonitions on city regulations and renovation. So far, his official stint. But the Korman dream got to him; so, on his own, he stayed around to instruct and supervise the largely inexperienced if eager volunteer wreckers and carpenters, helping to make such impossibilities as the child-scale amphitheater happen. Defining his entrapment later, Neuringer said he saw his role as ''bringing some order to Bette Korman's infinite madness.''

The double basement when GAME took over was a typical New York junk pile: dust, dirt, dampness. Walls were knocked down, lugged up the stairs, the refuse of many years was cleared away. Parents, principals, students, teachers, artists from the community, friends all helped. ''We had wrecking parties, painting parties,'' says Ms. Korman. ''I was practically living here. And I'm not letting up now,'' she adds. A carpenter is frequently on hand, still carrying out improvements.

The space itself illuminates GAME's spirit and modus operandi. In fact, Ms. Korman thinks of her project as a model suitable for adaptation throughout the country—a way of creating a working environment just about anywhere and at minimal cost ($3,500 for GAME's rehabilitation)—in

school, church basement, loft, garage, storefront, or warehouse. And to facilitate such adaptations, GAME has included renovation details in a how-to booklet being prepared as a guide to others interested in creating such resource centers.

## GAME at age three

By the light of sheer numbers, GAME came a long way in three years. When it moved into its own center, it was serving two schools on an operating budget of $43,000. By 1974/75, it was serving four schools as well as other children and adults from the community on a budget of $100,000. Besides the considerable support from the Rockefeller Brothers Fund, money now comes from the four participating schools, the National Endowment for the Arts, the New York State Council on the Arts, Museums Collaborative, two adjuncts of the New York City school system—Community School District 3 and the Learning Cooperative—and the Edward John Noble and other foundations.

The basic day program remains as before, presumably enhanced by experience and new recruits, and now in "active contact" with 2,000 children from the four participating schools, 35 full-time teachers from these schools, plus 50 part-time teachers, 50 student teachers, and 20 paraprofessionals. Additional teachers and student teachers attend teacher-training workshops. The weekly after-school workshop draws 200 children a year from the community in general, at $15 for a ten-week session, and there is an evening crafts instruction program for 100 adults for the same fee. Besides these formal programs, the center's free special events and community and parks projects (such as sheep-shearing and bread-baking), some held in conjunction with museums, draw hundreds of children and adults from the community.

GAME's volunteers include junior and senior high school students, parents, student teachers, and an art therapist. In Ms. Korman's view, the center's links are stronger than ever with five major museums—the Metropolitan, South Street Seaport, Brooklyn, the American Museum of Natural History, the New York Historical Society. In May 1975 GAME worked with museums on two events: a Maritime Day, in partnership with ten sea-faring workshops and South Street Seaport, and a horticultural Good Earth Day program with the Museum of Natural History. With the Metropolitan Junior Museum, GAME cosponsored a crafts festival in Central Park, preceded by considerable work and observation by the children at the museum.

Besides specific projects relating classroom themes to museum collections, GAME makes extensive use of specialists for "bonus" workshops dealing with off-beat subjects. For example, Pop Top Terp, whom Ms. Korman found through the Museum of Contemporary Crafts, gave six child and teacher workshops in the ecological use of soda can pop tops. Duny Katzman, cloisonné expert from the Cloisters, offered five-week workshops in cloisonné and repoussé. The

director of the paleontology department at the American Museum of Natural History gave slide and fossil-casting demonstrations for teachers and students (and later took 70 children on a real fossil dig in upstate New York). And Ida Talalla, an instructor at the Brooklyn Museum, carried out two five-week classes on cross-cultural tie-dyeing that included a visit to the textiles collection at the Metropolitan (and a return visit to GAME by its textile curator), another to the "Denim Show" at the Museum of Contemporary Crafts, and a demonstration by a Japanese dancer of the ins and outs of an intricately patterned tie-dyed kimono.

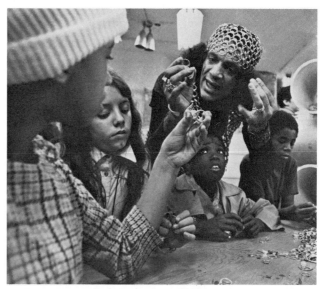

**Pop Top Terp, an expert in the ecological use of soda can pop tops—his specialty is designing and making clothes from the metal rings—gives a how-to lesson to children at GAME. He is one of a number of resource people the center draws upon.**

The center has a number of other enterprises in operation, in the pipeline, or planned: a "documentation evaluation," a semiannual publication called *Art and the Integrated Day*, various other publications and handbooks, and a consultation and advisory service called GAME Environments. There is, as well, a potpourri of extras, such as the Whole School Programs, wherein community residents, young and old, make huge banners for the schools, macramé hangings, quilts.

GAME's major backer, the Rockefeller Brothers Fund, is phasing out as scheduled with the third year of funding. Although financial support from the four schools has increased and funding from the community school district continues, GAME has become increasingly dependent on finding other sources of support. Meantime, like many arts organizations that squeeze themselves, however ingeniously, into storefronts, the center needs more space—for more clients and more equipment.

As the 1974/75 school year neared its end, Ms. Korman's critics seemed somewhat more vocal than they had been in GAME's first years. Some said that GAME had become

preoccupied with being "showy," that quality of craftsmanship was being sacrificed to quantity of projects. But they worried especially about what they see as the director's reluctance, or inability, to carve out a firm, sustaining base for GAME within the school system. Yet Ms. Korman, though she naturally deplores the constant scrambling for funds, feels that GAME has made steady progress in refining and extending its services, and that the center eminently exemplifies the kind of "linkage" between school and museum that best functions on neutral territory. On this point, informed opinion seemed sharply divided. Mrs. Alexander, for instance, believes, much as she admires GAME, that "such activities could be organic and happening in each school," that the experiences at this and other resource centers are too isolated from the child's school and community life.

On the other hand, the principals of two of GAME's participating schools stress the value of a center removed from school premises. Lou Mercado of P.S. 75 thinks of GAME as an "enabling center," where Ms. Korman, as catalyst and initiator, helps to develop ideas that "can last the teacher a whole year." Sid Morrison, former principal of P.S. 84, defends GAME's independence as essential to the kind of innovation it provides.

As for the director herself, she can cite achievement in coping with the school bureaucracy while also keeping outside of it. "Three years ago I couldn't get Stanley Rose on the phone," she says, speaking of the acting director of the board of education's Bureau of Art. Matter-of-factly and without rancor she adds, "Now that he has visited GAME and seen that it is real and accepted by the schools, he calls me. You see, the board responds to what is known. Stability and credibility are important."

By 1975 her funding strategy continued to stress multiple sources—federal, state, local, and private. She is putting more emphasis than before on the school connection—without trying to add more schools. Thus she is negotiating with the district superintendent and the school board of Community School District 3 to provide a "resource and consultant service" to the rest of the district's schools. "Because there are empty rooms in some schools due to declining population," she has written, "we are proposing to help teachers set up a GAME resource center in each school and simultaneously train the teachers how to run them."[4] This enterprise, if accepted, will do more than meet the district's requirement that more than four schools be served. It will also postpone if not solve the problem of finding bigger and maybe better space for GAME.—*A. G./J. M.*

## Notes

[1] For sources of quotations without footnote references, see list of interviews at the end of this report.

[2] Public Schools 75, 84, 9, and 166.

[3] P.S. 75 carried out this idea. The enthusiasm of the participants and the quality of the work were such that GAME has published

a booklet on the cross-cultural alphabets study (*Signs, Symbols and Alphabets*).

[4] "Proposal for Curriculum Reform through the Arts Project," submitted by GAME to the Rockefeller Brothers Fund, April 6, 1975, unpaged.

## Interviews and observations

Alexander, Grace George. Acting Assistant Director for the Bureau of Art, New York City Board of Education. October 12, 1974.

Korman, Bette. Director, GAME. April 3, 25, 26, May 1, and November 6, 1974; February 7 and June 18, 1975.

Lander, Jennifer MacLiesh. Former Project Director, Cultural Resource Center Program, Museums Collaborative. April 25, May 1 and 10, 1974; February 18, 1975.

Mercado, Luis. Principal, P.S. 75, Manhattan. April 3 and 25, 1974.

Morrison, Sidney. Former Principal, P.S. 84, Manhattan. April 3 and 25, 1974.

Neuringer, Clark. Architect, Consultant to Educational Facilities Laboratories, New York, New York. April 11, 1975.

Norman, Jane. Senior Rockefeller Fellow, Metropolitan Museum of Art. March 22, 1975.

Snedcof, Harold. Program Associate, Rockefeller Brothers Fund, New York, New York. April 24, 1974.

Talalla, Ida. Consultant to GAME. April 11, 1974.

Observations of children and teachers at GAME: February 18 and June 20, 1975.

*Photographs: courtesy of GAME, Inc.*

## THE NATIONAL CENTER OF AFRO-AMERICAN ARTISTS: THE ELMA LEWIS SCHOOL OF FINE ARTS

122 Elm Hill Avenue
Roxbury, Massachusetts 02121

**An almost all-black school for the arts in Boston's Roxbury section dedicates itself to highly disciplined, sequential instruction—and demonstrates that such structured learning is both popular (the waiting list is long) and successful. Here, too, a museum on school premises is integrated into art history and studio courses, and a mobile-unit version spreads the message of the museum and school to predominantly white Boston suburbs. CMEVA interviews and observations: September and November 1973; February and October 1974; March, April, September, and October 1975.**

### Some Facts About the School

1.  **General Information**

    Founding: 1950. In 1968 the school spawned the National Center of Afro-American Artists (NCAAA), of which it is now the teaching division.

    Collections: The school has access to the collection of the NCAAA, which includes 500 objects of African, Afro-American and Caribbean art and artifacts; paintings, sculptures, and graphics by black Americans; and a special photographic collection on Haiti. The school has a library of approximately

1,200 volumes focusing on African, Afro-American, and West Indian art.

Number of paid staff: 100 (about 25 of these are part-time).

Number of volunteers: Variable; generally project-bound.

Annual operating budget: $800,000 (fiscal 1973/74).

Annual education budget: Because it is an educational institution, the school's entire operating budget is devoted to education.

Source of funding: Grants, gifts ($100,000 a year for the music program from the Ford Foundation, 1969–1973, with a terminal grant of $950,000 in 1974[1]; contributions from other sources totaling about $500,000 a year); earned income from annual fund-raising events and performances by the center's professional groups; limited endowment holdings.

## 2. Location/Setting

Size and character of city: Roxbury, a section of Boston, is part of a standard metropolitan statistical area with a population of 2,753,700 (1970 census). A predominantly black community, Roxbury is now a depressed area in which the National Center is a major employer.

Climate: New England, seasonal.

Specific location of institution: In a residential area a few blocks from the Grove Hall and Humboldt Avenue commercial centers, directly across from Franklin Park.

Access to public transportation: Public bus stops at the corner; elevated public train stops within six blocks. Limited free parking available.

## 3. Audience

Enrollment: Preschool children, ages three-and-a-half to six; children, ages six to twelve (boys admitted free, girls charged a tuition, which may be waived according to the capacity of the guardian to pay[2]); teenagers and adults (all subject to tuition fees, but with possible waivers); periodic special student groups, from correctional institutions or alternative schools. The student population averages around 400 younger children and 225 teenagers and adults; other groups vary. No racial, national, ethnic, or religious stipulations are made regarding application.

Attendance: Public receptions, performances, and other events draw an estimated annual attendance of 125,000.

## 4. Educational Services

Organizational structure: The Elma Lewis School of Fine Arts is the teaching component of the National Center of Afro-American Artists. NCAAA consists of two dance companies, a museum, the Elma Lewis Playhouse in the Park, two theater companies, a technical theater department, an experimental theater, the Black Persuasion and the Children of Black Persuasion (two singing and performing groups), a classical orchestra, a jazz orchestra, and the Elma Lewis School of Fine Arts. The school includes divisions of dance, drama, music, costume and design, and visual arts, each headed by a director and having its own departmental administrative staff and faculty. Policy is made by two boards of directors, one for the center, the other for the school. The director of the school and the center, Elma Lewis, along with the general administrative staff and department heads, constitute the day-to-day governing body.

Range of services: Classes, performances, talent management and booking services, film presentations, exhibitions, social services (such as housing, school busing, street cleaning—questions the center becomes involved in as part of its commitment to the idea that the arts and culture should be closely related to everyday life), public receptions and other special events, Afro-American Cultural Program for Catholic high schools, and Perspectives in Black Art for Howard University extension school.

Audience: Largely black (about 5 percent of the students are white). Suburban and city public schools are served by mobile unit.

Objective: To provide a measure of intellectual and psychosocial enrichment through the arts.

Time: Preschool children come Thursdays from November through June; other children come after school, from 3:30 to 6:30 P.M., and on Saturdays from 9:30 to 5:30. There is also a full-time summer program from July through August. The center is open and accessible 24 hours a day.

Information and documentation available from the institution: *The National Center of Afro-American Artists,* brochure, 1973; thematic outline for classes.

---

To Boston's black community, the National Center of Afro-American Artists (NCAAA) is its cultural spokesman, the source of an energetic supply of artistic talent, and a major employer in the largely black section of the city known as Roxbury. To the young people and adults who populate the center's classes, the NCAAA is a highly disciplined arts educator whose influence on its students is meant to be ethical and moral as well as cultural and artistic.

In the years since Elma Lewis—a black teacher, actress, dancer, choreographer, administrator, and writer (who has also been described as "black America's Sol Hurok, Tyrone Guthrie and P. T. Barnum in one ample, dynamic female form"[3])—first opened her 25-pupil Elma Lewis School of Fine Arts in 1950, much has changed in Roxbury-Dorchester and in the school itself. Once an almost wholly white area with a small number of well-established black families, Roxbury became in the 20 years between 1950 and 1970 the center of Boston's black ghetto. During the same period, the Elma Lewis School grew, largely with the financial and moral support of the black community, from a small studio in Miss Lewis's Roxbury apartment to an institution that employs a staff of 100, handles a student enrollment of 600 young people and adults, and includes, under the umbrella of the National Center of Afro-American Artists, a professional dance company; a museum (created in 1970 by an agreement between the center and the Boston Museum of Fine Arts); a mobile museum; a free summertime platform for artists and performers called the Elma Lewis Playhouse in the Park; two theater companies; a technical theater department; an experimental theater; a professional chorus; two singing and performing groups, the Black Persuasion and the Children of Black Persuasion; a classical orchestra; a jazz orchestra; and—interwoven among these various components—the Elma Lewis School of Fine Arts, the center's teaching arm.

## The Elma Lewis educational philosophy

What has not changed as the National Center has grown are the purpose and attitude Elma Lewis originally brought to her

young pupils. She has insisted from the beginning that art is a discipline with strong intellectual and psychological implications for minority children. The school's "curriculum philosophy" emphasizes responsibility, values, integrity, moral and ethical guidelines, individual achievement, and collective cooperation. It also emphasizes the importance to black children of "the sense of continuity, dignity, and unity that they can only gain from their own artists and the history of their own art."[4]

The Elma Lewis faculty, in concentrating on "cognitive" and "psychosocial" development of the children, seeks to both reinforce and supplement what they learn in public school. In drama classes the children are taught to read with understanding, to improve their writing skills by creating short plays and poems, to take responsibility and cooperate with others by knowing their parts and doing jobs upon which the success of the production depends. From the music classes they learn fractions (a quarter note equals two eighth notes or four sixteenths) as well as major scales and music theory; from the costuming classes, not only basic stitchery, design, and pattern-making, but even writing and publishing, for the students assemble their own fashion magazine. In the art classes students are taught "to look at ordinary things in a different way," a skill, says the school, that "extends into all aspects of a person's life, including his intellect"; it is an ability that "lies at the very heart of any creative use of the mind."[5]

On the cultural side, the Elma Lewis program directs the children toward their African and black American roots, on the grounds that black children need a sense of the "beauty, intelligence, and worth" of the things their people have created. This sense begins with the way the children are taught to approach their own work: drawing from an African tribal expression, "We like to do all things beautifully," the school points out that "for this tribe [the Woloff], everything is a work of art, the way they walk, the way they dress, the way they tell a story or decorate a vessel":

> The school tries to stress this idea that everything the children do, if it is an expression of themselves, is beautiful. This teaches the children to have pride in themselves, but even more, it affects their moral development. All things must be done beautifully, including how a person relates to and treats other people. To another African tribe the word for art is synonymous with the word for generosity.[6]

To do something "beautifully," then, is not only an intellectual but a cultural discipline. Lessons in ballet teach children to carry themselves well; as the best way to develop a dancer's strength and flexibility, ballet is a prerequisite to the study of African dance. Exercises in drama class teach the children to speak clearly and distinctly and to develop body coordination; theater games help develop their sense of perception.

The content of the courses is specifically and purposefully related to black culture. Students are led through a year-long series of themes—Africa, the black family, black institu-

tions, black artists, black heroes, black love, the black triumph—that permeate all their classes. In the visual arts program, while the school is studying black artists, for example, students are introduced to living black artists and shown slides of their work as image makers for the community. For the segment on Africa in the same program, students learn African techniques for printing, stenciling, and dyeing fabrics; they practice making the African patterns and learn the traditional African tales that the symbols in the patterns represent. Slide presentations on tribal art are followed by pottery or mask making based on African models. In the music classes, the history of Afro-American music leads to a survey of the political struggle of American blacks.

The moral is constant. Black love is taught as a relationship "one to another"—old and young, brothers and sisters, strangers and friends. The unit on black family stresses the interdependence between adults and children. Black institutions, the children learn, help stabilize the "new black nation"; under this theme, too, they are given lessons in "how to use the established institutions of the society."[7]

In every way, the National Center has tried to become an expression, in the words of one of its brochures, "of an area of American culture seldom recognized and often suppressed in our history."

## How the school is organized

Students come to the Elma Lewis School for classes after school and on weekends. The classes are arranged for three kinds of students—preschool (three-and-a-half- to six-year-olds), standard (six- to twelve-year-olds), and teen-adult (thirteen and over). Standard and teen-adult groups are further divided by proficiency—elementary, intermediate, and advanced.

Five divisions constitute the school, each with its own director and faculty of artists, craftsmen, and college students: dance (ballet, modern, and African), drama, music (theory, voice, and a variety of instruments—piano, violin, cello, flute, guitar, and African drums), costume and design (history, sewing, pattern drafting, fashion illustration, and wardrobing), and visual arts (art history, drawing, design, painting, textiles, sculpture, graphics, and ceramics). Closely tied to the visual arts division is the center's museum of African, Afro-American, and West Indian art, and a mobile museum—a 10-by-35-foot trailer launched in the fall of 1974—that goes to public schools in the greater Boston area.

The program for preschoolers is offered once a week, on Thursdays, from November through June. The children—most of them from two nearby alternative schools, the Roxbury Free School and the New School for Children, whose art classes are at the center—are given introductory classes in each of the five divisions.

Children must be at least six years old before they can attend the school on a "full-time" schedule (after school, 3:30 to 6:30 P.M.) under the "standard" category. This

group makes up the largest segment of the center's student body; in 1973/74 it numbered 375 out of a total enrollment of about 625. These students must take 15 class hours a week according to the following schedule: Monday, dance and art; Tuesday, music and costuming; Wednesday, drama and costuming; Thursday, music theory and art; Friday, dance and drama. The six- to twelve-year-olds are required to follow this schedule for two years before they are allowed to concentrate on one area. Classes are also offered on Saturday between 9:30 A.M. and 5:30 P.M.; in addition, students may enroll in the July–August summer program.

At the teen-adult level, most students have chosen one of the arts as their specialty. Although there are older people in this group, some of them in their sixties, the age range for most students is between 19 and 26. Many of the over-12 students started out at the school as children (average stay of students in the school is three years). A member of the center staff has estimated that 8 to 10 percent of this group will become professionals, some to become affiliated with one of the National Center's troupes, others to take off on their own or join other professional organizations.

## Applications and acceptances

Students are enrolled at the school in order of application. There are only three requirements: each student must be interviewed with, vouched for, and supported by a parent or other adult; no child is allowed to leave school at the end of the day without an adult supervisor; and parents or sponsoring adults must agree to take part in regular center events—receptions, parties, productions, and parent meetings. No questions are asked about a student's health, intelligence, or special talents. Tuition charges, once $10 a month, are now $15, and these may be waived or reduced if circumstances dictate.

Though the school makes few demands on entering students, entrance itself is something of a needle's eye. It is not unusual for applicants to wait up to two years for one of the school's 600-plus slots to open up; in 1974 there were over 200 students on the school's waiting list.

## The museum program

Closely connected to the center's visual arts program is its museum, which opened in January 1970. The curator, Barry Gaither, is also chairman of the visual arts division, and the museum is the source for most of the objects and slides used in the school's art history and studio courses.

The museum is also closely tied to the Boston Museum of Fine Arts. It was, in fact, begun as a joint project of the two institutions, an idea that Miss Lewis took personally to MFA Director Perry Rathbone and Board President George Seyboldt in 1969. Instead of starting a new and separate outreach program, she reasoned, the MFA could do more for the black community—and establish a more solid relationship with it—by forming an alliance with the National Cen-

ter, which was already well rooted there.

The arrangement the two institutions devised, although it was not meant to last forever, was extraordinarily reciprocal. Of the NCAAA museum's annual $100,000 budget, the MFA contribution accounts for about $35,000—$20,000 of which goes into exhibitions, about $10,000 for the salary of the museum's assistant director who is technically on the MFA staff, and $5,000 on which Gaither can draw for certain services the NCAAA museum "buys" from the MFA (the cleaning of paintings, for example, or storage of exhibition shipments the center is not ready to receive). In addition, Gaither himself is paid by the MFA; although he works practically full time at the National Center's museum and in the Elma Lewis School, he holds the title of special consultant in the painting department at the MFA. This title qualifies him for technical support from the MFA and makes the museum a kind of "department" of the MFA as well as the National Center: Gaither regularly reports to the MFA board and accounts to it for the MFA portion of the museum's budget.

Gaither's MFA title also gives him a voice in some of the MFA's exhibition, purchasing, and personnel policies. Every 12 or 14 months he organizes a major exhibition of African or black American art at the MFA. He advises the museum on additions to the collection in African, Oceanic, pre-Columbian, and contemporary art. And he frequently recommends people for jobs at the MFA. As a member of the MFA curatorial staff he also has a chance to do some traveling and conduct research that the National Center's limited budget might not otherwise allow.

Exhibitions at the Museum of the National Center, which represent the work of black artists from all over the world, are meant for both the school's students and the general public. There are between eight and ten shows a year, many of them organized with the help of the artists whose works are in the exhibition, a few even with children from the school who learn from their exposure to the museum's regular exhibitions how to mount and hang the annual April show of their own work. The museum's small staff (two curators, two gallery attendants, a manager of the slide collection, and a half-time secretary) is also augmented by apprentices and work-study students from Boston-area universities. Between six and eight of these students are assigned to the museum each year, serving as catalogers, conservators, researchers, and docents.

The center's museum has a special mission to make black artists known. It publishes a quarterly journal, *Affairs of Black Artists,* maintains an index of several hundred black artists for the use of scholars and potential clients, and recommends artists for commissions and jobs.

## Mobile museum project

The museum's newest addition is a mobile unit that began life in fall 1974. It was set up with grants from the U.S. Office of Education under its Metropolitan Planning Project, which "seeks as its goal to reduce minority group isolation by hav-

ing the cities and suburbs work together on a project.'' In this case, the joint partners were the National Center and the public schools in the nearby suburbs of Weston and Brookline.[8]

The 10-by-35-foot trailer, sometimes driven by Gaither himself, is filled with African masks, musical instruments, sculpture, head-dresses, and appliqué work, which make up an exhibition called ''Ancestral Vibrations.'' The first of several exhibitions planned for the trailer, this show on Africa is the starting point for a cross-cultural program, meant to be closely related to what each class is studying in the ''partner'' school. To plan the mobile museum's debut, which took place in Weston in October 1974, the Elma Lewis staff met with teachers, students, and resource advisers from the school during the summer (the meetings had been scheduled to take place monthly starting in January and to include parents and other interested citizens from Brookline as well as Weston, but funds and approvals from Washington came too late for the schools to carry out this schedule).

As the result of the plans, the mobile museum stayed in Weston for four weeks, from October 6 to November 3, roughly one week at each school. During the visit Gaither came to talk about the historical and religious background of the objects; students got a chance to try out some of the whistles, drums, rattles, and wooden headrests; a part-time art teacher in Weston, a black woman from West Africa, helped the students develop curriculum-related projects for 4th- and 7th-grade social studies classes; and the Children's Dance Company from the National Center gave an evening performance for residents of the town.[9]

From Weston, the museum moved on to Brookline, Wellesley, and other Boston suburbs, staying for several weeks in each location and bringing with it a cultural experience these predominantly white enclaves could have had in no other way. For each school system that invited the mobile museum to visit, there were substantial costs; the fact that several systems paid them and expected to do so when the museum returned with another exhibition another year is testimony to the value schools must feel they are getting from the experience. The weekly rental fee is $500, payable to the National Center's museum (though the federal grant paid for the trailer and its outfitting, the center is obliged to pay for its staffing and upkeep). In addition to the fee, the schools must agree to provide security, electrical power, and insurance beyond what the center carries on the mobile museum itself. Performances by the Elma Lewis troupes, such as the one given by the Children's Dance Company in Weston, are contracted for separately.

## What does the National Center have to tell the schools?

The educational philosophy the National Center promulgates and the attitude it takes toward the place of the arts in human development hold lessons for schools and museums as well. In a kind of testament Elma Lewis wrote in 1970 on the role of the National Center of Afro-American Artists in the black community, she explains how she feels the arts can lead to the ''psychic freedom which will allow maximum personal growth.'' For 20 years, she points out, there have been ''endless discussions'' in the black world about the ''relative merits of cultural revival as opposed to economic growth,'' and of political direction as opposed to educational achievement. In the end, she concludes, ''for mental and emotional health'' all are necessary; none is a luxury. The ''creative energies'' of the nation's black population must be ''nurtured and preserved for posterity.''[10]

The National Center is undeniably ethnic and, for some, even separatist in its mission, and Miss Lewis's dreams for the long-range future place the center on a ''national platform'' as ''the artistic focal point of the country''— ambitions that go well beyond an educational approach to the arts that schools can be expected to have any practical relation to. But as a teaching institution for young people, quite apart from its large cultural mission, the school component daily demonstrates its belief that the arts are a necessity and that good art comes from the same kind of disciplined, rigorous instruction and application that American education requires in other subjects.

''We try to combat the fallacious idea,'' said Barry Gaither, ''that people can go about doing their own thing.''[11] He continued:

Children's art simply can't be said ''hurrah'' to, because then children never understand what it is that's being confirmed in their work. . . . They don't see the difference between what's [good] and what's trash. [So] you have to help a child make judgments on what he sees, and you have to help him to build his own criticism as he works.

This attitude toward art education is combined in the Elma Lewis School's philosophy with the ''sense of discipline [a child needs] in order to locate himself,'' as Gaither has put it. It is not possible, Gaither noted in an interview, just to do your own thing, ''because the world consists of limits imposed on you by circumstance and other people.''

It is what environment means [said Gaither]: limits to your own movement. So we try to get young students to see that they have some obligations, but that privately there is no limit to what they can do. We would like a child to be willing to take on the world, but to know that he's not taking it on to defeat it; rather, he is taking it on to bring it into some harmony with his own objectives. . . .

Whether schools or museums can do anything to help black children understand where they ''come from,'' they can surely learn from the Elma Lewis attitude toward art education and toward dealing with children, as one observer put it, whose setting is disruptive and disordered. At the Elma Lewis School, teaching may start with what the children know—with popular culture, for example, songs and dances that help them feel at home—but it soon demands that the students apply themselves to other material, including, said Gaither, ''material they might not like but come to respect.

We try to provide a launch," he noted, "toward a much bigger world with supports that allow them to develop some confidence and some sense of reference so that they are not destroyed by the larger world but are able to order it around their own experience and values."

Perhaps the discipline and the cultural and moral support black children receive in an almost all-black environment cannot be duplicated anywhere else. But the twin ideas that there is joy and confidence to be gained from order and discipline and that the arts are necessary for mental and emotional health are amply demonstrated at the National Center. It is perhaps time for serious educators in schools and museums everywhere to take heed.—*E. H. /B. Y. N.*

## Notes

[1] According to the *Ford Foundation Letter,* September 15, 1974, the terminal grant was to be divided between the music school ($300,000 over three years) and an endowment fund to be matched two-to-one from other sources.

[2] Traditionally the black male has not participated in the arts (a generality that has some notable exceptions, of course). Waiving tuition for boys is an effort to attract more of them, and it is apparently working; the ratio of boys to girls in NCAAA programs is about one to one.

[3] Ken O. Botwright, "Elma Lewis Art School Gets Ford Foundation Gift," *Boston Globe*, June 21, 1974.

[4] "Curriculum Philosophy," from a brochure on the mobile museum project, 1974, p. 3.

[5] Ibid., p. 4.

[6] Ibid., p. 3.

[7] Thematic outline for classroom use at the Elma Lewis School of Fine Arts," October 1974–August 1975.

[8] Nancy Foster, "Mobile Museum of Africa Visits Field School Students," Waltham (Mass.) *News-Tribune*, October 16, 1974.

[9] Ibid.

[10] "The National Center of Afro-American Artists, Its Role in the Black Community," March 14, 1970.

[11] For sources of quotations without footnote references, see list of interviews at the end of this report.

## Interviews

Blackman, Vernon. Director, Drama Program, Elma Lewis School of Fine Arts. September 17, 1973.

Blumsack, Lawrence. Director of Public Relations, National Center of Afro-American Artists. November 19, 1973; October 9 and 10, 1974.

Ceesay, Momodou. Teacher, Visual Arts Program, Elma Lewis School of Fine Arts. October 10, 1974.

Cooper, James. Principal, Highland Park Free School, Roxbury, Massachusetts. April 17, 1975.

Cordice, Lucy. Director of Costuming, Elma Lewis School of Fine Arts. September 17, 1973.

Emerson, Mrs. Kendell. Member, Board of Directors of the Elma Lewis School of Fine Arts. March 27, 1975.

Eutemey, Karen. Teacher, Visual Arts Program, Elma Lewis School of Fine Arts. September 17, 1973; October 9, 1974.

Gaither, Edmund Barry. Director, Visual Arts Program, Elma Lewis School of Fine Arts; Curator, Museum of the National Center of Afro-American Artists. September 10 and 17, November 19, 1973; February 3, October 10, 1974; telephone, September 29, October 1, 1975.

Gulliver, Adelaide Cromwell. Member, Board of Directors of the National Center of Afro-American Artists; Director, Department of Afro-American Studies, Boston University. April 16, 1975.

Kazis, Israel. Rabbi, Congregation Mishkan Tefila, Newton, Massachusetts. October 11, 1974.

Kennedy, Harriet. Assistant Director, Museum of the National Center of Afro-American Artists. October 10, 1974.

Matthews, Gregory. Teacher, Drama Program, Elma Lewis School of Fine Arts. October 10, 1974.

Neblett, Renee. Teacher, Visual Arts Program, Elma Lewis School of Fine Arts. September 17, 1973; October 10, 1974.

Ross, John. Director, Music Program, Elma Lewis School of Fine Arts. September 17, 1973.

Wilson, John. Member, Board of Directors of the Elma Lewis School of Fine Arts; Associate Professor, Boston University School of Fine Arts. April 17, 1975.

# Orientation Galleries and Special Exhibitions for Schoolchildren

## Introduction

One way an art museum can help children learn about art is to provide them with a place where they can explore the subject for themselves with a minimum of overt teaching. Many museums have set aside such spaces and invested considerable thought in designing both temporary and permanent orientation exhibits specifically for elementary schoolchildren. Among the most famous of these children's galleries are the Junior Museum at the Metropolitan Museum in New York and its counterpart at the Art Institute of Chicago.

The three galleries described here are perhaps less well known, but all of them have been produced at relatively modest cost (about $5,200 for a year's installation in one gallery, $20,000 for a four-year show in another), and all contain useful lessons for other museums interested in trying orientation spaces or making changes in children's galleries already in operation.

The Artery at the Indianapolis Museum of Art, conceived in part as "a channel of communication," is actually the stairwell used by almost all the school groups that visit the museum. Although the Artery serves several purposes—not least the chance for Indiana artists to exhibit their work at the museum—its basic and slightly controversial objective is to give young visitors a way to learn about tools, materials, and art objects by touching them.

"Shapes," on the other hand, is one of a series of special

exhibitions designed by the High Museum in Atlanta to introduce schoolchildren to some basic ideas in art. It is, in the words of the report here, "above all, a teaching tool" with which the museum's guides can help children focus on balance, composition, mood, and the language of visual art (children learn in the exhibition, for example, to identify the cylinder and other shapes both in art and in the world about them). The method is not just touching, though children are allowed to use their hands freely, but a variety of sensory, visual, and physical experiences—even sliding down a chute—to bring home the ideas that form the theme of the show.

The Yellow Space Place at the Arkansas Arts Center in Little Rock is also meant to introduce children to basic elements of the visual arts—color, form, space, and line. But it is perhaps less of an introduction to the center itself than a place where children can spend all their visiting time, either as members of a school tour or as part of a family excursion; indeed, one of the remarkable things about the Yellow Space Place is that children can be safely and productively occupied there while parents visit the rest of the center at their own pace. With its carefully picked exhibit themes, its encouragements to let children (and adults as well, it has turned out) manipulate and create on their own, and its emphasis on visual communication above the verbal, the Yellow Space Place has had an influence on parents and on the Little Rock public schools—and even on the Arts Center itself.

### Some issues . . .

Although each of the projects here takes a different approach to teaching children about art, the three are based, first, on an acknowledgment of what is clearly a natural human urge—to add a tactile and physical response to the visual experience—and, second, on the premise that orientation to art in an art museum requires some isolation from the distractions of the galleries themselves.

On the subject of tactile response, anyone who has seen an art owner, or, if the truth be known, a museum curator caress the contours of a piece of sculpture or a beautifully molded vase must admit that touching is an almost irresistible impulse of the art-sophisticate and art-neophyte alike. If it were not so, art museums would not need to invest so much of their money and protective energies warding off visitors' eager hands.

Some British museums—the Victoria and Albert Museum, the London Natural History Museum, and the Geffrye Museum, in particular—have found that a pad and pencil go a long way toward satisfying the participatory, tactile urge. The act of copying details—"the fold of drapery, the droop of a mouth, the turn of a head, a gesture, the shape of a flower," Renée Marcousé's words—furthermore, not only occupies the viewer's hands but it focuses his attention and helps him look at art, as Marcousé points out, "with greater understanding."[1]

The American way, to judge from these examples, is

more elaborate. For one thing, it often tends instinctively to equate manipulation and visual reinforcement with the kind of mechanical gadgets and pushbuttons that are evident in these projects—an audiovisual cube in the Artery; handles to crank, illuminated rods that form shapes in the darkness, a movie projector in "Shapes"; a rear-projection screen "activated by a child-high switch" and a pushbutton-test wall in the Yellow Space Place. Just as evident is the trouble with such gadgets: the Yellow Space Place authors found that "buzzing and dinging had greater appeal than reading and choosing," the film projector in "Shapes" required so much upkeep that it was "often inoperative," and the Artery's audiovisual cube "has never operated properly." The advice of the Indianapolis Museum staff may be especially useful here: "Don't put too much faith in machines."

Machinery aside, the physical response is a strong element in all three programs. Part of the Artery is expressly a touching gallery, because the staff is convinced that the chance to touch at least some exhibits relieves rather than encourages the need to touch objects elsewhere in the museum. In the Yellow Space Place children are not only allowed to manipulate and sit on exhibits but are provided with materials and ideas, based on the exhibit themes, to explore in a craft area. In the "Shapes" exhibition, guides lead children in group compositions, body sculpture experiments, and games.

As for isolation of the orientation space from the galleries, the staff members who worked with "Shapes" are particularly supportive. They feel that trying to teach children about such concepts as form, dimension, and negative space in the galleries is difficult because the children are too easily distracted. In the special exhibition guides can concentrate their discussion on one basic idea at a time—provided that the fun-house aspect of the exhibition is not itself a distraction—and use it later as a point of departure in the museum before the works of art.

Although "Shapes" incorporates a few original objects in its exhibits, the Artery and Yellow Space Place are built mainly around them. In Yellow Space, indeed, the exhibit and its theme provide the basis for all that follows—film, manipulation, craft activity, and workbook.

### . . . And some questions

Like most attempts to introduce children to the art and museum experience, each of these projects raises questions of efficacy that are not always answered in the reports and, in fact, may vary with the beholder.

One of the problems with "Shapes," for example, is that parts of it seem to be so much fun for the children that they sometimes ignore its more serious lessons—and the guides are thus forced to teach the children what the exhibition is about instead of using the exhibition to help them see and understand the permanent collection. Whether or not the Artery satisfies the visitors' urge to touch before they reach the main galleries, it does make a pointed distinction between the touchable work of local living artists who have not yet "ar-

rived'' and the untouchable art to be found in the museum collections. And the evidence here suggests that the Yellow Space Place might easily give the young visitor the idea that manipulation is what art is all about.

In each case, children are being invited to regard the visual arts as an attractive and even exciting subject of interest. Yet there is the inevitable question of what the art experience is and how children might best be prepared for it. Looking at art, in the end, is not the same as looking at form, space, and nonart; nor is it, strictly speaking, the same as touching and making. The museum experience is a contemplative one, an exercise of eye and mind more than hand and body. Can children learn to see what is in works of art if they are not taught to look at them? Can they learn to concentrate by being isolated from distraction? Should works of art be offered as illustrations of a process, tool, shape, or form—or as illustrations of anything else?

Like other orientation galleries for children, these three have grown out of a belief that the young can be helped to see and understand what happens inside a work of art. Each provides an entry point to the art museum, on the theory that one has to start somewhere. This chapter and the questions it raises are about that somewhere.—*A. Z. S./B. Y. N.*

## Note

[1] "Animation and information," app. D, *Museums and Adult Education,* Hans L. Zetterberg (London: Evelyn, Adams & Mackay, 1968), pp. 60, 61.

## INDIANAPOLIS MUSEUM OF ART: THE ARTERY

Indianapolis Museum of Art
1200 West 38th Street
Indianapolis, Indiana 46208
**A museum stairwell does service as an orientation gallery where visitors—mostly schoolchildren—find touching artists' tools and materials and a few art works a satisfying educational prelude to tours of the collections. CMEVA interviews and observations: November 1973, May 1974.**

### Some Facts About the Gallery

**Title:** The Artery.
**Audience:** All who enter the museum via the stairwell where the Artery is located; no numbers kept, but about 90 percent are class tours.
**Objective:** To give visitors a chance to touch some objects and study tools, materials, and works of art that will lead them to a better understanding of gallery objects.
**Funding:** Regular museum budget.
**Staff:** Planned by education and design staff, installed and maintained by design staff; no special staff assignment.
**Location:** In the museum stairwell.
**Time:** During museum hours.

**Information and documentation available from the institution:** None.

At the museum entrance used by all school groups and by any visitor entering from the parking level is a three-story stairwell that offers easy access to museum galleries on all floors. Its walls and landings are ringed with works of art from the collections and from local artists, along with photographs, tools, materials, unfinished works of art, and explanatory labels. The simpler labels are at a child's eye-level, the more sophisticated at adult eye-level. The entire stairwell gallery is designed to make the museum's collections easier to see and understand.

The theme is taken from an old Chinese proverb: "I hear, I forget; I see, I remember; I do, I understand." Doing is what the Artery is partly about; touching the raw materials an artist uses, touching some works of art, touching tools—all are encouraged. At hand for touching are marble, clay, bronze, steel, limestone, brushes, pigments—as well as sculptures lent by local artists happy to have their pieces caressed by curious hands.

The museum invites artists around the state who have entered any state show to offer work to the Artery. It is a good opportunity for artists to exhibit their work—and for visitors to see it. Museum insurance covers such pieces "beyond normal damage by hands."[1]

The Artery was designed by the education department in consultation with the preparation (design) department. Its layout is related to gallery installations: sculpture first, as the first landing enters the sculpture court, then paintings leading to the second landing, which opens into the painting galleries.

One of the most effective teaching objects is an unfinished wood sculpture, made of walnut board about 150 years old and once used in an Indiana barn. The dimensions of the original board are visible at the base and are clearly pointed out. The artist blocked out a design in red, cut it with various chisels, further shaped it with rasps and sandpaper. The finished portions are stained with oil to darken the wood, bring out the grain, and prevent checking or splitting.

The same emphasis on process—how an artist makes a work of art—appears in other sections of the stairwell. A single canvas is part untreated, part covered with gesso, part with sketches and paint. The printing section shows woodcuts and four etched plates, encouraging the visitor to follow the copper plate with ground through the drawn design, to the etched, cleaned plate and the printed picture. Unfired and fired ceramics, cloisonné enamel vases in varied stages of work, and other unfinished works complete the Artery's didactic installation. They are exhibited side by side with works from the museum collections.

Except for certain pieces exhibited in cases, everything is out and within easy reach. Yet the museum's security problems have been nil: "Our great concern was unfounded,"

says an education staff member. ''Nobody took an object or plucked tools off the wall.'' This is not to say that allowing visitors to touch things does not bring some problems. A ''touch'' gallery requires the most durable displays possible. Visitors are apparently so delighted to be allowed to touch in a museum that they touch even the labels; some have even been taken. The first year the labels were printed on cardboard, applied to the walls with pressure-sensitive tape; they were in disarray and fairly grubby by the end of the year. The curator of education noted, ''Our shabby labels in the gallery will be replaced by plexiglass ones, and we have now initiated a program of regular maintenance.''[2]

The condition of labels may be less important than the quality of label copy. Education staff members write the labels, trying the copy out on each other to make sure there are no words or concepts a schoolchild could not understand. They succeeded, in some instances with prose of simple distinction. Some of the labels include quotes from artists about works they are lending. But some, inevitably, include art vocabulary unfamiliar to many museum visitors; long lists of definitions—of ''scumble,'' for instance, or ''impasto''—can require tedious concentration.

Education and preparation staff members offer certain cautions to other museums whose physical layout provides only a stairwell for an orientation gallery:

• Put only flat things on the walls, as much for the safety of the visitors as for the safety of objects.

• Recognize that most adults are not going to bother taking the stairs if there is an elevator handy, and that other institutions may have the experience of Indianapolis, where schoolchildren, who must enter the museum from their bus stop via the stairway, constitute 90 percent of the Artery's visitors.

• Don't put too much faith in machines: an audiovisual cube on the first floor, showing an artist at work, has never operated properly.

Despite the lack of use by adult visitors, the growing shabbiness of the area during the year, and the continuing maintenance requirements, the museum education staff is ''sold on the touch-gallery concept.'' It has not found that children want to touch objects in the galleries because they have been allowed to touch the Artery's displays. In fact, photographs in the stairwell of objects in the galleries appear to spur a kind of treasure hunt, sending students looking for the real thing.

A press release sidles around the debate over whether a museum ought to let visitors touch the objects in its care: ''Although the physical objects must be protected, they cease to be of value if the spirit that marked their creation can't be transmitted.'' The staff believes the Artery—''a channel of communication,'' is one of its definitions—transmits that spirit and offers a way to allow museum visitors to touch some objects and perhaps thereby to see other objects with greater understanding.—*A. Z. S.*

## Notes

[1] For sources of quotations without footnote references, see list of interviews at the end of this report.

[2] Letter from Peggy Loar, curator of education, to CMEVA, July 12, 1974.

## Interviews

Dankert, Marla. Assistant Curator of Education, Indianapolis Museum of Art. November 14, 1973; May 9, 1974.

Loar, Peggy. Curator of Education, Indianapolis Museum of Art. May 9, 1974.

Moreland, Sue. Curatorial Assistant for Special Education Programs, Indianapolis Museum of Art. May 9, 1974.

## HIGH MUSEUM OF ART: ''SHAPES''

The High Museum of Art
1280 Peachtree Street, N. E.
Atlanta, Georgia 30309

**Connections among abstract shapes, art works, and the everyday world were made for Atlanta schoolchildren through the popular High Museum exhibition, ''Shapes.'' Tours through this ten-room labyrinth were conducted by volunteer guides, who gave related art classes in inner-city classrooms and other High galleries. CMEVA interviews and observations: April, May 1974.**

**Some Facts About the Exhibition**

**Title:** ''Shapes.''

**Audience:** All ages but directed to young people; approximately 150,000 visitors between the opening in 1970 and the closing in 1974.

**Objective:** According to the brochure, ''Shapes,'' was ''an environment which gives children a chance to perceive the nature of shape in a new way and to physically experience ways in which shapes affect space.''

**Funding:** $20,000. Sponsored by Mr. and Mrs. Lindsey Hopkins, Jr., and the Members' Guild of the High Museum of Art, with donations of materials from area businesses. Cost of refurbishing in 1973: $1,000, provided from revenues of admission fees to ''Shapes.'' Admission fees also provided the salary of the weekend attendant. Donations of 25¢ for children and 50¢ for adults were requested when ''Shapes'' was open to the public. Members and school groups were admitted free. (At first, everyone was admitted free; the institution of the fee seems to have discouraged vandalism.)

**Staff:** Originated by museum staff and volunteers. Designed by Robert Allen. ''Shapes'' was maintained by the education department staff and maintenance crew of the Arts Alliance. Tours of the exhibition and programs given in conjunction with it were conducted primarily by volunteers.

**Location:** In the Junior Gallery adjacent to the McBurney Decorative Arts Gallery and the Junior Activities Center, which houses the education department on the third floor of the museum.

**Time:** September 1970 to May 19, 1974. A new exhibition called "The City," also for young people, opened in the fall 1974, to continue until 1977. "Shapes" was open to school groups on guided tours during museum hours, to the public on Saturday and Sunday from 12 noon to 5 P.M. (limited hours for the public were necessary because of the lack of security inside the exhibition).

**Information and documentation available from the institution:** "Share Our Adventure," brochure for potential Junior Activities Center volunteers; "Dialogue Guidelines," mimeographed guide to volunteer tours through "Shapes"; "Shapes: Adventure and Discovery," brochure produced for opening of the exhibition.

---

On a Saturday morning in spring 1974, a group of people ranging in age from preschool to adult clusters near a velvet guard rope on the third floor of the High Museum in Atlanta, Georgia. The group includes several high school students and two sets of parents, one with a toddler, the other with a teenage daughter. They are waiting for the noon opening of "Shapes," a special exhibition now in its fourth and final year at the museum.

As the guard rope comes down and the lights go up, the teenager eagerly leads her parents through the entrance of "Shapes." The younger parents follow, and soon their child is squealing with delight, as much at the antics of the other visitors as at the colorful kinetic exhibits. The high school students rush from one exhibit space to the next, then back again, calling to their companions to hurry up and share in the next discovery.

## What was "Shapes"?

The second in a series of High Museum exhibitions for schoolchildren (the first, which opened in 1968, was "Color, Light, Color"), "Shapes" closed in summer 1974 to make way for a new show called "The City." But during the four years it was on view, "Shapes" was the cornerstone of the museum's education program for schoolchildren. As the museum's brochure describes it, the exhibition was designed as an environment that "gives children a chance to perceive the nature of shape in a new way" and to experience just how shapes affect space.[1] Located in the third-floor Junior Gallery, "Shapes" was divided into ten rooms or "spaces," each of which centered on one or two ideas—dimension, geometric versus free form, illusion versus reality. The exhibition was participatory: every room invited the visitor to do something rather than simply look. Most of the school groups that visited "Shapes" were escorted by a trained museum guide, a volunteer who brought to the task goals that the High's Junior Activities Center holds for the entire museum program. (For a report on the High's volunteer programs, see chapter 5.) In the museum's "Volunteer Notebook," these goals are stated as exhortations to the volunteers to

. . . emphasize the special experience that may be had in the museum. Our efforts should be directed toward ex-

panding educational dimensions, rather than simply duplicating what goes on in a classroom or can go on there.

. . . stimulate creative seeing and visual awareness.

. . . evoke personal responses to what is seen and discussed.

. . . elicit active involvement in looking . . . challenge the intellect, make each child become more sensitive and critically aware of his surroundings.

We must tailor-make our programs as much as possible, taking into first consideration the specific children involved.[2]

The High's curator of education, Paula Hancock, described "Shapes" as "a real change-of-pace point for the schoolchildren's museum visits"; she felt that children's impressions of the museum as a whole changed because of their experiences in "Shapes."[3]

## A trip through "Shapes"

As a child steps through the doorway of the McBurney Decorative Arts Gallery into the Junior Gallery, he has a clear view of three-foot-high blue letters, *S h a p e s,* painted on the circular yellow walls describing the outside of the exhibition. But as he walks toward the entrance of the exhibition he may notice that the *h* seems to change shape. In order to appear normal from the doorway of the McBurney Gallery, the *h* is actually distorted on the two curved walls. Thus is previewed one of the themes of "Shapes," illusion and reality.

The child begins his exploration by weaving his way around the cylindrical walls as he approaches the entrance. If he is on a tour with a museum volunteer, his group may spend a little time in the hallway outside the exhibition discussing

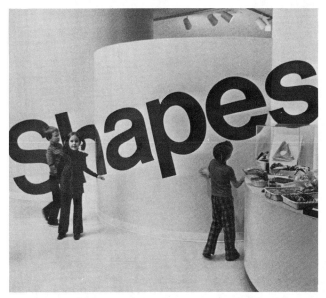

Children investigate the curving walls that define the entrance to "Shapes." Close up, they find that the painted letter *h* is distorted in order to appear normal from a distance. Thus, a beginning lesson about shapes: illusion and reality.

some of the concepts of shape in a number of original works by such artists as Donald Judd, Sol Lewitt, and Alexander Calder that are on view in this hallway.

The exhibit spaces in "Shapes" are not all regular in size or rectangular in shape. The spaces form a labyrinth and the exits are not placed opposite the entrances. This labyrinth design also allows three groups of ten children each to tour "Shapes" at the same time without seeing or interfering with one another. The child may not always be immediately aware of the exit in each space and may not find it so tempting to rush through until he has explored the space.

A very young child begins his adventure in "Shapes" cautiously because the entrance curves into a dark, circular room (see room *1* on the accompanying floor plan). But it is not long before he discovers something he can do in the exhibit. In the center of the room is a blue-carpeted column containing three windows; a black light in each catches the

portion of an object in the center that is touched with phosphorescent paint. With a yank on a handle under each window, the child can set the object vibrating. Thus, in one window the movement of a pencil-size rod with an illuminated point gives the suggestion of a line; in another window the vibrating of a rod illuminated horizontally makes it look like a square plane; in the third, illuminated rods that outline a square seem to form a cube.

By the time he finds the entrance to the next space, presumably the novelty of setting things in motion has worn off. The child curves his way through a tunnel (*a* in the floor plan) with textured floor and ceiling. At its end is a bright, white room (*2* in the floor plan) containing three giant geometric shapes made of polyurethane foam and covered in white vinyl. Simple two-dimensional geometric shapes painted on one wall are followed by three-dimensional concave shapes set into the adjacent wall (see *b* in the floor plan). Geometric

**Floor plan of the "Shapes" exhibition.**

shapes dominate the room—triangle, square, polygon, circle, tetrahedron, polyhedron, cube, and sphere. They are also shown in relation to others—heart shapes in a print by Jim Dine and arches and windows in a photographic blow-up of a building. The child eagerly climbs on the large foam shapes, placed so he can reach out to trace the inside of the concave shapes in the wall.

In the third room are more large foam shapes, but these are free-form, colorful pieces of contemporary furniture. Around the walls are large photographic blow-ups of natural and man-made objects. The label at the entrance asks the visitor, "Do you ever wonder why things are shaped the way they are? Many natural and man-made objects are designed just to carry out certain jobs. Can you find examples where man has also thought about safety and beauty?"

In another darkened room (4) the concept of dimension is reintroduced by shadows. The child steps up to four window boxes (f); in each a form is attached to the back of the box with a rod that goes through the center of the form and comes out the window, where a handle allows the visitor to rotate the form. As he manipulates the forms, the child is expected to notice the difference between two and three dimensions: the three-dimensional forms—a cone, a sphere, and a cylinder (the fourth is a flat circle) cast distorted and exaggerated shadows. (Though the four geometric forms are shaped differently, there is a point in their rotation at which they all cast circular shadows.) In a corner of the room is a square of light on the floor where the child may cast free-form, abstract shadows of his own.

Light from the fifth gallery space (5) is blocked out by floor-to-ceiling strips of red and purple felt (g) easily parted to reveal a large, adult-sized concave mirror. Suspended

from a hexagonal frame made of metal pipes, it provides an almost endless source of fascination. Elsewhere in the room are a pair of framed, painted Vasarely scarves vibrating with color, and a bubbled mirror of convex circles in which the child can see himself distorted many times over. He can also peer through three concentric circles cut through the walls of the adjacent hallways. These two parallel hallways (j), comprising a series of small hills, form a path into gallery 6.

This next space offers a variety of charms. A machine churns out bubbles with strange curves and angular shapes. A mirrored dead-end hallway (m) with concave and convex walls creates distorted images of the people in it. A fish tank is set at child's eye level in one wall. The guide here has an opportunity to talk about how many shapes are around us all the time and what determines those shapes. If the children are old enough, the volunteer may lead them into a discussion relating the curves in the bubbles to those in vaulted ceilings and spiral staircases, or connecting the mirror distortions to other factors that make things seem different from the way they are usually perceived.

A cylindrical slide sends the child from the sixth to the seventh exhibition space and deposits him on a soft landing pad in front of a rear projection screen. The designers' expectation was that the visitors would settle down at this point for a film that shows Christo, the conceptual artist, wrapping the rocks on the coast of Australia in huge sheets of canvas and the canvas then being dramatically slashed to tatters by the fierce ocean winds. But for one thing, the projector required more upkeep than the staff could manage and so was often inoperative. For another, the pace through the exhibition had quickened considerably by this time, and the slide only added to the child's excitement. Instead of settling down to watch

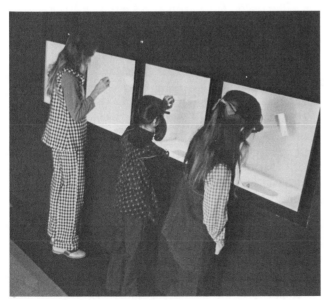

Shadows teach about dimension in the fourth "Shapes" gallery. Children turn handles on protruding rods to rotate forms inside lighted boxes, and they observe that the three-dimensional forms cast distorted and exaggerated shadows.

Children tumble down a cylindrical slide to get from the sixth to the seventh "Shapes" gallery and end up on a soft landing pad. One purpose of the slide is to introduce the concept of "cylinder."

the film, he would scramble back up for another trip down. (Asked how she would change the exhibition now, the curator of education said she would put the slide at the end.)

To the right of the screen is a wall with two small windows that open onto two of the classic Ames Distorted Rooms (*8* and *9*). When two children from a group enter the rooms and walk to the far ends, one seems to grow smaller and the other larger. Their companions quickly search for the reason—the change in the dimensions of the black and white floor tiles, the scale of the furnishings, and the size and shape of the rooms.[4]

*Pastorale*, an etching by Milton, hangs at the end of one of the rooms. It portrays an illusionary landscape in which, the child may discover, perspective has been altered; it would not actually be possible to see everything in the print at the same time, yet the artist has allowed us to see them all at once.

The child goes from the distorted environment into the last exhibition space (*10*), an empty room with a mirrored wall. Here he is encouraged to form shapes with his body, alone and with other children, and to compare his shadow to his reflection.

Although the spaces in "Shapes" are sparsely filled, each exhibit—bubble machine, Christo movie, free-form furniture—serves as a starting point for new perceptions of the space that surrounds us. For a short time the child's attention has focused on shape and its many aspects: dimension, geometry, perspective, illusion, function.

### "Shapes" as a teaching tool

Although "Shapes" was open on weekend afternoons to casual visitors, it was constructed primarily for use by the volunteers in the museum's education program for schoolchildren. The education staff at the High felt strongly that the children should not only be guided and challenged as they went through the exhibition, but also helped to integrate their experience in "Shapes" with other exhibitions in the museum, with art in general, and with the world around them.

Therefore, while the exhibition was up, two of the museum's regular programs were designed around the shapes theme—Discovery, a six-part series for inner-city 4th graders, and Elementary-Art to the Schools, a three-part series for 6th graders. Both incorporate visits to the schools by volunteer guides before the classes come to the museum, and both emphasize the importance of several visits, not just one. (For further information on these programs, see chapter 6.)

In the Discovery sessions at the schools, the volunteers introduced the children to the concepts and vocabulary of the basic themes of the "Shapes" program: line, movement, and rhythm; two-dimensional shape and space; three-dimensional shape, form, and space; texture and sound; color and mood; and composition and rhythm. The five sessions in the "Shapes" exhibition and in the galleries would then build upon the children's basic understanding of these abstractions, sometimes with the help of professional dancers and

musicians, who would make connections between music, the movements of the children, and the composition and mood of the paintings. For their last museum session, groups of five or six children were asked to fill terrariums, which they could take back to their school, as a lesson in composition.

For Elementary-Art to the Schools, the volunteers showed the students slides of the museum and of the elements of art all around them, gave them materials to shape their own wire and wood sculptures, and introduced them to a variety of games. In one called "Rubberman," to emphasize composition and mood, the volunteer would ask one student to assume a limp stance and then have his classmates "sculpt" him into a resemblance of Rodin's *The Shade*.

On their first visit to the museum, the Elementary-Art to the Schools class, broken up into small groups, would visit two galleries and "Shapes." When the students came back to the museum a week later, they would produce their own film on color and shape, the volunteer all the while emphasizing the connection between the subject matter—"Shapes," a Renaissance painting, or a contemporary sculpture—and the students' own experiences.

Several works of original art in the Junior Gallery near the entrance to "Shapes" were often used as starting points for discussions about art in both programs. For instance, a Gutman sculpture introduced the concepts of positive and negative space and Jensen's *Doubling Squares* the concepts of shapes, line, concentric shapes, balance, and serial design.

### The role of the volunteer guide

The unguided visitor's tour through "Shapes" was enriched by labels posted throughout the exhibition. These provided explanations, questions, and suggestions for activities to orient the visitor, introduce him to the vocabulary of shapes, and encourage him to participate in the environment. For example, in the space with the windows containing forms that cast shadows was the following label:

> What causes shadow? Is a shadow two- or three-dimensional? Shadows can become elongated, distorted, or exaggerated, depending on where the light is coming from. Turn the knobs to change the shadows. Reach under the light to make shadows with your hands.

Such guidance may have been of some use to the casual visitor, but the museum education staff knew that it was inadequate for teaching children in the exhibition. So the volunteers were carefully trained to organize the school programs and guide the children through "Shapes."

Each group's tour through the Junior Gallery and "Shapes" was modified by the guides to correspond with the youngsters' age and experience with art. To help him, the volunteers were provided with four basic tools:

1. Dialogue Guidelines to the Junior Gallery Exhibition Area and "Shapes," which gave ideas for concepts that could be discussed with each painting in the exhibition area and in each room of "Shapes."

2. A notebook including dialogue suggestions, background

material on the museum's collections, and ideas for improvisational games to be used in conjunction with particular paintings, prints, or sculpture.

3. Program formats that incorporate visits to the schools with materials, slide presentations, studio projects in the Junior Activities Center, and exploration of the galleries and "Shapes."
4. "Busy Baskets" to carry on the tours. These contained glue, scissors, yarn, and pipe cleaners for discussion of line; newsprint and crayons for texture rubbings; and wooden geometric forms, rectangles of colored paper, flat cardboard geometric cutouts, and an ink pad to illustrate print concepts. The guides also carried two giveaways, a rectangular card with the hours of "Shapes" printed on it and a flyer about the exhibition. The card had a square viewing hole in its center, next to which was printed the admonition, "Shapes of the city are all around you. Take a look." The flyer contained the suggestion that children "cut along the green lines and rearrange the parts of this square to form another basic geometric shape."

The volunteers were warned that they would not have time to deal with all the questions or subject areas suggested in the guidelines and would have to choose an approach to "Shapes" based on the readiness of the children and the 20 or 30 minutes allotted to each group inside the exhibition.

In some group visits the volunteer guide spent most of her time using "Shapes" to explain dimension. She would begin by asking the children how they might measure the Rickey sculpture at the entrance to the High Museum. Often she discovered that the children did not quite understand how height, width, and depth add up to three dimensions. In each section of "Shapes," then, she would emphasize the meaning of dimension, and at the end of the tour, she would lead the children to look for dimension in certain objects in the collection: "How does the artist use dimension in painting?" "Does the artist suggest dimension or paint a perfectly flat surface?"

## Successor to "Shapes": "The City"

The idea of integrating the museum experience—"Shapes," as well as other tours and instruction—with the children's own lives has been carried on in the new exhibition that replaced "Shapes" in the fall of 1974. In contrast to both "Shapes" and its predecessor, "Color, Light, Color," "The City" is directed not so much at awareness of the elements of art as at discrimination about environmental design.

In her description of the new exhibition, Paula Hancock sums up the rationale behind it:

. . . A city contains all the elements of design—line, color, light, shapes, space, movement, texture, harmony, rhythm, balance, and form. These elements, though present in every city, are often lost on urban inhabitants intent upon the practical and impractical aspects of their town. If people became more aware of the ways a city utilizes space, light, color, shapes, etc., and were more discriminating in their approval or disapproval of the ways in which city-space is designed, architects and planners would have to become more thoughtful of the total visual impact of their designs. . . . "The City" is aimed at making children—and adults—more critically aware of their urban surroundings . . . triggering more creative seeing and thinking about the city, and, ultimately . . . encouraging youthful citizens to seek improvements in their physical environment.[5]

## Are such exhibitions necessary?

It was easy to see that people enjoyed their experiences in "Shapes." These experiences were tactile, participatory, visual, and intellectual, depending on each visitor's age, education, and the guidance to which he was exposed. But given all the other educational activities and programs at the High, how useful is an exhibition like "Shapes"? Is it more than just a fun house? Do children really learn there?

For the museum staff, "Shapes" itself achieved several things. First, it provided an opportunity to isolate a single concept. Such abstractions as form, dimension, and negative space are often difficult for children to understand. Dealing with one concept in the galleries themselves may require the volunteer to override many other elements that divert children—the size and strangeness of the place, not to mention the colors, the people, the subject matter. "Shapes" was, above all, a teaching tool, enabling guides and children to concentrate on a basic understanding of the elements of art and build from it to a more complex analysis of the balance, composition, and mood of a particular work.

Second, "Shapes" helped the children learn the language of visual arts. When asked at the beginning of their visit to identify the forms that made up the outer walls of "Shapes," no one in a group of 4th graders could give the right answer. By the time they left, they knew the word "cylinder" and could spot it in a number of disparate elements of the exhibition—from the Gutman aluminum sculpture in the Junior Gallery to the shape that enclosed the popular slide chute. They could also count and name innumerable other shapes that filled their lives and the works of art they saw in the museum.

The museum staff and volunteers were convinced, too, that they were able through the exhibition to introduce the larger ideas of balance and composition in the interaction of shapes with one another. Forming group compositions and experimenting with body sculpture, children could begin to make the connections between the straightforward messages in "Shapes" and the more complex compositions in the galleries.

"Shapes," like other exhibitions in the High Museum's orientation series, is regarded as a point of departure, not an end in itself. "What we strive for so diligently," writes the High's director, Gudmund Vigtel, "is to establish a tradition of appreciation, of passion for the visual arts where there is none—as yet."[6]—*S. R. H.*

## Notes

[1] "Share Our Adventure," brochure of the High Museum Junior Activities Center directed to potential JAC volunteers.

[2] Fall 1972.

[3] For sources of quotations without footnote references, see list of interviews at end of this report.

[4] For a discussion of the Ames room, see R. L. Gregory, *Eye & Brain,* 2nd ed. (New York: McGraw Hill, World University Library, 1973), pp. 178–181.

[5] An indication of the rise in costs for such exhibitions is that the design and construction for "Color, Light, Color" in 1968 was between $8,000 and $9,000; for "Shapes," $20,000; for "The City," about $45,000.

[6] *A Report covering the Period July 1, 1968 to June 30, 1969* (Atlanta, Georgia: High Museum, 1969), p. 8.

## Interviews

Donahue, Maureen. Nine-year-old Atlanta student touring "Shapes" exhibition at the High Museum. April 4, 1974.

Grant, Marena. Curator of Education, Loch Haven Art Center, Orlando, Florida. May 14, 1974 (at the High Museum).

Hancock, Paula. Curator of Education, High Museum of Art. April 3, May 16, 1974.

Vigtel, Gudmund. Director, High Museum of Art. May 16, 1974.

*Photographs and drawing: courtesy of the High Museum.*

## ARKANSAS ARTS CENTER: YELLOW SPACE PLACE

The Arkansas Arts Center
MacArthur Park
Little Rock, Arkansas 72203

**A viewing, working, audiovisual participation gallery for children that grabs their elders, too. "Interaction occurs between the object and the child," says the director. "His answer is the work he makes himself in the gallery." A sampling from the exhibits: a sorcerer's chest in stoneware, George Washington in embroidery, a Calder circus on film. Budget: about $5,200 in 1973; visitors: about 27,500. CMEVA interviews and observations: October and November 1973, January 1974.**

### Some Facts About the Gallery

**Title:** Yellow Space Place.

**Audience:** Focus is elementary-age children, although as a walk-in educational gallery it appeals to older and younger children as well. Over 10,000 young people visited the gallery on scheduled tours in 1973/74; records of casual visitors are not kept, but the center estimates that approximately 27,500 persons visit annually.

**Objective:** To provide, in the words of the Arts Center director, "an open educational atmosphere in which a child can make his own connections with basic aesthetic concepts—color, form, space, line."

**Funding:** A grant from the Arkansas Arts and Humanities Council titled "Exhibits for Children" is matched from the museum budget, mostly in-kind services: first year, $2,000; second year, $2,100;

third year, $2,600. A yearly contribution of $500 is made by the Junior League of Little Rock.

**Staff:** Director of education, a maintenance man, and 16 volunteers.

**Location:** The Yellow Space Place is a 40-by-32-foot room located off and slightly above the second floor of the Arts Center.

**Time:** The gallery is open during Arts Center hours: 10 A.M. to 5 P.M. Monday to Saturday, noon to 5 P.M. Sundays and holidays. Exhibitions are changed about four times a year.

**Information and documentation available from the institution:** Catalog-workbooks published for each exhibition; selected slides of some exhibits; newspaper articles from the *Arkansas Democrat* (January 10 and July 4, 1971).

Of her own childhood exposure to art in Little Rock scarcely more than 20 years ago, the Arkansas Arts Center's director of education, Rebecca Rogers Witsell, commented, "All I ever saw here [in what was then the Museum of Fine Arts] were Territorial portraits and glass. When I was a high school senior in St. Louis and saw my first original Impressionist painting, it was practically a religious experience. Before then, I had never seen a painting that wasn't a portrait. I thought that's what art was."[1]

Mrs. Witsell's use of the Yellow Space Place, the center's gallery for children, is a happy merger of institutional goals and personal enthusiasm. Besides the broad range of studio classes the center offered—and the almost weekly traveling exhibitions that stop there—she wanted to create an accessible and eye-opening gallery where children could develop a better understanding of the scope of artistic expression, far beyond Territorial portraits. This she saw as one way to exhibit and provide a format for the museum's diverse collection, which includes a large number of contemporary works by regional artists.

**Program of the center.** At the Arkansas Arts Center, exhibitions of visual arts are just part of a program serving the whole state. "It is an institution," Director Townsend Wolfe has remarked, "devoted to culture in the making." As such, it seeks to nurture an environment conducive to the growth and understanding of the arts, to provide an opportunity for the artist and his audience to share experiences, and to provide an inspiration for the student.[2]

In Little Rock it attracts audiences for music, theater, dance, and film programs. The center offers special lectures and forums related to current exhibitions, such as a lecture by Gerald Nordland on contemporary California artists, or an informal presentation by one of the resident artist-teachers—Don Hayes on glassblowing, Manolo Agullo on dance. Students of all ages attend classes in the visual and performing arts.

For far-flung audiences across Arkansas, the center's state services program offers the Traveling Players, a group with a repertory of affordable productions for adults and children.

Twelve traveling exhibitions for public places are available. An artmobile visits approximately 160 communities during each two-year circuit. Performances by one of the state's four symphony orchestras can be arranged through the Arts Center, along with a host of lecture-demonstrations and a traveling artist available to schools for two-week residences.

## A museum transformed:
## A new place for children

When, in the 1950s, the Junior League initiated a program to enlarge and rejuvenate the Museum of Fine Arts of Little Rock and secured support from the city and the Rockefeller Brothers Fund, the present institution began to emerge. As it keeps on changing and growing, it heeds the words of the late Winthrop Rockefeller, one of the center's staunchest and most generous supporters, who rallied behind the Junior League's initial efforts: "Well, girls, if we're going to build an arts center, let's do it right!"[3]

For Wolfe, the Yellow Space Place is one aspect of "doing it right":

> We believe in artists and their art as a valid form of communication. An art object has communicative values that words do not have. Providing an open educational atmosphere in which a child can make his own connections with basic aesthetic concepts—color, form, space, line— is what it's all about. We are educating in the most beautiful way, and I don't want to do anything that would break down this openness, that would make the child feel watched. Interaction occurs between the object and the child; his answer is the work he makes himself in the gallery.

Physically the Yellow Space Place is a place apart. Without arrows or signs, it must be discovered. To the left of the main stairway that leads to the second floor of the Arts Center, a come-on banner, "Yellow Space Place," announces the gallery's location; additional banners that surround the come-on are made of children's tempera paintings blown up. A few more stairs to a small landing, a turn, and six steps bring the visitor to the gallery, 32 feet x 40 feet, a half-story above the second floor. One wall is yellow (the gallery's name was chosen through a children's contest; the winner got a scholarship to the Saturday School).

**The gallery.** For all the studio work and participation that goes on in it, the heart of the Yellow Space program is the ingeniously arranged exhibition. To facilitate openness and visual dialogue, each show since the Yellow Space Place's inception in 1970 has adhered to the same basic format: (1) an exhibit area with original works of art; (2) an audiovisual area with a supplemental slide or short film, shown on a rear-projection built-in screen and activated by a child-high switch; (3) a participation area where a child may explore or manipulate things; (4) a work area, with materials provided for creating objects related to the show's theme; (5) a catalog

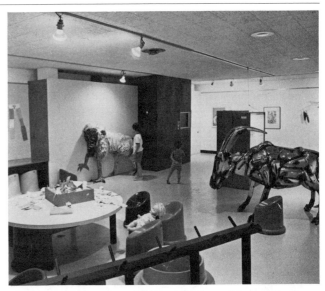

**Inside The Yellow Space Place original art objects reflecting a theme—here, "Animals in Art" (1972)—are exhibited near a work area where children can create their own art from materials provided by the museum.**

or workbook for children to take home to reinforce their museum experience.

Exhibition themes may be built around subject matter ("Toys Designed by Artists," "Animals in Art"), an art concept ("Shape," "Space"), or materials ("Build a Space," "Expressions in Fabric"). Every show is designed, through careful juxtaposition of objects, to allow the individual visitor to make his own visual comparisons. "People in Art," for example, showed three portraits of George Washington: an oil painting by James Peale, a stitchery portrait with American flag by Joana Photicoo, and a shaped-canvas portrait by Memphis artist Ted Faiers. Such juxtapositions reinforce one of the gallery's goals: the illustration and comparison of multiple options. Concepts and terms receive verbal definitions only where appropriate, and always briefly, with the exhibition design itself carrying the aesthetic message.

Although some early shows included a testing mechanism to see if children had grasped the concepts presented, "right" and "wrong" are no longer part of the program's vocabulary; "quality" and "content" are. As Mrs. Witsell has noted, "If a child can discover that 50 artists can look at the same landscape and each respond to it in a different way, how can he help but know that his individuality is his most important asset?"[4]

**Two sample exhibitions.** A 1973 show, "Expressions in Fabric," was dominated by a red vinyl-and-cloth soft sculpture of a banana split by Marigold A. Lamb, entitled *How America Influenced Me.* The exhibition included an embroidery folk portrait of George Washington and a Japanese landscape, a contemporary dyed-fabric collage, a

mola appliqué,[5] and a number of large knotted and woven hangings. Two life-size soft-sculpture dolls were propped up against a wall. Bright colors dominated the room, bouncing the eye from color to texture to subject. Against one wall, heavy seamen's ropes hung from the ceiling, with color-coded instructions painted on the wall for basic macramé knots and a simple crochet pattern. The work table provided strips and scissors for weaving paper.

Unlike most exhibitions, which rely on the Arts Center's permanent collection, a 1973/74 show called "Toys Designed by Artists" resulted from a juried regional competition. In an age in which mass-plastic violence is considered playful, the toys were startling. One group of neighborhood children remained in the gallery for over an hour, pulling the strings on two puppets with papier maché heads suspended in a glass case and putting nickels in a squat cone with a mouth that, after appropriate creaks and clanks, returned the nickel on its tongue.

Stuffed soft sculptures invited sitting and rolling. A small stoneware chest opened to reveal a completely furnished

In "Toys Designed by Artists," a 1973/74 juried exhibition in the Yellow Space Place, children could play with the exhibit objects. Here, a Little Rock youngster experiments with Becky and Marcel by Betty F. Easley—wood, cloth, and papier maché marionettes suspended in a glass case.

room, glass-protected, with its resident sorcerers. One child approached it, looked, and sat cross-legged, waiting for the magic to begin. Another child at work on a paper construction at the craft table leaped up periodically to stand in front of the small movie screen showing Alexander Calder's circus. When urged back to the table by a friend, he called back, "Wait. I can't yet. They're just getting to my favorite part." Children often pop around in the gallery from work table to object to film and back. Yet with all the movement, damage has been slight and, according to Mrs. Witsell, in all cases reparable.

**Ideas from the workbooks.** What the exhibitions teach visually the accompanying workbook-catalogs supplement. Available for ten cents at the sales desk near the entrance to the Yellow Space Place, the books—8½-by-11-inch pamphlets with brightly colored covers and eight or twelve pages of black-and-white reproductions, simple graphics and captions, and plenty of space for children to draw—illustrate some of the objects in the exhibit, suggest a running progression of things to do, and offer a work section at the end for more extensive at-home projects. Whether the workbooks hold their own against television, only the child who takes one home, or his household, knows for sure. Although only 500 are printed for each exhibition, many are purchased by teachers who apply Yellow Space Place concepts and projects with the children in their classrooms.

The book produced for "Toys Designed by Artists" suggested creating a "noise machine," making a kite from scratch and then "seeing if your shape and colors will fly," drawing a game ("If you make it on paper, you can roll it out any time you want to play"), and making a "Wooden Surprise":

Collect as many scraps of wood as possible. Look everywhere—empty thread spools, toothpicks, popsicle sticks, worn out broomhandles, carpenter's scraps and broken furniture. They can be chosen for their color (type of wood), texture (rough or smooth), and size. The color can be changed with the addition of paint or made shiny with shellac. The surprise here is that what you collect will determine what you make; it can range from a pull toy to a tree house. Try Elmer's glue or nails for attaching parts that will not move. Experiment with loosely driven nails and wire for parts that move.[6]

## What the Yellow Space Place has taught the Arts Center

Three years' experience produced a few changes in the Yellow Space Place, and a few surprises. In the early months of its life, some exhibits featured a "Buzz-Ring-Ding" wall of multiple choices designed to reinforce correct answers to basic ideas taught in the exhibit. Graphically exciting though the wall was, the education director soon discovered that buzzing and dinging had greater appeal than reading and choosing, particularly among the clientele that could not

read. Subsequent shows have tended to rely less on verbal literacy and testing and more on visual literacy and creative response.

One of the surprises has been the gallery's popularity with adults as well as children. "I guess I forget that adults can be as visually inexperienced as children," Mrs. Witsell says. "And they don't seem intimidated by learning something here." It is not unusual, for example, to see a gray-haired elementary schoolteacher sitting purposefully at the craft table designed for children, explaining that she is making things to share with her students but obviously enjoying the process herself.

A second surprise has been the Yellow Space Place's help in changing the attitude of the Little Rock Public Schools toward using the center. Where direct overtures had only modest success and a Junior-League cosponsored "arts awareness" project foundered for lack of interest, the new gallery appears, in Wolfe's words, "to have made the public school people reappraise ways they might work with the center. It helps to convince them that we are interested in education and art beyond pure aesthetics." A tangible result has been to enlist center cooperation in broadening the curriculum of French and Spanish classes. Language students visit the center for a lecture by Wolfe, a film on the art of the country they are studying, a gallery tour, and a visit to the studios.

Wolfe also feels that the gallery has had a positive, if subtle, impact on the center as a whole, freeing other gallery areas from lengthy aesthetic documentation. The Yellow Space Place frees gallery-visiting families as well, permitting adults to view other exhibits at their own pace, knowing that younger members are happily and safely occupied. Seeing their children's involvement and interest at first hand, Wolfe believes, has also helped families to perceive art as a worthy educational pursuit and encouraged enrollment in the Saturday School, which offers a variety of studio art classes for children.

## Attendance and support

The gallery attracts a devoted cadre of repeaters who find it an oasis of tactile art in the usual museum desert of untouchable objects. Its audience is about equally divided between those for whom it is a stopping-off place on a school tour and those who wander in during a family excursion. The Arts Center estimates that approximately 27,500 persons visit the Yellow Space Place annually (the number of visits actually recorded by the center is of course much smaller, for only organized tour participants are registered).

Grants from the Arkansas Arts and Humanities Council, matched mostly through in-kind services by the Arts Center, plus a $500 annual contribution from the Junior League of Little Rock, support the gallery. During fiscal 1973, four shows were mounted for $5,200. Such costs as the catalog-workbooks are kept to a minimum, as the center does its own printing.

## An assessment

For Wolfe, an outstanding aspect of the program is educational openness seasoned with a little risk: "We feel it is important to show children that we are willing to take a chance by having original art available. The level of art and of expectation is high." No guard is stationed in the Yellow Space Place itself; the guard at the foot of the stairs leading to the gallery can keep an eye on the major works exhibited. The two high school students who were added to the staff in 1973 for an hour after school and on weekends keep the paste pots full and answer questions; they neither police the place nor overtly teach.

The opportunity for children to respond to an exhibition by creating an object of their own sets the program off from those in many museums, where fear of mess and damage prevails. By providing this opportunity, the Yellow Space Place enhances the face-to-face meeting of children—and adults—with art. Neither deacons nor docents are required, as Wolfe points out, because "we don't preach art here." Dialogue is direct.

To one observer, the Yellow Space Place is a "visually exciting room with educationally seductive overtones." Children and art seem to be in true interaction, happy and low-key, possibly profound, possibly not. Whether the gallery's open and inviting ambience actually promotes the kind of direct dialogue Wolfe talks about is harder to determine, especially given the official position that any attempt to monitor the room would endanger its very vitality. It could be argued, however, that unobtrusive observations by Arts Center staff might help make exhibitions even more effective than they are—if indeed such escalation were possible.

The shows observed in 1973/74 for this report appeared to be highly effective. Chosen by Wolfe and Rebecca Witsell, the objects were installed and variously augmented by Mrs. Witsell in a way to bring out immediate response in child and adult alike. Gimmicks? To be sure. Some observers might object to their conjunction with art, but the Arts Center sees nothing sacrilegious in making the dialogue between child and object entertaining as well as educational—in importing, for instance, a fun-house mirror to illustrate the principle of distortion in an exhibit of "People in Art," or in the same spirit letting kids put their own heads through a hole in an otherwise finished portrait created for the occasion.

In sum, the Yellow Space Place comes through as a series of alluring sights leading the visitor in one direction after another. Whatever sins of commission the purist might denounce, it would be hard for anyone to deny that the Yellow Space Place omits that traditional museum sin—the installation that invites the visitor to go once around an exhibit, get finished, and get out.—*B. K. B.*

## Notes

[1] For sources of quotations without footnote references, see list of interviews at the end of this report.

2 "Statement of Aims and Purpose," Arkansas Arts Center brochure 1973/74.

3 "History of Arkansas Arts Center," prepared by Junior League of Little Rock.

4 Rebecca Rogers Witsell, letter, November 9, 1973.

5 Mola appliqué (sometimes called reverse appliqué, because the artisan begins with a number of layers of cloth and cuts down to reveal the colors desired for a particular pattern) is a fabric expression of the Cuna Indians of the San Blas Islands, off the coast of Panama. Probably originating during the period of Central American colonialism and made with imported fabric, functional mola are rectangular pieces of fabric, shoulder-to-shoulder in width, shoulder-to-hip in length. They are sewn together on a yoke with a short sleeve and are worn as a shirt. The Cuna Indians originally painted their bodies; the mola is a translation of these designs—originally geometric, now commonly including figures or animal forms—to fabric. Mola originally meant cloth; now it means blouse. (Small mola are popular tourist items; they are featured artistic embellishment on all Braniff airplanes.)

6 "Toys Designed by Artists" workbook.

## Interviews

Anderson, Rosemary. Docent Coordinator, Arkansas Arts Center. January 18, 1974.

Bond, William P., Jr. Director of Performing Arts, Arkansas Arts Center. October 11, 1973.

Cabe, Gloria. Docent, Arkansas Arts Center. January 18, 1974.

Cherry, Pauline. Director of State Services, Arkansas Arts Center. October 11, 1973.

Kaplan, Leon. Administrative Assistant, Arkansas Arts Center. January 18, 1974.

Witsell, Rebecca Rogers. Director of Education, Arkansas Arts Center. October 11, 1973; January 18, 1974; telephone, October 7, 1974.

Wolfe, Townsend. Executive Director, Arkansas Arts Center. October 11, 1973; January 18, 1974; telephone, October 9, 1974.

## Bibliography

The following are the titles of some of the exhibition-related workbook-catalogs available to children who used the Yellow Space Place. Dates correspond to the period of each exhibition. All were designed by Rebecca Rogers Witsell and published by the Arkansas Arts Center.

*People in Art,* March 15–June 30, 1972.
*Animals in Art,* July 15–October 31, 1972.
*Shape,* March 1–June 15, 1973.
*Expressions in Fabric,* July 1–November 7, 1973.
*Toys Designed by Artists,* November 30, 1973–March 15, 1974.
*How the Artist Views the City,* April 1–July 15, 1974.
*Plants and Flowers in Art,* June 28–August 18, 1974.

*Photographs: View of Yellow Space Place, Edwin L. Ross. Child with marionettes, Robert Ike Thomas, Arkansas Democrat.*

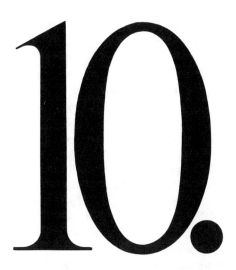

# Visual Arts Programs for High School Students in Museums and Schools

museum's staff and collections to prepare for the national Advanced Placement examination in art history; a passing grade usually gives them college credits.

440 **Teenage Teachers: Explainers in the Exploratorium.** Answering visitors' questions about the perceptual exhibits is a paid job for some 60 trained high school students, who comprise the entire floor staff of this science-art museum.

442 **Institute of Contemporary Art: VALUE—Visual Arts Laboratory in Urban Education.** In a jointly sponsored school-museum program, 11th and 12th graders went out into the city for six-week periods to study the urban environment through the visual arts and media.

447 **National Portrait Gallery: "The Trial of John Brown."** Gallery staff stages the trial of the famous abolitionist in secondary school classrooms to interest students in the times of famous characters whose portraits they will later see on a museum tour.

448 **Indianapolis Museum of Art: Indianapolis High School Council.** High school students from around the city meet every two weeks in the museum, attend events, and suggest programs for their peer group. (Box)

450 **The Department of High School Programs and an Experiment in "Arts Awareness" at the Metropolitan Museum of Art.** A large urban museum established a separate department for high school programs and experimented with highly controversial (and much copied) techniques for turning on teenagers, especially those from the inner city, to art and the museum.

**Reports elsewhere in this study that include visual arts programs for high school students:**

## Introduction

For years, art museum educators have been trying to pry secondary school students out of their classrooms and into museums. It has been a notoriously difficult task and, until fairly recently, unsuccessful. Art in the schoolroom and field trips outside it might be practical for elementary schoolchildren, but most high school students have hewed to rigid daily schedules, which allowed no time for travel away from the school grounds[1]—and in which, furthermore, art was most noticeable by its absence. Unless it was "industrial arts," art has been deemed useless for students going straight to work after high school and unnecessary for students preparing for college, as high school art courses have customarily carried no credit for college admission.

In 1932, a conference on "Art and Adolescence" held at the Fieldston School in New York noted that young people stopped coming to art museums at about age 13, when high school requirements began to pile up.[2] A 1938 survey by Robert Tyler Davis for the General Education Board revealed that few of the 54 museums queried had high school programs, largely because class schedules prevented students

from leaving school and coming to the museum.[3] In her 1944 report of the board's pioneer support of museum efforts to cooperate with high schools, Lydia Bond Powel attributed the difficulties of the five museums under study to "the main stumbling block of most art efforts on the secondary level—preparation for college."[4]

For museums that have tried to design programs for high school students in the years since these studies, not much has changed. There has been, to be sure, a good deal of theorizing about the need for the arts in the secondary school curriculum and for high school students to learn about the arts, along with other subjects, in programs out of school.[5] Except for a small minority of students, however, these ideas have not generally become real. The arts are still easily wiped off the secondary school map by the stroke of an education commissioner's pen, usually set in motion as the result of budget cuts and higher costs that leave no money or teaching staff for the "frills."

Even so, it can be argued that several developments in recent years have produced a relatively hospitable soil for the arts at the high school level,[6] and reports in the chapter that follows indicate that a few (a qualifier that needs emphasis

here) museums and school systems have taken advantage of it. As with other changes in American schools during the early 1970s, many of these developments have their roots in the social, education, and economic ferment of the sixties.

**Urban migration.** The population shifts of the 1950s and 1960s, in which the major American cities became increasingly nonwhite and the areas around them increasingly white, had substantial impact on the schools, especially the high schools. In just a few years, enrollments in some urban high schools went from 80 or 90 percent white to 80, 90, and 100 percent black, Puerto Rican, or other dominant minority. Manned largely by middle-class white teachers and administrators who were used to predictable, career-bound middle-class students, these schools could not adjust quickly to their new charges, many of them near-adults toughened by the ghetto streets and rejection by society at large. Inner-city high schools turned to other institutions and to radical alternatives to help them cope.

Like their counterparts in the thirties who responded to the Depression with a variety of programs for the unemployed,[7] museum staff members began to devise ways to help the high schools and to "reach," through the arts, students who were turned off by nearly everything else. At the same time, the growth of alternative high schools—also designed primarily to deal with the turned-off minority student—with their more flexible schedules and an impetus to draw on a variety of urban resources to educate young people who had no natural contact with them through family or friends, gave museums and other arts organizations a chance to bring students out of school during regular school hours and work with them on the institution's home ground.

While the money and the interest lasted, federal education programs helped too. Both the Urban Arts program in Minneapolis and the University City, Missouri, high school arts section (see reports in this chapter) were begun with Title III funds, and the University City program was specifically aimed at trying to adjust the high school to an influx of poor black migrants from the St. Louis inner city. In several cases the National Endowment for the Arts has picked up where federal education funds left off. In Boston, Endowment grants helped to support the Institute of Contemporary Arts' VALUE (reported on here), which was aimed largely at inner-city teenagers. Endowment funds were also the primary source of support for the Metropolitan Museum's Arts Awareness program (in this chapter), a nonverbal approach to art that invited participation mostly from minority students in alternative high schools.

Some museums adjusted to their new urban constituents with their own or private funds. The Whitney Museum's Arts Resources Center, described here, was established in a ghetto area on the Lower East Side of New York with the help of annual foundation grants; its studio facilities have been free to drop-in students who are, again, almost all inner-city teenagers. At the National Portrait Gallery in Washington,

staff members intent on serving students in the local high schools brought to their classrooms a dramatization of the trial of Abolitionist John Brown, a subject chosen specifically to interest young black people in the offerings of the museum.

**High school reform and education research.** Closely related to the troubles urban high schools have faced in trying to educate their new enrollments, but fueled, too, by student revolts against bigness, impersonality, "excellence," and irrelevance (among other evils) in the universities of the sixties, are seven national studies—all of them undertaken between 1972 and 1975—that attempt to reform, revitalize, and redirect the U.S. high schools.[8] These studies have drawn on educational research into adolescent learning and behavior patterns, as well as the experiments tried during the sixties to counteract bigness and to bring school closer to the students' lives.

A common theme in these studies is the need to "correct" the idea of the comprehensive high school, which had been recommended in the last wave of reform in secondary education and spurred on by Sputnik in 1957. James Conant's 1959 study, *The American High School*, placed the new emphasis on the central school big enough to provide the sophisticated facilities and teaching that would help the United States catch up to Russia.[9] The correction most frequently urged by the current study commissions is to open up the high school and its inhabitants to the world outside. They suggest that the high school no longer be the solitary institution responsible for the education of adolescents and that community institutions become "new learning centers," providing broader and therefore, they believe, more effective instruction. In other words, the comprehensive high school is to be replaced by "comprehensive education."

In this scheme, the arts should take their place on an equal footing alongside other legitimate student interests. For example, an idea favored by the national panel assembled by the U.S. Office of Education (chaired by John Henry Martin) calls for reduced time on academic subjects in the school, perhaps as little as two to four hours daily. To expand students' horizons, give them "real" experiences, and allow them to pursue their individual interests, the panel would send students into the community for the rest of the day to learn through participation in arts organizations, not to mention places of government, public service, sport, and business.[10]

Another study put a similar idea this way:

In the years ahead, students whose needs are being adequately provided for will remain in traditional school environments. Students who are artistically inclined will learn in art museums, studios, and conservatories. Students who are skill-oriented will enter specific skills development centers or greatly expanded apprenticeship programs. Scientifically minded students will study in libraries, museums, zoos, and laboratories.[11]

What has led these study groups to such conclusions is not just reaction against older ideas that have run their course. They have been influenced often by educational research that seems to explain the students' own rebellions against the big, custodial school that directed some of them only toward college and the rest only toward less demanding jobs or the streets. With dropout and truancy rates that in some city high schools run as high as 50 and 60 percent (for some ethnic groups, the dropout rate is up to 80 percent), it has become clear that students are, as the expression goes, voting with their feet against what the schools have to offer them.

And yet, it would seem, students are capable of more, not less, than they are given. Educational researchers have found, among other things, that adolescence is the peak of physical and mental development. As for the adolescent mind, Jean Piaget and others distinguished it from the child's by its "leap" to formal thinking, to the ability to think abstractly and beyond the present, to think about thinking and about itself as feeling and experiencing. Indeed, say some educators, the "adolescent discovery of the subjective is a condition for aesthetic feeling in the adult sense."[12]

In further support of their ability to deal broadly with the arts at this age, Piaget has found that adolescents make "reality secondary to possibility." They are able to think about the things that might occur in a situation, to imagine a variety of alternatives. Given an assignment to produce the color yellow, for example, an adolescent will combine as many chemicals in as many ways as possible. Piaget concludes that the adolescent mind is flexible, versatile, reversible, inventive, capable of directing abstract thought and emotions to ideals as well as people. It has achieved what has been described as "an advanced state of equilibrium," in which "the possible and the ideal captivate both mind and feeling."[13]

Such conclusions challenge Benjamin Ives Gilman's disdain for the "attempt to put within adolescent grasp masterpieces embodying the utmost reaches of thought and refinements of expression," an attempt he characterized as "treachery to art."[14] The findings of Piaget and others support the belief of some museum educators today that high school students are the most appropriate school audience for serious efforts at education in the making of art, in art history, and in critical analysis of works of art. Joshua Taylor, director of the National Collection of Fine Arts, has observed that when a young person begins to examine critically what he can make with his own hands, when his "mind outstrips his hand," he is ready to join the adult world that recognizes creativity "as more an act of mind than turn of hand."[15]

As for the specific ideas of the reformers—in spite of the fact that, in the words of one skeptic, the times may be "out of joint" for the current crop[16]—some schools and some museums have already organized programs closely attuned to recommendations in the reform studies. Both the Exploratorium in San Francisco and the Metropolitan Museum in New York (see reports in this chapter) have provided paid jobs for high school students, who receive credit for their work, in the one case as guides, or "Explainers," to its exhibits and in the other as useful apprentices to curators, conservators, and administrators.

On the schools' part, the variety of alternatives advocated by reformers exists in several public school systems. Designed partly to appeal to individual student interests and partly to answer orders to desegregate the schools, "magnet" high schools emphasize such areas as aviation trades, real estate management and construction, oceanography, law, premedicine, communications, politics, urban and public service, business.[17] In Texas, a state where magnet schools began to be seriously developed in the sixties, a new high school of music and the arts has been organized as part of Houston's small but growing network of special interest schools. (Less career oriented is the University City High School, whose director is interested more in educating the future consumer than the maker of arts.)

**Art, affluence, and the search for meaning.** Part of this trend toward magnet or special interest schools stems from a national stress on career education. Reacting to the complaint of American businessmen that so many graduates of the public high schools had to be retrained to be fit for employment, then-U.S. Commissioner of Education Sidney Marland set aside funds in the early seventies for the development of demonstration programs in career education. These would eventually expand to embrace the vocational schools, but would add to their more narrow focus on entry-level skills a broad introduction to career possibilities and the combination of studies, including the liberal arts, they demand.

Fuzzy as the career education program was, it did encourage some school systems to look more carefully at the many kinds of work available to their graduates and to bring their educational offerings up to date. One result was that some school systems began to discover that there was indeed a growing popular interest in the arts and that this interest opened up job possibilities in several fields—not only in arts institutions but, as the Conklin Report in New York State pointed out, in television, film, urban design, architecture, publishing, retailing, and, of course, entertainment.[18] Not everyone agrees that the arts fit easily into the job market, and some educators feel that preprofessional high schools for the arts not only segregate talented students from their potential audiences, but raise unrealistic career expectations among the students. Nevertheless, the Houston High School for the Performing and Visual Arts is one example of a school that has career preparation as one of its goals. An earlier one, not reported here, that has become the prototype for such career schools in the arts is the 25-year-old High School of the Performing Arts in New York. Others have recently been opened in Washington, D.C., Newark, and Winston-Salem (see a more complete list at the end of this report).[19]

Beyond the career possibilities, however, the arts boom of the affluent sixties has had some effect on students and educators who have begun to see the arts as integral to a full

life. The arts as central to education is a cause, indeed, ardently championed by such groups as the Arts in Education staff of the JDR3rd Fund and promulgated, too, by several of the high school reform commissions of the mid-1970s. Drawing on a study paper that declared, "Experiences with the arts are distinctive for the way they lead to self-disclosure, to an acute awareness of the self,"[20] the National Panel on High Schools claimed in its final report:

> One of the greatest benefits from artistic involvement related to general education for all adolescents is the development of perceptual thinking. The artistic process of systematic planning, testing, executing and evaluation, almost simultaneously, seems to be one of the most productive kinds of thinking.[21]

The school system in University City set for itself the goal of making the arts part of the general education of all students on just this basis—that the arts are central to the development of all human beings, not only artists. The experiment, begun in the University City elementary schools, has now spread, for reasons mentioned earlier, to the local comprehensive high school, where an arts-centered section was established in 1973.

Not all high schools are by any means able to offer high quality programs in the visual arts, and in some cases either the school or individual students have turned to art museums to provide the training they want. In cooperation with local high schools, the Cleveland Museum of Art gives an Advanced Placement course in art history, which takes place at the museum (see report). Though the course leads to the Advanced Placement exam, the idea goes beyond such preparation: museum instructors who teach the class make broad use of the museum's collection and offer a professional academic resource to students who could not get such exposure anywhere else. Many able young people get their first taste of art history in this course; for the museum world, it becomes a way of attracting academically talented students into a field that sorely needs them. At another museum, the National Collection of Fine Arts in Washington, D.C., local high school students may enroll in the Discover Graphics workshop. The program, also described in this chapter, combines meticulous printmaking instruction on excellent equipment, careful use of museum collections, and close working relationships between the schools and a teacher who is artist-in-residence at the museum.

These two programs, and the Urban Arts program as well, point up something the museum is uniquely able to offer high school students: the sense of uncompromising quality in the visual arts. Young people can learn to coordinate eye, mind, and hand in studio programs elsewhere; nowhere but in the art museum can they be exposed to the visual standards that the works of art there hold up to viewers who have been prepared to value such quality. For the Urban Arts program in Minneapolis, the rationale for the participation of arts institutions and artists is the same: they raise the level of performance and give the students models of excellence, something

the schools cannot often do without professional help.

## Issues without sure answers: The problems of museums as "new learning centers"

If some of these programs seem to present good news to educational proponents of the arts who have worked hard over the years to arouse support for them in the schools, it should be pointed out that these few examples of success hardly constitute a national movement. In its search for promising museum programs for high school students, the CMEVA staff did not find many.

And in the schools themselves, the National Education Association Research Division study of music and art in the public schools in 1962 reported that nearly half of all American secondary schools offered no opportunities in the visual arts. Furthermore, in those schools that did provide visual arts courses, fewer than 15 percent of the students were enrolled. The report also noted that at the secondary level, at least 20 percent of art teachers did not have "adequate" preparation.[22] A later statistic, for 1972/73, indicates that the number of secondary school students (grades 7–12) studying art had risen to 27.2 percent—some improvement, but not very much.[23] In spite of the fact that "most" of those who responded to a Louis Harris survey for the Associated Councils of the Arts in 1973 wanted more arts education for their children than they felt the schools were giving them, taxpayers and legislators alike resist the arts as effete and unnecessary, especially at a time when students seem to be failing in the "basic" skills and jobs are scarce.[24]

Even if schools should lay more stress on the arts, there would still be problems getting high school students and art museums together. For one thing, most of the programs described in this report require flexible scheduling. But there appear to be practical limits to flexibility, as museums can learn from the Ford Foundation's candid report on its ambitious ten-year (1960–1970) Comprehensive School Improvement Program:

> Without exception, questions of student autonomy and discipline were raised by granting free time. This, along with the perceived erosion of academic standards, resulted in pressures from the communities as well as from within schools to revert to more traditional patterns of organization.

The report further observed that "the expectations of the community and, in fact, certain regulations, required that children be out of sight and confined to the school building during school hours."[25]

Alternative high schools and programs—whose flexible scheduling, small classes, attention to individual interests, and idealistic young staffs have made them so congenial to out-of-school activities—face uphill struggles for survival in nearly every city that has tried them. Many school systems have made enormous investments in large, well-equipped buildings, constructed during the years of rising enrollments and faith in the comprehensive school, and they are not about

to abandon these investments for a proliferation of smaller units harder for principals and superintendents to control. In the face of budget cuts and higher personnel costs, furthermore, many schools can no longer afford to experiment with ideas that have not yet proved themselves with hard statistics, no matter how inadequate the techniques for producing such statistics seem to the critics to be.

On the museum side, there are problems, too. One of them is also money. Of the 11 examples described here, only the two high schools of the arts are paid for almost entirely out of tax-levy school funds, and two more—Cleveland's Advanced Placement course and the National Collection's Discover Graphics—largely out of museum budgets. The rest depend at least partly on foundation, state, or federal grants, which in some cases have already run out and in others must be solicited anew each year. At a time when many museums are hard put to keep their doors open and their collections in good condition, it is not likely that these programs can be greatly expanded.

Another difficulty museums face is numbers. High school reformers of the mid-1970s rather blithely assumed that the "new learning centers" in the community can be readily adapted to the needs of the schools. In a preliminary report, the National Panel on High Schools, for example, declared that museums are among the "most underdeveloped educational possibilities in the community."[26] But there is little evidence in the reformers' reports to indicate that the recommendations for further development of this resource were made in consultation with museums. On none of the seven commissions that have reported so far have museums been represented, and none of the reports has dealt carefully with questions of funds or numbers of students who might begin flowing into museum buildings (not to mention libraries and other cultural institutions) if the learning center idea takes root. The Metropolitan Museum, by far the country's largest, was able with considerable effort and outside money to deal with an enrollment of about 3,700 students a year, most of whom came for only a few hours a week (and an uncounted number of whom were repeaters). Even if this figure represents a reasonable proportion of the high school students in New York City who might actually "go to school" in the Metropolitan, it is not likely that smaller museums with access to fewer resources and much smaller staffs would be able to handle anywhere near as many. The same is true of other museums in such cities as Minneapolis, Washington, Chicago, Cleveland, Detroit, Los Angeles, and San Francisco, where only a handful of people account for the paid education staffs. Among those museums that have already tried to carry on learning-center programs for high school students, several have found that the administrative burden can be heavier than the instructional one.

There is also the problem of accreditation. Frank Oppenheimer, director of the Exploratorium and a former high school instructor himself, has warned that museums must never become certifying institutions. How, then, should they work with schools—as complementary or supplementary places of instruction or as authors of courses that attract specific segments of the newly available high school audience? Furthermore, if the students are to receive credit for their museum work—and there is evidence in several of these programs that such incentive is necessary to keep students on their toes—what kind of credentials might be required of museum staffs, particularly if they begin to threaten the jobs of unionized teachers whose job ticket is a state license?

## Ideas these programs present

Not all these questions can be answered now. Nevertheless, the germ of some solutions does exist in several of the programs described in this chapter.[27] One is contained in the Cleveland Museum's Advanced Placement course. This plan frankly acknowledges the interests of an elite group of students who have the sophistication to choose advanced work in art history. Under such an arrangement, museums would be dealing at a relatively high academic level with a small number of young people in whom the art profession can afford to invest. Curators themselves, not just museum educators, have found at places like the Museum of Modern Art (see chapter 1) and the Metropolitan that contact with such students is stimulating and worth their time—and, in the case of the Metropolitan's apprentices, helpful as well.

The Whitney Museum's Art Resources Center, as well as the VALUE program in Boston, has also been built around the idea of intensive—and in both cases, expensive—programs for small groups. The Whitney makes clear that it is committed to spending money, thought, and energy on the small band of students interested enough to seek out visual arts experiences, rather than scattering effort among thousands of students brought in by the decision of teachers, schools, or other agencies.

Another answer is suggested by the Indianapolis High School Council, again a self-selected group of students who become friends of and participants in the museum. Exploratorium Explainers, even more closely integrated into the life of the museum, have the added advantage of helping the museum deal with larger numbers of students, whom the small Exploratorium staff could not handle itself, and they do so for less pay (even though the money is not easily raised) than a full-time staff would cost. Similar cost-saving is represented in the National Portrait Gallery and Metropolitan Museum programs, which have used college interns to give courses and make classroom presentations.[28]

Still another suggestion is offered by the idea of the laboratory, under which a museum could run a series of experimental programs to teach the visual arts using the museum collections, always bringing along the teachers as well as the students to take part and thus learn how they might use the museum themselves. Such experiments are not cheap, and they demand even more expertise than courses conducted

by museum staff directly for the students: teachers, like the rest of us, need very good models and intensive experience with them in order to decide whether or not a new approach is worth adopting.

## High school students: for some, a preferred audience

Among the museum educators who have had a chance to deal extensively with high school students, there are several who regard this age group as an especially receptive and satisfying audience for museums. Unlike children in early and upper-elementary grades, high school students are able to conceptualize, to pursue subjects independently, to concentrate on a project over time, to make their own choices. With some guidance and help, they are sophisticated enough to use the museum's random-access education system creatively. They are also in a position to begin making career decisions that a good museum experience can influence.

Perhaps, as educators with long experience in the schools agree, "enrichment" outside the school can have little impact on the school itself; only if it is "institutionalized," to quote one former superintendent of schools, will arts education become part of the schools' job. As long as museums and other cultural institutions assume the arts and "enrichment" part of the job—and do it free—they relieve the schools of their responsibility to create the kind of environment in which the arts can work their leavening effect on the curriculum and in the daily lives of all members of the school community. One question for museums and those who design and support their programs is how to effect those changes in the schools that will restore the arts to their rightful place in the curriculum. It is possible that art museums as cultural custodians might well have a stronger role in helping to make those changes than they have taken so far.

In the meantime, it is clear from the programs covered here that the art museum can and probably ought to contribute significantly to the education of individual high school students. Though museums may not have satisfied themselves that they have found the best ways to reach, serve, teach, and welcome those students, the reports in this chapter chronicle some especially thoughtful efforts to do all those things. —*A. Z. S./B. Y. N.*

## Notes

[1] See the Grace Alexander interview in this chapter for some typical problems with the secondary-school group tour.

[2] Held in cooperation with the Child Study Association; see report in *Worcester Art Museum Bulletin*, vol. 23, no. 2 (July 1932).

[3] Robert Tyler Davis, "Summary of Report on Function of the Art Museum in General Education," for the General Education Board, 1938 (unpublished). A respondent from the Worcester Art Museum wrote, ". . . The time of the high school student is considered more valuable than that of the grade pupil. Time schedules in the high schools are rigidly enforced, and school officials are not, as a rule, favorably disposed to any activity which tends to disrupt the regular program" (p. 25). Davis found that, even up against rigidity from the schools, some museums tried valiantly to reach high school students. Most of their work centered on sending "specimens" of art into the classroom. (See chapter 11 on Instructional Materials in this volume.) Most museums found that they were "little used by high school groups." As an example, the Art Institute of Chicago reported that only ten high school groups visited it in 1937. What broad use there was seems to have been made by "selected" students, as in the large lecture and sketching classes at the institute, for which students were chosen by the Chicago public schools.

[4] Lydia Bond Powel, *The Art Museum Comes to the School* (New York: Harper, 1944), p. 23. Powel observed that the last two years of high school were especially loaded with academic subjects, leaving little time for activities of "less value." Among museum educators, Thomas Munro of the Cleveland Museum especially lamented the "distortion" college admission requirements imposed on high schools. See his "Art in American Life" in 1941 *Yearbook of the National Society for the Study of Education.*

[5] A note on secondary schools: as generally used, "secondary" means "high school"—that is, grades 9 through 12, or 14- through 18-year-olds. Indeed, whatever other confusions the label may cause, "secondary" always *includes* those grades in the once-common plan that organized schools into eight grades of "elementary" and four grades of "high" school. As other plans have developed, the terms have grown a little shaky. Strictly and technically speaking, according to the Office of Education, U.S. Department of Health, Education, and Welfare, "secondary" includes more than grades 9 through 12 in the following forms of school organization for the 12 grades:

> 6-6 system: the top six grades—"secondary"
> 6-3-3 system: the top six (3+3)—"secondary"
> 6-2-4 system: the top six (2+4)—"secondary"

Another kind of definition is offered by *Educational Research and Development in the United States*. U.S. Department of Health, Education, and Welfare, Office of Education (OE-12049, December 1969, p. 11). Junior high schools are three-year intermediate schools between the six-year elementary and the three-year senior high school. High schools are three- or four-year secondary schools offering an academic, technical, or vocational program, or—when organized as a comprehensive high school—all three in the same institution, with offerings leading to graduation and a diploma. They may operate above the level of an eight-year elementary school (8-4) system or a combined elementary/middle school system (4-4-4) or above the three-year junior high school and six-year elementary program where the organizing pattern is 6-3-3.

[6] This chapter includes, with the few exceptions noted in the particular reports, programs aimed at the senior high school. A few 7th and 8th grade programs, like "Focus and Perception" at the Art Institute of Chicago (see chapter 6), are not included, for they do not fit into the Office of Education's definition of "secondary."

[7] See "Issues in Art Museum Education," this volume; also Alma S. Wittlin, *Museums: In Search of a Usable Future* (Cambridge, Mass.: M.I.T. Press, 1970), p. 179.

[8] The seven reports are

*American Youth in the Mid-Seventies,* Conference Report, National Association of Secondary School Principals, December 1972.

*The Greening of the High School,* ed. R. Weinstock. I/D/E/A and Educational Facilities Laboratory, New York, March 1973.

*The Reform of Secondary Education,* National Commission on the Reform of Secondary Education (B. Frank Brown, chairman), June 1973 (New York: McGraw-Hill, 1973).

*Youth: Transition to Adulthood,* Report of the Panel on Youth of the President's Science Advisory Committee, June 1973 (Chicago: University of Chicago Press, 1974).

*Discussion Draft, Report of the National Panel on High Schools and Adolescent Education* (John Henry Martin, chairman), published by I/D/E/A for use in the 1974 Fellows Program, with the permission of the U.S. Office of Education and the chairman of the panel. The final version of the report, published by the U.S. Office of Education in August 1975, was not ready for use in the CMEVA study.

*The Adolescent, Other Citizens, and Their High Schools* (New York: McGraw-Hill, 1975).

*New Roles for Youth in the School and the Community,* Report of the National Commission on Resources for Youth, New York, 1974.

See also Carnegie Commission on Higher Education, *Continuity and Discontinuity,* chapter on "Improvement in Secondary Education" (New York: McGraw-Hill, 1973).

For a quick, succinct summary of the reforms suggested by several of these studies, see William Van Til, "Reform of the High School in the Mid-1970s," *Phi Delta Kappan,* March 1975, pp. 493–494.

[9] John Esty, Jr., "Secondary Education in America: A Study of Needs, Directions and Possibilities," submitted to the Education Committee, Rockefeller Brothers Fund, New York. Revised version, January 31, 1974, p. 5.

[10] *Discussion Draft,* pp. 25, 28–29.

[11] *Reform of Secondary Education,* pp. 11–12.

[12] See L. Kohlberg and C. Gilligan, "The Adolescent as Philosopher," *Daedalus,* fall 1971, p. 1064.

[13] Herbert Ginsburg and Sylvia Opper, *Piaget's Theory of Intellectual Development, an Introduction* (Englewood Cliffs, N.J.: Prentice-Hall, 1969), pp. 202–205.

[14] *Museum Ideals of Purpose and Method* (Boston: Museum of Fine Arts, 1918), p. 287.

[15] "The History of Art in Education," a lecture given at a seminar in Art Education for Research and Curriculum Development, Pennsylvania State University, 1966.

[16] Van Til, "Reform of the High School," p. 494.

[17] See Leonard Buder, "'Magnet' High Schools in City Are Pulling," *New York Times,* July 3, 1975.

[18] For one of the most comprehensive studies to date of the arts as industry, see *Cultural Resource Development: Preliminary Planning Survey and Analysis* (the Conklin Report), chap. 3, New York State Commission on Cultural Resources, March 1973. The commission found that the "culture industry" in the state is a multi-billion-dollar business. Not counting those employed in such culture-related fields as tourism, restaurant management, hotels, television, publishing, recording, and commercial theater, the study pointed out that more people were employed by nonprofit cultural and arts organizations in 1970 than in the state's steel production industry. It also estimated that the state's culture industry had operating expenditures that year twice those of agriculture.

[19] The Vocational Education Act (VEA), passed in 1962 and amended in 1968, has brought federal money into vocational schools. Some new schools focusing on the arts are Western High in Washington, D.C., which opened in September 1974, following similar schools in Newark, Winston-Salem, and other cities. And some cities, like New Orleans, have added to their secondary system an arts center, which offers a half-day of arts instruction to students who take their academic work at "home" schools during the other half of the day.

[20] Maxine Greene, professor of philosophy and education, Teachers College, Columbia University, "The Arts in the American High School: A Proposal Prepared for the National Panel on High Schools and Adolescent Education," p. 9.

[21] *Discussion Draft,* p. 172.

[22] "Music and Art in the Public Schools," published by the National Education Association Research Division, with the assistance of the National Art Education Association and the Music Educators National Conference, 1962.

[23] *The Condition of Education,* 1975 edition, National Center for Educational Statistics, Education Division, U.S. Department of Health, Education, and Welfare (Washington, D.C.: Superintendent of Documents, Government Printing Office).

[24] *Americans and the Arts: A Survey of Public Opinion* (New York: Associated Councils of the Arts, 1975), p. 115. In the 1970s, "basic" often means reading and math. But what is basic in one era is not always basic in another. In his annual report in 1912, the superintendent of schools in New York City listed as "the ordinary school studies which all civilized peoples grant are essential—reading, grammar, arithmetic, history, geography, drawing, penmanship, spelling." See Diane Ravitch, *The Great School Wars, New York City, 1805–1973* (New York: Basic Books, 1974), p. 170.

[25] Paul Nachtigal, *A Foundation Goes to School* (New York: Ford Foundation, 1972), p. 230.

[26] *Discussion Draft,* p. 182.

[27] In addition to those programs reported on here, many art museums have designed special services to high school students. The St. Louis Art Museum has offered a summer course and now gives a Saturday morning course for high school credit; the Brooklyn Museum in 1968 offered a summer seminar on Afro-American art; the Cleveland Museum has offered humanities courses; San Diego City schools have had a cooperative program with the Fine Arts Gallery of San Diego in which teenagers help to plan programs; the Junior Arts Center—a creation of the Los Angeles County Schools, the Los Angeles Recreation Board, and the Los Angeles County Museum—has a teenager on its board. As long ago as 1938 Grace Ramsey reported junior docents at the William Rockhill Nelson Gallery in Kansas City and at the Children's Museum, Boston (see her *Educational Work in Museums,* New York: H.W. Wilson, 1938, p. 115).

[28] The Clark Art Institute in Williamstown (see chapter 6), on the other hand, once tried to use Williams College students to conduct tours for elementary schoolchildren and reported that the attempt was "a disaster." Maybe the students would have been more successful with high school visitors, who were closer to the students' age and conceivably more interesting museum compan-

ions; the University Art Museum at the University of California, Berkeley, not included in this report but surveyed by the CMEVA staff, has tried that relationship with what the education staff considers satisfying results.

## Arts and Humanities Public Secondary Schools

(Alphabetically by state)

Alabama School of Fine Arts
800 8th Avenue, West
Box A-16
Birmingham, Alabama 35204

New Haven Regional School for Performing Arts
Orange and Audubon Streets
New Haven, Connecticut 06510

Miami Northwestern Senior High School
7007 N. W. 12th Avenue
Miami, Florida 33150

St. John's River Junior College
Florida School of the Arts
Palatka, Florida 32077

Quincy High School #2
3322 Main Street
Quincy, Illinois 62301

New Orleans Center for Creative Arts
6048 Perrier Street
New Orleans, Louisiana 70118

English High School
Boston, Massachusetts

Cass Technical High School
Detroit, Michigan

Children's Theatre Company
Technical School
201 East 24th Street
Minneapolis, Minnesota 55404

Honors Art High School, Shaw School
5329 Columbia Avenue
St. Louis, Missouri

Arts High School
550 High Street
Newark, New Jersey 17101

Institute of American Indian Arts
Cerrillos Road
Santa Fe, New Mexico 87501

East Harlem School of Performing Arts
346 East 117th Street
New York, New York 10035

High School of Art and Design
1075 Second Avenue
New York, New York 10022

High School of Fashion Industries
225 West 24th Street
New York, New York 10011

High School of Performing Arts
120 West 46th Street
New York, New York 10036

LaGuardia High School of Music and Art
Convent Avenue and 135th Street
New York, New York 10027

North Carolina School of the Arts
P.O. Box 4657
Winston-Salem, North Carolina 27107

Central High School
212 East 6th Street
Tulsa, Oklahoma 74119

Riverside Center for the Arts
3219 Green Street
Harrisburg, Pennsylvania 17110

High School for Performing and Visual Arts
3517 Austin Street
Houston, Texas 77004

Western High School
35th and R Street, N.W.
Washington, D.C. 20008

Penn Central School
3rd and R Street, N.E.
Washington, D.C. 20002

## HOUSTON HIGH SCHOOL FOR PERFORMING AND VISUAL ARTS

3517 Austin Boulevard
Houston, Texas 77004

**One of several secondary schools in the Houston public school system that offer career training as well as academic courses, this school, founded in 1971, concentrates on the arts and the media. It serves 10th, 11th, and 12th graders, bringing them together with professional artists. CMEVA interviews and observations: September 1973; March, May, and September 1974.**

### Some Facts About the Program

#### 1. Institutional Information

Title: High School for Performing and Visual Arts.
Founding: 1971.
Staff: In arts, 14 full-time, variable hourly; academic, 29 full-time, one hourly; media technology, project director and 2 full-time teachers.
Operating budget: Arts and academic departments: $528,765 (1972/73); $408,925 (1973/74); $410,532 (1974/75). The 1974/75 budget for arts and academic departments breaks down as follows: faculty, $402,801; supplies, $3,136; equipment, $2,370; utilities and rental, $1,725; fees and dues, $500.

The 1973/74 operating budget for the media technology department was $42,730, allocated as follows: project director, $16,500; faculty, $18,430; supplies $7,400; maintenance and repair, $400.
Funding: The Emergency Schools Assistance Program, Title 45, provided a planning grant of $125,000 in 1971; a separate grant of $100,000 from Texas Education Agency got the media technology department started at the same time. Since January 1972, the school has been funded by the Houston Independent School District (HISD) with incidental support from the Fine

Arts Advisory Council, Media Technology Advisory Board. The cost per student per year is $700, the same as for other HISD high school students. The state pays approximately $1.85 per student per day.

2. **Location/Setting**

Size and character of city: Houston, Texas, with a city population of 1,232,802 (1970) and a standard metropolitan statistical area population of 1,985,031 (1970), is the third largest port city in the United States, with foreign trade in excess of $2 billion. An important space center, it is also the most diversified manufacturing city in the South. The petrochemical industry and trade and banking account for the largest volume of business, their glassy architectural symbols dotting the urban landscape with aggressive exclamation marks. Houston's population is 80 percent Anglo (6 percent of whom have Spanish surnames) and 20 percent black. City school tax is based on $32 per thousand, with a 53 percent valuation.

Climate: Hot, humid summers; mild (humid) winters.

Specific location of institution: In the center of the city; in proximity to the Museum of Fine Arts, Houston, the Houston Contemporary Arts Museum, and Rice University; and across the street from the Houston Technical Institute (HISD).

Access to public transportation: Public buses available.

3. **Audience**

Enrollment: 600; approximately 200 in each class, sophomore, junior, and senior. The ethnic mix (1973/74 figures) is 52 percent Anglo, 32 percent black, and 16 percent Mexican-American. Attrition levels at approximately 20 percent per year, all classes.

4. **Educational Services**

Organizational structure: The school is headed by a director. The governing authority is the HISD.

Range of services: Offers a realistic option to students who are not stimulated by traditional high school environments and who are on the brink of dropping out. The program combines technical, arts, and academic studies aimed at challenging the "academic underachiever" and students with talent and serious professional ambitions. Media technology graduates may find immediate employment in local business or industry or may go on to further specialized training.

Objective: To develop talents in art, drama, dance, media, and music; to prepare students academically for further study in these areas; to develop the skills necessary for employment in these areas; and to demonstrate the interrelatedness of the arts and to lay the groundwork for a lifetime participation and pleasure in the arts.

Time: Same as regular school year, August to May. Students of the Houston High School for the Performing and Visual Arts, however, spend one hour more per day in school than do other Houston high school students.

Information and documentation available from the institution: 1971 proposal, brochures, and Southern Association of Colleges and Secondary Schools evaluation.

"In the beginning we had a dream, more than a realistic idea," recalls Ruth Denney, director of Houston's High School for Performing and Visual Arts, "We knew that kids could be stimulated by work in the arts, but if we could also turn them on to coming to school, this school

would work, even though kids come here from every academic level, running across the entire intellectual, economic, and ethnic gamut."[1]

It was the heat of political reality that forced the dream to flower. Like many other big-city boards of education in the late 1960s, the Houston school board faced student restlessness and discontent with traditional education, plus pressures for racial integration and for school programs that prepared students to earn a living.

A high school for the arts provided one possible solution, Mrs. Denny suggested to the school board. At the time, she held an administrative post in the Houston Independent School District and was known in the system as a capable drama teacher. Teaching dramatics in secondary schools had proved to her that a good band or drama teacher could keep otherwise apathetic students in school, even when the teacher-student relationship occupied only one period in a school day. Why not, then, a school that capitalized on what held students—extensive and even preprofessional work in media, drama, dance, music, or the visual arts—combined with courses usually available in academic high schools?

By combining technical, arts, and academic programs, Mrs. Denney and the Houston School Board hoped to construct an environment that would stimulate "academic underachievers," provide realistic choices for students on the brink of dropping out, and challenge students with talent and serious professional ambitions. Multiple programs and a varied student body would mean that the new school would operate not only as a "specialized" high school but as a school where teenagers of different kinds of ability, experience, and ambition would work together.

**The local situation**

Vocational and technical high schools and community colleges have sprouted all over Texas in recent years, encouraged in part by the Vocational Education Acts of 1963 and 1968. The community colleges and the special vocational courses they offer are what James Haynie, assistant director, Post-Secondary Division, Texas Education Agency, calls "the fastest growing part of education in Texas." Some of the same energy spurred the agency, which is the state education department, to establish vocational-technical high schools. In 1965 there were fewer than a hundred voc-tech courses offered in the state; by 1974 there were 73,000 students enrolled in 1,018 voc-tech high school programs. As a matter of state policy, all such programs are offered in secondary schools with comprehensive programs. State policy requires, too, that all the state's community colleges provide courses that build on and continue high school voc-tech programs.

In Houston, for instance, three special technical-career high schools have been established in the last decade:

- The Houston Technical Institute, founded in 1964, with an enrollment of 1,400.
- The High School for Performing and Visual Arts, founded

in 1971, with a maximum enrollment of 600.

- The High School for Health Professions, founded in 1972 on the Baylor Medical School campus, with a maximum enrollment of 355.

A high school for science is in the works, designed particularly to train students to work in Houston's petrochemical industries, and a night high school is on the drawing board. Only the night school qualifies as an ''alternative'' school, said Britton Ryan, an assistant superintendent in the Houston Independent School District. He insisted the others are not alternative schools for ''troubled youth'' but are providing the best of two worlds—both comprehensive and special education—under one roof.

The 2,355 Houston students currently enrolled in these special high schools represent only one percent of the total public high school enrollment of 212,000. The Houston Independent School District enrolls only students living within the city limits and does not serve residents of the six-county metropolitan area beyond Houston's city line.

## The first steps

The High School for Performing and Visual Arts opened in the fall of 1971 with a planning grant of $125,000 from the Emergency School Assistance Program, Title 45. The initial grant paid for pre-opening planning, staff salaries, and the development of materials for the first (10th grade) class of 200. Since January 1972, the school has been funded by the school district.

An integral part of the school from the first, the media technology department began with a special $100,000 grant from the Texas Education Agency. Such funding for technological education required the following assurances from the school district: (1) that a local job market, paying wages substantially above the minimum, exist for graduates; (2) that advanced training in the high school's curriculum offerings be available at local community colleges, in keeping with state policy; (3) that the high school undertake the subsequent operation of the program, thus ensuring its continuation; and (4) that the program have the advice and support of local business and industry. To meet the last requirement, an advisory board of local executives provides guidance, materials, and occasional equipment, and works with the media technology department to arrange on-the-job training.

## How the school tries to meet its objectives

Four stated objectives provide a frame of reference both for insiders and for outside observers on the development of the High School for Performing and Visual Arts:

- To train students in particular arts or media.
- To prepare students for further study in college, conservatory, or professional school.
- To teach skills students need to get and keep jobs.
- To promote insight into all the arts and their relationships as a way to a lifelong participation and pleasure in the arts.

Beyond these objectives is the unstated but universally understood purpose of the school to provide a harmonious environment for racial integration.

The last goal has so far proved to be one of the easiest to accomplish, according to staff and students. Because it is the only arts and media high school in the city, the High School for Performing and Visual Arts is what education journalists call a ''magnet''; it draws students from all of Houston's 33 junior high schools. The students come ''because they want to.'' They represent the city's range of economic and ethnic groups and levels of academic ability. During the 1973/74 academic year, 52 percent of the students were Anglo, 32 percent black, and 16 percent Mexican-American, in a city whose population is 20 percent black and 80 percent white. (There is no census classification for Mexican-American, only a count of those with Spanish surname as part of the white population; 6 percent of Houston's white population is so recorded.)

To recruit this diverse student body, high school guidance counselors visit all junior high schools and explain the various high school options available in Houston. Admission to the arts high school—possible in either the 10th or 11th grade, but not in the 12th—is by application, audition, and interview. Students applying to the media technology department must take a battery of general tests. Mrs. Denney and her faculty make clear that students are chosen on the basis of promise rather than developed talent and that to stay in the school they must re-audition each year. She maintains that re-auditioning ''keeps students on their toes.'' Mrs. Denney had no figures on those who do not make it through the re-auditions—''several,'' she estimated—but said that academic failure is nearly always the reason for students being asked not to return.

To accommodate both the intensive special and the academic curricula, the school day of all voc-tech high schools is one hour longer than the conventional Houston comprehensive high school schedules. At HSPVA, each student takes four academic subjects and works an additional three-hour block of time each day in art or media. Tenth-grade students work in their art major three days a week, in their minor twice a week; 11th-grade students begin to specialize more, and 12th graders, where possible, take on part-time apprenticeships as well.

## HSPVA in operation

Students entering the school for the first time must feel a little lost. It does not look like the junior high schools they have come from: surrounded by a tall cyclone fence, a two-story brick building dominates a ''campus'' dotted with boxy one-room portable classrooms. The main building was once an annex for the Houston schools' administrative offices and before that the educational wing of a synagogue; the portable classrooms occupy what used to be a front lawn. Now diagonal footpaths crisscross the struggling grass of the courtyard in front of the main building, which looks out at the looming presence of the Houston Technical Institute across

the street. Sounds of whirring machinery and an occasional burst of music mingle in the air.

First-time students must feel a little found as well as lost. Where else are changing classes signaled by a gong? Rescued from the yard of a surplus store, the gong plays tonal patterns composed by music students and triggered by a device a math class hooked up to the school computer. Every time the gong is struck, students stream into the courtyard, forming a medley of bright outfits and sounds.

Everywhere inside the portables and main building there is evidence of the school's special nature—a sound synthesizer in the math room, a puppet theater and Noh drama masks in the English department, in the halls supergraphics sliding around corners and over doorways and curling into the letters of the areas they define: music, media, drama, art. A group of drawing students sketches a class at work in the dance studio; physiological and botanical drawings line the walls of the biology room, a reminder that the course is titled "Visualize Yourself."

Studio art facilities are limited; stacked canvases and portfolios vie for space with students at easels. Art history classes rely heavily on the extensive personal slide collection of Pat Zeitoun, who teaches the subject in all grades. She also keeps an eye on students' work in drawing and design, trying to relate studio work to art history lessons. "You should have heard the sighs and groans when the students learned they'd have a three-hour block of art history every week," Mrs. Zeitoun confessed. "But now that they know we can communicate as one artist to another and still talk about art history, we do much better."

An art history survey for sophomores and juniors uses H. W. Janson's *History of Art* as the basic text and Michael Levy's *A History of Western Art* as a supplement. Seniors make detailed comparative studies of various periods and undertake independent study projects. Although Mrs. Zeitoun encourages the students to use local museums, no systematic program has been worked out with any art institution.

### Special projects: correlations

Committed to the goal of making connections among arts and between art and academic study, the faculty designs special "correlations" at least twice a year as part of academic courses. These correlations are meant to tie a significant theme or idea in an academic discipline to a student's major art interest. Some are generated by research but produced as a performance or other art work rather than as a term paper. Some of these efforts are strained: two biology students, for example, singing a rousing version of a "Kidney Song" ("Any waste you excrete, I excrete better. . . . No, you can't; yes, I can"). But some correlations satisfy the faculty's insistence that both parts—the artistic and academic—of the correlation are equally important: art students drawing cells in the styles of Rembrandt and Picasso, a biology student choreographing and dancing an interpretation of the chemical process of blood-clot formation.

Even the more successful correlation projects do not lend themselves to brief verbal summary. Perhaps the most frequently described is the original musical drama titled "You, Me, and Who," written, staged, and performed by HSPVA students, first at an auditorium in downtown Houston and then at the annual Fine Arts Festival of the University of Texas at Austin. It began as a 1971/72 playwriting class project and developed into an interarts correlation as students, meeting during the summer vacation months, added original music and choreography. (The play was produced by the Junior League as a special event for children). The play's central characters skip school, get lost in an enchanted forest, meet a variety of monsters and adventures, and return to school liberated by experience—there to live, the audience hopes, happily ever after. Directed to an audience of young children, the short, lively musical drama seemed to many adults a charming and competent production.

### The underlying philosophy—and some results

Staff and faculty at the High School for Performing and Visual Arts are accustomed to skepticism about the usefulness of these "correlations." The director believes they are especially appealing to those students whom education jargon labels "underachievers," who fulfill their academic potential when they are allowed to learn by doing what they enjoy. No one claims, however, that arts training is a sure way to lure dropouts back to math and science. The assistant principal, Lawrence Anderson, deplores a prevalent misconception about the school: that its educational premise is based on the idea of salvation through art. Not so, says Anderson.

How salvation or even salvage actually occurs is more complex. Mrs. Denney maintains that the arts, because of the preparation and training they require, help students develop a self-discipline that carries over into other areas. "We may not be making Phi Beta Kappa members out of some of our students, but we are making them feel the importance of getting an education," she believes. "Slow learners are given every break. The others are pushed to capacity."

Guidance counselor Jeanne Wootters points to results: "I can name 10 or 15 in our first graduating class who would not still be in school if it had not been for us. They are students whose basic abilities go from the highest to the lowest, so it has nothing to do with academic ability." Although it is too soon to predict definite career choices, a survey Mrs. Wootters conducted among that first graduating class indicates that 55 percent planned on a career in arts or in media technology; another 39 percent anticipated careers ranging from home economics to law, religion, and electrical engineering.

Of this class of 178, 9 students received advanced college placement in English, 9 in studio art, 6 in art history. Class members garnered over $220,000 in financial aid, scholarships, and talent awards. Most (115) planned to continue their education in a four-year college or university; 15

planned to attend art or drama school, and 7 others had already signed professional contracts with dance or music groups; 9 planned to attend a junior college, 9 others to continue school of some kind.

These 178 were the survivors of an entering sophomore class of 200, plus 38 who entered the school as juniors. Clearly, the school is not the answer for all students who are admitted. Though some of the 60 non-survivors of that first class dropped out of all formal education, most returned to comprehensive high schools in the city.

Attrition has leveled out during the school's first four years to about 20 percent per year. Students who do not pass academic or arts courses are asked to leave. Students who leave on their own cite these reasons: too much hassle to travel so far to school; not enough social life (pep rallies, dances); parental suspicion of a "different" school, combined with the student's own inability to deal with the variety of colorful "kooks" the school attracts; tough competition; having to "start from the bottom," or being unable to do "my own thing in my own way." Not surprisingly, other students give some of the same reasons for liking the school.

Students who remain offer among their reasons the importance of instruction by "the cream of Houston's artistic specialists" and nationally prominent artists who serve as visiting lecturers. Faculty and director agree that it is the artist's authenticity, not his fame, that communicates. When a painter closes a special class with the admonition, "If you're not your own disciplinarian as an artist, no one can do it for you," students listen. When the Paul Taylor Dance Company visits the school, students see the dedication, discipline, and fatigue that are all part of being a professional dancer. The school may nourish and protect its students but, according to one English teacher, as they come to know professional artists the students soon lose any lingering delusion that they will become famous as soon as they graduate.

### The personality of the school

"We are a strange, emotional, temperamental group of people," an English teacher says with a smile, "but we are also like a big family. We look out for each other." Mrs. Denney suggests that the sense of family or community develops as students recognize "what they are doing is approved by their peers, an important consideration with the high school age. In many cases the students who are so fine here were laughed at in their other schools because they liked music or art or dance better than football. This is a different climate."

According to counselor Jeanne Wootters and others, the size of the school has something to do with that climate. She believes that for many students satisfaction "had all to do with finding a school that was small enough to give them the time to develop something they do well, to help them build a self-image right here on this location." Mrs. Wootters maintains that such development takes place more easily in a school where a student is one of 600 instead of 3,600.

Some critics say it is neither size nor sympathy that has made the High School for Performing and Visual Arts effective so far; they remain suspicious of a special school catering to a select student body and offering a more expensive education than Houston's large comprehensive high schools. HSPVA counters that its budget is based on the same $700 per year per pupil as any other Houston high school. But the rumor persists, and is denied, that the media technology department gets undisclosed gifts from business and industry. As some criticism had come from conservative factions, there was a question during the three-year trial period whether HSPVA would maintain its equilibrium when a conservative school board was elected to replace the liberal board that had first brought the school into being. HSPVA seems to have survived the changeover. It has hung on long enough, furthermore, to receive state accreditation and now believes it will be a permanent part of the Houston school system.[2]

Reassessment, trial and error, and political prudence have wrought changes at the school during its first four years. When the school opened in 1971 with 200 students, it could be a "looser" place than in 1974 with 600. Mrs. Denney describes the school's movement in these four years toward more discipline in all areas. In hiring the school's teachers, she takes particular interest in their approach to developmental needs of individual students. Not all teachers are state-certified; the Texas Education Agency says that performance, rather than credentials, can determine hiring. She believes that teachers who are *not* artists may be more likely to stress structure in their teaching. Acknowledging that a good artist is not necessarily a good teacher, she is always on the lookout for the rare artist-teacher who, she believes, "serves the needs of the student-artist best."

Students who remain at HSPVA demonstrate loyalty and affection. One junior observed, "You know, last year [in another school] I was out of school 66 days; this year I was out 4. I'm a person here, not just another one of those 'damn kids' teachers have to tolerate." Many students comment on the sense of community, rooted perhaps in their realization that coming out of so many separate backgrounds they have been able to create a new institution. One young man on the eve of his graduation, observing that HSPVA has no school colors, reflected for a moment, and said, "Yes, I guess we have. They're white, black, and brown."—*B. K. B.*

### Notes

1 For sources of quotations without footnote references, see list of interviews at the end of this report.
2 In 1974 the media technology department of HSPVA also received a National Merit Award from the Technical and Vocational Division of the U.S. Department of Health, Education, and Welfare.

## Interviews

Anderson, Lawrence G. Assistant Principal, High School for Performing and Visual Arts. May 23, 1974.

Churchwell, Berdia. Biology Teacher, High School for Performing and Visual Arts. May 23, 1974.

Denney, Ruth. Director, High School for Performing and Visual Arts. September 27, 1973; March 20, 1974; telephone, September 27, 1973.

Guemple, John. Associate Commissioner for Occupational Education and Technology, Texas Education Agency. Telephone, September 17, 1974.

Kammerdiener, David. Student, High School for Performing and Visual Arts. May 23, 1974.

Leach, Dorothy. Mathematics Teacher, High School for Performing and Visual Arts. May 23, 1974.

Mers, Larry. English Teacher, High School for Performing and Visual Arts. May 23, 1974.

Sheard, David. Studio Art Teacher, High School for Performing and Visual Arts. September 27, 1973.

St. John, Mark. Student, High School for Performing and Visual Arts. September 27, 1973.

Weld, Wendy. Student, High School for Performing and Visual Arts. May 23, 1974.

Whitley, J. B. Coordinator of Vocational and Technical Education, Houston Independent School District. Telephone, September 16, 1974.

Wiley, Shirley. English Teacher, High School for Performing and Visual Arts. September 27, 1973.

Wootters, Jeanne. Guidance Counselor, High School for Performing and Visual Arts. May 23, 1974.

Zeitoun, Pat. Art History Teacher, High School for Performing and Visual Arts. Telephone, September 12, 1974.

## UNIVERSITY CITY, MISSOURI, HIGH SCHOOL OF THE ARTS

University City High School
7901 Balson Avenue
University City, Missouri 63130

**Various high schools around the country are using the arts to keep "turned-off" as well as talented students in school. University City's variation: an arts-centered school-within-the-school offering a half-day of arts courses each semester to about 200 students and a wide range of arts courses to the rest of the comprehensive high school's 1,500 students. This report covers HSA's first year, 1973/74, with some statistics for the fall 1974 semester. CMEVA interviews and observations: April, September, November 1973; March, June, December 1974.**

### Some Facts About the Program

**Title:** The University City High School of the Arts.

**Audience:** 230 students (spring 1974), enrolled in three classes.

**Objective:** To establish alternative and additional courses and methods of instruction toward the end of keeping young people in school, enlarging arts choices, and providing career possibilities.

**Funding:** In 1973/74, $64,432 from Title III of the Elementary and Secondary Education Act for some salaries, field trips, guest artists, evaluators, supplies, and workshops; other expenses paid from the budget of the comprehensive high school.

**Staff:** Project director, 5 teachers, and a secretary.

**Location:** In University City High School.

**Time:** Regular school calendar, plus later afternoon and evening courses and some weekend activities.

**Information and documentation available from the institution:** Grant proposal of 1973; grant continuation proposal of 1974; course booklet 1974/75; evaluations by CEMREL (Central Midwestern Regional Educational Laboratory).

Grant applications rarely get to the heart of the matter, but University City's came close. Its 1973 request to the Missouri Board of Education for funds for a High School of the Arts asked for money to reach students who "do not relate well to school, do not see school as related to their needs, and are disenchanted by the schedule of classes."[1]

University City proposed to reorganize a section of its one high school into an arts-centered school-within-the-school. The arts offered a plausible way for University City to deal with student apathy and absenteeism, because it considered itself a community "vitally interested in the arts,"[2] with a significant number of its 50,000 residents professional artists and craftsmen, university people, serious if not wealthy patrons of art and culture. Its school administrators and teachers believe, according to their proposal, that "the arts can play a central role" in stimulating students, capturing their imaginations, and improving their lives.[3]

The school system had already embarked on an ambitious effort to integrate the arts into the general curriculum, focusing until 1970 on teachers and students in the elementary schools. A 1971 survey of the arts experiences and needs of junior and senior high students revealed that 65 percent thought that talking or working with a professional artist would be a very valuable experience, whereas only about one-third recorded any enthusiasm for traditional, classroom-oriented art courses and school-sponsored extracurricular art activities.[4] Asked to rank activities according to their own preferences, the students ranked attending an art museum or exhibit next to the bottom of the list. Visits to art museums, galleries, or exhibits rated the highest attendance figures, however, probably because (as the survey noted) trips to the art museum were sponsored on a regular basis by the school.

Tom Lawless, director of the High School of the Arts (HSA), believes that the survey, plus the arts-centered curriculum used in University City elementary schools, helped to provide a "foundation" for the high school experiment. He also thinks that he "probably got a sense of the structure and logic of what I'd always done" from watching and thinking about the work of CEMREL (Central Midwestern Regional Educational Laboratory; see report in chapter 11) in the UC schools.[5] But he is certain that there was already a consensus among high school and district staff that many senior high students wanted to take arts courses but could not

because of scheduling problems, regimented class periods geared to a traditional curriculum, and the limited number of arts classes available.

HSA—an arts-centered school-within-a-school—is a fledgling effort to move away from the familiar pattern of secondary-school arts education, in which most students take no art or music classes (unless required to, which is rare) and the few who are seriously considering arts careers take the few arts electives offered. One premise of HSA is that the familiar system of electives, which is used primarily by students seriously interested in art, might be "essential to provide training and concentration for the artists of the future,"[6] but that it is neither suited nor fair to the general student. HSA wanted a system under which every student could take courses in art.

At the same time, HSA did *not* want to move so far away that it abandoned the traditional large comprehensive high school. University City already had one alternative high school at another site; it did not want a second. By establishing a section of the comprehensive school as a place for everybody to "try out" the arts, University City High School staff hoped to encourage the arts "to pervade the school," in the words of Hugh Burns, assistant principal of University City High School and one of the founders of HSA. One goal of HSA reflects this hope: to enroll 700 of the school's 1,500 students in at least one arts course. In addition, HSA courses are open to the 150 students enrolled in the alternative high school.

## Goals for students enrolled in HSA

The primary goal of HSA is to provide an arts-centered curriculum for about 200 students. The target audience is dual: students who show a keen interest in and curiosity about the arts *and* those who are apathetic and eager to leave school early.

HSA set out to design a schedule and a curriculum that would attract and satisfy those two distinct student groups. Two specific and different measurable goals were set for the first year, 1973/74, reflecting the kinds of students expected to enroll: (1) a 20 percent improvement on the College Entrance Examination Board achievement tests in arts, and (2) a 20 percent increase in school attendance.

Social changes in University City (actually a St. Louis suburb) affected the definition of the audience. Seven years ago, in 1967, the suburb's population was 100 percent white, largely middle class. By 1974 it was 50 percent black, the school population 60 percent black; the racial change brought economic and social changes, as poorer families and fewer educated adults moved into the city. About 80 percent of University City High School's graduates had traditionally gone on to college; a small but steady number had chosen Advanced Placement courses and early graduation. In the last three years, AP courses had dwindled to three (two in social studies, one in physics). Absenteeism and dropout rates had gone up. So University City High School was trying to pro-

vide in the High School of the Arts courses that would stimulate and appeal to some talented students and at the same time lure apathetic students into traditional academic courses through the arts. Faculty and staff see the arts as an especially attractive path to education—"humanizing" and "personalizing" are words often used in their documents and conversations.

Though HSA tried to reach both student audiences, its first enrollees were "white, bright, and female," recalls Hugh Burns. The staff worked to pull in a more representative sample of students, but the enrollment for 1973/74 never got below 60 percent white (and those, predominantly girls) in a school that is 60 percent black. Burns was hopeful that the 1974/75 racial proportion would edge toward 50-50, and indeed, although HSA's second-year enrollment remained primarily white and female, a sizable number of black boys and girls ("who entered as a group," Burns noted) enrolled. There are still not many white male students, but the 23 boys enrolled in the fall 1974 dance classes are about evenly divided, black and white.

## The school-within-a-school begins

When it first opened in the fall of 1973, HSA enrolled as "full-time" (see following paragraphs) students 140 of the parent high school's 1,500 students. In the second semester, spring 1974, 230 students enrolled—"satisfied customers," Tom Lawless happily called them—but enrollment for the fall semester of 1974/75 fell to 150. More than 700 students took at least one HSA arts course during 1973/74; in the fall of 1974, that number rose to over 800. Recruitment of students, for one course or for a full-time enrollment, is largely informal—by word of mouth, personal acquaintance—but also includes slide-tapes and special events. Everyone is encouraged to try the wide variety of arts courses offered.

A full-time HSA student spends half the school day, or at least three class hours, in arts courses, the other half in regular academic classes. The full-time students meet together once a week in their own section of the building. The meetings are intended to encourage a sense of community, as is the physical space. Painting big vivid signs up the stairwells and around the halls, HSA students have tried to make themselves a home.

HSA studios are crowded with students working on sculptures, pots, constructions, textile designs, preliminary sketches. Teachers, visitors, students wander in and out, interrupting some students with chatter and horseplay, making no dent in the stubborn concentration of others. When Tom Lawless ambles in, half a dozen students call out from their work, some walk over to pass the time, and others look up from the work tables to catch at his arm and pick up the thread of conversations left unfinished the day or week before.

What does he look for in the teachers he hires to work with these students he so plainly cares about? Lawless says he tries to find teachers with specific art skills who want to do inter-

disciplinary work and who welcome personal relationships with teenagers. "Programs aren't worth a damn unless you have people who can get things going with kids," Lawless says. "The better the teachers are in their own areas, the more open they are to try out our ideas. Generation or age has nothing to do with it—I can show you old teachers who are terrific at picking up on valid connections." Color has little to do with hiring either, though when the one black teacher on the staff left at the end of 1973/74, Lawless hoped to find another black to replace him—and did.

To avoid duplication and competition, HSA staff and the arts staff of the high school are considered one; Tom Lawless heads both. (He also teaches six courses and oversees an "open studio" during lunch hour.) Four persons, including Lawless, are paid from ESEA (Elementary and Secondary Education Act) funds. All other arts and HSA staff are regular members of the high school staff and are paid out of school funds.[7]

### Structure of HSA: courses and curriculum

Thirty-six semester courses were offered in the 1974/75 Fine Arts Department of the University City High School, ranging from art history and "comprehensive musicianship" to a course in games as an art form. They are divided into three categories:

1. General foundation arts courses, which the faculty calls "exploratory" courses.
2. Traditional or career-directed studio courses focusing on production in one art form and progressing from basic to advanced work.
3. Interdisciplinary courses involving two or more of the arts, or combining regular academic subjects with one or more of the arts.

Varying levels of student sophistication (and diligence) are implicit in the course offerings and explicit in the prerequisites, or lack of them, and in the stated "expectations" for students in each course. Students taking art history courses are expected to attend class regularly, to fulfill class assignments, and to develop a "basis for critical evaluation when viewing art exhibitions, visiting architectural sites, etc."[8] A few courses set near-professional standards: advanced art, for example, expects students "to demonstrate a high degree of skill, insight, individuality and regular work habits," while the second-year photography course requires for admission the successful completion of the first-year course and "a professional interest in photography." Less strenuous courses bear evidence to the staff's desire to "provide for every level of student interest in the arts." It is interesting to note that the 1973/74 course offering in games—whose expectation was simply "willingness to master new games and a desire to create"—got so few applications it was dropped.

In the visual arts, examples from each category include

1. A general or exploratory course in painting, which meets only one hour a day. Painter-teacher Tony Cleto starts with the Kimon Nicolaides curriculum of gesture, con-

tour, cross-contour[9]—what Lawless calls the "nitty-gritty," which he encourages his staff to emphasize.

Or the introductory art history course, which includes museum visits and architectural field trips around St. Louis. First given in the fall of 1972 by long-time art supervisor-teacher Victor Porter Smith, the year-long course has now attracted enough students to become a permanent fixture.

2. Career-directed courses in jewelry, textiles, or other media, or advanced classes in painting, such as those taught by Lawless during school hours or at night.

3. Smith's spring 1974 interdisciplinary course in American art, developed at the request of an American Studies teacher, and the 18-week sequence, titled "Abstraction," which allows students to work in successive weeks with faculty in sculpture, ceramics, art history, painting, drawing, dance, and drama, focusing on the elements of abstraction in all the arts.

A minicourse that correlates art with academics—"We try to get out of the arts and make good valid connections in other areas," as Lawless says—is a three-week unit in chemistry and ceramics that focuses on glazes. The ceramics teacher works with chemistry students in basic ceramics technology; the chemistry teacher works with advanced ceramics students in chemistry theory and lab technology.

Eager to make HSA school hours more flexible, Lawless and his staff were able in 1974/75 to introduce an extended school day: additional credit classes scheduled from 3 to 9 P.M. permit students to start their school day later than usual. Some HSA teachers are left with "free" periods to allow them to take over academic classes whose teachers—of English, languages, social studies, or other subjects—are working with HSA students.

Flexible standards characterize the staff's approach to students. Acknowledging his willingness to nurse along difficult students, Lawless says, however, "we really grind the good ones, teaching them skills, the nitty-gritty of drawing, making slides, putting a portfolio together. But I always tell 'em these skills are hard to market, so learn to weld or cook, so you can support your bad habit."

Yet professionalism for the good students is not his primary goal: "I want it to be as wide an experience as possible. I don't want anybody to come out of here at 17 saying, 'I'm a painter.'" Though about 80 University City High School graduates now in college are arts or art studio majors, he insists he is not running a preprofessional program; he thinks of most of his students as consumers of the arts.

### Resources available to HSA students:
### Museums, media lab, slide center, and artists

**The museum.** HSA dance teacher Sherry Londe readily concedes that her first visit to the St. Louis Art Museum was poorly planned. She took 60 students at once, with little preparation. She had not expected, she says, that the museum

would mind if her students brought musical instruments or food to the galleries. Museum education staff expressed dismay at her lack of preparation and the size of her group, but stoutly helped her through the visit. One museum staff member explained that he had expected her students' improvisations to be responses to the paintings, but he thought the students were instead "really reacting to each other."

Yet the first school session following the museum visits gave no evidence of the confusion both dance teacher and museum staff candidly reported. The students were apparently indifferent to circumstances that seemed "chaotic" to adults. Their dances related to paintings they had seen: two girls danced the "mellow" movements they found in a Seurat painting, and another danced the emotions she felt in a large landscape of a storm-clouded lake.

Sharing that class, both the dance teacher and the painting teacher talked with students about visual and expressive elements in painting and dance, about the artist's difficulty in making his materials—whether paint or body—do what he wants. Londe's advice, balanced between criticism and encouragement, set the tone for the earnest working session: "Nothing you do is dumb—you're just having problems with it. Think about your work that way, and you can keep trying to fix it."

**The gallery.** A small gallery in the school library was set up in October 1972, where student work and outside shows can be exhibited. A pleasant well-lit area, the gallery is in steady use for exhibitions; at least two during the 1973/74 year showed good student prints, drawings, paintings, and sculptures, all installed sympathetically and attractively.

**The media lab.** Beginning about six years ago with a small JDR 3rd Fund grant, the media lab developed into a film and audiovisual library that supplements the school's regular library and into a resource that fills requests from teachers and students. Though it is also designed to allow students to research and execute their own audiovisual ideas, the director laments there is little time for that.

**The slide center.** About 15,000 slides are available in the large school library. The center uses the same slide cabinets, made by a local firm,[10] as the St. Louis City Schools media lab and the St. Louis Art Museum's teacher resource center (for a report on the resource center, see chapter 11).

**Artists.** Artists are among the rich resources of University City. During 1973/74, there was "great professional and community involvement," Hugh Burns said. "Practicing artists who knew and respected [Tom Lawless] came in and worked with the kids, [and] HSA became a much more exciting place for kids." Lawless firmly believes, as his 1974/75 outline says, "Only by involving the students with practicing artists both in and out of school, can they understand the life and function of the artist. It is of the greatest importance that

the student realize the place the arts can have in his daily life."[11]

## Evaluation of a beginning

Differences between the first and second years, 1973/74 and 1974/75, reflect the different temperaments of the two men who have so far taken major responsibility for HSA. Its originator, Hugh Burns, is an inventive teacher and administrator, interested in the potential of an experimental arts school within a conventional high school. Tom Lawless, the project director, is an artist and teacher unconcerned with research and deeply involved in the lives of students.

The first-year proposal, with its specific objectives of improved academic standing and increased attendance, was written by Burns. The second proposal, which kept the 20 percent decrease in absenteeism as an objective but dropped the goal of improvement on College Entrance Examination achievement tests, was written by Lawless. The two men worked together productively and well during the first year of HSA, their talents meshing though their positions on many issues differed (on Advanced Placement, for example, Burns welcomed a resurgence of parental interest in AP courses, whereas Lawless questioned whether "it's worth crowding a student"). Unfortunately for HSA—and for other school people eager to have firm research data on the HSA experiment—Hugh Burns moved to another school system in 1974/75.

Both Lawless and Burns believe a sense of unity was slowly beginning to grow by the end of the first year among some HSA students. Striking the fine balance of a school-within-a-school, with its own personality yet not isolated from the larger school, has not been easy. Both men cite "uncommon experiences" that draw students closer together—such as dance performances around town or faculty friendships—but both acknowledge that tensions, largely racial, have run high at the school in the past.

Despite guarded staff optimism that "things are better now," an observer wonders: a dance class is disrupted by loud music outside the open window, and a girl goes to the window to call out a request to turn it down; seeing that the music is coming from a black boy's car, she shrinks from the window and shrugs to the class, all white like herself—"I don't want him to see who I am." Black students at first resisted signing up for HSA dance classes, saying they "deny black roots," unless they could work with the black physical education teacher who stresses African rhythms.

Though it is probably true, as many observers suggest, that University City and other "in-town" suburbs are only now going through the racial and social changes that St. Louis and other big cities went through a decade ago, there is cold comfort in the observation. Few big-city school systems coped well with the dramatic changes in racial population and attitudes that confronted them.

How does HSA feel from the inside? "It feels good most of the time, but it can be tough," said Burns at the end of the

first year. Student enrollment goes up and down, but Lawless cited "the kids who tell me, 'If it wasn't for the High School of the Arts, man, I wouldn't be here.'"

Such informal comments do not constitute an evaluation. No pretesting was done, so Hugh Burns's hopes for "firm research" in a relatively controlled setting have been dashed. Evaluation results cannot specifically measure whether the hoped-for 20 percent improvement in CEEB achievement test scores was realized. Nor can they fairly measure the 20 percent decrease in student absenteeism, for a more rigid enforcement of school attendance requirements since the spring 1974 term has caused a sharp drop in all class-cutting.

A year and a half is too brief a time for assessing such a program. Tom Lawless, who is gradually imprinting his personality on HSA, believes that Hugh Burns left behind a "good design," whose elements, Lawless said, are an innovative curriculum, good methods of instruction, the extension of the school day, and an alternative administrative set-up within the school that cost over $60,000 to establish. He is convinced it is worth doing—and, furthermore, that the costs are not too high. "Once established," he insists, "an extra $5,000 a year could make it go."—*A. Z. S.*

## Notes

1 "High School of the Arts," Application Submitted to State Department of Education, Jefferson City, Missouri, from the School District of University City, Missouri, revised June 27, 1973, p. 5.
2 Ibid.
3 Ibid.
4 Querying a cross-section of 900 students—150 at each grade level, 7–12—the survey revealed certain information about what those students (829—or 92 percent—who returned the questionnaires) knew, felt, and hoped for in arts experiences. Information about the visual arts included that the visual arts ranked first in school-initiated activities, second in the percentage of students working on their own without instruction, third in activities outside school with instruction. Ibid., p. 58.
5 For sources of quotations without footnote references, see list of interviews at the end of this report.
6 "High School of the Arts," Application for Continuation Grant (to the State Department of Education, Jefferson City, Missouri) from the School District of University City, Missouri, May 1, 1974, p. 19.
7 Letter from Hugh Burns, May 9, 1974.
8 All course descriptions and requirements are from University City Course Booklet, 1974/75, pp. 50–58.
9 *The Natural Way to Draw* (Boston: Houghton Mifflin, 1941).
10 Multiplex C., Inc., 4153 Bingham, St. Louis, Missouri. 1974 telephone number: (314) 865-5005.
11 1974 proposal, p. 24.

## Interviews

Banks, Rose Marie. Supervisor of Humanities/Ethnic Studies, School District of University City. April 24 and November 5, 1973.

Beeks, Earl. Principal, University City High School. November 6, 1973.

Bloom, Kathryn. Director, Arts in Education Program, JDR 3rd Fund. September 18, 1973.

Burns, Hugh. Assistant Principal, University City High School; English Teacher; Liaison with High School of the Arts. November 6, 1973; March 8, 1974; telephone, June 27, 1974.

Cleto, Tony. Painter; Painting Teacher, High School of the Arts. November 6, 1973.

Fessler, Ann. Media Lab, University City High School. November 6, 1973.

Larkin, Marie. Art Supervisor, St. Louis City Schools. March 8, 1974.

Lawless, Tom. Project Director, High School of the Arts; Chairman, Art Department, University City High School. November 6, 1973; March 8, 1974; telephone, June 27, 1974.

Londe, Sherry. Dance Teacher, High School of the Arts. November 6, 1973; March 8, 1974.

Savage, Charles. Curator of Education, St. Louis Art Museum. March 9, 1974.

Smith, Victor Porter. Art History Teacher, High School of the Arts. March 8, 1974; telephone, December 20, 1974.

## Bibliography

Reiss, Alvin., "Art Education Is No Longer a Coffee Break for Teacher," *ARTnews*, September 1973, pp. 30–34.

"High School of the Arts," Application Submitted to State Department of Education, Jefferson City, Missouri, from the School District of University City, Missouri. Revised June 27, 1973.

"High School of the Arts," Application for Continuation Grant, May 1, 1974.

The JDR 3rd Fund Report, 1972. 50 Rockefeller Plaza, New York, New York, September 1972.

University City Course Booklet, 1974/75.

## MINNEAPOLIS PUBLIC SCHOOLS: URBAN ARTS AND HUMANITIES

Minneapolis Public Schools
807 N. E. Broadway
Minneapolis, Minnesota 55413

**A distinctive school program using museums and other arts organizations. Initiated under Title III auspices, now sustained by the Minneapolis Public Schools with help from local benefactors. Intensive, out-of-school workshops for secondary students, plus growing in-school program for full range of grades. CMEVA interviews and observations: October 1973; January–August 1974.**

### Some Facts About the Program[1]

**Title:** Urban Arts and Humanities.

**Audience:** Primarily junior and senior high school students, but as the program grows, an increasing number of elementary schoolchildren will take part. Of the 29,115 students who participated in 1974/75, 3,799 were from elementary grades, 24,426 were from junior and senior high (300 of these were in daily workshops), and an additional 890 participated in summer programs. Some 20

arts organizations in the Twin Cities are involved.

**Objective:** To bring students in direct contact with professional artists both in the school and outside—in theaters, studios, and museums—in order to enrich the schools' offerings and to reflect the art consciousness of a community that takes special delight in its own exceptional arts resources.

**Funding:** Total operating budget for the first five years: $127,250 (1970/71), $146,645 (1971/72), $141,162 (1972/73), $137,162 (1973/74), $143,229 (1974/75). Urban Arts was initially funded by Title III of the Elementary and Secondary Education Act. The Minneapolis Public Schools support it now, with the help of private businesses and foundations and (in 1974) a grant from the National Endowment for the Arts. Major allocations of the 1974/75 budget as follows: $42,729 for staff salaries, $10,000 for student transportation, $2,500 for office supplies, $64,000 for daily workshops contracts, $24,000 for "in-school" events.

**Staff:** Director, one clerk (full time), and 3 liaison teachers (a little more than half-time each).

**Location:** In the Minneapolis Public Schools and in artists' working environments.

**Time:** During the school year, with a summer program for grades 4 and up. Urban Arts began in September 1970, became Urban Arts and Humanities in the fall of 1973.

**Information and documentation available from the institution:** Information on contractual arrangements with arts organizations and artists, scheduling, busing, and other practical details is available directly from Urban Arts. So is *Urban Arts,* a 15-minute, 16-mm film in color.

---

No one familiar with Minneapolis will be surprised that the city is responsible for one of the nation's notable educational programs built around the arts. The program, Urban Arts and Humanities, is among those rare examples of "innovative" arts programs initiated under Title III of the Elementary and Secondary Education Act that has continued, expanded, and improved on its own after federal funding ran out.

Various factors help to account for this phenomenon. First, there is the extraordinary number and quality of active arts institutions and practitioners in the Twin Cities. Though the money problems common to arts institutions everywhere abound here too, they are more readily met—if not solved—in this metropolitan area because of the responsiveness of the general art-loving public and the support of local patrons, corporate and individual.[2] A second factor is a school system with a reputation for enlightened and imaginative leadership that is willing to take chances, is open to change, and is sensitive to the opportunities made possible by community resources, outside funding, and gifted individuals inside and outside the system.

Another, and more specific, factor in the success of Urban Arts is that, unlike so many of the country's school systems, Minneapolis was not among the first to jump on the ESEA bandwagon with its arts proposal. Rather than come out in 1966 or 1967 with a hastily conceived program, the Minneapolis Public Schools waited until 1970 to submit its proposal for "An Arts Opportunity Program." In the meantime

on its own, with some help from outside funds, the schools tried various ways of bringing students and teachers together with the arts and artists and early in 1970 hired Wallace Kennedy, an experienced schoolteacher and theater man, to coordinate these out-of-school arts activities and to prepare the Title III proposal. The proposal was accepted, and Urban Acts came into being in September 1970, with Kennedy in charge.

## The program, 1973/74

As the school year opened in the fall of 1973, Urban Arts became Urban Arts and Humanities (though it is still usually called by the shorter name), and moved from its old quarters on the south side of Minneapolis into the main school administration building. Its report line in the annual school budget was changed from "Federal Projects" to "English and Humanities." In welcoming the changes, the Minneapolis Public Schools' report on Urban Arts for 1973/74 proclaimed the continuation of the program staff's "autonomy with Wallace Kennedy as full-time project administrator." To Kennedy the name change represented an attempt to be more "honest" about what the program is all about: Urban Arts has always tried to relate the arts to other kinds of knowledge, especially the humanities. The line-item shift meant that Urban Arts was now integrated into the regular curriculum, with the additional support of Seymour Yesner, the system's consultant for English and humanities, who had just returned from a year's leave at New York City's Lincoln Center.[3]

It also meant that for the first time the school system rather than Title III would be contributing the major share of the $127,000 budget. About 30 percent of this amount came from nine local companies and foundations and another 10 percent from the National Endowment for the Arts and the State Arts Council. The 1973/74 budget was about $10,000 more than it was in 1970/71, Urban Arts' first year, when Title III funding accounted for around 90 percent.[4]

**Who takes part.** Officially—and increasingly, in reality—Urban Arts is a two-ply project: an out-of-school program that in 1973/74 offered students 14 daily workshops with studio and performing artists, and an in-school program that in the same period brought artists from eight different arts organizations to the schools for sessions or series. Designed primarily for junior and senior high school students, Urban Arts usually includes children from 4th grade up in its summer session, which in 1974 offered 25 different courses. Only junior and senior high school students, in about equal numbers, are enrolled in the out-of-school daily workshops during the school year. With the stepping-up of in-school programs in 1973, more and more elementary schoolchildren were participating—in the Minneapolis Institute of Arts program called ARTS (an acronym for Arts Resources for Teachers and Students), for instance, where they took part in a number of dance residencies and classes, and in eight-week residencies by the Concentus Musicus, where 5th and 6th

graders learned to sing madrigals and to play the recorder and the harpsichord.

Altogether, to use an often misleading and widely deplored statistic, Urban Arts was "reaching" or "serving" over 14,000 students, a figure that included the thousands who may have had two hours' exposure all year to one or another arts experience, mostly passive, as well as the few hundred workshop participants who may have been actively involved in dance or sculpture or theater every day for as much as 80 hours during the year. Both the Urban Arts staff and Schools Superintendent John Davis (as of summer 1975, president of Macalester College in St. Paul) were keenly aware of the discrepancies behind the program's statistics and tried hard to ameliorate them.

**Relations with arts groups.** There is little question, however, of Urban Arts' basic achievement in establishing good working connections between the Minneapolis School System and some 20 arts organizations in the Twin Cities. Approximately 400 students who leave their home schools daily to work with artists and museum professionals are learning—on stage, in studio, darkroom, or museum—to make art and to understand it in a way difficult if not impossible to duplicate in a classroom that is subject to the rigidities of school scheduling and the professional limitations of many, though certainly not all, schoolteachers. And as solid and extensive programs are arranged within the schools, again largely through these local arts groups, the student body as a whole is getting a kind of education in the arts that is not common in the average American school system.

The Minneapolis area is almost the ideal environment for such a program. The city itself, a center of culture for the upper Midwest, supports a wealth of arts institutions. Two major art museums have strong complementary collections—the Walker Art Center, a vast twentieth-century collection; and the Minneapolis Institute of Arts, a large, more generalized collection of pre-twentieth-century Oriental, European, African, pre-Columbian, and American art. Both museums run extensive programs for the public; both cooperate with Urban Arts. Besides the Minnesota Orchestra, one of the country's major symphonies, the Twin Cities have a number of distinguished chamber music groups, opera companies, and other musical organizations. As for the theater, it is equally active. The Guthrie Theater, the Children's Theatre Company, the Minnesota Ensemble Theater, and the Guild of Performing Arts are but a few of the local theater groups. All of their studios, stages, and workshops became learning environments for Urban Arts.

Winters here at the headwaters of the Mississippi are long and hard. The coldest temperatures in the nation are often recorded just north of the Twin Cities. Although some tourists come through the cities during these months, it is the local people who fill the theaters, concert halls, and museums.

It is, in short, an art-conscious community that actively supports the arts. John Davis believes that the school system should reflect this environment:

> The expectation of quality [in the arts] is high here in Minneapolis, and the exposure to quality is more universal. . . . There is a broader base of participation in the arts here. It follows, then, that the schools would be reflectors of attitudes which would be translated into opportunities for the artist and the student to come together.[5]

Besides enriching the schools' offerings, Urban Arts gives professional artists the chance to make money teaching something they love. Moreover, it is helping to create a support system for the arts. Through the program young people come to delight in the arts and to realize the value of the institutions that keep them alive.

## How and why Urban Arts came to be: two prime movers

> The philosophy of the program . . . depends primarily on direct contact between students and professional artists, with the students in many cases approximating experientially the discipline, training, and creative activities of artists. Initial energy is oriented toward the experiences; secondarily toward the intellectualization of those experiences.[6]

**The view of the superintendent.** If Urban Arts ranks high among U.S. public school arts programs, especially programs geared primarily to teenagers, a good part of the credit goes to John Davis, who was superintendent of the Minneapolis schools from 1967 to 1975. Always eager to strike out in new directions and to find ways to use the resources of the Twin Cities to complement school programs, Davis saw in Minneapolis a constituency that might be especially receptive to the arts in education.

The use of cultural institutions as part of the school curriculum was not new to Davis. As superintendent of Lincoln, Massachusetts, schools, the post he held before coming to Minneapolis, he established a relationship between the local schools and the De Cordova Museum of Art. He recalled,

> I can still in my mind's eye see the children from Lincoln crossing the fields and walking up the hill to De Cordova, which was just in the backyard of the school complex. . . .
> I came [to Minneapolis] with an experience and understanding of how important art could be in its multiple form . . . for students of all ages . . . and so I was delighted to find the interest here.

For all his vigorous support of Urban Arts while he was the Minneapolis superintendent, Davis showed no inclination to embrace what he regarded as the extreme positions of some arts-in-education advocates. The arts should occupy an integral place in every child's education, yes. Equal billing? Maybe, and if not now, someday. But Davis shied away from the education-through-art evangelists who would set right the notorious school imbalance on the side of the verbal and logical by tipping the scales in favor of the arts. As a man

convinced of the power and importance of the arts, he argued their case in terms that stress the pragmatic and possible.

Davis believed, for example, in the interconnections in all learning and deplored the pigeon holes to which conventional curriculum design delegates subject matter. Just as the arts can be relevant to learning history, so a knowledge of math might help in making art. Davis did not, however, push the idea of the arts as the *core* of the curriculum, because he thought such a curriculum might be reduced to absurdities like learning chemistry by mixing glazes rather than conducting the usual laboratory experiments. Forced to set priorities, Davis put reading, writing, and numbers before the arts because (1) these are the skills people must have to cope with society, and (2) most teachers are trained to work with these skills:

Schools do best what teachers are trained to do best, and that's in the development of the child's ability to read, write, and do numbers. . . . We have to capitalize on the competencies which the typical—and I mean that in the best sense of the word—teacher brings, and those skills are in the areas of the basics. . . . Our job is to teach the basics and to heighten the interest and imagination of students so that they want to translate those skills over into the excitement of the arts . . . and the elaboration of that calls for the availability of specialists. The specialists come as historians, the specialists come as philosophers, and the specialists come as artists. . . .

If there are students who have gone through our system at the secondary level in Urban Arts who have never touched chemistry, or physics, or who have never gone beyond first-year French, or first-year algebra, who have never had a good hard course in problems of democracy or American history, I think there's an indictment, exciting as what they have done may have been. . . . For tomorrow, it's important that we do more now to ensure the preservation of the arts and the artist, but I'm not at all certain that we have any license for attempting to do that and at the same time minimize the importance of other substantial subject matter.

Davis saw great value in teaming artists and classroom teachers to make their distinctive contributions—the artist with fresh vitality and up-to-date knowledge of the field, the teacher with classroom experience and knowledge of the students and their background.

**The director's view.** However strong the superintendent's advocacy of Urban Arts and his rapport with Wallace Kennedy, it was natural that Kennedy, as the program's director, viewed its mission and potential from a somewhat different perspective. He put more stress, for instance, on the crucial role the arts can play in education by fostering not only sensibility and self-assurance but also a mode of thinking important to the students' development. "Just because we can get kids to read and do math in their early years doesn't mean that they are going to become good learners," he has said. Part

artist, part teacher, Kennedy has been thrown constantly into close communication with artists and teachers and, most important, with the youngsters who are what the program is all about. "This is the first administrative job I've had," he said, "in which I can get close to kids."[7]

To Kennedy, Urban Arts is nothing less than an experiment in holistic learning (that is, learning through the body, mind, senses, and emotions), and he has expressed his hope that the program will affect art education throughout the school system:

The state of education in the arts itself is and has been lamentably static. . . . Arts teachers haven't had much exposure to what's happening to the arts as they are practiced by the professional artist. Nor have they had much exposure to the arts as they have been recorded in the museums. . . . What we're trying to do is bring the high level of energy, the creativity, the change that the arts have in the professional world and in the art museums into education in all forms.

Like Davis, Kennedy believed from the start that artists could combine their special gifts with those of teachers to make arts education vital for the students—ideally, all kinds of students and not just those particularly attuned toward the arts. Kennedy had very much in mind the boredom that many teenagers seemed to feel toward school and all its work. Among other things, Urban Arts was designed to make junior and senior high school more challenging, exciting, and productive. Thus, from the beginning of the program the prime requisite for a student's admission to Urban Arts has been manifest interest and enthusiasm, rather than outstanding talent. All courses have been given for credit, with a pass-fail grading system.

### Growing pains

In its brief life, Urban Arts has had its share of problems. In spite of the careful planning, favorable environment, and intelligent leadership, the program had to cope with numerous difficulties and misunderstandings from the start. The problems, as Davis and Kennedy would be the first to agree, were by no means wholly resolved at the end of the program's fourth year.

Aside from all the crises bound to beset a ground-breaking enterprise that seeks to meld any bureaucracy with the arts, two major and familiar problems emerged as Urban Arts developed. One was the rivalry, mutual suspicion, and sometimes even hostility between professional artists and classroom teachers. The other was the effort to achieve a dual purpose: to provide for a relative few an extended and intensive experience in the arts, and at the same time to try to relate the arts to the overall curriculum and thereby reach the general student population.

**The trial year.** In the first year of the program, Urban Arts took all its students outside the schools to locations around both Minneapolis and St. Paul. For part of every school day,

during the quarter or quarters they were enrolled, students worked with artists in concert halls, behind scenes in the theater, in studios, and in museums. Over the school year 626 students were enrolled in 13 courses, 327 in the 9 summer courses. During this first year, for instance, some Urban Arts students attended workshops at the Minneapolis Institute of Arts and the Walker Art Center. Working with docents and education staff, the groups carried out small research projects and presented seminar reports. One course, called "Museum Arts," focused on how a major art museum brings art to the public. Students worked with the conservator, associate director, and curators of the Minneapolis Institute of Arts. Some students created their own exhibitions, wrote captions for labels; others put together a catalog. Student reaction to this course was positive. Sample: "Urban Arts gives me the genuine atmosphere of an art museum. To be exposed to the real thing [authentic art works] and knowledgeable people is great."[8]

Urban Arts has been zealous in evaluating itself and arranging outside evaluation. In his report for the first year, 1970/71, one outside evaluator (Lloyd Hezekiah, director of the Brooklyn Children's Museum) commended the range and depth of the program's exposure of students to the arts, saying that "it illustrates and strongly supports the widening belief that the arts should become an integral part of the school curriculum in public schools throughout the nation."[9] He recommended, however, that Urban Arts should be more closely linked to classroom activity, though he conceded that neither classroom teachers nor artist-instructors then favored such a link.

**Second year and the artist-teacher problem.** Partly as a result of Hezekiah's findings, but more from their own convictions, the Urban Arts staff in the second year of operation (1972/73) decided to bring artists and museum professionals into the schools to team up with classroom teachers, meanwhile continuing the outside workshops. Only those artists who had worked well with the students in the workshops were chosen. A prime criterion besides talent was the capacity to stimulate youngsters and to reflect the energy and special quality of "the great world of art."

An artist could work a maximum of one full year in a school or two consecutive years half-time; each was required to instruct at least two hours each day, five days a week. He could if he wished continue his workshop with students outside school. Most of the artists hired have been young, still awaiting recognition.

With all his classroom experience, Kennedy was well aware of the tensions that can mount between teachers and artists. Artists who came to the schools for a day or less, he had observed, were often uncomfortable and unsure of what they were expected to do. Nor did classroom teachers know what to expect; they tended to assume the role of disciplinarians, not knowing how else to contribute. Kennedy believed that the rivalry would dissipate if the students, classroom teachers, and artists had repeated contact with one another. So when Urban Arts began bringing artists into the schools, it was rarely for a one-shot visit; usually they would be scheduled for at least five visits. Kennedy felt that time gave the artist a better sense of his audience:

> I think that Urban Arts has found a way in which an artist has a fair and honest and satisfying chance to learn what he can do. When he works with kids over a period of time, he really can tell that. When he's asked to come in and perform or do something for a short period of time, he leaves the place feeling terribly uneasy about whether he's ripped somebody off, whether he's done something that's worthwhile for himself. There's been too much star syndrome associated with everything the artists do in the school. And that's not helpful to either the artist, the arts, or education. We need another way of being at ease and being relaxed with artists.

Thus Kennedy and his staff, conscious of the risks of mixing artists and classroom teachers, tried to establish a good liaison between the two groups and between them and the students. To this end, they set up an advisory committee that, among other things, determined where and for how long each artist should teach and tried to match artist to a particular school activity already in progress. Once such schedules were set, the Urban Arts staff publicized the residencies in each school, and teachers signed up for the various time slots. As most were filled soon after the notices were posted, the Urban Arts staff members felt reassured by teacher reaction to the program and assumed with some reason that their liaison work was paying off in general understanding of Urban Arts among school people. Superintendent Davis stresses the "unusual and supportive role" that principals and teachers have played in "making possible the effective development and maintenance of the Urban Arts program."[10]

**Teacher response.** It was true, to a degree, that bringing artists into the schools was working out as planned and was giving Urban Arts a new and broader dimension. It had more direct impact on greater numbers of students and now on classroom teachers themselves than the exclusively out-of-school orientation of 1970/71. That teachers signed up promptly for all the residency opportunities is not necessarily positive evidence to this effect, however; some teachers, according to one report, felt pressure from their principals to sign up and did not always find the results productive. On the other hand, there is little doubt that other—perhaps most—teachers found genuine stimulation and help in their repeated contact with artists.

A notable example was the reaction to the "Adopt a School Program" that in 1973/74 brought members of the Minnesota Orchestra to Ramsey Junior High. As part of their residency at the school, they teamed up with the school's music staff in teaching strings and woodwinds, worked with English and social studies classes, and joined forces with the

student orchestra in concerts. According to Kennedy, the experience not only made a more sophisticated group of musicians out of the students, but even more exciting to him, "it regenerated a man [one of the school's music teachers] who's loaded with talent but who had become so discouraged prior to this year that he wasn't working at his peak capacity. . . . After 25 years in his career he's not going to fold up now and anticipate retirement. He's going to do the greatest things he has ever done." The veteran teacher himself confirmed this testimony: "It was a chance to meet the professionals. . . . It was a real shot-in-the-arm to a stinking activity." The reaction from the artists was equally enthusiastic. As the associate conductor of the Minnesota Orchestra said, "We care and we like to show it. . . . The only reason musicians teach is because they love to play and they at one time had good teachers."

**Reactions to, and from, the students.** Despite such gratifying results, Kennedy, Davis, and others concerned with Urban Arts were still learning, in the program's fourth year, that there was more groundwork to do to make Urban Arts known and understood, to achieve rapport between artists and schoolteachers, and to temper the nonconformist or even "elitist" image that the early years, with their concentration on out-of-school workshops for a few hundred students, had created. If there was a tendency for their fellows and their schoolteachers to find the students in the program clannish and self-congratulatory, it is hardly surprising.

As these students experienced the informality of working with artists in studio or museum or on stage, they became more aware of flaws in their home schools and sometimes were outspoken about them. In the spring of 1972, Urban Arts retained a research group called Heuristics, Inc., to study the program. A random selection of 28 students was asked to keep unsigned daily journals on the Urban Arts workshops. Here are some excerpts:

- The art class here is far more professional than my high school class.
- I am not as satisfied with my home school as I used to be—probably because it seems like a piece of drab, dingy, gray cloth, as compared to a piece of magic flying carpet.
- [Urban Arts] is making me more aware of the problems that may someday destroy my home school—the feelings that the students are of no value, but the teachers get all the power to tell the kids things—and the parents can be insulted by a teacher. . . . Kids and parents should be the ones who demand to rule what's going on.
- High school, you send me with your fantastic lies. . . . You know you just tire of the games more than anything else—the roles, the way you have to manipulate and perform so convincingly, just to get by.[11]

Although a preponderance of positive statements without this invidious edge came out of the study, there were enough like those quoted here to underscore the gulf between Urban Arts students and the stay-at-schools, and the related lack of

understanding between classroom teachers and artists, as witnessed by the following journal excerpts:

- A lot of the teachers and administrators at high school frown upon Urban Arts, because it offers an alternative, which they cannot figure out. . . . Public school is jealous of the response Urban Arts gets just by being Urban Arts.
- I also get a lot of shit from the [home school] teachers who don't like Urban Arts school. But that's their own problem.
- It's funny, the teachers at my high school don't take [Urban Arts] seriously. They think . . . we go there just for fun and want to be lazy. I find this attitude again and again.[12]

Another Heuristics study was conducted after the artists had been teaching in the schools for two years, with students again keeping daily diaries about their Urban Arts experiences. In contrast to the year before, students were now more positive about their home schools. Typical reactions included

- It's so nice to be able to find musicians in my high school and do something with them.
- I went to school today—out of curiosity.[13]

**One school's assessment.** Just after school opened in fall 1974, three members of Central High School's staff—two English teachers and a counselor—expressed their views of Urban Arts in an informal interview. Central enrolls about 1,000 students, more than a third from racial minorities, mostly black. Though students from the school had been enrolled in Urban Arts from the start, few artists had ever come to Central.[14]

The three faculty members joined in several complaints about the program, by now familiar to Kennedy and his colleagues and clearly not resolved by measures taken from the program's second year on. For one thing, it became clear that the Urban Arts liaison efforts were not entirely effective. If the program were to move into Central High, one of the English teachers said, it would "increase the minority enrollment in Urban Arts, and it would decrease the elitist image." In making her analysis, she came up with a memorable coinage for the average Central High student's view of Urban Arts and its members: "Strange people who do peculiar things outside somewhere."

All three agreed that the elitist label was not unjust—that Urban Arts students were typically nonathletic and that many if not most of them were academically gifted, from white, liberal, fairly affluent homes. According to the counselor, Urban Arts "attracts the nonconformist; some of the kids were a little tuned off to school. Sometimes Urban Arts was successful in working with that tuned-off kid; sometimes it wasn't." He added, in what may well be a common school complaint about the program, "I'm hot and cold to Urban Arts. . . . Some kids get turned on by it and it's good for them. Others get interested in the arts program and they let their school work go to hell. . . . They lose a good balance and they become just artists." He felt, too, that because Urban Arts was the only alternative to the standard curriculum available to junior high school students, counselors

tended to overuse it for problem students of all kinds and not just the bright tuners-out.

All three Central staff members also felt the "image problem" could be alleviated through better communications between the Urban Arts staff and classroom teachers. Though all admired Kennedy ("he knows what high school is all about"), they cited practical problems interfering with effective communications—for example, the need for a teacher to find and prepare a substitute if the teacher is to attend one of Urban Arts' open houses, which take place during school hours. The school schedule as it affected students also represented a minus for Urban Arts, one of the teachers citing a girl who had to take physical education mornings at school, though she spent the afternoon in Urban Arts ballet and exercises. Apparently, too, some band instructors felt they lost their best students to the program.

Objections such as these are inevitable perhaps and, as they are attributable in part to growing pains, relatively easy to meet. On the other hand, Urban Arts received an accolade from the Central High group for what may well be a program plus that Kennedy *et al.* did not anticipate—the return that some Urban Arts students bring to their schools. Both the English teachers had used workshop students as aides in their classes. One student, for a semantics lesson, demonstrated dance as a form of nonverbal communication. Several students had enlivened creative writing classes by reading and discussing their own poems with their classmates. "They just took the class over," said one English teacher. "They used skills I had not equipped them with." Apparently the experience was well received by the other students, who sometimes just accepted the idea that their fellow students were doing their thing without inquiring or being told where they might have learned it.

By 1973/74 Urban Arts' in-school programs included, in addition to the Minnesota Orchestra's all-year residency at Ramsey Junior High, a variety of Minneapolis Institute of Arts programs presented during several sessions (12 hours) over a month's time in each of eight schools at all levels; a dance course arranged through the Metropolitan Cultural Arts Center for two elementary schools and two junior highs; and two-and-a-half-hour demonstration concerts given at 20 schools by the St. Paul Chamber Orchestra.

### How Urban Arts deals with the visual arts

Although Urban Arts concentrates heavily on the performing arts, the program has from the start included the visual arts and worked closely with Minneapolis's two major art museums.[15] Particularly noteworthy have been the exhibits arranged with the museums and the part taken in them by Urban Arts students. Most of the collaboration with the Walker Art Center, however, aside from exhibits and the summer program, has brought students together with the museum's visiting artists in theater and dance.

The collaboration with the Minneapolis Institute of Arts has, by contrast, hewed more closely to the visual arts both in

the schools and in museum workshops—photography, architecture, art history, museum organization and practice, studio art. The institute's major education program, known as ARTS/AOP (an acronym for the merger of Arts Resources for Teachers and Students, an elementary-school program, with the Arts Opportunity Program for secondary schools; see box in chapter 11), has worked in different ways with the Minneapolis public schools and has given considerable attention to teacher training.

The relation with Urban Arts has been marked by numerous shifts in emphasis and procedure as the result, among other things, of organizational changes at the institute and, notably, of the closing of the museum between 1972 and 1974 to allow for massive building expansion. During that period members of the institute's education division held sessions with students and teachers in four of the city's schools, not only in studio art but in combinations of art with every discipline from mathematics to home economics.

The 1973/74 program, assisted by funding from Urban Arts, expanded to include kindergarten through 12th grade; the four-member staff that worked in the schools now provided expertise in the performing as well as the visual arts. The institute believes that this intensive experience in the schools has greatly enhanced the museum's value to the schools and its rapport with schoolteachers. As for the children, the institute's educators like to quote one 4th grader's response to a question on ways to improve the ARTS program: "Haveing it more offen [sic]."

**Two exhibitions, with student guides.** During the spring of 1973, the Walker Art Center and the Minneapolis Institute of Arts put on a cooperative exhibition of American Indian art and culture. The show—which Wallace Kennedy, who is not prone to understatement, has called the "very best Indian exhibit ever mounted in the history of man"—occupied four galleries at the Walker and four galleries that the institute, its own buildings still closed, rented in a barely completed skyscraper in downtown Minneapolis. Twenty-five American Indian students who were members of Urban Arts worked full time in the galleries during the nine weeks of the extremely popular show, for which they received a full quarter's credit in American history, English, speech, and art.

According to Kennedy, the credit was well earned. The Indian students brought to their work at the exhibition a deep identification with Indian legend and history. (In fact, when the institute staff saw the students in action, they pulled their docents out of the exhibition, giving the students a free hand.) Armed with this background, the students eagerly learned from the curators the particulars about the objects on display, each student choosing a category to suit his individual knowledge and taste. (One student, for example, stationed at the display of pipes, had himself made a pipe that was on permanent exhibition in a German museum.)

To understand how much the students learned in the nine weeks, according to Kennedy, one must know something of

the local Indian population and the peculiar plight of Indian students in Minneapolis. Far from being militant, he says, the Minneapolis Indians keep very much to themselves and go off several times during the year for a week or two at a time with their children to tribal gatherings. In part because the Indian students miss these weeks of school, teachers tactfully refrain from calling on them in class, fearing to embarrass them. So they sit quietly, usually get poor grades, and mingle scarcely at all with the white students.

Kennedy was particularly enthusiastic as he described the impact of the exhibit experience on the student guides or "advocates." Not only did they become specialists in particular fields of Indian art but, according to Kennedy and the teachers released for this assignment, the recognition they gained in the museum setting virtually transformed these young Indians, at least for the time. Besides their work at the exhibition, the Indians also performed their advocacy role at various schools in the area, explaining the show and their own specialties to students and teachers in advance of a scheduled tour. The guides themselves chose these assignments, concentrating on schools with few or no Indian students and little knowledge of Indian culture. It was also reported that as the result of talking to all kinds of people—in contrast to their silence in school, except among themselves —their speech and self-assurance markedly improved.

The success of the student program at "American Indian Art: Form and Tradition" encouraged the Walker to recruit students as guides for a 1974 exhibition called "New Learning Spaces and Places" (for a report on this exhibition, see chapter 2). Here the criteria for the guides were entirely different: the 65 students had all been recommended for their special interest in computers, technology, and education. The exhibition, which stressed educational technology and the relation of architecture and the environment to learning, required versatile students capable of explaining the intricate display and of encouraging visitors to participate in the installations or "experience areas."

Again, the guides received course credit for the time they would normally have been in school. During both exhibitions, the students were paid $1.80 an hour for all nonschool time. The guides at "New Learning Spaces" agreed to work in the galleries four school days, plus a minimum of 40 additional hours during the six weeks of the exhibit. According to Walker staff members, it would have been far more difficult to involve high school students as effective guides without Urban Arts assistance. The Walker's total cost was about $400; the school system contributed much more.

**A workshop in film and photography.** Another example of visual arts programing in Urban Arts has been a popular workshop, introduced in the first year of Urban Arts, that plunges students into film and photography. Students work with an artists' collective called Film in the Cities, a program of the St. Paul Council of Arts and Sciences. It is, in effect, a cooperative of young professional filmmakers who have

pooled their efforts and equipment to carry on their own film and photography work and to teach young people. Through Urban Arts the group contracted with the Minneapolis Public Schools to work as teachers. The project is subsidized by the Minneapolis and St. Paul schools, local foundations, and the St. Paul Council. Although some equipment was bought out of the Urban Arts budget, most of it belongs to the laboratory. Students who, after being interviewed, are accepted by the artists, work in the laboratory two hours every day, five days a week.

The film and photography workshop has demonstrated that certain advantages accrue from working with an established group of artists, rather than with individuals. This program, for example, bypasses two crucial problems that schools often face: (1) inadequate facilities (photography and film expenses run high, and most schools can afford only simple, nonprofessional facilities for a few students), and (2) the frequent incompatibility of artist and school environment (many school programs involving artists fail by trying to confine the artist too closely to school regulations). In the film and photography workshop, the artist teaches in an environment specifically designed for his work. If a particular artist cannot teach a class on a given day, another member of the collective fills in for him.

Furthermore, when schools contract with teachers outside the system, they avoid much of the red tape that often makes school operations inefficient and costly. The artists are not forced to make bids when they purchase materials. Unlike teachers, professional artists get a discount on materials; they can buy the desired brand in the exact quantity needed at the time it is needed. And unlike schools, no custodians are required; the artists and students keep the studios clean.

Film in the Cities occupies a one-time warehouse in downtown St. Paul, entered through a nondescript door off a main street. Inside, a large mural looms abruptly to the right; to the left the space opens into a spacious room two stories high, teeming with action. Teenagers of high school age are all over the place in long hair, T-shirts, jeans, sandals.

Four students sit in a lounge in a far corner. Two slouch in worn overstuffed armchairs, two are on the floor. One is describing a shot he wants to capture; the rest listen. In another corner students dismantle lighting equipment. One is carrying on a loud conversation with a young woman who is storing costumes on a rack above on the mezzanine floor. At the end of a dark hallway, a group of five huddles around a ticking projector and watches bright-colored abstract forms dance on a blank wall. One of the group is a professional filmmaker. They watch in silence.

Up a steep ladder, more students move about on a makeshift second floor. The alcoves here are animation studios. Heavy work boots hammer on the wooden floor; the sound carries. It is 3:30. Two young men push brooms, a third follows with a dustpan. For all the informal atmosphere, everyone seems to mean business. One member of the cooperative expresses his pleasure with the Urban Arts stu-

dents. They are serious about what they do. If they are not, they get out. This place is intense, no frills; it is a work place.

### The first four years: retrospect and prospect

At the close of its first year without federal funding, Urban Arts had achieved, on balance, an impressive record. It had advanced a long way from the early concentration on out-of-school workshops that involved less than one percent of the school population. There was evidence that the workshops and the growing in-school program were reinforcing each other and thus helping to mitigate the image of a special program for special students. Obviously, as the superintendent and the program director both recognized, much more work had to be done to eradicate this image, to enhance understanding and cooperation between schoolteachers on the one hand and artists and arts institutions on the other, and to integrate the arts more effectively into the regular school curriculum. The major development was expected to be expansion of the in-school program while maintaining, but not increasing, the out-of-school workshops.

To encourage this development, Kennedy intended to devise and carry out better ways to engage the interest and cooperation of the schoolteachers and to counteract some teachers' resentment of Urban Arts as one more demand on their time and energy. ("Whenever I go to speak before an auditorium full of teachers," Kennedy says, "I know I begin with a negative audience because they had to take the time from their students to sit and listen.")

The 1973/74 annual report included two plans for bringing the teachers in closer touch with Urban Arts and Humanities. The budget for the following year specifically provided for assigning six teachers to work with students and museum staff on exhibitions. The other plan took account of the "number of art teachers in Minneapolis Schools [who] are productive, exhibiting artists" and would make it possible for such teachers to share their particular skills and talents through short-term residencies in schools (K–12) other than their own.

The report also set forth various plans for maintaining and increasing outside funding, federal and other, in part to enable the school system to make "a major effort" to find out as much as possible about the actual effects of having artists work with students in such programs as Urban Arts.

In the absence of this kind of evaluation, it would be foolhardy to risk more than a tentative judgment on Urban Arts 1970–1974. But all the evidence sampled in this study suggests that the program has made a strong and increasingly effective effort to integrate the arts more fully into education, to improve instruction in the arts, to establish a successful partnership with a wide range of artists and arts organizations, to engage students and, to some extent, teachers in a fresh approach to learning, and to open up new vistas and choices for individual students. The program's staff and the school administration have also demonstrated an exceptional openness to change and to changing opportunities, and a

willingness to recognize and grapple with the program's shortcomings and problems. To some observers, the very fact that Urban Arts is not static but constantly evolving and changing is the most promising sign of all.

### Postscript

In the 1974/75 school year, Urban Arts served about 29,000 students (over half of the school population), as compared with the one percent in its first year. It offered thirteen daily workshops, six in-school programs (similar in scope to the Minneapolis Institute's), and four "extended events" and exhibitions. An Advanced Placement course in art history was begun in spring 1975, in collaboration with the University of Minnesota and the Minneapolis Institute of Arts. The course was at once a workshop and one of five humanities "affiliate" programs.[16]

The affiliate programs, so called because they are funded outside the Urban Arts budget by both private and public sources, are a sign, according to Wallace Kennedy, of the school system's efforts to incorporate the arts into general education and to move away from teaching them as separate and obviously underrated disciplines. A Minneapolis Ensemble Theatre program, for instance, funded by the Bush Foundation, is designed primarily to help students with language. Other programs include one for junior high schools sponsored by Young Audiences and another in which Urban Arts collaborates with the school system's art department.

To coordinate arts-in-education plans for the whole school system, a new committee chaired by Wallace Kennedy was organized. Its other members are the Minneapolis Schools' consultants for art, music, English and the humanities, and physical education, plus a school principal on special assignment.

The U. S. Office of Education has made a Title III grant of $56,000 to the Minneapolis Schools to develop evaluative materials and reports on Urban Arts and comparable programs elsewhere.—*J. A. H./J. M.*

### Notes

[1] The report describes the program during 1973/74, but the detailed budget information here and the enrollment figures appended to the report were available for 1974/75 only. These figures suggest no change of substance in the program in the year's interval.

[2] In 1966 the Minnesota Orchestra was included in the Ford Foundation's ten-year, $80.2-million program of assistance to 61 symphony orchestras in 33 states, and was one of six top-ranking orchestras required to match foundation funding of $2 million two-to-one. By June 30, 1971, the matching deadline, all six had made it, but only the Minnesota by the remarkable ratio of very nearly four-to-one ($7.9 million).

[3] The Minneapolis school system includes such consultants as part of its permanent staff, to advise on all major curriculum divisions.

[4] This report, because it reflects research done during 1973/74, is largely focused on Urban Arts as of that school year. The check-

list preceding the report and the enrollment figures in the appendix at the end of this report, however, include detailed information for 1974/75 that was not made available for 1973/74.

[5] For sources of quotations without footnote references, see list of interviews at the end of this report.

[6] *Urban Arts and Humanities, Annual Report, 1973/74*, p. 3.

[7] *Urban Arts Program, Project Director's Report, 1970/71*, p. 7.

[8] PROSE *Evaluation of the Urban Arts Program, spring 1972*.

[9] *Urban Arts Program, Project Director's Report, 1970/71*, p. 40.

[10] John B. Davis, Jr., letter to CMEVA, August 6, 1974.

[11] PROSE *Evaluation*, spring 1972.

[12] Ibid.

[13] PROSE *Evaluation*, spring 1973.

[14] By the following year, the program had moved into Central.

[15] In 1973/74 workshops included five in dance, three in theater, two in music, two in the visual arts (wood sculpture and film), and one in writing.

[16] For the 1974/75 enrollment figures for the workshops and programs, see the appendix at the end of this report.

## Interviews and meetings

Davis, John B., Jr. Superintendent of the Minneapolis Public School System. May 28 and August 29, 1974. (In July 1975, Davis became president of Macalester College in St. Paul.)

Eaton, Rod. Project Coordinator, Film in the Cities Laboratory. April 30, 1974.

Evenson, Howard. String Orchestra Instructor, Washburn Senior High School, Ramsey Junior High School. Telephone, June 19, 1974.

Friedman, Martin. Director, Walker Art Center. January 30, 1974.

Friedman, Mildred S. Design Department, Walker Art Center. March 25, 1974.

Gaiber, Maxine. Supervisor, School and Curriculum Services, Minneapolis Institute of Arts. April 26, June 21, and June 28, 1974.

Johnson, Javan. Vocal Music Teacher, Bremer Elementary School. June 27, 1974.

Jolles, Carol. English Teacher, Central High School. June 20, 1974.

Jordan, Mary. English Teacher, Central High School. June 20, 1974.

Kennedy, Wallace. Director, Urban Arts Program. October 28, 1973; January 26, May 1, June 20, and August 29, 1974.

Mennes, Dawn. Liaison Teacher, Urban Arts Program. June 25, 1974.

Newton, Jack. Liaison Teacher, Urban Arts Program. June 25, 1974.

Papke, Carolyn. Teacher, Bethune School. May 1, 1974.

Sloan, Sally A. Chairman, Mathematics Department, South West Junior High. March 5, 1974.

Smith, Henry Charles. Associate Conductor, Minnesota Orchestra. Telephone, June 19, 1974.

Zollar, Paul. Counselor, Central High School. June 20, 1974.

## Bibliography

Aronson, Judith. "Urban Arts Program, An ESEA Title III Project of Minneapolis Public Schools, Report and Recommendations of

Visiting Evaluation Consultant," Webster College, Missouri, April 1973.

Heuristics, Inc. PROSE [*Personal Reports of Subjective Experiences*] *Evaluation of the Urban Arts Program*, spring 1972.

————.PROSE *Evaluation of the Urban Arts Program*, spring 1973.

Kennedy, Wallace, and Marge Hols. *Urban Arts Program Project Director's Report, 1970/71*.

*Urban Arts and Humanities, Annual Report, 1973/74*.

## Appendix

The following is a list of the 1974/75 Urban Arts and Humanities programs and workshops, the participating arts organizations, and the number of students who took part. Again, however, it must be noted that the intensity of the students' involvement varied widely—from as few as 2 to as many as 80 hours over the school year. (The 300 junior and senior high school students enrolled in the daily workshops tended to spend the most time in the program.)

| In-school programs | Number of students participating | |
| --- | --- | --- |
| Elementary stage movement | 90 | elementary |
| Renaissance music | 80 | elementary |
| Minnesota Orchestra residency | 1,940 | junior and senior high |
| St. Paul Chamber Orchestra demonstrations | 6,750 | junior and senior high |
| Children's Theatre residency | 30 | senior high |
| Minneapolis Institute of Arts: | | |
| ARTS | 721 | elementary |
| AOP | 2,434 | junior and senior high |

| Special events | | |
| --- | --- | --- |
| Minneapolis Institute of Arts: | 3,246 | elementary |
| Mobile gallery | 492 | junior high |
| Walker exhibition: "Projected Images" | 20 | junior and senior high |
| Pilobolus Dance Theatre | 8,132 | junior and senior high |
| Art history enrichment program | 5,400 | junior and senior high |

| Affiliate programs | | |
| --- | --- | --- |
| Bush Foundation: Minnesota Ensemble Theater and Minneapolis Schools Collaborative | 120 | elementary |
| | 900 | junior and senior high |
| Minnesota State Arts Council and the National Endowment for the Arts: Artists in the Schools and Dance and Poetry | 1,088 | elementary |
| | 240 | junior and senior high |
| Minneapolis Institute of Arts and the University of Minnesota: Art History Advanced Placement | 24 | senior high |
| Young Audiences: North Area Humanities Project | 1,852 | junior high |
| Minneapolis Schools Art Department: Teacher-artist demonstration | 30 | elementary |
| | 890 | junior and senior high |

**Daily workshops***

| | |
|---|---|
| Ballet | 29 |
| Modern dance | 35 |
| Contemporary dance | 45 |
| Stage movement | 20 |
| Power and movement | 20 |
| Instruction with a musical instrument | 5 |
| Fundamentals, theory, composition | 9 |
| Film and photography workshop | 20 |
| Wood sculpture | 15 |
| Minnesota Memories Writing Workshop | 20 |
| Minnesota Ensemble Theater | 16 |
| Children's Theatre | 55 |
| Children's Theatre technical workshop | 11 |

## THE MUSEUM FIELD TRIP FROM THE TEACHER'S SIDE

**Wherein are described the perils of a schoolteacher who tries to take a group of 9th graders from a public junior high school on a trip to a New York City museum.**
*Interview with Grace George Alexander, acting assistant director of the Bureau of Art, New York City Board of Education, October 12, 1974.*

**Q:** What's it like for a junior high school teacher in New York City to prepare for even a simple museum visit?
**Alexander:** Let me explain. First, the teacher (in this case an art teacher) has to decide which of all the 500 children she teaches in one term will be the recipients of this experience. So she thinks about the kids who are involved in some kind of art activity in one of her classes, where a museum experience will support or open up or in some way enrich what the child is already involved in. That would be one way of doing it. So she picks a class. Let's say it's a class making costumes and designing sets for a school play. She's going to take them to both the Costume Institute at the Metropolitan and to the Impressionists at the Modern, because you can see lovely costumes there, or she'll take them somewhere else. In other words, she wants them to see not just the Costume Institute but be exposed to other art forms that deal with costumes—maybe the Metropolitan Egyptian Wing to talk about head, neck, and body costume jewelry.

Okay, she picks a class of 25 boys and girls. She asks them, "Would you like to go on a trip? It means that you won't have to attend all your classes on that day. Are there any tests that day?" If there are tests, she doesn't take them out; she finds another day. More questions. "How many major subjects would you be missing?" The major subjects, let's say, are social studies, English, and language. Well,

fine, because that's interdisciplinary, you see, and so the teacher then talks to the social studies and English teachers. "I'd like to take class 5.3 on this particular day for a day's trip. What are you planning in your program? Would it be all right for the kids to miss class if they discuss something about the trip in terms of what they're doing in social studies and English?" Well, she has two colleagues who are sympathetic, and they say it's okay if the kids don't miss their homework for that day.

Then she says to the kids. "How many of you work after school?"—because even the junior high school kids, if they don't work, they have to babysit, or they have chores to do, or they have to go to the dentist, or something. So she clears it with the kids. Then she writes a note and makes an appointment with the principal. She says, "I would like to take my art class out on such and such a day." He says, "Well, that means we have to give you a bus, and I don't know what that's going to do to the budget because we only have $x$ number of dollars to hire a bus for that day." So she says, "Well, they're big kids, they don't need a bus, I just need to get transportation passes for them. We can go on the subway." And he says, "Well, in that case, all right, but you have to write to the district superintendent to get it approved." So, she presents a form to the principal, which then goes to the district superintendent for approval, and that comes back to the principal.

Then she gets releases. Each child is given a release to take home to the parent, who signs, "I, the mother of José Gonzalez, give my child permission to travel from 9 A.M. to 4:30 P.M. from Russell Sage Junior High School to the Metropolitan Museum. I do not hold the Board of Education responsible for any accidents that may happen on the way." The teacher finds out when she gets the releases back that some parents do not want to excuse their children to go. So she asks one of her friends who teaches English or social studies or whatever, "May Mary, Alan, and Hugh stay in your class for that day?" And the other teacher says, "Okay, send them in, but please don't send me any discipline problems." So she tells Mary, Alan, and Hugh, "The class is going and you can't go or you don't want to go; this will be your assignment for that day." All right.

The teacher then makes the appointment at the museum. She may find that day already booked, because she forgot to check with the museum beforehand to find out if there was a spot. That is not going to happen with our hypothetical class; we'll say that she has already made the appointment. Now she has either made an appointment to have a tour with a museum lecturer, or she has made an appointment merely to bring the children to the museum. Maybe she can only do this at some museums—the Museum of Modern Art, for instance—if they are ninth year junior high school, because ninth year is considered high school, and the museum may not have a tour program for junior high school students unless they are booking to go on a particular tour. This teacher's going to bring them to the museum because she already

---

* All daily workshop students were in junior or senior high school.

knows that she is going to show them the Impressionists, let's say.

But she knows that you can't take 25 9th-grade students in a group and tell them this is that and da-da-da-da and expect the 25 kids to stand there. She knows beforehand that she is going to divide the group into smaller sections of, let's say, six kids in a group, and for each of those six kids, she herself has to be sure there's one strong leader in that group to hold those kids together, or she has to have enough parents to go around, one for each subgroup.

Okay, then before the kids go on the trip, she has to talk to them about why they're going and something about what they might expect when they get there. Let's assume they've never been there before; therefore she will give them a floor plan. She knows the museum inside-out. She'll tell them that such a thing is on this floor, and such a thing is on that floor, so they'll know the kind of physical space they're coming to. This is especially difficult at the Met, but I've done that at the Met, and it has worked quite well.

She'll talk to them about travel time so they know when they'll be home from school. She'll talk to them about the proper clothing to wear, because some kids don't understand that when they go on a museum trip, it's not just a social field day. They'll want to wear their best clothes because it'll be a social exchange as well. There'll be boys and girls and it's a day away from school, and they may have some extra spending money. They may want to wear heels and tight pants, or whatever. So she'll tell them it's really another school day, and they can wear school clothes, but they ought to look nice because there will be other people in the museum and if they don't look nice, the people in the museum will want to know what school they came from. And please don't chew gum. First of all, they don't allow gum in the museum. It's a rule. And if you chew it and then try to sneak it away somewhere, you'll be embarrassed. And you may not smoke. And how many of you have enough money to pay for a lunch if we have to eat in a restaurant? If not, how many of you can bring a bag lunch? Well, there's a little park, and we can bring our bag lunches over there. But you must remember it's a business area and a lot of business people eat there, too. So you kind of have to sit together and don't throw your bags on the ground.

Now if you take notes, please don't use ink, and don't lean on the wall and don't lean on the pictures. Write with pencil. You're going to have a very exciting time, and you're going to see a lot of things that you don't understand. Don't get angry. Just go with the understanding that nobody's going to make you say how you like something or whether it's good or bad. We'll talk about your reactions, how you felt about the things you saw when we get back together. You're not going to have to write a written report when you get back. We'll have different ways of talking about the experience. Maybe you'll act out some little anecdote that happened at the museum, or maybe you bought some picture postcards and would like to show them on our video camera, or maybe you'd like to make some little sketches, or whatever. In other words, the follow-up experience will not be a written report, unless a child wants to write a poem or make up a story about one of the characters in the painting. That's just part of it.

You have to understand that there are other things a teacher has to worry about. Children have to eat, children have to go to the toilet. They have to have some secret place to be. They can't be in a group all the time. They have to have some intimacy and secrecy with their best friends.

There can be trouble, too. Even if the teacher told the children not to wear expensive jewelry, maybe one child did wear his brother's watch. He took it out of his brother's drawer the day of the trip, and somehow or other he didn't listen to the teacher and didn't stay in the park. Instead he walked over to where there's some demolition going on, and he got mugged and the watch got stolen. That night, the teacher is on the phone with the parent saying, "I'm sorry, I know that your boy did something that he wasn't supposed to do, but it was an accident. Please try to explain it to his brother. There were regulations, but somehow he was carried away. I'm awfully sorry. He wasn't hurt, he's safe. You needn't worry about that." The parent might say, "I'll never let my kid go on a trip again," or the parent might say, "Good for him, he learned by experience he's not to use his brother's watch when his brother didn't give him permission."

But all the implications of this experience go far beyond the museum experience.

**Q:** How many teachers get so discouraged that they wouldn't go?

**Alexander:** Many.

—*F. G. O./A. G.*

## NATIONAL COLLECTION OF FINE ARTS, SMITHSONIAN INSTITUTION: DISCOVER GRAPHICS

The National Collection of Fine Arts
Smithsonian Institution
8th and G Streets, N. W.
Washington, D. C. 20560

**Learning to make prints and to look at them is only part of what this museum offers to high school students. Other features: concentrated work with a first-class printmaker, disciplined use of excellent tools and equipment, careful study of the museum's graphics collection, and close cooperation with schools. CMEVA interviews and observations: March, April, and June 1974.**

### Some Facts About the Program

**Title:** Discover Graphics Project.

**Audience:** Selected secondary students and their teachers. Schools in the greater Washington area are eligible and must apply for admission to any one of the "cycles" (each cycle being a four-week workshop course); schools may participate as repeaters. Twelve to fifteen students participated from each selected school.

**Objective:** "To help students and their teachers use the resources

of the museum to understand more fully the creative process and the role of art and artists in their lives.''

**Funding:** $12,800 (1973/74) from the museum budget.

**Staff:** Supervised by the staff associate in secondary education and conducted by the artist-in-residence. Participating teachers assist in the workshop portion of the program and supervise the classroom segments. Three art apprentices assist in the workshop and are paid by the museum and the District government.

**Location:** Museum workshop and print gallery.

**Time:** Six four-week cycles throughout the school year. Participating students are in the museum one full day per week. Program began in September 1971.

**Information and documentation available from the institution:** Teacher handouts, program descriptions, evaluation data to be compiled and summarized.

---

Once a week, for four successive weeks, a group of ten to eighteen high school students is excused from an entire day's classes to attend a museum workshop on intaglio printmaking. They are accompanied by a member of their art faculty, also excused for the day. During this cycle, the school has a visiting instructor and the loan of a circulating press, around which to plan special activities for its other students. Despite the usual problems of scheduling and the resultant tensions among school faculty, the program is fully subscribed. About 250 students from 18 schools participate over the course of a year. The cost, budgeted at $12,800 for 1973/74, is met from the general museum budget.

This "experimental" program in concentrated high school participation is called "Discover Graphics." In view of its acceptance by teachers and students, it is hardly an experiment any more. Much of its success may lie in the planning and supervision by two former high school teachers turned museum educators.

## Background: 1971–1974

One of these former teachers and the originator of the program, Jane M. Farmer, was staff associate for secondary education at the National Collection of Fine Arts from March 1970 to April 1972. One of the programs she developed for high school students, the Discover Graphics workshop, grew out of a felicitous combination of her experience as a printmaker, the decision of the Washington Print Club to hold its second annual high school graphics exhibition at the NCFA, and the institution's desire to make concentrated use of its outstanding graphics collection. Mrs. Farmer arranged a Printmaking Day, which offered tours of the collection, films, and demonstrations by graphic artists. It drew 600 students and teachers, most of whom arrived at the beginning of the event and stayed until the end.

Such interest seemed to call for something more sustained, so a large room near the education office and on the same floor as the print collection was converted into a workshop and its walls hung with an exhibition of printmaking tools, photographs, plates, and prints, accompanied by large didactic labels. A grant from the National Endowment for the Arts, under the joint Office of Education-NEA Artists-in-School Program, furnished funds for materials and the salary for an artist-in-residence. A special "media tour" of the print collection was arranged with the NCFA's volunteer docents. A telephone conversation with Charles Brand, owner of Brand Presses in New York City, about photographs to be used in the exhibition produced an offer to donate an intaglio and a lithograph press for the workshop.

The original Discover Graphics program was launched in September 1971. Ten classes from the District of Columbia school system participated in the workshop with their teachers, spending four mornings with artist-in-residence

---

## Two Philadelphia Museum High School Programs

Philadelphia Museum of Art
Parkway at 26th Street
Philadelphia, Pennsylvania 19101

### "The Truth about Art"

St. Joseph's Preparatory School, a neighbor of the Philadelphia Museum of Art, is a Jesuit high school with a reputation for high academic standards and an experimental approach to education. The school asked the museum's education division to participate in its interdisciplinary humanities course for freshmen.

"Originally it was supposed to be linking my concept of teaching in the galleries with their concept of humanities," Carol Stapp, developer of special projects, said, "but I felt I had to twist material in the collection to do that."* With the school's consent she devised a program that would explore with the students basic problems in confronting works of art. "The Truth about Art" brings the eight freshman classes to the museum for four visits a year, with an

introductory lecture by Mrs. Stapp at the school before each set of visits and a follow-up afterward.

At the school she introduces some of the reasons for establishing and maintaining museums: the exercise of taste, the education of "the masses," tax deductions, art as a commodity—issues calculated to make the students aware that art is not isolated from politics and economics and that there *is* no single truth about art. Before the visit titled "The Break with Realism in Nineteenth-Century Western Art," she discusses perspective, optical illusion, and other deceptions of the eye in "realistic" art; the gallery visit concentrates on the differing views of reality taken by French Academicians and Impressionists.

### Journey to the Center of the Museum

The Academy for Career Education is one of the many alternative programs in the Philadelphia school system. Its now-familiar premise is that young people will develop greater incentive to learn

John Sirica. He was assisted by 11 art majors from Federal City College, a neighbor of the NCFA, who earned from six to eight credit hours for their work, in combination with a 12-week etching course Sirica gave them in his own atelier—his donation to the program. The resulting exhibition at the NCFA of prints by both high school and college students demonstrated to Mrs. Farmer that the quality of the work produced reflected the quality of the students' experience.

To her, these elements contributed to the success of the initial phase:

1. The interaction with a practicing artist.
2. The interaction with the college students, volunteer docents, and museum staff members.
3. The participation of the [art] teacher as student and teacher.
4. The availability of high quality materials and equipment.
5. The length of the sessions (three hours each instead of the usual fifty-minute class).
6. The museum atmosphere with its vast collection of prints and visual stimuli, its scholarship and personnel resources, and the print workshop (including the exhibit on printmaking techniques).
7. The etching medium, which lends itself very well to teaching high school students fundamental skills involving the use of line, tone, and composition, etc., as well as artistic craftmanship and discipline.[1]

Brand expressed his satisfaction with the project by donating two intaglio presses that would travel to the schools involved in the program.[2]

When Mrs. Farmer retired from the museum in 1972, she proposed as her successor another teacher, Teresa Covacevich Grana, whose work in the D. C. high schools she knew. Ms. Grana had already introduced a variety of innovative printmaking projects into several large high schools. (One of her students had won first prize in the first Washington Print Club exhibition held at the Library of Congress; a calendar of graphic work by her students was featured by the library in its national newsletter.) Critical of routine museum offerings for students, Ms. Grana felt that to reach students a program must respect their capabilities and also the demands that the school system makes upon them.

She found several problems awaiting her. Topmost was money. Original funding through the Federal City College program ended when the college decided not to participate for a second year. Mrs. Farmer had unsuccessfully sought cooperative funds through the District of Columbia and other local school systems for the "experimental" program.

Ms. Grana's first goal was to make the project an integral part of the Smithsonian. After six futile months of seeking grants, she and the museum's director, Joshua Taylor, agreed that the program must be written into the operating budget. Funds for materials were made available from the Smithsonian's office of elementary and secondary education. The National Collection of Fine Arts paid Sirica on a contract that did not provide for a summer program. A new college link was set up with the District of Columbia Teachers College. As both Dr. Taylor and Ms. Grana wanted the college course to be taught in the museum and as Sirica resigned from the project to devote more time to his own work, the new Discover Graphics director now sought an artist-in-residence who was interested in teaching, would make a commitment to the workshop, and knew the field of lithography as well as intaglio.

In August 1973, after months of interviewing prospective candidates, Ms. Grana selected Allan Kaneshiro, who holds

---

if they can make practical use of their information and skill in the "real world," where "practical use" translates into payment for services. In the three years the academy and the Philadelphia Museum of Art have cooperated in this program, some students have come to the museum as paid apprentices. It has not been a wholly successful experiment, according to Carol Stapp, because the program changed each year as the academy's requirements changed and because assigning students to curatorial offices—when there was small chance they would become curators—seemed unrealistic. (For another view of apprenticeships in curatorial offices, see report on the Metropolitan Museum department of high school programs in this chapter.)

The 1973/74 program, arranged through the museum's education division rather than its personnel office, seemed more promising. The ten high school students devised a game, suitable for ten-year-olds, that would agreeably introduce the children—and in the process the apprentices themselves—to all aspects of museum work. Mrs. Stapp got the project started with a question-and-answer session, using small cards she had prepared bearing pictures of museum objects and activities, from Old Masters to television sets and vacuum cleaners. Piqued and often baffled by this sampling of the diversity that makes up a museum, the group then toured the museum's attics, workshops, offices, studios, and boiler rooms—a journey, in short, to the center of the museum.

Agreeing that the general public shared their puzzlement and curiosity about backstage activities, the students created their own board game, using some of the Stapp images that had stumped them and others of their own contriving. Though they may be over-optimistic to think the game marketable, their work not only demonstrated enthusiasm but also came up with a creditable product.
—B. C. F.

---

*Quotations and other information drawn from interviews with Mrs. Stapp and Patterson Williams, the museum's administrator of school programs, March and April 1974.

master's degrees in graphics (from Pratt Institute) and in secondary education.

## The program in 1974

Kaneshiro's residency revitalized the workshop. His belief in orderly procedures matches Ms. Grana's; hers was reinforced by a visit to the Petersburg Press, a British printing firm where, as she says, "you can eat off the floors." Although the Discover Graphics workshop may not quite meet these rigorous standards, one could quite comfortably eat from the tables when a class had finished its day.

The program, offered to all area high schools, brings a wide range of students into the workshop. Some come from schools where art education has progressed little over the past 20 years, and others from schools that offer a sophisticated choice of media instruction, including printmaking on school-owned presses.

Selection of students is left to the schools. One art teacher in a school with a strong arts program has said that ideally "those students who would benefit most, the most talented and creative," should participate.[3] Such students, however, are likely to be the most involved in other school programs. Thus, as this teacher's school was scheduled in the last cycle of the year, when pressures on the students are at a peak, those who discovered graphics were largely underclassmen, and not necessarily the most creative.

In another school with a less rich arts program, the art department may not even see the most talented students. Therefore, said one art teacher from such a school, "when we know we're coming here, we throw it open to everyone in the school. Some of these kids had a hard time even preparing a drawing, but they want to be here."

Even for students with access to and experience with a school press, use of the museum's presses provides a heightened respect for quality. So the circulating presses go out to these schools as well. (One result has been increasing requests from schools for help in obtaining their own Brand presses.) Ms. Grana is delighted that the lesson in quality has made its mark and feels that the acquisition of professional printmaking equipment by the schools will create still greater interest in the workshop and the print collection.

One goal of the program has always been to lead the schools toward study of the NCFA graphics collection. Vocabulary lists, teacher and student handouts, and technique charts are provided for those attending the workshop and travel with the presses to the schools.

The collection itself is an exciting teaching tool. Kaneshiro uses its classic examples to illustrate his advice to students that each process of printmaking has its own best uses: the nature of the medium is implicit in a given print. In addition, splendid examples in the collection of the singular ways an artist can use any printmaking skill may lead a student to enlarge his own artistic vocabulary. In the words of a teacher experiencing the Discover Graphics program with her students for the first time, "They can go out into the galleries at any point in their work and compare the proof they just pulled with the very finest in the same technique. I can't teach them the difference they can see with their own eyes. They know how good they could become."

A teacher of students from a school with a poorly endowed art department stressed the value of the total museum experience:

This is the only place my kids will learn printmaking, but that's not what they really learn. Here they are supplied with the very best: quality paper, quality tools. These kids will be out there setting priorities for education in a few years; I want them to learn that it costs money to be a good artist. And the way the workshop is run: so clean and professional. It teaches them respect for the tools and the craft. *This* is what it's like. This is the beginning of being an insider.

## The structure of the program

During each four-week workshop cycle, three different classes meet on Tuesdays, Wednesdays, or Thursdays, from 9:30 A.M. to 3:00 P.M. (There are six cycles a year, from October to June.) Before the first visit students are asked to prepare five working drawings which can be translated into intaglio. After viewing a film, *Four Artists, Four Media*, students and teacher see a demonstration of the intaglio process and then begin work on their plates. On the afternoon of the second visit a volunteer docent gives each student a magnifying glass and takes them all on a tour of the NCFA's print collection, where they examine and discuss traditional techniques and their variations.

The remainder of the cycle, visits three and four, are used to explore intaglio techniques further, to print editions, or to start new plates. With no set requirement save the production of a single print to be added to the Discover Graphics collection, each student works on his own.

During the four-week cycle other students in the school share the workshop experience through the circulating press, which they may use for approximately three weeks. Students who have attended the workshop can continue their projects at school and also instruct their classmates.

Finally, the museum offers a Discover Graphics tour for students who have used the circulating press but were unable to attend the workshop. Ms. Grana, convinced that all printmaking students should use the collection, informs each school that accepts the circulating press of the obligation she feels it has to bring students for the tour.

Each Friday Kaneshiro holds an open workshop, with individual consultations if desired, for both student and teacher "graduates" of the program.

## The Arts Apprentice program

In addition to the workshop schedule, supervision of the circulating presses, and demonstrations in the schools, Kaneshiro soon found himself deluged with routine preparation work, from washing tarlatan to filing reports. As he saw

his time stretched thin by the success of the program, he realized that the program needed steady help, of the type the City College students had once supplied.

It turned out that workshop help was available from the NCFA junior interns, who are part of the museum's secondary education program. For these students, learning to care for the tools and to order the setting for creativity provides an understanding of the artist beyond appreciation of the finished work. They now help maintain the workshop under Kaneshiro's supervision and, in return, have the privilege of spending their extra time in the workshop on their own graphics projects.

For the major task of supervising the circulating presses—almost a full-time job in itself—the education department created the Arts Apprentice program. Recruiting from area colleges, Ms. Grana sought art majors with a background in printmaking, a goal of professional teaching, and personal initiative. She chose three: one each from Federal City College and Howard and American universities.

Each apprentice is now responsible for scheduling and delivering a circulating press in each cycle, for preparing and restocking the graphics supplies that accompany the press, and for the demonstrations in the schools. Each does routine servicing of the presses; major adjustments, when needed, are handled by Kaneshiro. One apprentice has matted the collection of student work for the department.

Two of the apprentices are paid for their work through Youth Opportunity Services; the third, who is not a District resident, through an NCFA stipend. "This is the first job where I've done what I'm supposed to," said one, referring to the tendency in many practice-teaching and internship programs to dump "dirty work" on the student teacher. In May 1974, the last cycle of the Discover Graphics year, each apprentice took a turn at running the introductory session in the workshop—showing the film, presenting the demonstration, and helping students to begin work on their plates.

Kaneshiro's introductory demonstration, supplemented by a list of graphics terms for the students, is methodical and clear. As he progresses, he integrates each step with what students have just seen in the film. As he finishes each process, he cleans, washes up, and disposes of trash with the same care and concentration he gives to plate and tools. The example he sets is obviously noted by the students. When they begin their own work, they check themselves and each other to maintain order and cleanliness in the workshop. As individual students arrive at points in their work that take them beyond the techniques of the demonstration, Kaneshiro uses the opportunity to show the class the fine points of hand wiping or soft ground etching. When problems arise, he also brings these to the attention of the class, which sometimes learns a lesson in the serendipity of error.

### Integration into NCFA

In August 1974 Kaneshiro was made a permanent member of the NCFA staff, completing the integration of the Discover Graphics project into the museum's education program. According to Director Grana, there is no other program in the Smithsonian Institution with these distinctive characteristics: concentrated experience over time both in techniques of a medium and in study of examples of these techniques in the museum's collection; participation by both high school and college students; instruction by a first-rate artist and access to professional materials and equipment; and supportive experiences in the schools that also give nonworkshop students a share in the program's benefits.—*B. C. F.*

### Notes

[1] Jane M. Farmer, "Think Intaglio," *Art Education,* April 1972.

[2] Brand and Mrs. Farmer were honored at the High School Graphic III Exhibit. Brand donated the third circulating press that spring, making it possible for each cycle to have a press. Most recently, Brand donated a larger etching press, needed to meet program expansion.

[3] For sources of quotations without footnote reference see list of interviews at the end of this report.

### Interviews

Farmer, Jane M. Former Staff Associate for Secondary Education, National Collection of Fine Arts. June 10 and 12, 1974.

Foote, Martha. Art Teacher, West Springfield High School, Springfield, Virginia. April 24, 1974.

Giles, Patricia. Art Teacher, Woodson High School, District of Columbia. April 23, 1974.

Girard, Camille. Art Apprentice, Howard University. April 3 and 24, 1974.

Grana, Teresa Covacevich. Staff Associate for Secondary Education. National Collection of Fine Arts (as of April 1975, Associate Curator for Secondary Education). March 29, April 3 and 26, June 10, 1974.

Kaneshiro, Allan. Artist-in-Residence, Discover Graphics Project. April 23, June 16, 1974.

Sheehan, Richard. Art Apprentice, Federal City College. April 24, 1974.

## WHITNEY MUSEUM OF AMERICAN ART: STUDIO PROGRAM OF THE ART RESOURCES CENTER

Whitney Museum of American Art
945 Madison Avenue
New York, New York 10021

**A museum-supported studio program, staffed by artists, housed in a shabby warehouse, and loosely linked to the school system, is open to any New York City teenager who wants to drop in and make art. The controversy: is the value to the students—most of them poor—worth the $60,000 a year the program costs? Museum staff and some professional artmakers say yes; funders say maybe not. CMEVA interviews and**

observations: **November 1973; January, March, and June 1974; July 1975.**

### Some Facts About the Program

**Title:** Studio Program of the Art Resources Center.

**Audience:** An estimated 300 per year, excluding the summer program that enrolls 55 (age range, 15–23); mostly from poorer neighborhoods and encompassing a broad cultural and racial mix; 25 to 35 students per year are served intensively.

**Objective:** To allow interested teenagers, especially those from the city's ghetto neighborhoods, a chance to make art in an open and trusting atmosphere with a minimum of supervision or structure.

**Funding:** $60,000 (1973) from the Van Ameringen Foundation, Samuel B. Kress Foundation, the New York Foundation, the D. S. and R. H. Gottesman Foundation, and the National Endowment for the Arts Expansion Arts Program—raised by the Whitney Museum.

**Staff:** 4 instructors, in addition to the administrative staff of the department; no volunteers.

**Location:** 185 Cherry Street, in a converted warehouse building on the Lower East Side of Manhattan.

**Time:** The building is open from 10 A.M. to 7 P.M. daily, except Sundays, throughout the year. Time and extent of participation depends entirely on the students and varies widely from occasional visits up to almost daily attendance for five or more years. Program began in 1967.

**Information and documentation available from the institution:** Brochures and notices on program.

---

The Whitney Art Resources Center sits by itself on Cherry Street, in a far corner of New York's Lower East Side. The Manhattan Bridge is almost directly overhead. The building, a former warehouse, is a lonely remnant of an indefinitely stalled urban renewal project. Large graffiti-like letters, "ARC," identify the center. The same letters and a large arrow painted on a bridge piling show the way to an open red door.

The interior of the three-story building is big, open, and, despite the din from the bridge, quiet—strangely separate from the bustle of the Lower East Side. The street floor comprises a large gallery, a welding studio, and a large space containing a table saw, stacks of lumber, and a huge roll of canvas. Partitions divide the second floor into a maze of smaller rooms that run anywhere from 15 to 25 feet square. The basement is a vast space scattered with easels and tables. There are two darkrooms and some partially set up silk-screen apparatus. Large paintings lean against all the walls. The detritus of art-making is everywhere—old boards, rags, tables smeared with paint.

One gray morning early in 1974 two boys, one black, one Hispanic, were painting in the basement, two girls were painting on the second floor—a total of four students at work in the building.

The Art Resources Center occupies 15,000 feet of space; every year the Whitney Museum has to raise about $60,000 to maintain the ARC Studio Program. Since 1967, hundreds of inner-city teenagers have come and gone. Of them all, the

staff estimates, perhaps 25 to 35 each year find their lives deeply enriched through their work at the center. So questions arise:

- Is it worth it?
- Can making art in the manner of an artist really change the lives of tough street kids?
- Is a program like this—in no way related to a museum's collection, and located miles away—a valid form of museum education?

In the words of one museum director, the Whitney's Studio Program is "just a bunch of kids hanging around."

But this strange space cannot be so easily dismissed. Unwinding its many puzzles reveals a program premised on the value of intensive involvement with a few, respect for the vision and ideas of teenagers, confidence in the ability of art-making to change lives, and pragmatism regarding the educational services of museums. It was designed for inner-city teenagers—kids with problems, kids who are boisterous and tough. Yet as they work there, the center is quiet; it has the air of an artist's studio.

### Background

When the Whitney began planning the studio program early in 1967, it intended to place it in the South Bronx, in space provided by the local school district and Lincoln Hospital. Close cooperation with public school art teachers and encouragement of their own art-making as a means to revitalize their teaching were to be important parts of the program.

For a number of reasons the project evolved differently. So far as the museum educators could judge, the schoolteachers were anything but receptive to the experiment; for their part, the Whitney's artist-instructors distrusted an alliance with the teachers, sensing in them not only small sympathy with the idea of the studio program but also considerable anxiety about their own job security. Too, the designated space was inflexible in both the ways and hours it could be used. It became clear that the program needed greater independence in order to proceed.

Furthermore, as the South Bronx itself is a geographically isolated community, locating the program there would have virtually excluded the rest of the city. In the late sixties many teenagers in the South Bronx, which is largely Spanish-speaking, still ran in gangs. Teenagers from Harlem or Brooklyn could not be expected to enter this foreign turf. Thus, when the Whitney found 15,000 square feet of space for $10,000 rent per year at 185 Cherry Street, it decided on the Lower East Side. In contrast to the South Bronx, the Lower East Side offers a broad ethnic mix. Once heavily Jewish, the area around Cherry Street is now a nodal point of black, Spanish, Italian, and Chinese communities.

The space on Cherry Street was cheap because the city planned to condemn the building to make way for an urban-renewal project. In 1969 when the city was preparing to pull the building down, the Whitney joined with the neighborhood community council in an appeal to the Department of

Real Estate: if the city would leave the building up, the Whitney would assume the cost of repairs and maintenance (comparable to the rent, about $10,000 annually). The appeal succeeded, and the program stayed. Because of setbacks in the urban renewal project, the Whitney has estimated that the building will be available for another ten years.

Several assumptions underlie the studio program. The first is that making art is valuable in itself. The second is that no one has to open young people's eyes to the world of art; all they need is the means of affirming their vision. The third is that the students get involved in art by doing it. The fourth is that the present-day urban environment makes the arts a necessity.

In the words of David Hupert, head of the museum's education department,

> Culture in an urban setting, especially a dense urban setting, is equivalent to the great outdoors in the rest of the country. It is one thing to be poor in South Dakota and then just walk outside your house and romp with your dog over the hill for a little while. When you come back to your poor house, at least you have romped over the hill. There ain't nowhere to romp in New York, so you romp in the spirit and that's where cultural activities come in.[1]

**The studio program: an open, free nonsystem**

The Art Resources Center is open year-round from 10 A.M. to 7 P.M. daily except Sunday. If an interested teenager wanders in off the street, an instructor takes his name, address, and telephone number, gives him materials, shows him how to build a stretcher and prime a canvas. The rest is up to the student. There are no classes, no teaching, no entrance requirements.

The atmosphere at the center is open, trusting, and free. Says a former student, "It's a place you can come down to and get your rocks off any time you want—for 30 minutes or for a full day."

To judge from conversations with several of the students, they tend to be cynical; they feel cheated, exploited and bullied by their schools, families, and society. In deliberate contrast, the program is passive. No one gives orders or plans activities. The educational process is a slow building up of the participant's trust—in the program and the people who run it, in art-making, and ultimately in himself.

In the program's first years, the instructors made their own art in the center, sharing their methods, their ideas about art, and, most important, their work habits. The students copied them, but with constant encouragement to work out of their own ideas and concepts of quality. At the time the program began, the Whitney Museum's Independent Study Program got under way in the same building, and its college students provided additional role models. (For a report on the Independent Study Program, see chapter 12.)

Seven years old in 1974, the studio program has steadily increased the freedom allowed participants. At first teenagers were brought from school to the center for work at predetermined periods. At one time students and instructors met together for formal criticism. A brief, and disastrous, experiment used the college students as teachers: the teenagers were not about to listen to these predominantly middle-class out-of-towners. The single lasting, effective system has been a nonsystem—one in which each participant begins a painting or other work on his own. If he gets into trouble, he and an instructor talk about it. If he gets fed up, he leaves. If he wants to try again, he comes back.

Several years after the program began, some of the first participants were still there. As these teenagers matured and younger students followed them, the program became more self-sustaining. The instructors no longer felt the need to work in the center themselves; in 1971 the museum moved the independent study students out. The atmosphere of individual, concentrated work continued as before.

The rules at the Art Resources Center remain flexible. Although the building supposedly closes at 7 P.M., a few students have been given keys so that they can work nights. Most of the participants, having been pushed around by one institution or another much of their lives, view any new structure with suspicion. So the ARC does everything to convey the feeling that the center is their place.

Any such free-wheeling program risks thievery. But theft has been rare, partly because all materials—paints, brushes, canvas, and photographic supplies (budgeted at approximately $8,000 per year)—are free. Incidents that do occur (one student phoned a friend in Puerto Rico) the museum writes off as one expense of maintaining the program's spirit. As an instructor said, "We give ten yards for every inch."

Essential to the program's character from the start has been instruction by practicing artists. Four of them, one a graduate of the program, constitute the ARC staff. (The museum's education department oversees the program.) One works in the mornings, two in the afternoons, one on Saturdays—a schedule that allows time for their own art.

Allotting more than half the program's annual budget to the artists' salaries indicates the weight the museum gives to their role. The instructors see themselves as art-makers rather than art teachers and regard the participants as younger art-makers rather than art students. As a result, the students tend to act as they see artists acting. Their work takes on personal meaning, in contrast to the assigned and graded projects of public schools.

**ARC's students**

The first ARC participants were brought from Brooklyn's Ocean Hill-Brownsville section when the city was in an uproar over school decentralization and this "demonstration" district was the storm center. Rhody McCoy, the district's administrator and a leading spokesman for community control, cooperated with the Whitney, released students from school, and even sent several who had been suspended.

One ARC instructor obtained a Certificate of Competency

license from the Board of Education so that he could legally transport his recruits from Brooklyn to Cherry Street during school hours. Three times a week he took the train to Brownsville and brought back a group of 20 7th and 8th graders for sessions that lasted four hours on weekdays and all day on Saturday. Though they were among the most interested art students in their schools, none of them had ever seen acrylic paint or canvas.

Meanwhile, the center was attracting other young people from its immediate neighborhood. Over the years ARC's recruits have continued to come mainly from Brooklyn and the Lower East Side, with special and increasing response from the Chinese community. (For teenagers from uptown Manhattan and beyond, ARC is an hour-long subway ride away, too far for successful participation in what is essentially a drop-in program, even though a few dedicated participants travel from Long Island and Yonkers.) The majority of the students are still from needy backgrounds, but the age range is now 15 to 23—a healthy development, the instructors believe, because they feel this age group is more mobile and able to work under more flexible conditions. And their attraction to the program, the instructors feel, reflects a need that is not being fulfilled elsewhere in their lives. Hupert himself would prefer younger recruits, mainly because, in his words, "it's better to catch the kids before they get into high school, before their patterns of behavior and attitudes are set by intense social pressure to conform, before their sensitivities are deadened."

Though few official records are kept, estimates of the number of participants in the program range from 75 to 300 a year, exclusive of a special summer program that enrolls 55. (Variations from year to year depend on how actively the instructors recruit.) Given the program's nature, a more important if elusive statistic is how many youngsters the program really turns on to art and the making of it. The instructors estimate 25 to 35 per year, a number they find eminently satisfying.

As the studio program is primarily for out-of-school hours, no more than five participants work in the center most mornings. But 15 to 20 show up in the afternoons, evenings, and Saturdays, when school is out. More than 15 or 20 students in the center at once threaten the ambience of a professional studio so essential to the program, say the instructors. Some young artists come to the center every day, others weekly or biweekly, a few even more rarely. Some have been coming to the center for five years or more; others stay for a year or only a few months.

## Recruitment

The kind of recruitment effort undertaken in 1967 was never repeated. It has been replaced by diverse means of luring students to the center. Cooperative arrangements with the schools continue to be one source of students. An agreement the Whitney originally had with a few individual schools is now official citywide. A letter to district art supervisors from the board of education's supervisor for art for high schools points out that work at the ARC meets high school art requirements (the general procedure is to give participants credit for one course). In addition, the ARC has participated, to varying degrees, in some of the alternative education programs within the school system—the internship program, for example, which allows students to spend large blocks of time at the ARC for four months, and the City-as-School program, in which they can receive credit for working in institutions outside of the classrooms.

The center puts on its heaviest recruiting drive during the annual Art Expo, a week-long art-careers event in which 20,000–25,000 New York teenagers take part in school-sponsored field trips. Another, if less effective, recruitment aid is the book on city art resources for high school students that the Art consortium puts out every year, in which the ARC has a page. Word of mouth also helps: one young artist, who heard about the ARC from a girl he met in Central Park while he was flying a kite, has been with the program ever since.

The only exception to ARC's essentially laissez-faire recruitment policy is the Summer Parks Project. Of the 55 participants in the summer program, the Youth Services Administration pays approximately 20 students, some of them already active there, a stipend of $40 per week to work as "employees" of the center. Projects to date: the rehabilitation of Manhattan Bridge Park, including some bright murals; the construction of a large play-sculpture elephant for a small park on East Third Street; and the creation of a garden and park in a vacant lot near the center. This last project was planned as a two-year endeavor in cooperation with the Brooklyn Botanical Gardens and Museums Collaborative, which financed the project in 1973. (There was no summer program in 1974, nor did the garden-park enterprise continue for its second year. The ARC stayed open, however.)

It would seem that recruitment is critical to the continued vitality of the ARC studio program. The ARC cannot depend, as art centers in middle-class communities do, on parents to motivate their teenagers to seek out a place to make art. The students whom the ARC is trying to reach may have a greater need to make art than their more privileged contemporaries, who have so many options open. The problem is that inner-city teenagers usually lack the background that lets them recognize this need; somehow they must be shown that art-making is respectable and rewarding.

Identification of the few who will stick with the program and make something of it requires constant recruiting, for turnover in a program like the ARC is bound to be high. Instructors have learned to expect that out of 100 recruits perhaps only one will become deeply committed to making art as a way of life. For this one the program can serve as what the Whitney likes to call a "life preserver."

The procedure demands tremendous amounts of staff time and energy. One staff member frankly admitted that after seven years of recruiting, his energy had waned.

## ARC and the public schools

Although the ARC's formal relation with the New York City Board of Education implies good recruitment possibilities, this huge bureaucracy still throws up roadblocks to thwart the Whitney's overtures. To compound the problem, the ARC staff tends to be fully as suspicious of the schools as their students are—students who have encountered little but trouble and frustration at school. And this shared attitude illustrates an inherent tension of the studio program or any comparable experiment. For at the heart of the program is the instructors' identification with the students and sympathy for their resentment of "the system."

Whereas the staff does credit certain art teachers and supervisors with important contributions to the program, they report continuing difficulties with individual schools and districts despite the formal Whitney-board of education cooperation. They hold that many art supervisors "are asleep" and that many art teachers resent the opportunity students have to gain art credits outside of school. Important facts about the studio program, the staff has discovered, are not always passed on to students by district supervisors, department chairmen, and teachers.

Firmly as he supports the instructors and recognizes the importance of their rapport with the students, Hupert speaks in a different, though not contradictory, voice. He believes that the very existence of the program depends on some kind of sustained and mutually fruitful connection with the schools and that this goal precludes an out-and-out adversary stance on the museum's part. Despite all the lapses his instructors point out, Hupert feels that ties with the board of education have grown stronger in seven years: the very fact that the studio program is now accepted for credit in some schools represents a small triumph. In his view, the Whitney's education programs are adjuncts, not alternatives, to the school system: "For *some* students, we can do more, more efficiently and more effectively." But he holds that no single system (or nonsystem) has all the answers.

## ARC and the Whitney

The collections of the Whitney Museum play little part in the studio program. Although ARC students occasionally go to New York exhibitions, such museum visits originate with the students themselves.[2] The opinion among the staff members is that objects in a museum mean little to a ghetto teenager. They feel, in fact, that keeping their kids *out* of the museum is best, that for them learning about art comes from doing it. The consensus at the Whitney is that a museum's prime contribution to such a program as ARC derives not from its collection, but rather its fund-raising resources, administrative expertise, bookkeeping, insurance, and credibility. Because the Whitney is not bound by any rigid educational tradition nor by pressure to come up with a "product," it can give an alternate—or "adjunct"—program the security of a large and prestigious institution without the constraints of formal education.

The studio program of the Art Resources Center has inspired similar programs in New York City, but few of them have lasted more than a year. To the Whitney staff, starting a program like this one and then stopping it is worse than not starting it at all.

The most observable effect of the ARC on the Whitney is the dedication, at all staff levels, to this, their first ambitious education project. (Each year the Whitney's director actively helps fund-raising.) Maintaining and persuading others of their commitment, however, is no easy task: the numbers reached by ARC are small; the results are not highly visible; the project is expensive; support by the public school system is still inadequate; recruitment is difficult.

The staff realizes that the Whitney cannot pump $60,000 a year into the ARC indefinitely. Charging tuition would destroy the essence of the program. Hupert believes the ARC can look forward to perhaps seven more years of independence during which it must find a way to establish a "more structured" relationship with the school system, not least because such a link would make the studio program more attractive to funders.

## The balance sheet: Is ARC a useful model?

All told, the studio program has had, according to staff estimates, a deep and lasting effect on perhaps 200 teenagers during its seven-year life. Having learned better how to cope with themselves and the system, they generally show marked improvement in their regular schoolwork and graduate from high school. The program has helped get 25 of them into college, sometimes through scholarships (although five or six have dropped out). But such achievements, although important and gratifying, are tangential to the basic purpose of the ARC. So is turning out accomplished artists who can make a living out of art. (No art-related careers to date can be credited to the ARC, but it is too early to look for such results.)

To the Whitney and ARC staffs, the essence of the program is art as a life process and as a force for benign change in individual students and, if possible, the community. The museum staff believes, incidentally, that the simple existence of the ARC in one location for seven years as a place where neighborhood kids feel free to go, together with the gallery exhibitions, has contributed to the stabilization and self-identity of the community around Cherry Street.

The most tangible outcome of the program is the works of art it has produced. To people who follow the arts in New York, the ARC is now fairly well known—if only as a place on the Lower East Side where teenagers are producing big, flashy, professional-looking paintings.

To the practicing artist, however, there is more to the ARC work than up-to-the-minute professionalism. In 1968 students in art schools were all painting with masking tape; so were ARC participants. But because the experience of these streetwise kids kept their work firmly wedded to content, political or personal, it escaped the vacuity that usually goes

with trendiness. The better ARC pieces seem to have an inner tension growing out of the energy and the meaning these teenagers have invested in their art—a symbol of the program's goals that have been realized.

For many teenagers in other urban settings, art can fill a crucial gap. Although there are numerous urban art centers not unlike the ARC, few of them have produced the ARC's special effect. Three critical elements in the program's success are the key to adapting it to other settings. The first is the long-term commitment, in both time and money, of the sponsoring institution. The second is unceasing, vigorous, sensitive recruitment. The third—artist-teachers who refrain from "teaching"—may be most important of all; it is what makes the Whitney's program distinctive.

The artistic spirit that informs the Whitney program is rare and virtually undefinable. Teenagers at the ARC work day after day—not with people who know clever ways to make things that are pretty or expressive, not with people who believe that art is fun or therapeutic or even valuable, but with artists who know from experience that art is essential.

There is a surface foolishness to the ARC Studio Program: Why are poor kids who need to make a decent living making these big paintings? Why are they not at least learning commercial techniques like mechanical drawing that will be of some *use* to them?

The spirit of art-making the ARC artists impart to the program vitiates this objection. Because it has meaning, art imparts meaning to life in all its aspects. An ARC instructor, when asked whether to his students the program was a fringe benefit or a basic need, answered by asking, "Is art necessary to society?"

### Postscript: 1974/75

By summer 1975, the ARC program was in what Hupert called "serious trouble": some of the major private donors who helped sustain the program for six or seven years were losing interest and becoming eager to channel their money into newer projects. Unless new contributors were found— and fast—the studio program would probably close down by mid-1976. Nor had the link to the school system improved markedly. Some students could still receive credit for work done at the ARC, but the most crucial support the board of education could give, fund-raising assistance, was not forthcoming.

Mostly as a result of funding problems, the center cut back on its hours and staff time and, in 1974, introduced more structure into its operation. Although any teenager may still drop in to make art, a policy of evaluation of students' work has begun. Fifteen "private" studios were created in the ARC space and are assigned on a rotating basis to students, each of whose work is evaluated by the artist-teachers every three months. The staff, in consultation with the teenager, decides whether he can continue to use the studio.

There have been some other changes as well. The program

is now reaching a younger audience (age range is about 13 to 19, rather than the earlier 15 to 23), a turn that Hupert approves. And the ARC is now offering two afternoon courses, which city high school students may take for credit—one in printmaking (aquatint, etching, silkscreen) and one in camera-making (pinhole cameras). In July 1975, 20 students were formally enrolled in the printmaking course and 10 in the camera-making course.—*F. G. O.*

### Notes

1 For sources of quotations without footnote references, see list of interviews at the end of this report.
2 Additional exposure to art comes from the ARC gallery, which has an active exhibition schedule and shows the work of young artists not represented by commercial galleries, as well as the work of ARC participants and neighborhood artists. A showing of the work of ARC participants is also presented each year in the Whitney Museum.

### Interviews and observations

Anderson, Laurie. Director, Art Resources Center. Telephone, July 23, 1975.
Basdel, Gregg N. Instructor, Art Resources Center. March 19, 1974.
Hupert, David. Head, Education Department, Whitney Museum of American Art. November 7, 1973; March 8 and 22, April 5, and June 11, 1974; telephone, July 25, 1975.
Silberberg, Robert H. Instructor, Art Resources Center. March 19 and June 7, 1974.
Smith, Michael. Instructor, Art Resources Center. January 8, 1974.
And students in the program. January 8, 1974.

## CLEVELAND MUSEUM OF ART: ADVANCED PLACEMENT ART HISTORY COURSE FOR HIGH SCHOOL SENIORS

Cleveland Museum of Art
11150 East Boulevard
Cleveland, Ohio 44106

**Advanced Placement, or how to skip a college course by taking it in high school. Inaugurated 20 years ago in most subjects, but reached the arts (studio art, art history, music) only in 1971. In 1974 the Cleveland Museum of Art became the first museum to offer an AP course in art history. Problems, prospects, interim findings. CMEVA interviews and meetings: throughout 1974/75 academic year.**

### Some Facts About the Program

**Title:** Advanced Placement Art History Course for High School Seniors.
**Audience:** 21 high school seniors, from 12 schools in the Cleveland area.
**Objectives:** To teach art history to academically talented high school seniors, using works of art, slides, and other resources of the

museum, in preparation for the 1975 Advanced Placement Art History test of the College Entrance Examination Board, which is the final examination for the course.

**Funding:** Museum provides all services for an enrollment fee of $25 per student, which is waived in case of financial need. Students also buy books required for the course and pay an examination fee ($27) to the examination board if they choose to take the Advanced Placement exam.

**Staff:** One museum instructor (an assistant curator in department of art history and education).

**Location:** In the museum.

**Time:** The class meets for a two-hour session twice weekly—Tuesday after school and Saturday afternoon—between September and May. The 1974/75 academic year was the first year of the program.

**Information and documentation available from the institution:** Mailing from museum, *News and Calendar of CMA,* January/February 1975.

An Advanced Placement course in art history was offered in 1974/75 by the Cleveland Museum's Department of Art History and Education. The first time such a course has been offered by an art museum, it is not only a pioneer venture for the Cleveland Museum, but a sort of minesweeper watched carefully by other art museums.[1]

## Advanced Placement: background

About 20 years ago high schools started to offer students the opportunity to take courses that would give them "advanced placement" during their first year of college. Starting with most of the basic subjects, the Advanced Placement program by 1974 covered virtually the entire high school curriculum, with 17 examinations offered in 13 fields. It was not until 1971, however, that the program was extended to include the visual arts, both studio art and art history, and music. By 1972 the number of students taking both art tests had doubled to about 300. In May 1975, 443 high school students nationally took the art history exam.

In essence, Advanced Placement (or AP) is the label for special high school courses and examinations that give the qualified student a chance to skip the normally required college freshman introductory courses in a given subject and enter a more advanced course.[2]

For many years museum professionals and others concerned with the quality and nature of art education in the high schools have been trying to strengthen the study of art, including art history, which is seldom taught. Progress has been slow; the initiation of Advanced Placement marked one breakthrough. Because Advanced Placement seems a special program for the talented few, some of its supporters justify its inclusion in high school curricula by emphasizing other features: enrichment and the love of learning or, more pragmatically, an AP student's chance to get a college degree in less than four years. For instance, Professor H. W. Janson of New York University, one of the prime movers for Advanced

Placement in art history, stresses these broader purposes:

This particular subject . . . lend[s] itself to enriching one's life and to discharging . . . the responsibility toward the visual environment in which we live. . . . This program would help to educate a more committed and discriminating class of art patrons. . . . What we would like to do is to encourage visual independence. We would like to encourage people to look consciously at these decisions that they will be increasingly faced with, not only in their private lives but also in their public lives. . . . Making life in a community . . . more gracious, more livable, more human is perhaps in the long run as important as cleaning up the environment in terms of getting rid of industrial pollutants. . . .[3]

The AP test in art history, as in other fields, is designed for the ambitious student. According to every AP booklet issued by the College Entrance Examination Board, each AP course and examination "normally covers the equivalent of a full-year college-level course," and the examination papers are graded by carefully selected high school teachers, college teachers, and others, using "the same college-level standards as were applied in constructing the examinations."[4]

Precisely how or even whether Advanced Placement helps to wedge art history into the high school curriculum is still an open question. Are the ever larger numbers of students taking the AP test the measure of success? And does this accomplishment indicate that art history is finally taking root in the high school curriculum? One advocate of art historical studies for high school students argues that "the study of world history is . . . in a sense incomplete without the study of world art."[5] If this position seems indisputable, it remains nonetheless true that few high schools find it possible to introduce art history into the curriculum, much less an Advanced Placement course. Janson has advised high school teachers of "another way to get your foot in the door. That is to encourage individual students to take the Advanced Placement examination on the basis of work they have done themselves with your encouragement and even a bit of private tutoring."[6]

Stratagems proposed by another teacher of teachers if it is impossible to institute an independent course in art history include working art history into studio art and design courses, or working it into a general humanities course, in which "almost invariably literature takes pride of place . . . accurately reflect[ing] the cultural emphasis on the verbal arts."[7]

## Planning the Advanced Placement course at the Cleveland Museum

Given this backdrop of imponderables and its own long-term interest in introducing art history to high school students, the Cleveland Museum decided to inaugurate an AP course in 1974/75. This course is related to two of the museum's other educational ventures in 1974—a full-credit course for graduate and undergraduate students at Case Western Re-

serve University and a six-week summer institute for high school teachers. (See the report on the summer institute, which includes a brief account of the university course, in chapter 11.)

Announcement of the year-long course went first to interested local teachers. In the opinion of Gabriel Weisberg, Cleveland's curator of art history and education, teachers are crucial to a museum's relationship with students as well as to the goal of fitting art history into high school curricula. Of some two dozen teachers invited to a planning meeting in February 1974, approximately ten attended. The curator explained the museum's intent to teach art history using original works of art in the museum collections. Celeste Adams, the assistant curator entrusted with the course, presented her outline of class plans and assignments. No one at the meeting, from museum or schools, raised other substantive issues.

As outlined, the course included weekly slide-lectures focusing on the history of Western art (and reflecting the requirements of the AP examination); weekly gallery visits; independent reading and other assignments, plus a worksheet of questions "designed to assist students in applying art history principles directly to museum objects."[8] Students were required to produce two papers in the fall term and an independent project in the spring term. They had the option to take the Advanced Placement examination, which is given in May at the museum, for possible college credit. Many of those students who took the exam and received from the national AP readers—*not* from their museum or classroom teachers—a grade acceptable for advanced standing at the colleges they entered have additionally earned college credits for their course at the museum.

## Arrangements with teachers and students

Each schoolteacher with a student enrolled in the course received a copy of the course outline, and each school librarian the list of required books.[9] Arrangements were made individually with schools and schoolteachers. The work of students who elected to take the museum course was accepted for full credit by one Cleveland school system teacher of an Advanced Placement art history course. A teacher of AP art history in a suburban school system gave a supplementary course for her students enrolled in the museum's course. According to Miss Adams, the museum course qualifies for academic credit at all the participating schools, independent of the grade on the AP exam.

Selection of students is equally individual. Some students applied at the urging of a teacher, others on their own. Two AP students had been in the non-AP art history course Miss Adams offered in the spring of 1974 as a trial run. Although the museum's criteria for acceptance were left unstated, both Weisberg and Miss Adams believe that academic aptitude is essential for a student to survive the rigors of the course, however talented he may also be in studio work. For admission to the 1975/76 course, she decided to require at least a *B* average.

## The experiment begins

The course began on September 24, 1974, with 21 high school seniors from 12 area high schools. Meeting on Tuesday afternoons in museum classrooms and on Saturday afternoons in museum galleries, the students and their museum instructor established—quickly, to their mutual relief—an informal relationship. Celeste Adams describes it:

I don't want to be the figure behind the podium. I want students to challenge what I say so that I can learn about them and from them. Though I've been teaching in the museum galleries for four years, within the first few gallery sessions students had suggested to me new ways of looking at objects. We've all come to recognize our own bias of taste. They attack mine, and I attack theirs. I think we both learn in the process.[10]

Most of the students say they had a "general" acquaintance with the museum collections before entering the AP course and that, in fact, their pleasure in art, more than the college credit they hoped to receive, prompted them to enroll. They agree it is hard: one who took the more relaxed spring 1974 course with Miss Adams said ruefully, "Well, it's certainly more work than last spring!"

A student seriously tempted by a career as a practicing artist described her feelings after a month in the course: "I used to come to the museum often for enjoyment, but now I look more closely at objects and look for different things. I'll always love the beauty of art, but now it's exciting to realize I can discuss it objectively." True, a couple of students stopped taking the new course for credit at the end of the first semester, though they still audit it. But in general the posing of adult standards appears to be the secret of what success this course may enjoy. Another student put it succinctly: "We expect it to be hard. We aren't children."

## Evaluating

Although the course will probably have to run two or three years before its validity can be assessed, the students' "success" can be measured by their scores on the AP exam. Of the 21 students enrolled, 15 chose to take the exam in May 1975. Nationally, 443 high school students took that exam; fewer than 10 percent scored a grade of 5, the top possible score. The Cleveland Museum's students did exceptionally well; six of them (or 40 percent) scored a 5, and all but two scored either a 3 or 4, grades most colleges accept for academic credit, advanced standing, or both.

Given this achievement record, the Cleveland Museum's approach may interest other museums curious about instituting similar courses. Weisberg, who has been involved in the AP Art History program since it began and who is chief reader-designate for the 1975/76 exams, believes that no AP course, including this one, should be judged by the number of students enrolled, because the nature of the program mandates small classes of highly qualified students. In his view, the special requirements for the museum's AP art history course include instruction by a trained art historian with an

M.A. who likes working with high school students and clearly understands the AP goals; supervision by another trained art historian; a comprehensive collection of slides; access to art objects of high quality; a convenient and adequate library; participation by enough schools to give the program breadth; a year-long fruitful collaboration between the museum instructor and schoolteachers who understand AP goals and requirements and take an informed interest in their students' term projects.

**Follow-up**

One aspect of the AP program over which the museum has no control is the response of the colleges to the AP work and scores submitted by students. Given the widely publicized financial pressure on colleges, it is possible that some colleges will not give even successful AP students credit toward a college degree, instead requiring them to pay for a full schedule of college courses. Advanced standing—that is, allowing a freshman student to take higher-level courses— costs the college nothing if it is not tied to academic credit toward graduation for the courses the student is allowed to skip.

The Cleveland Museum is asking each student to return a questionnaire at the end of the first college term, indicating how his or her college treated the AP results. A second questionnaire will go out at the end of the first full year, asking the students about their continued interest and study in art history.

**A paradox?**

Beyond the eventual assessment of the Cleveland's AP course there looms a curious question. Assume that this course succeeds in its long-range goal of wedging art history into the curriculum of local high schools; then will not that very success make the museum's AP course unnecessary? To Gabriel Weisberg, a good museum collection is the *sine qua non* of a good art history course. He agrees that such a course could be developed jointly by museums and high schools, perhaps taught partly in the schools, partly in the museum's galleries. He insists, however, that any high school that fails to make regular use of an available collection like the Cleveland's cannot offer a respectable art history course, AP or non-AP.—*A. Z. S.*

---

## Notes

[1] Other museums now offering an AP course include the Minneapolis Institute of Arts, which began its program in spring 1975.

[2] Some colleges give academic credits as well as release from introductory courses to entering students who pass AP examinations with acceptable scores.

[3] From ''Remarks Concerning the Advanced Placement Program in Art History,'' by Professor H. W. Janson, at an inaugural dinner for the Summer Institute in Art History for High School Teachers, College Park, Maryland, July 13, 1973, published in *A Report on the Summer Institute*. Professor Janson goes on to say, '' . . . Of course I am interested in getting college freshmen who already know that there is such a thing as the history of art. They can begin on the next higher level because they will get college credit for the introductory course, the equivalent of which they will have had in the last year of high school . . . and we improve our selection of future scholars in the area. But this is obviously only a small part of the total effort. A small part that could not possibly justify all the things that we are doing'' (pp. 16–18).

[4] *1974/75 Advanced Placement, Art*, College Entrance Examination Board (Princeton, New Jersey), pp. ii–iii.

[5] William M. Kloss, ''Teaching the History of Art in the Secondary School,'' *A Report on the Summer Institute in the History of Art for High School Teachers Given at the University of Maryland 1973*, p. 2.

[6] Janson, *Report on the Summer Institute*, p. 21.

[7] Kloss, ''Teaching the History of Art,'' pp. 3–4.

[8] Course outline prepared by Celeste Adams, February 1974.

[9] See lists at the end of this report.

[10] For sources of quotations without footnote references, see list of interviews at the end of this report.

---

## Interviews and meetings

Adams, Celeste. Assistant Curator, Department of Art History and Education, Cleveland Museum of Art. Meetings, interviews throughout 1974.

Biehle, Helen. Art Teacher, Laurel School, Shaker Heights, Ohio. Telephone, August 8, 1974.

McIntyre, Dorothy. Humanities Teacher, Orange High School, Orange Village, Ohio. June 25 and July 31, 1974.

Weisberg, Gabriel. Curator, Department of Art History and Education, Cleveland Museum of Art. Meetings, interviews throughout 1974.

---

## Bibliography

Adams, Celeste, Jay Gates, and Gabriel Weisberg. ''The Art Museum and the High School: The Advanced Placement Approach to the History of Art,'' *Art Journal*. Fall 1975.

---

## Required Reading for Advanced Placement Art History Courses

**Text for Course:**

H. W. Janson. *The History of Art*. New York: Harry N. Abrams, and Englewood Cliffs, N.J.: Prentice-Hall, revised, enlarged edition, 1969.

**Paperback Reading for Fall Semester:**

1. Joshua C. Taylor. *Learning to Look*. Chicago: University of Chicago Press, 1957.
2. Erwin Panofsky. *Gothic Architecture and Scholasticism*. New York: Meridian Books, 1957.
(or)
George Henderson. *Chartres*. Baltimore: Penguin, 1968.

3. Anthony Blunt. *Artistic Theory in Italy*. Oxford: Oxford University Press Paperbacks, 1962.

**Paperback Reading for Spring Semester:**

1. Kenneth Clark. *Landscape into Art*. Boston: Beacon Press, second edition, 1972.
2. Walter Friedlander. *David to Delacroix*. Cambridge, Mass.: Harvard University Press, 1952.
3. Clement Greenberg. *Art and Culture*. Boston: Beacon Press, 1961.

**Recommended Reading for Advanced Placement
Art History Course** (fall 1974–spring 1975):

Recommended available one-volume histories of art and one-volume topical art histories. Most of the books contain bibliographies of more specialized literature.

**1.  One-volume histories of art:**

Clark, Kenneth, *Civilization,* New York: Harper & Row, 1970.

Fleming, William. *Art and Ideas*. New York: Holt, Rinehart & Winston, revised edition, 1968.

Gardner, Helen. *Art through the Ages*. New York: Harcourt, Brace, Jovanovich, revised edition, 1970.

Gombrich, E. H. *The Story of Art* (also available in paperback). London and New York: Phaidon, 11th revised and enlarged edition, 1966. Distributed by Frederick A. Praeger, New York.

Levey, Michael. *A History of Western Art* (also available in paperback). New York: Praeger, 1968.

Robb, David J., and J. J. Garrison. *Art in the Western World*. New York: Harper & Bros., third edition, 1953.

Upjohn, Everard M., Paul S. Wingert, and Jane G. Mahler. *History of World Art*. New York: Oxford University Press, revised and enlarged edition, 1958.

**2.  One-volume histories of art consisting of illustrations only:**

Janson, H. W. *Key Monuments of the History of Art,* New York: Harry N. Abrams, and Englewood Cliffs, N. J.: Prentice-Hall, 1961.

Upjohn, Everard M., and John P. Swedgwick, Jr. *Highlights, an Illustrated History of Art*. New York: Holt, Rinehart & Winston, revised edition, 1963.

**3.  Introductions to art and topical art histories:**

Eitner, Lorenz. *Introduction to Art: An Illustrated Topical Manual*. Minneapolis: Burgess Publishing, 1961.

Elsen, Albert. *Purposes of Art,* New York: Holt, Rinehart & Winston, third edition, 1972.

Knobler, Nathan. *The Visual Dialogue*. New York: Holt, Rinehart & Winston, 1973.

Lowry, Bates. *The Visual Experience*. New York: Harry N. Abrams, and Englewood Cliffs, N.J.: Prentice-Hall, 1961.

Pierce, J. *From Abacus to Zeus*. Englewood Cliffs, N. J.: Prentice-Hall, 1968.

Other books used in the course are recommended in the "Advanced Placement Art Course Description," 1976/77, of the College Entrance Examination Board, Princeton, New Jersey.

# TEENAGE TEACHERS:
# EXPLAINERS IN THE EXPLORATORIUM

The Exploratorium
3601 Lyon Street
San Francisco, California 94123

**High school students answer visitors' questions and explain perceptual phenomena in this museum where science is joined with visual art. Along the way, the Explainers gain confidence and sometimes new direction; they also offer one model for out-of-school learning, applicable to museums anywhere.** CMEVA **interviews and observations: April and May 1972; December 1973; June 1974.**

**Some Facts About the Program**

**Title:** The Explainer Program.

**Audience:** 60 high school students and 12 college students per year.

**Objective:** To prepare students to explain exhibits to visitors and schoolchildren and to serve as museum floor staff in place of guards or tour guides.

**Funding:** Annual cost is approximately $50,000. Program is funded by the National Endowment for the Arts, with a matching grant from the Rockefeller Brothers Fund. Some College Explainers are supported by a work-study program, some receive institution support.

**Staff:** Museum staff hires the students and provides an eight-hour orientation preceding their first day of work. Ten Explainers work full-time (20 hours per week), 10 work part-time (8 hours per week, on weekends). Students generally may work no more than two four-month terms.

**Location:** In the Exploratorium.

**Time:** The museum is open to the public from 1 P.M. to 5 P.M., Wednesday through Sunday. Program began in 1969.

**Information and documentation available from the institution:** Mimeographed handout.

More like a warehouse or an airplane hangar than a museum, the building that houses the Exploratorium has been used as a garage for Army trucks, a telephone book distribution office, a Fire Department headquarters, and the site of 18 indoor tennis courts. It was originally built by architect Bernard Maybeck for the 1915 Panama-Pacific International Exposition, and the exterior still looks like a "ruin" made for a movie set.[1]

Completely reconstructed in 1965, the building—the Palace of Fine Arts in San Francisco—is now the home of one of the most unusual museums in the United States. Its three acres of space under high vaulting roofs were transformed in 1966 into a "museum," a title that founder and director Frank Oppenheimer immediately qualifies: "When we used the words science museum, nobody liked the word *museum,* because it had a passive content for some people . . . [so] we invented the word 'Exploratorium.'"[2]

The Exploratorium is one of the least passive museums ever invented; it is full of exhibits that visitors are urged to

handle, to "discover" for themselves—many of the exhibits require visitor manipulation and participation in order to reveal their mysteries. But most visitors need help, and signs stuck around the vast cavernous interior offer it: "If you have any questions, ask a Red Jacket." Teenage boys and girls wearing red jackets are Explainers, high school students hired and trained by the Exploratorium to act as guides. They constitute the entire floor staff of the "museum." Instead of conducting tours, they wander through the hall or station themselves at particular exhibits, answering some questions and asking others, striking up conversations with visitors and encouraging them to try out one or another of the 300 exhibits. (For a report on the Exploratorium's education program for elementary schoolchildren, see chapter 6.)

## How Explainers are chosen

The Explainer program is arranged, at the Exploratorium's request, by the job counselors of high schools throughout San Francisco. Students chosen for the program work four hours a day, five days a week—three school afternoons and both weekend afternoons. The museum is open to the public from 1 to 5 Wednesday through Sunday, so these "full-time" Explainers are there whenever the museum is open. For their 20-hour week, they receive academic credit and $2.25 an hour. "Part-time" students work only on weekends, earning the same pay scale for their eight hours of work. There are usually eleven full-timers and ten part-timers during each four-month period; five of them are hired for a second term to serve as a nucleus for the new group, and sixteen new Explainers are chosen each term from approximately fifty applicants.

Students are selected through interviews by the museum staff. The staff does not search for students with scientific talents or ambitions. What it looks for, says Oppenheimer, is students' reactions to exhibits and an ability to articulate this reaction. The capacity to learn, and to keep on learning, is crucial for an Explainer. An Exploratorium bulletin emphasizes the need for this basic curiosity:

We feel that the Explainer job is more enjoyable than [many] other jobs possible for high school students. At the same time it is more demanding, and, when hiring students, one must keep this in mind. We have also found that student interest is usually initially keen, but that it wanes and must be constantly re-stimulated. However, the returns do exceed the investment. The job is quite definitely educational and, as such, its utility to the Explainer is limited only by the extent of his or her curiosity.[3]

## The training program

The premise of this "quite definitely educational program" is one all teachers appreciate: you learn a subject well when you try to teach it.

This was precisely what Oppenheimer had in mind when he invented the Explainer idea. He said of it,

[The idea] grew out of seeing demonstrators at other museums, for example, the Paris Museum. But one of the things that everybody knows is true is that you begin to learn when you start to teach, and normally that is hard to do in the classroom. It is hard to get the students to do the teaching. But here there is very much this process of learning and teaching. We teach the Explainers a great deal, and they learn on the floor, but they are immediately translating what they have learned into teaching it to a different audience. And so, it is the best as-you-learn teaching situation that I have seen.

And the students have a lot to learn, as most of them enter the program without much science background and need instruction about the exhibits and the purposes of the Exploratorium. One 17-year-old Explainer told a *Newsweek* reporter, "I never took very much science, but I'm learning a lot. I didn't even know what a laser was until I started working here and people asked me about it."[4] Another, whose talents are more musical than scientific, said of his Exploratorium experience, "This place has changed my whole way of thinking about how the world is." From still another, "Everybody always says that they learn more about people than science. For me . . . it's been the other way around."

Each new group of Explainers receives an eight-hour orientation to the museum and its exhibits during the two weekends before they begin work. Once they have started their jobs, the students continue to get hour-and-a-half lectures on Saturdays and Sundays before the museum opens; almost all of the lectures use the exhibits as props. Explainers are also encouraged to keep notebooks on visitors' questions and to talk with each other as part of their Exploratorium education. This "learn while you earn" technique, the staff believes, allows each student to proceed at his own pace and to acquire some understanding of the exhibits by actually handling them. "Furthermore," says the bulletin, "the Explainers are encouraged to think on their feet and to make educated conjectures if they do not know the exact answer to a visitor's question. This approach encourages visitors to do the same and that is, after all, what we're all about."[5]

The point of hiring students with no special knowledge or interest and teaching them to "teach" is also the point that Oppenheimer wants to make with as broad an audience as possible: that the barriers separating ordinary people from science can be broken down. He is entirely satisfied to trust visitors to use their own senses to learn something about science—and he trusts the Explainers and the visitors they talk with to exchange ideas. "The approach works both ways; often the visitors enjoy instructing the Explainers and equally often the visitors feel that young people can understand this material better than older people."[6] Some observers suggest that adult visitors feel more comfortable talking with high school students than with expert adults who might be amused by their lack of knowledge about basic scientific concepts.

### For some, the beginning of a career

Most of the Explainers began not only with little or no background in science but also with no thought of working in a museum. More than half come from minority-group families—Chinese, black, and Chicano—and the group is consistently divided equally each term between males and females. Although their stay at the Exploratorium is, say staff members, "too brief to make young scientists of them all, it does open their eyes and interest them enough to bring families and friends from all locations and strata of San Francisco society."[7]

Several Explainers, even so, have been inspired by their experience not only to go on with school but to pursue new fields of study. The staff estimates that about 10 percent of the Explainers, some of whom might not have gone on to college at all, have taken up technical subjects or the arts, decisions that are directly attributable to their experience at the Exploratorium.

Just as important to the Exploratorium staff is the "visible growth in self-confidence and maturity of these teenagers, who often were hesitant to walk up to strangers and offer to help with complicated scientific apparatus."[8] At the end of his tour at the Exploratorium, one Explainer wrote, "I know I've been here a long time (almost ten months), but as I look back, it's gone quickly. I've learned about lasers, holograms, defraction, refraction, the right hand rule . . . light, and to blow glass. I've learned more about people, how to deal with them and approach them and I've also among the rest of this learned more about myself." According to their parents and teachers, said Oppenheimer, many of the students had been drifting before they came to the Exploratorium. He is proud that the work there has given them new direction.

### Costs and spinoffs

The Explainer program has been operating since 1969. Its current annual cost is about $50,000, paid by the National Endowment for the Arts with a matching grant from the Rockefeller Brothers Fund. This total cost of $50,000 includes the wages of the Explainers and the salary of their instructor-supervisor. In effect, this sum constitutes the Exploratorium's guard costs, for the presence of the Explainers on the floor obviates the necessity of hiring paid guards. Oppenheimer estimates that at least eight would be needed, at an annual cost of about $38,000—without any of the benefits to the visitors, the students, or the community provided by the Explainer program.

In addition to the Explainer program, with the help of grants from the National Science Foundation the Exploratorium hires four to six high school students each summer to help construct and repair exhibits and conduct experiments. These students are not part of the Explainer program but are hired as apprentices and assistants and bring scientific talent and knowledge to their work at the Exploratorium. Some install their projects for visitors to handle and for the Explainers to help with, but others do their own demonstrations for the public.

Together the Explainers and the specially talented students form an unusual group of "teachers" in an unusual "museum."—*A. Z. S.*

### Notes

[1] K. C. Cole, "An Introduction: What is an Exploratorium?" p. 9 (undated).
[2] For sources of quotations without footnote references, see list of interviews at the end of this report.
[3] "Explainer Program," mimeo sheet from the Exploratorium, January 2, 1974.
[4] *Newsweek*, December 13, 1973, p. 82.
[5] "Explainer Program," mimeo sheet from the Exploratorium, January 2, 1974.
[6] Letter from Frank Oppenheimer, October 22, 1974.
[7] "School in the Exploratorium," report from the Exploratorium, p. 3 (undated).
[8] Ibid.

### Interviews

Grinnell, Sheila. Codirector for Exhibits and Programing, Exploratorium. April 26, 1972; December 1, 1973.
Norris, Kevin. Explainer, Exploratorium. April 26, 1972.
Oppenheimer, Frank. Director, Exploratorium. April 11 and 26, May 25, 1972; December 1, 1973; June 21, 1974.

## INSTITUTE OF CONTEMPORARY ART: VALUE—VISUAL ARTS LABORATORY IN URBAN EDUCATION

Institute of Contemporary Art
955 Boylston Street
Boston, Massachusetts 02115
**High school juniors and seniors from diverse neighborhoods and schools spent about six weeks together using the city of Boston as a "learning environment." A small program with big dreams, for racial as well as educational progress, VALUE raised as many questions as it answered for the two sponsoring institutions, the Boston school system and the ICA. CMEVA interviews and observations: August 1973–September 1974.**

### Some Facts About the Program

**Title:** VALUE (Visual Arts Laboratory in Urban Education).
**Audience:** High school seniors (12th grade) and some juniors (11th grade), approximately 250, mostly from the city of Boston but with some suburban representation (about 20 percent by the spring semester of 1973/74).
**Objective:** To teach students about the urban environment through the visual arts and media, and to allow them the freedom to work closely with peers from different communities on projects that deal directly with the people and problems of the city.
**Funding:** $70,000, or about 30 percent of the institute's operating budget. In addition, the salaries of two public school teachers were

donated by the Boston public schools at a cost of $34,000 per year; space was also provided free by the city schools at a cost of $5,000 annually. Cost per student: approximately $450.

**Staff:** 4 full-time, 2 from the institute plus 2 from the Boston public schools; 3 part-time artists and media specialists for the whole year; 10 part-time local artists for periods of about three weeks; 15 part-time volunteers, all local college and university students.

**Location:** The third floor of a Boston public school administration building on Beacon Hill in downtown Boston.

**Time:** October to June: five cycles, each consisting of six or seven weeks, Monday, Tuesday, Thursday, Friday, 8:30 A.M. to 2:30 P.M. Summer sessions during July, five days a week from 9 A.M. to 3 P.M.

**Information and documentation available from the institution:** All student projects in the form of slide-tapes and videotapes are available at the institute; evaluation material; flyers for teachers' workshops; descriptive material about 1975 VALUE program.

---

The invitation to the February 1974 VALUE open house announced in prominent letters, "Recent Student Work Will Be Presented." Across the bottom of the invitation there was a modest reminder that VALUE is the acronym for Visual Arts Laboratory in Urban Education, a cooperative venture of the Institute of Contemporary Art, the Boston public schools, and other metropolitan area schools. Like previous VALUE receptions and student presentations, this midwinter open house signaled the end of a six-week cycle for about 50 participating students.

One of the many exhibits at the open house was a photo-essay project, a collective effort by several students who had not known one another before they entered VALUE. "You learn a lot about the city," said one, Deborah Fisher. "But you also come closer to other people, because the projects make you communicate with them more." Asked what she had learned about photography, she thought a moment: "Well, it's more than just using a camera. I mean there are other things to take pictures of than people, animals, and family celebrations."[1]

Thurmond Dixon is a junior in one of Boston's 18 high schools, who, with several other students, elected to visit elementary schools to talk with younger students about nutrition, ecology, public art, and urban sociology. "There are a lot of things about this city I've never really known about or taken a look at until I got involved with VALUE," he observed.

Five parochial school students built a detailed scale model of a housing development and recreation area for an East Boston site. The city of Boston had proposed several high-rise structures for the same vacant land; the city's plans displeased area residents, including the five VALUE students. During their six weeks in VALUE, they devised an alternate proposal. They asked area residents what sort of buildings they preferred, researched zoning requirements and other land use regulations, and interviewed city officials and others responsible for the site. Their research completed, the students came up with a proposal—featuring smaller buildings

and more recreational space than the city's plan—which the East Boston Community Development Corporation has urged city officials to consider.

**Background in brief**

The Institute of Contemporary Art is a direct descendant of New York's Museum of Modern Art, which established a branch museum in Boston in 1935. It became the ICA in 1938. Though without a permanent collection, the ICA sponsors an exhibition and program schedule that is designed, like MOMA's, to acquaint the general public with contemporary art. Regular ICA staff ran the pilot VALUE program in the spring of 1973; two new staff members—David Powell as director and Emily Kernan as deputy director—were hired to run the 1973/74 program.

The other sponsor of VALUE, the Boston school system, provided one teacher during the 1973 experiment and two teachers during the 1973/74 year. One teacher was chosen by the school administration, the other by the teachers' union.

Three artists worked as part-time staff and a dozen or so others on specific projects with students. Local experts—in politics, design, transportation, and other urban specialties—were invited to talk with the students. About 15 local college students served as adjunct staff. Though unpaid, all earned academic credit for independent study, usually in art or education, for the one-and-a-half to two days a week they worked.

The first crop of VALUE students, 30 in all and mostly seniors, came from Boston's English High Schol and the high schools of suburban Watertown and Ipswich. Usually recruited through the coordinators of "flexible" or "open campus" programs, students received credit for their six-week VALUE cycle in one of three subjects: English, social studies, or art.

The schoolteachers and ICA staff all were white; one "resource person"—an architect—and several college students were black. About 55 percent of all VALUE students were black.

**Content of the program.** Seeking to enlist students from both inner city and suburbs, VALUE billed itself as a program that would *use* the visual arts to help high school students "communicate about the urban environment, human and physical." Staff of the Institute of Contemporary Art, teachers, artists, and a range of professionals would work with students on urban design, photography, film, recording, video, and "other visual arts and skills. . . ."[2]

Each six-week cycle followed the same schedule. The first week was devoted to introductions: to staff, to fellow students, to the area of Boston selected for study, to the various academic disciplines (history, urban planning, sociology) and media skills (Polaroid camera, video portapak, audio-cassette) required for a VALUE project. Lectures and discussions centered on the development of simpler communities into complex cities.

During the next two weeks, students in small groups studied and mapped a specific area of the city, identifying possible sites of future development and practicing their new skills with cameras and other equipment. They talked with architects, artists, designers, and other specialists. By the end of these first three weeks, students had to choose projects and form working groups for the last three weeks: each group had to use the visual arts or the media as tools with which to study and present its project, and each group had to include students from more than one school. The projects explore some aspect of the urban environment. The first VALUE students, in the winter-spring of 1973, examined Boston's architectural heritage, specifically the Quincy Market and Faneuil Hall districts of downtown Boston, both rich in eighteenth- and nineteenth-century architecture, and both undergoing extensive restoration and renewal.

**Location.** VALUE operated from the third floor of an old Boston elementary school building in the historic Beacon Hill section. Known as the Myrtle Street Annex, the building now houses administrative offices; except to visit the Office of Vocational Guidance or to get a work permit, students had little reason to journey there.

VALUE had a reason for reclaiming part of Myrtle Street as a learning center. "One of the things VALUE sought to do was to bring kids to a neutral site where program content, not program location, would be their chief concern," said Emily Kernan, deputy director of VALUE. "We wanted both white and black kids to feel comfortable at VALUE's headquarters, and the Beacon Hill location was just right for making both groups feel at ease."

Transportation costs to VALUE headquarters were paid by the program. Boston students were given free passes for the mass transit system, and suburban students were bused into town.

The institute's 1974 report describes the annex as "somewhat inhospitable," not only because of its "substandard" physical provisions but because of "some friction" caused by the sudden appearance of students in a school building inhabited by "minor school department officials whose last contact with students was in dim recorded history."[3]

**Purpose.** The Institute of Contemporary Art says VALUE "was forged" from a number of ideas: the city as classroom, getting students involved in "real life," mixing students of different races and backgrounds at a "neutral" site, using the visual arts, among others.[4]

Andrew Hyde, former director of ICA, believed that adolescents need a different kind of educational experience than most schools offer. "This alternative must involve them," he wrote, "in a situation where they have some control, offered without tokenism, based on trust in the value of their judgments and opinions."[5] VALUE was designed, at least in part, to encourage adolescents to develop their own projects, take

responsibility for marshaling human and technical resources, travel about the city as they worked, and learn to use limited time efficiently.

As for the Boston school system, it was planning a new High School of the Arts at the time that VALUE was set up. School officials hoped VALUE might serve as a model of sorts, offering clues for the new school and its curriculum. In the face of political pressures on desegregation that were building up in Boston during 1972 and 1973 (and violently erupted when a busing plan later went into effect), the school system saw VALUE as one desegregation alternative to forced busing: through VALUE white and black high school students might begin to work together on their common environment, metropolitan Boston.

**How the 1973/74 project worked**

The pilot project completed, VALUE staff planned an expanded program of several six-week cycles for the academic year 1973/74. To include more students from more schools throughout an entire school year required two ICA full-time staff and a second full-time schoolteacher. With its two full-time teachers and space in the Myrtle Street Annex, the Boston school system contributed $39,000–$34,000 for teachers' salaries and $5,000 for rental space. As Powell and Kernan attended to administration, both teachers were free to help students work on projects; provide tutorial help where needed; maintain communication among students, parents, and classroom teachers; and, by their very presence and involvement, give the program additional credibility in the schools.

The slightly more than 120 high school students who participated in the postexperimental VALUE program in 1973/74 were recruited through Flexible Campus coordinators, Open Campus programs, and the Greater Boston Educational Collaborative (EDCO).[6] In each six-week cycle, the students were about equally divided, black-white and male-female. They enrolled for a variety of reasons. "The program did not stipulate any qualifications for participation, and the reasons for students enrolling ranged from a serious interest in video, photography, and knowledge of the city to the welcome prospect of not having to go to school every day."[7]

Like the VALUE students in the pilot project, the groups followed an itinerary-curriculum, did collaborative projects, and met a wide range of local experts. They spent four days a week at VALUE and one day (Wednesday) in school. All three 1973/74 groups studied Boston Harbor Islands and related waterfront areas. Boats provided and crewed by the Metropolitan District Commission carried students to the islands—some of which are inhabited—where they explored the history, ecology, development, recreational use, folklore, and abuse of the areas.

Throughout the six-week period, students were "tested," in written and oral exercises after lectures and field trips, on relevant words, terms, and concepts. Their replies were one measure of what, if anything, they were learning, and where

improvement was needed. As students began to work with various media and to devise their projects, the staff, teachers, and resource people charted their progress. Students charted their own progress, too, keeping journals in which they recorded their observations and insights, the problems they faced, and their success in meeting the goals they had set for themselves. These were not private journals but were used by staff and teachers, along with the written and oral exercises, to evaluate student work. The resource people, staff, and teachers also judged the quality of students' final projects as to organization, presentation, and content.

Approximately one out of every six students spent 12 consecutive weeks, or two "cycles," in the program, continuing projects already begun and helping to introduce new students to VALUE. A good academic record and permission of parents and school authorities were VALUE's requirements for these "repeater" students; most were seniors and had some idea about what they would do after high school.

## Evaluation of the 1973/74 year

VALUE ended the 1973/74 year on a generally positive note: a total of nearly 200 students had participated, and attendance was high; staff found the quality and inventiveness of projects quite good; and the two high school teachers believed that VALUE students were learning. "Where you really see changes," observed James Buckley, whose high school classroom experience covers 11 years, "is in writing skills and reading skills. The students learned how to organize, plan, use resources, and put their thoughts down in a coherent way." He also noted that occasionally specific issues interested students enough to spur them to academic study; the pollution issue, for instance, led some students into science courses. One formal evaluation reported, "English High School staff observed that borderline students often became much more attentive after a VALUE cycle. This carried over to attendance, study habits, etc."[8]

Staff, schoolteachers, and evaluators saw plenty of room for improvement, however. The institute's report of the 1973/74 year states, "It is difficult to single out the most troublesome problem, but it probably was the recruitment of students."[9] The recruitment of suburban students was a particular problem. Because of the commitment of Boston's superintendent and other school officials, it has been anticipated that Boston students would constitute about half of the participants during any given cycle; for most of the 1973/74 year they far exceeded this proportion. (The cycles were scheduled on the basis of the Boston school calendar, which proved to be different from the calendars of the several suburban systems.) During the spring, "when the release of seniors is a more accepted idea," suburban participation increased to nearly 20 percent of total student enrollment.[10]

The difficulty in getting students released from school for six weeks reflected the skepticism of some classroom teachers and school officials. A new and unproved program, VALUE required that students be away from school for a con-

siderable block of time and for reasons that seemed unclear, or dubious, to some school people. Staff ruefully acknowledged the lack of communication with the schools: "Most students' home school teachers knew little about the program, and had negative attitudes toward the students' participation (based largely on their absence from class)."[11]

VALUE's ability to attract a good mix of students—a broad range of interests and backgrounds, and a good balance of race and sex—also faltered in the face of skeptical and uninformed teachers and school officials. One independent evaluator of the program observed, "What happens . . . is that very bright students and those who are not doing much of anything in school are given the freedom to enroll. The mainstream boy or girl, who requires regular class work to keep up and simply cannot afford to miss four days of math or French . . . is prevented from participating."[12] Yet those directing and working in VALUE found the six-week cycle too short. With only three weeks allowed for the student project, little or no time remained for correction or revision—an especially severe limitation in videotape projects.

For some students, as skeptical observers suggested, VALUE was "just a pleasant and welcome interruption of the school routine." But for others it was a valuable experience; Boston school Superintendent William Leary (since replaced) said at one open house that "the VALUE program is for me the best evidence that people can work together—work together in programs that are positive, beneficial to all, and which involve a sharing of communication."

If general student opinion is accurately reflected in a small sample survey—of 15 students, suburban and urban, white and black, male and female—then many students believed that VALUE enhanced their visual perception and their sense of personal growth. Almost all reported changes in their reaction to television, for instance; now they spotted zoom effects and discerned the composition of commercials. One student said she "began to see the parts as well as the whole." About half said they spent some of their spare time taking photographs; a few talked seriously about careers in photography, city planning, or landscape architecture.

The two researchers who conducted this survey believe that VALUE also helped some students to grow. One talked of applying some of VALUE's lessons to his personal life, where he was "expected to be the man in the family." It was the repeaters, who went through more than one VALUE cycle, who seemed most successful in rejecting old racial and class stereotypes. Several white students spoke of "getting over their prejudices about blacks." One black student reported, "The blacks hung around together and the whites . . . hung around with other whites, but we communicated and got along with each other."[13]

## The future, dimly seen

In its short life, VALUE has raised questions that the 1973/74 experience could only partially answer. What about better communication between VALUE and home schools—a

modest enough goal? Workshops with teachers in ten metropolitan high schools were held in the fall of 1974 in preparation for future student projects. The student-staff ratio—about six to one—allowed good working arrangements but meant a per-pupil cost for VALUE students of about $450 for six weeks. Whether the money is well spent can be debated, especially when compared with the unusually low student-teacher ratio in the Boston school system of 16 to one and the $1,400 per-pupil cost for an entire year for Boston high school students.[14]

The desegregation pressures in Boston came to a head with the court mandate in the fall of 1974 that students attend schools outside their neighborhoods. VALUE undertook no student projects in the first few months after that decree. By December 1974, both the director and deputy director had left ICA, and the institute had to decide whether to try to run a spring 1975 program to fulfill the terms of the 1974/75 grants ($30,000 from the National Endowment for the Arts, $6,000 from the Massachusetts Arts and Humanities Foundation, and $5,000 from philanthropist Godfrey Cabot) or forfeit the money.

Short-lived though it was, VALUE gave some evidence that the visual arts can be useful tools for helping adolescents as they mature. It is one example of an arts program that provides more than a simple adjunct to school routines.

But VALUE answered inconclusively the Boston school system's questions: Are media tools useful and valuable learning devices or only costly props? How responsibly can students learn on their own outside the classroom? How many students care to learn about the arts, the media, their city? Can the visual arts be used to foster good will among students of diverse, even hostile, cultural and ethnic groups?

In assessing the overall impact of VALUE, James Buckley, one of the schoolteachers assigned full-time to the project, said,

> As a result of the VALUE experiment, we've developed a prototype program called Humanities Using Boston, in which the performing, visual, and communicative arts will be used to study the city. . . . When the High School of the Arts is established we hope to have the program there and involve many more students.

## Postscript: summer 1975

Although the staff turnover in late 1974 precluded a spring program, VALUE did use the remainder of its grant money to run a final six-week cycle in July–August 1975. Fifty teenagers, recruited through the Neighborhood Youth Corps, participated in workshops conducted by local artists: graphics, video, creative writing, mural painting, city planning, and landscape design. Emily Kernan, who returned to direct the summer program, said that although VALUE effectively ended in August 1975, the institute does plan continuing education efforts, probably in the area of teacher training.—*E. H.*

## Notes

[1] For sources of quotations without footnote references, see list of interviews at the end of this report.

[2] *VALUE*, a position paper, September 1973, pp. 2, 4.

[3] *VALUE*, published by the Institute of Contemporary Art, 1974, p. 4.

[4] Ibid., p. 1.

[5] *VALUE, Open City-Boston '76*, published by the Institute of Contemporary Art, 1973, p. 1.

[6] EDCO, a nonprofit organization in Cambridge, Massachusetts, working with ten metropolitan school systems, offers programs in special education, reading, and vocational training for high school dropouts.

[7] *VALUE, Open City*, p. 5.

[8] Sara Benet, "An Evaluation: The Visual Arts Laboratory in Urban Education (VALUE)," May 1974, p. 7.

[9] *VALUE*, ICA, p. 16.

[10] Ibid.

[11] Ibid., p. 14.

[12] Benet, "An Evaluation," p. 6.

[13] Barrie D. Bortnick and Carol Nordlinger, *A Report of the VALUE Program, 1973/74*, a preliminary investigation of student experiences and suggested procedures for future study of the program, July 1974, pp. 3a, 5, 7, 8.

[14] *Annual Statistics of the Boston Public Schools*, school year 1971/72, School Document no. 1, 1973, p. 7.

## Interviews

Benet, Sara. Doctoral Student, Harvard University, and Curriculum Development Specialist. April 5 and June 12, 1974.

Buckley, James. Teacher, English High School, Boston. January 16 and February 15, 1974.

Dixon, Thurmond. Student, Roxbury High School, Boston. February 15, 1974.

Fisher, Deborah. Student, Jeremiah Burke School, Boston. February 15, 1974.

Garber, Susan. Director of Public Art, Institute of Contemporary Art, Boston. September 20, 1974.

Kernan, Emily. Deputy Director, VALUE, August 13 and December 10, 1973; January 4, February 15, and September 10, 1974; telephone, June 30, 1975.

Leary, William. Superintendent, Boston Public Schools. August 3, 1973.

Powell, David. Director, VALUE. August 13, November 19, December 10, 1973; February 15, April 10, July 8, September 4, 1974.

Rockefeller, Sydney. Director, Institute of Contemporary Art. February 15, 1974.

# NATIONAL PORTRAIT GALLERY: "THE TRIAL OF JOHN BROWN"

National Portrait Gallery
8th and F Streets, N. W.
Washington, D. C. 20560

**A dramatic reenactment of the trial of abolitionist John Brown, performed by staff of the National Portrait Gallery with the help of student "jurors," sets the stage for a lively lesson that ties the world of portraiture to the American history and other curricula in Washington, D.C., area junior and senior high schools. Classroom theatrics are followed up by discussions in and tours of the gallery itself, led by specially trained aides.** CMEVA **interviews and observations: April, May, September 1974.**

## Some Facts About the Program

**Title:** The Trial of John Brown.
**Audience:** Junior and senior high school students from the Washington, D.C., metropolitan area.
**Objective:** A reenactment of the trial is used to introduce students to the collection of the National Portrait Gallery and to serve as an extension program to enrich school curricula in disciplines such as government, black studies, and American history.
**Funding:** $12,454 annually, supplied from the operating budget of the gallery.
**Staff:** A staff member supervises the program; 3 full-time staff members devote a portion of their time; 6 to 8 aides from area colleges are employed part-time.
**Location:** Local junior high and senior high schools and the National Portrait Gallery. The drama takes place in school classrooms; the follow-up visit to the museum takes place in a multipurpose room and in the galleries.
**Time:** The trial is a 90-minute program in the schools followed a week later by an hour visit to the Portrait Gallery. It is conducted between January and May.
**Information and documentation available from the institution:** "Services of the National Portrait Gallery Education Department," flyer to local schools. (Planned but not yet available at the time of this study: an archival tape, a portion of which will describe the program, and a teacher package.)

---

"This court is now in session." The judge instructs the members of the jury about their responsibilities. They are told that at the end of the trial they will have to reach a unanimous decision about the guilt or innocence of the defendant, John Brown, on three counts: (1) murder, (2) conspiracy to incite slaves to rebellion, and (3) treason against the State of Virginia. They need agree on only one of those counts to see John Brown sentenced to death.

The jurors are intent as the prosecutor calls his first witness, Mr. Thaddeus Rockefeller, a banker from Boston, Massachusetts. The prosecutor establishes the fact that John Brown has sought guns, ammunition, and money from Mr. Rockefeller and a group of Boston abolitionists at two separate times, most recently six months before his raid on Harper's Ferry. The prosecutor carefully establishes the

moral dilemma of Mr. Rockefeller: should he help support Brown in the *defense* of free state supporters and citizens in Kansas, even though blood may be shed, or should he help support Brown in the *offensive* slave-running project into the Southern states?

The defense attorney heightens the tension of the courtroom atmosphere with heated questioning of Mr. Rockefeller. "Just what do *you* know of the conditions of slaves in the South? Just what do you consider an abolitionist to be, Mr. Rockefeller? Just how long do you think those slaves can wait for your political methods to change slavery to freedom? Don't those individual slaves have a right to defend themselves?"

The jurors nod, frown, and write out questions to pose later, and at last the judge asks if they have any questions of this witness. They do. Some of the questions concern the inferences they have drawn from the evidence introduced. Other questions indicate the jurors' own struggles with the issues of law and order and the institution of slavery. Did John Brown intend violence, or was he simply trying to get the slaves out of the South by smuggling them out?

What has been the evidence? The court has accepted documents and a sword that Rockefeller's grandfather used in the Revolution and that Rockefeller presented as a gift to John Brown. The documents include a list of towns in the South that appears to be in John Brown's handwriting; each town is the site of a federal arsenal. The jury is given the chance to see the evidence as well as question the witness.

## How high school classes take part in the "Trial"

The jurors, however, are not a group of citizens from Virginia in 1859. They are students in a contemporary high school class in the Washington, D. C., metropolitan area. And their verdict will not decide the life or death of John Brown. Rather, it will become the basis of a discussion in an American history, English, or black studies class. High school and junior high school teachers in a number of disciplines are requesting a reenactment in their classrooms of the "Trial of John Brown" by the staff of the National Portrait Gallery. In most cases this classroom experience will be followed by a visit to the National Portrait Gallery.

Four days a week, from January to May, a team of education aides and staff members from the gallery have been going to one of the area junior or senior high schools to set the stage for a stirring courtroom battle. Six play the roles of judge, three witnesses, two attorneys; one staff member doubles as projectionist. Few props are needed, and the trial can take place within the space of a typical classroom. The judge wears a blue robe and uses a gavel to keep order in the court. One of the group portrays a poor white Southern farmhand who is a witness in the trial. He makes ample use of dialect, wears suspenders to hold up worn jeans, affects a stiff leg from a wound earned in the Mexican War, and frequently wipes his brow and spectacles with a red bandana. In order to set the scene more vividly, slides are projected on a screen:

portraits of John Brown and some of the men with him, two views of Harper's Ferry, and a view of the house where John Brown planned the raid and where the stiff-legged witness, Seth Armstrong, saw ''pikes and guns'' being loaded onto a wagon in the dead of night by Brown's men.

Evidence introduced in the trial is taken into custody by the bailiff, who is played by a member of the class and given the responsibility of circulating the evidence among the jurors. In addition to the sword of Thaddeus Rockefeller and the photographed list of towns with federal arsenals, evidence submitted to the jurors includes a copy of the constitution for freed slaves, allegedly found in a cache of John Brown's possessions, and a copy of John Brown's final speech delivered in Charlestown, Virginia, on November 3, 1859.

**Role of the Portrait Gallery staff**

This traveling show is the work of two teams from the National Portrait Gallery, one that goes out to the schools on Mondays and Wednesdays and the other scheduled for Tuesdays and Thursdays. Each team comprises at least one staff member of the gallery's education department, aides from local colleges (paid by the hour from the education department's budget), and, in one case, a graduate student intern on a gallery fellowship.

Although they conduct essentially the same trial in each school over a semester, each reenactment is different as it is affected and changed by the questions, emotions, and experience of each class. The players try to stay in character and in time, 1859. The judge reminds the jurors, when necessary, that they must confine their questions to the testimony presented. The judge usually has to limit the number of questions in order to keep to the schedule, usually an hour and a half, which is not always easy because the presentation is lively and the players enjoy their parts. For example, when the judge frequently reminds the witness, Seth Armstrong, just to answer the questions asked of him, Mr. Armstrong responds, ''Ah am, if you'll jest let me get to them in ma own way.'' At other points the judge may have to remonstrate with Mr. Armstrong to be quiet and listen to the questions. ''Ah am, y'r honor, ah'm jest fill'n' in ta empty spaces.''

Student response to the trial and the chance to participate in it is almost uniformly favorable. The trial of John Brown was chosen deliberately both to fit the curriculum of the Metropolitan Area schools and to confront issues of race by engaging students in an historical event still loaded with moral questions (in 1973/74, 96 percent of the D. C. schools' 136,133 students were black). For example, a student-juror asks of Mr. Rockefeller, ''You're *white*. Why are *you* an abolitionist?'' From another comes the comment, ''How are you going to convince politicians against slavery?''[1]

**The follow-up visit: a new role for gallery aides**

In most cases a class trip to the National Portrait Gallery follows the trial at school. The trip may be centered on the historical issue of slavery, the literature of the mid-1880s, or the political figures of John Brown's time. The trial is used as a jumping-off point for different academic subjects, as well as an introduction to the portrait collection.

Usually the same aides who presented the classroom trial greet the students at the museum. Typically, a class is divided

---

## Indianapolis Museum of Art: Indianapolis High School Council

Indianapolis Museum of Art
1200 West 38th Street
Indianapolis, Indiana 46208

When the Indianapolis Museum of Art decided to form a High School Council in 1973, 33—or all but a few—of the city's high schools agreed to appoint a student to the new organization. The museum regarded its invitation as important: the first letter to the principal of each school came from the museum's curator of education; the second, to the student representative, came from the education staff member responsible for the council.

The council's role is to act as a liaison between the museum and the students, not between the museum and the schools. Each student is asked to take back notices of events at the museum that can be posted on the high school bulletin board. The museum staff hoped that council members would encourage friends and acquaintances to take broader advantage of museum programs: the two most hopeful signs have been good attendance at the museum film series and a slightly increased enrollment in high school studio classes.

The High School Council meets every two weeks, on Tuesday evening, when the museum is open till 9 and when concerts, exhibition openings, and other special events are traditionally scheduled. Meeting from 5:15 to 9:00, the students and the museum staff member responsible for the council hold a short business meeting, eat dinner (which they usually pay for themselves), and finish the evening in the museum at a film, lecture, or other program.

Though originally the museum staff thought that seniors would be the likeliest prospects for council membership, it has turned out that 11th graders are the dominant group. This promises some continuity for the next year. In general, the staff regards the council as a pleasant and productive way to open the museum to high school students and to get their ideas for appealing programs. Membership has now been expanded to the 186 high schools in the metropolitan area, including the small townships that ring Indianapolis.
—*A. Z. S.*

---

**Interview**

Marshall, Ray. Assistant for Media, Indianapolis Museum of Art. May 9, 1974.

on arrival into three or four small groups, and one aide is assigned to lead each discussion. One group is asked to try to imagine itself as wealthy Bostonians in support of abolitionists, another as freed slaves in Canada, the third as house and field slaves in Virginia in the mid-1850s (who are invariably asked how long they have been in captivity and whether they have ever tried to escape).

After a bit of discussion to help the students get into their imagined roles and feelings, one of the staff enters the room playing John Brown or his lieutenant. Dressed in a black coat and a wide-brimmed hat and carrying a rifle and pike, all borrowed from the Smithsonian's National Museum of History and Technology, he addresses each group in turn, explaining his plan; he asks the Bostonians for financial support, the freed slaves to enlist as recruits, and the slaves if they are willing to risk escape. After a few embarrassed giggles, the majority of the class dives in eagerly to argue the relative merits and risks of supporting Brown. The Bostonians are even given blank checks on the Old Bay State Bank of Boston, to be dated with the current month and day in the year 1859.

It is the aides' crucial job at this point to bring out historical facts and to help answer students' questions: "How much was a lot of money in 1859?" "What would happen to the slaves who escaped?" "What is 'conspiracy to incite riot'?"

The final part of the program is a discussion-tour in the galleries, by the same three or four groups, dealing with important figures of John Brown's time—Harriet Beecher Stowe, Robert E. Lee, Ulysses S. Grant and his generals, Harriet Tubman, Frederick Douglass, Abraham Lincoln, Henry David Thoreau, and Henry Clay, all of whose portraits hang on gallery walls.

When the gallery's recruitment and training program works well, the American history and American studies majors from local colleges who serve as tour guides have the knowledge and imagination to summon instructive responses to the students' questions. But one of the weaknesses of the tours in the gallery, as opposed to the well-prepared classroom performance of the trial, is that the training of the aides does not give them enough understanding of portraiture itself, and the chance to teach about the art of portraiture in the presence of the gallery's collection is often lost.

## Lessons of the "Trial" project

Several points can be made about the way the gallery worked out its program that might be helpful to all museums:

1. "The Trial of John Brown" was devised not by museum staff with no classroom experience but by two former high school teachers—Dennis O'Toole, curator of education, and Lisa Strick, associate curator of education, both of whom knew how students and their teachers could be successfully reached.

2. The education staff felt that the gallery had to find a way of working with high school students and teachers through both the school curriculum and the museum col-

lection. With "The Trial of John Brown" the museum has committed time and money in the classroom as well as in the galleries.

3. In recruiting aides, the gallery has chosen college students steeped in American history rather than volunteer docents to staff the program. Notices are sent to area college placement offices, and in 1974/75 the gallery's education staff interviewed 30 students for eight positions. The aides are hired on a civil service level and are paid for ten hours a week, plus travel expenses. The staff looks for recruits who would be unself-conscious enough to play a dramatic role and relaxed enough to engage high school students in the galleries. Once chosen, the aides are given a script, a biography of Brown, readings on the Civil War, and many, many rehearsals. Six experienced players then stage the trial for the newcomers to observe.

4. Finally, the education staff sought and clearly found an entertaining method for enlivening American history for high school students, bringing it home to them in twentieth-century terms, and thus joining the inner-city student to an exploration of an art form that is often difficult to put across.

—*S. R. H.*

## Note

[1] Question asked of the witness, Thaddeus Rockefeller, by a high school student in the role of juror at the reenactment of "The Trial of John Brown" on April 8, 1974, at Dunbar High School, Washington, D.C.

## Interviews

O'Connor, Mary. Teacher, Sherwood High School, Sandy Springs, Maryland. Telephone, September 16, 1974.

O'Toole, Dennis. Curator of Education, National Portrait Gallery. May 9 and September 6, 1974.

Strick, Lisa. Associate Curator of Education, National Portrait Gallery. May 9, 1974.

## Observations

Classroom visit, Dunbar High School, Washington, D.C. April 8, 1974.

Class from Key School, Silver Springs, Maryland. Tour of National Portrait Gallery. May 9, 1974.

Ninth-grade class in U.S. Government from Sherwood High School, Sandy Springs, Maryland. Tour of National Portrait Gallery. May 8, 1974.

Classroom visit, Washington School of Ballet, Washington, D.C. April 1, 1974.

# THE DEPARTMENT OF HIGH SCHOOL PROGRAMS AND AN EXPERIMENT IN "ARTS AWARENESS" AT THE METROPOLITAN MUSEUM OF ART

Metropolitan Museum of Art
1000 Fifth Avenue
New York, New York 10028

**In a program as controversial as it is comprehensive, the Metropolitan Museum establishes a separate department for high school programs, offers a wide array of visual arts courses, many of them for inner-city students, and provides an example from the museum side to proponents of out-of-school learning. Defenders and attackers have their say here about a facet of the program called Arts Awareness, a highly developed, widely publicized, and heavily documented attempt to develop a nonverbal method of teaching the language of the visual arts. CMEVA interviews and observations: periodically from April 1972 to May 1975.**

**Some Facts About the Department of High School Programs and Arts Awareness**

**The Department of High School Programs.**

**Audience:** Students and teachers from junior and senior high schools in the New York City area.

**Objectives:** To develop programs that center on students' interests, needs, and experience and that take maximum advantage of the museum's collections and curatorial staff; to experiment with teaching techniques and subject matter, using the museum as an education laboratory; to establish the museum as a community resource, with special emphasis on new audiences; to demonstrate and document educational ideas and methods to other institutions; to publish educational materials on art for use in schools.

**Funding:** Total expenditures of $94,293 in 1973/74, paid out of funds from the Metropolitan operating budget and grants, especially for Arts Awareness (see following section). In addition, the board of education provides one staff position, and the New York State Council on the Arts provides the salary for another.

**Staff:** A paid staff of 5 full-time and 7 part-time employees (not including Arts Awareness instructors); 16 volunteers.

**Location:** Classes and independent student work take place entirely at the museum in classrooms, offices, and galleries.

**Time:** Throughout the school year during the day and after school; summer classes for both students and teachers.

**Information and documentation available from the museum:** A Xeroxed history of the department, called simply, "The Metropolitan Museum of Art, Department of High School Programs," written by the staff and edited by Nancy Miller, a volunteer in the department. (For documentation of Arts Awareness, see following section.)

**Arts Awareness.**

**Audience:** In spring 1972, the first term of the program, 75 students and 10 teachers from two junior high schools and two senior high schools in New York City and one high school in suburban Mamaroneck; in spring 1973, 125 students and teachers from one junior and four senior alternative high schools, and two parochial high schools, all in New York City; in 1974, one class of 20 Junior

Museum students. Students ranged in age from 12 to 19; 70 percent were black and Spanish-surnamed; most were average students.

**Objectives:** (1) To test the validity of multiple museum visits as an educational process, and (2) to develop a method of teaching art to urban high school students that could be readily adapted by other institutions.

**Funding:** Three grants from the National Endowment for the Arts, all of them requiring matching funds: $35,000 in 1972, $50,000 in 1973, and $11,200 in 1974. The grants were matched by in-kind contributions for salaries and materials from Metropolitan operating funds and small grants from private foundations. They were used to pay the salaries of a coordinator, artist-teachers, stipends for the participating teachers, and materials, in addition to the documentation. Another $25,000 grant from the Fairchild Foundation paid for four demonstration films (see Information and documentation).

**Staff:** In 1972, a project director and 7 artist-teachers; in 1973, 7 artist-teachers, 8 members of the museum staff (part-time on the project), and 11 participating teachers who received stipends for their part in the project.

**Location:** In classrooms and galleries at the museum and on some occasions outdoors.

**Time:** During the regular school day, spring 1972 and 1973.

**Information and documentation available from the museum:** Two reports—*Arts Awareness* and *Arts Awareness II,* both by Bernard Friedberg; five films—one on the 1972 program (19 minutes), one on *Line* (23 minutes), and three others on sound, space, and color (total of 13 minutes)—on methods of teaching Arts Awareness.

Though several U.S. art museums have designed programs for high school students, the Metropolitan Museum in New York is one of the few to create a special department for them. It was organized in 1968, just two years before the museum celebrated its centennial. The department flowered during a time when the Metropolitan's support of its education program was especially strong. In 1970 the head of the education department was made a vice-director, and what had been a single division of the museum was split into six separate education departments—the Junior Museum, High School Programs, Public Education, Community Programs, the Slide Library, and the Thomas J. Watson Library. Of a total museum staff of 515 in 1970/71, education departments accounted for 12.5 percent, employing about 75 people; in 1971/72, a combination of grant and museum operating funds took the budget for these departments over $1.6 million.

Until 1968, high school students had been unevenly treated at the Metropolitan. Sporadically the focus of most of the museum's educational energy, they had lately been dealt with through the Junior Museum, mainly as members of guided lecture tours.[1] The creation of the new department was to change all that, filling the Metropolitan galleries with inner-city students and young artists in T-shirts and blue jeans; an array of cameras, video portapaks, cables, and sometimes preposterous props; and an assortment of curators and administrators who were alternately supportive, tolerant, baffled, and outraged.

### The museum as learning laboratory

The beginnings of the Department of High School Programs were innocuous enough. The department grew primarily from projects developed by the museum (and paid for by several large corporations) to spread the centennial celebration into high schools in New York and around the country. Two of the programs were based on packages of materials for use in the classroom; the third offered Centennial Memberships to 38 high schools in the New York City area, a scheme that combined lectures at the schools, consultation with the teachers, and class visits to the museum's centennial exhibitions.

Because virtually all the staff members hired to administer these programs were young and new to the museum education world, they were neither fettered nor tutored by the Metropolitan's earlier attempts to work with secondary schools. Because the staff members were at the same time energetic, bright, and impatient, they quickly decided which trials they wanted to build on and which errors they would leave behind. Within the first two years of the department's existence, the staff could draw up five operating conclusions:

1. The one-shot gallery talk, no matter how well done, fails to reach many students who come, "hostile and unprepared," for appointments arranged by their teachers.
2. Before trying to give information about a work, the staff should focus on getting students to look at art.
3. Programs should be student-centered, tailored particularly for individual students who are interested enough to come often to the museum and who can earn school credit for their museum work.
4. The department's small staff is better used in the museum itself than in regularly programed visits to the schools; in the museum the programs should be designed to "take maximum advantage of the collections and expertise" of the staff, especially the curators.
5. The best way to extend the museum's resources is to provide materials for use in the schools; they should be developed in line with "recent trends in education and available media."[2]

On the basis of these conclusions, the department

- stopped giving guided tours, except to between six and ten New York public schools addicted to annual visits;
- instituted programs with public alternative schools, whose schedules were flexible enough to allow students to come regularly to the museum for courses or individual projects;
- designed a series of after-school courses, offered weekly in 12-week cycles;
- set up apprenticeships and work-study programs;
- expanded the number of in-service courses for teachers;
- launched its Arts Awareness program, meant to answer the problem of getting students to look at art rather than simply receive information about it.

In all this, the department was self-conscious about trying to serve as a model and pace-setter not only for other museums but for art educators everywhere (a role that many, but by no means all, museums ascribed to the Metropolitan). It was one reason why the staff wanted its programs to be "solid, well managed . . . and well documented":

> . . . The Metropolitan is a highly visible forum not only for matters of art historical concern, but also for art education. People in search of new ideas, or wanting support for old ones, watch closely what goes on here. We can demonstrate how a museum can be an effective resource for schools reaching beyond their walls, how even the most "difficult" of students can relate to art, and we can provide extensive and convincing evaluation data about these. We become an influence for change in educational patterns in schools and museums, both of which are facing serious challenges at present. This "laboratory" role has become a cornerstone of our programming.[3]

The programs that emerged from these ideas were ambitious and varied, requiring the staff in many instances to devise courses and student projects to fit individual situations. But it was the department's policy from the beginning that the Metropolitan be identified as a semiofficial community resource for public high school students. What the museum's high school staff did during those four years offers, in effect, a practical example of what it means to provide "a learning environment" for certain high school students as a regular part of their school day.

### Programs for students, aged 13–18

Between fall 1971 and spring 1974 the high school department's staff members gave courses and workshops or took after-school responsibility for nearly 3,700 students and teachers from schools throughout the New York metropolitan area. They came for a variety of experiences, but all of them were there under a well-defined series of programs.

**"Alternate" school programs.** One was arranged with several of the board of education's alternative schools, which serve relatively small numbers of junior and senior high school students, many of whom are considered potential dropouts, and do so under circumstances relaxed enough to allow for out-of-school activities. (Although these alternatives are often referred to as "push-out academies," some of the schools in the Metropolitan program were designed for bright students who wanted the advantages of a small school or were ready to drop out because they were bored.) In addition to schools the board of education designated as alternatives, these programs were also meant to attract students from traditional schools that encouraged out-of-school activities and had made changes in their structure to allow for them.

The museum offered three kinds of classes: courses planned to be part of the school curriculum, independent studies for individual students, and special courses to introduce students to the museum. All of them were organized under the direction of Marcia Kreitman, a high school art teacher on the payroll of the board of education's Bureau of Art.

About 20 such courses were offered each year, lasting anywhere from 4 to 30 weeks. The most time-consuming for the museum staff were the classes that had to be planned to fit the school curriculum.

One example was a course designed by the Clinton Program—a free-floating alternative school for about 160 junior high school students—called "Creation-Destruction, Birth-Death." In the class the students traced this theme through myths, religion, ritual, and art of several cultures, which they explored at school and in weekly sessions with Ms. Kreitman at the Metropolitan. The final presentation, after 12 weeks of study, was a "Festival to the Dying Sun," held at the winter solstice. For it, the students designed their own costumes, based on paintings, sculpture, and photographs of costumes in the museum's collection. They "sacrificed" a lamb they had baked (it was made of chocolate brownie dough) and staged a ritual farm dance in which each student took the part of the sun, one of the seasons, or an element of creation and destruction.

Courses like these require more planning time between the teacher and the Metropolitan staff than they usually received, a source of some frustration for the staff. Even so, Ms. Kreitman estimated that preparation for each curriculum-based course took at least two to four hours a week, depending on how much background knowledge of the subject and the collections she already had. In addition, she spent up to two hours a day supervising students in the Independent Study Program. There were anywhere from three to ten of these students each term, who based their research projects at the Metropolitan. One studied design themes in textiles; another "structured her own learning" by designing and building a dulcimer, ultimately with the help of a curator in the musical instrument department; a third student wrote a paper comparing the Gertrude Stein circle in Paris to present-day artists' groups in New York's SoHo; still another made a series of original costume designs for Garcia Lorca's play, *Blood Wedding*. All students in this program received credit for their work from the three schools that took part.

In the third program, Museum Experience, nearly 1,100 students from 71 schools were introduced to the Metropolitan's collections. The pattern here was to investigate a particular theme through a combination of Arts Awareness techniques (see following paragraphs), studio work, slide shows, lectures in the galleries, a visit with a curator, and sometimes the chance to organize an exhibition in the school. According to Ms. Kreitman, "the success, continuity, and follow-through of this program varied. In some cases, there was so much entering and dropping out during the course of a project that at times only a small number stayed on to finish it. This usually reflected administrative and organizational problems in the school, which were prevalent in the initial stages of most new alternative school programs."[4]

**Apprenticeships and work-study programs.** High school students could also have an "intense experience" in the museum by working there, as apprentices, volunteers, participants in a work-study program, or Executive Interns.

Apprenticeships were offered to what the department described as "highly motivated" high school seniors. For a stipend of $100, each student was assigned either for a fall or spring semester or for two months in the summer to work in one of the 23 museum departments participating in the program.[5] Apprentices spent half their time on filing and other departmental chores and the other half on research for the department or for an independent project. Between 1970 and mid-1975 there were 120 apprentices in all.

Each of the apprentices has worked in departmental storerooms, several have been given assignments to catalog objects, at least one of them repaired armor alongside the armorers, many have learned such skills as costume conservation and book-binding, and some even received basic teacher training in the education departments. An average of seven apprentices a year have been hired, after their apprenticeships were over, for per-diem jobs in the departments where they were originally assigned, and, according to Enid Rubin, a member of the staff who supervised their work, within one 18-month period three students switched into art programs in college as a result of their experience. Says Ms. Rubin, " I am really sold on the program as one that mutually benefits our understaffed departments and these serious young students."[6]

Students willing to work without pay could do essentially the same things as apprentices under the museum's work-study and after-school volunteer programs. Executive Interns, who were part of a cooperative plan between the local board of education and one of the city agencies (the program has since gone national), were placed with Metropolitan executives and given a full semester credit for "a broad and challenging exposure to the realities and responsibilities of managerial positions,"[7] the kind of assignment, according to some members of the staff, that left them with "a lot of empty time on their hands."

**After-school program.** The broadest effort of all was invested in the department's week-day-afternoon and Saturday courses, given free (although "toward the end," according to the department head, Philip Yenawine, the students were charged for materials) to any high school students interested in taking them. Since these after-school classes were taught by volunteers, art history and art education students from New York University, as well as the museum staff, the department could afford to offer a wide variety—145 different courses between summer 1970 and spring 1974. They attracted a total enrollment of 3,160 students.

The most popular were skill-oriented studio classes—painting, drawing, and crafts. But there were also courses in art history and art appreciation, the latter taught both by the "arts awareness" method and more traditional approaches. Ms. Rubin, who was in charge of the art history classes, designed such titles as "Generation Rap," a course that

combined teenagers with older people to discuss certain works in the collection, and "The Naked and the Dead," a course that dealt with nudity in art and attitudes toward death. In other classes, architectural history might be taught on New York City streets, or medieval subjects—music, food, costume, iconography—combined in the study of objects at the Metropolitan's uptown branch, the Cloisters.

The classes typically drew bright students from parochial, private, and a few of the more academically demanding public high schools in the city. Enrollment per class ran between 8 and 15, though as many as 50 students might sign up for a workshop in drawing, for instance, and nearly as many would stay to the end. Attrition rates tended to be higher for other kinds of courses, partly, the staff believes, because they were too much like school not to carry academic credit.

### Programs for teachers

Both in- and pre-service teachers were considered an important audience for the department, and several courses were added for both categories during these years, all of them for credit.

For teachers in service, there were several art survey courses ("Masterpieces of Fifty Centuries," "American Art," "European Painting," "Modern Art") and courses that showed the teacher how to use the museum as a resource ("Art Appreciation and Sensitivity Training," "How to Look at Paintings," "Art Survey and Teaching Techniques"). As in classes for students, Arts Awareness techniques were the basis for about half the courses for teachers. According to Ms. Kreitman, the teachers were motivated to discuss ways of carrying questions further with students More about this approach later.

In all, there were 12 courses for teachers, about 2 offered each semester, with a total enrollment of about 285 between fall 1970 and fall 1973. Teachers paid $10 for a semester-long course that met once a week for an hour and a half. All New York City teachers received credit through the board of education. In June 1973 the department also gave two week-long workshops on Arts Awareness techniques for teachers and museum educators.

For teachers in training, the museum offered a place for student teaching, and all or a substantial part of the internship of about ten students from five or six colleges (including New York University, Hunter College, City College, Skidmore College, Hope College in Michigan, and Keane College in New Jersey) was undertaken at the Metropolitan. Students served as assistants to the high school staff, and several gave after-school courses of their own.

### Educational materials for schools

Panel exhibitions, filmstrips, kits to prepare students for visits to the museum have been turned out steadily for use by high schools since the department was organized, and well before. These materials are discussed separately in chapter 11.

### Arts Awareness

Of all the laboratory work the Metropolitan's high school department staff did during the four years Philip Yenawine was its director, the most widely copied and the most controversial was its experiment with "Arts Awareness"—a technique, as Yenawine describes it, that tries "to break down the barriers between high school students and art objects and the institutions which house the objects."[8] Begun in 1972 under a grant from the National Endowment for the Arts, the program put its indelible stamp on the high school department in just three years. It influenced and permeated almost everything else the staff did—courses for teachers, after-school classes, the training of volunteers.

The program also gave the department's critics, particularly the museum's curators, a convenient handle to crank whenever the students seemed to be getting out of hand. "I think that business about making things out of blue wood," said one curator, "and moving them around and clapping your hands in the gallery or that awareness business is way over my head—or beneath my feet. . . . I don't see it at all. I don't think you have to go into a room of abstract painting and move around in the feeling of the colors—all that kind of stuff to me is blarney."[9] For guards, according to one evaluation of the program, Arts Awareness was "a constant source of annoyance," and administrators and curators alike worried about the safety of the works of art if students were to be allowed to roam around "uncontrollably" in the galleries.[10]

Yet the program developed true believers not only out of the staff members and volunteers closest to it, but out of scores of followers in schools, other museums, and funding agencies as well. To those familiar with the theater games and improvisational museum tours that grew from a combination of Stanislavsky's "Method" and the sensitivity sessions so prevalent in the psychotherapy of the sixties—not to mention Isadora Duncan's dancing in museum galleries in the twenties—Arts Awareness held few surprises. But in few museums has the improvisational approach been expanded into such an elaborate program as it was at the Metropolitan. Too, there was something about the drawing together of these games with great art (especially abstract art), a formidable museum space, urban high school students of the seventies, and young artists who played the part of pied pipers, as one observer called them, that made Arts Awareness a seductive teaching tool—even, in the words of an admirer of the program who was clearly biased toward the Arts Awareness version of physical, nonverbal response to high art, "the most exciting new avenue in museum education."[11]

**An outline of the program.** In brief, Arts Awareness was a series of experiences, predominantly nonverbal, in related arts—movement, music, photography, video, in particular—designed to teach high school students the language of art and to stimulate a direct response from them to the visual art in the museum.

Perhaps the crux of the method is that young people were given the chance to act out, to dramatize for themselves, such elements of art as line, texture, tension, focal point, spatial relationships, color, mood. If a student formed "spatial shapes" with his own body and together with other bodies in larger combinations, if he then photographed and drew these shapes, and if he were asked to identify nothing but spatial shapes in works of art one after the other—chances are he would remember the phenomenon and respond to it the next time he encountered it.

In one of the Arts Awareness exercises that took place outside the museum in Central Park, students were blindfolded and led from one point to the next with string as a kind of warm-up to help them become aware of senses other than sight ("warm-ups" were important in the Arts Awareness scheme) and to give a clue, as one Arts Awareness brochure puts it, to "the frame of reference to be used that day."[12]

In this case, it was not the other senses so much as the string: the students were asked, once the blindfolds came off, to "draw" lines with string using trees, park furniture, and members of the class as points of connection, the purpose being to dramatize, in artist-instructor Randy Williams's words, the fact that "geometry gives a painting stability." And always, Williams stressed, the student should think of attaching the string to himself as a basic element in the relationships, whether to a painting—in which the lines lead the viewer's eye—or to three-dimensional sculpture or to "every living thing." In further development of the exercise, students could change the "sculpture" they had created with the string by tightening the tension between some points and letting it fall slack between others.

Working with young, committed artists, the students— one or two of the classes from New York suburbs, but most of them from alternative programs in New York City public high schools and almost all of them from lower-income black and Puerto Rican families—came to the museum once a week for 15 weeks. In the 1972 program, in which 75 students and 10 teachers took part, each session lasted an hour and a half, and each group of students saw the same artist three times. The program was modified the second year (125 students) so that after the first two or three sessions students could choose to work with one team of artists (sound and movement or literature and theater, for example) for the balance of the term. As the program was conceived, this repetition of visits and of contact with the same people was necessary not only to drive home the basic lessons but to help the students feel comfortable in the museum and with their own responses to art.

**The importance of rapport and faith.**  In one of the several evaluations of Arts Awareness written during the course of the program, Bernard Friedberg quotes one student who said, "First I thought it wasn't going to turn out right, you know. Then after awhile I said, no. It was okay. It turned me on."[13] Watching turned-off students begin an Arts Awareness "ex-

perience" tended to raise some of the same fears in a wary observer. Would it turn out right?

There were times when it did not. In one class, the leader of a well-known contemporary dance troupe who came in as a substitute teacher "performed" for the students instead of "interacting" with them. The students, who could neither follow his intricate steps nor understand what he was trying to do, soon turned the hour into a rout. A few of the bolder boys, pork-pie hats jammed on their heads, began trailing the dancer back and forth across the room in exaggerated imitation of his movements. The rest sat it out. Try as he might, the dancer could not budge them from the hostile knots they formed around the walls.

The best artist-teachers, on the other hand, worked very hard to become what Yenawine called coparticipants. For Yenawine, "integral involvement" was crucial:

I won't deny the fact that the kind of teacher you are, the kind of personality you have is really critical to this. . . . People . . . talk a lot about the need for students and teachers to interact [and] about participatory learning. . . . But few teachers have ever gotten down off their pedestal. They want to, and they think they are quite often, but they aren't. They aren't saying you're as good as me. And one thing about Arts Awareness is that you can't really lie; . . . if you're really doing it, you do break down the barrier. . . . I've got to be part of it just as much as the next guy. . . . I've got to keep it together, but on the other hand, I have to be so integrally involved that the kids see me as a sort of coparticipant.

Equally important was belief in the method. "Some people would get put off by it," Yenawine said about the observers who were constantly visiting the classes, "and those vibrations carried, because [what is] quite critical in Arts Awareness teaching is that you've got to have confidence in what you're doing; you've got to believe it, or it can fall apart."

**The Arts Awareness theory of nonverbal learning.**  A good deal of the belief depended on one's attitude toward the way information is absorbed. The Arts Awareness system, according to Yenawine, "does not put down [verbal] information; it simply doesn't rely on it. It does not tell me back what I told you." In an interview, Yenawine expanded on the point that information comes in a variety of forms through several senses and that the impact of nonverbal information is often the lasting one:

Randy [Williams, a member of the staff who was a cornerstone of the program] is what I call a good Arts Awareness teacher, and he almost never uses movement. It's not required. The thing that's his strength is his studio activity. But what he's trying to do is to get kids to be aware of the fact that information comes into their eyes and that they have a response to it.

What we try to do with various activities is to get the kids to simulate—not imitate, but simulate—the creative pro-

cess, so that they do what artists do: they participate, for example, in choice-making. They are aware that there *are* choices to be made. . . . Say, for instance, that you're working from a painting . . . to translate the colors to lines. There's a process that you're going to go through that has . . . to do with figuring out what both [colors and lines] mean (whatever "mean" means). You can't define it very well, but there is an impact.

The best commentary, the most coherent, the most intelligent, the most objective commentary I've heard on this kind of teaching has come from structural psychologists, Piaget-type people who are aware that in order to study what's going on in education you've got to do a lot of observation of people, that seeing the patterns [of behavior] is as important as any information you might get from any kind of question or test. . . . In discussing the . . . project with people like David Perkins [director of Project Zero at Harvard] I've gotten as far as I ever have in understanding what cognitive education goes on in essentially nonverbal situations—and there's a whole load of it. People don't really want to take that into account. If you can't add it up in the end, if you can't write it down, if it doesn't become a sentence—which of course it can in some kids and can't in others, shouldn't, doesn't need to—[it doesn't count].

It's always so irritating to me that when you ask someone what the most important learning events are in their lives, basically they don't talk about school situations. They might mention something that is close to a classic learning experience, like walking into a space and being aware for the first time of . . . what Byzantine art was all about [for instance]. . . . Usually it's not the lecture on Byzantine art that they remember, [even though that might have been] critically important in bringing them to the point of being able to walk into a Byzantine church and getting a sense of what it was like in that part of the world in the early Christian era. A lot of people learned the most from the divorce they had or the child they birthed. . . .

The real point of Arts Awareness is to liberalize . . . to say that you've got to change relationships between teachers and students. You've got to drop the assumptions you have about anything and start fresh.

**Effect on the students.** Because Arts Awareness techniques were the basis of much of the high school department's approach to visual arts education, many audiences were exposed to them. But essentially, there were three kinds of participants—inner-city students from alternative schools, suburban and private-school students, and teachers.

To Yenawine and his teaching staff, Arts Awareness seemed to work differently with each group, but most important, according to Yenawine, was the response it stimulated among the members of the group as they interacted with one another. With black and Puerto Rican inner-city students, the task was to overcome hostility toward the museum and high

art and instill confidence in them toward their own responses. Said Yenawine of the students,

. . . We found that quite often [they were] expressing themselves by Arts Awareness activities, and they were getting confidence in their own ability to deduce something through the encouragement we gave them by saying, "You're right. That's terrific." And if they were just telling how they felt, and moving how they felt, they were exhibiting a whole lot: they were breaking down barriers they had put between themselves and other people.

For example, most of them wore coats and hats and had transistor radios when we'd start programs, and we couldn't get them to take them off. [But finally] we got them over their fear of being ripped off, which was one of their basic fears. We could also get them to . . . take off this armor they always wore. . . . They were letting defenses fall.

Howard Levy, a poet who later carried some of the Arts Awareness methods to a program he led at the Museum of Modern Art (see report in chapter 1), made the same point: the students in the Metropolitan program, he said, gained confidence in their responses; they felt at home in the museum and comfortable with the art there.

Suburban and private-school students exhibited a different kind of initial reaction. Where inner-city students were actively hostile, middle-class students were what Yenawine called apathetically hostile. "They needed to realize," said Yenawine, "that no matter what you knew and how well you could regurgitate it, it didn't make any difference unless you could interact with other people and make use of it in a practical sense." Arts Awareness, Yenawine felt, forced them to "engage":

. . . Quite often their learning was entirely intellectual, entirely in the head; feeling, an actual relationship with something, was very difficult for them. The only way they could ever approach art was through dates and history. . . . The only thing wrong with that is it doesn't help when they confront a work of art that's unfamiliar to them. They just don't know how to respond if they can't put it into an intellectual context. So with those kids it was essentially a loosening up. . . . Arts Awareness forces them to feel. They are the ones with whom it is most productive . . . [even though] they need longer spoon-feeding just to start trusting another sensibility about themselves.

For Marcia Kreitman, perhaps the most responsive of all groups were the teachers who came for in-service courses. Her classes with them always drew on Arts Awareness techniques. The point of the classes was to take the teachers through the same steps as the students and to help them work out appropriate student projects.

In a typical class, she might lead the teachers through the Greek sculpture galleries, asking them to express their own reaction to the sculpture in each gallery—archaic, classic, and Hellenistic—first through gestures (focused on the head, chest, and pelvis, three body zones that had been identified,

by a mime who worked in the program, as centers of energy), then through words. Ms. Kreitman found that the teachers warmed up easily to the exercises and were stimulated by them to move on to the next questions that were raised by the Arts Awareness exercises.

**What are the next questions?** If Arts Awareness is meant to be an introduction to art—dramatizing the vocabulary, forcing participants to look, arousing the senses to respond— it is perhaps natural to wonder where one goes from here. As one curator put it, the aim of an approach like this must be to help people grow from the nonverbal level to "come closer to where we are." "The museum," she pointed out, "cannot bend all the way down, because it would be a negation of all we stand for." Arts Awareness was to her, as to some other observers, an elementary first step.

What questions, then, *are* motivated by nonverbal response? As almost every Arts Awareness class dealt with first-time students, one of the few practical tests of Step 2 was a year-long course with students from suburban New Rochelle. This group, Yenawine found, wanted to do more of the same, but this time under its own control: the students organized their own classes, chose the projects, and worked toward more sophisticated methods of expression in theater, multimedia, and literary association. Yenawine sensed, too, that students were inspired to develop skills to create their own art, perhaps because the Arts Awareness emphasis drew them into the artist's creative process rather than the social and historical context in which he worked.

For instructor Randy Williams, next steps were inherent in the first: his goal was to make students curious about the art they saw and to pick up information unintentionally. After ten sessions, he noted, the students knew, for example, all the paintings in the twentieth-century gallery; along the way, they had learned something about art history, about artists and art movements, about the way certain works of art were produced. But they had not been taught these things directly; they learned only in response to their own questions. "Never say art works are great," said Williams of his approach; "don't try to work on appreciation."

The important thing was to excite and interest the students the first time. "You had to get them immediately," said Williams, "or you lost them forever." And the techniques of Arts Awareness, the believers argue, worked: "There was no way," said Yenawine, "we could have taken a class of tough girls from the Bronx to a Degas painting and explained movement. We would have been put down right away. But with Arts Awareness, we could do a *true* movement thing, and they loved it. They really looked at the paintings, and they couldn't stop talking about what they meant."

**Critics and countercritics.** If Arts Awareness was so successful as a teaching tool for high school students, why was it so controversial? Why did it arouse so much passion among supporters and detractors alike?

One reason for the criticism, according to Yenawine, is that the critics never bothered to try to understand what Arts Awareness was meant to do. Henry Geldzahler, curator of twentieth-century art at the Metropolitan, and one who complained at some length about the program, based some of his skepticism on his contact with an ex-participant and an incident he happened to catch one day in one of the first-floor galleries:

I had a high school student who came out of that Arts Awareness. . . . This was a kid 16 or 17 years old. When he came out of that [program], his idea of something to do would be to go to a gallery and ask people if they saw the flash between the green and the red. Try to do a survey of how many people saw the flash. It's Arts Awareness because when the green meets red—it's not about art, it's about something else. . . .

I'm from another school, another time. You don't go to eight years post-high school art historical training without being hurt by it and touched by it. I still see it in the old-fashioned way. And I still think that pushing blue things around the gallery is not the answer. Like there'd be a squared-off arch, which one person has. Another would have a column. Then you'd go into the Blumenthal Patio and move the column through the arch. I couldn't believe my eyes.

To hear from the other side, the author of the arches exercise, Howard Levy, remembers the episode as a moment of significant psychological growth in his students: they learned by opposing arches of various sizes that smaller arches could neutralize larger ones and thus, according to Levy, that apparently overwhelming authority figures could be neutralized by the alliance of lesser figures. The demonstration, set in a museum space containing several arches, was meant to be a visual experience that dramatized a point (admittedly political as well as aesthetic) the Arts Awareness staff wanted to make. It was misunderstood, Yenawine felt, because "I could never get anyone at the Met to come and look or discuss it seriously."

Even those who did come were sometimes put off. One member of the museum's education hierarchy, who admitted she is "not in favor of Arts Awareness," said she had watched part of an Arts Awareness session on the Egyptian collection conducted by one of the department's best volunteers, "a super girl."

She had really prepared them well before they went into the galleries, so the students were all eyes, ready to look. But when they arrived at the entrance [to the Egyptian galleries], they were hurried past the sphinx and brought into an open space in the galleries for their warm-up in a circle. It had nothing to do with Egypt. The students began kidding each other and showing off. They weren't looking at art. They were given an assignment to go look for something to do for a skit. I left at that point, so I don't know what happened. But it seems to me that Arts Awareness is inappropriate to the museum. It wouldn't appeal to me.

I'm too shy for it. It doesn't have anything to do with art.

"My basic feeling," said Jane Norman, a long-time art educator and researcher and a senior Rockefeller fellow at the Metropolitan in 1974/75, "is that this is not museum education. It uses art as a backdrop. You can only dance in front of a Jackson Pollock, not a Chinese landscape or a Renaissance madonna." Yenawine vehemently disagreed that art was used as a backdrop:

It is both the inspiration for and the content of everything we do. We get into iconography, materials, style. Arts Awareness is most successful when art is *not* used as a background. And it *can* be used well with Renaissance art. In order to teach various concepts, we can do a lot with role–playing, for example, with the physical structure of the painting, and with composition. Marcia [Kreitman] has had the students duplicate the composition with their bodies—something you can do easily with many of these paintings because the composition is repeated over and over; only the numbers of people and the details are changed.

Ms. Kreitman also took students through other kinds of role-playing exercises to help them understand Renaissance art. In one approach, she asked students to try to engage an early or high Renaissance madonna in an imaginary conversation to discover what kind of person she might have been (What is her voice like? Does she enjoy talking to people? Does she like the attention she is getting? How does she feel about being a mother?). Students, Ms. Kreitman said, found the high Renaissance madonna an easier conversational partner, more "human and worldy," less forbidding. "As a result of this kind of focus," Ms. Kreitman feels, "students recognize the differences in treatment of human form—space, light, environment, depiction of theme, or characterization of the mother-child relationship. [It helps] lead to a discussion or simply a reinforcement of understanding of the changes in values, ideals, and social movements of the time."[14]

Beyond its content, there may have been other reasons why the program tended to stir up controversy. It was expensive: the cost, including grants and museum funds, totaled nearly $200,000 during the first three years. Parceled out among the 75 students who participated the first semester, in 1972/73, the estimated $70,000 budget for Arts Awareness came to $930 per person. Yenawine has pointed out that this sum included an $8,000 film on the experiment, and that if it and an evaluation brochure are deducted, the cost per person was closer to $750. Second-year costs were somewhat lower, and Yenawine believed the price without evaluation and other extras (a second film, which turned into four shorter films; a second brochure on the program; stipends to teachers from participating schools; more students; and a report on the program by New York University professor Howard Conant) would come closer to what most museums could pay. He does not deny that the program depends on people who are highly knowledgeable about the related visual and performing arts to make it go, as anyone who has seen improvisational tours led by amateurs can testify. But he feels that staff members can be both chosen and trained for this kind of education, rather than primarily for the inculcation of art historical information, and thus need not require extra funds.

Curators, administrators, and guards complained about the disruptive use of the galleries for Arts Awareness classes and wished they could take place elsewhere. In his evaluation, Howard Conant reported a curator's displeasure over the use of galleries "like an arena," cords strung between works of art to form what he called "cats' cradles" (an event that an administrator of museum security recorded on camera to make his point to higher-ups), bongo drums, and burning incense. Another curator told Conant "she gets hysterical when she hears about youngsters dancing in the galleries," even though she admitted she had never accepted an invitation to observe and participate in the program.[15]

There is no doubt that most museum personnel are unnerved by behavior near works of art that is anything less than sedate, and Arts Awareness participants were clearly not sedate. Yet there was no reported damage to the works of art during the three years the program operated at full steam at the Metropolitan. And all but the most critical observers gave the program good marks for engaging young people not usually attracted to the museum. A few even praised the concept and content of the program: one curator, quoted in the Conant evaluation, said that "having students replicate aspects of sculptural works with their own body movements is a really wonderful way of helping kids understand art," and another commended specific ideas in the program, which she felt were "probably better than dragging the kids through [the museum] two by two in a line."[16]

It was Metropolitan Director Thomas P. F. Hoving's opinion that Arts Awareness needed someone with the dedication and zeal of Phil Yenawine to do it well. But he would have preferred to see the idea tried with a younger audience that is "unburdened by reading" and that needs to get a feeling of art. He felt, too, that some of the opposition to Arts Awareness derived from the way it looked. "The people Phil brought in here," said Hoving of the long-haired, blue-jeaned young artists who led the Arts Awareness classes, "simply aroused a knee-jerk reaction [in the museum] against the program. If you want to carry on a revolution in a bank, you have to dress like a banker and behave like one."

Perhaps the most sympathetic judgment of Arts Awareness is one by Enid Rubin, a scholarly member of the high school department staff who worked with the museum apprentices, knew the Arts Awareness staff well, and had a chance to observe the program closely over the two and a half years it was in full swing at the museum. She writes,

On paper it was a striking program, and sometimes it lived up to every bit of verbal description expended on it. But too often it was marred by breakdowns in ancillary electronic equipment (e.g., the video monitors or portapaks) and lesson plans that were more impromptu than planned.

Over and over, I felt its greatest successes took place where the teacher was outstandingly charismatic. Even then, it was hard to pin down the success beyond the fact that kids, many of whom otherwise would not have come to the museum, were not only in it but enjoying it and themselves. Perhaps that is indeed enough.

. . . For all the curators' fears, no objects were damaged, and Phil [Yenawine] always maintained that any spectators enjoyed watching and were not disturbed by the dance movements or theater improvisations. Whenever I watched, this seemed quite true. It was the guards, the curators, but not the public that minded. (However, the public did trade its object watching for people watching, and in a museum, many would rate that fact with a minus sign.)

Today with shows like the Impressionists and the Scythians packing the museum more tightly than ever, it would seem that Arts Awareness, as in fact all of education, needs some galleries of its own—yes, with real objects in them. After all, one of the points of Arts Awareness was that the student subsequently would look at his world and at other museums and their art with an awareness of how to cope with and respond to the new and strange. The more vigorous Arts Awareness exercises could be confined to new, well-designed education galleries and the new insights carried over elsewhere in the museum.

I should further say that Arts Awareness techniques have a valid place in museum education that is not, *per se,* "Arts Awareness." I cannot be an Arts Awareness teacher on a full-time basis, but I have found many of its ideas most useful in changing the pace of a class session, taming the overconfident, and giving an opportunity to the less verbal students.

Though I often disagreed with Phil over specifics, his philosophy and outlook, plus his charismatic vitality, gave a life and morale to the department that we miss.[17]

### What implications for education?

Yenawine left the Metropolitan at the end of 1974, having lost, he felt, a growing number of rounds with the museum's administration. What will survive of his department's attempt to serve its new-found high school audience is not now clear. Like so many museum educators, Yenawine had a personal style on which his staff and his program seemed to center; a new department head may not fit the old mold.

But for the time, the audience, and perhaps even the place, the ideas generated in the Metropolitan's Department of High School Programs between 1970 and 1974 may come close to providing an outline to educators of just how useful an art museum can be in any attempts to go beyond the schoolhouse walls for adolescent education. Because the Metropolitan either paid the staff itself or found extra funds for almost all its classes and internships, however, any real partnership with the schools was barely tested here. No one knows for sure, it the schools were to give credit for any course students

wanted to take at the museum, how much experiment the board of education would have allowed, how much supervision it might have demanded, and thus how much freedom the museum staff might have lost. Alternative schools are one thing; academic high schools are another, and the New York City educational establishment, like other large urban systems, tends to take a dim view of alternative teachers who might replace or take funds away from staff members already on school payrolls. There is also the hassle, as Marcia Kreitman has pointed out, of meshing school, teacher, student, and museum schedules and purposes, all of which proved in the Metropolitan program in one way or the other to be energy-draining obstacles to easy cooperation.

Perhaps when the administrators and the schools are ready to offer systematic out-of-school education tailored to students' special interests, somewhere in the Metropolitan Museum's archives there will be at least one set of plans on which they might draw.—*B. Y. N. from research by F. G. O. and A. G.*

### Notes

[1] For a brief history of programs for high school students at the Metropolitan, see Barbara Y. Newsom, *The Metropolitan Museum as an Educational Institution* (New York: Metropolitan Museum of Art, 1970), pp. 25–26.

[2] "Metropolitan Museum of Art Department of High School Programs," May 1974, pp. 1–2.

[3] Ibid., pp. 1, 3.

[4] Letter to CMEVA, June 16, 1975.

[5] The stipend was originally $200, but the students themselves agreed to halve it so that more apprenticeships could be offered.

[6] Letter to CMEVA, June 15, 1975.

[7] "Metropolitan Museum of Art Department of High School Programs," p. 5.

[8] Introduction to report on *Arts Awareness, a Project of the Metropolitan Museum of Art,* by Bernard Friedberg, n.d., p. 1.

[9] For sources of quotations without footnote references, see list of interviews at the end of this report.

[10] Howard Conant, "An Evaluation of the 1973 Arts Awareness Program of the Metropolitan Museum of Art," August 1, 1973.

[11] Frederick G. Ortner, "Arts Awareness Evaluation," n.d., p. 3.

[12] Bernard Friedberg, *Arts Awareness II* (Metropolitan Museum of Art, n.d.), p. 9.

[13] Ibid., p. 7.

[14] Letter to CMEVA, June 16, 1975.

[15] Conant, "An Evaluation," pp. 22–25.

[16] Ibid., pp. 22 and 24.

[17] Letter to CMEVA, June 15, 1975.

### Interviews

Bialy, Jerome. Director, Thomas Jefferson High School Alternative School. April 14, 1972.

Burnham, Edward. Project Director (1972), Arts Awareness, Department of High School Programs, Metropolitan Museum. April 7, June 9, and June 23, 1972.

Condit, Louise. Deputy Vice-Director in Charge of Educational Affairs, Metropolitan Museum. Telephone, June 12, 1975.

Geldzahler, Henry. Curator, Twentieth-Century Art, Metropolitan Museum. August 1, 1974.

Hoving, Thomas P. F. Director, Metropolitan Museum. July 8, 1975.

Kreitman, Marcia. New York City Board of Education, Bureau of Art. February 20 and May 13, 1975; telephone, June 17, 1975.

Levy, Howard. Poet, Arts Awareness Teacher. Telephone, April 18, 1975.

Miller, Nancy. Volunteer, Department of High School Programs, Metropolitan Museum. Telephone, May 8, 1975.

Norman, Jane. Senior Rockefeller Fellow, Metropolitan Museum. March 22, 1975.

Raggio, Olga. Chairman, Western European Arts, Metropolitan Museum. Telephone, September 15, 1975.

Rubin, Enid. Lecturer, Department of High School Programs, Metropolitan Museum. Telephone, May 8 and September 15, 1975.

Segal, Jerry. Teacher-in-Charge, the Clinton Program, New York City Board of Education. Telephone, May 9, 1975.

Williams, Randy. Instructor, Department of High School Programs, Metropolitan Museum. April 12 and 14, 1972.

Yenawine, Philip. Associate Museum Educator-in-Charge, Department of High School Programs, Metropolitan Museum. February 9, March 28, 1972; December 9, 1974; May 23, 1975; telephone, May 8 and 23, June 3, 1975.

## Observations

Evenson, Dudley. Video Artist, Arts Awareness Instructor. With class from Thomas Jefferson High School's alternative school. April 14, 1972.

Muller, Jennifer. Dancer, Arts Awareness Instructor. With class from Mamaroneck (N.Y.) High School. May 10, 1972.

Price, Stephen. Photographer, Arts Awareness Instructor. With volunteers from the Department of High School Programs, Metropolitan Museum. April 6, 1972.

In addition, CMEVA staff members visited several other Arts Awareness classes between 1972 and 1974, including one at Cornell University, Ithaca, New York, in February 1974.

## Meetings

Members of the National Endowment for the Arts Expansion Arts Panel (Vantile Whitfield, Miriam Colon, Joan Sandler, and Stephanie Singer); John Kerr, Director of NEA's Education Programs; and members of the Metropolitan Museum staff. October 24, 1972.

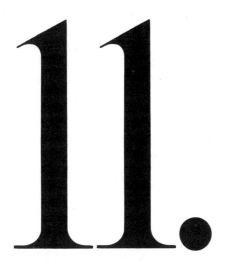

# 11.

## Teacher Training and Classroom Materials

501 **Museum of New Mexico Suitcase Exhibits.** Original artifacts that reflect the state's disparate cultures are packed in specially fitted trunks for circulation to grades 1–6; instructions help teachers introduce children to regional history and folk art.

502 **The Children's Museum MATCH Boxes.** Children can learn by discovery how other people live and work through these object-filled learning kits. (Box)

**Reports elsewhere in this study
that include programs for teachers:**

## INTRODUCTION

In 1932, a museum educator named Roberta M. Fansler advanced the notion that teachers rather than museum educators should lead museum tours. In a paper delivered at a conference on "Art and Adolescence" she said,

I believe that theoretically it is better for us to teach the teacher and leave the important task of taking the children through the gallery to the one who knows the children best. A small staff of museum instructors cannot hope to supply teaching service to an entire city school system once that entire system of teachers is alive to the value of this type of visual education. On the other hand, if we act as museum assistants to the teachers, we will be able to make one hour's teaching go a very much longer way. . . . The teacher can then bring her own children to the museum and from her intimate knowledge of their capacities use the material to the best possible advantage.[1]

The idea of choosing the teacher to receive the art museum's educational message on behalf of his students has long and honorable antecedents.[2] In some museums, in fact, focus on the teacher has precedence over every other audience. For the Victoria and Albert Museum in London, a kind of mother church for American museums when they were first created in this country, training teachers to use the museum is "a matter of policy." Renée Marcousé says of that museum's program that it is not only the museum's policy but its responsibility:

In the Victoria and Albert Museum concentration on courses for students in training to be teachers has been a matter of policy. Personal experience suggests that the museum education officer has an essential, but limited part to play in children's visits to the museum. We cannot prepare them for the visit nor can we follow it up later; we can ensure, however, that the child spends as much time as possible in the galleries. If, however, there is no prior active participation by the teacher, there will be less understanding, less ability to use opportunely the stimulating and vivid impressions of the children.

I find that only when the teacher has himself had the experience of looking, of learning to read an object visually, of appreciating the many issues and interests which can be roused, is he able to make full educational use of the museum visit. . . . Responsibility for the follow up in the classroom, the guiding and shaping of the personal response of individual children lies then with the teacher, whether in the history, geography, English, or the art lesson. It is the museum's task to ensure that the teacher is trained to do this.[3]

If few American museums (this study found none) have made the training of teachers a matter of policy in quite the same way the Victoria and Albert has, there are indications that museum educators are increasingly convinced of the need to ally themselves with the classroom teacher if they want to reach the children. For one thing, many museums have found that their small staffs and limited budgets cannot be stretched to cover all the school groups that demand access to them. A museum experience, they reason, is only one

small part of a student's educational life, and what that experience means to a student is often determined more by the way the teacher fits the visit into classroom studies than by the museum educator or docent who conducts the visit.

At the Brooklyn Museum, for example, the education staff members realized halfway through their In-Depth Series (see report in chapter 6 and the section on the Spock Workshops in the Museums Collaborative report, chapter 4) how little they knew "about life in the schools" and "how much they [had] ignored the teachers by focusing on the children." The Brooklyn staff discovered, too, that "no matter how good or how intensive the museum program may be, unless it somehow relates to the work that goes on at the school and brings in the teacher more actively, a series of four or six long visits can be hardly more significant than a single short one."

**"Theoretically . . . better to teach the teacher."** Not all museum educators feel so strongly about the need to reach the teacher: for many museum workers much of the fun of museum education is with the children; their teachers are usually harder work. Yet there are several practical reasons why some museum educators think their own teaching energy might more usefully be spent on teachers than on the mass education of their pupils:

1. By the simple arithmetic of the multiplier effect, understaffed museum education departments can reach through teachers far more students than they can reach alone. In times of austerity (the present period is one), as museum budgets are cut and there are fewer staff members to take care of school groups, it becomes all the more important for teachers to be trained to lead their classes themselves.

2. Professional teachers who have become confident in using the museum would be doing the job that is now often done by part-time volunteers who are not professionally prepared to teach the young.

3. Because the same teacher, who knows his students and is clear about what he wants them to learn in the museum, would be teaching in both places, he could achieve a better integration between museum gallery and classroom.

4. Museum educators would have more time to work with teachers, students, and schools on the special projects that many consider their first responsibility. Many of these projects include those meant to help teachers and school groups become more independent—simple guides and training sessions to show teachers how to conduct their own visits, educational exhibitions and orientation spaces, and resource centers designed for teacher use.

### What museums have tried

For museums, the goal of their programs for teachers is twofold: to give teachers exposure and practice that will make them confident and comfortable not only in the museum but with art itself, and to try through teachers to integrate works of art into the education of the young. Over the years museum staffs have devised a variety of encouragements toward these ends: workshops, pre-service and in-service courses for credit, cooperative planning on museum projects, instructional materials, classroom exhibitions, consultation hours, exhibition previews, newsletters, teacher centers, special memberships, teacher evenings, symposia, programs for the teachers of teachers, and even, on one or two rare occasions, money.

Some of these ideas are described in detail in this chapter and elsewhere in the study. A few examples:

- At the St. Louis Museum of Art, a teachers' resource center offers slides, information sheets, workshops, and a special staff to help teachers fit works of art into their curriculum units and to train them to conduct their own museum visits.

- The Milwaukee Art Center organized a program in the early seventies that sent one staff member around the county demonstrating to teachers in their classrooms the use of the center's instructional packages, designed especially for local school curricula, and taking back the teachers' ideas for new packages.

- The Museum of Modern Art in New York (see chapter 1), which has long worked closely with teachers, regularly schedules evening events and special film showings for teachers, some of them organized with the help of teachers themselves, and keeps up a continually renewed supply of slide and film sets for teacher use.

- The Museum Education Roundtable in Washington, D.C. (see chapter 15), was established in large part to bring teachers and museum educators together so they could discuss their mutual interests.

- Museums Collaborative in New York (see chapter 4) contributes a monthly column to the teachers' union newspaper, each column based on a theme—the teaching of French, or environmental studies, or the American Indian—that gives teachers an annotated list of museums, zoos, and other community sites they can visit with their classes.

- The Children's Museum, Boston (see chapter 3), runs a teachers' resource center that edits and displays teaching packages and offers recycled and leftover industrial materials for classroom use.

- The Memorial Art Gallery in Rochester, New York, keeps a supply of loan materials—shadow-box exhibits, framed reproductions, and original objects—for teachers to use in their classrooms (see chapter 1). Teachers can request materials on a theme and borrow them for up to a month at a time. The gallery also has worked closely with teachers to develop art and culture units for curricula in local schools.

- In its program with the East Cleveland schools, the Cleveland Museum of Art (see chapter 6) asks that teachers work alongside their pupils in studio classes as a way of involving them specifically in the training the children receive and in giving teachers and their students a shared experience.

Useful and creative as such programs may be, however,

many museums find that trying to interest and "train" teachers is more of an effort than they can sustain. Henry Watson Kent, the Metropolitan Museum's first supervisor of education, looking back nearly 40 years after the brave resolve he made in 1910 to offer "definite instruction" to teachers as well as pupils—and after nearly 40 years of doing just that (few museum educators have carried out such long-term and elaborate programs for teachers)[4]—wrote in 1949, "The work with the New York schools promised to be of a rather uphill kind, teachers and pupils being busy with their own curricula and our kind of art not being thought of real importance. . . ." Kent finally decided that the museum had to have the interest of the board of education itself before instruction of the teachers could get anywhere, and he persuaded the museum's trustees to authorize the appointment of a supervisor to work between the museum and the schools. But Kent clearly gave up: "For one reason and another," he admitted, "the scheme was not carried out."[5]

Even those museum staff members who feel they have helped some teachers become knowledgeable and independent enough to lead their own classes believe that most teachers are still "paranoid in museums," as one museum educator put it, and prefer to put their classes in the hands of museum staff. The classroom teachers who know the museum collections and purposefully bring students to study and enjoy works of art are such a rarity that museum instructors pass around their names much as college students tell their friends of inspiring professors. It seems to be so difficult to reproduce such teachers that many museum educators become discouraged and decide to concentrate instead on the more immediate rewards of dealing directly with the children. Perhaps for the same reasons, many designers of curriculum materials (see reports on CEMREL, the Metropolitan Museum, Milwaukee Art Center, and others in this chapter), have decided either to try to make their packages "teacher-proof" or to bypass the teacher and aim their instruction at the students. Either case is simply another declaration of the position that Laurence Coleman took some time ago: "It is the teacher who holds education back."[6]

## Sources of the Problem

Yet taking that position does not solve the relation between museums and teachers. The hard questions remain. Why is it such a slow, uphill job to help most teachers become comfortable users of museums in their teaching? Is it, as Coleman suggests, the fault of the teacher, or is it, as Kent lamented, that "our kind of art" is not "thought of real importance"? What goes wrong in the museums' many attempts to reach teachers? Why do some teachers respond better than others? Why are so many—perhaps most—teachers uneasy in art museums? Why does the subject of art and the use of objects seem often to elude them?

### Teacher training

One reason why many teachers are not comfortable in art museums may be that they have had so little experience in them. Unlike some European universities, colleges of education in the United States rarely ask their students to explicate a work of art in a museum (a requirement for graduate examinations for prospective art teachers in the Netherlands, for example). Learning to know a museum collection in the same way a teacher in training is expected to learn his way through the library is practically unheard of in this country.

As for the study of art itself, most teachers' colleges require no more than a semester of studio art for elementary schoolteachers; art history is hardly mentioned. In 1975 only 14 states specifically called for a minimum number of art credits—somewhere between one and nine hours in "the arts"—for certification (other states either are vague about art requirements or do not refer to them at all).[7]

Because most certified teachers come to the classroom, to say nothing of the art museum, with a limited exposure to art and museums, some museum educators have suggested that the best way to remedy the situation is to work with universities in pre-service programs. At least two schools of education, George Washington University in Washington, D.C. (see chapter 14) and the Bank Street College of Education in New York (its program started too late to be included in this study), have instituted programs to train their students to work in and make better use of museums. Circumstances may prompt others to do the same, if educational reform continues to advocate a wider use of community resources and the teacher surplus continues to force education schools to seek out new employers for their students.

Perhaps the arts are given such short shrift in teacher preparation because so few school systems demand them—a reflection, in turn, of our society's esteem for the arts. Perhaps the time allotted to professional teacher training is simply too brief; Harry Broudy, professor of the philosophy of education at the University of Illinois and a respected figure in the field of aesthetic education, contends that "genuinely professional education for teaching calls for more extended specialized study than we now require."[8] Perhaps the nature of the teacher's training is unrealistic, as Yale University's Seymour Sarason suggests, pointing to the "inadequate formal training" teachers are given to prepare them "for the realities of the classroom" and for "what life in a school would be."[9] The Ford Foundation concluded after a ten-year experience with its Comprehensive School Improvement Program that the public schools and universities have "little capacity for respecting and understanding one another."[10] And Martin Haberman, a member of the education faculty at the University of Wisconsin, calls universities "change agents who educate teachers for the best of all nonexistent worlds" and recommends that "we . . . support rather than crush organizations outside the university that seek to prepare teaching personnel. . . ."[11]

So far, those museums outside the university that have tried to fill the gap in teacher education generally have been disappointed in their efforts at pre-service teacher training. One example was a single-semester course on the museum as a teaching resource, initiated by the Metropolitan Museum in 1970 and taught in the museum primarily by the staff of Teachers College, Columbia University (with museum staff support). Museum staff members judged, on the basis of students' final papers, that the students seemed not to understand the point of the course—largely, they concluded, because the Teachers College faculty itself was not all that interested in the museum as a teaching resource. In St. Louis, where a local teachers' college requires a museum course for all students, some staff members of the St. Louis Art Museum have suggested that in-service teachers make better clients for museums than students with no experience. "Maybe," said one, "you shouldn't get to them in training but wait till they're in classroom practice. . . . Then they panic—and maybe *then* we can help them."

### Training on the job

The most ubiquitous kind of museum program for teachers is probably classes for teachers already at work in the classroom given by museum educators and accredited by the local board of education. Many museum educators have chosen in-service courses because they have discovered that success with pre-service courses involves endless difficulties—in negotiating accreditation, establishing close working arrangements with universities, and finding faculty members who understand the museum well enough themselves to be any help to their students—and that classroom teachers looking for specific ideas are a more rewarding clientele.

Teachers themselves have expressed their preference for training on the job. An evaluation of training programs for inner-city elementary teachers published in 1972 found that the 248 teachers who took part in the study regarded specific, nontheoretical, practical, on-the-job seminars as the most helpful resource for dealing with the problems they faced in the classroom. They felt that such seminars were superior to lectures, academic coursework, and "foundation courses taught in classroom style."[12]

The need for help on the job is clearly one of the reasons behind many of the teacher centers that have sprung up in the last decade around the country and such cultural resource centers as GAME (see chapter 8) and its counterparts elsewhere in New York City (described in the report on Museums Collaborative, chapter 4). The success of these centers with teachers (never mind, for the moment, the problem of funding them) is what one experienced teacher feels is among the "few hopeful developments" in her profession. "It is exhilarating," she says, "for teachers to work with teachers."[13]

Although none of the usual in-service courses is reported in this chapter, some of the communication problems en-

countered by the Cleveland Museum's summer institute in art history for high school teachers, which is described here, will sound familiar to museums that have tried less ambitious in-service training: the "wrong" teachers came; many of them wanted more methodology, more how-to, less art history; the museum scheduled the course to begin before all the schools were dismissed for the summer; teachers felt they could not imitate what the museum instructor did.

**How and what to teach.** Perhaps the most critical issues embodied in the "teacher-training" programs in this chapter have to do with the kinds of pedagogical models and curriculum content that museums offer teachers.

To begin with pedagogy: Should a teacher learn how to lecture before a work of art, give slide talks, stimulate discussion, lead role-playing, devise lesson plans, or simply learn the lay of the museum land—the library, the galleries, the location of specific objects and collections? Should the museum staff set an example, function as resource, or serve as critic? Furthermore, are museum educators exemplary teachers themselves? Can they show teachers the best ways to catch and hold children's interest?

In the Cleveland institute, the museum had a stated purpose: to help high school humanities and social studies teachers incorporate art history, and particularly an advanced placement course, into the curriculum. But 21 of the 26 teachers who enrolled in the course were not humanities or social studies but studio art teachers, and what they wanted most to learn was not how to teach advanced placement classes in art history but how to incorporate art history into their studio courses. The institute pointed up the persistent need teachers—especially studio art teachers, who are generally charged with teaching art in secondary schools—have for specific help with their daily classroom performance.

So teachers who came to the Cleveland summer institute expected to get a course in "methods" of teaching art history—"what slide to use and what to say about it," as one participant put it—and most were disappointed. One who was not unhappy with the course called herself "a pragmatist—I take what I need and use it." Another, confounded by the ambitious scope and approach of the institute and by the museum instructor's facility, asked for a less complex course "for us run-of-the-mill art teachers who combine art history and studio work."

The variation in confidence, capacity, and knowledge among teachers showed up, too, in the St. Louis Museum's efforts to train teachers. From the evidence reported here, the St. Louis clients seemed to need two things: (1) more direction from the staff than they were given in order to become secure performers, and (2) more carefully chosen models to follow as examples of good museum teaching style. The Sturbridge Teacher Center, in contrast, is very clear about presenting its staff and method as models. Its intent is to teach its participants "as it would have them teach." In the Mil-

waukee Art Center program it was a teacher who had seen and remembered how the museum lecturer made her presentations who "did well"; the teacher who had never watched a demonstration did poorly.

Curriculum reformers have made similar discoveries. Elliot Eisner has reported that the usefulness of the detailed art curriculum he and his associates developed for teachers "with little or no in-service education"—on a Kettering Foundation grant at Stanford University during the 1960s—depended, after all, on training. Seven units of nine lessons each, replete with such instructional materials as slides, reproductions, color boards, transparencies, and tactile sheets, plus history, critical ideas, and "sequenced learning" in the making of art, were enough to keep an elementary schoolteacher busy for a couple of years if she taught art about once a week. At the end of the long and careful project, Eisner concluded "that teacher will need more in-service education than what we provided. . . . A curriculum, it seems, can do only part of the job. . . ."[14]

The other question is what to teach. This question of content proved especially thorny in the Cleveland summer institute because the enrollment of studio teachers surprised the museum, which had prepared a course for humanities teachers. Not only did the Cleveland experience, like the three summer institutes in other cities that preceded it, reveal a fact of life in secondary schools—that teachers of studio art are often the high school teachers entrusted with whatever (if any) instruction in art history is offered—but it also revealed some obvious gaps in the kind of education offered to studio art teachers; as one teacher noted, the course created "an awareness of some poor training on the part of most college art education departments." It raised questions about what the museum's role should be, or can be, in filling that particular gap in the education of school art teachers. And, further, it raised the larger issues of what museum educators want classroom teachers to know about art—and of who should decide, the museum or the teacher.

As very few schools and museums systematically work together in devising programs for schoolteachers, and as only a few schools seem to be actively seeking courses from museums, decisions about content tend to be made by the museum. Even among museums, these decisions are hotly debated: does the art museum want to instruct teachers in art history, art as illustration of history, perception and visual analysis, connoisseurship, relations among the arts, aesthetics, studio techniques, gallery or classroom teaching methods, art as politics or life or sociology or anthropology—and if all of these, might that be too much?

The Minneapolis Institute of Arts demonstrated four gallery approaches to its collection in six of its ten weekly classes for teachers—thematic, historical, cultural, and improvisational—and in the other four sessions introduced them to the organization and activities of the institute and two of its sister museums in town. Thorough as the institute may have tried to be in these sessions, six classes on the content of the collection obviously had its limitations. The Brooklyn Museum, attempting to train teachers for the same purpose as the Minneapolis Institute—to become independent leaders of their classes on museum tours—felt that the teachers would need a minimum of 15 sessions on content alone. Sturbridge Village has held week-long workshops on just one subject at a time and shorter workshops on the teaching process, on one specific subject, and on specific local resources.

### Understanding the teacher

One difficulty that hampers cooperative efforts between museum educators and classroom teachers seems to derive from the perceptions each has of the other. For museum educators, as for others who do not spend much time in the schoolroom, it is often difficult to imagine what a teacher's professional life is like and what the boundaries of his world and experience are. The result is that some museum people tend to overestimate what teachers can absorb and others to join the chorus of critics who lump all teachers together as rigid, insensitive to their students, unable to deal with the subject matter of art, and, when they bring their classes to the museum, excessively interested in getting a day off.

But to turn the matter around, for many teachers the museum is a cold, incomprehensible place, where mute objects of uncertain educational value follow on each other in confusing sequence. The floors are hard, the children unruly, the bus trip a hassle (for some of the specifics, see interview with Grace George Alexander in chapter 10), and the museum staff not always sympathetic or skillful.

For if the museum educator might wish for teachers who are better prepared, who know more about his institution and have mastered the art of visiting it, the schoolteacher has a right to expect the same of the museum educator: that he know more about the world of the school, demonstrate more flexibility in his approach to his subject matter, take a more humane interest in the teachers he is trying to instruct, and perform more sensitively and professionally as a teacher himself.

Because courses for museum educators to learn about the schools are not nearly so numerous as courses for schoolteachers to learn about museums, this kind of reverse evaluation is less common. But when schoolteachers do comment on their museum colleagues, as some of them have done for this study, it is clear that they expect a model of pedagogical professionalism from museum educators that they do not always find. Schoolteachers worry about the relaxation of discipline in the museum, the tendency of museum instructors to move too fast or to use terms that are unfamiliar to the children, or the failure of museum educators or docents to try to understand the learning process in children. Said one outspoken teacher trainer recently, "Museum guided tours are abysmal. The museum instructors don't know anything about child development and the tours [often] just turn kids off. It's pathetic."[15] (Philip Youtz, director of the Brooklyn Museum in the 1930s, would have agreed with

her. "We are out of touch," he wrote of museum educators in *Museum News* in 1933, "with the latest psychological studies of the learning process. For the most part we are unacquainted with the experiments of the progressive schools here and abroad. We have no well thought out theory of education, no grasp of the relation between museum and school education.")[16] Equally critical is the charge brought by a high-level school administrator who was interviewed in this study: museum staffs, she said, are not "strong" enough to be taken seriously as educators.[17]

Such criticisms may be extreme, and perhaps museum educators rarely hear them. But they point up the need for museum educators, in order to earn their credentials with schoolteachers, to get to know schools, schoolteachers, and schoolchildren better, to listen to them more carefully, and to learn something of the institutional conditions and restraints that shape the way teachers carry on their work and the priorities they place on their subject matter. One problem with almost all the programs museums devise for teachers and schools, as the reports in this chapter indicate, is that they begin with the museum and take place on its turf. Consequently, they offer museum educators only limited exposure to the teachers' everyday real world.

Some museums have tried to overcome the handicap by hiring schoolteachers to design and direct their programs, as the St. Louis Art Museum did with its Teachers Resource Center and the Milwaukee Art Center with its instructional packages. Both Milwaukee and the Minneapolis Institute of Arts, furthermore, sent staff members into the classroom either to make presentations or to work more closely with the teachers, and the Detroit Institute's project to design instructional materials, led by an ex-teacher, has moved back and forth between the drawing boards and tests in some of the local schools.

Yet in many of these programs, there are signs that the understanding has not been complete. Its trust in teachers led the Milwaukee staff, for example, to rely too much on the teacher's ability to duplicate quickly the museum instructor's demonstration lesson. The St. Louis staff, suffering from the same virtue as Milwaukee, at first offered workshops for the teachers so easygoing that it was soon clear the museum was missing a chance to instruct teachers in museum standards of dealing with the visual and aesthetic elements of works of art. The Museum of Modern Art, which has attempted to treat teachers as special members of its audience rather than solely as points of entry into the schools (see chapter 1), also overestimated the teachers' sophistication when it showed avant garde films without the kind of careful explanation the teachers evidently required.

Some teacher workshops try to sidestep the problem of the museum staff's ignorance of the school by immersing the teacher in the museum. One example is the Sturbridge Village workshops reported in this chapter, to which teachers come every day for two weeks straight in the summer and then return for eight two-day sessions throughout the school year. The aim is for the teachers to become sufficiently steeped in the museum environment so that they can begin to develop ideas of their own to incorporate into the curriculum; the burden of "relevance" is thus placed on the teacher, not on the museum, on the assumption that the teacher is in the best position to organize the material for his students. Martin Friedman, whose Walker Art Center in Minneapolis has tried a similar plan, feels that the immersion of teachers in the museum for a semester at a time is, ultimately, a way to salvage the guided tour.[18]

But even long-term workshops on the museum's turf beg the question of the museum's ignorance of the schools. There is no evidence in any of these reports that museum educators are taking the kind of initiative that will enable them to become true partners with schoolteachers—periodic immersion in the daily life of teachers with their children in the schools. Perhaps those museums that have come closest to understanding the life of the schools have on their staffs teachers who serve as a liaison between the museum and the schools—as Henry Watson Kent advocated so long ago. Such a move would seem to be an important first step for any art museum that is serious about making the teacher comfortable there.

And even that step may not be enough. As Seymour Sarason points out, "the loneliness of teachers (and others) has many sources, but heading the list are the feelings that their plight is neither understood nor appreciated and that they have only themselves to fall back on." It is only by actually spending time in the classroom that what Sarason calls the complexity of the teacher's job can be felt—the unremitting pressure to cover a certain amount of material in a certain length of time; to manage day after day a classroom of the same 25 or 30 children who "vary enormously in . . . academic achievement, intelligence level, behavior, interest, likeability, and maturity"; and to do so with inadequate training, little contact with their peers, and virtually no "meaningful helping services." "The modal teacher," concludes Sarason, "divides the adult world into two groups: those who understand this complexity and those who do not. . . ."[19]

The art museum's cause, it would seem, might benefit more if museum staffs were part of the first group than the second. It is a rare teacher who knows the museum, perhaps, but it seems to be a rarer museum educator who knows the school.

## Instructional materials

Probably nowhere are the problems of content and understanding of the classroom clearer than in the classroom materials that art museums regularly design for teachers to use in the schools. Almost all of the materials described in this chapter are meant either for classroom teachers or for teachers of such nonart subjects as social studies, American history, and the humanities. (And most of them are used by these teachers as well; the Metropolitan Museum, among others, has found that art teachers do not often buy packages,

preferring, the staff guesses, to spend their limited funds on studio materials.) With the exception of the Children's Museum MATCH units and CEMREL's Aesthetic Education Program (the latter created by an educational laboratory, not a museum), most of the packages begin, as might be expected, with the museum's own collections and special exhibitions.

Their common purpose is to insert art or the object into the curriculum, and they all wrestle with the same questions:

- Should the content of the packages be subordinate to the curriculum, complement it, try to redesign it, or ignore it?
- Should the packages simply "instruct" the teacher and allow him to create his own order from the materials, or should the content be made "teacher-proof"—that is, carefully structured and based on the assumption that the teacher has neither the time nor the sophistication to design his own use for what he learns?
- What, indeed, does the teacher know? Should he be addressed primarily as a teacher or primarily as a well-educated adult?
- What kinds of curricula are at any time recognizable, appealing, and acceptable to the schools—and even if acceptable, what kinds are valid? Is it safe to assume that curriculum divisions are forever fixed? Will there always be "history," "literature," and "math"? And if so, into which curricula can art be most successfully wedged? Or should there be, as CEMREL argues, a separate curriculum for aesthetic education?
- Can teachers use *any* packages well without some training?

The program designers here have each made their own assumptions in answer to these questions. The Detroit Art Institute has aimed at the social studies curriculum, which its project is meant to complement with slides of works of art as both historical and aesthetic documents. Each of its units contains a wealth of information from which the teacher may pick and choose: art history, references to visual detail, art from other countries and cultures, suggestions for creative activities in the classroom, plus slides of many kinds of art works, including engraving, metalwork, painting, and architecture. CEMREL's purpose is to invent a rather highly structured aesthetic education curriculum with games and real or simulated art materials. Its one package on "high art" focuses on three basic Japanese aesthetic principles—preservation of natural qualities, simplicity, and asymmetry—and presents the Japanese tea ceremony as the central aesthetic experience.

The New Mexico suitcases and the Children's Museum MATCH units—both of them basically anthropological (having to do with human customs, activities, artifacts) in approach—simply offer artifacts around which teachers can construct almost any educational experience they want children to have. The Metropolitan Museum, learning both from its experience with earlier designs and from answers to teacher questionnaires, gives the teacher a variety of specific ideas in packages that borrow at least part of their format from commercial publications teachers have grown used to.

The Milwaukee Art Center has made virtually no attempt, beyond a single demonstration, to give teachers ideas for using its packages, addressing them as intelligent readers who can pick up what they want from the museum's exposition of the subject; for constructing new and presumably useful packages, the center has depended, rather, on personal contact and feedback from the teachers in staff visits to the schools. As for the question of curriculum, the Milwaukee staff determined that there is such a thing as standard subject matter and tailored its packages to fit sequential course work in the schools—on the grounds, said one staff member, that "that's what teachers want."

If there is no single lesson in the experiments described in this chapter, some general guidelines for designing classroom materials can be drawn from conversations and observations conducted for this study.

1. Whether it is for determining the content or creating a useful format, there is no substitute for knowing intimately the audience, both the teachers and the students, in its working habitat.
2. "Testing" materials in the classroom to see how teachers use them is only important if you know what to do about the results. Some of the most highly tested packages in this study were nevertheless among the most poorly used, even by specialists who had been trained to deal with them. If a package is complex, if it tries to introduce totally new ideas, if it requires machinery or expertise that teachers cannot manage without help, if the text is long and boring, chances are that it will require more work than most teachers are willing to give it.
3. Packages should be attractively designed, their texts well-written, their slides carefully produced; teachers are people, too.
4. It may or may not help to involve teachers directly in the assembly of a package, contrary to some of the expressed desires of their spokesmen (see following section); it is, nonetheless, of utmost importance that teacher opinion and feedback be carefully observed, listened to, analyzed, and continually built back into the program.
5. Any museum interested in producing teaching materials should be clear about why it is doing so and what it aims to gain. Money is one of many acceptable motives: if commercial publishers can make it, museums should be able to as well. Profit, furthermore, is one sure test of a product's acceptance in the marketplace. But museums have a wide array of knowledge, educational experience, and important material to offer schools; with thought and careful research of the market, the competition, and their own educational goals, museums should be able to make a significant contribution to life in the nation's classrooms. From the samples covered for this study, it is not clear that they are now fulfilling their potential.

## Methods of Change

After a decade of educational innovation, when money could buy more outside expertise and equipment than most American schools could absorb, students of reform have come to several conclusions about teachers and schools and the ways to effect change. And several of them feel that one of the places where the educational innovators went wrong was in their insensitivity toward teachers—the role they play in the classroom, the burden that new programs and teaching methods place on them, and the degree to which success depends on the early participation of teachers as co-authors and consultants. A research team from the University of Oregon's Center for the Advanced Study of Educational Administration pointed out in a report in 1973 that "educators in a school implementing a large-scale organizational innovation can expect to face two readily identifiable problems. First, each teacher [will] be inundated with work. Second, each should be prepared for unremitting criticism while adjusting to the new demands required by the change in procedure."[20]

Teachers, says Florence Miller, a member of their ranks, have had enough.

> They have become suspicious of elaborately funded and staffed programs that are top-heavy with paper and administration. They have come to doubt the value of introducing vast changes in the delicate balance of school functions and interrelations because there is seldom sufficient evidence that the children will gain substantially. They are bitter because modest projects that generate in the teachers' lunchroom have less chance of implementation than mighty programs that barrel in from the state Capitol or from Washington. Perhaps most painful is the feeling that teachers are not considered wise enough to make serious decisions about education, just adept enough to carry them out. . . . It is difficult for teachers to maintain a professional stance when they are reminded over and over again that almost anybody knows more about teaching children than they do.[21]

From what he has seen, Seymour Sarason would agree with her:

> In every . . . program I observed, the teachers were presented with a ready-made program, and in some instances they learned about it in the local newspaper. The advice of teachers was never sought, the problems that could occur were never discussed, teachers were given no role in formulating a training or selection program, and, needless to say, teachers had no opportunity to express the professional and personal problems and questions they might have about the [program]. . . .[22]

In several programs described in this study, museum staffs have clearly heeded the necessity for teacher participation. The St. Louis Teachers Resource Center, for example, was established in response to teachers' expressed needs for slides, workshops, information, and "perhaps most of all, a sense that somebody in the museum cared." The Museum of Modern Art's high school program (chapter 1) was revised on the basis of visits to the schools to see how the materials were being used and to find out what the teachers wanted; the staff evaluator learned about a host of small details that bothered the teachers and that the museum was able to correct in subsequent packages. In addition, the museum has asked teachers, working in teams, to contribute and write into the packages ideas for using its films and slide sets—and the museum has "paid" them for their work by giving them free books and, later, in-service credits from the board of education.

There is another lesson for museums in the educational reform experiences of the sixties: change takes time. Lillian Weber, a pioneer in the attempt to establish open-classroom education in the United States, has estimated that to train a classroom teacher to handle the method takes six months of intensive work with an adviser, two years to bring him to the point where he can feel "self-creating," and more support after that to help him through emergencies—at least three years in all before a teacher can become reasonably independent.[23] As Lydia Bond Powel noted about the General Education Board museum-school project referred to elsewhere in this study (see introduction to chapter 10), in three years "it was only fairly started."

## What Museums Can Do

In his book, *The School and Society*, John Dewey (whose ideas are perhaps paid as much homage in the 1970s as at any time in this century) describes an educational society that brings "all things educational together." Among other rich ingredients he sees there, "the library and museum are at hand."

If the art museum is to become an integral member of the educational society—not just a supplement or a complement, an expendable add-on—its staff members must become partners with others at work in that community. And as long as museums invest themselves so heavily in the education of the young, they must consider themselves close allies of the schoolteachers to whom society has given primary charge for its children.

That alliance requires of museum educators, specifically, certain responsibilities toward teachers. An administrator in the Bureau of Art in the New York City public school system is quoted elsewhere in this study (see report on the Museum of Modern Art, chapter 1) in a plea to museums to help the teacher. She says,

> [Our greatest need] is getting more teachers [to be] more competent, more confident, and more capable of developing and executing programs within their own classes. . . .
> Take a teacher who is not confident . . . who has nobody to consult with in her school and may even have an unsympathetic principal. She needs some kind of support, some

kind of wellspring to get her moving. And that just might happen with a museum experience, because if she is consulted, if she's part of the planning of a museum program, working together with museum people and [offering] her own expertise in dealing with children, she'll be offering something that immediately makes her feel more valuable and more comfortable and more confident. . . .

The planning and conceptualizing of a program should be collaborative from the beginning so there's a real understanding of what you are after, what the goals are, who's going to participate, what's going to happen to them afterwards.

The programs described in this chapter, all of them directed in one way or another toward the teacher, have taken several tacks. But basically, they fall into two categories—in-service courses and workshops and materials for use in the classroom. In every case, these programs raise fundamental questions about the kind of help that is more useful for teachers to get from museums—and about the kind of help it is possible for museums to give.

Although not every program here can be said to have the teacher clearly in focus, several show signs of reaching out to him in ways that try to understand his problems and to give him a handhold into the world of art. If these programs are not always successful, they represent at least a beginning, perhaps the first of many steps museums, teachers' colleges, schools, publishing houses, and educators and administrators in all these institutions will have to take in order to exploit the art museum's educational resources to the full. The effort requires what those who know teachers well have asked for: time, cooperation, collaborative planning, encouragement, and, perhaps above all, models of professionalism to which teachers can reasonably aspire.

Museums hold in trust an endless supply of ideas, visions, human mysteries to be unlocked for audiences of all kinds. It may be true that none of the museum's several audiences is more frustrating or more difficult, but it is also clear that none is more important than teachers, none more worthy of all the energy, imagination, and intelligence the museum can command. It is not too much to urge that museums put the best people they can find to work on that job.—*A. Z. S./B. Y. N.*

## Notes

[1] "The Museum and the Cultural Education of the Child," from the Fieldston Conference on "Art and Adolescence," Worcester Art Museum *Bulletin*, vol. 23, no. 2 (July 1932), p. 58.

[2] In a 1938 survey ("Report on Function of the Art Museum in General Education, for the General Education Board," unpublished), Robert Tyler Davis found that many museums offered written guides or training sessions to teachers or sent materials out to schools, the most ambitious of which may have been MOMA's circulating exhibits (chapter 1) or Worcester's loan exhibitions to secondary schools to complement the work of the classroom and based on the required reading lists for college entrance credit. When Grace Fisher Ramsey surveyed museum education departments at about the same time, she found 52 museums offering courses for teachers in service or for student teachers (*Educational Work in Museums of the United States* [New York: H. W. Wilson, 1938]).

[3] "Animation and Information," app. D, *Museums and Adult Education* by Hans L. Zetterberg (London: Evelyn, Adams & Mackay for the International Council of Museums, 1968), p. 62.

[4] For a list of some of the programs for teachers carried out at the Metropolitan under Kent's direction, see Barbara Y. Newsom, *The Metropolitan Museum as an Educational Institution* (New York: Metropolitan Museum, November 1970), p. 79.

[5] *What I Am Pleased to Call My Education* (New York: Grolier Club, 1949), p. 147. Lydia Bond Powel's description of the experiment to strengthen the working relationship between museums and secondary schools concluded that the success of any such effort depended in large part on close and cordial relationships between museum staff and school staff and recommended that museums have a "liaison" officer to work with teachers (*The Art Museum Comes to the School* [New York: Harper & Bos., 1944]).

[6] *The Museum in America: A Critical Study*, vol. 2 (Washington, D. C.: American Association of Museums, 1939), p. 367.

[7] Elizabeth H. Woellner, *Requirements for Certification for Elementary Schools, Secondary Schools and Junior Colleges*, 40th ed. (Chicago: University of Chicago Press, 1975).

[8] *The Real World of the Public Schools* (New York: Harcourt Brace Jovanovich, 1972), p. 59.

[9] *The Culture of the School and the Problem of Change* (Boston: Allyn & Bacon, 1971), pp. 155, 172.

[10] *A Foundation Goes to School: The Ford Foundation Comprehensive School Improvement Program, 1960–1970* (New York: Ford Foundation, November 1972, p. 35.

[11] "Twenty-Three Reasons Universities Can't Educate Teachers," reprinted from *The Journal of Teacher Education*, vol. 20, no. 2 (summer 1971), n.p.

[12] "Evaluative Assessment of Exemplary Pre-Service Teacher Training for Inner-City Elementary Teachers," 8 vol. (Los Angeles: Contemporary Research, Inc.; findings outlined in *Report on Education Research*, vol. 5, no. 2 (January 17, 1973), pp. 11–12.

[13] Florence Miller, "Panaceas Come and Go, but Teachers Endure," *New York Times*, November 16, 1975, p. 30.

[14] *Teaching Art to the Young, a Curriculum Development Project in Art Education* (Palo Alto: Stanford University, 1969), pp. 132–133.

[15] Telephone interview, November 4, 1975.

[16] Quoted by Theodore Low in *The Educational Philosophy and Practice of Art Museums in the U.S.* (New York: Teachers College, Columbia University, 1948), p. 85.

[17] Letter, July 1975.

[18] Comment at meeting of the American Assembly, "Art Museums in America," Arden House, November 1, 1974.

[19] *Culture of the School*, pp. 152, 157.

[20] *Education Recaps*, Educational Testing Service, Princeton, New Jersey, vol. 12, no. 8 (May 1973), p. 3.

[21] Miller, "Panaceas Come and Go," p. 30.

[22] *Culture of the School*, p. 150.

[23] Interview, May 22, 1973.

## Bibliography

The books and articles listed here are a few that the editors have found especially helpful in examining the subject of teacher training and the production of instructional materials by art museums.

Arnheim, Rudolf (project adviser). *The Art of Seeing*, a curriculum in visual education. Produced by The American Federation of Arts, with a major grant from the Ford Foundation. A series of films, essays, discussion questions, and activities designed for developing visual perception.

————*Visual Thinking*. Berkeley and Los Angeles: University of California Press, 1954.

Bloom, Kathryn. "Arts Organizations and Their Services to Schools: Patrons or Partners?" *An Emerging Pattern for Educational Change—The Arts in General Education*. Prepared by the staff of the Arts in Education Program of the JDR 3rd Fund. January 1974.

Boas, Belle. "The Art Museum and the School." Worcester Art Museum *Bulletin*, vol. 23, no. 2 (July 1932).

D'Amico, Victor. *Experiments in Creative Art Teaching: A Progress Report on the Department of Education at the Museum of Modern Art, 1937–1960*. Garden City, N.Y.: Doubleday, 1960.

Eisner, Elliot W. *Teaching Art to the Young, a Curriculum Development in Art Education*. Palo Alto, Ca.: Stanford University, 1969.

Eisner, Elliot W., and David W. Ecker. *Readings in Art Education*. Waltham, Mass.: Blaisdell, 1966.

Haberman, Martin. "Twenty-Three Reasons Universities Can't Educate Teachers," *Journal of Teacher Education*, vol. 20, no. 2 (summer 1971).

Hausman, Jerome J., evaluator. *The Museum and The Art Teacher*. Final report of a project sponsored by George Washington University, National Gallery of Art, and the U.S. Office of Education, December 1966.

Kent, Henry Watson. "Art Museums and Schools," *Educational Review*, vol. 40, no. 1 (June 1910).

Nachtigal, Paul, ed. *A Foundation Goes to School*. New York: Ford Foundation, 1972.

Oppenheimer, Frank. "Teaching and Learning," *American Journal of Physics*, vol. 41 (December 1973).

Powel, Lydia Bond. *The Art Museum Comes to the School*. New York: Harper, 1944.

Sarason, Seymour. *The Culture of the School and the Problem of Change*. Boston: Allyn & Bacon, 1971.

*Teacher Education for Aesthetic Education: A Progress Report*. St. Ann, Mo.: CEMREL, Inc., 1972.

## SUMMER INSTITUTES IN ART HISTORY FOR HIGH SCHOOL TEACHERS

**Four summer institutes for high school teachers; all four related experiments in ways to wedge art history into the high school curriculum. Some questions raised here: what role to give Advanced Placement in art history, how to attract teachers from fields outside studio art, where to find the greatest institutional leverage. CMEVA interviews and observations: November 1973–December 1974.**

**Some Facts About the Program**

**Title:** Summer Institutes in Art History for High School Teachers.

**Audience:** High school teachers in a variety of disciplines, though most were studio art teachers and some junior high school teachers attended. Enrollments: University of Cincinnati, 16 (1972), 21 (1973); University of Maryland, 43; Cleveland Museum of Art, 26 in 1974 (of whom 18 completed the course).

**Objective:** To help high school teachers introduce or strengthen art history instruction in secondary education.

**Funding:** University of Cincinnati, total cost figures not available, though participants' tuition payments and university's in-kind contribution were supplemented by $2,500 from the Eleanora Alms Trust in 1972, and $5,750 from the university and $1,500 from the Ohio Arts Council in 1973; University of Maryland, total cost figures not available, but principal funder was the National Endowment for the Humanities; Cleveland Museum, $25 tuition from each enrollee, plus funds from the budget of the department of art history and education.

**Staff:** University of Cincinnati, 2 supervisors (an art historian and an art educator); University of Maryland, a director, plus faculty of the university art department and visiting lecturers; Cleveland Museum, the assistant curator of the department of art history and education and an experienced high school humanities teacher.

**Location:** University of Cincinnati—at the university, the Taft Museum, and the Cincinnati Art Museum; University of Maryland—at the university and the National Gallery in Washington (visits to other area museums were optional); Cleveland Museum—at the museum.

**Time:** University of Cincinnati, a six-week course in summer 1972, two three-week courses in summer 1973; University of Maryland, a six-week course in summer 1973; Cleveland Museum, one full day per week for six weeks in summer 1974.

**Information and documentation available from the institutions:** Reports on the Cincinnati and Maryland programs available from the universities' art departments.

Can summer institutes for high school teachers help substantially to introduce or strengthen art history instruction in secondary education? Is this goal advanced or retarded if the institute emphasizes Advanced Placement?[1] These questions were posed by four separate but related institutes held at the University of Cincinnati in 1972 and 1973, at the University of Maryland in 1973, and at the Cleveland Museum of Art in 1974.

These institutes were hardly the first efforts to wedge art history into the high school curriculum. Charles Sawyer, a former teacher at Andover Academy and later a University of Michigan professor, reminisces:

At least as I have seen it, there isn't a great deal of credible history of art being taught in the secondary school, and I'm frankly a little discouraged by that because I would have said in the thirties we were making real progress. Up to the time of World War II, I thought a great deal of progress had been made in ten or fifteen years. . . . I felt really very hopeful that the progress would go on, but from what I've seen going on in the secondary schools in the last ten years not too much has been done.[2]

## University of Cincinnati, summer 1972

A few schools, for the most part independent preparatory schools or special public schools (like New York's High School of Music and Art), offer art history courses. An effort to increase their number and to improve the quality of art history instruction was undertaken in 1972 on the invitation of Professor H. W. Janson on behalf of the College Art Association and the Advanced Placement Program of the College Entrance Examination Board.[3] That six-week summer institute at the University of Cincinnati was a sort of "pioneering venture" that "set an educational pattern."[4]

What was the pattern? Of the 16 teachers who enrolled, according to one report, "all but one were certified art teachers. . . . One of the group had conducted an Advanced Placement course in art history in 1971/72. Most of the others hoped to add to or strengthen art history instruction in secondary schools; none of these were to be responsible in the next year for an actual advanced placement course. The academic preparation of the group in art history was widely varied in scope, content, quality, and recency of their studies."[5]

The institute's chief goals for its teacher-students were to improve their understanding of the concepts, resources, and techniques of the professional art historian; to refresh or increase their knowledge of the major styles and key figures of Western art (without rote learning of names and dates); and to help equip them to transmit their knowledge and understanding to high school students.

Although one of the two supervisors of that summer institute deprecated its attention to "models of classroom technique or syllabus construction," some teachers disagreed, noting that "the preparation and discussion of practical curriculum planning warranted more attention."[6]

## Two 1973 institutes:
## Maryland and again Cincinnati

One defect of the 1972 Cincinnati institute—a student body limited to one city and its environs—was effectively overcome by the 1973 institute at the University of Maryland.[7] Funding from the National Endowment for the Humanities (plus "encouragement" from the College Art Association, the National Art Education Association, and the College Entrance Examination Board) allowed 43 secondary school teachers—half from outside the Washington-Baltimore area—to attend a six-week institute at the university's campus in College Park.

The Maryland institute did not emphasize Advanced Placement, though representatives of the AP program were included as visiting speakers to explain the program and its procedures.[8] Instead, the focus was on high school humanities courses as the setting for art history instruction.

But for all the shift in emphasis, it was still primarily high school art teachers who came, rather than teachers in the humanities. The director of the 1973 Maryland institute speculates, plausibly enough, that this was "very likely" the result of using the National Art Education Association's mailing list. Few were interested in the Advanced Placement program. Like the Cincinnati supervisors before him, the director found "quite early during the session . . . that most of the participants expected and wanted more teaching methodology than we had originally planned for."[9]

At the second institute at Cincinnati, in the summer of 1973, certain changes were made. The project undertook to provide "advanced training for museum docents and art teachers, in two terms, three weeks each . . . with art history lectures and planning of projects to improve art education in museums and schools, some projects aiming specifically at better collaboration between the two agencies."[10]

Some students were particularly impressed by the emphasis on the new relationships between schoolteachers and volunteer museum docents. Others commented favorably on such ideas as the use of local buildings for art and architectural research for capturing the interest of their students.

Both of the 1973 summer institutes used local art museums. The University of Maryland program included weekly visits to the National Gallery in Washington and optional visits to other museums in the area. The University of Cincinnati program included both the Taft Museum and the Cincinnati Art Museum.

## 1974: The Cleveland Museum's
## institute and related ventures

It was not until 1974 that an art museum took the initiative in a systematic effort to encourage art history in local high schools. The Cleveland Museum of Art's summer institute was part of a three-pronged effort to this end. The most adventurous part of this campaign was the museum's own Advanced Placement course in art history for high school seniors.

**A university course.** A second part of the campaign was the course the museum offered at nearby Case Western Reserve University, primarily for art education students. Art 394 attracted, on the average, eight students to its weekly classes at the museum. It was taught jointly by Gabriel P. Weisberg, curator of the museum's Department of Art History and Education, who holds an adjunct professorship at the university, and by Jay Gates, an assistant curator in the department. The aim was to introduce students to the methods and principles of art historical studies as well as to the concepts and objectives of Advanced Placement, in the hope that when they themselves began teaching these ideas would be familiar.

For example, Weisberg explained how an art historian tries to solve the problems of influences and relationships by analyzing the nineteenth-century movement called Japonisme, a favorite topic. Stressing stages of influence—direct copying, modified use, assimilation—he compared two Whistler paintings: one an 1864 painting of a woman dressed in a kimono and looking at Japanese prints spread around her, the other an 1880s portrait of Thomas Carlyle that demonstrates assimilation of Japanese visual ideas.

Because the examples were visually persuasive, the students seemed readily to see and accept the curator's point. The question of whether a teacher can as effectively make such points with objects in a museum's collection as with well-chosen slides was raised by no student and mentioned only in passing by the curator. Art 394 classes generally included a visit to the galleries, though one student wistfully noted she wished there "could have been more gallery-type classes."[11] But the students have been generally responsive to the course.

**The summer institute.** The Cleveland Museum's 1974 summer institute for secondary schoolteachers was modeled on the earlier institutes at the universities of Cincinnati and Maryland and tried to profit by their experience. The education staff members planning the institute never expected that enrollment would be dominated by art teachers. Not only did explicit announcements go out to teachers of English and social studies as well as art, but the education department hired as cosupervisor of the course (along with Jay Gates) Dorothy McIntyre, a high school history teacher with long experience teaching humanities and Advanced Placement courses in history. To little avail, as it turned out.

Of the 26 teachers who signed up (and paid $25 to enroll), all but four were studio art teachers. There were two English teachers, one French teacher, and one graduate assistant in art history from a state university. No social studies teachers enrolled, despite the museum's effort to reach them through a detailed announcement in the newsletter of the Greater Cleveland Council for Social Studies. Half a dozen of the art teachers came from junior highs, to the museum's surprise. In announcing that the course was for secondary schoolteachers, the museum staff used "secondary" to mean "high school," not realizing that the term can embrace junior and senior highs. These contradictory expectations point to the institute's greatest drawback: it attracted a number of teachers for whom it was not designed. And neither teachers nor institute seemed to understand each other very well. Communication flagged from the very beginning. The museum, for instance, scheduled the course to begin before all schools were dismissed for the summer, including those of some teachers who had enrolled. Also, many teacher-students expressed surprise at the idea that they were being encouraged to teach Advanced Placement art history; one even criticized (loudly) the inclusion of AP when it had not been announced. (It had. The assistant curator concluded, wearily, that the teacher must not have read the syllabus.)

Of the 26 who enrolled, only 18 completed the course, which consisted of morning and afternoon sessions one day a week for six weeks. Evaluations from 13 of those who completed the course unanimously agreed that there was "not enough time" to cover the ambitious bibliography and assignments or to devote to classroom methods. The cosupervisors agreed. Even before the course began, they had decided to extend the afternoon sessions by a half-hour, to

"provide extra time for the students to experiment with the means of applying art historical subjects to the classroom situation."[12]

Teacher evaluations reported a high degree of satisfaction with the slide-lectures (and with Gates, the museum lecturer, whose personable and enthusiastic manner apparently won over many otherwise querulous students), a moderate degree of satisfaction with what the course actually provided, and a broad dissatisfaction with the conception, organization, and purpose of the course. Representative quotes from the evaluations:

- Lectures were always highly stimulating. . . . Manner of presentation was an excellent example of effective "teaching method."
- It was a pleasure to sit through the lectures, even though most of the material was not a revelation. The methodology was practically nonexistent.
- It was of little benefit to me except to reaffirm some concepts I use and create an awareness of some poor training on the part of most college art education departments. [This from an M.F.A. in painting who has taught one of the few art history courses in a Cleveland area high school.]
- Because of the limited use at present of advanced placement in art, I think the course should at the present time take a less rigid fixed direction—but heading in the direction of the advanced placement idea eventually.
- I would be interested in working on individualized instruction for the Advanced Placement students, as I believe only a small group in my school would participate.
- Very valuable for me as a non-art teacher.
- The information given in the art history lectures was good, but how to teach it in the classroom was hardly touched on.
- The goals were not clearly stated. It seemed there would be more of an emphasis on methods of teaching rather than a survey of art history.

Semantics may be the rub here. When the brochure announcing the institute referred to "Advanced Placement methodology" or to "new methods in presenting art history to high school students," it meant specifically those methods used in Art 394 that are the tools of the art historian: comparison, search for stylistic influences, social settings, and other research methods. But to a schoolteacher, "methodology" appears to mean how to plan and present a class lesson in art history, where to find resources for it, or, as the humanities teacher assisting with the course said, "what slide to use and what to say about it."

Jay Gates felt that these misunderstandings put him and Mrs. McIntyre in a difficult position. "First," he said, "she had not expected to deal with a group made up almost exclusively of art teachers, and, for that matter, neither had I. Secondly, she rightly assumed that the teachers in the course had come to learn something about AP. What she ended up with was a group of art teachers, many of whom wanted specific lesson plans for studio art courses. Neither of us was prepared to give them much help on this."[13] In her evalua-

tion, Mrs. McIntyre reported, "Much of the method I was prepared to teach was not possible because the participants were unwilling to prepare" the AP assignments or study the materials.[14]

Teachers' complaints confirm this observation: "The AP discussions hardly set curriculum or daily plans. . . . Also, why didn't we have someone who knows how to teach art studio and art history?" Another asked for "a similar course for us run-of-the-mill art teachers who combine art history and studio work." One teacher, who has 30 undergraduate hours in art history, said she had "hoped to learn how to teach about" art history, not to learn *more* art history. She went on to report that she has 11th- and 12th-grade students one-and-a-half hours a day, five days a week, in an elective art class, where they work happily at studio projects. What she wanted was to learn how to use slides without losing their interest.

Some teachers, apparently the more experienced and sophisticated ones, looked for—and found—other satisfactions in the 1974 summer institute. An English honors teacher was pleased with the course, for his own pleasure and for background in literature classes. Another said, "I'm very pragmatic. Whatever is offered, I take and use as I wish . . . and I use art history as part of classes in studio practice."

The museum instructors especially sympathized with the teachers' complaints about limited time. "It seems presumptuous to try to do art history plus classroom application in twelve sessions," Gates acknowledges. Another difficulty "is in finding the right level. . . . What I kept trying to do was to show them that the material is not difficult but that they, like most people, are simply not trained to 'read' information they are getting from a work of art."

The reasons for a teacher-training class in art history methods inside a museum seemed plain enough to museum staff: to present art historical information with objects right at hand, to try out the idea for other museums, and to use highly trained museum educators who can set standards for high school teaching of art history.

The idea of the museum educator as model, or the art historian as model, failed to realize the museum's hopes. Though one teacher expressed the admiration of all—the curator "should be bottled and sold to revive art history courses!"—none of them felt able to perform in the classroom as he had in the lecture hall and galleries. "You cannot lecture by the hour to high school students," another teacher said. "We cannot imitate what he did."

Whatever the early communication problems, during the six weeks the institute lasted candor and cheerful determination characterized the relationships between the instructors and their teacher-students. Although the assistant curator stuck to his art history lectures and the humanities teacher stuck to her AP guns, both also tried to add new material and approaches to help their students. One successful revision was an extra session "behind the scenes," which made the museum seem less forbidding to the teachers.

The teacher-students had some suggestions for future courses: inviting teachers to help plan and to explain what they need; identifying those teachers, trained to teach art history or Advanced Placement, who might be eager to learn what the museum is eager to teach; approaching the problem of the university training of art educators, as Art 394 modestly tried to do.

The cosupervisors suggested some changes, too. It would be useful, they agree, to hire for a subsequent institute a high school art studio teacher who has experience in teaching art history and in using the museum; then the museum could act more effectively as a "broker" between its own staff and its teacher-students. Another possibility, suggested by the humanities teacher, would be to change the schedule from one day a week for six weeks to five days a week for a month, to provide adequate time for workshops. The assistant curator agrees there are a lot of changes that might help: "I think we have a good core course, but it needs some revision."[15]

## Summary

The most basic questions raised by the separate summer institutes of 1972, 1973, and 1974 deal with the teaching of art history in high schools: Who shall teach it? Within what department? With what resources or back-up from outside the high school? Presumably the answers must come from the high schools themselves. Yet the summer institutes discussed here demonstrate that the impetus for wedging art history into America's high schools came primarily from outside the high schools: from universities and professional associations and a museum.

The questions, therefore, that seem proper for museums, colleges, and universities to ask themselves center on how they can best collaborate with high school teachers, administrators, and students. If the Cleveland Museum's year-long AP art history course for high school students proves to be a success, by museum and by student standards, someone is sure to suggest that perhaps museum education departments simply bypass local high schools and assume the job of teaching art history. That seems an unlikely path for most museum education departments to tread.

To the advocates of art history as a high school subject for the broadest possible student audience, may not emphasis on Advanced Placement limit that audience? What should be the role of museums in that debate? If AP is not the appropriate mechanism, what is?

The hardest questions center on teacher training. The lessons from the four summer institutes suggest that

- Whenever and wherever art history is taught in American high schools, it is usually taught by studio art teachers, many of whom are—or feel—ill-prepared to incorporate art history into their classes.
- If the studio art teachers enrolled in these institutes reflect accurately the state of studio art teaching in most high schools, then agencies other than high schools might gen-

erate more effective results—the College Art Association, for instance, and the National Art Education Association.

• If art history is to be primarily an Advanced Placement course, it might be wise for museums, colleges, and universities to work with high school teachers of social studies and humanities and with their professional organizations to devise courses that can fit into their curricula.

—*A. Z. S.*

## Notes

1 In brief, an Advanced Placement course enables a qualified high school student to take a college-level course in one or more subjects and therefore, if he meets AP's high standards, to skip the comparable freshman course when he enters college and proceed directly to a sophomore course. For a fuller explanation of AP and of the program's recent inclusion of art, see the report on the Cleveland Museum's AP art history course in chapter 10.

2 For sources of quotations without footnote references, see list of interviews at the end of this report.

3 "A Report on the CEEB Institute for Secondary School Teachers of Art History (June 22–August 2, 1972)," University of Cincinnati, p. 1.

4 Letter from H. W. Janson to Gabriel Weisberg, October 4, 1972.

5 University of Cincinnati report, p. 2.

6 Ibid., pp. 2, 5.

7 Ibid., p. 5. A supervisor commented that the 1972 fees ($360 for Ohio residents, $576 for out-of-state residents), plus summer residence costs, "were too great to attract the intended population, i.e., experienced secondary art teachers. . . . [An] adequate student body, including out-of-state residents, can only be attracted through outside funding."

8 Two talks related directly to the AP program: a talk by Donald Sowell of Cincinnati and a complete explanation of AP exams by Francean Meredith of the Educational Testing Service in Princeton. (Letter from Don Denny, director, Summer Institute in Art History, 1973, to Gabriel Weisberg, October 8, 1973.)

9 Letter from Don Denny, October 8, 1973.

10 Undated report on Summer Art History Institute, University of Cincinnati, 1973, to Ohio Arts Council.

11 Ellen Clark, undergraduate, studio, art education.

12 Jay Gates, "Report on the Advanced Placement Summer Institute in Art History for Teachers," September 9, 1974.

13 Ibid.

14 Dorothy McIntyre, undated evaluation.

15 Gates, "Report," p. 6.

## Interviews

Adams, Celeste. Assistant Curator, Department of Art History and Education, Cleveland Museum of Art. Meetings, interviews throughout 1974.

Balsen, Ida. Upper Elementary School Teacher, Art and Social Studies, Cincinnati. November 13, 1973.

Biehle, Helen. Art Teacher, Laurel School, Shaker Heights, Ohio. Telephone, August 8, 1974.

Bozzuto, Donna. Volunteer Docent, Cincinnati Art Museum. November 13, 1973.

Eilers, Mary. Art Teacher, Aurora High School, Aurora, Ohio. June 25, 1974.

Gates, Jay. Assistant Curator, Department of Art History and Education, Cleveland Museum of Art. Meetings, interviews throughout 1974. Class visit, June 25, 1974. Special interviews, June 25, July 1 and 31, 1974.

Jerdon, William. Art History (Honors) Teacher, Cleveland Heights High School. June 25, 1974; telephone, August 8, 1974.

Masley, Barbara. Art and Humanities Teacher, Mayfield High School, Cleveland, Ohio. June 25, 1974.

McIntyre, Dorothy. Humanities Teacher, Orange High School, Cleveland, Ohio. June 25, July 31, 1974.

Reis, Ken. Art Teacher, Grades 7–12, Covington, Kentucky Schools. November 13, 1973.

Sawyer, Charles H. Chairman, Museum Practice Program (till fall 1974), University of Michigan, Ann Arbor. December 13, 1973.

Shelton, Charles. English (Honors) Teacher, Rocky River High School, Cleveland, Ohio. June 25, 1974.

Stevens, Dorothy. Volunteer Docent, Taft Museum, Cincinnati, Ohio. November 13, 1973.

Weisberg, Gabriel P. Curator, Department of Art History and Education, Cleveland Museum of Art. Interviews throughout 1974. Class visit, March 6, 1974.

Wilson, Roslynne. Head, Department of Education, Cincinnati Art Museum. November 13, 1973.

Wiltse, June. Art Teacher, Grades 4, 5, 6, Cincinnati, Ohio. November 13, 1973.

Wygant, Foster. Head, Department of Art Education, University of Cincinnati. November 13, 1973.

## Bibliography

Adams, Celeste; Jay Gates, and Gabriel Weisberg, "The Art Museum and the High School: The Advanced Placement Approach to the History of Art," *Art Journal*. Fall 1975.

## ST. LOUIS ART MUSEUM: TEACHERS RESOURCE CENTER

St. Louis Art Museum
Forest Park
St. Louis, Missouri 63110

**A resource center in a museum for regular classroom teachers provides what teachers say they want—equipment, slides, workshops, information. Its aim: to make teachers knowledgeable about and comfortable with art and the museum. All services are free, though some slide kits may be purchased. CMEVA interviews and observations: April, November 1973; March, May 1974.**

### Some Facts About the Program

**Title:** Teachers Resource Center.

**Audience:** Schoolteachers at all levels, kindergarten through college. In 1973, 597 teachers (about 10 percent of the area teachers) borrowed slides; they reached an estimated 91,000 students.

**Objective:** To help teachers become acquainted with the collection of the museum and learn to use the collection as a teaching resource.

**Funding:** $15,000 for start-up costs from the Harry S. Freund

Foundation and the Arts in Education Council of Greater St. Louis. The Missouri State Council for the Arts gave $3,000 for production of a teaching kit. The program's operating budget is about $10,000 a year, excluding salaries, which comes from the museum budget: (1974) $3,000 for slides, $2,000 for hardware, $4,000 for a catalog of slides. According to the coordinator of the center, the slide section is "essentially self-supporting," as the sale of slides helps pay for new slides and maintenance of present collection. (In 1973, 4,437 slides were sold, each for 50¢ or less, for a total income of $2,218.50.)

**Staff:** A full-time coordinator; 2 part-time professional staff members; a part-time student; a volunteer.

**Location:** A room in the education department of the museum.

**Time:** Open year-round, Monday through Saturday, 8:30 to 5:00, and Tuesday evenings (when the museum is open till 9:30) by appointment. The center lent its first slide-kit on September 1, 1971.

**Information and documentation available from the institution:** Brochures and newsletters.

---

You are a teacher and you want to use the local art museum for your classes. How would you like to do it? The St. Louis Art Museum education staff, after asking many teachers that question, answered it in 1971 with the Teachers Resource Center. The center is a study room in the museum education department, plus a second room full of hardware. It is, as well, a collection of slides and information sheets (about 30,000 of them), a series of workshops, and a small staff convinced that the classroom teacher armed with a good curriculum and a good resource center can learn to do a first-class job of using the museum collection in his teaching and may consequently develop a sensitivity to works of art.

The center is designed primarily for the regular classroom teacher—not the art teacher—and its aim is to overcome a common attitude among local superintendents, principals, and teachers "that art museums are for artists and only art classes benefit from visiting them."[1] The center grew out of two St. Louis-based projects, one a study to find out how teachers wanted to use museums, the other a 1970 project of the city's Metropolitan Educational Center for the Arts to develop packaged materials for classroom use. The study, which was made by CEMREL (the Central Midwestern Regional Educational Laboratory; see report in this chapter) and supported by the JDR 3rd Fund in 1968/69, was seen by some high-level educators primarily as a way to prove that what teachers really wanted was packages. Instead, said Georgia Binnington, who directed the study, it showed that "teachers are not just henchmen," that they wanted help in and information about the museum, not simply packaged materials to use in their classrooms, but that they felt they encountered resistance from the museum.[2] The center was meant to be one museum answer to that problem.

To establish the Teachers Resource Center cost $15,000, a sum that was drawn from sources that included a local foundation and the Arts in Education Council of Greater St. Louis; later a grant from the Missouri State Council for the Arts made possible the production of teaching kits. The

operating budget is about $10,000 a year (excluding salaries, which the general museum budget covers).

## What the center offers to teachers

Charles Savage, the education curator at the museum when the center was established, has said of it, "I think it was one of the most positive experiences we've had—the 'clients' now know they can tell us what they need and we can listen to them." What did the teachers want? Slides. Workshops. Information. And, perhaps most of all, a sense that somebody in the museum cared and was ready to help them understand the mysterious thing called "the museum as a teaching resource."

Defining as the center's audience teachers in the Greater St. Louis area, the museum's education staff decided to include in its slides only objects in the museum's collections. A fact sheet, developed from the information originally prepared for docent training, accompanies nearly every slide. A set of slides (generally 20) and fact sheets are available as a "kit" in these subjects: African art; American art; art of the ancient world; Chinese art; French art (with a French-language tape); medieval art; Renaissance art; myth and mythology—all clearly responsive to curriculum categories.

In addition, a teacher may design an individual kit with slides and fact sheets chosen from the center's slide-viewing racks or cross-reference catalog. (The museum has made duplicate catalogs widely available to such local educational resources as school libraries and media centers. A number of individual teachers have said the cross-reference catalog first brought the center to their attention.) However the teacher chooses to use the center's resources, slides and sheets may be borrowed free for a week; slides can be purchased for 50¢ each, slide-kits for $5.

Or a teacher may design a project that does not depend on the center's slides. The center's hardware—sound-over-sound stereo tape recorder, cassette recorder kit, a copy camera, super-8 camera, editor and splicer, among many other pieces of equipment—can be used free of charge in the center by any teacher in the St. Louis area who has attended one of the center's special hardware workshops. (See list and prices of the center's hardware following this report.) All the teacher has to supply is the idea and the software (tapes, cassettes, or film); the center staff provides not only the hardware but instruction and help in using it.

## Workshops: strenuous but not demanding

General workshops introduce teachers to the collections and to the basics of slide use. Like all the center's services, workshops are free, though a teacher can earn graduate credit by paying a $20 fee to nearby Webster College. Whether held on three successive Saturdays during the school year or on five consecutive days in the summer, these workshops follow a pattern: after a quick run-through of the center's resources, about 25–30 teachers spend most of the time in the galleries with education staff lecturers, winding up with a show-and-

tell session where each teacher presents a five-minute slide talk demonstrating a classroom use of museum objects.

To a visitor, the hours-long gallery sessions seem strenuous. But the teachers stick it out, attentive and even alert to the end. There is, however, little evidence in the final session that much of the gallery experience has rubbed off on them. At a typical demonstration session where the teachers showed off their new and still somewhat shaky skills (many put their slides in upside down or sideways, mispronounced the names of tribes, dynasties, or artists), the clearest impression was of the great diversity in the capacity, training, and confidence of the teachers.

- A 2nd-grade teacher showed poor-to-middling slides she had made from a picture book so her children could learn to read from a big blow-up of the printed page.
- A high school teacher of creative writing and science fiction showed abstract paintings and constructions, and the print of a man being devoured by a machine, to stimulate her class to debate "Could there be true science fiction before the Industrial Revolution?"
- A librarian devised an imaginary session on the currently popular topic "Death and Dying," with slides of funeral art—tomb rubbings and plaques, death masks,

mummies—as the beginning of a discussion of funeral customs, attitudes toward death, and the arts and rituals surrounding death in different societies.
- A teacher of gifted secondary students showed museum slides to make "more credible" the ancient myths she taught in a comparative literature course: Oedipus on a Greek vase, an austere Osiris, a South Indian dancing Shiva in a circle of fire.
- A primary-grade teacher working on a "mammals unit" showed slides of animal figures in clay and described, in painfully mangled terms, the lost-wax process.
- An art teacher prepared for a 9th-grade craft class in Indian pottery a series of slides of pre-Columbian objects showing surface decoration applied, carved, or painted on clay.

Though the museum education staff assumed that some formal guidance was crucial to the fullest use of the center, the workshops as originally designed were fairly permissive. In the first workshops, Raymond Breun, the center's coordinator, objected to nothing, corrected no errors, though he did sometimes fix a crooked slide or ask an occasional question. He handled the session alone, accepting each five-minute presentation with equable good will. (At one final session, for instance, Breun's first comment after more than

## Old Sturbridge Village: The Teacher Center

Old Sturbridge Village
Sturbridge, Massachusetts 01566

In 1971 Old Sturbridge Village, in cooperation with ten local Massachusetts school districts, began a teacher-training program at the museum's teacher center, using funds from Title III of the Elementary and Secondary Education Act. An outgrowth of an earlier Village program to train teachers in the use of the museum and in such instructional methods as inquiry strategies, the program takes as its goal the redefinition of the roles of teacher and student in educational programs that use resources outside school.

The program is a one-year cycle enrolling about 30 teachers, about evenly divided between elementary and secondary schools. It begins with a two-week summer workshop in which the teachers explore the Village as a learning laboratory and decide on a focus for their study, which they develop into a curriculum. After the summer workshop, the teachers continue their work with the Village in eight two-day sessions throughout the school year and in field studies in their own communities.

Alberta Sebolt, project director, views the year-long process as "modeling" behavior for teachers; the center teaches its participants as it would have them teach.* For a two-week summer workshop on the family, for example, the agenda might follow these lines:

For the first day and a half, staff members present materials to the teacher—a study of the family and its function, as well as census and other contemporary data. Then the participants are asked to analyze the process they have just gone through and to build alternative content into the curriculum; a teacher not especially interested in the family unit might deal with income or with job preparation for

work roles. At the end of the workshop other teachers who have previously worked with the teacher center join the participants for an inquiry session to see how—and if—the workshop process advanced the project's goals of enabling them to use resources outside the school in their classwork. (For a report on group tours for schoolchildren at the Village itself, see chapter 6.)

Besides this central project, the center offers a variety of shorter workshops, all using a similar pedagogical approach. In 1974 a one-week workshop on curriculum design was based on a historical museum's resources, another on the community. Other shorter workshops—on the teaching process, on specific subjects, or on specific local resources—are held throughout the year.

The project has a staff of four: two former schoolteachers who conduct the workshops, a researcher who helps to provide background information, and a classroom teacher on six-month loan from the Springfield school system, who acts as liaison between the project and the schools. (In addition, a member of the Village's education center staff works closely with the project.)

By June 1974 approximately 90 teachers had been enrolled in the project, representing about half the schools in the Worcester and Springfield systems and about 25 or 30 different school districts. For a fee of $1,000 a year, a school system may send a teacher for training and have the center conduct workshops in their schools. When Title III funding ($70,000–$75,000 a year for three years) ran out in July 1974, the program received a $35,000 grant from the state of Massachusetts and now serves as a state demonstration site, an example of museum-schools cooperation.—*B. N. S./A. Z. S.*

---

*Information in this report is based on interviews with Ms. Sebolt on February 5, 1974, and June 1 and 9, 1975.

an hour was on the value of music as an accompaniment to slides and a mild observation that "too many words can sometimes ruin the slides.") A former high school classics teacher, he is sympathetic to the average classroom teacher's uneasiness toward objects of art and wants the teacher to feel free to try slides, to try the museum, to come to the center without fear of criticism.

Initially, Savage and the education staff planned not to attend these final workshop sessions at all, so as to avoid intimidating the teachers. But they began to fear the loss of "a great opportunity to educate."[3] One of the staff pinpointed the weakness of the original procedure: "Are workshops to learn how to use the museum or to learn how to use the Teachers Resource Center?"[4] In summer 1974, partly as a result of observations made by staff and visiting colleagues, members of the education department staff began to participate in the final workshop sessions, to provide information, judgment, and encouragement to teachers.

**Teacher response to the center**

Teachers who have attended the workshops have called the demonstration session "useful" and "helpful"; one confessed that she had rarely visited the museum before and that the workshop had "made the museum more real" to her. Statistics suggest that a growing number of teachers in the St. Louis area are finding the museum "more real," or at least more useful. During the center's first year of operation, ending July 1972, 280 teachers borrowed over 9,000 slides to reach more than 42,000 students. During 1973, the number was up to nearly 600 teachers, who borrowed over 18,000 slides to reach about 91,000 students.[5] (Between 1971 and 1973, the number of slides damaged, lost, or stolen was only 46.)

These numbers encourage the museum's education department in its concept of the center as "one good way to reach the enormous student constituency." Though the center's primary and most visible audience is the classroom teacher, its ultimate audience is each teacher's students. The long-range goal is expressed by Savage: "The day may well come when the students of teachers who have become involved with the collection through TRC may as citizens insist themselves upon high standards."

The *Museum Newsletter*—edited by an education department lecturer and published every two months during the school year especially for teachers—notes films, courses, exhibitions, and events of special interest. It always includes an article by a teacher describing his or her use of the museum as a teaching resource. Furthermore, the coordinator tries to reach teachers through a heavy schedule of visits to schools and teacher meetings (he made 71 in the center's first year, 139 in 1973).

**Which teachers come to the center and why?**

Word of mouth, expected to be a major force in bringing teachers to the center, has not been very important, according to an informal survey by three marketing students at Washington University.[6] The more influential factors included: a teacher's habit of using museums for personal pleasure, the teacher's academic subject (social studies, art, English, and foreign languages dominate), and a school policy encouraging field trips. Factors that apparently do not affect teacher use of either the museum or the center included: grade level taught, number of years in teaching, and the teacher's background of college art courses. (It might be worth noting for other museums interested in creating such a center that no math, science, or physical education teachers and only a few special-education teachers used the museum or the center during the period of the survey.)

Sixty percent of the teachers using the center the year of the survey came from St. Louis county schools, 15 percent from St. Louis city schools, the remaining 25 percent from adjacent school districts in Missouri and Illinois.[7] Though Curator of Education Savage has said that "the ideal teacher knows the collection and can use the center and its materials with confidence,"[8] more than half the center's users continued to ask for a museum docent to guide their class visit.

Men and women studying to be teachers constitute a special segment of the center's audience. A local institution, Harris Teachers College, requires all its students to take a course titled "Methods of Teaching and Introduction to Art," using the museum. One Harris faculty member who knew the museum well confidently took her classes there. Another, more comfortable if she could hand over her class to education staff lecturers, reported that some of her students "say they don't like art, see no relationship between the museum and the community, and never plan to use the museum in their teaching."

Recognizing how many teachers-in-training feel that way, the coordinator and staff lecturers emphasize to all student teachers the essential freedom of the center: not only does it cost nothing, but each teacher is free to decide how to use it. Breun is fond of saying, "You are the only one who knows your kids and can translate this for them," and "Why not come in and use us as a classroom?" A lecturer on the staff repeated, "We're in business to help you" and stressed the teacher's individual decision on ways to use museum resources.

Student response has not always been what the museum staff hoped for; one education student innocently summed up the art-as-adjunct-to-social-studies approach: "If I ever teach 6th grade, this would be great." Most classroom teachers readily announce that they use the museum slides as illustrations for historical ideas. Although the coordinator finds this approach perfectly sound, other education staff would like to see more teachers learn to use museum slides and museum objects as tools for teaching visual analysis and style, in the way art teachers and museum educators use them.

Georgia Binnington, a former education staff member who conducted the JDR 3rd Fund study that helped to shape the Teachers Resource Center, believes that education depart-

ments in colleges and universities are not a museum's best source for teacher clients. Like Breun, she wants the center to make a systematic approach to graduate departments in literature, for instance, whose alumni might teach in high schools or college. "We have to show them it's so damn exciting they can't afford to miss it," she said. As for the elementary schoolteachers: "Maybe you shouldn't get to them in training but wait till they're in classroom practice. When they first get into the classroom and are bombarded, then they panic—and maybe then we can help them."

Ms. Binnington feels that one approach the center currently takes—the demonstration method, inviting education students to observe education staff members with children in the galleries—has strong possibilities. But even good approaches, with strong possibilities, are not foolproof. A Harris instructor who had taken her students to watch two docent-led tours observed politely that both turned out to be rushed and poorly run; she also observed, with even more circumspection, that some professional staff lecturers leave students apathetic, where others know how to find the right style. A little candor all around could identify those museum staff members best equipped to serve as models for classroom teachers.

## Some issues the St. Louis center raises for other art museum educators

1. What the Teachers Resource Center sets out to provide for classroom teachers is confidence and props: some teachers need one more than the other. Art museum observers of almost any philosophy—except, of course, the dyspeptic few who want nothing at all to do with classroom teachers—might agree that the center's basic idea is exemplary, with its stress on freedom of access and use. What even its admirers might disagree about, however, is its workshop policy.

An argument can be made for the position first taken by the staff: that as the classroom teacher is too often awed by the art museum, the most wholesome position the museum can take is uncritical and encouraging, hoping that certain museum habits and standards will prove catching. An equally strong counter-argument can be made: that museum habits and standards must be learned directly from art museum educators who know and care as much about art objects as about teachers learning to use them. The center coordinator at St. Louis has spoken for the first argument; an education curator visiting from another museum spoke for the second when he said, "an extraordinary teaching opportunity was being missed" in the early workshops.

2. A museum education department providing instructional materials to teachers must make a basic decision about what it is instructing them *in*. Is it art as illustration of history, as visual elements, as both, or something else? The different opinions voiced by St. Louis museum education staff accurately reflect the debate that currently preoccupies many thoughtful museum curators and educators. By accepting, indeed encouraging, the classroom teacher's freedom to choose any comfortable approach to the museum object, the St. Louis resource center has not come down on one side of this debate. The majority of teachers using the center have chosen to see art as an adjunct to other subject matter—history, literature, language. Only art teachers have used the center's resources primarily to instruct their students in the visual elements of a work of art. Any art museum interested in setting up such a resource center is forced to consider the implications of this split.

3. St. Louis's 1968/69 study discerned a "lack of communication between the museum's educators and the staffs of the schools it serves."[9] Few museum education departments have tried to meet this problem and to satisfy teacher needs more directly or more generously than St. Louis's; any problems the St. Louis staff has discovered lie in wait for every museum education department. All museum educators are beginning to understand that "communication" can cover the whole range of school needs, from those systems eager for the museum instructor to come out to the classroom to learn the facts of daily school life (especially if that life is lived in harsh neighborhoods) to curriculum-writing and reforming committees with specific measurable learning objectives they press museum educators to accept.—*A. Z. S.*

## Notes

1. Georgia Binnington, "Innovative Education in the Art Museum, a Report of Findings and Proposals Resulting from a Project of the JDR 3rd Fund," City Art Museum of St. Louis, October 1, 1969, p. 4.

2. For sources of quotations without footnote references, see list of interviews at the end of this report.

3. Charles Savage, curator of education, St. Louis Art Museum, letter to CMEVA, May 30, 1974.

4. Terry Sharp, audio-visual technician, quoted in letter from Savage, ibid.

5. No figures were kept on the use of camera and taping facilities, but the staff's general observation is that three teachers use the copy camera every week and that three teachers a month use the taping equipment. The museum's newsletter for teachers carried to every junior and senior high school in the St. Louis area an article by a teacher who has used TRC hardware (Judith Morton, "Visual Aids for High Schools," *Museum Newsletter*, February–March 1974); its praises for the hardware facilities may encourage other teachers to use them. The article notes that commercial slides cost at least 75¢ each and that developing one's own costs about 8¢–10¢ per slide; with an investment of $28.50 in a reusable bulk film loader and ten reusable snap-cap cassettes plus 100 feet of color film, and with the free use of TRC equipment and TRC staff help, the teacher began a slide collection for her school.

6. Untitled survey, by three unidentified students at Washington University, "Summary," pp. 33–43.

7. One factor in the low rate of use by St. Louis city teachers was the city system's media center, with many slides of museum objects; as that center is available only to the city system's staff of art

teachers, St. Louis City classroom teachers have grown accustomed to relying heavily on the excellent 22-member staff for most of their art work and all of their museum visits. Several St. Louis City art teachers are also assigned by the city art supervisor to conduct city school tours in the museum. As of May 9, 1974, the museum has been accepting appointments directly from city schoolteachers.

[8] Savage, letter, July 8, 1974.
[9] Binnington, "Innovative Education," p. 1.

## Interviews and observations

Bellos, Alexandra. Assistant Lecturer, Education Department, St. Louis Art Museum. March 9, 1974.

Binnington, Georgia. Former Project Director, JDR 3rd Fund Report; former Staff Member, Education Department, St. Louis Art Museum. November 7, 1973.

Breun, Raymond. Coordinator, Teachers Resource Center, St. Louis Art Museum. April 25, November 6, 1973; March 9, 1974.

Larkin, Marie. Art Supervisor, St. Louis City Schools. March 8, 1974.

Lindsay, Claudia. Art Department staff, St. Louis Public Schools. April 25, 1973.

MacTaggart, Carol. Special Teacher of Art, St. Louis Public Schools. March 8, 1974.

Penny, Wanda. Instructor, Esthetic Education Department, Harris Teachers College, St. Louis, Missouri. November 7, 1973.

Savage, Charles. Curator of Education, St. Louis Art Museum. April 25, November 6 and 7, 1973; March 8 and 9, 1974; telephone, May 30, 1974.

Schmerz, Nita. Instructor, Harris Teachers College; Art Department staff, St. Louis City Schools. November 6, 1973; March 8,1974.

Sharp, Terry. Audio-Visual Technician, Education Department, St. Louis Art Museum. At workshop session, March 9, 1974.

Stockho, Thelma. Senior Instructor, Education Department, St. Louis Art Museum. With classes in museum, November 7, 1973; March 9, 1974.

## Equipment list, Education Department, March 1974

| Number | Item | Replacement Cost |
|---|---|---|
| 1 | *Honeywell 805A, Repronar (1975, $615) | $350.00 |
| 1 | *Nikon FTN 35mm camera & f3.5 55mm lens | 525.00 |
| 2 | *Kodak Carousel 850ZH projectors @ $200 | 400.00 |
| 2 | Kodak Carousel 750H projectors @ $150 | 300.00 |
| 2 | Kodak Carousel 800Z projectors (not now produced. Replacement: 850ZH projector @ $200) | 400.00 |
| 2 | UniVision Rear View slide projection boxes @ $85 | 170.00 |
| 1 | *Sony 630 tape deck | 450.00 |
| 1 | *3m Wollensak tape deck | 175.00 |
| 1 | *Norelco Cassettecorder kit | 50.00 |
| 1 | *Bolex 160 Macrozoom super-8 camera | 325.00 |
| 1 | *Eumig reg-8 & super-8 projector | 225.00 |

| Number | Item | Replacement Cost |
|---|---|---|
| 1 | *Minette super-8 editor | 50.00 |
| 2 | *Multiplex #52 slide-stor cabinets with trays @$435 | 870.00 |
| 1 | *Multiplex light surface for #52 cabinet | 88.00 |
| 1 | *Copy stand for Nikon camera + lights | 150.00 |
| 1 | *Garrard monaural turntable | 75.00 |
| 1 | *AR Stereo turntable | 100.00 |
| 1 | Monaural amplifier with two 20″ speakers in cabinet | 175.00 |
| 1 | F1.4 lens for Carousel projectors | 85.00 |
| 1 | *Sony DR-7A stereo earphones | 10.00 |
| 1 | *Kodak slide-synch-tape adapter | 35.00 |
| 1 | Timer electrical apparatus for TD-101 | 35.00 |
| 3 | Pix-mobile A-V tables @ $80 | 240.00 |
| 1 | *Set: Hernard 3-D white tile letter set (1″, ½″, ¾″) | 25.00 |
| 1 | *Set: Hernard 3-D white tile letter: ¾″ only | 5.00 |
| 1 | Nikkormat FTN camera body | 220.00 |
| 1 | Nikkor Zoom-Auto lens 43–86mm | 210.00 |
| 1 | Nikkor Auto 135mm lens | 220.00 |
| 1 | Micro Nikkor-P Auto 55mm lens | 210.00 |
| 1 | Nikkor Auto 28mm lens | 322.00 |
| 1 | Nikon UV filter | 10.00 |
| 1 | GBC LK-3 Quartz lighting kit | 140.00 |
| 1 | Pro bag | 40.00 |
| 2 | Rolls seamless paper @ $12 | 24.00 |
| 2 | Umbrella reflectors @ $27 | 54.00 |
| 1 | Vivitar tripod mod 1220 | 32.00 |
| 1 | Vivitar tripod | 16.00 |
| 1 | Nikkormat case | 24.00 |
| 1 | Dissolve unit | 25.00 |
| 1 | *Montage Audio-Mate cassette recorder | 225.00 |
| 1 | *Super-8 film splicer | 8.00 |
| 1 | *Kodak film splicer | 12.00 |
| 1 | Nikon A2 filter | 10.00 |
| | Total replacement cost | $7,100.00 |

*The TRC staff considers these items essential to the existence of a resource center.

**Addenda:**

Kodak Ektachrome 5038 slide copy film: $13.80 per 100 feet

Kodak Ektachrome 5258 Tungsten film: $28.60 per 100 feet

Development cost, 36 exposure roll Ektachrome: $3.61 (includes mounting in paper mounts)

Notes: Prices above include 20% discount
   100 feet of film gives 18 36-exposure rolls, or 648 slides

Daylite film loader (reusable forever): $12.00

Cassettes or magazines for loading film into: $0.20 (also reusable, but you must ask the developing company to return them. Kodak developing on a mail order will *not* return cassettes or magazines.)

Wratten filters for the Repronar 805A: $0.75 each
   You will need a filter pack of some 25 different value filters.

Nikon filters: Use Vivitar 80A and 85B filters: approx. $8.00–$10.00 each
   People bring in daylight film rather than Tungsten; or you may want to use Tungsten film in the daylight. Depending on film set-up, these filters are invaluable.

# SLIDE PACKAGES AND TEACHER TRAINING AT THE MILWAUKEE ART CENTER

**An art center with a small staff and limited money builds its school program around visits to public school classrooms, slide packages based on temporary exhibitions and needs expressed by teachers, and training sessions with teachers in the classroom—a continual cycle of close cooperation with the schools. CMEVA interviews and observations: October 1973; February, May, and September 1974; May 1975.**

### Some Facts About the Program

**Title:** School Programs.

**Audience:** Kindergarten through 12th grade, Milwaukee County Schools; instructional materials sent to schools throughout the State of Wisconsin.

**Objective:** To extend the life of the center's exhibitions and make the permanent collection a useful source to public schoolteachers in English, social studies, the humanities, and studio art at both the elementary and secondary level.

**Funding:** Salary of the coordinator is paid for out of the annual appropriation to the Art Center from Milwaukee County; rental and sales fees cover much of the cost of producing the materials.

**Staff:** One full-time coordinator, who administers the programs, gives the classroom presentations and instruction to the teachers, and develops the teaching packages with the help of other members of the education staff. Some classroom presentations and packages have also been the work of university interns, who do their practice teaching through the center. Volunteers give gallery tours at the center.

**Location:** The Art Center galleries and public school classrooms.

**Time:** During the school year.

**Information and documentation available from institution:** Texts for color slide programs; annual reports for 1972 and 1973; brochures.

---

When the Milwaukee Art Center was created in 1957, it inherited a private collection and a public mission. The collection was the legacy of the Layton Art Gallery, founded in 1888 by an English immigrant named Frederick Layton, who settled into local life as a successful meatpacker, civic leader, and collector of nineteenth-century European and American art.

The public mission was derived from the Milwaukee Art Institute, which merged with the gallery to form the Art Center. Organized in 1888, the institute—known first as the Milwaukee Art Association—was the idea of a group of German-immigrant artists, who assembled under its aegis to paint (heroic battle scenes and huge land- and seascapes were among their favorite subjects), to give art instruction, and to hold exhibitions.

In some contrast to the "rarefied elitism" often attributed to the Layton Gallery, the association was avowedly public spirited. Within its first three decades it began giving Saturday classes for local children and exhibiting the work of Wisconsin painters, sculptors, designers, and craftsmen. By 1918 it had coaxed annual grants from the city (since 1971 taken over by Milwaukee County), significantly broadening, according to one Art Center account, the city's artistic base along the way.[1]

The result of this mix of public and private approaches to art is what Joseph Reis, the Art Center's director of education from 1969 to 1974, has called "the major art museum in the state of Wisconsin"[2] and a teaching institution for young people."[3] It has always been, said Reis, "imbued with community dynamics, and it has this kind of community role that gave it a vested interest in the aesthetics of the city. . . ."

### The rationale for the school programs

One consistent manifestation of this interest in urban aesthetics has been the center's concern for preserving the architecture of Milwaukee. Several of its exhibitions in recent years have focused on the nineteenth-century buildings and the ornaments crafted by the European artisans who settled in the American heartland during the mid-1880s. Another interest, drawn from the early years of the institute and the center's role as the state's "major art museum," has been promotion of regional art and crafts, around which the center has organized traveling exhibitions for circulation throughout the state.

These exhibitions and the mission behind them have also formed the basis of the center's programs for schoolchildren. The programs include class and teacher orientation sessions at the museum by a member of the staff, presentations at the schools, slide packages and circulating exhibitions for classroom use, demonstrations in the schools to help teachers use the slide packages, and tours of special exhibitions led by docents at the center.

Because the Art Center's education staff is small, the museum cannot afford to waste money or motion, and it is intent on making sure that each of these educational activities, as education curator Barbara Brown puts it, "dovetails together." The in-class presentations have served the double role of making contact with the school and training classroom teachers to use the slide packs; the slide packs and circulating exhibitions prepare the students, and the teacher orientation sessions prepare the teachers for all the resources offered at the Art Center. Furthermore, not only are nearly all the circulating exhibitions and slide packages designed around the themes of shows at the center, but they are also meant to serve the regular school curriculum—social studies, history, literature, home economics, studio art, and art appreciation, in particular—and the current interests of the children and their teachers.

### Development of the slide packs

Although the circulating exhibitions and docent tours at the museum are steady offerings, the heart of the school programs is the slide package for use in the classroom. Ideally,

the Art Center would like to be able to reach every classroom in the county. But as there are 150 schools in all and only one coordinator to serve them, obviously the center cannot make the rounds to every school, let alone every class. So the slide packet has become what Reis has termed the "surrogate for the person." Under the Art Center's scheme, the special services coordinator, as the school programs staff member was called, has been both a resource person for curriculum materials from the center and a trainer of the classroom teachers—the link, says Reis, between the museum and the schools.

The first slide packs were developed in 1967 under a Title III grant to the Milwaukee Public Schools. With the Title III money, the center was able to hire an art teacher from one of the local schools as the director of the Title III program. He worked with an advisory board—composed of art teachers and supervisors, principals, artists, representatives from the center, college art instructors, and volunteers—to develop a school program. The emphasis was on the center's collection of American art, tailored particularly to the social studies curriculum. The Title III program combined creation of the slide packages with presentations in the classrooms, which the art teacher—after a brief and unsuccessful try at sending volunteer docents to the schools—made himself, thus setting the pattern the center was to follow when Title III funding ran out in 1969.

At that point the art teacher returned to his job in the schools. But the slide packages had become sufficiently popular so that the center decided to continue developing more materials and to absorb the costs into its education budget. (In effect, the slide packs became a county-supported program, for the county's contribution to the museum is earmarked for education.) The center hired Mary Rae as coordinator of all school programs and put her to work on the slide-pack cycle.

Her method was to take the slide shows to roughly two schools a day, make the presentation in the classroom, and get to know the teachers well enough so that she could not only show them how to use the packets themselves but draw from them and their students ideas and interests that would form the basis of new packages. She would then go back to the Art Center and with the help of another staff member and an inexpensive slide copier (the unit cost the center $140), she could assemble a new package that would be ready for circulation to the schools within three or four weeks.

By this method, the center could keep a flow of 12 to 15 different slide packs going at a time, weeding out at one end and adding new packages at the other as exhibitions at the center and interests of the teachers dictated. In one three-year period, the center's small staff developed 20 slide packs, some with the help of teaching interns from nearby universities (University of Wisconsin-Milwaukee and Lawrence University, among them) who worked one semester on the center's school programs.

## Content of the packages

In any single annual catalog of available slide packs, the subjects offered to teachers might range from colonial American art to contemporary crafts and pop art. Many of the themes, according to members of the center staff, reflect suggestions from teachers—"The American Indian," for example, "Architecture and Urban Planning," "Contemporary Black Artists," "Fibers," and "Clay." Other themes are related to the curriculum in the schools: "The Wisconsin Artist" is designed for use in 3rd-grade social studies classes that deal with the history and structure of the state; "Colonial America" is meant to be used in 5th-grade social studies classes.

Each packet contains a minimum of 20 and a maximum of 40 slides, most of them in color. With each group of slides is a mimeographed text, usually about 26 pages, written by center staff; when the packet is based on a show at the center, an exhibition catalog is included as well. For presentations in the classroom by the school programs coordinator, artifacts or actual works of art have sometimes been added to the slide show.

The text is meant to prepare the teacher, not to be read aloud to the students. For the most part, it consists of entries, anywhere from 50 to 200 words long, that give art historical information or, in some cases, descriptions of art-making processes as background on individual artists or their works. A packet on "Understanding Modern Art," for instance, traces the major movements of the last 100 years by giving, first, a short descriptive paragraph on each, then a paragraph on each slide that illustrates and amplifies the characteristics of the movement and its derivatives. Realism, for example, is introduced thus: "The Realism of the mid-nineteenth century, though revolutionary in its own time, serves as the traditional base from which artists were to 'free' themselves as they sought new modes of expression from the later nineteenth century to the present day." The 26 slides that follow this introduction begin with Bastien-Lepage's *The Wood Gatherer* and end with *The Unattainable* by Arshile Gorky, "an important transitional figure between Surrealism and Abstract Expressionism." Presumably, by the time the reader has come this far, he is ready for this description of Pop Art:

> As we have seen, Pop Art grew out of the gestural phase of Abstract Expressionism, drawing not only from roots in Surrealist psychic automatism, but stemming back further to the Dada tradition of ready-mades, total Environments, and Happenings. But Abstract Expressionism of the 1940s and 1950s also yielded a continuing interest in abstraction. These later movements in abstraction are characterized by greater precision in handling of paint and by crisper definition of color areas. The random, personalized brushwork of the Abstract Expressionists is replaced by order and formality.[4]

Clearly, the text is written for the adult reader. It assumes some prior knowledge about art and art movements, although the staff feels it is careful to explain terms that it considers unfamiliar to most teachers. But the staff makes no attempt in the text to offer teaching ideas or the kind of follow-up suggestions that are common in instructional materials published by other museums.

## Cost, price, and distribution

The slide packs, like the circulating exhibitions, largely pay their own way. They are offered either for sale or for rent: sale prices, which represent cost for the museum, are $10 for 20 slides, $15 for 40; all packets rent for $2 each and must be returned to the Art Center within two weeks. The Milwaukee County schools, in which most of the classroom presentations tend to take place, are charged nothing for the coordinator's visits.

As for distribution of the slide packs, Joe Reis described the packages as ''self-generating: there have been more and more loans and purchases after loans.'' In 1973 total sales to schools all over the state were 166, up nearly 14 percent from 1972, which, in turn, had seen a 44 percent increase over 1971.

Classroom presentations have been another matter. Because there has been only one person to make them, only so many schools can be covered: working to capacity, the coordinator could visit no more than two schools a day. Although the 217 in-class visits in 1972 represented an increase of 39 percent over the year before, the visits dropped to about 100 in 1973, mainly because the coordinator became ill. The museum, recognizing that the school visits are too much for one person, stated in its 1972 annual report that this part of the school programs ''will probably not show much more growth in the future, given the present limitations of one staff member's time.''

## Does the program train teachers?

Although the Art Center continues to offer in-class presentations, it regards them as ''a public relations and demonstration function'' aimed at encouraging teachers to incorporate the center's resources into their own teaching.[5] How well the demonstrations actually train the teacher to use the materials is the question. Former coordinator Mary Rae believes that schoolteachers could learn to give an effective slide presentation after seeing it done professionally once or twice. But she feels strongly, too, that good results require careful preparation on the part of the teacher, including study of the text that accompanies each slide pack.

Observation and the answers to the questionnaire sent out with each rental package suggest that teachers often omit the necessary study of the text.[6] From the questionnaire returns, the staff has concluded that most teachers look at the written material, but few read it completely before their classes. One teacher nonetheless did well in a class observed in 1974, because he apparently remembered the technique demonstrated the previous year and also because he made apt connections between the slides and his students' work. Another teacher, who had never seen the museum's slide demonstrations, showed *Fibers* without opening the information-crammed text; his discussion with the students about the pictured wall hangings and fabrics seldom got above the level of this exchange: Q: ''Why do you like it?'' A: ''It's nice.''

Staff members are quick to point out that this last episode is a misleading example of the way most teachers use the center's material. ''It's the only one of its kind in the history of the program,'' observed Barbara Brown. Yet when Mary Rae watched these two teachers at work, she was less optimistic about the use of the text. Neither teacher referred directly to it. ''That's disturbing,'' she said, ''because we put a lot of work into those.''

## Questions about the center's approach

As it is a common problem with instructional packets of all kinds to get teachers to read the contents, it is not surprising that the Art Center's materials may not be carefully read. Yet the study of the text of the program raises several questions.

1. The Art Center staff has said,

We're trying to give [teachers] a resource they wouldn't normally have available to them. . . . We want to work more with teachers at the elementary and secondary level, asking them how we can fit these programs better into the curriculum. We want to reach the English teacher, the history teacher . . . the teacher in the humanities. . . . We see our role as tying art into life.

But the text itself rarely makes any reference to the curriculum or the activities at various grade levels that help the teacher make the slides mean more to the students. The reading matter is basically art historical; it does not tie art closely to life. Is this the result of the way the art historians who write the text are trained—and does it indicate a need for a special approach to art that might be more in tune with the experiences and observations of today's young people?

2. The museum's education staff has devoted much thought and time to the textual information that accompanies the slides. Yet if, as it appears, teachers who rent the programs make scant use of the center-prepared texts before showing the slides, might their needs be better served by simpler scripts that attract the teacher's attention and that might be more easily adapted to classroom presentation?

3. The Art Center has made an attempt to add to its in-class presentations special orientation sessions for several teachers at the schools, in which the coordinator explains the Art Center's range of services and briefly demonstrates the slide program. These sessions have been slimly attended, partly, Mary Rae felt, because teachers do not receive credit for them. Beyond correcting that problem, might the center not get greater mileage from its small staff and from its in-

vestment in the slide packages if the coordinator spent less time presenting the slides in the classrooms and more time working with teachers in the schools or the museum?

4. At a time when many museum educators have modulated their school tours and other programs to stress themes and concepts rather than chronology and historical periods, the Milwaukee Art Center has done pretty much the opposite. Is the center, in its seemingly "old-fashioned" philosophy, more closely attuned than other museums to current school trends—to yet one more swing of the public school pendulum away from the interdisciplinary and other reforms of the fifties and sixties to the standard subject-matter divisions of earlier generations?

If the Art Center's absorption with its building program makes it hard for the education staff to think of making changes in its classroom materials program now, at least to the last question education curator Barbara Brown's answer is a resounding *yes*. From its close contacts with the schools, the Art Center has concluded that its "old-fashioned" attention to subject-matter divisions and historical periods is the right direction to go. "We got that from the schools," says Brown. "It's what they want."—*J. A. H./J. M./B. Y. N.*

## Notes

[1] Philip L. Crittenden, draft of a history of the Milwaukee Art Center, May 23, 1975, p. 3.

[2] Milwaukee Art Center Education Department Programs and Services, 1971–1972, p. 1.

[3] For sources of quotations without footnote references, see list of interviews at the end of this report.

[4] Color slide program produced by the Milwaukee Art Center, pp. 1, 12.

[5] "Notes on Present and Future Developments in Education at the Milwaukee Art Center," p. 3.

[6] On an attractive yellow card, teachers are asked how the program was used (as "inspiration," supplementary study material, general art experience); whether all or only a selection of the slides were shown; how much, if any, of the text was referred to.

### Interviews

Benedict, Albert. Art Teacher, Milwaukee Public Schools. May 15, 1974.

Brown, Barbara. Curator of Education, Milwaukee Art Center. September 12, 1974; May 12, 1975.

Rae, Mary. Special Services Coordinator, Division of Interpretation, Milwaukee Art Center. February 8 and May 15, 1974.

Reis, Joseph. Former Curator of Education, Division of Interpretation, Milwaukee Art Center. October 11, 1973; February 8, 1974; June 3, 1975.

## METROPOLITAN MUSEUM TEACHER KITS

The Metropolitan Museum of Art
Fifth Avenue and 82nd Street
New York, New York 10028

**Lessons learned from the Metropolitan Museum's elaborate Centennial education packages helped the staff design simpler, cheaper, and more salable teaching materials around the museum's special exhibitions. Slides, biographies, dittomasters, discussion and activity suggestions encourage student as well**

## Services for Teachers at the Minneapolis Institute of Arts

Minneapolis Institute of Arts
201 East 24th Street
Minneapolis, Minnesota 55404

Three programs for local teachers offered by the Minneapolis Institute of Arts demonstrate, the institute staff believes, not only that classroom teachers and museum instructors can work together on all levels, but that a consistent, long-term approach to museum education programing is superior to one-shot tours and workshops.

**A ten-week course for credit.** In an attempt to help teachers become independent leaders of their classes on museum tours, the institute gives a course that introduces 20 teachers (the limit for each class) a semester to the museum's collections. At the beginning of the course, each teacher is given an assignment to design a museum visit for his class, take the class to the museum using that plan, document both the plan and the trip, and evaluate the effectiveness of each. At the tenth session of the course, the teachers must report on every aspect of the assignment. During six of the ten class meetings, institute staff members demonstrate various approaches to the

collection—thematic, historical, cultural, and improvisational—and discuss the organization and activities of the institute. Three of the sessions, conducted partly by staff members from other institutions, are devoted to the resources of the Walker Art Center, the University of Minnesota Museum of Art, and the Minneapolis Institute's own Arts Resource and Information Center (see following paragraphs).

Like all teacher credit programs in the Minneapolis school system, the institute's course was developed in consultation with and approved by the Professional Growth Committee, whose chairman serves as liaison with the institute and arranges for verification of credits earned by teachers in the course. The course costs the teachers $10 each and carries the equivalent of the University of Minnesota's quarter credit, on which salary increments in the Minneapolis school system are based. The ten two-hour sessions, offered one day a week after school, satisfy the school system's requirement of about 20 hours of study.

**Arts Resource and Information Center.** Another service the institute offers to local teachers is a center that provides information about arts events, people who are available to come into the class-

as teacher initiative. CMEVA interviews and observations: February, March, April 1975.

## Some Facts About the Program

**Title:** The School Exhibition Service (Macmillan Publishing Company) and instructional packets on special exhibitions (Metropolitan Museum Publication Department).

**Audience:** The School Exhibition Service is directed at high school teachers in social studies, English and the humanities, art, and "one other area appropriate to the theme." Special exhibition packets are designed for both elementary and high school teachers and students. One kit on the Impressionist exhibition (1974) was meant to be purchased by individuals, libraries, and other institutions. Many of the special exhibition packets have been bought by college students and individuals for home use.

**Objective:** To prepare teachers and students for museum visits; in some cases to provide a substitute for tours; and to help teachers, especially those unfamiliar with art, to incorporate art into curricula of other disciplines.

**Funding:** School Exhibition Service paid for and marketed by Macmillan Publishing Company: initial package (portable metal frame, ten laminated panels, slides, recording, and written materials) sold to schools for $1,700; same package without frame, $1,500; total sales, 1,200 packages; series planned for schools with federal education funds, which were cut off soon after project started; low sales blamed in large part on high cost. Modified package (slides, record, curriculum manual) now available through Macmillan's Library Service, $50; with panels, $150. Another (filmstrip, record or cassette, and teacher's guide), $21.95.

Tapestry exhibition kit (slides, written instructional material), marketed by museum and designed to be self-supporting. Total sales: 500 at $3.95 each.

Impressionist exhibition kit (slides, laminated reproduction, dittomasters and written materials in folders, pass to museum, map,

and calendar of events): $5,000 from National Endowment for the Humanities grant; cost of museum staff time, in addition to grant, not calculated. Total packets produced: 1,000.

**Staff:** School Exhibition Service series researched and prepared by staff of the Department of High School Programs, with assistance from various curators; tapestry exhibition kit prepared and produced by publications and high school department staffs; Impressionist exhibition kit planned by staffs of education, curatorial, and publications department, and produced by publications department.

**Location:** Sold at the museum and by mail order. All packages designed for school classrooms, though many bought for home use.

**Time:** School Exhibition Service begun in 1969, instructional packets on special exhibitions in 1974.

---

When the Metropolitan Museum first established an education department under Henry Watson Kent in 1907, it provided guides, circulars, and special written information about the collection to local teachers. Education staff interest in such help for teachers has alternately flourished and faltered since, but in recent years the museum has "put considerable effort" into printed guides that teachers may study with their classes before coming to the museum.[1]

### Centennial packages

The Metropolitan's most comprehensive materials program was undertaken during the museum's 100th anniversary in 1970, when it joined with two publishing firms, Rand McNally and Macmillan, to prepare filmstrips and classroom exhibitions based on Metropolitan and other museum collections, for distribution to high schools all over the country.

Of the two projects, the one with Macmillan Publishing Company, called the School Exhibition Service, was the

---

room, and places for field trips, as well as lending materials like suitcase exhibitions and slide-tape kits. The center as a support system for teachers—and, indirectly, for arts people and places throughout the Twin Cities—developed out of the institute's ARTS/AOP program (acronyms for Arts Resources for Teachers and Students, the museum's program for elementary schools, and its Arts Opportunity Program for secondary schools).

**School and Curriculum Services.** The ARTS/AOP and the center spawned by it are the major ventures of the institute's school and curriculum services. The service offered to classroom teachers (grades K–12) by that part of the museum's education division was an unexpected consequence of staff visits to classrooms during two years of a massive institute building program. In the classrooms museum staff members "repeatedly discovered" ways that the visual arts and other arts can "enliven" areas of the curriculum; they therefore "rejected" both an "arts for art's sake" approach to schools and the one-shot tour to the museum.* They adopted, instead, the idea that the school curriculum be the core of the institute's program for schoolchildren and teachers. Under the 1973/74 program, month-long arts units paralleled school studies. Classroom teachers and museum staff jointly planned these units with the cooperation of principals, who encouraged teacher participa-

tion, provided released time for meetings, and approved bus transportation for field trips.

One of the program's basic aims was "to provide teachers with the knowledge and skills necessary to carry on similar activities" when museum staff and other arts workers have left the classroom. One example of a curriculum unit integrating school studies and the arts was a 4th-grade math curriculum called "Fractions and Geometry." Students used fractions to measure materials in making a mobile sculpture, studied the relations between fractions and rhythms with musicians and dancers, talked with an architect about the uses of geometry in architecture, visited unusual buildings, and constructed full-scale suspension structures and geodesic domes.

Various elements of all three special services have been funded by the institute, the Minneapolis Public Schools, and, in 1973/74, by the Urban Arts Program of the Minneapolis schools (see full report in chapter 10). The total cost of these services in 1973/74 was $43,892—$10,000 from the Urban Arts budget, the rest from the institute.—*A. Z. S.*

---

*Quotations and other information in this report were drawn from an interview on November 4, 1974, with Maxine Gaiber, supervisor of school and curriculum services at the institute, and from documents provided by the institute.

more ambitious and certainly more costly. Each of the packages, which focused on a particular theme, was priced at $1,700. It included a portable folding metal frame that held ten 3-by-3-foot laminated panels for exhibition in the school; a set of slides and a long-playing record with accompanying text for use in the classroom; and, for the teacher, a curriculum integration manual in each of four disciplines—social studies, English and the humanities, art, and "one other area appropriate to the theme."[2] Each manual contained the transcript of the record, texts from the panels, and special articles researched and written by Metropolitan staff or by Macmillan consultants. A school could choose to buy a package without the metal frames for $1,500.

The series had been planned for schools with ample funds from federal education grants, which were cut off soon after the project started. All those involved with the project cite its high price as the primary reason that it did not succeed—if success is defined as wide distribution: the total sale of the exhibits by mid-1974 was 1,200, and the highest number of sales for any single package was 350. Reasons other than cost have been suggested: that the packages were too large and the panels unwieldy and difficult to sell, send, or use; and probably more important, that the salesmen had never handled a product like this and were uncomfortable with it. (One experienced teacher of teachers offers a rule of thumb: "If the salesmen can't figure it out, forget it for the teachers.")

Left with a large supply in its warehouse, Macmillan is now marketing the package material in smaller units through its Library Service. Six are being sold as slide, record, and curriculum manual kits at $50 each, with the laminated panels (without the metal frame) offered at an additional $100. Eight others are being offered as sound filmstrip programs, with record or cassette and teacher's guide, at $21.95 each.

**A sample exhibit.** One of these packages, titled *Rembrandt: Love and Compassion*, is representative of the Metropolitan's approach.[3] It contains 25 slides (of works in the Metropolitan collection as well as in other museums), with a brief discussion of each and suggestions for class discussion based on several slides—for example, a comparison of surface qualities achieved in a painting (*The Night Watch*), a drawing of a woman sleeping, and an etching. The transcript of the curator's recording is the text of these slide discussions. It is engaging, succinct, brimming with the enthusiasm and knowledge that a good curator brings to his work; in this case, the curator was John Walsh, Jr., then associate for higher education and assistant curator of European painting.

Four Metropolitan education staff members researched and wrote essays on Dutch history, Dutch culture, Rembrandt's techniques, the education and training of the Dutch artist, a chronology of political and cultural events between 1602 and 1688, encompassing Rembrandt's life (1606–1669), a biography of the artist, an annotated bibliography, and the panel copy. Added to these are an essay addressed to the teacher and suggested lesson plans, written by teachers who serve as consultants to Macmillan.

Lesson plans for the art teacher focus on specific ways to introduce elements of the package into studio work or discussions of art history or critical analysis; they suggest using the slide lecture as an introduction to any of the lesson plans or alone "to provoke discussion and analysis of Rembrandt's art. However, it should be stressed that too much analysis can spoil pleasure of contemplation. . . ."[4] The essay and lesson plans suggested for the teacher of Family Life—the fourth discipline judged "appropriate to the theme" of this package—stress not Rembrandt's methods or techniques but the subtitle of the unit, "Love and Compassion." The essays addressed to teachers and the lesson plans do not compare favorably in style, content, or clarity with the essays written by either the Metropolitan education staff or the curator.

Testing these materials in the classroom was a minor aspect of the project. Some museum staff members believe that an average teacher could not get through all the material in each "massive" package, and they suspect that few tried. One reports that the packages were most widely and best used by a local New York parochial school whose principal simply instructed the teachers to use them. Another museum staff member watched the *Art of Black Africa* material being used "very well" in a "difficult" class in a New York public high school by a "very intelligent" teacher. Pressed on the meaning of her adjectives, she reported that the teacher did not show the slides but instead talked about African geography, tribal arrangements, and religious customs, and told the students they could see the slides if they wished—an offer no student accepted. She also observed that the exhibition panels had "no meaning or appeal for the kids there" and that they did not look at them closely.

### The 1974/75 project

The Metropolitan has continued to fulfill the terms of its contract with Macmillan. In the meantime, the museum began a new effort in 1974 to provide instructional materials to teachers.[5] In its slides, discussion suggestions, and background material, this attempt is similar to the centennial project. But there are provocative differences: this one is designed to make money, or at least be self-supporting; it is supervised by the publications department, not the education staff; it is both smaller and more modest; and the material is aimed directly at students and teachers working together in a classroom—no curator's voice on records or cassettes, no exhibition material.

It began almost by accident. Expecting the museum to be so "mobbed" during the lavish 1974 exhibition of medieval tapestries that school tours would be impossible, the education and publications staffs joined forces and produced in a few weeks (memories range from three to six) a teacher's packet priced at $3.95. They sold all 500. It was just a teacher-general sales instructional packet, according to Enid Rubin, a staff member in the department of high school pro-

grams who wrote the text and is a veteran of the centennial project. Joan Goodrich, administrative manager for the publications department, agrees, calling it a "conversation piece."[6]

However casual the material or its presentation, Rubin, Goodrich, and others who worked on it watched with interest the careful tabulations made by the sales staff, which sent questionnaires to each customer. They found that many bought it for home use and that it was unexpectedly popular with college students. Teacher responses puzzled Ms. Goodrich: the inexperienced ones did not use the activities section (which she considered "the most important" part of the package), whereas older teachers did. She speculates that older teachers are more adventurous because, like experienced cooks, they are willing to take a few chances; new teachers, like new cooks, stick close to the recipes—in this case, the "activities"—they already know. Her response: to put activities into the student section as well as the teacher section, in the hope that student interest in trying new things would stimulate and encourage teachers to do the activities.

That change was incorporated into the second package, for the Impressionist show in the winter and spring of 1975. It contains slides, biographies of artists, suggestions and questions for the teacher—all conventional elements of museum instructional materials. If any one element can be picked out as "new," it is the use of materials unfamiliar to museum educators but familiar to school people: dittomasters for the students and chalk talks for the teachers to do with students.

Dittomasters, which can be easily run off on a machine and handed out to students, are classroom staples; "some teachers buy them by the bookful," observes a museum staff member. Four dittomasters, two for elementary grades prepared by Roberta Paine of the Metropolitan's Junior Museum, and two for high school students prepared by Ms. Rubin and Ms. Goodrich, are included in the Impressionist package. Ms. Paine based one of the elementary-level dittomasters on her popular booklet, *How to Look at Paintings*, and focused the other—"in the spirit of a game"—on definitions of terms like still life, genre, portraits. One dittomaster for high school students is a pop version of *Le Charivari*, a Parisian newspaper of the 1870s; the other offers a series of related activities ("for music lovers," "for actors and video people").

If Joan Goodrich's calculations are correct, giving the students such varied activity suggestions ought to be more stimulating than just dumping all the suggestions into the teacher's lap. Not that the package ignores the teacher. The entire package consists of a poster, a laminated reproduction of a Monet painting, and three 8½-by-11-inch folders. The first folder contains, along with the dittomasters, chalk talks for the teacher, suggested class sessions, background material (an essay, a time line, a map), and—just for fun—a related activity for the teacher: Madame Renoir's recipe for chicken sautéed in butter, taken from Jean Renoir's memoir of his father.[7]

The second folder is the most conventional of the three: it contains a plastic packet of 12 slides (all from the museum's collection) and some information about each, including questions the teacher might pose to the students. The third contains artists' biographies, names (Barbizon School, Durand-Ruel, among others), an annotated bibliography, and a brief glossary ("broken color," "picture plane"). It also contains passes for the teacher and a guest to the Impressionists exhibition, and a museum map and calendar of events, all designed to welcome the teacher to the Metropolitan. All three folders are simply written, and laid out with plenty of white space, pictures, and drawings.

## Evaluation of the Impressionist package

Distribution of the Impressionist package was complicated. Initially the museum had planned to publish and sell the materials itself, but the National Endowment for the Humanities—whose subsidy of the entire exhibition covered costs of research and editorial work done outside the museum on the materials, as well as a seminar to be based on them—stepped in with an additional offer to buy, at cost, all the packages for free distribution to teachers. It was a tempting offer, which Ms. Goodrich hesitated to accept: she was convinced that teachers, like other consumers, value more what they have to pay for. Furthermore, because these packages were to be the first in a planned series for teachers on the museum's permanent collection, she was reluctant to set a precedent by giving the first set away free. So she worked out an arrangement with the Endowment under which it would buy about half of the 1,000 packets produced, the rest to be sold over the counter at the museum. The "free" packets were sent, together with an evaluation questionnaire (following this report), to selected teachers in a variety of disciplines who had visited the exhibition with their classes, plus a cross-section of public, private, and special education schools in the tristate area the museum serves (New York, New Jersey, and Connecticut).

Of those who returned the questionnaire, 75 were selected to attend the seminar at the Metropolitan.[8] Representing many different academic levels and disciplines, these teachers were to discuss this and future packages with one another, with Metropolitan staff, and with educational consultants also invited to the seminar. This work on the questionnaires and at the seminar is meant to constitute "payment" for the materials and thus, Joan Goodrich hopes, to confirm for the teachers the value of the packets.

What are the questions the Metropolitan staff wants answered by these teachers?

1. Is the material simple enough for the teacher to remember without having to read it aloud to the students? Ms. Goodrich believes that a teacher ought to be able to *recall* information and *talk* about it while the slides are being shown in a dark room.
2. Does the material encourage the teacher—and the students—to want to visit the museum? Any museum?

Each folder in some way extends an invitation, discusses museums and ways to visit them.

3. Does the material "relate the experience in the classroom to the museum and then back to the classroom again," as Joan Goodrich hopes? She would like the postmuseum experience to be a "good" one, "not a test after the visit."

4. Do the teachers find the packages attractive and appealing? She firmly believes that teachers need good-looking packages just as much as other consumers do, that "visually beautiful" packages not only appeal to the teachers-as-customers and make them enthusiastic about teaching the material, but also "tell them visually" what the written content of the package is about.

5. Do the teachers sense that the museum people who put the package together understand and care what a teacher does in a classroom? Ms. Goodrich argues that the material teachers can really use—the dittomasters and the chalk talks, or the poster and reproduction, for instance—are not only useful inside the classroom but are signals to the teacher that the person preparing the package understands the classroom and knows what teachers find helpful there.

Even before the seminar and the final tabulation of questionnaires, Ms. Goodrich had some preliminary comments on teacher use. She has found that art teachers do not buy the packages; most customers are teachers of social studies, language arts, and foreign languages. The reason? She believes it may be that high school art teachers feel their primary responsibility is to help the student develop his portfolio and are therefore more likely to spend money on studio materials than on museum packages or even on trips to a museum. Like many other museum people, she believes that art teachers, at any grade level, do not know how to correlate their work with other fields and are slightly embarrassed by that inadequacy, whereas teachers of other disciplines do not expect to know anything about art, anyway—and therefore feel freer to admit their lack of knowledge and to buy and use materials on art and art museums.

## Making and merchandising
## the Impressionist packages

The first step—"a very important step," Joan Goodrich insists—in putting together the Impressionist package was a meeting at which the guest curator (in this case, Charles Moffat, a fellow from New York University's Institute of Fine Arts) talked with the education, community, and publications staffs about important points of the show and gave them a simple bibliography. Enid Rubin undertook the research. The curator, as well as other staff, read her text for accuracy and emphasis. Joan Goodrich worked out the structure, design, and production, correlating work prepared by Ms. Rubin, Ms. Paine, and others.

One element missing from the Impressionist package, as a result of this process, is the element that was most successful in the earlier centennial packages: the curator's script. Ms. Goodrich feels the curator's "charisma and special affection for objects are of special value," and she would like in some future package to reinstate that element. She thinks the "ideal" way to put such a script together would be for a staff member to "role-play" the part of the interested but uninitiated visitor questioning the expert, getting his answers on tape and then editing it.

Though she believes it is probably easier to sell such packages for temporary exhibitions that present "an immediate need" to the visitor—like the tapestry and Impressionist shows—than for the permanent collection, she is willing to try both, because she firmly believes there is "a market out there."

Just as firmly, she believes that if the packages can get to that market, they can make money for the museum. She has contracted with an audiovisual company to enlarge the Impressionist packages into four filmstrips, four cassettes, plus written materials for sale to schools, public libraries, and other institutions, for about $90. The sales of the series, plus the sales of the package for the home viewer (see a report on this package in chapter 2), will help support the museum's educational programs for teachers. She believes individual teachers constitute an important market, if packages can be priced low enough to allow a teacher to buy one out of pocket.

The museum's budget for the Impressionist package was nearly as complex as its distribution. First, there was the National Endowment for the Humanities grant, which provided over $5,000. Second, although the Metropolitan does cost-account the time of its staff working on a specific project, it includes this staff time in the product cost at a lower rate than does the commercial publisher (roughly three times cost for the museum staff time versus four to five times for commercial publisher personnel). Third, so many special deals were made with suppliers and outside firms—slides, printing, the poster, the reproduction (the manufacturer of the laminated plaque did the job for free, with some amiable arm twisting)—that the on-paper cost figure of $3.50 per package is "wildly unrealistic," Ms. Goodrich says. "It doesn't include the blood, sweat, and tears in negotiations of all those prices."

But, she argues, that negotiation is the key. Contractual arrangements between museums and educational publishers are frequently unwise and naive on both sides, she says, and she is determined that new Metropolitan projects be financially sound as well as curatorially expert and educationally helpful. Her definition of an educationally useful museum visit is a small group or individuals who are well prepared and who know what they want to see, led by a teacher who can serve as a guide for the class. Then, she hopes, both "teacher and the museum staff can relax about kids in the galleries."

The hope is familiar to every museum educator who has ever prepared instructional materials for schools.—*A. Z. S.*

[1] A 1970 report on the Metropolitan as an educational institution describes the guides: ''At the elementary and junior high school level, the guides give teachers information about a section or theme to be studied in the Museum; suggestions for classroom preparation, including word lists and a bibliography; and a preview and sometimes a map of the visit itself. A more detailed guide, designed for teachers escorting their own classes, leads the teachers from one object to another, suggesting comparisons and topics for discussion.'' Barbara Y. Newsom, *The Metropolitan Museum as an Educational Institution* (New York: Metropolitan Museum of Art, 1970), pp. 80–81.

[2] Macmillan Library Services sales brochure for Multi-Media Kits.

[3] Other titles in the series (some of them still in the works) are *Art of Black Africa, The Art of Discovery, Abstract Painting, Tutankhamen's Treasures* (the most popular), *Protest and Hope, Impressionism, The Doors to the Renaissance, The Glory That Was Greece, Chivalry: Courtly Love and Other Pastimes, American Houses: From Wigwam to Mansion, Troubled Waters: The Plight of Venice, Siddartha: The Boy Who Became the Buddha,* and *American Roads: From Farm Paths to Superhighways.*

[4] Art/Curriculum Integration Manual, *Rembrandt: Love and Compassion,* Metropolitan Museum of Art School Exhibition Service and the Macmillan Company, p. 1.

[5] Just prior to the ''new effort'' in 1974, the department of high school programs produced a series of very simple kits—a short bibliography, a page of background information (one for each student), and ten to twenty slides—which sold for $5 or a little more each. Themes were medieval, twentieth-century, Renaissance, French nineteenth-century, and Egyptian art.

[6] For sources of quotations without footnote references, see list of interviews at the end of this report.

[7] Jean Renoir, *Renoir, My Father* (New York: Little, Brown, 1962).

[8] By April 1, 1975, over 100 answers had come in; careful—or at least intricate—tabulations were made of all responses.

## Interviews

Goodrich, Joan. Administrative Manager, Publications Department, Metropolitan Museum of Art. February 20 and April 1, 1975.

Rogoff, Anita. Associate Professor, Department of Art, Case Western Reserve University. March 5, 1975.

Rubin, Enid. Assistant Educator, Department of High School Programs, Metropolitan Museum of Art. February 20, 1975.

## Evaluation questionnaire for teachers.

Teachers who received the Metropolitan's Impressionist package also received a questionnaire, which, they were told, would be used to evaluate the usefulness of the materials and help the museum staff improve future cultural curriculum materials. The form noted that although it was not necessary for the respondents to have used the packet before answering the questions, it was ''imperative'' that they review all of the material in the packet or at least refer to each section before making comments. This is a summary version of the evaluation form:

1. Make a brief statement about the quality and/or usefulness of each of following: (*a*) slide presentation; (*b*) lesson plans for elementary level, lesson plans for secondary level; (*c*) dittomaster techniques; (*d*) general format of material presented to teacher (graphics, etc.); (*e*) laminated print; (*f*) overall adequacy of information provided about the artist, his work, his life and culture out of which and for which the art work was created. (Here, teachers were invited to make any additional comments.)

2. Would you recommend this form of instructional material to other teachers?

3. Is this a subject you would ordinarily cover in your current course of studies?

4. How extensive is your art background? Self taught? A few courses? Major field?

5. Are you able to use this knowledge in your current teaching situation? Briefly explain your answer.

6. Would you present more classes in art if you had materials and methods such as these available to you?

7. How many students do you come in contact with each day?

8. What is the average number of students in each of your classes?

9. What areas of the curriculum do you teach? (Check as many as needed). Social studies, art, music, English, language, other (explain).

10. What grade level do you teach?

11. How many years have you been in the field? Under 3, 3–5, 6–8, 9 and over.

12. Do you bring your classes to the [Metropolitan] Museum or do you expect them to visit the museum on their own? Will you and your class be able to visit a museum this year? Where?

# DETROIT INSTITUTE OF ARTS CURRICULUM PROJECT: ARCHITECTURE AND THE VISUAL ARTS IN EARLY AMERICA

Detroit Institute of Arts
5200 Woodward Avenue
Detroit, Michigan 48202

**An attempt by a major art museum to develop curriculum-related materials for classroom use on a national scale. Still in the test stage, the project tries to deal with basic questions of conceptual versus art historical approach, with the help of a regional education laboratory and a national foundation. CMEVA interviews and observations: September, December 1973; January, July 1974; January 1975.**

## Some Facts About the Program

**Title:** A Teacher's Resource for Art and Social Studies.

**Audience:** Designed for a national audience of elementary and secondary teachers of American history, social studies, and art. Three units so far completed are directed at teachers of upper-elementary grades 5 and 6.

**Objective:** To help the teacher, and through the teacher the student, to recognize that art is an essential element of social studies,

and to provide curriculum materials that explain and illuminate the visual arts as both historical documents and works of art.

**Funding:** The Detroit Institute pays the salary of a research specialist and of other staff who contribute to the development of curriculum materials; it also pays for all materials. The institute's total expenditures came to about $25,000 through 1974. The JDR 3rd Fund pays for travel expenses of staff working on project and for a consultant's periodic services; its total expenditure through 1974: less than $3,000.

**Staff:** A single research specialist, in steady consultation with institute education staff and in periodic consultation with others, including JDR 3rd Fund staff and CEMREL (Central Midwestern Regional Educational Laboratory) staff.

**Location:** Materials are being tested in several schools in the Detroit area.

**Time:** Project began in fall 1972. By the end of 1974, three subunits were completed and a fourth was under way.

**Information and documentation available from the institution:** None currently available, but requests are welcome.

---

### September 1973

Twenty-one 5th graders follow their homeroom teacher, Mike Goralowski, into a large classroom at Brooklands School in Rochester, Michigan. They have come to meet some visitors from the Detroit Institute of Arts, 30 miles away in a city few of them ever visit. One visitor is Christine Schneider, who has a slide projector, a batch of slides and photographs, and a lesson plan to try out.

The children are shy, but then so is Miss Schneider. It takes a little while for them to feel easy with each other. After the shades are pulled to block out the brilliant September sun, she shows them slides of portraits of people they may have heard of—Martin Luther King, Mahalia Jackson—asks if they have pictures of themselves or of their families, puts on a slide of Gilbert Stuart's Athenaeum portrait of George Washington. Miss Schneider calls it a "friendly" portrait, but the children overcome their shyness enough to disagree: "He looks strict to me." "Not grandfatherly, no ma'am." "Looks as if he doesn't like kids."

Miss Schneider points out other things: the brush strokes, light and dark areas, differences between the way the face and surrounding areas are painted. Critically eyeing the slide, the students observe, "There's more paint here than there." "The artist must have pushed down harder in that spot." "You can even see the brush marks."

On comes a slide of the same portrait on a dollar bill, and the children abandon all reserve: they listen attentively to Miss Schneider's explanation of how the lines make lights or darks, curves or hollows, according to their shape and direction. From money and printing, it is only a step to a discussion of counterfeiting, which absorbs the children, who blink and shift reluctantly when the lights go back on.

### December 1973

Miss Shirley Michelotti's 25 5th graders at Larkshire School in Farmington, Michigan, welcome three visitors from the Detroit Institute, nodding and waving energetically during the teacher's introduction, and briskly return to their work. They are studying money and banking, and the current assignment is to design some money.

In a swift run-through of photographs of American presidents, Miss Michelotti quickly arrives at George Washington on the dollar bill. In rapid succession she shows slides of portraits of Washington by Charles Willson Peale, Rembrandt Peale, Gilbert Stuart, and others—six in all. The children are astonished that they cannot recognize, at least not right away, the familiar portrait on the dollar bill, and small hot debates flare up around the room as children argue over the identity of the sitter.

Turning the lights back on, Miss Michelotti passes out dollar bills and magnifying glasses. Class conversation ranges over counterfeiting, Latin words, Roman numerals, and what such exacting work requires of hand and eye.

### January 1974

The 6th graders in Mrs. Jean Hoyer's class at Henry Haigh School in Dearborn, Michigan, are studying the American Revolution. A volunteer docent from the Detroit Institute, Mrs. Beebe Moss, who had visited the class in late November with material about George Washington, returns on a pale January day to talk with the students about Paul Revere. Her slides feature a postage stamp of Paul Revere and Copley's portrait of Revere interrupted at his work, slides that lead into a discussion of crafts and craftsmen in colonial America. A slide of a print portraying the Boston Massacre prompts a lively class discussion of propaganda and the uses to which art can be put. Slides of buildings and architectural monuments remind the students of Greek and Roman buildings Mrs. Moss had shown on her earlier visit. They anticipate her questions, ask their own, notice details: one points out "ruffles on the bridges," another asks what kind of work Paul Revere's children did.

### The purpose of school visits:
### test, test, and test some more

All three sessions were testing the draft curriculum on American art and architecture prepared by Christine Schneider at the Detroit Institute of Arts. The curriculum is designed to provide the upper-elementary grade teacher with complementary materials for her social studies units. What the institute's project proposes is to help the teacher, and through the teacher the students, recognize that the visual arts are essential elements of social studies and that they can be studied both as historical documents and as works of art. Museum educators, classroom teachers, and volunteer docents have tested the material with hundreds of children in dozens of Detroit-area classrooms.

In most sessions not conducted by professional museum staff, it is an inescapable observation that the work of art as social document wins out over the work as a source of visual pleasure and instruction. Museum staff, recognizing that

most teachers use the curriculum to illustrate social studies, debate the most effective way to introduce visual elements and confidence in teaching them into the teacher's use of the material.

Counterfeiting was one such effort. Miss Schneider justifies it by its appeal to children. Some staff members question it. "Couldn't it be tied in to good versus bad paintings," suggested one, "and let the children decide if the personality of a sitter can really come across in a bad painting?"[1] Some outside observers have judged it off-target and overdeveloped, one noting, "If it is any consolation, there is considerable historical evidence to show that money has a way of leading people astray."

Other observers admire the content of the instructional materials; the Roman numerals, the study of money designs and monetary systems, the new vocabulary, seem to them elements the classroom teacher can connect with the more familiar material of language arts and social studies curricula. This information may not make a teacher more knowledgeable about the visual arts, such admirers concede, but they point out that any teacher continually using these materials may really learn to "see" them.

It is also worth noting that skeptics and admirers alike comment on the high quality of the works of art (and of the slides) Miss Schneider has chosen and on her meticulous research.

The other general and equally unsurprising observation made in dozens of classroom visits is the varying levels of confidence and competence among the teachers. In some schools, teachers welcome the flexibility of slides; in others they say, directly or indirectly, that they prefer the built-in sequence of filmstrips that require little more than manual dexterity. Some teachers are aghast at the amount of material Miss Schneider's curriculum provides; others, like Miss Michelotti, welcome the wealth and variety of material and skillfully pick and choose from it what they want. One art supervisor in another large Midwestern city looked over the curriculum and observed, "There is a wealth of material in this draft. It is a scholarly museum approach, but I believe it 'tells too much about penguins' for the elementary child I know, and it may well be too much for many teachers. I do see it as a valuable curricular aid to secondary students who are blessed with a strong teacher."[2]

Whatever these observations suggest, the act of testing the museum's curriculum materials in the classroom is one distinction of the Detroit Institute's ambitious project. The careful testing and revision of curriculum materials is unusual enough to warrant investigation by other art museums.

### The origin and development of the project

Detroit's curriculum project grew out of a volunteer program called Art to the Schools, supervised by the museum's education staff and designed to take slides, reproductions, and information into 4th, 5th, and 6th grades. Believing that classroom teachers needed greater help in using museums and works of art, Chairman of Education Richard Mühlberger sent a memo to the institute's director setting forth in question-and-answer form his reasons for wanting to begin a teacher-training project. The memo—to which Willis Woods, then director, responded enthusiastically—can be summarized as follows:

- Its purpose: to break down the idea, common among teachers, "that art is a specialist's area."
- Its method: to present materials "as much like standard teaching aids as possible" that each teacher can "use in her own way."
- Its premise: that "we, the museum, must demonstrate the possibilities" of using the museum and its collections.

Mühlberger's original plan was to design materials that Detroit schools could fit into their curricula and to draw on the institute's collections so that schoolchildren could see the original works of art they had been studying. He also intended to aim specifically at the junior and senior high schools nearest the museum, thus balancing the institute's program emphasis on elementary schools and solving the transportation problem that afflicts all public institutions in a city served by endless highway systems and limited public transportation.

### The Detroit project goes national

Such local considerations eventually disappeared from the project, as new ideas were absorbed into it. Many came from the JDR 3rd Fund. Because the fund had long taken an interest in arts in the general curriculum, Mühlberger talked with the director of the fund's education program, Kathryn Bloom. Recognizing that they shared many goals—Miss Bloom says she had been trying "for years" to interest major art museums in undertaking such a project—they agreed to work together.

Miss Bloom believes that many museums "are trying to solve their educational problems with school visits by doing more of the same—adding more and more lecturers, paid or volunteer, to schedule more and more museum visits." For museums with very active programs, she argues, "more and more is no answer." She adds,

I believe one good alternative is to develop instructional materials based on the curriculum of schools, which then can be made available to all teachers in the entire school system that wish to use them. Some of these teachers may never visit the [museum] with their classes, but they have museum resources in their classrooms. And teachers who come to the [museum], along with their children, should have some useful knowledge as background for the visit.

Further, Miss Bloom believes, instructional materials that emphasize the best example of a work of art available—from any museum, wherever it is—"can be used in any school district," all over the country. She is convinced that "this is the market textbook publishers are interested in."[3]

Consequently, the JDR 3rd Fund proposed some priorities of its own:

- The materials would be developed jointly by school people and museum people to meet clearly perceived classroom needs.
- Those materials should be tested every step of the way in the classroom.
- The schools in which they are tested should spend no more than the average per-pupil cost throughout the nation—between $700 and $800 per year in grades 4–6.
- The material should be designed to serve the "large majority of teachers that do not have access to museums [and] also very limited resources."
- The instructional materials or "packages" should be published by a textbook company and distributed nationally.[4] (See JDR 3rd Fund proposal following this report.)

Once the institute and the JDR 3rd Fund staffs pooled their priorities, the project began. The institute hired as curator-researcher Christine Schneider, a nun (Sisters of St. Joseph) who has taught art and art history for 30 years at every level from elementary school through college. The institute approached two Detroit schools already participating in Art to the Schools and meeting the $700–$800 requirement, as well as one suburban school (chosen because the institute had worked successfully with it for many years) that spends $1,300 per year on each student.[5]

The fund provided a plan, or "road map," to the institute for Miss Schneider's work. Based on an examination of the content of social studies curricula in the middle grades (taken from the University City, Missouri, public schools), the plan reflected some changes in such curricula. Miss Bloom sums up those changes:

> Rather than studying different countries in different grade levels, such as the United States in grade 5 and world civilizations in grade 6 (which was typical ten or twenty years ago), the content of social studies at present is more apt to be organized around central "ideas" or "themes" or "concepts" that are considered important to children's education. Examples include "man and his environment" and "redesigning the city."[6]

Both the museum and the JDR 3rd Fund staffs see the fund's major contribution as that of "catalyst, a source of contacts, credibility, encouragement, and advice," as Richard Mühlberger puts it. The fund has provided very little money to the institute's project, probably less than $3,000, most of it for travel costs and outside consultants' fees. The institute had invested, by the end of 1974, an estimated $25,000, primarily for salaries.

Miss Schneider began working in fall 1972. Drawing on the University City "road map" and on some textbooks used in Detroit city schools (see list following this report), she wrote a text, selected slides, and tested in both city and suburban schools. To her own notes and observations she added evaluations from teachers and volunteers. Then the revision process began.

## A description of the curriculum

Designed to fit into social studies curricula on early America, the first three units dealt with art and architecture of the eighteenth century. Each was titled *Portrait of Early America* and was focused on portraits of Americans who played an important part in colonial life and the Revolution—Washington, Revere, and other heroes—and on the events they took part in, the houses they lived in, the objects they made. Each unit also included slides of related works of art, perhaps from other countries or periods. The divisions of each unit were art appreciation subject matter; cultural background; teacher aids; interdisciplinary integration; creative activities.

About 50 pages of text, bibliography, and suggested follow-up activities, addressed to the classroom teacher, made up each curriculum unit, along with 20 to 25 slides. Thoroughly researched and documented, the text provided abundant art historical information and references to visual detail—indeed, in the judgment of some observers, more than many teachers could find a way to use.

Many arts were covered: engraving (stamps, coins, broadsides, prints); metalwork, from coins and silver teapots to bronze-casting (perhaps the first time Daniel Chester French's *Minute Man* has been looked at as a way to learn about the lost-wax process); architecture, domestic as well as public and military.

Each of the American paintings was presented against a visual background of European art. Grant Wood's *Midnight Ride of Paul Revere* was compared to Flemish towns and landscapes in the backgrounds of paintings by Campin and Roger van der Weyden; Copley's portrait of Paul Revere was compared with Jan van Eyck's portrait of St. Jerome in his study.

Such use of European sources, and accompanying shifts in time, seemed to Miss Schneider a way to organize materials around central themes; to the JDR 3rd Fund staff, this organization seemed art historical rather than related to school curricula. That issue—what sort of organization best served school needs—was the subject of a meeting in summer 1973, the first full-dress presentation of the curriculum project to representatives of the JDR 3rd Fund. The arguments of the fund staff and consultants prevailed.

So the "conceptual" approach is used in Miss Schneider's fourth curriculum unit, under way by the end of 1974, *Private and Public Places*. Much smaller than the first three units, *Private and Public Places* uses slides of about a dozen paintings and provides about 15 pages of information and program suggestions for the classroom teacher. The new booklet is vertical and illustrated, unlike the earlier horizontal typescript. Just as important as the change in scale, scope, and format is the shift in emphasis from the teacher to the student, who is the primary target of this fourth curriculum unit. It is a workbook for the child, aimed at the child's experiences, with extra material for the teacher.

These changes were the direct result of conferences among Detroit Institute staff, JDR 3rd Fund staff and consultants, and representatives of the Central Midwestern Regional Educational Laboratory (CEMREL). At the urging of the fund staff, Schneider and Mühlberger visited CEMREL's St. Louis offices and studied CEMREL's evaluations; these evaluations of the curricular materials and methods CEMREL staff has tested in St. Louis schools document the kind of learning children derive from active work with materials—painting, drawing, design—that relate to works of art they are learning about.

## Where does the project go from here?

As a result of cooperation between the institute and CEMREL staffs, both in St. Louis and in Detroit, and of the efforts of the institute and the JDR 3rd Fund to get the curriculum project into shape for editing and publication, Mühlberger reported that a fruitful relationship has developed between CEMREL and the institute. The fourth curriculum package is indeed taking a different form, building on the experience of the student (as CEMREL has advised) and adding historical material for teachers.

Now the institute must raise $30,000 to do for its curriculum materials what CEMREL and the Asia Society did for the CEMREL instructional unit on the Japanese tea ceremony (see report in this chapter)—to evaluate it in a brainstorming session and come up with ideas for presenting it. *Then* the institute must find $150,000–$200,000 to put the curriculum materials into final shape. Director Frederick Cummings of the Detroit Institute is, like his predecessor, enthusiastic about the project and has undertaken to raise the necessary money. Mühlberger noted that "it's been a great luxury" to have Miss Schneider serve as researcher for two full years without pulling her off the project to do other work.

Although CEMREL staff will advise and help test and design the new curriculum units, it will not publish them. Nor is the institute counting on Viking/Lincoln Center, the publishers of CEMREL's instructional materials, to publish or distribute. It is counting on the JDR 3rd Fund to make contacts with textbook publishers, as it has already made contacts for the institute with consultants and with CEMREL staff, and to take a major role at that point. Kathryn Bloom believes that textbook publishers have access to the schools that art book publishers do not have; because she would like to see national distribution, Miss Bloom is eager to help bring into being a curriculum suitable for a textbook publisher. Her long-range goal for the project is a set of curriculum materials that can be taught at three levels—upper elementary, junior and senior high—and the development of the same kind of spiral curriculum for courses in world civilization.—*A. Z. S.*

## Notes

[1] For sources of quotations without footnote references, see list of interviews at end of this report.

[2] Letter to CMEVA staff, March 21, 1974.

[3] From notes from Kathryn Bloom to CMEVA staff, June 5, 1975.

[4] Taken from interviews and a JDR 3rd Fund memo dated May 1972 (see text following this report).

[5] Chrysler School, Detroit: $768 from the Detroit Board of Education, $186 in state or federal assistance; Martin Luther King School, Detroit: $573 from the Detroit Board of Education, $74 in state or federal assistance; Larkshire School, Farmington: $1,341 from the Farmington Board of Education. Each of the Detroit schools had been in the Art to the Schools program for three years, Larkshire for four years. Chrysler is an integrated school, serving a downtown area that includes some high-rise apartments. King serves a poor black neighborhood. Larkshire serves a suburb, many of whose residents are characterized by museum staff as "transient," largely white; the school has some black students.

[6] From Kathryn Bloom to CMEVA staff, June 5, 1975.

## Interviews and observations

Bazirium, Ted. Principal, Henry Haigh School, Dearborn, Michigan. January 24, 1974.

Bloom, Kathryn. Director, Arts in Education Program, JDR 3rd Fund. September 18, 1973; telephone, July 1, 1974.

Bowen, Esther. Principal, Brooklands School, Rochester, Michigan. September 24, 1973.

Cummings, Frederick J. Director, Detroit Institute of Arts. September 24, 1973.

Curtis, Kyra. Department of Education, Detroit Institute of Arts. September 24, 1973; January 24, 1974.

Downs, Linda. Assistant Curator, Department of Education, Detroit Institute of Arts. September 24, 1973.

Featherstone, Lois. Volunteer, Art to the Schools, Detroit Institute of Arts. September 24, 1973.

Freyermuth, D. Rae. 5th-Grade Teacher, Larkshire School, Farmington, Michigan. December 5, 1973.

Goralowski, Mike. 5th-Grade Teacher, Brooklands School, Rochester, Michigan. September 24, 1973.

Hausman, Jerome. Consultant, JDR 3rd Fund. January 24, 1974; January 24, 1975.

Hoyer, Jean. 6th-Grade Teacher, Henry Haigh School, Dearborn, Michigan. January 24, 1974.

Hunter, John. Department of Education, Detroit Institute of Arts. September 24, 1973; January 24, 1974.

Lanigan, J. Allen. Principal, Larkshire School, Farmington, Michigan. December 5, 1973.

McPeek, Juanita. 5th-Grade Teacher, Brooklands School, Rochester, Michigan. September 24, 1973.

Michelotti, Shirley. 5th-Grade Teacher, Larkshire School, Farmington, Michigan. December 5, 1973.

Moss, Beebe. Volunteer, Art to the Schools, Detroit Institute of Arts. January 24, 1974.

Mühlberger, Richard C. Chairman of Education, Detroit Institute of Arts. September 24, December 5, 1973; January 23, 1974; January 8, 1975.

Schneider, Christine. Department of Education, Detroit Institute of Arts. September 24, December 5, 1973; January 24, 1974; January 8, 1975.

Schwartz, Nita. Department of Education, Detroit Institute of Arts. January 24, 1974.

Students at Brooklands, Larkshire, and Haigh schools.

Timmins, M.A. Director, Media Center, Larkshire School, Farmington, Michigan. December 5, 1973.

## Social studies texts used in preparation of instructional materials.

1. *At Home around the World*, Ginn.
2. *Backgrounds of American Freedom*, Macmillan.
3. *Asking about the U.S.A. and Its Neighbors*, American Book.
4. *Many Peoples, One Country*, Ginn.
5. *The Social Sciences: Concepts and Values*, Harcourt Brace Jovanovich.
6. *Eurasia, Africa and Australia*, Ginn.
7. *United States, Canada, and Latin America*, Ginn.
8. *American History for Today*, Ginn.

## A JDR 3rd Fund proposal for the development of instructional materials: "A Project to Develop and Publish Instructional Materials in the Visual Arts for Use by Teachers in the Schools."

During the past several years a number of projects have been supported by the Arts in Education Program of the JDR 3rd Fund which are directed toward the objective of making all of the arts an integral part of the general education of every child, and the progress made demonstrates that this objective can be reached. In addition to being incorporated into the ongoing programs of the schools where they are taking place, the plans and procedures which have emerged in the pilot projects are serving as examples for the development of similar programs by an increasing number of school systems that consider "the arts for every child" an important educational goal.

Most of the projects supported by the Fund, and several others that are moving in similar directions, are comprehensive plans that affect many aspects of the schools in which they are located. The experience and knowledge they provide has helped to identify several priorities for intensive developmental work to assure quality in teaching and learning.

One such priority is the need for instructional materials which can be used by classroom teachers. At present most teaching and learning in the visual arts involves children in drawing, painting, and crafts. This experience is highly desirable, but other aspects of learning are virtually ignored—learning to look at, understand, and enjoy works of art, and to see them as creative and expressive documents from their own times. There ought to be a way, then, to make available to schoolteachers certain basic and substantive ideas about the visual arts which can be used imaginatively in classrooms with children. A number of museum educational programs provide services of this nature to school systems, but the large majority of teachers that do not have access to museums also have very limited resources to rely upon.

The project to develop instructional materials for teachers incorporates the following elements:

1. It draws upon a wide range of visual materials which are available, mainly as a result of museum education and publication programs, but which are largely inaccessible to schools and in a form which teachers do not know how to use.

2. Selected materials, which may include slides, reproductions, films and film strips, are being put into a form which will make them accessible to schools. Content is being planned so that it will be immediately useful to classroom teachers in making connections between the visual arts and history, social studies, and/or literature. School personnel, as well as museum people, are involved in this task.

3. It is expected that the instructional materials, or "packages," will be published and distributed by a textbook publisher that is well established in serving the schools nationally.

## The National Gallery of Art's Evaluation of the Extension Service

The National Gallery of Art
Constitution Avenue at 6th Street
Washington, D. C. 20565

For many years the National Gallery of Art, through its extension service, has provided films and slide-lectures on its collection to schools across the country. These films and slide-lectures are available at no cost except for return postage and insurance (for a $25 valuation). In August 1974 a new department, extension program development, was established to assess and revamp the service's instructional materials.

Thirty-seven slide-lecture kits (containing slides, 12-inch record, and text) and 14 films in the service's catalog—some twenty years old, most about ten years old, few newer than that—were assessed by extension program development staff and client-users. For museum educators working on similar projects, the staff's detailed analysis of these materials and their use is provocative. Briefly summarized, the staff found that

1. There was no correlation between the quality of programs and

their popularity; titles rather than quality "sold" the packages.

2. Films ranked higher than slide-lectures in popularity with clients.

3. Records seem less desirable than tapes or cassettes.

4. The titles of the most frequently booked programs suggest they are suitable for young children.

Joseph Reis, head of extension program development, concludes that titles are just about all a client can go by and that the client cannot judge the quality until he has used the material, when it is already too late.* For example, the four most widely used films could be characterized as general introductory programs: *The American Vision, Time Enough to See a World, Art in the Western World,* and *A Gallery of Children*. The last was ranked next to the bottom by users, who had been attracted by its title and had been disappointed in the film. The same discrepancy plagued the slide-lectures: the most popular, *Introduction to Understanding Art*, was ranked lowest on the quality scale by the extension program staff and thirty-first out of thirty-seven by client-users.

The program's new slide-lecture packages, primarily for elemen-

Several characteristics differentiate this project from a number of publishing programs which originate in museums. First, the content of the instructional materials grows out of a collaborative effort between museum people and school personnel including teachers and curriculum specialists, and is designed to meet clearly perceived needs in the classroom.

Second, after the general idea of content is formulated, the "package" is tried out by the writer in a classroom with children. If it shows promise, it is further developed by the writer and, in turn, tried out by teachers with children. If this trial works, the package then undergoes a final revision which incorporates ideas and methods of presentation suggested by the teachers to improve its usefulness.

Third, the instructional materials are targeted for particular grade levels. The initial work being done centers on the United States from colonial times to the present, which is taught in the 4th, 5th, or 6th grade in every school. A logical projection of this plan would be concerned with a different set of approaches appropriate to the junior and senior high levels, where the United States again becomes a major topic of study. Like the United States, the study of world civilizations usually receives major emphasis at three levels: the middle grades, the junior high, and the senior high. A long-range goal is a series of packages designed for use at six levels from the 4th through the 12th grades.

We feel that this plan can be managed well within a two- or three-year time period and produce a specified set of carefully conceived and tested teaching materials that would be ready for commercial publication and distribution. The Fund would expect to establish a brokerage function for several purposes: to further refine and develop the long-range plan; to contract for services to develop the teaching materials; to identify the schools and individuals from public education whose cooperation is needed in the developmental task and for the try-out of ideas and packages; and to find ways to work with textbook publishers that have access to the schools and, particularly, teachers.—Kathryn Bloom, May, 1972.

# CENTRAL MIDWESTERN REGIONAL EDUCATIONAL LABORATORY (CEMREL) AESTHETIC EDUCATION PROGRAM

CEMREL, Inc.
3120 59th Street
St. Louis, Missouri 63139

**A national education laboratory develops elaborate curriculum packages to provide aesthetic education to children and teachers across the country. The underlying philosophy: aesthetics should be part of every child's basic education. The laboratory also supports teacher training in existing programs and eight affiliated "learning centers." CMEVA interviews and observations: April, May 1973; July 1974; January, March, May, August 1975.**

## Some Facts About the Program

**Title:** Aesthetic Education Program.

**Audience:** Students, teachers, and administrators in more than 40 states and 200 school systems.

**Objective:** To produce, test, and disseminate a set of curriculum resources for elementary and intermediate public schools and to design appropriate teacher-education programs; "to enable a pupil to respond more fully to aesthetic qualities in both his man-made and natural environments."

**Funding:** Operating budget (1974), $1,420,901, of which 99.1 percent comes from the National Institute of Education, the rest from other sources such as grants for development of specific packages. Kits are sold to schools: prices run from $15 to over $90.

**Staff:** 53 in St. Louis. Number of consultants varies.

**Location:** Packages are developed at CEMREL headquarters in St. Louis and used in schools around the country.

**Time:** Program began in 1967.

---

tary grades, contain cassettes rather than records and are designed to be mass-produced—the only way, Reis is convinced, to get high technical quality. (The old packages were made in units of 200; Reis argues that 1,000 is the minimum for mass production.) At this writing, he is working to establish a consortium of museums to cooperate in developing and distributing instructional materials. He believes it could serve as a clearinghouse, avoid duplication, and be an agent for the mass production and national sale of instructional materials for arts and humanities subject matter.

Another major national educational program of the museum, developed in cooperation with Scholastic Magazines, is a curriculum package for secondary schools called *Art and Man*. Conceived as a way to help junior and senior high school students and teachers "bring the arts into English, social studies, art, and humanities classes," the package organizes each unit around a central theme in art and literature.

Until 1974/75, each unit, of which there have been six during an academic year (October, November, December–January, February, March, and April–May), consisted of a 16-page student magazine, containing anywhere from 18 to 26 full-color reproductions or details; a 12-page teacher's guide without color plates but

with suggestions for discussion and follow-up activities; facsimile reproductions; color slides; 10-inch records; and audio filmstrips. "We did a very concentrated and extensive telephone survey of major subscribers," reports Margaret Howlett, editor of *Art and Man*, "and the consensus was that they would prefer to drop the filmstrip, rather than having to pay more for the entire package." The new package thus contains only the magazine and teacher's guide.

*Art and Man* was first published in 1970. By 1973/74 it had reached 4,935 classrooms (a circulation of about 150,000 copies of the magazine) at a yearly subscription cost between $2 and $3 per student, depending on the number ordered; a teacher's guide is free with 20 student subscriptions. The package is distributed directly to classroom teachers, who may sample the first issue and the teacher's guide before subscribing.—*A. Z. S.*

---

*Quotations and other information in this report are based mainly on interviews on January 22, 1975, with Reis, Ruth Perlin, and Laura Schneider of the extension program development staff; on correspondence with Margaret Howlett, editor of Scholastic Magazines; and on documents provided by the museum.

**Information and documentation available from the institution:**
Brochures, newsletters, catalog, publications, bibliography, and
complete information packets.

Many educators have yearned to cut the time and red tape that
separate educational research from educational practice. The
Cooperative Research Act of 1965, amended by the Elementary and Secondary Education Act, established several regional education research centers to try to accomplish just
that. The center in St. Louis, one of the few to survive the
drastic federal budget cuts in 1972, is now nationally known
by its acronym, CEMREL—Central Midwestern Regional
Educational Laboratory. CEMREL staff work in math,
reading, science, and a dozen other school subjects, but
CEMREL's major interest for art and museum educators is
its Aesthetic Education Program.

**The Aesthetic Education Program (AEP).** The program
began in 1967 under the joint auspices of CEMREL and the
Arts and Humanities Division of the U.S. Office of Education. By 1975 it was "the largest development project in the
arts currently funded by HEW [the Department of Health,
Education and Welfare]."[1] CEMREL's Aesthetic Education
Program has attracted wide publicity with its ample budget
($1,420,901 in 1974, over 99 percent of it from the National
Institute of Education), large staff (53 at CEMREL headquarters in St. Louis, plus consultants around the country), and
traveling exhibition, "The Five Sense Store," described by
CEMREL as a "hands-on exhibit which introduces adults
and children to the joy of learning and the nature of aesthetic
education."[2]

Anyone who has ever tried to describe aesthetic experiences (Emily Dickinson, at least, was graphic when she explained how she could tell she was reading real poetry: "If I
feel . . . as if the top of my head were taken off")[3] will
sympathize with CEMREL's efforts to describe aesthetic experiences and aesthetic education. Few of CEMREL's written statements get closer than this one: "The aesthetic experience comes from the fact that the object or happening exists
and that the person feels his life is richer because it
exists"[4]—a definition that Miss Dickinson, for one, would
hardly have found a spine-tingler.

All the money, staff, promotion, and information that have
been poured into CEMREL's Aesthetic Education Program
are intended to achieve one primary goal: to get an aesthetic
education curriculum into America's schools. Bernard
Rosenblatt, the program's associate director, believes that an
aesthetic education curriculum should be as distinctive and
comprehensive as a curriculum in math, social studies, or any
other subject, and that it should teach the *arts as arts*—on
what he calls "a parity basis" with other subjects—in addition to "using the arts to teach about other things."
Rosenblatt says, "When you *use* the arts to teach other subjects, you're *not* teaching the arts. Whatever else the arts may
be *used* for, the *intent* of AEP is to make the arts the *content*
of an aesthetic education curriculum." He believes that such
a separate curriculum *can* be a rich resource to other curricula
and that "the arts can link up with other academic subjects
and with everyday life" by providing aesthetic experiences
to schoolchildren and their teachers, and by helping them
understand those experiences so they can make aesthetic decisions in everything they do.[5] CEMREL staff realistically
see their AEP units also as complements or supplements
to existing school arts programs, but the separate distinctive aesthetic education curriculum remains their primary
goal.

Stanley S. Madeja, director of the Aesthetic Education
Program, draws an analogy between aesthetic education and
general science. He believes the arts should be taught as an
area of study to all children throughout elementary school
and speculates that the "general" study might stop about 7th
or 8th grade, to be replaced at that level by individual disciplines such as dance, theater, visual arts, and music. One of
CEMREL's major campaigns is to make the arts and aesthetic
experiences part of the education of *all* children at *all* grade
levels. Madeja feels there is no need to search for a justification of aesthetic education, no need to use the arts to "enrich" social studies or some other subject; on the contrary, he
says, "the human capacities which the arts enlarge and
satisfy"—seeing, listening, feeling—"are not now being
trained in American schools," and as a result, "we don't
have enough people socially conscious of the aesthetics of
our culture."

So CEMREL's Aesthetic Education Program is trying to
make everybody—at least in the schools it can get into—
conscious of aesthetics. Its primary purpose is *not* to train
future artists or to identify gifted students but to train what at
least one CEMREL staff member has called "whole people"
and "informed citizens." A high-ranking CEMREL official
has observed that the curriculum packages are aimed at all
children and all classroom teachers and are geared to average
levels of ability and interest. Like many other arts educators,
he distinguishes this approach from arts programs in societies
with what he calls "a higher aesthetic consciousness," like
Japan and Germany; and like many other American arts
educators, he notes that those countries present models "inconsistent with . . . American education goals," specifically
"rigor" in training and "a smaller group" to be trained.

AEP tries to make the average child conscious of aesthetics
by offering him the chance to do and make art. The educational premise is that experience and activity are the best
ways to learn to understand and judge the arts. "We want
kids to value, to react, to analyze, to perceive, to evaluate, to
see a thing, to do it," said a former CEMREL staffer, who
observed that the program's emphasis on experience has
been tied to a philosophy that "backed away from 'high
art.'" It is a posture that Madeja and Rosenblatt deny.

## From premise to practice: AEP curriculum packages

To introduce aesthetic education into schools CEMREL has put together a series of packages that its catalog describes as "self-contained teaching unit[s] offering ten to fifteen hours of classroom instruction."[6] The packages are designed to teach concepts and languages of the arts. Each package deals with one element of art or with relationships between elements, and most are carefully organized to present information and experiences in a particular order—what educators call "sequencing." Those individual units which are heavily sequential deal with subject matter that, in CEMREL's staff judgment, *require* step-by-step structure, like the Japan unit described later in this report. Whether units are strictly sequential "depends on the concepts to be learned, the age level of the learner, the kinds of . . . activities . . . consultation with content and pedagogical experts,"[7] according to Bernard Rosenblatt. Although individual units may be sequential, the whole cycle of units is not.

The reason why a package usually concentrates on one element or on relationships between elements within an art—such as character and plot in literature, shape and shapes-and-patterns in the visual arts, or sounds and silences in music—is that the AEP staff is wary of "integrated" arts curricula. Arts curricula based on the similarities among the arts, a fairly common approach now in art education, "could be based on erroneous connectors, sometimes used due to oversimplification," says Rosenblatt, though he believes "there are justifiable ways to relate the arts and not lose the integrity of the art forms," and cites a CEMREL package, *Centers of Attention*.

AEP packages come in large, sturdy, glossy boxes, covered with striking graphics and containing materials, instructions, and equipment. They arouse the extremes of either admiration or hostility in teachers, artists, and museum educators. Admirers agree with CEMREL staff that the packages are well thought out and organized to provide nearly everything a teacher could need or want to teach about an art form. Critics find the packages "appallingly mechanical" or a "cumbersome" way to teach art; one teacher of teachers says, "they take away the one thing a teacher values most: initiative."

About 200 school systems had tried some CEMREL packages by 1975. Though many parts of individual packages can be reused, the curriculum can be a substantial investment for a school. The least expensive student packages cost $15 for a six-student set; they go up to $75 for a set containing small cameras, and over $90 for one containing magnetic tapes, reels, and splicing equipment. Teacher packages are priced anywhere from $4.95 for a simple written guide to $130 for the materials that accompany the most expensive student package, *Arranging Sounds with Magnetic Tapes*.[8]

## AEP packages in the classroom

Though the teacher packages are designed (often by artist-educators) for the elementary classroom teacher with no special skill, knowledge, or interest in the arts, they are used by arts specialists, too, often to demonstrate the packages to the classroom teacher.

Like almost all classroom materials, the CEMREL packages may offer sound, well-designed programs and introduce useful new educational ideas—but once out in the wide, unpredictable world of the average schoolroom, they are almost totally at the mercy of the teacher who presents them. Watching even an arts specialist in a school in the heart of CEMREL-land, University City, Missouri, use the package called *Examining Point of View* with a dozen or so 6th graders was not, at least for two observers in the spring of 1973, a cheering experience. As she read the text aloud, the specialist paused to point out perspectives and camera angles with a viewfinder, to introduce some new works, and to encourage the students to use the package's Simplex Snapper cameras to take pictures of their own. The classroom teacher sat for a time with her visiting observers, excused herself, and then returned to the classroom to resume the academic work the arts specialist had interrupted.

Later, another classroom teacher in that same University City school talked about the package titled *Constructing Dramatic Plot*, which introduces through games the basic elements of plot structure, character, setting, incident, conflict, crisis, and resolution. Asked how she applies the lessons of the package to her literature classes, she expressed surprise: "Oh, I don't," she explained. "*This* is for the aesthetic education class."

Other visitors to the same school system have had better luck. One is Charles Mark, editor of the Arts Reporting Service, who writes of being told by a 5th-grade class that it had done about 20 plays in the three months it had been using the dramatic plot package; he was especially impressed by the students' easy use of theater vocabulary—"conflict, crisis, resolution"—and by the close attention they paid to one another's performances. He says he "didn't talk to one doubtful individual, adult or child, but I did talk to kids who could not tell me about their work in the arts because they didn't know where art began and 'ordinary' schooling stopped. They simply accepted all the arts as part of history, social studies, or language studies."[9]

## How an aesthetic education curriculum package is developed

Specialists in various art fields work with CEMREL writers and researchers to "brainstorm" the subject of a package, to determine what teachers need to know, how to present materials to teacher and student and in what sequence, and what kind of equipment to include. Testing the kit in its experimental version begins in a "hothouse" school, with a teacher and

students who have never before used CEMREL's AEP materials and with a curriculum developer and evaluator present "taking notes and observing how the materials work with children at average reading levels."[10] After review, discussion, and revision (including ideas and approaches suggested by the classroom teacher), the materials are pilot-tested in schools with students of varying socioeconomic backgrounds, whose teachers work alone. To assess the unit's effectiveness at this stage, the classroom teachers keep journals to report on their own and their students' responses to the package; students are tested and their "products" evaluated; and CEMREL evaluators interview teachers.

An example of a recent package, one that incorporates some "high art" in a departure from original practice, is titled *Japan: An Approach to Aesthetics*. Developed by the Aesthetic Education Program staff with the cooperation of the Asia Society and supported by a grant of about $30,000 from the JDR 3rd Fund, the package takes as its primary purpose to introduce into the ordinary American classroom some basic Japanese aesthetic principles. It focuses on three: preservation of natural qualities, simplicity, and asymmetry. Each principle expresses an aspect of the central concept of Japanese aesthetics, which is, according to the package, "that people are a part of nature and, therefore, should love and respect the natural world."[11] Calligraphy, landscape gardening, flower arranging, pottery, and other Japanese arts are included; most are related to the tea ceremony, which is presented as the central aesthetic experience. A museum curator of Far Eastern art calls the tea ceremony "an aesthetic education almost unequaled in its directness and subtlety" and "excellent" for teaching about Japan; but after studying the package (without seeing it used in a classroom), he commented that "the tea ceremony is far less useful as a means of enlarging the capacities of American kids," which is CEMREL's goal for all of its packages. On the other hand, a museum educator who concentrates on Far Eastern art admired the unit as a possible preparation for a class visit to a museum—and observed with keen disappointment that such a follow-up or enrichment activity is not suggested to the classroom teacher anywhere in CEMREL's Japan curriculum.

How the Japanese unit—which is designed for 4th, 5th, and 6th grades—was developed demonstrates CEMREL's system. Work began in February 1973 with a preliminary investigation of goals and topics by a CEMREL writer and a research assistant with a background in Asian studies hired for the project. Throughout the spring and summer of 1973, CEMREL staff met with Asia Society executives, consultants, and funders, and Asian scholars, including the directors of the Asia House Gallery in New York and of the Freer Gallery in Washington, D.C. By October 1973 the elaborate experimental package was ready to be tested in schools.[12] Revisions, analyses, and evaluations took most of the 1973/74 year, and in June 1974 the final evaluation report,

incorporating suggestions from teachers and observers, was submitted and accepted. In the summer of 1975 CEMREL was looking for a publisher to make the kit nationally available. (The Viking Press and Lincoln Center for the Performing Arts jointly publish most of the CEMREL kits, in what Stan Madeja calls a "high-risk" publishing venture; 50 percent of the royalties go to CEMREL, 50 percent back to the federal government.)[13]

The observations in the evaluation report on the Japan package clearly illustrate that program's emphasis on structured presentation of materials. CEMREL staff argue that structured sequential learning is central to certain ideas in the Japan package—such as the correct way to do calligraphy. They point out that such rigidity is not used in all CEMREL packages but only "where appropriate." Writing about the presentation in the classrooms where the package was pilot-tested, an evaluator reported,

. . .Problems occurred only when the teacher did not follow [the objectives, classroom management strategies, and teaching procedures outlined], when he or she omitted doing the practice exercises, did not read instructions aloud with the children or followed a laissez-faire approach to conducting the activities. For the activities in this package to be successful the teacher must structure them very closely. For example, he or she must lead the whole class through one exercise at a time and critically monitor the process and results before proceeding to the next exercise. . . .[14]

The evaluator recommended to the writers of the package that detailed instructions be given to teachers:

The suggestion . . . that the teacher act as calligraphy master should be inserted . . . and the role made explicit to the students. For example, if the students are accustomed to working more independently, the teacher should explain the change in approach by saying something like the following: "Today we are going to find out what it would be like to learn calligraphy in Japan. We are going to do these activities as if we were in a Japanese classroom. I will be the calligraphy master . . . and I am going to be very strict about the way you sit and hold your brushes and make your words."[15]

Other recommendations by the evaluator also reflected the philosophy that teachers need to be guided in all aspects of the classroom management and instruction while using the package:

Some examples of student-teacher dialogue [should be included in the Guide to] help teachers to be more effective critics of the children's efforts. . . . Emphasize to the teacher that classroom trials of the ink painting activities have shown that they are much more successful when structured and timed as outlined in procedures 4 and 5. . . . Many if not most teachers will need to have the "hints about how certain brush strokes can be used to do an exercise" spelled out.[16]

## Assessments and questions raised by educators, in and out of museums

A number of museum educators have noted, as did Richard Mühlberger, chairman of education at the Detroit Institute of Arts, that "the bulk of CEMREL's materials stop just short of application of the aesthetic principles to the fine arts."[17] Unlike some museum people who recoil from CEMREL's highly structured packages, finding them "over-designed" or "too rigid" or "flashy," Mühlberger suggested that the institute use and test the Aesthetic Education Program packages in its galleries, in the hope that the materials might prove to be "connectors between the student and the art object."[18] (At last report, Detroit was trying to locate funds for that test.)

A former evaluation consultant to CEMREL, Donald Jack Davis of North Texas State University, admires CEMREL's "very sound goals" derived from scholarly research,[19] but has some reservations: "My greatest concern is how they arrived at the package—the process as well as the content of the packages." He notes that certain elements of art (texture and shape, for instance) are used, whereas others (like color) are omitted; he believes these choices were sometimes dictated by editorial rather than educational considerations and fears that "a child who went through that curriculum might think these are the only elements of art."

Like many other educators, especially teachers of teachers, Davis questions the idea of any package designed for the untrained teacher: "I'm not certain anyone will ever make the kinds of curriculum [materials] that untrained teachers can use." Although agreeing that CEMREL's workshops and demonstrations are useful for the schools buying the aesthetic education packages, Davis cautions that "workshops don't solve the problem of training."

## Teacher training in aesthetic education

CEMREL staff members agree that training teachers is an essential part of the job of introducing aesthetic education into schools. During 1974 and 1975 CEMREL sponsored eight Aesthetic Education Learning Centers around the country, each cosponsored by "two or more organizations—public school districts, colleges and universities, and other education and arts departments and institutions."[20] CEMREL prefers to cooperate with existing teacher-education programs rather than to supervise or take responsibility for these centers; it sees its own role as evaluating, implementing, and providing curriculum materials.[21]

As Stan Madeja has written,

CEMREL's Aesthetic Education Program has been concerned with the development of an analogous and complementary teacher education program. However, the laboratory's main thrust is in the development of products, whether these be ideas or materials. Thus the laboratory did not expect it could or should carry on massive teacher training without the assistance of existing agencies and institutions now engaged in the process. . . . [The] laboratory was willing to accept the responsibility for orienting or familiarizing these other organizations with the information needed to implement [teacher-education] programs.[22]

Madeja has further observed, "What's really funny is it's difficult to get money for training, harder than for products."

One learning center is in Harrisburg, Pennsylvania, under the auspices of the Arts and Humanities Division of the State Department of Education. As the first, and still, in 1975, the only, state to embark on an extensive use of the Aesthetic Education Program—40 Pennsylvania school districts in 1974/75 were using AEP packages—Pennsylvania's experience in training its teachers to use the curriculum packages may be instructive to other school and museum educators.[23]

Bill Thompson, director of Pennsylvania's Aesthetic Education Program, believes the CEMREL packages are a good way to get "teachers and students on their feet" and started on the road to imaginative teaching of aesthetics, but only as a start, a "first step." He says the "low-confidence, low-competence teacher" can respond to the packages in one of three ways: quit altogether; learn to use them on a routine basis and just "stay with them"; or make the leap—what Thompson calls the "eureka moment"—to individual creativity. He admits that the packages are heavily "linear" (that is, great emphasis is placed on the order in which the materials in the package are used), but insists that the goal is "to free teachers to their own creativity; if they don't move beyond the first step, if all you see in a school is teachers using the CEMREL shapes, for instance, then it's a failure." He mournfully describes a classroom event he considers such a failure: a teacher putting the CEMREL shapes on the board and urging the children to look at them; a child in her class "looked up at the ceiling and saw a biomorphic shape and said, 'There's a shape up there, there's a shape,' and the teacher answered, 'No, *these* are shapes, that's not a shape.'"

Thompson believes, as he says, that "the program doesn't work for anybody unless you get them a lot of reinforcement," so Pennsylvania has embarked on an extensive workshop project. According to Clyde McGeary, director of art education, the state board of education quickly found that the aesthetic education packages, which might be used enthusiastically at first, were "dying on the vine" without a teacher-reinforcement program. McGeary says that when Thompson was hired to undertake teacher workshops—not necessarily related to CEMREL packages but designed to help teachers to integrate aesthetic ideas, including AEP ideas, into their curricula—the program "perked up again." (In addition to conducting the workshops, Thompson's office puts out a newsletter for teachers, called *The Arts File*.)

And how do McGeary and Thompson assess teachers' responses to the packages? McGeary reports that art teachers

are often negative, "because they feel they can do better" than the CEMREL boxes. Thompson believes that classroom teachers, on the other hand, generally find them helpful and points out that it is "very easy for people in the know to lose touch with people who aren't," for art teachers (in schools or museums) to forget that classroom teachers often feel inadequate to teach art or aesthetics. For those teachers, the packages do a useful job, Thompson says. But he and McGeary agree that sophisticated teachers quickly "transcend" the packages. Both men seem satisfied with the CEMREL Aesthetic Education Program packages as a first step. "We have found CEMREL helps," McGeary says, "but we have also found it cannot be the whole diet."
—*A. Z. S.*

## Notes

[1] Carkhum, Jacki. "The Five Sense Store—A Curriculum for Aesthetic Education," *Children Today*, March/April, 1975, pp. 15–16.

[2] "Our Bag" #2, CEMREL publication, spring 1975. First shown in April 1973 at the National Collection of Fine Arts in Washington, the exhibition is now touring the United States and Canada through the Smithsonian Institution Traveling Exhibition Service.

[3] The entire passage is quoted in *Life and Letters of Emily Dickinson*, by Martha Gilbert Dickinson Bianchi, and goes like this: "If I read a book and it makes my whole body so cold no fire can ever warm me, I know that is poetry. If I feel physically as if the top of my head were taken off, I know that is poetry. These are the only ways I know it. Is there any other way?"

[4] "Our Bag."

[5] For sources of quotations without footnote references, see list of interviews at the end of this report.

[6] *The Five Sense Store—The Aesthetic Education Program*, CEMREL catalog, copublished by the Viking Press and Lincoln Center for the Performing Arts, 1975, p. 3.

[7] Letter to CMEVA, November 3, 1975.

[8] Further information on packages is available from Education Sales Department, The Viking Press, 525 Madison Avenue, New York, New York 10022. The 12 sets available in the spring of 1975 were *Creating Characterization*; *Constructing Dramatic Plot*; *Creating Word Pictures*; *Examining Point of View*; *Rhythm/Meter*; *Relating Sound and Movement*; *Shape*; *Shape Relationships*; *Shapes and Patterns*; *Tone Color*; *Arranging Sound with Magnetic Tapes*; and *Texture*.

[9] Charles Mark, "All the Arts for Every Child Revisited," *Arts Reporting Service*, March 15, 1974, p. 3.

[10] Carkhum, "Five Sense Store," p. 18.

[11] *Japan: An Approach to Aesthetics*. Teacher Guide, Pilot Test Version, October 24, 1973, p. 1.

[12] The experimental package contained one teacher guide; 30 student books, *The Way of Nature and Art*; 30 student books on the tea ceremony, *Cha-no-yo*; 30 cards explaining the "Role of the Guest"; one slide-tape presentation including 132 slides in a Carousel tray and one reel of taped sound track which includes spoken Japanese vocabulary from the package; one film on the tea ceremony, titled "Cha-no-yo: The Role of the Host," with one reel of taped soundtrack for the film; a sound-vision synchronizer; a manual explaining how to use the synchronizer; 2 straw mats (or one double mat); a door frame; a *tokonoma*; 15 cardboard boxes (to make 30 trays for miniature landscapes); 30 pounds of sand; 30 plastic forks; lichen; 4 packages white paper, 8½" x 11"; one package white paper, 12" x 18"; 3 quarts of black ink; 26 brushes; 30 small jars for ink, with lids; 30 paper saucer palettes; one set of 5 cards demonstrating ink techniques; 3 jars of rubber cement; 2 rolls of tape; one roll of brown paper; one ball of twine; 12 dowels; 10 packages of clay; 30 wooden bases; 30 popsicle sticks for modeling tools; 3 cutting tools, 8 *ikebana* slides; one roll of florist tape; one roll of florist clay; 8 florist frogs; 2 cans of tea; one set of cha-no-yo utensils, including tea bowl (one set includes 2 tea bowls), used-water jar, fresh-water jar with lid, ladle, scoop, whisk, caddy, white cloth, colored cloth.

*Necessary materials not included with the package:* Carousel slide projector; reel-to-reel tape recorder; 16-mm film projector; screen (or blank wall); 60 paper cups (or more) for water, or 30 reusable water containers; rulers; pencils; scissors, construction paper; plants, flowers, branches (to be gathered by teacher or students); rocks (about 9 per student to be gathered by teacher or students); bucket (to hold *ikebana* plants in water); soda bottles, plates or shallow dishes, one for each *ikebana* arrangement; paper (such as newspaper) to cover work area; equipment and supplies for firing and glazing tea bowls (optional).

[13] Carkhum ("Five Sense Store," *Children Today*, p. 18) reported in the spring of 1975 that "materials have been developed and tested in 40 states and 200 school systems," a slight rise from Madeja's 1973 figures of 189 school districts in 38 states; a 1975 information flyer says 10 units available in 1975 were being used in "over 260 school systems."

[14] Hall, Betty, "Report—Japan: An Approach to Aesthetics," experimental version, Aesthetic Education Program/Asia Society (submitted by Stanley S. Madeja and Nadine Meyers), p. 129.

[15] Ibid., p. 33.

[16] Ibid., pp. 28, 47, 41.

[17] Letter to Kathryn Bloom, JDR 3rd Fund.

[18] Ibid.

[19] Barkan, Manuel; Laura H. Chapman; and Evan J. Kern, *Guidelines: Curriculum Development for Aesthetic Education*: (St. Louis: Central Midwestern Regional Educational Laboratory, 1970–ERIC: ED 048274.) Also Manuel Barkan, "Curriculum and the Teaching of Art," *Report of the Commission on Art Education* (Washington, D.C.: National Art Educators Association, 1964).

[20] Carkhum, "Five Sense Store," *Children Today*, p. 18.

[21] Ibid. Bernard Rosenblatt's definition of CEMREL's role in the AELCs includes "offering technical assistance; helping to maintain lines of communication; assisting in bringing various groups together; assisting in designing comprehensive programs for schools; helping to generate and identify various approaches to teacher education" (memo, November 3, 1975).

[22] *Teacher Education for Aesthetic Education: A Progress Report* (St. Ann, Missouri: CEMREL, 1972), p. vii.

[23] Pennsylvania had been working toward an arts curriculum for secondary schools in the mid-1960s, says Clyde McGeary, the state director of arts education, and the department had gradually come to believe that they should begin instead on the elementary

school level. In the late 1960s, Pennsylvania undertook a broad experiment with the CEMREL packages, including nine school districts and three state colleges—Lehigh in arts administration, Penn State in work with art teachers, and Indiana (Pa.) in work with elementary schoolteachers.

## Interviews

Banks, Rose Marie. Coordinator of Social Studies, Black Studies, and Humanities, School District of University City, Mo. April 22, May 11 and 12, 1973.

Bloom, Kathryn. Director, Arts in Education Program, JDR 3rd Fund. July 7, 1974.

Carkhum, Jacki, Assistant Director of Public Information, CEMREL. Telephone, May 20 and 27, 1975.

Davis, Donald Jack. Professor, North Texas State University, Denton, Texas. Telephone, July 1, 1974.

Everitt, John. Executive Director, Arts and Education Council of Greater St. Louis. April 22 and 23, 1973.

Faison, Tracy. Specialist Teacher in Theater and Dance, School District of University City, Mo. April 22, 1973.

Graziano, Sherry. Public Relations, Aesthetic Education Program, CEMREL. April 23, 1973.

Madeja, Stanley S. Director, Aesthetic Education Program, CEMREL. April 23, 1973.

McGeary, Clyde. Director, Arts and Humanities Division, and Director of Art Education, Pennsylvania State Department of Education, Harrisburg, Pa. Telephone, May 28, 1975.

Mühlberger, Richard. Director of Education, Detroit Institute of Arts. January 8, 1975.

Reimer, Bennett. Kulas Professor of Music, Director of Music Education, Case Western Reserve University. March 5, 1975.

Rogoff, Anita. Associate Professor, Department of Art, Case Western Reserve University. March 5, 1975.

Rosenblatt, Bernard. Associate Director, Aesthetic Education Program, CEMREL. September 20, 1975; telephone, November 3, 1975.

Savage, Charles, Jr. Curator of Education, St. Louis Art Museum. April 22, 1973.

Thompson, William. Coordinator, Aesthetic Education Program, Pennsylvania State Department of Education, Harrisburg, Pa. Telephone, May 28, 1975.

Tratter, Lee. Principal, Greensfelder School, School District of University City, Mo. April 22, 1973.

Unruh, Gladys. Assistant to the Superintendent, Curriculum and Instruction, School District of University City, Mo. April 22, 1973.

Vandeventer, Roger. Visual Arts Supervisor, School District of University City, Mo. April 22, 1973.

Williams, Anita. Teacher, Greensfelder School, School District of University City, Mo. April 22, 1973.

## Bibliography

*The Arts File*, newsletter published by the Pennsylvania Aesthetic Education Program. Editor, Bill Thompson.

Carkhum, Jacki. "The Five Sense Store—A Curriculum for Aesthetic Education," *Children Today*, March/April 1975, pp. 15–18.

CEMREL newsletters, vol. 9, no. 1 (Winter 1974); vol. 9, no. 2 (spring 1975).

*The Five Sense Store—The Aesthetic Education Program.* CEMREL catalog copublished by the Viking Press and Lincoln Center for the Performing Arts (1975).

Madeja, Stanley S., and Harry T. Kelly. "A Curriculum Development Model for Aesthetic Education," *Aesthetics and Problems of Education*, ed. Ralph A. Smith (Urbana, Illinois: University of Illinois Press, 1971), pp. 345–356.

Mark, Charles. "All the Arts for Every Child Revisited," *Arts Reporting Service*, March 15, 1974, pp. 2–3.

"Our Bag" #2, a CEMREL information mailer. Spring 1975.

*Teacher Education for Aesthetic Education: A Progress Report.* Report resulting from the 1971 Teacher Education Conference at CEMREL, November 29–December 1. CEMREL, Inc., Aesthetic Education Program, St. Ann, Missouri, 1972.

The following were developed by CEMREL's Aesthetic Education Program for the Asia Society:

Hall, Betty. *Report—Japan: An Approach to Aesthetics.* Experimental version. Aesthetic Education Program/Asia Society. Submitted by Stanley S. Madeja and Nadine Meyers.

*Japan: An Approach to Aesthetics. Teacher Guide.* Pilot Test Version, October 24, 1973.

Tarleton, Bennett, and Ellen Edman. *Cha-no-yo.* Student book on the tea ceremony, experimental version. Designed by Charles Derleth. (Includes cards titled "The Role of the Guest" and "The Role of the Host.")

———. *The Way of Nature and Art.* Student book, experimental version. Designed by Charles Derleth; calligraphy by Martha Hazelton (Gong Shu) and Isao Kawashima.

## MUSEUM OF NEW MEXICO SUITCASE EXHIBITS

The Museum of New Mexico
P. O. Box 2087
Santa Fe, New Mexico 87501

**Artifacts from the Museum of New Mexico's collections, reflecting the state's disparate cultures, both old and modern, travel in trunks to 1st- through 6th-grade classrooms. Accompanying instructional aids suggest ways teachers can use the thematically arranged exhibits to introduce children to regional history and folk art. CMEVA interviews and observations: April, June, and August 1974.**

### Some Facts About the Program

**Title:** Suitcase Exhibits.

**Audience:** Schoolchildren, grades 1–6 (some of the exhibits can be used for grades 7–9). An estimated 5,000 children were served in the 1973/74 school year.

**Objective:** To teach children about the history and culture of the Southwest through the use of original artifacts from the museum collection and supplementary instructional materials.

**Funding:** Several Weatherhead Foundation grants—two to the history division, which began the program, and two to the education division. The amount of the grants: $9,000 (1971), $21,000 (1972), $11,600 (1973), $14,000 (1974). Each of the large kits costs approximately $500; the prop kits, about $250.

**Staff:** Curator-in-charge, assistant curator, researcher, education consultant, 2 research-preparator-designers.
**Location:** Artifacts for the suitcase exhibits are drawn from various divisions of the Museum of New Mexico. As of 1974, suitcases were distributed to classrooms in schools throughout the state from the four regional materials centers of the State Department of Education located in Las Vegas, Albuquerque, Roswell, and Las Cruces.
**Time:** During the school year. The program began in fall 1972.
**Information and documentation available from the institution:** "How to Make Suitcase Exhibits," a slide-tape by Renee Friedman of the American Association for State and Local History; evaluation report on the program by Ann Taylor.

---

The Museum of New Mexico in Santa Fe serves a state of more than 120,000 square miles with a culturally disparate population of about one million persons: 50 percent Anglo, 40 percent Hispanic, and 10 percent Indian. As part of its effort to teach schoolchildren about their own and the other dominant cultures in the state, the staff of the museum's education division has devised several traveling programs that make the rounds of elementary schools.

One of these is a series of suitcase exhibits, trunks constructed as learning kits and packed with artifacts, photographs, vocabulary cards, and suggestions for related classroom programs, all emphasizing regional history and folk art. Most of the larger suitcases, full footlocker size, are multicultural. For example, a cooking kit contains Indian baskets and pots, Spanish ware, and Anglo crocks and butter molds (see photograph 1). The smaller, or prop, exhibits are built around simpler themes such as pottery, weaving, or hats (see photograph 2).

Items for the suitcases, which are constructed by the edu-

cation staff, are borrowed from the fine arts, history, anthropology, folk art, and education divisions of the museum. Each piece is an original and most are old, although some modern objects are included for comparison. No two trunks are identical.

**How the suitcases are used**

The suitcases are delivered to teachers of 1st through 6th grades on a prearranged basis, usually through one of four regional distribution centers affiliated with the state education department.[1] The inside lid of each trunk is fitted with a portfolio containing supplementary pictures and maps and written teaching materials. These explain the period and function of each artifact and the relationships among the various items in the trunk. They also contain suggestions for demonstration and explanation techniques, such as games and exercises to help relate the exhibit to the children's experience.

For example, the teaching material with the cooking kit emphasizes how each culture used available materials to construct or repair utensils: the Indians ground foods with stone and the Anglos with mechanical devices of wood and metal; the Spanish colonists, as they did not have access to metals, had to repair and reforge their utensils repeatedly. Among the suggestions for class activities in conjunction with this kit is one where the teachers have the children make their own clay pots and then cook food in them. (Although the children can examine closely and even touch most of the items, rare or fragile objects from the museum collection are never used in such activities.)

Other suitcases include objects of clothing from different cultures and eras, toys and games, maps, and gadgets. One

## The Children's Museum MATCH Boxes

The Children's Museum
The Jamaicaway
Boston, Massachusetts 02130

One of the first museums to develop instructional materials that could be displayed in the classroom and, more important, used and manipulated by children, was the Children's Museum in Boston. It is still in the packaged-curriculum business with its popular MATCH boxes. MATCH stands for Materials and Activities for Teachers and Children and is just what its name says: a series of units, each designed for a relatively intensive study of a specific topic over a two- or three-week period in the classroom, and containing objects, films, games, pictures, recordings, projectors, supplies, and a detailed teacher's guide that "structures the use of the unit."*

The educational premise of MATCH boxes is that there are "ideas that cannot be conveyed through words," ideas that can be best learned "when tangible things are available to examine, sort, or build with." Children can use the objects in each MATCH kit to learn through their own "discovery": they can grind corn to make

a food, *nokake,* that Algonquin Indians ate; they can drill soapstone using a bow-drill as the Netsilik Eskimos do; they can set up a "publishing company" with a portable press, type fonts, and paper, and write, edit, print, and bind their own books.

Sixteen MATCH units were originally developed and tested in the schools by Children's Museum staff. Nine copies of each unit were available for loan to schools, but heavy local demand and risky (and expensive) shipping eventually prompted the museum to stop circulating its MATCH boxes outside the New England area.

The museum continues to send MATCH units to New England schools for a modest fee, from $20 to $40 for two to three weeks' loan. These fees cover minor repairs and replacement of materials "worn out or consumed in normal use," but the borrowing school is responsible for the cost of replacing "missing or carelessly used nonexpendable items." A staff member reported, "On an average, in recent years, approximately 3,000 units, both MATCH boxes and more conventional loan exhibits, circulate to 100 school systems."

The MATCH project was funded for its first four years (1964–

particularly popular exhibit deals with the life and culture of the early cowboys.

## The design of the suitcases

The suitcases are square or rectangular trunks, purchased from a local Sears or Montgomery Ward store, that have been relined with red and yellow felt. Felt-covered plywood partitions are built to conform to the specifications of each display. Some, such as the cooking suitcase, shown in photograph 1, are fitted simply with shelves of various sizes from which items are removed for demonstration. Others have drawers with knobs for small objects, or a series of remov-

**Indian Pottery Kit: display box opened.**

**The Cooking Exhibit.**

able trays with leather pull straps. In the 20-inch-square cowboy kit, the tools and implements are attached to one tray for display; chaps and ropes are folded or coiled in another and can be removed and spread out.

Some trunks hold several small wooden display boxes. One such arrangement, for a prop kit on Indian pottery, is shown in photograph 2. The display box is packed with others inside the trunk, and can be independently removed. Opened, it reveals six compartments, each encasing an individual pot. The design is explained by Elizabeth Dear, one of the museum's education curators:

> We had a big problem with this kit because . . . pottery is very fragile and breakable. So we designed this kit where

1968) by the U.S. Office of Education, with a grant of about half a million dollars. In 1968/69, the American Science and Engineering Company, in partnership with the museum, began developing and marketing commercial versions of the MATCH units for sale to school systems, curriculum centers, and teachers' colleges. Six such MATCH units are now available at prices ranging from $357 to $525. One—*The City*—is suitable for K–4th grades; four—*Japanese Family, Paddle-to-the Sea* (about the Great Lakes), *Medieval People,* and *Indians Who Met the Pilgrims*—are designed for intermediate elementary grades; and one—*A House of Ancient Greece*—is for intermediate and high school students.

One example, *Japanese Family,* is briefly described here (and can be compared with the CEMREL package on Japan; see report in this chapter). The kit suggests that the teacher divide the class into five Japanese "families," with each child playing the role of a specific family member and each family focusing on different aspects of family life. Each group sets up house using materials provided for it: family room, altar, dining area, and so on. After each group learns how to use its space and objects, its members act out their parts for the other children. The families study their family histories and family trees to learn about traditional Japanese family structure; the kit includes an authentic Japanese family register and

an illustrated family history on which the children model their own family registers. Dozens of objects—ranging from kimonos and shoes to calligraphy brushes and clay to bean curd soup packets, chopsticks, and a low dining table to religious objects (brass bell, Buddha statue, incense burner) and books (comic books and poetry) —are included in the package, along with a record and guides for students and teacher. The total cost is $495. A 16-mm black-and-white film, *The Japanese,* which is optional, brings the cost of the total package to $770.

Museum staff say that the packages "make no effort to relate to fine art—it's not a subject for us."

The Children's Museum (see report in chapter 3) also offers teacher workshops, a resource center, a shop for teachers, and a recycle center, a corner of the museum that overflows with odds and ends—everything from fabric remnants to mismatched nuts and bolts, most of it donated by local industries—that any inventive student or teacher could use for classroom projects.—*A. Z. S.*

---

*Quotations and other information in this report are based on interviews in June 1973 with Michael Spock, director of the Children's Museum, and Carol Ann Feldman, a museum staff member, and on documents provided by the museum.

it's padded with foam rubber on the bottom and on the sides and on the top. The top fits right on. You could drop the whole trunk and nothing would happen. Each piece has a separate box. Almost all the pieces are modern, as we didn't want to take chances with anthropology pieces that are very fragile. They all fit very snugly; the only way they could break is by the kids handling them.[2]

The rectangular toy and game suitcase, one of the larger exhibits, is fitted with removable vertical display cases that contain dolls and other toys covered by plexiglass. A hat exhibit travels in a smaller square trunk that includes a mirror set into a removable tray so that children can look at themselves as they try on historic headgear.

### More "involvement" for children?

Although the suitcase exhibits have been well received by teachers and school administrators as well as children, some teachers have pointed out what they believed to be the one flaw in the program: it does not involve the children with actual art materials. Ann Taylor, an evaluator of the program from the Southwest Regional Education Laboratory (now closed), suggested that the kits are not meant to be self-contained: "The object of the kits is to use things in the environment as props for teaching, not just the objects in the kit." She suggested several further steps that the museum might take to make the kits more stimulating to the schools:

> There should be trilingual slide-tape presentations that accompany the kits. These would [help] motivate kids to create their own activities. . . . The suitcase exhibit is a ready-made experience center, a vehicle to get [children and teachers] involved. But we must design questioning strategies and give the teacher ideas for activities with the

artifact in various disciplines. Rather than just use pictures in the hat kit, the child should experience a sunbonnet in the sun.

The museum's education staff has welcomed the suggestions and has said it wants to study them, but it has also made it clear that any additions to the exhibits would probably cost more than the museum could afford.—*E. S. C.*

### Notes

[1] Security for the exhibits became a major concern after one of the trunks was stolen from a teacher's car; insurance coverage did not include theft from an automobile. The museum now requires that the trunks be kept in a locked classroom and asks the schools to share the insurance burden while the exhibits are on their property.

[2] For sources of quotations without footnote references, see list of interviews at the end of this report.

### Interviews

Interviews with the following persons took place on April 1, June 16, and August 6 and 13, 1974:

Dear, Elizabeth. Curator for Education, Museum of New Mexico.

Goodman, Margaret. Consultant, Museum of New Mexico.

Hammel, Pat. Special Projects Coordinator, Fine Arts Division, Museum of New Mexico.

Stone, Jess. Historical Researcher, Museum of New Mexico.

Strel, Don. Curator, Fine Arts Division, Museum of New Mexico.

Taylor, Ann. Educational Evaluator, Museum of New Mexico.

Warner, Michael. Director for Education. Museum of New Mexico.

# III.

## The Art Museum and Its College, University, and Professional Audiences

# Part III
# The Art Museum and Its College, University, and Professional Audiences

The educational activities of museums are usually most visible in programs for children and lectures and tours for adults. But there is another audience, often hidden from the general public and yet perhaps the museum's most sophisticated, best prepared, and most "natural." It is composed of scholars, researchers, artists, students of the fine arts in universities and colleges, collectors, dealers, restorers—a cognoscenti that is able to use the museum on its own terms and often does so without much fanfare on the part of the museum. Behind these knowledgeable professionals is a still less visible group of present and potential staff members, in whose behalf a variety of training programs and other activities takes place, both in the museum and in the universities that have committed themselves to preparing people for museum work.

The chapters in this section contain something about all these audiences and the ways in which museums do, and, sometimes do not, serve them. Some of these audiences are reasonably well attended to. The programs described in chapter 12 that link universities and art museums are only a few of such relationships that have been established in many academic centers. In addition, there are many services for scholars, students, and researchers that do not show up in the reports here. Among curators, for instance, the time spent answering inquiries from scholars, meeting with and often advising collectors, and consulting with graduate students is an important, yet unmeasurable and often unrecognized, educational contribution museum staffs make to the public in the course of their working day. Several museums sponsor scholarly symposia, of the kind the Frick Collection in New York and the Art Institute of Chicago have carried on for graduate students in art history for many years, and most art museums maintain extensive book and slide libraries to which they allow scholars and students free access.

Some of the professional audiences of the art museum wish they were better served than they are. Among those who feel they have been unfairly ignored are artists and art students, whose participation in museum life is considered in chapter 13. Constant and "selfish" users of museums, they would like to be consulted by museums, according to artist and teacher Louis Finkelstein, and their needs for educational exhibitions, professional encouragement, and museum space given at least as much thought as the needs of other members of the general and professional public.

As for museum professionals themselves, they have received increasing attention from both museums and universities. Beginning with a program for future curators in 1908 at the University of Iowa, the preparation of museum staffs has grown to include conservators and, more recently, educators. Training for educational work in museums, in fact, has become a preoccupation not only of the museums and universities that have established fellowships and graduate programs, but of teachers' colleges, too, which have begun to see the educational and employment possibilities museums offer their graduates.

Most of the training programs discussed in chapter 14 are designed as full-time courses for beginning and sometimes experienced educators. But museum educators have also begun to find ways to provide for their professional growth on the job. As the reports in chapter 15 (and in others noted in the table of contents) indicate, museum educators have organized themselves into local and regional consortia, in some cases simply to meet one another and share experiences, but in others to arrange seminars and try collaborative programs. And in the early 1970s museum educators laid the groundwork for their own professional "society," which holds the promise of giving this field more coherence and respectability than it has had since American museums were born.—*B. Y. N.*

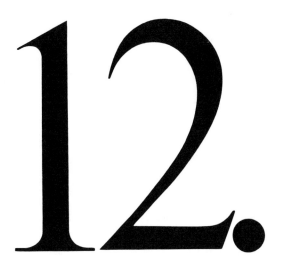

## University-Museum Relations

## Introduction

As centers of scholarship, art museums have much in common with universities. They hold seminars and lecture series, they often have at their disposal book and slide libraries that match and sometimes surpass the resources of universities. Art museum curators and art history professors are the products of essentially the same academic training, they deal with the same subject matter, they read and frequently write for the same journals, and both like to consider themselves fundamentally scholars and teachers. University professors and museum curators are often interchangeable: professors are asked to serve as guest curators of special exhibitions, to write catalogs, and to lead museum seminars; curators often hold adjunct professorships at nearby universities, they share tasks with university professors on archaeological excavations, and whether or not they are teaching in universities, curators are sometimes asked to advise students and to sit on committees that qualify students for graduate degrees.

Yet over the years, to judge from the literature and the countless hours of discussion that have been invested in the subject, there has developed a decided, if gentlemanly, difference between the museum's approach to art and the university's, and very little that either institution has done seems to have succeeded in bringing the two closer together. In a 1966 report for the College Art Association called *The Visual Arts in Higher Education*—one in a long line of such studies dating at least as far back as 1912—Andrew Ritchie describes the dichotomy in its most basic terms:

> The curator is too often prone to sneer at the university man's preoccupation with abstract scholarship, derived from a study of books and photographs; the university scholar, on his part, looks upon many curators as superficial showmen and second-class scholars, unable or unwilling to do serious research. In too many instances both parties are guilty to some degree of the accusations leveled against them. . . .[1]

Max Friedlaender, whose famous studies on Netherlandish painters began when he was working in Berlin's Kaiser Friedrich Museum, put the same idea this way:

> The community of scholars consists of two groups—one may even say, two parties. The university chairs are mostly occupied by people who like to call themselves historians, and in the museum offices you meet the connoisseurs. The historians strive especially from the general to the particular, from the abstract to the concrete, from the intellectual to the visible. The connoisseurs move in the opposite direction, and both mostly never get further than half-way—incidentally, without meeting each other.[2]

Curators and professors have been called "incompatible personalities," and graduate students who choose museum rather than university careers often enter their work with a sense of inferiority. "The essence of success in art history," Cleveland Museum Director Sherman Lee has said, "is verbalization. Gifted connoisseurs cannot finish the Ph.D. program because they are not verbalizers. The best verbalizers are encouraged into teaching, and the least good book learners are sent to museums."[3]

All of this might not matter so much if there were not a genuine wish—expressed not only in studies and discussions but in many serious attempts to devise appropriate programs—on the part of scholars and teachers in both museums and universities for the two sides to be brought at least as far as the bargaining table. Their aim is to win for the object of art, the direct testimony of the eyewitness, as someone has called it, if not supremacy over, at least equality with the book, the slide, and the photograph as a source of knowledge, not only in the study of art but in the study of the humanities as a whole.

## The art historian versus the connoisseur, the old polarity

On the face of it, the insistence that scholars, and particularly art scholars, expose themselves to original works of art seems logical enough. Those works are, after all, the primary "documents" on which the history of art is based. What has happened, however, is that the study of the history of art—a discipline that did not develop until the first part of the nineteenth century in Europe and the 1870s in the United States (and whose origins, ironically, owe much to scholarship that emanated from museums)—reaches into so many fields of inquiry that an art historian can spend a lifetime reading about the geographical, literary, social, technological, cultural, religious, iconographic, mythic, and philosophical influences surrounding a work of art without devoting very much time to the work itself.

Erwin Panofsky compares the art historian to a medical researcher and the connoisseur—the collector, the museum curator, or expert—to a diagnostician: the connoisseur "deliberately limits his contribution to scholarship to identifying works of art with respect to date, provenance and authorship, and to evaluating them with respect to quality and condition"; the art historian tells us "about the formal values of the picture, about the interpretation of the subject, about the way it reflects the cultural attitude of [say] seventeenth-century Holland, and about the way it expresses [the artist's] personality."[4] For John Pope-Hennessy, director of the Victoria and Albert Museum in London from 1967 to 1973,

"connoisseurship becomes scholarship only when research into specific problems is prosecuted to exceptional depth or when the study is consciously directed towards some larger synthesis."[5]

No one disputes the necessity of both functions in the study of art at the scholarly level. What many partisans deplore is the dichotomies that have grown between these two functions and between those who carry them out. For it is the belief of those who work with objects of art, in universities as well as museums, that the "real thing" is necessary for scholars if their work is not to suffer, as Ritchie says, from "the critical anemia that results from overexposure to mere books and photographs." Ritchie is one who feels strongly that "the would-be art historian or artist . . . must expose himself for long periods of time to the works of art of the past and present. It is these works, after all," Ritchie points out, "when absorbed in all their fabulous diversity that feed the imaginations of the artist and the scholar, each according to his needs."[6] Francis Henry Taylor, director of the Metropolitan Museum from 1940 to 1954, was not so kind in his plea for more direct contact with the original object. Like many others, he blamed the separation of art historical scholarship from the study of the work itself on the Germans:

. . . The German passion for classification and spinning a priori theories from artificially established premises had already begun to assert itself at a very early date. It set a standard for unintelligibility which has remained in vogue until the present day, and which has done more to keep the public out of our museums than any regulations issued by trustees or governmental bureaucracies have ever succeeded in doing. . . .

There is a strange irony in the fact that the art galleries in this country, filled with works of art originally collected by the brilliant open-minded humanists of the Italian Renaissance, are being made a battleground for conflicting attributions of iconography and authorship by scholars trained in the Germanic tradition of knowing everything about a work of art except its essential significance.[7]

Pope-Hennessy is somewhat more enthusiastic than Taylor on the subject of scholarship and works of art. "What the museum gains from the presence of scholars on its staff," says Hennessy, are the "tangible advantages" of confidence and better purchases:

Scholarship offers a platform of security. In the area of the scholar's specialty, the museum can operate with greatest confidence. And I think you will agree that in large museums the interesting, really individual departments are those which have been shaped by the taste and knowledge of some scholar on the staff. . . . A survey was carried out not long ago of the buying of English silver for the Victoria and Albert Museum, and it left no doubt at all that when the relevant department was in the hands of nonscholars money was wasted and opportunities were missed, and that when a scholar was in charge the public interest was much better served. . . .

. . . Generally speaking there is a difference between scholarship in a museum and scholarship promoted in a university. The difference can be summed up in the word "practicality." In museums it is hardly ever possible to study problems to that point of no return when useful work becomes a complicated academic exercise. Museum officials, thank heavens, cannot study iconography; time is too pressing and life too short. And since there is a premium on results . . . they cannot have recourse to the smoke-screen of footnotes that so often masks a failed attack. The continuous contact with works of art implicit in working conditions in museums ensures that whatever other vices it may have museum scholarship is seldom theoretical.[8]

## The influence of the slide

Perhaps as much to blame for the separation of university scholarship from the original object as the German "passion for classification" is the invention of the slide. For that single chemical-mechanical discovery has made possible the kind of art historical analysis that no museum or art collection in the world could provide. Slides can bring together in one room monuments that cannot be moved, frescoes that cannot come off the wall, objects that repose on opposite sides of the globe. Students can conveniently compare one with another without stirring from their seats, lectures can flow smoothly without the noisome distractions of a museum gallery, professors can demonstrate their "neat point-making pairs."

Few technological developments have so dramatically changed the base of a field of humanistic study. Slides have made it possible for university art history departments all over the country to operate quite successfully without museums or substantial collections of any kind. They may be partly responsible for the fact that the dominance of the Northeastern universities—in particular, Harvard, Yale, Columbia, the Institute of Fine Arts, and Princeton—in the production of doctorates in art history has begun to fade: between 1930 and 1962, those five schools accounted for 73 percent of all art history Ph.D.'s in the United States, 75 percent in 1961/62 alone;[9] by 1972–1974, their share of the market was down to 44.2 percent.[10]

Even where strong museums are available—and it has been estimated that there is an important art collection within 100 miles of almost any location in the country—many university professors rely largely on slides in their teaching. Aside from convenience, one common reason, given here by the director of New York University's Institute of Fine Arts, is that even the best museum collections are not rich in some fields. Another reason, as a Columbia University graduate student explains, is that the fine points of a painting may be almost impossible for a large class of students to see in the gallery; students may be asked to look at the original on their own, but the slide does better for the lecture.

Logistics are another problem. A museum seminar often requires special arrangements with the museum, overtime

pay for a guard if the class is held after hours, curatorial accompaniment in storerooms, extra personnel to move and handle objects, and travel difficulties if the museum is any distance from the university base. These arrangements can become costly as well as inconvenient. Columbia University has found that a single course at the Metropolitan Museum can run up a bill of $3,500, a deterrent to any academic department on a tight budget. The dream of René d'Harnoncourt when he was director of the Museum of Modern Art in New York was to make such arrangements simpler by establishing an international study center, where scholars could work easily with objects of all sizes and students would be welcome guests (see chapter 1).

In spite of the problems, there are some art historians who believe that studying works of art directly is worth any price. One professor has gone so far as to declare that if he were teaching Renaissance art in an area where none of this material was available, he would take his class to see the best art he could find, whether it were African, pre-Columbian, or twentieth-century, because a sense of original objects, even of the ''wrong'' period, is the starting point of all study of the visual arts.

### Some answers to overuse of the slide

For universities and faculty members determined to integrate original objects into the study of art history, there are several possible solutions to awkward logistics. This chapter contains examples of at least three: the university museum; alliances between universities and large public museums nearby; and, when objects cannot come to the students, special arrangements for students to move to the objects.

**University museums.** For schools far from large urban centers, an especially popular answer to the need for students to be exposed to original objects is the on-campus museum. Yale's Gallery of Fine Arts (see report in this chapter) was the first university museum in this country.[11] It was built in 1832 to serve Yale's painting and drawing classes. Not until the 1940s did Yale institute a department of art history, one of the last universities to do so, and the gallery begin to take on the close relations it has since developed with art historical scholarship.[12] At Harvard, where art history was born in this country with the lectures of Charles Eliot Norton in 1869, the museum came later: the first quarters of the Fogg Museum were opened in Hunt Hall in 1895, but it was 1927 before the Fogg moved into its present building and became a fully usable modern museum. (As former director John Coolidge described the pre-1927 Fogg, it had ''a lecture hall in which one couldn't hear, a library in which one couldn't read, and galleries in which one couldn't see.'')[13]

Even though many of these university museums serve the art and architecture departments as well as other parts of the university community, characteristically their ties are closest to the art history faculties. Sometimes the art history department and the museum are housed together: classes at the University of Kansas (see report in this chapter) are held in the museum building, and offices of the art history department are located there; in addition, the four full-time professionals on the museum staff have joint appointments on the art history faculty, and art history students serve as guards and paid assistants on museum projects. The same is true of the Williams College museum (surveyed for but not included in this study), whose works of art can be picked up and handled by faculty and students almost at will.

The advantages of a museum on campus, of course, are not only that travel time and trouble are avoided but that collections and exhibitions are organized almost entirely with teaching needs in mind. At Yale, faculty members have a voice in acquisitions decisions, students and faculty members help to choose and set up special exhibitions and to write catalogs for them, and access to storage rooms involves a minimum of red tape. In several universities, professors also serve as curators, and in a waning few the chairman of the art history department doubles as director of the museum.

There are, naturally, some disadvantages to the university museum. Because acquisitions budgets are inevitably small, university-museum collections, with notable exceptions, tend to be made up of gifts of inferior quality. Because the collections are thin in many periods, spotty in others, students are often forced, as Columbia University's Dean of Graduate Studies James Beck has pointed out, to do papers year after year on the same works of art. To fill the galleries, many university museums have to rely on loan shows, whose subjects may not always fit the curriculum faculty members have laid out. The fact that students learn about works of art in most university museums by dealing with them directly— an advantage often cited in behalf of teaching collections— carries with it the problem of conservation: museum purists might be horrified to see students handle objects and even drink beer out of tankards in the collection at Yale, for example, or to hear that objects in some other university collections have been lost or broken as the result of policies that allow students relatively free access to the storerooms.

Although university museums are often designed largely to serve art history faculties, many have made an effort to draw other academic departments into their programs. At Yale, use of the gallery by other university departments is described as ''irregular and superficial.'' But the University of Kansas Museum has initiated several interdisciplinary ''productions'' that have involved American studies, history, Latin American, English literature, theater, music and art education, and humanities faculties. At Southern Methodist University the art education department built one of its programs around the Goya collection at the university's Meadows Museum. Except for its collection of Chinese and Japanese painting (which is in heavy demand by the students of Orientalist James Cahill in the art history department), the Art Museum at the University of California, Berkeley, according to a curator there, is better used by the university's

other departments than it is by art history (she named as examples English, journalism, French, library science, and art education), and the museum has often scheduled exhibitions specifically for them.[14] At the Utah University Museum of Fine Arts in Salt Lake City a show of Indian miniatures was mounted partly for the use of the department of Middle Eastern studies, an exhibition of Dürer engravings has been the occasion for language tours by the humanities departments, and a request from art students was answered by a show of William Wiley drawings.[15] In addition to its use of students for help with exhibitions and its loan of exhibition space to the university's Institute for the Arts, the small Sewall Art Gallery at Rice University in Houston has cooperated with the school of architecture on shows it wanted for its students and regularly exhibits student and faculty work.[16]

Increasingly, too, university museums see as part of their responsibility serving the community beyond the campus. The Yale Gallery's department of public education, whose job is primarily to serve the community, conducts school tours, sends slides, filmstrips, and reproductions to schools, and offers the public a "Sunday series" of films, concerts, performances, and lectures.

The art museum at the University of Kansas, a state institution supported by public funds, is even more aggressive toward its community. The museum's education department not only works closely with local schools, but sends teaching materials out to classrooms throughout the state and cooperates with the university's Division of Continuing Education in a traveling exhibition program for audiences in the more sparsely populated areas of western Kansas (see reports in this chapter and in chapter 3), many of the shows built around the work of Kansas artists. The Blaffer Gallery at the University of Houston is an example of a small university art center that also serves the off-campus community; it has been host to the major craft show and painting exhibition in the Houston area and regularly devotes particular attention to a single regional artist whose work would be of "didactic interest" to the community.[17]

One university museum studied here, the Memorial Art Gallery of the University of Rochester in upstate New York (see chapter 1), lost its university base when the campus was moved to an outlying section of town. Though it still has nominal support from the university, the gallery has become almost exclusively a community rather than a university museum—living proof that proximity is crucial to effective academic use of museum resources.

**Formal ties with large public museums.** In the 1966 College Art Association report, Andrew Ritchie makes a plea for more alliances between the campus and the public museum: "Everyone stands to gain by collaboration," Ritchie concludes. "Standards of curatorial scholarship can be improved in the cataloguing and publication of public museum collections by closer collaboration with university scholars, and the scholarship of the faculty can be enlivened and improved by close, day-to-day examination of original works of art."[18]

In large urban centers, where there are good public art museums, several universities and museums have worked out cooperative arrangements for teaching, museum training, and special exhibitions. The Institute of Fine Arts, New York University's graduate department of art history, set up its quarters at least half an hour away from the university's main campus in order to be near the Metropolitan Museum, with which it has maintained close relations since 1929 (see report in this chapter). At least six of the Metropolitan's curators teach at the institute as adjunct professors in any given year, and the institute's joint training program with the Metropolitan places several students in curatorial offices for internships. Although some professors, principally those who are also curators, hold their classes at the museum, others can request objects from Metropolitan collections to be brought to the institute's conservation laboratories for study there. In addition, the institute's program in conservation is partly supported by the Metropolitan, and the museum often calls on conservation experts from the institute for help with special problems.

Columbia University, farther away from the Metropolitan than the institute and thus more restricted in its access to the museum, also lists a number of curators as adjunct professors and holds several courses each year in Metropolitan (and other museum) galleries. But partly because it is separated physically from the city's major museums, Columbia has not developed the same dependency on them as the institute: where institute students use the Metropolitan's libraries as primary resources, for instance, Columbia has built up its own facilities and even has a small teaching collection of its own.

More ambitious, in its way, is the Joint Program in Art History begun in 1967 by the Cleveland Museum of Art and Case Western Reserve University. So close is the arrangement between the two institutions that the program has much in common with the relations normally found between a department of art history and a university museum. The program is administered by a committee equally divided between university and museum staff members, and exhibitions have been mounted cooperatively by the two institutions, in at least one case by students in the program.

Where the resources of such universities as Columbia and the Institute of Fine Arts are closely balanced with the resources of local museums (both Columbia and IFA have strong art history faculties, and there is considerable depth in the academic departments that surround them), the Cleveland Museum and the Case Reserve art history department are less evenly matched. The result is that the museum supplies more than half of the art history faculty in any given year (but much less than half the number of courses) and contributes more than half the cost of the program. Because the program is dependent on the museum's libraries, which the university could not afford to duplicate even if it wanted to, the museum's library staff is "overworked," its facilities

"overused," and access by other students limited. The fact that other university departments—languages, history, philosophy, for example—are relatively weak where the museum's collections are especially strong (medieval European and Oriental art) is another handicap the program has had to face. And yet the program has the considerable advantage of a museum administration that is committed to its success.

On a smaller scale, the Museum of Modern Art has opened its facilities to colleges and universities in the area for study hours while the galleries are closed to the general public (see chapter 1), a program that grew out of a request from a Yale professor to bring his class to a Gertrude Stein show in 1970. Like other museums in New York, MOMA offers free passes to college and university students through art and art history departments. And like other museums, too, it occasionally invites university specialists to serve as guest curators for its exhibitions.

**Moving the students to the objects.**  A third solution to the need for access to original objects—and the least common, to judge from the research for this study—is to offer students the chance to live with art objects up to a semester at a time. Although many university museums, especially smaller ones in rural areas, have been able to serve their students remarkably well with a succession of temporary loan shows, it is becoming clear that it is not only safer, but in the face of insurance, packing, and shipping costs, easier and cheaper to move people than objects.

Two New York museums, the Metropolitan and the Whitney, have tackled this problem in their individual ways. The Metropolitan makes available a variety of fellowships for independent or directed study, summer internships for undergraduates, and assistantships in curatorial departments for graduate students. All carry a stipend, and all are listed in a booklet the museum circulates annually to college and university campuses.

The Whitney's solution is its Independent Study Program, described in this chapter. It brings 25 undergraduate and graduate students to New York each semester for studies in either art history and museums or studio art. Students receive credit for the program from their home schools, and from the museum they receive exposure to and often outright education at the hands of artists, critics, art historians, collectors, curators, dealers, galleries, and museums, with which New York abounds. In the art history and museum side of the program, students are given study space at the Whitney, access to the museum's facilities, and free passes to local museums and libraries. For their academic requirement, students must prepare a research paper, which brings them into direct contact with works of art; in addition, they attend regular weekly seminars, and all of them are expected to work at the Whitney's Downtown Branch (see chapter 3) three days a week, designing and installing exhibitions and managing the attendant museum business.

## The persistent problems

It is possible to conclude from this recital that what New York University professor H. W. Janson calls "the barrier between the museum profession and the university art historian" (see report on the Cleveland Museum-Case Reserve Joint Program) is well on its way to dissolution. And, to be sure, there are some observers and participants who see a change. "The battle lines are moving," says Institute of Fine Arts Director Jonathan Brown. Others are not so certain. The suspicion lingers, particularly among museum staffs, that universities still push the "well-dressed, well-spoken, not very bright student" into museum work, reserving the "outstanding scholars" for their own academic purposes. Although New York University's IFA has "committed" itself, to use Brown's word, to museum training and the use of curators as members of its faculty, many of the institute's professors do most of their teaching in the classroom and rely heavily on slides, just as Columbia's professors and the noncuratorial faculty of most other universities do.

Much as museum scholars would like to see more object-grounded scholarship from the universities, it is not mere snobbishness that motivates their criticism of the university way. There is a genuine concern that university-based scholarship is unnecessarily arid and conservative, that its preoccupation with books and what Taylor calls "a priori theories" excludes the original object and the aesthetic experience with "stultifying" results, and that it too easily deprecates the museum career and the important scholarly work being done in museums. Says Ritchie on these subjects,

> The preoccupation with soundness, the overemphasis on method, the caution and conservatism of American art history are university-bred qualities. They are academic qualities. . . . The acceptance procedures of graduate programs and the hiring policies of departments, the world of committee action and deanly decree—all these are designed to smooth out irregularity and to minimize eccentricity. . . .
>
> The academic establishment has failed . . . to release into society any sizeable number of productive nonuniversity scholars in art—museum men, critics, publicists, dealers.[19]

For Metropolitan curator Olga Raggio, quoted in the IFA-Columbia-Metropolitan Museum report here, the university attitude toward museum scholarship is unfair: "There is not enough recognition in the academic world of the serious scholarship done in museums. In fact, it is often more serious and more intense . . . and it often breaks new ground." Thomas W. Leavitt, director of the Herbert F. Johnson Museum at Cornell, feels that the university is a kind of professional club, continually pushing museums in the university direction. "But the real problem with universities," says Leavitt, "is that they may be stultifying to education."[20]

Not all the problems between universities and museums are of the university's making. Partly because the museum

does not always value or even admire the university degree, its academic requirements for curators are usually less than the university's. Museum people, Metropolitan curator James Draper has noted, have the feeling that "a Ph.D. doesn't make a good curator," and it is common among the Metropolitan's curators, as well as those at other museums, that many have not completed that degree.

In addition, museums tend not to reward scholarship or to offer curators incentives to undertake it. Where European museums may give a curator as much as two months a year for research and at U.S. universities faculty members have both summers off and periodic sabbaticals, it is a rare American art museum that allows its curators extended leaves for study and travel. A committee chaired by Harvard's Seymour Slive in 1966 pointed out that "fellowships for travel and research or a system of leaves-with-pay comparable to the academic sabbatical are urgently needed" for museum personnel.[21] Equal status for university professors and museum curators clearly depends to a large degree on equal pay, benefits, tenure, and time off. Though some museums have begun to offer sabbaticals and to pay their senior curators at levels that can compare favorably with university salaries, it is still the rule that curators tend to be pinned down to their jobs by administrative detail and exhibition schedules and that extensive leaves are more than many museums can afford.

Equal pay and perquisites are only some of the remedies that have been suggested to heal the breach between museums and universities. Pope-Hennessy notes that "it is not always a question of salary, but rather of imponderables, greater liberty of movement, greater freedom from pressure, a higher premium on the products of the mind." He points out that such support of curatorial scholars to let them develop their collections "as they wish" must be granted by museum trustees. "Unduly rigid trustee control is often an impediment," writes Hennessy. "And I cannot help suspecting," he adds, "that museums would develop in a freer and more individual way if boards could be persuaded to accept the hazards of greater flexibility."[22]

On the university side, Sherman Lee would like to see the definition of "a top student" enlarged "to include the connoisseur and gifted teacher." Slive and others have urged "grants to enable museum curators to teach at neighboring colleges or universities, and for faculty members to spend a leave of absence at a public museum to do research, work on a catalogue, or prepare an exhibition."[23] Others have suggested that museum training is even more important for future professors than it is for future curators: professors need to learn how to handle objects and to understand the techniques and problems of conservation; they need to be given the chance to study museum collections so they know what is in them; they should be able, as few now are, to teach toward, in Benjamin Ives Gilman's phrase, as well as from works of art.

Metropolitan Director Thomas P. F. Hoving feels that museum-university problems could be alleviated if curators and professors were trained in exactly the same way through the Ph.D. He suggests that museum training courses yield to strong university-based art historical education that would precede any exposure to museum practices. Most of those who have looked closely at present museum training programs, in particular the one jointly administered between the Metropolitan Museum and the Institute of Fine Arts, agree with Hoving on at least one point—the need for higher academic accomplishment and stricter standards for students recruited for museum careers (precisely the goal of the Ph.D. museum studies program in Cleveland, for example). If students continue to be attracted to the study of the arts (according to one set of figures, the enrollment for advanced degrees in the fine and applied arts went from 9,255 in 1960 to 28,748 in 1970, an increase that is not accounted for simply by a general rise in university enrollments),[24] it is possible that the shortage of both university and museum jobs will deter universities from accepting any but the very best students and the museum will benefit from that more careful screening as a result. "It is a moment," Slive has said, "for museums to rise to the occasion."[25]

But perhaps the most hoped for outcome of any of the remedies tried or recommended here is that the art museum will someday serve as a primary center of research and inspiration for students and scholars in all the humanities. Writes Ritchie, ". . . The art historian . . . because of the diverse range of his interests, extending as they do to languages, literature, history, sociology, [and] psychology . . . is in a peculiarly advantageous position to encourage a greater rapport between the humanistic disciplines. The art museum may well be one of his principal instruments in achieving this community of outlook."[26]—*B. Y. N. with the help of research by F. G. O., B. K. B., E. S. C., and B. N. S.*

## Notes

1 Andrew Ritchie, *The Visual Arts in Higher Education* (New Haven, Conn.: College Art Association of America, 1966), p. 103.

2 Quoted by James M. Hester in "The Urban University and the Museum of Art," *Papers from the Seventh General Conference of ICOM* (New York: Metropolitan Museum of Art, 1965), pp. 20–21.

3 Interview, October 2, 1974.

4 *Meaning in the Visual Arts* (Garden City, N.Y.: Doubleday Anchor Books, 1955), pp. 19–20.

5 "The Contribution of Museums to Scholarship," *Papers from the Seventh General Conference of ICOM*, p. 34.

6 Ritchie, *Visual Arts in Higher Education*, pp. 98, 114.

7 *Babel's Tower: The Dilemma of a Modern Museum* (New York: Columbia University Press, 1945), pp. 16–17.

8 "Contribution of Museums to Scholarship," pp. 35–36.

9 *Visual Arts in Higher Education*, p. 5.

10 *Survey of Ph.D. Programs in Art History* (College Art Association of America, Committee on Graduate Education in Art His-

tory, 1975), pp. 12–16. (For a more complete breakdown of Ph.D. production by geographical region, see note 2 in the report on the use of the Metropolitan Museum by Columbia University and the Institute of Fine Arts.)

[11] See Vincent J. Scully, "Visual Art as a Way of Knowing," *The Fine Arts and the University* (Toronto: Macmillan of Canada, 1965), p. 54.

[12] See *Visual Arts in Higher Education*, pp. 3–4.

[13] Interview, April 30, 1974.

[14] Interview with Brenda Richardson, February 1974.

[15] Interview with E. F. Sanguinetti, director, February 1974.

[16] Interview with John O'Neil, director of the gallery, March 21, 1974.

[17] Interview with Richard Stout, acting director of the Blaffer Gallery, March 21, 1974.

[18] *Visual Arts in Higher Education*, pp. 102–103.

[19] Ibid., pp. 57–58.

[20] Interview, September 18, 1975.

[21] *A List of the Needs of the Visual Arts in Higher Education*, a report submitted to the board of directors of the College Art Association of America by the Resources and Planning Committee, February 1966, p. 22.

[22] "Contribution of Museums to Scholarship," pp. 42–43, 35.

[23] *A List of the Needs*, p. 25.

[24] Table 95, *Digest of Education Statistics* (Washington, D.C.: U.S. Department of Health, Education, and Welfare, 1973), p. 81.

[25] Comment at a meeting of the American Assembly, Arden House, November 1, 1974.

[26] *Visual Arts in Higher Education*, pp. 108–109.

## Bibliography

The books and articles listed here were particularly useful in assembling this chapter. They represent only a small portion of what has been written on the subject of university-museum relations.

*A List of the Needs of the Visual Arts in Higher Education*, a report submitted to the board of directors of the College Art Association of America by the Resources and Planning Committee, Seymour Slive, chairman. February 1966.

Ackerman, James S. "The Arts in Higher Education," *Content and Context: Essays on College Education*, ed. Carl Kaysen. New York: McGraw-Hill, 1973, pp. 219–266.

*The Arts on Campus: The Necessity for Change*, ed. Margaret Mahoney. Greenwich, Conn.: New York Graphic Society, 1970.

*The Fine Arts and the University*. Toronto: Macmillan of Canada, 1965.

Hamilton, George Heard. "Education and Scholarship in the American Museum," *On Understanding Art Museums*. Englewood Cliffs, N.J.: Prentice-Hall, 1975. pp. 98–130.

Johnson, James R. "The College Student, Art History, and the Museum," speech given at Wheaton College, n.d.

Morrison, Jack. *The Rise of the Arts on the American Campus*. New York: McGraw-Hill, 1973.

Panofsky, Erwin. *Meaning in the Visual Arts*. Garden City, N.Y.: Doubleday Anchor Books, 1955.

*Papers from the Seventh General Conference of ICOM*. New York: Metropolitan Museum of Art, 1965.

*Report of the Committee on the Visual Arts at Harvard University*. Cambridge, Mass.: Harvard University, 1956.

*The Visual Arts in Higher Education*, ed. Andrew C. Ritchie. New Haven, Conn.: Yale University Press, for the College Art Association of America, 1966.

# PATTERNS OF COOPERATION BETWEEN THE YALE UNIVERSITY ART GALLERY AND YALE UNIVERSITY DEPARTMENT OF THE HISTORY OF ART

Yale University Art Gallery
1111 Chapel Street
New Haven, Connecticut 06520

**A university museum and art history department break down old barriers by a conscious effort to open communication, compromise conflicting interests, and share resources. Students use gallery collections and storerooms, organize exhibitions, research catalog entries. Besides holding a growing number of classes and seminars in the gallery, art history professors help make nearly all acquisition decisions and do informal curatorial work. CMEVA interviews and observations: November 1973; January and April 1974.**

**Some Facts About the Art Gallery**

1. **General Information**

   Founding: 1832. (Yale has the oldest university museum in America.)

   Collections: Approximately 50,000 objects (includes some groups of objects). The collection is encyclopedic in range with special strengths in early Italian painting (Jarves collection, 1871), American decorative arts (Garvan collection, 1930), twentieth-century art (Société Anonyme collection, 1941).

   Number of paid staff: 44, of whom 19 are professionals.

   Number of volunteers: 4, plus 4 honorary curators.

   Operating budget: Approximately $350,000, including salaries but excluding maintenance and utilities, which are paid by the university.

   Education budget: Approximately $30,000 (or 8.5 percent of the operating budget) for the education department, including salaries; however, because the gallery is an academic support service of the university, its entire operating budget may be considered an education expense.

   Source of funding: 60 percent from general university funds, 25 percent from endowment, grants, and gifts; the remainder from memberships.

2. **Location/Setting**

   Size and character of city: Founded in 1638, New Haven has become a major New England commercial and manufacturing center, but even with its population of 137,707 (1970 census), the city tends to be dominated by Yale University (9,912 students). The visual and performing arts flourish here, and the city is noted for its fine contemporary architecture. New Haven has begun to react to Yale's infringement upon its identity as well as its space, and relations with the mixed population of the community have increasingly become an issue at the school. As one affirmation of this new community awareness, the street level of Yale's new museum, the Yale Center for British Art and British Studies, has been designed to consist of public shops instead of an imposing façade.

   Climate: Temperate; cold, damp winters, hot summers.

Specific location of institution: Within the university, adjacent to the downtown commercial area.

Access to public transportation: Public bus lines; limited parking; regular train service to New Haven from New York and Boston.

### 3. Audience

Membership: Approximately 1,000 family members pay $20 per year; 50 student members pay $10. There are also contributor memberships (at $50) and sponsor memberships ($250 and up). Benefits include the *Bulletin*, exhibition catalogs, and picture books, invitations to special programs, and exhibition previews. The Friends of American Arts at Yale has 150 members: junior members, $25; individual or family, $100; corporate, foundation, or professional sponsor, $250; benefactor, $500; and life member, $10,000.

Attendance: 110,000 annually.

### 4. Educational Services

Organizational structure: A separate department, headed by a curator of education, is responsible for public education; a large part of gallery education services, however, is for the university and is organized through the director or a curator.

Size of staff: A full-time curator of education, two full-time gallery lecturers, one paid docent (part-time), one part-time Yale University student, occasional volunteers.

Budget: $30,000 from the university, chiefly for education department salaries.

Range of services: For the general public: loan materials, tours, in-service training for high school teachers, special events including a "Sunday series." For the university: cooperation in making museum resources available to classes, special teaching exhibitions, two museum studies courses, cooperation with the Department of the History of Art in its introductory methods course, graduate seminars, sponsorship of student-prepared exhibitions.

Audience: The New Haven community, adults and children; main obligation to the university faculty and students—specifically in the Department of the History of Art.

Objective: To encourage the general public to learn from and enjoy its collections; to involve students with museum objects in as active and direct a manner as possible through the study of original objects, the cataloging of collections, and the planning and preparation of special exhibitions.

Time: The museum is open Tuesday through Saturday, 10 A.M. to 5 P.M.; Thursday evening, 6 to 9; Sunday, 2 to 5 P.M.

Information and documentation available from the institution: None.

For more than half of Yale's graduate students in the history of art—and, to a lesser degree, for the almost 5,000 undergraduates taking courses in art (half of Yale's undergraduate enrollment)—original objects have, in a wide variety of ways, become an important part of their training. Close and continuing cooperation between the Yale University Art Gallery and its department of art history has made this extensive use of museum resources possible.

Scholars and museum people, who often differ as to the uses and interpretation of works of art, sometimes form opposing camps. At Yale, however, a working relation between department and gallery has been cemented by a common assumption. The chairman of the history of art department, Egbert Haverkamp-Begemann, states it in these words:

The efforts that the art gallery and our department are making in this cooperation in educating students on the undergraduate and the graduate levels is based on the realization that the work of art after all is the primary source of our discipline. It's terribly easy to get carried away by slides and books and by the traditional teaching process at colleges and universities and to forget . . . that all this teaching and all this studying is concerned with the work of art. . . .

Unless we bring in the work of art as an original, we are bound to get into trouble and to stimulate generalizations, abstractions, and theoretical views that are unsound. . . . Therefore the involvement of the students in the works of art is essential. . . .

To go down to a more practical level, we are not only giving our instruction to people who will be teachers in the future. We hope that our students will also be art historians working in museums—that is, curators. . . . We feel that curators are better at their jobs if they have a solid instruction in the history of art. Yet one can't be a really good art historian without knowing about the objects. It's absolutely necessary to have that training. . . .[1]

Both department and gallery are strongly committed to this goal of integrating works of art into the study of the history of art. Just the same, a number of serious policy questions arise:

- How can the gallery solve problems of organization and access, security, and preservation versus free access and use? Who gains entry to the museum, under what circumstances, and on what authority? Which measures tend to promote beneficial use and which are inhibiting or unwisely restrictive?
- On the dual appointment question, who is appointed to departmental and curatorial staffs, and how can this contribute to the balance of respect and cooperation that must exist between department and museum?
- Should museum training be integrated with art history or kept separate?
- What is the balance that should be struck between objects and ideas in the teaching of art history?

The resolution of these issues is not easy. Teaching from original materials and making them available for this purpose demands enormous amounts of time and energy from both department faculty and gallery staff and generates some tension between the two groups. The gallery's director, Alan Shestack, poses their differences this way:

. . . It would be a lot easier to run this museum, and I think it could be run on a much more professional level, if we were not trying to cooperate with the department on a continuing basis. The small staff is virtually driven crazy by the continuing and often inordinate demands placed upon it by an increasingly active faculty. I am not sure that what we are doing could be repeated elsewhere, unless an

incredible amount of good will existed between the museum and the University faculty. Faculty members tend to ignore conservation problems and are often . . . willing to see a work of art deteriorate as long as it serves teaching needs! Obviously, museum people have to resist this kind of attitude.[2]

In spite of such differences, the atmosphere of cooperation between the gallery and the department prevails. Both parties attribute this to a spirit of good will, open lines of communication between staff and faculty, and a joint commitment to the value of original works of art in the study of the history of art. Yale people say they do not have a program but an attitude. This attitude goes back to the first teaching of art history at Yale.

## A continuous tradition

Founded in 1832, the Yale University Art Gallery is the oldest university museum in America. As early as 1869 John F. Weir, first director of the Yale School of the Fine Arts (which then included the gallery), was teaching from the gallery's Jarves collection of Italian primitives. It was not until the late 1930s, however, that formal teaching of the history of art became an important part of the Yale curriculum. At this time, with the arrival of Henry Focillon and Marcel Aubert, a tradition of art historical education based on connoisseurship became firmly established. Present senior faculty members at Yale—Charles Seymour, Jr., Sumner McK. Crosby, and George Kubler—were students of these men, and today Seymour teaches from the Jarves collection, as J. F. Weir did before him. Seymour meets his class in a seminar room in the gallery, which brims with storage bins and examining tables; original examples of the subject under discussion are never more than an arm's reach away.

## Organization and access

The Yale Art Gallery appears in the budget of the university as an academic support service in the same way that a biology lab does. The gallery's greatest resource in the performance of this service is, of course, a university collection surpassed in depth and breadth only by the Fogg's at Harvard. A major factor in making this resource available is the physical connection of the buildings that house department and gallery. Students can walk through the gallery on the way to class and satisfy in a moment an urge to see a work of art. The gallery is organized to take the fullest possible advantage of this asset.

Faculty members do not have to make advance appointments to visit a storeroom. Students are supposed to make appointments and be accompanied by a staff member to the storeroom, but the relationship is casual. Many students do not make appointments but are allowed in if they are known to the registrar; advanced graduate students doing special projects are sometimes given keys.

The registrar says the fact that the department is small enough for her to get to know most of the students personally tends to build her confidence in them and accounts for much

of the freedom they are allowed. Not all students have taken advantage of this opportunity in the best way, however, and a few minor thefts (pieces of jade and some pre-Columbian objects) have caused a tightening of the regulations.

The registrar's files are accessible from 9 to 5 daily except Monday. As a result, the registrar's office is very much a hub of activity for students of art history. This service puts strains on a small staff, but the benefits the staff feels it is offering the students offset most of the irritations caused by the additional work. The handling of museum objects by students has never resulted in damage.

The registrar does have some complaints, however. She cites weeks during which as many as 300 undergraduates in the introductory course have descended on her with requests to see objects and files. She questions the usefulness of her materials to beginning students and especially wonders whether they are seriously enough involved to warrant her staff's extra work. The registrar has also expressed a wish to be given advance notice of large projects by course instructors, as well as copies of information and research done on gallery objects by faculty and students.

Besides the registrar's office there are four seminar rooms available in the gallery for individual or class study of museum objects by students and faculty. The most active of these is in the prints and drawings department, where students are invited to the office to view the art work for study or for pleasure from 10 to 5 daily without an appointment. Average attendance is 90 visitors per week.

The gallery allows classes that begin before the usual ten o'clock opening time to come in early so they can meet in the gallery, and it stays open on Thursday nights (under an arrangement paid for by the art history department) to accommodate specific classes. In addition, although the gallery is closed to the public on Mondays, students and faculty are admitted. (This practice has been curtailed since the Fogg coin theft, much to the disappointment of students who made use of this quiet time for uninterrupted work in the gallery. However, classes are still admitted on Mondays if the instructor stays with the students.)

**The acquisitions policy.** A strong indication of close ties between gallery and department is the acquisition policy of the gallery's director. Acquisition, Shestack feels, must be supportive of faculty teaching purposes. As a result, with the exception of the director's discretionary fund from which he purchases prints, drawings, and photographs (his own field), all acquisitions are made by Shestack in consultation with relevant faculty. In the same way, priority for conservation of works of art is given to those objects that faculty want exhibited for teaching purposes. Works of art that may be needed by the department are never lent to special exhibitions during the academic year. Xeroxed copies of all loan requests are sent to the appropriate faculty for approval.

Shestack says the gallery bends over backward to serve the art history department. But until relatively recently, this was

not the case. The gallery's priorities, as in many museums, were, in descending order, acquisitions, exhibition of the permanent collection, special exhibitions, and university cooperation. Acquisition in particular was considered the sole province of the director. Since Shestack became director in 1971, this order of priorities has been reversed, and Yale's tradition of commitment to the value of original materials in the study of art history has been given a renewed vitality.

Access to study collections and registrar's files, seminar rooms in the gallery, hours that coincide with those of the department, and a supportive acquisition policy are necessary to making the gallery the academic support service the university considers it. In serving the department as fully as possible, however, the gallery must carefully weigh the expense of this utilization against its basic function to preserve the works of art in the collections. A great deal of reinstalling is done in a teaching museum in response to faculty needs, and passing objects around a table or moving fragile works for a didactic show hastens their deterioration. The gallery's aim in cooperating with the art history department is to seek the delicate balance necessary both to care for the Yale collection and to achieve the maximum interaction between students and the gallery's resources.

## Honorary curators and
## the dual appointment question

Although dual appointments are normally thought to strengthen university-museum relations, Shestack discounts the value and usefulness of formalizing university-museum ties in this way.[3] He feels that in dual appointments, teaching responsibilities tend to take precedence: correspondence on a curator's desk can be temporarily neglected; class preparation cannot. In addition, although it is an idea the university would like to squelch, a faculty position still has greater prestige, so with a few exceptions, holders of dual appointments usually make more effort to succeed at teaching. Shestack has found this to be consistently true in his own case as well as others'. Another teacher-curator at Yale disagrees. He believes that teaching makes him a better curator: it keeps him thinking, broadens his viewpoint, and makes him more analytical about the collection. And he denies that he spends less time on his curatorial work as a result.

The tradition at Yale has been for the staff of the gallery to be filled out by a number of unsalaried, largely honorary curatorships appointed from the department. At a certain stage in his career a professor could expect to be appointed to a curatorship appropriate to his field. Over the years certain resentments have built up when these appointments were not made as expected, or when the department did not reciprocate by bestowing teaching positions on gallery staff members. Need and ability have not always been the reasons for these appointments, and the fact that a candidate for such a position was or was not a Yale graduate was sometimes a surprisingly important consideration. As a result, although dual appointments have sometimes been a great asset to department utilization of gallery resources, they have as often represented a paper relationship only and at times have created tensions rather than furthered cooperation. Shestack says of this situation:

My goal is to have everybody on a friendly basis meeting and discussing his needs, and have the gallery respond as appropriately as it can to those needs. But I don't want to have eight members of the faculty with titles in the gallery, because that has traditionally made the other members of the faculty feel that they aren't welcome. . . . I don't want certain members of the faculty to feel that they have privileged status here. . . . Every member of the faculty— junior, senior, whatever—has absolutely free access to me, and to the curators, and to the collection. If the collections are strong in a particular area, then that person who teaches in that area should use them . . . but we shouldn't create curatorships out of thin air.

. . . I'm willing to listen to any intelligent proposal made by any member of our art history faculty or at the University of Bridgeport, the University of Connecticut, Fairfield, Trinity College, or Hartford. Wherever it comes from, if the proposal is good and we can afford to do it, I'm for it—especially if it's a proposal that involves students in the activity.

The decision by Shestack, approved by a vote of the senior faculty, has been to let honorary curatorships atrophy. In their stead, the director wants to appoint full-time salaried curators with more responsibilities and greater independence, as has already been done in one instance.

At the same time, informal participation by the faculty in curatorial functions is being strongly encouraged. Robert Herbert, professor of the history of art, says it is now assumed that if you are on the faculty you can do with the university's possessions in the gallery what you need for the sake of your instruction without the sanction of an additional title. Anne Hanson, professor of the history of art, who like Herbert has no formal gallery appointment, has also been extremely active in gallery business, organizing exhibitions almost every semester and preparing catalogs.

Although dual appointments are on the decrease at Yale, university-museum cooperation is on the rise. The primary reason is an intangible and fortuitous one: most of the art history faculty and gallery staff know each other well, see each other often, and maintain what seems to be close, friendly, and efficient communication.

## Use of the gallery by classes

Fully one-fifth of all exhibition space at the gallery is made available for hanging works of art specifically related to classes. The demand for the use of this teaching space, located principally on the ground floor, is heavy, and a system has been instituted to distribute it as equitably as possible. At the beginning of each year the chairman of the department sends a memo to all faculty asking for their requests for gallery space. A schedule is made up, and the chairman informs the

director of his department's needs. Almost all requests are accommodated, although when the demand is particularly heavy, special arrangements have to be made. For example, parts of the permanent exhibition space are rearranged or a box of prints is put aside in the print room rather than hung on the walls, as is the normal procedure.

These special teaching exhibitions are handled in exactly the same way as any other temporary exhibit sponsored by the gallery. The layout of gallery space is redesigned to accommodate the material best, and labels are made by the gallery. The show is fully professional and is expected to be of benefit to the public as well as to the student body.

This system, where the faculty can request exhibitions relevant to its teaching, also works in reverse: the gallery often requests classes or shows by the department that will reexamine neglected gallery material. An example is a seminar in Greek vases, offered in the spring of 1974, which one of the professors conducted at the request of the director. The Yale Gallery has a collection of some 800 Greek and Etruscan vases, the majority of which have not been exhibited or studied since 1917. The seminar was based on this material, and the students prepared a show and catalog of it. The exhibition, held in 1975, was, in Professor Anne Hanson's words, "a major success."

The extent to which any particular class takes advantage of the opportunities offered by the gallery varies widely. In the 1973/74 academic year, 9 of 33 undergraduate classes met in the gallery or used it regularly; 17 of 28 graduate courses used the gallery to varying degrees. Of the 25 history of art faculty members, 19 make some use of gallery resources, although most demands in the gallery are made by a core group of 4 or 5 faculty members. Of course, a major factor in this kind of utilization of the gallery is the strength of the collection in various areas. Renaissance, twentieth-century, graphic art, and American art courses at Yale can rely as heavily on the gallery as they do simply because the collections can sustain this amount of investigation. Courses in Baroque art, medieval art, and architectural history, on the other hand, use the collection very little, if at all.

Although teaching from originals puts demands on the resources of any collection, it also puts demands on the instructor. Comparisons cannot be made as easily as with slides, the students get less of a sense of structure, and the instructor must work with the examples in the collection. Even though it is a less flexible way of teaching, Shestack feels that being forced to talk about the object in front of him is worth the effort. It is also more realistic to teach from originals because the objects will never be seen in those neat, point-making pairs outside of a slide lecture anyhow.

## Making assignments real:
## the Montgomery approach

The fact that many Yale classes meet in the gallery, have access to objects put aside or hung especially for their use, and are taught by faculty members who have close ties formally or informally with the gallery, allows for several different kinds of interactions among students, works of art, and the museum.

Particularly well used is the Garvan collection. For Professor Charles Montgomery's survey of American decorative arts, for example, tankards and mugs are taken out of the cases and filled with beer. Covered with frost and with foam running over the sides, the mugs, which represent various styles and periods of American silver-smithing and pewter-making, are passed around the room for the students to drink from. They are heavy; they are cold and frosted; and they become something quite different from display items in the case. Similarly, punchbowls are brought out and punch is made in them. (Certain donors to the American arts collection were incensed when they heard of this, but Montgomery is firm in his conviction that direct contact is the way a student can best come to understand and appreciate the reality of these objects and the culture they reflect.)

In the same way that Montgomery wants the objects he teaches from to become real to his students, he wants everything his students do to be something more than an academic exercise. He uses his curatorial responsibilities to accomplish this. Students in his American arts classes write five papers, four of which involve cataloging individual objects in the collection and are written in the gallery in front of the objects. The fifth is longer and more creative. This work, when it is good, usually turns up later in some tangible way as a label, an entry in a catalog, or part of an installation. Because his students know that much of their class work has practical application and is considered useful by the gallery, Montgomery claims that the level of students' work, as well as their interest in the field, has been raised. Montgomery says that when he assigns a paper now, students come to him to ask, "Well, what needs doing?"

Some of these papers became real in a 1972 catalog for a special exhibition of American furniture: the entire text was the production of Yale students. Explanatory captions written by one student, who had just completed his graduate work, were supplemented by outstanding student papers from the American decorative arts course. The drawings that accompanied many of the entries were also by students in the course, as was the cover design. The project was supervised by a graduate student.

In the fall of 1970 a reinstallation was planned of the gallery's American silver to mark the publication of a two-volume catalog of this collection. Two of Montgomery's students devised an intricately programed multiscreen slide show to focus the eye on similarities and contrasts of design as well as on details of craftsmanship that could not be presented by conventional means. The product, called "A New Way to Look at Old Silver," was 500 slides taken by the students and shown on six screens in 15 minutes, accompanied by music. The slide show was so successful that it was

taken to Colonial Williamsburg the next spring, where it was named the year's most imaginative project in American arts at the Annual Antiques Forum. The students who conceived and executed the project did so as interested volunteers and received no class credit. The following year the same students put together a similar but more ambitious show to survey all of the American arts and Yale architecture as their final paper for the American arts course.

### Vincent Scully's introductory course

If Charles Montgomery is one vital source of student activity within the gallery, Vincent Scully, who teaches a large (enrollment is approximately 350) and popular introductory art history course, is another. The class meets three days a week. The first two sessions are slide lectures. In the third, the class is divided into sections of 20 to 25 students, who are taught by second- and third-year graduate students; with few exceptions, they meet in the gallery. Exposure to actual works of art is thus one of the basic goals of the course. According to Scully, art history's fundamental contribution to the humanities is its combination of visual and verbal experiences; meeting in the gallery is necessary to bring the two fully together.

The introductory course has been structured this way since 1965. A significant motive for increased reliance on gallery resources has been a desire to reduce the congestion in the slide room caused by section leaders and faculty members who often competed for the material they needed to teach. The teaching assistants assert that they get their best student response when they are in the gallery: there is more excitement, and those who are reticent in a classroom open up more. The assistants also say that these gallery visits are the best teaching experience they have had, and that trying to elicit responses from students about works of art improves their own ability to derive meaning from them.

The introductory course requires a final term paper that is written on a single painting in the gallery. The students sit on the floor of the gallery, writing in front of their subjects. They are also able to visit gallery storerooms and use the registrar's files in connection with this work.

Scully is a strong advocate of the educational function of museums, and he sees the overprotective, hermetic character of many museums as totally at odds with their historical reality. He believes museums have to learn to regard their objects "as artifacts, not as fetishes," and he feels that the kind of teaching he does in the gallery helps to break down its cultish character. Of the objects in the Yale Gallery he has said, "[Their] function is, of course, the stimulation of ideas, because the objects are involved with a liberal arts curriculum. . . . Even if they're expended eventually in that pursuit, the ideas are their true children and the things out of which they'll be reborn in other works of art." Scully thinks that it is important, for example, for students to be able to touch sculpture; Shestack does not often allow this (the pres-

ervation function of museums is strongly felt at the gallery). Nevertheless, Scully feels that the gallery has done much to support his teaching and is very satisfied with their relationship.

### The "methods" course

Since the mid-fifties, the equivalent in the graduate school of the undergraduate introductory course has been "Methods of the History of Art," required of all graduate students. One aspect of this course is a detailed report on a work of art in the gallery—a study that usually amounts to between one-third and one-half of the work for a course that varies from one term to one year in length. (The average course load is three per term, making this project a major aspect of the first year of study.) These papers are supposed to be of publishable quality, and the better ones are included from time to time in the *Yale University Art Gallery Bulletin*.

The gallery objects to be studied for the "methods" papers are chosen from a list prepared by the instructor, who sends a memo to the faculty and gallery staff each fall asking for suggestions of objects that deserve further study or present an intriguing stylistic or iconographic problem.

The gallery provides the resources necessary for students to do scholarly work for their "methods" projects. The objects chosen are put aside in a special room near the registrar's office. When the student wishes to work from his object, it is brought out by the registrar and placed on a table for this purpose in the office. If a student is working from a painting, the gallery will remove the frame if he desires. The gallery will also undertake any basic lab work (X-ray, ultraviolet, infra-red, photography) that the student deems necessary. In one case the university dendrological institute investigated the type of wood in an object for a student.

In 1973 the gallery began providing a seminar room on its premises specifically for the "methods" course. Objects used in the course are kept there, and students in the course may enter the room to study them at any time simply by getting a key from the registrar. Projects undertaken by the "methods" course students in the fall of 1973 included the identification of 25 problematic objects, an examination of New Haven architectural ornament, and the selection of the best works in a recent exhibition, followed by a discussion of the criteria used in this selection.

Although the faculty attaches great weight to the importance of the "methods" course (and success or failure in it can mark the rest of a student's graduate career), some students are not convinced of its worth. Perhaps the most universally disliked aspect of the course is a standard assignment that requires the compilation of a long bibliography on an art historical subject. In contrast, the writing of a short paper that seeks to explain an unidentified gallery object was considered the most exciting problem given the class. Commenting on long research papers on gallery objects, students interviewed for this report agreed that generally the objects they were

expected to study were not of sufficient interest to sustain the work that was required.

### Cataloging seminars

One of the most common of the specialized courses at Yale that relies on museum resources is the cataloging seminar. In general, a faculty member who is writing a catalog as part of his own scholarly work conducts a seminar that allows students to participate in the project. In addition to covering the general period that the objects represent, each student is responsible for a certain number of catalog entries on the condition, literature, provenance, authorship, authenticity, date, and exhibitions of the work. Students are given credit in the introduction to the final publication for the entries that were their responsibility; in some cases, they even sign them.

Probably the single most ambitious cataloging enterprise in which students were involved was a catalog of Yale drawings undertaken by art history department chairman Haverkamp-Begemann when he was curator of prints and drawings for the gallery.[4] Seminars devoted to this project were given in fall 1963 and spring 1964. Each of nine students was responsible for between 10 and 30 entries, which varied from simple listings of attribution, medium, and bibliography to lengthy descriptive articles with supplementary illustrations. Additional student entries to this publication came from "methods" course projects (1958, 1960, 1964, 1965); from Ford Foundation museum training fellows (1967/68); and from a master's thesis. All told, 19 students working over a period of ten years contributed 254 of the final 648 catalog entries in the publication—plus an appendix of 378 entries.

Also published in 1970 was the result of another long-term student-faculty collaboration—the Jarves collection catalog by Charles Seymour, Jr., and students. Both projects were financed by a matching grant from the Ford Foundation. Still in preparation in 1974 were catalogs of the Société Anonyme collection, including related documentary material, by Robert Herbert and students, and of the pre-Columbian collection by George Kubler and students.

### Cataloging at other museums. 

The department's cataloging projects have not been confined to works in the Yale gallery. In a project financed by the Ford Foundation and the National Endowment for the Humanities, Yale faculty and students are working in cooperation with the Wadsworth Atheneum in Hartford to prepare definitive new catalogs of parts of its collections—a task so large that at least one member of the Yale faculty has wondered whether it can all be done by students from one university. Hanson and Herbert are doing nineteenth- and twentieth-century paintings; Seymour, early Italian paintings; and Begemann, seventeenth-century Dutch and Flemish paintings.

Begemann's Atheneum seminar in 1973 was made up of five graduate students, some of them in their first year, but all

with some background in northern Baroque art. More than 120 paintings were studied. For the first four or five sessions the students met in Hartford and studied a group of the most important paintings while they learned cataloging procedures. The paintings were then divided by style or subject matter—for example, pre-Rembrandtists, Rembrandt school, Italianate landscape, Rubens school, fruit and flowers. These more or less coherent groups were then assigned to individual students, each of whom ended up with responsibility for about 20 paintings.

In addition to many trips to Hartford, the class also visited New York libraries on several occasions, and near the end of the term made a three-week trip to the Institute of the History of Art in the Hague for final research. Because this research was done under a grant, it was arranged with the Atheneum that students and faculty receive remuneration for each work of art cataloged. Normally the university does not allow students to be paid for work that is part of a class, but Begemann cleared this payment with the provost of the university and the dean so that—in agreement with the students, the Atheneum, the foundations, and the university—the cataloging fees could be converted into travel money. By the end of the course, according to one student, all catalog entries were in their final form and awaiting publication.

The prospect of doing work that will be published, and of traveling in connection with that work, is a great incentive for a more serious endeavor on the part of the students, but according to some, the most critical factors in the success of all these projects seem to be the personality of the instructor and a sufficient degree of planning, structure, and coordination so that the students can be given the freedom to do something they see as truly their own and also of intrinsic worth.

### Exhibitions by students

Easy access to a museum and its works affords students rare opportunities to plan and mount shows—and to gain the unusual insights and experiences that such a process can provide. Among the earliest student shows at Yale were the "Language of Form" exhibits of the early sixties, aimed at initiating undergraduates to art historical problems, and Begemann's "Color in Prints" show in 1962, the catalog of which is still an important document on this subject. Students working on this show wrote individual entries and one of several chapters on the history of color in the graphic arts. Perhaps the most elaborate student exhibition from this period was "Neo-Impressionists and Nabis in the Collection of Arthur G. Altschul," which Robert Herbert and students organized in 1965. As the gallery was still in a transitional phase, allowing students active participation in its affairs, this project was in reality much closer to a cataloging seminar than a show.

By 1969, enough student shows had been done so that the approach had become wholly natural. In that year Yale stu-

dents worked on the "Danube School," a major loan show of South German and Austrian prints and drawings from 1500 to 1560, for which many works were borrowed from museums abroad (in 1970 the show traveled to the City Art Museum of St. Louis and the Philadelphia Museum of Art). In spite of earlier successes with student shows, this one was less than satisfying for both students and faculty. The catalog, which was long (109 pages) and fully illustrated, was evidently too ambitious; the material was difficult, and the need to do much of the research in German proved too rigorous for students with inadequate backgrounds.

An alternative and less ambitious student exhibition was conducted at Yale in 1973 by Anne Hanson. The 1973 show grew out of an initial assignment in a graduate seminar on Cubism—to search the collections in the print room for examples that would define the limits of the Cubist movement in subject and style. The students gathered their results in a small didactic exhibition that was put together in a little more than two months. The catalog runs 11 mimeographed pages for the 35 prints and drawings in the show, and the total cost of producing 1,000 copies was $200, shared by the department and the gallery. The whole exhibition was drawn almost exclusively from the gallery collection, with the exception of two key prints lent by the Boston Museum of Fine Arts.

Ambitious student exhibitions like the "Danube School" are costly, demand extensive preparations, and require an adviser who is willing to pick up the pieces if students do not have the motivation and ability to complete the work. In many cases the impetus students are given by working on an important and elaborate project makes these shows worth the effort, but several faculty members are beginning to feel that often it makes better sense to do shows like the one on Cubist prints. These small didactic shows are a flexible and effective teaching device that can be used in almost any course without the usual entanglements of budget, planning, and unprepared students.

Other representative recent exhibitions by students at Yale have included

- "Options and Alternatives: Some Directions in Recent Art," a major show in the spring of 1973. The exhibition presented a cross-section of recent progressive art, including films and performances. It was selected by two visiting curators and organized with the assistance of an undergraduate class. Each of the 11 students in the course was responsible for preparing material on two artists for the catalog (2,500 copies for $15,000).
- A 1971 show, which also came out of an undergraduate course, called "American Arts at Yale 1971 to 1651." The show was installed in the Garvan Furniture Study, a 10,000-square-foot space in the basement of the Yale University Press. It sought to relate furniture forms visually to other objects of the same period. The class of 70 students was given almost complete freedom in the selection of the show's 400 objects. In addition, they wrote the $200

catalog, set the type for it, made a poster, designed and built the installation, and put up the show themselves.
- An exhibition of 42 Currier & Ives prints, prepared and hung by a student who had participated in the American arts show, another undergraduate in American studies, and the curator of prints and drawings. The team also produced a small catalog. Several of the prints from this show were incorporated into pull-out racks in the permanent Garvan installation.
- "Four Directions in Modern Photography: Paul Caponigro, John T. Hill, Jerry N. Uelsmann, Bruce Davidson," organized in 1972 by a graduate student in the museum course working under the director. The director picked most of the photographs for the show; the student wrote the catalog (2,500 copies for $4,000; it consisted of an essay on each of the artists and an introductory essay), selected the half-tones, hung the show, and worked independently with the exhibition and catalog designers and the museum crew.
- "American Drawing 1970–1973," conceived and executed by a graduate student as a tutorial in 1973. Thirty-five artists were represented by one drawing each in the exhibition (15 from commercial galleries, 12 from private collections, 3 from the artists, and 5 from the recent gallery acquisitions). All the works were selected by the student, who also wrote the catalog (2,500 copies for $2,000) and laid it out, in the form of a large poster, with the help of a professional designer. The student arranged and hung the show herself. Work on the show took from January 1973 to June 1974.
- "Seven Realists," a 1974 show by four students in the "museum" course (see following paragraphs). The students collaborated with the director in the selection of the artists, and each wrote essays on two of the artists for the catalog (2,500 copies for $6,000). The students made several trips to New York galleries where they spent time with artists, dealers, and loan forms. Despite their involvement in all aspects of the exhibition, they felt they could have learned more from this project had they been given greater freedom and responsibility in the selection of the artists and the show's final statement.
- The paintings and drawings of Edwin Austin Abbey, 1973. The show, which traveled to the Pennsylvania Academy of Fine Arts and the Albany Institute of History and Art in 1974, was conceived by the gallery's curator of American paintings and executed by two graduate students working under him in a museum tutorial. Each student wrote a 20-page essay for an elaborate catalog (4,500 copies for $19,000) that has become the definitive work on this painter.[5] The students spent nearly three years on the project. The gallery's conservator spent a full year cleaning and doing minor restoration on the 72 paintings and drawings in this show. Working with him and the designer was one student, who consulted with the American paintings

curator weekly. The selection of the works to be restored and shown (the majority of Abbey's work was bequeathed to the gallery) was made by the students in consultation with two curators and the director. The students also hung the show and wrote the press releases.

Thus, student exhibitions at Yale come in many varieties. Some are costly and elaborate; others are done on a shoe-string. As many as 70 students or as few as one may work on a show—third-year graduate students and undergraduate sophomores alike. A student may be given almost total responsibility for an exhibition, or he may be restricted to a minor and even a narrow role. Exhibitions at Yale are often open-ended projects that can expand or contract depending on available exhibition funds and the desires and abilities of the students and faculty involved.

The one thing all student shows have in common, however, is a serious scholarly motivation. This scholarship may take the form of essays for the catalog or the carrying out of all technical aspects of an exhibition. If museum procedures are learned, so much the better. But student shows are more than museum training exercises, and the student catalogs more than mere exhibition announcements. Both the shows and the catalogs are intended to provide information that will endure and be of use beyond the life of the show.

## Museum training

In 1972 a museum training course open to second-year graduate students was instituted by the gallery with help from the National Endowment for the Arts. For students who join the class, the main motive seems clearly to be the chance to work on an exhibition. Through these shows the museum course is acting as an important impetus for increased activity by graduate students in the gallery.

In turn, Yale's museum training curriculum is expanding. In 1973 a second term of the course was offered by Jules Prown, director of the Yale Center for British Art and British Studies. Preparations were being made in 1974 for an undergraduate museology course.

The gallery is not, however, headed toward a separate museum training program. Yale's long-standing policy has been to encourage museum careers through extensive student contact with the gallery, but without separating students interested in museums from the rigors of art historical training. Art history has become a language common to both fields, and museum people need to know how to put their material into a clearly organized and accurate art historical context, much as scholars need to have a sense of the intrinsic meaning of the object itself.

Professor Hanson further illuminates the problems of traditional museum training and the value of Yale's desire to integrate the two studies:

I feel strongly that mixing art historical research and practical work with objects in museums is the best way to train people for *either* teaching or museum work. It allows students to experience both approaches and to make informed decisions about their careers. It teaches all concerned respect for those on the other side of the fence, and it makes both better art historians and better curators. I would hope that if more institutions had our kind of constant interchange, eventually some of the traditional barriers between the museum world and academia might break down and respect be accorded where it is deserved. . . . I can see many good aspects of typical museum training. Its more formal nature ensures that students cover problems in an orderly way. But it does separarate sheep from goats too early, I think, and it lacks the constant sense of discovery offered by our approach.[6]

## Public education

In general, the role of public education at the Yale University Art Gallery is very much deemphasized in favor of its educational responsibilities to Yale students. The gallery's public education department consists of a curator and two lecturers, plus some part-time help and occasional volunteers. Its chief activities are school group tours, a loan program of slides, filmstrips, and reproductions for schools, and a "Sunday series" of films, concerts, performances, and lectures.

An increasing interest in public education does seem to be emerging in the gallery, however, due largely to discussions that have been coming out of the museum training course. According to members of the Yale faculty, a university museum, because of its greater freedom for experimentation, should be in the forefront of public education, and students should be considered an important resource in this activity. Students do often write didactic labels for their shows, and they sometimes prepare other accompanying materials of a more general nature than the exhibition catalogs. Students frequently give gallery tours and "Sunday series" talks to supplement those by education department staff.

Several faculty members and their students, however, agree that there should be some systematic coordination between the education department and the faculty and student contributors to gallery activities. One faculty member suggested using the curator of education to train students in the presentation of material to different audiences. There appears to be some awkwardness on the part of the gallery's education department about approaching the art historians, and the department of the history of art is still wondering if it has the time or responsibility to initiate some form of cooperation itself. As yet the Yale gallery has not realized its goal to become a leader in public education.

## The gallery's relations with other departments

Use of the gallery by other university departments has been, for the most part, irregular and superficial. According to one history of art department member, it cannot be otherwise because other disciplines do not claim to derive meaning from objects, but use them merely to illustrate the subject matter in their fields. Nonetheless, the practice of using visual materials seems to be slowly increasing. One regular

gallery user notices a growing number of faculty from other departments in the art history department's slide room, and an instructor in black studies and American folklore regularly uses objects in his classes and makes a point of directing his students to gallery exhibitions and events. Instructors in archaeology also occasionally request small exhibitions.

The gallery director is trying to encourage gallery use by other departments, but notes that there is a communication problem because most people in other departments do not know what is in the collection or how these objects might relate to their work. Also, the collection is not comprehensive enough in many areas for it to be useful to historians. A minor exception has been the use of the gallery's extensive collection of World War I Russian posters by a class in Russian history. However, new inroads in wider gallery use have been made through interdisciplinary courses such as "Art and Literature in America," and, when it is completed, the Yale Center for British Art and British Studies will provide a major incentive to the use of museum resources by other university disciplines because of the incorporation of vast amounts of documentary material as well as works of art in its collection.

Although Yale is sensitive to differences of opinion between museum people and scholars, this problem is minor compared to the lack of understanding between artists and art historians. For example, the gallery's director frankly admits that he had not tried to cooperate with Yale's School of Art and Architecture.[7]

One sign of an improving relationship between art school and gallery, however, lies in an interdisciplinary course entitled "Film and the Art Object," given in the spring of 1974. The course grew out of one curator's desire to create a group of short films for a minitheater in the Garvan installation, which would provide background material on objects in the collection and present them in a new way. Meanwhile, the School of Art and Architecture was trying to strengthen its film department, and the production of the films provided an opportunity for its students to do something concrete. The two groups, consisting of six students from the film, graphic arts, and architecture departments and seven students from the history of art and American studies departments, cooperated in making six six-minute super-8 films.

## The value of original materials in the teaching of art history

It is clear that the role the gallery plays in art history education at Yale is a vigorous one. This grows from the extent and quality of the gallery's holdings, the physical proximity of the gallery and the Department of the History of Art, and the tradition of connoisseurship-oriented art history at Yale—all in the service of a number of faculty and staff members deeply committed to the furthering of a cooperative relationship. There is also a benefit in the intimacy of the department's small size—only about 50 graduate students.

The question now is, what does this emphasis on original materials mean? In the case of the use of museum resources in the study of the history of art, the question largely revolves around a philosophical issue of the relative roles of ideas and objects in art history. Addressing this subject, the department chairman says,

Of course, the history of art as the history of objects is entirely dependent on the knowledge of the objects. The history of art as ideas needs sound knowledge of the objects, because otherwise this history of ideas may very well be wrongly directed or come to conclusions that are unsound simply because of lack of knowledge of the objects. All art historians, however theoretical or however practical, however much directed toward the history of ideas or toward the history of the object, need to be continuously refreshed by the knowledge of the objects. It's my belief that if art historians were cut off from the objects, art history would atrophy. . . .

We know from experience in art history that the separation of art historians from the objects has resulted in very grave mistakes. During the war in Europe when all the objects were hidden in the tombs or in bunkers in order to prevent their being destroyed, the capacity of art historians to attribute works of art diminished severely; and it is only because of the war that fakes like those of Vermeer and others needed so much time to be detected.

According to Begemann, photographs cannot be interpreted properly and theoretical issues cannot be dealt with usefully until students are acquainted with basic information about the original object. In the words of a colleague, "What we're trying to show our students is that what we're talking about is real objects. They may have condition problems, they may have been repainted, and all this has to do with what you say about them in your lectures or what you write about them in your book."

Begemann says that, generally, student papers tend to synthesize published material and be aimed at a general public. In projects that deal with original materials, like cataloging seminars, their efforts are directed toward basic information for a professional public. The students tend to eliminate generalized synthetic work and concentrate on analytical investigations.

In addition to providing a basis for sound art history, work with museum objects also gives students a broader and more truthful view of this discipline. The gallery's curator of American paintings says that when a student first begins taking art history courses, he assumes that he is getting everything and that there are clear, uncomplicated progressions of style. Museum experience reveals to him the complexity of art history as well as the selectivity of general books and slide lecture courses. One of this curator's students reinforces this point by saying,

When you're faced with a painting in the gallery, when you see it for the first time, you don't know what it means. You have to find where that painting belongs. . . . If you're in a slide room instead, you know what you're

going after. You have a certain point in mind, and you illustrate it with a slide.

A further benefit of Yale's gallery-department cooperation has been its usefulness as a model for bridging the long-standing rift between museum people and university-based art historians. One faculty member says, "More and more scholars are having something to do with museums, and the common complaint of museum people about scholars is that they don't understand the practicalities of getting things done, hanging shows, catalog deadlines, printers' deadlines." On the other side, the most common complaint that scholars have about curators is that they are overprotective of their objects, too security conscious, and often unable to fulfill requests.

Working together at Yale, scholars and curators are trying to come to a better understanding of each other's problems and at the same time to train their students to have the flexibility to move effectively between these two complementary areas.

## Results of the cooperation: student and faculty reaction

Interestingly, although the students interviewed here seemed to have strong positive reactions to their museum experiences, only a few were seriously considering professional museum work (two recent graduates accepted curatorial positions). The inequality between university and museum positions is strongly felt: tenure, a nine-month year, the prestige of a teaching position, and the greater freedom and flexibility offered by an academic career generally outweigh the students' interests in working with objects. Students also seem to feel the pressure of a largely unspoken but still very real faculty opinion that museum work should be reserved for students without the wherewithal for pure scholarship.

Gallery-department cooperation from the student point of view is most important because, except for student teaching, work in the gallery through either preparation of an exhibition or contribution to gallery publications is the one concrete contribution they get to make in school. One student said that taking hold of something, measuring it, and cataloging it provides a necessary contrast to the intangibility of his academic work. The students affirm that these concrete projects in the gallery are accessible, that they do not have to be sought out, that there are many opportunities for anyone who will take advantage of them, and that a substantial percentage of the students do.

For their part, faculty members believe that the emphasis on gallery resources in the teaching of art history has resulted in students who are less reluctant to consider museum positions, have developed good museum habits themselves, and are carrying the Yale approach over into their own teaching. There is great pressure on students of art history to spend large amounts of time in a library becoming well-versed in the literature of their field, learning languages, preparing papers. As a result, it is often difficult for them to find the time to go to museums. Yale students, according to one faculty member, are spending more time visiting not just the Yale gallery, but all museums because of gallery-department cooperation. In addition, they are more discriminating about what they see in museums.

By far the most important result of Yale's department-gallery cooperation, however, is the feeling students have developed for works of art. The love of art objects seems to have been instilled in a large number of Yale students. One stated, "I can honestly say that the reason I am in museums today, as opposed to being in English . . . is because of the very exciting initial exposure to objects that I had with a professor in a museum. I'd been to museums all my life and had always been interested in painting and sculpture, but it was this particular teacher's gift—it was a very inspirational one—of really being able to help you see. . . ."

Another student said that her first interest in the history of art came through the writings of Panofsky, and this original intellectual involvement was changed gradually over several years to the understanding of forms as a language. She added that she is now approaching the material much more visually.

Most students apparently wish to maintain some kind of tie with a museum. According to one, the ideal situation would be to spend half the year in a museum and half in a university. Another, who has been among the most active students in the gallery—as a participant in both terms of the museum course, collaborator on exhibitions, docent, and special assistant to the director—said she still prefers teaching to the "administrative passiveness of being a curator." But she believes some attachment to a museum is necessary as a "correction" to teaching, and she would accept a curatorial position over a teaching position that left her in complete isolation from objects.—*F. G. O.*

## Notes

[1] For sources of quotations without footnote references, see list of interviews at the end of this report.

[2] Letter to CMEVA, March 21, 1974.

[3] The Yale Department of the History of Art at present has three joint appointees, two with the gallery and one with the Yale Center for British Art and British Studies. Two other gallery curators are lecturers in the department, but are entirely supported by the gallery. In addition, Shestack is an adjunct professor for the department. This is a token honor because he has no tenure, and there is no department money to keep him should he leave the gallery, but it is an important symbol of cooperation.

[4] E. Haverkamp-Begemann and Anne Marie S. Logan, *European Drawings and Watercolors in the Yale University Art Gallery, 1500–1900* (New Haven and London, 1970).

[5] The Yale University art gallery has no regular exhibition funds, and money for all exhibition catalogs is raised from outside sources. In this case the chief contributors were the National Endowment for the Arts and the two institutions to which the show was lent.

[6] Letter to CMEVA, March 22, 1974.

[7] As the School of Art and Architecture is the one other major segment of the university that does depend on works of art as its primary source, it is unfortunate that the gallery and art school do not find more mutual interests. For example, almost all gallery exhibitions are organized around a historical theme; in art schools students are generally required to take basic two-dimensional and three-dimensional design courses. The opportunity to prepare exhibitions organized around these design principles would be of tremendous value to art students. In many museums there is still a resistance to art historians and their students roaming in the galleries, changing attributions, complicating and questioning established procedures. There seems to be a parallel here in the promise that art schools hold for doing things in museums in yet another way.

## Interviews

### Faculty and gallery staff

All faculty members are from the Department of the History of Art unless otherwise noted.

Burke, James D. Lecturer and Curator of Prints and Drawings. November 8, 1973.

Dickson, Janet Saleh. Curator of Education. November 8, 1973.

Farris, William. Assistant Professor, Department of American Studies. January 28, 1974.

Hanson, Anne. Professor. November 8, 1973.

Haverkamp-Begemann, Egbert. Professor and Chairman of the Department. January 9 and April 10, 1974.

Herbert, Robert. Professor. January 17, 1974.

Montgomery, Charles F. Professor and Curator of Garvan Collection. January 9, 20, 28, 1974; April 10, 1974.

Prown, Jules. Director of Yale Center for British Art and British Studies; Professor. November 8, 1973.

Ritchie, Andrew Carnduff. Former Director, Art Gallery. n.d.

Ross, Fernande E. Registrar. January 17, 1974.

Scully, Vincent. Professor. January 21, 1974.

Seymour, Charles, Jr. Professor and Curator of Renaissance Art. January 17, 1974.

Shestack, Alan. Director, Art Gallery; Adjunct Professor. November 8, 1973; January 9, 1974; April 10, 1974.

Stebbins, Theodore E., Jr. Assistant Professor; Associate Curator of Garvan Collection; Curator of American Paintings. January 28, 1974.

Talbot, Charles. Associate Professor; Director of Graduate Studies. January 21, 1974.

### Students

All students are graduates in the Department of the History of Art unless otherwise noted.

Belson, Charles. Fine Arts Undergraduate. January 28, 1974.

Brettell, Richard. January 17, 1974.

Casteras, Susan P. January 21, 1974.

Howze, William. Graduate in American Studies. January 28, 1974.

Kane, Patricia E. Also Assistant Curator of Garvan Collection. January 9, 1974.

Orr, Tina C. January 17, 1974.

Quick, Michael. January 28, 1974.

Saunders, Eleanor. January 17, 21, 1974.

Silver, Kenneth E. January 21, 1974.

Troyen, Carol L. January 17, 1974.

## THE UNIVERSITY OF KANSAS MUSEUM OF ART AND "THE SPIRIT OF SYNTHESIS"

University of Kansas Museum of Art
University of Kansas
Lawrence, Kansas 66045

**One way a small Midwestern university museum spreads its services and its message to the "wider" university community is by getting students and faculty from other departments and a variety of townspeople to help out with exhibitions, catalogs, museum instruction. CMEVA interviews and observations: October 1973; January, February, March 1974; July 1975.**

### Some Facts About the Institution

1. **General Information**

   Founding: In the 1920s, when Sallie Casey Thayer donated her collection of objects to the University of Kansas. The museum officially opened in 1928. Her expressed intent for the gift was "to advance and encourage the study of the fine arts in the Middle West."

   Collection: 500 paintings, 12,000 decorative art objects, 500 pieces of sculpture, and 6,000 pieces of graphic art. The museum has a general collection of Western art from medieval through modern. The strengths of the collection are in baroque paintings (seventeenth and eighteenth centuries), American painting (nineteenth and twentieth centuries), photography, and decorative arts.

   Number of paid staff: 4 full-time professionals with split appointments in the art history department; 3 half-time professionals.

   Number of volunteers: About 14 docents work with programs run by the curator of museum education.

   Operating budget: $121,672 (1974) from the state of Kansas, $20,000 from private donations for acquisitions during 1974.

   Sources of funding: National Endowments for the Arts and the Humanities, Kansas Cultural Arts Commission, Lawrence Art Guild, University Endowment Association, private donors.

2. **Location/Setting**

   Size and character of city: Lawrence, a city of 30,200 (with very few minority people) is about 40 miles west of Kansas City. It is a small, self-contained community with no heavy industry in the region. There are many post-Civil War homes on quiet, shaded streets surrounding the university campus.

   Climate: Mild from March to October, some snow from December to February.

   Location of the museum: On the campus of the university.

3. **Audience**

   Membership: 160 museum patrons ($50–$100 a year) and benefactors ($100 a year and up), 130 general members ($10 a year), and 30 student members ($5 a year). Another student group called "Student Friends of Art" donates a certain amount toward a fund used to purchase an art object that will be added to the permanent collection.

   Attendance: 65,000 (1974).

4. **Educational Services**

   Organizational structure: The education department is a separate entity.

Size of staff: Curator of museum education, 14 volunteer docents.

Budget: No figure available.

Source of funds: Kansas Cultural Arts Commission, Lawrence Art Guild, National Endowments for the Arts and Humanities, Endowment for the University of Kansas, and the operating budget of the museum.

Range of services: Tours of the galleries, school presentations in the classroom, music programs, poetry readings, lectures, films, traveling exhibitions, radio programs, art workshops, adult classes.

Audience: No breakdown.

Information and documentation available from the institution: General publications by the University of Kansas Museum of Art, including articles about objects in the collection, reports on activities, exhibition catalogs, miscellaneous monographs and brochures, and a bimonthly calendar of events.

In the spring of 1960, the director of the University of Kansas Museum of Art, Edward A. Maser, read a paper at the annual meeting of the American Association of Museums in Boston, in which he described "one of the problems of university art museums, particularly in the Middle West." It is, he said, "to make the university public, the students, the faculty, and the staff, at least aware that the museum exists and that it can play a certain role in their lives, studies, and research."[1]

The University of Kansas museum began working on the problem in 1951 with a bulletin, as Maser says, "for, by and in spite of a college faculty," called the *Register of the Museum of Art*. Although the purpose of the bulletin was to try to interest the university community—especially other members of the faculty—in new acquisitions at the museum, it was not until Maser invited a professor of English literature to contribute a short article to the *Register* in 1954 that the breakthrough to the faculty was successfully made. And so began a tradition, now well established at "KU," not only of drawing on faculty members outside the department of art history for articles and catalog entries, but of enlisting other academic departments in universitywide celebrations of a culture, a period, or an idea.

Indeed, the "spirit of synthesis," as one observer has called it, has permeated the museum. Housed in a late-nineteenth-century sandstone building just across the road from the natural history museum and close to the student union, the museum serves as the headquarters for the university's department of art history, a laboratory for practice teachers from the department of art education, and an exhibition space where faculty members from engineering, architecture, and Romance languages have been known to work together to assemble shows or participate in special events. The museum is host to local schoolchildren and adults alike, and for people across the state who may never visit Lawrence or view the art museum's collection of baroque paintings (among other strengths in its holdings), it

makes its presence felt with traveling exhibitions and instructional materials for the schools.

If the University of Kansas Museum of Art is typical of university museums in self-contained Midwestern communities that rely on the university for a good portion of their cultural resources, the museum is also a relatively aggressive and well-rounded institution of its type. And it provides a useful contrast to university museums, like Yale's, where access to metropolitan cultural centers tends to make them more specialized and perhaps less active in pursuit of public audiences beyond the university.

## The KU philosophy: the museum is your livingroom

The fact that the museum building is one of the oldest on campus—the wooden stairs creak, and pipes are exposed to view—probably contributes to the relaxed attitude of the staff toward the museum audience. Director Charles Eldredge, who came to Kansas from the doctoral program at the University of Minnesota, takes the position that "a museum should be lived in":

I'm much happier when I see people bringing children into the museum and enjoying it as they would their own livingroom. This going through in hushed tones, with reverence as if someone had died, that's not what it's all about.[2]

The basis for the livingroom attitude may also lie in the museum's origins. The museum began life in 1928, with a donation of 7,500 items—literally a houseful, complete with the bed sheets—from Sallie Casey Thayer, whose family fortune had come from a dry goods business in Kansas City. Determined to bring culture to the prairie, Mrs. Thayer gave the university the objects of art that had surrounded her in her home. The legacy included examples of Oriental and American art, including three works by Winslow Homer.

Since the Thayer gift, the museum has added steadily to its holdings. They now range through Western art, from medieval to contemporary, including Old Master paintings from the Kress collection, master prints from the Kade collection, and contemporary works from the Swenson collection. Much of the museum's collection, however, has been in storage ever since an arsonist set fire to the student union during campus unrest in 1970 (when the invasion of Cambodia by U. S. troops touched off student demonstrations throughout the country). Whether the livingroom atmosphere will prevail when the stored part of the collection is moved into a new building, to be opened in 1978, remains to be seen. In the meantime, the museum's small staff tries in a variety of ways to design programs and activities that will appeal to all segments of the community and help them feel at home with works of art.

## The museum and the department of art history

The museum's closest academic relationship is with the department of art history. The offices of the department are in

the museum, faculty members hold their classes in the basement lecture hall, the four full-time professionals on the museum staff have joint appointments on the art history faculty, and art history students serve as guards and paid assistants on some museum projects. Until 1968, the chairman of the art history department and the director of the museum were the same person, a situation that developed partly because the museum was created first (the department itself was established in 1950).

The alliance between the museum and the department does not mean that the slide-versus-object teaching question has been settled at Kansas, any more than it has anywhere else. Even when they teach within the museum building, some art history faculty members use slides almost exclusively in their classes, rarely venturing into the collection. Their reasons are various: they do not want to bother an overworked museum staff, there is no place where objects can be safely and adequately shown, survey classes are too large to bring into the galleries, and one example of a period or a style is not enough to justify the trouble either of bringing it out to view or of trying to mount a small exhibition around it. Some of these faculty members have admitted they are not even aware of what they could use in the collection.

But others, especially teaching members of the museum staff, are frequent users of the collection in their courses. Perhaps the most successful integration of the collection into teaching is in seminars at the graduate level. In these, students working under faculty supervision have not only designed and installed the shows and written the catalogs but conducted tours once the exhibitions were up.

During the spring of 1973, for instance, six graduate students (in a seminar led by Charles Eldredge on curatorial problems and museum techniques) assembled an exhibition of American drawings and watercolors from the museum's own collection. The exhibition was to draw on a mass of material that had never been adequately organized or inventoried. As the students investigated the collection, they discovered several works whose significance the museum had been unaware of—an early signed and dated drawing by Homer Martin, for example, and some preliminary mural studies by Daniel Huntington. The students' research also inspired additions to the collection; "it grew," said Eldredge, "as it was being studied." By the end of the semester, the students had experienced a full load of museum work—scholarship, exhibition design, installation, interpretation, and acquisition.

A similar exhibition by students followed the American drawings and watercolors show, this one in the winter and spring of 1974 on photographs from the collection, which the students also helped to catalog for the museum under the supervision of photography curator James Enyeart. Next on the list is a program in which students will be trained to catalog nearly 1,500 Japanese prints and the museum's collection of textiles and decorative arts, a task the museum hopes to complete before moving into its new building in 1978.

## Scholarly exhibitions with other university departments

An advantage of the university's size (18,250 students and about 1,100 faculty in 1973/74) is that interdisciplinary work is possible. Faculty members in various departments know one another, and the departmental divisions are not so bureaucratic nor the specialties so narrowly pursued that cooperative projects cannot easily be undertaken.

In 1967, when Marilyn Stokstad was director of the museum, she and Associate Director Bret Waller persuaded the University Theatre, the department of English, and the department of art history to join forces with the museum to stage what Ms. Stokstad described as "an interdisciplinary, interdepartmental production drawing upon the University's scholarly and cultural resources for the purpose of bringing to life the image of an age and its artists; in this case, the eighteenth-century London of Thomas Rowlandson and Richard Brinsley Sheridan."[3] The theater produced Sheridan's The School for Scandal, with sets designed from Rowlandson drawings on exhibition at the museum during the run of the play. The play was studied in English literature classes and the drawings examined by students in art history. Essays and notes from each department were assembled by the museum to form the catalog of the exhibition and program notes for the play.

The year before, the museum used "the famous Tuesday receptions" of the poet Mallarmé as the historical focus for an exhibition of symbolist art and literature of the 1880s. There were paintings and prints by Degas, Gauguin, Manet, Monet, Edvard Munch, Renoir, Rodin, Vuillard, and Whistler, several of them from books these artists had illustrated. Again, the catalog contained essays by faculty members, this time from the department of French and Italian as well as history of art.[4]

Other exhibitions—one on seventeenth-century Spanish drawings, another on American artists in Italy, and, several years earlier, an exhibition celebrating the 100th anniversary of the publication of Burckhardt's studies of the Italian Renaissance—were occasions for joint ventures with American studies, history, Latin American, and humanities faculties. Says Eldredge,

These attempts to understand the cultural and social context of art, add depth to our exhibitions. We want other departments to help select themes for our shows that will broaden their scope beyond straight art history and aesthetics. The attempt doesn't always work, but it is important to try to have several different events play off each other so that they will compound the experience for the students and other members of the university community.

## The department of visual arts education and the museum

The museum is an independent agency within the university, without formal relation to other departments or divisions. It does have close ties, however, with the department of visual arts education, whose chairman, Phillip Rueschhoff, has said he sees a "trend" toward the use of museums by art education students. It arises, he thinks from their interest in "less structured" settings and the need for public school teachers to help their students learn to use the museum.

As a beginning, the art museum, the Museum of Natural History, and the department of visual arts education devised a cooperative project in 1971 that offers a series of Saturday workshops to children in the Lawrence area. The themes, agreed on and worked out jointly, are intended to help children see the relationships among art, natural history, and their environment. A typical workshop starts with improvisations in front of a landscape at the art museum, then moves outdoors for a nature walk, and returns to the department of visual arts education where children can project slides they have made from the leaves, feathers, and twigs they collected on their excursion. Working with the curators of education at the two museums, the art education students help guide the children in studio projects.

Encouraged by experience with the visual arts education students, the museum's curator of education invited music education students to experiment with sound in the improvisational tours that have become a staple of the museum's program for local schoolchildren (see following paragraphs). As part of their course work, undergraduates invented tours in which children translate visual rhythms and patterns into movement and musical sounds (for descriptions of similar approaches, see the reports on the East Cleveland program, chapter 6, and the Metropolitan Museum high school programs, chapter 10).

## The museum and the community

Although Lawrence is just 40 miles from Kansas City and its famous William Rockhill Nelson Gallery, among other cultural attractions, the town itself is a community in which much of the intellectual and cultural life revolves around the university. Even its tree-lined streets and Victorian houses, set in one of the state's few hilly regions, surround the school, which was built on the town's highest hill in 1865, just after the Civil War.

If the setting seems feudal, university people insist the town-gown relations are not. Many faculty members are involved in local politics, and the university's cultural and athletic events are enthusiastically supported by local citizens. Before the art museum took on any scholarly distinction, when it was still a decidedly local collection, it was an institution that attracted as much town as university interest, limited as that interest was. And after the museum was remodeled in 1948 and the collection given a more sophisticated installation by its first professionally trained director,

John Maxon,[5] the museum still elicited what the museum's directors often felt was more than its share of local concern: elderly women in town continued to march in regularly to register their indignation over "Catholic art" and nudes.

In 1968, when then Director Bret Waller appointed the museum's first curator of education, James Enyeart, the museum took an official step toward recognition of the local citizenry as part of its reason for being. Enyeart began a docent program for schoolchildren—a visit to the classroom, followed by a tour at the museum, the subject matter tied to the curriculum. When Enyeart moved on to become curator of photography in 1971, Eldredge hired a former art history student at the university, Dolo Brooking, to take Enyeart's place.

The choice was fortuitous. Ms. Brooking's interdisciplinary interests included "progressive" education and the theater as well as art history. Outgoing, articulate, and unprepossessing ("She doesn't threaten people," one observer has noted), she has also turned out to be tireless in her pursuit of "the community"—university, town, and state—and the means of getting people involved. When she started work, Ms. Brooking's first move was to visit 16 art museums from St. Louis to Boston to find out what was going on and to look for people and programs that might help her define her philosophy. (What she found, she has said, was curators of education "on the defensive, getting their Ph.D.'s, writing scholarly articles, looking for innovative ideas and reassurance.") Closest to her own ideas were the Arts Awareness program at the Metropolitan Museum and the improvisational work being promulgated by Susan Sollins, formerly at the National Collection of Fine Arts in Washington, D.C.

Back home, Ms. Brooking set up her own improvisational tours for children; organized town-gown events to help relax local relations, which had been strained by the campus events of 1970; wrote a column for the Lawrence *Daily Journal-World* and moderated a weekly half-hour radio show designed to promote local interest in art. She also began reaching out across the road to the university's Museum of Natural History, the department of art education, and beyond it to other parts of the university community in the "spirit of synthesis" that now dominates the education program as well as the rest of the museum's activities.

**"The Extended Hand," a symbolic exhibition.** If Ms. Brooking has had a special effect on the Lawrence community, it is probably in her enthusiastic absorption of the disparate talents she finds everywhere about her. Those who take the initiative to offer their services, she points out, are not the only potential volunteers; they are simply the people who see the relationship between themselves and the museum. Others may not volunteer, she says, because it has never occurred to them how they can be useful. "People want to use their expertise in a different way . . . [and they] are so pleased to stretch out and reach in other directions if you only ask them."

There are several ways Ms. Brooking has found to ask for help and a variety of uses to which she has put it. An exhibition organized by the education department in early 1974 is typical of the method. Called "The Extended Hand," the exhibition was designed around the endless ramifications of the human hand—its uses, symbolism, structure, evolution, ornamentation, and dressing. The exhibition was built around original works by artists as diverse as Hiram Powers, Auguste Rodin, and Arman, all focused on the human hand and most borrowed from collections in this country and Europe. The visitor was introduced to the show through a participatory gallery intended to "heighten their awareness" of the artists' interpretations of the hand.

To stage the three-week exhibition, Ms. Brooking called on a range of resources from both the university and the town of Lawrence:

- A teacher specializing in perception and early learning at a local parochial school helped to design the show so that visual and tactile experiences would be integrated.
- The Space Technology Center at the university arranged for the loan of a one-level quantizer from a local corporation for one of the participatory installations.
- A professor from the design department worked for "hundreds of hours" with three of his students to build another installation (a perceptual acoustical sensitizer); other students from the department hand-lettered the large, easy-to-read labels for the show and lent it several hand sculptures; posters for the exhibition were made by a professor of printmaking from the painting and sculpture department; graduate students from the visual arts education department made complex handprint patterns for the display.
- The director of the Hand Rehabilitation Center at the university medical center lent x-rays, a large anatomical model of the hand, and illustrations of sign language.
- For a publication on the exhibition distributed to schools, a member of the economics department contributed instructions for playing the washboard; from the design department came a plan for "an easy-to-build electronic eye musical instrument";[6] and librarians searched out prints and photographs of "rare examples of hands in their collections."
- With grants from the Kansas Arts Commission, as well as the National Endowment for the Arts, the docent chairperson traveled to schools in a 40-mile radius of Lawrence to tell classroom teachers about the exhibition.
- After touring the exhibition at the art museum, children were taken across the street to the university's natural history museum where staff members showed them "hands" in both skeleton and live form—lizards, walking catfish, penguins, and bats.
- On opening night, all those who attended contributed their handprints to a 24-foot panel at the entrance to the show.
- At one of the special events tied to the show, two faculty members played "hand-related" music in accompaniment to readings on the subject of the hand.

**Programs for the Lawrence schools.** Much of the education department's activity, as in other art museums, centers on children in the local public schools. And like other art museums, too, this one tries to supplement the art curriculum, which the schools' cultural arts coordinator, Wayne Nelson, admits is weak (for the 4,000-pupil system, there is only one art consultant available to all the town's elementary teachers; he appears four times a year in each classroom).

The art museum's 14 docents concentrate on in-class slide presentations and gallery tours for the 5th and 6th grades, visiting all the 5th grades in the fall and the 6th grades in the spring. Fifth graders are led through an exploration of shape, line, form, and color through slides of objects in the museum collection and photographs taken in the Lawrence area. Sixth graders take part in a question-and-answer session on the mood and feeling of similar slides.

Gallery tours at the museum lean heavily on improvisational theater techniques, in which the docents receive special training. Docents try hard to elicit children's feelings about and sense of identification with a work of art. Their purpose, in Ms. Brooking's words, is to make the immobile object, through physical participation and game playing, "as potentially vital as the moving images which surround us in daily life."[7] On one tour, for example, children were asked to imagine and then act out their reactions to feeling the skin of a fish in a still life: there was much squirming and expression of distaste as the children pretended to pass the fish along to each other and considerable relief when it was carefully placed back in the still life and the group moved on to another painting.

**Publications.** In addition to the scholarly catalogs produced by the museum on its exhibitions, the museum has generated, through the education department, materials for use in schools. Perhaps the most ambitious of these so far have been the loose-leaf portfolio of ideas based on "The Extended Hand," and a booklet of poems by Lawrence students called *Art Is Me,* written after their visits to the museum. The "Extended Hand" portfolio, developed by Ms. Brooking and one of the museum docents who is a former art educator, contains illustrations of objects in the show, instructions and diagrams on how to make working models of the participatory exhibits, a page on the history of palmistry, and even a story, "The Hand" (what else), by Guy de Maupassant. The portfolio, paid for by the National Endowment for the Arts and Kansas Arts Commission grants, was sent to every grade school in the state.

*Art Is Me* is drawn partly from responses to a questionnaire the museum passed out over a two-year period to 6th-grade students as they left the museum, asking them to write a poem or draw a picture "inspired by what you saw at the museum" (the title comes from one of the children's poems).[8] Although the booklet is meant partly to reach children who cannot

come to the museum, it is also an invitation: it has been sent to 400 schools within driving range of Lawrence, together with a list of museum services for all ages.

## The museum and the state: traveling shows

In addition to its scholarly work with other departments of the university and its educational services for the Lawrence community, the museum conducts, with the Division of Continuing Education, a traveling exhibition program for outstaters. Started in 1969 and encouraged by the university's chancellor—admittedly to help dispel the elitist image many Kansans had developed about the Lawrence campus (Kansas State, the land-grant university at Manhattan, was often considered more down-to-earth, less dangerously "intellectual" than KU)—the program takes exhibitions particularly into the more sparsely populated areas of western Kansas. "Our minivan," says Wallace May, director of classes for continuing education, "may be their only contact with culture." (For a description of this vehicle and the portable exhibition cases that fit into it, see chapter 3.)

Both the museum and the Division of Continuing Education seem to feel their alliance is a promising one. The division has an enrollment of 48,500 persons throughout the state, 4,500 of whom take classes for credit. In the federal prison at Leavenworth alone, between 600 and 1,000 inmates, a third to one-half the population, are enrolled in the division's programs. Wallace May looks on the university's museums as "a tremendous resource" and notes that the division's videotape capability, coupled with the four cable stations in western Kansas, could give even wider exposure to the van exhibitions. "We are crying for materials," he has said of the television possibility.

**"Kansas in Transition."** Another kind of traveling exhibition, not carried on the minivan, was organized by the museum in 1974. Called "Kansas in Transition," the show and its accompanying symposium were designed to encourage people to look at their environment to see how industrialization and urbanization have changed social behavior. According to Dolo Brooking, not only was the exhibition an example of the way the museum fulfills its obligation to the public that supports the university, but the response to it demonstrated "rising expectations on the part of the taxpayer as to what the museum and the university can and should do."

The exhibition was assembled by Curator of Photography Enyeart with a $25,000 grant from the Kansas Committee on the Humanities and the National Endowment for the Humanities. Photographs and slides taken by Enyeart and another Kansas photographer showed what was happening to traditionally rural land in the state; they recorded the results of migration of Kansas farm dwellers to the cities and examples of "the vitality of ethnic heritages and the value of unchanged areas."[9] In each of the six cities and towns to which the exhibition traveled—Colby, Garden City,

Wichita, Coffeyville, Shawnee Mission, and Topeka—it was opened with a symposium, organized by staff members of the museum and the university's Institute of Public Affairs and Community Development and led by Ms. Brooking. The panel in each case consisted of a representative from the local community, a member of the state government, a university professor, and an official from another state. Discussions between the panel and the audience were taped, and the audience responses were added to the labels of the exhibition as it moved to the next community.

## The communal spirit and the wider community

The University of Kansas Museum of Art may not be unique—and lays no claims to being altogether successful—in its attempts to define and serve a variety of audiences. Bret Waller, who preceded Eldredge at Kansas and now directs the art museum at the University of Michigan, feels that it is the mark of all the better university museums that they consciously attract their audiences and their working colleagues from a wide community, both on campus and off—people who live nearby, members of the museum, alumni, scholars at other institutions, special audiences within the university, and residents throughout the state.

But the size of the University of Kansas, its location in a relatively homogeneous small town, the museum's purposeful communal spirit, and perhaps, as several people in Lawrence have remarked, a new public interest in the arts in Kansas—"a sense of adventure, a sense of experimentation," "the idea that there is more to life than just making money and doing a daily job"—have combined to give this oasis of culture in the Midwestern prairie, as Edward Maser hoped, a role in the life, studies, and research of its community.—*J. A. H./B. Y. N.*

---

## Notes

1 "A College Bulletin for, by and in spite of a College Faculty," undated reprint; read at the 55th Annual Meeting, May 26, 1960.

2 For sources of quotations without footnote references, see list of interviews at the end of this report.

3 Foreword to *The School for Scandal: Thomas Rowlandson's London, a Catalogue of the Exhibition Held at the Museum of Art, the University of Kansas, February 8–March 12, 1967.*

4 The exhibition and its related activities are described in detail by Bret Waller in a *Museum News* article in October 1966.

5 Like his successor, Edward Maser, Maxon moved from Kansas to Chicago; he is now vice-director for collections at the Art Institute.

6 *The Extended Hand, a Portfolio of Experiences for the Hand,* assembled by Dolo Brooking, curator of museum education, and Leni Salkind, educational consultant, University of Kansas Museum of Art, 1974.

7 "A Philosophy and Curriculum for Educating Museum Educators," paper delivered at the Midwest Art Historians meeting in Minneapolis, Minnesota, April 1974, p. 7.

[8]*Art Is Me,* Miscellaneous Publications of the Museum of Art, no. 93, University of Kansas, 1974.

[9]"A State in Transition—the Human Dimension," a program for the exhibition and symposium at the Johnson County Public Library, Shawnee Mission, Kansas, March 4, 1974.

## Interviews

Ashton, Ray. Coordinator for Public Education, University of Kansas Museum of Natural History. January 21, 22, 1974.

Brandon, Marilyn. Department of Music Education, University of Kansas. February 27, 1974.

Brooking, Dolo. Curator of Education, University of Kansas Museum of Art. October 2, 1973; January 21–22, February 26, March 25–27, 1974.

Connelly, James L. Associate Professor, Department of the History of Art, University of Kansas. March 26, 1974.

Eldredge, Charles. Director, University of Kansas Museum of Art. October 2, 1973; January 22, February 26, 1974; telephone, July 24, August 1, 1975.

Hoffmann, Sally. Docent Chairperson, University of Kansas Museum of Art. January 22, March 26, 1974.

May, Wallace R. Director of Classes in Division of Continuing Education, University of Kansas. January 21, 1974.

Nelson, Wayne. Cultural Arts Coordinator, Lawrence Public Schools. January 21, March 25, 1974.

Newsom, Barbara. Division of Continuing Education, University of Kansas. March 25, 1974.

Rueschhoff, Phillip. Chairman, Department of Visual Arts Education, University of Kansas. January 21, 1974.

Salkind, Leni. Docent, University of Kansas Museum of Art. February 22, 1974.

Scoby, Sylvia. Teacher of Perceptual Studies, St. John's Elementary School. January 22, March 27, 1974.

Shipman, O. B. Cabinetmaker, University of Kansas Museum of Art. January 22, March 25, March 27, 1974.

Stokstad, Marilyn. Associate Dean of the College of Liberal Arts, University of Kansas. January 21, 1974.

Stump, Jeanne. Assistant Professor, Department of the History of Art, University of Kansas. March 26, 1974.

## Bibliography

*American Drawings and Watercolors from the Collection of The University of Kansas Museum of Art*, catalog, June 10–July 8, 1973.

*Art Is Me*. Miscellaneous Publications of the Museum of Art, no. 93, University of Kansas, 1974.

Brooking, Dolo. "A Philosophy and Curriculum for Educating Museum Educators," paper delivered at the Midwest Art Historians meeting in Minneapolis, Minnesota, April 1974. Reprinted in *Museology Programs: Professional Standards and Practical Considerations*. Minneapolis: Midwest Art History Society, 1975, pp. 21–27.

*The Extended Hand, a Portfolio of Experiences for the Hand*. University of Kansas Museum of Art, 1974.

*Language of Light, a Survey of the Photography Collection of the University of Kansas Museum of Art*, catalog, February 3–24, 1974.

*Les Mardis, Stéphane Mallarmé, and the Artists of His Circle*. University of Kansas Museum of Art, catalog, November 28, 1965–January 3, 1966.

*The School for Scandal: Thomas Rowlandson's London, a Catalogue of the Exhibition Held at the Museum of Art, the University of Kansas, February 8–March 12, 1967*.

Waller, Bret. "Mallarmé at the University of Kansas," *Museum News*, October 1966, pp. 21–26.

# HOW TWO UNIVERSITIES, COLUMBIA AND THE INSTITUTE OF FINE ARTS, USE THE METROPOLITAN MUSEUM OF ART

The Metropolitan Museum of Art
1000 Fifth Avenue
New York, New York 10028

**Students, faculty, and museum staff give their opinions on the use of museums by two university graduate departments of art history—both of them richly endowed with distinguished faculties and scholarly resources—and on a museum training program jointly administered by museum and university. Problems of the joint training program and suggestions for its improvement center on supervision, screening, academic standards, and follow-up with graduates. CMEVA interviews: March 1970; September, November 1973; September, October 1974; February, May, December 1975; April 1976.**

### Some Facts About the Program

**Title:** Museum Studies in the Department of Art History and Archaeology, Columbia University; the Joint Museum Training Program, Institute of Fine Arts, New York University, and the Metropolitan Museum of Art.

**Audience:** Graduate students in the Department of Art History and Archaeology, Columbia University (237 in good standing, 1974/75); graduate students at the Institute of Fine Arts (340, 1974/75) and students in the Joint Museum Training Program (10, 1974/75).

**Objective:** For the Columbia and IFA faculty and students to use the collections of the Metropolitan Museum in the study of the history of art at the graduate level; for students in the Joint Museum Training Program, "to provide a systematic training for . . . curatorial and research positions in the museum field."

**Funding:** Columbia and the IFA both hire Metropolitan Museum (and other) curators as adjunct professors, some of whom teach regularly, others on an every-other-year schedule. Unless special guards are required for classes after hours, students and adjunct faculty members have free access to the museum's galleries and by appointment to its storage rooms and offices.

The Joint Museum Training Program offers three Ford Foundation fellowships a year for matriculated Ph.D. students; each stipend is $4,000 a year, renewable up to three years, plus a $500 annual allowance for married fellows with one child, $250 for each additional child; a travel, book, and photo fund, $2,500 for each three-year fellowship, goes with the stipend. Out of this nine-year grant, begun in 1968, the Metropolitan receives matching tuition at the rate of $183 per course and an overhead payment of $4,250; the IFA receives $21,000 in overhead.

**Staff:** 37 members of the art history faculty at Columbia, 6 of whom were adjunct professors from the curatorial staff of the Metropolitan in 1974/75; 39 members of the faculty at IFA, 6 of them also adjunct professors from the Metropolitan staff. The Joint Museum Training Program at IFA is supervised by a faculty member from the institute and coordinated on the museum side by a curator appointed by the museum. A joint committee of the two institutions administers the program.

**Location:** Classes and seminars are held in the Metropolitan's galleries, storerooms, and offices. Objects of art are occasionally brought to the conservation center at the institute.

**Time:** The Joint Museum Training Program began in 1956; Columbia has employed adjunct professors from the Metropolitan since 1950.

**Information and documentation available from the institutions:** Catalogs and course announcements.

For students of art history who choose to study at either of the two graduate schools of art history in New York City, Columbia University and New York University's Institute of Fine Arts, the chance for exposure to original works of art would seem to be one of the best in the United States. In the city's major museums are some of the nation's richest collections of American, twentieth-century, Asian, American Indian, Western European, Egyptian, and "primitive" art, and libraries to match them at such institutions as the Frick Art Reference Library, the Museum of Modern Art, the Morgan Library, and the Metropolitan Museum of Art. The Metropolitan alone has a collection of objects that spans 50 centuries, perhaps the most comprehensive concentration of art works anywhere in the world. According to one of its own reports, the Metropolitan library, which in 1974 totaled 200,000 volumes, "is considered the leading art research library in the Western Hemisphere and one of the world's foremost resource centers for scholars working in the field of art."[1]

It is perhaps no wonder, with such attractions, that between 1972 and 1974, Columbia University and the Institute of Fine Arts produced 22.6 percent of all the nation's Ph.D.'s in art history—more than Harvard, Yale, and Princeton combined, more than all ten of the leading Midwestern university art history departments, and more than twice as many as all West Coast universities put together.[2]

The New York City museums obviously cannot take all the credit for the relatively high Ph.D. productivity of the Institute of Fine Arts and Columbia University. The quality of their faculties, course offerings, and research facilities clearly plays a large part in student choice. But if it can be safely assumed that the art collections in New York are important attractions for both the students and the faculty members who teach them, it is appropriate to ask how these two institutions make use of New York's resources. Although both Columbia and the IFA hold classes at several local museums and draw adjunct professors from them as well, for both institutions the closest formal ties are to the Metropolitan Museum, above all other museums in the city. The rela-

tions between the museum and each of the universities are thus of particular interest here.

## Columbia University

The Metropolitan's formal relations with local universities began with Columbia College in 1891, when the two institutions sponsored a joint lecture course, open to the public, on Greek archaeology and aesthetics. By 1892 the museum had set aside a special room for the Columbia lectures, equipping it with lantern slides, lanterns, and screens; Columbia provided and paid for the lecturers. In return, the Metropolitan curators delivered lectures to college students before objects of art in the museum two days a week. The next year, according to the museum's annual report for 1893, the Columbia lectures had become so popular with the public that the museum had to enlarge the hall, and in 1896 the museum reported that the free Columbia College lectures "are evidently destined to become an important factor in the education of the community, as well as a potent agency in arousing public interest in the activities and benefits of the Museum."[3]

The Columbia lectures continued for several years and were added to in 1913 with extension courses on art appreciation and the study of original works in the museum. The extension courses were still going strong in the thirties. So were the Columbia lectures and the university's special classes for public schoolteachers. Columbia faculty members continued to meet with their students at the Metropolitan throughout the next two decades. Although the Metropolitan had long since offered some of the same privileges to other local universities that Columbia had enjoyed since the 1890s, by the late 1950s the museum's closest relations were reserved for Columbia and the Institute of Fine Arts. The museum's annual report for 1958/59 mentions collaboration with the two institutions "in the training of more advanced classes and students"; it goes on to argue that "art studies can be pursued most effectively in the presence of actual collections" and notes that during the year "Columbia held regular classes in the Museum, a number of them taught by members of our staff."[4]

## The Institute of Fine Arts, New York University

New York University first appears in the Metropolitan annals in 1923, when the university made an arrangement, in the words of the annual report, "which the Museum will gladly extend to other universities."

. . . The educational program was enlarged this year by a number of advanced courses of lectures, having the extent and standards of academic work. Instruction has been given in the Museum by members of the Department of Fine Arts of the University and members of the Museum staff. . . . Illustrations were chosen wherever possible from the Museum galleries and collections, supplemented

by loans, and by lantern slides, etc., from both the University and the Museum.[5]

When the Institute of Fine Arts itself was established as the university's graduate department of art history in 1929, it had no classrooms or equipment of its own, so classes were held in the Metropolitan's basement, and students worked in the museum's library. Recalling the conditions he found when he taught there in 1931, Erwin Panofsky writes that "smoking was forbidden under penalty of death and stern-faced attendants would turn us out at 8:55 P.M. regardless of how far the report or discussion had proceeded."[6]

In 1958 the institute moved from its quarters on East 83rd Street to the James B. Duke house just down the street from the Metropolitan, "precisely," as the university's former president, James M. Hester, has noted, "in order to be near the Museum."[7] The ties became particularly close in 1956, the year the museum training program (see following section) was jointly developed by the two institutions. Under it, students study with both Metropolitan curators and members of the institute faculty and take an internship at the museum.

In addition, several of the museum's curators in any given year are listed on the institute faculty, institute professors sit on some of the Metropolitan's visiting committees, and the museum's library, by official agreement—and in the past a financial one as well—is considered the basic library resource for institute students. (In 1973/74, the graduate student registration from the institute—3,262, or 16.5 percent of all readers registered at the library—was second only to the museum's own staff and more than twice the number recorded from Columbia, which has such a comprehensive art history library of its own that its students are not dependent on outside resources.)[8]

## Graduate Study in Art History

### The Columbia program

Columbia's Department of Art History and Archaeology offers five basic graduate programs—the history of Western art, classical art and archaeology, Near Eastern art and archaeology, Far Eastern art and archaeology, primitive and pre-Columbian art and archaeology, and the history of architecture. In one way or another, museums and private collections are drawn on in all five programs: "Visits to several museums and collections," says the graduate-school catalog, "form part of the assigned work in many of the courses."[9]

In addition to the visits, Columbia has made arrangements with several local museums, principally the Metropolitan, for both adjunct professorships and for classes held at the graduate (and undergraduate) level in museum galleries. Of the 95 art-history course listings in the 1974/75 graduate school catalog, 11 were scheduled to be given at local museums (including the Morgan Library and the American Numismatic Society), 6 of these, in turn, at the Metropolitan.

The Metropolitan courses included an introduction to connoisseurship (European paintings), a history of Oriental carpets, fourteenth- to sixteenth-century costume in Persian painting, decorative arts in Persian manuscript painting, medieval metalwork and ivories, and problems in Dutch art of the seventeenth century.

Almost all the courses based in museums were conducted by museum curators who also held teaching appointments. In 1974/75, out of a total faculty of 37, there were 12 curators in such posts at Columbia, 6 from the Metropolitan. That number varies from one year to the next, depending on sabbaticals and the number of curators available to teach. In 1975/76, for example, only three Metropolitan curators held Columbia appointments, not including one former curator who had joined the Columbia faculty full time and continued to teach at the museum.

Outside of the adjunct professors, few Columbia faculty members make an effort to move their classes to the museum. For one thing, the Metropolitan and most other New York museums are half an hour and more away by public transportation, and although at least one member of the department, Director of Graduate Studies James Beck, has suggested the idea of a special bus service to nearby museums, distance continues to be an obstacle.

Another deterrent is money. Unless the course is held during the museum's regular hours, the university must pay the Metropolitan guard fees of about $50 a night and additional fees for rent of the auditorium and the use of the museum's projectionist, whose pay is about eight times the wage a student would earn, say Beck and the department's chairman, Alfred Frazer. A single course can cost the university as much as $3,500. It is one reason, says Frazer, why there is a diminishing number of courses offered at the museum and why the university values the Metropolitan's open hours on Tuesday evenings: "It would be a real loss if we couldn't take the students there on those nights," Frazer has said.[10] When seminars are held during regular museum hours, the only cost to Columbia is the salary of the adjunct professor, which is prorated at less than faculty pay because the university is not responsible for his benefits.

But like other university art history departments, Columbia's is wedded to the convenience of the slide-lecture and the breadth of example it offers. Third-year graduate student Robert Simon has noted that "in every undergraduate class we had to do a paper on museum objects. Undergraduate courses send students to original art more. This is forgotten in graduate school. There the problems center on who did it and what makes for an artist's unique style. It is hard to point out these things to a large group in a museum." For this kind of study, in Simon's view, slides are often necessary:

> The experience of original objects is wonderful; there is nothing like it, and it is necessary for studying art. But much of art history deals with problems—tracing influences, comparing features of several works, studying the development of ideas in great monuments. Slides are

relied on because everything can be brought together, and they are a more practical way to keep the flow and continuity of the lecture. In a museum an object is studied less as part of an art historical scheme, more in terms of its provenance, which is not considered in academic work. Simon pointed out, too, that in graduate school students are expected to go to museums on their own, and Columbia students, like other university students in New York, are regularly offered free passes and special memberships by several local museums.

### The Institute of Fine Arts program

Academic work at the Institute of Fine Arts is structured with art history and archaeology at its core and two museum programs on either side, one in conservation and technology of works of art, and the other the museum training program. In art history and archaeology, students can take a master's degree in any one of six major areas—Far East, India, and Islam; ancient Near East and Egyptian, Greek, and Roman; early Christian, Byzantine, and Western Medieval art to 1400; Western art 1400–1750; Western art 1750 to the present; and prehistoric and primitive art. Doctor's degrees may be taken in any one of 32 specialties, including conservation and technology. Special interdepartmental programs for Ph.D. students have been designed in classical art and archaeology, Near Eastern art and archaeology, and Far Eastern and South Asian art.

The institute has long drawn on museum curators for part of its teaching staff, the majority of them from the Metropolitan, and it has also regularly scheduled classes and seminars at other local museums. Whether or not it was a typical year, in 1974/75 the institute offered 71 art history courses, not counting its museum training and conservation programs. Of these courses, 7 were scheduled for sessions at the Metropolitan and one at the Brooklyn Museum. (When the museum training and conservation programs are added in, the number of museum-based courses rises to 13 out of about 125.)

With few exceptions, courses held at the Metropolitan were led by adjunct professors from the museum, who in 1974/75 numbered 6 out of a total faculty of 39—a proportion that the institute maintains with some consistency year after year. (Included as adjunct professor in this count is a member of the IFA faculty who is consultative chairman of the Metropolitan's department of Islamic art, Richard Ettinghausen.) The exceptions were a seminar in Spanish baroque paintings conducted by the IFA's director, Jonathan Brown, who schedules one course a year at the Metropolitan, and a seminar on Attic gravestones, given by IFA professor Evelyn Harrison, which emphasized archaic and classical originals in the Metropolitan.

Other seminars either built around the Metropolitan's collections or scheduled to be held at the Metropolitan were readings in Middle Egyptian, non-Attic black-figure vase-painting, Islamic paintings, and sixteenth-century Italian drawings (this seminar took advantage of an exhibition of drawings from the Louvre during the preceding term).

Although the institute's teaching in the museum is largely confined, as Columbia's is, to courses given by the adjunct professors, Brown points out that other members of the faculty frequently use other collections that are stronger than the Metropolitan's in several areas—the Brooklyn Museum in Egyptian art, for example, and the Morgan and New York Public libraries in prints and drawings. In addition, according to one former institute student, IFA professors have often assigned papers on works in the Metropolitan collections and several have given what has been described as "undue emphasis" in their courses to works in a field where the Metropolitan is strong.

Nevertheless, because the institute is so near by and its formal ties with the Metropolitan are so close, several members of the museum's curatorial staff and some of the institute's former students who have worked at the Metropolitan tend to be particularly—if not, as in Brown's view, excessively—critical of the institute's use of the museum for study of original objects. Constance Lowenthal, a former museum training student and now a member of the Sarah Lawrence College art history faculty, has concluded from her experience both at the institute and at the Metropolitan that institute professors give too few classes at the museum and too few assignments there. "It is not the Metropolitan's fault," she said; "if an institute professor asked, a curator would help." During her museum training internship in the Metropolitan's department of European paintings, she found that "whenever a serious student calls, he can get access."

James Draper, associate curator in the museum's department of Western European arts, who coordinated the museum training program for the Metropolitan for two years, has found, too, that IFA students are not assigned work at the museum as much as he feels they might be. "Student use of the museum is minimal," he said. "I worked in the drawings department for a year, and in all that time, only one or two students came to look at anything. Lecture courses rarely send students over to look at objects. Institute students often don't know what the Metropolitan has." Another former IFA student now working at the Metropolitan felt that the regular IFA faculty "doesn't use the museum as much as it should" because it is so "settled"—what one Metropolitan curator described as "a bit stale in its thinking."

Brown admits that "many institute faculty could function without museums," but he also points out that there are some fields "where museum resources are not rich." According to Harry Bober, a professor in the humanities who also supervises the museum program at IFA, attention to individual objects can easily become an excuse for not dealing with their broader art historical context. Instead of inventing exercises for using objects, what the institute tries to do, he notes, is to use them "naturally," however they fit the material covered in a particular course. Students might be advised that related

materials are on view at the Metropolitan, or objects might be brought from the museum to the institute's conservation lab for study.

(Bober himself, instead of taking students to the museum, sometimes puts a small piece of sculpture in his pocket before he goes into class. During the lecture he shows several slides of the object, which give it a monumental scale, brilliant color, and luminosity. When he takes the object from his pocket, he says, students find that the slides have given the object far more importance and interest and focused more attention on it than it would have attracted if it were only one of many small sculptures in a glass case. At the same time, says Bober, the students see that the original has very little to do with the images perceived from the slide.)

**Logistics and cost.** Adjunct professors are paid by the institute for their teaching, but otherwise no money changes hands. The institute is not charged for classes given at the museum, nor for the relatively heavy use of the Metropolitan's art reference and slide libraries, stack privileges, and the several carrels allotted to IFA students each semester.

In return for these services, however, the institute offers a certain number of scholarships each year to museum staff members (the number varies from year to year), and Metropolitan staff are allowed to take individual courses at the institute without paying a fee. Brown is careful to point out that these privileges are not to be conceived as "payment" to the Metropolitan: "Each institution," he says, "makes its resources available to the other; our relationship is based on good will." He is "reluctant to get into an accounting of costs" because it might lose the "good will" that sustains the program. "Now both sides are deriving intangible benefits . . . on a rough parity," he feels.

Ann Leven, the Metropolitan's treasurer affirms the fact that there has been no accounting of costs. "There are no figures," she says. Although the museum has recently tried to pull the figures together, so far, according to Leven, the "quid pro quo for the use of the museum's facilities is not measurable because there has been no study." Like most private institutions, IFA has had to deal with deficits in recent years, and as the institute is not subsidized by New York University and must, as Brown says, pay its own way, there has been a tightening up on some of the scholarship awards to the museum staff. "We have cut down on some of the people to whom we have given course money for a long time," Brown explained; "it is not fair to take money away from poorer students when [museum curators] are earning good salaries and can afford to pay for the courses themselves."

## Museum Training

Aside from the adjunct professorships, the closest working relations between the Metropolitan and the institute are centered on the museum training program, and there is nothing in the Metropolitan's relations with Columbia that compares with it.

Although Columbia students have often taken summer internships at the Metropolitan and several have had special fellowships at the museum, the university offers no specific museum training—and, in fact, has not until recently been particularly sympathetic to museum work. According to Robert Simon, "either you were a professor or you were nothing."

Frazer and the department's director of graduate studies, James Beck, have admitted that the university "in the past" recommended the "well-dressed, well-spoken, not very bright student" for museum work. With some exceptions, Frazer and Beck said in an interview, "outstanding scholars don't go to museums." There is a need for fund raising in the museum world that makes it "essentially more social." "The museum and the academic worlds are separate," they declared, and both were critical of the fact; "museums are not drawing on university scholarship," and the academic world, in turn, "has avoided problems of attribution [that interest the museum] because those problems are connected with the market."

### The Joint Museum Training Program

Whether or not there has been any tangible change of attitude at Columbia toward museum work, the IFA has "made a commitment to it," in Brown's words, through its Joint Museum Training Program with the Metropolitan. It is what Brown calls "the leading museum training program in the country," with a "record in producing museum personnel." It is commonly agreed in the museum world, too, that the program has usurped the role once held by Harvard's Fogg Museum under Paul Sachs (who stopped teaching in 1949).

The program was established by the Metropolitan Museum and IFA in 1955, and the first students reported for class in the fall of 1956. Its stated aim was "to provide a systematic training for students who wish to follow careers in curatorial and research positions in the museum field."[11]

Translated into slightly sharper terms, the idea of the program's sponsors was to lure new talent into the museum profession from the academic world and to give a wider range of students a way into a profession that had long been dominated by the sons of wealthy families. At the same time, by maintaining high academic standards, the program would try to correct the well-recognized mutual suspicion between museum curators and university scholars. Both IFA and the museum felt that curators should be as well trained as the professors and the university scholars should be more familiar with original materials. By working together, perhaps the two groups would gain each other's respect and benefit from each other's knowledge.

Although the students in the program must be admitted to the Graduate School of Arts and Science of New York Uni-

versity as regular M.A. candidates in the history of art, the program is administered by a joint committee and is under the supervision of the directors of the museum and the institute. The degree, either an M.A. or a Ph.D. in the history of art, is awarded by the institute; a Certificate in Museum Training is issued jointly by the two institutions.

While they are at the institute, students must fulfill the same academic requirements as any M. A. candidate—33 credits (11 courses), a distribution requirement, a reading knowledge of French and German (a Far Eastern language may be substituted for either, with written permission of the faculty adviser), and two qualifying papers.

In their first year students take two courses oriented toward connoisseurship or one course in connoisseurship and what is usually referred to as Museum I (Museum Training and Connoisseurship I: Introduction), a one-semester course. At the end of their first year, students apply to the joint committee for permission to take Museum II (Museum Training and Connoisseurship II: Connoisseurship), also one semester. Students are selected on the basis of their performance in the connoisseurship courses, their overall academic record, and an interview. (Screening here has traditionally left between half and two-thirds the number in the course.)

Those students who have successfully completed Museum II and all academic requirements for the M.A. and have been accepted by the institute as candidates for the Ph.D. are then eligible for the internship, or Museum III (Museum Training and Connoisseurship III: Internship). This is one semester of full-time, supervised work in the museum beyond the master's degree.

Museum I is conducted by the institute, paid for and located there, and taught by an IFA appointee (recently a curator emeritus who is an adjunct professor on the IFA faculty). Museum II is conducted by the Metropolitan, meets in the museum, and is supervised by a museum staff member. Where Museum I is meant to introduce students to the museum world—the history of American and European art museums, problems in museum administration, and a wide array of curatorial responsibilities—Museum II is meant to be basically object-oriented. Students may have seminars with as many as 10 or 12 Metropolitan curators, who are free to conduct the sessions as they see fit.

Part of Museum II is a project. For many years this was an acquisition exercise, for which each student was given a budget of first $35, later $1,000, to buy an object and defend his choice to a panel of Metropolitan curators; when it was clear that the performance had become too tense for the students to be productive, the exercise was replaced by projects devised by the supervisor, which have ranged from a student exhibition to the completion of lengthy accession and de-accession forms for objects in the Metropolitan collection.

For Museum I and Museum II, students receive three credits each. Museum III is worth six credits, which may be used toward a doctor's degree but do not count toward the

M.A. Museum III internships are awarded at the discretion of individual curators. In some departments, students are given "real" responsibility, access to the department's storerooms, and the chance to work with its objects; in others, students may spend their time reorganizing files.

**Reactions to the program.** The IFA-Metropolitan program has been an important source of museum directors and curators in the years since it began. According to one IFA list, which mixes graduates of the joint training program with alumni of IFA's regular M.A. and Ph.D. programs, there are more than 100 institute graduates working in museums, 17 as curators at the Metropolitan alone. Whether these students might have moved into museum jobs without the training program is a question the records do not answer. But it is also a question that has been raised both directly and indirectly in the dissatisfactions with the program expressed by some of its critics.

For what emerges in discussions of the museum training program is a sense that useful as the program has been in drawing young art historians into museum work, the program as it has developed is not sufficiently demanding to prepare students for the kind of professionalism museums need. Former coordinator of the program for the Metropolitan, Jim Draper, feels that Museum I, for example, aims at too low a level. John Walsh, former curator of European paintings at the Metropolitan and coordinator of the program between 1968 and 1973, calls Museum I an interesting but "gut" course.

As for Museum II, Olga Raggio, chairman of the department of Western European arts at the Metropolitan and an adjunct professor at the institute, finds it fragmented. The problem, as the newly appointed coordinator of the program, Margaret Frazer, sees it, is that in the two-hour sessions curators have with the students there is no plan and no chance to build rapport or judge what direction the class should take. According to Frazer, "some curators are more adept teachers than others, but the time they are allowed is often too short even for the best teachers to get to know and inspire the students." And the difficulty is compounded by the problem of supervision: "The role of the coordinator is very ambiguous," she says; "the coordinator gives assignments and submits a grade but never actually teaches a class. It's frustrating for both the coordinator and the students. The coordinator follows the students [throughout Museum II] but must rely on the opinion of other curators who see the students for only three or four hours."

Jonathan Brown agrees that supervision is a problem, particularly in the museum internship, where he feels that both the institute and the museum are at fault. The question, says Brown, is how to reform it. Supervision, he notes, "gets into the problem of territoriality"; he finds it difficult for institute faculty to pass judgment on the work of a museum department. "We need a meeting of the minds," Brown has said.

"The museums must determine for themselves what they require [in their curators]. The subject needs study."

For John Walsh, supervision is a problem throughout the program, not just at the museum or the institute. Students, says Walsh, need consistent advice; they should have someone to help them with both personal and professional development. No matter how "extraordinary and demanding" the quality of the teaching may be, "what falls apart is the students who need criticism and guidance. The institute's museum-program students have felt in jeopardy. They have no one but their dissertation sponsor. There is no career advice, no follow-up. . . ." Walsh would like to see a single supervisor for the entire program, "a special person at the institute, a professor who knows the score."

Connie Lowenthal, who calls the overall supervision of the program "spotty" by both IFA and the museum, says that her "main beef" against the program is its failure to follow up on graduates. "There is no official encouragement to curators to get people into museum jobs," she says, "and little encouragement to the students to complete their course work and begin the Ph.D." (Raggio agrees.) Of all the museum program students Lowenthal knew who received Ford Foundation fellowships (which were established in 1968 precisely to encourage museum training graduates to complete the Ph.D.)—three each year for five years between 1969 and 1974—"none has so far finished the Ph.D., only one is working in a museum, and one expects to finish this year."

**Proposed solutions.** Brown himself is optimistic about changing the program to meet the claims made against it. "It's a question of fine tuning," he has said, "not designing a new motor." Brown and Metropolitan Director Thomas P. F. Hoving have begun to hold meetings about the program, and Brown expects that they will find a better solution to its management, perhaps by jointly appointing a single administrator.

Among those who have been close to the program at the museum, the changes can come none too soon. So concerned have several of the senior curators been about the program, in fact, that they have considered taking the matter of revamping it into their own hands. Those who were interviewed for this report were virtually unanimous in their suggestions for improving the program: it should last longer, it should be more demanding academically, and students should enter it at a higher academic level.

Draper feels that Museum II should be a year-long course with more concentration, more credits, and at least three months for each student to meet with a curator instead of the few weeks that now apply. He would make Museum I a lecture course on the history of collecting, and he would offer the Museum III internship more credits. In addition, both Draper and Walsh think the internships should carry a stipend. "NYU is very expensive," says Draper, "and so is the city; many students need jobs now because part-time work is necessary." Walsh agrees; he calls the internships "slave labor." Brown feels that as it is not legal to pay students and give academic credit, the institute might be able to work out a tuition remission arrangement here.

Margaret Frazer's suggestions, offered when she was just beginning to formulate her ideas about the program, were to make Museum I and II a year-long intensive course and to assign responsibility for coordination to the professors who teach the course. It would be an "advanced seminar," in which groups of students would tackle a curatorial problem and follow it through to the end: they might install a room, for example, or plan an exhibition with the advice of a curator; the work, said Frazer, should be "real and practical." Before students undertake such assignments, however, Frazer thought the institute should give them "object orientation" by assigning them objects to study and catalog. In the museum course itself, students should be given experience in connoisseurship and administration—and, Draper would add, the unglamorous aspects of curatorial work.

Olga Raggio, who is both a highly respected curator and teacher and someone who has given the program a good deal of thought, feels that the present program is "not very relevant" partly because "it is not run as a really *joint* educational venture with full partnership and understanding of each side's point of view." She thinks that the program should be a professional (a word she emphasizes) course, Museum II "to be taken only after the M.A. is completed."

Essentially Raggio feels that once the student has completed two years of graduate work in art history—"art history is the requirement," she says—he should be free to concentrate on the problem of applying his academic training to a museum rather than to a teaching situation. "A longer and more serious Museum II should then introduce the student to the existence of different approaches and problems within the context of actual collections," says Raggio, "exposing him to conservation and instructing him in such specialized concerns as catalogs and exhibitions." She adds, "Museum work is a technique and a profession, just as teaching is a profession. Students should decide to follow one or the other."

Raggio would like to see "higher requirements" for the program, and she suggests that students specialize more, perhaps in just two fields, and receive more time with the curators in the fields they choose. She recommends, too, that university faculty members, not just students, take internships at museums so that they could understand what goes on there: "The institute does not know the museum," Raggio asserts.

The Metropolitan's director, Thomas P. F. Hoving, wonders whether it is time to rethink museum training altogether. It is Hoving's experience that many of the "best" curators come from scholarly backgrounds, entering museum work as "completely honed" art historians.

A very fundamental question must be raised at this time, and that is whether museum training, at least as we have known it over the past several years, is any longer valid at all—whether, in fact, there is even any need for it. Perhaps the best way to discover and nurture curatorial talent would be for art historians to progress through graduate school, as they have done for decades, becoming fully immersed in the methodological and theoretical aspects of art history. After that training is completed, those who really want to go into museum work, or think they do, can be picked from the Institute of Fine Arts, Columbia, or another graduate school. Then would be the time to expose them to the connoisseurship, exhibition, and conservation aspects of museology. Those who want to stay in museum work would have the complete training in both methodology and connoisseurship. This is how training was done for many years, and it proved to be successful. Perhaps this is the way, indeed, to look at museum training now—in a practical manner.

Although Brown did not say so directly, he indicated that if museum training were to satisfy the museums' interests academically, it would have to emphasize scholarship over "training" and, for all practical purposes, take the route of the regular Ph.D.'s—a route, it would seem, that both Hoving and Raggio favor too. "More scholarship in curators," Brown said, "will require having followed serious, high-quality, advanced study in art history. The M.A. is no longer an adequate degree, [especially those that] are only one year long with minimum requirements."

## Scholarship: Museum and University

The debate over the museum training program itself had in many ways only begun to take form at the Metropolitan when this report was written, and discussions between the institute and the museum were in more embryonic stages still. Jonathan Brown was inclined to be more patient than some of his Metropolitan colleagues; he felt the "battle lines" had moved, that a "very slow and quiet change was already well advanced" in the attitudes of museum and university toward each other. "People are now going into museum work," said Brown, "with the same background as they go into university work. There has been an inevitable professionalization of museum staffs, and economic pressure [has helped this development] because there are fewer university jobs."

But a fundamental problem that surfaces for Brown when he talks about the differences between university and museum work, and that is clearly on the minds of museum staff members as well, is the attractions for scholars offered by one institution over the other:

American museums are structured in a way that doesn't allow research, unlike European museums, where curators don't get into fund raising and where they are given a chance to do research and are constantly publishing. The financial and social structure of the American museum is at the heart of the whole matter. . . . What a serious student of art history needs is time to do one's work. That is missing in many museums because there is too much ancillary work. Metropolitan curators wear eight different hats, and a lot of them are forced to farm out their research. . . . A curator of paintings has no time to do research.

Olga Raggio, well known for her scholarly productivity, defends museum scholarship: "There is not enough recognition in the academic world of the serious scholarship which is frequently done in museums," she has said. "In fact, it is often more serious and more intense; it requires more initiative and fresh thinking, and it often breaks new ground. Museum people resent the academic attitude. . . . We are engaged on so many fronts that we must have widespread activities; we have a wide audience, and therefore we must learn to publish in a variety of ways."

But Raggio also feels strongly, with Brown, that museums do not allow their curators enough time for research:

It is absurd that there should be competition [between museums and universities]. One problem is that there are not enough benefits in museums: we should have more time for sabbaticals, something that now only the very best people in museums get. Any creative scholar values time to do creative writing, thinking, and reading. He must get away from his desk. The elite of curators especially want these benefits. It will be serious if this goes on; museums will not attract the best people. It is always a crucial thing to ensure their growth.

As centers of research, these three institutions—the Metropolitan Museum, the Institute of Fine Arts, and Columbia University—have few rivals anywhere in the world. Together, they constitute a formidable resource for students of the visual arts. To the degree that they draw on the other scholarly resources available to them—the language, literature, history, philosophy, architecture, and anthropology departments within the universities, and the many general and specialized collections in New York City—the art history faculties of both Columbia and the Institute of Fine Arts have an unusual chance to produce broad-gauged scholars for both the museum and university worlds.[12]

The fact that the Metropolitan Museum is available to both these institutions on almost any basis they choose, and that the museum's collections lend themselves particularly well to teaching, is for many people in the museum world an enviable responsibility. Few universities and few large museums are so well matched as these, as the Cleveland Museum-Case Western Reserve program, for one (see this chapter), makes clear. If the formal arrangements that have obtained between the Metropolitan Museum and Columbia and IFA are not altogether satisfactory to everyone who is familiar with them, it is partly because the possibilities for object-grounded scholarship appear to be so infinitely more promising here than the realities seem so far to have delivered.—*F. G. O./B. Y. N.*

# Notes

[1] Elizabeth R. Usher, chief librarian, Metropolitan Museum, "The Metropolitan Museum of Art Library," draft of an article for the *Encyclopedia of Library and Information Service*, 1974, p. 12.

[2] The figures: Institute of Fine Arts: 47 Ph.D.'s, 12.5 percent; Columbia: 38, 10.1 percent; Harvard: 45, 12 percent; Yale: 21, 5.6 percent; Princeton: 17, 4.5 percent. The total for all five schools: 168, or 44.2 percent.

The ten Midwestern universities (University of Chicago, Northwestern, Case Western Reserve, University of Illinois, Indiana University, University of Iowa, University of Michigan, University of Minnesota, Ohio State, and the University of Wisconsin): 80 Ph.D.'s, 21 percent.

The West Coast (University of California at Berkeley, Santa Barbara, and Los Angeles): 35 Ph.D.'s, 9.2 percent.

See *Survey of Ph.D. Programs in Art History* (New York: College Art Association of America, Committee on Graduate Education in Art History, 1975), pp. 12–16.

These figures have changed considerably since the study for the College Art Association in 1963 directed by Andrew C. Ritchie. According to that research, between 1930 and 1962, 73 percent of all Ph.D.'s were produced by the top five universities: Harvard, 28.9 percent; the Institute of Fine Arts, 18.8 percent; Princeton, 10.4 percent; Yale, 7.5 percent. See *The Visual Arts in Higher Education* (New Haven: Yale University Press, 1966), p. 5.

[3] Metropolitan Museum of Art annual reports for 1891, 1892, 1893, 1896, pp. 506, 507, 537, 574, 676.

[4] Pages 46–47.

[5] Page 25.

[6] Epilogue: Three Decades of Art History in the United States," *Meaning in the Visual Arts* (Garden City, N.Y.: Doubleday Anchor Books, 1955), p. 331.

[7] "The Urban University and the Museum of Art," *Papers* from the Seventh General Conference, International Council of Museums (New York: Metropolitan Museum of Art, 1965), p. 22.

[8] "Public and Graduate Student Registration for the Fiscal Year 1973/74," Metropolitan Museum Library, July 8, 1974. Total staff registration, 5,567; IFA, 3,262; Columbia, 1,418.

[9] *Columbia University Bulletin: The Graduate School of Arts and Sciences*, 1974/75, pp. 102–103.

[10] For sources of quotations without footnote references, see list of interviews at the end of this report.

[11] "Some Museum Positions Held by Institute of Fine Arts Alumni," Xeroxed sheet.

[12] Columbia's graduate department of art history and archaeology is in the middle of a campus where students and faculty can and do work back and forth with the school of architecture and the graduate departments of history, English and comparative literature, philosophy, languages, and religion (which also offers courses through Union Theological Seminary across the street). These departments, Frazer has said, often use the slides and other visual documents from the department of art history. In turn, students of Far Eastern art, for example, have available to them strong departments in East Asian languages and culture, Middle East languages and cultures (27 courses in Semitic languages in the 1974/75 graduate school catalog alone; 18 in Altaic, Central Asian, and Turkic; 12 in Iranian and Persian; 9 in Indic; 6 in Armenian). Students can take a graduate degree in medieval and Renaissance studies through any one of nine departments, including art history and archaeology, French and Romance philology, Germanic languages, history, or Italian. A special interdepartmental program in ancient studies draws on the departments of art history and archaeology, Greek and Latin, history, Middle East languages and cultures, and religion.

Although the institute is about as far from the main campus of New York University as Columbia is from the Metropolitan, its students, too, can, and in several cases must, supplement their art history studies in a wide variety of academic fields—anthropology, classics, comparative literature, French, Italian, Spanish, and Germanic languages and literatures, several Semitic and Ancient Near East languages (Akkadian, Sumerian, Arabic, Hebrew, Persian, Turkish), Near East history. There are 65 courses in Slavic languages and literature listed in the 1974/75 graduate school catalog and, in addition, nearly 90 courses in film. For the Ph.D. program in Far Eastern art and archaeology, students are required to be competent in either Chinese or Japanese, or both, and to take a minor in some aspect of Far Eastern history or literature. A Ph.D. in Near Eastern art and archaeology requires reading competence in Arabic and Persian, Akkadian or Sumerian; in Egyptian art and archaeology, students must be able to read Ancient Egyptian (advanced courses in Ancient Egyptian are given by the institute). Similarly, classical art and archaeology requires 18 points of graduate study in Latin, Greek, ancient history, epigraphy, and numismatics. In Near Eastern studies, a cooperative arrangement with Princeton University's program allows students to take courses at either institution.

Both Columbia and IFA provide advanced students in archaeology with the chance to take part in excavations abroad. Both, too, have close ties with the American Academy in Rome and the American School of Classical Studies in Athens, where graduate students may carry on independent research.

# Interviews

Beck, James H. Director of Graduate Studies, Department of Art History and Archaeology, Columbia University. May 27, 1975.

Bober, Harry. Avalon Foundation Professor in the Humanities, Adviser to the Conservation Center, and Supervisor of the Joint Museum Training Program, Institute of Fine Arts, New York University. September 19, 1974.

Bothmer, Dietrich von. Chairman, Department of Greek and Roman Art, Metropolitan Museum of Art; Adjunct Professor of Fine Arts, Institute of Fine Arts, New York University. March 31, 1970.

Brown, Jonathan. Associate Professor of Fine Arts, Director of the Institute, and Chairman of the Department of Fine Arts, Institute of Fine Arts, New York University. February 26, 1975; April 9, 1976.

Draper, James David. Associate Curator of Western European Arts, Metropolitan Museum of Art. November 10, 1973; December 17, 1975; telephone, December 16, 1975; April 21, 1976.

Eisler, Colin T. Professor of Fine Arts, Institute of Fine Arts, New York University. September 19, 1974.

Frazer, Alfred. Chairman, Department of Art History and Archaeology, Columbia University. May 27, 1975.

Frazer, Margaret English. Associate Curator, Department of Medieval Art and the Cloisters, Metropolitan Museum of Art; Adjunct Associate Professor, Department of Art History and Archaeology, Columbia University. Telephone, December 18, 1975; April 9, 1976.

Hoving, Thomas P. F. Director, Metropolitan Museum of Art. July 8, 1975; telephone, April 9, 1976.

Kneeland, Deborah van Dyck. Assistant Director for Administration, Institute of Fine Arts, New York University. Telephone, September 16 and 19, 1974.

Lee, Sherman E. Director, Cleveland Museum of Art. October 2, 1974; February 26, 1975; telephone, April 15, 1976.

Leven, Ann R. Treasurer, Metropolitan Museum of Art. Telephone, December 22, 1975.

Lowenthal, Constance. Professor, Department of Art, Sarah Lawrence College. December 17, 1975.

Parker, Harry S., III. Formerly Vice-Director for Education, Metropolitan Museum of Art; Director, Dallas Museum of Fine Arts. November 15, 1973; telephone, April 19, 1976.

Pilgrim, James. Deputy Vice-Director for Education, Metropolitan Museum of Art. Telephone, December 22, 1975.

Raggio, Olga. Chairman, Department of Western European Arts, Metropolitan Museum of Art. Telephone, September 15, 1975; April 10, 1976.

Simon, Robert. Ph.D. Candidate, Department of Art History and Archaeology, Columbia University. Telephone, December 17, 1975.

Walsh, John, Jr. Formerly Curator, Department of European Paintings, Metropolitan Museum of Art; Adjunct Professor (now Professor), Department of Art History and Archaeology, Columbia University. September 12, 1974; February 14 and 26, December 16, 1975; telephone, November 7, 1973; April 8, 1976.

Wortman, Jeffrey. Student, Joint Museum Training Program, Institute of Fine Arts, New York University. September 17, 1973.

# THE CLEVELAND MUSEUM OF ART AND CASE WESTERN RESERVE UNIVERSITY: JOINT PROGRAM IN ART HISTORY

University Circle
Cleveland, Ohio 44106

**A unique cooperative arrangement between a private university and a nearby public (but privately funded) museum provides instruction at both the undergraduate and graduate levels in art history. It draws, though not quite equally, on the staff and resources of both institutions. From its successes (increased use of art works by university faculty and students, broader access to students for some museum curators) and from its problems (juggling institutional and individual priorities), other museums and universities may find useful guidelines in their efforts to work together. An interesting aspect for a few selected students: the Art Museum Studies Program, supervised by the museum and leading to a Ph.D. granted by the university. CMEVA interviews: December 1973; May, September 1974; November, December 1975.**

**Some Facts About the Program**

**Title:** The Joint Program in Art History.

**Audience:** Undergraduate and graduate students in art history at Case Western Reserve University and the Cleveland Museum of Art.

**Objective:** To use the collections, resources, and staff of the museum, and the resources and faculty of the university for instruction in art history to students, from freshman level through the Ph.D.

**Funding:** Average annual cash share contributed by Case Western Reserve University is about $30,000 to the museum for curatorial and library support, plus faculty salaries, tuition waivers, and routine administrative costs. (Total art department budget for 1974/75: $226,855.) Average annual financial share contributed by the Cleveland Museum of Art: a "ballpark" figure of $100,000, including student stipends, rental space, library and slide room costs, utilities and maintenance, but excluding curatorial salaries and administrative costs. In 1975 the university gave an additional $50,000 grant for a year-long sculpture program. Support for the Art Museum Studies Program: for 1972–1975 three tuition grants and student stipends of $6,000 each, two from the Kress Foundation, one from a private Cleveland foundation; for 1974–1977, two tuition grants and student stipends of $7,050 each from the National Museum Act.

**Staff:** Art history faculty at Case Reserve (4 full-time, 2 part-time); between 10 and 12 curators at the museum, 5 to 7 of whom are active.

**Location:** In the Cleveland Museum classrooms, galleries, and study areas, and at the university.

**Time:** The Joint Program began in 1967; the Art Museum Studies Program began in 1972.

**Information and documentation available from the institution:** Case Western Reserve University catalog of courses; descriptive material and regulations issued by the university.

Next-door neighbors for over 50 years, the Cleveland Museum of Art and Western Reserve University long cooperated in certain programs. As early as 1917, only a year after the museum opened, a course in art appreciation given in the museum auditorium drew several hundred university students. For some years, the curator of education at the museum, Thomas Munro, was also the chairman of the university's small art department, and a number of curators taught university courses for undergraduate and graduate students.

During the 1960s, changes at both institutions prompted a new and somewhat more formal relationship. In 1967 Western Reserve University and Case Institute of Technology, another next-door neighbor, joined to create a federated university, Case Western Reserve University. The study that planned the federation also encouraged the "new" university to explore the possibilities of cooperation with some of its several dozen neighbors in University Circle, a mile-square area of institutions, clustered around the university, that have traditionally dominated the cultural and educational life of Cleveland.

When Harvey Buchanan, then coordinator of the university effort to establish cooperative plans in the humanities, approached the Cleveland Museum of Art, he found a ready response.[1] The museum by that time had a new director, Sherman E. Lee, appointed in 1958; a new curator of education, James R. Johnson, who succeeded Munro in 1967; and a new name for the education department, the Department of Art History and Education. Lee's response to the university's inquiry was in part based on his appraisal of the pressures then exerted on art museums to be educational institutions. In his judgment, much of what passed for new educational approaches in museums was "show biz"—and show business is not exactly his idea of what a museum is all about (see his essay at the beginning of this book). If the art museum is to be a truly educational institution, he reasoned with Buchanan, then, in addition to its customary teaching, it ought to be doing the educational work most appropriate to it: scholarly education at the university level.

In 1967, Lee submitted to the museum trustees a report of "tentative conclusions" Buchanan and he had reached. It recommended establishing a joint program between the museum and the university's Department of Art that would provide "instruction at both the undergraduate and graduate levels in art history for university students."[2] The trustees were skeptical, according to Lee. Their reluctance was based not so much on the financial burden the joint program would place on the museum as on the fear that teaching duties would pull museum curators away from the work for which they were principally hired. The trustees accepted some and "reserved judgment" on others of the "tentative conclusions," which outlined a cooperative scheme for planning, teaching, facilities, and financing. That scheme has changed very little since 1967. Nor have the tentative outlines been made more precise or permanent; nothing more formal has been drawn up to govern the joint program. It operates on a mix of good will and prudence on both sides.

The outline considerably enlarges the old habits of cooperation between the university and the museum. Amiable as the earlier patterns had been, they were not extraordinary: curators in many museums have taught occasional courses at nearby universities. The present arrangement, for all its deliberate informality, is a more comprehensive and detailed cooperative plan for undergraduate and graduate education in art history than exists between any other general art museum and university in the country. Harvey Buchanan, now provost of the university's Division of Humanities and the Arts, who has with Sherman Lee nurtured the program from its beginnings, sees it as an "art history department in a museum."[3] Lee has said his primary goal is "to educate students." For both, it is an effort to achieve, between neighboring independent institutions, the close relationship a university art department can usually have only with its own museum—and to include in that intimacy one of the great museum collections in the nation.

## A Brief Background

The present existence and future potential of the joint program may best be understood by a brief history that sets into the context of past time and place the university, the museum, and the city in which both are located.

Western Reserve College was established in 1826 in Hudson, Ohio, a small town 26 miles southeast of Cleveland. Its founders, men instrumental in developing northeastern Ohio (which was, officially, the Western Reserve of Connecticut), "refused to consider Cleveland as a possible location for the college because it was a lake port, full of temptation for the innocent student."[4] Like most other small private colleges of the early nineteenth century, Western Reserve was oriented toward an education in the classics and preparation for the ministry; it also had from the beginning a scientific bent, especially in astronomy and meteorology and in medicine (at an affiliated medical school established in Cleveland in 1843).

Within 50 years, Cleveland began to look considerably more acceptable than it had seemed to the Western Reserve College founders. In the early 1880s, Case Institute of Technology, a private scientific school, was established in Cleveland, and the trustees of Western Reserve College saw distinct advantages in moving their liberal arts school near Case. They bought adjoining land and began to hold classes on the Cleveland campus in 1882; by 1884 Western Reserve University was chartered, comprising the various departments of the college and the medical school. In the next decades it added a school for women, schools of law, dentistry, and library science, the country's first graduate school of social work (in 1916), a school of nursing, and an adult education division.

Both Case and Western Reserve flourished as Cleveland prospered. Between 1900 and 1930, Cleveland was one of the fastest-growing cities in the United States, fifth largest in 1920.[5] Bolstered by the city's heavy industry, Case made a special reputation for itself. Western Reserve was becoming an excellent private university. As the city grew, a number of cultural institutions were established: between 1910 and 1925, they included the Cleveland Orchestra, the Cleveland Playhouse (the oldest regional theater in the country), and the Cleveland Museum of Art, which was founded in 1916.

Since the 1940s, Cleveland and its metropolitan area, like many older industrial cities that ring the Great Lakes, have not grown as rapidly as cities in other sections of the country. Slowed economic and population growth has naturally affected all local institutions, but Case, with its broad support from the city's industrial corporations, and the museum, through substantial private gifts and adroit but conservative curatorial and administrative management, have continued to flourish.

During the 1950s and 1960s, cooperative ventures be-

tween Case and Western Reserve increased: the two institutions adopted a common academic calendar, arranged for registration interchange, merged some departments and services. Federation seemed "the dictate of common sense." The resulting Case Western Reserve University combined a private scientific and technological institute and a private liberal arts school into a private university with special strengths in the sciences. Since the federation, and especially since the financial and careerist pressures of the early 1970s on all American higher education, the humanities divisions of Case Western Reserve have been pared down. History, English, and language departments were smaller in 1974/75 than at the time of the merger in 1967. Among the humanities divisions, only the art department has grown—from three to four faculty members in art history.

However promising its conception in 1967, the joint program ran head-on into the university's financial difficulties. The result is that the program has not yet become everything Lee and Buchanan hope it will eventually be. Still, both men express patient satisfaction with the program, and Buchanan even says, "In some ways it exceeds my hopes."

The birth pangs and early development of the joint program provide an instructive model for university-museum cooperative efforts in art history education, especially in the light of a 1966 College Art Association report that noted the "insufficient number of strong centers of undergraduate and graduate instruction" in art history outside the Northeast and its recommendation for "the establishment of relatively small but possibly quite productive centers of graduate study in the various main regions of the United States."[6]

## The Premise: To Educate Freshmen as well as Future Professionals

In designing the joint program, the Cleveland Museum, for one, was quite sure about what it wanted to avoid. According to Sherman Lee, the museum was dissatisfied with museum training programs "that turned out people highly trained in art history and only happy and productive in major Eastern museums." The museum was equally displeased, Lee said, with other programs "producing people who were not art historically trained enough and therefore unable to cope with the problems of scholarship and connoisseurship in a serious art museum." Beyond that professional dissatisfaction, there was considerable disappointment—expressed in many museums by many curators—in the conventional college and university art history education that is dependent more on slides than on original works of art.

Consequently, the joint program is what its organizers call a *complete* program in art history. It draws on the museum and the university staffs and resources for undergraduates, art history majors, M.A. and Ph.D. candidates, and future museum professionals in what may be its most unusual aspect, an art museum studies program. This latter part of the

joint program (described in more detail later in this report) is the special responsibility of the museum curatorial staff and culminates in a Ph.D., granted by the university.

The Cleveland Museum's philosophy—indeed, any art museum's philosophy—is that the object is the heart of the matter: says one of its brochures, "The Museum believes that original source material and original works of art provide the best foundations for art history studies on any level."[7] With the foundation of its extensive library and exceptional collections, the Cleveland Museum wanted to have a hand in the education of art history students and in the education of another generation of art historians.

The joint program gives students equal access to curators who can teach them connoisseurship and to art historians who stress the cultural and historical context, iconography, or other aspects of the history of art. Museum curators and Case Reserve faculty emphatically agree that students benefit from a variety of approaches to the study of art. Lee's position is that the art historical approach makes "a great contribution to the history of ideas," but he would like to see that approach "leavened by the use of objects," a kind of "planned filtering" of connoisseurship into the teaching of art history. That is the basic conviction on which the entire joint program is based: the study of art history is incomplete without *both* approaches.

The program has two audiences: the undergraduate student and the future art historian or museum professional. Lee argues that art history is the broadest humanities discipline available to undergraduates, calling as it does on history, philosophy, literature, and a variety of cultural and social studies.[8] H. W. Janson of New York University, the joint program's 1975 visiting professor, agrees, adding that the study of art history provides information about all cultures everywhere, including those that "have left us no other documents."

Janson further believes that one goal of a strong undergraduate program in art history should be the encouragement of "the growth of a broad segment of the public that could become art patrons." If art history could be, like history or literature, the kind of general humanities major that attracts students who do not intend to make a career in the field, Janson has speculated, more college-educated people—on whom cultural institutions generally depend for support and understanding—would understand and support museums and artists.[9]

But for Janson it is the professional goal that is paramount: "The primary goal of university-museum programs is to break down the barrier between the museum profession and the university art historian." He believes that if the same kind of education is provided for those going into college teaching or museum work, then at least one of the "barriers"—what he calls "the university professor's reliance on slides and photographs and the curator's general lack of interest in teaching"—may yield. Lee considers this breach in the professional barricade *not* the joint program's primary goal but

"one of its important side effects"; for him the main goal of the Cleveland program is "to educate students" and to draw on the broad discipline of art history and the rich collection of the museum to do so.

## The Structure of the Joint Program: Facts and Figures

### The museum's part

Under the joint program, ten to twelve of the museum's curators are appointed to adjunct professorships at Case Reserve (the number changes with shifts in staff). Because Buchanan and Lee agreed at the beginning that the old moonlighting ought not to be part of the new arrangement, the university "buys" curatorial services from the museum, which remains the sole employer of the curators. The museum determines the salary and adjunct status of teaching curators; Lee, acting for the museum, recommends the appropriate rank of each appointment. After consultation with the chairman of the art department, Buchanan makes the appointment on behalf of the university. Each teaching curator signs an annual appointment contract with the university.

Most art history classes are conducted in the museum, whether taught by university faculty or museum curators. Students have access to the museum collection, library, and other facilities, access that is limited in the undergraduate years but practically unlimited on the graduate level.

**Teaching.** Theoretically, each curator with a university appointment teaches an average of one semester course in every two-year period; some teach more often, others not at all. Curators are encouraged but not required to teach. "Given our circumstances—the collections, our history, our place in the community—I don't see how we could *require* curators to teach," Lee has said. Nevertheless, a few curators ignore the encouragement, leaving the teaching chores to their colleagues who feel the desire or duty.

No one presses the curators who teach to give courses that fit into the overall design of the art history curriculum. Though the choice is left to the discrimination and interest of individual curators, their suggested courses must satisfy the usual university requirements for degree credit and must be approved by faculty committees and the provost. The system is simple: the museum's curator of art history and education asks curators what they would like to teach and when—and if there are scheduling or topic problems, the chairman of the university art department straightens them out informally.

Seven of the twelve curators listed as adjunct professors in 1974/75 (four full professors, the others assistant, associate, or instructor) taught university courses during that academic year. In fall 1974, nineteen undergraduate and five graduate students enrolled in a popular course taught by John Cooney, curator of Egyptian Art. (At his retirement from the museum in 1975, Cooney became a visiting professor at the university, retaining the title of research curator at the museum.) Two other curators offered graduate-level seminars with limited enrollments; museum and university staff shared team-teaching responsibilities for a methodology course required of incoming master's degree students; and the museum curator responsible for the art museum studies program taught two courses open only to those doctoral students.

(In 1974/75 the university paid the museum $26,000 to cover curatorial teaching salaries—$14,187.50 for the six curator-taught courses listed for the fall of 1974, $10,812.50 for four curatorial courses taught in spring 1975. The formula: the university pays one-eighth of a curator's annual museum salary during the semester he teaches. The sum is calculated on a percentage of each teaching curator's museum salary; when the director teaches, the calculation is made on the basis of the top curatorial salary.)

Because the university's Department of Art includes no Orientalists, the three curators in the museum's Department of Oriental Art offer a general introductory course every three years; they also teach individual courses in Chinese, Japanese, or Indian art. In the spring 1975 semester Sherman Lee, who is senior curator of the department as well as director of the museum, taught a combined undergraduate-graduate course in Japanese paintings; in the spring 1976 semester, Stanislaw Czuma, curator of Indian Art, offered a combined-level course in Indian sculpture. Those curators who teach at the undergraduate level generally also offer these courses to graduate students with additional requirements. But some curators prefer to teach only at the graduate level; the museum estimates that 30 percent of its courses are "exclusively reserved for graduate students."[10]

**The library.** The museum library has 84,950 volumes, 150,000 photographs, and 172,000 slides, and it subscribes to more than 600 art historical journals and bulletins. According to the museum librarian, Daphne C. Roloff, the museum in 1974 spent over $270,000 on the library—for books, binding, periodicals, slides, photographs, salaries, and supplies.

In addition to the main reading room, which seats 34, the book library includes a curators' reading room and nine study carrels in the stacks, available to curators or to Case Reserve art history graduate students and faculty, who are the only nonmuseum staff granted access to the closed stacks. Until fall 1975 the library was open to all students at all area colleges and universities for reference and research. Because the number of outside readers doubled between 1972 and 1974, student admission was finally restricted to graduate students only.[11] As the joint program is the only graduate program in metropolitan Cleveland (there are a very few others within about a 50-mile radius), that action effectively closed the museum library to students at most colleges and universities in the area. Upper-level undergraduates in the joint program may use the museum library with a letter from an art history faculty member.

Open to those graduate students every day (even Mondays, when it is closed to museum members, and on Wednesday evenings while the university is in session), the museum library "functions as a departmental library," according to Mrs. Roloff. It buys and catalogs books requested by the university art history faculty, sets up reserve bookshelves, and its staff—eleven full-time (of whom six are professionals) and seven part-time—does "a fair amount of reference work for students."

For many years, the museum's extensive slide collection was available without charge to anyone: to students and faculty from all area colleges and universities, as well as to secondary school teachers, artists, independent art teachers, museum members, and the general public. In order to cut down on this widespread use and to make the slide collection more readily and completely available to curators and faculty teaching in the joint program, in the summer of 1972 the museum began charging all non-Case Reserve borrowers for the use of slides. (The charge scale: $2 for the first twenty slides, $1 for each subsequent package of ten or fewer.) The net result was a sharp drop, as intended, in circulation of slides, from over 104,000 in 1971 to about 50,000 every year since. In 1974, the total slide circulation figure was 53,930.

To choose two months from that year—March and October, each at the midpoint of an academic term—is to get a sense of the proportion of use by CWRU art faculty and graduate students, measured against use by all others. In March 1974, CWRU art faculty and graduate students borrowed without charge 1,596 slides; faculty and graduate students from all other area colleges and universities (about half a dozen) borrowed 1,573 slides—and paid about $157.30 for the privilege. In October 1974, Case Reserve art faculty and graduate students borrowed 2,559 slides; that month, graduate students and faculty from other schools borrowed 2,203—with the same financial arrangement.

**Other facilities.** As noted, most art history courses are taught in the museum classrooms and galleries, bringing Case Reserve students into the museum every day. The museum charges the university nothing for this use of space and absorbs all utility, maintenance, and other costs. University faculty do not have master keys that allow them into storage areas, but, Lee has pointed out, "we don't have the kind of depth in storage that some museums have. Nearly everything is out, open to one and all." If a faculty member asks to have a case opened to examine works of art with a class, a curatorial assistant must be available.

The museum's *Bulletin,* a scholarly publication issued ten times a year, carries articles by curators, by contributing scholars, including university faculty, and, on occasion, by graduate students. The museum annually provides $4,800 in stipends for two museum fellowships, to which the university contributes $6,000 for tuition. (Each fellow receives $5,400: a $3,000 tuition grant from Case Reserve and a $2,400

stipend from the museum; the student works ten hours a week at the museum as a condition of the fellowship.)

## The university's part

The university recruits and admits students, sets the degree requirements, and grants degrees. Between 1972 and 1974, undergraduate majors in art history increased at a time when university enrollments were declining.[12] (And the decline has been dramatic: between 1970/71 and 1974/75, undergraduate enrollment at Case Reserve was down by 27 percent, from 5,167 to 3,769 undergraduates. Even more disturbing to the university, whose president, Louis A. Toepfer, reported that "enrollment is nearing the point of critical mass," was the fact that in the fall of 1974 fewer than 650 new freshmen enrolled compared with 1,147 freshmen only five years earlier.)[13] In 1974/75, 42 undergraduates majored in art history, and 14 new graduate students (12 M.A. and 2 Ph.D. candidates) enrolled out of the 17 accepted by the university from 37 graduate applications. During 1974/75, there were 21 full-time, 19 part-time master's students, and 7 full-time, 11 part-time doctoral students. Between September 1968 and September 1975, 120 students began graduate work in art history: 63 M.A. degrees and 16 Ph.D. degrees were granted.[14]

The B.A. in art history requires 120 semester hours of academic credit, 24 hours in the major and 15 hours in related fields that must include 6 hours of studio art and 9 hours of aesthetics and closely related humanities courses. Although the degree does not require a foreign language (a university decision), art history faculty members encourage majors to study a language.

Admission to the graduate program does not require the Graduate Record Examination but does require three undergraduate research papers, at least one of which must be in art history. Since September 1973, M.A. and Ph.D. students have been required to demonstrate by examination reading knowledge of two foreign languages; before that, only one was required. In September 1974, for the first time, all M.A. students were required to take a course in methods of art historical research. There are two plans for earning the M.A.: both require a minimum of 27 hours, of which at least 21 must be in art history. One plan requires a thesis (equivalent to not less than 6 semester hours) but no comprehensive examination. The second requires a written and an oral comprehensive examination plus a paper demonstrating "scholarly ability."[15] The Ph.D. degree requires an additional 18 hours of course credit plus 18 hours of dissertation research, after the general examinations have been passed.

**Teaching.** Case Reserve's Department of Art consists of four full-time art history faculty (one tenured associate professor, three untenured assistant professors), two tenured part-time full professors from other disciplines, and one tenured associate professor and lecturer in art education.

Besides the introductory survey course, the four full-time art history faculty members offer undergraduate and graduate courses in Byzantine, medieval, Renaissance, modern, and American art. The two part-time university faculty members, who are full professors with primary responsibilities in other university departments, offer nineteenth-century art-humanities courses and classical art and architecture. Visiting professors periodically offer graduate courses: the late Wolfgang Stechow served as visiting professor in the early 1970s after his retirement from Oberlin College (and as curator emeritus at the museum), and in fall 1975 H. W. Janson taught two courses.

"We try to offer our basic courses in cycles," explained Associate Professor Walter Gibson, chairman of the department, "the introductory course every year, the intermediate courses every other year. With seminars we try to achieve maximum flexibility, according to student and faculty interests. So our plan is fair regularity at the bottom, flexibility at the top." A number of courses primarily for junior and senior undergraduates are also offered; with additional required papers and readings, these same courses are available for graduate students too.

The teaching load is five courses per year, and each faculty member usually offers at least one graduate seminar every year.[16] In the fall 1974 semester, the university roster listed 31 courses in art history through the joint program; 6 of them were combined 300- and 400-level courses, bringing the "official" total to 37 and including 9 "directed reading" courses and 3 courses open only to art museum study program students. Twenty-four were offered by university faculty.

**The university library.** Across the street from the museum, the university's 800,000 volume Freiberger Library for humanities and the social sciences contains about 26,500 titles in the visual arts and subscribes to about 125 periodicals in the visual arts and art history. A circulating as well as reference library, the Freiberger has a strong collection of architectural history (relic of an architecture department now phased out), humanities resources, journals in art and archaeology, and undergraduate texts not owned by the museum's more scholarly library. Freiberger's accessions policy in the visual arts since the joint program began has been to complement rather than to duplicate museum holdings.

Figures for university library acquisitions in art history are scattered through several different budgets, but "a fair estimate" of the amount spent on books in the visual arts and art history during 1974/75, according to Buchanan, would be "somewhere between $4,000 and $5,000."[17] (Some of these funds go for multiple copies of survey texts for undergraduates and in recent years for additional holdings in art education.) In a four-week period in fall 1975, 746 titles in the art division circulated.

**The university's contribution to the museum library.** In addition to book purchases for the Freiberger, the university pays $5,500 a year to the museum for the purchase of books. Though books bought with university funds bear the university bookplate, they are shelved at, cared for by, and belong to the museum. In March 1975 the university gave the museum a one-time additional grant of $3,000, half for books and half for slides, as part of the special sculpture program (see following section). And for the first time, in 1975, the university also paid $500 to the museum to help keep the library open on Wednesday evenings throughout the academic semesters of 1975/76.

**Other facilities and services.** All art history faculty offices are housed in a university building a short walk from the museum. Some seminars, tutorials, and an occasional class are taught at the university, though most are held at the museum, as noted earlier. The art department has a small slide collection, though no budget from the university to expand it, and consequently relies heavily on the museum's slide library. The art department has no picture collection (about two years ago it added its small collection to the museum's large collection of photographs). It has no visual study area for students.

University funds are available to selected students for travel, research, and special projects. Five of the sixteen successful Ph.D. candidates between 1968 and 1975 received dissertation fellowships of $4,500 to $5,000; four spent a year in Europe, the fifth in India. In addition, the university provides a number of full fellowships, teaching assistantships, and tuition grants. In the 1975/76 academic year, the Department of Art had four full-time university fellows, three teaching assistants, about ten tuition grantees, and two museum fellows with tuition grants of $3,000 each.[18]

As part of the joint program, the art department has established the Ohio Area Art Symposium. At the first annual conference, which was cohosted by the museum and held there in May 1975, 15 papers were read by graduate and undergraduate students from 13 art history departments in Ohio and bordering states.[19]

## The Joint Program: Where Do the Two Institutions Join, and Where Is the Program out of Joint?

The university and the museum struggles in the joint program are perhaps common to every cooperative enterprise: juggling institutional schedules, financial burdens, and administrative responsibilities, as well as the often more intractable considerations of individual priorities and capabilities, personalities, goals, standards, and concerns about status. Nearly everyone involved in the joint

program—students, curators, faculty, administrators—believes it is a good idea, some more fervently than others. None is yet completely satisfied with the way it works.

### Money

If there is a subject currently painful for both universities and museums, it is money. Neither institution here cost-accounts its share of the joint program. Unofficial "ballpark" estimates put museum costs at $100,000 a year for expenses incurred by the museum library (Mrs. Roloff figures, for example, that she requires one full-time and one half-time additional staff member for the joint program's needs), plus rent, utility, and maintenance costs generated by steady classroom use in the museum. This figure excludes curatorial and administrative costs.

Estimates of the university's contribution range from a low of $31,500 (the actual cash paid to the museum in 1974/75 to cover $26,000 in curatorial teaching salaries and $5,500 for use of the museum library) to a high of over $280,000, a figure that fails to make any distinction between the joint program and the entire art department budget and includes all department salaries, administrative costs, tuition waivers and fellowships, the university's grant to "Sculpture Directions '75," as well as payments to the museum and to both libraries.[20]

Harvey Buchanan has tried to put the subject of money in perspective:

> The important point is that this kind of guesswork . . . misses both the spirit and the fact of what we are trying to do. Any shared activity, any joint program obviously generates joint costs, and these costs must be sustained jointly in some reasonable way if a really cooperative program can be said to exist. What needs to be done, I believe, and what I would like to do, is work with the museum to find ways to *support*—not *reduce*—their costs and ours. The simple fact is that the program costs both institutions some money—it does not show a profit for either side in dollars. If it is to endure, it must show a profit to both institutions and their constituents as a valid intellectual and educational endeavor.[21]

Sherman Lee wholeheartedly agrees with Buchanan's attitude toward the costs of the joint program. But he has also made it clear that "the museum *does* put in more than half the cost" of the joint program itself and that cost-accounting would provide the evidence—which no one considers worth spending the time and money to gather.

The art department has no funds of its own; its budget comes entirely from the university. As Walter Gibson reported to the provost in January 1974, "further development of the program will necessitate greater financial support from the University, mainly in the appointment of additional faculty members."[22] Everyone on both sides of the street (literally, one street separates the museum and the university) agrees that a larger university faculty is desirable, but the university has not yet come up with the money.

A number of suggestions have been made about increasing the size of the faculty and the amount of money the university contributes. One is a joint museum-university appointment, but Lee has cautioned that "it would depend totally on the qualifications of the faculty person; most art history faculty haven't had the depth of experience in connoisseurship a full museum curator would have." And Buchanan has pointed out that higher student enrollments in art history courses would bring in additional tuition income, but he has also noted that "the more curators restrict their enrollment to small graduate seminars, the more restricted is the university's ability to support more than salaries." The university's $26,000 salary contribution to the joint program in 1974/75 paid for ten curator-taught courses, which brought to the university tuition income of $23,700.[23]

(Some observers have noted that the same $26,000 could enable the university to add one distinguished senior professor to its small and relatively young faculty, but though that would add to the department's luster and prestige, it would provide nowhere near ten courses in a single academic year. On the other hand, Assistant Professor Inabelle Levin notes, "the $26,000 which we paid to the curators could pay the salaries of two assistant professors teaching five courses each or the equivalent number of ten courses taught by the curators."[24])

"In the best of all possible worlds," Buchanan has said, "we'd have a stronger department and be in a position to be more equitable in distributing the financial burden." According to Lee, the university has been "more forthcoming" with money in the last year; it gave a $50,000 grant for the "Sculpture Directions '75" program (see following section). But for the moment the joint program is, in Buchanan's judgment, "underfunded" on both sides, with the present financial arrangements "just taking the pressure off." He has pointed out that the museum has never asked for more money because "Lee and his trustees understand—but it can't go on forever." Lee acknowledges the program's cost "is a drain on us, yes, but still worth doing. I don't look on it as money contributed to Case Western Reserve University but as a contribution to education in general and to the education of museum professionals—and as beneficial to the museum and to museum staff."

If Buchanan is correct in his statement that "true joint funding is probably essential to a joint program," the present uneven distribution of financial burden and the failure of the two institutions to undertake consistent joint funding efforts for the future are major flaws in the Cleveland experiment.

### Planning

The joint program is administered by the joint art committee, consisting in 1974/75 of Lee and Gabriel P. Weisberg, curator of the Department of Art History and Education, for the museum, and Levin (acting department chairman while Gibson was on sabbatical) and Buchanan for the university. No one serves as chairman. The committee meets sporadi-

cally, "when it seems necessary," as one member has said. (William Talbot, the museum curator initially responsible for the art museum studies program, reported to Lee, Weisberg, and Levin, but not to Buchanan; Weisberg was to take over responsibility for the art museum studies program in the 1976/77 academic year.)

All traditional departmental responsibilities are discharged by the university faculty, few by the curatorial adjunct professors. There is no systematic joint admissions policy or review procedure. What policy exists is pragmatic: a curator is generally asked to review doctoral applications in his special area; as chief curator of the museum's Department of Oriental Art and in the absence of an Orientalist on the university art faculty, Lee reviews M.A. and Ph.D. applications in that field; and the museum recruits, interviews, and, with university approval, admits students to the art museum studies program (see following section).

Curators do not attend faculty department meetings, nor do they sit on the faculty curriculum development committee that designs and schedules offerings in art history. Members of the two staffs meet often and informally, simply because they are all in the museum galleries, library, slide room, and restaurant nearly every day. There is generally one formal meeting a year of the complete joint program staff. Most curators have not wanted to share in the program's administration, some because they are content to limit their involvement to teaching, others because they emphatically want no part of "more bureaucratic headaches." Faculty members generally agree that departmental affairs are their own responsibility.

This question of joint planning and administration, like the question of costs, raises the issue of the boundaries of the joint program: how much does it, and should it, include of the two independent partners' activities? Curatorial attendance at faculty department meetings, for instance, is "touchy," said one faculty member, who pointed out that faculty are not invited to curatorial meetings or to discussions about acquisitions for the museum collections. Another faculty member labeled the boundaries on curatorial involvement in faculty activity as "compassion rather than exclusion—we see how busy they are with their museum work." Buchanan explained that adjunct professors at Case Reserve do not "normally" take part in departmental affairs, though as a "courtesy" they may be invited to; he believes it a greater courtesy—and greater wisdom for the health of a joint program—not to ask too much of curators: "You'll kill it if you give the curators a ton of work."

But Gabriel Weisberg has argued that there should be a joint admissions procedure, curatorial attendance at faculty department meetings and membership on a curriculum development committee, and more regular meetings of the two staffs. As a former university professor and now the curator most directly responsible for the museum's part in the joint program, he understandably feels more keenly than most curators the desire to be "involved" in departmental ac-

tivities. However, the informality and flexibility deliberately built into the joint program by Buchanan and Lee has satisfied most staff on both sides, largely because it respects the autonomy of individual faculty members and curators, and probably also because it fits the relaxed "Cleveland style" they have all grown comfortable with.

That informality and flexibility have extended to the four-member joint art committee; Buchanan has called it "a useful device we haven't used as much as we might," and Lee agrees that a better use of the decision-making powers of the joint art committee would enable staff in each partner institution to work with greater understanding of the other and of the joint program. In any joint enterprise, Lee has observed, "problems can arise if boundaries are not clearly defined—and we have erred on the side of flexibility."

If Lee is correct in this assessment, the present informality may gradually give way to a more precise structure, but only gradually: he is a firm believer in the value of flexible working arrangements. He also recognizes that curators can have "no official place in the department; they are not full-time members of the university and as adjunct professors they have no responsibilities and no privileges."

## Teaching

The responsibility for deciding what courses should be offered lies with the university art department, working with the provost. Though the museum is not committed to any specific number or kind of courses ("no moral obligation or other absolutes," said Buchanan), curatorial courses have averaged about five a year, or the equivalent of one full-time faculty; as noted earlier, each faculty member's teaching load is five courses during the academic year.[25]

Two direct results of this lack of contractual commitment or obligation are what one curator has called "rather erratic course offerings" and a university roster that "gives a distorted picture" of available courses because it lists nearly a dozen curators as adjunct professors, some of whom rarely or never teach. Department of Art faculty have made the same observation. Another curator reserved his severest judgment for the university's dependence on museum curators and insists that the university ought not rely on curators to do more than "fill in the gaps."

Which, in effect, is all they do. The problem is that the gaps are considerable, given the size of the art history faculty. (The professors protest that "size does not determine quality" and point to other small art history departments of high caliber, such as Oberlin, Cornell, and Bryn Mawr.[26]) The full-time faculty provide all of the basic courses in Western art, from the introductory survey course to secondary surveys to more narrowly focused seminars—a total of 20 undergraduate and graduate courses per year.

Curators generally offer courses in their specialties to both graduate and upperclass undergraduate students. Curator Henry Hawley draws distinctions between curatorial teaching on the undergraduate and graduate levels: "I don't think

that I've brought much, if anything, that is unique'' to under-graduate classes, which he says he teaches ''more or less as anyone who knows the subject would teach them.'' In his judgment, curatorial skills are useful on the graduate level whether the museum collection is large or small, so long as its objects are excellent: ''Even with comparatively few objects illustrative of quality, [a curator] can teach about a lot of fields in a small graduate seminar. For connoisseurship, it's necessary to have high quality but not a vast collection.''

If the undergraduate students are adequately served, as most (but not all) say, by the combination of faculty-taught and some, even ''erratic,'' curator-taught courses, what about the graduate students? Perhaps because this is the level in which curators tend to be most interested—and most needed—the cooperative aspects of the joint program work smoothly at the graduate level. Curators help write Ph.D. exams and conduct orals, submit questions for the M.A. comprehensive exam (but do not grade them), and serve as advisers to doctoral students along with the regular faculty adviser (whenever a faculty member and a teaching curator are specialists in the same field, they jointly advise students on the M.A. thesis and on the Ph.D. examinations and dissertation).

But Sherman Lee cautions that ''graduate-level work requires depth'' and believes that the university department is ''too small for the potential of the museum relationship.'' All art historians at the university agree that additional faculty would be desirable, and Buchanan readily admits that the department's size makes the addition of the teaching curators ''necessary'' for the university's art department. An evaluation team from the North Central Association, which spent time on the campus in May 1975, commented in a report, ''One basic concern [in Arts and Humanities] is that because of small size and continuing decline in size, the quality of Ph.D. programs may soon suffer.''[27]

**The value of teaching for the curators: pro and con.** Though some curators complain about teaching duties while others ignore or shoulder them cheerfully, most believe that teaching has value for them. Weisberg, the most enthusiastic of the teaching curators, has said:

. . . Teaching really keeps the curators on their toes. . . . There's nothing better than having excited students around to stimulate curatorial staff, to keep them on the edge of their seat, to shake them up a bit, to question—I think this is an absolutely wholesome essential—and that's a benefit.

Another agreed that ''it sure keeps your horizons spread out . . . but it also keeps you from the work you came to the museum to do.'' Two curators said they feel teaching helps the curator clarify his thinking and can even affect installations and labels. For curator Henry Hawley, teaching ''forces me to back away from particular works of art and look at a period of history more than I generally do in my curatorial work.'' He reported that in a series of galleries he installed in

fall 1975, he felt ''more of an obligation or an interest . . . to fit objects into a broader historical context'' for the museum public.

**The value of the collection for faculty and students.** One of the points on which university and museum staff concur without reservation is the value of confronting original works of art. Assistant Professor Edward Olszewski reported that students in the introductory survey course—which includes 26 gallery tours and 10 to 12 brief object-oriented papers—evaluated the use of ''real works as very impressive, the most appealing aspect'' of the course. The syllabus for that course includes study questions that can best be posed in a museum setting. Some samples: describe the proportions of two Greek vases; select one interesting figure on each vase and draw its outline; describe how the artist organized the major figures.

Though at least one enthusiastic student reported, ''A lot of people feel if we didn't have the museum, there'd be no reason to be here,'' curators and faculty agree that even a rich collection like Cleveland's cannot completely represent the whole history of art. Where its collections are small—in High Renaissance paintings, for instance—slides are essential. In any limited area of the collection, generalizations based on landmark works may be contradicted by atypical examples in the galleries. And even the high quality of the collections can present a problem; one faculty member wryly but seriously pointed out in a December 12, 1975, memorandum that ''often third-rate works are very useful for resolving problems in iconography, for explaining the currency and transfer of a formal motif, mechanisms of studio training, the cultural awareness and popularity of a theme or subject.''

What has been called the ''critical anemia'' that results from overexposure to books and slides is not one of the joint program's problems. Works of art are central to most courses, though students have reported that the program points up the different ways university faculty and curators use works of art in their teaching. One student said flatly, ''The use of objects is *always* at its best with curators,'' and the professors have responded that the frequency with which the galleries are used depends, in part at least, on the nature of the course. Some students have said that only the introductory survey course uses the galleries with real consistency; others disagree, observing that all faculty members stress the need to confront the original in the galleries. One Ph.D. student noted that ''it's all there, everything's out—graduate students can go and do as much looking as they like''; she believes that faculty properly leave the looking to the students themselves. But this same student enthusiastically described a course given by the curator in her field (William Wixom, curator of medieval decorative arts) that met in the galleries every Monday, when the museum is closed to the public: ''He'd open the cases, hand out pairs of white gloves to each of us, and then we'd examine and discuss objects with him—a great experience!''

True, it is not quite so simple for a faculty member to get at

a case as it is for a curator, but one M.A. student speculated that the real problem for university faculty is what she called "the academic hang-up: the dynamic tension between slides of monuments that make a point" and the real object "that may not make exactly the point you want it to make." Art faculty do not readily accept these student judgments. Like the curators, faculty members hold to the value and necessity of teaching from both objects *and* slides. Walter Gibson suggested that differences of outlook are to be celebrated rather than lamented and said that the joint program has "encouraged both curators and faculty to draw from each special approach." He added that "the university faculty is not only aware of the need to confront the object, but we have been known to do so ourselves."[28]

**A new teaching possibility, and attendant problems.** Some senior instructors in the museum's department of art history and education could, Weisberg and others believe, bring to undergraduate teaching their enthusiasm and broad knowledge of the collections. Celeste Adams, assistant curator in the department, believes some department staff— those with an M.A. degree and considerable teaching experience—could be effective teachers. "It would depend," she said, "on what the course is, how it would affect our other responsibilities. But, after all, college freshmen aren't that much different from high school seniors in the Advanced Placement Art History course." (For a report on that high school program at the Cleveland Museum, see chapter 10.)

Though Levin and Olszewski, among others, have found the suggestion interesting and said they would welcome the addition of museum education staff, they have pointed out that hiring graduate assistants as section leaders and instructors in the introductory survey course is "a vital aspect" of any graduate program, for it enables faculty to single out and help support the better students and to give them some training and experience as teachers.

## Facilities

One serious lack for undergraduate students is the absence of a visual study area in either the museum or the university, what one curator calls "a much needed area." A usable picture collection, and even the slides used in a lecture class made available for second and third looking, are usual elements in many art history departments. The museum's picture and slide collections, which are available to graduate students, are not open to undergraduates. Lee contends that a visual study area for undergraduates "is the responsibility of the university"; most art department faculty agree, but some believe that books "with hundreds of photos are more useful" for study than either slides or photographs, a position Lee himself supports.

University faculty have mentioned another problem that troubles them more directly: the limited schedule of museum library hours. One said,

When I took the job here, I had four or five other offers, and the pay here was the lowest. I took the job because of the association with the museum. But it hasn't worked out that well for me: museum library hours don't allow me to do my own research, unless I steal daytime hours away from my office and am unavailable to students. I don't think that would be fair, so I don't do it. I come down on Wednesday nights or weekends, but otherwise the museum library is no use to me; books don't circulate, not even overnight, and that's a bit of a disadvantage.

**Exclusivity.** Another group put at a disadvantage by the library policies is the undergraduates at the half-dozen other colleges and universities in the Cleveland area who can no longer use the museum library now that it is tied so closely through the joint program to Case Western Reserve. Nor can graduate students or faculty at other colleges use the slide library without charge. Buchanan points out that limited use by non-Case Reserve students can probably be attributed to "the fact that we are the only university nearby which offers a graduate program and therefore have research-oriented students. If that were to change, the library situation would change also."[29]

Some curators regret that they cannot occasionally work with students at other local colleges; "some of them are being very well trained," noted Weisberg. Both Buchanan and Lee hope that someday the joint program will be well enough established to serve students from other schools, but for the present the museum's services are primarily geared to the joint program's needs. Meanwhile, as Lee has pointed out, the collections remain free and open to all; the museum charges no entrance fee.

## A year-long program of joint work: "Sculpture Directions '75"

One highly successful outcome of the joint program was "Sculpture Directions '75," which the art department and the museum undertook with a grant of $50,000 from the university. It was an ambitious project: an entire year of programs, exhibitions, courses, workshops, and lectures devoted to one medium, sculpture. Buchanan described it as "a really joint effort, prestigious for the program," and Lee called it "a pretty darn good example of how the joint program can develop."

Between January and December 1975, 18 lectures, 9 exhibitions, 14 courses, and a clutch of studio critiques crowded one another for attention from students in art history and studio courses, museum members, and the general public. Even before the "Sculpture" year began, the museum mounted a major exhibition of sculpture by Giacometti; during the year it presented four additional lectures on sculpture, a retrospective exhibition of Louise Nevelson's work (and a small contemporary gallery-museum in the University Circle mounted, simultaneously, an exhibition of Nevelson's prints), an educational exhibition of its own sculpture collec-

tion drawn from every area of the museum, and an impressive show of Renaissance bronzes from the museum and from other Ohio collections. At the university gallery, the nearby Institute of Art (a professional art school), and elsewhere in the University Circle, other exhibitions of sculpture went up. Each semester, university or museum faculty offered courses concentrating on sculpture, in addition to the regular courses.

In fall 1975 H. W. Janson came as visiting professor to teach two courses: an undergraduate-graduate course in Renaissance and Baroque sculpture and a seminar on problems in nineteenth-century sculpture. Out of the problems course grew a small exhibition mounted jointly by Janson, six M.A. students, and a supervisor in the extension division of the museum's department of art history and education, Andrew Chakalis. Janson chose works of art from the museum, his own collection, and local collectors and dealers and assigned each student to research and install one thematic area of the show.

None of the students had ever worked on an exhibition from start to finish. Chakalis took them into the museum's carpentry shop, paint shop, conservation rooms, and greenhouse, and debated with them every step of the way. He found that their greatest difficulty in thinking about and working on the exhibition was "visualization: they had to pull themselves away from the literary context—they had to parallel a visual context." They suggested piles of photographs and labels until Chakalis persuaded them to winnow down the secondary material—what he calls "clutter"—and "let the objects tell their own story." The students had a lot of ideas they wanted to get across, and Chakalis said he learned a lot from them at the same time that he helped them "make decisions on the basis of what it was *important* to compare."

The resulting show, which opened December 10, 1975, was a handsome, visually persuasive exposition of certain ideas that nineteenth-century sculptors wrestled with. A small catalog, prepared by the students under Janson's supervision and paid for out of a $500 grant from the university, accompanied the show. All other costs—and they were "under $500," Chakalis said—were absorbed by the museum: "We worked with what we had." The students' pleasure in "seeing this whole thing materialize," said Chakalis, was matched only by his pleasure in seeing them "gradually come to understand how scale, juxtaposition, lighting, and color could make their points for them."

The $50,000 grant from the university went into salaries ($14,000 for the visiting professor, $3,000 for faculty), supplies ($13,000, which included $3,000 to the museum library for additional books and slides and $8,000 for the catalog, museum expenses, and publicity costs for the museum's "Traditions and Revisions" show), speakers ($9,500), travel ($1,800), student help ($2,600), and administrative overhead for the art department ($4,700).[30]

## The Art Museum Studies Program

If any program currently in operation is designed to create the curator-scholar the art museum profession says it needs, it is the Art Museum Studies Program (AMSP), which is part of the joint program. Nearly every recent study of the art museum and its professional needs has pointed out that museums have been less successful than academia in attracting the ablest art history students. The 1966 College Art Association report concluded that "the academic establishment . . . has failed to release into society any sizable number of productive nonuniversity scholars in art—museum men, critics, publicists, dealers." It further pointed out,

> The prospective curator has for too long been selected from the less scholarly, lower half of a class, a student with some "flair" for the subject but unable or unwilling to devote himself for enough years to the strenuous requirements of the most advanced degree, the Ph.D.

The report recommended that

> . . . the scholarship of both the teaching and curatorial fraternities . . . be placed on an equal level and the preparation for this scholarship must also be on a single standard of high performance. To put it briefly, connoisseurship, "flair," a "good eye," without the ability to control enthusiasms by precise research, is dangerous; precise research without an eye for the relative quality of the object or objects being studied can lead to a sterile, bookish art history.[31]

Cleveland's art museum studies program combines the academic art history requirements of the Ph.D. with practical museum experience in research, connoisseurship, exhibition, conservation, and education. Supervised primarily by the museum's curatorial staff, the AMSP culminates in the Ph.D. granted by the university. It is neither a "museology" nor a "museum training" program, but a rigorous education in connoisseurship and art history of the curator-scholar who can, as Sherman Lee has said, work "in museums that accept the real responsibility to be something more than an art center."

The program's emphasis on scholarship and experience, rather than on specific courses in museum practice, is consistent with the findings of an earlier study, the 1956 Harvard report, which noted "striking unanimity among our many consultants that breadth of experience and sound scholarship are more valuable assets to the future museum man than specific training in museology." The Harvard report affirmed that "museum training is best founded upon the same basic training which graduate students in the history of art should receive under optimum conditions."[32]

### The conditions: academic

Admission to the AMSP, which is approved by both institutions, requires the M.A. ("or its equivalent") and reading

knowledge of one foreign language. To complete the program and satisfy both the university degree requirements and the museum studies requirements, students must take 18 credit hours of art history, spend 18 credit hours on dissertation research, and add a second language. In addition, students must take 9 credit hours of museum studies in the first academic year, a 3 credit-hour summer internship, and a 6-credit-hour internship in the museum during the second academic year.

Finally, they must pass the art history Ph.D. examination and submit an acceptable Ph.D. dissertation, which may be a scholarly exhibition catalog or the traditional scholarly research paper. (Both the written and oral Ph.D. examinations at Case Reserve assume a previous comprehensive M.A. examination and test the candidate on the general field in which his particular study falls, on his special field, and on a related non-art-history field.)

Doctoral study in art history requires considerable depth in related fields—history, language, philosophy, among others. No university in the 1970s can be expected to cover the whole of world culture, but any university's particular limitations are of special concern to the doctoral candidate. Further, the effort to mount and maintain on the doctoral level a joint program in any field requires some meshing of the strengths and weaknesses of both partners.

In this respect, the Cleveland Museum and Case Reserve are unevenly matched. Of the Cleveland Museum's rich holdings, the most exceptional are the medieval European and the Oriental collections. But according to its catalog, Case Western Reserve's history department is especially strong in American and modern European history; its offerings in Oriental history are small, limited to Chinese history and one special studies seminar in Asian history. In languages, the university offers graduate degrees in Western European languages but is weak in Far Eastern languages.[33] The philosophy department, which like many contemporary philosophy departments concentrates on logic, offers only one upper-level course in aesthetics and a few others related to the history of art.

The requirement of 18 credit hours in art history theoretically can be satisfied by the required museum studies courses and internship, but supervising curator William Talbot says a student who did that would "never pass the Ph.D. exams." He estimates that most AMSP students take four or five courses (12 to 15 hours) of art history in addition to the internship and museum studies courses. Harvey Buchanan sees the AMSP as "a marvelous extension" of the joint program, though he acknowledges that the university's relationship to it is "not strong." Its academic courses are taught by university faculty or by curators, its museum courses only by the curators. Curators generally serve as first and second advisers because of the program's heavy emphasis on curatorial work, while art history faculty members serve as third advisers for general examinations and as liaison with the university. (The exception is Oriental Art; as noted elsewhere, the university's art faculty includes no Orientalist, and the museum's curatorial staff in Far Eastern art assumes all instructional and advisory responsibility.)

### The conditions: time, travel, and money

**Time.** Originally scheduled to be a 24-month program, the AMSP began in the fall of 1972 with three doctoral candidates, two in American art, one in Chinese art. In fall 1974 all three were still working in the program, though one of the students in American art was about to flunk out. One of the successful candidates has declared, and most curators back him up, that three years (or "three years plus") is a more realistic figure for the time a student needs to complete the program. By the 1975/76 year, one of the first group had finished all work but the dissertation and was teaching in another state; a second had withdrawn; and the third was still working with the cheerful expectation that "I might spend the rest of my life" trying to finish (pressed for a more exact period, he figured four years).

The nine hours of museum studies courses required in the first year—"History and Philosophy of Museums and Collecting" and "Introduction to The Cleveland Museum of Art"—also introduce the students to most of the curators. "It was good to work with them," reported one student, "seeing how they interpreted and approached their collections, each very differently." The students' principal inquiries to each curator focused on (1) defense of purchase, (2) defense of installation, and (3) interpretation of their galleries for the public and relation to the education department.

One student described her life at the end of the first year as divided: "course work, art history, and piecemeal work in the museum." By the second year, heavy on the museum internship in a curatorial department, she found it more concentrated in the museum, but observed that museum work includes "a little bit of everything—whatever comes up: the painting catalog, record-keeping, research, my own exhibition." Talbot reported that students who entered in 1972 said they did not have enough time for museum education and that all were eager to meet dealers.

**Travel.** Students travel with curators not only to meet dealers but to visit other museums, galleries, and collectors. Trips outside Cleveland have included New York and Washington (with the curator of medieval decorative arts), New York only (with the curator of American paintings), and conferences and exhibitions (one was "Fakes, Forgeries, and Other Deceptions," an exhibition at the Minneapolis Institute of Arts, described in chapter 2 of this study).

**Money.** Two of the first group of students were funded by a Kress Foundation grant, the third by a private local foundation. Kress granted $13,000 per year for three years (the third-year support for the dissertation research). Each of the two Kress students received $500 for travel and $6,000 to be divided between tuition to the university and living expenses.

The museum received no money to support the AMSP in its earliest years.

Beginning in 1974/75, two new students were accepted for a three-year program, both in Oriental art. They were supported by the National Museum Act; each received $7,050—$3,550 for tuition to the university and $3,500 stipend. (Unlike the Kress grant, the National Museum Act grant also included 5 percent administrative overhead reimbursement for the museum.) The museum has been the applicant and conduit of funds for the AMSP part of the joint program; it passes those funds on to the university to cover tuition costs and student stipends.

## The conditions: in the museum

The museum internship is, according to Bill Talbot, "much more subtle than an ordinary internship—and therefore more difficult to do, to supervise, and to understand." He has likened it to a seminar in which a student is supervised by a professor through the detailed study of one collection, one series of objects, one idea. "Take as an example," he suggested, "a seminar on Chardin. A student working for a semester on Chardin's still lifes would certainly learn a lot about them and about other still-life painting. But he'll get no landscape painting, say, or the broader range he'd get if the course were in French eighteenth-century painting."

With this analogy, Talbot does not argue that this internship or "any internship is the intellectual equivalent of a well-done course that covers a lot of art history: one teaches a little about a lot, the other a lot about a little." To teach and supervise such an internship, he has said, requires much of curator and student: "Tasks have to be set, expectations made evident, the student has to persist and learn how to do the unimportant quickly—exactly what you have to learn to work in a museum."

The balance between important and unimportant work is a critical one in a curator's life. Sherman Lee believes that anyone going into museum work must learn he is going to have to do a certain amount of paper-pushing: "Your whole week's schedule can be changed by a letter that crosses your desk unexpectedly one morning. That doesn't usually happen in a university professor's life, but it happens to a museum curator all the time." Talbot agrees that one of the curators' responsibilities is to see that the internship is balanced toward curatorial research and never becomes "just record-keeping or letter-pushing; your first order of business is digging into objects." It is a struggle, he has admitted, to keep after that "first order or business," but a struggle oftener won than lost, in the judgment of students who have been in the AMSP.

AMSP students do their doctoral dissertation under the supervision of the curator with whom they have been working. "It puts the whole responsibility in the hands of the curator," noted Talbot. "He has to be behind it philosophically and willing to give the time." Of the two students already at work on the dissertation, one also undertook a small exhibition in conjunction with a major museum show.

Supervised by Gabriel Weisberg, the curator responsible for the "Japonisme" exhibition and her dissertation adviser, Carol Clark gathered objects, researched them, wrote a catalog, and, with the considerable help of education department designers, mounted a show of Japanese influences on American arts and crafts.

## Some questions about the AMSP

Why the Ph.D.? Does Sherman Lee, the prime mover of the AMSP, see the degree as increasingly important for museum professionals? "Emphatically, no." He has pushed the program because he can see no other way at present for the museum to be involved in a program of higher studies in museum work than to be associated with a degree-granting institution. Lee and Talbot, both of whom have their Ph.D.'s, feel the same about the degree: Lee has called it "just something to get behind you," and Talbot has said the degree is "by no means a requirement" for a museum curator. But to both of them, its assets are obvious: the longer, deeper study makes for better scholarship, and the degree provides what Talbot calls "career flexibility": "If museums move more and more into the educational field, then the academic degree will permit greater involvement" in university work.

One curator pointed out that the basic premise of the AMSP internship—that a student can "apprentice" in one museum as preparation for work in any number of other museums—is undermined by the "enormous variety of internal organization of museums." Citing his own field—decorative arts, which some museums organize by time periods, others by country of origin, still others by different patterns—he said, "Museum training is pretty messy because museums have so little uniformity in their requirements for people." It is a point acknowledged by Lee, who nevertheless argues that despite this diversity, "there's a whole spectrum of museums that desperately need people with sound training in art history and who also know how to deal with the many different problems that come up in art museums." Lee believes the Cleveland Museum is "a logical place" for such a program, because it is "historically a good museum, committed to high museum standards."

The issues of the Ph.D. and the exclusive relationship between the museum and Case Western Reserve University are raised from time to time. Lee has said he would be "very happy" to see develop out of the AMSP something like a Cleveland Museum of Art Institute for Museum Studies, open to students who pay their money to any degree-granting institution they choose, and who could get their credit, if they wish, in academic degrees. "I keep coming back to the idea of a 'nesting place,' somewhere between the museum and the university," he said, a place that could "straddle" two or more institutions and "take the load off" the parent institutions. The present art museum studies program is a necessary beginning, he believes, in the effort to educate the curator-scholar art museums need.

## A Summary of Cleveland's Experience—and Its Applicability Elsewhere

The single most significant aspect of the joint program is its regular, frequent, and intimate use of works of art of the highest quality by students at every level of university work—"an art history department in a museum," in Harvey Buchanan's words. To provide this intimacy between students and works of art, many universities have established their own art museums; but, according to the 1966 College Art Association report, most university museums a decade ago were "in an embryonic state" and "likely to remain so for many years to come." Acknowledging these limitations as "inevitable" in all but a few fortunate university museums, the report suggested that universities enter into collaborative programs with neighboring public museums: "Nothing can take the place for the foreseeable future of the large comprehensive public collections."[34] Very few museums and universities have attempted this collaboration in a systematic way, and none so comprehensively as Case Western Reserve University and the Cleveland Museum of Art.

In entering into such a collaboration, they have confronted some—though surely not all—of the problems any independent university and independent art museum might expect. Location, for instance: their effort to establish a "relatively small but possibly quite productive center of graduate study"[35] outside the Northeast has been hampered, as the 1966 CAA report might have predicted, by the dominance of the Northeastern schools, which in the mid-1960s caused "art departments in all other sections of the country [to be] starved for scholars of national or international reputation"[36] and which still in the mid-1970s works against many universities and cities outside the Northeast.

The addition of museum curatorial teaching staff to the university faculty has been "necessary" for the university's small art department, and yet at the same time "erratic," because teaching is not a curator's primary responsibility. In starting a joint program, any museum and university (even one with a larger art history faculty of its own) will face the question of how to mesh two staffs, two sets of priorities, two schedules. Short of some firm contractual agreement binding each curator to teach a specific course at a specified time, that question could prove perennially troubling. Independence and autonomy are not easily or lightly ceded by any university or museum, anywhere. Cleveland's approach has been to leave all agreements very informal, trusting to good will, patience, and prudence all around. Such informality might not satisfy all universities and museums—and clearly does not satisfy every staff member of the joint program—but it seems to satisfy most and to work moderately well.

Where good will exists alongside excellent facilities, very little strain is placed on good will. Without the museum's excellent library and good slide collection, the university could not offer substantial graduate programs. Indeed, as the 1966 College Art Association report pointed out,

The amount of work involved in the selection, acquisition, and processing of books and in the organization and maintenance of a good art library goes beyond the capacity of all but a very few departments. Yet without such a specialized library, graduate teaching and advanced scholarship are difficult or impossible.[37]

Few universities maintain an art library the size of the Cleveland Museum's and even fewer the size of the joint program's combined library facilities available at the museum and the university.[38] Even these superior facilities have been overused, the museum library staff overworked, and limitations to undergraduate access made necessary, in order to provide adequate service for curators, faculty, and graduate students.

Limitations on money, however, do exert a strain on good will. The particular financial arrangements between Case Western Reserve University and the Cleveland Museum might not be easily duplicated elsewhere: the museum's combination of a director eager to use the museum as a scholarly teaching institution, of trustees willing to support a program they are partially skeptical about (though it certainly establishes the museum as a bona fide educational institution for tax purposes), and of a healthy financial endowment, may be unusual. Plagued by many of the fiscal problems afflicting most universities in the early 1970s—especially rising costs and declining enrollments—the university has not substantially increased its annual contribution to the joint program, has not yet added distinguished senior faculty, and has increased its small department by only one assistant professor. As Sherman Lee has pointed out, the faculty is at present "too small for the potential of the museum relationship," especially for superior graduate study.

No one in Cleveland claims that the joint program is the ideal model for cooperative ventures between universities and museums. That ideal relationship must be "symbiotic," as Buchanan says, "beneficial to both and harmful to neither," and it is the relationship toward which he and Lee are patiently working. Another image, one drawn not from nature but from social behavior, is applicable to the present circumstances of Cleveland's joint program and probably to any joint program undertaken elsewhere between independent institutions: that of the morganatic marriage, between partners of unequal status. If in Cleveland circumstances have cast the museum in the aristocratic role, in other cities it may be the university that is richer or more distinguished. Wherever joint programs are tried, this uneasy question of balance—of financial and administrative burdens, of staff, time, quality, and priority—may be inevitable.

In Cleveland, questions of status and rank can usually be set aside because both staffs are agreed on the basic premise: that the study of art history is incomplete without both academic and museum contribution. What the Cleveland experiment has going for it that can be translated to other places—where money, staff, traditions, and circumstances

will differ from Cleveland's—is this conviction that both kinds of teaching are necessary, that, as Walter Gibson says, curators and faculty can at the same time celebrate their differences and learn from each other. It need not be an impossible goal: the idea that the study of art history belonged in the university curriculum was itself not widely accepted for many years, but by 1956, as the president of Harvard University noted in his preface to the university's report on the visual arts, it was generally accepted "that the study of art belongs in liberal education and in the university."[39] The Cleveland experiment is based on the conviction that the study of art belongs equally in the museum.

Despite its practical difficulties, both Buchanan and Lee remain committed to the joint program. Its first eight years have been slow going, Lee says, but he is determinedly optimistic: "It may take 20 years" for the program to become what it ought to be and can be, yet he is convinced of its "theoretical desirability." Lee's stoic estimate does not seem so long to Buchanan, who says, "I want this program to last beyond us: once the principle is established, the possibilities are there."—*A. Z. S.*

## Notes

[1] An example of another ready response to the university inquiry is the joint program with the Cleveland Institute of Music. As both the university and the institute are degree-granting institutions, their arrangement, which dates from 1968, is considerably different from the more limited joint program with the museum. All students majoring in music are enrolled jointly by the institute and the university. Each school remains independent while working cooperatively with the other. The institute concentrates on the education and training of professionals in the arts of performance, composition, and related musical disciplines and activities, while the university offers study in the scholarly fields of music history and musicology, and in music education. The program offers B.A., M.A., and Ph.D. degrees.

[2] Memorandum, May 24, 1967.

[3] For sources of quotations without footnote references, see list of interviews at the end of this report.

[4] *General Catalogue of Case Western Reserve University for 1975–1977: Undergraduate and Graduate Courses*, p. 3.

[5] By 1950, the beginning of suburban sprawl after World War II, Cleveland was down to tenth in rank among U. S. cities; by 1974 it was fourteenth and its population in the city proper was down to a pre-1920 level of around 680,000 (standard metropolitan statistical area in 1974 was 2,064,194, the same number as 1970).

[6] *The Visual Arts in Higher Education,* ed. Andrew C. Ritchie (New Haven, Conn.: Yale University Press, for the College Art Association of America, 1966), p. 40.

[7] James R. Johnson and Adele Z. Silver, *The Educational Program of The Cleveland Museum of Art* (Cleveland, Ohio: Cleveland Museum of Art, 1971), p. 21.

[8] For further discussion of this issue, see *Report of the Committee on the Visual Arts at Harvard University*, John Nicholas Brown, chairman (Cambridge, Mass.: Harvard University Press, 1956), starting p. 11.

[9] The authors of *The Visual Arts in Higher Education* (p. 29) urge that the introductory art history survey course, the "bread and butter of most art departments," be recognized for its cultural importance: "If the American audience for art has enormously increased in recent years, this is partly because of the mass courses in art offered by the universities and colleges. The new audience for art is almost wholly college-bred, and in its education the survey course has had a dominant share."

[10] "The Cleveland Museum of Art Evaluation on Graduate Education in the Joint Program with Case Western Reserve University," submitted by Sherman E. Lee and Gabriel P. Weisberg, January 13, 1975.

[11] Announcement from Sherman Lee and Daphne C. Roloff to area universities, colleges, and schools, July 2, 1975.

[12] Walter Gibson, "Evaluation of Graduate Programs in the Department of Art," submitted to provost, Division of Humanities and Arts, January 18, 1974.

[13] "Report from the President," *Case Western Reserve University Annual Report of the University: 1974/75*, p. 4. Undergraduate enrollment figures from the registrar's office, Case Western Reserve.

[14] Enrollment figures for 1974/75 from annual reports of Department of Art for 1974/75, submitted to the provost, Division of Humanities and Arts, June 1975. Statistics based on commencement rosters in the provost's office.

[15] *Graduate Programs in the Department of Art*, Case Western Reserve University, revised, 1974.

[16] The authors of *The Visual Arts in Higher Education* point out (p. 55) that in 1966 six lecture-hours per week were "the standard in the better departments" and note the difficulty of pursuing research in a university setting because of the "burdens of committee work and other academic obligations, of thesis supervision and counseling, and the petty administrative chores which are becoming the bane of life in the American university."

[17] Memorandum, December 9, 1975.

[18] Inabelle Levin, memorandum, December 23, 1975.

[19] In addition to activities undertaken through the joint program, the art department, like the museum, undertakes independent programs. A two-course sequence in museum studies for undergraduate majors and M.A. students was introduced in the fall 1974 term, with the cooperation of the history department. The first course, on the history and administration of museums, is team-taught by an art department professor and staff members of several museums in the University Circle, including the art museum; the second course is an internship in a museum, gallery, or arts council, supervised by the department.

In February 1975, the art department added a new program, a double master's degree in art librarianship. Granting the M.A. in art history and the M.S. in library science, the program requires a minimum of 42 course credit hours, 21 in library science and 21 in art history, including the methodology course required of all art history M.A. students.

The university's art gallery, which is not a museum, provides experience for students in planning exhibitions; graduate students serve as part-time director and registrar of the gallery under the supervision of Assistant Professor Carol Nathanson.

[20] Buchanan and Levin, separate memoranda, December 23, 1975.

[21] Memorandum, December 9, 1975.

[22] "Evaluation of Graduate Programs."

[23] Buchanan, memorandum, December 23, 1975.

[24] Memorandum, December 23, 1975.

[25] Five curator-taught courses, which equal one full-time equivalent faculty, go into the calculation of faculty-student ratios in art history. Dividing the number of students taught in each department by the number of full-time equivalent faculty in each department, Buchanan reported these faculty-student ratios in 1974/75: English, 11.6 students per faculty member; history, 11.4; art history, 9.6; classics, 3.3. "Part of the reason for these ratios in art," Buchanan pointed out in a memo of December 9, 1975, "is the very low enrollments in some of the curator-taught courses." In other words, though the curators add a considerable number of courses to the roster, they do not always add a considerable number of students to the tuition pool, nor do they take much of the load off the full-time art department faculty—at the same time that they bring down the faculty-student ratios in the art department head count.

[26] Oberlin College's art history staff numbers 6. There are 42 art history majors, plus 6 majors in conservation, 4 in classical archaeology, and 3 independent majors who structure their own majors with the help of an adviser from the art history faculty. In addition, there are 37 combined art majors, an unstructured major that requires a student to take 12 hours each of art history and studio, with an additional 8 hours from either area. There are 16 M.A. candidates, 7 in residence and 9 in absentia, plus 8 M.A. candidates working in the Intermuseum Conservation Association. Oberlin offers no Ph.D. in art history.

Cornell's full-time art history faculty consists of 10 members, 6 tenured, 4 without tenure. There were in 1975/76, 28 undergraduate art history majors, 2 M.A. candidates, and 13 Ph.D. candidates ranging from first year doctoral students to those completing their dissertations. The department grants 2 or 3 Ph.D.'s in art history each year. The faculty also includes university staff with appointments in other departments who are not included in the faculty count here. Full-time faculty load: four courses a year.

Bryn Mawr's count is approximate. There are 5 full-time art history faculty, 3 of them tenured. There is also a 5-member faculty in archaeology, which is responsible for all art courses in the classical and ancient areas. The average number of undergraduate art history majors is 25. The "overall" count of graduate students is 30-plus, which includes approximately 10 to 12 M.A. students; the doctoral students, like Cornell's and Case Reserve's, range from first-year to the last stages of dissertation research. Full-time faculty load is one intermediate course, one graduate seminar in one semester and one advanced upper-level undergraduate-graduate course in the other semester.

[27] *Evaluation Report of the North Central Association*, quoted in the university's *Annual Report, 1974/75*, p. 25.

[28] Gibson, memorandum, December 21, 1975.

[29] Buchanan, memorandum, December 9, 1975.

[30] Tammar Koehn, office of the provost, Division of Humanities and Arts, Case Western Reserve University. Telephone interview, December 3, 1975.

[31] *Visual Arts in Higher Education*, pp. 58, 103–104.

[32] *Report on the Visual Arts at Harvard*, p. 28.

[33] Students at CWRU can earn graduate degrees in French, German, Russian, and Spanish (through the Ph.D. in French and German, the M.A. in Spanish, and the B.A. in Russian). Undergraduate courses in Far Eastern languages go through the intermediate level in colloquial Mandarin Chinese, plus two English-language courses in the literature of China and Japan; Arabic, Bengali, Hindi, Japanese, and Tibetan are listed in the catalog for self-instruction, providing to the student texts and matching tapes and "limited but regular contact with a native speaker." CWRU catalog, p. 155.

[34] *Visual Arts in Higher Education*, pp. 113–114.

[35] Ibid., p. 40.

[36] Ibid., p. 38.

[37] Ibid., p. 41.

[38] *Survey of Ph.D. Programs in Art History* (College Art Association of America, Committee on Graduate Education in Art History, 1975), pp. 46–51.

[39] *Report on the Visual Arts at Harvard*, p. v.

## Interviews

In addition to the dates noted, the author of this report has had frequent conversations during 1972–1975 with those listed here, as well as with other members of the museum and university staffs and with students who are not listed.

Adams, Celeste. Assistant Curator, Department of Art History and Education, Cleveland Museum of Art. Telephone, December 3, 1975.

Barksdale, Beverly. General Manager, Cleveland Museum of Art. December 1, 1975.

Buchanan, Harvey. Provost, Division of Humanities and Arts, Case Western Reserve University. November 26, 1975.

Clark, Carol. Ph.D. Student, Art Museum Studies Program, Case Western Reserve University-Cleveland Museum of Art Joint Program. December 19, 1973.

Chakalis, Andrew. Supervisor, Extension Division, Department of Art History and Education, Cleveland Museum of Art. December 1, 1975.

Cole, Debbie. Ph.D. Student, Case Western Reserve University-Cleveland Museum of Art Joint Program. November 25, 1975.

Dempsey, Charles. Chairman, Art Department, Bryn Mawr College, Bryn Mawr, Pennsylvania. Telephone, December 17, 1975.

Esper, Karen. Humanities Librarian, Freiberger Library, Case Western Reserve University. Telephone, December 2 and 3, 1975.

Gibson, Walter. Chairman, Department of Art, Case Western Reserve University. December 15, 1975.

Grossman, Albert. Controller, Cleveland Museum of Art. December 1, 1975.

Hawley, Henry. Curator, Post-Renaissance Decorative Arts, Cleveland Museum of Art. November 25, 1975.

Hess, Steve. Slide Librarian, Cleveland Museum of Art. December 6, 1975.

Janson, H. W. Visiting Professor, Case Western Reserve University-Cleveland Museum of Art Joint Program, November 19, 1975.

Koehn, Tammar. Humanities and Arts Division, Case Western Reserve University. Telephone, December 3, 1975.

Leavitt, Thomas W. Director, Johnson Museum, Cornell University, Ithaca, New York. Telephone, December 17, 1975.

Lee, Sherman E. Director, Cleveland Museum of Art. September 27, 1974; November 25, 1975; telephone, December 14, 1975.

Levin, Inabelle. Acting Chairperson and Assistant Professor, De-

partment of Art, Case Western Reserve University. November 21, 1975.

Milne, Jewell. Registrar's Office, Case Western Reserve University. Telephone, February 19, 1976.

Olszewski, Edward. Assistant Professor, Department of Art, Case Western Reserve University. Telephone, December 8, 1975.

Roloff, Daphne C. Librarian, Cleveland Museum of Art. November 25, 1975.

Smith, Karen. M.A. Student, Case Western Reserve University-Cleveland Museum of Art Joint Program, November 25, 1975.

Talbot, William. Curator in Charge of Art Museum Studies Program, Case Western Reserve University-Cleveland Museum of Art Joint Program. December 15, 1975; telephone, September 21, 24, 1974.

Weisberg, Gabriel P. Curator, Department of Art History and Education, Cleveland Museum of Art. May 29, September 24, 1974; November 19, 1975; telephone, December 8, 13, 14, 1975.

# WHITNEY MUSEUM OF AMERICAN ART: INDEPENDENT STUDY PROGRAM

Whitney Museum of American Art
945 Madison Avenue
New York, New York 10021

**Graduate and undergraduate students from around the country study studio art or art history-museum practices in this museum program designed to give them the best the New York art scene has to offer: experience in exhibition and staff work in a museum; seminars and individual study with famous artists, art critics, and art historians; their own studio space with instructors who guide rather than teach; visits to other museums and galleries. CMEVA interviews: November 1973; January, March, April 1974.**

### Some Facts About the Program

**Title:** Independent Study Program (ISP).

**Audience:** 25 undergraduate and graduate students each academic semester from colleges and universities throughout the country; students may concentrate in either studio art or art history-museum studies.

**Objective:** To ease the transition from student to professional by making New York City's art resources fully available and by giving students the responsibility for making, studying, and exhibiting art.

**Funding:** About $55,000 per year, which comes from the Helena Rubinstein Foundation, the Andrew W. Mellon Foundation, and the National Endowment for the Arts; space and utilities for the Reade Street studios are donated by the City of New York. Between 1970 and 1974 the museum charged each student $600 per semester for tuition; under a policy instituted in 1974/75 there is no charge except a $200 fee for studio art students.

**Staff:** The museum's head of education programs and his assistant; one full-time and 2 part-time studio instructors; and over 40 New York City artists, critics, and art historians who act as tutors and seminar leaders.

**Location:** The Whitney Museum, the museum's downtown branch, and studio facilities at 29 Reade Street; also, other New York museums and galleries and artists' studios.

**Time:** Each student enrolls for one or two semesters of the academic year. The program began in 1967.

**Information and documentation available from the institution:** Exhibition brochures and reprints of reviews.

Since 1967 the Whitney Museum in New York City has sponsored programs in alternate education that have grown and prospered. Increasingly these programs point a challenging finger at the education establishment and say, "Look, for some students it works better this way." One is the studio program of the Art Resources Center for teenagers (see report in chapter 10); another is the Independent Study Program, better known as the ISP.

The ISP offers a semester of advanced study in studio art or in art history and museum studies. Twenty-five graduate and undergraduate students from a wide range of colleges and universities across the country are admitted each term.[1] Approximately 15 are in studio art, the remainder in art history and museum studies. Students receive up to 16 hours of credit for participation in the ISP by registering for independent study with their home schools. The program is intended to ease the transition from student to professional by making New York City's unique art resources as fully available as possible and by giving students the responsibility for making, studying, and exhibiting art.

The ISP is a rich and varied program with practically unlimited opportunities for the ambitious student; but, as is also true of the Whitney's Art Resources program, there are no classes or fixed curricula. A student takes as much or as little from the program as he is ready for. Most are ready for a lot.

When the ISP began in 1967, it included students of art history, studio art, and art education. All were given studio space in the Art Resources Center on Manhattan's Lower East Side (where the studio program began the same year). After the first term, the Whitney's education department (by now under a new director, David Hupert) decided that art educators did not fit into the program and, further, that although art history and studio art have links, students cannot be expected to pursue both intensively. So the art history students were moved uptown to the Whitney and the studio art students given space in the resources center.

In 1971 the ISP moved to expanded studios on Reade Street. The same year a grant from the Helena Rubenstein Foundation enabled the program to offer art history students an option of work in museum studies. In February 1972 students of museum studies opened their first Whitney exhibition, "Free Form Abstraction."

### Seminars

Weekly seminars with New York artists and critics, for all students, make up the only set structure of the ISP. Seminar leaders in the spring 1974 semester included Lawrence Alloway, Donald Judd, Richard Artschwager, Yvonne Rainer, Phil Glass, Lucy Lippard, and Brice Marden. (Each seminar leader receives an honorarium of $150.)

In selecting seminar leaders the ISP staff tries to balance established figures with younger talent. These seminars illus-

trate one of the program's chief assets. Because the Whitney is in New York City, where it plays a prominent role in exhibiting contemporary American work, it can regularly call on artists who are rarely, if ever, accessible to college and university students.

## Studio art

The ISP studios downtown on Reade Street occupy the basement of a former bank awaiting demolition.[2] Each student has his own work space, approximately 20 feet x 20 feet. (The high-ceilinged, windowless studios retain the strange ambience of their former life, thanks to the large, open bank vaults with elaborately devised, massive doors.) The space includes a darkroom and limited shop facilities; basic videotape, audio, and photographic equipment is available. Students supply their own materials and provide for their own housing.

Staff for studio art consists of three instructors, one fulltime and two part-time, who work alternate semesters and are available every afternoon. The studios are open 24 hours a day to students, who all have keys. The staff, assuming that participants are mature and responsible, exerts no pressure on them to produce a certain amount of work or even to see the instructors. Some students do produce a lot of work; others concentrate on following New York exhibitions or something else. The ISP staff considers a successful term one in which four or five out of fifteen students are "good."

Like the studio program of the Art Resources Center, the ISP is casual and open, grounded in the belief that artmaking comes out of the individual and cannot be taught. Indeed, both programs are self-consciously removed from what one instructor calls "the bastion of art education,"[3] and both are the subject of controversy among art and museum educators in New York City and elsewhere.

The ISP's most important source of new candidates for studio art is seminar leaders and former students. Of 110 students applying for the fall 1974 semester, only 15 were accepted. The ISP looks for students with an intelligence that manifests itself in their art work. Recommendations and slides of work are required for admission into the studio program; grades and Graduate Record Exam scores are not. According to one instructor, formal art background has had no correlation with success in the ISP. Art education in the traditional sense, he insisted, has given no evidence of ever having been useful, and he called it "fraudulent, pernicious, insidious, generally evil, and predicated on false notions which are designed to perpetuate themselves."

Once a person is accepted into the ISP, instructors feel a commitment to him and will do nothing to interfere with his self-defined needs. Although there is no teaching as such, the instructors say they try to bring as much discourse and information to the program as possible. Central to this process is the instructors' dislike of what they construe as the condescension in the usual relation of teacher to student. As the ISP gives no grades, it has denied itself the traditional weapon to

force students to fulfill predetermined goals. The relation of instructor to student, developing organically as the term proceeds, may be that of mentor or peer; there may be no relationship at all. Any discussions tend toward broad philosophical issues rather than specific aesthetic ones. The chief emphasis is practical—how to find a decent work space, how to live in New York. One instructor talks about his New York survival course, which includes such information as how to "plumb" a loft.

The Reade Street studios are within walking distance of the section of artists' lofts and galleries known as SoHo; many of the people who are making New York art what it is are associated with the program as seminar leaders. Said one instructor, "the content of the program *is* New York." The work done on Reade Street proves his point. Most of it strongly reflects the work shown in the more advanced New York galleries.

This geo-aesthetic asset, however, can also be a liability. The most frequent criticism of the ISP is that a program so strongly "scene-oriented" and careerist produces superficial work. ISP instructors assert that the reverse is true. Their New York experience makes many students cynical about both the myth of success and the ability of the art support system of dealers, collectors, curators, galleries, and museums to meet the needs of artists.

However one resolves this question, it is clear that students in the ISP are given something their colleges cannot offer. Whether a student accepts or rejects the New York art scene, participation in the ISP powerfully affects his development as an artist.

## Art history and museum studies

A requirement for ISP students in art history is a major research paper on an aspect of American art of their own choosing. Students are given study space at the Whitney, staff privileges to use the museum's facilities, and free access to most of the city's museums and libraries. Research papers are guided by individual tutors selected by the student in consultation with the head of the Whitney's education department. The panel of tutors includes New York's most prominent critics and art historians—such people as Dore Ashton, Richard Kostelanetz, Hilton Kramer, Genevieve Oswald, Robert Rosenblum, and Leo Steinberg. Although the relation of student to tutor varies according to the individuals concerned, most students see their tutors weekly. (Tutors receive $600 per semester per student.)

The Whitney's education department lays great stress on the process and the product of research in the ISP. No pressure is put on students to complete their papers, but research they must (and research they do, if only because college and university credit hinges on it). The ISP research requirement has produced lively results—a film, *The End of Art*, a spoof based on interviews with artists and critics; a publication, *Art-Rite*, begun by three former ISP students; curatorial jobs in a variety of museums, including the Whitney.

Their research for the ISP brings art history students into direct contact with artists and works of art. All too often, in university settings, art history is studied at some distance from the subject. "Very few art historians," said Hupert, "can make use of living artists as . . . sources of information." Nor does art history always connect with original works of art: "University-trained art historians frequently can get a degree and get out of school without ever having a real sense of what an art object is." In Hupert's view, work with objects "has a potential of giving much more life to any sort of art history." He feels just as strongly about the ISP's value in bringing research-plus-object to museum studies, so that the student can bring "a solid research capability to the museum." Without the art history and research emphasis, Hupert feels the ISP's museum studies would be meaningless.

**Other requirements for art history students.** With the opening of the Whitney's Downtown Branch Museum in September 1973 (see report on the branch museum, chapter 3), the ISP's art history and museum studies entered a significant new phase. As the branch is staffed entirely by ISP students, the museum studies component of the program began to receive much greater emphasis than before, and all art history students are expected to be deeply involved in museum studies. Most of them stay in the program for two semesters so they can complete the complex process of bringing major exhibitions from conception to final closing.[4]

Students in art history-museum studies are expected to work at the branch three five-hour days a week. Two days a week they work on their research papers and meet with tutors. The regular weekly seminars, an additional weekly seminar in museum practices conducted by Whitney's education department and other staff, preparation of exhibitions, and visits to galleries and museums take up another three days. According to the acceptance letter that students receive, this schedule adds up to the normal Whitney ISP eight-day week.

Of the thirty students who applied for the fall 1974 term in art history-museum studies, ten were accepted. Although applicants are judged primarily on the merits of a written proposal, recommendations are also important. That so few students applied for art history-museum studies compared to the number of studio applicants was seen as a result, in part, of this required proposal; the greater interest in studio art is obviously the major reason. Applicants are chosen by Hupert, who gives more weight to the ability and intelligence shown in the proposal than to its actual feasibility. The most important criterion is a feel for museum work, as opposed to a simple desire to get away from school and come to New York.

Although grades and Graduate Record Exam scores are not required, most art history students send them anyhow (studio art applicants do not). Eight of the fourteen students accepted for the fall 1973 term in art history-museum studies had had some museum experience, but such experience is not an important criterion for acceptance. In fact, only one of ten students accepted for the fall 1974 term had significant museum experience.

The Whitney is more interested in making museum work a real career alternative for the best students of art history than it is in producing fully trained museum staff. Trying to counteract the forces that push the best art historians into university careers, the Whitney welcomes students just prior to or early in their graduate studies—before they have decided on a career. But as David Hupert said, "Students who do not [plan to] enter the museum field are not pariahs [in the ISP]. The experience of working with art objects and doing research using prime sources can only enhance an academic education."

**Running the branch; student shows**

Two students have keys to the Whitney's Downtown Branch Museum and are responsible for opening and closing it every day. Other students rotate their work at the branch; four or five are there daily. Students design and install the exhibitions, design and see to the printing of posters and invitations, write the press releases, arrange openings, answer the phone, handle the museum's copious correspondence, review work for shows, act as guards, write labels, make appointments to have floors and windows cleaned and walls painted—in short, handle all the business of running a museum (except, as one Whitney executive pointed out, the somewhat critical matter of fund raising).

During the hours the museum is open, half the students are on the floor as guards or "advisers," and the other half in the back office. Though they admitted that a guard's work is boring, students interviewed for this report agreed that professional guards would create the wrong atmosphere; furthermore, they noted, guarding allows them to learn about the audience. The branch museum is run entirely by the Whitney's education department; the department head and his assistant supervise the students' work. During the course of a week both of them are in and out of the branch, but the students, as they gain experience, need less and less direction. Indeed, students point out that they themselves have final say in virtually all aspects of running the branch. The single exception is printed matter, which must be specifically approved by the department head before it goes out. Said one student about working at the branch, "It's been a fabulous experience."

Indeed it is an important part of the Whitney's strategy to encourage in students this sense of their own responsibility. Though Hupert's guiding hand—and sometimes that of other Whitney officials—is very much in evidence, decisions about whether or not to do particular shows are left to the students. (Hupert cited two occasions in 1974 when he told students that he thought certain shows would not work; the students disagreed, and the shows went on.)

Each term a major Whitney exhibition is entirely produced

by ISP students. As in most Whitney education programs, the freedom students enjoy is the most remarkable aspect of these shows. At the Whitney a student show means more than just allowing students to help, or even giving them responsibility for an already-planned exhibition. Instead, students are given a time slot and a floor of the museum. The result—from concept through research, selection, design, catalog, installation, publicity, and opening—comes entirely from the students. The single major restriction is that the show must (with minor exceptions) be drawn entirely from the museum's permanent collection—not unduly limiting, for there are 3,000 objects in the Whitney collection. From the museum's perspective, the restriction makes sense for two reasons. First, as students are generally allowed only three months to prepare their show, it helps to keep the scope manageable. And second, it releases the overburdened curatorial staff from the task of putting together exhibitions from the permanent collection. Most student shows cost about $2,000, which goes chiefly for printing the catalogs and shipping. These catalogs are small brochures that introduce the shows rather than scholarly efforts of enduring value.

The first ISP student show, from February 26 to April 9, 1972, was a survey of American abstract art of the 1950s entitled "Free Form Abstraction." The following fall the student show was "The City as a Source," November 22, 1972, to January 1, 1973. This exhibition attempted to show "how an artist sees his urban environment, draws inspiration from it, and is influenced by it."[5]

For the spring term students did "ꟽuƨɘuM" (sic), a conceptual show that presented the Whitney Museum itself as a system, with sections on acquisition, storage, structure, architecture, and history. Among other things, the show presented the history of the Whitney's purchases from its annuals; photographs of the museum staff with job descriptions they had written themselves; videotapes of the dismantling of a show, an opening, and comments by artists on the Whitney; and behind the scenes at the Whitney—floor plans, photographs, accession forms, and samples of such things as folded canvases and crated sculpture. In the short catalog for "ꟽuƨɘuM" the ISP students wrote

> Our position as temporary staff members has given us a unique view of the museum and its structure. We have had intimate access to the museum's staff, files, and collection which we as visitors could view with a detached eye. We have maintained our objectivity by dealing with the most concrete aspects (chronology, structure) of the museum in isolation, keeping aesthetic and sociological considerations to a minimum.[6]

### Some student shows

The opening of the downtown branch greatly increased the possibilities for student exhibitions. Work began with a brainstorming session in September 1973. So great was the number of exhibition ideas that the students divided into uptown and downtown groups. The uptown group did "Frank O'Hara: A Poet among Painters," February 12 through March 17, 1974, at the main museum; the downtown group did "Nine Artists/Coenties Slip," January 10 through February 14, 1974, at the branch. "Frank O'Hara" attempted to connect this poet's work with that of his painter friends by juxtaposing the poems—printed on the walls in large type—with related paintings. "Coenties Slip" presented the work of artists—including Kelly, Rosenquist, Indiana, Martin, and Youngerman—who in the mid-1950s had studios in a lower Manhattan neighborhood, since razed to make way for new office buildings. Appropriately, the building which now houses the branch is one of those that stands on the landfill over Coenties Slip.

The idea for "Coenties Slip" (the first show in which students were able to make extensive use of loan materials) came from an exhibition of drawings by the same group of artists that an ISP student had seen in a SoHo gallery. Deciding the idea needed to be expanded, the students, as usual, divided up the work. One did the poster, one the paper work. Each student researched and arranged the loans for the work of one or two artists. According to one student, the best part of doing the show was working with the artists, although sometimes this had to be done by phone (because nearly all student shows are on contemporary art, learning to deal with artists is particularly stressed in the ISP). The students working on "Coenties Slip" said they found everyone—artists, galleries, private collectors—very cooperative.

For the spring 1974 exhibition, some students wanted to show light sculpture, others to concentrate on artists' use of new materials: the result was "Illuminations and Reflections." Once the topic had been decided, everyone had suggestions for artists and pieces to include; the show was the result of refining these suggestions until they made sense as a unit.

Since the opening of the branch, the distinction between student shows and nonstudent shows has become somewhat blurred. Of the seven shows at the branch between September 1973 and July 1974, five were—at least in the students' own view—entirely or largely their work. In addition to "Coenties Slip" and "Illuminations," the students also did "Three Sculptors," "People and Places," and "Clay" (a show of California ceramics). "Three Sculptors" grew out of one ISP student's idea of surveying the sculpture in the Whitney's permanent collection. When the scope proved unmanageable, Hupert pared it down to Nevelson, Calder, and Smith. "People and Places," drawn mostly from the permanent collection, represented a compromise between the students who wanted to do a landscape show and those who wanted a show of portraits.

For these shows each student in turn acted as curator. The student curator made most of the selections for the show by going through a book of photographs of the Whitney's collection and had the final say in which objects were to be included. One of the most eccentric objects in "People and Places" indicated the freedom students have in putting the

branch shows together: when a Staten Island folk artist heard about the new downtown museum, he brought in his work; the students decided to include his plywood model of the Empire State Building in their show. The piece, constructed with the aid of newspaper photographs of the 1930s, sports 6,300 windows, quantities of silver paint, and a red light on the tower.

**Reactions: students and critics.** The educational value of their shows is given considerable weight by the ISP museum-studies students, though the Whitney does not always share their view. Significantly, several students expressed greater interest in museum education than in curatorial work. The downtown audience is less sophisticated than the Whitney's uptown, so at the branch, exhibitions of more "difficult" work alternate with shows that are easier and more familiar. In "People and Places" paintings by such artists as Henri, Benton, and Hopper, which the students felt would draw their audience in, were juxtaposed with pieces by Warhol and Lichtenstein, which they hoped would help to broaden their audience's taste. For most of their exhibitions students give either slide shows or gallery talks, depending on the material, twice weekly.

Their shows for the Whitney—uptown and downtown— are a tremendous learning experience, said the ISP students, chiefly because of the size and interest of the New York City museum-going public. As most of the shows are reviewed in the city's daily and weekly newspapers or in art periodicals, students gain a sense of doing something important. Lawrence Alloway of *The Nation* called "Free Form Abstraction" "a well-conceived show, timely in indicating a possible renewal of interest in this somewhat discredited area of recent art, and, at the same time, accurately locating a strength of the collection." He said, however, that "The City as a Source" failed: "Incongruous and incompatible art works were assembled. . . ." He found "ɯuǝƨυM" "exceptionally interesting."[7]

For Hilton Kramer of the *New York Times*, "Nine Artists/Coenties Slip" was "rewarding both for its works of art and for its historical significance. . . ."[8]

Peter Schjeldahl wrote of "Frank O'Hara" in the Sunday *Times*: "A stab has been made at establishing . . . a fascinating chapter in the cultural history of New York City." He called it "a singular show," but said that the "esoteric" documentary section of the exhibition "contributes to a sense that this is a sort of skeleton show, a connect-the-dots puzzle that is mainly dots. One hopes that its mysteries will be a spur to the kind of scholarship that it is sorely in need of."[9]

James R. Mellow said of "People and Places," in another *Times* review, that it was "irrepressibly oddball." He wrote, "The organizers of the Whitney show seem to have viewed the history of modern American art as a series of one-night stands—some brilliant performances, a number of routine turns, and a few nostalgic vaudeville acts."[10]

**Funding**

Almost all money for the Independent Study Program is raised annually. Funding comes from the Helena Rubinstein Foundation, the Andrew W. Mellon Foundation, and the National Endowment for the Arts. These contributions, combined with student tuition, provide an operating budget of about $55,000 per year. The chief expenses are staff salaries and fees for tutors and seminar leaders. Rent and utilities are free because the Reade Street studios are owned by the city.

For the first three years the program charged no tuition. In fall 1970 the Whitney introduced a $600 fee, partly as a fund-raising device. Liberal scholarships, however, greatly reduced the intake from tuitions. An annual enrollment of 50 students could have produced $30,000; in the academic year 1972/73 the museum received $17,000 from tuition; in 1973/74, only $15,000.

ISP tuition problems arise because students are given credit for their work at the Whitney from the colleges and universities where they are enrolled. In order to get this credit, students are sometimes required to pay full tuition at their home institutions, which—combined with the ISP tuition and the cost of living in New York—can become a severe burden.

The way students are charged varies greatly. At Harvard and New York University, for example, students must pay both the Whitney tuition and their university's regular fee for each credit hour of independent study. At Yale, on the other hand, they receive credit and pay only a nominal registration fee. In a third variation, at the Maryland Institute of Arts, the school charges a student regular tuition but then uses it to pay the Whitney tuition.

Ultimately, the museum has decided, the fairest and simplest recourse is to do away with tuition altogether. Although it entails a certain cutback in activities, the Whitney decided to charge only a nominal $200 fee for studio art starting in the academic year 1974/75.

The tuition charge for museum studies-art history students was suspended in 1973 because of the opening of the branch. Students pay off their tuition by working at the branch at $5 per hour. Once the tuition is paid, the students go on "assistantships" and continue to work for $3 an hour. (This money comes from the operating budget of the branch.) The museum reasons that binding the students by an hourly wage makes them more responsible than they would be with a flat grant. So far the system has worked well.

**Relations between the ISP and the museum**

The museum studies-art history part of the ISP is clearly dependent on the collections and physical plant of the Whitney Museum. The relation between museum and program grows less clear, however, with the ISP's studio artists. Showing student work in the museum every year is very nice; it is good for an art student to have free access to a museum;

the Whitney name provides exceptional seminar leaders who normally would probably not be available to students. There would seem to be no reason why this part of the ISP could not be sponsored by a local university, a foundation, or even the city itself.

Yet none of these other institutions has sponsored a program like the ISP, a gap the Whitney Museum is beginning to fill. Because it is not bound by any doctrinaire educational theories or structures, the Whitney has no tradition to break in order to undertake educational experiments. According to one of the ISP's instructors in studio art, a museum should not be just a repository, but rather a "holistic" enterprise that operates against the mechanistic structure of society. Helping to develop studio artists is not a necessary function for the Whitney, this instructor went on to say, but he gave all praise to the museum for doing what it is doing.

In designing an education program the Whitney asks only three questions:
- Is there a need?
- Can we fulfill it?
- Does it do something valuable for the participants?

In the case of the Independent Study Program, the answer to all three questions is *yes.* —*F. G. O.*

## Notes

[1] The majority of the students are from New York State, with a high proportion also coming from California. Students have entered the program from over 50 colleges. A sampling: Harvard, Yale, Radcliffe, Vassar, Bard, Hobart, Michigan State, Stanford, Reed, Colgate, Columbia, Skidmore, Tulane, the Universities of Colorado, Georgia, Kentucky, New Mexico, and Southern California, Pratt Institute, Maryland Institute of Arts, San Francisco Art Institute.

[2] The way the Whitney obtained this facility is explained in an interview with David Hupert that is part of the report on the downtown gallery in chapter 3 of this study.

[3] For sources of quotations without footnote references, see list of interviews at the end of this report.

[4] The ISP continues "informally" during the summers, according to a Whitney staff member. Seminars and studio work are suspended, but those students who stay in New York through the summer months continue to staff the downtown gallery. They are paid for the work, though they do not receive college credit for it.

[5] Press release, Whitney Museum of American Art, November 1972.

[6] *иniэгиM* (New York: Whitney Museum of American Art, 1973), p. 2.

[7] "Art," *The Nation*, April 1973, p. 573.

[8] "Romantic 'Nine Artists/Coenties Slip,'" *New York Times*, January 12, 1974.

[9] "O'Hara—Art Sustained Him," *New York Times*, March 4, 1974.

[10] "Modern Art—A Series of One-Night Stands?" *New York Times,* March 10, 1974.

A comparison between student shows at the Whitney and at Yale (see report on the Yale program, this chapter) may help to put museum training into a better perspective. Because of the enormous freedom the students are given, the Whitney program has no equal in terms of giving students the nuts-and-bolts experience of putting on a major show or running a museum. What is gained in freedom and experience, however, is perhaps lost in professionalism and scholarship. Part of the problem is that the Whitney employs no professional designers, and exhibition design on the whole is not a strong point of the museum. Because the ISP, until 1973/74, was a one-term program and much of the energy available for a show went into all the detailed mechanics of realization, the shows have had little art historical weight compared to those at Yale. By contrast, students at Yale worked on some shows for well over a year. Yale is training scholars who know how to work in museums; the ISP is more audience-oriented and students learn how to get things done. Each program is working out of its strengths. Yale has broadened traditional art historical training by its emphasis on objects. The Whitney is bringing in students of art history for a brief period and filling them with information and expertise not available in a university setting.

## Interviews

Chisholm, Nan. ISP student; Senior in Art History at Mills College. March 27, 1974.

Clark, Ronald D. ISP Instructor. January 15, March 29, 1974.

Diao, David. ISP Instructor. January 15, 1974.

Hupert, David. Head, Museum Education Programs, Whitney Museum of American Art. November 7, 1973; March 8, and 22, April 5, 1974.

Kleinberg, Jane. ISP Student; Junior in Art History at Oberlin College. March 27, 1974.

Marshall, Richard. ISP Student; Graduate in Art History at University of California at Long Beach. March 27, 1974.

Schoonmaker, John. ISP Student; Junior in Painting, Pennsylvania College of Art. March 27, 1974.

# The Artist and the Museum

## Introduction

Among the many programs art museums have designed for their audiences in the 1970s, it is not common to find one that addresses itself to the needs of artists. This neglect, which sometimes borders on antipathy, is relatively recent. In the eighteenth century the Louvre set aside half the time it was open exclusively for artists to copy and study its collections. In this country, artists were among the founders of many of the art museums that began to proliferate in the nineteenth century—the Metropolitan Museum,[1] the Memorial Art Gallery in Rochester, New York, and the Milwaukee Art Institute, to name a few—and many of the museums that followed them in the twentieth. Throughout the nineteenth century, in fact, artists were a distinctive feature of museum staffs and boards of trustees, and as copyists they regularly filled the galleries with their easels and paints.

With the rise of art history as a respected academic discipline in the late nineteenth and early twentieth centuries and the beginning of professional training for museum personnel, artists gradually faded from the museum scene. Modernism's "antihistorical" art had its influence, too; in recent decades the Old Masters lost their hold on artists as a primary source of inspiration. Today, even though most museums exhibit the work of living artists and many bring artists in to teach or lecture, as copyist, curator, administrator, or trustee, an artist has become a rare phenomenon. (In 1966 the Metropolitan's last artist-curator, Robert Beverly Hale, the man who brought the first Jackson Pollock into an American museum, retired; his place was taken by an art historian.)

Whether or not this exodus has been healthy for either artist or museum—and opinion is divided about it—there are signs that change is in the wind. The reports in this chapter reflect a few of the ways that artists and museums have been coming together in the sixties and seventies.

### The museum as an educational resource for artists

In some museums artists are returning in professional capacities, but one role they never abandoned was as members of the discriminating, "consuming" public. Louis Finkelstein, a painter and professor of art at Queens College in New York, says in an interview here that "artists . . . flock to museums like religious people go to Mass. They are always in museums." Andrew Ritchie notes in a 1966 study that artists "consume" art in museums with an "intense selfishness."[2]

As learners, artists have long used the museum through its studio school. Museum-associated art schools, in fact, were among the earliest and most ambitious manifestations of the educational purpose stressed in American art museum charters. According to Joshua Taylor, "the art academy which served to aid artists and point them in the right direction and the public display of works of art were from the beginning united, and it is significant that when serious museums were organized [in the late nineteenth century] they usually were associated with an art school."[3]

The first museum studio school was one started by the Pennsylvania Academy of the Fine Arts in 1813 (the academy itself was founded in 1805, primarily as a museum of casts to encourage people to "learn from the antique"; the school, which is part of the academy, came later). The School of the Art Institute of Chicago was one whose founding, in 1866, actually preceded the museum. Later in the nineteenth century, museum schools were started either together with or soon after the museums themselves were born: the School of the Boston Museum of Fine Arts was opened in 1876, six years after the museum was founded; the Minneapolis Art Institute in 1886; the Corcoran School of Art in 1887; and the Brooklyn Museum Art School in 1898.[4] The Layton Art Gallery, located in the same building with the Milwaukee Art Institute, was founded in 1888.

One contemporary art school that has been closely tied to the program of its museum is the de Young Museum school in San Francisco, described in this chapter. Founded in 1966, for the first ten years of its life the school was located on the museum's premises (it moved to temporary quarters away from the museum in early 1976 to make room for new construction but is scheduled to return when the wing is completed). In it, 32 professionals teach studio classes to about 6,000 students a year—over half of them practicing artists, according to the curator-in-charge—in painting, drawing, print-making, photography, metal arts, sculpture, ceramics,

and textiles. The classes have been correlated with the collections and temporary exhibitions, and both artist-teachers and their students have used the collections to learn about specific techniques and to stimulate ideas.

For some museums the presence of an art school has been enough to provide the necessary educational-institution designation for tax purposes. But as the contemporary art world has begun to tolerate a variety of styles, including a new realism, the museum collections are becoming more interesting to museum schools. At the Boston Museum of Fine Arts School, surveyed for this study but not included in it, clay modeling classes use classical and Egyptian sculpture, and students in its methods courses (a purely technical course in which painting, mosaic, gold leaf, and gesso ground techniques are studied) analyze the work of a single painter or sculptor through examples in the collection. The school has a studio in the museum for this purpose, where works of art from the museum's study collection can be brought and students can work whenever the museum is open.[5]

The Whitney Museum of American Art is another that offers studio instruction, though in an unconventional way. College and university students from around the country receive academic credits for spending one or two semesters in an independent study program (described in chapter 12) that offers them optional guidance from professional artist-instructors and contact with New York artists, collectors, dealers, curators, and critics. Each student is given his own studio space in the basement of a downtown office building.

**Copying.** Another specific use of museums is in the still nascent revival of copying. For Louis Finkelstein, copying is *the* way to learn about and understand art. It provides the "sustained physical contact," says Finkelstein, necessary to "appreciate . . . that special quality" of art works. Israel Hirschberg, instructor of a copying class at the Maryland Institute College of Art (see "Copying in the Museum," this chapter), regards copying as a valuable way in which "the artist can extend both his visual and technical vocabulary and thereby enrich his own work."

But copying has been, as Finkelstein says, in bad odor for decades now, and its revivers have met opposition. For one thing, it is still considered reactionary and academic in many art schools and museums, requiring at the very least, according to some of its detractors, sophisticated instruction in order to be a useful method of learning to paint. For another, in two museums where the experiment was tried, administrators found easels, messy paints, and bulky canvases a problem: the paraphernalia got in the way of group tours, artists sometimes used the wrong sinks, and they were uncooperative about leaving at closing time. Instructors and students in the two programs reported here—the Maryland Institute's with the National Gallery and the New York Studio School's with the Metropolitan—have been discouraged by the "red tape" and "lack of cooperation" they say they have encountered in the museums.

At the same time, a proponent of copying has reported one small victory: Finkelstein says that he was able to convince the Metropolitan to lend some of its casts to Queens College for its art students to restore and copy from. If the list of requests presented to Metropolitan Director Thomas P. F. Hoving in 1972 is any signal, what artist-copyists would like next is free admittance to the museum, new and more relaxed rules on the use of the galleries for copying, access to the galleries at times when the museum is closed to the public (something akin to the study hours offered to college and university students at the Museum of Modern Art; see chapter 1), and display of paintings that may not be masterpieces but are valuable for the education of artists (as Finkelstein puts it, "taking the less prized resources of the museum and putting them into circulation for learning needs").

**Fellowships and shows.** Beyond the encouragement of copying, there are other services artists feel the museum can provide them. A recommendation put forth to the Metropolitan Museum in 1973 was that it establish fellowships for artists, which would allow them to function not simply as "pseudo-scholars or -educators" but as pure researchers in "artistic creativity." The proposal suggested that the artist-fellows also engage in one- or two-day-a-week educational projects—such as teaching in the Junior Museum or giving a lecture series for adults—and thus make the museum "the beneficiary of a steady stream of inventive and stimulating ideas to revitalize its ongoing programs."[6]

Regional art shows are another service that artists want from museums and that a growing number of museums do offer local professionals. Particularly in small museums far from the nation's art-making centers, these shows, which are often juried, are a valuable, and sometimes the only, way for artists to test themselves against critical standards. (The Greenville County Museum of Art [see chapter 3] once videotaped an interview in which a juror of a regional show described his selection process; the result, according to museum staff, was as instructive to the artist entrants as it was to the general public.)

### The artist as educator in the museum

The most common, and to some the most appropriate, use of artists in museums is as teachers of or about art. For Elsa Cameron, curator-in-charge of the de Young Museum Art School, the primary concern when she set up the school was how the museum could serve local artists: "What do artists need? Well, money, jobs, shows. . . . I knew we couldn't show all the artists [and we] couldn't subsidize them, but we could create jobs." The school employs artist-teachers, not only to conduct the studio classes but to assist in docent training, help install and design educational programs for special exhibitions, and operate and staff the museum's outreach program, Trip-out Trucks (see chapter 7).

Another artist-teacher who did more than simply teach was Robert Blood, the literal artist-in-residence from 1961 to

1967 at the old Schenectady Museum in New York State (this chapter). He bartered his time as a studio teacher, carpenter, exhibition designer, and caretaker for a small stipend, an apartment in the museum building for himself and his family, studio space, and money for materials to do his own work. The museum and the artist both felt well served by the trade; Blood pointed out that one of the strengths of such an arrangement is that it can temper the rigidity of an overstructured institution.

At the Cleveland Museum the artist-as-teacher idea took the form, one summer, of stationing a young art student in one of the galleries to copy a painting and answer visitors' questions (see report on "Copying in the Museum," this chapter). In the eight weeks he was there, the artist says, about 800 visitors were led to make thoughtful judgments about qualities in the original (a landscape by Claude) as compared to the copy: "The viewer progressed beyond passive observation and became involved in rudimentary forms of criticism."

The Philadelphia Museum used videotapes of artists talking about their lives and work to supplement "The Invisible Artist" (see chapter 2), one of a series of educational exhibitions to dispel popular misconceptions about art and artists. Visitors—and perhaps museum personnel as well—saw that although a few artists do conform to the "bohemian" stereotypes, many lead quite "normal" lives, steeped in the conventional concerns of family, friends, money, pets. The Greenville County Museum of Art is another of the many museums that have taped interviews with artists as educational complements to special exhibitions.

The use of artists as teachers has become almost *de rigueur* in museum outreach programs. One example is the High Museum's Georgia Art Bus, in which art and artist travel together for one- or two-week stays in small towns in the state's hinterlands. Contemporary art hangs in school corridors or cafeterias while the artist conducts classes and workshops for schoolchildren and adults, many of whom have never seen original art before or had any visible connection with art. (For more on this and other outreach programs that use artist-teachers, see reports and introduction in chapter 7.)

### The broader uses of artists in museums: a debate

Whether the programs described here—and similar ones in museums around the country—reflect a trend back toward a closer relationship between the art makers and the institutions that collect, preserve, and exhibit art is not certain. But not all observers believe that the two should be more closely joined or that artists should have a significant voice in museum policies. Artist Walter Darby Bannard is one who argues that museums and artists are in many ways "natural antagonists," who must "keep a wary distance" from each other. "This means strain and altercation," he says, "but that is the natural order of things, a check and balance."[7] Egbert Haverkamp-Begemann, chairman of the Department

of the History of Art at Yale University, too, sees a "natural conflict" between artists and museums. "The art historian must be objective," he has said. "His purpose is to establish the historical significance of an object. The artist, on the other hand, must be subjective . . . in touch with the personal meaning a work of art can have for him. . . . Art history and the practice of art," he concluded, "must be kept virtually separate."[8]

But other critics assert that when it comes to putting art objects before the public eye, the two should not be separated. Andrew Ritchie sees in the artist a "valuable corrective" to the curator as he "consumes" works of art that feed his needs:

Actually, this specialized approach to art, this intensely selfish, if you like, consumption of art, can be a very valuable corrective to a collecting policy of acquiring objects of more historical than artistic importance. The artist's eye may see through the technical or emotional shortcomings of a work of art more quickly than a curator whose judgment of artistic values may have become clouded by historical or iconographic considerations.[9]

Louis Finkelstein also emphasizes the corrective role that artists can and should play in the museum. If, as he claims, the art historians and scholars who run and staff museums do not understand the "true meaning" of art and are "endemically deficient in a philosophic view of [their] own state of knowledge," who, then, should be the pervasive "contact" between the art in the museum and the general public? Artists, of course: as artists are the ones who give meaning to art in the act of creating it, only they can convey its meaning as more than an object of iconography, technical achievement, or connoisseurship. Only artists, he adds, can grasp and communicate the social functions of art, "the cementing, healing, bridging role" it plays in a democracy:

The fact is that this can be communicated to a very large number of people in the society—not simply the names and dates of art objects, the textbook answers, but the very real feelings and experiences and values and analyses and sense of power. In short, [an] optimistic view of the world . . . (one needs an optimistic view—our whole nervous system is predicated on it) is communicated by works of art. . . .

Pop culture, with its crassness, its cynicism, its evasion of social responsibility, takes over only by default of those people who should know better. They are the learned part of the community that is not realizing these real resources [in art] and explicating them in a consequential manner fit for democratic consumption and adequate to their potential for teaching and leading people to do better things.

Finkelstein makes no specific suggestions for how the sensibilities of the artist can infiltrate museum structures—though he anticipates despairingly the kind of artist the Metropolitan Museum, for example, would call on if it chose to put one on its board: "A Motherwell or a Bannard; you

know, the people who have a chic view of the cultural imperialists.''

Bannard disagrees with Finkelstein's basic premise: ''I think it is too bad that so many of artistic temperament do work for museums. The art museum is the public agent for the arts, not an 'artistic' organism.''[10] Further, Bannard is quite sure of the capacities in which artists should *not* serve museums—as trustees, administrators, or advisers for exhibitions or acquisitions. ''[An] artist's participation in the museum,'' he argues, ''would be a self-serving conflict of interest, like hiring a drug manufacturer to work for the Food and Drug Administration.'' Besides, he adds, ''the psychology of the artist is not fitted to work well within an organization.''[11]

Where artists, especially ''successful'' ones, do belong in the museum, says Bannard, is precisely where they are most commonly found—as ''explicators'' and teachers of young artists. ''Here is the place for intelligent innovation. Young artists could be given rigorous training in their craft, which includes dynamic understanding of art as well as how to treat a canvas. . . . Museums could do it well, and artists could be a valuable part of this.''[12]

Like other debates in the museum world, the question of the artist's place in museum affairs can perhaps only be settled in practice, not speculation. But it might be pointed out that in other artistic professions—music, the theater, film, and literature, for example—the artist has been known to function successfully, and sometimes even happily, as administrator, editor, policymaker, or critic: the conductor of a symphony orchestra is often composer as well (who receives as much applause for conducting his own works as he does for performance of the compositions of his friends); the director of a theater group may also be a playwright or actor; the most talented filmmaker is likely to carry on a variety of administrative and managerial chores; the poet may function as teacher, critic, and historian. Only in the visual arts, in these later years, is it raised as a conflict of interest when the artist functions in the multiple capacities of creator, administrator, connoisseur, historian, and critic. Not everyone is successful at any kind of job, but it may not be entirely fair to condemn all artists to the single-minded pursuit of their own art by shutting them out of consideration for gainful employment in the museum, which may be their natural home. As for the artist's contribution to the formulation of museum policies, it may be, as painter Jack Tworkov and others have maintained, that an artist has no desire to become involved in museum-board issues, especially as a token member.[13] Yet who can say that the artist may not be among the museum's most useful advisers—in education, acquisitions, exhibitions, or finances—when some of our most financially troubled museums are advised almost exclusively by businessmen?

George Wald, professor of biology at Harvard and Nobel prize winner is an eloquent defender of the rationality of the artist and of his rights as a participant in the institutional affairs of our time. Although Wald is speaking of the university in the passages that follow, he could as well be addressing the similar resistance in the museum:

It is a curious paradox that, highly as the university esteems the work of art, it tends to take a dim view of the artist as an intellectual. Indeed it takes the harshest view of the contemporary artist. An artist sufficiently enshrouded in the mists of time, with the patina of age upon him, is acceptable like any other antique as a proper object of veneration and study. The contemporary artist, however, is often regarded with suspicion, if not with ruder feelings. He is assumed to be a flighty, undependable, unpredictable person, something of a blemish upon his own productions.

Indeed the higher the esteem in which his art is held, the more suspect the artist. . . . It is the genius that makes the trouble. The work of genius may be the keystone of our civilization, but it takes little persuasion to believe that the genius himself is uncivilized.

On inquiring more deeply, one encounters the curious view that the artist does not know what he is doing. It is widely believed and sometimes explicitly stated that the artist, however great his art, does not genuinely understand it, neither how he produced it, nor its and his place in the culture and in history. These things require historians, critics, philosophers. We have even heard it said that the artist is the ''last person'' properly to understand his art. . . .

When one considers what manual skills, what grasp of composition, what restraint in execution, what capacity for subsuming detail to the integrated whole, are needed to produce an authentic work of art, one realizes that these are the very highest affirmations of the intellect, and altogether incompatible with any failure of the mind or of the personality. Art is the epitome of order, the very negation of disorder. . . .

Instances might well be found in which, in the view of contemporary and later scholars, the artist as historian or critic has expressed faulty judgments. Yet it would be difficult to maintain with assurance that the artist is more likely to err in this regard than the professional art historian or critic. However imperfect his evaluations of art and artists may be, they are probably no less reliable than the judgments of others.

. . . The artist is a creative intellectual, the great artist great both as artist and as intellectual. The university should welcome him. One needs indeed to ask the question, not whether the artist is worthy of the university but whether the university is worthy of him.[14]

Wald pleads not only for understanding of the artist but for ''quiet and time'' and the ''the cultural stimulation from which his work can receive content.''[15] He also asks that the university reexamine its relation to the artist. The art museum, ultimately as dependent for its existence on the production of living artists as on the works of those long dead, might well decide—in the formulation of its educa-

tional policies and programs, not least—to reexamine its relation to the artist too.—*F. G. O./A. V. B./B. Y. N.*

## Notes

[1] Among the artists who helped to found the Metropolitan Museum were painters John F. Kensett, Worthington Whittredge, Vincent Colyer, and George Baker and the sculptor J. Q. A. Ward. See Calvin Tomkins, *Merchants and Masterpieces* (New York: E. P. Dutton, 1970), p. 29. Bryson Burroughs, a painter, was a curator of the museum for 28 years between 1909 and 1934, and he made many distinguished purchases for the museum during those years, including its first Cézanne. Tomkins, p. 168.

[2] *The Visual Arts in Higher Education,* ed. Andrew C. Ritchie (New Haven: Yale University Press for the College Art Association of America, 1966), p. 107.

[3] "The Art Museum in the United States," *On Understanding Art Museums*, ed. Sherman E. Lee, (Englewood Cliffs, N.J.: Prentice-Hall, 1975), p. 35.

[4] Jack Morrison, *The Rise of the Arts on the American Campus* (New York: McGraw-Hill, 1973), pp. 26–27.

[5] Telephone interview with William A. Bagnall, dean of the school, n.d.

[6] Frederick Ortner, education fellow, Metropolitan Museum, "Project Outline—Artists in the Metropolitan Museum," Xeroxed, January 1973, p. 4.

[7] "The Art Museum and the Living Artist," *On Understanding Art Museums*, pp. 177, 183.

[8] Interview, April 10, 1974.

[9] "The Museum of Art: The Museum and the Studio Program," *Visual Arts in Higher Education*, p. 107.

[10] "The Art Museum and the Living Artist," pp. 178–179.

[11] Ibid., p. 178.

[12] Ibid., p. 180.

[13] Interview, March 19, 1975.

[14] "The Department of Design," *Report of the Committee on the Visual Arts at Harvard University* (Cambridge, Mass.: Harvard University, 1956), pp. 44–46.

[15] Ibid., pp. 46, 47.

## Bibliography

*The Arts on Campus, The Necessity for Change*, ed. Margaret Mahoney. Greenwich, Conn.: New York Graphic Society, 1970.

*On Understanding Art Museums*, ed. Sherman E. Lee. Englewood Cliffs, N. J.: Prentice-Hall, 1975.

*The Visual Arts in Higher Education,* ed. Andrew C. Ritchie. New Haven, Conn.: Yale University Press for the College Art Association of America, 1966.

Wald, George. "The Department of Design," *Report of the Committee on the Visual Arts at Harvard University.* Cambridge, Mass.: Harvard University, 1956.

For a broader balance of artists' opinions, see *Documents of Modern Art*, series ed. Robert Motherwell (Viking Press) and the writings of Ad Reinhardt, Carl André, Donald Judd, and Robert Morris.

## COPYING IN THE MUSEUM

**A look at copying—an old art form making a small and troubled revival—at three museums: two that participate in cooperative programs with art schools, one that places a hired copyist in the galleries to lead visitors into perceptual analysis of an art work. CMEVA interviews and observations: January 1973–December 1974, February 1975.**

When the Louvre was first opened to the public in 1793, it set aside five of every ten days exclusively for artists to study and copy its collection. It was largely through this encouragement that the Louvre became known as the laboratory of French art.[1] When the first American museums were formed nearly a century later, they adopted the Louvre's policy; giving artists and students permission to paint or model from the works in their galleries became a fundamental means of museum education.

As the tenets of modernism finally began to be incorporated into professional art education in the 1930s, copying as a basic learning tool lost ground. Important copies by modern masters, such as van Gogh's of Delacroix, Cézanne's of Poussin, Matisse's of De Heem, and Derain's of Breughel, were forgotten as artists pursued individual expression and the new aesthetic principles. By the 1970s, a process that had fed artists for thousands of years had virtually died out. Although European art education had maintained this tradition, in the few American museums where copying was still allowed it had become an anachronism, a recreational activity for a few, mostly elderly, amateur painters.

### New beginnings at the Metropolitan

In the early 1970s, artists and museums in a few locations began to revive copying. Until 1931 the Metropolitan Museum of Art, like many others, had a special room where artists could work from objects of their choosing without being disturbed by the general public. But in that year, according to one Metropolitan curator, a Raeburn painting was stolen from this unguarded copying room, so the museum closed it. The Metropolitan was increasingly cramped for space anyway and, as the copyists raised few complaints, the room was never reopened.

In 1970, largely because of the heavy traffic and increased activities in the galleries during the museum's centennial celebration, the Metropolitan curtailed all copying. But art was beginning to change; no single style dominated the New York art scene, and artists, as so often happens in a period of confusion, began to return to the past for inspiration. In 1971 a small group of painters who were pursuing a new style of realist painting met with the Metropolitan's director to present a number of requests, among them that the museum allow copying again. The result was that in fall 1972 the museum opened the galleries once more to copyists.

Although it was apparent in art schools around the city that students were interested in this experience, few came to the

museum and the service continued to be used chiefly by hobbyists. For one thing, the program was not publicized, so many students did not know of its existence. For another, the copying regulations, which had not been revised in 20 years, were long and complicated. Too, students were uneasy about exposing themselves to public scrutiny in the busy galleries, and they were intimidated by the museum's attitude that copying was an unimportant additional service. Furthermore, working in the museum was an inconvenience: paints, palette, and canvas had to be lugged to a location miles from any art school—all for an activity that was encouraged by only a few teachers.

Nevertheless, copying had regained a foothold, however tenuous, as a legitimate learning exercise for art students. What follows is a description of the three copying programs: two are cooperative endeavors between museums and art schools, geared to the needs of students; the other places a hired copyist in the galleries of the Cleveland Museum as a way of drawing the casual visitor into perceptual analysis of an art work.

## Two cooperative art school-museum programs

### The New York Studio School and the Metropolitan Museum.
At the request of the New York Studio School, the Metropolitan began a pilot program in fall 1973 to correct some of the flaws in its copying policy. The Studio School was founded in the 1960s by a group of rebel art students from Pratt Institute. Its curriculum consists simply of four hours of drawing in the morning and four hours of painting or sculpture in the afternoon. It offers no degrees, admits only carefully selected full-time students, and boasts a distinguished faculty. The school, which prides itself on keeping apart from the pressures of fashion while drawing vitality from its existence in the heart of the art world,[2] has become a center of renewed attention for those with more traditional or "basic" attitudes toward painting and sculpture. It seemed the perfect partner for the Metropolitan's project.

One goal of the project was to make serious art students aware of the services the Metropolitan offered. The method was uncomplicated. A Studio School painting class simply met in the museum's European paintings galleries and worked from the pictures on view rather than from the usual figure model or still life. After an initial orientation session, a group of ten students came to the museum each afternoon and spread themselves throughout the galleries. Each worked from one painting for two weeks; one day a week their instructor gave individual criticisms in front of the picture the student was copying. At the end of each two-week period, another group moved in, a policy that allowed all interested students to participate.

### The Maryland Institute of Art and the National Gallery.
At the same time the Metropolitan-Studio School program was getting underway, a nearly identical class was started by the Maryland Institute College of Art in cooperation with the National Gallery of Art in nearby Washington, D.C.

The National Gallery has traditionally supported copying in its galleries, and it has always been a simple matter for a member of the general public to arrange for an easel and space in which to work. The museum's general policy has been to limit the number of copyists to 15 at any one time—the maximum number for which it can store and maintain equipment and which the staff feels can work without impeding traffic in the galleries. This policy was waived for the Maryland Institute class: the museum accommodated these 15 students in addition to its regular load.

Israel Hirschberg, instructor of the class in 1974/75, said he felt the extra effort on the museum's part was worth it:

> Copying attracts very talented and serious students. . . . It's a difficult course; I ask for a lot of work. In a six-week cycle at the museum they do two copies and after that a variation based on the copies. It takes discipline and a commitment. These students are trying to find themselves through hard work.[3]

**Results of the two programs.** In its initial term the Metropolitan's first cooperative project with a professional art school seemed to be going exceptionally well. The students were working hard and conscientiously at the museum, and more students than the class could hold were trying to get in. The sight of their fellow art students painting in the museum encouraged students from other schools to apply for copying permits, and a few instructors from other schools made inquiries about starting similar classes. At one point, the museum was concerned about its ability to accommodate everyone who was interested.

By spring 1974, however, a number of problems had developed. The Studio School students and their instructor complained that not only were the museum's rules too strict, but also that they changed from week to week: at times the students could leave their palettes in the museum overnight, at others they could not; galleries available one week were out of bounds the next. No single staff member took charge of the program; different curators had different ideas about what could be allowed. The registrar's office, which was responsible for the administration of the program, was caught in the middle. For its part, the museum staff found the class increasingly uncooperative and its demands increasingly burdensome. Students sometimes worked too late in the galleries, sometimes cleaned brushes in sinks they were not supposed to use. The program's inconveniences began to outweigh its benefits: student attendance dropped off, and instructors came less frequently to give criticisms.

In fall 1974 the program continued but on a much smaller scale. Many of the students and their instructors had grown skeptical about what the Metropolitan could offer them. The museum, which had never decided what it should offer the class or how far it would commit itself, was strapped for both gallery space and staff time because of the opening of a large

Impressionist exhibition. So it was willing to issue fewer copying permits, and fewer students were applying for them. Even the staff of the registrar's office, usually copying's most sympathetic advocate in the museum, felt that the program had become ineffective by its second year.

Nor had all gone smoothly in the Maryland Institute-National Gallery program. Instructor Hirschberg complained that sometimes a painting was removed before a student had time to finish his copy, that the museum would not admit the student copyists to those galleries that were routinely used for school tours, and that other galleries were sometimes closed if a tour wished to enter, interrupting the students' work: "One of my students sets up his easel and begins to paint, and all of a sudden he is told to move it; some kids are coming through."

Hirschberg singled out the elementary school programs in the museum for his particular ire: "I can't believe those kids get, in a five-minute walkthrough, anything like the feeling my students have for the paintings they are copying. If those are the museum's priorities, I think they are wrong." He said that he had complained to the museum's administration about such problems and was told that he was fortunate to be able to use the National Gallery for his class at all.

Hirschberg pointed out that the Walters Gallery in Baltimore has cooperated more fully with the institute program: "They don't have a long set of rules about copying. We are free to come and go, to do our work as we need to. No one has to move when the kids come through." But the Walters has a very small collection, he said, compared with the National Gallery's "store of treasures," and he mourned the opportunities lost through what he saw as lack of cooperation. "So much of our energy that could be spent in copying goes into fighting red tape."

### The copying controversy

The value of copying is not so widely accepted outside copying classes as it is within them. Said Hirschberg, "People here say it's a cop-out; why not be original? They say that all the time. The art world is making us self-conscious."[4] Those art schools and museums that fought the battle for modernism in the 1930s have been particularly appalled by what they see as academicism sneaking back again. Some who observed the New York program were partially appeased when they saw that the students were doing *alla prima* studies to investigate the spatial and color structures of the pictures they were copying rather than simply imitating the style and techniques of the original.

But even this practice distresses others who believe that if copying is to be a valid exercise it must respect the means by which the original was created. One Metropolitan curator said scornfully, "What they do doesn't even look like the paintings," and he added that he thought the students were only looking for free gallery space. (This hostile attitude was not widespread at the Metropolitan. Though considered a curious and low-priority project, the Studio School copying class nevertheless had received broad, if muted, support within the museum.)

In spite of the logistical and other problems they have encountered in the museums, however, students and instructors in both the Metropolitan and National Gallery programs remain firm believers in the value of copying. Said one student in the Maryland program,

I was 17 in my first painting course at the institute. I was in a state of continual nervous agitation. It was a self-perpetuating tradition of ignorance. I was expected to sit there and paint. What was missing?—a premise to start working from, a feeling of having a tradition to go from. Teachers are afraid to tell students anything—they don't want to inhibit their creativity.[5]

For her and her fellow students the missing tradition was found in the pictures hanging on museum walls. Making an analogy to a different art, she said, "No bricklayers today can put up buildings like the ones being torn down."[6] Hirschberg explained the purpose of the course by quoting K. E. Maison's *Art Themes and Variations:* "The copyist is in the act of questioning, examining, accepting, and discovering the thought of his predecessor. To compare a great copy with a great original is to attend a conversation between great artists."[7] In his own words he continued,

Great artists of the past were never vain about copying the masters before them. It was the accepted way of doing things; the way to learn. We all as children learned by imitation. Art students must become students of art—that is, they must rid themselves of their peculiar notions of originality and open themselves to the wisdom of the masters. By copying, the artist can extend both his visual and technical vocabulary and thereby enrich his own work. . . . The student need not be afraid of becoming a mere copyist—we are twentieth-century painters and cannot avoid bringing our own sense of time and place to our work.[8]

Mercedes Matter, the New York Studio School's dean, agreed:

I remember that as a young girl I painted at the Metropolitan from the Cézanne of rocks and trees and from El Greco's *Toledo*. . . . I think that looking at paintings in this probing way is an irreplaceable source of learning for a young painter.[9]

It seems clear, then, that for many artists the experience of a work of art demands more direct contact than just viewing. For them, understanding a work of art involves realization—the connection between eye and hand. Despite the availability and popularity of color reproductions, the act of working out individual artistic problems in front of their most inspired solutions in the original cannot be replaced. Regardless of its value to artists wishing to return to traditional forms—or, for that matter, the inconvenience to museums—the practice of copying, to some recent observ-

ers, deserves to be treated as the fundamental device it was in the past for understanding art.

In the words of Eugene Leake, former president of the Maryland Institute,

> The position of the artist in relation to the museum seems to be the least important, as far as the museum is concerned. Yet the reawakening of young artists to what the museum offers them is symbolic of the cultural health of the nation. A healthy America is dependent on its healthy young artists.

A Studio School copying student was hopeful in this regard: "There has been a change from the attitude that museums are there to tell you what *not* to do. We are return-ing to the traditions of Western art that are maintained by the study of art in museums."

## Copying and the general public: The Cleveland Museum program

One of the most interesting side effects of the Metropolitan's copying program was the attention it received from the general visitor. Intrigued by the work they saw students doing in the galleries, visitors gave increased attention to pictures they might normally have passed by and often engaged the students in conversation. Although it sometimes became a distracting annoyance, the students generally answered questions willingly and responded warmly to the public's interest.

**Copyists in the museum have always attracted their share of visitors' attention. The Cleveland Museum, which placed a hired copyist in its galleries for eight weeks, hoped his activity would teach as well as intrigue visitors. Above, a print by American artist John Sloan,** *Copyist at Metropolitan Museum of Art* **(1908), from the Rosenwald Collection of the National Gallery of Art, Washington, D.C.**

In at least one case, a visitor told a student she preferred his copy to the original; the student disagreed and explained—persuasively, according to the visitor—the differences between the two pictures.[10]

The idea that watching a copyist at work could encourage visitors to look more carefully at the original painting was one that also intrigued Sherman Lee, director of the Cleveland Museum. In a conversation with Eugene Leake, director of the Maryland Institute, about the institute's class, Lee began to speculate about the possibility of employing a copyist as an educator in the Cleveland Museum galleries. So in the summer of 1974, the museum hired a local art student, Leonard Koscianski, to work in the galleries for eight weeks. Koscianski's "job" was to copy paintings on Sunday afternoons and to answer visitors' questions. Koscianski himself was convinced that the public could become more deeply involved with a work of art by addressing it through a copy—that is, perceptually. He wrote,

> The major tools that have been used [in museum education] in the past have been written material and public lectures. Primarily, these methods communicate information regarding a perceptive phenomenon using abstract or conceptual means. This shift from percept to concept weakens the impact this information might have on the viewer.[11]

He deliberately chose a painting—a landscape by Claude—that he believed most visitors neglected in favor of more striking objects. By working in front of the painting, he hoped to help visitors—many of whom, he believes, are so distracted by the number and variety of objects in museum galleries that they do not really *see* anything—focus their attention on it. Koscianski hoped that his visual approach to the picture would encourage visitors to begin their own perceptual investigations of the original.

According to the copyist, the results were "beyond expectation," and he estimated that some 800 persons, mostly fellow art students, experienced the Claude in the way he had hoped. Koscianski gave several reasons for this success. Because he was not a teacher or lecturer, but, like the visitors, a student of the painting, they felt freer in approaching him. With their common interest in the picture, visitors and Koscianski had a ready conversational opening. The presence of the copy allowed, indeed provoked, comparison; visitors were led to make judgments about qualities in the Claude—atmosphere, light, color—in relation to the copy. The copyist wrote, "The viewer progressed beyond passive observation, and became involved in rudimentary forms of criticism."[12] Visitors were fascinated by the changing form of a work of art in process. It is easy to forget that a painting hanging on a museum wall was not always there and in that form. Visitors saw that, like the copy, the museum's painting also once existed in time, was formed and struggled over by an artist.

The Cleveland Museum was pleased with the success of its small eight-week experiment and planned to continue the project, perhaps even adding more copyists. It was also considering a copying class for visitors. The museum had no intention of offering painting classes for amateur artists, but saw copying—if it could be kept separate in visitors' minds from artistic creation—as an especially valuable and underused means of exploring and understanding works of art.
—*F. G. O./B. C. F.*

## Notes

[1] Calvin Tomkins, *Merchants and Masterpieces* (New York: E. P. Dutton, 1970), p. 31.

[2] Letter from Mercedes Matter, dean of the New York Studio School, to Harry Parker, vice-director for education, Metropolitan Museum of Art, June 6, 1974.

[3] For sources of quotations without footnote references, see list of interviews at the end of this report.

[4] Quoted in Gabrielle Wise, "Institute 'Rebels' Are Going Back to Old Fundamentals," *The Sun* (Baltimore), March 12, 1974, p. B1.

[5] Ibid.

[6] Ibid.

[7] Ibid.

[8] Ibid.

[9] Letter from Matter to Parker.

[10] According to a museum staff member, another unexpected benefit of the copying class at the Metropolitan was the interest of the museum guards. Students and guards shared the same space for the better part of a day; they became friends, discussed the pictures, and as a result, the staff member suggested, the guards were more alert, happier, and more effective in their jobs.

[11] Leonard Koscianski, "Copying as an Educational Tool," report to Sherman E. Lee, Cleveland Museum of Art, July 29, 1974, p. 1.

[12] Ibid., p. 3.

## Interviews

Information about the Metropolitan Museum-New York Studio School program was drawn from interviews between January 1973 and December 1974 with the following persons:

Bell, Leland. Instructor, New York Studio School.

Buchanan, John. Registrar, Metropolitan Museum of Art.

Gardner, Elizabeth E. Curator, European Paintings, Metropolitan Museum.

Geldzahler, Henry. Curator, Twentieth-Century Art, Metropolitan Museum.

Morsches, Richard. Vice-Director for Operations, Metropolitan Museum.

Moskowitz, Herbert. Office of the Registrar, Metropolitan Museum.

Parker, Harry S., III. Vice-Director for Education, Metropolitan Museum.

Walsh, John, Jr. Curator, European Paintings, Metropolitan Museum.

And the students in the program.

Other persons interviewed for this report:

Hirschberg, Israel. Instructor, Maryland Institute College of Art. February 19, 1975.

Leake, Eugene. Former President, Maryland Institute College of Art. February 19, 1975.

## Bibliography

Reff, Theodore. "Copyists in the Louvre, 1850–1870," *Art Bulletin* 46:552-559 (December 1964).

*Reproduction of* Copyist at Metropolitan Museum of Art *used by permission of the National Gallery of Art, Washington, D.C.*

# THE FINE ARTS MUSEUMS OF SAN FRANCISCO: THE DE YOUNG MUSEUM ART SCHOOL

M. H. de Young Memorial Museum
Golden Gate Park
San Francisco, California 94118

**An art school located inside a museum and open to all ages provides a casual and friendly, but highly professional, atmosphere for students in a variety of studio art classes. Cooperation between school and museum staffs, even though sometimes marred by competing priorities, enriches the experience for students, artist-teachers, and curators alike. CMEVA interviews and observations throughout 1973/74.**

### Some Facts About the School

**Title:** The de Young Museum Art School. (Though it is housed within the M. H. de Young Memorial Museum and shares some staff members with the museum, the art school is, nevertheless, a separate, nonprofit corporation.)

**Range of services:** In addition to its regular schedule of classes, the school offers exhibition-related classes and docent training programs. It also operates the Trip-out Trucks program, has started a teenagers' volunteer program, lends equipment such as looms, kilns, and potter's wheels to community arts centers.

**Audience:** Nearly 6,000 students enroll each year, age three to adult.

**Objective:** To offer professional art and art history classes taught by artists utilizing the museum collection.

**Funding:** Administrative overhead, space, utilities, and two administrative positions are paid for by the city of San Francisco; user fees pay nearly all other costs. In 1974 costs were $52,692 for classes, $33,000 for Trip-out Trucks, $5,000 for art apprentice program.

**Staff:** 32, with 161 volunteers.

**Location:** Within the museum.

**Time:** Throughout the year, seven days a week, four nights a week.

**Information and documentation available from the institution:** Catalogs and brochures, slides, teachers' guides for Trip-out Trucks including information on objects in trunk exhibits and bibliography, students' questionnaires evaluating the program.

A new museum school, founded in 1966, has revitalized the old principle of the interdependence of museums and fine arts training. Charged and energetic—the de Young's vice-director of administration and personnel has compared its office to a campaign headquarters—the de Young Museum Art School shows that the studio arts can thrive in a museum setting and at the same time serve a multiplicity of museum purposes, both traditional and otherwise.

### The school's structure and funding

The art school is a separate nonprofit corporation originally located in 8,000 square feet of renovated auditorium and gallery space in the M. H. de Young Memorial Museum. It offers professional art classes taught by practicing artists who use the museum collection for both studio art and art history. The American Association of Museums Accreditation Committee report on the Fine Arts Museums of San Francisco (which embrace the de Young) says of the school,

> The Museum Art School program appears to be outstanding, offering a very imaginative and innovative curriculum. This activity operates as a safety valve, providing employment for minorities and artists and serving ghetto children as well as the rest of San Francisco. No such balance seems to be evident in the rest of the museum's programs.[1]

The school offers a sequential curriculum in painting, drawing, printmaking, photography, metal arts, sculpture, ceramics, and textiles. Though space is cramped, the equipment is complete and professional. There are 36 Gilmore looms, bronze-casting facilities, lithography and etching presses, 25 potter's wheels, 2 large gas-fired kilns and 5 electric kilns, as well as a raku-ware kiln. According to Elsa Cameron, the school's curator-in-charge, the quality and scope of the school's equipment should be consistent with the museum's high standards for the works of art it displays.

The school is open seven days a week, four nights a week year-round, and offers classes for ages three through adult. Enrolled in 1974 were three adults (age 14 and up) for every child, two women for every man. Most adult students are between 25 and 40. In a city whose population is 32 percent nonwhite, one-third of the art school staff and 20 percent of its enrollment is nonwhite. In its first two years the school attracted more Asians than whites, a racial balance that is not typical of most de Young programs. On an average day, 300 students are in the art school. Enrollment varies between 5,000 and 8,000 a year (in 1973/74 it was 5,970). The size of the staff ranges between 30 and 40 (32 in 1973/74).

In 1970 the school was accredited by six Bay Area colleges. It is also approved for teachers' increment credits by all area school districts. Serious students of art and art history make up 51 percent of the school's enrollment.[2] (A surprisingly large number of art history students take courses at the school, most often in the techniques and materials of museum objects.)

Administrative overhead, space, utilities, and two administrative positions are paid for by the city—the museum's chief patron. Beyond this support, however, the school is sustained almost entirely by user fees. As classes must reach

a minimum enrollment in order to be scheduled at all, insecurity has become a fact of life for all the teachers who offer experimental new classes each year.

Class fees are calculated at 80 cents per instructional hour for children and $1.20 per instructional hour for adults. Even though this does not count material, models, and use of equipment, for which students pay additional fees, the price is reasonable as studio instruction goes. A children's class meeting one hour a week for ten weeks costs about $12. A 12-week, two-hour adult class ranges from $28 for painting and drawing to $55 for ceramics (including clay, glazes, firing, and 12 hours of open studio time each week). The Museum Society, a membership group, supports 300 scholarships for children, awarded on the basis of interest and enthusiasm. The school also offers between 50 and 100 partial scholarships for continuing students under a work-study program. These scholarships are supported by user fees.

The school's atmosphere is friendly and casual. Students answer phones, sweep floors, and help stack kilns. Projects in the crowded classrooms invariably spill over into one another. Children's and adult classes tend to mix to the benefit of both. On a typical day students weave in the same room that others use for dyeing fabric. Calligraphy and frame-making classes take place in the same room.

A watercolor class works in the museum garden, a ceramics class does raku firings at the garden entrance, and a class sketches in the museum galleries. In the middle of all this hubbub a crew of students, the video class, wanders through the school with a portapak recording the day's events.

### How the art school uses the museum collections

The art school calls itself "a place where people can learn more about their perceptions, the museum's objects, and the history of art." What separates it from San Francisco's many other art schools is its heavy use of the museum collections, its correlation of class offerings with temporary exhibitions and other museum activities, and the contact its students have with the museum's visiting artists, visiting curators, and regular curatorial staff. The art school says it does not run a recreational or "arts and crafts" program. Its purpose is to give children, the general public, and serious art students respect for and familiarity with museum collections through constant interchange between the creative process and museum objects.

The art school teachers use the museum collection daily. Quilts and coverlets from the study collection are brought to classrooms from basement storage areas so that textile students can study and touch them and learn pattern weaves. Medieval and Renaissance tapestries hanging in the galleries are used for design ideas. During an open studio one jewelry student pressed his wax model around a shell to create a spoon that when completed showed the influence of an English salt spoon displayed in a case he passed each day. Sometimes an entire class is devoted to a single object—a tapestry of peasants using ferrets to catch rabbits, a genre painting, or an Egyptian sculpture. Besides working in the same medium as the object studied, students learn something of the culture it represents.

Integrating painting and drawing instruction into the museum experience has been a particular challenge for the school in the face of the recent tradition that has stressed individual expression and all the freedom these media allow. The de Young teachers use original art objects in their teaching. In one class the students draw both from Old Masters and from contemporary works displayed in several Bay Area museums. They work in the de Young's Renaissance galleries, where a costumed model takes her pose from a painting. Students also sketch landscapes from the scene in front of the museum and then inside from paintings. The purpose of the course is to compare the ways different artists draw by exploring their works through the drawing medium itself. The instructor says he wants his students "to be able to use what they see to produce an interesting drawing rather than a correct representation."[3]

One children's class in 1969, repeated with variations several times since, created a film called *The Great Museum Theft*. Of this production, whose script was written by students, its instructor says, "The guards became actors as one of the kids escaped from the building with an unframed paper tempera painting that we had painted and signed 'Rembrandt.'" The project was successful enough to warrant an afternoon première, with popcorn.

The school uses other resources in Golden Gate Park besides the de Young. One class studies a Japanese brush painting of a fish in the Asian Museum (which is in the de Young), then goes across the way to the Steinhart Aquarium to see live fish and, back in the school, makes rubbings of a fish with Japanese ink. Another class, after inspecting floral motifs in a tapestry, goes to the adjacent aboretum to find living examples. A third class walks to the nearby Japanese tea garden and then returns to the de Young to find spatial and structural similarities in Chinese landscape painting.

Clay-dust footprints lead from the ceramics room to cases displaying Spanish lusterware, earthenware from Mexico, and the blue-and-white porcelain of Asia. Although ceramics classes use modern technology, they explore a wide range of historical ceramic styles to learn the potter's ancient heritage.

During a temporary museum exhibition of Native American ceramics in 1973, the school used the galleries for demonstrations; four of the Indian artists in the show taught special classes, showing students techniques of preparing clay from the earth, building coils, burnishing with a rock, preparing bee-weed as an underglaze, decorating surfaces with a yucca brush, and firing in a pit kiln. The students then proceeded, not to make Indian pots, but to apply Indian methods to ceramic creations of their own. In the process, they acquired some knowledge of Southwest Indian ceramics and a respect for Indian culture, as well as methods they could use in their own studios.

In addition to classes, the art school schedules workshops, taught by guest artists, that relate to specific areas of the museum collection. In 1974, for example, a Japanese potter from Kyoto conducted an intensive workshop on the utensils of the tea ceremony. The collection of the Asian Museum provided the inspiration for this course.

Visiting curators as well as visiting artists augment the art school's own resources. In 1968, for example, a Japanese scholar doing research on the Brundage collection taught a class called "Things that Fly and Float." Although the teacher's English was limited, students learned how to make and dye paper, fold origami boats, and build kites of rice paper and bamboo. An exhibition of East Indian art brought to the museum a curator who was also a painter. According to the museum's former curator of paintings, "Children loved to watch him paint and to paint with him. One day he asked if they knew where India was, and the reply was with cowboys. He immediately brought out maps and a globe, and told stories of India." Altogether, some ten or twelve guest curators have taught for the school.

**Some benefits and problems.** As important as any specific program in an art school that uses museum resources is the museum environment itself and its effect on students. As the art school has no separate entrance, students must all make their way through a maze of galleries. The school has no reception area; a door in a French period room opens directly into the school's working space. According to the school's director, this sometimes shocks museum visitors but, especially for children, the walk through the museum on the way to class can be both "awesome and magical." "The environment," she says, "makes for fantasies, imaginary trips back into time and to far-off places."

The museum can be frightening as well as enticing, however. One parent, speaking of her child's fear of the museum's guards and 40-foot ceilings says, "If a child is three feet high, used to eight-foot ceilings, and then is followed by a man in a dark suit, how can he be comfortable in a museum?"[4] But as children come to class week after week, the museum ceases to be alien. Certain objects become old friends. Says Ms. Cameron,

I have always said that the magic of the museum is the environment. I believe that people should make art part of every day, and a museum visit should not be some special event. The art school serves this function because people come in once or twice a week to the museum for class. We must think of ourselves as a unique art school that serves the museum.

One observer comments in a letter to the museum director, "Probably the most interested and enthusiastic group of people come through the [museum] doors headed for the Art School. En route, they make many stops in the galleries or point out exhibits to their children. . . . This easy familiarity with the 'hallowed' galleries is the first step for many people toward feeling at home and with the museum."[5]

To be sure, day-to-day access to the galleries by many students can be a problem as well as an asset to a museum. Those clay-dust footprints leading from the classrooms to exhibition cases are less appreciated by the museum's administrators and maintenance crews than by the art teachers. Noisy, excited children who run rather than walk between gallery and classroom distress the guards. And for the children, a gruff reprimand may be all it takes to ruin an otherwise fine day.

Most serious, however, is the issue of security. Students enter the gallery lugging boxes of brushes, paint, and sharp instruments. For all that it means to the art school's spirit, students' access to classes through the galleries creates problems, especially in the evenings. Though the museum itself is not open nights, the school often holds nighttime classes, to which students must come through the museum's main entrance. With one special guard on hand just for the program, students are free to wander in five dark galleries on their way to classes. Despite the fact that there has been no vandalism or theft during the school's nine years of operation, the potential for trouble still worries the museum. Says Ms. Cameron,

The kids that are creative are troublesome to the guards and administrators. In fact, one administrator asked me how I knew the guest puppeteer was not a kleptomaniac. Security makes the administration paranoid, yet we want people to come into our museums and learn. We need good security systems so that we can develop good education programs.

**How the art school serves the museum**

The art school brings the museum an involved new audience of some 6,000 students a year, many of whom, in Ms. Cameron's view, come to regard the museum both affectionately and responsibly. The art school, however, considers itself an educational institution with responsibilities that encompass the entire San Francisco community. The school therefore performs many other educational services beyond its own program. According to the curator-in-charge,

The school is an idea and an energy. It is not confined to the museum walls. Our teachers are active all over the Bay Area. They consult with schools and community centers, help with exhibits, loan equipment, refer people to jobs and classes—a lively group of citizen-artists. Gone are the days of an artist painting in his attic without contact. That is an old illusion. In fact, we used to teach a course, "The Politicization of the Artist."

Among the responsibilities the art school assumes is docent training—largely studio courses to acquaint the docents with different art media and to supplement their lecture classes in art history. Docents for the Asian Museum enroll in an intense ceramics survey course. Those for the collection of the traditional arts of Africa, Oceania, and the Americas study lost-wax casting, batik, tie-dyeing, and wood carving. Docents for the Western collection enroll in "Materials and Methods of Painting." Here each student grinds and mixes

his own watercolor, egg tempera, acrylic, and oil paint, and then does a painting in each medium. Says the museum's director, "Such direct manual involvement with artists' materials is a valuable experience for those who teach others about art."[6] These classes, which are optional, are paid for by the Docent Council. About a third of the museum's 375 docents take advantage of them.

The art school also often helps with the museum's special exhibitions. For "The Flowering of American Folk Art," which came on loan from the Whitney Museum in 1974, the staff worked closely with the museum's membership group to develop educational components for the show. The school trained docents in techniques illustrated by objects in the show as well as in their historical background. The art teachers gave demonstrations and seminars on the techniques of American folk arts. The school arranged field trips to artists' studios where visitors could see contemporary folk art being created. Methods classes that related directly to the exhibition were highly popular with visitors.

The de Young Museum Art School also operates an outreach program: brightly painted mobile units called Trip-out Trucks that bring art and artists to San Francisco schools and neighborhoods (see report in chapter 7). It also has a regular program of one-year loans of such equipment as looms, kilns, and potter's wheels to community arts centers. A volunteer corps of over 200 "art apprentices," ranging in age from 14 to 60, goes to these centers, as does regular art school staff, to help them set up and run their own art classes. The art apprentices also help out with regular classes, receiving in return museology training and free tuition to classes.

The school has lent two floor looms to the American Indian Center and given the center's weaving instructor a scholarship to its classes. By sharing with the center slides rented from the American Crafts Council, the school has made it possible for classes to be given at a community location as well as at the museum.

The loan of a kiln and a potter's wheel to the Kearny Street Workshop (see report on Neighborhood Arts Program, chapter 4) has resulted in a ceramics program at this Chinatown art center. Art school teachers have advised young people in the conduct of the program and have often repaired the kiln.

## The role of the practicing artist

When the art school began, Ms. Cameron's primary concern was to make the de Young "relevant" to Bay Area artists and to create jobs for them. She says of her artist-teachers,

> I figured the first thing a museum should do is serve the artists of the community. What do artists need? Well, money, jobs, shows. The de Young is primarily an encyclopedic museum of historic art, so I knew we couldn't show all the artists. We couldn't subsidize them, but we could create jobs. That is what I did as a first step. Then the second step was to interest people in art and artists. The museum was the perfect vehicle. We had live artists teaching plus the treasures of the past. It was like a time capsule

for the students. . . . Probably the energy of artists working together in the museum environment is what I find most exhilarating.

Although the teachers are hired by the school and have little contact with the museum administration, they feel that their daily interaction with the guards, the preparators, the curators of other departments makes for continual influence in the museum. The conservator of decorative arts and the metal arts teachers, for example, share information about molds and casting. The curator-in-charge of decorative arts works with the weaving teacher. The curator-in-charge of exhibitions once invited the chairman of the school's painting department to exhibit his work in the museum. The museum's registrar and its curators also help with the school's outreach programs, and the curator of painting and sculpture has brought study pieces from the collection into the Trip-out Trucks for schoolchildren to see.

Through all this informal interchange, the museum has become as accessible and familiar to artists as it is to the school's students. It has thus begun to reflect what many Bay Area artists need and want—sometimes in such specific ways as exhibitions, jobs, and contacts with collectors. But the most important result of artists at work in the museum has been their influence on the students. According to Ms. Cameron, the school's atmosphere encourages warm and enduring relations between older and younger artists that she believes are uncommon in traditional art schools. The de Young's director says, "Suzanna [his young daughter] keeps asking to come to work with me so she can spend the day with Richard in the ceramics studio."

Most of the artists work part-time on schedules that vary widely from semester to semester depending on class enrollments. They are paid $5.10 per teaching hour. A job at the art school is thus neither secure nor lucrative, but because of free time for their own work, the museum environment, and the school's lively ambiance, artists seem to relish their museum employment. One sign of their interest in the school is that one year the teachers voted to put money from class fees into better equipment instead of pay raises. It is common for instructors to lend their own equipment to the school or buy extra supplies with their own money.

## Conflicts

Ms. Cameron is ardent in her defense of the school and its staff and, like many leaders of such causes, she dreams about how these artist-teachers might expand their scope.

> There is so much we could be doing if we had teachers' salaries. We have this resource of artists who know the collection and are damn good artists in their media. They are also good communicators with kids and adults. It would be tremendous to use these artists as guides—to offer a process experience for museum visitors, whether it be a class or a seminar in conservation. We have a comix artist who could do great guidebooks for the lay public. We have a good film and video person who could do some tour

and perception programs with teenagers. We have mimes who are terrific with little kids in the galleries. There are two great Japanese potters who can bring the Asian Museum to life, also a scroll-maker from China who is a calligrapher and was trained in old traditions. Really a varied and integrated group—the only spark in the whole museum structure.

Somehow we have this very exciting, diverse group of artists who are kept in the back of the museum. Most hold M.A.'s, most with lots of art history as well as studio. Imagine the energy and ideas that a group of artist-educators could come up with for museum education. Ideas I hear in jest are really very workable.

The museum administration, with other priorities and another orientation, is not always as hospitable to such dreams as the art school staff might like. For Ms. Cameron, the rebuffs loom large:

It's sort of like living in Israel. Most often we are in constant crisis, because we don't know what's going to happen. The art school is at constant war with or alienated from the museum structure. . . . It is as though the school is always fighting to keep financially ahead, to keep from giving up classroom space, to keep the museum open on Mondays or nights, and to keep from being generally forgotten by the administration.

The conflicting interests of the museum and art school came to a head in 1974 when it appeared that the museum was going to move the school temporarily to make way for a new collection. The uprooting was temporarily averted (see following paragraphs), and both sides reaffirmed their allegiance to common or at least complementary goals. Nevertheless, the art school staff, often out of phase with the museum's thinking, continues to expect the worst.

Problems like cleanliness and security concern school and museum alike. In such matters their differences are in emphasis rather than substance. The museum and the school both revolve around the interaction of people and objects; for the school, however, the people come first, for the museum, the objects. Because in any given week the school brings about a thousand people into the museum, any week is apt to generate at least minor conflict. "If kids smear ink in a back room of the school or if a student brings a friend in after hours," Ms. Cameron says, "the museum wants to know why. If, on the other hand, a guard gets offended and locks a classroom door, the school takes issue with the museum's lack of cooperation."

## Withal, cooperation

So far both the de Young Museum and its art school have kept their tensions under control. For nine years the two sides have been able to accommodate their different priorities, the art school achieving what it considers a remarkable degree of integration with the museum structure. For Ms. Cameron, the explanation lies in the school's history.

When Ms. Cameron came to the museum in 1966, the de Young had no education program (two people who had done children's classes and tours since the 1940s retired in 1965). She was given the title of curator of education, a $500 operating fund, and three months to set up a studio art program. The early school program that resulted, says Ms. Cameron, looked like this:

It was crazy. We had no classroom space, so I used galleries and the courtyard. I did lots of Saturday performances: dance, music, plays, and museum walks. The kids would draw the performers or sketch in galleries. That summer I arranged for a minimal fee to be paid for classes, and I hired students from San Francisco to teach. From the beginning, we used the museum collection even with preschool classes. There were courses called Kings, Queens, Knights, and Castles that would lure kids into the medieval galleries.

The time was right for this museum school to catch on. It was before Neighborhood Arts [see report in chapter 4] or Project Headstart, and parents were searching for programs for themselves and their kids. The thing just grew. There was a very creative parents' group, lots of artists who wanted to teach, and a swarm of people who would come to cake sales and pottery sales. Those were our fund raisers.

We created the assistant-curator [in charge for the art school] job for Richard Fong in 1968. It was really political action, as the city had not created a new job at the museum since World War II. We got petitions from about 15,000 people and went to the supervisors' hearing with about 800 people, all young artists and parents of various racial groups. Our platform was for the museum to hire an artist who could relate to the community. We have a big Asian population, and Richard [an Asian] was the right man for the job.

Except for an independent docent program run entirely by volunteers and also started in 1966, the art school *was* the education department of the de Young. According to Ms. Cameron, the program grew in three stages:

1. Creating jobs for artists and making them conscious of the meaning of the museum and its school.
2. Acquainting the general public with the process and result of making art.
3. Gaining contact with an even wider community through outreach programs.

The school was directed equally to museum education and to studio art.

Between 1966 and 1974 other educational programs at the de Young grew. In 1968 the museum hired a second curator of education for special programs, and in 1973 appointed a vice-director for education. Throughout this period, however, the art school remained more or less independent, and Ms. Cameron continued to wear the two hats of curator-in-charge for the art school and curator of education. In 1972, when the museum merged with the California Palace of the Legion of Honor to form the Fine Arts Museums of San

Francisco, the school, by then accredited by Bay Area colleges for professional study, officially became the de Young Museum Art School.

Although the art school evolved from a studio-oriented museum education department into a separate nonprofit corporation housed within the de Young and largely free of the museum's administrative hierarchy, it has remained closely integrated with the workings of the museum. The two art school curators, as staff members of the museum's education department, sit on the education committee and help plan all museum education programs: consultant service, open studios for the general public, the Trip-out Truck visits to schools, and support of community art centers through services and loans of equipment. The school's curator-in-charge and her assistant hold curatorial rank in the museum; special museum exhibitions form a major part of their responsibilities.[7] (Each de Young curator undertakes at least one major temporary exhibition every year and sits on the museum's exhibition committee.)

It is this interconnection of museum and art school staff and programs, combined with the school's commitment to the museum as an instrument for training artists and for enhancing the vitality of the community, that has made possible the de Young Museum Art School and its distinctive record of accomplishment.

**Postscript**

Late in 1975 the de Young Museum began renovation and expansion of the wing where the art school had been housed, making way for a restaurant, the museum's collection of American art, a conservation laboratory, and what Director Ian White describes as "vastly improved quarters for the Art School." During the renovation period, the art school moved to a building on the outskirts of San Francisco's financial district—an urban renewal area a half-hour drive from the museum, which has attracted many artists' studios and noncommercial "alternative" art galleries.

In its temporary quarters, the school has added rent to its monthly bills for utilities, equipment, and materials. But both the director and assistant director continue to receive their salaries from the museum as members of the curatorial staff (they are paid by the city), and the salaries of several instructors are being paid out of funds provided to the city through the Comprehensive Employment Training Act (a federal program begun in 1974).

Elsa Cameron expects the school's character, and especially its relation to the museum collection, to change with the move to the new location. The program will be aimed more toward the business community, less toward children and the neighbors who came to the school from residential areas around Golden Gate Park. A street-level gallery, for example, is designed to show works of art that local business people can buy and that Cameron hopes will help educate them to discern quality. The school's classes for children, meanwhile, are being held at the zoo, the Academy of Sci-

ence, the de Young, and the Palace of the Legion of Honor.—*F. G. O.*

## Notes

[1] Goldthwaite H. Dorr III, chairman, American Association of Museums, Accreditation Committee Report on the Fine Arts Museums of San Francisco, 1973, p. 3.

[2] *Art School Annual Report, 1972/73.*

[3] For sources of quotations without footnote references, see list of interviews at the end of this report.

[4] Sybil Dixon, parent, evaluation interview, Project Headstart Program, spring 1968.

[5] Mrs. Lee Follet, San Francisco Unified School District Liaison for the Junior League Art Apprentice Council, letter to Ian McKibbin White, director, Fine Arts Museums of San Francisco, May 14, 1974.

[6] Address by Ian McKibbin White to the Docent's Council, June 1972.

[7] Over the years the art school's shows have included a children's environment built by several artists, reported on the front page of the San Francisco *Chronicle*; carousel animals; Victorian toys; the ceramic sculpture of William Accorsi and of David Gilhooly; the work of Charles Eames; the work of Peter Max. In 1973/74 the art school put on six shows.

## Interviews and observations

Cameron, Elsa. Curator-in-Charge, de Young Museum Art School. April 1973, interview with Linda Draper; December 3, 1973.

Cookinham, Michael. Artist-Teacher, de Young Museum Art School. May 5, 1974.

Egherman, Ronald. Vice-Director of Administration and Personnel, M. H. de Young Memorial Museum. June 14, 1974.

Hansen, Anne Lewis. Artist-Teacher in Pottery, de Young Museum Art School. May 29, 1974.

Murray, Alden. Curator of Painting, M. H. de Young Memorial Museum. June 16, 1974.

Peacock, Marylou. Registrar, de Young Museum Art School. May 21, 1974.

Silverberg, Leonard. Artist-Teacher in Painting, de Young Museum Art School. April 15, 1974.

Stevenson, Jim. Curatorial Assistant, de Young Museum Art School. March 21 and May 5, 1974.

Ziady, Jonathan. Artist-Teacher in Drawing, de Young Museum Art School. May 28, 1974.

## THE SCHENECTADY MUSEUM ARTIST-IN-RESIDENCE PROGRAM

The Schenectady Museum
Nott Terrace Heights
Schenectady, New York 12308
**A small regional museum hires a live-in artist to act as teacher, custodian, all-round staff member. The artist gets an on-site apartment and studio and the chance to develop his own art work. The result: a seven-year mutually satisfactory relation-**

ship that could perhaps be duplicated elsewhere. CMEVA interviews: December 1973.

### Some Facts About the Program

**Title:** Artist-in-Residence.

**Audience:** The artist, the museum, and, indirectly, the museum's audience.

**Objective:** The immediate objective for the museum was to lower its fire insurance payments by having a live-in custodian; for the artist, to achieve economic security that would allow him to develop his art work.

**Funding:** Artist was paid from the museum's operating budget for work he did around the museum.

**Location:** In the old Schenectady Museum, formerly the Schenectady County Poor House.

**Time:** From 1961 until 1967, when the museum moved into a new facility.

**Information and documentation available from the institution:** None.

From 1961 to 1967 the Schenectady Museum, which serves the upstate New York area around Albany, Troy, and Schenectady, had an artist-in-residence program that was precisely that: an artist who lived in the museum. Chartered in 1938, the museum had its quarters in the former Schenectady County Poor House until its new building was opened in 1967. Thus, one of the reasons that Donald K. Smith, then museum director, created the artist's post was to provide a 24-hour security check on what was clearly an antiquated and flammable structure.

But there were other and, to Smith, equally compelling reasons. He wanted to provide another museum staff member at "reasonable" cost and to raise the prestige of the museum and its art classes in the eyes of the community.[1] At that time the exhibit space was divided between science—including a planetarium and "history wall"—and visual arts, mostly temporary exhibitions with an emphasis on contemporary art.

### How it worked: a small success story

Smith offered the artist-in-residence job to a young sculptor, Robert Blood, who was then teaching art courses at the museum. The advantages for Blood were a small stipend ($600 per year), an apartment for his family, and a studio within the museum building, plus money for materials for his own work. In return, the artist was to do guard duty, teach classes, and act as custodian during hours the museum was closed.

Once the program had begun operation, both parties found that it was necessary to be flexible about mutual obligations. The guard duties were replaced at Blood's request by carpentry and exhibition work and, instead of the stipend, he was paid $1.50 an hour for these jobs. The schedule for his work was made less rigid, and his contributions as a staff member were made as the need arose. In return for this freedom, Blood accommodated the museum's necessary shifts in both

schedule and availability of studio space. He says that the success of the program depended on an agreement that the museum's needs came first and that the artist himself could be more flexible than the institution.

As it turned out, the museum and the artist integrated their needs so successfully that no one commented on the fact that Blood's pick-up truck gradually became the museum's and Blood its willing chauffeur; nor did anyone in the museum question the sounds as Mrs. Blood worked on her piano compositions or gave her music students their afternoon lessons—or the reverberations of young Peter Blood's tricycle as he rode it in what one observer called "endless circles" around the apartment.

From the inception of the program both parties recognized that the building in which the museum was housed was unsatisfactory and would have to be replaced. Though it was never considered that Blood would go on to occupy living space in a new building, no exact date was set for the end of the program. There was simply an expectation that termination of the museum's need for Blood's services would coincide with the time when the artist no longer needed the museum.

As it happened, Blood's residency did end at such a time. He felt he was outgrowing the museum, especially as he was accepting more, and more promising, commissions and was gaining a local reputation. So Blood moved into his own home several months before the museum moved into its new building. He was there to help move the collections and, until 1974, continued to teach classes at the new facility.

In the seven years of his residence at the museum Blood became well known in Schenectady and the surrounding area both through his two or three classes a week and through the many private commissions on which he had worked. In 1970 his local patrons, with the guidance of the museum, organized a retrospective exhibition of his work and produced a fine catalog for the museum.

And the museum continues to support its former artist-in-residence. In 1973 Director George H. Cole raised funds from the community to commission a major work by Blood for the permanent collection. Cole was also instrumental in a decision by the Schenectady City Council to award another large commission to the sculptor.

### The live-in artist: some conclusions

Robert Blood feels that one of the major contributions of such an artist-in-residence program is that it can temper the rigidity of an overstructured institution. He points out that although for the most part the staff came to accept—indeed, take for granted—the family life and the creativity going on over their heads, they were conscious of the relationship and proud of their adaptation to what they considered an unconventional situation. Blood says he also found that his teaching in the museum increased his ability to verbalize his concepts and methods as an artist, something he now does with considerable skill. He feels that the atmosphere of the

museum was conducive to creativity for both him and his wife (who is herself achieving a local reputation as a composer). His position at the museum gave him the economic security as well as the time and the space to accept and execute the private commissions that now allow him to support himself entirely as a working artist.

Although acknowledging the unique circumstances that gave birth to the live-in artist program at Schenectady, Blood maintains that the idea would be a sound, practical one for many small regional art museums. The mutual benefits to the artist and the museum are, he thinks, obvious. And for him the key to the success of the relationship was "not in its structure, but in its flexibility."—*B. C. F.*

## Note

[1] Quotations and other information in this report are based on interviews in December 1973 with George H. Cole, current director of the Schenectady Museum, and Robert Blood, who was the artist-in-residence.

## AN INTERVIEW WITH LOUIS FINKELSTEIN

**An artist and teacher gives his views of art and museums and their uses for and by the artist, the art historian, the student, the lay audience, and society at large. Some issues he discusses: the inadequacy of purely art historical approaches, the control of museums and art "fashions," copying, the educational uses of reproductions and minor works, teaching children about art, the "cementing, healing, and bridging role" that art and museums can play in a "rudderless society." CMEVA interviews: December 1974 and May 1975.**

*Louis Finkelstein is a painter and professor of art at Queens College, City University of New York. He was born in New York City in 1923 and has haunted its art museums steadily almost ever since. This is an amalgamation of two interviews, one on December 3, 1974, and the other on May 27, 1975.*

**Note:**  To help the reader find his way through this interview, the editors have inserted subheads throughout the transcript. These are to be regarded only as a general and not an infallible guide to Mr. Finkelstein's ruminations. Some samples:

### On artists and the museum

- I know hundreds of people in New York who go to museums on a conservative estimate at least twice a month, in a purposeful, discriminating way. . . . They're not dummies; they're not bums, although they might dress like bums. . . . They are not the scholars whom the museum staff would identify as significant. . . . But if one is to take an ethical view or a moral view . . . of the museum's true function, very often . . . these artists are more the true

disseminators of what the museum keeps as a heritage than anybody else.

- The museum officials, museum officers, curators, virtually everybody related to the museums that I can see, do not actually know this artists' constituency with which they deal, have never identified it. . . . The amount of ignorance that museums have on this score is monumental and will probably never be dispelled.

- Some people pooh-pooh the idea of copying in a museum simply because they don't understand it and because they have sought advice from a generation of artists who themselves don't really understand the function, the meaning, and the use of museums. . . . And those are the kinds of artists to whom museums, 99 times out of 100, will go for advice on what the artist needs the museum for. Why? Because they're part of the same unconscious apparatus of a verbal, promotional culture, not a visual one.

- There has to be a real revolution . . . in the way art is studied. . . . [Museums] must understand the art objects in no perfunctory sense, and [they must] use the perceptions of those people who do [understand art deeply]. They must even play a part in revising further the education of those people who are going to have a responsible part in transmitting the culture, so that a museum, for example, will use to lead its gallery tours art students who have some insight and enthusiastic use of the objects.

### On art

- We wish life would have the clarity of a work of art, which is what we call the unity of a work of art when it is finished. . . . A great work of art can have itself a virtually inexhaustible repository of meanings, so that one can come back to it time and time again and find fresh awareness.

- One can lay bare by a comparative analysis, in exactly the same way that a biologist in comparative biology lays bare, what are meant by organic structures and their functions and something of the true nature of works of art.

### On art history

- . . . Of all the humanistic disciplines, art history has the least self-critical apparatus; it literally does not define what it is doing, never understands it well, and is always playing out relatively small intellectual games in terms of local self-interest and patronage rather than working out critical principles of knowledge. If anybody in a physical science behaved the way our art historians behave, they would be laughed out of the laboratory in five minutes. . . .

- Graduate students in art history . . . tend to overvalue certain public celebrities and what looks like very important work because it is rationalized according to certain formulizations: fashion, vanity, avant-gardeness. . . . They don't have solid ground even while they are shaping public understanding in a variety of ways.

- There are whole generations of people who are learning

classical art and Renaissance monumental art by books and slides, who don't know beans from apple butter and who, by the time they get to Europe, are already tracking down material for their dissertations. So they never go to look at the great works, only details.

### On learning from objects

• When I was a kid, everybody went to see the plaster casts of the Greek antiquities at the Met. Why? Because you can learn things from them. They would be invaluable in art history classes for explaining the nature of Greek sculpture. . . . You can learn it in a book; a lecturer can tell you with a slide. But there is so much more you can find out when you encounter the three-dimensional objects, even in replica, even if you only have two casts.

### On teaching the young

• [Speaking of a group of black children, 6–16, making pencil sketches of an Albert Cuyp landscape:] Their activity was such that you could not help believing that it communicated something real to them. Furthermore, they were being educated to an enormous number of things that the docent tour through the museums and the high school groups that wear out the floors in great numbers in the mornings at the Met . . . don't learn. They were really learning.

• . . . The 9-year-old can learn more than the 19-year-old art major, as a rule, about perspective, about the proportions of the Parthenon, about the presentation of the figure in Greek and Egyptian friezes, by drawing them, by visual observation, by soaking it up as visual culture.

• If you teach a child something like anatomy, perspective, spatial analysis, art appreciation, even though that child may not have the verbal or historical perspective that an adult would have, nevertheless you make a connection on the level of his or her nervous system. It is a kind of cultural drill, a reinforcement or a building of values. . . . Isn't this one of the real roles of museums?

### On art educators

• . . . The people who remain in this [art education] establishment and grow old in it and become the authoritative bureaucracy, the decision-making and guideline-making people, they are the ones who never understood drawing or seeing or art making in the first place and are chock-a-block with the theory needed to earn their doctorate degrees, to rise to positions of authority and power within the system.

### On copying

• To really appreciate, to have contact with that special quality I deem works of art as having, requires sustained physical contact. This comes about only (or largely) through some kind of copying . . . copying in the broadest sense, from rough thumbnail sketches to rather extended drawings to replicas of work in an analagous medium. . . .

### On the role of the museum

• . . . If museums have any function, it is to stave off or to leaven the curse of a mob in a mass society. And it can't happen just by the school groups going through and getting a smattering of something that, in the end, has no effect.

• Art can work for the community as a whole, not just in a mass way but through the individual members of the community. In this way, works of art can promote, through the voluntary participation of all a society's members, the cementing, healing, and bridging role that in times past was played by the teaching of the Church or the veneration of ancient customs. . . .

---

**Q:** Mr. Finkelstein, I want to explore with you some of the ways artists and museums can best function as educational resources for each other. What do you feel are the most important areas in which artists and museums can work together?

**Finkelstein:** My immediate reaction is that, by speaking of the relationship between museums and artists in the professional, art school sense, you are already casting your net too narrowly. This sense does not really describe the artist's interest in the museum, but only describes one range of formalization, which from the point of view of institutional communication, of course, would be the most natural one, but it's not the deepest or the realest one, and if I'm to speak on my convictions, I have to speak to that first.

Now, I've lived in New York virtually all my life; from the time I was eight years old I frequented museums. I went to the Met every week, you know, like many typical middle-class New Yorkers. I learned as much in museums as from books, and I learn to this day. I could not be the person I am, much less the painter or artist or whatever, without just that access to the museum. One becomes a writer through contact with the monuments of literature, not because of a course in creative writing. In the same way the natural role of museums has been continued by the scores and perhaps hundreds of artists who flock to the museums like religious people go to Mass. They are always in museums; they never affect the policies; they feel they are an immense resource, and they are never identified. I know hundreds of people in New York who go to museums on a conservative estimate at least twice a month, in a purposeful, discriminating way. Often they know, not in a scholarly, authenticable way but in a very real way, more about individual items in the collection than the scholars who are part of the museum staff. They're not dummies; they're not bums, although they might dress like bums.

There is a culture of artists, would-be artists, interested laymen, former art students who have gone into other fields,

people who are very, very seriously involved in museums (in the music world they would be the people who buy the seats way up on top, you know, who are not subscribers but who know all the fine points of an aria and who come with the score or something like that). Being one of them in some sense, I have to speak for the interests of that unidentified crew of very serious users who are real users, who sometimes become, as I have, teachers, who are sometimes well enough known as painters or sculptors or something like that to be slightly noticed in the operation of things, but who are a part of the real continuity of art. They often fit in the interstices of other identifiable publics, but they are not laymen, and they are not the scholars whom the museum staff would identify as significant. Neither are they donors or benefactors or patrons of the museum in the usual sense.

But if one is to take an ethical view or a moral view, however you say it, of the museum's true function, very often individual by individual these artists are more the true disseminators of what the museum keeps as a heritage than anybody else. When I was a kid I already knew and learned from parts of this community—Gorky,[1] for instance, and then people no one has ever heard of. And even now if I go to a museum with somebody who has more knowledge than I about a particular thing, and I know there are many of them, they teach me. And I teach other people. Way before I ever thought of being what one would call a professional painter, there were such people who continually taught me, and they're always there.

### Where the art historians fail the art

Now, [the artists'] use of the museum and their perceptions of the museum are very different from the uses and perceptions of the scholar. But the funny thing about this unbaptized group of people is that their perceptions tend to coincide with the perceptions of very refined people—a Panofsky, or an Offner, or a Schapiro—that is, there is sometimes a common cause. Why? Because it's natural in the art that it will reach out and make certain things understood. This is not true, however, of the scholars in between and certainly not the officials and the other people in between, you see?

The museum officials, museum officers, curators, virtually everybody related to the museum that I can see, do not actually know this artist constituency with which they deal, have never identified it. It's almost hard to conceive that they will ever succeed in identifying it. The amount of ignorance that museums have on this score is monumental and will probably never be dispelled. Why? Because the training and orientation of the people who are given the museums are quite different from the training and orientation of the artists who have given museums their objects; the museum people's understanding of the practice of art is rather low. They come usually from the field of art history, which despite its many outstanding triumphs is endemically deficient in a philosophic view of its own state of knowledge.

**Q:** What do you mean by that?

**Finkelstein:** I mean that of all the humanistic disciplines, art history has the least self-critical apparatus; it literally does not define what it is doing, never understands it well, and is always playing out relatively small intellectual games in terms of local self-interest and patronage rather than working out critical principles of knowledge. If anybody in a physical science behaved the way our art historians behave, they would be laughed out of the laboratory in five minutes because they don't define their field of discourse. Consequently they educate people poorly, and these poorly educated people go out in the world and particularly the museum world—and I'm not being nasty; I tell you I am simply describing what I have been told by scores of graduate students in art history; it's not something I dreamed up myself—they go out ignorant and fearful, and all they have to latch on to is the *dernier cri*, the fashions of the marketplace. And they do this continually; they have no impetus to look further because of both the rewards from the outside world and the proddings of the people from whom they've gotten their degrees. So they are trained like some kind of pigeon—you know, Skinner's pigeons up at Harvard that they put through various paces—to do everything *but* recognize what an artist is and what the artist's interest is. And then they proceed to art museums. They are very unsure of themselves, they all look over each other's shoulders to see what is the fad, and they never realize the artist's real use in museums.

**Q:** Can you clarify these criticisms of art historians?

**Finkelstein:** Mr. [Sherman] Lee, for example, a scholar for whom I have the greatest respect, argues that the works of art in museums have art historical value—they tell us something about other men, times, and places. I believe it is his view that *my* primary interest in the works of art in museums is what I can learn from them for my hands, for my eyes, that will help my professional career as an artist—to learn how to paint, draw, and sculpt. But you see, in between what he considers to be my practical interest and what I conceive to be his historical interest there lies something more elusive, but very important, and that is the way art objects of various sorts can affect our lives.

### Meaning in a work of art

**Q:** What is this more elusive meaning works of art have?

**Finkelstein:** A work of art takes some period of time to make, an extended duration. In the course of this period, the artist has many different kinds of ideas, many different fixes on the meaning of his experience, both the experience of the world he might be involved in portraying or that leads him to act in a certain manner, as well as the experience of ideas that well up directly from the work of art which he is making. Any thought in itself constitutes a very limited duration. We might as well put the same thing another way: a thought is something that can only last a very small time and then is succeeded by another thought.

The fact that the work of art as a static and enduring object continues to exist as the receptacle of all these impulses, all these ideas, all these meanings that are gleaned from experience, means that they are reconciled with each other and give special definition to each other, by their copresence in the work, in a fashion that in life we have only the fleeting intimation of possessing. We wish life would have the clarity of a work of art, which is what we call the unity of a work of art when it is finished. Now, in consequence of this, the user of the work of art, in the actual, individual consumption of it at whatever level, can relive some of these events, which I describe as not simply events of making but events of giving meaning through the act of making, through form and color, the elements of the art object.

Now, to be sure, there is not one precise communication that emanates in a uniform fashion from a given work of art that is authoritatively received by one person the same as another. It seems, rather, that even for one individual, a great work of art can have itself a virtually inexhaustible repository of meanings, so that one can come back to it time and time again and find fresh awareness.

What are these awarenesses? These awarenesses are, first of all, about its ostensible subject matter if it is identifiable as a representational picture. But I think that due to the very rich, what I call polyreferential, nature of our nervous systems, the intrinsically poetic character of the brain itself— our gift, so to speak, for living as human beings—the events in a work of art far transcend their literal meanings, and become encapsulations, metaphors, carryings-over, and reflections back upon the meaning of other experiences. So that if we experience a human body in space, and space has a certain kind of reciprocal relation to the human body through certain means, this is a reflection. It incorporates within it many other reflections on the nature of humans in the universe, on the nature of human possibility, on the nature of harmony, or power, or desire, or a host of other things that will vary according to the person, according to the repertoire of responses that he possesses at the time he brings it to this confrontation. And I think the range of these far exceeds what is usually diagnosed, or what is usually held to be the meaning of the work of art.

Meanings of works of art tend to circulate around the kinds of things that are treated by iconography and iconology, the studies of particular usages within particular styles and how these are incorporated into the intellectual, humanistic life of a culture. And I think it quite deservedly so. This is what I mean when I speak of art historical value. But you see, this fragments the picture (or any work of art) so that there is an iconographical side, an iconological side, wherein supposedly all the meaning resides. And then there is simply the technical side: how the work of art is made or how to make another one like it or what we could comment on about stylistic analysis as its own field. There is also connoisseurship, discerning who made it or under what influences, out of what school or what date—which are all, again, very legitimate problems in scholarship.

But the actual physical form and uniqueness of the work of art itself carry meanings, which against the highly verbalized tradition are themselves a very important part of the intellectual and emotional life of any civilization. That is to say, the things we admire as formalistic or stylistic qualities are not merely vehicles to deliver the meanings that are identifiable on the iconographical level. We can trace out the stories of Raphael's tapestry cartoons, but it is rather in the spatial proposals of Raphael, in the stance of the figures, in the degree of their bulks, in the production of light, of gesture, that we find many, many deeper meanings. Just as Adam Smith projects the law of supply and demand as the invisible hand that directs economic activity, so there is a kind of unidentified, but in this case available to vision, creation of the world by works of art, which is distilled in each person's rehearsing of the art, reviewing of it, and which then becomes an important part of that person's values, that person's sense of self-meaning, that person's repertoire of responses.

Before the Renaissance works of art were regarded as useful objects fulfilling certain magical, ceremonial, communicative, didactic, and other functions. But I guess it is since the self-consciousness of the Renaissance that we differentiate works of art according to how they are made; that is, some are made better than others, or some are more beautiful or more telling, or have certain degrees of rightness that others don't. In short, everything that qualifies a work of art as a work of art, divorced from any extra-aesthetic function, is due to something else contained within it, something not simply of excellence of a general sort, but something very specific within each individual work of art that we regard as quality. This kind of quality goes beyond being symptomatic of its period or capable of handling a certain amount of symbolism, a certain amount of function, or dealing with certain standardized ways of being made, certain formulae, certain transmissions of rules of construction. The recognition of the virtue, the importance of the individual master, of the perfection of a work of art, also means the coming together, the lodging of certain values in a highly precise way unique to that object.

### Topicality versus quality

Let me put this in another way. Last year I heard a talk by Lorenz Eitner (I mention his name because he's a well-known art historian who is aware of the problem). He made a separation, if I get it right, between questions, as he called them, of value and questions of quality. By value he meant topical value, like the fuss a work of art would make, or the importance of being the first to do that, or the work's involvement with certain iconographical or historical issues. For example, Delacroix's *Massacre on Chios* exhibits a topical value because it refers to the Greek revolution and indi-

cates the concern of European intellectuals for progressive, libertarian political causes, and also because it manifests the beginning of Delacroix's use of broken color. Against these topical values we can put the question of its quality. How good a picture is it? What else does it have in it that would make students sit rapt in front of it for days to analyze? Those are the things that Eitner characterizes as the enduring values in the work—it's a pompous phrase, but how can you say it?—the things that last past its topicality and constellate it into a great number of mutually defining relationships with other works of art, many more than the art historian usually investigates.

Scholarship will never catch up with these relationships because they are always fresh and remain to be seen anew by creative people rather than through the medium of documents, and that's what this unbaptized group of people that I was speaking about, who are the seedbed of artistic creativity in a more natural way, has to offer—and not in a way prompted by the fashions of the moment or publicity, that is to say, the topicality of a work. They will always be discerning the elements of quality in works of art, given certain individual prejudices, of course.

I raise this issue on principle because if the museum has the function of safeguarding something, that is, of maintaining a continuity with the past—and by continuity with the past I mean indicating in what sense the experiences of the past are present, usable, meaningful, valuable for people—it's not on the basis of topicality, but this more enduring, continuous aspect. To me this is the naturally informed use of the museum that people such as I have described carry on, communicate, preserve, make meaningful. And it's like the transmission of esoteric doctrine by gurus. It has to be done by live people. It's not done by documents; it's done by conversation and by the activity of looking and analyzing.

The point here is that the people who commonly are given charge of running museums, or who tend to support museums because they are wealthy, or who are in the scholarly community, or the art bureaucracy, or culture bureaucracy—whether it be state councils of art, or junior curators, or directors, or whatever—primarily by their training and orientation (certainly there are exceptions), do not necessarily have, or at least by overwhelming tendency don't exhibit, the instincts that recognize and cultivate the qualities of works of art in the way I am presenting them here.

I think this can be seen very particularly in the training of art historians. Over recent years I've had the opportunity to discuss this problem with graduate students in art history and virtually unanimously they realize it's a problem. They're good archivists; they command a certain amount of literature, but their training disposes them to a certain narrow kind of response to works of art. They have very little conviction toward the life of the work of art in virtue of its particular form, very little precision, very little recognition. When they come to contemporary art, they have only certain verbal for-

mulizations of what contemporary art achieves, way out of keeping with what is supported by the facts. They tend to overvalue certain public celebrities and what looks like very important work because it is rationalized according to certain formulizations: fashion, vanity, avant-gardeness, and so on. They don't have solid ground even while they are shaping public understanding in a variety of ways.

My friend, Leo Steinberg, is one of the exceptions. He had an undergraduate education as an artist, he went to the Slade [the Slade School in London], and it was only there, when he was a painting student, that he became also an art history student of Borenius. This got him interested in art history. Now, of course, he's a very able and imaginative scholar, and he still draws very beautifully, and it's his animal attachment to drawing that leads him, while not as far as I would like to see him go, at least a good deal further into the specific nature of an art object than very many of his colleagues. It is only through in-depth sensuous contact with art objects that this improbable communication on the aesthetic level can take place.

## The museum as "social cement"

**Q:** What you seem to be saying is that some artists have perceptions of works of art that greatly increase the communicative power and value of the works, and that these perceptions are often neglected or missed altogether by art historians and museum people. How can the way of relating to works of art that you are describing affect a museum's educational function?

**Finkelstein:** Let me put what I've said into a wider social context, not that that is the only one, but to me it is an urgent and ever-present one, and one that the museums must heed in some way if they are to have public credibility, public support, and more importantly from my way of looking at it, a genuinely public function that can be filled by no other kind of institution.

All our sensuous experiences in some way affect our lives. They condition what we grasp as meaning and value and the way we grasp it. Now, the conditions under which we live, although we don't act on them deliberately at any one time, form the grounding of what we consider our lives to be.

In other epochs when life was a good deal simpler, the institutions that gave value to life, portrayed its meaning to all the members of the human community or society, were more effective, more clear—and their problems were simpler. The perspective of medieval man was virtually contained within the preachings of the Church, given some range and variation, to be sure. Renaissance man in certain key cities had a much wider expansion of that horizon, but he proceeded with the orderly idea that the creative individual's place within the universe was to fulfill a divine Christian scheme with a real self realization through individual achievement.

In modern life, for a great variety of causes—and one might say an almost irrecoverable, certainly irreversible,

change of events—all people, regardless of their station in life, tend to be in some measure agitated, alienated, fragmented, not quite in control of their belongingness with the universe, or within the scheme of things as they perceive it in their daily lives.

It is the presumed nature of our society that people have the ability to entertain goals, not because of authority from the top down, but because the society provides for, encourages, and makes possible our own autonomy as human beings. To the extent that our society is a society (that is to say, a fabric, not just an economic compulsion or physical force made convenient), there must be a belief that we, as even very large groups of people, are capable of interaction in an optimistic, constructive, and rational way that allows us to achieve these goals. I think it's the case within our own lives that these assumptions tend to be breaking down in various ways. We don't feel we have the social control or social polity that we once thought our society possessed, even a very short time ago. Problems of crime, delinquency, mental illness, anomie, alienation, fragmentation of society into various special interest groups (I don't care whether they are large corporations or some lunatic fringe like the Weathermen) show that the nature of this society is different from that of medieval society, at least as we behold it from a distance, and at least as we believe it able to distribute its blessings.

Now museums, it seems to me, and this is my underlying thesis, have a clear role in here, a real role to enable this society to maintain itself as a voluntary, free society in the deepest sense.

If we regard the museum as an active force in a society beset with problems, we must see it as one of society's resources for the social cement that allows people to enjoy or pursue goals held in common because they are universally regarded as praiseworthy and achievable goals. That is the principle of voluntarism and a free society in the deepest sense. There must be an optimistic feeling about the individual's place in the world, a feeling that the individual has some worth because he recognizes his own resources and the possibility of control, analysis, and mobility through those resources. This feeling affects the social morale of all the actions of a populace and is the real driving force of a society. In the deepest sense, that's what we would hope a museum would promote.

Museums have been maligned by being characterized as only the representatives of a past elite. The social critics of the museum would say, well, what do we see here but the taste and the conspicuous consumption of a master class that has used it for propaganda, prestige, or status in order to make the larger fraction of mankind subservient to its power. This is the way the museum is under attack, isn't it so? And when the museum, and your own study, is funded by the elite—the name Rockefeller becomes already a source of suspicion— you know, what are they doing? Is it part of their cultural imperialism to enslave the minds of the masses by saying that they are the only benefactors and they have to be obeyed

because they're indispensable in this function, that their values have to be adopted?

You know, that's the kind of question that is raised. Now, *in fondo*, that has to be wrestled with. It's a deep challenge for museums and our whole culture right at this point. And it happens to be true to a degree. We look at the de Medici and they were manipulators; we look at their taste and that of others, and they were an oppressive, dominant element in the society at the expense of the rest of the society. But along with this is the fundamental point that the resources that they patronized, and that were exemplified in those objects that we regard as high art, do touch and ennoble and deepen the lives of every human being—not just the aristocracy—who comes in contact with them. Within the taste of the aristocracy and the monied class there is the real value inherent in the object that is no other than that same value I was talking about earlier in this conversation—the *enduring* value of the work of art.

Now, the fact is that this can be communicated to a very large number of people within the society, not simply the names and dates of the art objects, the textbook answers, but the very real feelings and experiences and values and analyses and sense of power. In short, that optimistic view of the world to which I refer (one needs an optimistic view—our whole nervous system is predicated on it) is communicated by works of art. And not in any artificial way. Pop culture with its crassness, its cynicism, its evasion of social responsibility, takes over only by the default of those people who should know better. They are the learned part of the community that is not realizing these real resources and explicating them in a consequential manner fit for democratic consumption and adequate to their potential for teaching and leading people to do better things.

**Q:** Is this what you were getting at when you spoke about participating in the individuality, uniqueness, but great richness of interpretations a work of art has?

**Finkelstein:** Yes, it's the sharing of the possibility of many responses within works of art that I am interested in and interested in promoting. Art can work for the community as a whole, not in a mass way, but through the individual members of the community. In this way works of art can promote, through the voluntary participation of all a society's members, the cementing and healing and bridging role that in times past was played by the teaching of the Church perhaps, or the veneration of ancient customs, or something like that. For me, the essence of modernism is voluntarism, the recognition of the worth of the individual and of the value of the spontaneous responses of the individual. And it is the achievement of a degree of security within those responses that creates what I call optimism within the world and within the society. This is neglected as a factor in works of art for two reasons: the antiquarianism of scholars who look at works of art only as conveying something about the tumultuous past, and the bandwagon with-it-ness, the superficiality, of modern tastemakers, who regard only the quite hermetic,

laboriously involved behavior of the very small, elitist, self-defining avant garde as important artistic activity. Their failure results then in a deformation of the very natural ways in which any number of works of art could work for the community as a whole.

## Copying: the way to discover art

**Q:** You've outlined an ambitious role for museums in society. How can it be brought about?

**Finkelstein:** Here comes the turning point in my argument. Because to really appreciate, to have contact with that special quality which I deem, and have attempted to portray, works of art as having requires, in my judgment, sustained physical contact. This, it seems to me, comes about only (or largely) through some kind of copying. And here I mean copying in the broadest sense, from rough thumbnail sketches to rather extended drawings to replicas of works in an analogous medium—for example, a copy in oil paints of an oil painting. All of these at various levels are an important aid in communicating something of the essence of the work of art. And I mean this not in the sense of learning something simply for my hand and eye—that is to say in the technical sense of exercising a profession—but in a more subtle and deeper sense, analogous perhaps to the amateur chamber music player who will never perform on a concert stage: his performance of Bach or Schubert or Beethoven may be very inadequate when compared with a professional's performance, but it has value because of its propaedeutic or formative effect on him, and what it does for his psyche. So, too, something like this happens in the copying, however slight, of works of art.

When I was a kid, I think maybe I was the youngest copyist the Metropolitan Museum ever admitted—maybe I was 14 when I first copied there. I copied Cézanne's *Rocks in the Forest at Fontainebleau* and Poussin's *Midas Bathing in the River Pactolus*. I'll never forget copying them. I don't have the copies anymore—they were probably atrocious—but what could be substituted for that in terms of communication? Four years ago I was in the Louvre, and I saw a person copying another Poussin, his *Narcissus*. I looked at the copy he was making. It seemed atrocious. It was a copy of a Poussin as if it had been by Kokoschka. I thought, "What a fool, to copy Poussin in that licentious way." The person turned around and greeted me, and it turned out to be someone who I knew but slightly then, but have gotten to know very well since—he teaches at the Maryland Institute of Art and exhibits at the Allen Stone Gallery. What he was doing was that very important activity: confronting an original work of art, and out of whatever depths he had of understanding, moving his experience further. It's very natural that he then finds the need to communicate what he's seen and goes back to be one of the leading figures in that quite influential and large art school in Baltimore, because he is charged up to understand something in a deep and real way that is not subject to the vagaries of fashion.

And this process continues. It continues whether the Metropolitan Museum believes in it or whether your committee believes in it. How many curators believe against it? In 1952, I spoke on this subject—I was supposed to speak on the role of museums in education—to a UNESCO conference of the same name, and I said the same thing. Of course, I was ridiculed by people from all sorts of countries who had never even heard of museums to copy in and whose ignorance about the real use of museums was abysmal because they had never engaged in five minutes of the kind of looking and activity, analytical activity, that you cannot do in a book or in a TV series, that you cannot verify except in sensuous contact with the precision of the original. You know, I think that I could teach 60 people for 60 years each in front of the *Parade* by Seurat in the Met, there is so much to learn there. How much could be copied there? It's inexhaustible. Do you see what I mean? The authority of the actual work of art, which the museum shelters and preserves and transmits and makes available, has a tremendously precise level of meaning which, because it is so precise, can be transmitted to many, many people.

Now, why do I go on like this? Because some people pooh-pooh the idea of copying in a museum simply because they don't understand it and because they have sought advice from a generation of artists who themselves, sometimes by their own testimony, don't really understand the function, the meaning, and the use of museums. They go on aping or mouthing the slogans of Courbet without understanding them. Courbet, in spite of his protestations about burning down the museums, was very steeped in visual culture. The idea of the museum historically and socially had an altogether different meaning for him than it does for the generations since, who themselves really don't know anything about it. It's like a bunch of virgins writing a sex manual. And those are the kinds of artists to whom museums, 99 times out of 100, will go for advice on what the artist needs the museum for. Why? Because they're part of the same apparatus, the unconscious apparatus, of a verbal, promotional culture, not a visual one.

## The "civilizing" virtues of copying

Now, if one sees that cultural situation, then one can ask, "What do you do in the museum?" You know, what do you *really* do in the museum? Well, the first thing is to develop faith and understanding in the real value of one's collections, and it has to be done by the individual mind, it can't be done by a recipe. One could call this connoisseurship, but it has to go beyond connoisseurship. The only place that I know as an institution that has tried to do this at all well was the old program at the Fogg Museum, which started with Arthur Upham Pope and was continued by Paul Sachs. Here are historians who were given a technical education in the making of pictures. You can say, well, I will learn the Venetian technique of the later quattrocento, and you can copy one of several very nice Venetians. They have a wonderful

Bellini—it's overcleaned—at the Fogg, from which you can learn Bellini's technique. Fine. But in learning that, you see, you learn not simply the factual matter of the reconstruction of that painting, but rather something you would call propaedeutic: it produces further learning. It adjusts your eyes to issues in art objects that you otherwise would not have the capacity to discern. So, you see, some of understanding about works of art has to go back to understanding better the practice of it. Relatively few art historians understand this. The few who do understand shake their heads, but they don't do much about it.

Let me give one further example that might stand for many others. Ammunition. About a year and a half ago I was at the Detroit art museum where I was allowed to visit an upper floor that had been shut off to the general public due to a shortage of money to pay guards. I found in one of the galleries there a group of black children, aged from roughly 6 to 16, under the charge of a young man, also black, I would judge around 20—perhaps a college student or some kind of poverty worker, or an art student, or a budding painter, or something—who clearly was taking this group of people to the museum as part of some community or antipoverty program. They were all sitting very silently and very hard at work before a large painting of cows in a landscape by the Dutch painter Albert Cuyp and were all making quite extended pencil copies of it. Now these kids were being very careful and were obviously absorbed and extending their work habits, their recognition, over a long period of time. They were sitting there making drawings that took two hours. And these were people obviously not art students, not even college bound.

Now, what was the civilizing virtue of that? It was manifold. First of all, it meant in very real, individuated terms to these people, representing an economically deprived group, something of the social cement I just spoke of—that the institutions existed for their benefit and to communicate with them. Their activity was such that you could not help believing that it communicated something real to them. Furthermore, they were being educated to an enormous number of things that the usual docent tour through the museum doesn't produce, and the high school groups that wear out the floors in great numbers in the mornings at the Met, you know, don't learn. They were really learning. It was a passionate conviction of this young man, else he would not have brought them there and instilled the reverence that they clearly had for these objects, yes? I was surprised not only by their absorption in this, but by the great range of skill, understanding, and coordination even the smallest of these children brought to this exercise.

Now here I have to introduce a finding about visual development that is not very well known or acknowledged. I'm referring to something cited by [Anton] Ehrenzweig [in *The Hidden Order of Art*, University of California Press, 1967, pp. 134–135] about the practice of a Mr. and Mrs. Mines, who are teachers of art in London, and there is further con-

firmation of this in the works of Jean Piaget. They have found out that there is an exceedingly wide range of visual material that one can teach even very young kids. This same kind of thing that Ehrenzweig cites has been confirmed rather directly by my wife over several years teaching in the education program of the Brooklyn Museum.

And this developmental fact is that between the ages of 6 and, roughly, 12 or 13 children have an amazing aptitude to acquire any of those visual skills you would associate normally with quite sophisticated artistic production. By this I mean linear perspective in the strict Albertian sense, anatomy, color theory, composition, spatial analysis. In short, anything that a good 19-year-old art major in a high-powered art curriculum can learn, a 9-year-old can learn as well—visually.

This ability leaves them with puberty, because they tend to become much more peer conscious and emulate the available conventions like comic strips and pop art and fashion illustration. Teenagers become very, very conventional, and also, because of their own anxiety sexually, they have severe inhibitions about drawing what they see about the human figure. But before the onset of puberty they have all these analytical skills and they can grow a whole lot. Of course we're talking about an enormous scale of individuals, yes? But the 9-year-old can learn more than the 19-year-old art major, as a rule—about perspective, about the proportions of the Parthenon, about the presentation of the figure in Greek and Egyptian friezes, by drawing them, by visual observation, by soaking it up as visual culture.

In citing this, I am immediately reminded of what has been, since Napoleon I believe, an important although dogmatically administered part of the French education system. And that is the use of art as a culturally forming, propaedeutic study in the same way that the study of Latin grammar or mathematics can be used, but it does not have a practical aim. And this is in line with what I was speaking about before. If you teach a child something like anatomy, perspective, spatial analysis, art appreciation, although the child may not have the verbal perspective or historical perspective that an adult would have, nevertheless, you make a connection on the level of his or her nervous system. This is what was happening with these small black ghetto children in the Detroit museum. It is a kind of cultural drill, a reinforcement or a building of values, a consciousness of values in the society. If you show a 10-year-old child a rational order of the world by these means, does it not constitute something continuous with what Leone Battista Alberti thought he was doing by demonstrating the harmony of the world through a system of linear perspective?

Isn't this one of the real roles of museums and deliverable in a much more important, enticing, concretized, and reinforced way through activities such as copying, for example? Isn't it a much better way of doing things than the kind of perfunctory art history lectures that might be given by community volunteers or teacher helpers, even with the best of

intentions? Or, God save us, art history graduate students who only know the formulae that have been drummed into them by their professors? Isn't it more real to encourage people to have the kind of contact that, on the animal, intimate level, really has a humane value?

## Art educators: "ignorant of the real learning processes"

**Q:** If these kinds of visual exercises are so important, if they have the civilizing, humanizing virtues you ascribe to them, why aren't they being more widely applied?

**Finkelstein:** I think there's a great deal wrong with a number of our collegiate art programs, our elementary school programs, our high school programs. If you look at the handbook on art curriculum put out by the art department of the New York State Education Department, you will find a whole bunch of stereotypes of learning activity, material that is simply insufficient, unsophisticated, outworn, not investigated because of a huge lag in learning theory.

People go out in droves, through the various institutional tracks of teaching—you know, mass teaching—with things that have filtered down through a bureaucracy, based on the, what can one say, the culture which exists within that bureaucracy. And this bureaucracy typically has been made up of—and I don't say it slightingly, just descriptively—the poorer art students in college art departments, who drifted over into education and who drifted out of it as soon as they could, seeking other advancement if their talents led them elsewhere. Consequently, the people who remain in this establishment and grow old in it and become the authoritative bureaucracy, the decision-making and guideline-making people, they are the ones who never understood drawing or seeing or art-making in the first place and are chock-a-block with the theory needed to earn their doctorate degrees, to rise to positions of authority and power within the system. They are actually cultivated to be ignorant of the real learning processes.

And meanwhile, I have a student right now who is doing student teaching, who has a tremendous knowledge of the drawing and the seeing process, and she's working with teenagers, and she's working well; she's a prize student, she's wonderful, she can jump through hoops, she's as good as any graduate student in the country in terms of artistic understanding; and she is virtually prohibited from implementing her artistic insights and convictions with the kids with whom she's practice teaching because the bureaucratic line says "no." Simply to go in with a pad and copy for two hours and that's your trip to the museum, as this young Negro boy did in Detroit, that's real humanistic learning.

Now, people are just beginning to discover that there are two hemispheres to the brain, and they have a very sketchy idea, which they vulgarize even in the best of the *New York Times* articles on the subject, that there is a visual way of learning concepts that is promoted by the analysis of what we call representation or problems in representation. If education isn't undertaken there, then it's a real failure of the educational establishment. The fact that most educational systems at this point are *retardataire* in this respect only means that it hasn't seeped through the reputable publications and that the facts haven't caught up with the culture.

**Q:** But you see the museums then as having a real educational role here, a chance to do something, particularly for children, that the regular educational structure has missed?

**Finkelstein:** Yes, I'm talking about what the artist knows. I'm speaking about the artist's culture that the artist actually lives in. And what is an artist? Except for the generation of people that came from philosophy programs, like Motherwell and Don Judd, the artist was initially the kid who drew well at the age of nine, who wanted to draw roller skates in perspective, or an airplane with all the wings on it, you know? And he learned it, among other ways, by copying in museums, by drawing wherever he could. There are zillions of those kids, because it's a natural use of their heads and nervous systems. It's part of human resources and it's neglected by the biases that have come from the simple retardation of the educational establishment and from the screwy shibboleths that have to do with the selling of modern art as the cure-all for everything.

The Museum of Modern Art is a boon to everybody, I'm sure. But the story that they got, the story that became progressive education through the workshops of Victor D'Amico [see chapter 1] and through the publicity about them that went to the progressive schools and then finally into the better class of education curricula for elementary school art, or even high school and junior high school art, came from artists who never learned how to draw because they were told that since Cubism nobody had to learn how to draw to become an artist. And that's why I saw that one has to work through the mind, through a real understanding of the way art objects work. Raphael is not of simply antiquarian importance if one sees how a figure by Raphael deals with the understanding that anybody, just out of their natural biological capabilities and understanding, can acquire about form. It's not simply a phenomenon anchored back in that period of European history. It's a real and continuing and present value.

I'm not by any means against expanding the historical indices of art education. People don't know about Indian art, for example, and one could as well draw a piece of Indian sculpture as a piece of Renaissance or Greek sculpture. I'm not saying this in a culture-bound way, that only the idols of Greece are to learn from, by no means. There is a Chinese cast-iron head of a lion in the Detroit Museum that could absorb a class of kids for hours. Everybody in Detroit should draw that lion, as far as I'm concerned. And the learning can be anywhere, provided that somebody is allowed to be knowledgeable enough to take part in it. Now, you're saying, why aren't the walls being beaten down by people having the same demands I do? Because the culture hasn't caught up. So

I'm giving you a report from the trenches; this is what art is about. And other people don't believe it, including Walter Darby Bannard; they never learned it.

## Copying as museum education

**Q:** So your feeling is that, really, the basic tool that museums should use in their education programs is drawing in the museums rather than the—

**Finkelstein:** The more I think about it—

**Q:** —rather than the group tour, which has been the traditional thing and which is becoming very discredited.

**Finkelstein:** Group tours—discredited?

**Q:** Generally, generally, I think—

**Finkelstein:** Well, why are they discredited? Maybe we can talk about that. I learned from group tours. I learned who Hatshepsut was, I learned what Chinese white was, and how James McNeil Whistler made etchings, you know. I'm quoting things I learned as an eight-year-old in the Met. You see? There I am, just thinking of that audience, and I was one of that audience. It can't be all bad. What's wrong with group tours?

**Q:** I suppose that any means of bringing people and museums together can have great value if it's used well, has some of the understanding, the feeling for works of art you've described. But I still want to know how you see your own ideas, particularly about copying, fitting into the scheme of museum education programs.

## Drawing in the museum

**Finkelstein:** Okay, let me try to specify these kinds of possibilities in a somewhat larger degree. First, I speak of copying in terms of opportunities, not scheduled, to sketch works of art; let us say, drawing from paintings and drawing from sculpture in dry media like pencil or crayon or something like that, which can be done fairly compactly. I recall doing it a couple of weeks ago in the Met from a very beautiful Boucher shepherd and shepherdess. Now there are things I can learn not only about Boucher, not only about how to draw, but about the nature of space and formal integration, almost in the same way a musician would learn about counterpoint from listening to some great predecessor. No Boucher reproduction that I've seen could quite transmit these things as effectively as just sketching in pencil a few details from the original.

Secondly, there are plaster casts. When I was a kid I drew constantly from the casts in the Metropolitan Museum. I can still remember the great thrill I had on some hot summer afternoons in the south wing drawing from a cast of Michelangelo's Medici Madonna—following the form, seeing the way the planes moved; and nobody at this time told me about planes, told me about form, or told me about Michelangelo. I must have been 11 or 12 at the time. I drew from this cast many times, and over a period of time learned a great deal from it, so that when I saw the original I was

prepared to learn really so much more. I can still recall sitting there in front of that cast. I know what room it was in; I know how I felt drawing it. That's really education. I've been starving for casts to send hundreds of students to draw from.

So even at that tender and quite naive age something unforgettable and real happened to me. The same sort of thing that a dancer, when he first leaps on a stage, understands; that a violinist understands when he first learns how to move through a key modulation and knows its purpose. These experiences transcend technique in the same way that they transcend historical recounting. They have deep human value.

Now I realize that the Metropolitan Museum, for example, cannot exhibit its casts any more. Its present floor space is too expensive, and it's needed for other kinds of exhibition functions, and the museum has grown a great deal since I was a kid. At the same time, I have embarked on a campaign of persuasion for the Metropolitan to divest itself of at least part of its cast collection that's stored and not serving any purpose. This is a major aim of mine—decentralization of the Met's cast collection, or at least, God help us, *preservation* of the cast collection.

I remember when the Brooklyn Museum threw out casts of the Parthenon frieze. They were wonderful things to learn to draw from. Anybody can draw from the Parthenon frieze, and the degree to which they can draw from it, or a decent cast of it, is the measure of how much they will participate in the life of Greece. This will have the almost identical culture-relating function as acting on the stage in *Oedipus Rex* or something like that.

So I think casts are very important, and I think museums have to recognize this, and if they cannot show casts within their current high priority exhibition spaces, then they should find cheaper space—abandoned school areas of some sort, exhibition areas that are not used—for those things. Certainly there is some kind of more or less secure real estate somewhere around where old cast collections can be housed, where art students, or other college students, or summer antipoverty programs, or community workers can bring small groups of younger people—or themselves—to practice drawing. Now I realize a lot of this has to be done by persuasion of art department faculty in colleges throughout the country, most of whom barbarically sneer at copying from casts.[2]

Then there is the copying of a painting by painting. I realize this is in as bad smell as other copying, but here I insist I'm right and the critics of my position are wrong, and by this time I think I know better about it than many of them. The real problem here is doing this in a way that allows the curators and museum staff to be responsive to the other needs of the public. The other problem is persuading people that this is a good activity.

You see, there's very little fusion of the two cultures—that is, the scholarly culture and what I refer to as the visual or

practical culture, the one that evaluates the meaning of the monuments a museum possesses in an altogether different way. But there are some people who do bring these two cultures together. Balthus does, given the exhibits he has put on since he's been head of the Academy in Rome.

Giacometti is a prime example of a person who revered museums and learned many, many things in them. Of course, if one goes back and talks about the nineteenth century the case would be obvious of artists using museums, but the shibboleth today is that twentieth-century artists don't bother with that any more. That's beneath their dignity. Well, it's a wrong stereotype. Leland Bell is one who doesn't feel that way. He has had a class in copying at the Metropolitan Museum over the past year and a half. It's tremendously valuable. It's not a great, brilliant thing to imagine that this would be a valuable class. It's only brilliant to implement because it's been so goddamn hard to implement—the value is self-evident. I know there were some problems with this class, but if Leland Bell were Barney Newman or somebody as favored and as outstanding as that, is there any way that he could make himself obnoxious to the museum authorities?

Ellsworth Kelly made himself obnoxious, you might say, by insisting, when they had that Henry Geldzahler show, that all those panels be arranged in one room in just a certain order. I thought it used up a lot of room, but Kelly was acting out of his integrity as an artist. I don't mean to criticize. The Metropolitan Museum is perfectly willing—and there's no other word—to kiss Ellsworth Kelly's ass because he's a celebrity, to make all kinds of celebrations over the sculpture of Adolph Gottlieb, which is ridiculous sculpture, because *he* is a celebrity. But Leland Bell [see report on "Copying in the Museum," this chapter] is a real and irreplaceable resource to the Metropolitan Museum or any museum that he comes in contact with because his perceptions arise from a lifetime of understanding the function of museums and their collections, and because he understands the presentness of the past. Consequently, when museums try to enlist the support of artists, first they must be discerning enough to understand what kind of an artist has an active stake in the museum. Leland is one of them, and if they had a grain of sense they would find others.

## The importance of casts and reproductions

So ways must be found to invite people to have the kind of experience those kids in Bell's class were given, to find the facilities for them, to encourage, let us say, the ideology or the philosophy that prompts copying. When I go to the Louvre or the Prado—to which I go at considerable expense and, you might say, with the strain of wanting to learn as much as I can every moment I am there—I'm never offended by the presence of copyists, even though some significant number in the Prado are commercial rather than student copyists. I assume there's a way of regulating this in an

equitable manner; you know, the discriminating function can be implemented somehow.

But for the benefit of the student copyist (even if there is a hard line to draw between a student copyist and a commercial copyist), it's better to err permissively, to let more people copy than to exclude one genuine student. God knows, he may be the Velasquez of the future. One of the things about the Prado, having all the paintings there together it is easy to see that everybody learns from everybody else. Each of the paintings learns from the other paintings. Why? Because the painters grew up in that museum and saw the other paintings. You know, Goya learned there, Velasquez learned there, Tiepolo learned there. I daresay Rubens when he got there wasn't above learning from the Royal collection, as you can see in that museum. So who's kidding whom? That's the way you learn.

Well, then, what to copy? Well, if you don't have the best works, it's important to have even second-rate works to copy from. There was in the Brooklyn Museum a portrait of a man, supposed to be by Greco, that proved to be a forgery. It is still a very useful work to have people copy from because there is enough understanding in it of Greco's technique and construction ideas that somebody could learn something from it. And somebody could learn something from any number of second-rate works that are not most esteemed by the public.

**Q:** Are you speaking now mostly about copying opportunities for artists, or do you see these things happening with a wider lay audience?

**Finkelstein:** The museum is a big net and people will be caught by certain things in it. You can examine even the histories of now-famous collectors of art, people like Lee Pomerantz, for example, who is an excavator on Crete. He made his first contacts with museums indiscriminately. So indiscriminate contacts will cause things to occur, as well as the programed ones.

You can learn some things in a book, or a lecturer can tell you with a slide, but there is so much more you can find out when you encounter the three-dimensional objects, even in replica. You can't understand monumental sculpture purely as a cultural phenomenon. You can't understand the ideas, the concepts, without seeing them in three dimensions.

There are whole generations of people who are learning classical art and Renaissance monumental art by books and slides, who don't know beans from apple butter and who, by the time they get to Europe, are already tracking down material for their dissertations. So they never go to look at the great works, only details. The great works can be known through their *replicas*, as they were known to art students in the past, whether they were art history students or painters or sculptors. So, you see, it's not only a question of direct copying, but taking the less prized resources of the museum and putting them into circulation for learning needs.

**Q:** So part of what you're saying is that, beyond their value for copying, minor works, even forgeries and reproductions

like casts, have a broad educational utility.

**Finkelstein:** Yes, learning is promoted even if you don't have the outstanding masterpiece, but only a good reproduction, whether in two or three dimensions, to compare with the works you do have. Katharine Kuh had a little gallery at the Chicago museum in which she did special exhibits. She would use one or two original works and then she added reproductions, photographic or printed reproductions. She used to get very good Hanfstangl prints. And she would install the gallery to make a didactic exhibition showing the place of one or two genuine objects that the museum had, where you could examine some theme and still see the physical qualities of the works, even if those the museum had happened to be second-rate works.[3]

The Giovanni di Paolo exhibition at the Met last year was another very good case in point. What I liked about this show was the scale of it. That is to say, it was on a scale of possibility that not only the Met, but a small museum lacking the resources of the Met, could manage. Now, if good transparencies of the Met's wonderful show of Louvre drawings were fabricated, they could be circulated to small museums that could pull out maybe five or ten fine Renaissance drawings and put them alongside. In Kalamazoo or Kansas City or really smaller places where there is a need, a small museum can take a few holdings and put the originals side by side with related works in good reproductions. This is being done—I can give you a number of other examples—but I mean something more as a continuing function of the museum: special exhibitions not continuous with the exhibition of the permanent collection. Many small museums could do such shows at relatively low cost and could be carrying out a variety of educational missions. I might add that I'm in favor of rather copious labeling.

Now what's the principle of it? The principle is that the museum has to look at its objects as they are learned from by artists and not just as a showcase for the interested layman, who will make a relatively casual use of them or even the few connoisseurs who will really be discerning. Sure, I appreciate the originals, but I think about the level of the elementary or high school groups who go in there and get a kind of pat lecture from a graduate student in art history who knows what to tell the kiddies because he got it from his survey course. If you assume there is some other standard of learning, some other level, between those groups and the precise knowledge of a Meyer Schapiro about a particular work, that's an audience that can well be catered to.

### Teaching through comparative analysis

Let me say something further about didactic exhibitions and the teaching of art. There is a way to present very sophisticated experiences, such as the spatial constructions of Degas, accessibly. For lack of a better term I call it comparative analysis. Briefly, the method is to take any aspect of works of art—subject matter, an approach to subject matter, the utili-

zation of space, problems of portraiture, or the use of color to make form—and then to make a continuous array of works of art that share as a common discourse one of these topics. By using works of art and aspects of works of art that may or may not be historically connected, one can see what works of art that are widely different in time or style have in common, what separates works of art of the same school. The criteria revealed by this means can then be used organically in approaching other works of art.

It can be done on any scale. One has to show the differentiation within the species in order to see the species. And by using very weak language in the sense of making judgments about the works of art, but very clear language in defining the differences, one can lead almost any observer to a natural way of feeling close to and making distinctions for him- or herself in the work of art.

I spent time a week ago with one of my classes just going through a couple of plates of the Pol de Limbourg *Belles Heures* and then comparing some of the treatments there with Fouquet's *Book of Hours of Etienne Chevalier*. The distinctions I was making were not the broad stylistic distinctions about the psychological reality behind the stylistic choice. I was talking about the degree of concentration on the person represented, be it the Virgin Mary or one of the saints or one of the bystanders, as a real person continuous with the experience of the observer or as some kind of transcendent or idealized person who had a very special ceremonial relation to the experience of the observer. And I did this by testing out various spatial, compositional devices, as well as color usages and other things.

Now I think the layman (and my picture of the layman is somebody who just hasn't come to be educated yet, but who always has a potential for education) or the young child can have a great deal of material put to him about what is called formal or compositional analysis of works of art, and how these become symbols of understanding the world, and how then these become very genuinely part of the intellectual life of a culture. This can happen in exactly the way Panofsky describes in his table of iconological levels where he shows how the iconographic elements within a work of art participate in the intellectual life of a given time. But further, the formal and sensuous elements of a work of art participate not only in the life of that time, are not only tied into the responses, needs, and values of that particular culture or historical moment, but have universal validity—if nothing else, as reference points for other kinds of experiences. And so one can lay bare by a comparative analysis, in exactly the same way that a biologist in comparative anatomy lays bare, what one means by organic structures and their functions and something of the true nature of works of art. I am quite sure that this will have to be taught in a much wider way than it is currently put through many of our programs. And I don't believe it should be restricted to professional programs for art history or art students. I think this method can point out some

of the real in-depth elements of artistic practice itself and would validate the use of the museum in a way not currently exploited.

## How the museum should use the artist

There has to be a real revolution, and I'm not saying that flamboyantly, in the way art is studied. The museums can only play a part in it; their recognitions then have to act in concert with other recognitions. But they must understand the art objects in no perfunctory sense, and [they must] use the perceptions of those people who do [understand art deeply]. They must even play a part in revising further the education of those people who are going to have a responsible part in transmitting the culture, so that a museum, for example, will use to lead its gallery tours art students who have some insight and enthusiastic use of the objects. I mean people who themselves have drawn from the objects—let *them* go in.

That's what this black youth in Detroit was doing, the one who had all these kids drawing from the Cuyp so reverentially. I mean, try to figure it out. What led him there? It could not have been sheerly mechanical: somebody saying, "You are getting so many dollars a week to keep these kids off the streets, do something with them." It must have been some conviction, some recognition. And it is that kind of recognition that the museum has to learn to cultivate. We have to steer in a more meaningful way toward the real qualities and transmissions that the art objects create. Indeed, if we were to examine them, these qualities lie at the bases of even the most sophisticated and cultivated rationales about art objects. They lie on a natural base; there is a naturally discernible good there, which is not the product of fashion or a fad in learning theory.

Consequently, when the museum reaches out for artists to be in contact with, to learn this themselves so they can further transmit it, they can't go fashion-mongering, they can't play the star system, and they can't ask the celebrities to play a part in it because the celebrities exist only to be admired and to use the museum to promote their own either cultural or simply commercial interests. But the further effort should be to get artists organized into the *use* of museums. People have said, and it's popular to say it now, that there should be at least one artist member on the board of a museum. But symptomatically and typically, who would be the artist on the board of the museum? A Motherwell or a Bannard; you know, the people who have the chic view of the cultural imperialists. (I define as cultural imperialists those who purvey art objects for their fashionableness, for their topical value, rather than their social utility, and who hold museums in contempt because they themselves are really ignorant of their role.) But if you went to the museum today and said, "Our only recommendation is that you have an artist on your board," it would be some ignoramus of that sort.

It's predictable, it's predictable. Well, somehow you must rub their nose in it that a Motherwell or a Bannard is not the sort of person, that the first qualification of taking an artist into any advising position is that he manifest an involvement in and an understanding of the actual social functions of the museum, including those that I've sketched out to you here—that is, the real social utility, the making of the social cement our society is so drastically in need of.

Look around you; look at what is called the Third World and your societies without a rudder—all serving the interests of the moment. If there is a hope at all for a voluntaristic society where people do things of a free will, it can only be because of convictions that its citizens have learned deeply, closely, as individuals. Because if you don't make individuals, all you make is a mob. And if museums have any function, it is to stave off or to leaven the curse of a mob in a mass society. And it can't happen just by the school groups going through and getting a smattering of something that, in the end, has no effect.

I don't know whether I've expressed myself adequately on this—it's a problem of great dimensions that's not going to be solved by the two of us sitting here on one December afternoon.—*F. G. O.*

## Notes

[1] For identification of names, see glossary at the end of this interview.

[2] Since this interview Finkelstein has reported that the Queens Museum exhibited in fall 1975 nine antique and Renaissance casts, on loan from the Metropolitan Museum. Restored by Queens College students and faculty, they were, he said, "used as indicated here by both college classes and school groups."

[3] For Kuh's own description of this gallery, see the interview with her in chapter 2.

## A Glossary of Names

Balthus (Balthazar Klossowski). French painter (b. 1908) best known for his later works of interiors and adolescent girls.

Bannard, Walter Darby. Contemporary painter and an editor of *Artforum*. (For his views on "The Art Museum and the Living Artist," see *On Understanding Art Museums* [Englewood Cliffs, N.J.: Prentice-Hall, 1975], pp. 163–184.)

Bell, Leland. Painter and instructor, New York Studio School, New York City.

Borenius, Tancred. British art historian and author, teacher at the Slade School in London.

Geldzahler, Henry. Curator, twentieth-century art department, Metropolitan Museum of Art, New York City.

Gorky, Arshile (1904–1948). Cubist painter, born in Armenia, emigrated to the U.S. in 1920.

Hanfstangl, Franz, Peter, Max, and Hans. A family of German brothers noted mainly for their publishing of lithographs and photographs in the nineteenth century.

Kelly, Ellsworth. American painter (b. 1923) noted for his bright (red, blue, green), bold, large canvases.

Kokoschka, Oskar (b. 1886). An Austrian Expressionist painter of bird's-eye view portraits, landscapes, and towns, as well as allegories inspired by legends or ideological themes.

Motherwell, Robert (b. 1915). American Abstract Expressionist painter who also studied philosophy at Harvard.

Newman, Barnett (1905–1970). American painter best known for very large canvases often consisting of a single strong color, modified only by changes of direction in the brushstrokes.

Offner, Richard. Art historian who, according to Panofsky, "developed connoisseurship in the field of the Italian Primitives into the closest possible approximation to an exact science."

Panofsky, Erwin. Art historian who taught for many years at the Institute of Fine Arts, New York City. Author of *Meaning in the Visual Arts*, among other books.

Pomerantz, Lee. Art collector and archaeologist (primarily in the eastern Mediterranean).

Schapiro, Meyer. Art historian and long-time faculty member, Department of Art and Archaeology, Columbia University, New York.

For the reader unfamiliar with names and titles of art works referred to in this and other reports in this book, a helpful aid is Peter and Linda Murray's *Dictionary of Art and Artists*, Penguin Books, 3rd edition, 1972.

## Training for Museum Education

and bolts of starting and running small, special-interest museums. Students tend to join the program because "they want to help their people," but employment after training has been a chronic problem.

**Reports elsewhere in this study
that describe or discuss museum training programs**

# Introduction

Museum training programs have mushroomed since the Belmont Report (or *America's Museums: The Belmont Report*, published in 1968 by the American Association of Museums) called attention to the need for specialized training for museum personnel, including those in education. Criticisms have been leveled against the report for encouraging such growth. But they might have been more fairly directed against the institutions that responded too quickly and without much—or, it sometimes seemed, any—investigation of who was offering what, and why. Both universities and museums set up training programs, ready to prepare the "professionals" the museum world needed and equally ready to receive the federal monies sure to follow the publication of the report. A 1970 AAM booklet listed 91 training programs,[1] and others have been established since then, including 3 reported in this chapter. As money has gotten tighter, federal support less generous (or at least less predictable), and jobs scarcer, problems confronting all these programs have intensified—but very few have been dismantled or retired from the field.

This chapter does not attempt to make either a comprehensive examination of all museum training programs or sweeping judgments about even the six included here. They are only a fraction of the programs extant and, more important, they were chosen on the basis of a particular concern: training professionals in museum education.

The students these six programs turn out number fewer than 50 in a given year. Even that figure is misleading, for some started very early and very small (the University of Minnesota graduated only 15 students from its museology program between 1963 and 1973, but in 1974 it had 9 students about to graduate, more than half the "alumni" of the entire program). Others started late and big (George Washington University's first-year M.A.T. program in 1974/75

enrolled 24 students), or late and special (the Institute of American Indian Art graduated its first class in 1974, fewer than a dozen Indian students).

Yet numbers are a concern, because there are not many museums in America: the 1971/72 study commissioned by the National Endowment for the Arts identified 340 art museums and reported that they were staffed by 35,600 persons. *But* more than two-thirds (67 percent) of those staff members were volunteers, about a third of them working in education. Only 22 percent—or 6,732 individuals—were full-time employees, and not all of those "professionals."[2]

What defines a "professional" in these museum jobs? The National Endowment study defined professional museum staff positions as "those requiring specialized training or experiences and include personnel such as curators, librarians, designers, and lecturers." The study did not, however, determine who fit the definition and left that task to the directors interviewed, with the result that "the classification of some positions as professional or nonprofessional may have varied from one museum to another."[3] In short, even art museum directors share no clear definition of what "professional" means. Susan Stitt, who conducted a study of "historical agency placement" under a National Endowment for the Humanities grant, has pointed out that "the guiding criteria [sic] is that the person is paid, not that the person has a minimum academic background, as is true in colleges and universities, or minimum experience *or* museum training."[4]

What this chapter does attempt is to find in these six programs their lessons for the developing field of museum education. One question that is raised in this study is whether the various approaches to museum training can produce, in the words of museum educator Patterson Williams, "the loyalty to the object that is central to museum work, including education work in a museum"—and whether these approaches can also produce a commitment to serve museum audiences.

## Recruitment

Defining their goals as variously as they do, these six programs necessarily define their candidates differently too. Who comes into them turns out to be a critical factor, according to these reports. Some observers have argued that art history departments, at least the way many of them are now organized, may not be the most fertile territory for the potential museum educator, because of their continuing emphasis on scholarship, research, and the trappings of academe. Not so, say two of the programs included here: both the University of Michigan and the University of Minnesota welcome, through the conventional graduate school application route, students with art history backgrounds, and provide for them art history curricula as the first half of their "training." (Michigan also encourages students to enter the program who have already completed the M.A. in art history.) Both programs insist that the education suitable for the art museum curator is equally suitable, indeed necessary, for the art museum educator. Many working museum educators vigorously agree. Barbara Wriston, vice-president in charge of education at the Art Institute of Chicago, insists that "every museum educator ought to have a scholarly specialty in which he can hold his own with a curator."[5]

The third university-based program, George Washington University's new M.A.T., is designed as a one-year program, is centered in a school of education, and trains only educators; it is multidisciplinary, providing similar training for students who might wish to work in art or history museums, science centers, schools, or other institutions—students for whom the distinction between learning from books and learning from objects is fundamental. Its directors embarked on an ambitious search for students who showed a strong interest in both an academic field *and* in museums; who had experience with people that indicated an ability to supervise, to organize work, and to empathize with others; and who could express themselves clearly, with spirit and energy. Applicants who seemed too "one-sided"—focused either on the audience with little understanding of the value of museum collections or on the subject matter at the expense of the audience—were rejected. If this highly selective and purposeful recruitment did not guarantee success for the pilot project year, it considerably narrowed the risks.

One program reported here did not require even a minimum record of academic competence. The Institute of the American Indian Arts Museum (IAIA) sees the Native American Indian student and his community, which has rarely been able to afford opportunities for academic advantages, as its principal constituency. Few students applied for the program's first year (1974), and the director accepted all. To be an Indian youth and to want to come were enough.

As the long report on the Rockefeller Foundation fellowships in museum education points out, the programs developed differently in each of the three home institutions studied—the Metropolitan Museum in New York, the M. H. de Young Memorial Museum of the Fine Arts Museums of San Francisco, and the Walker Art Center in Minneapolis—and recruitment patterns consequently followed different goals. The basic purpose of the fellowships was to train educators for traditional museums and for community arts centers, primarily to serve the "new audience" the Rockefeller Foundation saw evincing interest in art museums. Some applicants trailed behind them the glories of academic awards and honors, whereas others, deemed equally (or sometimes more) desirable, had learned their arts in the streets and had no experience in museums. The student mix in the Bay Area museums and at the Metropolitan posed far greater risks than the George Washington selection method, with predictable difficulties. But Bay Area Codirector Elsa Cameron here defends the mix as worthwhile "because . . . it allows for individuals to be trained for museum positions who otherwise could not have entered this profession."

The oldest of these museum-centered training programs is Toledo's. What Toledo asks of its applicants is just what a university asks: a B.A. in art history and a good academic record. What it offers them, that a university does not, is the chance to work right out of college and to find out whether the museum field is really for them before they go on to more years of study.

## Curriculum: academic work and "real" work

**Academics.** Closely tied to the purpose of each program, the curricula reported here are anything but uniform. Probably the most traditional as training for museum work are the academic requirements at Michigan and Minnesota. At Michigan a year of academic work in art history and courses in museum philosophy and practice precede a year of internship. At Minnesota there is a full year of straight art history and a summer seminar in museum philosophy and practices before the internship year begins.

Both offer far more subject-matter courses than the George Washington program, which requires only 12 credits in the subject the student plans to teach (art history, history, zoology, etc.), but GW's requirements in learning theory and teaching methods are conventional ones for graduate education students. The university's unusual addition to the curriculum is a series of subjects that the program's directors believe essential to education in a museum: audience studies, group dynamics, communications, even interview and publicity techniques.

None of the programs based in museums offers systematic art history study. Toledo offers seminars (and those not always as regularly as students wished) in various aspects of museum work—conservation, exhibition, research, and administration—and Toledo's 1973/74 fellows pressed hard for education theory to inform their constant gallery teaching. The Rockefeller program at the Metropolitan offered similar seminars, plus workshops in community arts and also the opportunity to take academic courses, but "tried to discourage [the second- and third-cycle fellows] from taking

degree courses,'' as the coordinator, Ada Ciniglio said, ''because it was clear [from the first year's experience] that they couldn't be full-time students and fellows at the same time.''

At a level roughly comparable to junior college, the Institute of the American Indian Arts Museum in Santa Fe offers only Indian art history. Its two-year curriculum in museology is geared to the small local Indian museum whose resources and personnel serve Indian communities; it is almost entirely practical, covering everything from carpentry to security to filing systems. Charles Dailey, head of that unusual program, says his purpose is to train ''a student going home to set up a whole museum with nobody to help him.''

**Internships.** The special element in all these programs, whether in universities or museums, is the internship. Bret Waller pointed out in a 1971 report on museum training programs that nearly all the directors, curators, and educators he queried stressed the value of the internship experience.[6] The AAM Museum Studies Curriculum Committee recommended, in 1973, that a museum studies course ''should provide internship in one or more accredited museums for a period of at least two months and up to one year.''[7] And Susan Stitt's broad survey of a related field—training programs for history museum workers—conducted for the National Endowment for the Humanities reported that respondents felt an ideal internship should last 10 to 12 months and should be full-time and supervised by someone (or by several persons) who take ''a complete interest in the intern.''[8]

Internships in each of these six programs meet most, and in some cases all, of the recommendations. At Michigan, where former long-term chairman Charles Sawyer acted on the belief that ''an internship is probably the most drastic need'' for anyone going into museum work, a student is required to work in one of the university museums during his academic year and then spend two full semesters of the second year as an intern at a museum outside the university. One Michigan student reports here, ''I felt I was in fact a staff member of that museum, not a Michigan student doing some field work . . . I really almost forgot it.'' Minnesota accepts into the second, or ''museology,'' year of its program only as many students as it can arrange internships for, usually at Twin Cities museums. George Washington requires of its students ''field work'' two days a week in schools during the fall semester, and during the spring semester a two-month internship in a local museum.

All three university programs report some difficulties in the internship, largely because it is the one aspect of their programs beyond the university's control. They all put commendable effort into matching student to internship museums, but once the match is made, Michigan and Minnesota keep hands off, like prudent in-laws. Sidney Simon, a professor at the University of Minnesota and formerly a museum director, suffers no separation anxieties when his students leave for their internships, finding it consistent with

a university's emphasis on ''individual initiative.'' Charles Sawyer says that because the internship is the museum's responsibility, one of his problems ''is to defend the faith that the museum is always right,'' a faith he does not always really hold. Explaining why he takes that position, he says in the Michigan report in this chapter,

> In my view museums, large and small, remain highly individual and subjective institutions largely influenced by the particular perspectives of their directors, trustees, or benefactors. It is something of a shock for graduate students, as interns, to discover this, but . . . it is part of their learning process in becoming museum professionals. . . .

Others, including students and museum staffs, are not so sure that being cut off from the university during the internship is such a good arrangement. Roger Mandle, assistant director of the Toledo Museum and a graduate of the joint museum training program conducted by the Institute of Fine Arts and the Metropolitan Museum, feels that the ''major failing'' of museum training programs is that universities ''never'' ask students how or what they are doing, consult with museum officials about the students' work, or make sure there is some correlation between their academic and museum assignments.

Jonathan Brown, director of the Institute of Fine Arts, points out that there is a question of ''territoriality'' here and that universities are reluctant to cross the museum line (see chapter 12). But to students and some museum staffs, the effect is that universities are simply indifferent—once a student is out of sight, they feel, he is also out of mind. What reformers would like to see is a strong agreement between universities and museums from the beginning on what each student is to do and how supervision is to be carried out, including arrangements for periodic reviews by the university and consultation between staffs of the two institutions.

Obviously, this kind of participation adds to the complexity of the university's job. Even the directors of George Washington's program, Marcella Brenner and Sue Hoth, who consider few aspects of their program more important than supervision of the internships, say they did not anticipate how much time and effort that would mean. No matter how much attention they might have given the student, they found they could not expect the museum supervisor to take the same amount of time—and their students criticized the failure of the program staff to observe them in action more often.

**Assessing the entire curriculum.** How do these six programs measure up against the recommendations of the AAM Museum Studies Curriculum Committee? All those recommendations—which were not designed for museum education and were based on the premise that the master's degree is ''normally the best one for museum professionals to hold''[9]—assumed a university setting for at least part of the museum training program. Rather than suggest a required

academic curriculum, the committee proposed a syllabus that would try to define the ten areas that a curriculum of museum studies should cover.

Three of the areas are specifically related to activities normally labeled educational: (1) presentation or exhibitions, (2) the public, and (3) cultural and educational activities of museums.[10] In passing, the committee did note that "a museum educator would find educational psychology courses or practice teaching invaluable." And it urged at least one course in how to use objects, another that covers the history and philosophy and function of museums, and another that touches "cogently upon all aspects of museum work."[11]

Michigan and Minnesota are generally organized along the joint university-museum scheme outlined by the AAM. Rockefeller Foundation programs either assume the M.A. on entrance into the fellowship or, for those candidates choosing community arts, eschews most academic considerations. Only George Washington's education-based program tries to provide educational psychology courses. All certainly provide seminars in museum philosophy and practice. Whether all adequately teach their students "how to use objects" is open to debate. Toledo, in effect, reverses the common procedure of a year of academic work followed by an internship; by offering the apprentice year first, it assumes—usually, as it turns out, correctly—that those students who found it stimulated their interest in museum work will return to school for the M.A. (One Toledo fellow has said, however, that in following that path she found it "frustrating" to have to go back to school to earn the credentials to get a job she already knew she could do.)

It appears that however helpful the AAM recommendations, programs designed especially for museum education training are making their own rules, sometimes as they go. There are no guidelines either broad enough or specific enough for them. Perhaps such guidelines will develop out of the programs studied in this chapter.

**Who administers: university, museum, or both?**

The only guidelines promulgated by the AAM committee on this subject recommended that "the museum studies program should be a graduate program taught in concert by an accredited university and by one or more accredited museums."[12] Respondents to Susan Stitt's National Endowment for the Humanities study of historical museum training programs concurred, and one respondent neatly summed up the argument for cooperative arrangements between museum and university for such training:

> I feel the museum with university affiliations is definitely the best approach. Too many "traditional academic" historians do not know how to interpret or "read" objects. I also strongly feel the programs need to be degree granting and have in-depth subject courses. Thus an affiliation with a university is desirable. But the museum has the distinct advantage of being concerned with the object and material culture.[13]

It remained for those art museum professionals and art historians meeting at the Museum Training Conference at the Metropolitan Museum on November 20, 1971, to suggest that museums, rather than universities, should control and take the initiative for programs. They pointed out that centering museum training programs in universities, which traditionally regard vocational programs with contempt, is to handicap them from the start. Bret Waller noted in his remarks at the conference that no one can for long escape the vocational aspects of these programs: "One can be a practicing and productive art historian without any institutional affiliation; but in order to be a curator or museum educator or administrator, one must work in a museum."[14]

The history of museum training programs is not much help here. It begins at the University of Iowa, where courses in museum studies, primarily for curators and conservators, were first given in 1908.[15] The Newark Museum was the first training institution to include education and field work, as part of the program that John Cotton Dana established there in 1925. Harvard's famous program under Paul Sachs began in the 1920s. In 1928 the University of Rochester offered a course in museum pedagogy, with practice teaching at the local museum of natural history and arts and sciences; in 1929 the Buffalo Museum of Science followed suit, and in 1935, the Brooklyn Museum.[16] A cooperative arrangement between New York University's Institute of Fine Arts and the Metropolitan Museum began in 1956.

So museum training programs, however dissimilar in content, purpose, and effectiveness, have always been divided between universities and museums. The programs reported here do not resolve the issues of how best to divide responsibilities. On one side are the arguments, like those advanced by participants in the Bay Area's Rockefeller program, and by some in the Metropolitan's, that people concentrating in community arts, even in their relationships with "traditional" museums, can become professionals without academic credentials. But if Chicago's Barbara Wriston and a host of knowledgeable museum educators, to say nothing of curators, are to be believed, a museum educator must have the credentials a museum curator has. On that side, Harry Bober of the Institute of Fine Arts, New York University, has said that scholarly training is required—"otherwise the basic idea of a museum as an historical inheritance is defeated."[17] Patterson Williams's lovely phrase, "loyalty to the object," haunts this discussion.

**Money**

Susan Stitt has suggested that the high level of stipend support she found for graduate-level museum training in history "may indicate a desire on the part of the funding agencies to increase the number of students enrolled . . . or to expedite the time spent in training."[18] Sometimes those "high"

levels caused trouble. At Minnesota the $7,000 stipend provided by the National Endowment for the Humanities was only $200 less than the salaries of museum professionals with several years' experience, and it became the basis for union negotiations on professional staff salaries. Perhaps there is another way to read those levels of stipend support—as an oblique effort to force up salaries in the profession.[19]

So long as the National Endowment for the Humanities stipends were available, few universities were willing to turn them down, despite dire warnings about the shrinking job market. As one Minnesota professor said, "We are assuming that continuing government support represents a genuine need on the part of the national museum community for trained personnel." As the National Endowment for the Humanities reduces its support for fellowships, is the museum world to read that as a sign that government policymakers no longer see a genuine need for more trained personnel in the nation's museums?

One government agency, the Bureau of Indian Affairs, does see a need in the Indian community and supports the Institute of the American Indian Arts Museum training program—a light burden at $3,000 a year, which also includes the costs of exhibitions. By contrast, the $750,000 appropriated by the Rockefeller Foundation for its ambitious program in four museums sounds enormous; stipends paid to individual fellows ranged from a high of $8,000 at the Metropolitan to a low of $4,000 in the Bay Area. One Rockefeller fellowship coordinator called the "program budget nothing short of luxurious," but all of the fellows report that the real luxury of their program was the travel it allowed—the chance to see and learn about the rest of museum country.

## Getting the job—and doing it

If museum training programs are designed to teach people to fill jobs that need filling, then who gets the jobs, how they get them, and how well they do them, are the final tests of those programs. Many observers suggest that the primary vocational utility of these programs is their visibility: prospective employers know where to look for prospective employees. Yet graduates of history museum training programs responded to the Stitt survey that they found their own informal job-seeking efforts—through friends or acquaintances in the field—more effective than their programs' efforts, and that they found an "imperfect flow of information between the supply of trained manpower, the training programs, and the demand for such manpower."[20] Consequently the one broad recommendation made by the Stitt study was for a kind of national placement service.

Among the six programs reported here, job placement practices vary widely. The University of Minnesota makes no provision for placing graduates of its museology program; most of them do get jobs, but the report indicates that graduates of the straight art history M.A. program have generally gotten higher-level jobs. Charles Sawyer of Michigan, on the other hand, believes that finding his students jobs

is a primary responsibility: "I personally accept the fact that the credibility of a program is job placement." So do the directors of the George Washington program, who placed about half of their first graduates (June 1975) in museum jobs, but with considerable exertion.

The problem rarely arises for Toledo and its fellows, as most go on to graduate school when their apprentice year ends. But for the supervisors of the Rockefeller Foundation programs at the Metropolitan and in the Bay Area, it is a central part of their responsibility, according to the terms of their grant. (Because so few Rockefeller fellows interned at the Walker, they generally did their job seeking alone, using the fellowship's generous travel allowance to scout the field.) Charles Dailey, of the Institute of the American Indian Arts Museum, has the most perplexing problem: after training some Indian students to work in museums, he has found that they do not respond enthusiastically to offers of jobs from outside the Indian world. He says he tries to convince them that even jobs they see as "token" are a chance to get "a foot in the door"—but he has had less than complete success.

**And doing it.** Getting the job is only the first step. Museum directors and education supervisors who have hired graduates of some programs reported in this chapter have made these comments:

• From a curator of education in a museum of contemporary art in a large Eastern city, of a graduate of George Washington's M.A.T. program: "Very well prepared . . . capable and productive—she produces a lot of information for the docents, and what she gives them includes content and educational methods. She goes on her own."

• From a curator of education in a large general art museum in the Midwest, of a Rockefeller fellow from the Walker: "Well trained, highly imaginative, has a broad ability to work with many people and objects. . . . Brings a strong interest in doing exhibitions. Good at tutorial one-to-one relationships."

• From the same curator, of a Toledo fellow, who has worked for him and studied with him: "Toledo very *definitely* helped her. . . . She was exposed to many different audiences and objects. . . ."

• From a community program director in a large general art museum on the East Coast, of two Rockefeller fellows, one from the Bay Area, one from the Metropolitan: "They don't know what they don't know. . . . They've been given projects that if they fail, it doesn't matter. . . . They come with an incredible lack of skill. . . . [When they come to work] they must unlearn much of what they learned as fellows."

• From the director of a small Eastern art museum of another Rockefeller fellow from the Metropolitan program: "It was one of the best appointments I've ever made. I've been able to go away . . . and leave the museum in his charge; he hangs important exhibitions; he has produced publications. . . . If another Rockefeller fellow applied for a job here, he

would certainly stand the best chance of getting it because of the training.''

• From the chief education officer of a federal museum of science and technology, of a George Washington M.A.T. graduate: ''She operated like a learner [a compliment]. . . . She's prepared an excellent volunteer handbook; she recruited all the volunteers and made good choices. She is familiar with many programs in museums around the country, and she is being given more and more responsibility.''

• From a curator of education in a Midwestern museum, of a graduate of Michigan's Museum Orientation program: ''She went to Michigan with a limited background [he had been sent her transcripts, along with a personal recommendation, by the head of the Michigan program], and I'd say it's to Michigan's credit that they gave her a chance . . . and she learned from it. She's a hard worker, determined, amiable, imaginative, and able to do a very sound job.''

Students themselves deserve the last word. Whatever complaints they may make while in their respective programs, and they sometimes voice loud ones, most agree that ''in retrospect,'' as one Bay Area fellow put it, ''the whole program was very worthwhile.'' A Metropolitan Rockefeller fellow agreed, reporting that ''most of the fellows were happy about the year and at the end were a very cohesive and solid group.'' Both of those fellows stayed in education; one Toledo ''graduate'' who moved from education to curatorial work—and estimates that he gave over a thousand lectures in his year at Toledo—says, ''Nothing will ever scare me again.''

## Accreditation, standards, goals

Whatever other lessons may be drawn from these six reports, they do not resolve the central dilemma facing museum training programs: what is the body of ''professional'' knowledge they should offer? Until art museums and their education staffs can agree on that, training programs for museum educators will continue to be as varied as the six reported here. The museum field has not made museum training a prerequisite to employment; indeed, there is no generally agreed-on credential for museum employment, especially in education departments.

Even the M.A.T. program at George Washington does not, according to Codirector Brenner, give graduates ''standard'' teaching credentials: ''If our graduates go to work in school systems, it is as bridge-builders and liaisons with museums. We are training museum educators, not schoolteachers who will go out and get licensed,'' she emphasized.[21] GW's position is comforting to observers who are uneasy about the intrusion of teachers' colleges and graduate schools of education into the museum training field. Museums, they say, are among the last places where uncredentialed educators—artists and volunteer docents, for instance—can teach without official scrutiny from a state or local accrediting body, and they fear not only the loss of freedom and flexibility that would follow on the imposition of accrediting standards, but also a sacrifice of content to learning theory in the training programs. (What degree-granting programs should offer instead, they insist, is what GW does in fact give: the rigor and discipline of the university that forces evaluation and student accountability for their work—something that several observers have missed in the more loosely structured Rockefeller program, for one.)

Many professional museum educators are convinced of the value of diversity, arguing that art educators, writers, art historians, trained teachers, artists, community arts people—*all* are necessary in an education department in a major museum. But what of education work in the smaller museum, or the art center, for which several of these programs are trying to ''train'' their students? Does the argument that curators and educators should have the same training still have the force it once did, before art centers and community arts groups entered the territory that was once the preserve of the traditional art museum alone?

Not even the art museum educators have the answers. On the subject of education and training, at a meeting in November 1971, they concluded,

The absence of criteria for the training of Museum Educators should not be seen as reflecting a lack of professional standards. The range of abilities and talents and training required in the museum education field is comparable to that found in the formal education in the humanities ranging from primary school teaching to graduate level instruction.[22]

—*A. Z. S.*

## Notes

[1] G. Ellis Burcaw, *Museum Training Courses in the United States and Canada* (Washington, D. C.: American Association of Museums, revised 1971).

[2] *Museums USA* (Washington, D.C.: National Endowment for the Arts, 1974), pp. 5 (fig. 2), 92, 97 (fig. 52).

[3] Ibid., p. 84.

[4] Report delivered at College Art Association meeting, Ann Arbor, Michigan, January 26, 1974.

[5] Interview, November 1, 1973.

[6] Report on the Museum Training Conference held at the Metropolitan Museum, November 20, 1971. See also Bret Waller, ''Museum Training: Who Needs It?'' *Museum News*, May 1974, pp. 26–28.

[7] *Museum Studies: A Curriculum Guide for Universities and Museums*, a report by the Museum Studies Curriculum Committee of the AAM (Washington, D. C.: 1973), p. 15.

[8] Susan Stitt, Linda Silun, ''Survey of Historical Agency Placement Opportunities and Training Needs,'' unpublished report for the National Endowment for the Humanities Office of Planning and Analysis, November 1974, pp. 301, 315.

[9] *Museum Studies*, p. 12.

[10] See pp. 27–28 of *Museum Studies* for full listing of topics under each of these three areas.

[11] Ibid., pp. 13, 14.

[12] Ibid., p. 11.

[13] Stitt and Silun, "Survey," p. 284.

[14] 1971 conference report, p. 6.

[15] L. V. Coleman, *The Museum in America: A Critical Study* (Washington, D. C., 1939), vol. 2, p. 419.

[16] Grace Fisher Ramsey, *Educational Work in Museums of the United States: Development, Methods, and Trends* (New York: H. W. Wilson, 1938), pp. 419–422.

[17] Museum Training Conference, November 1971, transcript of discussions.

[18] Stitt and Silun, "Survey," p. 256.

[19] For figures on salary levels in museums, see *Museums USA*, chap. 7, pp. 83–123.

[20] Stitt and Silun, "Survey," p. 337. See also pp. 329–330.

[21] Telephone interview, May 4, 1976.

[22] *Education in the Art Museum*, Proceedings of a Conference of Art Museum Educators, held in Cleveland, Ohio, November 4 and 5, 1971 (Association of Art Museum Directors, 1972), p. 23.

## Bibliography

Abbot, Edith R., L. Earle Rowe, Benjamin Ives Gilman. Report of the Committee of the American Association of Museums on training for museum workers in *Museums Journal* (Organ of the Museums Association), vol. 17, July 1917 to June 1918. London: Dulau and Co., 1918, pp. 8–11.

*Education in the Art Museum*, Proceedings of a Conference of Art Museum Educators, held in Cleveland, Ohio, November 4 and 5, 1971. The Association of Art Museum Directors, 1972.

Matthai, Robert A. "In Quest of Professional Status," *Museum News*, April 1974, pp. 10–13.

*Minutes of the Conference on Museum Training Programs*. Held at the National Gallery of Art, Washington, D. C., December 2, 1972. Reproduced and distributed under the auspices of the Office of Museum Programs, Smithsonian Institution, Washington, D. C., 1973.

*Museology Programs: Professional Standards and Practical Considerations*. Papers delivered at the Second Annual Meeting of the Midwest Art History Society. Minneapolis, 1975.

*Museum Studies: A Curriculum Guide for Universities and Museums*. A Report by the Museums Studies Curriculum Committee of the American Association of Museums; Charles van Ravenswaay, chairman; Henry Francis du Pont, director, Winterthur Museum. Washington, D. C.: American Association of Museums, 1973.

*Museum Training Courses in the United States and Canada*. Compiled by G. Ellis Burcaw. Washington, D. C.: American Association of Museums, revised 1971.

*Museums USA*. "Personnel" (chapter 7). Washington, D.C.: National Endowment for the Arts, 1974.

Parr, A. E. *Mostly About Museums*. New York: American Museum of Natural History, 1959.

*Program Announcement 1975/76, National Endowment for the Humanities*. Washington, D. C.: U. S. Government Printing Office, 1975.

"Report on the Museum Training Conference Held at the Metropolitan Museum of Art, New York, on November 20, 1971." Unpublished.

Stitt, Susan, and Linda Silun. "Survey of Historical Agency Placement Opportunities and Training Needs." Submitted to the National Endowment for the Humanities Office of Planning and Analysis, under O. M. B. Approval no. 128-S73002, November 1974. Unpublished.

Waller, Bret. "Museum Training: Who Needs It?" *Museum News*, May 1974, pp. 26–28.

Washburn, Wilcomb E. "Grandmotherology and Museology," *Curator*, vol. 10, no. 1 (1967), pp. 43–48.

## UNIVERSITY OF MICHIGAN MUSEUM PRACTICE PROGRAM

University of Michigan
Ann Arbor, Michigan 48104

**A good university art museum and art history department, highly motivated students, and a competent and concerned faculty characterize this museum practice degree program with a small-museum slant. The heart of the program is an eight- to ten-month museum internship, a reflection of the staff's philosophy that "work is the best teacher." CMEVA interviews and observations: December 1973; February, April–June 1974.**

### Some Facts About the Program

**Title:** Museum Practice Program.

**Audience:** Graduate students preparing for museum work and other students working toward an M.A. in art history with museum orientation. Approximately 20 are enrolled. Ten new students may enroll per year, each of whom spends the second year as an intern in a museum.

**Objective:** To provide basic orientation, training, and experience in museum work for those contemplating careers in museums of art, archaeology, or history.

**Funding:** Approximately $115,000, of which $77,500 is for student support; the rest is divided between the University of Michigan and the museum to provide travel stipends, and between the university and the internship museums to pay tuition or to contribute to the wages of the resident intern. Sources: National Endowment for the Arts, National Endowment for the Humanities, Horace H. Rackham School of Graduate Studies, the University of Michigan Museum of Art. Cost: tuition, $1,300 (in-state), $3,372 (out-of-state), plus living and incidental expenses.

**Staff:** One full-time, one part-time, plus varying appointments of members of Museum of Art staff, American Culture, and occasionally other departments.

**Location:** Classrooms and University of Michigan Museum of Art, or other university museums during first year; neighboring museums of art, archaeology, and history—but primarily museums of art—during the second, or internship, year.

**Time:** Two-and-a-half terms of academic work on Ann Arbor campus plus an eight- to ten-month internship, for a total of two calendar years. The program was established in 1963.

**Information and documentation available from the institution:** Listing in *Graduate School Bulletin*.

The Museum Practice Program at the University of Michigan graduates students, according to the program announcement, who "should be well qualified for administrative, curatorial, and educational positions in museums, college and commu-

nity art centers, historical societies, and related cultural institutions.'' An ambitious goal, sufficiently realized—in the judgments of faculty and graduates of the program, as well as of employers and teachers of its graduates—to prompt observers to ask: what makes the University of Michigan's Museum Practice Program an effective museum training program?

Four factors seem significant: the presence of a good university art museum; a comprehensive art history department; students with academic competence and career motivation; and a supervisory staff concerned with the personal goals and professional future—museum jobs—of each student in the program. Each observer may give different weight to these four factors, but any balanced judgment would be likely to conclude that an effective museum training program requires all four.

## The university museum and department of art history

Although the University of Michigan Museum of Art's collections do not rival those of the great urban museums in scope or excellence, they are described in a university publication as ''exceptionally well-suited for use in university research and training . . . [for] a primary emphasis in buying objects of art has generally been on their instructional value.''[1] The university museum has bought widely in prints and drawings, to add to gifts of mid-nineteenth-century paintings, Japanese prints, Oriental ceramics, and other works of art.

The museum is used by the university in several ways. A number of art history courses meet in the museum and draw on the collections for analysis and illustration of various styles and techniques; according to Marjorie Swain, the director's assistant, ''even art history survey classes characteristically come in the first week or two and look at objects and talk about techniques.''[2] Students in a museum research seminar study works of art in the museum's collections and write articles on the objects for the museum *Bulletin,* a publication begun by the museum in 1950. The museum also serves as headquarters and primary training ground for the Museum Practice Program.

The Department of the History of Art has 20 faculty members, five of whom are also associated with other departments or museums.[3] It offers courses in ''virtually every area of European, Near Eastern, Asian, and American art, and its degree programs include the Master of Arts and Doctor of Philosophy in both Western and Asian art.'' Between 1940 and 1973, the department granted 45 doctorates, 13 in Asian or Islamic art and 32 in Western art. At least 38 of these graduates now hold teaching or curatorial positions in major colleges, universities, and museums.[4]

## Admissions and internship placement

Admission criteria for the Museum Practice Program, as defined by the program announcement and by museum and university staff, encourage applicants who have already un-

dertaken some graduate study in the history of art, American culture, or other museum-related field, or who have had museum work experience before entering the program.[5] Over 90 students applied for the 1974/75 program, of whom only 10 could be accepted under a quota established by the graduate school. These 10 all had master's degrees in art history or related fields; 7 of them had previous museum experience.

Charles Sawyer, former chairman of the program (he retired as chairman in January 1975 and as faculty member of the program in September 1975), recommended that the fall 1974 program admit only nine candidates for the degree of Master of Museum Practice—six in history of art, three in American culture—''because,'' as he says, ''placing students in work experiences is central to the program and because the number of applicants has grown so dramatically (as have internships, from three to twelve over the past three to five years).''[6] He emphasizes, ''The important point is that the total number of museum candidates *in residence* should not exceed 15, regardless of the degree for which they are studying. This involves the size of the basic seminars as well as the number of internships available.''[7]

Placing students in internships and in jobs was a central preoccupation for the chairman during his 17 years with the program. He firmly believes that a graduate program in museum practice should take responsibility for helping to find jobs for its graduates:

I think it has to. I personally accept the fact that the credibility of a program is job placement. . . . I don't think there is any way you can fudge that. One reason, I guess, that we are at the moment being oversubscribed by an embarrassing amount is our track record so far is pretty good. I can't guarantee anybody that employment opportunities are going to be that good five years from now. . . . Nobody knows!

## The Museum Practice Program and how it grew

The need for trained personnel for museums of art and history was documented in *America's Museums: The Belmont Report*, published by the American Association of Museums in October 1968. That report gave a boost to existing museum programs and prompted the birth of uncounted new ones. The University of Michigan had already, in 1963, established the degree of Master of Museum Practice as an interdepartmental program under the administration of the graduate school. (In earlier years, beginning in 1957, university seminars in museum practice had been offered in association with the Department of the History of Art and with the Program in American Culture.)

For the 1973/74 and 1974/75 academic years, the Museum Practice Program received a special appropriation of $8,000 a year from the graduate school for fellowship support, $11,000 a year from the University Museum of Art for graduate research assistants, and grants from both National Endowments. Previous grants from the National En-

dowment for the Humanities (NEH) have provided fellowships for students preparing for careers in art or history museums; the grants from the National Endowment for the Arts (NEA), which has invested even more money in the program than NEH, have been directed to a regional training program in collaboration with four relatively small art museums in Michigan—Cranbrook, Flint, Grand Rapids, and Kalamazoo, all ''middle-bracket'' museums ($100,000–$300,000 annual income).[8]

The program is one of comparatively few in museum training with both an art and a history orientation. The exposure that students are given to a variety of museums and historical societies, in the language of the university's 1973 proposal to NEH, ''broadens their perspectives and enhances their potential base for future employment.''

### Requirements for the Master of Museum Practice

The staff of the Museum Practice Program considers the program a rigorous one. Students must accumulate a minimum of 36 credit hours, 6 more than the 30 hours minimum credit required for the Master of Arts degree. Students entering with previous graduate study can generally satisfy the program's academic requirements in two and a half academic terms (about ten months). Of the minimum 36 credit hours, 6 are satisfied by a two-term required seminar in Museum Philosophy and Practice, 6 by the required second-year museum internship, 2 by the thesis or research essay that develops out of the internship; the other 22 hours are satisfied by academic requirements, 16 in related fields (art history, for a student preparing to work in an art museum) and 6 in approved electives that fulfill the graduate school cognate requirement. In addition, each candidate for the museum practice degree must, during the first year, work 20 hours a week in the university museum.

Opinions differ on these requirements for the museum practice degree. The rigor is defended by the chairman of the program, Bret Waller, who has said, ''We don't want it to be a cheap degree.'' A former associate director of the program believes that the credit-hour requirement is too heavy, coming close to Michigan's 40-hour minimum requirement for the Ph.D. Marjorie Swain, herself a graduate of the Museum Practice Program and now assistant to the director of the university museum, argues against that view, pointing out that 8 of the credit hours—the second-year internship and the essay that derives from it—are ''work-experience hours for which we give academic credit.'' Chairman of the art history department Clifton Olds has observed that so many of the required credits are for non-art-history courses—the 8 work-experience hours, plus 6 hours for the philosophy and practice seminars—that only 22 hours are left for art history courses.

A second and slightly different degree, the Master's in History of Art with Museum Orientation, is offered through the art history department in conjunction with the Museum Practice Program. This degree is intended for students without previous graduate study or museum experience. On completion of the first year of graduate study, students interested in this program can apply for acceptance into the Museum Philosophy and Practice seminars. A few are accepted each year. Students in the M.A. in History of Art with Museum Orientation program must complete all distribution requirements for a regular art history M.A., plus the seminars and the work in the university museum required of museum practice students.

The biggest difference between the two programs is that the second-year internship is not required for the M.A. with Museum Orientation. If they can be placed, these students may do an internship, but they are given no credit for it. This degree, as a result, is less rigorous than the M.A. in Museum Practice. It allows students who have not made firm career choices to keep their options open.

### The academic curriculum of the Museum Practice Program

Though the second-year internship is the most important part of the program, the first year of academic work is central to the character of Michigan's museum training program. The degree is intended to be a solid academic one, with the program's practical aspects added on top. In the past the Museum Practice Program has been criticized for being too vocational because it gave credit for nonacademic work. Increased applications to the program in recent years, however, have allowed it to begin to accept primarily students who already have advanced degrees in academic subjects. As a result, the validity of this argument has begun to fade.

Offered in the first year of study are the following museum practice courses: Art Museum Philosophy and Practice I and II; Museum Procedures I and II; Research and Concluding Essay; and Historical Institutions. The two philosophy and practice seminars are required of all students, whether they plan to work in art museums or history museums. Designed to ''provide an orientation in museum work and a specific focus for some continuing experience in different phases of administrative, curatorial and museum educational activity,''[9] the courses have in the past been divided into a fall semester of class work and a spring semester of independent directed studies.

In response to expressed student desire that these seminars be more specific, the Museum Practice Program staff is putting together a handbook—''It's a how-to of basic mechanical functions,'' said Waller, who got the idea from the *New York Times Handyman's Guide*. It is planned not as original work but as a compilation of existing pamphlets on various aspects of museum work. The handbook will affect the curriculum of the philosophy and practice seminars: ''We don't have to spend semesters verbally communicating basic how-to information. . . . There's nothing more boring than a lecture on museum insurance, unless you're just at that moment trying to work out an insurance system, in which case it becomes terribly interesting.'' The handbook will serve as an

informal text for the seminars and as a manual for the internship.

Another change in the seminars affects the annual student exhibition. Traditionally, the student exhibition has been the concluding assignment of the fall semester, with the museum practice students as the "prime movers" and the M.A. students working as much as each wished. As of 1974/75, each student is required to conceive, plan, research, and organize an exhibition growing out of an academic course. Individual students, or several working together, plan exhibitions as if they will actually be mounted and then submit their designs to the faculty and staff. The exhibitions selected from among these fall semester assignments are mounted later, as part of the spring semester seminar, and every student is required to participate. The effort to encourage broader class participation, more academic content, and a longer period for planning and organization derives from Museum Practice Program staff admiration for similar programs, such as those at Brown University-Rhode Island School of Design, Columbia, and other colleges where student exhibitions are not confined to one semester. As Waller puts it, "anyone who has ever tried to supervise students organizing an exhibition in one semester knows that's not enough time."[10]

Courses appropriate for meeting the cognate and elective requirements for the Museum Practice or M.A. degrees can be selected from a wide range of subjects; cognates must relate in some way to the student's major work but tend to come primarily from such areas as American culture, anthropology, and history. Distribution of course requirements and electives is flexible, the interdepartmental and interdisciplinary character of the academic program reflecting Sawyer's preference for the "broader cultural spectrum" or "cross-ruff" over an "absolutely cellular history of art program":

> I think the use of more than one perspective on this material is particularly important. . . . The art people ought to look at history programs and history people ought to look at art programs. . . . The interrelationship between these different disciplines is important to me in my own perspective of what the museum field means. . . . I suppose I'm arguing that the art historian should have a broader base to work from than he or she has now and, on the other hand, that the museum-oriented person should have a very strong background in art history. . . . My mentor, Paul Sachs, felt very strongly . . . that people should not just major as undergraduates in the history of art and go on to take a master's in history of art and then a doctorate in history of art. He thought that was all nonsense, and I'm afraid I do too. I think you need—at least in the museum world—a considerably broader base.

There is some difference of opinion among art history faculty and museum staff about how the required art history courses can best be integrated into the museum practice curriculum. The controversy is the old one of slides versus original materials. About half the art history faculty uses the museum in a significant way for its teaching; the other half relies on slides. The argument advanced by those who favor slides is that only slides can present the great monuments, wherever they are, as well as a general view of the history of art.

Sawyer stresses the use of objects within the broader cultural spectrum. Speaking of art history faculty at many American colleges and universities, he has said, "Too many art historians have never really looked at a work of art in a total sense or haven't done so until they were preparing their dissertations. I think there is something basically wrong in that training, at least in the museum context. I would carry this into teaching as well, but that isn't my primary concern." With a quiet nod for emphasis, he concluded, "Art history as now taught is not productive for either curatorial or education work in a museum, because it's too cellular, often remote from the work of art."

**The internship: how it works**

The heart of the program leading to the museum practice degree is the internship and the philosophy it represents: work is the best teacher. The degree requires two full semesters, eight to ten months in all, in an internship at a museum outside the university, plus those 20 hours a week at a university museum during the first year. Explaining his insistence on work experience to a museum seminar of undergraduates, many of whom were mulling over the decision about graduate school, Sawyer said,

> One reason I feel so strongly about this work experience business . . . is that I've come to feel that nobody can really be credible in his field just by taking museum seminars or listening to me talk or somebody else talk on the subject. Really, if you want to go to the next stage, then it's the work experience in the museum here or in another museum in an internship that is the really basic thing you will get, and that is probably the most drastic need, I think, for anybody preparing in this field. . . .

There are several significant visible aspects of the internship: it lasts a full academic year; the intern is placed in the museum as a working staff member, not as a university student; and the museum assumes the primary responsibility for the intern. As Bret Waller pointed out, "The internship is structured to provide significant actual job experience. . . . The commitment we extract from the individual museum directors is that the intern not be put in a position where there is purely repetitive mechanical work." No requirement is made of the interns that they return to Ann Arbor during the internship year. What is required of them by the university is that they write a series of reports on their work— "technically, monthly reports," according to a university museum staff member, "but they often become quarterly."

One Museum Practice Program graduate said about her internship at the Toledo Museum of Art,

> It went very well. . . . I was assigned a supervisor, who was one of the curators and—it seemed important to me at

the time—I was given an office with the curators. I suppose the thing that impressed and pleased me most was that I was considered almost from the beginning to be part of the staff of the museum. I went to staff meetings. I was directed, I had someone to go to, to whom I was really specifically responsible. . . . I wrote intern reports monthly [to the chairman and to the supervising curator].

The internship was supervised almost exclusively by the museum, which was another reason I felt that I was in fact a staff member of that museum, not a Michigan student doing some field work. . . . I really almost forgot it. The fact that I was a Michigan student only came up when I came to do my research essay, which had to be approved by the chairman. In fact, that went completely through the museum, and it was sent to him by the museum.

The range of this intern's jobs at the Toledo Museum included registration, work on exhibitions, and education, but "in most cases, it was a matter of accompanying people on their jobs and observing. . . . It was left up to me to say, now I'm ready to do this, or may I go along with you to do that? And this I appreciated, too. I felt I was an absolutely independent member of the staff. I must say a free body in a busy museum is fair game for anyone, and there was not much free time." She recalled one of the more vivid memories of that internship year:

I had to install a show of the most incredible paintings I've ever seen in my life . . . and I did spend two days with these things in an empty white space and finally, tearing my hair out, ran for help. Help was very definitely available to me, but the feeling was that [you] should be allowed to . . . get fully into as many things as possible and then decide where you are most comfortable.

## The Regional Internship Program

As that intern pointed out, she was "walking into a fully established, perfectly self-sufficient big museum." By contrast, those students who have gone into the Regional Internship Program find that the smaller museums urgently need the intern, who sometimes fills a job the smaller museum cannot afford to hire someone for. A small museum "has to utilize the services of anyone who happens to be there, as if they were already a professional," observed another museum practice graduate.

In one of the Regional Internship museums, which had a budget of about $350,000, there was no registrar. The intern, who said she wanted a broad museum training experience as well as specific training as a registrar, became a sort of de facto registrar, rearranging all the registration files and reorganizing certain procedures. She described her work in a report to the program chairman:

I have found a great deal of revision needed in the files. I have found works that have been here as long as 30 years without ever having been registered, and many registered works that are no longer here but have never been formally de-accessioned. Therefore, I am endeavoring to make the

files reflect the current state of the collection and account for these discrepancies. I am also working on many incomplete and/or incorrect files.

This intern also served as an assistant curator, a job in which, she reported, "I have been involved in writing general information on objects in the permanent collection, and at times information about forthcoming exhibitions and special activities, for a calendar of events which is mailed to members each month." As librarian, she said, "I keep a card index of books and catalogues received and order what books I consider necessary for reference work, conservation, or dealing with the permanent collection or other exhibitions. . . . [The work has led to] the discovery of numerous books which were never recorded in our files, and many books which have disappeared over the years."[11]

The director of that small museum, the Flint Institute of Arts, explained his understanding of this intern's job: "[The intern] is here to see all exhibitions and loans are in good order, and all files are organized. . . . She has come as a full-fledged staff member." Another director of a still smaller museum—the Grand Rapids Art Museum, whose annual operating budget is $150,000—also served by the Regional Internship Program, saw his intern's responsibilities a little differently: "The ambitious mission of the small art center requires people to be flexible, it forces cooperation"; the intern, he felt, should be involved in policy-making at the host institution and should receive specific training from the museum staff. The intern in that art center gave tours to schoolchildren, put together an exhibition and wrote a catalog, and attended all board meetings during her internship year.

**Why the small-museum focus.** The Regional Internship Program, first operated in 1973/74, developed out of Sawyer's conviction that museums or art centers in small cities suffered from many "unmet needs." "There is apparently a strong sentiment," he has noted, "among these museums, representative of many others of modest size and resources, that the existing programs in museum training are not well adapted to meet their specific requirements and to provide potential candidates with the broad spectrum of knowledge and experience required in a community oriented museum."[12] He elaborated on the point in an interview:

I see here a difference in focus and perspective from the Ford Foundation curatorial [internships], which I should say were the flagship for training in this field; and I'm not quarreling with those at all, but I'm just saying that they represent one very specific part of the spectrum and not the whole story. . . . They felt their mission was what I call a filtered-down formula. And that's one way to do it, but I just don't think that the demands are going to be satisfied entirely from starting at the Met and NYU[13] and then putting people out into the provinces. . . . Once people are in New York they seem to want to stay there, and they leave with a certain amount of reluctance; also they get

very little sense of what the mission is or what kind of an institution these other places are. . . .

Anticipating internship situations in the small regional museums that are different from those in the larger museums to which University of Michigan interns had traditionally gone—specifically, "less individual supervision and more responsibility"—the university and the four regional museums agreed that interns going to these museums might "need a greater degree of maturity and more specific museum training and experience." They also felt that for the program to succeed, "the interns must be considered and treated as junior members of the museum staff with defined responsibilities as well as opportunities for a learning experience."[14]

### Institutional relations: the university and the internship museums

The university and the participating museums make no contractual or other formal agreement governing the preparation the student is expected to provide. The closest approximation is that arrived at by the university and the four small regional museums, who agree that the "essential common denominators" for preparation of student interns would be "a broad and thorough grounding in the history of art, with some area of particular interest and expertise; experience in some area of the practice of art and, ideally, some experience in teaching; and finally, an exposure to and orientation in museum work."[15] For the first time, one of the large museums long affiliated with the program, Toledo, in selecting its 1974/75 intern, sent the university a job description that spelled out what was required of the intern and asked the intern to specify, in turn, his goals for the internship year.

Matching students to internships is as informal and trusting as the university's agreements with the museums. Generally, the prospective interns visit a participating museum and indicate their interest; their names are then sent by the Museum Practice Program chairman to the museum director, who makes the final selection. Some museum directors are content to bypass this process; one says he simply asks the chairman, "Please send me the best quality student." Others are more demanding; the Toledo Museum included in its interviews of prospective interns a request that the student give an unprepared talk in front of an object and submit written work. Believing that it is "in the interest of all concerned to have this, as far as possible, a mutual choice,"[16] Sawyer ascertains students' special interests (though a graduate comments, "Sometimes I think the interns are pretty inscrutable") and assesses students' possibilities on the basis of their performance in academic courses and in work at a university museum.

**Museum as supervisor.** Once matched, the intern and the host museum are left pretty much on their own by the university. "The one problem we have to avoid," said Sawyer, "is a potential conflict between . . . the academic equation here

at Ann Arbor and their responsibilities to the museum." The university, he said, takes "no direct responsibility for those [interns] except as they continue to do graduate work here" in the required thesis or research essay.

The resulting pattern, as many of the program's graduates have observed, is of a student intern who rapidly ceases to be or feel like a student. "The internship is structured in such a way as to provide a significant *actual* job experience," said Waller. Individual museum directors are trusted to know that "repetitive mindless work is improper use of an intern," he observed, "but if there are less than comfortable working situations, that's part of life."

Not everyone may support the validity of this sort of internship. "As a learning lab, you might not set it up that way," admitted Waller, "but a small museum, frankly, can't do that." Said a museum practice graduate, "For all intents and purposes, it's as if you were employed by the museum . . . and it is really perhaps the best way to learn. You sink or swim, but nothing will ever frighten you again." Advantages of an internship over an ordinary first job are, or ought to be, that an intern can show ignorance without embarrassment and ask for—and receive—careful supervision.

Whether that supervision by the host museum staff is adequate and, more significant, whether it is adequately scrutinized and evaluated by the Museum Practice Program staff back at the university, are questions that trouble some observers.[17] The quality of the internship experience depends in great measure on the attitude of the individual museum director and the nature of the museum. What does the university see as its role? "We've said that the internship is the responsibility of the museum, and one of my problems is to defend the faith that the [host] museum is always right. I don't always feel it is, but I take this position with the student," said Sawyer.

Explaining why he is "inclined to take the museum side with the interns, even when I don't entirely agree with the museum's position," Sawyer said,

In my view museums, large and small, remain highly individual and subjective institutions largely influenced by the particular perspectives of their directors, trustees, or benefactors. It is something of a shock for graduate students, as interns, to discover this, but I think it is part of their learning process in becoming museum professionals. . . .

Without a nucleus of [mutual confidence and respect], I question whether any contractual agreement between the university and the museum can be a lasting one. Certainly the intern is entitled to a clear statement of his or her opportunities, privileges, and responsibilities under the arrangement, and to be treated with the courtesy and respect accorded any member of a professional staff. Here, frankly, standards obviously differ, but the candidate who can survive and adjust to these differences is most likely to succeed.[18]

Waller added, "If [the interns] feel that what they're doing is not satisfactory, then we can help."

But what if a museum is wrong? And how can the university help? As the university has not yet published criteria, guidelines, or specific requirements for the internship, it has customarily relied on what Sawyer described as "close continuing communication" and personal friendship between himself and the individual museum directors. This reliance on personal honor and judgment may mark the Michigan Museum Practice Program as a vestige of a time when the men and women who inhabited the museum world knew one another well and tendered one another the grave courtesy of unsullied trust. Such reliance may also be untenable. With Sawyer's retirement, more specific institutional agreements remain to be worked out.

**Steps toward better communication.** Sawyer himself made a beginning. During the first year of the Regional Internship Program, interns and representatives of the museums at which they work met twice with Museum Practice Program staff, faculty, and students. At these meetings, the interns reported on their experiences; one may wonder with how much candor they report in the presence of their "employers," but Sawyer feels that "the candor of these discussions and apparent lack of inhibitions has been quite impressive."[19]

A university museum staff member believes that these meetings are most useful for the prospective interns. The current interns, said one, "convey to them the hard facts of life, that in fact you are going to have to work every day and that things are going to depend on you to an extent that things don't depend on you in graduate school. You know, the world doesn't crumble if you don't get your paper in. Things can pretty well crumble if you don't get to work on time. That sounds trivial but is obviously an important aspect of the way one functions."

A newsletter from the program's staff to the directors of the four regional museums provides information and a sense of continuing university involvement in the internship. Perhaps the most significant element in that continuing involvement is a subject not yet mentioned: money.

**Financing the internships**

A grant of $30,000 from the National Endowment for the Arts covers the internship year in the four regional museums. Each of the participating museums is assigned $6,000 for the expense of an intern and a percentage of operating costs. The remaining $6,000 goes to the University of Michigan for general administrative expenses, a continuing responsibility assumed by the museum that includes the newsletter, regional meetings, and incidental expenses. (An additional NEA grant of $4,000 provided post-internship travel—$1,000 maximum for each intern—for the summer of 1974, and carried with it a request for a written report by the intern on that travel.)

The National Endowment for the Humanities is currently supporting one curatorial intern at the Toledo Museum of Art. Until 1973/74, Michigan interns there were supported entirely by Toledo Museum funds. Interns at the Henry Ford Museum are paid by that museum, which also contributes a modest allowance for travel and research. Internship arrangements with other museums—new internships are being established at the Detroit Institute of Arts and at the Indianapolis Museum—are made on an individual basis. In a few very limited instances, University of Michigan funds have provided financial support.

The NEH stipend is $5,000; the travel allowance to the intern is $500; travel allowance to the institution (which can be presented to the intern if the institution sees fit) is another $500. As is the case in all internship financial agreements, this money is considered a "fellowship" rather than a "salary," as the internship is required to satisfy and complete the degree.

Now and then a student will arrange his own internship, asking the university only for logistical assistance and not for money. A variation on the internship theme is now under consideration—a "floating internship," which would try to match a student whose specific interests are suited to a specific institution, without asking the institution to commit itself to future internships. These "floating internships," said Waller, "will give us the kind of flexibility we don't now have" to accommodate the person whose needs are not necessarily served by museums in the program. His assistant noted that "in the old days, when there were one or two persons in the program . . . there were these tailor-made internships, partly supported by [the University of] Michigan. . . . But there are a lot more people now, and it's a lot more expensive. That was ideal: to look around the country and find the best place for an individual and have the bargaining power to say we can support at least part of the internship." Both said that with, "six, or eight, or ten interns coming due at the same time, you just need to have a more institutional arrangement."[20]

**Assessment of internship procedures by faculty, staff, museums, and interns**

As the newest aspect of the Museum Practice Program, the regional internships raise the most unanswered questions. Two interns in the regional program complained about small towns and small museums. One said, perhaps inaccurately, that "small museums mean small towns." She added, reflecting on the problems small-town museums face, that she "couldn't take another small town." Another commented that one of the problems of working in a small institution is that "contact with other professionals is so limited one cannot get broad exposure." The director of one of these museums is more hopeful that the program will succeed in its goal of serving a neglected area—training the museum "generalist" who can do many things in a small museum.

Sawyer remains convinced that small museums have "unmet needs" and that "there are going to be ten jobs in these institutions as a class for every single one there is going

to be in one of the larger institutions." Of the program he conceived and shepherded through its early stages, Sawyer has observed, "we still have to prove out, because in this particular context I think ours is a pioneer program." If "proving out" requires closer and more systematic supervision of internships, as some observers believe, then Waller agrees that criteria, guidelines, and contractual agreements may be good to consider. To find out how things are going, Waller thought "it might be useful to have more of a sort of circuit-rider approach rather than a visitation with a group of people." But his assistant, Marjorie Swain, cautioned, "we'd want to avoid any semblance of checking up or any implication that we were monitoring it at all."

Beyond these specific and procedural questions, there were the larger questions raised by the Museum Practice Program staff in the customary university review of the program: funding and staffing, the credibility of the program nationally and regionally, and its size and scope.[21]

### Required work experience at a university museum

Each museum practice candidate is required to work at a university museum during the first, or Ann Arbor, year of the program. Students may choose to work in the Museum of Art or in the Kelsey Archeological Museum, whose staff supervises them in assignments discussed and agreed on with the chairman of the program.[22] Formerly, students working in university museums were paid (varying amounts, and occasionally not at all), but as of 1974/75 their campus museum work was degree-required and performed without pay. Like the required second-year internship, this separation of support from services is a bookkeeping device, but the program's staff believes it is an important one, for it equalizes the requirements and the rewards of all students. Every fellowship or scholarship student (and most students do receive aid) continues to receive the entire support due him on the basis of need and merit; it is simply no longer given as payment for services. The required "internal work experience" has a further value, according to a graduate: "It eases the transition [from student to intern], allows staff to get to know people and how they work—with other people, with objects, with responsibility."

The student has the option of working 20 hours a week for one term or 10 hours a week for each of two terms. Most opt for the second arrangement, as the first is the equivalent of a half-time job. A student may work more terms and may, if there is a strong reason, work each term in the same section of a university museum. The staff and faculty prefer, however, that students move from section to section, in the belief that they will learn more that way. A graduate of this "internal work experience" said she got a taste of everything—curatorial work, archives, registration, education, membership. She believed that the general orientation is "helpful; it doesn't preclude curatorial work but does introduce a student to everything in a museum, especially in a small museum."

### And what about museum education—or the training for it?

Though the program announcement of April 1974 includes educational positions among those for which Museum Practice Program graduates "should be well qualified," there are no specific courses and no specific training in museum education, and there are no methodology, visitor psychology, or other education sessions. Sawyer said ruefully that perhaps "education courses are worth trying, but my own instinct is that experience is the teacher in that equation." Students interested in museum education are encouraged to do research in it, the museum seminar bibliography includes a section on education, and the entire museum practice class calls on the education department of every museum they visit. A Museum Practice Program staff member noted,

There are a number of people now about to go into an internship who are very definitely interested in museum education. That's their focus. The internal work experience we give them . . . may have to do with writing audiovisual material . . . and their internships were chosen insofar as possible for their educational interest. . . .

Several of these students have taken courses in audiovisual techniques in the School of Education. Faculty and staff see this as a possible clue to future developments, as museums increasingly use audiovisual devices for teaching and as museum professionals or professionals-to-be turn to whatever credible sources they can find. Sawyer remarked, "I'd say these A-V courses are probably the first indication we've had that there are viable courses in the School of Education." Waller reported that two students

gave as their semester project a videotape on printmaking techniques as related to our collection. Another did a slide-tape on German Expressionist prints, and we spent a lot of time looking at these and critiquing them and talking about what it is to take a complicated subject and try to boil it down to 15 minutes. I think it's been very good for them, because it's the first time they ever tried to popularize something. These are basically art history majors, and they came away, I think, with an enormously increased respect for what popularization is all about—to try to boil it down and try to say something that is still true and yet is simple and concise enough to be comprehensible.

Sawyer commented, "I would have to say frankly that I don't think our correlation with the practice of art department or art education . . . is as close as it could be or as useful as it might be"; in those respects, he continued, "I'm not sure that [this program] does directly prepare a student for a career in museum education." But he added firmly, "I don't see any difference personally between preparing for museum education and preparing for museum curatorial work in a fundamental way. . . . A person who is interested in museum education needs to have that same kind of approach." Waller agreed:

It seems to me that the common language of museums is

the language of art historians and curators, and for an educator to function in that environment, he's got to be able to speak that language. And therefore even a person who is committed to museum education of the most innovative kind—in fact, especially [that person]—in order to succeed in a place of any size where he's going to be dealing with directors and curators who are essentially art historians, has got to understand what they're about and understand what the museum traditionally is about and understand the respective problems. Otherwise he'd be just frozen out.

A statement from Clifton Olds, chairman of the art history department, echoes what many art historians have long argued: that when visiting museums he often "overhears patently untrue" information. He stressed that anyone who teaches in an art museum "must have a strong academic background in art history." Art history rather than education or community services ought to be, he insisted, the heart of training for museum educators.

Sawyer agreed that "the student is caught" between rigorous requirements of general art history courses and museum-oriented courses and work apprenticeship. His own emphasis in the Museum Practice Program—one of the few museum training programs trying to turn out generalists for museum careers and trying to prepare students for careers in either art or history museums—is that students gain more from their general intellectual background than from either education courses or what is called "museology," which he considers "just a cycle of methodology." Speaking to an undergraduate class, he said, "Particularly if you are going to be in museum education, you have to be able to illuminate the material—a decent background in literature and language is essential, but of course it is essential for any well-oriented art historian anyway. . . ."

Clearly, then, the Museum Practice Program's academic preparation for museum educators has been precisely the same as for museum curators. Waller has indicated he will not change this approach: he intends to continue Michigan's broad training for future professionals in either art or social history museums but is apprehensive about museum education training programs that try to train people to teach in museums as different as he believes art museums and natural history museums are. (He has referred specifically to the broad-based philosophy of the new M.A.T. program at George Washington University; see report on that program in this chapter.) He sees the objects in those two kinds of museums as totally "different in function—art objects *can* be representative, but they are primarily unique, whereas the primary function of an object in a natural history museum is to represent all other similar objects."

**Practicing museum education.** The most direct education training open to a first-year Michigan museum practice student is teaching in the University Museum of Art. For a time, the museum provided group tours "on demand" to school

and adult groups from Ann Arbor and the surrounding area. It answered an expressed community need, said Sawyer, but he characterized it as "a selfish effort" to allow the museum training students to get some teaching experience.

The training was organized by the executive secretary of the museum's membership program, whose tours the graduate students observed before beginning their own. Though graduate students were expected to do their own research from the museum's files, the executive secretary provided them with general tour outlines, a summary of certain collections, and general instructions that stressed the question-and-answer teaching approach, offered sample illustrations of explanations children can understand—"this painting is made on the same fabric as your tennis shoe"—and made helpful suggestions on the logistics of greeting and ending tours.

Guides ranged in number from two to six, all unsolicited volunteers from the art history department of the Museum Practice Program. Most originally heard of the training from acquaintances, though by 1971/72 students in the Museum Practice Program were regularly informed that the work was available; it was, however, not required of them. One graduate said she "averaged about one or two tours a month and would estimate that the number of tours given by the entire museum ranged from approximately 10 in 1968/69, to 20 in 1969/70, to 30 or 40 in 1971/72."[23] She continued: "All tours for schoolchildren were general, though we did do special topics on request (Asian Art, American Art). Most groups were school classes from suburban schools (not local schools—probably due to lack of transportation funds) who could use field-trip money for their visits, or from ladies' clubs, with a few groups from local institutions such as Ypsilanti State Hospital." These tours ceased while the museum was going through a reinstallation in 1973/74; at this writing their resumption was under consideration.

**Some conclusions about the Museum Practice Program**

In summary, there are three major issues raised by the Museum Practice Program at Michigan:

1. The internship as a crucial element in museum training is the single indisputable fact of life in Michigan's program. "There's no other reasonable preparation," according to Waller. "The directors are saying what they look for in the potential curator or educator or staff member is museum experience . . . and what we are looking for is first jobs for people. . . . The question is how do you prepare people so that they're ready to go into a first job? I think the answer is through an internship." His statement echoes Sawyer's: "Nobody can be really credible in his field just by taking museum seminars. . . . An internship is . . . probably the most drastic need . . . for anybody preparing in this field."

2. The validity of the internship as "an actual job experience"—with the host museum taking the primary responsibility and the university taking a back seat—can be argued both ways. The Michigan staff defends its past and present

practice—what the former chairman calls "defending the faith"—on the grounds that most museums can be trusted to be fair and helpful to an intern. Having so far established no formal guidelines or requirements, the university has also set up no procedures to pinpoint or correct flaws in internships. It has been a gentlemanly agreement. As the program grows larger, and as the staff attempts to do the work of Sawyer—who "has done everything; he's a kind of irreplaceable person," according to Waller—"we're going to have to be more systematic, develop a kind of system that isn't dependent on his encyclopedic knowledge and extensive acquaintance throughout the country."

3. The program's emphasis on art history and related fields—the "cross-ruff"—is not likely to give way to an emphasis on methodology, technology, psychology, or any other approaches that fall under the unhappy heading of "museology." The language of the art museum is art history, argues Waller, and that's the language Museum Practice Program students will continue to be expected to learn, including those who go into museum education.
—A. Z. S.

## Notes

[1] *Research News* (Ann Arbor: University of Michigan, Office of Research Administration), vol. 22, pp. 2, 3.

[2] For sources of quotations without footnote references, see list of interviews at the end of this report.

[3] The University of Michigan Museums include the Museum of Art, one of the largest university museums in the country (see checklist), and the Kelsey Museum of Ancient and Medieval Archeology, which houses collections from the Mediterranean area and the Near East, including Egyptian objects from the Roman, Coptic, and Islamic periods. The latter is closely associated with both the Department of History of Art and the Department of Classical Studies.

[4] *Graduate Studies Handbook in History of Art*, 1972/73, pp. 5–7.

[5] Program announcement, April 1974.

[6] Charles Sawyer, memorandum to Museum Practice Committee, November 16, 1973.

[7] Charles Sawyer, letter to CMEVA, July 10, 1974.

[8] Ibid.

[9] Public Program Grant Application, National Endowment for the Humanities, NEH #PM-9259-254, May 1, 1974–June 30, 1975, p. 7.

[10] Letter to CMEVA, August 5, 1974.

[11] Report to the Museum Practice Program chairman from Pearson Marvin, December 1973.

[12] Letter from Charles Sawyer to Tom Leavitt, director, Museum Program, National Endowment for the Arts, March 31, 1971.

[13] New York University's Institute of Fine Arts museum training program, carried out in cooperation with the Metropolitan Museum of Art; see report in chapter 12.

[14] Sawyer to Leavitt, March 31, 1971.

[15] Ibid.

[16] *Newsletter*, Regional Internship Training Program, March 5, 1974.

[17] According to Sawyer, "The question of 'scrutinizing' is a delicate one. We have tried through our newsletter and occasional visits to encourage some common standards and procedures" (letter to CMEVA, July 10, 1974).

[18] Ibid.

[19] Ibid.

[20] Degree-required internships carry stipends that are not taxable, whereas nonrequired internship stipends are subject to taxes. Museum Orientation students have the option of an internship, if it can be arranged, and do not receive official UM credit for it. Their stipends *are* taxable and must be reported to the IRS, although the withholding is negligible as the amount of the stipends is low.

[21] *Newsletter,* Regional Internship Program, January 4, 1974.

[22] The official graduate school terminology is Practicum, meaning practical experience, which is measured in units. One unit is the equivalent of full-time work for one academic term; thus a student working 20 hours a week for one term earns ½ unit; ¼ unit is earned for 10 hours a week for one term. The museum internship is worth two units. (Thus the Museum Practice Program students are required to accumulate 2½ units, Museum Orientation students, ½.) The graduate school rejects the term "work experience" because of its apparent and misleading association with federally funded work experience programs; the term "internship" is rejected because that means doctors and hospitals.

[23] Janie Chester, memorandum, June 14, 1974.

## Interviews

Chester, Janie K. Student, Museum Practice Program, University of Michigan; Coordinator, Educational Fellowship Program, Toledo Museum of Art. February 12, April 2, 1974.

Clark, Carol. Graduate, M.A. in History of Art, University of Michigan; Student, Case Western Reserve University-Cleveland Museum of Art Museum Studies Program, Cleveland, Ohio. December 19, 1973.

Gaidos, Elizabeth. Graduate, Museum Practice Program, University of Michigan. December 12, 1973.

Hodge, Stuart. Director, Flint Institute of Arts, Flint, Michigan. April 4, 1974.

Mandle, Roger. Associate Director, Toledo Museum of Art. May 2, 1974.

Marvin, Pearson. M.A. in History of Art with Museum Orientation, University of Michigan; Intern, Flint Institute of Arts, Flint, Michigan. April 4, 1974.

Myers, Frederick. Director, Grand Rapids Art Museum, Grand Rapids, Michigan. April 5, 1974.

Olds, Clifton. Chairman, Department of History of Art, University of Michigan. December 13, 1973.

Sawyer, Charles H. Chairman, Museum Practice Program (till fall 1974), University of Michigan. December 12 and 13, 1973; June 13, 1974.

Slee, Jacqueline. M.A., History of Art with Museum Orientation, University of Michigan; Intern, Grand Rapids Art Museum, Grand Rapids, Michigan. April 5, 1974.

Swain, Marjorie. Graduate, Museum Practice Program, University of Michigan; Assistant to the Director, University of Michigan Museum of Art. December 12 and 13, 1973; May 15, June 13, 1974.

Waller, Bret. Director, University of Michigan Museum of Art; Chairman, Museum Practice Program (fall 1974). December 12 and 13, 1973; May 15, June 13, 1974; telephone, June 14, 1974.

Yassin, Robert. Chief Curator, Indianapolis Museum of Art; Former Assistant Director, Museum Practice Program, University of Michigan. May 9, 1974.

# GEORGE WASHINGTON UNIVERSITY'S M.A.T. IN MUSEUM EDUCATION

The George Washington University
Washington, D. C. 20052
**Careful screening of applicants, a highly structured curriculum, stress on learning theory and teaching techniques, and field work in both museums and schools characterize this university-based master's degree program in museum education. Although the first year's class in 1974/75 had more art history majors than scientists and historians, the program is meant to be interdisciplinary, and the students find the mixture stimulating. To make sure each student is immersed in content, one-third of the program is required coursework in one academic area; the rest is divided equally between audience and museum studies. CMEVA interviews and observations: November 1973; March and May 1975; March 1976.**

### Some Facts About the Program

**Title:** Master of Arts in Teaching in Museum Education.
**Audience:** In 1974/75, 24 graduate students, ages 22 to 47, from ten states and Israel. Students came from a wide range of disciplines: education, art history, fine arts, architecture, anthropology, French history, art education, natural science, zoology, botany, history, and American studies. Some are former teachers; many have had teaching experience. Half had some museum experience, ranging from undergraduate work-study to the directorship of a historical society.
**Objective:** To prepare professionals for work in museum education departments or for jobs that link museums and schools.
**Funding:** Planning-year funds came from the National Endowment for the Arts, matched by an anonymous donor, and from the budgets of the Department of Education and the Division of Experimental Studies. In 1974/75, the first year of the program, the National Endowment for the Arts contributed $44,248 (20 stipends at $1,200 each; 10 travel grants at $500 each; the rest for printing and honoraria), matched by tuition and in-kind services from the university. The National Endowment for the Humanities gave the program $18,600 that year (2 stipends at $7,000 each; 8 stipends at $1,200; and ten $500 travel grants).
**Staff:** During the planning year a program director from the department of education, a part-time coordinator, and a part-time secretary. Current staff includes the program director, a full-time research instructor, and a full-time secretary.
**Location:** Classrooms and offices in the university's department of education. Travel stipends enable students to visit museums in the Washington, D.C., area and other parts of the country. Students also attend meetings at local zoos and art, history, preservation, museums. Internships are arranged in area museums, the zoo, historic sites; field placement takes students into private and public elementary and secondary schools, as well as adult education settings.

**Time:** Ten months from July through May.
**Information and documentation available from the institution:** Printed brochure, the university catalog, an article prepared by the University Publicity Department.

As a teacher and principal in Maryland public schools, Marcella Brenner had often noticed that children returned from field trips to museums with a sort of "empty excitement"[1]: there seemed to be little connection between the trips and the curriculum of the school. Children, Brenner felt, did not quite understand why they had been taken to the museum in the first place.

Over the years, and particularly after she joined the education faculty at the George Washington University in Washington, D.C., Professor Brenner thought a good deal about what she calls the "lost opportunities" that museums represent in education. She found that at all levels, the university level not least, students and teachers failed to make use of the wealth of material available for study in the museums.

But she found, too, that the failure was not only the teacher's. In her experience, few museums in the D.C. area reached out to help the teacher; in fact, museums with some of the largest education departments seemed to offer least help of all. Teachers then, as now, said Brenner, did not know that there were people in museums to whom they could turn, who could match the school audience's needs with museum programs and personnel.

### The search for a training format

In 1972, Professor Brenner asked the director of the Corcoran Gallery, Walter Hopps, to help her find someone who could research and think through with her a possible course of study for museum educators that might prepare them more usefully for their work. Hopps recommended the curator in charge of the Corcoran education department, Sue Hoth, and agreed to release her half time to work with Brenner. Mrs. Hoth, an artist with both museum and university teaching experience and a graduate degree in education, shared Professor Brenner's interest in training for museum education and as one of the founders of Washington's Museum Education Roundtable (see report in chapter 15) had been active in trying to bridge the gap between educators in museums and teachers in schools. She also added to Brenner's concern for children her own interest in adult education and in "incidental" learning.

With financial backing from the university and a private donor, whose contributions were matched by the National Endowment for the Arts, the two women searched through museum training programs for courses aimed specifically at prospective educators. They found one program, the internship at the Toledo Museum (see report in this chapter). Beyond that, neither museums nor universities seemed to have taken the museum educator seriously; no institution had de-

vised the kind of joint museum-university program they had in mind.

Brenner and Hoth thus set about to design their own program. It would be university based, offering an M.A.T. from the department of education at George Washington, and it would make use of expertise from all Washington, D.C., museums, from the Smithsonian Institution to the local arboretums and zoo. For the planning year, May 1, 1973, to July 1, 1974, the two program designers set seven objectives:

1. To develop a curriculum that would integrate three areas of study—the collection, the audience, and the techniques of museum education.
2. To tap the expertise of both the university and museum communities.
3. To find money to pay students for their internships and thus open the program to a broad range of candidates.
4. To develop criteria for the selection of students.
5. To publicize the program widely.
6. To interview candidates for the first year of the program.
7. To identify the literature, people, and programs that already were a part of or could form a common body of knowledge for museum educators.

## Philosophy behind the curriculum and the program

For Brenner and Hoth, museum educators have enough in common, no matter what the content of their institutions, so that one course of study can encompass the training needs for them all. It is not a philosophy with which everyone agrees: many art museum educators, for example, feel that teaching people to look at painting and sculpture requires pedagogical approaches quite different from those most useful in science and history museums. But the authors of the George Washington program have considered their decision carefully and are prepared to defend it on two grounds: (1) all museum educators are interested in providing the maximum opportunities for the public to learn from and enjoy museum collections; (2) for all museum educators, the distinction between learning from books and learning from objects is fundamental.

This position has determined the basic characteristics of the George Washington program—the emphasis on understanding and communicating with the audience, the stress on learning theory and varied teaching techniques, and above all the interdisciplinary nature of the program and the diversity of background and experience among the students chosen for it. Indeed, so firmly committed are Brenner and Hoth to the idea of sharing (an often-used word in their conversation) among museum educators that they planned the program to be interdisciplinary—the first of its kind anywhere, they claim—and both of them have worked hard to develop a sense of communality among the students.

## Outline of the curriculum

The curriculum that has resulted from the Brenner-Hoth philosophy—and the many discussions they have held with educators of all kinds in the Washington area—is based on the idea, again, that each student must know one discipline well (in effect, the collection or a discipline closely related to it), the museum audience, and the museum as an educational setting. These three program areas provide the framework for a curriculum that combines study with field work in a museum and a school system.

The program is described as "an intensive one-calendar-year of work," consisting of 33 semester hours. Students enroll each year for an initial six-week summer session during July and August and complete the course at the end of the third semester in June the following year. At that point, according to the brochure, the graduate "will be qualified to enter an education department of a large museum as a staff member with special expertise, or to undertake broad responsibility for education programs in one of the smaller museums."[2]

This is the way the curriculum is arranged:

1. *Specialization in the student's undergraduate major*— art history, anthropology, botany, zoology, history, American studies, or "any content appropriate to education in a museum," as the brochure puts it. Each student must earn a minimum of 12 credits, to be taken each term throughout the three semesters of the program. These may be graduate or undergraduate courses, in which students may enroll at any of the university's eight schools or at one of the four other universities that are members with George Washington in a local university consortium (American University, Catholic University, Georgetown, and Howard).

   A "limited number" of students with previous work in psychology, sociology, or educational psychology are allowed to concentrate on museum education research, a course of study meant to make them useful as evaluators and researchers of museum audiences and education programs.

2. *Audience studies.* Course work here is designed to help students understand the learner, both individually and in groups, and the nature of learning. Subject matter ranges broadly: audience analysis for such things as age group characteristics and interests, group dynamics, special needs of the handicapped, exceptional children, and senior citizens; learning theory; the adult learner; body language; learning in the museum, including visitor behavior, the group tour and its alternatives, docent techniques, evaluation, and outreach; schools and other community institutions. There are also classes in practical communications skills—impromptu speaking; writing proposals, reviews, radio spots; interview techniques; designing publicity campaigns and the printed material to go with them.

   These classes are led mainly by Professor Brenner, who brings in a variety of one-time lecturers and consultants on special topics.

   Field work, which takes place during the fall semes-

ter, requires students to spend two days a week at a local public or private school, teaching or helping in the classroom and serving as a resource person between the school and the local museums. A weekly seminar is part of this field placement, which adds up to six credits.

3. *Museum studies.* The aim of the course work on the museum is to give students a sense of the institution as a whole and the responsibilities of people in it. Classes deal with administration and trusteeship, the planning and installation of exhibitions, duties of the registrar, interpretation of the object, and the history of U.S. museums and museum education. A major assignment the first term was to document one object exhaustively to help students learn about sources of research and analyze what aspects of an object should be conveyed to an audience. Another assignment, begun before the students came to Washington in the summer, was to research the history and changing goals of a museum near each student's home, bring the descriptions to the class, and use them to develop a time line on the history of U.S. museums.

To supplement the course work, students are asked to write reports on aspects of their visits to museums (analyses of visitor behavior and audience composition, for example) and are given a heavy assignment of outside reading. Again, several experts—curators, trustees, exhibition designers, and others working in and around museums—are invited to lead class discussions, which are organized by Mrs. Hoth.

In addition to museum visits, field work for the museum studies course consists mainly of one day a week in a museum during the fall semester and a university-supervised internship at a local museum during the spring term. A three-hour weekly seminar that accompanies the internship deals with specific subject matter (such as alternatives to group tours), problems students encounter in their placements, and the development of skills, such as research and documentation of programs. Students are asked to keep journals for both the audience and museum courses, to be read by the staff and discussed at the weekly meetings. The internship and seminar in museum education also carry six credits.

## Recruitment and selection

Once the university had approved the curriculum, the program staff mailed posters to about 1,200 museums and to department chairmen (history, American studies, geology, earth sciences, English, education, psychology, art, and archaeology) in 800 colleges and universities. The insert cards sent with the poster brought "many" requests, according to Mrs. Hoth, for the program brochure.

In addition, notice of the program appeared in *Museum News, History News*, the university's alumni magazine, *Arts Reporting Service*, the Museums Collaborative *Newsletter* in New York, and the newsletter of the National Trust for His-

toric Preservation. Letters went to the American Association of Zoological Parks and Aquariums. There were local radio interviews, presentations at professional meetings, and visits by the program staff to 20 colleges and universities on the East and West coasts.

The campaign brought 188 applications from 28 states, 180 of them women (a phenomenon due partly, Mrs. Hoth explains, to the large mailing that first year to art history departments in universities). Most of the candidates were interviewed by a committee that included members of the university staff and Washington-area museum educators picked to help with the selection.

**Interviews.** As with the rest of the program, the interviews have been carefully planned. They have two goals—to help candidates get an accurate picture of museum education and to force the interviewers to define the qualities required in an ideal museum educator.

As the coauthor of a book on what she likes to call the "professional conversation," Professor Brenner has, not unexpectedly, clear views about the agenda of an interview: it should inform all the participants, including the candidate; there should be a sequence of events that build confidence among them and that illuminate information as it is revealed; the interviewers should understand their individual biases and any barriers (the aspect of control an interviewer wields over the person being interviewed, for example) that might affect their ability to learn from the candidate.

In the M.A.T. program interviews, the agenda typically begins with an attempt to find out how much the student knows about museums and museum education; it then moves to questions about handling practical problems in museums or with particular audiences and finally takes up such individual problems as finances or housing, on which a student might need help from the university.

All of this tends to be interspersed with personal conversation on travel, on the most and least pleasant experiences the student has had (always dealt with supportively with such comments as, "Oh, I agree. That's a very difficult thing to handle"). As the interview progresses, Brenner looks for learning needs and potential and also the student's ability to share with the class a particular skill or attitude she has spotted in him.

Following this agenda, members of the interview teams soon learned during the first round in spring 1974 that they were looking for lively, well-reasoned, and well-expressed answers; a candidate's strong interest in his field and in museums; experience with people that indicated an ability to supervise, to organize work, and to empathize with others. In some cases, the interviewers sensed a lack of energy and drive or inability to follow through on a task. In other cases, they found the students' interests too one-sided—focused either on the audience with little understanding of the value of museum collections or on the subject matter at the expense of the audience.

**Selection.** Even though there was room for only 20 students in the first class, 33 applicants were chosen for the program, on the assumption, based on experience with other selection procedures in the school of education, that a third would not be able to come. The composition of the class reflected the fact that the largest number of applicants were women (180) and art history majors; of the 25 students (one subsequently dropped out for personal reasons) who were finally enrolled in summer 1974, 22 were women and 11 had specialized in some branch of the visual arts—fine arts, art education, art history, architecture, decorative arts and crafts. The rest represented a sprinkling of anthropology (3), American studies (3), history (2), education (2), natural science, botany, zoology, and English literature.

Although there are no discipline quotas in the program, there is no doubt that class balance was a factor in the choice of candidates, and the program staff was disappointed that so few science students applied to the program the first year. Placement potential was also a factor; if there were more openings in one discipline than another, candidates were advised to consider the fact before joining the program.

Almost all the applicants and therefore all but one of those finally selected were white. The staff felt it did make an attempt to recruit minorities: notices were sent to black colleges in the South (though none is on the list of schools the staff visited personally before the program started), and all black students who applied were interviewed. Professor Brenner, a member of the University Commission on Equal Opportunity, was "well aware," she said, "of the university's desire to enroll black students," but she felt strongly that students should not be accepted into the program who would not make it, and she found none who she thought were well enough prepared.

### How the program works: the pilot year, 1974/75

Compared with other museum education training programs described in this chapter, the schedule Brenner and Hoth laid out for the first year of the George Washington program was particularly closely structured. The staff blocked out a series of assignments and meetings for the program in advance and recommended to the students methods of recording notes and ideas and of developing individual resource files. Students were encouraged, too, to plan carefully themselves. Before trips and before meetings with visitors or outside speakers, the staff might take an hour with the class to decide what it wanted from the experience and try out sample questions to ask a speaker.

Brenner and Hoth felt not only that the structure was important to the success of the program, but that it actually allowed for more individual variation than a looser organization might have provided. Furthermore, they actively sought and built the program on the contribution each student could make to it. Part of their plan was to make sure that each student's experience was incorporated into the program and that each student develop research not just for his own use but for the benefit of others in the group.

As this was clearly a student-centered program, it is useful to examine just how the staff's responsibility toward the students was discharged—and how the program practiced what it preached.

**Travel.** One of the first group activities after the orientation week when the class arrived in July 1974 was a tightly packed two-day trip to Boston. There students visited four museums and met with trustees, administrators, and educators in each. Later in the year, sometimes alone, sometimes as a group, they went to regional and national conferences at sites as far-flung as Portland, Oregon, New Orleans, and Greenville, South Carolina. The trips were not simply sightseeing. They were meant to fit specifically the sequence of the course and the students' own interests.[3]

After each trip, students were asked to fill out a form in which they listed the names of institutions visited, people interviewed, dates, titles, exhibitions, and recommendations for future trips to the same place by someone else. Although the exercise was not one of the students' favorites—only three listed it as a good way to learn—they continued to record the information, partly because the record was required for reimbursement of expenses, but partly, too, because it had a use both for themselves and the next year's class.

**Journals.** An important part of the weekly assignment was the looseleaf diary in which each student recorded his activity, the problems he encountered, and his reactions to them. The week's journal was handed in every Wednesday; the staff read all 24, wrote comments on them, and returned them by Friday morning when everyone met for the three-hour weekly seminar.

One local museum educator, when he heard about the practice, commented on the "adolescent exercise" he thought it represented and predicted that the students would resent it as an attempt on the part of the program staff to exert too much control over the students' independent work. Not so, according to two of the students who dropped by Mrs. Hoth's office one day when she was gone to deliver their weekly writing. "I didn't think it was important until I wrote it down," said one. "It's a good thing; it makes [my thinking] clearer," said another later. Mrs. Hoth reported that the students kept the journals faithfully, and only a few complained about the assignment.

For the staff, the journals were an invaluable method of supervising each student's work. In one case, the journal revealed that the direction of an internship project was beginning to go awry; catching the trouble in its early stages, the staff was able to bring the student, the museum educator he was working with, and personnel from a local school together to correct the problem before it had gone too far. Through the journals, too, the staff discovered how students absorbed and

translated their experiences and thus what improvements needed to be made in the design of the program and techniques of communication within it.

**Resource files.** Because the staff regarded all students as professionals in training, it suggested that they begin to build research files to which they could continue to add. These included the trip reports (already mentioned), notes on their readings kept thesis-style on 5-by-8-inch cards, and a record of class discussions. All of this record-keeping was shared among the students: they divided up bibliographies, for example, and mimeographed their summaries of the readings that each student found most useful; responsibility for class notes was rotated and the staff secretary distributed the mimeographed results.

**Resource packets.** A different kind of research was embodied in the packets each student kept on certain specific subjects—video, for example, or age group characteristics. A student would choose a subject and collect as much research as he could find on it—a comprehensive bibliography, names of people important to the field, questions to ask before getting involved in the subject. As he assembled his research, he would duplicate copies for everyone else in the class, so that by the end of the year the students had packets of resources on 20 or more subjects.

**Workshops.** Throughout the summer term, the staff arranged special workshops, most with outside experts, on the nuts and bolts of museum work. These continued on a regular basis during the fall and spring. In addition to the Friday morning seminar, there was a workshop each Wednesday on subjects that students wanted more help with. Attendance at these was optional; yet at any given workshop between 18 and 20 of the class were present. Students who decided not to attend could use the Wednesday workshop time for one of the two exhibitions each was assigned to help mount.

Workshop topics, many of them suggested by students, ranged from the mounting of an exhibition to the use of office machines. The sessions were designed to be practical above all. These were some of them:

- Designing an exhibition "to enhance learning," a three-day workshop with Chandler Screven, professor of psychology at the University of Wisconsin, Milwaukee, who has developed several methods of testing museum visitors to see what they learn from exhibitions.
- Museum teaching techniques. One of the students with video experience taped members of the class as an evaluation of their ability to handle groups.
- The use of simple power tools for constructing exhibitions and giving instruction in studio workshops.
- The application of the computer to education work, especially for cataloging the collections and thus getting access to information about particular objects, storing conversa-

tions with artists, scheduling docents and tours, dealing with schools where computers are used.
- Silkscreening.
- Making slides.
- Use of audiovisual equipment—videotaping, recorded tours, audiocassettes for slide shows—taught by audiovisual technicians at the university.
- Coping without money.

Mrs. Hoth felt that these sessions were particularly valuable to students and planned the next year to spend more time on classes in the use of equipment. (Graduates of the program agreed: they found once they were in museum jobs that such specific skills saved them time and made them more immediately useful, and they wished there had been still more training.)

**Supervision of internships.** Of all the attempts the staff has made to attend to individual student development in the George Washington program, it considers none so important as its supervision of the internships, both in the schools and in the museum. What Brenner and Hoth say they did not anticipate, however, was just how much effort that would mean.

Before placing any students, the staff felt it devoted a good deal of thought to the situations themselves and spent many hours explaining the goals of the internships to potential supervisors and administrators in museums and schools. For the fall internships, Honey Nashman, director of laboratory experiences for the George Washington school of education and a local teacher with a special gift for locating school resources, not only found school and other learning-center slots for the students, but with the help of one of the students continued to stay in close touch with them throughout the term. Even so, the supervision received some criticism from the students. In an evaluating questionnaire passed out at the end of the semester, although students rated these school supervisors rather highly on some points, they did complain that the supervision was not frequent or thorough enough, and they recommended more contact between George Washington supervisors and participating teachers. They gave their George Washington supervisors generally good marks for helping each student with specific problems, but they were particularly frustrated by the difficulty teachers had in trying to understand the students' function as resource people and critical of the failure of the program staff to observe the students in action more than two or three times.[4]

The internships turned out to be one of the most time-consuming and least easily solved parts of the program. Brenner underscored the importance of supervision in an article about the program: "We feel," she wrote, "that regularly scheduled supervision of interns is a critical issue and an important responsibility of the university. Good supervision is expensive. Much staff time must be given to it; it cannot be done on odd Friday afternoons. . . ."[5] From the beginning of the year, Mrs. Hoth was concerned about it too: "I feel

strongly,'' she said, ''that [the internship and practical field placement] should be supervised carefully.'' She was afraid that students would be given menial jobs without any sense of how such jobs fit into the goals of the institution, and she especially wanted to avoid the kind of social situations that would give the interns access to trustees and other museum officials only at cocktail parties: students, she emphasized, should ''get the opportunity really to talk with people and question them . . . about the issues facing [museums]. . . . It is unusual,'' she said in describing the internships, ''to have trustees spend three or four hours with graduate students, and that is what we were able to arrange.''[6]

Mrs. Hoth, who was responsible for supervision of the museum internship, discovered first that it was not possible to find the ideal internship but that a student could have a useful experience even in a less than ideal place. She discovered, too, that the interest of the museums in the city was necessary to the success of the internships—and that interest involved meeting with museum staffs and getting ideas from them before the internships were set up. Once the students were placed, however, Mrs. Hoth found that she could not always expect the museum educator to take time to supervise the student, so there was no substitute for continued attention from the program staff.

**Communality.** Visitors to meetings of the first George Washington class noted a distinctively cooperative spirit among the group. Mrs. Hoth explained it by the fact that aside from the one elective course in each student's own field, the group spent all its class time and much of its study time together. Even after the internships began, students continued to return to the group to trade reactions to their experiences and draw on one another's research.

But there is no doubt, too, that the sense of communality had been consciously fostered by the program staff. If students from disparate backgrounds were able to work well together almost from the start, it was partly because Brenner and Hoth, who had much of the day-to-day responsibility for the students' work, expected them to do so and not only to resolve their differences but to make something constructive from them. They made a practice of developing small teams to cooperate on projects and often broke the class up into several discussion groups, which students took turns leading, so that competition for the floor was reduced.

During the second semester, Brenner and Hoth felt that the communality was beginning to fail. In searching for the cause, they decided it was not that the field placements allowed the students to spend less time together, but that one of the principal assignments in the communications course was the drafting of grant proposals, with the possibility of submitting them to funding agencies. The competition splintered the group, at least temporarily, and the staff subsequently made a determined effort to rebuild the sense of unity the group was beginning to lose.

## How the students reacted to the program

Students interviewed about the program praised the planning and the rather tight organization of the work (although one complained of the ''puppet'' quality of the structure at the beginning and the tendency of the course planners to make decisions without consulting the class). If there was a common response to the program from the students who formed its pilot class in 1974/75—beyond their general enthusiasm about the experience—it was that the course tried to cover too much ground in too short a time. One student called the program ''basically exposure,'' another described it as ''a tool to get into the profession,'' but there seemed to be agreement among most members of the class that however overambitious the program might have been in its first year, the most important corrective would be to allow the program to ''go longer and deeper,'' as one student put it, into every facet of museum education. Although the workshops gave the students practice in a variety of specific activities—from dealing with computer systems to making slides—at the end of the year many of the graduates felt they still did not know enough. Kelly Coleson, an alumna who was employed by the Hirshhorn Museum in Washington on the basis of her internship there, wished, for example, that she had learned more about how to make up budgets.

Next to wanting a ''longer and deeper'' program, students, like their supervisors, laid considerable stress on the internship. Even those with frustrating placements in the schools felt that their experiences had been especially valuable. They found that many teachers had little idea of museums except as ''rewards for the kids.'' ''For most of these teachers,'' one student wrote of his high school placement, ''the development of a study unit around a museum trip is a foreign concept.''

Other students, many of whom had had no professional contact with schools, had their first exposure to the inside workings of school and classroom administration. They heard teachers' gripes about museums and learned that many teachers, as one student noted, ''prefer to plan their own trips and take their own students through a museum.'' They also had a chance to cope with the logistics of getting a class to and from a site away from the school building.

Asked about the mix of disciplines represented within the group, several students expressed a wish for even more variety. ''It adds to everyone's scope,'' said one, ''to be exposed to ideas from zoos and botanic gardens. If anything, this program has been too much oriented toward art. . . . But the zoo person needs a different kind of help.'' For many of the students, the interaction within the class was an important part of the experience. ''I didn't expect the human situations this program created,'' said a graduate student from Brandeis University; ''but we have all entered it from different vantages, and the result is that we have learned from each other. We have shared solutions and built an open network of communication. We have even found dissension useful, because

we could treat each other as professionals. Interacting with this group, plus the discipline and being able to do something, is more important than just ideas."

**Placement.** The program's first graduating class came into the museum job market at a time when many museums were cutting their budgets and staffs, and Brenner and Hoth were sufficiently worried about placing the students so that they devoted considerable energy to finding them jobs. Placement was complicated by the fact that several of the students wanted to stay in the Washington area, where jobs were especially scarce and competition keen.

Nevertheless, 18 of the 24 students found jobs, 11 of them in museums; 2 in school programs, one as a teacher and museum resource for Washington, D. C.'s School without Walls and the other in an elementary school enrichment project; 3 in museum-related organizations; and 2 in art galleries. Most—13 of the 18—stayed around Washington, but others went to California, Tennessee, Alabama, New York, Louisiana, and Israel.

### The second year

The turn of the employment picture had an effect on the program's recruitment for its second year. As the pattern of personnel needs in museums became clearer, the university tried to explain carefully to new recruits which disciplines seemed to offer more openings than others. Beyond that, as long as placement can be secured, Brenner and Hoth point out that there is no discrimination against any particular discipline in accepting students into the program.

Nearly all of the applicants and many of the students accepted for 1975/76 were older (though the age range was narrower, 21 to 34, the median age was higher) and more experienced, either as teachers or museum educators. They represented a wider range of disciplines, and there were, according to Mrs. Hoth, many more history majors. There were also a few more men: 5 were accepted into a class of 21, as opposed to only 2 the first year. Although there was no member of a minority group in the second class (one student from Fisk University was accepted but could not afford to come), the university made more of an attempt the second year to find minority students by making visits to black colleges.

As for internships, more museums wanted interns than the program could supply. Mrs. Hoth felt that the supervision in both schools and museums was better the second year, and the fact that the program used some of the same schools meant that they understood better how to use the interns— though Mrs. Hoth said that "many school systems don't know what to do with 'enrichment,'" the category under which the museum interns seemed to fall.

### Some conclusions about the George Washington program

Although it may be too soon to try to judge the George Washington University M.A.T. program, two or three things about its operation seem so far to distinguish it from other experiments in museum education training.

One is the screening process, which has in several ways clearly worked in the program's favor. Employers who hired two of the graduates of the first year, one at the Hirshhorn Museum and the other at the National Air and Space Museum, both in Washington, have commented that recruitment for the program is "excellent." Out of 100 applicants for a job as education specialist at the Air and Space Museum, 5 of the 15 finalists were members of the George Washington program—as was the woman who got the job.

If the screening helps to establish the program with employers, it may also produce a class that is—at least by comparison with other programs described in this chapter— relatively homogeneous and "low risk." Students who have entered the program so far, though they may have varied in age and choice of subject matter, seem to share an interest in working within fairly traditional settings—museums and schools, rather than the community work toward which many of the Rockefeller Foundation fellows aim. The fact that there is little active recruitment of minority group members, furthermore, ensures relatively compatible goals and backgrounds among the students and reduces the kind of tension that has sometimes developed in other programs. Whether the program and the museum education field are well served by this omission is another question.

The George Washington program is marked, too, by its careful planning and structure. The fact that the program is based in a university and is subject to graduate-level academic standards may help to impose on the program a discipline not duplicable in a museum, where measurement is less of a concern than the daily relationships within the museum structure itself. (The university base also gives students a chance, as Mrs. Hoth has pointed out, to step away from day-to-day museum operations to analyze with other people the role of museums in education and to discuss the issues without being immersed in them.)

Although not all students may want as much structure as they are given in the George Washington program, it is apparent to observers that the careful organization of the course from beginning to end gives the students neither the leisure nor the cause for the kind of frustration that is noticeable in more loosely structured training programs. For the most part, the training at George Washington is specific to the needs of schools and traditional museums, and its practical focus seems to increase the students' confidence and their appetite for learning more once they are out in the world. Lynn Bondurant, education officer at the National Air and Space Museum, praised the intern he hired for being able to "operate like a learner" (he also found her interested in the audience, good at working with it and with other people, conscientious, and able to take on more and more responsibility).

In the same vein, Ted Lawson, curator of education at the Hirshhorn Museum said of the George Washington recruit he brought on as coordinator of docents that she understood

"the reality of the situation she ended up working in" and that she was immediately "productive" and capable of working "on her own."

On the subject of a third distinguishing feature of the program, internships, the George Washington staff has offered its own conclusions: after two years of wrestling with the problems internships involve, Brenner and Hoth feel that supervision is inevitably time-consuming, that internships themselves are probably always going to be less than ideal, and the "school and museum reality" needs to be carefully studied so that both staff and students can anticipate problems and be prepared to work out alternatives.

Beyond these judgments, it might be pointed out that the requirement for internships to take place in both museums and schools is an advantage museum-based training programs have not so far provided, and the George Washington students seem to have drawn singular benefit from it. They learned, often to their dismay, how much planning and organization a teacher's "hectic schedule" demands, how necessary it is to transfer such planning to the museum field trip, and how much confidence good organization can give to a classroom or museum teacher.

Perhaps the greatest contribution the George Washington program will make to the museum education field, in the end, is to infuse it with an attention to "education"—that difficult, nebulous, and often overprogramed discipline that has scared museum recruiters away from the teacher's colleges where "education" is "taught." Few critics of colleges of education would defend their tendency to stress teaching methods over education content or argue that this stress on methods has not spoiled classroom learning for many children. Yet, to judge from the reactions of some of the students who have taken part in the George Washington M.A.T. program, their year in the university's department of education has exposed them to the plight of both learner and teacher wherever they are and to the need for a deeper understanding of the process through which the learner must be led in order to get the most from each educational experience. That could be an invaluable lesson for museum educators anywhere. If the George Washington program continues as it has begun, it may be able to demonstrate the worth to museums of developing a better alliance between what they teach and how.—*B. Y. N. with supplemental research by B. C. F. and S. R. H.*

## Notes

[1] For sources of quotations without footnote references, see list of interviews at the end of this report.

[2] *Program for Museum Education Studies*, flyer from George Washington University School of Education, Washington, D.C. 20006.

[3] According to Mrs. Hoth, "several class sessions were spent at the beginning of the Museum Studies course discussing administration and trusteeship of museums and preparing questions for the trustees with whom the students would meet in Boston. Each guest speaker was given a question or topic that was usually rather specific. For example, students in art history went to the print study room of the National Gallery of Art for a meeting with Dr. Andrew Robison, curator of prints and drawings. Dr. Robison had been asked to discuss the guidelines he used in making choices of prints for the collection. He did this with prints that either had been recently purchased by the gallery or were being considered for purchase. At the same time, the others in the class talked with Edith Mayo about collecting contemporary materials for the Museum of History and Technology. In this way, the students were introduced to curatorial staff members, a curator's responsibilities, and perhaps most important of all, the students learned first hand about the value placed on collections and artifacts."

[4] The end-of-semester questionnaire was worked up by a committee of students with the help of Joseph Greenberg, a member of the education faculty at George Washington University who had a particular interest in qualitative statistical evaluations. After their fall internships in schools, the students rated themselves, using a scale of 1 (always) to 5 (never), on these goals:

| Rating | | |
|---|---|---|
| 2 | 1. | Become acquainted with the overall [school] curriculum. |
| 2 | 2. | Learn more about the behavior and interests of children. |
| 2 | 3. | Participate in classroom activities as a resource person. |
| 2 | 4. | Explore ways that the museums and school can be mutually responsive. |
| 2 | 5. | Plan and carry out field trips and follow-up activities with teachers who are interested. |
| 3 | 6. | Learn about the responsibilities of teachers, supervisors, and administrators in the school setting. |

The students were tougher on supervisors:

| Rating | | |
|---|---|---|
| 2 | 1. | Get to know the student. |
| 2 | 2. | Understand the particular school situation. |
| 2 | 3. | Help students with specific problems. |
| 4 | 4. | Observe students in action. |
| 4 | 5. | Provide good public relations for the program. |
| 5 | 6. | Talk with participating teachers about what you are doing. |

[5] Draft of an article for the *Bulletin* of the International Council of Museums, spring 1975. Now published as "Training for Museum Education at the George Washington University," *Museums Annual*, 1976, pp. 9–20.

[6] Memorandum, September 12, 1974.

## Interviews

Bondurant, Lynn. Education Officer, National Air and Space Museum, Washington, D.C. Telephone, March 22, 1976.

Brenner, Marcella. Program Director, M.A.T. Program in Museum Education, George Washington University. January 19, 1975.

Coleson, Kelly. Student, M.A.T. Program in Museum Education, George Washington University. March 28, 1975.

Heiberger, Barbara. Student, M.A.T. Program in Museum Education, George Washington University. March 28, 1975.

Hoth, Sue. Research Instructor, M.A.T. Program in Museum Edu-

cation, George Washington University. November 12, 1973; March 7 and 13, May 3, 1975; telephone, March 10, 1975.

Lawson, Ted. Curator of Education, Hirshhorn Museum and Sculpture Garden, Washington, D.C. Telephone, March 22, 1976.

Robinson, Marlene. Student, M.A.T. Program in Museum Education, George Washington University. March 28, 1975.

Welch, Nancy. Student, M.A.T. Program in Museum Education, George Washington University. March 21, 1975.

Yelen, Nancy. Student, M.A.T. Program in Museum Education, George Washington University. March 28, 1975.

# UNIVERSITY OF MINNESOTA DEPARTMENT OF ART HISTORY: MUSEOLOGY DEGREE PROGRAM

University of Minnesota
Department of Art History
108 Jones Hall
Minneapolis, Minnesota 55455
**This rapidly growing graduate museology program designed to train generalists for small museums faces, if it does not solve, some difficult issues: cooperation between university and museums, fellowships for students, the job market for graduates, administration, the very validity of museum training for an academic degree. CMEVA interviews and observations: October 1973; January, June–August 1974.**

### Some Facts About the Program

**Title:** The Museology Degree Program.
**Audience:** Master of Arts candidates in museology. Between 1963 and 1973, 15 students graduated from the program. In 1974, 9 students were in their second, or internship, year.
**Objective:** ''To give the student the academic training and practical experience necessary for assuming the administrative responsibilities of a small museum.'' The program also accepts students who wish specialized training for positions as curators, conservators, or educators.
**Funding:** Throughout most of the program's history the major source of funds was tuition paid by the students; fellowships were few. Since 1971 the National Endowment for the Humanities has awarded fellowships for all expenses (tuition and a $7,000 stipend in 1974) of the internship year to half the students. As of 1974, these grants were being awarded through the partner museums rather than the university.
**Staff:** One part-time program director who is also a professor of art history at the university. University faculty supervises the students during the academic year, museum directors and staffs during the internship year.
**Location:** The University of Minnesota campus and three partner museums in Minneapolis—the University Art Gallery, Walker Art Center, and the Minneapolis Institute of Arts. Other museums in the Midwest are used for all or part of the internships of some students.
**Time:** The program began in 1963. Students take 9 months of art history courses, a one-month museology seminar, and, usually a 9- or 12-month museum internship.
**Information and documentation available from the institution:** Museology degree program report, November 1973.

The University of Minnesota M.A. program in museology was begun in 1963 to give students the academic training and practical skills necessary to administer small museums. One impetus was purely pragmatic: the upper Midwest was dotted with small art centers and museums that needed trained personnel; the country's major museology programs, notably those at New York University and Harvard, were turning out specialists primarily for large urban museums.

The intent of the Minnesota program was never realized. By mid-1974 only two of its graduates—the first two, in fact—had gone on to staff positions in small museums, a result that the program's director, Marion J. Nelson, attributed partly to the program's deficits but partly, too, to the inclinations of the students.

## Operation of the Program

Nevertheless, the idea of combined academic and practical training and the generalist focus have been maintained, and in 1974 the two-year degree program had three major requirements: one academic year of study in art history, a month-long museology seminar, and a nine- or twelve-month internship at the Minneapolis Institute of Arts, the Walker Art Center, or the University of Minnesota Art Gallery.

### Academic training

In order to qualify for entrance into the program, all students who seek the museology degree must be admitted into the university's department of art history and then successfully complete the same first year of study required for the regular art history M.A. This means the accumulation of 30 quarter credits of art history in five ''subfields'' (two of which are seminars), a methodology course, and reading knowledge of French or German. No special use of museum resources is made during this year. Courses oriented toward connoisseurship are regularly offered by the department, but the university art gallery is not comprehensive enough and other Minneapolis museums not near enough for the department to make much use of original materials in its teaching.

### Museology seminar

Students are formally accepted into the museology program after they have completed the first academic year. Then during the summer they take a four-and-a-half-week, six-credit seminar, designed especially for them but open to all art history graduate students (a few students choose to take the seminar prior to their first year of graduate study). Sidney Simon, the course's instructor, calls it ''a look in depth at the whole concept of the museum as an idea and as an institution that is deeply rooted in our culture.'' Of the seminar's purpose, Simon says,

It is only secondarily a good and necessary introduction to the internship year. Its aim is not so much to ease the way of the student into that ''on-the-job'' year but to open his

mind to the problems faced by museums and to whet his appetite to try to solve them meaningfully, humanistically, aesthetically. In the seminar the student thinks "critically" about museums; "on the job" the student must learn to think "professionally," that is to say, institutionally. In the seminar he is an individual; in the museum he is part of a team.[1]

In addition to such an overall view of museums, Simon also feels that the seminar gives students a direct sense of the museum world:

> The goal of the seminar is practical; you simply cannot expect someone who has not had any contact with museums to step into a museum training situation without some preparation. . . . Some of the students who are considering careers in museums have had very little contact with them directly. . . . Through the seminar they can make choices about where they want to go and what they want to do during their apprenticeship.[2]

The seminar is meant to be intensive, and students are advised not to enroll for any other course during this period. The instructor changes the course from year to year, but its basic features are

- A two-page book review prepared from a selected list by each student in the first three days of class. Xeroxed copies of these reports are then given to the students to provide them with a concise synopsis of the basic museum literature.
- A research paper. Assigned topics have included "Museum Ethics," "Museums under Fire," "Museum Architecture," "Special Purpose Art Museums," "Educational Roles of Art Museums," and "The Art Museum and Community Relations." The final week of the seminar consists of panel discussions on these papers.
- A visit to each of the three participating museums. The museum directors and their staffs explain their particular institutions and then participate in what has been described as a no-holds-barred question-and-answer period.

Reaction to the seminar from a few graduates of the museology program interviewed for this study was mixed. Some thought the seminar prepared them well for their internship. Others felt that the program was too abstract, that it should have focused on particular museum problems rather than the history of museums and that it should have included information about the museum job market and pay scale (one graduate said that if she had known about job and salary prospects before her internship she might have changed her career plans).

In their second year, museology students take an eight-and-a-half-hour comprehensive examination that is basically the same as the one given to art history students but substitutes essay questions about museums for some art history.

## Internship placement and experience

The second year of study for the museology M.A. consists of either part-time or full-time museum work for 9 or 12 months, depending on each student's fellowship support. (The 15 quarter credits given students for their internship, combined with the 6 credits for seminar and the 30 credits for the first year of study, make up the full 51-credit requirement.)

Early in their first year of graduate study, interested students visit the Minneapolis Institute of Arts, the Walker Art Center, and the university art gallery to gather general information about the museums and to help them decide where to intern. In theory, application for an intern position is made in the spring of that first year, and the university tries to announce the placements by the end of the term. In practice, however, students often make their choice later, during the summer seminar.

No student is admitted into the museology degree program unless he can be placed in an internship; the number of students each museum is able to accept varies from year to year. Final placement decisions are made in consultations between the museums and the university's committee on museum studies and are predicated on the willingness of the museum to accept the applicant. Simon, who does much of the placement, says that positions are "worked out laboriously through much give and take on the part of all concerned. Individual student and museum needs are carefully balanced, and as much as possible the internship is 'custom-made.'"[3] If a student qualifies for the program, but feels that none of the three internship museums fits his interests, he and the program director try to find an alternate museum in the Midwest more appropriate for his study (both the Minnesota Museum of Art in St. Paul and the Art Institute of Chicago have accepted interns from this program).

The Minneapolis Institute of Arts, the largest of the participating museums, usually accepts three to five interns. Because of its extensive school programs, it attracts most of the students who have a particular interest in museum education. In their work with school groups, the interns serve as assistants to the professional staff members. (Maxine Gaiber, a former intern who was hired by the institute, has noted a general movement away from education and toward curatorial work among the interns. In 1973/74 only two of ten institute interns chose education.) A 1973/74 intern prepared a small exhibition for the institute's artmobile: she chose the theme—children's drawings—and designed, assembled, and installed the show herself.

The Walker Art Center generally draws interns with a particular interest in its specialized collection of contemporary art; it accepts one or two interns a year. A 1973/74 intern there was a major contributor to its exhibition, "New Learning Spaces and Places" (see report in chapter 2). She did extensive research for the show's catalog, contributed a two-page section to it, and helped select the objects shown. By special petition she worked at the museum full time instead of part time during the months before the opening. She said that working a 40-hour week and having responsibility made her feel "like a real staff member."

The University of Minnesota Art Gallery consists of three rooms in a large auditorium and a professional staff of four. Despite its limited budget, the gallery mounts ambitious shows intended to appeal to a diverse university community. One or two interns work at the gallery each year. Because it is small, duties are not strictly departmentalized, and the director assigns interns a variety of jobs: each, for example, is generally given the responsibility for an entire exhibition. For a 1973/74 exhibition one intern selected the objects from local public and private collections, wrote a catalog, supervised the design of a poster, did her own installation, and organized the opening. Although experience in the university art gallery is aimed particularly at students interested in small museums, the gallery director believes that "taking a chance on a student" and giving him a lot of responsibility is the best training for work in any size museum.

Once a student starts his internship, he has little or no contact with the university; the museums accept almost total responsibility for his training. Some interns, however, complain that because most of them are only at the museum half time they are never made to feel that they are part of the staff, or, indeed, anything more than "cheap labor." Program Director Nelson acknowledges that students sometimes complain about doing busy work but adds that many of them misunderstand the field: a lot of museum work *is* busy work, he says, and interns would be deceived if they never saw that aspect of museum life.

## Growth of the Program: 1968–1974

The Minnesota program is not large. By 1973 only fifteen students had completed the internship; of these, eight were holding museum positions—one was a public school art teacher, two were working on Ph.D.'s in preparation for more advanced museum positions, and four were still in the program.[4]

In its first eight years, the program averaged only one graduate a year. It was also simpler: students spent their first year studying art history at the university and their second as full-time interns in one or two of the participating museums. In 1968 the summer seminar was added to provide a transition to the internship, and the work requirement for the internship was reduced from 40 to 20 hours per week. During these first years many of the students had to take part-time jobs because they were paying full tuition to the university and receiving no remuneration from the museums; fellowship grants were few and meager.

### The NEH fellowships

All this was soon to change. In 1968 the American Association of Museums published *America's Museums: The Belmont Report*, a study that drew attention to the need for specialized training for museum personnel. In its wake came new funding sources to buttress existing museology programs and establish new ones.

One of the major new sources for museum training funds was the National Endowment for the Humanities (NEH). Beginning in 1971, NEH has awarded fellowships that cover all expenses of the internship year to about half the students in the Minnesota museology program. Initially these grants were given only to students who concentrated in museum education, but as of 1974 any museology student was eligible, and the stipend was increased from $2,400 to $7,000 for a 12-month period. As the grants include money for tuition and living expenses, thus relieving students of the need to find part-time jobs, fellowship students are required to work 40 hours each week at the museum (interns who pay tuition still work only 20 hours). At first, students could apply to NEH for fellowship money only during their internship year. After 1974 a limited number of fellowships were available for both years.

Accompanying this increase in funding has been a rapid growth in the size of the University of Minnesota museology program. Four students took the apprenticeship training in 1971/72, six in 1972/73, six in 1973/74; half of them had NEH fellowships. In the 1974/75 academic year the number of interns increased to twelve.[5]

Some of this expansion can be credited to increased student interest in museum work. Marion Nelson is one who feels that this interest has spurred the growth of the program as much as the availability of the NEH fellowships. He points out that the university cannot hold out the NEH grants as an attraction to students because it does not know from year to year whether the grants will be renewed. So students learn of them only after they come to the university.

Still, according to some members of the university faculty, the NEH fellowships have given tremendous impetus to its program. Sidney Simon describes the museology degree before it began to receive NEH support:

Prior [to the NEH grants] the program was marginal for lack of funds and clear priorities, not only *within* our Department, but within the museums as well. We had no priority fellowships to offer students who opted for the Museology degree, nor could the museums provide funds. What made the program viable at all before NEH support was the concept of "on the job" training, and with not very much emphasis on the training. And, given the situation, it worked reasonably well: the student[s] [were] thrown into the "job" situation and learned what museum work was about. . . .

Perhaps they suffered through that internship year, perhaps they shuttled from pillar to post, a little here and a little there, but in the end, they emerged as paraprofessionals. They had some art history at the graduate level, they had had pointed discussions about museums in the seminar, and they had a good long period in actual contact with the working situation in more than one museum. There were plenty of gripes and complaints, a few casualties, but on the whole it was an heroic, pioneering effort on the part of all. On balance, one need not be apologetic about what

was accomplished. One must remember it was at a time when museums were desperately in search of trained personnel at all levels of operation.[6]

## The Regional Museum Training Center Program

In addition to accepting many more students, the program is also attempting to return to its initial small-museum orientation. In fall 1974 the education division of the Minneapolis Institute of Arts initiated a project called the Regional Museum Training Center Program; it was funded by a $52,000 NEH grant and approved for the museology degree's internship requirement by the university.

The program was not yet in operation when this study was made, but the plans were that during their internship year in the Regional Museum Training Center Program, five students would spend 40 hours a week for 12 months at the museum and receive a $7,000 stipend from NEH. Three interns were to spend 9 months working at the institute, and then 3 months living near and working at a smaller rural art center. The other two interns were to spend the entire 12 months studying the problems of the small museum at the Minneapolis Institute and working with smaller art institutions near Minneapolis.

Under this same program the institute also intended to establish a series of auxiliary programs with the small art centers in which it would share staff resources as well as collections.

## Some Problems of Growth, Especially in Job Placement and Administration

The National Endowment for the Humanities funding has brought problems as well as benefits to the University of Minnesota Museology Program. For one thing, under the terms of the Regional Museum Training Program, in addition to the three to five interns from the university, the Minneapolis Institute of Arts can accept an equal number of interns from other colleges in the state. As the number of interns grows, students complain that aggressiveness is a requirement for getting the training they deserve and that there is a lack of personal attention and supervision at the institute.

Another problem is the relatively generous stipend NEH fellows receive. In some cases the $7,000 stipend is only $200 less than the salaries of museum professionals with several years' experience; it has thus become a factor, according to Barbara Shissler, director of the university art gallery, in intern-staff relations: at the Minneapolis Institute, for example, the NEH stipend became a basis for union negotiations on professional staff salaries in spring 1974. In 1973 the museums requested some remuneration for their services in the training of increasing numbers of interns; the university agreed to pay them $250 per student per term.

### The job market

More important, the university has had to begin considering the relation of the program's growing size to what appears to be a dwindling job market. The university makes no provision for placing graduates of its museology program, though so far most of its students have found jobs, some of them in the Minneapolis Institute of Arts or the Walker Art Center (in 1973 four of the program's eight graduates with museum positions were at these two institutions, one in a temporary job).

There are differing opinions about the wisdom of a museum's hiring its own interns. Samuel Sachs II, the institute's director, sees the internship program as a valuable testing ground for new staff. "Museums," he said, "benefit from the fresh approach of interns. . . . They can give you an invigorating look at your own operation. . . . Happiness is finding one or two in the group that you want to keep." The institute's associate director and head of the division of education, Orrel Thompson, feels differently. "An intern program," he has said, "isn't to develop future staff for the particular museum. . . . I think [interns] should be kicked out of the nest."

Some interns have assumed that the local participating museums were going to continue to absorb a certain percentage of the graduates. As it has become clear that the program is too large for the internship museums to provide job security, the students have begun to worry, and some of them have taken the university to task for not having an organized placement program and for not relating the museum job market to the number of students admitted to the program. Simon's answer:

> Academia is in a state of crisis insofar as jobs for high-level graduates are concerned. Naturally, there has been an increase of interest in museums as a new and untapped source for placing graduates. . . . At present there are no guidelines that I know of that can tell us what the job market is like. . . . We are assuming that continuing government support represents a genuine need on the part of the national museum community for trained personnel.[7]

Orrel Thompson, on the other hand, thinks that the growth of museum training programs is irresponsible. Noting that other kinds of educational institutions have purposely overtrained people for the field of education under the impression that more teachers would create more teaching jobs, he has found museums laboring under the same delusion:

> Museums are now as guilty as or maybe more guilty than the universities and colleges with teacher training. Teacher training became the thing to get money for and to flood the colleges with so that you could expand, and you could justify existence. Museums are now using the same approach, and few if any care what happens to the interns afterwards.

**One answer to the problem of jobs.** Those involved in the museology program are obviously concerned about what

they believe is a decreasing number of jobs available for graduates. One question some observers have raised is whether NEH and the university are being fully responsible in their encouragement of the program's growth in the face of these uncertainties. The university has found what it believes is one alternative to keeping the enrollment in its program high while still serving the real needs of the job market. The art history department, at this writing, hopes to open the museology program to graduates of the university's department of history. For Nelson, the motivation is that professional museum staffs ultimately "pay for themselves":

> I suppose every county in the United States has a historical society. I don't imagine that more than one percent of these has professional staff. And this is because [most historical societies] don't believe they could support a professional person. . . . I would like to educate the American public to understand the importance of professional personnel in museums. . . . The only way we can bring our interns into the professional museum picture is to train people in business. If interns learn the operation of a museum shop, fund raising, and membership programs, they will learn how to operate an institution that pays for itself. The museum professional will no longer be a deficit to a community. . . . We must train the future professional so that he can prove to a board of directors that he could pay for himself, and then we have to train the boards and the public to know that the museum professionals can pay for themselves.

According to Nelson, history students he had spoken to agreed with the validity of this approach. Some of them, too, had discovered that their advanced degrees had not led to jobs and felt that a museology degree might make them more employable. As art museums and history museums face many of the same issues, Nelson said, the museology curriculum in its present form suits the needs of history students—although its first part, the academic study, would have to be more rigorous than the curriculum designed for art history students. Before a history candidate could take the summer seminar, he would have to complete the work for a master's degree in history, which requires two years of academic work instead of the single year required of art history students who go into the museology program.

It is planned that history students would be placed as interns in several historical societies in Minneapolis. Each apprentice would work part time for one year and then receive a Master's degree in history with museum orientation. Barbara Shissler points out one problem in this arrangement that also reflects the real need for a history museum program: local historical societies do not yet have personnel well enough trained themselves to be able to train these prospective interns.

## Administration

Although the museology program staff plans to increase the program's enrollment still further by including history students, it has no plans to add more faculty to help administer the program. This situation, combined with what students see as the lack of personal attention and the scarcity of desirable museum jobs, creates a third growth-related problem. The art history faculty members complain about being overworked and say they do not have enough time to give the program the attention it needs. Many of them agree that the program needs a full-time specialist to run it (Nelson, himself a professor, can give only part time to administration). However, no new position is in sight because, as Barbara Shissler put it, the university and its college of liberal arts in particular have been "so strapped by retrenchment."

## Some Disagreements Between the University and the Museums

The success of the University of Minnesota Museology Program is wedded to close and continuing cooperation between the university and the three area museums that take the responsibility for the degree's internship year. The two groups have some basic differences about both the philosophy of museum training in general and the specific ways the program should be conducted. Sidney Simon, who has himself served as director of two museums, has pointed out that "there's a kind of museum temperament and a kind of academic mind, and the two don't always come very close together. . . . There's an iron curtain."

### The scholars versus the practitioners

The art history department emphasizes the importance of a strong scholarly background for successful museum work and feels that the university is best qualified to teach scholarly material. Some art history faculty say that a student with a straight art history M.A. can get a job as readily as one with a museum studies degree, and, indeed, their belief has been borne out by experience: by late 1973, the department had graduated 11 art history M.A.'s who had obtained museum jobs, compared to only 8 from the museology program—and generally the art history graduates were in higher level positions.[8]

For their part, the Minneapolis museum professionals assert the necessity of practical museum experience. They say that prospective museum employees must know how to work with original materials and be able to interpret and present them to the public. Minneapolis Institute Director Sachs was especially outspoken on the subject:

> It is very difficult to instruct someone in a classroom in what museum work is without dealing with works of art because museums primarily deal with objects. University art history training deals with the object once removed. . . . [The professors] are dealing with philosophical or intellectual concepts purely on a scholarly level. The curator combines both the scholarly approach and the humanistic approach: the approach to the object as an entity.

There's a degree of snobbism in universities and university art departments about their scholarship and how heady and what a tight little circle it is, and how you have to work for centuries to join the club. The public, which is what museums tend to deal with more and more, aren't scholars, and so to feed them a heavy diet of scholarship is going to get nowhere. This is not to say that museums are not centers of scholarship. . . . They are centers of scholarship wherein curators work and wherein university people work. It's too bad that more people from the University of Minnesota don't come over here and use [the institute's] resources, but they're much happier working with books and photographs.

In general, the museums opt for a more purely vocational program, whereas the university affirms the value of an academic program's greater breadth. Shissler feels that students need a broader range of courses than is available during the art history concentration of the first year; a wider variety, she has said, could lead to "an interdisciplinary approach so vital to making a museum of interest and help" to a diverse audience. Simon, too, has spoken out against narrow, "technical" training:

There are those who would have a more monolithic training program, a program that would literally *train* the student for work in a museum from the time he enters graduate study. I am entirely against this for our institution. We are not a technical institute; we are a college of liberal arts, and we are training art historians who want to make careers in universities, colleges, *and* museums. Just as an art school may train an artist differently from a studio art department in a university, so we look upon our educational task differently from a possible school that might "train" museum workers.[9]

### Control of the program

The directors of the Minneapolis Institute of Arts and the Walker Art Center have appointments in the university's art history department as adjunct professors of museology. Theoretically they work with the department's faculty to determine policy for the museology degree program jointly, but there is a tacit agreement that the several museums and the university will each determine for itself how its part of the program will be handled. According to Nelson, "the quality of the education experience [during the internship] is dictated by the institutions in the field because I don't think we should interfere." But, he continued, "our contact with students during their year of internship is not enough; we should meet with them more than once per quarter, more on a personal basis."

Simon disagrees, claiming that students are much too busy for regular contact, that the program director is available for individual consultation at any time, and that this separation of the internship experience "is in keeping with the university environment, where it is understood individual initiative is indeed the rule of the game."[10] Although he affirms the value

of the separate roles of the museums and the university in training museology students, he adds, "I don't think either [the university or the museums have] faced up to the responsibility fully. The university has to learn how to educate people who are going into a training program . . . and the museums must also learn how to train people once they are there." The point emphasized by one museum director was that neither the university nor the museums take the responsibility for "quality control" over the entire two-year program.

### NEH funding and university-museum cooperation: a shift in the balance of power

The problem of integrating the separate roles of the university and the museums in the museology program has been complicated by the NEH funding. Beginning in 1974 the NEH decided to award internship grants directly to the museums rather than to the university: the museums apply individually for fellowship money and then bypass the university by awarding grants directly to applicants—who do not necessarily have to be from the University of Minnesota. As a result, the museums have acquired complete control over the internship year for the fellowship students, and what was originally a university program that invited the participation of local museums has become a truly joint program.

Under the new grant procedures, the Minneapolis Institute of Arts was able to begin its regional training center, which refocuses the museology program on small museums. And the Walker Art Center received internship money that allowed it to correct what it felt was a serious lack in the program—an insufficient amount of time devoted to internship. In 1974 the art center used its NEH grant to keep its 1973 interns for a second full year. The university faculty protested that increasing the length of the internship in this way is in direct opposition to its own policy for the museology program.

In 1974 the Minneapolis Institute of Arts supported five interns under the NEH grants, the art center two, and the university art gallery one (under a third grant awarded to the university). Interns not under the NEH grants continued working part time for nine months as before, but the university's fear was that, with independent funding for internships, the museums would begin looking beyond the University of Minnesota for applicants (one intern in 1974 was not from the University of Minnesota) and would instigate requirements for interns that students without NEH support will not be able to meet. In fact, the museums *are* beginning to assert greater independence in the way internships are run, as Walker Art Center Director Martin Friedman has indicated:

The Art Center wants to participate in the establishment of program standards and selection of candidates for training here, and values opportunities to work more closely with the University of Minnesota Art History staff in the training of the interns. If, in the opinion of our staff, qualified applicants are not available from the university program,

we will consider selecting students from other institutions. The National Endowment for the Humanities grant permits, in fact encourages, this.[11]

For Sidney Simon, the museums' newly won control poses questions of university accreditation:

Now that NEH has made fellowship grants directly to the museums, they are independent of the university. The principle is clear: they shape their own distinctive internship offerings. We have an input, but they are in control and intend to exercise it to the full. They decide what they want, who they want, and what that person will do. They must also evaluate what that person does.

It must be understood that the knife now cuts both ways. We have a choice: if we like what they are doing we can advise our students to apply for admission to the internship year; if not, we can advise them to go elsewhere. The museum, in turn, need not be limited by the students we can send them at any one time. They are free to recruit elsewhere.

There is only one catch in all this. *We will not grant a degree to a student who is not in our program, who is not our student.* And, of course, where else *can* we send our students if not to the Minneapolis Institute or the Walker or our own university gallery? There are other places to be explored, but this exploration has not yet taken place.

In short, we are all working independently, *legitimately so*, but, in fact, we are more or less still in it all together. We all need each other and there is no getting around this fact. We are *now* trying to learn how to work independently and together all at the same time.

Will it work? I am convinced that it will. In principle and in practice the university will retain its coherent two-year degree program in museology and will negotiate separately with the various museums that have themselves been recipients of support for museum training programs.[12]

### The problem of continuity: effects on students and staff

The different points of view the university and the museums hold about museum training and the clear separation that has developed between the university and museums halves of the program, have led to what one intern noted with a sigh was "a communication gap between the university and the museum." Although the program's separation-of-powers policy is felt to be sound in the abstract, some interns think it has disrupted the continuity of the curriculum. Graduates have attributed this problem to the dissimilar nature of the three learning experiences: the first year of art history, they feel, does not prepare them for the seminar, and the seminar does not prepare them for the museum internships.

One graduate of the program thought that the university could improve the continuity by involving students with art objects instead of photographs during their first year of study. For her, "there's a lack of connoisseurship at the university." This same intern felt that the university should bring the interns together during their apprenticeship so that they

could benefit from one another's experiences and the students could learn more about their colleagues' efforts to find permanent work after graduation. (So far, the university has never held group meetings for second-year program participants; interns have gathered at the university in late spring to take the final comprehensive examination, but this session has not included a group discussion. The museology department requires that each student write a one-page description of his work each quarter of the apprenticeship; the students give these reports to a member of the museum staff but get no feedback from the university.) Other interns concur about the need for more contact with one another; said one in a frustrated tone of voice, "We should have met as a group at least once a quarter."

The communication problems students have felt in the program plague its organizers, too. According to Shissler, the university faculty, the museum professionals, and the interns are all working separately rather than as a group to try to improve the program. Nelson said that all parties meet once each quarter (the museum people said the meetings are held once a year) to iron out problems. He added that these meetings are sometimes emotional, but that there is give and take and differences are always worked out.

Although the problems and disagreements within the museology degree program may seem grave to some observers, Sidney Simon is one who feels they should be put in perspective:

Has there ever been a program anywhere of any kind about which students and faculty alike have not entertained misgivings? Good programs are always evolving in response to responsible and constructive criticism. Ours is no exception. The misgivings are those, in our case, associated with very natural growing pains. . . . Like all complex and difficult problems and programs this one will take time to settle. . . . In essence, [ours] is a healthy situation. . . . It is more a matter of reconciling different viewpoints. . . .[13]

Walker Director Friedman would agree: ". . . On occasions," he has said, "communication has been imperfect between the art center and the University of Minnesota on this important training program, [but] this in no way diminishes my respect for it. . . . Although the museum and university art history department have a considerable task before them in defining standards and coordinating activities related to intern training, the fact is that we consider this to be a worthy effort."[14]

## Conclusion

The vicissitudes of the University of Minnesota Museology Degree Program raise a number of issues that are relevant to museum training in general. These are some of them:

• The University of Minnesota program was started to fill the need of small Midwestern museums for professional staff. As it has turned out, the program serves primarily larger

museums. What balance should be struck between stated goals and needs on the one hand, and flexibility, organic growth, and planned changes in goals and curricula, on the other?

- The activities of a University of Minnesota intern during his apprenticeship are determined almost entirely by the individual student working with the individual museum. Some students have had good experiences; others have complained about a lack of attention and trivial jobs from which they did not learn. How carefully planned and consistent should internship experiences be? How is a student best integrated into the museum's operations? How much responsibility should he be given?

- The stipends NEH interns receive are sometimes painfully close to staff salaries. How and to what extent should students be supported during their internship?

- Some Minneapolis museum people see the internship as a testing ground for their own staff recruitment; others see it as a pure learning experience. Should a museum hire its own interns?

- The University of Minnesota is hoping to add history students to its museum training program. Are history museums and art museums close enough in intent and purpose for an integrated program to be useful?

- The University of Minnesota art history department and the program's participating museums have many divergent opinions about museum training, emphasized by the greater control NEH funding has given the museums. Students have complained of poor communication between the university and the museums that has given the program a lack of continuity. How can the opposing viewpoints be brought together into a unified program? How should power be distributed between university and museum?

- Many people at the University of Minnesota fear that the enrollment of the museology program has already exceeded job possibilities for graduates. How should programs and their funding sources determine responsible growth?

- University of Minnesota art history department faculty admits that their program is sometimes unnecessarily confused and disorganized because they do not have enough time to put into its administration. The university, however, is unwilling or unable to supply a full-time program supervisor. How can the program best join the desires of increasing numbers of students who want to participate in it with the availability of funds to support them?

- University of Minnesota art history faculty emphasizes the value of academic training for museology students. The local museums are pushing for more practical experience. What is the role of vocational training in academia? Do students compromise scholarship if they take specialized professional training in college?

- Graduates of the department with straight art history degrees have equaled or surpassed museology degree graduates in their ability to find museum jobs. How necessary, then, is specialized museum training? Do interns only fill positions that could provide permanent employment for art history graduates who can learn as well on the job? Do museology degree programs merely supply museums with a wider field of job applicants?

—*J. A. H./F. G. O.*

## Notes

[1] Letter to CMEVA, September 1974.

[2] For sources of quotations without footnote references, see list of interviews at the end of this report.

[3] Letter to CMEVA, September 5, 1974 from Sidney Simon.

[4] Museology degree program report, November 1973.

[5] The art history department includes in this number one NEH fellow at the Minneapolis Institute of Arts who is not a university student, and two NEH fellows at the Walker Art Center who have completed the degree requirements but are staying on for a second year of internship. Thus, there were actually nine new interns in the degree program in 1974/75.

[6] Letter to CMEVA, September 1974.

[7] Letter to CMEVA, September 5, 1974.

[8] Museology degree program report, November 1973. The museology degree program had graduated one museum director, one assistant director, one curator, one conservator, one research assistant, two museum educators (one in a temporary position), and one assistant for a period program. The art history program had produced three directors, two associate directors, two curators, one curatorial assistant, one registrar, and one assistant for special programs.

[9] Letter to CMEVA, September 1974.

[10] Letter to CMEVA, September 5, 1974.

[11] Ibid.

[12] Letter to CMEVA, September 1974.

[13] Letter to CMEVA, September 5, 1974.

[14] Ibid.

## Interviews

Friedman, Martin. Director, Walker Art Center, Minneapolis, Minnesota. August 2 and 23, 1974.

Gaiber, Maxine. Former Intern at the Minneapolis Institute of Arts, University of Minnesota Museology Degree Program; Director, School and Curriculum Services, Minneapolis Institute of Arts. June 21 and 28, 1974.

Hoos, Judith. Intern at the Walker Art Center, University of Minnesota Museology Degree Program. January 30, 1974.

Isaacs, Donna. Intern at the Minneapolis Institute of Art, University of Minnesota Museology Degree Program. June 20, 1974.

McKhann, Margie. Intern at the Walker Art Center, University of Minnesota Museology Degree Program. July 31, 1974.

Moses, Chava. Intern at the Minneapolis Institute of Arts, University of Minnesota Museology Degree Program. June 20, 1974.

Nelson, Marion J. Professor of Art History and Director, Museology Degree Program, University of Minnesota. July 10, 1974.

Sachs, Samuel, II. Director, Minneapolis Institute of Arts. July 19, 1974.

Sheppard, Carl D. Professor and Chairman of the Department of Art History, University of Minnesota. June 17, 1974.

Shissler, Barbara. Director, University Art Gallery, University of Minnesota. October 1, 1973; August 23, 1974.

Simon, Sidney. Professor, Department of Art History, University of Minnesota. June 17, 1974.

Thompson, Orrel. Associate Director and Chairman of the Education Division, Minneapolis Institute of Arts. June 27, 1974.

# THE ROCKEFELLER FOUNDATION FELLOWSHIPS IN MUSEUM EDUCATION AT THE METROPOLITAN MUSEUM, THE DE YOUNG MUSEUM, AND WALKER ART CENTER

**The growing attention to and need for museums to educate "new audiences" prompted the Rockefeller Foundation to finance three cycles of fellowships for education trainees in four major art museums from 1973 to 1976. The programs in three of them—each quite different—are described here. Differences have emerged in the recruitment, supervision, structure, emphasis (community arts versus traditional museum work), group projects, and individual study. Evidence in hand gives the program mixed reviews. CMEVA interviews and observations: September 1973–July 1975; January–April 1976.**

### Some Facts About the Program

**Title:** The Rockefeller Foundation Fellowships in Museum Education.

**Audience:** Potential museum educators (55 persons were admitted to the program between 1973 and 1976, of whom 53 completed their training); also established scholars, artists, and museum personnel who served as senior fellows at the Metropolitan Museum, 6 in all.

**Objective:** To provide professional training for persons entering the field of museum education. Equal stress is placed on recruitment, training, and job placement.

**Funding:** Grants totaling $750,000 from the Rockefeller Foundation (supplemented by $15,000 from the National Endowment for the Arts for the Metropolitan program): $350,000 to the Metropolitan Museum of Art; $188,000 to the de Young Museum and Neighborhood Arts Program in San Francisco; $136,000 to Walker Art Center in Minneapolis; and $40,250 to the Dallas Museum of Fine Arts. (The latter is not reported in this study.)

At the Metropolitan Museum, fellows received $7,000 in 1973/74, $7,500 thereafter, for a 12-month living allowance, a $1,000 travel stipend, and $500 for tuition reimbursement. In addition, they were allotted about $500 each for independent study projects during the fellowship. Senior fellows were given $10,000 for a six-month term.

In the Bay Area program, fellows received $4,000 living allowance for a 9-month term, $650 for travel, and up to $200 for job hunting. Between $500 and $600 was allocated for each fellow's individual project.

At Walker Art Center, fellows received a living allowance of $7,000 a year, plus a $1,000 travel stipend. Project allocations averaged around $4,000 a year above and beyond the museum's regular curatorial expenditures for such activities as publications, classes, and lecture series.

Administrative costs were about $25,000 a year at the Metropol-

itan, about $8,000 in the Bay Area, and about $10,500 a year (including capital expenses) at the Walker.

**Staff:** From 1973 to 1975, a full-time program coordinator at the Metropolitan; 2 part-time program directors in the Bay Area, plus a senior fellow who helped administer the program; no extra staff at the Walker. Outside consultants were employed in the Metropolitan and Bay Area programs to run seminars and workshops.

**Location:** The Metropolitan Museum, New York, the de Young Museum and other museums and arts organizations in the San Francisco Bay Area, and Walker Art Center in Minneapolis. Fellows also traveled to other museums around the country and abroad.

**Time:** Three years, 1973 to 1976. Fellowships were for 12 months at the Metropolitan Museum and the Walker, 9 months in the Bay Area. (After this report was researched, the Rockefeller Foundation extended the grants another two years, through summer 1978.)

**Information and documentation available from the institutions:** From the Metropolitan, reports available only in the museum library; from the de Young Museum, annual reports, individual reports by fellows, slides of projects, videotaped interviews with fellows; from Walker Art Center, one-page mailer announcing the program and descriptions of the fellows' projects.

In December 1972 the Rockefeller Foundation appropriated three-quarters of a million dollars for training programs in museum education. The money eventually went to four museums—the Metropolitan Museum of Art, the M. H. de Young Memorial Museum of the Fine Arts Museums of San Francisco, Walker Art Center in Minneapolis, and the Dallas Museum of Fine Arts—to provide fellowships to persons preparing to be administrators and planners of museum education programs as well as employees and directors of community centers, neighborhood museums, and community arts programs serving "the new audience" museums had discovered—or that had discovered museums—in the 1960s.

## Background: How the Fellowship Program Originated

The idea of specialized training for museum educators was not a totally new one, but it had rarely been put into action. A 1970 report on education in the Metropolitan Museum stated flatly, "there is no solid training offered [in the United States] for museum educators. . . . There is a growing demand for it in museums all across the country."[1] The demand, and the circumstances that prompted efforts to satisfy it, can be broadly summarized:

• There was a growing pressure on art museums to respond to the needs of the "new audience" that, though unschooled in the traditions of connoisseurship or high art, were nevertheless clamoring at its doors. The pressure was the result not only of changes in the political and social winds but of a widespread surge of public interest in the arts—what Howard Klein, the program director at the Rockefeller Foundation who handled the fellowship grants, called "the democratization of the arts."[2]

- With the establishment of the National Endowments for the Arts and Humanities and the passage of the National Education and Museum acts, relatively large amounts of public money were for the first time being made available to museums for public education. Museums had to justify this income, as well as their status as tax-exempt educational institutions.

- In 1968, the American Association of Museums published *America's Museums: The Belmont Report,* a study that called attention to the need for specialized training for museum personnel, including those in education.

## Meanwhile at the Metropolitan

The 1970 report for the Metropolitan Museum recommended that the museum inaugurate an on-premises museum education training program that would include study of educational theory, observation of classroom and museum teaching methods, practice teaching among children and adults, courses in visual technology and program measurement, visits to different kinds of museums and community centers, and original work on at least one museum education project.[3] Harry S. Parker III, then the Metropolitan's vice-director for education, was sympathetic to the recommendation; less than a year later, he proposed in an address to the International Council of Museums a ''course of study'' for museum education training that expanded on the suggestions in the report and added the study of visual perception and exhibition construction.

Parker also pinpointed the kinds of people who should be recruited for such a program: ''teachers and students of education, graduates in the humanities and social sciences, students of architecture, young people who have not earned college degrees but might be promising contributors to museum education programs . . . [and] museum personnel, experienced teachers, and other professionals. . . .'' And, he said, ''special efforts must be taken to attract members of minority groups. . . .''[4]

Parker and his staff acted quickly to establish such a program. Envisioning a pilot project small enough (six or seven participants at most) to allow individually designed courses of study for both experienced museum educators and newcomers to the field, and yet ambitious enough to provide fellowship grants for living expenses and travel, a faculty of consulting experts, and job placement services, Parker applied for and received a grant of $30,000 from the New York State Council on the Arts to run a nine-month pilot training program for four fellows in 1972/73.

The curriculum for those first fellows was organized into five areas:

- Weekly seminars with Parker and invited guests, where the fellows shared their experiences and helped shape the program throughout the year, and field visits to experimental school programs, teacher training organizations, community arts and education groups.
- Formal course work—generally in subjects that filled gaps

in each fellow's schooling—and instruction by museum staff in the operation of video, slide, and tape equipment. (One fellow completed an M.A. in art history at the Institute of Fine Arts during the year.)

- A two-month residency in a department of the museum's education division, which is divided into high school programs, public education, and the Junior Museum. Each fellow spent a month on assignment to a curatorial department as well. These brief internships enabled the fellows to work with regular staff in day-to-day activities (with the cooperation of the departments of European paintings and prints and photography, for example, one fellow helped prepare written materials and a small exhibition to accompany a temporary paintings show).

- Travel to education departments in American museums (Chicago, Toledo, Cleveland, Detroit, and Columbus, Indiana) and European museums (Paris, Amsterdam, London, Leicestershire, and Stockholm), as well as to a series of seminars conducted by Renée Marcousé at the department of art training in the University of London's Institute of Education.

- Research for work assigned in the seminars, courses and residencies, and an independent project for which each fellow submitted a plan and a proposed evaluation scheme. These individual projects reflected each fellow's special interests: one studied ways the Metropolitan could better serve, and be served by, the artist; another surveyed museum needs and possibilities for teacher training and resource services; one researched and wrote the catalog for a Frank Lloyd Wright exhibition; and the fourth investigated experimental programs for preschool-age children. Two group projects were included: participation in an audience survey the Metropolitan had commissioned and a new design for Junior Museum programs and facilities.

At the end of the year, one fellow enrolled in graduate school and three went on to jobs, including Ada Ciniglio, who stayed at the Metropolitan to help Parker run the next year's program. For Ciniglio, the most valuable aspect of the pilot project and the fellowship that grew out of it was the location at the Metropolitan and the guiding hand of Harry Parker: ''He was an upper-echelon administrator committed to education; that was extremely important. We were given tremendous access to people in the field.''

## Enter the Rockefeller Foundation

The pilot program under way, Parker began a series of discussions about museum problems, especially museum education, with Howard Klein of the Rockefeller Foundation. He found a receptive ally. Intrigued by what he saw as a shift in museum audiences and sensing, as he said later, an impending infusion of federal money into museum and visual arts education, Klein endorsed the idea of fellowships in museum education. There was also a suspicion, as one staff member of the Rockefeller Foundation put it, that most museum education departments were ''abysmally amateur . . . [that] do-

cents [were] sweet; they were donating their time, trying to fill a gap that the curatorial staffs did not want to fill." Klein enthusiastically recommended the idea to the foundation's trustees—whose chairman was Douglas Dillon, then president of the board of trustees of the Metropolitan Museum.

The broad outlines of what was to become the Rockefeller Foundation Fellowships Program began to emerge. In December 1972, the Rockefeller Foundation trustees appropriated $750,000 to be spent over three years to provide persons in "selected museums"—not yet chosen—with what the foundation called "a detailed understanding of the museum as an agency of community cultural development."[5] For Klein, the central idea was that the program would be closely allied to "the new dawn" of community interest in museums and the visual arts. A Rockefeller Foundation report, in fact, stated that selection of museums would be based on "the possibilities for shared work [and cooperation] with other museums and educational institutions . . . and community organizations."[6]

Eventually, the $750,000 was allocated this way: $350,000 to the Metropolitan Museum for about six fellows per year plus six senior fellows, available from January 1973 through June 1976; $188,000 to the M. H. de Young Memorial Museum in San Francisco for up to ten fellows per year, available from May 1973 through August 1975, later extended to mid-1976; $136,000 to Walker Art Center for at least two fellows per year, available from May 1973 through August 1976; and $40,250 to the Dallas Museum of Fine Arts for one fellow the first year and two the second (its program ran from July 1974 through June 1976). Some of the money was also set aside to pay the expenses of annual meetings of all fellows, which were to be held to help the Rockefeller Foundation evaluate the programs.

The foundation outlined three distinct components of the program, each to receive, according to Klein, "equal stress." *Recruitment* was to be broad, seeking candidates from museums, universities, art studios, and community arts organizations. *Training* was defined this way: there would be "training" fellows, who would receive instruction, work at internships in varied settings, and *not* provide services to the museum, and "senior" fellows, mature scholars who would pursue independent studies at museums and give instruction and support to the training fellows. *Job placement* was to include efforts by the program staff to gather information about job openings, help for the training fellows as they prepared their resumés, and even subsidies for some travel to job interviews.

On paper, the Rockefeller Foundation Fellowships were set—as Ada Ciniglio wrote two years later—"to provide personnel for these emerging institutions and for the programs which grew out of the enlarging social concerns of traditional museums."[7]

## Operation of the Programs: 1973/74

Because the first fellowship at the Dallas Museum was not awarded until this study was under way, what follows is an examination of the Rockefeller Foundation fellowships at three of the four participating institutions—the Metropolitan, Walker Art Center, and the de Young Museum-Neighborhood Arts Program (referred to as the Bay Area program)—principally during the academic and fiscal year 1973/74.[8] United under a common name and the same broad purpose, they developed into three quite different programs, each influenced by the nature of the sponsoring institution and its hometown, the characteristics of the fellows themselves, as individuals and as groups, and by the personalities and preferences of the project directors. The diversity was neither unexpected nor accidental; in describing the early planning of the program, Klein said, "We built it so that whoever did the program could do it their own way. . . . We agreed on something the Met would use, but [didn't want to] dictate the structure to other museums."

Before the individual components of the programs are taken up in detail, some basic facts about and major differences among the three in their first year should be noted:

- The Metropolitan Museum program, run first by Vice-Director Parker and then (after Parker left in December 1973) by Ada Ciniglio, was structured around a curriculum heavy on seminars, courses, assignments in museum departments, and research, with particular emphasis on the fellows' individual projects. Travel to other museums around the country and abroad was considered important to the fellowship. The focus of the program was to be balanced between community arts and audiences and traditional museum work and audiences, including the schools. As it turned out, the fellows themselves split into two groups, one interested primarily in community arts and the other in traditional museum education.

- The de Young Museum jointly sponsored the Bay Area program with the Neighborhood Arts Program (NAP) of the San Francisco Art Commission (see chapter 4 for a report on NAP). Two codirectors, Elsa Cameron from the museum and Stephen Goldstine from NAP, engaged the fellows in a rather loosely structured—but, the directors insist, focused—curriculum, and in "mini-internships" and individual projects in area museums and community arts organizations. The principal focus was on training to run small museums and nontraditional, community-based arts groups.

- Walker Art Center took on fewer fellows than either of the other programs and treated them as education staff members. The fellows were informally supervised by Martin Friedman, Walker's director, and they planned and executed their own projects, which were required to be consonant with Walker's stress on relations with community organizations, public schools, and universities. There was

no set curriculum. Instead, the fellows were encouraged to attend staff meetings, make contact with staff members in all departments of the museum, and establish "tutorial" relationships with staff.

## Recruitment and selection

**At the Metropolitan.** A printed brochure, sent to graduate art and art history departments and distributed at College Art Association meetings in the spring and early summer of 1973, was the Metropolitan's major recruitment effort. In addition, the museum published a booklet, *Opportunities in Higher Education at the Metropolitan Museum of Art*, that listed the Rockefeller Fellowships as one of several programs for independent or directed study.

Parker chose six training fellows, originally for one-year terms, although the program effectively ended after nine months for most of them. Parker also selected for six-month terms the two senior fellows, Romare Bearden, a well-known black painter with a particular interest in Afro-American artists, and Allen Sapp, a musician, university professor, and at the time executive director of the American Council on the Arts in Education. All but one of the six training fellows were either candidates for or had just received the M.A. degree; two of them were black. Work preferences were split between those who were interested in traditional museums and those oriented toward community arts. Each fellow received $7,000 for the year (this was increased to $7,500 the next year), plus a $1,000 travel allowance and a $500 tuition reimbursement grant.

**The Bay Area.** Twelve fellows were chosen from nearly 300 applicants from 13 Western states for the Bay Area program. Codirectors Elsa Cameron (curator-in-charge of the de Young Museum Art School) and Stephen Goldstine (director of the Neighborhood Arts Program of the San Francisco Art Commission) had flooded those states with press releases to state arts commissions and daily newspapers and letters to museum and art center directors. Looking for people who would return to their home areas to share their new skills when the nine-month fellowship ended, Cameron and Goldstine also tried to strike a balance between male and female, white and nonwhite.

They ended up with four women and eight men; six were nonwhite. The group included a filmmaker, gallery director, a curator, several artists (who combined their art work with other careers), two teachers, two art historians, a textile designer, two community organizers, and one person experienced in video and media. One member of the group, Jonathan Ziady, was both training and "senior" fellow; he participated in the curriculum and projects with the others, but he also helped administer the program, mostly by scheduling speakers and seminars. Each fellow received $4,000—the lowest stipend of the three programs because it covered only 9 rather than 12 months.

**Walker Art Center.** Unlike the other institutions, which recruited within a limited geographical region, the Walker sent a succinct one-page flyer throughout the country in late summer 1973. Its description of the candidates it was seeking for its 12-month residency: "Individuals with master's degrees in art history or humanities, or commensurate program experience in museums, teachers in public school art and humanities programs, artists, and personnel from community and cultural centers. . . ."[9]

In addition to the flyer, which was sent to community art centers, colleges and universities, and state arts councils, the art center placed advertisements in a number of professional journals. Over 100 inquiries came in; ten candidates were interviewed, and two were selected, to begin at staggered intervals, one in March 1974, the other in July of that year. Director Martin Friedman explained that the Walker chose to sponsor so few fellows and to schedule them at intervals because of the relatively small size of his staff, the tight job market for museum personnel, and his desire that they establish tutorial working arrangements. Each fellow at the Walker was paid $7,000 for the 12 months, plus $1,000 for travel.

## Curriculum and related activities

**At the Metropolitan.** Organized around seminars, courses, reading, visits, and workshops for the first phase, and around research and study assignments in the museum's education and community departments in the second phase, the Metropolitan curriculum was designed, in Harry Parker's words, to "emphasize the museum in society" and to be concerned with the "needs of the total community."[10] The curriculum was planned by Parker, who directed the program, and Ada Ciniglio, who acted as his assistant and as program coordinator until December, when he left the Metropolitan to become director of the Dallas Museum of Fine Arts and she was left with full responsibility for the program and the fellows (though not the director's title or salary). Ciniglio spoke later about the problems of designing a curriculum for a program that was not predicated on conventional, academic learning:

> . . . You can't just sit down and draw up a curriculum and expect that it will meet everyone's needs. The program was much more complex than that. We wanted the fellows to make some decisions about it as we went along. You see, this is a different educational process from the kind that goes on in classrooms, and it was complicated by the fact that, especially in the beginning, the fellows didn't really know what they wanted or needed.

Throughout the first six months of the program, Senior Fellow Bearden met with the training fellows almost weekly, talking with them about the work and problems of black artists in America; he also took them to meet art dealers, gallery directors, and artists. Senior Fellow Sapp met with the fellows more sporadically, primarily about fund raising,

proposal writing, and community arts.

Seminars with museum curators, university professors, and staff of local institutions were held throughout the year. Some of the training fellows themselves conducted seminars: one seminar was part of a museum workshop week at the museum (the fellows led the discussion on training museum professionals), and another was arranged with New York University graduate students enrolled in a course on the educational use of museum resources.

With their $500 tuition reimbursement grants, fellows took courses at New York City colleges and universities in art history, criticism, photography, and other subjects generally related to their efforts to complete the master's degree, which most were still working on. Two, in fact, finished their M.A.'s that year.

Within a month after they arrived at the museum, the training fellows began work on their individual assignments within the education or community departments. These ranged across the spectrum of educational work—written materials, exhibitions, evaluation of aspects of the department's work, a survey of audience needs, participation in neighborhood classes and in work with school programs inside the museum. One fellow worked both with GAME (Growth through Art and Museum Experience, a cultural resource center described in chapter 8) and with the museum's mobile unit, Eye Opener, to see at first hand the way community arts organizations, schools, and museums did or did not work together.

*Problems and dilemmas.* On paper, and occasionally in practice, the combination of activity, study, and talk worked well enough. But Parker's departure in December not only "broke the continuity of the curriculum," according to Ciniglio, who found the change "a difficult adjustment for both the fellows and me," but left the program without a home in the museum. Ciniglio added that Parker "had conceived the program and had made all the major philosophical and other decisions (up to that point). He left thinking that he would be replaced. . . . Certainly he felt that administration of the [fellowship] program should be a full-time job—and done out of the vice-director's office."

Instead, the Metropolitan's education departments were placed for six months under the "stewardship" of the vice-director for operations. The fellowships program "floated around for awhile," in Ciniglio's words, until it finally settled, by default some would say, in the offices of the department of public education. It was a painful time for the coordinator, who later said—without rancor, but firmly— "Neither Harry [Parker] nor anyone else in the museum had made proper provision for what would happen to the program after he left. . . . No one had ever made decisions about it or given it much thought."

Complicating the administration of the program still further was a difference of opinion about the program's direction between Ciniglio and Melanie Snedcof, then acting head-in-charge of public education (Snedcof took over as coordinator of the fellowships in fall 1975). Snedcof advocated giving each fellow a free rein to pursue whatever interested him, whether in or outside of the museum, independently and at his own pace.

Ciniglio wanted to pull the fellows together for at least some group activities, especially those concerned with building specific skills, and to force accountability for—if not evaluation of—the fellows' individual projects. "I came out of a teaching background," she said, "and I saw this program as 'tutorial' in nature. [I had in mind the ideal] of a student-mentor arrangement, in which a contract is drawn up to describe the goals and expectations. But [that wasn't realistic], because we didn't take on 'fellows' capable of independent research in this field."

So, in the absence of firm guidance and standards set from above, and without specific goals—but with very high expectations—of their own, some of the fellows were left to drift. Several expressed disappointment, and there is no doubt that they disappointed some observers who had great hopes for the program. Ciniglio commented,

> You have to remember that the program was being carried out in a very heavy political context. The original idea was that we were going to train the future leaders in the field of museum education, that these people were going to be directors of education departments, even directors of small museums, in ten years.

What critics of these "future leaders" saw was a group that exhibited little curiosity or enthusiasm in its encounters with the consulting experts or even with one another. Ciniglio admitted ruefully that she "made demands on the fellows that they didn't want to meet—they found it too hard. . . . I wanted to train museum educators, and some of them had other agendas." Those "other agendas," she said, were personal projects that had little or no relation to the fellowship training per se: the running of a private gallery for one fellow, development of an idea for a new museum for another, and active and continuous job-seeking for a third.

Still another dilemma centered on a sharp split in that first-year group between fellows who were in the program primarily to learn about traditional museum work and those who were most interested in community arts. The latter were in the minority, yet it was in large part because of this commitment that they had been chosen. It was also because of the hopes nursed by the Rockefeller Foundation that its fellowships could help a museum be, and be seen as, "an agency of community cultural development" that the fellowship program had been undertaken in the first place. There seemed little commonality of interest between the two community arts fellows and those who were in the program to learn how to work in a large, traditional museum. "The theory had been to bring people with these two orientations together so that they could learn from each other as well as from the museum," said Ciniglio. "The two community arts people had an entirely different set of needs, a different schedule

from the others. The community arts people were much more practical, and that was good, but often they just weren't interested in learning beyond their own experience—they wanted to do their own thing."

According to one of the "community" fellows, doing one's own thing was a chronic problem for the entire group. He found, he said, that any interest at all among the fellows in each other's projects was hard to come by. When he tried to pull the group into discussions of a project another fellow was doing—not a "community" project, but some work on the Metropolitan's upcoming special tapestry exhibition—he "had to fight to get them interested. It was embarrassing to [the fellow with the tapestry project]. When I saw that I thought, 'This is really a phony group.' We should have been able to share, but everyone was off on his own trip. We didn't do a group thing."

**The Bay Area.** Although a detailed curriculum for the Bay Area program had been outlined in the de Young's proposal to the Rockefeller Foundation, in practice it, like the plan at the Metropolitan, changed according to the needs and desires of the fellows and the dawning recognition of the project directors that, as Codirector Cameron put it, "theory must be flexible and responsive to the actuality of the situation." So the codirectors broke away from their original scheme to develop what Cameron called "a system that prepared students for a practical working experience and to be responsive to real people and life situations."[11]

The focus of the program was explicit in the name Cameron and Goldstine chose for it: Rockefeller Training Program in Museum Education and Community Studies. After all the changes required by what Cameron calls "input from the fellows," the 16-week curriculum of seminars and research that comprised the first stage of training included a little bit of everything: visits to Bay Area museums, galleries, community arts organizations, schools, and satellite museums; observation of museum education, docent, collaborative, multimedia, and outreach programs; seminars and workshops in exhibition design and installation, museum procedures—administration, registration, collection, conservation—and program assessment.

Seminars were conducted three days a week by "program implementers," most of them well-known arts administrators, museum educators, or community arts organizers. During this first stage, at the urging of the fellows themselves, each was assigned to one- or two-week "mini-internships" in areas that especially interested them: schools, docent programs, grants and funding, exhibitions, conservation, community arts, or publications. These brief internships added some "real" work to the 16 weeks of talk and observation and gave the fellows first-hand knowledge they could share with the group.

From the outset, group activities were important to the fellows and to Cameron, who divided them into four "action teams," each to plan and execute one program during the first stage of training. Cameron estimates that over 40 hours' work a week, throughout the 16-week period, went into these group assignments, which were a workshop for schoolteachers conducted in cooperation with the University of California Extension Service; an Asian-American exhibition that used existing community facilities to create a satellite museum; docent training; and participation in an exhibition of Third World artists in the museum.

Beyond the seminars, the "mini-internships," and the group assignments, the fellows attended workshops conducted by staff of the de Young Museum Art School and NAP to teach skills the fellows lacked and that Cameron and Goldstine believe are essential for a museum educator. The workshops covered photography, video and other audiovisual equipment, the use of power tools, accounting procedures, and publicity (from silkscreening posters to what Cameron calls "manipulating the media"). "If the fellow was not able to gain competence in these areas," she said, "at least he became familiar with the procedures."

As their final responsibility of the initial training period, the entire group designed and installed a "Native American Indian Ceramic Exhibition" at the de Young Museum, under curatorial direction. Eleven of the twelve fellows were able to work on one aspect or another of this temporary exhibition. Two spent time in New Mexico meeting the artists and helping to choose pieces for exhibition; one of these said later that living for three weeks with the potters at Acoma was "a marvelous experience." Three planned a docent training program for the show, two others selected the photographic murals for the exhibition walls and wrote explanatory labels, and four fellows worked with the museum designer and executed the wall graphics. They also helped with packing and unpacking objects, registering, checking, insurance, and with the more glamorous task of planning an accompanying program of films, lecture demonstrations, and dances.

Like the Metropolitan program, this one looked good on paper. Cameron says candidly that the first month was "disastrous." She says that she never anticipated the factors that would be so unsettling and that "completely dominated the first months of the training." The fellows came from such a geographic mix—rural areas, small towns, and big cities—that being thrown together into an urban environment as saturated with politics and problems as the Bay Area arts organizations are, staggered some of them. Confronted by the city and by the program's rigorous schedule, they were also challenged by one another, a new life style, and in some cases a reduced income (the Bay Area fellowship of $4,000 was by far the lowest of the three programs).

The strain showed in comments the fellows made during those early weeks. From one: "The exposure idea is fine, especially for those of us from areas where there aren't as extensive institutions and projects. . . . The emphasis that seems to prevail, however, is the personal, financial undertone." From another: "The third day seemed like the third month. . . . The best part of the day was when six of us found

ourselves in a Berkeley pizzeria with two large pizzas and gallons of beer. . . . We needed time to really get to know each other.'' On the third day, another fellow wrote, ''Up to this point [we have already been presented with] a vast selection of topics. I think it will take a little time for me to digest just what I heard [today].'' (Another confessed, on a different day, to falling asleep trying to listen to a seminar speaker who, the fellow reported, was ''a fast talker [who] talked too much.'') One of the fellows who said ''we were bombarded at the beginning,'' tempered the judgment with ''but then, too much is better than not enough.''

> Cameron analyzed the seminar problems this way:
> Although the speakers were extremely competent . . . they did not build on the previous speakers' presentations or on the prior knowledge of the fellows. . . . In the first month the fellows became victims of propaganda lectures and ideology rather than being treated as professionals and being invited to participate in a dialogue. . . .

So the codirectors began their revisions, and the ''mini-internships'' were born. But Cameron and Goldstine did not scrap the lecture-seminar method with its requirements of reading and field observation as the core of the curriculum. The meetings continued, three days a week, with an additional two-hour wrap-up session conducted by the fellows, at which they shared information and evaluated the week's activities. (Cameron and Goldstine got ''feedback'' from these wrap-ups only via anonymous comments on index cards.) And each fellow met once a month with the codirectors for individual evaluation and counseling, for decisions about an internship project, for discussion of readings, and for, as Cameron says, ''general encouragement and morale-boosting in a strenuous training program.''

**Walker Art Center.** Instead of being part of a class with a formal curriculum, each fellow entered the Walker program alone and was given free and informal access to the staff and to the steady stream of visiting artists and scholars who participate in the museum's programs. From his first day, a fellow was assigned to his individual project (described in the next section) and, said one Walker fellow, ''made to feel [like] a staff member.'' The other 1974 fellow was more explicit in this regard. ''We *were* the education staff,'' he said. ''For as long as I was there, there were no paid education staff members.'' (Director Friedman points out that ''there are always one or two people employed to work on education'' at the art center and that an acting head of education was in charge of scheduling for the Rockefeller fellowship program.)

Fellows attended all staff meetings and, according to the first fellow in the program, whose appointment overlapped the terms of two others, all felt as she did—that she was always treated as an individual, encouraged to do her own work, and given the same respect and freedom to choose her part of each project that other staff members had, and the

work invariably fitted into a program or event or project at the museum. Another fellow at the Walker described the fellowship's focus as ''learning to use the Walker as a resource. We may be doing lots of different jobs,'' he said, ''but it all adds up to presenting the Walker to the public.''

Because the Walker's collections consist primarily of contemporary American and European art, and its activities often reflect its vision of itself as an active agent of change within the community, the staff selected fellows with special interest in those areas. The Walker's broad arts program, which includes dance and music (and the activities of the Guthrie Theater, which is in the same building), was expected to be part of each fellow's schedule. Friedman informally supervised the fellows, and they were encouraged to get to know staff members in all museum departments and to establish ''tutorial'' relationships with them.

### Individual projects: short and long internships

**At the Metropolitan.** In addition to the assignments in education and community departments at the Metropolitan (described briefly under curriculum), each fellow had a curatorial assignment and devised an independent internship. Depending on the fellow's interest, the internship could be in one of the museum's client agencies or in a museum department. Placement for all assignments was arranged by Parker and later by Ciniglio with a supervisor to whom the fellow would be responsible.

Curatorial assignments were designed to give the fellows an understanding of a curatorial department's priorities, problems, and procedures. Five curatorial departments took on fellows for several weeks during 1973/74, usually to help with catalog research for a publication, label writing, audiovisual materials, or a loan exhibition the department was preparing.

''The curatorial assignments were most successful in those cases where the fellows came out with a real product—a publication or something of that sort—that would give them a sense of satisfaction and accomplishment,'' said Ciniglio. The fellow who helped research and write a catalog for a show, called ''Saints and Their Legends'' and mounted by the department of medieval art, agreed, noting that it was a valuable, if frustrating, experience. In a final report on her assignment, she wrote,

> My initial two weeks with the medieval department were interesting and fun. The curators were good to me; that is, I was treated respectfully as a [knowledgeable] student . . . whom they could rely on to do research properly. . . . But I was treated as a scholar [not an educator, mainly because] of the lack of understanding on [the supervising curator's] part of the Rockefeller fellowships. She could not comprehend the type of training we were receiving. [Another curator's] understanding was that I was a graduate student in art history referred to them probably by the education department. This point is most important, for it revealed to

me exactly how curators see departments of education. . . . I do not believe that [they] feel that educators have something to offer. . . .

Unfortunately, the Rockefeller fellowships or the education department was not given any credit by [the curator] in her introduction to the catalog [I helped write]—in fact, she stated that [it was] written entirely by the department of medieval art, which is a perfect example of her misunderstanding of my assignment with her.[12]

Supervisory misunderstanding surfaced in both the curatorial and independent projects. "Partly it was a matter of bad communication, partly a matter of many of the supervisors just not caring enough," said Ciniglio.

The real key, and something we were more aware of the next year, was to identify good supervisors who would do the job in a caring way. The need is to place the fellows with supervisors who are willing and able to be teachers. An intern should *never* be placed with someone who isn't excited about what the intern is doing. And in order to be excited, the supervisor has to be interested in the project the fellow is to carry out. That means that the project has to be one the supervisor wants or needs done.

The independent projects covered a variety of topics. One fellow surveyed systems of intramuseum communications, especially between educators and curators, in museums in New York City, Washington, D.C., Oakland, and San Francisco. Another worked at New York's Museums Collaborative on preliminary research for the citywide cultural voucher plan (for a report on the Collaborative and the voucher system, see chapter 4). A third mounted an exhibition of works by black artists at a school in the Bronx and helped guide schoolchildren through it; he later organized a slide and film seminar, "One Hundred and Fifty Years of Black Artists in America," which was presented at the Riverside Church.

**The Bay Area.** Each fellow in the Bay Area program had to design his own project, subject to approval by the project director, to be conducted over a six-month period within an education department or program of a local arts institution. Conceived as one-to-one "learning situations," each internship required a willing supervisor from one of the Bay Area museums *and* an adviser in the fellow's specialty area. Project directors looked for three factors when they judged the proposed projects: How clearly had the fellow defined his goals and his audience? How realistic were the ambitions of the project, given budget and time limitations? And how instructive would the project be to other interns and institutions? Each fellow was allocated $500 for the entire internship project and was required to submit a line-item budget, to keep a daily work record throughout the six months, and to record all project expenditures and all purchases made by purchase order (a maximum of $25 was allowed for petty cash).

The only fellow who did not complete an internship left the program to take a job at the Oakland Museum. Of the remaining eleven, six chose to work at the de Young, primarily in school projects. Some samples: preparation of a portfolio of drawings and text on the arms and armor collection; preparation of photographs and labels of the costume collection for a traveling exhibition on San Francisco and California history; interviews with classroom teachers to find out what they expected—and needed—from the museum; development of a training course on the traditional arts of the Eskimo for docents who conducted workshops for children in the schools and at the museum.

At two other museums, fellows devised internships related to interests they brought to the program. One created an exhibition of native American artifacts and conducted a two-day Indian festival at the Oakland Museum, and the other developed a video project based on audience response at the Exploratorium.

The remaining three fellows chose to work in community projects with the San Francisco Art Commission's Neighborhood Arts Program. One project was field research and a photography exhibition—which circulated to San Francisco schools and was exhibited in a community gallery—about three working-class families, with the expressed purpose of illustrating common elements among the families and thereby combating racism in the city's ethnic communities. Another was an exchange exhibition between a local storefront gallery, Galeria de la Raza, and a New York Puerto Rican cultural center, including community-oriented programs and lectures to accompany the show. The third was the creation of a community-based arts resource center, which published a monthly newsletter listing community arts events.

Important to the success of each internship, Cameron felt, was the way the intern was treated. She insisted that "the fellow was not considered an assistant in an education department; he was to be an asset pursuing his own project within the institution." At the same time, she said, she encouraged each supervisor to emphasize the project's relationship to the sponsoring institution and to impose professional standards on its execution.

Each fellow met monthly with his supervisor and an impartial evaluator and at the end of the six months submitted a report, accompanied by visual documentation, that had to be "suitable for publication." Judges of these reports were the supervisor, one of the project directors, and two consultants from some area of museum work.

The 1973/74 fellow who was both a training and a senior fellow also did an independent project, but he reported that he found his administrative work, itself a kind of "independent" project, the "best preparation" of his fellowship "because it got me into the realities of museum work." He had had no experience in a museum—"I was an artist and had been working menial jobs to live," he says—and the training gave him a set of professional skills and enabled him to get a

job he likes. He became assistant curator for exhibitions in suburban Walnut Creek, California, at its busy art center.

**Walker Art Center.** The only requirement for individual projects at the Walker—which were not called "internships," as they were part of the ongoing fellowship—was that they be in keeping with the nature of the programs that the museum regularly presents to the public. Director Friedman explained that "everything [the fellows] do is intended to be used. . . . These are not paper projects."

Slide-tape programs which are offered in a special "information room" at the art center, are a major activity at the Walker, and the first fellow made two early in her tenure, one of them for a special exhibition. She also wrote gallery notes to the museum's collection, devised tours for children from a suburban school, and planned—in cooperation with the Minneapolis park department—a series of studio classes in assemblage that a local sculptor helped teach.

A second began his fellowship by working outside the museum: he taught a studio class in the Minneapolis public schools' urban arts and humanities program (see chapter 10). From the beginning, he also visited a number of community centers, trying to publicize the services the Walker offered. As he explained it,

> One of the main reasons for my being here was [that] I had had some experience in New York with community projects. [It was thought] that I could be useful to the Walker in establishing the kinds of contacts they had never had before. . . . Most of the places and centers I visited were totally unfamiliar with what the Walker has to offer. We would go out to those places and find out where the resources are and how the Walker could be of service.

He also organized Open Studio, an artist-in-residence program sponsored by the Walker and five community arts organizations through which artists and advanced junior and senior high school students could meet and share ideas. This project was his own idea, and though it was in keeping with the spirit of Walker programs, it was unlike anything the museum had tried before, an indication, he said, of how open-minded the Walker staff was to new ideas.

But his enthusiasm for Walker's flexibility was tempered by his discouragement over the fact that, as he said, "there was no continuity in our projects. They ended when the fellow left because there was no one to carry them on—we were the only education staff." He thought this particularly regrettable in regard to programs the fellows developed with community organizations ("it let them down"), and he admitted that over time it diminished his own eagerness to start projects "that might have been significant in the long run."

Friedman's encouragement to the fellows to observe and have contact with museum staff, including administrators, in every department, meant that, among other things, the fellows took an active part in the training of docents and—something that left a more lasting impression than training on

at least one of the fellows—often filled in for docents who did not show up.

**Travel and conferences**

Individual and group travel was considered important in all three programs—nearly all the fellows agreed travel was "one of the strongest points" of the fellowship—though the Metropolitan fellows found travel much easier from their New York location than their colleagues from Minneapolis and San Francisco. The Metropolitan fellows traveled as a group to museums or conferences in Washington, Buffalo, New Haven, and Boston, and individual fellows traveled to Cleveland, San Francisco, Washington, Boston, Baltimore —and to Mexico and England—on their separate travel stipends of $1,000 each.

The Bay Area fellows made only one group trip, to New York City and Washington, D. C., during the two weeks after their sixteen-week curriculum ended and just before their six-month individual projects began. Nine had never been inside the Metropolitan or any of the Smithsonian museums, and seven had never been to the East Coast. Cameron believes that "the experiences of the trip provided a common concept for the group and gave them a renewed interest in art." For two of the Bay Area fellows, the trip East sparked ideas for their independent projects: one met staff of a Puerto Rican community center, and another was inspired by the Metropolitan's arms and armor collection to work on the de Young's collection when he returned to California.

Though Cameron saw the New York trip, at least in part, as an "exchange study program" between East and West Coast fellows, she reported that "there was only limited formal exchange of ideas and little or no interaction between the two groups." Ciniglio concurred: "The Metropolitan fellows did not get much out of [the visit], mostly because there wasn't a commonality of interest. The Bay Area fellows were so much involved in community arts, which was not the primary concern of most of the Metropolitan fellows."

Walker fellows especially welcomed their $1,000 travel allowances, for as one pointed out, "Minneapolis is so far away from any other big cities or from other museums." On her trips she developed a system: "First I would go through the collections, then I would go to the education department and talk with the curator or lecturer or whoever was there. It was a very good experience." Walker staff encouraged fellows to travel, not only to learn from museums around the country but also to give them a chance to make contacts for future jobs.

Fellows from all three programs came together for a day-long conference in Dallas in June 1974. Scheduled the day before the opening of the annual meeting of the American Association of Museums in nearby Fort Worth, the conference was meant to give the Rockefeller Foundation an opportunity to evaluate the progress of the programs. For the fellows, it was a chance to share and compare their experiences.

In the opinion of one fellow who attended, "the conference was ineffective, if only because one day is simply not enough time for the kind of sharing and discussion we wanted to do." Some fellows objected to the "show-and-tell" aspect of the meetings, and others were depressed by the general preoccupation with jobs. One fellow, who attended both the 1974 and 1975 conferences, reported that this concern deepened to gloom at the June 1975 conference, when the job market had considerably narrowed. Another, either more positive or more prudent than some, found the 1974 conference valuable: "I would suggest [attending the conference] to anyone before they get into the program, just to see where the fellows are."

### Job placement

By September 1974, the official end of the first fellowship year, all six of the Metropolitan fellows had been placed in jobs, four in education posts, two as curators in museums with relatively small staffs. Said Ciniglio, "That was before the museum job market really tightened up, and I was still getting letters from museums asking for people to fill jobs. So placement was not that difficult, and we could do it rather informally. Some of the fellows found jobs on their own."

Placement was more difficult and efforts more systematic for the Bay Area program, partly, according to Cameron, because the group was so large (twelve fellows) and partly because most of the fellows either did not want to leave San Francisco or were interested only in returning to their home states. The program administrators sent out "fact sheets" containing each fellow's resumé and a description of his internship project to museums and art centers throughout the West. By February 1975 ten of the twelve fellows were working in curatorial, educational, or community departments at museums and art centers, all but one in the West. (One fellow, who had been curator of exhibitions at Alaska State Museum when he entered the program, decided not to go back to Alaska, despite the tacit terms of the fellowship, because he "felt I had done all I could do there." After the fellowship ended, he "took a break from museum work for awhile.") One fellow dropped out of the program for personal reasons, and the twelfth stayed on to become a senior fellow in the 1974/75 program.

Walker staff members made no specific efforts to place their fellows in jobs, though Friedman readily made calls and gave recommendations when asked. One Walker fellow took a job as an educator at a museum of contemporary art, another in the education department of the Cleveland Museum, which had courted her before she became a fellow. Nevertheless, she began sending out letters soon after she came to Minneapolis and now believes that having to search for jobs was good for her.

**Employer feedback.** Plainly, the Cleveland Museum's curator of education is satisfied with the fellow he has hired. Her qualities, he feels, "speak as well for Walker's recruit-

ment choices" as for the guidance Walker staff provided. He respects her flexibility, imagination, and drive, which "you can't pick up in a [training] program," and feels she was given solid experience in a supportive atmosphere.

Richard Gregg, director of the small (annual budget around $350,000) Allentown Art Museum in Pennsylvania, is another satisfied customer. He hired as one of his three professional staff members a former fellow from the 1973/74 program at the Metropolitan, and had this to say nearly two years later about the fellow and his training:

It was one of the best appointments I've ever made. I've been able to go away . . . and leave the museum in his charge; he hangs important exhibitions; he has produced publications for us, including a catalog. [Allentown] is a museum that is perhaps more concerned with education than other museums our size, and not only was he a teacher before he was a fellow, but during his fellowship he worked in all kinds of exhibitions and other educational programs that are applicable here.

Like many small-museum directors, Gregg said, he finds it difficult to keep on top of everything that is happening in the museum field, and he has found useful, too, the contacts the former fellow had made with museum professionals during the training year:

His contacts have been significant for us. For instance, because of the training he knew about Susan Sollins's work [giving improvisational tours], and we recently had her come here to give workshops. I wouldn't have known about her.

Asked if he thought the Rockefeller fellowships program was good training for work in small museums, Gregg answered yes, with the reservation that "the Metropolitan will always be another whole world apart from small museums." But, he added, "exposure to that 'other whole world' is invaluable for anyone, and there's always something that can be carried over on a smaller scale."

Finally, Gregg gave what is perhaps an employer's highest accolade: "If another Rockefeller fellow applied for a job here," he said, "he would certainly stand the best chance of getting it because of the training."

Another employer is less happy about the program. Supervisor at a large urban museum, she feels that both she and the two Rockefeller fellows she has hired—one from the Bay Area and one from the Metropolitan program—have been "conned" into believing these programs prepare their participants for the real world of museums. "They don't know what they don't know," she says. Her analysis of the problem is that "they've been given projects that if they fail, it doesn't matter. . . . They're not required to stand up and do anything." Like Gregg, she thinks the fellows got "a good overview" of the museum education field, but, she said, "they lack specific skills."

Nevertheless, Melanie Snedcof, Ciniglio's successor as coordinator of the fellowships program at the Metropolitan, has suggested that perhaps an employer's judgment reflects

as much on the competence of the individual fellow, the personal relationships he establishes, the institution in which he does his professional work, and even the employer himself, as it does on the nature of the training program and the quality of its recruitment and screening.

## Changes in the Program, 1974–1976

The two larger and more complex fellowship programs—those at the Metropolitan and in the Bay Area—changed in their second and third years, as their administrators became more sophisticated and responded to new groups of fellows with different needs.

### At the Metropolitan

**Selection.** A major—what Ciniglio called a "crucial"—change in the selection of fellows was made in 1974/75 (and continued in 1975/76). Instead of resting with the judgment of one person, selection was turned over to a grants committee made up of curators, education staff, and administrators appointed by the museum's director to decide all fellowships and grants awarded by the museum. (Ciniglio pointed out that one fringe benefit of this new policy was greater curatorial interest in the program; once they had a hand in selection, she said, the curators also had a stake in what the fellows did in the museum.) For the Rockefeller fellowships, strong and specific career interests, and particularly broader work experience, became the primary criteria.[13] There was also, according to Ciniglio, a more concerted effort to recruit minority candidates in the second and third years.

"If we learned anything that first year," she said, "it was that it was not good to take people right out of graduate school. This kind of program is much more suited to those who have been around in the field for awhile." The 1974/75 fellows included an educator and an administrator from two of New York City's major museums, three persons who had worked in responsible positions in New York City community arts organizations, an elementary school art teacher, and a teacher of art teachers from England. Ciniglio believes that as a group the 1974/75 and 1975/76 fellows brought "higher intellectual quality," wider experience, and greater maturity to their fellowships. She noted, too, that by deliberate action of the selection committee, a higher proportion of the second- and third-year groups was interested in community arts. So the duality of the program remained, and with it some of the old dilemmas. (She cited as an example her observation that "curators have little in common with people from community arts backgrounds.")

**Senior fellows.** The Metropolitan also reorganized its senior fellowships, budgeting some of the money for short-term consultants who worked with the training fellows in special areas in which the senior fellows were not, and were not expected to be, experts. According to Ciniglio, this use of outside professionals was "enormously successful. The fellows utilized people with specific expertise in different fields and built continuing relationships with them. They'd go back to them later, during their individual projects, when they needed help and guidance."

Speculating about the senior fellowships after the program's second year, Ciniglio thought the proper focus for the program at the Metropolitan might be people already in museum education work who would work on fellowships that would "upgrade the profession." If these professionals could earn "an advanced degree that is experience-based," it might help "museum educators . . . establish parity with curators."

**Projects and courses.** Ciniglio also believes that she learned some lessons from the 1973/74 fellowship. She stressed group activities much more: the 1974/75 fellows produced a 100-page book that informally and jointly records their year together—and as they did it, says Ciniglio, "it helped them synthesize their experience, something the previous group never got to do."[14] (One observer was "horrified" by the book, finding it "arrogant" and insulting to museum educators: "Those fellows acted like they had discovered the museum education field, when they were just rehashing all the old issues.") One of the 1974/75 fellows agreed that the book had brought them together and said that by the end of the year the fellows were "a solid cohesive group"—but, she noted, "it took time."

Ciniglio felt the individual projects of the 1974/75 fellows were better organized, in large part because the assignments were better: she deliberately served as "broker" between the fellows and their supervisors to ensure that the projects would give the fellows "a meaningful work experience." She added that "the outside consultants helped the fellows, too."

For the first time in 1974/75, a specific amount of money ($500) was allocated to each fellow for his individual project, the system the Bay Area program had used in the first year. Each fellow submitted a proposal and kept detailed records. "There was some disagreement about whether this project money should just be pooled and each fellow given what he needed from the pot," said Ciniglio. Some of the project money eventually helped pay expenses for printing the 1974/75 book, and in 1975/76 the fellows did combine their allocations, instituting a formal bookkeeping system to keep track of the money.

Although the second-year fellows, like the first, received tuition reimbursement grants, Ciniglio said that she "tried to discourage them from taking degree courses. . . . It was clear [from the experience of the first group] that they couldn't be full-time students and fellows at the same time. We thought it was better for them to take short courses and workshops instead."

**Job placement.** The job market was "much worse by 1975," Ciniglio recalled, and, besides, some of the 1974/75

fellows wanted to stay in the New York area and continue their pre-fellowship habits: "These were people whose life styles revolved around a series of short-term jobs. They were used to scrounging for a grant here, a part-time job there to keep going, and they weren't really interested in full-time jobs."[15]

But Ciniglio was determined to be systematic in helping to place the fellows in jobs. She recalled the "concerted effort"—piles of letters to museums around the country describing the program and the fellows and lists of "contact people" for the fellows to write to—as one "the fellows, too, put a lot of time into." By early 1976, three were working full-time, one part-time, another free-lancing, and the last still looking for a job.

One problem that nearly all the Metropolitan's fellows faced, according to some observers, was "entry level"—or where they could fit their training to jobs they wanted. Priscilla Dunhill, director of Museums Collaborative, has pointed out that they are not beginners but neither are they "top-flight," ready to take over even a small institution; she believes that they are best suited for middle-level positions, precisely those jobs for which most museums draw on their own staffs. Another problem: nearly all wanted to stay in or around New York rather than go to the small-museum jobs for which both they and Ciniglio thought they were "highly qualified."

### The Bay Area

**Selection.** The community arts focus of the Bay Area program sharpened in the second and third years. According to Cameron, recruitment efforts focused on minority candidates who could take jobs in museum education or arts administration—especially native American Indians who could work in "their own museums and art centers"—as well as on educators and artists.[16]

In a report on the 1974/75 year, the program's administrators noted that the choices included "too many local people . . . [who] were involved with projects, friends, and previously founded biases toward museums and other city agencies." They recognized that "somewhere the selection process failed to find people who were serious towards museums and their use as viable education institutions."[17]

Midway through the year, one fellow had resigned, and three others had been asked by the directors to leave. Because they had trimmed the program down and accepted at the outset only eight fellows (and a senior fellow, plus the senior fellow of the 1973/74 program, who stayed on for a few months), this mass departure threatened to kill the program. To fill those spaces, the codirectors invited into the program four curatorial aides who had been hired by the de Young Museum through the Comprehensive Employment Training Act; when they entered, the 16-week "formal" curriculum was just about over and they embarked on individual projects. (Those four fellows were not the only ones to leave: near the end of the program year a dispute between the codirectors resulted in Goldstine's resignation.)

Cameron characterized the 1975/76 fellows as "older, more cynical, and predominantly artists, minorities, or community arts people," of "very diverse . . . educational backgrounds, ethnic heritage, and experiences as well as career objectives."[18] In its third year, the Bay Area program made what Cameron calls "a major breakthrough by having two Native Americans and a representative from the Park Service for Alaskan Native Americans in the program." She believes "these fellows will be able to train tribal members in their community and prepare Native Americans to work in their own museums."[19]

**Projects.** In an effort to reinforce the sense of group effort, a major change was made in the assignment of individual projects. Each fellow was expected to devise a project that related not only to the community but also in some modest way to the projects done by other fellows. For example, according to a report of the program administrators, one 1974/75 fellow photographed a community-participation Chinatown mural, organized by another, for a traveling community exhibit. This, they say, tied in with the work of a third fellow who coordinated the curriculum for Trip-out Trucks, a de Young Museum outreach program (see chapter 7).[20]

## In Summary

When Howard Klein said, "we built it so that whoever did the program could do it their own way," he clearly meant it. What emerges from this examination is that in each institution the program was shaped by its setting, the people who led it, the fellows it chose, and the goals it set for them.

**At the Metropolitan,** where the idea originated and where hope ran highest at the outset, the program encountered difficulties that, knowledgeable observers say, were directly related to the leadership of the program and the museum itself. In Ada Ciniglio's opinion, because a new administrator with a sole responsibility for education—and at the vice-director level—was never appointed to replace Parker, the Rockefeller fellowships "became just one of a number of programs within a department." What it needed, she added, was "a high-echelon person who would make a full-time commitment to it." What happened instead, it seems, was that any interest museum higher-ups might once have taken in the fellowships began to fade soon after Parker left. Asked about the program in summer 1975, Thomas P. F. Hoving, the Metropolitan's director, said, "I haven't paid any attention to it for six months, [but] I think it's going well."

This was reflected, too, in a confusion about the goals of the fellowships that ran from the highest echelons of the Metropolitan's administration down to the fellows themselves and was apparent even to casual observers. Said Museums Collaborative's Dunhill, who had contact with some of the

fellows during their curriculum and project phases, "It seemed like no one ever set [overall] goals for the program, no one ever asked 'What should we do this year?' They never knew what the program should come out with." (Ciniglio concurred but added that most of the fellows had "*individual* goals," which the program tried to help them meet.)

An example of the confusion: Louise Condit, the museum's deputy vice-director for educational affairs and a member of the committee that selected fellows in the second and third years, said it was her understanding that "community museums were the target of the program. . . . [The fellows] were to go back to the community and do things . . . rather than working in museums like the Metropolitan. . . . In the selection meetings the committee was looking for people with community ties." But that was not how the 1973–1975 coordinator—or, for that matter, most of the fellows—saw the program. Ciniglio's conception was that the program should be a "balance" between community arts and traditional museum work, and she said that one of her most difficult administrative tasks was "getting the community-arts-oriented fellows out of the community and into the museum when that's where they were supposed to be."

Jane Norman, one of the 1974/75 senior fellows and a professional museum educator who has done special projects at the Metropolitan for many years, told why she thought the fellowship year there was especially difficult and perhaps ultimately fruitless for the trainees who were interested in community arts:

I can't say I was surprised to find out that many of the fellows were unhappy at the Metropolitan. [Those who were community-oriented] could not see what the museum could offer [people who aspired] to become creators or directors of community museums and community art centers. The educational practices in the Metropolitan did not meet the needs of [these fellows'] clients. They questioned whether those programs had any relevance for the "new museum audience" that they were determined to serve. There was nothing being done to bridge the gap between the traditional middle-class approach to great art and the needs of a public new to art and museums. It would take at least five years [for the Metropolitan] to create and test programs to meet these needs—and until that happens, [many of the] fellows will have to flounder on their own.

Aware that there have been two distinct types of fellows in each year's program, Norman (unlike some observers) does not see the split as a "good balance":

There is something schizophrenic about the [fellowship] program: the prestige, power, and glory of the Metropolitan provides an uncomfortable environment for fellows who intend to become storefront directors. . . . [They] have very different problems from those who are training to be educators in major art museums. I question whether the two groups have much to offer each other. I'm not sure that the Metropolitan provides the best environment for

fellows whose aim is to create innovative community programs. . . .

Withal, she feels there are some positive aspects to the program, especially for fellows with a more traditional bent:

I do believe that it provides the ideal environment—with its collections, curators, and varied education programs—for fellows whose aim is to become innovative educators in large museums. The best thing about [it] was that those who wanted to, had the opportunity to learn about New York—its museums, art galleries, artists. This and the travel around the country and getting to know people were important experiences for all the fellows.

But, she added mournfully, "of all those fellows who arrived with no interest or knowledge about a great national museum such as the Metropolitan, some left as they came. In fact, some developed considerable hostility to the museum and its ways. . . . It's unfortunate."

Not everyone, of course, agrees with Norman's criticisms. Melanie Snedcof has defended what Norman calls the "schizophrenia" of the program: "We want [to turn out professionals who] can work in the community *or* museums *or* art centers." Moreover, she feels, the Metropolitan is indeed a place where people like the fellows can and should be experimenting with education programs. "Fellows can learn here," she asserted. "They can try things that they could never do in a regular job . . . and we attempt to choose people who can use the time and possibilities well. We fought *not* to have a [highly structured] program."

The value of the fellowships at the Metropolitan is also defended by Peter Blume, the 1973/74 fellow who was hired by the Allentown Art Museum in Pennsylvania. He characterized the program as one of "great breadth rather than depth" and said that it gave him "a good comparative knowledge of education programs in New York and other places. It exposed me to resources, especially people in the field, that I've drawn on again and again in my professional work." He also said that he had had a chance to investigate the literature of the museum education field because of access to the Metropolitan's library. "There was that scholarly aspect to the program that you probably wouldn't get anywhere else."

Finally, there is the debate about what the nature of a fellowship should be, especially in a museum as large and significant as the Metropolitan. Said Linda Sweet, coordinator of school services at the Brooklyn Museum,

I had [high] expectations based not so much on the idea of a museum training program as on that of a *fellowship*. I expected that [the fellows] would produce reports or projects that would make a contribution to museum education. A "fellow" [isn't usually] someone just being introduced to a field, but someone who has a foundation in it.

This concern had surfaced within the museum, and there had been an attempt after the first year to recruit more seasoned candidates. Ada Ciniglio, for one, learning from hard experience, speculated about a degree-granting program and possi-

ble concentration on "senior-type fellows" who could take care of themselves.

**In the Bay Area**, Elsa Cameron responded to criticism from an observer who visited her 1975/76 program in its fourth month:

> I believe that the Rockefeller Program is important because it is flexible and allows for individuals to be trained for museum positions who otherwise could not enter this profession. I find it difficult and painful to work with the Rockefeller Fellows because they are not alike; they do not understand chain of command and bureaucratic procedures; they question museum policies; they question traditions; and they resent assignments, seminars, reading material, and those in positions of authority.
>
> It's much like dealing with ten bucking broncos, but I have faith in the program and insist on their completing reading assignments, papers, group projects and attending seminars, and through it all, we fight. But when they are six months into it and start to [see] results of what they have completed and then put what they have learned into action in their independent project, there is a change from student intern to museum professional. And there is confidence and a commitment to the field. This group is still in the floundering stage—four months. . . . [The ones who] can handle it . . . in five years will be an asset to the field.[21]

The original objective of the Bay Area program was to provide training specifically for work in small museums and in community arts, and up to half the fellows were deliberately chosen from minority groups. Unlike the Metropolitan, none of the traditional San Francisco art museums has a long-established reputation for scholarship. The commitment of Cameron and Goldstine to community arts organizations and to a traditional museum's responsibilities to a broad community audience meant not only that the goals of the program were clear but that there was no polarization of the fellows' interests.

But near the end of the program's third year, Cameron pointed out that although the "community commitment" of the program and the fellows themselves had not diminished, "now [in 1976] the priority is museum survival—not developing new audiences but serving the ones already developed." Increasingly, she said, the fellows are being taught "how to raise money, to deal with legal problems, to run programs for school districts that don't have funds for field trips, to run programs on no money at all." As the Rockefeller fellowships program has matured and the funding climate has changed, she concluded, the directors have had to balance their "idealism with realism."

**At Walker Art Center**, the fellowships program was kept small, personal, and practical. Because the candidates were carefully screened, filtered into the museum single file, and immediately absorbed into the staff and, usually, the existing programs of the museum, the fellowship program was low-profile and noncontroversial. And the 1974 fellows felt they had learned a great deal during their year.

The question that must be raised here, however, is whether they were any more than temporary low-paid staff members—with the gloss of the "Rockefeller Fellow" title. At least one of Walker's former fellows would say they were not. It has been suggested that Walker ignored the original precept of the program that the fellows would not "provide services" to their host museums.

**Some lessons, few conclusions.** In each case, the problems and the successes of the program seemed to depend on three basic ingredients: the quality of the leadership, the degree to which the strengths of the host institution were drawn upon, and the understanding that all participants—not only the fellows themselves but everyone who dealt with them—had of the program's purposes.

Because the Walker Art Center is a small and tightly run institution and the director himself took charge of the program, its fellows seemed to be well integrated into the center's activities and given experience they valued. If Walker did not, as some observers insist, "train" its fellows—in the sense of offering them a guided curriculum of group activities and planned research and investigation into the museum education field—neither were its participants subjected to the sometimes distracting problems of group interaction, politics, and loyalties, or the need to carve out a place and function in the institution.

The most closely studied program for this report was the Metropolitan's, partly because several CMEVA staff members were either involved with or had served as consultants to it at various stages in its development. For this reason—and the fact that it took place in one of the country's most widely emulated art museums—judgments of the program here may seem especially severe. Nevertheless, the Metropolitan's program appeared to be more diffuse than Walker's: in a large and established institution with decreasing emphasis on "the community" in its own activities and increasing attention to its traditional audience, the program suffered because it was divided—not always in ways that were clearly comprehended by the institution itself—between traditional museum education work and experiments both based in and directed toward the community. The Metropolitan program suffered, too, from what amounted to lack of leadership: though the program had a coordinator, it did not have the benefit of a strong guiding hand, someone with power and authority in the museum and firm philosophical convictions about the direction the program should take. The Bay Area program was clearer about its goals, the leaders not only knew the surrounding world of museums and community arts but were active in it, and the ties of the program to the community itself seemed to be fairly strong. Certainly some of the difficulties both at the Metropolitan and in the Bay Area can be ascribed to the loose definition of the programs—or at least facets of them. As Ada Ciniglio has

pointed out, "a program that is not very highly structured is vulnerable to all kinds of administrative problems and disagreements."

In a way the Walker did not, the Metropolitan and Bay Area programs suffered—many would say to an ultimate good—from the difficulties of drawing in a high proportion of what both Ada Ciniglio and Howard Klein have called "high-risk" fellows: young, untraditional in their views, skeptical of established authority and procedures, many of them from minority groups and without "standard" credentials or experience. But if the efforts to include such fellows, and minorities in particular, succeed at the employment stage, these two programs will have made perhaps the more important contribution to the museum education field.

So far, in short, the results of the Rockefeller Foundation fellowships program are uneven and inconclusive. The fact that it has been both expensive and ambitious has subjected it to critical scrutiny of a kind museum internship programs normally do not attract. It is too soon to tell just what final effect the training might have on the fellows and on the field, but it is not too soon to hope that the weaknesses can be corrected—for the sake of future Rockefeller fellows, if the funders decide to continue the program, and for the benefit of other museum education training programs still searching for a workable model for the 1970s.—*A.V.B. with supplemental research by E.S.C., J.A.H., A.G., B.K.B., E.H., B.Y.N., and A.Z.S.*

## Notes

[1] Barbara Y. Newsom, *The Metropolitan Museum as an Educational Institution* (New York: Metropolitan Museum of Art, 1970), p. 93.

[2] For source of quotations without footnote references, see list of interviews at the end of this report.

[3] Newsom, *Metropolitan as Educational Institution*, p. 93.

[4] "The Training of Museum Educators," Ninth General Conference, 1971, mimeographed transcript.

[5] "The Rockefeller Foundation—Description of Training in Museum Education," internal report, p. 4.

[6] Ibid., p. 5.

[7] "Training for Museum Professionals—A Brief History," *Report from the Rockefeller Foundation Training Fellows in Museum Education at the Metropolitan Museum of Art, 1974/75* (New York: Metropolitan Museum of Art, n.d.), unpaged.

[8] The Walker's first fellow did not start until March 1974 and the second until July of that year. This section of the report, then, concerns the Walker program during calendar 1974.

[9] "Museum Education—A Twelve-Month Program at Walker Art Center," n.d.

[10] Quoted by Ada Ciniglio, "Rockefeller Foundation Fellowships in Museum Studies, 1973/74," internal report, December 1, 1974, p. 1.

[11] This and subsequent quotations by Elsa Cameron in this section of the report are from a document, "Rockefeller Training Program in Museum Education and Community Studies," that she submitted to CMEVA, April 23, 1974.

[12] Janet Blankenstein, "Final Report on Curatorial Assignment for Barbara Newsom," internal report, May 14, 1974, pp. 2–4.

[13] In committee language, these desirable qualities are described thus: a demonstrated interest in the visual arts, work experience in the visual arts that indicates a commitment to the field of museum education or community arts, the ability to define areas of interest as indicated in statements submitted to the committee, and evidence of self-drive and "a high creative energy level." (Memorandum from Melanie Snedcof and Ada Ciniglio to the grants committee, April 16, 1975.)

[14] The book: *Report from the Rockefeller Foundation Training Fellows in Museum Education at the Metropolitan Museum of Art, 1974/75.*

[15] Not all the fellows, in the Metropolitan or the other programs, were so laissez-faire about employment. At their annual conference, the 1974/75 group closely questioned Howard Klein, the Rockefeller Foundation representative, about job prospects and, according to one report, he had no answers except to say that the foundation very much hoped to turn museum education into a professional field. Klein himself points out that job placement is not the responsibility of the foundation but of the sponsoring museums. At least one former fellow—from the Walker program—disagreed: "I was really disappointed with [both the Walker and] the Rockefeller Foundation when it came to looking for a job. The museum didn't take enough responsibility, and the foundation should have been more interested in what happened to us." He added that he "wasn't the only fellow who felt [that] way."

[16] Letter to CMEVA, February 26, 1976.

[17] Elsa Cameron, Stephen Goldstine, Michael Chin, "The Bay Area Rockefeller Training Program in Museum Education and Community Studies, 1974/75," report, February 19, 1975, p. 3.

[18] Letter to CMEVA, February 26, 1976.

[19] Ibid.

[20] Cameron et al., Bay Area report, pp. 5–7.

[21] Letter to CMEVA, February 26, 1976.

## Interviews and observations

(Where specific dates are lacking, researchers failed to keep records.)

Bach, Penny. Coordinator, Department of Urban Outreach, Philadelphia Museum of Art. October 31, 1975; telephone, March 13, 1976.

Bearden, Romare. Rockefeller Foundation Senior Fellow, 1973/74, Metropolitan Museum of Art, N.d.

Bing, Bernice. District Organizer, Neighborhood Arts Program, San Francisco. April 15, 1974.

Blume, Peter. Rockefeller Foundation Fellow, 1973/74, Metropolitan Museum of Art. Telephone, April 9, 1976.

Brincard, Marie Thérèse. Rockefeller Foundation Fellow, 1973/74, Metropolitan Museum of Art. August 11, 1974.

Cameron, Elsa. Codirector, Rockefeller Foundation Fellowship Program in the Bay Area. April 18, 1974; July 30, 1975; January 30, 1976; telephone, April 22, 1976.

Ciniglio, Ada. Coordinator, Rockefeller Foundation Fellowship Program, Metropolitan Museum of Art (1973–1975). Throughout 1973/74; February 25, 1976; telephone, March 4, 10, and 15, April 26, 1976.

Condit, Louise. Deputy Vice-Director for Educational Affairs, Metropolitan Museum of Art. Telephone, April 8, 1976.

Dunhill, Priscilla. Director, Museums Collaborative, New York City. September 9, 1975.

Edwards, James. Rockefeller Foundation Fellow, 1973/74, the Bay Area. Telephone, March 10, 1976.

Friedman, Martin. Director, Walker Art Center, Minneapolis. September 18, 1974.

Goldstine, Stephen. Codirector, Rockefeller Foundation Fellowship Program in the Bay Area (1973–1975). January 30, 1974.

Gregg, Richard. Director, Allentown Art Museum, Allentown, Pennsylvania. Telephone, April 9, 1976.

Hazard, Ben. Curator of Education and Special Exhibits, Oakland Museum, Oakland, California. March 1974.

Hoving, Thomas P. F. Director, Metropolitan Museum of Art. July 18, 1975.

Klein, Howard. Program Director for the Arts, Rockefeller Foundation, New York City. July 30, 1974.

Lassiter, Mark. Rockefeller Foundation Fellow, 1974/75, Walker Art Center. September 17, 1974; telephone, April 23, 1976.

Norman, Jane. Rockefeller Foundation Senior Fellow, 1974/75, Metropolitan Museum of Art. August 5, 1975; telephone, March 10, 1976.

Oppenheimer, Frank. Director, Exploratorium, San Francisco. July 9, 1975.

Owens, Andi. Rockefeller Foundation Fellow, 1973/74, Metropolitan Museum of Art. N.d.

Parker, Harry S. Vice-Director for Education, Metropolitan Museum of Art (until December 1973); Director, Dallas Museum of Fine Arts. December 19, 1973; July 8, 1975.

Sapp, Allen. Rockefeller Foundation Senior Fellow, 1973/74, Metropolitan Museum of Art. N.d.

Snedcof, Melanie. Associate-in-Charge of Public Education; Coordinator, Rockefeller Fellowship Program (after October 1975), Metropolitan Museum of Art. December 12, 1974; December 17, 1975; telephone, April 8, 22, 1976.

Sweet, Linda. Coordinator of School Services, Brooklyn Museum, New York City. Telephone, April 9, 1976.

Weisberg, Gabriel. Curator of Education, Cleveland Museum of Art. Telephone, March 22, 1976.

Whyte, Robert. Supervisor for Education, San Francisco Museum of Art. February 1974.

Zakon, Ronnie. Rockefeller Foundation Fellow, 1974, Walker Art Center. September 17, 1974; August 12, 1975; telephone, March 8, 1976.

Ziady, Jonathan. Rockefeller Foundation Training and Senior Fellow, 1973–1975, the Bay Area. Telephone, March 10, 1976.

In addition, CMEVA staff members observed and took part in seminars with the fellows and spoke with supervisors, fellows, and senior fellows in the Metropolitan and Bay Area programs throughout the period from fall 1973 to summer 1975.

# TOLEDO MUSEUM OF ART: EDUCATIONAL FELLOWSHIPS

The Toledo Museum of Art
2445 Monroe Street
Toledo, Ohio 43601

**This pioneer program in museum education training uses its fellows as regular teachers in the museum. Most of the problems have stemmed from lack of focus—it is designed to turn out both educators and curators—and, according to the fellows, insufficient formal training in theory and methods. The major strength is the policy of intensive work experience for the students in the museum. CMEVA interviews and observations: September–November 1973; February, April, May 1974.**

### Some Facts About the Program

**Title:** The Educational Fellowship Program.

**Audience:** Between four and eight fellows per year, with at least a B.A. in art history. From August 1970 through the 1974/75 academic year the program served 23 fellows.

**Objective:** To provide the opportunity to prepare for a career in the museum field through extensive teaching experience, seminars in administrative, curatorial, and educational areas, and travel to other museums.

**Funding:** $5,000 per fellow, plus $500 travel allowance. Source was originally the museum through its Netti Ketcham Fund; later partial funding was provided by the National Endowment for the Arts.

**Staff:** One fellowship coordinator, with cooperation of the museum's assistant director (education), associate director, and other staff.

**Location:** In the galleries and studios of the Toledo and other museums.

**Time:** August 16 to June 15, a ten-month professional work schedule. The program began in August 1970.

**Information and documentation available from the institution:** Evaluation reports, film, brochures, teachers guides.

Faced with a continuing turnover in education staff lecturers, the Toledo Museum of Art in 1970 devised a program to bring in a new supply of lecturer-teachers every year. The assistant director responsible for education, Charles Gunther, acknowledges that necessity mothered the invention of Toledo's Educational Fellowship Program: "Historically [it] grew out of the fact that the museum itself could attract people . . . who were interested in working in a museum, but not necessarily interested in living in Toledo for any extended length of time. So we found that we were constantly training people. . . ."[1]

The education staff organized that training into a formal program: it offered $5,000 for a ten-month fellowship open to B.A. graduates in art history who were interested in exploring the museum profession and who would teach in the museum's extensive education program. As the first training program organized and funded by an art museum on its own, without university or philanthropic support, and as the only

one to use its fellowship recipients as regular teachers, the Toledo Educational Fellowship Program is unique.

## Aims of the fellowships

Designed to serve the Toledo Museum's particular needs, the program also assumes a broader purpose, what the brochure announcing the fellowship calls "an opportunity to prepare for a career in the museum field by relating principles and concepts to actual participation in an active major museum." The Toledo staff believes the program provides useful training for work in any American art museum. It does not see that work as limited to museum education departments. From the beginning of the program, Gunther has firmly declared that he does not believe the fellowship's primary purpose is to turn out museum educators; he is satisfied to see fellows become curators on the grounds that "a curator conscious of educational responsibilities is the best thing for the museum profession."[2]

Experience on the job is the primary ingredient of the fellowship; there are no formal academic courses. Seminars ranging over various aspects of museum work—conservation, exhibition, research, administration—reflect the program's intent: to provide an overview of the museum profession and retain flexibility as the program develops. Despite the program's title and emphasis on a heavy teaching workload, it offers little training in education techniques and methods. When Gunther calls it a "fellowship in public service," he may further confuse someone trying to determine just what the educational fellowship trains its fellow for.

Of the 18 fellows who participated in the first four years of the program, two are now established in curatorial departments, one in museum education. Most who entered with B.A. degrees went back to school to complete M.A. programs in art history or museology.

Those few who entered with M.A. degrees—an experiment during the fourth year (1973/74)—have voiced the most dissatisfaction with the fellowship.[3] They complained not only of the obvious problem of M.A.'s in a program originally designed for B.A. graduates but also of the basic uneasiness that some fellowship recipients and many outside observers have expressed: that the fellowship is not fully and precisely defined in the minds of the Toledo curatorial and education staffs. Those staffs would agree, but they would emphasize that fluidity and flexibility were consciously designed into the program so that it could change from year to year as flaws and questions surfaced.

Some criticism has come from outsiders, who wonder whether "young staff members are being assigned . . . educational tasks . . . at relatively low pay."[4] One 1973/74 fellow asked, "Are we just grant people who are here to give tours with a college education?"[5] A first-year fellow disagreed: "I was there to learn all I could, get all the experience I could, so what was there to complain about? The more I did, the more I learned." Another former fellow scoffed at the criticism: "I didn't feel I had enough to offer to be

exploited," he noted, observing dryly that exploitation is a fashionable social issue, which provides a too-simple perspective on the problems of an apprenticeship program.

What seems to be at issue is the nature of apprenticeships. The idea of apprenticeships is that people learn by doing—and by doing around people who have done more and have done it longer. Toledo's educational apprentices learn by doing, but, increasingly, they seem to want to learn, too, by instruction and experimentation. The first coordinator believes the fellowship program provided just what she wanted: experience, and lots of it, doing work that "really needed to be done—not make-work—and an introduction to the inner workings of a museum, not just to the education department." In Toledo, the work that needed to be done was teaching, teaching, and more teaching. Some recent fellows have questioned the value of their teaching experience as the *primary training* of a fellowship program.

## The operation of the program: 1970–1973

The program began in August 1970 with three fellows and a coordinator who had been a staff lecturer at the museum in 1969/70. After a month of intensive orientation to the city, the museum, and the museum collections, all four began a heavy schedule of teaching plus weekly two-hour seminars with museum curators and administrators and with other persons in related museum fields. Teaching schedules generally included three classes a day, Tuesday through Friday (two in the morning, one in the afternoon), the majority of them correlation tours that the museum traditionally offers to Toledo school classes, grades one through eight. Fellows also lectured to adult groups and taught in the museum galleries on Saturdays, when special programs brought in between 1,750 and 2,000 children, grades four through eight.[6] The fellows had partial responsibility for the organization of one major exhibition and total responsibility for two smaller exhibitions.[7]

In addition to the $5,000 stipend, the fellowship offers a $500 travel allowance. Each year, the fellows have traveled as a group to various Midwestern and Eastern museums. Each successive group has agreed with the first-year fellows' evaluation that "travel was probably the most valuable experience of the whole year,"[8] a conclusion that will surprise no one who has experienced the pleasures of intelligently planned visits to interesting places. (The coordinator proposes names of persons and places to visit, prepares itineraries and gathers catalogs, and provides background information.) One fellow summed up what she found most useful: "You learn that there are as many ways to do museum work as there are communities to do it in."

The first-year fellows noted that the heavy lecturing schedule was especially useful in putting them in touch with the diverse publics a museum serves. They also reported that their total responsibility for the small exhibitions was far more helpful than their peripheral responsibilities in the major exhibitions. Of those first four fellows, two stayed on

for another year to administer the program, and two went on to graduate schools with scholarship monies provided by the Toledo Museum.

**The second year.** The schedule for the 1971/72 fellows was much the same—orientation, seminars, teaching, exhibitions, and travel. In its evaluation report, the 1971/72 group recommended a closer relationship between the fellows and those who share teaching duties in the museum—the volunteer docents, who teach weekday school classes, and the professional staff members, who give the Saturday classes.

The chance to stay on for a second year, as the two co-administrators from 1970/71 had done, they found "a valuable option," but all four urged that "a single person coordinate the fellowship program and that that duty be his sole responsibility."[9] A former coordinator has commented that the movement from fellow to coordinator is "a double-edged sword; it's an advantage to have been a fellow, because continuity of leadership is essential, but the fellow must also make the transition to a staff position that can command the respect of the entire staff." Although the 1971/72 fellows found the program "exceptionally fine," the former coordinator warned that the increased sophistication and experience of new applicants would demand adjustments "to insure that its challenges keep pace with the variety of backgrounds represented."

**The third year.** By the fall of 1972, more than fifty students had applied for places in the program. The National Endowment for the Arts provided funds for two additional fellows, pushing the total to six. The Toledo Museum continued to fund four fellows, one of them a 1971/72 recipient who stayed on to administer the 1972/73 program.

Some changes were made: money from the National Endowment for the Arts freed a little time, allowing the fellows' teaching loads to be lightened to two classes a day with occasional days off from teaching for research or preparation for other lectures; fellows assumed more individual responsibilities, some for adult study groups, one for a high school program that tried to balance Toledo's established emphasis on the lower grades. The fellows' 1972/73 evaluation noted how much the success of the program depended on "the size of the staff and availability of personnel . . . [and] upon the individual capabilities of participants."[10] It was a politely veiled lament about busy curators and administrators and about fellows sometimes left to their own devices.

### The 1973/74 program: criticism and unrest

What seemed to emerge from the first three years was a pattern of graduates fresh from college doing a lot of teaching, getting a feel of the audiences they served, working on small exhibitions, meeting formally (and, occasionally, informally) with museum staff, visiting many museums, and gradually forming judgments about changes they might try to make in both the program and museum education practices.

All this and $5,000 a year seemed a pretty good thing to most of the fellows—until 1973/74. That year there were eight fellows, including the coordinator (who had been a 1972/73 fellow). Three, not including the coordinator, had completed their M.A.'s, two in art history, one in elementary education.

Of all the groups, this one was the most critical of the program; they complained—ungratefully, some observers thought—about the flaws they saw. It is only fair to both the fellows and the museum to note, however, that when asked if they knew of any other training program they wish they had entered instead, they chorused *no* just as loudly.[11]

The most visibly legitimate complaint that the 1973/74 fellows lodged against the program was the museum's failure to provide systematic weekly seminars, a failure the coordinator accepted as her own inability to schedule curators and other museum staff into regular meeting times. Halfway through the year, that problem was remedied.

Beyond that, the basic criticism was of the lack of focused training. Though the fellows shied away from charging the program with a sink-or-swim approach—they acknowledged that the coordinator discussed with them established approaches to children of various ages and demonstrated several lecture-tours—they wanted more "training" than they got. All insisted that no educational training was being given, or as one said, "I find it really strange that this is a museum education program and that there's absolutely no training in education." Another remarked, "It offers you the opportunity to experience museum education, but it doesn't give you the training."[12]

This same complaint has been expressed, with less hostility, by some fellows in each year. Few have said they felt comfortable or knowledgeable about teaching techniques and methods. The yearning for training may amuse some experienced teachers who would argue that there's no way to "train" for teaching, but the yearning has persisted. Clearly, some fellows wanted and expected more focus on educational training to help them do a good job as educators; how much their dissatisfaction derives from their misunderstanding of the program—which is not designed just to "turn out museum educators"—and how much from the program's failure to recognize a primary responsibility to inexperienced teachers, is a question that remains unanswered.

Even one of the most vocal critics, a 1973/74 M.A., conceded in a session with the group, "If I do not end up in an education job in a museum, I will be very happy for having had the experience of working with the public . . . and being here would make me an awful lot more conscientious about working with the education department." Another, equally dissatisfied, acknowledged, "Just being able to stand up in front of any group . . . and having absolutely no inhibitions about speaking has been fantastic." A more philosophical and generous member, a B.A. rather than an M.A., agreed: "I think that will emerge as the number one valuable experience . . . because being able to speak to a group and to size up the interests and intellectual and academic level of the

group . . . is really invaluable.'' A first-year fellow, who estimated he gave about a thousand lectures the year he was in Toledo, put it simply: ''Nothing will ever scare me again.'' All these comments bear out the hope of the first coordinator, who said, ''I don't see how people who go through the program can escape a better comprehension of what museum educators feel and do.''

**Other problems.** Is that comprehension enough for a fellowship program to aim for? The original fellows said yes; more recent fellows have said no. What was there about the fourth year that might explain their dissatisfactions? In addition to the failure of the seminar system, there were other problems:

- Size: there were more fellows than there are either curators or full-time education staff at Toledo.
- Educational level: for the first time both B.A. and M.A. students were accepted into the program.
- Personality conflicts: though perhaps inevitable in any group of human beings, it seemed an unkind quirk of fate that M.A. graduates with considerable confidence in their own critical faculties confronted a gentle coordinator who had not yet completed the M.A. degree.[13]

How much the size of the 1973/74 group and its members' sense of being left on their own (without ''adequate'' supervision, they said) accounted for the healthy give-and-take within the group cannot be measured. The fellows rejected the notion that they were too large a group for the museum to absorb, and complained instead that the roles of coordinator, staff, docent, and curator are so rigid that the fellows ''fit'' nowhere, and that the structure of the fellowship worked against their desires to be listened to and feel valued. They were listed in the museum's newsletter as staff members, although Gunther has said that the fellows were ''not junior staff members, not even part of the staff,''[14] and that they were ''not treated as junior staff members but as students in training.''[15] (This structure contrasts to the experience of a curatorial intern from the University of Michigan [see report in this chapter] who said of her year at Toledo, ''I was considered almost from the beginning to be part of the staff. . . . I went to staff meetings. . . . That student-professor problem just disappeared.'')

Even as ''students in training,'' the fellows wanted more evaluation and supervision than they received, and they suggested the program honored its implicit promises more in the breach (or in the brochure) than in the observance. To make up for the feedback they felt they were not getting from the museum, the fellows, sometimes including the coordinator, began to meet daily after their teaching assignments were finished, to discuss ''what worked today and what didn't.'' This exercise in self-evaluation seemed to them so ''obvious and significant and simple'' that they believed the program should have provided it for them. The fact that they provided it for themselves, and that they consequently saw themselves as supportive and affectionate colleagues, was a

source of pride. Maybe it would not have been so valuable if someone else had organized it for them. They ended up committed to the idea of feedback and evaluation as a necessary part of museum education work.

In a meeting halfway through the year, one summed up the dissatisfaction of the 1973/74 group:

We were always told that Toledo looked forward to its fellows as the new blood that comes in every year. And in that sense I feel we haven't been used as a good resource—you know, that our potential hasn't been realized, not the museum's potential, just our potential. Really, someone should listen to us and get our new ideas working in some way or enable us to do it ourselves.

## Toledo's response: changes in the program

Some Toledo staff members were listening, not just to the 1973/74 crop of fellows, but to the recommendations of the earlier years. Continuity of leadership, which has been crucial to the effectiveness of the program, will persist. The fellowship and internship coordinator, who had gracefully weathered a difficult year, was due at this writing to have as her sole responsibility the supervision of eight apprentices in 1974/75. These included a curatorial intern, funded by the National Endowment for the Humanities; two arts administration interns, funded by the Ohio Arts Council; and five educational fellows, funded by the Toledo Museum and the National Endowment for the Arts. All were to take a month of orientation together and then go on to separate projects.

Each apprenticeship began to carry a job description of the kinds of work and the amount of time allocated to each, so that as the associate director of the museum, Roger Mandle, put it, ''all fellows know exactly what they are getting into.'' In addition to this job description, in which the museum specified the opportunities it offers and the tasks it requires the apprentice to undertake, the fellowship coordinator asked each fellow to write a learning contract, ''listing the skills, knowledge, and experience you hope to acquire by June 1975.'' The coordinator planned to use this ''purely informal document . . . as a guide in training, and also as a standard by which to evaluate'' the museum's performance.[16]

According to the new plan the curatorial intern was to spend about 10 percent of his time teaching; the arts administration interns were to teach regularly. Each educational fellow was assigned to a major exhibition and to the curator responsible for it; the fellow was then to teach an adult class and outline any public education classes based on the show. As in the past, fellows were to organize and install small exhibitions.

The most striking difference was the fellows' deployment in the education department. They were to spend about 40 percent of their time teaching—twice a day for the first teaching month, then once a day, then twice a week—less than other years. They were to visit schools, establish teacher workshops, develop a resource center for teachers and the general public, and try to refurbish the correlation tours.

This shift was not designed merely to lighten the teaching load but, according to Mandle, to "provide more diversified and sophisticated educational training," including theories and methods (sessions on educational theory and practice are scheduled) and whatever other "special training will emerge, which nobody can yet define." Recognizing that some of the fellows' problems derived from their unfamiliarity with education practices, Gunther believed "it would be more to their advantage if they could work on Saturday with really accomplished studio instructors . . . and with the University of Toledo students who are here as educational interns, in a student teaching situation . . . and with the university professor hired by the museum who supervises all our practice teachers."[17]

The fellowship coordinator wanted the focus for educational fellows to shift to a greater emphasis on museum education. She agreed with those 1973/74 fellows who said, "There is a good opportunity here to develop something just in museum education," for Toledo's long-established educational programs are a valuable museum training resource.

At the same time, Mandle remained convinced that "educational and curatorial training are not mutually exclusive . . . that the same program *can* train for both kinds of work. In Toledo it's a take-off for both fields, if fellows can be deployed freely, versatilely, and flexibly." From Toledo Museum Director Otto Wittman's perspective, "the more curators understand about educators, and vice-versa, the better off both are. Education is not a bad place to start. It's a good first step, because education is basic to the whole museum field. We are not a warehouse."

Toledo has long taken the lead among museums in providing apprenticeships. In doing so, it has exposed itself to demanding relationships and to criticism of what it demands in return. It has fifteen years of experience with curatorial interns and four years with educational fellows to draw on in negotiating the difficult path it has constructed for itself in its ambitious 1974/75 apprenticeship programs.—*A. Z. S.*

## Notes

[1] Charles Gunther, report to the American Association of Museums on a museum training seminar, December 1972, pp. 56–57.

[2] For sources of quotations without footnote references, see list of interviews at the end of this report.

[3] Group interview with 1973/74 fellows, taped February 12, 1974.

[4] Barbara Y. Newsom, *The Metropolitan Museum as an Educational Institution,* (New York: Metropolitan Museum, 1970), p. 92.

[5] Group interview, February 12, 1974.

[6] The free Saturday program begins with 4th graders who enter a five-year sequence that ends with 8th grade. A general outline of the program follows: in 4th grade, the children employ different media and studio approaches, working with one teacher the whole year; in 5th grade, the class is divided into three groups that take turns with different teachers, studying painting, three-dimensional design, and gallery drawing; in 6th grade, the subjects are drawing, three-dimensional design, and a survey of art history; in 7th grade, painting, sculpture, and architecture; by 8th grade, they work on prints, more three-dimensional design, and contemporary art. The classes begin in September and continue for 30 weeks; each Saturday's session lasts an hour and a half. A former fellow and Toledo staff member said, "It's amazing how much carry-over there is!" (Karen Smith, interview, November 12, 1973.) There is a plan now under consideration to shift from 30 continuous weeks to two 14-week semesters.

[7] In the first year, 1970/71, the two exhibitions conceived, organized, and installed by the fellows, with cooperation of appropriate staff members, were a show on texture, called "Touch Me-See Me," and a show on the materials and techniques of glassmaking, called "Form, Surface, Color." ("The Toledo Museum of Art, Fellowship Program in Museum Education, A Report of the Past Year, 1970/71.")

In the second year, 1971/72, the fellows took complete responsibility for two shows: "Art in Textiles," an invitational exhibition of university student work focused on batik, macramé, and weaving; and "F-Stop," photography by students of several nearby universities. ("The Toledo Museum of Art, A Report of 1971/72.")

In the third year, the fellows were responsible for one circulating Smithsonian show and for two shows of their own: "Death: Allegory, Ritual, and Reality," an exhibition of objects from the museum collection and from local collectors; and "Considering All Things," an exhibition of objects recommended by museum staff as "having artistic merit" and emphasizing "the idea of art rather than traditionally conceived art objects." (Report to the National Endowment for the Arts, Grant no. A72-0-998, August 16, 1972–June 15, 1973.)

[8] 1970/71 report, p. 11.

[9] 1971/72 report, unpaged.

[10] 1972/73 report, p. 5.

[11] Group interview, 1973/74 fellows, taped February 12, 1974.

[12] Ibid.

[13] There are contradictory opinions about the level at which the educational fellowships should be pitched. If directed primarily at students with the B.A. degree, it can serve as a "pause," as one fellow puts it, to refresh the student between academic bouts, or as a chance for an undecided college graduate to see how appealing and stimulating museum work is or is not. If directed primarily to students who have completed the M.A., it may not as now constituted be "sufficiently demanding," in the words of a 1973/74 B.A. fellow. One former fellow, who was working on the M.A., recommended it as a fellowship for M.A. graduates, who can "apply experiences directly to the working situation . . . instead of feeling, as I do, like a fish out of water, full of 'working' ideas but back in school to get the M.A. credentials so people will hire me to do the things I want to do . . . and, besides, a person with an M.A. would be more useful to a museum education department." (The paradox of these judgments on hiring policies is inescapable.) Another former fellow, who admired the Ford Foundation fellowship, which was renewable for one year and provided generous travel allowances, thought Toledo's program could effectively be a two-year program, with the second year reserved for more special or advanced work, allowing B.A. and M.A. students to work together. Those 1973/74 fellows with only a B.A. degree argued that being in a program with M.A. graduates was a boon to them; they learned a lot, they said, not

least "that inside stuff about where to go for the M.A." The first coordinator believed it was "hard to gear a program equally valid for both. . . . They have different self-concepts, different experiences in thinking about art and work." The associate director of the museum saw the mixing of academic levels as "no problem." The 1974/75 program selected from over ninety applicants five educational fellows, four with a B.A., and one with an M.A.

[14] AAM report, December 1972, p. 57.

[15] 1970/71 report, p. 13.

[16] Janie K. Chester, letter to CMEVA, May 1, 1974.

[17] The Toledo Museum's relationship with the University of Toledo goes back to the 1920s. All university art courses are taught in the museum by staff hired and paid by the museum, with the approval of the university and with adjunct professorial status. The program includes art history, art studio, and art education. The university's slide collection, art library, and studio facilities, as well as classrooms and student teaching internships, are housed in the museum. Approximately 50 percent of the total art program's costs are paid by the Toledo Museum, which is partially reimbursed by tuition costs. "One of the great benefits," according to the director of the museum, "is that the student teachers who do their practice teaching here and work in the Saturday studio programs know the museum, and when they become teachers in the Toledo schools they can bring their classes here." In addition, every education major at the University of Toledo is required to take one art education class, which means every education major goes to that art class in the museum.

## Interviews

Chester, Janie K. Educational Fellow 1972/73; Coordinator of Educational Fellowship Program, 1973/74; Toledo Museum of Art. February 12 and May 2, 1974.

Clarke, Susan. Former Educational Fellowship Coordinator, 1970/71; now Curator, Addison Gallery, Phillips Academy, Andover, Massachusetts. Telephone, April 30, 1974.

Gunther, Charles. Assistant Director (Education), Toledo Museum of Art. October 27, 1973; February 12 and May 2, 1974; telephone, October 4, 1973.

Hinson, Tom. Educational Fellow 1970/71, Toledo Museum of Art; now Assistant Curator of Modern Art, Cleveland Museum of Art. September 12, 1973; May 1, 1974.

Mandle, Roger. Associate Director, Toledo Museum of Art. February 12 and May 2, 1974.

Smith, Karen. Educational Fellow 1970/71; Co-coordinator, Fellowship Program, 1971/72, Toledo Museum of Art; Lecturer, Toledo Museum of Art, 1972/73. (Now M.A. Student at Case Western Reserve University, Cleveland, Ohio.) November 12, 1973; May 1, 1974.

Swain, Marjorie. University of Michigan Intern at the Toledo Museum of Art, 1967/68; now Staff Member, University of Michigan Museum of Art. December 12 and 13, 1973; May 15, June 13, 1974.

Wittman, Otto. Director, Toledo Museum of Art. February 12, 1974.

And the following 1973/74 Educational Fellows who participated in group interviews taped on February 12 and May 2, 1974:
Barron, Stephanie J.; DeAngelus, Michele D.; Hoke, Victoria; Knight, Christopher; Lyons, Lisa; Rice, Danielle; Wilson, Malin.

## INSTITUTE OF AMERICAN INDIAN ARTS MUSEUM: MUSEUM TRAINING PROGRAM

Institute of American Indian Arts Museum
Cerrillos Road
Sante Fe, New Mexico 87501

**American Indian students receive practical museology training in a two-year, junior-college-level program at a museum-art school devoted to native American arts. The main purpose: to develop a cadre of young Indians who can start or work in small museums for their own people. One criticism: the program may be "isolated from real life." CMEVA interviews and observations: June 1972 to August 1974.**

### Some Facts About the Program

**Title:** Museum Training Program.

**Audience:** 10 to 12 native American (a term used to describe American Indians, Eskimos and Aleuts) students a year, drawn from states west of the Sioux nation, whose territory runs roughly from Kansas to North Dakota.

**Objective:** To train native Americans in museum work.

**Funding:** About $3,000 for exhibits and the training program; the staff is employed by the Bureau of Indian Affairs, U. S. Department of the Interior, and so receives government salaries.

**Staff:** 3 full-time museum staff who also act as faculty for the program.

**Location:** In the museum, which is located within the complex of the Institute of American Indian Arts in Santa Fe.

**Time:** Through the academic year; each student is in the program for two years.

**Information and documentation available from the institution:** Catalogs for special exhibitions and a report on the institute's activities, "Future Directions in Native American Art."

The basic goal of the traditional American educational system has been to prepare all individuals to function effectively in an average middle-class society. But ideal as this goal may be, the processes of mass education do not always lend themselves to singular problems. . . .

The American Indian has never truly subscribed to the common American middle-class dream, largely because of the fundamental differences existing between his life goals and those of society at large. The Indian value system always has been centered on the idea that man should seek to blend his existence into the comparatively passive rhythms of nature, as opposed to the dominant society's quest for control of nature through scientific manipulation of its elements.[1]

With this concept in mind, the Bureau of Indian Affairs, U.S. Department of the Interior, established the Institute of American Indian Arts in 1962. This is a national institution for

training in the arts directed to the special needs of today's youthful native Americans—the Indians, Eskimos, and Aleuts of the United States.

The institution is, in effect, a live-in art school technically within the city limits of Santa Fe, New Mexico. It is a kind of city in itself as well, a stucco and adobe complex of Spanish colonial-style buildings separated from the highway by a spacious lawn and a cyclone fence. Not far away from the institute are the historic Indian pueblos clustered along the Rio Grande and the villages of Spanish culture in the mountains north of Santa Fe. Brown adobe homes are nestled in the hills; the sidewalks are often dirt or wooden walkways, and many residential streets are unpaved. Shops displaying both contemporary and historical traditional Indian art, Spanish colonial artifacts, and crafts from Mexico, dominate the center of the city. The history and art divisions of the State Museum of New Mexico are located in this center; the anthropology and folk art divisions are in the foothills a few miles from the shopping area.

The Institute of American Indian Arts is an island of contemporary art activity located on the outskirts of Santa Fe. Indian students, most of them between 19 and 26, study art and live at the school. It is an example of what one Southwest anthropologist calls "the last segregated schools in America."[2] The Indian students like it that way. "Anglos can attend the school," said the institute's museum director. "In fact two have, but they dropped out immediately. The Indians prefer the school for themselves. It's something they have that they want to hold on to."

### The institute museum

At the institute's museum are collected and displayed the work of the students, the only collection of contemporary Indian art in the world. It includes traditional wares as well as contemporary paintings, sculpture, and prints. Nationally known artists are alumni of the institute, among them Fritz Scholder, Henry Goblin (arts director of the institute), Douglas Hyde, Charles Lo Loma, Alan Houser, and Marie Chino.

Charles Dailey is now director of the museum, but he is dedicated to the idea that the Indians should run their own museum. In 1972 he started a two-year museum training program, an intense museology course for native American students. His curriculum is geared toward the problems of a small museum in particular. As one Indian student put it, "Most of us will go home to help our people start a museum or exhibit their crafts. We aren't going to New York or California to work in a museum." The aim, says Dailey, is not an interesting job; "they want to help their people."

### The training program

Dailey runs the museum like a working laboratory, and the training is both practical and theoretical. Students install exhibitions in the gallery with consideration for label content and design, lighting, and such minute details as painting the head of the nail white. A visiting curator from a San Francisco museum praised the installation of one exhibit. It had, he said, "a professionalism we don't see at some major museums."

Dailey believes in the practical approach to museology because his graduates will need the skills to handle routine duties in museums without a staff or a budget. His classroom consists of three galleries, basement art storage, and an area for the study of museum procedures. Says Dailey, "I show them a slide of a label that is typed crooked next to a good slide, so they then can see how bad labels ruin an exhibition. I teach by comparison."

Dailey has over 2,500 slides available to the students that illustrate both the good and the bad in museums. Besides the crooked labels, he shows them slides of dusty tables, dirty walls, and uninviting entrances alongside attractive installations, well-designed signs, and new museum buildings, all assembled on his travels throughout the United States and Western Europe. For Dailey, education is "a transfer of human knowledge from one time to another to be associated and applied with that new problem or situation at a future time."[3]

As part of their generalist training, students clean floors and toilets once for the experience, mat and frame works of art, install exhibitions, learn photography both for assessment of works of art and for publicity. They learn "tricks of the trade"—how to make mannequins, install a low-cost security system, construct panels, pack and circulate art objects. Conservation of ethnological material and the handling of contemporary art is also part of the curriculum. So is an approach to Indian art history that is as rigorous in its way as the study of the art history of other cultures. Students are trained in the techniques of American Indian art forms. They can work buffalo hide in the traditional manner and know about mixing pigment for ceramic decoration or weaving on traditional looms.

Once in a while, the students get a chance to do some practical work outside the institute. One example was redesigning an exhibition unit and community center near an ancient kiva site at Picuris Pueblo. The U. S. government had constructed the center, which had been designed by a non-Pueblo anthropologist. The problem was that local residents were not using it.

The students examined the center and casually interviewed the elders and villagers. They returned to the institute and built a scale model incorporating the community's, and some of their own, ideas for changes that would make the center not only an intimate, comfortable working place for Indian artists, but also more harmonious with its setting and more reflective of the people it was supposed to serve. The model was then presented to the villagers to implement (the institute itself does not have funds to follow through on such projects).

The theory and history of museums is not ignored in the training. Each student leaves the program with a series of

notebooks that are essentially a reference anthology of articles from museum publications and conferences. He also leaves with a portfolio of the assignments he has completed, slides of the exhibits he has installed, and an evaluation of his work. The museum provides a telephone information service for its students so that anyone can call for information or help after he has left the program. Dailey's point in all this is simple:

> The training is to get past all the mistakes and knowledge and bring the kids up to today so they can run their own museums. I'm most interested in helping the small museum which involves people who have a budget of $200 or less and want a museum. A good museum man is not a man with degrees and all that, but someone who can use his head—who has good common sense. . . .

> The major thing a student gets here is something to take with him. He may not remember a blasted thing that I say, and I don't care if he does. What I really want to do most of all is show students *where* and *how* they can go to find information if they ever get into a particular situation. Education to me is not giving information. The experiences we give in a very fast way are the few places you can touch—hit on accession, hit on the theory of designing exhibits—that's fun, you can do it. We get the kids twenty hours a week for two years. We're talking about a student going home to set up a whole museum with nobody to help him.

### Related museum activities

The scope of services offered by the Institute of American Indian Arts Museum directly affects the training of the students. The museum provides a showcase for contemporary Indian art forms and expression. Art students as well as the museum students are trained in museum techniques. An artist is allowed and encouraged to hang his own show in the museum; Dailey gives him the tools and advice but stays out of the way, as artists often prefer to install their works themselves.

The immediate task of the museum is to catalog and accession its collection. This is primarily the job of the director and the curator-in-charge. Museum training students assist in this process minimally, observing and learning the techniques—primarily because, according to Dailey, "we do not 'use' the students as task forces but wish them to have a myriad of other experiences as well."

Any student on campus may come to the museum and check out a work of art. In some cases, students wait an hour while the piece is photographed and the accession cards are completed, one way that students who are not in the museum program also learn museum procedures. This lending service is a controversial function: students may select any piece for study, including a pot by Marie Martinez of San Ildefonso Pueblo, valued at $2,000. Because there has been no cause to break this trust, the policy is continued. The institute feels it is an important part of their education that art students be allowed to handle works of art and to study traditional techniques and images fashioned by earlier students of Indian art.

Exhibitions are circulated to Indian centers and to museums throughout the nation, and museum training students are directly involved in planning, designing, packing, and circulating these shows.

### Charles Dailey: the man behind the program

The experiences and personal philosophy of Charles Dailey have shaped this training program and created a curriculum unique to the needs of American Indians.

Dailey took his museum training at the University of Colorado and, since his graduation, has devoted his life to studying museums. He and his wife had always heard that the world's great museums were in Europe so they spent a year traveling there by motorscooter studying museums, and they volunteered their time assisting curators and preparators in several museums in Western Europe. "We found the museums there far behind the museums here, except in collections," he says.

Because the Daileys wanted to get as much from this experience as possible, they developed an evaluation checklist that they used to analyze these museums: name of museum, purpose, architectural relationship to area and purpose, basic design interpretation, exhibit evaluation (labels, collection lighting, mannequins), security, attendants' attitudes, sales counter, guide service, library, entrance fees, staff, and special exhibits of note. Dailey uses this checklist to teach his students and continues to employ it as he visits museums today. Budget constraints limited him to taking only three slides at each European museum, so he committed his impressions to memory through this exercise.

Following the European experience, Dailey and his wife continued this approach to museums in the United States. In Santa Fe, they discovered the place they wanted to make their home.

Dailey spent the next ten years as chief curator of exhibits at the Museum of New Mexico, where he designed, among other things, the first traveling "suitcase exhibits" (see chapter 11 for a report on this program) and floor-to-ceiling glass cases for objects in the Folk Art Museum.

He says he had mixed feelings about applying for the directorship of the institute museum, because he firmly believes that Indians should administer their own programs. "There are 68 Indian centers and—I'm just guessing now—at least 50 of them are run by Anglos," he says. "Indians should be running their own centers and talking about themselves."

Yet, he adds, he wanted "to do something about the way museums treat Indians," and he saw the idea of a museum training program at the institute as a potential remedy for the imbalance. So, when the job was offered, he took it. But he does not intend to stay indefinitely, because he does not want to become part of the problem: "As soon as I get the collec-

tion in order, I'm leaving. I've got to . . . [or] I'm being a hypocrite. . . .''

## Employment prospects for institute graduates

The museum training program graduated its first class in June 1974. It is a small program, usually ten or twelve students to a class. Partly because there is not much demand for this program, but partly, too, because Dailey wants the students to help their people, almost all applicants to the program are accepted. The geographical reach is also relatively narrow, taking in an area only as far east as the Sioux nation, whose territory runs roughly from Kansas to North Dakota.

The effects of the program on the Indian art centers are thus largely local, and they almost certainly will take time to be recognized. So far, the results are mixed. One graduate, for example, a Sioux woman, has gone home to start a museum that will incorporate a historic collection of photographs given to her people. During her training, she knew her career goal and was able to prepare herself specifically for it. She became knowledgeable about photography and studied the care and handling of prints as well as administrative techniques of fund raising, budgeting, and proposal writing.

But few other students have had such opportunities, and even when jobs are offered, they are received with complex responses. One Apache student expressed interest in working as a guide for the National Park Service. But when the job came through, he refused it. The reason, the institute later learned, was that the job required the purchase of a $150 ranger uniform; the student did not have the money and was too proud to ask for it.

There are other problems, too, Dailey has said, ''besides getting kids to talk about themselves. The students don't really relate to the museum idea. Museums are white, not Indian, institutions. Indian students don't want any part of them.'' For one thing, most job possibilities that have come to the institute are requests for receptionists and museum guides, which students regard as token positions. Dailey has tried to counter this attitude by telling the students to take advantage of jobs that ''put the Indian out in front'':

> If you think it is a token position, take it and make it such a valuable position that the museum can't do without you. The museum profession is the most exciting profession in the world because you can make the rules now. It is the only profession I know with this potential.

Students have also reacted with cynicism to the offers for internships and apprenticeships in museums that stream into the institute. Says Art Director Henry Goblin, ''They want to be the first institution to hire a red man on their team.'' A student adds, ''We don't want to be apprentices. We want jobs.''

But it is clear that the students have shown little interest in taking jobs in museums that either are out of their home territory or are not exclusively dedicated to Indian arts. A few Eastern museums have been anxious to hire Dailey's stu-

dents, but because none of the students came from the East or had lived in urban centers, none has expressed interest in the jobs.

Some critics feel the job problem could be solved by better communication and recruitment. One museum official has called the program ''isolated from real life,'' with ''little correlation between the needs of museums and the directions of the institute training program.'' Dailey is aware of the dilemma. He has said that he realizes recruitment could be organized to fit employment needs, but he has pointed out that the institute is designed to serve the Indian people, not the nation's museums, and as long as the students want to stay on their home ground and focus on the development of Indian art centers, there is little he can do to change them.

So graduates of the Institute of American Indian Arts museum training program come out prepared to embark on museum careers on their reservations or in other familiar environments. They are young, they do not have strong backgrounds in the research techniques of art history required by most art museums (the Rhode Island School of Design's accreditation of the institute's training course is the equivalent of a bare two years of junior college), and yet the students will not accept the junior jobs that conventional museums offer them. Almost all these students would require further training to qualify for jobs off their reservations. The few programs that do exist—such as the University of Colorado museology course for Indian students (which does not result in a degree)—are not strong enough to turn the students into the well-trained candidates they need to be. What is required, according to one observer, is an advanced program at a university in a semirural area, near Indian lands, with a faculty and an environment that is sensitive to the American Indian student.

## Problems and criticisms

The Institute of American Indian Arts Museum training program is isolated from other museums and trends in museum education. Although Charles Dailey personally subscribes to museum publications, it takes him at least a year to read this material and make it available to his students. ''You embarrass me by asking about the educational functions of a museum,'' he says. ''Everything I teach here is at least a year old. I can't get to conferences; we just don't have the money.''

This lack of communication is a negative factor in a museum training program. Dailey is not able to travel to see what museums are doing in the way of orientation galleries or installation techniques, or to see the urban phenomena of satellite and storefront museums. His students do not have the benefit of guest faculty nor the advantage of taking part in conferences with visiting museums outside the Santa Fe-Albuquerque region. If the students were exposed to other museums and could talk with other museum professionals, not only might they establish contacts for their own

museums, they might also be receptive to accepting jobs outside the Southwest. Too, the content of the training curriculum might expand, the resulting Indian centers would be more likely to educate the public, and museums would ultimately learn more about the American Indian.

Funds to support this kind of program are essential, yet a small staff with tremendous responsibility does not have the time nor the eloquence for proposal writing. Says Dailey,

> I have a bone to pick with the National Endowment for the Arts. If I sit down to write a proposal, it takes me away from my work for a week; then I'm a week or two behind. I don't have the right words. I don't get the grant. . . . Small museums operate on a crisis basis. We can't take the time.

Although various museums throughout the country have expressed a desire to hire American Indians or include American Indians in their training programs, to embark on such a project a museum would have to educate itself to the needs of Indian students and to programs like this one at the Institute of American Indian Arts. American Indians may be more receptive to museum jobs once museums make the effort to understand the contemporary American Indian and to become aware of the existing museum training program designed for native Americans.

There is another aspect to museum training for native Americans that will affect museums. According to a public statement of the American Indian Historic Society, which has been reiterated through the years, "the museums have become graveyards of Indian arts. These objects have to be returned to the tribes which owned them originally, and which are now restoring their facilities to protect and preserve them."[4]

It is probable that as students leave the training program at the institute and begin to build their own museums, they will be requesting "long-term loans" or the return of Indian material to their newly formed museums. At present, the major demand is for the return of religious and sacred objects that should not be on public view. Many tribes want these objects restored because they feel they own them. The Smithsonian Institution, for instance, is being asked to return all the sacred objects and at least one each of those objects that are duplicated in its collection.[5]

This development is a positive step for Indian museums, but it still ignores the needs of today's Indian. The Institute of American Indian Arts Museum exhibit program has the potential for communicating a strong message about the American Indian. This is now done only moderately well: the museum's operating budget of $8,000 a year and staff of three persons—who must also act as faculty—prevent it from expanding its present functions or its exhibition program.

The institute is also, in a sense, bucking a widespread trend. Museums, collectors, art and historical societies, and dealers are placing ever greater emphasis on historic American Indian artifacts and traditional art forms. But the Institute of American Indian Arts is devoted to contemporary art forms. A staff of nationally recognized artists is teaching both traditional techniques and contemporary expression; the resulting works are exhibited in the institute's museum. The students in the museum training program are acutely aware of contemporary Indian art, and as they start their own museums, they may combine the traditional with today's art, which will provide a service to Indian artists and instruct museums about these artists and their art. As one young Zuni Indian, who is in school at St. John's Mission in Laveen, Arizona, said, "After here, I'll probably go to the institute. I can be myself there. I don't want to make the pots of my grandmother."

The institute's basic argument is that Indians are contemporary human beings with contemporary ideas and must be allowed to express this position. Art dealers, traders, and collectors demand traditional Indian art because of the economics involved: people buy traditional Indian art. Museums covet and purchase historic artifacts while ignoring contemporary Indian art. Exceptions are the Institute of American Indian Arts Museum and the Amon Carter Museum of Western Art in Forth Worth, Texas, which was instrumental in organizing an exhibit of the works of institute alumni. The Heard Museum in Phoenix, Arizona, has also recognized this problem and recently purchased some contemporary paintings and sculpture. Heard Director Patrick Houlihan expresses the museum philosophy this way:

> I want . . . students from the Indian schools to be able to come in here and see that that painting and that sculpture were made by an Indian—and to take pride in that work and know that they can express themselves in any way they see fit.

Again, however, there is some criticism that the institute itself is not dealing with this problem more aggressively. According to a Santa Fe artist, "The problem with the institute is that it keeps art students from being exposed to mainstream art and measuring their work with that of artists other than Indian artists."

The conclusion is fairly obvious: the public and the professional art world must be educated about the contemporary American Indian artist, and the Institute of American Indian Arts is a logical agent to play a role in this process. Perhaps a sound beginning goal would be the elimination of the stereotype, which seems to be especially prevalent in the Southwest, of the Indian artist as a traditional craftsman living on the reservation. Writes one native American historian in a plea for a change in the way Indians are perceived,

> . . . We want your help to reconstitute our own culture, to reconstruct, in the best sense, our true history. We want the true story of our people known. We who are Indian scholars, Native historians, traditional speakers, medicine men, diagnosticians . . . we are the best interpreters of our people. Certainly there are some frauds and ignoramuses among us. But if you are intelligent, as it is generally believed, the sheep would not be difficult to separate from the wolves.[6]

—*E. S. C.*

## Notes

[1] Lloyd New, "Cultural Differences as the Basis for Creative Education," *Native American Arts I,* U.S. Department of the Interior, 1968, p. 5.

[2] For sources of quotations without footnote references, see list of interviews at the end of this report.

[3] Charles Dailey, *Why Museums? Why Museum Training?* Institute of American Indian Arts, p. 5.

[4] Quoted by Cory Arnet, in "Demand Grows for Return of Indian Art Objects by Museums in U.S.," *Wassaja,* August 1974, p. 10.

[5] Ibid.

[6] Jeanette Henry, *The Indian Historian* (spring 1970), quoted in James D. Nason, "Finders Keepers?" *Museum News*, March 1973, p. 25.

Dailey, Charles. Director, Institute of American Indian Arts Museum. September, October 1973; June, August 1974.

Goblin, Henry. Art Director, Institute of American Indian Arts Museum. August 1974; correspondence, June 1973.

McGrath, James. Santa Fe Artist and Collector. September, October 1972.

New, Lloyd. Former Director, Institute of American Indian Arts Museum. September 1972.

Students at the Institute of American Indian Arts. October 1973.

Activities at the institute. June 1972 to August 1974.

# Cooperation among Museum Professionals

## Introduction

One of the most interesting developments in the museum world during the past decade has been the growing cooperation among museums and museum staffs in a variety of areas. Museums have begun to pool their conservation work at such centers as Oberlin in Ohio, the Kimbell Museum in Fort Worth, and Denver in the Rocky Mountain area. Small museums and art centers have come together in organizations like the Gallery Association of New York State to share exhibitions, take part in annual training programs, and meet for workshops on subjects of mutual interest—labeling, space planning, art handling, audience development. The Texas Museums Consortium (see report in this chapter), an alliance that died almost aborning, was meant to follow a similar pattern. In another consortium, this one in Washington state, five small museums shared the first grant from the National Endowment for the Arts that allowed several institutions to buy works of art jointly.

The trend toward "ecumenicism" among museums, as

Hirshhorn Deputy Director Stephen Weil has called it, has affected museum educators as much as any segment of the museum world. Where collaboration has been dictated in other areas of museum operation largely by economics (small museums, in particular, cannot afford to duplicate expensive conservation facilities, to compete with one another for acquisitions, or to shoulder by themselves the costs of importing and insuring exhibitions on loan), among educators the impetus toward cooperation seems to have come mainly from the rising militancy in the late sixties of community groups whose attacks on large cultural institutions prompted many museum administrators to respond with education programs and brought many educators out of their offices and basement galleries into the streets to confront the museums' accusers. In several cities, education staffs from local museums met each other for the first time in stormy sessions held in ghetto storefronts. Several staffs, too, gained a sense of importance as museum administrators and public funders began to give museum education new attention.

## Some origins of collaboration

At least two formal alliances of museum educators described in this study, the Museum Education Roundtable in Washington, D.C. (this chapter) and Museums Collaborative in New York (see chapter 4), grew in whole or in part from the raised consciousness of the 1960s. The organizers of MER centered their first discussions, as the minutes read, on "the concern for cooperation with the area school system." As the enrollment of that school system is nearly 96 percent black and District museums had long been criticized for ignoring the local constituency, MER was clearly one attempt by museum educators to change their institutions' ways. The Collaborative, perhaps even more than MER, had its origins in community confrontation. The idea developed out of a conference of community and establishment museums in 1969, where the dissatisfactions of community groups were given thorough airing. One of the Collaborative's three assignments when it was formed in 1970 was to help museums "decentralize" (in the now-loose definition of the word) their resources, and most of the Collaborative's activities in the intervening years have concentrated in one way or another on just this task.

An important by-product of the aroused sensitivities of museum educators to underserved audiences has been an interest in sharing ideas and in learning to do a better job of being educators, rather than trying to escape the museum-education "swamp" for higher curatorial ground, as many of their predecessors had longed to do. Both MER and the Collaborative have given educators the chance to become more professional in their work—MER by offering workshops on such subjects as docent training and field trip planning, the Collaborative by creating its Museum Forum, which has brought not only educators but other museum staff members (curators, exhibition designers, and development officers) to regular sessions at various museums and cultural centers on

such subjects as program evaluation, city cultural policies, communications, program administration, and goal setting.

**The AAM President's Committee on Education.** Perhaps the most dramatic evidence of the growing interest of museum educators in their work, one another, and their professional status is the President's Committee on Education, formed in 1973 at the annual meeting of the American Association of Museums. Long suppressed by the association, which had rarely given education a place either in its meeting agendas or its official publications, the pride, "concern, dissatisfaction, frustration, and disgust" of museum educators, in the words of one of the committee's founders, erupted into a full-scale mutiny.[1] The educators demanded representation on the AAM Council and in its program planning, publications, regional and national meetings, and they set about to organize themselves not only nationally but regionally to accomplish their purpose: "to improve communication, primarily among museum educators, and secondarily among all museum professionals."[2]

## Who are we and what shall we do?

Beyond the initial organizing and discussion phases, the question, at least for the alliances described here, has been one of identity and power: who should be represented, where legitimacy comes from, what activities are most useful. MER, the AAM education committee, and the Collaborative agreed early on some forms of communication: MER and the Collaborative published catalogs of their members' services, primarily for the use of schools; regional networks put out a directory of museum educators, bibliographies, and in one area a regular newsletter. The Texas Museums Consortium, which was organized not around education but exhibitions and the possibility of shared services, got as far as the exhibitions; it foundered on the possibilities.

For the Collaborative, identity may have been a problem at times, but activities have followed one another almost without pause. The Collaborative's advantage has been that it started life as an independent organization, whose board and advisory committees included museum educators but whose legitimacy derived largely from the fact that it had its own money to spend; it was not dependent for survival on memberships or constituent consent. The result is that the Collaborative has had the freedom to incite and cajole, to design programs that would give museums something in return for their participation (the Collaborative almost inevitably awards museums and other organizations small grants to use in carrying out their part of the programs).

MER, in contrast, was born out of mutual need. Its members are the organization. They must be consulted on every move, and decisions are arrived at only after long discussion. An "introspective" group, as the report describes it here, MER has suffered an identity crisis almost from the beginning: how far can and should it go in developing its own programs and activities, should it remain local or take on

regional or national character, to what extent should it serve its members as opposed to the "Cause of Museum Education." With identity have come financial questions. As long as the organization could not decide its basic mission, it could not decide, either, to turn management over to a paid administrator—and it could not hire a paid administrator before it could explain to potential funders what the administrator would do.

The AAM education committee, too, has had its problems, function and identity not the least of them. According to one observer writing in 1975, the committee's principal weakness is "its reactive stance." There are plenty of issues to react to, she noted, but "the common problems and complaints of educators have [not been] relieved by the committee; . . . its function so far seems to have been to keep the pot boiling."[3] Some museum educators interviewed in 1975 had discerned little improvement in their professional status in the two years since the committee had been formed. And the committee's Western regional newsletter noted that the host museum for the AAM annual conference that year had not asked any member of the committee, including the museum's own director of education, to join in the planning for the meetings. The special irony of the situation was that the conference theme was "The Museum's Audience," a subject that educators look on as their main area of expertise.

Complicating the committee's life is the fact that the AAM itself has not been strong enough to give the committee support and direction. The result is that committee members were, at least during the first years, unhappy with the AAM's apparent indifference to their concerns. Yet to organize themselves outside the AAM is to compound the difficulties: money, staff, headquarters, leadership, policymaking, are formidable obstacles to any national interest group, especially in a field where money is in such short supply. Paul Perrot, assistant secretary for museum programs at the Smithsonian Institution, is one who feels that the questions raised by the education committee have fundamental policy implications for the AAM:

> We should think in terms of a total profession with ongoing disciplinary needs: the tools and mechanics of each discipline are changing and need to be shared within the discipline. [Educators] . . . need visibility: their representation should be assured of more than ad hoc position; they should not be allowed to disappear and then resurface every few years. This must be a policy of the AAM.[4]

The experience of the Texas Museums Consortium may be especially instructive on the subject of legitimacy. Launched with handsome grants and the good will of some of the state's strongest museums, the consortium was unable to earn the support of its members; ideas abounded, but in the end no one was willing to take the leadership or to follow it. The structure of the consortium had been determined before anyone really knew what the content of the organization would be.

On the other hand, the success of Museums Collaborative may hold some lessons on the subject of structure. Like the consortium, the Collaborative was founded outside the museum profession as an independent operator. Though its name and its purpose tie it to museums as primary constituents, the Collaborative has been able to move almost at will wherever it sees the needs. Its perceptions may not always have been accurate, and the Collaborative has been accused of such failings as "gimmickry" and undue attention to community groups at the expense of schools and museums. Yet it has been remarkably resilient in the five years of its existence as it has devised a variety of ways to encourage closer cooperation between museums and their underserved audiences and to stimulate museum staffs to respond more sensitively to these clients.

## The future of cooperation

It has often been pointed out that the problems of our time are becoming too complex and resources too scarce for institutions to duplicate one another's facilities and efforts and try to go it alone. But it is clear that collaboration is often a difficult and slow-moving process, requiring an openness and sense of security that not every institution can muster. When museum educators assemble, the temptation to show and tell is usually stronger than the instinct to share and discuss.

To move beyond questions of status to a point where museum educators can invest themselves deeply in the substance of their craft needs time, attention, leadership—things that cannot easily be given by volunteers who are preoccupied with full-time jobs. Perhaps a center such as the one proposed at the end of this chapter will help. But determined and thoughtful leadership, able to inspire the respect of the museum education profession and perhaps paid for its work, will undoubtedly help even more.—*A. V. B./B. Y. N.*

## Notes

[1] Paul Piazza, "Fighting the Good Fight," *Museum News,* vol. 52, no. 7 (April 1974), p. 33.
[2] Ibid., p. 34.
[3] Report submitted to CMEVA by Barbara C. Fertig, April 1975, p. 1.
[4] Interview, March 1975.

## Bibliography

*Museum News*, vol. 52, no. 7 (April 1974). Issue on "Museum Educators: What Are They Fighting For?"
Newsletters circulated in the various regions of the AAM President's Committee on Education.
*Summary of the Aspen Conference, September 23–25, 1973* (a meeting called to discuss the role of the American Association of Museums). Prepared for the American Association of Museums and available through the AAM.

# WASHINGTON, D.C.'S
# MUSEUM EDUCATION ROUNDTABLE

Museum Education Roundtable
1227 G Street, N.W.
Washington, D.C. 20005

**The growing pains of a group of Washington, D.C., museum educators who want to share ideas and concerns across institutional lines—among museums and with schools. Though the future is unclear, the most optimistic hope is that what began as informal group discussions might mature into a national communications network. CMEVA interviews and observations: June–September 1974; May and June 1975.**

### Some Facts About the Organization

**1. General Information**

Founding: Founded in 1969 as the Museum Educator's Roundtable. Incorporated in 1971 and name changed to Museum Education Roundtable (MER).

Staff: 2 part-time.

Number of members: About 100 museum educators and schoolteachers.

Operating budget: $18,470 (1973); $7,454 (1974).

Funding: In 1973, $15,500 came from a grant from the National Endowment for the Arts, the rest from the Roundtable's regular sources—membership dues ($10 a year), gifts, and publication sales (*Directory*). In 1974, all funds were from regular sources.

**2. Location/Setting**

MER is not an institution that is visited by the public, and it is relatively unaffected by transportation problems and meteorological factors. It is, however, strongly influenced by its location in the nation's capital, a city in which decisions are made affecting museums and education throughout the United States. The members feel a sense of national responsibility, and a number of the most active members work in national museums.

Washington, D.C.'s population was 756,510 in the 1970 census; it is part of a standard metropolitan statistical area with a population of 2,861,123 (1970 census). October 1973 school enrollment figures for the District of Columbia: 136,133 students, 95.73 percent of whom are black (72.34 percent of the city's population is black).

Specific location of the organization: MER's office is located in the northwest sector of Washington near the House Where Lincoln Died. Membership meetings are held at museums and other institutions around the city.

**3. Audience**

Membership: 100 members: museum professionals, school educators, and others who are interested in education using museum resources.

**4. Educational Services**

MER seeks to improve the educational services of museums through information exchange, and therefore all of its activities are educational.

Organizational structure: The Roundtable is governed by a board of directors.

Range of services: Publication of three editions of the *Directory: A Guide to Museums, Nature Centers, Parks, Historic Sites, and Other Resources in the Washington Area* and *Round-*

*table Reports,* an information newsletter for members: workshops for teachers and museum educators.

Audience: The members of the Roundtable and, indirectly, the children and adults they serve.

Objective: To increase cooperative efforts and planning between museums and schools, to foster professional development in museum education, and to expand and improve the educational role of museums. In 1974, MER broadened its scope in an attempt to create a network of communications among museums within a 200-mile radius of Washington (excluding New York and Philadelphia).

Time: Monthly meetings, year round.

Information and documentation available from the organization: *Directory; Roundtable Reports,* nos. 1–6, April to September 1973.

---

The Museum Education Roundtable, a young and lively organization in Washington, D.C., has attracted a good deal of attention from people across the country who have an interest in museums and education. For one thing, the organization presents a model that promises to illuminate and perhaps answer a few of the problems that plague this rapidly expanding field. For another, it is an example of a cooperative approach to common problems, offered at a time when there is wide interest in many parts of the country in new kinds of collaboration. In addition, the membership is principally middle-level professionals who are actually doing the job of museum education, a factor that impels the roundtable toward activities of unmistakable immediacy and practical worth.

MER, as most of its members call it (rhymes with fur), is not without its own internal problems, the most notable of which is that it has managed, at the age of five, to weather two full-blown identity crises.

Some of the strains on MER are the result of hazards of place. A museum organization in Washington is likely to be intimidated by the sense of power on all sides and the avowedly national focus of many local museums. Too, Washington museums have had a reputation in some circles for ignoring their local constituents, especially the poor who overwhelmingly populate the District and its schools.

From the beginning, MER has been ambitious, serious, and markedly introspective, constantly examining and reexamining motives and goals. It has always attempted to focus on crucial problems and issues, but it has never resolved the question of how far it should go in developing its own programs and activities. How local and unassuming should it be? How national should it try to become? Does it serve its individual members or the Cause of Museum Education, or both, and to what degree? That is what the current identity crisis is about.

### First issues

MER began life in the early fall of 1969 as the Museum Educator's Roundtable, a small discussion group made up of

educators from Washington museums including several departments of the Smithsonian Institution, the National Gallery of Art, and the Museum of African Art. From the minutes of the second MER meeting in October 1969, when officers were elected, there emerge the practical tone and substance of typical roundtable dialogue:

> The discussion . . . centered around the concern for cooperation with the area school system. Mr. Cutler said that the Roundtable should investigate ways to work directly with the classroom curriculum; to find solutions to school-museum transportation problems; to generate community and school interest in museum activities; and to find out the needs of the teachers and organize a museum's resources around these needs.
>
> Mr. Robert Works said that to think of ourselves as museum educators is restrictive. We should think of ourselves as educators in museums. Mr. John Bingham talked about inviting teachers to come to the museums to learn ways whereby he or she could make use of the resources in the museum without the aid of a docent. Mr. Bingham spoke of developing workshops for teachers. Those teaching techniques developed in a museum could be used in the classroom. Mr. Nathaniel Dixon suggested that the Roundtable try to assemble curriculum materials and study them in order to have an understanding of the relationship between what the schools are doing and what museums have.[1]

During that first formative year, MER members found that their meetings provided valuable opportunities to exchange ideas and information, and they reached agreement on a set of common problems, some of which appeared to be susceptible to a concerted approach. Most of the themes that were to occupy the time and the energies of MER for at least the next five years arose quickly:

- How to acquaint school administrators and teachers with local museum resources.
- How to ascertain the needs of teachers.
- How to foster general community interest in museum offerings.
- How to coordinate museum resources with the classroom curriculum.
- What museum educational methods should be explored beyond the guided tour.
- How to evaluate educational programs and their effectiveness for the schools.
- How to deal with school-museum transportation problems.
- How to reach a consensus on projects that would benefit all of the members and that could only be accomplished cooperatively.

Meetings, held at a succession of institutions, never lacked animation. There was no doubt that MER had sufficient reason for being—if only to provide a forum where museum educators, who find practical information hard to come by, could discuss their situation and their work. Members interviewed for this report were unanimous in their agreement that the exchange of ideas and information at MER meetings had been consistently helpful to them in their professional lives. They also said that the wide diversity of sizes and types of museums represented in MER—history, science, art—made surprisingly little difference in the colloquy. A transcendent commonality seemed to emerge that was recognized by all.

## The membership expands: enter the teachers

Having successfully brought themselves together, in 1971 and 1972 the MER members encouraged local Washington schoolteachers to join them. The initial response from the teachers was heartening. Attendance at monthly meetings swelled from about 15 to 35 or more. By January 1972, two teachers had been elected officers of the Roundtable and many others had taken out memberships.

But the inclusion of the teachers also brought problems. As the discussions increasingly turned to issues of pressing concern to both museum and school educators—especially procurement of buses and released time for teachers—and yet beyond the control of the combined membership, many of the initial joint meetings foundered in a sense of helplessness. Those teachers who felt that discussions of curriculum coordination were fruitless unless MER could help them get to the museum in the first place gradually dropped away.

The teachers who remained began to integrate their needs with MER's goals, and the membership settled down to work in areas it knew best. By and large, the teacher members turned out to be people who either use museums themselves or have had a good experience in taking their classes to a museum. For some, the early MER meetings served as an introduction to programs about which they had known nothing at all or not enough to want to bring their classes. For these people, hearing the programs described at MER meetings made a significant difference in motivation and thus convinced them that it was worth the rigors of arranging a field trip to give their classes something they knew was valuable and even exciting. (One former teacher member became so interested in the possibilities of museums as places of learning that in 1974 he was among the first students to enroll in the George Washington University M.A.T. program in Museum Education, described in chapter 14. Others have served on MER's board.)

The original move to join forces with school educators may have had some unrealistic goals, but it achieved a broadening of MER's constituency which, according to one MER member, might have been more instructive to both teachers and museum staffs than it probably was. In the end, MER's predominating interest in the problems of museums rather than schools and its habit of holding most meetings in museum buildings, may have been reasons enough why few teachers have been active in the organization.

## Incorporation, 1971

In the spring of 1970, the organization settled on its first group enterprise—the preparation and distribution of an

"Area-Wide Listing of Museum Educational Activities," a mimeographed directory of program offerings to be given to District-area teachers—and sent out a questionnaire to gather the requisite information. At the end of the 1969/70 meeting year MER's original secretary resigned and moved from Washington. The new secretary, Jane Farmer, and MER Chairman Edward Cutler, curator of education at the Museum of African Art, assembled a draft of the *Directory of Educational Opportunities in the Washington Area Museums*, which they distributed at the September 1970 meeting.

It was clear from this first program effort that MER would need money to provide even the most modest services. So the energetic Mrs. Farmer, who was at this time also setting up the "Discover Graphics" program at the National Collection of Fine Arts (see High School Programs, chapter 10), began looking into incorporation as a step toward receiving funds.

Two possibilities were considered: (1) forming an association that institutions would pay to join, sending their education staff members as delegates, and (2) forming an association of museum educators who would pay dues as individuals. MER members chose the second on grounds that it would be "a more appropriate level at which to solicit support and financial commitment."[2] The organization's name was changed to Museum Education Roundtable to indicate that membership would be open "to any individual who is interested in education using museum resources."

To assist the incorporation committee in its thinking, Donald Farmer, a local attorney who donated his services to MER, wrote a paper, "A Note on Corporate Formalities: Some Things to Consider before Incorporating." Though the paper is based on District laws, the first paragraph would be applicable anywhere:

> If your group is to organize as a corporation in the United States, the law doesn't allow you to run it any way you want to. Corporation laws of the states and the District provide that people who comply with certain formalities will be allowed to form organizations which have an existence independent of their individual members. If all the requirements of corporation law are met, individual members or officers are not liable for the debts or other obligations of a corporation; the corporation can make contracts, receive and disburse money, be exempt from taxes, and have a perpetual existence in its own name. But complying with the formal procedural requirements of corporation law can be a super drag for a small group of people. If you don't comply with the formalities, however, your group might as well not be a corporation, since it can be deprived of the benefits of incorporation by the first challenge from within or without—in other words, the first time you really need to be a corporation.[3]

The formal procedural requirements that threatened to be a "super drag" failed to daunt MER. These included the following:

1. Drawing up articles of incorporation and bylaws.

2. Keeping correct and complete books and records of account, and minutes of meetings of members, the board of directors, and all committees having any authority delegated by the board.

3. In the District of Columbia, giving all members with the right to vote written notice of every members' meeting, stating the place, day, hour, and, for special meetings, the purpose of the meeting.

4. Filing a tax return in any year in which the corporation has income, even if it is tax exempt.

5. Refraining from any activities that might be inappropriate for a tax-exempt organization.

6. Filing an annual report with the Superintendent of Corporations (along with a filing fee of $1).

7. Adhering to the rule that articles of incorporation can only be changed by a two-thirds vote of the members present or represented by proxy at a members' meeting, and by filing articles of amendment with the Superintendent.

The new MER, Inc., of 1971 now had an official purpose ("the promotion and development of museums in the Washington, D.C., area as educational resources"),[4] a board of directors of six, a nonprofit status recognized by the Internal Revenue Service, annual dues of $5, and a charter membership of some 30 persons.

One disadvantage of incorporation soon became apparent. MER, like those birds that lay their eggs in the nests of other species, had received certain benefits from the institutions in which its officers were employed—a bit of a typist's time, the use of a duplicating machine, paper and envelopes, postage. Now MER had to pay all its own bills; they may have been small, but so was the organizational bank account: in February 1971 the treasurer reported a total of $111.

### Money, projects, and other complexities

As the main reason for establishing a formal, legal identity was to be in a position to go after outside money, the next task was to work out detailed projects, write proposals, and submit them to funding agencies. In 1972, MER sent out a flurry of applications. Among the grants that came in as a result were $5,000 from the Hattie M. Strong Foundation and another $5,000 from the Morris and Gwendolyn Cafritz Foundation, which put MER in business. The board hired a coordinator—Mary Alexander, formerly educational coordinator for the National Trust for Historic Preservation—and MER settled into an office at 514 10th Street, N.W., just next to the House Where Lincoln Died. It was the breakthrough everyone had been waiting for.

The first project to be completed was the *Directory of Educational Opportunities in the Washington Area*, edited by Ms. Alexander and published in the fall of 1972. It listed 69 educational resources and gave information about collections, tours, and programs, and such further details as available auditoriums, libraries, programs for the handicapped, entrance fees, and the name of a person to talk to at each place—information that had never before been available in

this form. The entire edition—8,000 copies—was given away free of charge to teachers and anyone else MER thought might be interested. Answers to an accompanying questionnaire were uniformly favorable.

The Roundtable also received $10,000 from the National Endowment for the Arts in 1973 to present a series of six all-day workshops for local teachers (see following section). These were designed to "foster interaction between teachers and museum educators." Six bimonthly newsletters would disseminate the results of the workshops. Matching funds were to be provided in the form of the coordinator's salary and time contributed by MER officers.

The last in the set of proposals conceived by MER in 1972 was the evaluation component of an Elementary and Secondary Education Act Title III project, entitled "The World Is Your Museum," which was submitted to the U.S. Office of Education by the Public Schools of the District of Columbia. This small project, or piece of a project, represents a notable MER failure; it will be discussed in subsequent paragraphs.

Membership meetings continued, now devoted to single topics—"Off the Bus and In the Door: What Are We After?", "What Do Teachers Want from Museums?", "Exhibit Planning: Where Does Education Fit In?", "Museum Education for the Handicapped," "Improvisational Responses to Works of Art."

**Teacher workshops.** The six workshop sessions funded by the National Endowment for the Arts took place between March and August 1973. The topics were selected by the Roundtable board from suggestions made by museum educators and teachers:

1. Interpreting an exhibit for your class.
2. Exhibition design and education.
3. Educational techniques in the museum setting.
4. Media.
5. Docent training.
6. Field-trip planning.

Planning for the workshops was carried out in a mode which has become a MER trademark. Ms. Alexander called on the membership for ideas, then sat through lengthy and lively meetings, making notes, circulating minutes, working everyone's suggestions into step-by-step activities, and finally drawing on highly respected area educators to lead workshop participants in well-focused rounds of discussion and demonstration. Not surprisingly, workshops that had rolled easily out of the planning sessions were assessed the most useful by the participants.

The total number of participants for the six workshops was 105—53 museum educators, 36 schoolteachers, and docents, exhibition designers, and special education personnel from the public schools. Their consensus: the workshops were stimulating and useful to them in their work.

**Newsletter and directory.** MER feels it made its greatest impact, however, through the three-page newsletter, *Round-*

*table Reports: Activities of the Museum Education Roundtable.* Requests for copies of publications came from around the country, and a dozen persons in cities as distant as San Francisco, Dallas, and Gainesville, Florida, took out memberships in order to receive the newsletter. The organization was now well known locally, at least in museum and education circles, and was getting some degree of national attention. At the same time, mention of MER, its activities and its publications, was made in professional journals, and MER members were invited to speak at national and regional conferences.

With money from the Strong and Cafritz grants, a third edition of the directory, revised and expanded, again edited by Ms. Alexander, was published in 1973. Now titled *The Directory: A Guide to Museums, Nature Centers, Parks, Historic Sites, and Other Resources in the Washington Area*, the contents were expanded to list more than a hundred organizations and institutions. Of the 25,000 copies printed, 10,000 were again distributed free of charge to teachers in the local school systems. As the *Directory*'s primary audience, several schoolteachers reported they got more information from it about particular institutions than they did from the suggestions for field trips circulated by boards of education.

But the *Directory* also covers many places and programs in the Washington area that often go unnoticed in the wake of the strong attraction exerted by national monuments and museums. So MER looked on the *Directory* as a serviceable guidebook for the layman as well as the schoolteacher. Although grant monies covered the $6,800 cost of the edition, the Roundtable decided to sell copies on the general market to raise extra funds. But the efforts to place the *Directory* in competition with newsstand guides and picture-books stumbled into two blocks. First, its 8-by-11-inch format proved too large for merchants who figure their profits by the square inch of selling space, and second, as one *Directory* salesman noted, many people who come to Washington already have a fixed idea of what they want to see.

By February 1975, about 7,000 copies had been sold or given away; still the MER office looked like an island of directories in cardboard boxes surrounded by a few items of office furniture and equipment.

**Project #3: the dud.** "The World is Your Museum" was a Title III project of the art department of the District schools. According to the proposal, it was to have the goal of "intensifying the students' powers of observation and analysis":

Beginning in September, 1972, eight public and two nonpublic elementary art classes (grades K–5) drawn from each of Washington, D.C.'s eight school board wards will each participate in a series of 15 interrelated community resource visits. Through museums coming into the classroom and innovative museum tours related directly to specially designed audio-visual classroom curriculum kits, emphasis will be placed on expanding student perception and establishing cognizant [sic] and visual relation-

ships between encountered concepts and objects. Classroom discussions and projects will amplify resource visits and media presentations. Students will be encouraged to exercise verbal and nonverbal skills in recording and comparing their experiences, requiring visual acuity and increased retention.[5]

The proposal goes on to say that "the office of Dr. Edward Neuman, Museum Programs, Arts and Humanities, Office of Education, HEW, will assess this program without fee and compare it with other museum programs on a national basis." MER would also participate in the evaluation, for which $2,500 (out of a total of $39,200) was budgeted.

Cooperation between community organizations and schools is a process subject to a variety of difficulties, and this project encountered many. The MER board member who had spent the most time working with the art department on the proposal took another job and resigned from the board. Two of the staff of the art department also got jobs elsewhere. Time passed. MER board members had trouble finding someone to talk to about the project. Finally, after conversations in June 1974, it became evident that both parties had simply lost interest in MER's participation. The project, altered somewhat, had been renewed by the Office of Education, and it is still continuing—without MER's help.

For MER, it was a lesson in failed cooperation. The administration conceded that it could avoid another failure like this one by making sure enough people are committed to a project so that it can survive unforeseen changes in personnel. The MER staff also agreed that any future project description should contain a definite schedule of cooperative working sessions throughout the project period.

### The 1974 crossroads: how "professional" should MER become?

Ms. Alexander left her job as MER coordinator in the fall of 1973 and was replaced in January 1974 by a part-time coordinator, Mrs. Peggy Amsterdam. An inherent problem for MER from the beginning has been its heavy dependence on volunteer work by its board and members, all of whom have regular jobs and limited energies to devote to the organization. As MER's activities grew in number and complexity, this weakness became increasingly apparent—doubly so during periods when there was no staff member in the office.

In February and March 1974, MER conducted a telephone survey to determine the effect of the fuel shortage on Washington area museums, nature centers, and historic sites. The survey showed that there had been a high rate of cancellation of school tours and a significant increase in demand for the services offered by outreach programs—mobile units, teaching kits, staff presentations. The Roundtable sponsored a March 20 symposium at the Corcoran Gallery of Art on the effects of the energy crisis. Panelists from the Federal Energy Office, the National Endowment for the Arts, the Clearinghouse on Museums in the Energy Crisis, the Fairfax County

Public Schools, and the Washington Metropolitan Area Transit Authority offered little cheer, suggesting that museums would have to reassess their programs and do what they could to support mass transit. Stephen Sell, director of special projects at the National Endowment for the Arts, said that "when schools can no longer come to museums, it will become absolutely necessary for museums to deliver to schools."[6]

A small grant of $2,000 for general support was given by Mrs. Corina Higginson Rogers, a local philanthropist, late in 1973. But it hardly solved MER's financial problems. The treasurer reported that "during the first three months of 1974, MER spent money on its regular expenses at a rate of $1.10 for every 50 cents it took in in regular income. . . . Our checking account balance at the end of March was $1,525.42. If MER were to continue to spend and receive funds at the same rate it did from January through March 1974, it would run out of money at the end of August of this year."

At this review meeting, Chairman David Estabrook stated the obvious: "We're at a crossroads." He suggested three broad possibilities:

1. The Roundtable could revert to its original character as an informal, local discussion group, devoted primarily to information exchange.
2. It could continue living from hand to mouth, with an overworked board doing what it could to maintain the maximum level of activity.
3. It could actively seek funding wherever it might be found, accept national responsibility, and continue to grow. In this case, the board had concluded that a staff of two full-time and one part-time persons and an annual budget of at least $18,000 would be called for.

Other members of the board talked about the present financial status of the organization and MER's growing influence in other parts of the country. A group in Ohio had patterned itself after MER, and so had the Museums Collaborative's Forum in New York. The American Association of Museums Southeastern Region had taken MER's *Directory* as the model for its own. MER's correspondence was now nationwide.

The ensuing discussion left no doubt that the members wanted to make the big try. The question was how. Somewhere in their experience as builders of their Washington network, they knew, was the germ of a useful idea for museum educators elsewhere. In a talk with Alec Lacey, the deputy director of public programs at the National Endowment for the Humanities, it seemed clear enough to MER board members that the Endowment thought so, too, and MER submitted a proposal for enough funds to work out a plan to help museum educators create networks in other parts of the country. The National Endowment for the Humanities wanted the plan to focus on furthering the profession, encouraging museum educators to explore issues in adult edu-

cation, and drawing humanists into museums, both as scholars of museum collections and as an influence on what museums do with their collections.

With a six-month grant of $17,500, MER hired two part-time staff members, who set to work. One was charged with researching the needs and writing the proposal. He interviewed museum people in both D.C. and other cities, testing their receptiveness to the idea of a loose confederation among ''sister'' museums that would trade their experience in education. The other staff member investigated the issues—docent training, ''outreach,'' museum materials for colleges—that seemed to affect adult education in particular. She also coordinated planning meetings, prepared a resource file, and searched for likely participants.

From discussions in the board and membership planning meetings, they drew up a plan for a single network, to start, of 12 institutions within a 200-mile radius of Washington, excluding Philadelphia and New York. The network would spend one year developing a project around an identified need at each institution and begin to establish a small clearing house of materials and people. Three representatives from each member institution would participate, working in their own institutions with a MER field representative and with MER members who had similar problems or had solved similar problems. The MER office would serve as the network clearinghouse.

Meanwhile, at a June 1975 meeting, the MER board and membership appointed five committees: one to link the Smithsonian Institution's museum and museum training programs with George Washington University's Museum Education In-service Training Project (see chapter 14); a second to advise and assist a group setting up a ''curriculum center'' to coordinate museum programs with school curricula in a central location; another to supervise the publication of *Roundtable Reports* on a regular basis; a fourth to find a home for MER in city government or museum offices and to seek further funding sources; and a fifth to schedule and coordinate membership meetings.

At this writing, MER's future has not been resolved. But whatever direction it takes, there is no doubt that the roundtable has shown museum educators one way of getting together to give one another support and to think through their ideas and problems.—*Richard Grove with B. C. F. and S. R. H.*

## Notes

1 From MER files.

2 Membership meeting minutes, September 24, 1974.

3 November 1970, p. 10.

4 Board of directors meeting minutes, December 3, 1974.

5 Submitted to the U.S. Office of Education by the Public Schools of the District of Columbia, 1972, p. 1.

6 Taking into account these prophecies of doom, and, in addition, maintaining a watch on school policies to determine which were

temporary responses to last winter's crisis and which were long-range policy changes related to economic as well as energy problems, the MER board developed a proposal for a new set of workshops to instruct teachers in the availability and uses of existing outreach programs. The workshops would also include the development of new outreach projects tailored to curriculum changes and would try to identify hardware and other support systems within the schools. In thinking about the issues, which included the presentation, in a May membership meeting, of regional mobile programs, the board chose to delete a proposed workshop on mobile museums ''because the high cost of developing and maintaining mobile museums makes this type of program the least feasible form of outreach for museum education budgets'' (from draft of a letter to prospective funding agencies). Once again, planning for the workshops includes the publication of *Roundtable Reports* on the activities and conclusions, to be circulated to the members and the profession at large.

## Interviews

Alexander, Mary. Former Coordinator, MER. June 13, August 13, and September 14, 1974.

Amsterdam, Peggy. Former Coordinator, MER. June 25, 1974.

Bay, Ann. Education Specialist, Office of Elementary and Secondary Education, Smithsonian Institution; Member, MER Board of Directors. June 21 and 25, and September 30, 1974.

Estabrook, David. Director, Office of Elementary and Secondary Education, Smithsonian Institution; Chairman, MER Board of Directors. June 12 and 21, and September 30, 1974.

Farmer, Jane M. Former Staff Associate in Education, National Collection of Fine Arts; Former Chairman, MER Board of Directors. June 24 and September 14, 1974.

Grana, Teresa. Staff Associate in Education, National Collection of Fine Arts; Member, MER Board of Directors. July 19 and August 16, 1974.

(Peggy Amsterdam, David Estabrook, and Sue Hoth provided access to MER's records and files.)

# TEXAS MUSEUMS CONSORTIUM

Texas Commission on the Arts and Humanities
P.O. Box 13406
Capitol Station
Austin, Texas 78711

**A 22-month project that aimed to encourage cooperation among eight widely scattered Texas museums. Major benefit of the experiment: three loan exhibitions shared by members. Major deficit: little progress with cooperative services in administration, education, resource codification, film archive. CMEVA interviews and observations: June 1973–September 1974.**

### Some Facts About the Consortium

**Title:** Texas Museums Consortium.

**Audience:** Member museums were the Amon Carter Museum of Western Art, the Fort Worth Art Center Museum, the Abilene Fine Arts Museum, the Amarillo Art Center, the Museum of the Southwest (Midland), the Tyler Museum of Art, the Wichita Falls

Museum and Art Center, the El Paso Museum of Art. (For further information on these institutions, see lists at the end of this report.)

**Objective:** As defined by the Texas Commission on the Arts and Humanities in the original funding proposal, "To investigate, devise, and test ways in which a regional group of small and medium-size museums can pool resources, physical and human, in order to offer more qualitative and quantitative service to the people of their collective areas."

**Funding:** $60,500 (for 22-month grant period), including about $25,000 in salaries and benefits, about $20,000 for exhibitions and catalogs, about $4,500 for speakers. The remainder was spent on films, travel, and supplies. Sources were the National Endowment for the Arts, $30,000; Texas Commission on the Arts and Humanities, $20,000; member museums, $10,500.

**Staff:** One full-time project director and a part-time secretary. Directors of member museums served as an informal "board of directors" and, together with the executive director of the Texas Commission on the Arts and Humanities, determined policy and fiscal priorities.

**Range of services:** Organization of exhibitions to circulate among member museums ("Photographs: Landscapes of the American West"; "Drawings"; "Exponents of Modernism"); preparation of exhibition catalogs; sponsorship of guest speakers at member museums; development and selection of an archive of contemporary films. Other services included research on employee benefit and insurance programs and on computerization of collections, preparation of a survey on facilities and needs of member museums, and a resource codification.

**Location:** The consortium office was housed in the offices of the Texas Commission on the Arts and Humanities in Austin, located in the south-central portion of the state. Member museums were scattered throughout the state.

**Time:** The life of the consortium was from September 1, 1972, to June 30, 1974.

**Information and documentation:** Two reports by project director, "Report: Museum Consortium Project, September 1, 1972–March 1, 1974," and "Summary Report: September 1, 1972–July 15, 1974"; and *Forum,* vol. 1, no. 4 (autumn 1973), publication of the Texas Commission on the Arts and Humanities.

---

With a bow to the divided highways and oil wells that make one's personal apprehension of it possible, the Texas Highway Commission refers to Texas as a "land of contrasts." For Maurice Coats, the director of the Texas Commission on the Arts and Humanities, the slogan applies equally to the 28 art museums scattered throughout the state. He has observed, "The larger museums have art molding in the basement. Meanwhile, small museums struggle for every breath."[1] As though to underline the distance, if not the struggle, one museum director noted in a telephone conversation that his museum was 300 miles away from the nearest large city.

Until Coats assumed his Austin post in May 1971, there was no state funding of museum programs nor any vehicle through which cooperative programs might be developed, although museums had a long history of informal cooperation. That informal cooperation, notably among large and small museums in the Dallas-Fort Worth area—coupled with

a discussion between museum directors and the arts and humanities commission director at a Mountain Plains American Association of Museums conference in 1971—prompted Coats to call a meeting to consider other mutually beneficial areas of cooperation. He promised the assembled museum directors that if they could find some way to share resources, speakers, and catalogs—and if such sharing could be useful and important—the commission would provide a home for a coordinator and seek the necessary federal funding.

In further meetings it turned out that uppermost on the museum directors' list of perceived needs were high quality exhibitions. Sharing exhibitions, the directors felt, would help stretch modest exhibition budgets while providing a tangible argument for selling cooperative programing to museum trustees. Another need translatable into a program of "high visibility" was for a speaker's bureau to coordinate lectures by nationally prominent art historians and critics.

Still more potential fruits of cooperation were considered by the meeting: an archive of films for art museums; a directory, ultimately to be computerized, of the resources and services of individual museums within the state; substantive information about the contents of museum collections (nobody really knows, said one museum director, what is contained in Texas collections, and there are "quantities of erroneous information"); the possible purchase of group health insurance and other employee benefit plans; the development of confidence and familiarity among museum directors.

### The scope of the museum consortium project

On the basis of meetings with a group of museum directors and professional staff, the Texas Commission on the Arts and Humanities submitted a proposal in April 1972 to the National Endowment for the Arts Museum Program, under its "Wider Availability of Museums" heading. As the commission defined it, this project would "form a consortium of large and small museums to investigate, devise, and test ways in which a regional group of small- and medium-size museums can pool resources, physical and human, by which more qualitative and quantitative service would be offered to the people of their collective areas."

A meeting of the eight organizing members in July 1972 called for a pilot project that would develop in two stages, Phase I to be confined to the original members during the basic planning period, and Phase II to include possible expansion to additional Texas museums. The project would begin officially with the hiring of a director in September 1972 and would run through February 1974.

**Funding.** Both to get it off the ground and to induce museums to take part in it, the project hinged on receipt of a National Endowment for the Arts grant of $30,000, which came through in July 1972. A second source of funds was the member museums, each of whom contributed $1,500 toward the project. A third potential source of funds—the state's private foundations—soon proved sticky: local foundations

tended to confine their philanthropy to their own communities. So the commission was asked to pick up the entire $20,000 needed in matching funds.

**Membership.** Of the original consortium members, two—the Fort Worth Art Center Museum and the Amon Carter Museum of Western Art, also in Fort Worth—were designated "donor museums" on the basis of their collections and staffs. The third Fort Worth museum, the Kimbell, served simply in an advisory capacity. Because of the size of its program and staff, the El Paso Art Museum was named a potential user and donor, having offered to make its collections of Mexican Colonial art, pre-Columbian art, and American Indian art available. Smaller institutions were to be primarily "user museums"—the Abilene Fine Arts Museum, the Amarillo Arts Center, the Museum of the Southwest (Midland), the Tyler Museum of Art, and the Wichita Falls Museum and Art Center. The exhibition budgets of the smaller, "user" museums ranged between $3,300 and $25,000 and their total operating budgets between $30,000 and $79,000.

Distances between member museums varied widely. One museum director, not a consortium member (but a potential one had it expanded), maintained, "Distance is no problem; all you have to do is get in your car and go." For others, isolation is real. "Going is one thing, but a 14-hour auto jaunt to a one-day meeting demands No-Doz and perseverance, and flying there eats gluttonously into the travel budget."

The responsibilities of membership were outwardly simple. The ticket was the $1,500 support fee, to be borne by donors and users alike. Some gave services and staff time as well. Museums on the giving end emphasized that they were willing to take on extra work because they believed in the value and necessity of museum cooperation.

**Leadership and administration—and the looming conflicts.** The second responsibility of membership was to set policy on matters artistic and administrative, with the museum directors working together as a board of directors.

Although there was no formal board structure, leadership "emerged," in Maurice Coats's view or was deferred to the directors of the donor museums. One consortium member observed, "Henry Hopkins [director of the Fort Worth Art Center Museum] was the real pusher. His enthusiasm carried the consortium over the petty jealousies."

Potential administrative tangles were discussed at an early meeting. The project director, Martha Utterback, was hired by Coats under instructions from the consortium to work "under the direct supervision of the Texas Commission on the Arts and Humanities," as the minutes of the meeting read. It was her job to "implement the project within the guidelines and policies established by the consortium using its guidance on all artistic matters." Specific responsibilities included handling overall management and development, scheduling programs and exhibitions, compiling reports to the National Endowment for the Arts and to the arts and humanities commission, and coordinating the consortium project with other resources and projects of the commission, as well as with other organizations for the benefit of the project.

This job specification admitted some ambiguities. Utterback was to take "direction" from the consortium, yet work under the "supervision" of the arts commission. In the latter function she would operate within the staff hierarchy and procedures of the commission office: all project bills, for example, were paid out of the general arts commission account according to state fiscal procedures. Director Coats pointed out the advantages of locating the consortium office at the arts and humanities commission, such as reduced costs and improved communication with the National Endowment and other funding sources.

Advantages notwithstanding, the distinction between "direction" and "supervision" remained unclear. Was the consortium functionally independent or an arm of the commission? Was the project director working for the consortium, the commission, or both? The consortium's failure to clarify its relation to the commission was a signal weakness in its structure. It was to prove fatal.

## Objectives and priorities

As the Texas Museums Consortium embraced museums already informally cooperating on exhibitions, the development of an exhibition program was a first priority. It also defined hierarchy within the group. To the director with no collection, the colleague with prints in storage is king; if he is a generous despot, so much the better. The need for exhibitions brought the smaller museums to the larger ones.

Even so, there were those who questioned the reality of the "need." In the view of one director who was not a member, the consortium presupposed "the feeblemindedness of museum directors." He claimed that federal money to encourage cooperation is unnecessary, because sensible museum directors cooperate anyway. Rather, he felt, the consortium was designed to increase the action at the arts and humanities commission.

But the consortium was never intended as a medium solely for facilitating joint exhibitions, even though this was the most visible and most enthusiastically received result. One member observed that funding, although not necessary to cooperation, was in fact "the carrot that brought the museums together."

Other member-directors, agreeing that to borrow good shows was no problem, cited other kinds of cooperation and serious communication among peers as their goals for the project. More than one noted that although communication among directors was commonplace, the consortium would increase contact among members of curatorial, business, and education staffs.

The objectives stated in the original proposal were deliberately open-ended, leaving generous room for a variety of cooperative activities. But in practice the consortium devoted

most of its time and money to sharing speakers and exhibits. This narrow focus produced, on the one hand, tangible effects of consortium membership for museum directors to celebrate and, on the other, disappointment among other consortium members over the less tangible benefits of cooperation that might have developed during the project period, but did not.

Apart from the high-priority exhibitions, most resource sharing appears to have been initiated informally among consortium members. That all member museums use docents, engage in fund raising, deal with forms of outreach, and face the problem, as one museum director put it, "of growing our own staffs" might have been expected to focus the need for more sophisticated cooperation and communication. Instead, consortium meetings, particularly in the later stages of the organization's life, tended to be keyed to a crisis or deadline, leaving scant time to uncover and probe issues lying just beneath the surface. Thus, many of the possibilities that seemed so rich and promising to the most interested participants and observers of the consortium were neither explored nor developed.

## Three consortium exhibitions

What did result from the consortium's focus on exhibitions? Three shows were organized, primarily from the collections of the two major resources of the consortium, the Amon Carter Museum and the Fort Worth Art Center Museum. Drawing from material that had not been lent to the borrowing museums before, the consortium designed exhibitions around twentieth-century drawings, examples of modernism, and landscape photography of the American West. A packet of three individual catalogs was distributed to member museums. The exhibitions opened in September 1973 and circulated through May 1974.

"Exponents of Modernism," assembled with an additional loan from Meredith Long & Company, Houston, displayed some of the major developments in twentieth-century art with their cross-currents and influences since the early 1900s. Jean Arp, Marc Chagall, Julio Gonzales, Wassily Kandinsky, and Gaston Lachaise, and, among Americans, Stuart Davis, Marsden Hartley, John Marin, Georgia O'Keefe were represented in the show. Also included among the 54 pieces were works by Hans Hofmann and Theodore Stamos, with later examples of Pop Art by Roy Lichtenstein, Andy Warhol, and Jasper Johns. The catalog essay by Dave Hickey, whom advance publicity called the "primary catalyst for the exposure and recognition of contemporary Texas artists," was directed at viewers who had not seen many such shows before.

The second exhibition, "Twentieth-Century Drawings," was assembled entirely from the Fort Worth Art Center Museum and comprised the major portion of that institution's collection of drawings. Included among the 75 pieces were works by Alexander Calder, Alberto Giacometti, Wassily Kandinsky, Gaston Lachaise, Jacques Lipchitz, Piet

Mondrian, Henry Moore, Jules Pascin, Francis Picabia, and Kurt Schwitters. The author of the catalog essay this time was the museum's director, Henry Hopkins, who called drawings "the poetry of the visual arts. . . . They offer the viewer a unique exposition of the motor movement of—and the internal driving force behind—the artist's hand."

"Photographs: Landscapes of the American West" consisted of 46 photographs from the Amon Carter Museum, with loans from the University of Texas. The exhibition—which represented William Henry Jackson, Eadweard Muybridge, F. Jay Haynes, W.D. Smithers, and Edward Weston—documented the period between the westward exploration and the westward expansion and the corollary development of the photographer. Consultant to the exhibition, Professor Douglas George of the University of New Mexico, wrote in the catalog essay that the photographer became in this period a "faithful witness to his twentieth-century counterpart who consciously pursues art."

Although curatorial authority lay with the donor museums, all three exhibits were prepared and circulated by the project director from the consortium office in Austin. Her problems in assembling the exhibitions can be attributed in part to distance from the donor museums; they were compounded by the decision to put together three exhibitions meant to open simultaneously and run concurrently "for economy of catalog production, and for better publicity opportunities for the project. . . . Efforts were of necessity divided among the three exhibitions, to the detriment of all."[2]

The three exhibitions, each of which traveled to six museums, cost a total of $11,117, including insurance, packing, crate construction, transport, and some framing. For the three-exhibition package, in other words, each museum paid, $1,500 and got in return exhibitions that, divided six ways, cost $1,850—the added $350 coming from funds supplied by the consortium's grant from the National Endowment. In addition, each museum received at no extra cost a supply of catalogs for the exhibitions, which cost a total of $8,176.80 to produce, including the essays (the consortium paid $500 for each), design of the three-catalog packet, printing, and distribution. Consortium members agreed that by almost any standard the exhibitions were a good buy and cooperating on them made financial sense.

The "Exponents of Modernism" exhibition received particularly high praise for releasing to smaller museums art not generally accessible to them. It also served to demonstrate one of the unfulfilled potentials of the consortium. At one small institution, a visiting museum director was beset by local museum patrons who could not understand the art. "The community didn't accept it," he commented. Clearly, at this point the consortium could have benefited from a more aggressive education component.

The exhibitions, built from what was available in donor museums that had not been shown previously, were meant to be a start toward organized cooperation. As a director in Tyler remarked, "The shows were not terribly innovative.

Nobody did anything they *couldn't* have done. But,'' he added, ''they probably did things they wouldn't have done.'' Certainly one effect of the consortium was to broaden the area of what was possible, and to make the best that was possible a kind of moral mandate for all members through group process and group pressure.

## The speakers' bureau

Although the public lecture was an established educational vehicle within consortium museums, the speakers' bureau was to bring ''speakers of national reputation from outside the state, whom the museums could not readily obtain except through a cooperative fund.''[3]

The arrangements the consortium made for exhibition lecturers resulted, ironically, in a program that appeared to be basically uncooperative. Under the rules, the member museums could choose a speaker to address himself to any of the three exhibitions. But because of its controversial interest, all the museums wanted a speaker for the Modernism show. As speakers all came from out of the state at considerable cost, the consortium could afford to pay for only one lecture at each museum (although if the members had agreed to cooperate, each speaker could have made more than one appearance at several museums for smaller total expense to the consortium). The result was that there was no money left to bring in speakers for other exhibitions.

Nevertheless, the exhibition did draw a group of knowledgeable national figures to the state. Irving Sandler spoke at the Amarillo Art Center; Adelyn Breeskin at the Abilene Fine Arts Museum; Lucy Lippard at the El Paso Museum of Art; Joseph Masheck at the Museum of the Southwest in Midland; Brian O'Doherty at the Wichita Falls Museum and Art Center; and Robert Hughes at the Tyler Museum of Art.

The cost to the Consortium was $4,240.15, including honoraria and all expenses.

## Service efforts at the consortium

Consortium services were designed to help build administrative and educational cooperation in all the areas outlined in the consortium's project application to the National Endowment from a film archive to pension plans.

**Film program.** Under the terms of the consortium's proposal to the National Endowment, the project was to explore the possibilities for storing and maintaining a film archive at one or more of the regional service centers set up around the state by the Texas Education Agency, the state's department of education. Each had its own film library for schools; each was able to clean and care for films; and each, according to the consortium's proposal, was interested in collecting films for distribution.

As with other services of the consortium, the use of film for an educational companion to the three consortium exhibitions was a subject of considerable research by the project director. At the organization's meetings through 1973, Ut-

terback presented a variety of options. The consortium members decided against her first four proposals: storage and distribution through the Texas Education Agency; subsidizing, through the National Endowment for the Arts, rentals by member museum of films to correlate with the three exhibits; purchase of films that the Wichita Falls Museum volunteered to store, maintain, and distribute; and, finally, purchase of a collection of exemplary films that the Communication Center for Public Television and Radio, in Austin, would store, maintain, and distribute in exchange for broadcast privileges.

In the end, the consortium agreed to a plan to purchase and distribute a collection of the works of contemporary, independent American filmmakers, selected on the basis of recommendations made by one of the state's most knowledgeable film experts, James Blue, codirector of the Rice (University) Media Center in Houston.

The consortium's indecision was not without its benefits: the film archive became the recipient of two underexpanded budget lines—exhibitions and project director's travel. Still working to establish the archive after her job with the consortium ended June 30, 1974, the project director felt that the transfer of funds would allow for the purchase of a substantial film library available to the member museums for use as a series by fall 1974.

The investigation of what was available and how the consortium could relate to it gradually led the group to the basic issue: What substantively do we want to spend our money for? What are our priorities? Whether the consortium's final decision, to build an archive of films by contemporary filmmakers, was the most useful to all the members is open to question. No one knows, at this writing, how the films will be distributed and thus whether or not they will ever be used.

**Coding and computerizing museum resources.** The inclusion of resource codification in the grant proposal stemmed from the members' desire to know what each other's strengths were in collections, libraries, and professional expertise and to find out what might be shared.

There was some difference of opinion about what ''resource codification'' meant. The director of the Wichita Falls Museum, for example, defined it to mean assembling a printed directory. The project director, on the other hand, felt that the consortium should try to establish a system for computerizing ''the entire range of art collections in the state, as well as archival and personnel data,'' arguing that publications would be out of date by the time they could be compiled and printed.

After extensive research into computer systems currently available to museums, the project director recommended that the consortium accept the invitation of the University of New Mexico to join the so-called SELGEM system. She concluded, however, that consortium members were not ready for such a program.

Random discussions suggested reluctance on the part of museums with minor collections (more than half the consor-

tium) to commit time and money—even though the cost to each museum would be relatively low—to computerizing their collections without assurance that the museums with major collections would do the same. And these museums, in turn, were reluctant to invest much larger amounts of time and money without assurance that the computer network would include the major *national* collections as well. "The lack of major federal or foundation funding on a national basis appeared basic to the justification for the lack of interest. . . ."[4]

### Finale

The eight members of the Texas Museums Consortium met in Austin in February 1974, when the original project was to end (the National Endowment had by this time granted an extension through June), ostensibly to discuss plans for the second phase: enlarging the consortium to include as many as 24 art museums in the state. Joining the one-and-a-half-day meeting were ten representatives of these museums. Their coming to the meeting seemed to indicate either interest in or curiosity about an expanded consortium, although the form the larger body might take had not yet been decided.

One major proposal, submitted by Robert Kjorlien, director of the Tyler Museum, was based on the assumption that "although consortium membership has many benefits, the sharing of exhibits is probably the greatest."[5] His plan was for trios of museums to cooperate on one exhibition each year. With the investment from individual museums ranging from $1,000 to $3,000, the projected budget for five exhibits was $100,000; 15 museums would invest a total of $33,000 plus $7,000 worth of in-kind services, and the remainder would come from the National Endowment for the Arts and the arts commission.

Alternate but not dissimilar proposals put forward by the project director included an exhibition program based on $1,000 and $2,000 fees and other cooperative programs, such as a newsletter, exchange of staff, maintenance of an art film archive, and computerization of collections.

The director of the arts and humanities commission opened the meeting with a brief history of the consortium and noted that an increase in membership from 8 to 24 would add "the dimension of diversity." He then left the meeting.

After the opening remarks, there was brief attention to the Kjorlien proposal and to suggestions for other kinds of cooperation. As the day wore on, the Wichita Falls director expressed his continued enthusiasm for the consortium idea, but opposed the use of federal funds for permanent programs unless they generated a tangible product—in the case of the consortium, "on-going methods for communication" with emphasis on sharing expertise and programs in all aspects of museum work. Informal caucuses during the evening produced a more extensive list of cooperative exchanges of particular benefit to smaller museums.

Marching one after the other, speakers on the agenda, many of whom were not members of the original consortium,

put forth a tantalizing array of possible paths. But for all the proposals made and opposed, all the affirmations of the consortium and reservations about its effectiveness voiced by old and prospective members alike, no leader emerged to sort out the issues or give direction to the meeting.

Guests who expected to join an expanded version of a successful pilot found themselves in the middle of a family feud. Frustrations about the goals and values of the consortium, and the shape such an organization should take, were exploding on all sides. One thing seemed clear: though the people who came to the meeting had many real concerns, the structure that was meant to deal with them had been designed and built before anyone knew what those concerns would be. The consortium was, in sum, an idea without a market or a salesman to develop one.

By the morning of the second day, the director from Wichita Falls, who had been one of the consortium's most loyal and interested members, rose to move that the consortium be declared "nonfunctional at the end of the project period."

### Autopsy

Whatever went wrong with the Texas Museums Consortium—and whether or not it is salvageable—the idea of cooperation among museums may necessarily be a wave of the future. If the sharing and spread of knowledge are not incentive enough for such cooperation, finances may be. So the lessons of the Texas consortium are worth summing up:

**1. The institutional set-up.** The relation of the Texas Commission on the Arts and Humanities to the consortium raised serious questions of responsibility and authority. Legally the consortium was an adjunct to the arts commission; the commission applied for the grant, to be jointly administered by the commission director, who supervised the project director, and by the consortium members, who were to function as a board. All financial transactions and records were handled through the commission's fiscal officer in accordance with state policy. Further, when the consortium failed to obtain $15,000 from private Texas foundations, the commission appropriated money from its budget to ensure continuation of the project.

Functioning as a board of trustees, consortium members were given responsibility for determing priorities and policy. It was then the project director's job to implement these policies in accordance with "areas of mutual interest" outlined in the project proposal and "to investigate, devise, and test ways in which a regional group of small- and medium-size museums can pool resources, physical and human."

But the questions about the relationship between board policy and commission fiscal authority were never resolved, and in the inevitable tensions between these two controlling bodies, neither was ever given complete or clearly defined responsibility.

The director of the arts commission remarked in an inter-

view that he now realizes that he was "not effective in communicating to the museum directors that they should function as a board of directors." For their part, the consortium members preferred to remain within the shelter of the commission. It seemed to make fiscal as well as logistical sense for the project director to be located in the commission's office. But the question of leadership remained open. Leadership merely "emerged," partly in deference to the two major donor museums, Amon Carter and the Forth Worth Art Center Museum. When Henry Hopkins moved from the Fort Worth Art Center Museum to the San Francisco Museum in January 1974, the consortium lost one of its most articulate leaders, the other being Mitchell Wilder of the Amon Carter. It was weaker as a result.

**2. Original concept.** Not only was there a leadership problem, but according to the commission director, "the original concept was wrong, too. No state agency can set up a project and begin to attract people to it," he said in an interview. "Although that was not the original concept, that's what it turned out to be." A basic question that the project raised was to what extent does an agency like the arts commission create needs and to what extent does it simply fulfill them? One museum director, not a member of the pilot group, said that the consortium "failed" because it did not arise from a "native desire on the part of the institutions." Should an arts agency provoke a perceived, though not fully articulated, need or wait until the need speaks for itself?

**3. Structure versus informality.** Although the participating museum directors were ostensibly to function as a board and although they did make policy decisions for the consortium, the board had no organized structure or officers. Rather than assigning each member administrator or liaison responsibility for an aspect of the project, all members functioned as a committee of the whole on each issue.

For every decision, or lack of it, there is a history. In this case, the directors rejected structure because, as several commented, they wished to avoid the pitfalls of some regional professional organizations in which, they said, the organization became more important than its purpose. But as the director of the Wichita Falls Museum remarked later, "Systems can guarantee mediocrity; they can also give you a solid structure to work within." The desire to "keep things informal" may have been the consortium's way to evade definite, sometimes difficult responsibilities.

**4. Large and small museums.** The relationships between the large and small museums might well have been one of strained altruism. The donor museums (with one exception) gave not only collections and staff time but the $1,500 membership fee as well. For their part, the smaller museums were recipients. This implicit hierarchy, even when mitigated by leaders of considerable sensitivity, did not encourage a cohesive union of equals.

**5. Line of authority.** Informal and hence often ambiguous lines of authority among the consortium members, the project director, and the arts commission director inevitably produced discomfiture. For her part, the project director felt called on to implement the proposal as written, taking implicit direction from its agenda, trying to work in cooperation with the commission staff when this "did not run counter to consortium priorities," and developing and implementing subsequent refinements and directives from the board.

But because the board had no structure, the project director had no chairman to appeal to when a problem arose or a quick decision was needed. Neither was she autonomous within the commission, which gave her office space and supervision. For example, when she requested travel money to attend a lecture given by one of the consortium speakers, to see the exhibition installation, and to meet with staff at the same museum, the commission director denied her the funds because he decided that the trip was not essential to the project.[6] Yet when the project ended, almost $2,000 of travel monies was still unspent.

When asked in an interview to whom the project director was responsible, the arts commission director replied, "To them [the consortium members] . . . but their idea was not the same. They thought I was running the project and supervising her directly." This "confusion" dates back to an early board meeting in which the project director was instructed to work "under the direct supervision of the Texas Commission on the Arts and Humanities."

**6. Transience and history.** That this is a period of peripatetic professionals is nowhere more clearly illustrated than among the members of the consortium. Of the eight directors who applied with the arts commission director for consortium funding in the fall of 1971, only two were still at the same museums when the project ended three years later; one had moved to another museum within the consortium, and the five others had moved out of the state.

So membership in the consortium was for many like coming in on the middle of a movie. With the exception of the earliest meetings, at which comprehensive minutes were taken, informal letters provided the only ongoing documentation of the project. In order to make sense of what happened before each new member came on the scene, he would have to rely on conversations, individual letters of inquiry, or a search through the files.

• • •

After the consortium disbanded, the 72-page project report, along with an additional 20-page summary report, documented the plans laid and mislaid, the sights clarified at times and blurred at others. Another observer might see in the story of the Texas Museums Consortium a chronicle of emerging definition, purpose, and structure, fulfilling the experimental mandate of the proposal. To Robert Kjorlien, former director of the Tyler Museum, the consortium was essentially a trial, from which the members learned a great

deal about what museum cooperation means and which made the case for trying again with a different format. Said Ronald Gleason, director of the Wichita Falls Museum,

> I do think that cooperative programs on an individual basis will increase and improve from this experience. Perhaps there won't be as formal an organization in the future, but I think our heightened awareness of the possibilities will provoke the creation of changing mini-consortia according to need and ability.

—*B. K. B.*

## Notes

[1] For sources of quotations without footnote references, see list of interviews at the end of this report.

[2] Martha Utterback, "Report: Museum Consortium Project, September 1, 1972–March 1, 1974," p. 2.

[3] Ibid.

[4] Martha Utterback, "Texas Museums Consortium, Pilot Project, Summary Report," p. 15.

[5] Robert Kjorlien, "Proposal, 14 December 1973."

[6] In a letter to Chester Kwiecinski, February 1, 1973, to clarify this particular decision, Maurice Coats wrote, "Full responsibility for the administration of the program rests in this office. Martha Utterback is an employee of the Commission, and, of course, is governed by my direction." Verifying letter from Chester Kwiecinski to CMEVA, October 9, 1974, reads as follows: "The letter to which you refer was dated February 1 and the quotation in question is exactly as you stated it in your letter of September 25, 1974."

## Interviews and Meetings

Coats, Maurice. Executive Director, Texas Commission on the Arts and Humanities. June 25, December 6, 1973; June 10, 1974; telephone, November 26, 1973.

Deane, Ronald, Director, Museum of the Southwest. Telephone, January 3, 1974.

Fisher, James. Director, Amarillo Arts Center. Telephone, January 3, August 29, 1974.

Gleason, Ronald. Director, Wichita Falls Museum. Meeting February 6, 1974, in Austin; interview, June 13, 1974; telephone, January 3, March 11, September 10, 1974.

Hirsch, Betty. Director, Beaumont Art Museum. February 5, 1974.

Hopkins, Henry. Director, Fort Worth Art Center. December 12, 1973.

Kjorlien, Robert. Director, Tyler Museum of Art. June 13, 1974; telephone, January 3, September 16, 1974.

Kwiecinski, Chester. Director, Abilene Fine Arts Museum. Telephone, January 3, August 29, 1974.

Leeper, John. Director, Elizabeth Koogler McNay Art Institute. October 30, 1973; telephone, August 29, 1974.

Sipiora, Leonard. Director, El Paso Museum of Art. December 6, 1973.

Sullivan, Max. Director of Museum Program, Kimbell Art Museum. Telephone, February 1, 1974.

Utterback, Martha. Project Director, Texas Museums Consortium. Interviews and telephone interviews: June 15, October 3 and 24, November 8, December 12, 14, 19, 1973; January 19, February 19, March 7, April 12 and 25, May 22, June 11, 1974.

Meetings of Texas Museums Consortium: December 12, 1973, Fort Worth Art Center, Fort Worth. February 5–6, 1974, Villa Capri, Austin, Texas. April 3, 1974, Amon Carter Museum of Western Art, Fort Worth.

## Member Museums

The following is some basic information about the eight museums that were members of the Texas Museums Consortium.

**The Amon Carter Museum of Western Art**
3501 Camp Bowie Boulevard
P.O. Box 2365
Fort Worth, Texas 76101
**Founding:** 1961.
**Collections:** Carter collection of Remington and Russel works; paintings, prints, and drawings from the early nineteenth century to the present.
**Staff:** 5 curatorial; 32 others.
**Volunteers:** 52 members of the Fort Worth Art Museums' Docent Council serve in education.
**Annual operating budget:** Not available.
**Funding:** Amon Carter Foundation.

**The Fort Worth Art Center Museum**
1309 Montgomery Street
Amon Carter Square
Fort Worth, Texas 76107
**Founding:** 1910.
**Collections:** Graphics; nineteenth- and twentieth-century American drawings, paintings, and sculpture.
**Staff:** 6 curatorial; 6 full-time; 20 part-time.
**Volunteers:** 52 members of Docent Council of Fort Worth serve in education.
**Annual operating budget:** $34,291.58 (1973). Exhibition budget, 1973: $4,711.61.
**Funding:** City of Fort Worth, membership, contributions, bookstore revenues.

**The Abilene Fine Arts Museum**
Oscar Rose Park
Box 1858
Abilene, Texas 79604
**Founding:** 1927.
**Collections:** Small, no specialty.
**Staff:** 3.
**Volunteers:** 30; 15 working in education.
**Annual operating budget:** $30,000 (1973). Exhibition budget, 1973: $5,543.90.
**Funding:** Memberships and fund-raising activities.

**The Amarillo Art Center**
2200 South Van Burne (Box 447)
Amarillo, Texas 79109
**Founding:** 1966.
**Collections:** No collection at present.
**Staff:** 6 full-time; 6 part-time; 10–20 part-time teachers, depending on enrollment.
**Volunteers:** 100; 80 working in education.
**Annual operating budget:** $75,000. (Budget figure is for 1974.

There was no staff during 1973.) Exhibition budget, 1974: $9,500.
**Funding:** 90 percent from memberships; fixed operating expenses and salaries of director and janitor come from Amarillo College; additional funds from sales gallery, fund-raising events; Junior League.

### The Museum of the Southwest (Midland)
1705 West Missouri Street
Midland, Texas 79701
**Founding:** 1965.
**Collections:** Primarily Southwest art; collection of 300 European fans of the seventeenth and eighteenth centuries.
**Staff:** 5.
**Volunteers:** 100–125; 15 working in education.
**Annual operating budget:** $88,000 (1973). Exhibition budget, 1973: $20,000.
**Funding:** Memberships and endowments.

### The Tyler Museum of Art
1300 South Mahon Avenue
Tyler, Texas 75701
**Founding:** 1969.
**Collections:** Mixed; small permanent collection, all donated.
**Staff:** 3 professional; 8 others.
**Volunteers:** 20–25, all working in education.
**Annual operating budget:** $80,000 (1973). Maintenance is provided by Tyler Junior College. Exhibition budget, 1973: $25,000.
**Funding:** 60 percent earned income; 40 percent membership.

### The Wichita Falls Museum and Art Center
2 Eureka Circle
P.O. Box Z
Wichita Falls, Texas 76308
**Founding:** 1965.
**Collections:** Nineteenth- and twentieth-century American graphics.
**Staff:** 3 professional; 4 others; 15–20 part-time instructors.
**Volunteers:** 100; 25–30 working in education.
**Annual operating budget:** $106,000 (1973). Exhibition budget, 1973: $18,000.
**Funding:** 70 percent membership, 10 percent city; 5 percent school district; 15 percent earned income.

### The El Paso Museum of Art
1211 Montana Avenue
El Paso, Texas 79902
**Founding:** 1960.
**Collections:** Kress Collections of fourteenth- to seventeenth-century European art; nineteenth-century Western American and Mexican art; pre-Columbian art of the Americas; nineteenth- and twentieth-century European and American art.
**Staff:** 4 curatorial, directorial; 13 others.
**Volunteers:** 150, including approximately 50 in education, and 21 docents.
**Annual operating budget:** $173,568.68 (1973). Exhibition budget, 1973: $8,000.
**Funding:** All major capital expenses from the City of El Paso.

# Proposal for a National Center on Museum Education

As the Council on Museums and Education in the Visual Arts studied museum, school, and university programs around the country for this publication, it became clear that this is a field in which there are no perfect programs, easy answers, or ultimate solutions. Although there is a certain broad commonality among museums and art centers, each institution has its own unique audience, staff, and ecology; its programs are and must be unique as well. Thus, recommendations in this study are few.

One idea, however, has cropped up consistently as the CMEVA reporters and members have met with museum staffs around the country: the need for a nationally based information, resource, and communication center for educators in the museum and related professions. In a way, the publication of *The Art Museum as Educator* is a beginning, not an end. It was no accident that as the process of examination, reporting, and interpretation of education programs was going on, CMEVA staff members were introducing educators to one another, laying the basis for embryonic networks, sometimes throughout a region, occasionally within a single city. In fact, two of the stated purposes of the council from its inception were to "enlarge the range and level of discourse" and to "nourish communications networks" among museum educators.

Several efforts—Museums Collaborative in New York (see chapter 4), the Museum Education Roundtable in Washington, D. C. (chapter 15), and the American Association of Museums President's Committee on Education (see introduction to chapter 15)—make it clear that museum educators, in particular, have a natural curiosity about one another and a thirst for learning how staffs in other institutions handle problems they have encountered themselves. Cooperation across institutional lines—among museums and between museums and other educational institutions—seems to be an idea whose time has come.

What follows here are the bare bones of a plan for a center of museum education that might meet the expressed needs of museum educators in an organized, yet, we suggest, light-handed way.

## Services of the center

Essentially, the center would be a collector of information about educational programs that use museums, no matter what institution designs or offers them—schools, community centers, universities, school systems, teachers colleges, adult education departments, state education departments, or the national government, not to mention museums themselves. Once in hand, this information might be disseminated to interested clients in a variety of ways. The center could make up kits (see following paragraphs) tailored to certain typical needs, it could hold workshops and regional meetings, it could send out newsletters, it could "publish people," it could issue catalogs, and it inevitably would respond to every individual request.

The center's basic purpose would be to identify programs, people, ideas, and institutions for educators who want help in thinking through projects of their own, in the belief that educators should be encouraged to learn from one another's successes rather than blindly repeat one another's mistakes.

Specifically, the center would provide the following:

**1. An information exchange bank.** In such a resource would be an organized file of written reports, brochures, videotapes, recorded and transcribed interviews, photographs, slides, films, models, plans, instructional packages and kits. The center would contain a reference library of pertinent literature—books, periodicals, published and unpublished research, results of surveys, annotated bibliographies. (The files assembled by CMEVA for this project

would be turned over to the center as a beginning of its own collection.)

As one reason for establishing such a center would be to reduce the need for museum educators to make endless, and sometimes aimless, tours of the usual museums, much of this material would be organized so that it could be mailed out on short notice in usable form. One idea, which has been explored by a group of educators studying children's museums, is to make up boxes of materials on various themes—instructional packages for teachers, curricula for training volunteers, exhibitions and orientation galleries for children, for example—and lend them to users for a modest fee. As the children's museum group suggested, a kit on that subject might include videotapes, films, records, and reports on children's museums around the country; it could offer a compendium of budgets, sources of money, by-laws, administrative organization plans, facilities, gallery and building layouts. Such boxes could be developed for clients who are starting a museum from scratch, for those who want to change an educational program, and for any education department interested in what is going on elsewhere.

**2. A consultant brokerage.** The center would maintain and make available lists of people around the country, and of visitors from other countries, who have expertise in certain fields, such as adult education, program evaluation, the use of video for education, fund raising, certain educational techniques, educational exhibitions, teacher education, community programs, visitor psychology, volunteer organizing. These would be people who could be called on to give advice, to set up programs on a short-term basis, or to lead seminars and workshops.

The center would be able to identify appropriate consultants and in some cases might help organize workshops for purposes laid out by museums, schools, and regional or national educational conferences. The center should also be a source of names that might be considered for museum representation on educational planning councils, which so far have taken scant notice of the educational contribution museum staffs make (see the introduction to chapter 10 for the kind of commission on which museums should have been asked to serve).

**The users**

Clientele of such a center would be both individuals and institutions. It would include educators, directors, curators, exhibition designers, and volunteers from museums of all sizes who are interested in education; the staffs and students of teacher-training institutions, graduate schools of education, and undergraduate and graduate museum training programs in universities, teachers colleges, and museums; schoolteachers and principals; administrators of school sys-

tems, both city and state; funding agencies, museum trustees, and service organizations that use and support museums.

Anyone would be able to call on the center for help. But once its services had been tried and had proved themselves, the center might offer memberships and charge nominal user fees to support itself and to keep in touch with a steady core of its clients.

**Staff**

The center should be a low-budget, small-staff operation. Someone has suggested that there be no more than three persons—"an administrator, a madman, and a schlepper." Whatever the composition of the staff, the center's functions should not be so ambitious that its services become costly. With judicious traveling schedules and use of the phone, any such operation should not draw heavily on scarce financial resources. At the same time, a knowledgeable and efficient staff should be able to save the museum education field as a whole considerable money by offering research that museums must now duplicate one by one.

**Institutional home**

A good deal of thought has gone into the question of institutional affiliation and location for such a center, and CMEVA members have explored several possibilities. The council's recommendation is that the center be attached to an existing educational institution in a major urban area with easy access to transportation and communication networks. Because location in a museum might influence the direction of its program and create a bias in its audience, the council has concluded that a university base might be the best choice.

**Funding**

The center would have to depend at the beginning on foundation grants. How soon it could become self-supporting is a question that only its clients can answer. If it does its job well, the center should be able to attract fees for its services on the basic premise that these services will help museums and other clients make wiser use of their money and time. If the services are not worth some client involvement, even if it turns out that the fees have to be scaled to the ability of the users to pay, the center should either change its offerings or consider going out of business.

In the meantime, however, the Council on Museums and Education in the Visual Arts believes that the field of museum education deserves as much access to useful information and research as it can possibly be given, that a collection and dissemination point is badly needed by educators interested in improving their work, and that a center like the one outlined here could in the years ahead deal with some of the questions about the educational capacities of museums that have long gone unheard.

# Future Directions, Policy, and Funding

The brief paragraphs that follow are about what should happen next. They are meant for all of us who are interested in museums and education, but they are addressed particularly to museum directors, museum trustees, legislators, government agency and educational administrators, and foundation staffs—those who must decide whether the projects reviewed in this study point to a widespread application of museum resources to more effective education in the visual arts, or whether they are just a collection of interesting ideas that will blow away as seed money dries up and the programs' creators move on to the next project.

For those in a position to commit time, funds, and other resources to the transformation of promising models into broadly accepted, ongoing programs, my guess is that successful adoption depends less on the need the program addresses, or the particular solution to that need, or even the skill of the program's developer or administrator than on a number of subtler, frequently overlooked issues. Therefore, I would like to draw attention to these issues by outlining a list of "musts" that might be usefully applied by those who adopt and support museum programs in visual education.

**1. There must be candor from the start about the fundamental motives and limitations of museums, schools, and community organizations.** Planners must understand where real passions lie, what will complement basic institutional missions, and what will go against the grain. Art museums are absorbed more with objects than with people. Schools are focused on classroom learning rather than orchestration of the full educational potential of their communities. Neighborhood organizations are preoccupied with survival issues like housing, medical care, and jobs. Program designs must accommodate to and capitalize on these realities.

**2. There must be enough time for thorough program planning and development.** Effective teaching and learning requires clear objectives, carefully worked out instructional strategies, and continuous feedback to see whether the strategies are effective and the objectives are being met. Although people do learn on their own, even the discovery method works best in a thoughtfully organized setting, where the insights come easily and are quickly reinforced. From our experience in schools and museums, it is even clearer that head and paper planning without repeated tryout and revision based on what does and does not work seldom leads to useful programs. Even when a program has been successfully demonstrated in one setting, it must be redeveloped and retested before there can be any confidence that it will succeed in a new context. It is not unreasonable to expect a year or two of sustained work to develop a fully effective, debugged educational program. There seem to be no shortcuts to this time-consuming, but rewarding process.

**3. There must be adequate funding for developing and sustaining programs.** The enthusiastic commitment of volunteers using borrowed space and scrounged materials will not do the job. There must be money for curators to hire assistants to compensate for the time spent on educational projects; for substitutes to release teachers for planning and training sessions; for members of ethnic groups to receive honoraria for their advisory or consultative help; for program authors to pay for the use of institutional collections, administrative services, and space. Although these resources may already exist, they are usually heavily committed to other functions. Therefore, new activities must be accompanied by new funds, especially when those activities are seen as supplemental to the primary concern of the individuals or institutions being asked to help. Again, the experience of recent

projects suggests that a range of $25,000–$100,000 start-up funds and $8–$12/child/day operating costs (exclusive of transportation) are not extravagant for a program of any significance.

**4. There must be more long-range commitments from *both* program organizers and funding sources.** In the frantic sixties we were all run ragged by shifting priorities and a flood of pilot money that was almost never followed with adequate operating support. Client and institution alike grew cynical about the disparity between the expansive rhetoric that marked the beginning of the decade and the meager improvements in our day-to-day lives that we experienced by the end. A coherent plan for sustained funding must be built into each program's initial prospectus and then honored by all parties if the program is successful. Foundations and governmental agencies must begin to think of five- to ten- rather than one- to three-year funding cycles. The payoff for good work usually takes time. People who begin to depend on a service have the right to expect it to be there next year.

**5. There must be enough time for sustained educational experiences.** No matter how memorable, the one- to three-hour field trip is a thin investment when compared to the thousand or more hours a child spends every year in the classroom, to say nothing of the time he spends in front of a television set. Although some things can be absorbed by a child's mind very quickly, a ten- to thirty-hour program strategy allows a quite different kind of learning to take place. The pressure to expose ever greater numbers of people to museums must be resisted so that a way can be found to provide access to more in-depth learning.

**6. There must be a more effective way to structure the application of museum resources to educational needs.** The standard art museum education department seems poorly designed to perform this function. In a context where it is clearly understood, if not openly acknowledged, that the work of the education staff is secondary to the main institutional purpose, art museum education departments tend to come out on the short end of space, budget, and administrative priorities. Museum educators feel that they are unappreciated, low-caste members of the profession. A better investment might be a new kind of organization (the GAME program described in these pages is an important example) whose locus would move outside the museum to somewhere midway between the client and the institution. Staffed with exhibition, program, and materials developers, teacher trainers, and community workers, it would be required to respond to community, school, and individual learning needs by developing useful programs from the resources of the larger institutions. Working outside the museum, it could afford to

be more flexible and might even be more likely to command a satisfactory response from the large institutions. It would have the additional advantage of being able to draw on a wider range of community resources—other museums, academic institutions, government agencies, the media, business and industry—while either enhancing the conventional classroom experience or helping to broker students out of it.

**7. There must be a better funding route to give program clients—students, teachers, community workers, and the adult lay public—more direct control over program directions.** On the assumption that the person who spends the money should have the most to say about what that money buys, programs that fit people's real needs are more apt to come from bottom-up than top-down funding. It has been demonstrated in this report that museum programs initiated by the schools, for example, tend to be more effective than school programs initiated by the museums. Why not, then, fund the schools to purchase services from museums, rather than funding the museums directly? The burden would thus be on the museums to convince schoolteachers and administrators rather than government or foundation executives of the value of museum offerings. Educators might well give their business to those institutions that seemed to offer services best tuned to their special requirements. The marketplace might tend to stimulate more realism in budgeting and more dialogue between the parties most directly concerned. Such an arrangement might also get the funding sources off the hook, relieving them from having continually to monitor and make judgments about the efficacy of a particular program. Although some effort to earmark funds might still be necessary, schools could use funds to purchase services from a much broader range of cultural resources than museums alone are able to provide. The Museums Collaborative pioneering voucher project (see chapter 4) that allows neighborhood organizations to purchase services from New York City museums, is a promising if admittedly modest first step. It should be followed by other experiments like it in other cities under other circumstances.

**8. Finally, the essence of the museum experience must be understood to relate to the museum object, rather than to the museum building, gallery, exhibit case, guard, or docent.** The fact that museum visitors are too often overwhelmed by these secondary elements does not mean that this is what museums are all about. If the important things are the objects, then experiences with significant objects can be arranged in many other settings. With the one crucial proviso that fragile and irreplaceable objects must be adequately protected, our thinking can be much broader than it has been. The experience of chiseling a block of granite may inform a student about the craft of stone-working and enhance his understanding of a good piece of sculpture, but it does not have to happen in a museum gallery.

Many of these prescriptions may seem self-evident, but my own and others' experience in poking through the sad debris of abandoned educational projects suggests that we are not aggressive enough in our insistence on the application of such requirements. It would be a serious loss if the promising crop in this study—and the lessons they have to offer—were to suffer the same neglect.—*Michael Spock*

# Appendixes

# Appendix I
# Basic Information About Institutions in This Study

The following checklists are profiles, most of them based on data from the 1973/74 fiscal year, of almost all the museums and other institutions whose programs are described in this study. The only museums not included here are the Red River of the North Art Center in North Dakota, the University of Texas Art Museum (both represented by short reports for which institutional data was not collected), and several museums whose checklists appear at the end of the report on the Texas Museums Consortium in Chapter 15.

Because few museums follow the same bookkeeping and accounting procedures, budget figures here—especially those for education—cannot be reliably compared from one museum to another.

## THE ABILENE FINE ARTS MUSEUM

Oscar Rose Park
Box 1858
Abilene, Texas 79604

For basic information about this museum, see appendix to the report on the Texas Museums Consortium in chapter 15.

## ADDISON GALLERY OF AMERICAN ART

Phillips Academy
Andover, Massachusetts 01810

1. **General Information**
   Founding: Opened in 1931, a gift from Thomas Cochran, Phillips Academy class of 1890, in memory of Mrs. Keturah Addison Cobb.
   Collections: Restricted to American art, the collection ranges from primitive portraits to contemporary works and includes paintings, drawings, prints, sculpture, photographs, films, videotapes, early American glass and silver—approximately 2,000 objects in all. Featured are the works of major American artists and an extensive collection of contemporary New England paintings and sculptures.

Number of paid staff: 11, including 4 full-time museum professionals, 2 part-time curators, and 5 part-time professionals in the video art therapy program.
Number of volunteers: None.
Operating budget: $150,000 (1974/75).
Education budget: About $21,000 (1974).
Source of funding: Private endowment.

2. **Location/Setting**
   Size and character of city: Andover is an upper-middle-class community of 23,695 (1970 census), surrounded by the industrial cities of Lawrence, Lowell, and Methuen, and only 24 miles from Boston. Phillips Academy, the site of the Addison Gallery, is one of the oldest private secondary schools in the country; its students are drawn from around the world, lending an international aspect to the character of Andover.
   Climate: New England seasonal.
   Specific location of the institution: Campus of Phillips Academy, on Massachusetts route 28.
   Access to public transportation: Andover city bus stops at the campus; there is also excellent bus service from Lawrence and Boston.

3. **Audience**
   Membership: None.
   Attendance: 35,000 annually.

4. **Educational Services**
   Organizational structure: Addison Gallery is technically a department of Phillips Academy, although it functions autonomously. Because its mission is to serve both the academy and the community, it does not see itself as primarily an educational adjunct of the school. There is no separate education department. The gallery's video program, at present its only separate educational program, is administered by the gallery's director, who has weekly meetings with client project directors.
   Size of staff: Serving in the video art therapy program are 5 professionals (part-time); from 6 to 10 graduate and undergraduate student interns from Boston colleges; and high school interns from Phillips Academy (added in in the 1975/76 academic year).

Budget: About $21,000 (1974).

Source of funds: Operating budget (private endowment).

Range of services: Video art therapy program (includes drawing, painting, photography, movement, and video-making classes and museum visits).

Audience: Although gallery visitors are largely white and middle class, the education program at present serves primarily handicapped and minority children and adults.

## ALBRIGHT-KNOX ART GALLERY

1285 Elmwood Avenue
Buffalo, New York 14222

1. **General Information**

Founding: The Buffalo Fine Arts Academy, the governing body of the Albright-Knox Art Gallery, was founded in 1862.

Collections: Paintings, sculptures, drawings, prints, collages and assemblages, which span 5,000 years. The focus is on art from about 1872, with particular emphasis on that from 1942 on.

Number of paid staff: 42 full-time; 37 part-time (including those for education department programs).

Number of volunteers: 164 (45 of these are for education department programs).

Operating budget: $692,000 (1973/74).

Education budget: $43,500 (1973/74), not including Color Wheels which received $25,000 from the New York State Council on the Arts in 1974.

Source of funding: City of Buffalo; County of Erie; New York State Council on the Arts; National Endowment for the Arts; local foundation. From membership, gifts, and private sources, less than 20 percent.

2. **Location/Setting**

Size and character of city: Buffalo is part of a standard metropolitan statistical area with a population of 1,349,211 (1970 census). In 1960 Buffalo was the sixteenth largest city in this country; in 1970, twenty-fourth, with a population of 462,768. This represents the biggest drop in a decade among American cities. Buffalo is a large urban center, with a somewhat deserted core, but downtown renewal is in various stages. Puerto Ricans are a comparatively new minority group; among other large ethnic groups in the city, the Polish community is alleged to be the largest outside Warsaw.

Climate: Snow in winter can curtail activities; summer and early fall are the best seasons.

Specific location of the institution: Delaware Park; approximately two and one-half miles from downtown; in mostly residential surroundings; immediately across from the State Hospital and State University College campus.

3. **Audience**

Membership: 3,679 (as of May 10, 1974). Cost: family, $30; student, $12.50; individual, $20; sustaining, $50; life, $300.

Attendance: 273,202 (1974).

4. **Educational Services**

Organizational structure: A separate education department is headed by the curator of education who reports to the director of the gallery.

Size of staff: 8 full-time, including curator of education, assistant curator of education, 3 lecturers, a coordinator of Color Wheels, a keeper of the loan service and slide collection, and a

secretary; 24 part-time, including teachers and assistants for the Gallery's Creative Art Classes and Color Wheels classes; 25 volunteer docents; 32 Art to the School volunteers.

Budget: $43,500 (1973/74), plus $25,000 (1974) for Color Wheels.

Source of funds: Museum operating funds; New York State Council on the Arts, for Color Wheels (staff, supplies); Cummings Foundation funds (vehicle maintenance). Percentage of total museum budget going to education: approximately 13 percent.

Range of services: Creative art classes; family holiday festivals; children's room; gallery talks; lectures; films on art; guided tours; special slide talks; Art to the Schools; Color Wheels; loan service.

Audience: 85,814 (1973/74). Focus: 528 public school tours attended by 13,550; 35 public gallery tours attended by 805; 259 special tours for 5,293 adults and children; 186 adult education programs attended by 5,919; 352 children's art classes attended by 6,297; with 143 special events for children reaching 5,238; and extension programs, 48,712. In addition, 551 loans were made to serve an audience of 97,353.

## THE AMARILLO ART CENTER

2200 South Van Burne (Box 447)
Amarillo, Texas 79109

For basic information about this museum, see appendix to the report on the Texas Museums Consortium in chapter 15.

## THE AMON CARTER MUSEUM OF WESTERN ART

3501 Camp Bowie Boulevard
P.O. Box 2365
Fort Worth, Texas 76101

For basic information about this museum, see appendix to the report on the Texas Museums Consortium in chapter 15.

## THE ANACOSTIA NEIGHBORHOOD MUSEUM

Smithsonian Institution
2405 Martin Luther King, Jr. Avenue, S. E.
Washington, D. C. 20020

1. **General Information**

Founding: 1967.

Collection: The museum maintains no formal collection of its own; most of its exhibits are drawn from various Smithsonian collections.

Number of paid staff: 16 full-time (no part-time).

Number of volunteers: Casual; number varies.

Operating budget: $327,000 (1973/74).

Education budget: About $10,000 (1974), not including salaries.

Source of funding: Smithsonian (federal).

2. **Location/Setting**

Size and character of city: Washington, D.C. (population

756,510 in a standard metropolitan statistical area of nearly 2.9 million, according to the 1970 census) has the largest concentration of museums, nature centers, parks, botanical gardens, and historic sites in the country. It is the center for federal administration, headquarters for innumerable national organizations, and one of the country's leading tourist attractions. Its cultural facilities serve a mixed audience of visitors, short-term residents, and an indigenous population that is 72 percent black (public school enrollments are nearly 96 percent black). Educational resources include five universities: American, Catholic, Howard, Georgetown, and George Washington.

Climate: Cold winters, little snow; hot, muggy summers.

Specific location of the institution: On a main avenue in the center of the area of southeast Washington, D. C., called Anacostia. It is predominantly black and is a mixture of middle-class neighborhoods, extensive public housing, and impoverished areas. Anacostia is somewhat isolated from the rest of Washington by the Anacostia River, but is easily accessible by public transportation. The home of Frederick Douglass, now open to the public, is in the heart of Anacostia.

Access to public transportation: Very good; several bus routes serve the area.

### 3. Audience

Membership: No formal membership maintained.

Attendance: 69,467 (1974). Audience is primarily young people in the immediate community. Special events attract an audience from the scope of the Anacostia population.

### 4. Educational Services

Organizational structure: Supervisory program manager heads the education and development department and works under the director of the museum.

Size of staff: 2, including the supervisory program manager and the program manager, mobile division (responsible for development and implementation of mobile services and programs, under the director of the museum).

Budget: About $10,000 (1974), not including salaries.

Source of funds: Smithsonian (federal).

Range of services: Exhibitions; special programs related to exhibitions, with a comprehensive cultural approach, including music, dance, and food; tours; lectures; and films. The Anacostia Studies Project provides the community with information about its most immediate heritage and the history of the area. A mobile program takes small portable exhibitions and "shoeboxes" (small resource kits full of objects and ideas) to the schools, provides lecturers, conducts workshops and demonstrations out of a van. The van also transports the museum's portable library, which contains school textbooks by black authors and other books of special interest to Anacostia's children. A training program in exhibition techniques for minority people was scheduled to begin in 1975.

Audience: School groups, residents of the community. Special events draw a wider representation from the community, whereas exhibitions and programs primarily attract youth.

Objective: To bring to a low-income minority community, whose residents seldom come in contact with existing cultural resources, exhibits of objects from various Smithsonian collections, and to offer opportunities for open, nondirected learning in relation to the exhibits.

Time: 10 A.M.–6 P.M., six days a week; 1 P.M.–5 P.M. on Sundays; plus additional times in response to community needs.

Information and documentation available from the institution: Fifth anniversary commemorative booklet.

# THE ARKANSAS ARTS CENTER

MacArthur Park
Little Rock, Arkansas 72203

### 1. General Information

Founding: The Museum of Fine Arts, Little Rock, founded in 1927, was enlarged and reorganized as the Arkansas Arts Center in 1957. The present facility was occupied in 1963.

Collections: Now primarily devoted to twentieth-century works, notably American graphics, the permanent collection of approximately 1,500 works includes territorial portraits and glass.

Number of paid staff: 50 full-time, including 7 in administration, 5 faculty, 3 State Services staff, 14 maintenance and security staff, and 21 others; 25 part-time.

Number of volunteers: 504, including those involved in fundraising events.

Operating budget: $654,130.88 (1973/74).

Education budget: $47,610.45 (1973/74).

Source of funding: State Services programs and special contributions each provide 16 percent of the annual income. Other sources include donors, 12 percent; theater, 11 percent; museum shop and education, each 7 percent; exhibitions, 6 percent; membership and revenue sharing, each 5 percent; City of Little Rock, 4 percent; Arkansas Art Foundation, 3 percent; art supply store, 2 percent; and from art lending, Antiques Forum, Southland gift, volunteers, library, and ballet, 1 percent each.

### 2. Location/Setting

Size and character of city: With a population of 132,483 (1970 census), Little Rock is a commercial and industrial center for a two-county area (population approximately 344,000) and its cotton-, soybean-, rice-growing agricultural surroundings. Public buildings are a mix of modest contemporary and restored remnants (the State House and residences in the Quawpaw Quarter) that recall the early 1800s when Little Rock was a territorial capital.

Climate: Year-round climate is mild, often humid, with the thermometer hovering in the 80s in the summer and a winter average in the low 40s.

Specific location of institution: Both the Arts Center and the Museum of Science and Natural History are located a half-mile from downtown in MacArthur Park (named for Douglas MacArthur, who was born in Little Rock). The immediate neighborhood is racially mixed residential, with hotels and schools.

Access to public transportation: Public bus stop is three blocks away; the Arts Center operates a bus for children who take classes there; limited free parking is available next to the center.

### 3. Audience

Membership: 3,068. Student membership costs $5; family membership, $15.

Attendance: Total participation in all Arts Center programs in 1974 was 427,602, a 21 percent increase over 1973; 113,404 persons visited the galleries.

### 4. Educational Services

Organizational structure: The director of education is responsible to the executive director.

Size of staff: 7 full-time faculty (includes one with State Services and one with Neighborhood Arts) and a part-time faculty of 10. Sixteen volunteer docents work in education; 9 volunteers serve in the library.

Budget: $47,610.45 (7 percent of the Arts Center's budget). The education budget includes classes in visual arts, theater, and dance for children and adults, workshops by visiting artists, and a red English bus shared with the Museum of Science and Natural History to transport children to classes and special programs. Sources: class fees and the center's operating budget.

Range of services: Public classes in printmaking, pottery, sculpture, glassblowing, painting, drawing, drama, and dance; 52 exhibitions annually; concerts, theater, and films for children and adults; State Services and Neighborhood Arts Program.

Audience: Because State Services programs reach out to audiences the length and breadth of the state, the Arts Center has two major audiences, those who come to it and those to whom it reaches out. During 1974, 184,217 persons participated in State Services programs, an increase of 85 percent over the previous year.

# THE ART INSTITUTE OF CHICAGO

Michigan Avenue at Adams Street
Chicago, Illinois 60603

## 1. General Information

Founding: 1879.

Collections: General, with special strengths in nineteenth- and twentieth-century painting and sculpture; primitive art; prints and drawings; and American furniture.

Number of paid staff: 550, including museum, School of the Art Institute, and Goodman Theatre. In the museum alone, there are 92 paid staff.

Number of volunteers: 180.

Operating budget: $10,620,103 (1973/74) for the entire Art Institute, including the art school, the museum, and Goodman Theatre (does not include an additional $1,214,391 from restricted funds for accessions). Of the total operating budget, $4,296,418 was budgeted for the museum (not including $618,722 for the museum store or $637,733 for the restaurant).

Education budget: The museum education portion of the museum budget was $203,758.

Source of funding: 50 percent of budget is from earned income (admissions, tuitions, ticket sales); 10 percent, city taxes (Chicago Park District); 25 percent, endowment incomes; 15 percent, annual fund-raising and members' dues.

## 2. Location/Setting

Size and character of city: Chicago and its standard metropolitan statistical area have a population of 6,978,947 (1970 census), the city proper a population of 3,369,359 (1970 census). A city of diverse industry and commerce, Chicago accounts for 5 percent of the gross national product. Poets and journalists have always been intrigued by the city, and their characterizations of it color the impression most visitors take away: rough, dirty, sprawling, but with a sleek and lovely face turned toward Lake Michigan's long coastline.

Climate: Cold, windy winters; hot, windy summers.

Specific location of institution: The Art Institute is located in Grant Park. Lake Michigan is behind it to the east, the business and commerce of downtown Chicago (the Loop) is to the west of its front door. To the north, along the lake, are fashionable shopping areas and high-rise apartments; to the south are other museums that dot Grant Park. The museum is not in a residential area; most school groups who visit it must come a considerable distance.

Access to public transportation: Bus, train, elevated, and subway provide easy and immediate access to the Institute from every point in Chicago and its suburbs.

## 3. Audience

Membership: 52,000 individual and family memberships in 1974. Cost: $15 for individual, $25 for family.

Attendance: 2,000,000 visitors a year.

## 4. Educational Services

Organizational structure: Separate department of museum education, whose director reports to the president.

Size of staff: 14 paid staff members; 85 volunteers.

Budget: $203,758 for *museum* education (figure does not include the art school, which is a separate entity).

Source of funds: Operating budget.

Range of services: School visits are conducted for grades 5 and up; during December and January classes for grades under 5 are scheduled. For the casual visitor, introductions to the collections are offered free four times a week, and for adult visitors more familiar with the collections, subscription series, films, and artists' demonstrations. About 85 colleges and universities work with the professional staff to study the collections. The 9 Midwestern universities, public and private, that offer a Ph.D. in art history are invited to nominate a graduate student to read a paper at the institute's annual seminar. In addition to these activities, the department of museum education is responsible for the Junior Museum, a large volunteer staff, exhibitions, publications, and teachers' workshops. The department schedules the use of the Institute's three auditoriums for its own programs and those of the School of the Art Institute.

Audience: 200,000 elementary and secondary schoolchildren visit each year. In addition, there is a sizable college and university audience and a good representation of tourists.

# ART MUSEUM OF SOUTH TEXAS

1902 Shoreline
P.O. 1010
Corpus Christi, Texas 78403

## 1. General Information

Founding: Incorporated 1960; new building opened October 1972.

Collections: Mostly contemporary, under 50 pieces.

Number of paid staff: 15.

Number of volunteers: 56 docents; 15 slide lecturers.

Operating budget: $325,000 (1973/74).

Education budget: $38,207.69 (1973/74).

Source of funding: Corporate and private foundations, city, memberships, school district, grants, tuition, and fund-raising activities. Governing authority: Corpus Christi Art Foundation Board of Governors, chosen by nominating committee, elected by trustees.

## 2. Location/Setting

Size and character of city: Corpus Christi is a Gulf port with a

population of 204,525 (1970 census), 50 percent Anglo and 50 percent Mexican-American. Its principal economic activities center on oil and ranching, with some farming in surrounding area.

Specific location of institution: On the Gulf; across open space from Natural Science Museum. The museum's immediate neighbors are businesses, motels, city office buildings and lower-income residential.

Climate: Hot, windy, very humid.

Access to public transportation: None.

**3. Audience**

Membership: 2,400. Cost: $15 per family.

Attendance: 116,261 (year ended May 31, 1974).

**4. Educational Services**

Organizational structure: Separate department, headed by curator of education, who is responsible to museum director.

Size of staff: Curator of education; lecturer-librarian; secretary.

Budget: $38,207.69 ($17,057.69 for programs, $21,150 for salaries).

Source of funding: $24,000, Corpus Christi Independent School District; $2,000, Art Jamboree; $600, Junior League; $5,000, Texas Commission on the Arts and Humanities Film in Schools program; $6,607.69, operating budget.

Range of services: 5th- and 6th-grade tours, slide lectures, incidental tours, studio classes (all ages), and film series.

Audience: Over 16,000 participate in the educational program; about half are 5th and 6th graders who come for the special tours.

# THE BALTIMORE MUSEUM OF ART

Art Museum Drive
Baltimore, Maryland 21218

**1. General Information**

Founding: 1914 (The Downtown Gallery, 1972).

Collection: Diverse collection, with major strengths in the areas of eighteenth- and nineteenth-century American painting and decorative arts, nineteenth- and twentieth-century French painting and sculpture, and an extensive collection of pre-Columbian, Oceanic, and African art and artifacts.

Number of paid staff: 90.

Number of volunteers: 175.

Operating budget: $1,420,881 (1973/74).

Education budget: $82,000 (1974).

Sources of funding: City, membership, grants, museum school.

**2. Location/Setting**

Size and character of city: Baltimore, with a population of 905,759 (1970 census), is part of a standard metropolitan statistical area with a population of 2,070,670 (1970 census). Baltimore's early history centers on its activities as a seaport, the basis of its economic livelihood in the eighteenth century. The impact of sea trade diminished during the 1800s, and the city turned its attention to the development of residential and commercial areas. Baltimore is presently redeveloping its harbor area and is undergoing a reorientation to the waterfront as a financial and social center. Many new shopping and entertainment facilities have been integrated with existing structures.

Climate: Cold, rainy winters; hot, muggy summers.

Specific location of institution: In a rather "respectable" section of the city, bordering on a residential district and near the city's colleges. The museum's Downtown Gallery is located in Baltimore's business district.

Access to public transportation: On public bus line.

**3. Audience**

Membership: 5,204. Cost: $10 and up.

Attendance: In 1974, 201,886 at the museum and 36,611 at the Downtown Gallery.

**4. Educational Services**

Organizational structure: Separate education department is headed by a curator of education, who reports to the museum director.

Size of staff: 4 full-time, 10 part-time; 35 active volunteers (tour guides), 2–3 student volunteers, 3 summer interns (college students), one part-time volunteer working on special projects.

Budget: $82,000 (1974); includes salaries of full- and part-time museum education personnel (not of teachers, which board of education pays), materials, lecturers' honoraria, docent council expenses, summer intern stipends, community services, gallery interpretation (preparation of text materials, photos and photo murals, text panels), general operating expenses. Does not include maintenance.

Source of funds: City, membership, grants, museum school.

Range of services: School programs, adult programs, special exhibitions, publications, Downtown Gallery.

Audience: Good cross-section of the population of Baltimore.

# THE BIRMINGHAM MUSEUM OF ART

2000 8th Avenue, North
Birmingham, Alabama 35203

**1. General Information**

Founding: 1950; moved into Oscar Wells building, 1959.

Collections: Samuel H. Kress collection of Italian, Spanish, Dutch, and Australian works of art. English, French, and Dutch portraits and paintings; American Indian art and artifacts from Alabama, the Plains, the Northwest Coast; Remington bronzes; etchings and engravings; Oriental art; art of Africa, the South Seas and Palestine; European silver, porcelains, and glass; American contemporary paintings and water colors; the Beeson collection of Wedgewood; large collection of pre-Columbian art.

Number of paid staff: 22.

Number of volunteers: 45.

Operating budget: $293,080 (1973/74), not including the Museum Art Education Council, which is separately incorporated.

Education budget: $40,000 (1973/74).

Source of funding: City and private.

**2. Location/Setting**

Size and character of city: Birmingham, with a population of 300,910 (1970 census), is part of a standard metropolitan statistical area with a population of 739,274 (1970 census). It is the largest city in Alabama and one of the state's major industrial centers, with greatest production in iron and steel, metal products, machinery, and cement. Educational facilities include one university and three colleges.

Climate: Mild.

Location: In downtown Birmingham, close to Birmingham's

new civic center, the board of education, the Jefferson County Court House, and the city hall.

Access to public transportation: On a bus route.

### 3. Audience

Membership: Between 1,700 and 1,800 in 1973/74. Cost: individual, $3 or more; family, $5 or more; contributing, $100 or more.

Attendance: In 1973/74, 78,926.

### 4. Educational Services

Organizational structure: The Museum Art Education Council is a separately incorporated organization, receiving overhead benefits and operating costs from the museum; it is directed by a full-time coordinator.

Size of staff: 3 full-time professionals (coordinator, assistant coordinator, and artmobile driver-lecturer), 3 part-time lecturers, 20 volunteer slide lecturers, and 25 volunteer docents.

Budget: $40,000, including salaries and programs.

Source of funds: City Council through the board of education, grants, contributions, fees for classes, and museum budget (the museum contribution does not include salaries). In addition, a group of about 200 donors contributes from $10 to $2,000 annually.

Range of services: Art classes and workshops for adults and children, slide lectures, films, the Artmobile (with the Birmingham Board of Education), Christmas sale-exhibit of Alabama artists' work, volunteer training, and extension services to the schools.

Audience: The Artmobile serves grades 3–7 in city schools; slide programs and films serve art and history classes in elementary and high schools in Jefferson County; art classes serve children in grades 1–6, three-year-olds and mothers, and senior high school age and older.

## THE BROOKLYN MUSEUM

188 Eastern Parkway
Brooklyn, New York 11238

### 1. General Information

Founding: 1905.

Collection: Costumes and textiles, decorative arts, Egyptian and classical art, Middle Eastern art and archaeology, Oriental art, European and American paintings and sculpture, primitive art, prints and drawings.

Number of paid staff: 250.

Number of volunteers: 124.

Operating budget: $4,243,132 (1973/74).

Education budget: $1,687,543 (1973/74). This figure includes art research, acquisition, cataloging, and installation of objects; lectures; adult and school class instruction; special exhibitions; concerts; maintenance of art reference library.

Source of funding: City of New York; contributions and grants; admission to concerts, lectures, and tours; membership dues, tuitions, fees; bookshop sales.

### 2. Location/Setting

Size and character of city: The New York City borough of Brooklyn, taken alone, is the fourth largest urban area in the country. Its population of about 2 million is of mixed ethnic and economic make-up.

Climate: Northeast coastal climate with extremes of heat and cold.

Specific location of the institution: The Crown Heights section of Brooklyn, a mixed residential and semicommercial community; the museum borders on the Brooklyn Botanic Garden and Prospect Park.

Access to public transportation: Convenient to subways and buses.

### 3. Audience

Membership: 2,826. Life, $5,000 (57); donor, $500 (1); patron, $250 (2); contributing, $100 (45); sustaining, $50 (407); family, $30 (748); annual, $20 (1,275); senior, $10 (291).

Attendance: 588,617.

### 4. Educational Services

Organizational structure: Head of education reports to the assistant director for interpretation, who in turn reports to the museum director (*Note:* as of September 1975, the head of education reports to curator-in-chief).

Size of staff: 9 full-time; 12 part-time; 12 volunteers.

Budget: See above (no individual breakdown available for department).

Source of funds: See above.

Range of services: Programs for adults including gallery talks, seminars, participatory workshops, lecture demonstrations and films; classes and programs for children in the New York school system; In-Depth Series school program; workshop program in studio arts; free programs to introduce young people to the museum; volunteer, student teacher, and internship programs.

Audience: About 70 percent of the school classes come from Brooklyn schools; adult audience is also 70 percent Brooklyn residents.

## CASE WESTERN RESERVE UNIVERSITY

University Circle
Cleveland, Ohio 44106

### 1. General Information

Founding: Western Reserve College, founded in 1826, became Western Reserve University in 1884, and in 1967 became federated with Case Institute of Technology to form Case Western Reserve University.

Number of paid staff: Approximately 1,200 full-time faculty (including the School of Medicine whose faculty numbers approximately 400). The faculty in the Arts and Humanities division numbers 91 full-time.

Operating budget: $79.5 million (1974/75).

Sources of funding: Case Western Reserve University is privately operated. Approximately $28 million of its annual budget in 1974/75 came from grants for research and training, the remainder from tuition and fees, endowment (as of June 30, 1975, $79,500,576), State of Ohio appropriation, and others.

### 2. Location/Setting

Size and character of city: Large industrial center with a population of 750,879 (1970 census) and a standard metropolitan statistical area population of 2,064,194 (1970 census). Cleveland boasts some of the finest cultural institutions in the country (a European visitor once remarked it is the Vienna of the American continent). As is characteristic of many older Eastern and Midwestern cities, Cleveland's population has been steadily declin-

ing. Once the fifth largest city in the country, in 1970 the city had slipped to twelfth place, and in 1975 to fifteenth.

Climate: Winters are difficult, other seasons pleasant.

Location of the institution: In Cleveland's major cultural center, University Circle; edged by lovely parkland but neighbor also to inner-city decay.

Access to public transportation: Major bus lines run through the campus; a rapid transit train has a University Circle stop, and university buses deliver rapid transit riders to campus locations.

### 3. Audience

Enrollment, fall 1974: 8,843 total, including graduate and professional schools. Undergraduate enrollment alone was 3,525.

### 4. Educational Services

Organizational structure: For purposes of this study, detailed information on the department of art will be given here. The department is headed by a chairman who reports to the provost of the Division of Humanities and Arts.

Size of staff: One associate professor, 3 assistant professors in art history; one associate professor in art education, and 12 lecturers in studio art and art education. In addition, 12 curators of the Cleveland Museum of Art hold adjunct appointments on the faculty of the university's art department.

Budget: $226,855 (1974/75).

Source of funds: University budget.

Range of services: The department offers undergraduate programs in art studio, art education, and—in cooperation with the Cleveland Museum of Art—art history. A B.S. in art education is available through collaboration with the Cleveland Institute of Art. Graduate programs include Master of Arts in Art History, Master of Arts in Art Education, and Ph.D. in Art History (with a museum studies option). The department also offers, in conjunction with the School of Library Science, a double degree: Master of Arts in Art History and Library Science.

Audience: In 1974/75 there were 72 undergraduate majors in the department, 42 of whom were in art history. Graduate enrollment included 21 full-time, 19 part-time for the M.A., 7 full-time, 11 part-time for the Ph.D.

## CEMREL, Inc.

3120 59th Street
St. Louis, Missouri 63139

### 1. General Information

Founding: CEMREL (Central Midwestern Regional Educational Laboratory) was chartered in the State of Missouri in November 1965 as a private, not-for-profit corporation devoted to research and development of educational programs.

Number of paid staff: 179.

Number of volunteers: One, in the public information office.

Operating budget: $3,200,000 (1974).

Education budget: Total operating budget is devoted to education.

Sources of funding: 78.5 percent from the National Institute of Education; 17.3 percent from the U.S. Office of Education; 4.2 percent from miscellaneous sources.

### 2. Location/Setting

Size and character of city: St. Louis, Missouri, population 622,236 (1970 census), is the home of CEMREL, one of several such regional laboratories. CEMREL's research and programs are not confined to St. Louis and environs but are nationwide in scope.

Specific location of institution: In a rehabilitated building in the southwestern part of St. Louis.

Access to public transportation: Convenient to two major bus lines; near Interstate 44 and Interstate 40.

### 3. Audience

Membership: None.

### 4. Educational Services

Organizational structure: Director of aesthetic education program and directors of other programs and products report to the president of CEMREL.

Size of educational staff as distinguished from clerical, public information, and other services: 116.

Budget: $3,200,000 (CEMREL's entire function is educational).

Source of funds: See above.

Range of services: Research and curriculum and instructional systems development in mathematics, social studies, language, aesthetic education, early childhood education, teacher-training, and other community or school service programs.

Audience: Students, teachers, administrators nationwide.

## THE CHILDREN'S MUSEUM

Jamaicaway
Boston, Massachusetts 02130

### 1. General Information

Founding: 1913 by the Science Teachers' Bureau in Boston, which installed the museum's small nature study collection in a city-owned building in Olmstead Park. The museum was chartered as a separate organization in July 1914.

Collections: Natural history objects (birds, shells, rocks, insects); cultural artifacts (primarily Japanese and native American); nineteenth- and twentieth-century Americana (household furnishings, utensils, clothing, dolls, games, books, magazines)—over 50,000 cataloged artifacts.

Number of paid staff: 52.

Number of volunteers: 20 teenagers, who serve as junior curators; 30 pre-adolescents, who are called museum helpers; 15 volunteers; 60 work-study students, who serve three-month internships (the museum pays 20 percent of the salaries for students in funded programs).

Operating budget: $630,213 in fiscal year 1974 ($739,917 in fiscal 1975).

Expenditures for education: $414,000 (FY 1974) for the programs of the visitor center, the resource center, and the community services division. In all, about 69 percent of the museum's budget is allocated to direct educational services.

Source of funding: Earned income from admissions, kit circulation and course fees, sales and royalties ($326,693 in fiscal year 1974, or about 50 percent of the museum's operating budget); research and development project grants and contracts ($167,037); unrestricted gifts and investment income ($142,900). Grants have come mainly from the National Endowments for the Arts and Humanities, the U.S. Office of Education, and private foundations.

### 2. Location/Setting

Size and character of city: The population of Boston proper in

1970 was 641,071 and the standard metropolitan statistical area was 2.7 million. The city is multicultural, diverse in its socioeconomic mix, and heavily populated by college and university students (there are 47 degree-granting institutions in Boston's metropolitan area).

Climate: New England seasonal.

Specific location of institution: In two old mansions, a converted auditorium, and several outbuildings in a transition area of mixed-income (welfare, blue-collar, and professional) families and ethnic background (Hispanic, Irish Catholic, black). The area is situated between predominantly black Roxbury and predominantly white, suburban, middle-class Brookline.

Access to public transportation: Although the museum is only two blocks from bus and trolley lines, they are far out on one of the spokes of a radial transit system, and the museum is therefore especially difficult to reach without a car.

**3. Audience**

Membership: 2,000. Families living within the City of Boston pay $8 a year; others, $16. Privileges of membership: free admission to the visitor center, 10 percent discount on sales shop purchases, and monthly newsletter. (In 1972, the membership structure was changed to encourage more sustained use of museum resources and provide a "lower access threshold" for low-income clients.)

Attendance: Visitor center, 185,000 (1974); resource center, 10,000–15,000 adults who work with 200,000–300,000 children; community services division workshops, 750 adults who work with 5,000 children.

**4. Educational Services**

Organizational structure: No separate education department; the entire operation of the museum is organized to serve its clients' educational needs.

Size of staff: Visitor center, 17 (5 part-time); resource center, 13 (one part-time); community services division, 9 (5 full-time and 4 part-time).

Budget: $414,000 (1974).

Source of funds: Admissions, fees, contracts, and grants.

Range of services: Exhibitions, workshops for teachers and community workers, programs for visiting school groups, circulating collections and teaching kits, a recycled materials shop, and an extensive resource center that allows classroom teachers and other adults to try out published and homemade educational materials.

Audience: Visitor center—school groups and their teachers, families, children on their own, the general public. The resource center—teachers, students of education, museum educators and other adults working with children. Community services—community-based groups working with children (day-care centers, camps, settlement houses, recreation centers, kindergarten and nursery schools), individual children from the neighborhoods, and families.

# THE STERLING AND FRANCINE CLARK ART INSTITUTE

Williamstown, Massachusetts 01267

**1. General Information**

Founding: 1955 by private collectors Robert Sterling and Francine Clark.

Collections: Renaissance to modern, with special strength in nineteenth-century European and American art, including an extensive collection of French paintings and sculpture by Courbet, Daumier, Corot, Millet, Renoir, Degas, Monet, Manet, Rodin, and Carpeaux; prints and drawings from the fifteenth to the twentieth centuries; old silver, primarily English, from the sixteenth century on.

Number of paid staff: 28.

Number of volunteers: About 20.

Operating budget: $500,000 to $750,000 annually.

Education budget: No separate allocation for education.

Source of funding: Private endowment.

**2. Location/Setting**

Size and character of town: Williamstown is a small (population 8,500), picturesque rural college town set in a valley of the Berkshire mountains in the northwest corner of Massachusetts. The cultural and economic life of the community focuses around Williams College (enrollment: 1,300), which occupies the center of town and houses the Adams Memorial Theater, in which professional productions are presented in the summer, the Chapin Library, and the Williams College Museum of Art. The town is near other summertime cultural attractions, including Tanglewood and Jacob's Pillow.

Climate: New England seasonal.

Specific location of the institution: About a half-mile from the center of the town.

Access to public transportation: None. The institute is an easy walk from the town and college.

**3. Audience**

Membership: None.

Attendance: About 100,000 a year.

**4. Educational Services**

Organizational structure: No separate department. Educational activities are overseen by an associate director, who reports to the museum director.

Range of services: Tours; slide-lectures and slides available to local schools.

Audience: Focus is on elementary school groups, although other ages are served on request. Average yearly participation: 6,000 elementary schoolchildren, 2,000 high school students, 1,000 adults in groups.

Objective: Tours for schoolchildren are an introduction to elements of all the arts—theater, dance, music, and literature, as well as the visual arts—and are planned to "direct and assist children in becoming more aware of different art forms, the interrelationships among them, and some of the elements common to all."

Location: Most educational activities take place in the institute's galleries.

Time: October to May.

Information and documentation available from the institution: Xeroxed descriptions of tour programs.

# THE CLEVELAND MUSEUM OF ART

11150 East Boulevard
Cleveland, Ohio 44106

## 1. General Information

Founding: 1913; opened to the public June 6, 1916.

Collections: General and comprehensive, including the arts of all cultures. Outstanding collections: all arts of the Far East, European decorative arts. Most apparent weaknesses: contemporary "avant-garde" painting, sculpture, photography.

Number of paid staff: 230 full-time; 100 part-time.

Number of volunteers: None.

Operating budget: $3,678,511.81 (1974).

Education budget: $233,399.85 (1974). (*Note*: extension exhibitions, publications, and other budget items which could legitimately be included in education budget are not included in this figure, which covers only salaries and operating costs of department.)

Source of funding: Private endowment, primarily, plus a very few endowment grants for special undertakings. (The Cleveland Museum is one of the few museums in the country funded primarily by private endowments.) Endowment, as of December 31, 1974: $61,112,363.78.

## 2. Location/Setting

Size and character of city: Large industrial center, the twelfth largest city in the United States, according to the 1970 census, with a population of 750,879 and a standard metropolitan statistical area population of 2,064,194. Between 1910 and 1920 Cleveland earned a reputation as a center of vigorous political reform and social/philanthropic organization; during the same decade it first brought into being its orchestra, art museum, resident professional theater, and a host of other cultural institutions which today are a primary source of pride to many Clevelanders. The rate of population growth has slowed drastically in the last two decades; Cleveland's metropolitan area, including Akron and Canton, lost population between 1960 and 1970.

Climate: Winters are difficult, wet, cold, and snowy, and winter attendance at many cultural, religious, and other events is adversely affected by the climate; the other seasons are pleasant.

Location: In the University Circle area, which includes dozens of cultural, medical, educational, and religious institutions, with lovely parkland—but ringed by decaying houses, light industry. The Circle is relatively remote from residential areas and is about a ten-minute ride from downtown Cleveland.

Access to public transportation: Inconvenient but possible.

## 3. Audience

Membership: 8,225 (1974). Cost: annual membership (family or individual), $15.

Attendance figures: 458,863 (1974).

## 4. Educational Services

Organizational structure: Separate education department, headed by curator, who reports to the director of the museum.

Size of staff: 12 full-time paid professional staff, including curator, associate curator, two assistant curators; 8 part-time instructors. Also, 2 full-time staff paid by Cleveland school district specifically for school classes. Saturday and afterschool museum classes: 16 teachers, 17 assistants, for each of three sessions (fall, spring, summer). No volunteers.

Budget: $233,399.85, including only salaries and operating costs (6.3 percent of total operating budget).

Source of funds: Museum, plus modest payment for services from a few school systems, and occasional scattered grants.

Range of services: For schools: tours, teacher training courses, some special classes. For adult audience: members' courses, public lectures, gallery talks, publications on aspects of the collections. For all audiences: slide-tapes on the collection and on special exhibitions, exhibitions in education department classroom area. For children: studio and gallery classes, Saturdays, after school, and during summer vacation.

Audience: Program for adults: 53,013, including Case Western Reserve University classes. Program for young people: 75,675. Total: 128,688.

# CONTEMPORARY ARTS MUSEUM

5216 Montrose Avenue
Houston, Texas 77006

## 1. General Information

Founding: Organized in 1948 as the Contemporary Arts Association, the museum occupied several temporary exhibition areas until its first building was constructed the following year; the present structure was built and occupied in 1972.

Collections: Contemporary paintings, sculpture, constructions.

Number of paid staff: 11 full-time (5 are curatorial-administrative, and 6 maintenance, secretarial, security); 34 part-time artist-teachers for Art after School and in-museum classes.

Number of volunteers: Approximately 15 docents; others volunteer for one-time fund-raising projects, the maintenance fund drive in particular.

Operating budget: $250,000 (1974).

Education budget: $40,000 (1974).

Source of funding: Maintenance fund drive, memberships, grants, special gifts, museum store, tuitions.

## 2. Location/Setting

Size and character of city: Called the "fastest growing city in the U.S." when the Contemporary Arts Association was founded there in 1948. Houston had a population of 1,232,802 in the 1970 census, and its standard metropolitan statistical area had a population of 1,985,031. Houston is the most diversified manufacturing city in the South; it may well be one of the most diversified and culturally healthy, having its own resident grand opera, symphony, ballet, and theater groups. Three major art museums and over seventy galleries offer a broad spectrum of exhibitions yearly.

Climate: Mild winters; humid, hot summers.

Specific location of institution: The parallelogram structure of the Contemporary Arts Museum, sheathed in stainless steel, points to the Museum of Fine Arts, Houston, diagonally across the street. The neighborhood blends an older residential area with a burgeoning cultural center including museums, art galleries, and nearby Rice University.

Access to public transportation: On a direct bus route from several southwest area residential neighborhoods, and from the central business district, approximately 2 miles distant.

**3. Audience**

Membership: 2,100 (1974). Cost: student membership, $7.50 per year; active adult membership, $20.

Attendance: During 1974, 150,000 (not including Art after School participants).

**4. Educational Services**

Organizational structure: Education department is headed by a chairman of education, who reports to director of museum.

Size of staff: Curator of education, approximately 33 part-time studio and performing arts instructors.

Budget: $40,000. Budget for education includes Art after School classes, similar classes held at the museum, supplies and equipment, and the curator's salary.

Source of funds: Funding is from tuition, grants, and gifts.

Range of services: Classes in painting, drawing, sculpture, filmmaking, photography, creative drama, and dance.

Audience: 800 children, teenagers, and adults attend in-museum classes.

# THE DETROIT INSTITUTE OF ARTS

5200 Woodward Avenue
Detroit, Michigan 48202

**1. General Information**

Founding: Institution founded 1885; first building opened 1888; moved into present building 1927.

Collections: 101 galleries, arranged historically by cultural groups or national schools. General, comprehensive collection, with special strengths in Dutch and Flemish painting, Italian Renaissance arts, American painting.

Number of paid staff: 97 (with maintenance, guards, and other auxiliary staff added, total is 185).

Number of volunteers: 475.

Operating budget: $5,307,678.11 (1973/74).

Education budget: $310,660.73 (1973/74).

Source of funding: City of Detroit, $2,242,039; Founders Society, $2,665,639.11; Detroit City Theatre Association, $400,000.

**2. Location/Setting**

Size and character of city: Nearly all traces of the city's original French settlement (called D'Etroit) were destroyed in a fire in 1805. Throughout the nineteenth century the city developed as a frontier town; in mid-century its population was less than 50,000 inhabitants, and it was the seventeenth largest city in the country. The first automobile factory in Detroit was built in 1899.

By 1970 Detroit was the country's fifth largest city. About half of its population of 1,513,601 (1970 census) is black; it is part of a standard metropolitan statistical area with a population numbering 4,199,931 (1970 census). Detroit has the nation's highest crime rate, over 800 homicides in 1974. It is the center of the Western Hemisphere's single largest enterprise, the $50-billion-a-year auto industry.

As the Detroit Institute of Arts is owned and operated by the City of Detroit, the city's economic troubles directly affect the museum. Eleven staff members at the institute, including all but two of the education department's professional staff, were laid off in January 1975 as part of the city's temporary cutbacks.

Climate: Cold, snowy winters, with weather typical of the Lower Great Lakes region.

Specific location of institution: The institute is about 50 blocks from downtown, on a broad thoroughfare; it is flanked by the public library, Wayne State University, and other cultural and medical institutions. Decaying business, industry, and residences surround these institutions.

Access to public transportation: On a public bus route.

**3. Audience**

Membership: 11,624. Cost: $10 for students and senior citizens; $20, individual; $30, family; $125, patron.

Attendance: An estimated one million visitors annually (exact figures are not kept). Education department reported an attendance of 128,105 for 1974 (an additional 250,000 attended Theatre Arts Department education programs).

**4. Education Services**

Organizational structure: Education department is headed by a chairman of education, who reports to director of museum.

Size of staff: 7 professional full-time staff; 5 secretary-clerks; part-time staff varies; volunteer staff of 265.

Budget: $310,660.73; includes programs, educational exhibits, salaries and benefits, and publications.

Source of funds: The City of Detroit, the Founders Society, grants and gifts.

Range of services: Docent tours related to elementary school curriculum serve 50 percent of school classes requesting tours. Art to the Schools, also a volunteer project supervised by education staff, reaches between 25,000 and 30,000 students. Other services include information desks and information service gallery aides; teacher-training programs; extensive publications; lectures and courses for the general public; films; film workshops; studio classes.

Audience: 128,105 (1973/74). School tours account for about one-third of total museum visitors. Despite efforts to serve *city* schools, education staff estimate that there are seven (or more) suburban schoolchildren for every city child visiting the museum.

# M. H. DE YOUNG MEMORIAL MUSEUM

Golden Gate Park
San Francisco, California 94118

**1. General Information**

Founding: 1895. In 1973, the M. H. de Young Memorial Museum and the Palace of the Legion of Honor joined to form The Fine Arts Museums of San Francisco. The collections are housed at separate locations.

Collections: General and comprehensive, ancient through American, the strongest being the American collection.

Number of paid staff: 110.

Number of volunteers: 375 docents.

Operating budget: $2.1 million (1974).

Education budget: $183,494 from operating budget. (Adding outside funds for special programs the total expenditure for education is $652,186.)

Source of funding: $1.6 million from City and County of San Francisco; $500,000 from membership group, investments, and fees; plus grants for special programs.

**2. Location/Setting**

Size and character of city: San Francisco, with a population of 715,674 (1970 census), is second only to Manhattan Island in

population density. Thirty-two percent of the population is non-white; the enrollment in San Francisco schools is 77 percent nonwhite. Set among high hills, San Francisco is one of the most picturesque cities in the country—a mecca for tourists, with its familiar cable cars, Fisherman's Wharf, Chinatown, and other famous attractions. San Francisco covers 44.6 square miles at the tip of a peninsula that forms one of the world's finest land-locked harbors. It is the chief port and financial center of the Pacific Coast. The San Francisco-Oakland standard metropolitan statistical area has a population of 3,109,519 (1970 census).
Climate: Temperate.
Specific location of institution: Golden Gate Park in central San Francisco.
Access to public transportation: One public bus to front door of museum and two bus lines to street location within walking distance.

3. **Audience**
Membership: 9,500 (1974). Cost: individual, $20; student (under 25), $7.50; family, $30; senior (over age 65), $10.
Attendance figures: 1,100,000 (1974), including the Asian Museum (access to the Asian Museum is through the de Young).

4. **Educational Services**
Organizational structure: A separate education department is headed by the vice-director for education, who reports to the museum director.
Size of staff: 37, including 31 art school staff members and one docent council supervisor. Volunteers: 161 serve the art school, 375 staff the Docent Council.
Budget: Total expenditures for 1973/74, $652,186. This amount includes $468,692 for special programs financed by outside funds.
Source of funds: 8.7 percent of the operating budget ($183,494) is allocated to education; grants fund specific programs.
Range of services: Tours, in-school docent program, catalogs on collections and exhibitions, art school, mobile outreach program, intern training, orientation gallery (in process).
Audience: Over 120,000 children per year are served by the education program through tours, in-school program, art school, and mobile outreach; 14 interns are training in the museum; and a lay audience participates in tours.

# ELMA LEWIS SCHOOL OF FINE ARTS

122 Elm Hill Avenue
Roxbury, Massachusetts 02121

1. **General Information**
Founding: 1950. In 1968 the school spawned the National Center of Afro-American Artists (NCAAA), of which it is now the teaching division.
Collections: The school has access to the collection of the NCAAA, which includes 500 objects of African, Afro-American, and Caribbean art and artifacts; paintings, sculpture, and graphics by black Americans; and a special photographic collection on Haiti. The school has a library of approximately 1,200 volumes focusing on African, Afro-American, and West Indian art.
Number of paid staff: 100 (about 25 of these are part-time).
Number of volunteers: Variable; generally project-bound.
Operating budget: $800,000 (1973/74).

Education budget: Because it is an educational institution, the school's entire operating budget is devoted to education.
Source of funding: Grants, gifts ($100,000 a year for the music program from the Ford Foundation from 1969–1973, with a terminal grant of $950,000 in 1974*; contributions from other sources totaling about $500,000 a year); earned income from annual fund-raising events and performances by the center's professional groups; limited endowment holdings.

2. **Location/Setting**
Size and character of city: Roxbury, a section of Boston, is part of a standard metropolitan statistical area with a population of 2,753,700 (1970 census). A predominantly black community, Roxbury is now a depressed area in which the National Center is a major employer.
Climate: New England, seasonal.
Specific location of institution: In a residential area a few blocks from the Grove Hall and Humboldt Avenue commercial centers, directly across from Franklin Park.
Access to public transportation: Public bus stops at the corner; elevated public train stops within six blocks. Limited free parking available.

3. **Audience**
Enrollment: Preschool children, age three-and-a-half to six; children, age six to twelve (boys admitted free, girls charged a tuition, which may be waived according to the capacity of the guardian to pay**); teenagers and adults (all subject to tuition fees, but with possible waivers); periodic special student groups, from correctional institutions or alternative schools. The student population averages around 400 younger children and 225 teenagers and adults; other groups vary. No racial, national, ethnic, or religious stipulations are made regarding application.
Attendance: Public receptions, performances, and other events draw an estimated annual attendance of 125,000.

4. **Educational Services**
Organizational structure: The Elma Lewis School of Fine Arts is the teaching component of the National Center of Afro-American Artists, NCAAA consists of two dance companies, a museum, the Elma Lewis Playhouse in the Park, two theater companies, a technical theater department, an experimental theater, the Black Persuasion and the Children of Black Persuasion (two singing and performing groups), a classical orchestra, a jazz orchestra, and the Elma Lewis School of Fine Arts. The school includes divisions of dance, drama, music, costume and design, and visual arts, each headed by a director and having its own departmental administrative staff and faculty. Policy is made by two boards of directors, one for the center, the other for the school. The director of the school and the center, Elma Lewis, along with the general administrative staff and department heads, constitute the day-to-day governing body.
Range of services: Classes, performances, talent management and booking services, film presentations, exhibitions, social services (such as housing, school busing, street cleaning—

---

*According to the *Ford Foundation Letter*, September 15, 1974, the terminal grant was to be divided between the music school ($300,000 over three years) and an endowment fund to be matched two-to-one from other sources.

**Traditionally the black male has not participated in the arts (a generality that has some notable exceptions, of course). Waiving tuition for boys is an effort to attract more of them, and it is apparently working; the ratio of boys to girls in NCAAA programs is about one to one.

questions the center becomes involved in as part of its commitment to the idea that the arts and culture should be closely related to everyday life), public receptions and other special events, Afro-American Cultural Program for Catholic high schools, and Perspectives in Black Art for Howard University extension school.

Audience: Largely black (about 5 percent of the students are white). Suburban and city public schools are served by mobile unit.

Objective: To provide a measure of intellectual and psychosocial enrichment through the arts.

Time: Preschool children come Thursday from November through June; other children come after school, from 3:30 to 6:30 P.M., and on Saturdays from 9:30 to 5:30. There is also a full-time summer program from July through August. The center is open and accessible 24 hours a day.

Information and documentation available from the institution: *The National Center of Afro-American Artists*, brochure, 1973; thematic outline for classes.

# THE EL PASO MUSEUM OF ART

1211 Montana Avenue
El Paso, Texas 79902

For basic information about this museum, see appendix to the report on the Texas Museums Consortium in chapter 15.

# ELVEHJEM ART CENTER

The University of Wisconsin
800 University Avenue
Madison, Wisconsin 53706

## 1. General Information

Founding: 1962; opened to the public in September 1970.

Collections: Over 400 paintings, Old Master to modern, with strongest representations in Italian and Netherlandish, and Russian icons; graphics (1,200 prints and drawings, the museum's most complete and representative collection); sculpture (about 50) and decorative arts, with extensive holdings in ceramics; ancient art, especially coins; East Indian miniature paintings and stone sculpture. The Kohler Art Library of the art center houses 60,000 bound volumes, including periodicals, and 1,600 vertical file items.

Number of paid staff: Administrative, 5; curatorial, 4; education, one; security, 10; building and grounds, 4.

Number of volunteers: 37. Of these, 36 are docents in the education department; one volunteer works at sales desk.

Operating budget: $250,000 (1973/74).

Education budget: $887.43 (1973/74), not including the salary of the curator of education.

Source of funds: University budget, primarily. Private money and donations paid for the building.

## 2. Location/Setting

Size and character of city: Madison, Wisconsin, with a population of 172,007 (1970 census) is largely dominated by the University of Wisconsin, which annually swells the city's population and gives it the character of a large college town. Blacks, the

largest minority, comprise about one percent of Madison's population.

Climate: Severe winters, with four months of snow.

Specific location of institution: On the campus of the university.

Access to public transportation: At least seven city bus routes come within a half-block of the museum.

## 3. Audience

Membership: 792. Cost: individual, $10; family, $20; student, $5.

Attendance: 70,145 in 1973/74. Admission is free and open to the public.

## 4. Educational Services

Organizational structure: The education department is headed by the curator of education, who reports to the director of the art center. The art center is officially a department within the university; its director reports to the dean of the College of Letters and Sciences.

Size of staff: One paid (curator of education); 36 docents.

Budget: 1973/74 expenditures for programs totaled $695.94; an additional $191.49 was expended for office supplies and miscellaneous. Income is derived from program earnings and newspaper sales. The curator's salary is paid from the museum budget.

Range of services: Guided tours for children and adults; noon lectures in the galleries twice a week during the academic year; occasional gallery concerts and lectures by university faculty; slide sets for loan to teachers; self-tour for visitors; children's newspaper project; and cassette videotapes on the museum collection for television.

Audience: In 1973/74, 6,418 took part in guided tours; 843 attended 54 "minilectures"; and concerts and formal lectures (21 altogether) attracted 2,466. Children, from nursery school through high school, represent the largest slice of the audience (2,251 from Madison, 2,709 from nearby towns and cities).

# EVERSON MUSEUM OF ART

401 Harrison Street
Syracuse, New York 13202

## 1. General Information

Founding: The Syracuse Museum of Fine Arts was founded in 1896, in 1960 became Everson Museum of Art of Syracuse and Onondaga County.

Collections: Contemporary American paintings and sculpture; traditional American paintings; nineteenth-century American paintings on loan from the Onondaga Historical Association; Cloud Wampler collection of Oriental art; seventeenth-, eighteenth-, nineteenth-century English porcelain; contemporary American ceramics.

Number of paid staff: 20.

Number of volunteers: 50.

Operating budget: $474,000 (1974).

Education budget: $50,000 (1974).

Source of funding: City, county, state, National Endowment for the Arts, membership, contributions.

## 2. Location/Setting

Size and character of city: Syracuse, with a population of 197,297 (1970 census), is part of a standard metropolitan statis-

tical area with a population of 635,946 (1970 census). An industrial city, home to some 500 manufacturing plants that turn out products from air conditioners to china and candles, Syracuse is known nationally for its ceramics competitions. It is politically and culturally conservative, a significant factor in museum-community relations.

Climate: Seasonal. Heavy snowfall and blizzards in winter months curtail participation in cultural events.

Specific location of institution: In a commercial area.

Access to public transportation: Excellent.

3. **Audience**

Membership: 2,290 (1974). Cost: $25. In addition, 110 corporate members pay from $100 to $5,000 annually for membership.

Attendance: 200,000 (1974), including school tours.

4. **Educational Services**

Organizational structure: A separate education department is headed by a curator of education who reports to director of museum.

Size of staff: The curator of education and 38 docents.

Budget: $50,000.

Source of funds: Operating budget.

Range of services: Art classes for children, teenagers, and adults; Auburn Prison art workshop; Jamesville Penitentiary art workshop; Hutchings Psychiatric Hospital workshop; docent program; volunteer program; traveling exhibitions; in-service class for city school teachers; poetry readings, preschool deaf classes; programs for senior citizens; lecture series; artist-in-residence program.

Audience: In addition to the traditional museum audience, the Everson reaches out to those with special needs—prisoners, the mentally disturbed, deaf, and elderly.

Objective: ". . . To teach people how art affects their life . . . to continue to provide a wide variety of programs and activities for all the members of the community: the young, the old, the rich, the poor."

Time: Educational programs are offered year-round.

Information and documentation available from the institution: Joan Watrous, "Community Opinion of a Regional Museum: Views on the Everson Museum of Art, Syracuse, New York," *MetrOpinion*, vol. 1 (January 1973); museum newsletters.

# THE EXPLORATORIUM

3601 Lyon Street
San Francisco, California 94123

1. **General Information**

Founding: 1969.

Collections: About 200 scientific exhibits that demonstrate the principles of human perception.

Number of paid staff: 17 full-time, 56 part-time, 5 commissioned for special projects.

Number of volunteers: The manager of the Exploratorium store, a teacher, and a course planner are full-time volunteers; 38 part-time volunteers.

Operating budget: $380,000 (1973/74).

Education budget: The museum is an educational institution whose entire budget is allocated to education.

Source of funding: Federal, State of California, and City and County of San Francisco; private foundations, corporations, and individual donors; internally generated funds (store receipts, donations, fees for special programs). The Exploratorium is a gratis tenant of the City and County of San Francisco.

2. **Location/Setting**

Size and character of city: San Francisco, with a population of 715,674 (1970 census), is second only to Manhattan Island in population density. Thirty-two percent of the population is nonwhite; the enrollment in San Francisco schools is 77 percent nonwhite. Set among high hills, San Francisco is one of the most picturesque cities in the country—a mecca for tourists, with its familiar cable cars, Fisherman's Wharf, Chinatown, and other famous attractions. San Francisco covers 44.6 square miles at the tip of a peninsula that forms one of the world's finest landlocked harbors. It is the chief port and financial center of the Pacific Coast. The San Francisco-Oakland standard metropolitan statistical area has a population of 3,109,519 (1970 census).

Climate: Temperate.

Specific location of institution: Within the exposition hall of the Palace of Fine Arts, adjacent to the city's Marina, and tucked into a tree-protected area along the approach to the Golden Gate Bridge. The Romanesque ensemble—a colonnade and rotunda and a huge curved exposition hall—was designed by Bernard Maybeck for the 1915 Panama-Pacific International Exposition. The hall now includes the Exploratorium and a 1,000-seat theater. In front of the pink buildings is a small lagoon with surrounding greenery. A residential area of upper- and upper-middle-class apartments is adjacent to the Palace grounds.

Access to public transportation: Two municipal bus lines pass within two blocks of the Palace. Although travel time to the site can take as long as an hour from many parts of the city, San Francisco maintains a free transfer system, which permits passengers to reach their destination for a 25-cent fare.

3. **Audience**

Membership: About 260. Membership fees: individual, $10; family membership, $15; student membership, $5. Membership privileges include a 10 percent discount in the Exploratorium store, invitations to special receptions, the Exploratorium Membership Bulletin.

Attendance: General public, 300,000 per year; students in scheduled class visits, 50,000.

4. **Educational Services**

Organizational structure: The governing authority of the Exploratorium is the Palace of Fine Arts Foundation; the Exploratorium is headed by Dr. Frank Oppenheimer, its creator and director.

Range of services: Field trips; school visitor program; School in the Exploratorium program; manual arts program; concerts; participatory science exhibits designed to stimulate discussion, writing, and drawing; artists in residence program; Explainer program.

Audience: Of the 26,558 who participated in scheduled school visits between October 1973 and April 1974, including kindergarten through college tours, slightly over 50 percent were from grades four through six. On the other hand, of the museum's 300,000 annual visitors, 50 percent are over twenty-one years old and 25 percent are under ten years; 30 percent come from San Francisco, 40 percent from other Bay Area locations, and 30 percent from outside the Bay Area.

Objective: To provide a learning environment outside the classroom situation where individuals may develop an understanding of human sensory perception.

Location: In the museum and in schools, with field trips to other community locations.

Time: Throughout the year.

Information and documentation available from the institution: *Exploratorium: Light, Sight, Sound, Hearing* describes many Exploratorium exhibits. Printed in the Exploratorium's graphics shop, it is bound with a loose-leaf clip, so that sections may be added or removed in the future. The first edition contains 45 pages, plus red-green glasses used for color perception sections in the booklet. A film is now being produced; two videotapes are available, one on visitor response to and use of video, and the other on an Explainer workshop use of video.

---

# THE FORT WORTH ART CENTER MUSEUM

1309 Montgomery Street
Amon Carter Square
Fort Worth, Texas 76107

For basic information about this museum, see appendix to the report on the Texas Museums Consortium in chapter 15.

---

# FORT WORTH ART MUSEUMS' DOCENT COUNCIL

1309 Montgomery Street
Amon Carter Square
Fort Worth, Texas 76107

## 1. General Information

Founding: 1968.

Number of paid staff: One.

Number of volunteers: About 150 active docents.

Operating budget: $8,064 (annually, including staff salary).

Sources of funding: The three art museums of Fort Worth (Amon Carter Museum, Fort Worth Art Center Museum, Kimbell Art Museum),* plus a three-year grant of $18,000 (starting 1973) from the Junior League of Fort Worth.

## 2. Location/Setting

Size and character of city: Located on the banks of the Trinity River in North Central Texas, Fort Worth, with a population of 383,455 (1970 census), is part of a standard metropolitan statistical area with a population of 762,090 (1970 census). Fort Worth's economy has long been agriculturally oriented but today includes a diversity of industries such as aerospace, automobile, medical, petroleum. Its cultural institutions include a symphony orchestra, an opera association, a community theater, a ballet association, and three art museums.

Climate: Mild and moderate most of the year; very hot July and August. For the most part, outdoor activities can take place all year long.

---

*For information on the Amon Carter Museum and the Fort Worth Art Center Museum, see report on the Texas Museums Consortium in chapter 15. The Kimbell Art Museum, a private operating foundation, does not publish its financial reports.

---

Specific location of the institution: In a city park area, Arlington Heights, in the western part of city.

Access to public transportation: Served by city bus.

## 3. Audience

Membership: About 150 active docents.

## 4. Educational Services

Organizational structure: A tour coordinator reports to the heads of the education departments at the three participating museums.

Range of services: The council schedules guided tours and school visits and administers the art history course for docents.

Audience: In 1973, guided tours at the Kimbell and Amon Carter museums (Fort Worth Art Center Museum was closed for construction) served 14,816 Fort Worth schoolchildren, kindergarten through high school, with primary emphasis on 5th and 6th grades. Tours were also given for 984 college students and 7,066 adults. Total served: 22,866.

---

# GAME, INC.

260 West 86th Street
New York, New York 10024

## 1. General Information

Founding: Incorporated in July 1973 as GAME (Growth through Art and Museum Experience), Inc.

Collections: Natural artifacts (fossils, bones, geodes, shells) from the American Museum of Natural History and artifacts from the museum shops of the Brooklyn Museum, the American Museum of Natural History, and the Metropolitan Museum of Art.

Number of paid staff: 3 full-time, 12 part-time.

Number of volunteers: 28.

Operating budget: $100,000 in direct support and in-kind services (1974/75).

Education budget: All of GAME's activities are educational.

Sources of funding: Rockefeller Brothers Fund, New York State Council on the Arts, New York Community Trust, Museums Collaborative, National Endowment for the Arts, the Edward John Noble and other foundations, New York City Board of Education, Manhattan School District 3, and Manhattan public schools 9, 166, 84, and 75.

## 2. Location/Setting

Size and character of the city: New York City, with a population of 7.9 million in a standard metropolitan statistical area of about 15.5 million, is the nation's leading industrial and commercial center. Its five boroughs boast 42 museums, plus many parks, zoos, botanical gardens, theaters, and concert halls. Its educational facilities include 6 universities, 23 colleges, 976 public schools, over 1,000 private schools, and 199 public libraries.

Climate: Seasonal.

Specific location of the center: A double storefront basement on Manhattan's Upper West Side. (GAME staff members sometimes work in the public schools and give workshops for teachers and other professionals at colleges, museums, and other locations. Some special events are held in city parks.)

Access to public transportation: Excellent. The center is close to the IRT Seventh Avenue subway and the 86th Street crosstown and Broadway bus routes.

## 3. Audience

Membership: A membership program, open to the public, was being planned when this report was researched. Fees were to be graduated from $10 to $25 a year.

Attendance: In 1974/75, formal programs served about 2,200 schoolchildren, 100 school professionals and paraprofessionals, and 100 adults. Several thousand more children and adults participated in community projects and special events.

## 4. Educational Services

Organizational structure: GAME is governed by a board of directors (three principals from local public schools) assisted by a board of advisers (heads of parents' organizations, educators, artists, community leaders). The director is responsible to the board of directors, and other staff members to the director.

Size of staff: 3 full-time, 12 part-time, 28 volunteers.

Budget: $100,000 (1974/75).

Range of services: Publications—*Art and the Integrated Day* (50 pages, biannual), documentation evaluation, curricula folders, calendars of events, newsletter (published three times a year), books by children for children (*Song of Myself; Signs, Symbols and Alphabets*)—day program, after-school program, adult evening center, whole school programs (banner-making workshops, quilting bees), free Saturday afternoon films for children, in-service and pre-service courses for teachers, museum visits, cosponsorship of museum special events, community projects.

Audience: In 1974/75, the day program served some 2,000 schoolchildren (grades 1–6) and over 100 teachers, student teachers, and school paraprofessionals; after-school program, about 200 children from local schools and community; adult evening program, about 100 neighborhood residents; community projects and special events, several thousand children and adults, mostly from surrounding community.

Objective: GAME's primary focus is as an arts, media, and cultural resource center for students and teachers at four local elementary schools. Workshops and programs at the center are designed to tie into school curricula and collections and programs in New York City museums.

Time: All programs run from September to June. Day program, Monday–Thursday, 9 A.M.–5 P.M.; after-school program, Wednesday, 3–5 P.M.; adult program, Wednesday, 7–9 P.M.; community projects and special events, no specific schedule.

Information and documentation available from the center: *Art and the Integrated Day*, biannual magazine; newsletter (published three times a year); curricula folders: *Song of Myself* and *Signs, Symbols and Alphabets* (books by children for children); super-8 films.

# GEORGE WASHINGTON UNIVERSITY

Washington, D.C. 20052

## 1. General Information

Founding: Columbian College in the District of Columbia was founded in 1821 by grant of charter from Congress. The name was changed in 1873 to Columbian University and in 1904 to The George Washington University.

Number of paid staff: 875 full-time faculty (78 percent with doctoral degrees), and 308 part-time faculty.

Operating budget: $79 million (1974/75).

Sources of funding: The university is private, nonsectarian, privately endowed, and governed by a board of trustees. Additional support includes private and public grants as well as tuition from more than 15,000 students.

## 2. Location/Setting

Size and character of city: Washington, D. C. (1970 census: 756,510 people in the city proper, 2,861,123 people in the standard metropolitan statistical area of which Washington is a part) has the largest concentration of museums, nature centers, parks, botanical gardens, and historic sites in the country. A mecca for tourists, the city offers an abundance of opportunities for museum educators to meet with the public, and the city is in many ways an ideal center for a museum education training program. In addition, Washington's public school system, 95.73 percent of whose pupils are black (1973 school enrollment), presents a challenge to education students and the District's colleges of education alike.

Climate: Generally mild; humid in summer. The area is blessed with a beautiful spring and fall; it is far enough south to avoid most heavy snowfalls. The mild climate encourages outdoor activities; Washington's many parks are often used for natural history and history programs as well as for recreation.

Specific location of the university: In northwest Washington (the campus is bounded by Pennsylvania Avenue and 19th, F, and 24th streets), very near the White House, the Corcoran Gallery of Art, the National Endowment for the Arts, the John F. Kennedy Center for the Performing Arts, the Renwick Gallery, and the National Trust for Historic Preservation. The Smithsonian museums on the Mall are only a few minutes away by car or public transportation.

Access to public transportation: Good.

## 3. Audience

Enrollment: 15,359 (1974/75), of whom 5,173 are undergraduate students.

## 4. Educational Services

Organizational structure: The university has twelve divisions and schools and three libraries (students also have access to library facilities in many federal agencies and national organizations). The Master of Arts in Teaching in Museum Education is administered by the Department of Education within the School of Education (the program is interdisciplinary, however, and students take courses throughout the university).

Range of services: The university offers 73 undergraduate degree programs. A wide range of graduate programs provides the student in museum education with many graduate-level courses which can be related to museum collections—for example, American studies or art history. Other services include the speech and hearing clinic, the reading center, veterans education, the university computer center, and continuing education for women. The university also maintains a consortium agreement with other universities in the District.

Audience: All 50 states and 101 countries are represented in the student body.

# GREENVILLE COUNTY MUSEUM OF ART

420 College Street
Greenville, South Carolina 29601

### 1. General Information

Founding: Opened to the public in 1959; new building opened March 9, 1974.

Collections: The arts of North America, with special emphasis on twentieth-century United States, particularly South Carolina and the Southeast. The collection of approximately 1,000 works ranges from pre-Columbian ceramics from Costa Rica to nineteenth-century ware from Edgefield, South Carolina.

Number of paid staff: 15.

Number of volunteers: 75 in the education department.

Operating budget: $296,410 (1974). This amount includes $10,000 for capital additions in 1974; it does not include special exhibitions or acquisitions.

Education budget: $25,000 (1974) for education department programs, staff salaries, supplies, and maintenance. Other education expenses include the art school, $40,000, and the Electragraphics department, $33,254.

Sources of funding: County, private donations, membership fees, tuition fees, and commissions on sales.

### 2. Location/Setting

Size and character of city: Greenville is a small city of 61,436 (1970 census) in a county with a population of about 265,000; 48 percent of the citizens are without high school diplomas, 80 percent are white, 20 percent are black. Greenville is one of South Carolina's major manufacturing areas, calling itself the "textile center of the world." Situated in rolling hills, with some cotton crops, Greenville draws most of its sustenance from textile mills. The unemployment rate is usually very low. Near the highest point in South Carolina, the Sassafras Mountain, Greenville is neighbor to Spartanburg, South Carolina, and Smokey Mountain communities and tourist attractions.

Climate: Mild. In the foothills of the Appalachian Mountains there is less of the southern lowlands' heat.

Specific location of the institution: In a parklike setting. The new museum completes a master plan that includes a community theater with symphony rehearsal hall built in 1965 and a county library built in 1970. (Activities are coordinated among these independent organizations. For example, the opening of the new museum included an exhibition of work by N. C. Wyeth, augmented by a theater production of *Treasure Island*, a library lecture on the "Brandywine Heritage," and a symphony concert featuring two works on N. C. Wyeth composed by his daughter, Anne Wyeth McCoy.) The new location of the museum is more accessible to the downtown shopping area than the old Southern mansion that was formerly its home.

Access to public transportation: Close to public bus route.

### 3. Audience

Membership: 1,000 in the Greenville County Art Association.

Cost: student, $5; individual, $15; family, $25; club, $25; patron, $50; corporate, $100–$1,000.

Attendance: 100,000 in 1974, an increase of nearly 50,000 over previous years. The new museum continues to draw more than 100,000 annually.

### 4. Educational Services

Organizational structure: A separate education department is headed by the curator of education, who reports to the museum director. Much of the museum's educational programing, however, is the result of close cooperation between the education department and the Electragraphics department (described in chapter 3). The museum also has a school of art (annual enrollment close to 1,000), which is a separate division within the museum.

Size of staff: Education department: 2 full-time and 60 volunteers; Electragraphics department: 2 full-time; art school: one full-time and one part-time administrator, and 17 part-time instructors.

Budget: Education department: $25,000 for programs, staff salaries, supplies, and maintenance; Electragraphics department: $33,254; art school: $40,000. The sum of these expenditures for education accounts for 33.4 percent of the museum's total budget.

Source of funds: Private contributions, dues in the Greenville County Art Association, county funds, state and federal grants, tuition fees.

Range of services: School programs in the museum for nearly every grade level, puppet performances, suitcase exhibits, audiovisual orientations, gallery tours, studio demonstrations, docent training, and an art reference library are the responsibilities of the education department. The Electragraphics department and the education department cooperate in the production of montages, videotapes, films, children's television programing, and video with artists for the state-operated student artmobile.

Audience: General public, members of the Greenville County Art Association, students in the art school, and, beginning in May 1973, 11,431 schoolchildren, grades K–12, from public and private schools in Greenville and surrounding counties, as well as university students and Greenville Technical students. In addition, the museum sees itself as serving the artist population of the Southeast.

# THE HEARD MUSEUM

22 East Monte Vista
Phoenix, Arizona 85004

### 1. General Information

Founding: 1929.

Collections: Southwest Indian arts and crafts; paintings by American Indian artists; native American, Asian, African, South American, Oceanic artifacts—over 50,000 cataloged artifacts altogether.

Number of paid staff: 18.

Number of volunteers: Women's Guild of 600 members.

Operating budget: $250,000 (1973/74).

Education budget: $15,000 (1973/74).

Source of funding: Annual Heard Foundation grant of $25,000, matched by Phoenix newspapers, private contributions, guild benefits, gift shop revenues, membership fees, admission donations of $1 general and 50¢ for children and students.

### 2. Location/Setting

Size and character of city: Phoenix, with a population of 581,562 (1970 census), is part of a standard metropolitan statistical area with a population of 968,487 (1970 census). The state capital and largest city in Arizona, it is largely a white upper- and upper-middle-class community, with many retired persons;

South Phoenix has black and Chicano populations. Located in the rich Salt River Valley, Phoenix is an important center for the electronics, aviation, furniture, steel, and aluminum industries, though it is perhaps best known as a winter retreat and health resort.

Climate: Desert; sunny year-round; hot summers, pleasant winters; year-round temperature ranges from 50° to 110°F.

Specific location of institution: Near downtown Phoenix, in an upper-middle-class residential neighborhood.

Access to public transportation: A half block from a city bus line.

### 3. Audience

Membership: 2,450 (1974). Basic fees are $10 for individuals, $15 for families. Privileges of membership: discount on museum publications, invitation to previews and openings, free admission to Sunday movies and other special programs, use of library.

Attendance: No official count is made, but the director estimated 400,000 attended in 1974.

### 4. Educational Services

Organizational structure: No separate education department. The educational aspects of the museum's activities are carried out by three curators, including curator of Indian arts, curator of anthropology, and curator of collections, who report to the director.

Size of staff: 4 full-time; 50 docents.

Budget: $15,000, or 6 percent of total operating costs.

Source of funds: From operating budget.

Range of services: Tours of museum are conducted by docents; tours for scholarly, professional, or college groups are conducted by staff members. The library is available for use by scholars, museum members, and students at no cost and by appointment. Other services include classes, traveling exhibitions, and six publications concerning primitive art and the museum.

Audience: 43,000. Although the focus is on schoolchildren (15,000 annually), educational services also draw the general public and professionals, among them American Indians.

## THE HIGH MUSEUM OF ART

Atlanta Memorial Arts Center
1280 Peachtree Street, N.E.
Atlanta, Georgia 30309

### 1. General Information

Founding: 1905; new building in use in 1968.

Collections: Western art from early Renaissance to the present; includes print collection, decorative arts, and African art.

Number of paid staff: 14 full-time; 6 part-time. Maintenance and security are provided by the Atlanta Arts Alliance.

Number of volunteers: Approximately 1,000 volunteer members of the Members Guild participate in guild-sponsored groups such as the Junior Committee, the Collectors, the Young Careers, and the Young Men's Round Table, docents, Department of Children's Education volunteers, Museum Hostesses, and the Decorative Arts Committee.

Operating budget: $427,522 in 1973; $465,000 in 1974.

Education budget: $63,400 in 1974 for salaries and supplies (does not include funds for "The City," the Georgia Art Bus, or "Shapes").

Source of funding: The museum is a private nonprofit organization, with no admission fee, supported by memberships, private donations, businesses, and foundations. Community support through membership dues provides more than one-third of entire expense budget. Income from membership has increased since 1966, when $35,120 was collected, to $175,000 in 1974.

### 2. Location/Setting

Size and character of city: Situated in the foothills of the Blue Ridge Mountains, metropolitan Atlanta, with a million and a half people, 54 percent of whom are black, is the major urban center for the South. Twenty degree-granting institutions of higher education are located in the area.

Climate: Mild.

Specific location of institution: The Atlanta Memorial Arts Center, which houses the High Museum of Art, the Atlanta Symphony Orchestra, the Alliance Theatre Company, the Atlanta Children's Theatre, and the Atlanta School of Art, is located in a business and residential section of the city.

Access to public transportation: On a bus route.

### 3. Audience

Membership: As of May 1974, membership was 7,600. Cost: family, $20; individual, $10; patrons, $100 to $5,000. One thousand members join the Members Guild for an additional $5 to give service to the museum. Patron memberships, which have grown from 102 to 544 over the past five years, represent only 8 percent of the total membership but 45 percent of the income generated by membership.

Attendance: 305,413 (1974).

### 4. Educational Services

Organizational structure: Separate department with curator of education who reports to the museum director.

Size of staff: 4 full-time; 2 part-time; 190 volunteers.

Budget: $63,400 for 1973/74, includes salaries and program supplies. Additional education expenses are $20,000 for "Shapes" exhibition; $45,000 for "The City" exhibition; and $8,000 for the Art Bus.

Source of funds: Museum budget; City of Atlanta through the Arts Alliance; volunteer support through sales of creative materials for children; subscription sales to Adventures in Looking; films; lectures; and grants.

Range of services: Publications, tours, creative packaging of art materials, coordinated school and museum visit series, children's workshop subscription series, Georgia Art Bus, film series, lecture series, special events, demonstrations in conjunction with exhibitions, Looking at Art course for members, outreach programs, volunteer training, special exhibitions ("Shapes" and "The City"), and the Junior Activities Center workshop.

Audience: Large number of museum volunteers, Atlanta schoolchildren, the museum membership, and general public. Elementary Art to the Schools reached 3,663 Atlanta 6th graders in 1973/74; an additional 5,036 schoolchildren participated in other museum education programs (270 of these were inner-city children who took part in a special program).

# HIGH SCHOOL FOR THE PERFORMING AND VISUAL ARTS

3517 Austin Boulevard
Houston, Texas 77004

## 1.  General Information

Founding: 1971.

Number of paid staff: In arts, 14 full-time, variable hourly; academic, 29 full-time, one hourly; media technology, project director and 2 full-time teachers.

Operating budget: Arts and academic departments: $528,765 (1972/73); $408,925 (1973/74); $410,532 (1974/75). The 1974/75 budget for arts and academic departments breaks down as follows: faculty, $402,801; supplies, $3,136; equipment, $2,370; utilities and rental, $1,725; fees and dues, $500.

The 1973/74 operating budget for the media technology department was $42,730, allocated as follows: project director, $16,500; faculty, $18,430; supplies $7,400; maintenance and repair, $400.

Source of funding: The Emergency Schools Assistance Program, Title 45, provided a planning grant of $100,000 in 1971; a separate grant of $100,000 from Texas Education Agency got the media technology department started at the same time. Since January 1972, the school has been funded by the Houston Independent School District (HISD) with incidental support from the Fine Arts Advisory Council, Media Technology Advisory Board. The cost per student per year is $700, the same as for other HISD high school students. The state pays about $1.85 per student per day.

## 2.  Location/Setting

Size and character of city: Houston, Texas, with a city population of 1,232,802 (1970) and a standard metropolitan statistical area population of 1,985,031 (1970), is the third largest port city in the United States, with foreign trade in excess of $2 billion. An important space center, it is also the most diversified manufacturing city in the South. The petrochemical industry and trade and banking account for the largest volume of business, their glassy architectural symbols dotting the urban landscape with aggressive exclamation marks. Houston's population is 80 percent Anglo (6 percent of whom have Spanish surnames) and 20 percent black. City school tax is based on $32 per thousand, with a 53 percent valuation.

Climate: Hot, humid summers; mild (humid) winters.

Specific location of institution: In the center of the city; in proximity to the Museum of Fine Arts, Houston, the Houston Contemporary Arts Museum, and Rice University; and across the street from the Houston Technical Institute (HISD).

Access to public transportation: Public buses available.

## 3.  Audience

Enrollment: 600; approximately 200 in each class, sophomore, junior, and senior. The ethnic mix (1973/74 figures) is 52 percent Anglo, 32 percent black, and 16 percent Mexican-American. Attrition levels at approximately 20 percent per year, all classes.

## 4.  Educational Services

Organizational structure: The school is headed by a director. The governing authority is the HISD.

Range of services: Offers a realistic option to students who are not stimulated by traditional high school environments and who are on the brink of dropping out. The program combines technical, arts, and academic studies aimed at challenging the "academic underachiever" and students with talent and serious professional ambitions. Media technology graduates may find immediate employment in local business or industry or may go on to further specialized training.

Objective: To develop talents in art, drama, dance, media, and music; to prepare students academically for further study in these areas; to develop the skills necessary for employment in these areas; and to demonstrate the interrelatedness of the arts and to lay the groundwork for a lifetime participation and pleasure in the arts.

Time: Same as regular school year, August to May. Students of the Houston High School for the Performing and Visual Arts, however, spend one hour more per day in school than do other Houston high school students.

Information and documentation available from the institution: 1971 proposal, brochures, and Southern Association of Colleges and Secondary Schools evaluation.

# THE INDIANAPOLIS MUSEUM OF ART

1200 West 38th Street
Indianapolis, Indiana 46208

## 1.  General Information

Founding: 1883, as "Art Association"; until 1969 called the John Herron Art Institute; moved to new building and renamed the Indianapolis Museum of Art, 1970.

Collections: Representative collections of European, American, and primitive art, scattered examples of ancient art. Concentrations in Oriental jades, seventeenth-century Dutch painting, porcelains, American nineteenth- and early twentieth-century painting.

Number of paid staff: 79 full-time, 76 part-time, including teachers.

Number of volunteers: 1,805 give a minimum of one day a month; this includes 200 docents.

Operating budget: Approximately $2,000,000 in 1973/74.

Education budget: $196,350, or nearly 10 percent of total operating budget.

Source of funding: 96 percent from private sources (special gifts, admissions, fees, sales shop, investment income, and memberships); 4 percent from schools, grants, and other public sources.

## 2.  Location/Setting

Size and character of city: Indianapolis, with a population of 744,743 (1970 census), is part of a standard metropolitan statistical area with a population of 1,109,882 (1970 census). It is the largest and most important city in a state of a little more than 5 million population. The city—and the museum—sees its major role as statewide. Like most American cities, it has its "old money," which has traditionally underwritten the museum and other cultural activities; its "new money" is apparently more involved with sports and the speedway, which is Indianapolis's claim to national fame.

Climate: Generally moderate winters with some severe storms; hot, dry summers.

Specific location of institution: The museum, in a spanking new building (1970), is set about 5 miles from downtown in 154 acres of formal gardens, woods, pools, complete with a 40-acre lake and an old canal.

Access to public transportation: None.

**3. Audience**

Membership: 11,043; 1.08 percent of population, the highest of any museum, according to the 1974 American Art Directory. Membership cost: Annual family, $15; "education" membership (student, teacher, clergy), $7.50, and up. A reciprocal membership, at $100, includes membership also in the Corcoran Gallery, the Metropolitan, the Museum of Fine Arts in Boston, the Philadelphia Museum, the Detroit Institute, the Dallas Museum, and the Toledo Museum of Art; there are 43 reciprocal members.

Attendance: 600,000 annually. Admission is free.

**4. Educational Services**

Organizational structure: Separate education department is headed by a curator, who reports to the museum director.

Size of staff: 12, including two secretaries; 12 part-time.

Number of volunteers: 7 docent chairmen help coordinate approximately 200 docents in seven groups; one Artery helper.

Budget: $196,350, or nearly 10 percent of operating budget. (*Note*: The total operating budget of approximately $2 million includes a sizable amount for buildings and grounds care; excluding this amount, the percentage of monies used for education is much greater.) Expenditures are as follows: $86,350 for the budgeted education program; $10,000 for special programs funded by grants; $100,000 for salaries, wages, fringe benefits.

Source of funds: $14,000 from city covers all Indianapolis Public Schools museum programs. Other sources include: National Endowment for the Arts, Junior League, class tuitions, private grants.

Range of services: A library of 25,000 slides for use by professionals, study groups, and staff; film series, concerts, lectures; bi-monthly news bulletins; program notes and film schedules; brochures for art classes and special events; 16-mm films and educational filmstrips, multi-image shows for gallery use; closed circuit video for in-house and public productions; clearinghouse for audiovisual, multi-image information, films, and videotapes; special educational projects with schools; program tours for grade schools, high schools, colleges, adults on general collection and specific areas; a touch-educational gallery to relate with tours; training of approximately 200 volunteer docents; extension lectures in the schools, grades 1–12; high school student council and related exhibitions.

Audience: 28,607 school students on 1,405 tours, 600 in museum classes; 430 adult tours; 240 adult classes; 15,000 attended special performances.

# INSTITUTE OF AMERICAN INDIAN ARTS MUSEUM

Cerrillos Road
Sante Fe, New Mexico 87501

**1. General Information**

Founding: 1962.

Collections: Contemporary American Indian arts and crafts (the only such collection existing), including between 5,000 and 8,000 items of paintings, sculpture, jewelry, textiles, costumes, basketry, musical instruments, ceramics.

Number of paid staff: 3 full-time.

Number of volunteers: None, although many students are involved in museum maintenance activities.

Operating budget: Approximately $8,000 a year, including $6,000 for classroom instruction and $2,000 for exhibits. Utilities, building maintenance, and major repairs are financed by the school. Staff are government employees; their salaries are not included in the museum budget.

Source of funding: Bureau of Indian Affairs, U.S. Department of the Interior, plus National Endowment for the Arts grant.

**2. Location/Setting**

Size and character of city: Santa Fe has a population of 41,167 (1970 census), 50 percent Anglo, 40 percent Spanish, and 10 percent Indian. The institute and the museum serve the entire state of New Mexico, which has a population of approximately one million.

Climate: Temperate spring, summer, fall; mild winter.

Specific location of institution: In the heart of the historic Pueblo Indian settlements clustered along the Rio Grande about 3 miles from the center of Santa Fe but, technically, within the city limits.

Access to public transportation: None.

**3. Audience**

Membership: None. Enrollment: about 300 high school and college-age American Indians, Eskimos, and Aleut; 10 to 12 are in the museum training program. Fees: none.

Attendance: 3,300 from July 1973 to January 1974; 30 to 50 persons visit the museum daily in the fall and winter; up to 100 per day in the summer. Open Monday through Friday.

**4. Educational Services**

Organizational structure: The museum has no separate education department. The director of the institute serves as museum head, teaches museum theory and problems, and is the receptionist, secretary, and janitor for the museum. He designs and installs exhibitions, handles public relations, maintains collections, plans traveling exhibitions, and is the planner-designer of outlying visitors' centers. He oversees the work of the curator of traditional techniques and the curator-in-charge.

Size of staff: 3.

Budget: About $6,000 yearly for classroom education and $2,000 for exhibitions.

Source of funds: Bureau of Indian Affairs, U.S. Department of the Interior.

Range of services: The institute trains about 150 high school juniors and seniors and 150 college freshmen and sophomores (American Indian, Eskimo, and Aleut) per year. Majors include museum training, graphic arts, teacher training, crafts (ceramics, sculpture, metals), accredited by Rhode Island School of Design. Humanities program includes Indian history; comparative literature; arts and civilization of the Americas; native American contemporary affairs, beliefs, and behavior; psychology; creative writing and media workshops. Courses and programs are also offered in the performing arts. The institute contains a museum with a permanent collection and mounts a series of special exhibitions. Special events and exhibits: 1973 Mountain-Plains Museum Conference covering "Indian

Museums'' and ''Use of Indian Collections in American Museums''; 200 museum professionals attended. There are eight traveling exhibits that cover traditional and contemporary American Indian art and artifacts, and five more were planned for completion by June 1974. The institute maintains the Bureau of Indian Affairs Cultural Studies Research and Resource Materials Development Center.

# INSTITUTE OF CONTEMPORARY ART

955 Boylston Street
Boston, Massachusetts 02115

## 1. General Information

Founding: 1935, as a branch of the Museum of Modern Art; in 1938 it was incorporated as a separate institution.
Collection: No permanent collection.
Number of paid staff: 11.
Number of volunteers: Approximately 100.
Operating budget: $211,000 (1974).
Education budget: $70,000 (1974).
Source of funding: National Endowment for the Arts; Massachusetts Council for the Arts and Humanities; individuals and private foundations, both local and national.

## 2. Location/Setting

Size and character of city: Boston is a part of a standard metropolitan statistical area consisting of 78 surrounding cities and towns with a population of 2,753,700 (1970 census); the City of Boston alone has a population of 641,071 (1970 census). The ''Hub of the Universe'' and the ''Athens of America,'' as it has been called by its admirers, Boston is not only an important center of the historical beginnings of the American nation but a varied cultural and literary center in present-day American life as well. Renewal has transformed downtown Boston into a new government center, and skyscrapers crowd the financial district, which is home to Boston's banking and financial enterprises. Boston's school system has an enrollment of 100,000. Within the immediate area there are 52 colleges and universities.
Climate: New England, seasonal.
Specific location of institution: The institute is located in the center of a business, shopping, and residential area. Its recently acquired (February 1972) permanent home is a former police station, which will contain, among other things, a computer link-up through a nationwide catalog system that provides information on major contemporary art objects and artists in the U.S.
Access to public transportation: Bus and subway transportation are immediately available.

## 3. Audience

Membership: 400 (1974). Cost: individual, $20; family, $25.
Attendance: 4,735 (1974). (During 1974 the institute was housed in temporary quarters pending a move to the new galleries. Since the move membership has tripled, and attendance will be at least double that of 1974.)

## 4. Educational Services

Organizational structure: Two of the institute's permanent staff administer the education program, which is headed by the director of VALUE, who reports to the director of the institute.
Size of staff: 2.
Budget: $70,000, or about 30 percent of the operating budget.

Source of funds: Operating budget.
Range of services: The VALUE program comprised the entire educational program of the institute during 1973/74.
Audience: The VALUE program is designed for junior and senior high school students.

# JUNIOR ARTS CENTER

Barnsdall Park
4814 Hollywood Boulevard
Los Angeles, California 90027

## 1. General Information

Founding: 1966. The buildings and class programs were opened to the public in May 1967.
Collection: Approximately 200 works by young people ages four to seventeen, including paintings (watercolor, acrylic, and tempera), print media (etching, silk screen, wood, and lino block), drawings, and photographs. There is also a cataloged but unedited collection of 8-mm student films.
Number of paid staff: 9 full-time; 13 art instructors paid hourly; 1 to 4 occasional gallery attendants. Veterans are hired, as needed, under the Emergency Employment Act; during the summers, workers are hired from the Neighborhood Youth Corps.
Number of volunteers: Approximately 25.
Operating budget: Averages approximately $200,000 per year. There is no separate budget for education; the entire function of the Junior Arts Center is educational.
Source of funding: The City of Los Angeles. In addition, the Friends of the Junior Arts Center attempt to raise $10,000 annually through membership and special fund-raising events. This money is allocated for art supplies and equipment (some is set aside to help cover a health insurance plan for art instructors who are not covered under the city plan). Cost per person for class participation: $35; for gallery and special programs: $1. Governing authority: The Junior Arts Center is a division of the Municipal Arts Department of the City of Los Angeles.

## 2. Location/Setting

Size and character of city: Los Angeles, with a population of approximately 3,000,000, is home to an extremely varied mix of ethnic and income groups. In the neighborhood of the Junior Arts Center alone there are Spanish surname and black (Barnsdall Park edges sizable communities of each); a large Asian community spreading out from Little Tokyo and Chinatown and including Philippine, Korean, and Thai people; a sizable representation of Lebanese, Syrian, and Arabic peoples, as well as Central European Jews and white Russians; in recent years there has been an increasing influx of Central and Eastern European families. Children of 18 different ethnic groups attend the public school across the street from the center. Income groups range from the extremely wealthy residents of Hollywood Hills to the north to low income and poverty-level residents to the south.
Climate: Temperatures range between 50° and 80°. The mild climate and extreme lack of rain during recent years has made possible the scheduling of outdoor activities in the park as part of the class program. From July through August, however, a heavy smog level, when not relieved by wind, is a deterrent to outdoor activities.

Specific location of institution: On an olive tree-studded hill in Barnsdall Park in what is known as the Los Feliz district—also called East Hollywood. Adjacent to the center is the Hollyhock House (designed by Frank Lloyd Wright in 1920), the Municipal Art Gallery, and the Arts and Crafts Center, operated by the Recreation and Parks Department, for adults.

Access to public transportation: On major bus lines.

### 3. Audience

Membership: No memberships. The programs of the Junior Arts Center are offered free of charge to all citizens of Los Angeles.

Attendance: Classes: approximately 3,200 students make approximately 30,000 visits yearly; some attend for an entire semester, others as little as one session only. Gallery program: 23,000 yearly. Special events: 1,000.

### 4. Educational Services

Organizational structure: The Junior Arts Center is one of five divisions of the Municipal Arts Department of the City of Los Angeles. The director, who is also the division head, reports to the Board of Trustees and to the general manager of the Municipal Arts Department, who is directly responsible to the mayor of Los Angeles.

Range of services: Tours or participation visits (determined by nature of current exhibit), approximately 100 hours of instruction weekly for 40 weeks per year (three quarters plus a summer session), special events such as Indian sand painting and Kachina doll carving, visits of a pantomime artist and a drama group, kite days at public schools. In the schools: artists from the center conduct special programs; staff assist in mural-painting projects. In the community: participation in events and projects such as the County Art Museum's annual Youth Expression Festival and the All-City Arts Festival. For adults: workshops for those who work with children; a training program for volunteers to work as classroom assistants.

Objective: To offer young people in Los Angeles the fullest opportunity to develop their creative capacities through participation in the arts.

Time: Open year-round.

Information and documentation available from the institution: Brochure, Junior Arts Center, 1968; announcements of classes each semester, 1968–present; postcards of drawings by stuents; slide presentations.

## THE KIMBELL ART MUSEUM

Will Rogers Road West
P.O. Box 9440
Fort Worth, Texas 76107

The Kimbell Museum has chosen not to disclose information about its staff, budget, organizational structure, and other matters covered in these institutional checklists. For information about specific Kimbell programs, see chapters 5 and 6.

## MEMORIAL ART GALLERY
## UNIVERSITY OF ROCHESTER

490 University Avenue
Rochester, New York 14607

### 1. General Information

Founding: 1913.

Collections: Approximately 5,000 objects survey world art from ancient Egypt to contemporary America. The collection includes a good selection of American painting and some American folk art. No masterpieces.

Number of paid staff: 40 full-time; about 50 part-time art instructors.

Number of volunteers: 230 (Women's Council and docents).

Operating budget: $745,000 (1973/74).

Education budget: $35,000 (special programs not included).

Source of funding: From membership fees, about 50 percent; university support, about 12 percent; New York State Council on the Arts, about 10 percent; class fees, about 9 percent; endowment, about 10 percent; plus admissions fees, gifts, token support of city and county.

### 2. Location/Setting

Size and character of city: Rochester's population of 296,233 (1970 census) includes the highest percentage of skilled, technical, and professional employees of any major metropolitan area in the country. Rochester is sixth highest of all American cities in per capita income and has one of the nation's highest ratios of Ph.D.'s and millionaires. The black population increased from 6,500 in 1950 to 33,000 in 1964; 15,000–20,000 Puerto Ricans reside in Rochester. Rochester's standard metropolitan statistical area is 882,667 (1970 census).

Climate: Cool, temperate winters due to closeness of Great Lakes.

### 3. Audience

Membership: Approximately 8,600, of whom 800 are "special gift" memberships costing $30 and up; 241 are corporate memberships at $25 and up; the rest are family memberships at $20.

Attendance: 170,000 in 1973/74, of whom 36,000 attended the Medieval Faire and 60,000 the Clothesline Show. Admission to the museum is 50¢; senior citizens are admitted at half-price.

### 4. Educational Services

Organizational structure: The Memorial Art Gallery is legally a department of the University of Rochester, but it functions as a totally independent institution. The assistant director for education of the museum heads a separate department and reports to the director of the museum.

Size of staff: 5 full-time, 6 part-time. In addition to the regular staff (some of whom spend time on special programs), 49 part-time workshop instructors and aides assist in Creative Workshop and Allofus Art Workshop activities, along with 110 volunteers.

Budget: $35,000 annually for the operating expenses of the education department ($26,000 pays a portion of staff salaries, the rest for supplies, equipment, telephone, etc.). Other gallery activities that are educational in nature are funded by separate budgets: exhibitions, lectures and programs, the library, Creative Workshop, Allofus Workshop, and others.

Range of services: Gallery tours, loan materials, travel-exhibits, in-school lectures, visiting artists, Creative Workshop, Allofus Art Workshop, library, classes for the handicapped,

some lectures and films, teacher-training classes, community art shows, and special events for children.

Audience: Serves most segments of Rochester community but reaches primarily the white middle class.

Objective: "To be an instrument of art education."

Time: Open year-round.

Information and documentation available from the institution: None.

# METROPOLITAN MUSEUM OF ART

Fifth Avenue and 82nd Street
New York, New York 10028

## 1. General Information

Founding: 1870.

Collections: Covers 5,000 years representing arts of Egypt, Babylonia, Assyria, Greece, Rome, the Near and Far East, Europe, pre-Columbian cultures, and the U.S.; painting, sculpture, architecture, prints, drawings, glass, ceramics, metalwork, furniture, period rooms, textiles, costumes, arms and armor, musical instruments. Roughly one million objects in the collection.

Number of paid staff: 852 full-time; 100–250 part-time, depending on season, special exhibitions.

Number of volunteers: 367.

| | | | |
|---|---|---|---|
| Arms and Armor | 2 | Medieval Art | 4 |
| Ancient Near East | 3 | Membership | 32 |
| Catalog | 2 | Photograph Studio | 1 |
| The Cloisters | 8 | Photograph & Slide | |
| Community Programs | 7 | Library | 8 |
| Conservation Lab. | 1 | Primitive Art | 2 |
| Costume Institute | 34 | Prints & Photographs | 5 |
| Drawings Department | 1 | Public Information | 2 |
| European Paintings | 2 | Public Education | 139 |
| Far Eastern Art | 4 | Sales | 8 |
| Greek and Roman Art | 1 | Office of Vice-Director | |
| High School Programs | 39 | for Finance | 1 |
| Junior Museum | 50 | Twentieth-Century Art | 1 |
| Library | 7 | Western European Arts | 3 |

Operating expenses: $13,962,004 (1973/74); expenditures for education: $1,448,049 (includes community programs and libraries).

Source of funding: Endowment (41.1 percent), City of New York (20.4 percent), memberships (6.3 percent), auxiliary activities (8.2 percent), admissions (7.6 percent), gifts and grants (5.8 percent), contributions (6 percent), royalties and fees (1.9 percent), all other (2.7 percent).

## 2. Location/Setting

Size and character of the city: New York City, with a population of 7.9 million in a standard metropolitan statistical area of about 15.5 million, is the nation's leading industrial and commercial center. Its five boroughs boast 42 museums, plus many parks, zoos, botanical gardens, theaters, and concert halls. Its educational facilities include 6 universities, 23 colleges, 976 public schools, over 1,000 private schools, and 199 public libraries.

Climate: New York has a temperate climate which seldom affects attendance at cultural institutions or events.

Specific location of institution in the community: Manhattan's Upper East Side, on the edge of Central Park.

Access to public transportation: Several bus lines stop in front of the museum; subway seven blocks away.

## 3. Audience

Membership size (June 1974) and price:

| | |
|---|---|
| Student ($15) | 1,496 |
| Individual ($25) | 16,551 |
| Family ($40) | 6,030 |
| Sustaining ($100) | 1,574 |
| Supporting: | |
| Contributing ($250) | 173 |
| Donor ($500) | 35 |
| Sponsor ($1,000) | 13 |
| Patron ($2,500) | 3 |
| total | 25,875 |

Attendance: 2.5 million visits (up 13.5 percent from 1972/73).

## 4. Educational Services

Organizational structure: Seven educational departments—Junior Museum, high school programs, public education, education at the Cloisters, community programs, Thomas J. Watson Library, Photograph and Slide Library.

Title of department head: Deputy vice-director for educational affairs reports to vice-director for curatorial and educational affairs, who reports to the director of the museum.

Size of staff: 63 full-time, 24 regular part-time, plus apprentices, interns, fellows, and volunteers.

Budget: $1,488,049 (10.7 percent of the total annual operating budget) for education, community programs, and libraries.

Source of funds: Same as 1. Source of funding.

Range of services: Programs for children (visits for schoolchildren, weekend and vacation activities for individual children, activities for members' children); programs for high school students (school visits, courses offered after school and weekends, apprenticeships in various departments, school visits to the Cloisters); services for teachers (in-service courses); educational materials (museum publications, multimedia programs, films and filmstrips, slide library); university and professional training (undergraduate courses at the museum, museum training, museum workshop program, international museum studies program [discontinued 1974, lack of funds], summer museum training programs, fellowships); services for the general visitor (orientation galleries, reading room [discontinued 1974, lack of funds], publications, free gallery talks, taped tours, free films, Sunday at the Met subscription lectures); community programs (borough exhibitions, technical assistance, senior citizens, workshops, community exhibitions, community art lectures, Spanish language program, community leadership series, Cloisters programs). Educational facilities include the Cloisters, Junior Museum, Photograph and Slide Library, the Thomas J. Watson Library, concert and lecture rooms.

Audience: September 1973–May 1974, 147,000 people in 6,000 registered groups participated in the educational programs: junior museum tours and visits, 68,000; high school tours, visits, and programs, 45,000; college tours and visits, 22,000; and adult tours and visits, 12,000. At least that many again, coming as individuals, took part in after-school, weekend, and summer programs, or took advantage of self-service materials prepared by the education departments such as taped tours, orientation aids, treasure hunts.

# MILWAUKEE ART CENTER

750 North Lincoln Memorial Drive
Milwaukee, Wisconsin 53202

1. **General Information**

   Founding: In 1957 the Milwaukee Art Institute and the Layton Art Gallery joined to form the Milwaukee Art Center. An extensive addition, under construction during the period of this study, will almost double the present exhibition space.

   Collections: All historical periods are represented; the emphasis is on modern and contemporary paintings and sculpture from Europe and America.

   Number of paid staff: 30.

   Number of volunteers: 75, all docents in the education department.

   Operating budget: $546,666 (1974).

   Education budget: $110,167 (1974); about 20 percent of the operating budget.

   Source of funding: Membership, plus money from Milwaukee County and annual fund drives.

2. **Location/Setting**

   Size and character of city: With a population of 717,372 (1970 census), Milwaukee is the thirteenth largest city in the country; the standard metropolitan statistical area (which includes four counties) has a population of 1,403,887 (1970 census). Known for its cleanliness and beauty as well as its breweries, Milwaukee also has enthusiasm for its cultural institutions, among them the Milwaukee Public Museum, the Performing Arts Center—home to the Milwaukee Symphony Orchestra, a resident repertory theater, and a resident opera company—and of course the Milwaukee Art Center, whose collection is housed in a building designed by Eero Saarinen. Although Milwaukee is characterized by a strong German influence, the ethnic mixture also includes blacks (14.7 percent), American Indians, and other minorities.

   Climate: Cold, damp winters; mild, semihumid summers.

   Specific location of institution: In the Milwaukee County War Memorial Building on the shore of Lake Michigan, a few blocks from the downtown area, on a major thoroughfare.

   Access to public transportation: Bus lines run directly to the front door. Limited free parking is available.

3. **Audience**

   Membership: 3,000 (1974). Cost: benefactor, $5,000; patron, $1,000; advocate, $500; supporting, $250; sustaining, $100; associate sustaining, $50; family, $20; individual, $17.50; student, $5.

   Attendance: The institution could not provide figures because of construction of a new wing, which has kept parts of the museum closed during this period.

4. **Educational Services**

   Organizational structure: The education department is a separate department within the museum.

   Size of the staff: 5 full-time; 75 docents.

   Budget: $110,167 (1974).

   Range of services: In-class presentations; adult tours and school tours; teacher orientation sessions; slide programs, rentals, and sales; rental of resource materials; special exhibitions; circulating exhibitions; lectures; seminars; film series; concerts; docent training; classes for children.

   Audience: "We serve the entire community," says a spokesman for the institution.

# THE MINNEAPOLIS INSTITUTE OF ARTS

201 East 24th Street
Minneapolis, Minnesota 55404

1. **General Information**

   Founding: 1915.

   Collections: General art historical museum; strong collections of Oriental objects (bronzes and archaic jades), Italian painting (strong in Roman eighteenth-century), Dutch painting, German expressionists, tapestries.

   Number of paid staff: 50.

   Number of volunteers: Approximately 200 active.

   Operating budget: $935,000 (1973/74).

   Education budget: $165,000 (1973/74).

   Source of funding: Derives primarily from endowed funds which are mostly local; also grants (private and public), tax money from Hennepin County, a small amount from the schools, donations, membership. Governing authority: Minneapolis Society of Fine Arts.

2. **Location/Setting**

   Size and character of city: The Minneapolis/St. Paul standard metropolitan statistical area has a population of 1,813,647 (1970 census). The population of Minneapolis is 434,400 (1970 census), 4.3 percent black and 1.3 percent American Indian. Minneapolis is a lively cultural center, home to the Minnesota Symphony Orchestra, the Tyrone Guthrie Theater, the Minneapolis Institute of Arts, and the Walker Art Center, as well as numerous theater companies, dance organizations, art centers, two operas, and 30 art galleries. Approximately 20 degree-granting institutions of higher learning are located in Minneapolis and St. Paul.

   Climate: Minnesota has the most extreme temperature difference of any state in the Union. Winters are long; snow falls by mid-November and is usually on the ground until April. Summers are hot and humid.

   Specific location of institution: In a city park and a middle-class residential area.

   Access to public transportation: A bus line runs about one city block from the institute.

3. **Audience**

   Membership: The Minneapolis Society of Fine Arts, which includes the Art Institute, the College of Arts and Design, and the Children's Theatre Company, has a total membership of 8,000. Cost of membership: individual, $15 for one year, $25 for two years; family, $25 for one year, $45 for two years; educator, $12.50 for one year, $20 for two years; family of educator, $17.50 for one year, $30 for two years; individual, nonresident (25 miles or more from the institute), $10 for one year, $15 for two years; nonresident family, $15 for one year, $25 for two years; student, $5 for one year; individual life membership, $500.

   Attendance: 550,550 attended society functions of the institute and the Children's Theatre Company in 1971. (These are the

latest figures available, as the museum closed in the fall of 1972 for approximately two years of construction and renovation.)

**4. Educational Services**
Organizational structure: The chairperson of the education division, who is also the associate director of the institute, reports to the director.

Size of staff: 14; 60 docents.

Budget: $165,000.

Source of funds: Staff salaries come from operating budget of the institute. Additional programs, staff, supplies, and equipment are funded by grants from private and public sources, and from the Minneapolis public school system.

Range of services: Lectures, docent tours, recorded tours, programs to assist teachers in curriculum development, inner-city and statewide artmobile outreach, films, adult and children's classes, demonstrations, publications, programs for the visually impaired, programs to distribute information about activities in the region, exhibitions, slide-tapes.

Audience: Teachers and schoolchildren; a good cross-section of the adult population.

# MINNEAPOLIS PUBLIC SCHOOLS

807 N. E. Broadway
Minneapolis, Minnesota 55413

**1. General Information**
Founded: Circa 1870.

Number of paid staff: 7,075 (1973/74); 6,970 (1974/75).

Number of volunteers: 1,000 (1973/74); 1,200 (1974/75).

Operating budget: $75,593,430 (1973/74); $80 million (1974/75).

Source of funding: Local, state, county, and federal.

**2. Location/Setting**
Size and character of city: The Minneapolis/St. Paul standard metropolitan statistical area has a population of 1,813,647 (1970 census). The population of Minneapolis is 434,400 (1970 census); 4.3 percent are black and 1.3 percent are American Indian. Minneapolis is a lively cultural center, home to the Minnesota Orchestra, the Tyrone Guthrie Theater, the Minneapolis Institute of Arts, and the Walker Art Center, as well as numerous theater companies, dance organizations, art centers, two operas, and 30 art galleries. Approximately 20 degree-granting institutions of higher learning are located in Minneapolis and St. Paul.

Climate: Minnesota has the most extreme temperature difference of any state in the Union. Winters are long; snow falls by mid-November and is usually on the ground until April. Summers are hot and humid.

Specific location of institution: The Minneapolis Public School System includes 91 attendance centers within the city limits of Minneapolis.

**3. Audience**
Enrollment: Total for 1973/74: 58,187; K–12: 13,470; junior and senior high: 14,040. Total for 1974/75: 55,570; K–12: 13,149; junior and senior high: 13,584.

**4. Educational Services**
Organizational structure: During the period of the CMEVA study, the Minneapolis Public School System was headed by Superintendent John B. Davis, Jr. (resigned June 30, 1975, to become president of Macalester College, St. Paul, Minnesota). Urban

Arts and Humanities, that portion of the Minneapolis educational program which is the focus of this study, functions autonomously within the system, with Wallace Kennedy as project administrator.

Range of services: What sets the Minneapolis educational program apart for the purposes of this study is its innovative arts program, which is discussed in detail in chapter 10. Urban Arts and Humanities, as it is called, brings artists from eight different arts organizations into the schools for workshop sessions that serve a full range of grades; junior and senior high students participate in an out-of-school workshop program in various locations with studio and performing artists.

# MUSEUM EDUCATION ROUNDTABLE

1227 G Street, N. W.
Washington, D. C. 20005

**1. General Information**
Founding: Founded in 1969 as the Museum Educator's Roundtable. Incorporated in 1971 and name changed to Museum Education Roundtable (MER).

Number of paid staff: 2 part-time.

Number of members: About 100 museum educators and schoolteachers.

Operating budget: $18,470 (1973); $7,454 (1974).

Sources of funding: In 1973, $15,500 came from a grant from the National Endowment for the Arts, the rest from the Roundtable's regular sources—membership dues ($10 a year), gifts, and publication sales (*Directory*). In 1974, all funds were from regular sources.

**2. Location/Setting**
MER is not an institution that is visited by the public and is relatively unaffected by transportation problems and meteorological factors. It is, however, strongly influenced by its location in the nation's capital, a city in which decisions are made affecting museums and education throughout the United States. The members feel a sense of national responsibility, and a number of the most active members work in national museums.

Washington, D.C.'s population was 756,510 in the 1970 census; it is part of a standard metropolitan statistical area with a population of 2,861,123 (1970 census). October 1973 school enrollment figures for the District of Columbia: 136,133 students, 95.73 of whom are black (72.34 percent of the city's population is black).

Specific location of the organization: MER's office is located in the northwest sector of Washington near the House Where Lincoln Died. Membership meetings are held at museums and other institutions around the city.

**3. Audience**
Membership: 100 members: museum professionals, school educators, and others who are interested in education using museum resources.

**4. Educational Services**
MER seeks to improve the educational services of museums through information exchange, and therefore all of its activities are educational.

Organizational structure: The Roundtable is governed by a board of directors.

Range of services: Publication of three editions of *The Direc-*

tory: A Guide to Museums, Nature Centers, Parks, Historic Sites, and Other Resources in the Washington Area and Roundtable Reports, an information newsletter for members; workshops for teachers and museum educators.

Audience: The members of the Roundtable, and indirectly, the children and adults they serve.

Objective: To increase cooperative efforts and planning between museums and schools, to foster professional development in museum education, and to expand and improve the educational role of museums. In 1974, MER broadened its scope in an attempt to create a network of communications among museums within a 200-mile radius of Washington (excluding New York and Philadelphia).

Time:Monthly meetings, year-round.

Information and documentation available from the organization: The *Directory; Roundtable Reports*, nos. 1–6, April to September 1973.

---

# MUSEUM OF FINE ARTS

465 Huntington Avenue
Boston, Massachusetts 02115

## 1. General Information

Founding: In Copley Square, in 1870; on its present site, in 1909.

Collections: Outstanding collections of Chinese, Japanese, Indian, Mesopotamian, Egyptian, Greek, Roman, and European art, including sculpture, paintings, prints, drawings, and decorative arts.

Number of paid staff: About 350.

Number of volunteers: About 40 to 50, excluding Ladies Committee and those associated with department of public education, or 115 to 125, including school volunteers and educational aides.

Operating budget: Approximately $5,048,000 for year ended June 30, 1974. (This amount does not include the Museum School, which operated on $1.4 million in 1974.)

Education budget: $350,000 (1973/74); $369,000 (1974/75).

Source of funding: Current operating revenues amounting to about $2.5 million come from membership, admissions, Museum Shop, restaurant, etc. Endowment, annual appeal, and other gifts account for another $2.5 million.

## 2. Location/Setting

Size and character of city: Boston has a population of 641,071 (1970 census) and is part of a standard metropolitan statistical area having a population of 2,753,700 (1970 census). The academic and cultural center of New England, the city is characterized by the contrast between the Puritan New England population, historically the source of the museum's support, and the great annual influx of students.

Climate: New England seasonal.

Specific location of institution: The museum bridges the gap between the once elegant and still beautiful Fenway—a park in Boston's "emerald necklace" designed by Frederick Law Olmsted—and the run-down and overcrowded Huntington Avenue.

Access to public transportation: Boston's public transit system runs to the museum's front door.

## 3. Audience

Membership: Approximately 13,500. Cost: student, $5 or $10; artist, $5; individual, $20; couple $30; and up.

Attendance: 535,006 in 1973/74, down from 608,171 in 1972/73. Adults pay an admission fee of $1.50; children under 16 are admitted free; Sundays from 10 A.M. to 1 P.M., admission is free to all.

## 4. Educational Services

Organizational structure: The head of the department of public education reports to the director of the museum.

Size of staff: Approximately 12 professional staff; approximately 75 volunteers.

Budget: $350,000 (1973/74); $369,000 (1974/75); about 7 percent of the annual operating budget.

Source: Operating budget.

Range of services: For children: a school visit program in which volunteers visit the school classroom prior to a volunteer-guided tour at the museum; a number of special school projects; art classes; a school lecture program; and an education gallery. For teachers: teacher orientation workshops. For adult museum visitors: gallery talks, lecture series, film programs, overseas tours, slide-tapes and film programs in conjunction with exhibitions.

Audience: Children (about 40,000 students from the Boston schools visit the museum each year), teachers participating in workshops, and other interested adults.

---

# THE MUSEUM OF MODERN ART

11 West 53rd Street
New York, New York 10019

## 1. General Information

Founding: 1929.

Collections: About 40,000 works of art from the period 1870–1970, generally agreed to be the most comprehensive collection of modern art in the world. The collection includes 3,000 paintings and sculptures, 2,600 drawings, 10,000 prints, 800 illustrated books, 3,000 examples of furniture and useful objects, an unknown number of architectural drawings, 2,000 posters, 14,000 photographs, 4,500 films, in addition to a reference library of 30,000 volumes.

Number of paid staff: 365; 61 of these are staff of the 6 curatorial departments, 31 of the curatorial staff are professionals. Education staff, 4 full-time and 1 part-time employees.

Number of volunteers: 50 members of the Junior Council; 175 members of the International Council; occasional other volunteers.

Operating budget: $6,317,402 (1973/74). The 1973/74 education budget was $212,000, or 2.65 percent of the museum's operating budget. Except for a few functions, primarily the curatorial study centers, this sum includes all the museum's educational expenditures, including staff salaries.

Source of funding: Admissions fees, membership dues and contributions, exhibition fees, grants, endowment funds, federal and state government support.

## 2. Location/Setting

Size and character of the city: New York is the nation's largest city, with a population of 7.9 million in a standard metropolitan statistical area of about 15.5 million (1970 census). This includes about 1.6 million blacks and nearly a million Puerto

Ricans (70 percent of the Puerto Ricans in the United States reside in the New York area).

New York is the country's leading industrial and commercial city as well. Its five boroughs boast 42 museums plus many parks, zoos, botanical gardens, theaters, and concert halls. Its educational facilities include 6 universities, 23 colleges, 976 public schools, over 1,000 private schools, and 199 public libraries.

Climate: Temperate. Lowest average monthly temperature over a 30-year period is 33°F., highest 77°F. The weather seldom affects attendance at cultural institutions.

Location of institution: Commercial area in mid-town Manhattan, near several other museums, just off Fifth Avenue, one of New York's main shopping centers.

Access to public transportation: Subway is right across the street, other subway and bus routes in the area.

**3. Audience**

Membership: 30,000.

Attendance: 900,000 annually.

**4. Educational Services**

Organizational structure: Director's special assistant for education runs an education office; there is no separate education department.

Size of staff: 3 full-time, 1 part-time, 1 intern.

Budget: $212,000 in 1973/74.

Source of funds (1973/74): $75,000 from the Noble Foundation, $15,000 from the Noble Foundation Endowment, $41,000 from the New York State Council on the Arts, $10,000 from the Howard Johnson Foundation, $5,000 from the museum's operating budget, $50,000 from the National Endowment for the Arts and the National Endowment for the Humanities and other foundations, $13,000 from the New York City Board of Education, $3,000 from the Gallery Dealers Association.

Range of services: Special admission rates for students from junior high through college age; teacher orientation (including preparatory materials and tours); New York City Public High School Program (guided tours, student training program, student seminars, teacher and student passes, films, slide sets); graduate study hours; museum training program (internships, volunteers, museology visits); lectures, gallery talks, study centers, library; Museums Collaborative workshop and forum; distribution of books to community organizations.

Audience: 6th grade through college students from both public and private schools. Complexion of public school groups reflects the population of the New York City public schools, 36.6 percent black, 27.1 percent Spanish-surname, 34.3 percent other. Beyond the services to schools, education programs tend to concentrate on a specialized audience of scholars and college and university students in the New York area.

## MUSEUM OF NEW MEXICO

P.O. Box 2087
Santa Fe, New Mexico 87501

**1. General Information**

Founding: 1909.

Collections: History division: 12,000 artifacts, emphasizing Southwest history and ethnology and featuring photographs by Ben Wittick, T. Harmon Parkhurst, John K. Hillers, and Charles

Lummis. Folk art division: 12,000 artifacts, with the emphasis on Spanish colonial art and folk life, including international costumes and a collection of 200 photographs. Laboratory of anthropology: 46,000 artifacts, much of the material from archaeological digs in the Southwest, including Southwest Indian pottery, textiles, jewelry, and basketry. Fine arts division: 3,067 paintings, drawings, sculptures, and photographs, mostly the work of Southwest regional artists from the late 1800s to the present, including Indian artists from 1910 to the present. Education division: 500 artifacts.

Number of paid staff: 96.

Number of volunteers: 65.

Operating budget: $886,661 (1973/74).

Education budget: $36,574 (does not include grant money).

Source of funding: State of New Mexico, grants.

**2. Location/Setting**

Size and character of city: Although the museum is located in Santa Fe, it serves a statewide audience of one million people, 50 percent of whom are Anglo, 40 percent Hispanic, and 10 percent American Indian.

Climate: Seasonal. Hot summers, snow in winter.

Specific location of institution: The education division is located in the Palace of the Governors, Santa Fe.

Access to public transportation: The museum's programs travel to the audience.

**3. Audience**

Membership: 802 (1974). Cost: individual, $10; family, $25.

Attendance: 516,345 (1974).

**4. Educational Services**

Organizational structure: The education division is one of 12 divisions of the museum; it is headed by a curator in charge, who reports to the director.

Size of staff: 5 full-time.

Budget: $36,574. Six percent of the total museum budget is allocated specifically to education; some services, however, are shared among the divisions and therefore not reflected in the budget figure for education.

Source of funds: State, and grants from the National Endowment for the Humanities and the Weatherhead Foundation.

Range of services: Programs arranged for various public associations; audiovisual programs, including slide-tapes and filmstrips; suitcase exhibits, traveling mobile exhibits, circulating exhibits; museum school; and a museum consultation program providing free materials on administering museums and historical societies.

Audience: The school mobile unit reaches approximately 60,000 to 65,000 elementary schoolchildren (grades 1–6) annually. Eight circulating exhibits are seen by approximately 30,000 to 40,000 visitors annually. The suitcase exhibits for elementary schoolchildren are used by about 5,000 children each year.

## THE MUSEUM OF THE SOUTHWEST (MIDLAND)

1705 West Missouri Street
Midland, Texas 79701

For basic information about this museum, see appendix to the report on the Texas Museums Consortium in chapter 15.

# MUSEUMS COLLABORATIVE, INC.

830 Fifth Avenue
New York, New York 10021

1. **General Information**

   Founding: Established in 1970 by the New York City Parks, Recreation, and Cultural Affairs Administration (PRCA), with a $50,000 program grant from the New York State Council on the Arts; incorporated as a separate not-for-profit educational institution in July 1972 (though it has retained its affiliation with PRCA).

   Number of paid staff: 3 full-time administrators and a secretary; cultural voucher program, a three-year project begun in 1974, employs a separate staff of 2 full-time administrators and a secretary. Consultants hired as needed for special projects.

   Number of volunteers: Schoolteachers, museum educators, curators, and trustees, and scores of specialists—from artists to botanists and deep-sea divers—have donated time to projects sponsored by the Collaborative.

   Operating budget: In 1974/75, $294,543, including $60,000 for staff salaries (see below); $6,500 for the Education Forum; $218,717 for the cultural voucher program. Operating expenditures for the first four years: $114,692 (1970/71), $132,967 (1971/72), $138,884 (1972/73), $241,349 (1973/74).

   Administrative budget: In 1974/75, $60,000, plus rent, telephone, and duplicating services from the city. Administrative expenses for the first four years were roughly the same.

   Education budget: All of the Collaborative's programs are educational.

   Sources of funding: The New York State Council on the Arts, the National Endowments for the Arts and Humanities, the National Museum Act, private foundations, and the sale of exhibition portfolios. About half the budget for the 1974/75 cultural voucher program came from the Fund for the Improvement of Post-Secondary Education of the U.S. Department of Health, Education and Welfare. The Department of Cultural Affairs of the Parks, Recreation and Cultural Affairs Administration gives the Collaborative office space, phones, supplies, and other services.

2. **Location/Setting**

   Size and character of city: New York City's nearly 8 million residents are spread over five boroughs: Manhattan, the Bronx, Brooklyn, Queens, and Staten Island. Not only are these boroughs significantly different from one another in their ethnic and income mix and in the dispersal of cultural and educational institutions, but neighborhoods within each borough vary widely. Between 1950 and 1970, 2 million predominantly white middle-class residents left the city and were replaced by 2 million black and Puerto Rican immigrants. This is a significant part of the population the Collaborative is designed to help museums serve. New York's population: 7,895,563 (1970 census); standard metropolitan statistical area: 11,528,649 (1970 census).

   Climate: Seasonal.

   Specific location of the organization: The Collaborative's administrative offices are in a commercial building at the upper edge of Manhattan's midtown business district. However, its seminars, workshops, and other events are held at museums and other sites throughout the city.

   Access to public transportation: Excellent to poor, depending on the neighborhoods in which the activities are held.

3. **Audience**

   Membership: None. Twenty-five New York City cultural institutions are listed as official participants in the Collaborative, but the organization works with a wide variety of agencies and institutions all over the city. Not only museums, but community arts organizations, public schools, and human welfare agencies take part in Collaborative programs and events.

   Attendance: Participation in Collaborative programs varies; a single event such as "Art Swap Day" may draw several hundred people, whereas workshops may be limited to as few as ten.

4. **Educational Services**

   Organizational structure: The Collaborative is governed by a 15-member board of directors, drawn from museums, schools, business, and the New York community.

   Range of services: Workshops, seminars, conferences; joint educational programs for museums and schools and museums and community organizations; services to museum professionals through the Education Forum (see below); a cultural voucher program, under which ten community organizations (in 1974/75) purchased services from seven cultural institutions; administration of a network of five school-based or -oriented cultural resource centers, which serve as experimental learning laboratories; the Education Forum, which sponsors week-long workshops, all-day seminars, and open meetings for educators from the city's museums, zoos, and botanic gardens; publications: *Annual Manual* (a directory of museum education programs), "The Inside Track" (a column in the teachers' union newspaper), a *Newsletter* (information for staff members of museums and community arts organizations).

   Audience: The Collaborative's primary direct audience in its first years was museum educators throughout New York City; increasingly the Collaborative has designed its programs for other museum professionals. Its indirect audience is students, teachers, and adults, especially those in the culturally underserved neighborhoods of the city.

   Objectives: (1) To develop a structure by which New York museums can jointly decentralize their goods and services, and (2) to support museum educators and other museum professionals who are attempting to deliver museum services to new audiences.

   Time: Programs operate year-round.

   Information and documentation available from the organization: A wide variety of newsletters, posters, program announcements.

# THE NATIONAL COLLECTION OF FINE ARTS

Smithsonian Institution
8th and G Streets, N. W.
Washington, D. C. 20560

1. **General Information**

   Founding: Opened in 1968.

   Collections: The emphasis is on American art, with collections dating from the Revolution to the present; over 11,000 pieces of art, ranging from paintings and prints to sculpture and works of the WPA. Small Indian and European collections.

Number of paid staff: 96.

Number of volunteers: 85.

Operating budget: $1.514 million (1973/74).

Education budget: $84,000 (1973/74).

Source of funding: Smithsonian budget, one or two grants.

**2. Location/Setting**

Size and character of city: Washington, D. C. (population 756,510 in a standard metropolitan statistical area of nearly 2.9 million, according to the 1970 census) has the largest concentration of museums, nature centers, parks, botanical gardens, and historic sites in the country. It is the center for federal administration, headquarters for innumerable national organizations, and one of the country's leading tourist attractions. Its cultural facilities serve a mixed audience of visitors, short-term residents, and an indigenous population that is 72 percent black (public school enrollments are nearly 96 percent black). Educational resources include five universities: American, Catholic, Howard, Georgetown, and George Washington.

Climate: Cold winters, little snow; hot, muggy summers.

Specific location of institution: In the commercial center of the city, somewhat removed from the other Smithsonian branches flanking the Mall. The museum shares the renovated Old Patent Office building with the National Portrait Gallery.

Access to public transportation: Museum is on main public transportation lines and directly accessible by the subway system now under construction.

**3. Audience**

Membership: Smithsonian Associates—national, 620,000; Washington area, 50,000. Costs: national (magazine subscription), $10 annual membership; Washington area (resident), $15 and up annual membership.

Attendance: 312,000 (1974). Large influx of school groups, smaller numbers of families, and individuals. People who go to the museum do so intentionally; its relative isolation from the Smithsonian Mall museums results in a drastically reduced tourist audience.

**4. Educational Services**

Organizational structure: Separate education department. Department head is curator (education), who reports to the director.

Size of staff: 6 full-time, including curator, associate in secondary education, associate in elementary education, artist in residence, 2 secretaries; one part-time docent coordinator.

Budget: $84,000 (1973/74), includes staff salaries; Discover Graphics; special events (Portfolio Day, Children's Day, etc.); docent training; those exhibitions arranged through the education department, especially exhibitions in the "Discover" Gallery; "Explore" Gallery (children's gallery). Education budget does not include education staff travel, or publications.

Source of funds: Smithsonian budget (federal allocations), grants.

Range of services: Exhibitions, extensive school tours, self-tour packets, teacher handouts, museum workshop program for secondary students (with simultaneous in-school outreach segment); Junior Intern program for secondary students in the Greater Washington area; Smithsonian publications and calendar; public programs.

Audience: Primarily school tours (80 percent elementary, 20 percent secondary). Adult tours offered, but only about one-eighth of the tours conducted are at this level. Approximately 18 schools participate in the museum workshop program annually, and 15–30 secondary students are enrolled as Junior Interns each year. There is a moderate tourist influx, far under the attendance at the Mall museums.

# THE NATIONAL GALLERY OF ART

6th Street and Constitution Avenue, N. W.
Washington, D. C. 20565

**1. General Information**

Founding: Established by Act of Congress, March 24, 1937; opened in March 1941.

Collections: An outstanding collection, including European and American painting, sculpture, decorative arts, and graphic arts from the twelfth to the twentieth century; eighteenth and nineteenth-century French, Spanish, Italian, American, and British paintings; European Old Master paintings; sculpture from Late Middle Ages to present; Renaissance bronzes; Chinese porcelains.

Number of paid staff: 546.

Number of volunteers: About 120.

Operating budget: $6,236,765 (1973/74).

Education budget: $453,000 (1973/74).

Source of funding: Federal appropriations. The National Gallery is technically a bureau of the Smithsonian Institution but is an autonomous organization governed by its own board of trustees, headed by the Chief Justice of the United States.

**2. Location/Setting**

Size and character of city: Washington, D.C. (population 756,510 in a standard metropolitan statistical area of nearly 2.9 million, according to the 1970 census) has the largest concentration of museums, nature centers, parks, botanical gardens, and historic sites in the country. It is the center for federal administration, headquarters for innumerable national organizations, and one of the country's leading tourist attractions. Its cultural facilities serve a mixed audience of visitors, short-term residents, and an indigenous population that is 72 percent black (public school enrollments are nearly 96 percent black). Educational resources include five universities: American, Catholic, Howard, Georgetown, and George Washington.

Climate: Generally mild; little snowfall; humid in summer.

Specific location of the institution: In an area bounded by the Mall and Constitution Avenue, between 3rd and 7th Streets.

Access to public transportation: On several bus routes and subway route.

**3. Audience**

Membership: Smithsonian Associates—national, 620,000; Washington area, 50,000. Costs: national (magazine subscription), $10 annual membership; Washington area (resident), $15 and up annual membership. There are no memberships in the Smithsonian's individual museums.

Attendance: 1,263,690 (1974).

**4. Educational Services**

Organizational structure: A separate education department is headed by a curator in charge of education, who reports to the assistant director of the museum.

Size of staff: 17.

Budget: $453,000. Additional amounts from trust funds supported the gallery's calendar of events and guest lecturers.

Source of funds: Operating budget (federal appropriations).

Range of services: Informational programs in conjunction with special exhibitions, including guided tours, a recorded tour, lectures, films, large wall labels, and radio programs. Other services include formal education program for children, docent program, intermuseum and school loan service, and traveling exhibitions.

Audience: Educational events drew 155,073 in 1974. Of the total, 107,125 attended gallery talks, tours, and lectures. Volunteer docents gave tours to 34,622 schoolchildren (1,377 classes), a decrease of more than 18,000 from the previous year caused by the energy crisis that curtailed many field trips.

# THE NATIONAL MUSEUM OF NATURAL HISTORY

The Smithsonian Institution
Constitution Avenue at 10th Street, N. W.
Washington, D. C. 20560

## 1. General Information

Founding: 1846, opened to the public, 1911.

Collections: Extensive collections in anthropological materials, zoology, entomology, botany, mineral sciences, and paleobiology.

Number of paid staff: 345.

Number of volunteers: 140 docents; roughly 60–65 other volunteers.

Operating budget: $6,680,000 (1973/74).

Education budget: $78,000 (1973/74).

## 2. Location/Setting

Size and character of city: Washington, D. C. (population 756,510 in a standard metropolitan statistical area of nearly 2.9 million, according to the 1970 census) has the largest concentration of museums, nature centers, parks, botanical gardens, and historic sites in the country. It is the center for federal administration, headquarters for innumerable national organizations, and one of the country's leading tourist attractions. Its cultural facilities serve a mixed audience of visitors, short-term residents, and an indigenous population that is 72 percent black (public school enrollments are nearly 96 percent black). Educational resources include five universities: American, Catholic, Howard, Georgetown, and George Washington.

Climate: Moderate winters, humid summers, pleasant in spring and fall.

Specific location of the institution: The museum is located on the Mall between the Capitol of the United States and the Washington Monument, in close proximity to the Smithsonian Castle (the administrative building of the Smithsonian complex, so called because of its eight crenelated towers), the National Museum of History and Technology, and the National Collection of Fine Arts. Within easy walking distance are other renowned tourist attractions and historic sites, including the National Archives, Ford's Theater, and other Smithsonian collections. Surrounding the Mall are the downtown business and shopping district to the north, federal office buildings and agencies to the west and south, and historic Capitol Hill.

Access to public transportation: Excellent; museum is on a regular city bus route as well as the route of the Tour Mobile, which circles the Mall area museums and monuments.

## 3. Audience

Membership: There are no membership programs for individual Smithsonian bureaus; the Smithsonian Institution has national and resident associate memberships.

Attendance: 3,067,694 (1973/74), a large portion of whom were out-of-town visitors. (A report entitled "Smithsonian Visitor," by Carolyn Wells, published in 1969, describes the visitors to the National Museum of Natural History and the National Museum of History and Technology.)

## 4. Educational Services

Organizational structure: A separate department of education is headed by a chief of education who reports to the director.

Size of staff: 4 full-time (including secretary and tour scheduler) and 5 part-time; 180 volunteers.

Budget: $78,000, including salaries.

Source of funds: Museum budget.

Range of services: School services include guided tours on a variety of themes including ecology, mammals, prehistoric life, evolution, African cultures, Indians and Eskimos, Latin American archaeology, and people of Asia. Tour programs include demonstrations, participatory activities, and handling of artifacts; some include a school classroom activity first, followed by a visit to the museum. "People of Asia," for example, includes a classroom activity on an aspect of Asian culture such as a Japanese tea ceremony or a lesson in Chinese calligraphy. Tours for the public are provided by volunteers. The Discovery Room is administered by the education department with the cooperation of the exhibition services office.

Audience: The school programs serve both a local and a regional audience. (A newsletter prepared by the Smithsonian's office of elementary and secondary education is sent out to all area schools six times a year.)

# THE NATIONAL PORTRAIT GALLERY

Smithsonian Institution
8th and F Streets, N. W.
Washington, D.C. 20560

## 1. General Information

Founding: 1962, by Act of Congress. Opened to the public in 1968.

Collections: Paintings, sculptures, and other objects associated with the men and women who influenced and shaped American history and culture—"a national dictionary of national biography."

Number of paid staff: 48 full-time, 10 part-time.

Number of volunteers: 35.

Operating budget: $1,031,000 (1974), not including guards or building maintenance.

Education budget: $67,000 (1974).

Source of funding: Federal appropriations; some private money. Governing authority: Smithsonian Institution.

## 2. Location/Setting

Size and character of city: Washington, D.C. (population 756,510 in a standard metropolitan statistical area of nearly 2.9

million, according to the 1970 census) has the largest concentration of museums, nature centers, parks, botanical gardens, and historic sites in the country. It is the center for federal administration, headquarters for innumerable national organizations, and one of the country's leading tourist attractions. Its cultural facilities serve a mixed audience of visitors, short-term residents, and an indigenous population that is 72 percent black (public school enrollments are nearly 96 percent black). Educational resources include five universities: American, Catholic, Howard, Georgetown, and George Washington.

Climate: Generally mild weather prevails, with humidity climbing in the summer. The area is blessed with lovely spring and fall weather and is far enough south to avoid most heavy snowfalls.

Specific location of the institution: Unlike the majority of Smithsonian institutions, the Portrait Gallery is located five blocks north of the Mall, in the downtown commercial district, near the new central District Public Library designed by Mies Van der Rohe. It shares the historic Old Patent Office building, one of the early federal office buildings, with the National Collection of Fine Arts. The two museums also share a courtyard and pleasant lunchroom.

Access to public transportation: On several bus routes and subway route. The building is within easy walking distance from downtown shopping district.

### 3. Audience

Membership: Smithsonian Associates—national, 620,000; Washington area, 50,000. Costs: national (magazine subscription), $10 annual membership; Washington area (resident), $15 and up annual membership. There are no memberships in the Smithsonian's individual museums.

Attendance: 350,000 yearly. Many are tourists, but there is a substantial local audience as well. (As a fairly new addition to the Smithsonian and not directly in the path of tourists, the Portrait Gallery requires visitors to note its location on general Smithsonian brochures.)

### 4. Educational Services

Organizational structure: A separate education department is headed by the curator of education, who reports to the museum director.

Size of staff: 5 full-time, 7 part-time, and 35 volunteers.

Budget: $67,000 (1974); includes salaries, supplies, and programs.

Source of funds: Federal appropriations through the National Portrait Gallery budget; some outside private funding for projects such as docent training and enrichment programs.

Range of services: Tours for adults; Discover Portraits I, including visit to the school, use of slides and dialogue, portrait-making, and follow-up tour; Discover Portraits II, including visit to the school, role-playing, photography, and follow-up tour; Discover Portraits/Black History, a variation on the Discover Portraits theme, with an emphasis on portraits and histories of black Americans; portrait workshop for students; dramatization of the "Trial of John Brown" in schools and follow-up tour; programs, visual materials, and publications in connection with temporary exhibitions and permanent collection; student publications on exhibitions (available from the Government Printing Office).

Audience: Walk-in visitors; adult groups; elementary and secondary students in their classrooms and in the gallery.

# NEIGHBORHOOD ARTS PROGRAM
# SAN FRANCISCO ART COMMISSION

165 Grove Street
San Francisco, California 94102

### 1. General Information

Founding: The Neighborhood Arts Program (NAP) was started in 1967.

Number of paid staff: The San Francisco Art Commission is staffed by 10 professionals in the arts plus a director and an executive secretary. The Neighborhood Arts Program has 8 to 35 part-time employees, hired as needed.

Number of volunteers: Volunteers are used sparingly as instructors, and only when they can be relied on to keep a commitment to teach for a semester. Only about a dozen are involved at any one time in the program.

Operating budget: For the Neighborhood Arts Program, about $300,000 per year.

Education budget: About $60,000 (representing about 20 percent of the total budget) supports the workshops program. Of this, $36,000 goes for salaries, and the remaining $24,000 supports eight neighborhood workshops at $225 per month plus special workshop projects.

Source of funding: City and County of San Francisco, National Endowment for the Arts, Zellerbach Family Fund (Zellerbach funds sustained NAP in 1968 and 1969 and now amount to $30,000 a year). New and expanded programs are funded by separate grants and donations, mostly from the San Francisco Foundation and the California Art Commission.

### 2. Location/Setting

Size and character of city: San Francisco, with a population of 715,674 (1970 census), is second only to Manhattan in population density. Set among high hills, San Francisco is one of the most picturesque cities in the world and a well-known tourist mecca. It is small in area, bounded by water, and divided into clear-cut neighborhoods and ethnic communities, the best known of which is Chinatown. Thirty-two percent of the population is nonwhite; the enrollment in San Francisco schools, 77 percent non-white.

Climate: Temperate.

Specific location of program: Citywide.

### 3. Audience

Memberships: No formal memberships.

Attendance: About 50,000 persons attended free performances, classes, and workshops sponsored or cosponsored by NAP. Through its services to artists and art organizations and performing companies, however, NAP indirectly reaches 300,000 persons.

### 4. Educational Services

Organizational structure: The San Francisco Art Commission is a division of the city government. The commission's director of cultural affairs oversees the Neighborhood Arts Program, which is administered by a director.

Range of services: In addition to NAP, the art commission sponsors an annual city art festival, a pop concert series, and a gallery that exhibits the work of local artists. The commission also oversees the design quality of city structures and assigns 2 percent of the cost of these buildings to art enrichment—

graphics, sculpture, murals, or other forms. The NAP sponsors or cosponsors about 100 performances each year, about 120 classes, workshops, and master classes yearly; designs and prints leaflets for about 600 art groups and organizations, distributes free booklet on basics of art publicity (*How to Manipulate the Media*); offers consultation on publicity needs, free use of lighting and design equipment and film projectors, stage truck, and Neighborhood Arts Theater for performances, rehearsals, and classes; provides assistance in proposal writing and grantsmanship. District organizers help arts groups set up community programs.

Audience: NAP workshops attract about 1,500 children, teenagers, and adults to about 150 workshops and classes per year. The audience for NAP performances raises the attendance to a total of about 50,000 per year.

Objective: To encourage grassroots arts programs in the neighborhoods, to establish liaison among community groups, and to increase support for neighborhood artists and cultural organizations.

Time: Throughout the year.

Information and documentation available: *How to Manipulate the Media*, and annual reports, 1970/71, 1971/72.

# THE NEW ORLEANS MUSEUM OF ART

City Park
P.O. Box 19123
New Orleans, Louisiana 70179

## 1. General Information

Founding: 1910; Wisner Wing, Stern Auditorium, and City Wing completed in 1971.

Collections: The collection has strongest representation in Spanish Colonial, African, pre-Columbian, nineteenth- and twentieth-century European and American art, and photography. There are representative pieces in French Salon and Barbizon, Far Eastern, Italian Renaissance and Baroque art, as well as Louisiana portraits.

Number of paid staff: 37 full-time; 2 half-time.

Number of volunteers: 500 names are listed. Total number working in education: 84; of these, 55 are docents working in the Wisner Wing and the Gallery, 29 are in library and research.

Operating budget: $518,072 (1974).

Education budget: $92,637 (1974).

Source of funding: Derives primarily from the City of New Orleans, with other funds from memberships and private contributions. Governing authority: The museum is owned by the City of New Orleans and administered by a board of trustees.

## 2. Location/Setting

Size and character of city: Census figures for 1970 show a standard metropolitan statistical area population of 1,046,470; in 1970 New Orleans itself had a population of 593,471, of whom 323,420 were Anglo and 267,308 black. Known most for the Vieux Carré and the yearly Mardi Gras which gives it frenetic life, New Orleans remains a city whose architectural face reflects a French lineage but whose present-day population includes nearly 50 percent blue-collar blacks. A sizable number of wealthy and near-wealthy inhabit a center-city island called "the Garden District." New Orleans is a city of strongholds: General

Andrew Jackson ended the War of 1812 there at the Battle of New Orleans, and, more recently, Mayor Robert Mastri oiled the remaining administrative gears of the Huey Long political machine. Today its real pulse beats somewhere within the Bourbon Street jazz rhythms still echoing through Preservation Hall, the sawing and hammering that restores buildings from the Garden District to Canal Street, and the shouts of dock workers overseeing the transfer of up-river cargo floated to the port where river and ocean meet.

Climate: Mild, semitropical, humid.

Specific location of institution: In the middle of City Park.

Access to public transportation: Two bus lines stop at the City Park entrance, a short walk from the front door of the museum.

## 3. Audience

Membership: Approximately 2,000. Cost: individual, $15; family, $25; student, $5.

Attendance: During 1974, 165,578 persons visited the museum. There is no admission fee.

## 4. Educational Services

Organizational structure: Both the senior curator of education, responsible for the Education Department, and the curator of education report to the director of the museum.

Size of staff: 3 curators, 2 full-time secretaries, 1 scheduling secretary, 2 guards, 1 half-time educational assistant, and assorted part-time teachers.

Budget: $92,637, or nearly 18 percent of the annual operating budget; included in this amount is $65,882 for staff salaries and $26,755 for programs.

Source of funds: The City of New Orleans, with additional donated monies, funds staff salaries and programs through the operating budget. Other programs, staff, supplies, and equipment were initially funded by the Women's Volunteer Committee of the museum, the Junior League of New Orleans, and the Jewish Council of New Orleans.

Range of services: Gallery and Wisner Wing tours, teacher workshops, docent training, adult art classes, free Saturday children's workshops, summer children's art classes, puppet shows, films, lectures, concerts, exhibitions, slide-tapes, and radio program.

Audience: 31,000, of whom 19,000 are children and 12,000 are adults (general public). During the 1973/74 school year, 8,570 persons, grade 4–adult participated in gallery tours; in grade 4 pilot program (two visits), 780; in Wisner Wing tours, K–3, 4,890; in Puppet Playhouse, 3,274.

# OLD STURBRIDGE VILLAGE

Sturbridge, Massachusetts 01566

## 1. General Information

Founding: Old Sturbridge Village is the re-creation of a representative New England community of the period 1790–1840. The exhibits include an operating farm from ca. 1800, a store, a tavern, a meeting-house, houses, shops, mills, and other characteristic structures. In these buildings costumed interpreters explain the exhibits and demonstrate rural crafts of the period. The buildings contain an enormous variety of objects, such as furniture, latches, hinges, saws, pewter, copper, brass, pottery, glass, and china found in New England houses and barns.

Number of paid staff: 600–700 (number varies according to season).

Number of volunteers: None.

Operating budget: $3,833,903 (1974).

Education budget: $309,900 (1974), of which $255,000 is for staff salaries alone.

Source of funding: Admissions fees, sales, royalties, and gifts, plus endowment income (which amounts to less than 5 percent of the Village's annual income). The Village is an independent nonprofit educational institution.

## 2. Location/Setting

Size and character of city: Sturbridge is a small town of 4,878 (1970 census), settled ca. 1730, whose principal activities center on Old Sturbridge Village and the tourist populations it draws.

Climate: New England seasonal.

Specific location of institution: On a site of more than 200 acres, west of Worcester in central Massachusetts, close to the junction of the Massachusetts Turnpike and the Wilbur Cross Highway (Connecticut).

Access to public transportation: Easy access by bus or car.

## 3. Audience

Membership: None.

Attendance: Approximately 600,000 in 1974, including about 90,000 schoolchildren, college students, and teachers. The Village is open all year; the admission fee is $4 ($1.25 for children ages 6 to 14).

## 4. Educational Services

Organizational structure: There are three separate divisions, museum administration, business administration, and public affairs, each headed by a vice-president. The museum education department (headed by a director for museum education) is part of the division of museum administration, headed by a vice-president and director for museum administration and interpretation.

Size of staff: 9 professional staff, including 2 in the Teacher Center; 4 clerical staff. In addition, there is a nonprofessional teaching staff of briefers, escorts, and team leaders, who work 20–40 hours per week.

Budget: $309,900, or 8 percent of the institution's operating budget.

Source of funding: Operating budget.

Range of services: For elementary and secondary students: field studies (group tours); for college students: special field studies and work-study programs. For teachers: publication of 13 different resource packets based on documents in the Village's collection, a teacher-training program, as well as short workshops on pedagogical methods and seminars in history and social science. For inner-city and special education students: special programs.

Audience: Elementary and secondary students in school groups (about 90,000 per year); a small number of college students (less than 100), including, 5 or 6 work-study students each year; teachers (about 400–450 per year).

# THE PHILADELPHIA MUSEUM OF ART

Parkway at 26th Street
Philadelphia, Pennsylvania 19101

## 1. General Information

Founding: 1876.

Collection: 300,000 pieces of American, European, Asian, and Indian art; photography center; especially strong collections in the areas of European art, twentieth-century works, the decorative arts, and Pennsylvania Dutch pieces.

Number of paid staff: Approximately 200 full- and part-time corporate staff members; 150 city staff (primarily security and maintenance).

Number of volunteers: Approximately 31 administrative volunteers and 150 volunteer guides.

Operating budget: $5,304,757 (1973/74).

Education budget: Approximately $262,000 (1973/74); this figure is for the Division of Education only (see below).

Source of funding: City support, membership, museum shop sales, appropriations (commissioners of Fairmount Park), contributions for specific operating purposes.

## 2. Location/Setting

Size and character of city: Philadelphia is part of a standard metropolitan statistical area with a population of 4,817,914 (1970 census) and whose own population numbers 1,950,098 (1970 census); more than one-third of the population is nonwhite (based on 1970 statistics). The city prides itself on distinct neighborhoods. each with a unique character and variety of offerings. Philadelphia is both a center of intellectual activity and the home of a nonintellectual "establishment": patrons of the arts, according to local reports, are not necessarily those most interested in the arts. The city is steeped in American history and tradition, with many historical landmarks and museums.

Climate: Cold, rainy winters; hot, muggy summers.

Specific location of the institution: The museum is at the junction of Fairmount Park and Benjamin Franklin Parkway. Although it is adjacent to several communities, it is somewhat isolated by the high-speed main roads that surround it.

Access to public transportation: Public buses operate weekdays during rush hour only; the closest stop is about a quarter of a mile from the museum. A "cultural loop" bus, operating weekends only, stops at the museum. A large parking lot is available but spaces are quickly filled in the morning and difficult to find in the afternoon. Taxis are probably the best way to get to the museum, but they are not easily hailed at departure.

## 3. Audience

Membership: 16,000 (1974). Cost: $15 for single membership, $20 for family membership; includes newsletter and monthly calendar.

Attendance: 576,635 (this is yearly average for the period 1972–1974).

## 4. Educational Services

Organizational structure: The Division of Education is headed by a chief, who reports to the director of the museum. The Department of Urban Outreach (see chapter 3) is a separate department with educational activities. The Fleisher Art Memorial, which provides free studio art classes, is also separate, with its own budget and staff.

Size of staff: In the Division of Education, 8 full-time office staff; 6 full-time lecturers; 7 part-time lecturers; 2 members on the board of education.

Budget: About $262,000 (1973/74) for the Division of Education, not including the slide department and library; $112,360 (1973/74) for the Department of Urban Outreach; and about $145,000 (1973/74) for the Fleisher Art Memorial.

Source of funding: For the Division of Education, an annual allocation of $100,000 from the Commonwealth of Pennsylvania, $100,000 from program income (90 percent from studio classes, 10 percent from lecture and film series), $32,000 in special grants ($7,000 from the Nevil Trust Fund for programs for the blind and $25,000 from the Wintersteen Fund for Student Center exhibitions), and about $30,000 from the museum's operating budget.

Range of services: School programs, studio classes in the museum, exhibitions and displays, concert and film programs, outreach volunteers, museum library and slide collection, intern training seminars, urban outreach programs focusing on two neighborhoods in the city, and a graduate course in museology taught by the director.

Audience: Most of the audience is from Philadelphia and surrounding communities. Three-quarters of the visitors to education programs in 1973 were children on school tours (34 percent of the tours were for Philadelphia public schoolchildren). The remaining quarter attended without a guide, took part in the summer program ("Talk and Sketch"), or participated in the classes conducted through the board of education.

# PORTLAND ART MUSEUM

1219 S.W. Park
Portland, Oregon 97205

## 1. General Information

Founding: 1892.

Collection: Northwest Coast Indian art; European painting and sculpture from the Renaissance to the twentieth century; American art; Asian art; ancient art; art of pre-Columbian America; Cameroon art; English silver.

Number of paid staff: 45 full- and part-time.

Number of volunteers: 250–500.

Annual operating budget: $850,000 (for year ending August 31, 1974).

Annual education budget: $90,000 (for year ending August 31, 1974).

Source of funding: Private endowment.

## 2. Location/Setting

Size and character of city: Portland, Oregon's largest city, has a population of 382,619 (1970 census) and is part of a standard metropolitan statistical area having a population of 1,009,129. Sparked by the active support of its citizens, Portland is being rebuilt and revitalized.

Climate: Mild, with much rain.

Specific location of the institution: Near the downtown city center.

Access to transportation: Twenty-seven buses come within four blocks of the museum.

## 3. Audience

Membership: 5,419 (1974). Cost: student, $5; individual, $15–$24; family, $25–$99.

Attendance: 89,932 (1973/74).

## 4. Educational Services

Organizational structure: Department of education is headed by the coordinator of education, who reports to the curator.

Size of staff: 2.

Budget: $90,000 (includes programs, salaries, and supplies).

Source of funds: Membership, endowment, gifts, bequests, and grants.

Range of services: Library for members, docent tours for the public and for school groups, gallery talks by docents and professionals in the community, lectures, films and film study center, suitcase exhibits (elementary schools), slide and tape course in understanding art (high school), one scholarly publication per year.

Audience: Lay audience, professionals, and school groups. In 1973/74, 9,332 persons participated in guided tours.

# JOHN AND MABLE RINGLING MUSEUM OF ART

P.O. Box 1838
Sarasota, Florida 33578

## 1. General Information

Founding: 1930

Collections: Paintings, sculpture, and prints from the fifteenth through the seventeenth century form the bulk of the collection, with a smaller representation through the twentieth century.

Number of paid staff: 80 full-time; 30 part-time, including guards.

Number of volunteers: 110 in the education department; another 200 volunteers serve throughout the museums.

Annual operating budget: $1.3 million (1973/74).

Annual education budget: $63,000 (1973/74).

Source of funding: Primarily the State of Florida.

## 2. Location/Setting

Size and character of city: Sarasota's population of over 40,000 includes a large retirement population and some migrant workers. Located south of one of Florida's three major urban areas, Tampa and St. Petersburg, Sarasota is a popular tourist attraction, the center of a truck farming area, and the county seat.

Climate: The highest point in Florida is only 345 feet above sea level; a mild climate year-round, punctuated by a rainy season, allows much out-of-doors activity, although winter months in Sarasota can be considerably cooler than the vacation spots of Miami and Key West.

Specific location of institution: The museum complex, which includes the Museum of Art, the Ringling Residence, the Museum of the Circus, and the Asolo State Theater, is located in suburban Sarasota, bounded on one side by the New College campus, on another by residences, on a third side by a major traffic artery, and on the fourth side by the warm Sarasota Bay. The Ringling Residence looks directly over the water and at one time could have been entered by a dock at the veranda.

Access to public transportation: On a major traffic artery (U.S. 41); public transportation available but difficult.

3. **Audience**

Membership: 2,000. Cost: $15, individual; $25, family.

Attendance: About 475,000 annually to the entire museum complex. Over 90 percent are tourists or one-time visitors.

4. **Educational Services (1973/74)**

Organizational structure: The education department is a separate department, headed by a director of education, who reports to the museum's director.

Size of staff: 4 full-time; 110 volunteers.

Budget: $63,000, not including funds for the Art Caravan.

Source of funds: Museum budget, Allied Arts Councils of Sarasota and Manatee Counties, Women's Exchange of Sarasota, National Endowment for the Arts, Florida Fine Arts Council, and Members Council.

Range of services: Docent-guided tours; Art Caravan; art classes for young people and adults; workshop tours for elementary grades; portfolio tours taken to area schools; workshops at Old Folks Aid Home, Sarasota Welfare Home, Happiness House Rehabilitation Center, and juvenile detention homes in Sarasota and Manatee counties; exhibitions and 20 slide-tape lectures circulated statewide; Annual Young People's Art Exhibition; exhibitions of the work of youth organizations; participation in the annual Children's Art Carnival; maintenance of slide files on the Ringling collection; maintenance of archive of Florida artists; and film library.

Audience: Schoolchildren, children with learning disabilities, museum membership, adult community. Tours were given for 20,000 visitors in 1972/73. Workshop tours were conducted for 3,000 4th graders.

# THE ST. LOUIS ART MUSEUM

Forest Park
St. Louis, Missouri 63110

1. **General Information**

Founding: St. Louis Museum of Fine Arts was founded by Washington University in 1879. In 1911 its name was changed to City Art Museum of St. Louis, first major art museum in the country to be publicly supported. In 1971, county taxpayers accepted a share of the cost, and the name was changed to the St. Louis Art Museum.

Collections: The collection is general and comprehensive; it is strong in American painting and decorative arts, pre-Columbian objects, and European paintings. The Sub-Saharan African collection is good, as are the Japanese and Chinese collections. Most apparent weakness: American Indian.

Number of paid staff: 103. Curatorial staff: 5, including director.

Number of volunteers: About 135; 40 at visitors' desk, 40 at bookshop, and 55 docents, 41 of them active.

Operating budget: $1,287,142 (approximate amount for 1974). Education budget: $89,380.

Source of funding: City and county taxes pay operating costs. Memberships and other private sources supplement accessions monies.

2. **Location/Setting**

Size and character of city: St. Louis—population, 622,236 (1970 census), standard metropolitan statistical area population,

2,363,017 (1970 census)—was established and flourished on the north-south Mississippi River trade route during the westward movement. Although St. Louis was the third largest city in the country in 1870, Chicago's growth as a rail center redefined St. Louis's position to that of an important regional river city, characterized by an active cultural life and a Southern flavor.

Climate: Hot, muggy, often cloudy; the presence of the river is palpable.

Specific location of institution: In a park which is a "cultural center," and adjacent to Washington University, the planetarium, Historical Society, the zoo, and the botanical gardens. This American version of the Acropolis is a common phenomenon in many Midwestern cities.

Access to public transportation: No public transportation directly to the door of the museum; one can get off a public bus at the zoo and walk up the hill to the art museum. There is adequate public parking for private vehicles and school buses.

3. **Audience**

Membership: 7,597 in 1973/74. Cost of membership: family $18.50; student $10.

Attendance: Approximately 495,000 (1974). Admission is free, though there is a request for voluntary entrance fees to some special exhibitions.

4. **Educational Services**

Organizational structure: Curator of education, reports to director.

Size of education staff: 8 professional staff, and 6 Saturday "pro's" (who lecture to adults or give studio classes to children); 55 volunteer docents, 41 of whom are active. (A volunteer docent may be inactive for only two years before being asked to retire.)

Budget: $89,380. (Between 6 and 7 percent of total museum budget goes to education.)

Source of funds: From the museum budget, with occasional gifts or grants from outside sources, such as local foundations or the State Council for the Arts.

Range of services: Lecture courses open to the public; weekly gallery talks; Tuesday night lectures; general tours for adult visitors on Saturday and Sunday afternoons; school tours; educational exhibitions (about one per year); modest studio classes for children (in very limited facilities); Teachers Resource Center, which provides slides, information, workshops, newsletter, and services to teachers. Evaluation sheets are given to visitors.

Audience: 126,401 (1974); 779 teachers made use of the Teachers Resource Center.

# THE SCHENECTADY MUSEUM

Nott Terrace Heights
Schenectady, New York 12308

1. **General Information**

Founding: 1934.

Collections: Contemporary paintings and sculptures; fine collection of nineteenth- and twentieth-century fashion and textiles; regional artifacts ranging from paleontological specimens to representation of General Electric's contributions to applied technology.

Number of paid staff: 15.

Number of volunteers: 300–400.
Operating budget: $220,000 (1974).
Education budget: $30,000 (1974).
Source of funding: City, county, membership, grants.

## 2. Location/Setting

Size and character of city: Prosperity centers on General Electric, which in 1974 was relocated, causing unemployment and a decreased tax base. Downtown is partially deserted, shabby. Nevertheless, from the museum's windows, Schenectady is a beautiful little town, full of church steeples and Federal architecture, nestled in the Mohawk Valley. The city has a population of 77,958 (1970 census).

Climate: Severe winters; moderate, somewhat muggy summers.

Location of the museum: According to a recent survey, the museum is located across the street from the boundaries of center city. Its immediate neighbors are residential poor and a shopping center; beyond that, the campus of Union College, the public library, and City Hall.

Access to public transportation: Good.

## 3. Audience

Membership: 2,100. Cost: $10 and up.
Attendance: 75,000 (1973).

## 4. Educational Services

Organizational structure: Separate department; education supervisor reports to the director of the museum.

Size of staff: Education supervisor; 75 volunteers.

Budget: $30,000 (1974); includes education supervisor's salary, interpretive materials, traveling education kits for schools, purchasing of books and periodicals, volunteer training expenses.

Source of funds: City, county, membership, grants.

Range of services: School programs, art classes.

Audience: Predominantly elementary school groups.

# SEVEN LOAVES, INC.

177 East 3rd Street
New York, New York 10009

## 1. General Information

Founding: In October 1972, when seven community arts programs on New York City's Lower East Side banded together to share administrative, fund-raising, and public relations resources. It received its first grant in December 1972.

Number of paid staff: 3 full-time—a coordinator, an assistant, and a secretary—who act as consultants and trainers to the member groups. (Member programs employ about 60 staff members, not including Neighborhood Youth Corps, Urban Corps, and other workers who are paid by outside sources.)

Number of volunteers: 5. In addition, people from all the member groups give time to the coalition's activities; the number varies widely depending on tasks to be done and time of year. (About 400 volunteers serve the member programs.)

Budget: $55,000 in calendar 1974; $58,000 in 1975.

Sources of funding: The National Endowment for the Arts, the New York City Department of Cultural Affairs, five local foundations (the Fund for the City of New York, the Robert Sterling Clark Foundation, the Rockefeller Brothers Fund, the Edward John Noble Foundation, and the New York Foundation), Banker's Trust, and miscellaneous contributors.

## 2. Location/Setting

Size and character of the city: New York's 7,895,563 (1970 census) residents are spread over five boroughs: Manhattan, the Bronx, Brooklyn, Queens, and Staten Island. Not only are these boroughs significantly different from one another in their ethnic and income mix and in the dispersal of cultural and educational institutions, but neighborhoods within each borough vary widely. Between 1950 and 1970, 2 million predominantly white middle-class residents left the city (New York's standard metropolitan statistical area was 11,528,649 in the 1970 census) and were replaced by 2 million black and Puerto Rican immigrants.

Climate: Seasonal.

Specific location of the organization: A storefront on Manhattan's Lower East Side (population: 182,000, according to the 1970 census), an area about 16 miles square, bounded by Lafayette Street, City Hall, the East River and East 14th Street. There are a number of smaller neighborhoods within this large one, among them Chinatown and the East Village. The area is mixed residential and commercial, deteriorated, and predominantly minority and poor.

Access to public transportation: Most people walk to program sites; several bus and subway routes serve the area.

## 3. Audience

Membership: This has fluctuated since the coalition's founding. In mid-1975 there were six full-fledged Loaves and three affiliates. The full members were Basement Workshop, Lower East Side Printshop, Cityarts Workshop, Charas, La Semilla, and El Teatro Ambulante-El Coco Que Habla. The affiliates were the 4th Street i, Los Hispanos Co-op, and Media Workshop.

Attendance: Together the members directly served about 5,400 local residents with a combined income (including central office) of $360,000 in 1974. It was estimated that in 1975 this had increased to over 7,000 persons on a combined income of about $592,000. (Member program budgets include about 5 percent earned income from sale of products and services.)

## 4. Educational Services

Organizational structure: Seven Loaves is governed by a board made up of the autonomous member groups, to which the coalition's staff acts as consultant and trainer. Operational procedures and membership standards are set out in bylaws. All decisions are reached by majority vote. Each member group has a coordinator or director who is its administrative head, and each sends one representative to Seven Loaves board meetings.

Range of services: Administrative training for staffs of member groups, joint fund-raising, opportunities for sharing of resources, assistance in economic development projects, program coordination, information and referral, publicity.

Audience: The chief audience for Seven Loaves is the member groups; occasionally other neighborhood and nonprofit organizations also participate in the training and other services. The member groups themselves work mainly within the Lower East Side community, though most engage in projects that have a citywide or national audience as well.

Objectives: To ensure the survival of local community arts programs by providing a center through which they can learn administrative and fund-raising techniques, raise money jointly, share

resources, and become more visible and credible to both funders and residents of the community they serve.

Time: Seven Loaves operated year-round.

Information and documentation available from the organization: Brochures.

# SOUTH TEXAS ARTMOBILE
# DOUGHERTY CARR ARTS FOUNDATION

P.O. Box 8183
Corpus Christi, Texas 78412

## 1. General Information

Founding: 1969.

Collections: The Artmobile's traveling exhibitions are comprised of objects on loan from museums such as Dallas Museum of Fine Arts, National Gallery of Art, and others.

Number of paid staff: 3: a part-time director, a driver, and a curator.

Number of volunteers: Approximately 30, plus an area chairman and a publicity chairman in each of the 27 communities visited by the Artmobile.

Operating budget: $36,794 (1973/74); this amount includes salaries, truck maintenance, insurance, and exhibit expense.

Education budget: $15,700, allocated as follows: curator's salary, $7,000; materials and supplies, $2,100; exhibit expense, $6,600.

Source of funding: $2,000 grant from Texas Commission on the Arts and Humanities, remainder from Dougherty Carr Arts Foundation.

## 2. Location/Setting

Size and character of city: "Home-base" is Corpus Christi, but for eight months of the year the Artmobile travels throughout Southwest Texas.

Climate: Hot summers, mild winters.

## 3. Audience

Membership: None.

Attendance: 32,799 persons visited the Artmobile in 1973/74. Approximately two-thirds of this number were children on school tours; the rest, adults.

## 4. Educational Services

Organizational structure: A board of directors oversees the activities of the Artmobile; a director administers the program.

Size of staff: 3 paid; about 84 volunteers.

Budget: $15,700.

Source of funds: Operating budget.

Range of services: The South Texas Artmobile is the only program of the Dougherty Carr Arts Foundation; it provides tours for school and community groups, a gallery open and free to the public, slide lectures to schools, and workshops and lectures by a curator.

Audience: The general public, including schoolchildren, in small communities throughout South Texas.

# THE TAFT MUSEUM

316 Pike Street
Cincinnati, Ohio 45202

## 1. General Information

Founding: Opened in 1932 as a public museum. Previously this handsome Federal house, built in 1820, was the residence of Mr. and Mrs. Charles P. Taft.

Collections: 580 objects, primarily seventeenth- and eighteenth-century Chinese porcelains, an important collection of European enamels, glass, and crystal, and paintings of the Barbizon schools, as well as Dutch, English, and American paintings, some of excellent quality, including some masterpieces. The collection is closed; most of it was assembled by Mr. and Mrs. Taft, with an occasional object added later by their two daughters.

Number of paid staff: 17, of whom 2 are full-time museum professionals, the rest administrative, security, or custodial. (Fall 1974: a part-time educator was added to the professional staff.)

Number of volunteers: About 40.

Operating budget: $192,500 (1973/74).

Education budget: $14,700 (8 percent of the museum's budget) is used for publications, library, exhibitions, programs, publicity, and prorated salary. (Omitting salaries, the education budget is 4.5 percent of the museum's budget.)

Source of funding: Private endowment, annual Fine Arts Fund drive, plus small state grant. In 1932, Mrs. Taft left $1 million as a restricted endowment for the Taft Museum, which provides less than 75 percent of the museum's income, with less than 25 percent provided by the citywide Fine Arts Foundation. The $30,000 deficit in the last fiscal year was made up by the Cincinnati Institute of Fine Arts.

## 2. Location/Setting

Size and character of city: With a population of about 500,000 (though Greater Cincinnati numbers over a million), Cincinnati calls itself "The Queen City of the West," after a name Longfellow gave it in a poem. What accounts for its distinctive character among Ohio's cities? Perhaps the hills, with houses tucked in every crevice, perched on every outcropping, looking out over the Ohio River; perhaps its first substantial settlement—German burghers who endowed the city with a hunger for good food and good music. A diversified economy with new industries since World War II, a conservative citizenry, a long record of reform city government (led by the Tafts whose house is now the Taft Museum) make Cincinnati a pleasant, staid city.

Climate: Mild, damp winters; humid, sweltering summers.

Specific location of institution: Commercial area, five blocks from the center of downtown.

Access to public transportation: Public bus. Limited free parking is available behind the museum.

## 3. Audience

Membership: None. The museum is free and open to the public.

Attendance: 40,000 (1973/74). Open weekdays, 10 A.M. to 5 P.M., Sundays and holidays, 2 to 5 P.M.

## 4. Educational Services

Organizational structure: No separate department.

Size of staff: The 2 professionals (the director and the designer), plus about 40 volunteer docents.

Budget and funding: The $14,700 budget for education comes from grants and the museum's operating budget.

Range of services: Tours, school visits, musical programs.

Audience: Once largely white and middle class, now considerably expanded by publicity, interest in downtown, and the In-School program. In 1973/74 there were 546 educational programs (tours, lectures, musical events, and special programs) attended by 21,123 persons.

# TEXAS MUSEUMS CONSORTIUM

Texas Commission on the Arts and Humanities
P.O. Box 13406
Capitol Station
Austin, Texas 78711

## 1. General Information

Duration of consortium: September 1, 1972–June 30, 1974.

Number of paid staff: One full-time project director and a part-time secretary.

Operating budget: $60,500 (for 22-month grant period), including approximately $25,000 in salaries and benefits, approximately $20,000 for exhibitions and catalogs, about $4,500 for speakers, the remainder going for films, travel, and supplies.

Sources of funding: National Endowment for the Arts, $30,000; Texas Commission on the Arts and Humanities (TCAH), $20,000; member museums, $10,500.

## 2. Location/Setting

Size and character of state: The consortium was housed in the offices of TCAH, in Austin, the capital of Texas, located in the south-central portion of the state. The scope of its membership, however, was statewide.

Climate: Mild winters, sunny year-round.

## 3. Audience

Membership: The Amon Carter Museum of Western Art, the Fort Worth Art Museum, the Abilene Fine Arts Museum, the Amarillo Art Center, the Museum of the Southwest (Midland), the Tyler Museum of Art, the Wichita Falls Museum and Art Center, the El Paso Museum of Art. (For further information on each institution, see program report in chapter 15.)

## 4. Services

Organizational structure: Directors of member museums served as informal "board of directors" who together with TCAH executive director determined policy and fiscal priorities. A project director was responsible for administration.

Range of services: Organizing exhibitions to circulate among member museums ("Photographs: Landscapes of the American West," "Drawings," "Exponents of Modernism"); preparation of exhibition catalogs; inviting guest speakers to lecture at member museums; development and selection of an archive of contemporary film forms. Other services include research on employee benefit and insurance programs and on computerization of collections, preparation of a survey of facilities and needs of member museums, and a resource codification.

Audience: The member museums and, indirectly, their audiences.

# THE TOLEDO MUSEUM OF ART

Monroe Street at Scottwood Avenue
Box 1013
Toledo, Ohio 43697

## 1. General Information

Founding: 1901.

Collection: General, comprehensive. Strengths: over 2,000 pieces of ancient and modern glass; Italian, Dutch, French paintings of seventeenth and eighteenth centuries.

Number of paid staff: 75 full-time, including 4 or 5 curators.

Number of volunteers: 60 (50 art docents, 10 music docents).

Operating budget: $1.34 million (estimated for fiscal year 1973/74; exact figures not available because of conversion to a new fiscal reporting period).

Education budget: $383,618 (estimated for fiscal year 1973/74).

Source of funding: Endowment, investment, membership fees, tuition, gifts, and grants; 90 percent private, 10 percent grants.

## 2. Location/Setting

Size and character of city: Toledo is a city of 383,818 (1970 census) with the sagging economy familiar to those Midwestern cities that ring the Great Lakes and have long depended on heavy industry as the backbone of the town; Toledo's major industry is glass. Its downtown is practically nonexistent; yet there continues to be substantial civic interest, largely focused on the museum, which is the center of the city's cultural life.

Climate: Cold raw winters, hot muggy summers.

Specific location of the institution: In a pleasant parklike setting at the rim of downtown, in a changing semiresidential neighborhood.

Access to public transportation: Museum is on main public transit line (Monroe Street bus).

## 3. Audience

Membership: Over 7,000. Cost: $15 and up.

Attendance: 368,491 in 1974 (213,605 adults, 154,885 children). Museum flyer notes, "A higher percentage of Toledo's citizens use and enjoy their museum than is the case in any other American city." Annual attendance often exceeds the city's total population—and Toledo is not, by the wildest stretch of the imagination, a city for tourists.

## 4. Educational Services

Organizational structure: Separate education department, headed by assistant director for education, who reports to the director, and is responsible for the Art School, the University of Toledo's art classes, as well as the education programs of the museum.

Size of staff: 3 full-time; 50 docents.

Budget: $383,618 (estimated), including salaries; $245,515 of this amount is budgeted for University of Toledo Art School programs, leaving $138,103 for general museum education ($32,000 is allocated for Saturday classes).

Source of funds: Grants, Junior League, city schools, university fees, and memberships. (The museum repeatedly emphasizes that membership contributions are the primary source of support for the museum's free Saturday classes, tour program for public and parochial schools, and other free educational activities.)

Range of services: Exhibitions, studio classes for adults and children, publications, extensive school tours in art and music,

adult lectures, plus all University of Toledo art classes held in museum.

Audience: Free Saturday classes for children draw between 1,750 and 2,000 each week; about 900 grade school classes (or 60,000 children) participate each year in Gallery Program visits, and another 10,000 children come for one-time visits during the school year; more than 300 adult clubs and study groups visit the museum each year, some as part of planned sequence of visits.

## THE TYLER MUSEUM OF ART

1300 South Mahon Avenue
Tyler, Texas 75701

For basic information about this museum, see appendix to the report on the Texas Museums Consortium in chapter 15.

## UNIVERSITY CITY SENIOR HIGH SCHOOL

7401 Balson Avenue
University City, Missouri 63130

### 1. General Information

Founding: That portion of University City High School devoted to courses in the arts, that is, High School of the Arts, opened in September 1973.

Number of paid staff: 80.

Operating budget: $1,237,554 (1973/74). Of this amount, $1,118,234 is allocated for salaries and $119,320 for supplies. The art department's budget for supplies, $4,450, was spent as follows: materials, $2,754.14; textbooks, $551.62; equipment, $604.42; field trips, $339.30.

Source of funding: University City School District.

### 2. Location/Setting

Size and character of city: University City is a suburban-urban city immediately adjacent to St. Louis. The population of 46,309 (1970 census) is about half middle class (including university people and professors), about 40 percent lower middle class, about 10 percent on Aid to Dependent Children. Current total tax levy is $5.61 (45$^e$ is debt service). The population is changing from white to black, as is typical of many urban municipalities. Seven years ago, University City was 100 percent white. Now school population is about 60 percent black, residential population less than 50 percent black.

Climate: Mild winters, hot muggy summers.

Specific location of the institution: The school is centrally located within the municipality of University City, as it is the only senior high school for that community.

Access to public transportation: Public buses available.

### 3. Audience

Enrollment: 1,500–1,530 students in 10th, 11th, and 12th grades. (Total University City school population is 7,500.) High School of the Arts enrollment: 140 students in the first semester (fall 1973); 230 students in the second semester (spring 1974); 150 students in the fall semester (1974/75 school year).

Attendance: 20 percent cut at least one period; less than 10 percent full-time absenteeism. Attendance rates of High School of the Arts: about 18 percent cut at least one period; less than 10 percent full-time absenteeism.

### 4. Educational Services

Organizational structure: The entire function of University City High School is, of course, educational. The CMEVA study involves a separate phase of the institution's educational services—the High School of the Arts (HSA), which is headed by a project director, Tom Lawless, who reports directly to the principal, Earl Beeks.

Size of staff (HSA): 11, including one black male, two full-time and one part-time white females, balance white males. Four of the 11 are paid directly from the Elementary and Secondary Education Act (ESEA); all are regular members of the University City High School staff.

Budget: $64,432 (1973/74), plus normal operating funds required for routine operation. Cost per person of HSA is $1,093; district expenditure per pupil per year is $800. The additional amount needed for HSA students is paid out of ESEA Title III funds.

Source of funds: $64,432 from Title III, ESEA; remainder from University City High School. ESEA money pays for half of project director's salary, for two teachers and a secretary, plus $11,625 for additional field trips ($500), guest artists ($3,000), evaluators ($1,125), materials, supplies ($2,000), and workshop ($5,000).

Range of services: Courses and programs prepared especially for 12th-grade students who "have shown signs of wanting to leave school early," for 10th and 11th graders who seem "apathetic" to school, and for "students who have expressed a strong desire to have more experiences in the arts."

## UNIVERSITY OF KANSAS MUSEUM OF ART

University of Kansas
Lawrence, Kansas 66045

### 1. General Information

Founding: In the 1920s, when Sallie Casey Thayer donated her collection of objects to the University of Kansas. The museum officially opened in 1928. Her expressed intent for the gift was "to advance and encourage the study of the fine arts in the Middle West."

Collection: 500 paintings, 12,000 decorative art objects, 500 pieces of sculpture, and 6,000 pieces of graphic art. The museum has a general collection of Western art from medieval through modern. The strengths of the collection are in baroque paintings (seventeenth and eighteenth centuries), American painting (nineteenth and twentieth centuries), photography, and decorative arts.

Number of paid staff: 4 full-time professionals with split appointments in the art history department; 3 half-time professionals.

Number of volunteers: About 14 docents work with programs run by the curator of museum education.

Operating budget: $121,672 (1974) from the state of Kansas, $20,000 from private donations for acquisitions during 1974.

Sources of funding: National Endowments for the Arts and the Humanities, Kansas Cultural Arts Commission, Lawrence Art Guild, University Endowment Association, private donors.

### 2. Location/Setting

Size and character of city: Lawrence, a city of 30,200 (with very few minority people) is about 40 miles west of Kansas City. It is

a small, self-contained community with no heavy industry in the region. There are many post-Civil War homes on quiet, shaded streets surrounding the university campus.

Climate: Mild from March to October, some snow from December to February.

Location of the museum: On the campus of the university.

**3. Audience**

Membership: 160 museum patrons ($50–$100 a year) and benefactors ($100 a year and up), 130 general members ($10 a year), and 30 student members ($5 a year). Another student group called "Student Friends of Art" donates a certain amount toward a fund used to purchase an art object that will be added to the permanent collection.

Attendance: 65,000 (1974).

**4. Educational Services**

Organizational structure: The education department is a separate entity.

Size of staff: Curator of museum education, 14 volunteer docents.

Budget: No figure available.

Source of funds: Kansas Cultural Arts Commission, Lawrence Art Guild, National Endowments for the Arts and the Humanities, Endowment for the University of Kansas, and the operating budget of the museum.

Range of services: Tours of the galleries, school presentations in the classroom, music programs, poetry readings, lectures, films, traveling exhibitions, radio programs, art workshops, adult classes.

Audience: No breakdown.

Information and documentation available from the institution: General publications by the University of Kansas Museum of Art, including articles about objects in the collection, reports on activities, exhibition catalogs, miscellaneous monographs and brochures, and a bimonthly calendar of events.

# THE UNIVERSITY OF MICHIGAN MUSEUM OF ART

Alumni Memorial Hall
The University of Michigan
Ann Arbor, Michigan 48104

**1. General Information**

Founding: First acting director appointed 1946; building renovated into museum in 1967.

Collections: Western art, sixth century to present; Far Eastern, Near Eastern, African and Oceanic; painting, sculpture, decorative arts, graphic arts, ceramics, manuscripts. Approximately 6,500 objects.

Number of paid staff: 15.

Number of volunteers: 30.

Operating budget: $302,085 (1973/74). Included in this amount is an estimated $100,000 for utilities, custodial service, building and grounds maintenance, which is borne by the university; acquisition funds are not included.

Source of funding: University (state), membership, occasional grants.

**2. Location/Setting**

Size and character of city: Ann Arbor is filled with the usual book shops and boutiques of a university town, as well as the shopping centers and residential sections of a small Midwestern city. Ann Arbor proper has a population of 99,797 (1970 census); the standard metropolitan statistical area population is 234,103 (1970 census). Only 45 minutes from both Toledo and Detroit, Ann Arbor has a hint of suburbia about it, though the university's activities make it livelier than most Midwestern suburbs and towns.

Climate: Snowy winters, normal upper-Midwest seasons, which have "no appreciable effect" on winter and summer activities of the museum, according to the assistant to the director.

Specific location of institution: In the center of the university.

Access to public transportation: The museum is within walking distance of everything on campus; no special bus service.

**3. Audience**

Membership: 800 in 1973/74 (increased to 1,500 in 1974/75); about half are nonuniversity. Cost: family membership, $25; student membership, $5.

Attendance: 60,000 (estimated; specific figures for 1973/74 not available). The potential general audience is largely the undergraduate student body (17,000) and the total university community (33,000). Large events, sponsored by the Friends of the Museum account for a good bit of the attendance.

**4. Educational Services**

Organizational structure: The museum is an educational facility and does not have a separate department of education. It is administered by an executive committee (consisting of the dean of the College of Literature, Science, and the Arts; the dean of the College of Architecture and Design; the chairmen of the departments of art and of the history of art, and two members appointed by the president of the university), chaired by the director of the museum, who reports to the university vice-president of academic affairs.

Range of services: Tours are offered to schoolchildren and community groups on a demand basis and are generally given by graduate student assistants under the supervision of the executive secretary of the Friends of the Museum. The museum publishes two *Bulletin* issues each year, along with catalogs of special exhibitions. An audiovisual information center is currently being established; two video slide-tapes have been produced, and several others are in production.

Audience: University faculty and students.

# UNIVERSITY OF MINNESOTA

Minneapolis, Minnesota 55455

**1. General Information**

Founding: 1851. The university is one of the original land-grant colleges.

Collections: The University of Minnesota art gallery's collection is strongest in twentieth-century American paintings, prints, and drawings; a few Old Masters.

Number of paid staff: 4,680 full-time faculty, 214 part-time faculty at all campuses. The Minneapolis campus alone has 4,056 full-time and 187 part-time faculty.

Operating budget: $256,412,221 (1973/74).

Sources of funding: State, federal, private endowment, tuition and fees.

**2. Location/Setting**

Size and character of city: The Minneapolis-St. Paul standard

metropolitan statistical area has a population of 1,813,647 (1970 census). The population of Minneapolis is 434,000 (1970 census), of which 4.3 percent is black and 1.3 percent American Indian. The university is one of about 20 degree-granting institutions in the Twin Cities. A lively cultural center, Minneapolis is the home of many art galleries and art centers; two of the most famous, the Minneapolis Institute of Arts and the Walker Art Center, cooperate with the university in a museology degree program (described in chapter 14).

Climate: Minnesota has the most extreme temperature difference of any state in the Union. Winters are long; snow falls by mid-November and is usually on the ground until April. Summers are hot and humid.

Specific location of institution: The Mississippi River divides the campus, which is conveniently located about a five-minute drive from the downtown centers of both Minneapolis and St. Paul.

Access to public transportation: Bus stops at campus.

3. **Audience**

Enrollment: 42,970 full-time (fall 1974) at the Minneapolis-St. Paul campus. Four branch campuses across the state enroll an additional 8,400 full-time students.

4. **Educational Services**

Organizational structure: The Department of Art History, the "educational service" that pertains to the training program described in this study, is headed by a chairman, who reports to the dean of the College of Liberal Arts. The university art gallery is a separate service unit, headed by a director, who reports to the vice-president for academic affairs.

Size of staff: Art history faculty numbers 13. In addition, the directors of the Minneapolis Institute of Arts and the Walker Art Center have appointments in the university's art history department as adjunct professors of museology. The art gallery has a professional staff of four.

Budget: For the art history department, approximately $350,000 (1973/74).

Source of funds: State, National Endowment for the Humanities, Kress Foundation, Smithsonian Institution, private endowment.

Range of services: The department offers a B.A. in art history, M.A. in museology-art, M.A. in museology-history, and Ph.D. in art history. The undergraduate catalog lists 91 courses, some of which also carry graduate credit. Thirty-six courses are listed for graduate credit exclusively.

Audience: The department serves about 1,900 undergraduates and 65 graduate students. In 1974 the department received 120 applications for graduate study; 60 were accepted for admission. Of the 30 who enrolled, 7 intended to obtain museology degrees.

# VIRGINIA MUSEUM OF FINE ARTS

Boulevard and Grove Avenue
Richmond, Virginia 23221

1. **General Information**

Founding: In 1919 Judge John Barton Payne gave his art collection to the Commonwealth of Virginia, and in 1932 he gave $100,000 toward construction of a museum. With the aid of other donations and a 30 percent WPA grant, the museum opened its doors to the public on January 16, 1936, the first state-owned art museum in the country.

Number of paid staff: Approximately 140 full-time, 27 part-time, plus a varying number of theater actors.

Number of volunteers: 865 (includes 750 from Members Council, 12 from Junior League, 103 from Youth Guild).

Operating budget: Approximately $2 million (1973/74); $1,624,954 from state funds.

Education budget: Approximately $182,151 (1973/74).

Source of funds: State and federal. Acquisitions are made through private donations and with income from endowments.

2. **Location/Setting**

Size and character of state: Virginia has a population of 4,908,000 (U.S. est. 1974) and an area of 40,817 square miles. The state's geography varies widely from a low coastal plain to the Piedmont plateau, the Blue Ridge Mountains, and beyond to the Alleghenies in the west. Manufacturing and agriculture and mining play important roles in the economy of Virginia. It is a popular tourist center, with its many historical attractions and recreational facilities. The entire state has 70 institutions of higher learning.

Climate: Winters are relatively mild, with an average temperature range in January of 50° F to 32° F (based on records for a 30-year period).

Specific location of institution: The museum is situated on a 13-acre site, at a major intersection, in a residential section in Richmond's west end.

Access to public transportation: On a public bus route; plenty of free parking available.

3. **Audience**

Membership: 14,000. Cost: $12 for students and teachers; $25 for individuals ($15 for those outside of metropolitan Richmond); $40 for families ($25, state and national).

Attendance: About 260,000 annually.

4. **Educational Services**

Organizational structure: This state-owned museum's mandate from the Legislature of Virginia is to "bring education in the arts to all Virginians." The museum's primary function, therefore, is education, and its audience is statewide. There is no separate department of education; all programs, except for performing arts, are the responsibility of the Programs Division, headed by a programs director, who reports to the director of the museum.

Size of staff: Approximately 40 in the Programs Division.

Budget: $182,151, including salaries of craft instructors and Artmobile drivers and curators.

Source of funds: Operating budget and private donations.

Range of services: Artmobiles, an art lending service, art teaching kits, classes in all areas of the arts (including theater, photography, and printmaking), a resident craftsman program, curatorial services, guided tours, juried exhibitions, consultation, publications, a fellowship program, an art reference library, educational television, and a gallery orientation program.

Audience: ". . . all Virginians."

# THE WADSWORTH ATHENEUM

600 Main Street
Hartford, Connecticut 06103

1. **General Information**

   Founding: 1842 (the Wadsworth Atheneum was the first public museum in the country).

   Collections: Paintings and sculpture from the fifteenth century to present day, pre-Columbian objects, Meissen porcelain, firearms, English and American silver, textiles and costumes, bronzes, armor, and glass.

   Number of paid staff: 86, including part-time curatorial aides and art instructors.

   Number of volunteers: 50.

   Operating budget: $1,077,626 (1974).

   Education budget: $138,881 (1974).

   Source of funding: 50 percent endowment, 30 percent grants, 20 percent earned income.

2. **Location/Setting**

   Size and character of city: Hartford, with a population of 158,017 (1970 census) and a standard metropolitan statistical area population of 663,891 (1970 census), is an urban and suburban, multiethnic city with a primarily financial economy (insurance, banking, and some industry) and several institutions of higher learning.

   Climate: New England seasonal.

   Specific location of institution: Downtown Hartford.

   Access to public transportation: On city bus line, with limited bus service from suburbs.

3. **Audience**

   Membership: 2,693 (1974). Cost: student, $7.50 per year; family, $18; single, $15. Membership benefits: monthly newsletter, special members' events; 10 percent discount on some items in Atheneum shop.

   Attendance: 230,549 (1974), including about 15,000 in school tours and 15,400 to the Tactile Gallery.

4. **Educational Services**

   Organizational structure: Separate department, headed by director of education, who reports to director.

   Size of staff: 9. 5 are full-time, 4 part-time.

   Budget: $138,881, includes programs and salaries.

   Source of funds: Operating budget.

   Range of services: Docent tours for school groups; adult tours; resource material available on loan for classroom use; art classes for children and adults; Tactile Gallery exhibitions.

   Audience: School groups; casual and steady museum visitors; in addition, blind and partially sighted (to the Tactile Gallery).

# WALKER ART CENTER

Vineland Place
Minneapolis, Minnesota 55403

1. **General Information**

   Founding: In 1879, by Thomas B. Walker, who established the first art gallery in the Midwest with objects from his personal collection of bronzes, miniatures, and jewelry from the ancient Mediterranean.

   Collections: Mostly twentieth-century American art, with some nineteenth-century American landscapes and some European pieces; also Oriental jade and ceramics. In all, 400 paintings, 450 graphic works, 50 photographs, 180 pieces of sculpture, 66 ceramic objects, 4 metal objects (contemporary decorative arts), 18 American Indian baskets, 14 pieces of ancient glass, and 216 pieces of jade.

   Number of paid staff: 42 full-time, including 3 curators; 45 to 50 part-time (including restaurant workers and security staff).

   Number of volunteers: About 25.

   Operating budget: $1,501,336 (1973/74).

   Education budget: $343,256 (1973/74), including all expenses except staff salaries.

   Source of funds: The T. B. Walker Foundation provides nearly 40 percent of the Art Center's support. The rest comes from government agencies, private foundations, and the public.

2. **Location/Setting**

   Size and character of city: The Minneapolis/St. Paul standard metropolitan statistical area has a population of 1,813,647 (1970 census). The population of Minneapolis is 434,400 (1970 census); 4.3 percent are blacks and 1.3 percent are American Indians. Minneapolis is a lively cultural center, home to the Minnesota Symphony Orchestra, the Tyrone Guthrie Theater, the Minneapolis Institute of Arts, and the Walker Art Center, as well as numerous theater companies, dance organizations, art centers, 2 operas, and 30 art galleries. Approximately 20 degree-granting institutions of higher learning are located in Minneapolis and St. Paul.

   Climate: Minnesota has the most extreme temperature difference of any state in the Union. Winters are long; snow falls by mid-November and is usually on the ground until April. Summers are hot and humid.

   Specific location of institution: Near downtown Minneapolis, on a major highway.

   Access to public transportation: A public bus stops in front of the center. There is limited free parking; finding a space is sometimes a problem.

3. **Audience**

   Membership: 3,647 (1973/74), including 2,028 regular members; 1,389 education members; 230 sponsors. Cost: regular member, $20; education member, $12.50; senior (over 62), $12.50; contributor, $50; sponsor, $100. Admission to the Art Center is free.

   Attendance: 454,000 (1974).

4. **Educational Services**

   Organizational structure: A separate department of education is headed by director, who reports to museum director.

   Size of staff: One full-time director, one full-time secretary, one half-time tour coordinator. Two interns from the University of Minnesota and two from the Rockefeller training program work with the education department as well as in other departments.

   Budget: $343,256 (not including salaries).

   Sources of funds: National Endowment for the Arts, National Endowment for the Humanities, T. B. Walker Foundation, Rockefeller Foundation, Minnesota State Arts Council, and several corporations in Minneapolis.

   Range of services: Exhibitions; summer programs with Minneapolis Public Schools (these programs involve young artists, filmmakers, graphic designers); lectures; concerts; films; infor-

mation room (presentations of slides and tapes about collection, exhibitions, or special topics); intern program (University of Minnesota and Rockefeller fellowships).

Audience: The general public; nearby schools and universities; local community organizations.

# WHITNEY MUSEUM OF AMERICAN ART

945 Madison Avenue
New York, New York 10021

1. **General Information**

   Founding: 1930, by Gertrude Vanderbilt Whitney.

   Collection: Approximately 3,000 objects of American painting and sculpture.

   Number of paid staff: 108.

   Number of volunteers: No regular volunteer program.

   Operating budget: $2,308,764 (1973/74).

   Education budget: $214,944 (1973/74).

   Source of funding: Endowment, admissions, memberships, sales of publications, contributions, and grants.

2. **Location/Setting**

   Size and character of city: New York is the nation's largest city, with a population of 7.9 million in a standard metropolitan statistical area of about 15.5 million (1970 census). This includes about 1.6 million blacks and nearly a million Puerto Ricans (70 percent of the Puerto Ricans in the United States reside in the New York area). New York is the country's leading industrial and commercial city as well. Its five boroughs boast 42 museums plus many parks, zoos, botanical gardens, theaters, and concert halls. Its educational facilities include 6 universities, 23 colleges, 976 public schools, over 1,000 private schools, and 199 public libraries.

   Climate: Temperate. Lowest average monthly temperature over a 30-year period is 33° F., highest 77° F. The average yearly precipitation in the form of snow or sleet is 13.1 inches; the weather seldom affects attendance at cultural institutions.

   Specific location of institution: Upper East Side, an expensive residential area mixed with commercial.

   Access to public transportation: Near Lexington Avenue subway and bus lines.

3. **Audience**

   Membership: No regular memberships; 750 "Friends of the Whitney" pay $100–$250 annually; 60 corporate members pay $1,000 or more.

   Attendance: About 358,000 annually, of whom about 100,000 are nonpaying. Admission is $1; admission passes may be purchased at $15 annually ($5 for students). Admission to the Downtown Branch is free; attendance there averages about 400 daily, though for certain shows it has been as high as 1,600 persons on a single day.

4. **Educational Services**

   Organizational structure: Separate department; the head reports to the museum director.

   Size of staff: 11; no volunteers. The Branch is run largely by students in the Independent Study Program who are supported by assistantships.

   Budget: $214,944, a little more than 10 percent of annual operating budget.

   Source of funds: Contributions, grants, and fees.

Range of services: For general public: preparation of educational material for exhibits, tours, preparation of audiovisual aids to assist school groups, maintenance of a downtown branch museum for workers in the Wall Street area, provision of an Art Resources Gallery for young artists not attached to commercial galleries. University services: "Seminars with Artists" (a three-credit graduate course), Independent Study Program. Youth services: The Art Resources Center Studio Program for high school students, the Summer Parks Project for high school students.

Audience: Nearly a fifth of those who come to the museum are schoolchildren on scheduled visits; the rest, general public. Twenty-five graduate students are enrolled in "Seminars with Artists," 50 graduate and undergraduate students participate in the Independent Study Program each year, 350 high school students are in the Studio Program, and 25–50 high school students participate in the Summer Parks Project.

# THE WICHITA FALLS MUSEUM AND ART CENTER

2 Eureka Circle
P.O. Box Z
Wichita Falls, Texas 76308

For basic information about this museum, see appendix to the report on the Texas Museums Consortium in chapter 15.

# YALE UNIVERSITY ART GALLERY

1111 Chapel Street
New Haven, Connecticut 06520

1. **General Information**

   Founding: 1832. (Yale has the oldest university museum in America.)

   Collections: Approximately 50,000 objects (includes some groups of objects). The collection is encyclopedic in range with special strengths in early Italian painting (Jarves Collection, 1871), American decorative arts (Garvan Collection, 1930), twentieth-century art (Societé Anonyme Collection, 1941).

   Number of paid staff: 44, of whom 19 are professionals.

   Number of volunteers: 4, plus 4 honorary curators.

   Operating budget: Approximately $350,000, including salaries but excluding maintenance and utilities, which are paid by the university.

   Education budget: Approximately $30,000 (or 8.6 percent of the operating budget) for the education department, including salaries; however, because the gallery is an academic support service of the university, its entire operating budget may be considered an education expense.

   Source of funding: 60 percent from general university funds, 25 percent from endowment, grants, and gifts; the remainder from memberships.

2. **Location/Setting**

   Size and character of city: Founded in 1638, New Haven has become a major New England commercial and manufacturing center, but even with its population of 137,707 (1970 census), the city tends to be dominated by Yale University (9,912 students). The visual and performing arts flourish here, and the

city is noted for its fine contemporary architecture. New Haven has begun to react to Yale's infringement upon its identity as well as its space, and relations with the mixed population of the community have increasingly become an issue at the school. As one affirmation of this new community awareness, the street level of Yale's new museum, the Yale Center for British Art and British Studies, will consist of public shops instead of an imposing façade.

Climate: Temperate; cold, damp winters, hot summers.

Specific location of institution: Within the university, adjacent to the downtown commercial area.

Access to public transporation: Public bus lines; limited parking; regular train service to New Haven from New York and Boston.

## 3. Audience

Membership: Approximately 1,000 family members pay $20 per year; 50 student members pay $10. There are also contributor memberships (at $50) and sponsor memberships ($250 and up). Benefits include the *Bulletin*, exhibition catalogs, and picture books, invitations to special programs, and exhibition previews. The Friends of American Arts at Yale has 150 members: junior members, $25; individual or family, $100; corporate, foundation, or professional sponsor, $250; benefactor, $500; and life member, $10,000.

Attendance: 110,000 annually.

## 4. Educational Services

Organizational structure: A separate department, headed by a curator of education, is responsible for public education; a large part of gallery education services, however, is for the university and is organized through the director or a curator.

Size of staff: A full-time curator of education, two full-time gallery lecturers, one paid docent (part-time), one part-time Yale University student, occasional volunteers.

Budget: $30,000 from the university, chiefly for education department salaries.

Range of services: For the general public: loan materials, tours, in-service training for high school teachers, special events including a "Sunday Series." For the university: cooperation in making museum resources available to classes, special teaching exhibitions, two museum studies courses, cooperation with the Department of the History of Art in its introductory methods course, graduate seminars, sponsorship of student-prepared exhibitions.

Audience: The New Haven community, adults and children; main obligation to the university faculty and students—specifically in the Department of the History of Art.

Objective: To encourage the general public to learn from and enjoy its collections; to involve students with museum objects in as active and direct a manner as possible through the study of original objects, the cataloging of collections, and the planning and preparation of special exhibitions.

Time: The museum is open Tuesday through Saturday, 10 A.M. to 5 P.M.; Thursday evening, 6 to 9; Sunday, 2 to 5 P.M. Information and documentation available from the institution: None.

—*N. R.*

# Appendix II
# Institutions and Programs Surveyed for This Study

Listed here are all the museums and other institutions visited by the CMEVA staff in the initial survey for this study. It is from this list that the final institutions and their programs were chosen.

Under each institutional entry is a list of programs the staff observed and some of the topics discussed with the people who were interviewed. Almost all visits were made between May and December 1973, and the programs listed here reflect some, though not all, of the activities carried on by these institutions during that period. Dates next to some of the entries record specific visits made by the reporting staff. They do not, however, include all visits: some institutions were visited by more than one staff person on more than one occasion, and in a few cases, studies were begun that eventually had to be dropped, either because the programs were aborted or because the research could not be sufficiently developed by the staff to produce a well-documented report.

Programs marked with an asterisk (*) are those finally selected for study in this book.

## Alabama

### Birmingham

**Birmingham Museum of Art** (9/15/73)
Slide lecture series for schools.
Artmobile.*

### Mobile

**The Mobile Art Gallery**
New docent program.
Lecture tour of schools in six counties.

### Montgomery

**Montgomery Museum of Fine Arts**
Dancers for art interpretation in the galleries.
Cooperative program with Troy State University to train museum workers.

## Alaska

### Anchorage

**Anchorage Historical and Fine Arts Museum**
The Far North Workshop: combination docent tour and studio art experience based on the far north experience.

### Fairbanks

**University of Alaska Museum**
Exhibits relating to studio art courses.
Plans for sculptor in residence.

### Juneau

**Alaska State Museum**
Alaska multimedia education program.

## Arizona

### Flagstaff

**The Museum of Northern Arizona**
Didactic exhibitions.
Summer internships emphasizing museum research.
Museum training (a grant from the Weatherhead Foundation to train a Hopi Indian in museology to act as curator of the Museum of Hopi Arts and Crafts Center).
Friends of the museum (docents in the schools).
High school student volunteers.
Traveling exhibitions.

### Levin

**St. John's Indian Mission**
Traditional Indian arts and crafts are taught using natural materials.

### Phoenix

**Heard Museum of Anthropology and Primitive Art**
Educational exhibitions using tapes, videotapes, labels, and the juxtaposition of objects and the necessary equipment for creating the objects.*

Docent tours for grades 3–8.

Heritage from the Heard: objects from the museum study collection are circulated to the Tempe School District.

"Try on Museum," a circulating exhibition of Indian footwear for elementary schoolchildren.

Teacher training in anthropology.

Videotaping of museum collection for the Institute of American Indian Arts, Santa Fe.

**Phoenix Art Museum**

The Junior Museum.

Studio classes.

Docent program.

Speakers bureau: docents speak to school and community groups.

Arts awareness: inner-city program including arts, crafts, and field trips.

## Tucson

**Arizona-Sonora Desert Museum** (11/18/73)

Native animals and plants on view in natural setting.

Emphasis given to conservation of critical natural resources by showing vital relationship existing between soil, water, plants, wildlife, and people.

**Arizona State Museum, University of Arizona** (11/18/73)

Museum of Indian Anthropology.

15,000–volume library of anthropology, history, and technology.

**Hopi Cultural Center**

Exhibits relating the history and art of the Hopi nation.

**Tucson Art Center, Inc.** (11/18–19/73)

Studio classes instructed by artist-teachers.

Artist in residence.

Art Center School.

**Tucson Public Schools, Art Department** (11/17–20/73, 4/16/74)

Exhibition: "The Blanket Around Us: Considerations and Reflections of Our Spaceship Earth."

Artmobile.

Educational materials: kits and displays.

**University of Arizona Museum of Art** (11/17/73)

# Arkansas

## Little Rock

**Arkansas Arts Center** (10/11/73)

Yellow Space Place.*

# California

## Berkeley

**Berkeley Art Center**

Instructional program in theater.

Annual outdoor art festival.

Serious exhibition program in the gallery.

Proposed storefront art classes and black cultural center.

**Lawrence Hall of Science, University of California**

Educational science center: unstructured tours based on participatory exhibits conducted by university students; computers for composing music; perception devices; jigsaw puzzle game exhibits; question-answer exhibits; workshops for teachers; school class visits; university classes; biology laboratory, planetarium, library; computer system available to schools.

**University Art Museum**

Improvisational tours for school groups given by trained university students who receive class credit.

Summer and weekend workshops with artists as teachers.

Artist-in-the-school program.

Student use of collection for the study of Oriental art history.

Storage area of collection available to students by appointment.

Exhibitions geared to needs of campus instructors.

## Compton

**Communicative Arts Academy**

Visual arts, drama, and music classes.

Prison program; community-oriented programs.

## Fresno

**Center for the Study and Preservation of American Folk Life (proposed)**

Proposed national folk art center adjacent to the California State University at Fresno, to include gallery workshop areas, archives; workshops for weaving, textiles, woodworking, and other folk arts; ceramics and dance classes and exhibitions; traveling exhibitions; permanent collection.

**Fresno Arts Center**

Studio classes.

Children's classes sponsored by the Junior League.

Adult extension classes sponsored by the university guest artists workshops with special crafts exhibits.

## Fullerton

**Munchenthaler Culture Center**

"Through One's Eyes," photography exhibition. Symposium on photography in cooperation with California State College.

Group tours with volunteer docents (200 docents).

Use of audiovisual aids including television.

Children's classes and adult classes including language and culture.

Teacher training experimental arts and crafts program for 13 weeks.

Cosponsoring cultural events with local colleges.

Scholarly work in humanities and arts.

Indian ceramics show.

Artist-in-residence program.

## Long Beach

**Living Sea Museum, Queen Mary**

Educational exhibits and audiovisual presentations.

Tours for general public and school groups; also bilingual tours. Guides are well trained and paid.

**Long Beach Museum of Art (new museum)**

## La Jolla

**La Jolla Museum of Contemporary Art**

Educational program ideas included arts-in-the-schools program; after-school art class sponsored by the museum; museum publication written by high school students dealing with visual

awareness of the community; college students employed in a work-study program; museology training program in cooperation with University of California, San Diego; development of community consciousness of museum as vehicle for arts awareness; programs for senior citizens.

Pocket parks.

## Los Angeles

### Frederick S. Wight Museum, University of California, Los Angeles

Docent tours.

Incidental education in outdoor sculpture garden.

Educational exhibition: "African Art In Motion."*

### Inner City Cultural Center

Emphasis on the performing arts; however, directions indicated interest in the visual arts (one arts and crafts class and two photography classes).

### Junior Arts Center*

Gallery exhibitions.

Studio art classes for children and young adults.

Achievement through Art, school program, grades 4–6.

P.I.E. Intergroup Education, a Title I program to integrate an educationally deprived school with a culturally enriched school.

Arts and technology art teachers and scientists plan the curriculum as a joint effort.

Open Space (an ecology program) was contracted to offer a media program emphasizing visual awareness.

In-service teacher training (museums as a natural resource).

Sponsor of community-oriented ethnic exhibitions and festivals.

Children's Museum.

400 docents give school and group tours.

### Los Angeles County Department of Parks and Recreation, Cultural Arts Division

Ceramic Conjunction: invitational and open competitive ceramic exhibition held in conjunction with the public library.

Inner-city mural program: selected artists painted street murals in Los Angeles County. Project funded through National Endowment for the Arts.

Project Imprint: photo and graphic workshop.

Youth Expression: cooperative high school arts program in conjunction with the Los Angeles County Museum of Art.

### Los Angeles County Museum of Art

Docent art workshop; traditional docent tours with 257 docents; docent program working with the deaf and hard of hearing.

Acoustical guides; bilingual tours and labels for exhibitions.

Plans for collaboration between the museum and universities: advanced study/university cooperation-museum internships planned with the Arts Management Program at UCLA.

Exhibits on Paul Strand and Henry Moore, accompanied by films.

Youth Expression: community art festivals are planned at the museum by a council of students and community representatives.

### Municipal Art Department

Sponsors performances in parks.

Sponsors classes for adults at the Municipal Art Center, Barnsdall Park.

Responsible for Municipal Art Gallery.

Maintains Junior Art Center.

### Museum of Cultural History

Program of visiting lecturers and loan materials and exhibitions for community locations.

### Watts Tower Art Center

Art classes for children.

## Oakland

### California College of Arts and Crafts Art Gallery

Exhibitions of contemporary arts and crafts of interest to studio students.

Exhibits of faculty and student work.

### Oakland Museum (Art, Science, and History Divisions)

Oakland Unified School District teacher in residence at the museum.

Museum on wheels: mobile museum program.

In-service teacher training (museum as a natural resource).

Sponsor of community-oriented ethnic exhibitions and festivals: "Three Generations of Chinese."

Children's Museum.

Docents (400 active): school and group tours

### Oakland Parks and Recreation Department

Studios I and II, for teaching visual arts to children and adults.

Scrapmobile: Summer mobile program to street locations.

Decentralization: art classes sponsored at recreation centers throughout the community.

Galleries exhibiting student and faculty work at Studios I and II.

## Palo Alto

### Palo Alto Cultural Center

Houses theaters, music rooms, galleries, and studios.

Special exhibitions and special events related to them.

Workshops.

Future goals: artist in residence, artist in the schools, lectures.

## Palos Verdes Estates

### Palos Verdes Art Museum

Exhibitions.

Volunteer docents.

Active studio class program.

## Pasadena

### Baxter Art Gallery, California Institute of Technology

Exhibitions of social and aesthetic significance to student body.

### Pasadena Museum of Modern Art (9/7/73)

Studio art workshops for children and adults; family workshop once a month in specific media.

Workshop tours for schools; studio art experience precedes a museum docent tour.

High school teacher residency training program to instruct students to act as aides in the studio program.

Museology for junior and senior high school students in order to involve students, teachers, and parents in the museum and assist them in gaining skills for developing community art programs.

Art Circus, a monthly performing arts program designed to appeal to all ethnic groups.

## Richmond

### Richmond Art Center

Exhibition and rental galleries.

Studio classes for children and adults (scholarship program available).

Docents act as tour guides and receptionists.

Free teacher-training courses.

Decentralized community art classes for children.

## Riverside

### Riverside Municipal Museum

Docent program emphasizing communication.

Decentralization of educational exhibitions to recreation centers in the county.

## San Diego

### Fine Arts Gallery of San Diego

Entire museum staff is involved in educational programing.

Public lecture series: "Meet the Masters."

Timkins series: scholar in residence.

Connoisseur series aimed at the collector.

Youth Council on the Arts, composed of high school students who act as advisers to the museum (now disbanded).

FANS, Fine Arts Novices, is a teenage service club assisting the museum in special programs.

Docents program with 75 active docents has an in-school program of auditorium talks on art history to the entire school system.

University-museum cooperation with art history students at University of California, San Diego.

Exhibition on "Dimensions of Polynesia."

Education exhibitions: "City Is for People," sculpture exhibition designed to educate people in visual awareness (the need for art in the city).

### Youth Cultural Center

The center offers performing arts classes to children twice a week. The Fine Arts Gallery hopes to "plug in" to this center in order to offer studio art classes.

## San Francisco

### Almond Rod Youth Gallery

Gallery sponsored by the Student League of San Francisco and dedicated to exhibiting student work from the Bay Area.

### Alvarado School Community Program

Visual awareness and studio programs in the schools, in which every child participates. Some schools provide special space; other programs are held in classrooms.

### Asawa Gallery at Mission High School

Gallery sponsored by the San Francisco Unified School District and the San Francisco Museum of Art Woman's Board, for student, faculty, and parent work.

### Black Man's Art Gallery

A private and self-sustaining gallery, which mounts educational exhibitions dedicated to black American culture.

School groups tour many of these exhibitions.

### California State University at San Francisco Gallery

Museum training program using the gallery as a teaching laboratory.

Exhibitions directed and installed by students.

### de Young Museum Art School*

Studio art classes for children and adults: employs 31 artists; enrollment 5,000 students a year.*

Trip-out Trucks: mobile program to bring art and artists to schools; grade 1 to high school.*

Docent/truck program: "plug in" of docents to the truck program, adding art history and art appreciation to the studio experience.

Trip-out Trunks: suitcase exhibits to the schools.*

Art apprentice program trains community volunteers in studio art to work on trucks in the communities and schools. Sponsored by the Junior League of San Francisco.*

Rockefeller Foundation Fellowships in Museum Education: advanced emphasis on museum education.*

Artist Referral Switchboard: service of jobs for artists.

### Energy

Counseling for high school students, Sunset district, San Francisco.

Summer arts and crafts programs.

### Erotic Art Museum

An attempt was being made to "upgrade" the image of this museum. Channels of communication were opened with local universities to use the museum collection in art history and sociology classes. (In 1975, the museum went out of business.)

### The Exploratorium

Participatory and learning exhibitions.

Explainers (tours by trained high school students).*

School in the Exploratorium (SITE).*

Concerts on Wednesday evenings.

### Fine Arts Museums of San Francisco

Educational exhibitions include permanent gallery installation, "The Traditional Arts of Africa, Oceania, and America."

Docent tours (375 docents) for general public and school groups.

In-school docent program has slide presentation to prepare a class for a museum visit.

Museums Exhibits Studio Art (MESA).

Docents for the deaf and the hard-of-hearing.

Tapestry docents: docents working in the area of conservation, cleaning, and repairing the museum's tapestry collection for an exhibition in 1976.

Proposed program of media tours with the collection and special exhibits.

Orientation gallery to the Africa, Oceania, and America Gallery in process.

### Galeria de la Raza*

Storefront gallery in the Chicano/Latino district, sponsored by the San Francisco Foundation through the San Francisco Neighborhood Arts Program; sponsors films, studio art classes.

Exhibitions of Chicano/Latino artists.

Exhibitions by community request.

Formerly sponsored artist-in-the-schools project and beautification of the Mission Project (mural painting).

### Greenification of the School Yard

Revenue-sharing funds are available to 16 schools for the construction of playground sculptures by parents and community volunteers.

### Intersection

Film program.

Evening life drawing classes, an NAP project.

Feminist art program (music, poetry, gallery exhibits).

Acts as an umbrella agency to sponsor community arts programs: Centro Latino, Children's Art Workshop.

## Josephine Randall Junior Museum

Primarily a science museum housing small animals and a permanent dinosaur exhibition.

Workshops for school groups and organizations based on the exhibitions.

Studio space for woodworking, printing, textiles, ceramics, and drawing and painting, as well as geology, biology, and lapidary studies for ages 9–16.

## Kearney Street Workshop*

Cooperative artist workshop in Chinese community.

Summer workshops in ceramics, painting, and photography for children.

Yearly workshops for young adults in photography and silk-screen.

Occasional educational exhibitions.

Production of silkscreen prints to educate the public about the Chinese community.

## Museum Intercommunity Exchange (MIX)

Programs in performing arts in the San Francisco Museum auditorium (emphasis is on community groups).

Children's art programs sponsored during the summer at community locations.

Two traveling exhibitions of minimurals and children's art available to the schools.

Series of exhibitions with emphasis on community and unknown artists.

## San Francisco Art Commission's Neighborhood Arts Program*

Services for community groups, which include typing, Xeroxing, publication of posters, and financial assistance for programs in both visual and performing arts.

Program is decentralized into seven districts. Each district organizer sponsors workshops, festivals, events, and performances within the district.

## San Francisco Art Institute (Diego Rivera, Emanuel, and Atholl McBean Art Galleries)

Exhibitions of contemporary art.

Professional instruction in the arts.

Participatory programs in the galleries in Food Art.

Urban arts program: institute students in community field work teach art and develop children's art programs at centers and parks throughout the city; they receive college credit for their work.

## San Francisco Educational Auxiliary

Volunteer organization providing tutors and teacher aides in the schools. The program has thousands of volunteers. The Junior League of San Francisco has provided funds for six paid district organizers in order to decentralize the volunteers and provide better communication among them. It is through the assistance of these volunteers that many art programs happen in the elementary school classroom.

## San Francisco Foundation

In-service workshops involving three local public schools.

Curriculum being developed with City College of San Francisco.

Work with Foothill College to develop an interdepartmental curriculum (photography, graphic arts, plastic arts).

Network of the City College students, high school students, and elementary school students to try to help them function more organically together.

Art-in-the-Schools: lending Ruth Asawa sculpture to five public schools.

## San Francisco Museum of Art

Docent program, including tours for school groups and general public.

Media tours planned around special exhibitions ("Dough-in," "A Taste for Space").

Plans for an orientation gallery.

John Swett School Project of the San Francisco Museum Woman's Board; a local public school was "adopted" by the museum: enrichment programs were sponsored and carried out, including mural painting, field trips.

Art classes include mime, filmmaking, billboard art, ceramics, neon sculpture, painting, drawing, photography.

Art teacher in residence planned with the San Francisco Unified School District.

Gallery at Mission High School, a project of the San Francisco Museum Woman's Board, with the Alvarado School Community Program (see above).

## San Francisco Recreation and Park Department

Art classes in painting, drawing, ceramics, and sculpture for children and adults.

Decentralized art classes at various recreation centers throughout the city.

## San Francisco Unified School District

Ethnic art in schools (artists of ethnic heritage present an auditorium program at selected schools).

Beautification program: artist-consultant assists a class with mural-painting projects in the schools.

Art teachers in every junior high and senior high school.

Art relief teachers in selected elementary schools through Emergency School Aid Act.

## South of Market Community Center

Grassroots storefront center started by students at San Francisco State College, now taken over by community residents.

Tutoring, arts and crafts classes, and field trips for community residents.

Community action, which resulted in the building of a minipark and the hiring of a recreation director on city funds.

## Telegraph Hill Neighborhood Center

Child-care center.

Adult and children's classes in the arts.

San Francisco Neighborhood Arts Program sponsors many programs at this center.

## 24th Street Place

Tutoring center for community children emphasizing art.

Balmy Alley Project: artists, children, and community residents have united to cover both sides of an alley with murals.

## San Mateo

### San Mateo County Junior Museum

Division of the Parks and Recreation Department.

Docent program.

Animal tours/ecology program.

Loans of science materials to schools.

After-school classes.

Special programs at school assemblies.

## San Rafael

### Louise A. Boyd Marin Museum of Science
Nature and science classes.
"Touch Me" room: stuffed animals, bones; acts as orientation gallery.
Museum contracts with country school districts and private schools for an in-class program.
Museum mobile van.
Docent program (18 docents), school tours at museum.
High school interns help care for animals and teach classes.

## Santa Ana

### Charles W. Bowers Memorial Museum
Temporary educational exhibits: "Charms and Small Sculpture of Egypt," "Etchings of Rembrandt," and "Insect Show."
Volunteer docents for school groups, elementary, secondary, and college.
Use of rear projection slides and coordinating loop slides with exhibitions.
Museum, community, and adult education programs.
Mobile museum project in process.
Plans to expand facilities for an art school and one schoolroom.
Plans for intern program with California State College at Fullerton.
Lectures on anthropology, marine biology, ceramics.
Plans for a children's workshop in an adjacent building.

## Santa Barbara

### Art Galleries, University of California, Santa Barbara
Exhibitions relating to courses offered by the university.
Informal collaboration with the Santa Barbara Museum of Art in developing awareness of the architecture and environment of Santa Barbara (environmental design exhibition).
Some student involvement in organizing exhibitions.

### Santa Barbara Museum of Art
Active docent program.
Saturday media tour program for children employing art majors from the University of California, Santa Barbara, as volunteers.
Studio art classes.
Library and slide library.
Scholarly research: project of cross-cultural iconography for the community; an educational exhibition and handbook by university students; underworked portions of the collection (art history students and professors at the university were hired to do research and write papers on portions of the museum collection for the docents and scholarly community).
Museology training for volunteer students in the registration department: undergraduate students gain experience in registration and help to redefine and update procedures and the storage area; graduate students gain experience working directly with art objects and on publications.

## Santa Clara

### de Saisset Art Gallery and Museum, University of Santa Clara
Videotape collection; extensive use of video. Current project: videotaping New Deal art in California.
Docent program.
School tours of collection.

## Walnut Creek

### Civic Arts Center
Exhibition program.
Docent program.
School tours.
Pilot project in the schools: specific classes dealing with perception.
The Docent Art Box, in which each docent collects his own things to use with children.
High school interns at the gallery receive school credit. They assist with installation and lead student tours for their schools.
Artist-in-the-Schools Program: district pays the gallery to provide an after-school art activity for students.

# Colorado

## Denver

### Children's Museum
Mobile, participatory exhibits.

### Denver Art Museum
Docent training program and support group.
Non-English-speaking gallery tours.
Gallery for the deaf.

### Model City Program
Studio program.
Liaison between art institutions and Denver communities.

### Museum of Natural History
Docent training.

### State Historical Society of Colorado
Student docent program.
Role-playing in group tours.
Docent training cooperation with Denver Art Museum.

# Connecticut

## Hartford

### Wadsworth Atheneum
Tactile Gallery for nonvisual aesthetic experiences.*
Docent program.*

## New Haven

### Yale University
Relations between Department of the History of Art and Yale University Art Gallery.*
Public education programs.
Plans for advanced study in the humanities at the Center for British Art and British Studies.

# District of Columbia

## Washington

### Advisory and Learning Exchange
Support services materials, kits, and feedback from teachers.

### American Institute of Architects, Octagon House (7/10/73)
Exhibition.

Cooperative architecture tour with Corcoran, National Trust, and Renwick for high school students.

**Anacostia Neighborhood Museum***

Tour for school groups.

Performing arts; arts festivals.

Temporary exhibitions.

Youth council.

Research on the history of blacks in the District of Columbia.

Speakers bureau.

Mobile unit.

Museum training.

**Corcoran Gallery of Art** (3/30, 7/10/73)

Joint project with other museums focusing on cityscape and architecture for high school students and teachers in both art and history.

Self-orientation questionnaire for the American collection.

**Dumbarton Oaks**

Services to scholars of Byzantine studies.

**George Washington University**

M.A.T. in museum education.*

Orientation program on Africa.

Adult education programs.

Traveling presentation.

Slide kits.

**Museum Education Roundtable** (6/12/73)*

Meetings, workshops, and newsletters to establish continuing relationships among teachers, curators, designers, and other related professionals.

**Museum of African Art** (5/29/73)

**National Collection of Fine Arts**

Docent program.

Discover Graphics project: a four-week workshop program in printmaking techniques and print study for secondary students.*

Improvisational tours; Discover graphics tours.*

Portfolio Day: an annual program that brings high school students and college admissions officers together to discuss career opportunities in the arts.

Junior interns and college interns: two separate programs, both with the objective of providing work-learning experience in the museum on a sustained basis.

Children's Day: springtime festival for children, organized by docents.

**National Gallery of Art**

*Art & Man,* a monthly magazine published by Scholastic Magazines under National Gallery direction.

**National Museum of Natural History**

Discovery Room.*

**National Portrait Gallery**

"The Trial of John Brown": a re-enactment of the John Brown trial in local high school classrooms by education staff and aides.*

**National Trust for Historic Preservation** (7/10/73)

Joint architecture tour for high school students with Renwick, Octagon, and Corcoran.

**Office of Museum Programs, Smithsonian Institution, Psychological Studies** (5/29/73)

Annotated bibliography of museum visitor behavior.

Research of visitor learning at the Renwick Gallery.

Plans to begin publication of museum research journal.

**Renwick Gallery** (7/10/73)

Joint tour for high school students with National Trust, Corcoran, and Octagon.

Research of visitor learning in the exhibit of the glass of Frederick Carder administered by the Office of Museum Programs Psychological Studies.

**Smithsonian Institution** (5/29, 7/5 & 19/73)

Research on exhibition effectiveness.

National study of education programs of history and science museums.

Study undertaken of Smithsonian Institution Traveling Exhibition Service (SITES) services and audiences.

**Textile Museum**

Three-day seminars provide a forum for scholarly exchange in the field of textiles.

## Florida

### Coral Gables

**Lowe Art Museum, University of Miami** (7/16/73)

Relationship of university museum to the community.

Educational exhibitions.

Docent guild.

Humanities festival on "The American Scene."

### Gainesville

**Florida State Museum, University of Florida** (2/28/74)

Administrative structure of the museum, including a cooperative interdepartmental preparation of the budget.

Department of interpretation combines education with interpretive exhibition.

Plans for an "object library" with public access for study of the collection.

Docents man portable carts with education materials and resource information as an alternative to giving tours in the galleries.

### Jacksonville

**Cummer Gallery of Art** (7/18/73)

Docent program.

"Today in Jacksonville": program to acquaint the city with the gallery.

Lecture series.

Museum interns.

**Jacksonville Art Museum** (7/18/73)

Visual education center supported by school system.

Puppet workshops and Light and Shadow Theater for adults.

Shoe-String Puppet Company.

Studio classes.

"Stages of Man": cooperative program with Children's Museum and Afro-American Center.

New docent training program, including a psychologist consultant and use of "Civilisation" series and California Discovery films.

### Miami

**Miami Arts Center** (7/16/73)

Sister-city exhibition program (Miami-Bogota).

Exhibition program for city schoolchildren and teachers.
Studio courses.

## Orlando

### Loch Haven Art Center (7/17/73)
Community-oriented studio classes.
Workshops in connection with exhibitions.

## St. Petersburg

### Museum of Fine Arts (7/12/73)
Volunteers (many are retired professionals).
Video program; film series with college students.
Seminar series in humanities.

## Sarasota

### Ringling Museum of Art (7/13/73)
Outreach programs.
Art Caravan.*
Circulating educational exhibitions.
Children's workshops.

# Georgia

## Atlanta

### High Museum of Art
"Shapes," a labyrinth exhibition of shapes in nature and art, including paintings, photographs, participatory exhibits. Tours led by docent and related to other museum galleries.*
Mobile unit.*
Arts and Humanities Center provides work space for Atlanta public school students and teachers.
Docent training.*

## Savannah

### Telfair Academy of Arts and Sciences, Inc.
Reorganization of collections and physical plant.

# Hawaii

## Honolulu

### Honolulu Academy of Arts
Gallery education program: well over 20,000 children visit the academy yearly, free of charge. The 20 major galleries within the museum are utilized in this program. Unit lessons for pre-academy visits are in process and consist of slides and written material supplied to the schools. Docent program in this area includes intensive one-year training that readies the docents to take tours of both school and special groups through the galleries.
The art center holds classes at the academy for public school groups and children and adults from the general community. Classes are offered in drawing, batik, ceramics, collage.
Lending collection: this library makes available to the public such things as ceremonial wardrobes of the Chinese court, poi pounders, Thai gongs.
Audiovisual center.
Studio program: professional school for local artists.

Extension service: outreach programs, such as lectures and slide shows.
Program development: research on museum education.
Teacher who acts as liaison between academy and young people.
Emphasis on educational exhibitions and a concern for building cultural ties with the community.
"Namba Art": funds were raised by the Japanese community for this exhibition. Related activities: an orientation gallery with slides and tapes, Sunday demonstrations of Japanese crafts.

### Queen Emma Summer Palace
Slide-lecture presentation and tour.
Classes in Hawaiian and crafts.

### Tennent Art Foundation Gallery
Escorts who explain the life and works of Madge Tennent, a local artist.
Lessons in studio art.

# Illinois

## Chicago

### Art Institute of Chicago (11/1/73)
Focus and Perception: a series of museum visits made by certain Chicago junior high classes. Museum visits are based on McGraw-Hill books of the same name, on classroom teachers' use of those books, and on individual tours arranged by volunteer staff assistants in the museum.*
Subscription Series: lectures for an adult audience on aspects of the museum collection. This series is judged by the director of museum education the "most successful" adult education program of the department.
Gallery Games: ambitious test-games for individuals visiting the galleries, designed for children of various ages and for adults.
Television programs based on the institute's collections: a series of ten was projected, the first to be shown Christmas 1973, growing out of the favorable curatorial and public response to the television program on the Renoir show, made by Don Knox of the Chicago educational television station.

### University of Chicago, Department of Art (11/1/73)
The David and Alfred Smart Gallery: a new university museum (in planning) to be used by all graduate departments of the university.
Art to Live With: a program, made possible by a legacy, that enables university and college students to rent framed prints for their rooms. Rental fee: $2 per year per object, of which there are about 400. (Some paintings are included in the rental collection.)

# Indiana

## Indianapolis

### Children's Museum(11/14/73)
Most programs suspended during construction of new museum; only traditional visits continue during this period.

### Indianapolis Museum of Art (11/14/73)
Search: a series of school visits designed specifically to integrate black and white schoolchildren, out of which have

come some modest new approaches to education for the Indianapolis volunteer docents.*

The Artery: an orientation gallery through which school classes pass on their way into the galleries, this didactic gallery presents tools, half-finished objects, works of art that can be handled, plus extensive explanatory labels.*

Humanities center: plan for a statewide center on the museum grounds where arts and humanities faculty and students can meet.

Film center: plan for a film archive that would serve the state of Indiana.

Volunteer docent training programs: the traditional approach to the training and deployment of volunteers, sympathetically supervised by the associate curator who was originally a volunteer docent.

# Iowa

## Des Moines

### Des Moines Art Center
Docent tours.
Studio class for members and college students.

# Kansas

## Lawrence

### University of Kansas Museum of Art*
Docent program.
University-museum relations.
Traveling exhibitions.

# Kentucky

## Berea

### Appalachian Museum, Berea College (9/12/73)
Ceramics apprenticeship.
Man in the Arts: required freshman course.
Weekly crafts demonstrations.
Student involvement in the museum.
Museum methods course.

## Frankfort

### Kentucky Arts Commission
Circulating exhibitions.
Encouragement of workshops with art guilds and clubs.
Artist in residence.

## Lexington

### Living Arts and Science Center (9/13/73)
Classes for schoolchildren (with particular attention to "special" classes of slow or disturbed children), held in studio and gallery spaces, to fill a void in school art programs, to alert teachers and parents to qualities of children's art, and to provide manipulative, tactile experiences for "special" children.

## Louisville

### J. B. Speed Museum (9/14/73)
Museum alliance of volunteers.

Beyond Spring: summer workshops for teenagers that encourage them to become members of youth committee.
Junior fellowships.
Gallery for the blind.

### Kentuckiana Metroversity (9/13/73)
Youth arts program for Louisville children.
Workshops in performing arts.
Film available about program.

### Junior Art Gallery, Inc.
Workshops related to exhibitions.
Demonstrations often given with tours of exhibitions.
Exhibitions that often include at least one touchable object.
"Please Touch" exhibition.
Studio courses.

## Pippa Passes

### Alice Lloyd College
Photographic archives to promote awareness of and preserve the visual arts of central Appalachia.
Appalachian Learning Laboratory funded by the National Endowment for the Humanities.

# Louisiana

## New Orleans

### New Orleans Museum of Art (9/13–14/73)
Single visits for kindergarten to 3rd grades and all "special" classes, designed for systematic development of child's response to the museum as a pleasant place, using games, gallery experience, and studio activities. Evaluation is part of program.
"A Museum Experience – Africa."*

### New Orleans Parish Schools (9/14/73)

# Maryland

## Baltimore

### Baltimore Museum of Art (3/14/74)
Downtown Gallery, located in the business district of the city, with an aim to tap the audience of that specific area.*
Studio program.
Junior museum workers.
Liaison program with Baltimore City Schools; city teacher on the museum staff as a docent; practice teaching credits allowed for docent work in the museum.
Summer internship program.
Baltimore City Fair museum booth.

### Maryland Institute, College of Art (11/1/73)
Ongoing and unstructured relationship between school and neighboring museums.

### Towson State College, Asian Art Center
Access to Collection: service of the Asian Art Center which allows students and faculty to "check out" objects for use in dormitory rooms and offices for both study and enjoyment.
Asiavan: mobile unit featuring folk art from the collection; it visits area schools, community centers, shopping centers.

## Massachusetts

### Andover

#### Addison Gallery, Phillips Academy
Addison Gallery Television (AGTV).*

### Boston

#### Boston Public Schools

#### Children's Museum*
Community services project is set up to assist community centers with programs, materials, and some teacher training.

#### Institute of Contemporary Art
Visual Arts and Laboratory in Urban Education (VALUE) pilot program, eventually leading to establishment of High School of Arts, uses city environment to teach vocational skills in the arts.*

#### Massachusetts Arts and Humanities Foundation

#### Metropolitan Cultural Alliance
Network of community arts and museums which provides mutual support.

#### Museum of Fine Arts
Docent program.*

#### National Center of Afro-American Artists
Elma Lewis School Visual Arts Program teaches about 450 students, mostly Afro-Americans: dance, music, studio art, drama, costuming. Goal: discipline, experience, skills, for students who have few chances at any of the three.*

#### Summerthing, Mayor's Office of Cultural Affairs
A citywide arts festival aimed at large and diverse audiences, now (after several years of existence) looking into school systems. Relationships among cultural, political, educational communities and Boston neighborhoods would be focus of study.

### Cambridge

#### Fogg Art Museum, Harvard University

#### Peabody Museum, Harvard University

### Lincoln

#### De Cordova Museum

### Milton

#### Museum of the American China Trade
Summer day-school program.
Kits based on China trade objects made by children who attended the summer day-school.

### Old Sturbridge Village

#### Old Sturbridge Village
Escorted thematic tours for 4th–6th grades. 1973/74 tours were organized around work, family, community.*
Teacher center.*

### Williamstown

#### Sterling and Francine Clark Art Institute
Children's program for 2,000–3,000 pupils in grades 2, 4, and 6 from rural towns of western New England and eastern New York State. Teachers, parents, and art history students from Williams College are involved in the program.*

### Worcester

#### Worcester Science Center

## Michigan

### Ann Arbor

#### University of Michigan Museum of Art (12/12–13/73)
Graduate program in museum practices: a two-year program, featuring one year of academic work and one year of internship in a museum, that prepares students for work in a large or small museum, an art or social history museum, by giving a general and practical acquaintance with museum work.*

### Detroit

#### Detroit Institute of Arts (5/1, 9/24, 12/5/73)
American Studies curriculum for upper elementary classrooms: an ambitious project designed for national distribution, adding visual arts education and some art history to the current curriculum for American history in those grades.*
Art to the Schools: a volunteer program, coordinated by a staff member, that takes slides and reproductions into the classroom.

### Rochester

#### Brookland Elementary School

## Minnesota

### Minneapolis

#### Gallery of the University of Minnesota
Museology students set up exhibitions and write catalogs.*
Summer program of studio classes for faculty children and children from local area.

#### James Ford Bell Museum of Natural History (5/31/74)
The Touch-and-See Room.

#### Minneapolis Institute of Arts
"Fakes and Forgeries."*
Edina project: two-week pilot project run by institute personnel, community resource people, and teachers, to give primary schoolchildren an intense exposure to African culture.
Art Mobile: one inner-city art mobile focusing on minority cultures, one statewide art mobile focusing on the general collection.
Information packs: slides and written material about collection are sent to five state regions.
Improvisational tours.
Services for teachers.*

#### Minneapolis Public Schools
Urban Arts and Humanities program.*

#### Minneapolis Society of Fine Arts' Children's Theatre Company.
Productions involve the collection of the Institute of Arts.
Research programs at the museum for building set designs and costumes.
Theater staff makes videotapes to be used as parts of shows in galleries of the museum.

**Pillsbury-Waite Cultural Arts Center** (3/12/74)
Fine arts program for handicapped adults.

**Walker Art Center**
Audio-visual Gallery, also known as the Information Center.
Rockefeller intern program.*
Teacher intern program.
Metropolitan State Junior College project.
"New Learning Spaces," exhibition on school architecture.*

### Moorhead

**Red River of the North Art Center***

### Rochester

**Rochester Art Center** (3/12/74)
Total Arts Day Camp: 68 children in grades K–6 were involved in both visual and performing arts activities.

### St. Paul

**Aesthetic Environment Learning Center** (3/12/74)
Creative movement in art and dance.

**Minnesota Museum of Art** (3/12, 4/30, 5/21/74)
Group tour program for schoolchildren.
"Artists Need to Eat Too": symposium on careers in art.

**St. Paul Public Schools** (10/15/73)
Specialized learning centers.
Pilot programs of resident artists in the schools.

## Missouri

### Kansas City

**William Rockhill Nelson Gallery of Art and Atkins Museum of Fine Arts**
Creative arts center: studio class for tuition-paying children.
Television publicity for museum produced by education staff.
Picture Lady Program.

### St. Louis

**St. Louis Art Museum** (4/26, 11/6–7/73)
Teachers Resource Center: a room in the education offices of the museum where St. Louis-area teachers can borrow slides, information sheets, prepared or tailormade kits for use in their classrooms. The center also provides free use of cameras, tape recorders, and other mechanical equipment.*
Group tours for schoolchildren: conducted by volunteer docents, these tours meet at regularly scheduled times in the museum auditorium, where they see slides and hear a brief introduction to the museum by a staff member.

**Central Midwestern Regional Educational Laboratory (CEMREL)**
Aesthetic Education Program.*

### University City

**University City Senior High School** (11/7/73)
High School of the Arts: a school within a school, designed to attract the high-potential dropout who may find arts courses attractive enough to keep him in school and in some traditional academic courses.*

**University City Schools** (4/25/73)
University City curriculum packets: devised by University City

personnel, these are more closely tied to specific class levels and course content than the CEMREL kits, but share many of their objectives.

## Montana

### Billings

**Yellowstone County Fine Arts Center**
Community-oriented programs.
Docent tours.
Traveling exhibitions.
Local artist and folk art research and exhibitions.

**Yellowstone Art Center** (10/29/73, 9/11/74)
Traveling exhibition.

### Bozeman

**Ketterer Art Center**

## Nebraska

### Omaha

**Joslyn Art Museum**
Festival of Sight and Sound in which Strategic Air Command Army band plays music that relates to pieces in collection.
Docent program.

## Nevada

### Reno

**Nevada Art Gallery**
Docent program: tours of special exhibitions and in-school program of slide lectures on art appreciation.
Studio classes for children and adults on Saturdays and during the summer.

## New Jersey

### Newark

**The Newark Museum**
Docent-guided gallery visits, either art-oriented or related to social studies.
Workshops in colonial and American Indian crafts.
Rocks and minerals workshop.
Lending collection: 10,000 objects (models, replicas, or originals) intended for use in the classroom.
Exhibitions for the blind.
Adult activities: gallery talks, films, extension service.

### New Brunswick

**Voorheges Gallery, Rutgers University**
Limitations in program caused by specialized collection.

### Princeton

**The Art Museum, Princeton University**
Collection complements courses offered by department of art and archaeology.

Study collection and study exhibitions.

Successful utilization of collection due to coordinated staff and administrative structures.

Docent training.

## New Mexico

### Albuquerque

#### Museum of Albuquerque

Education exhibitions that encourage community participation include hot air balloons and the history of aviation in the Southwest.

Docent program (30 docents) emphasizes communication through artifacts. Goal is "for every presentation to leave the viewer with more knowledge."

#### Southwestern Co-operative Educational Laboratory (7/4/73)

A federally funded laboratory (since phased out) established in 1965 through the Elementary and Secondary Education Act.

#### University Art Museum, University of New Mexico

Collection includes 3,000 prints from Tamarind and a comprehensive history of photography.

Docent program: training for special exhibitions; emphasis on guiding high school groups through the museum.

Courses in museology offered at the university through the museum and the Maxwell Gallery (anthropology). A total of ten units is possible.

Public lecture series of four lectures a year.

Yearly symposium on crafts.

### Roswell

#### Museum of Roswell Art Center

Artist-in-residence program: each year six artists receive studio space, living expenses, and $300 a month with a goal of upgrading art in New Mexico.

### Santa Fe

#### Institute of American Indian Arts Museum

Museology training program for native American students emphasizes all phases of museum operation. The museum and adjacent work area comprise a laboratory for teaching about small museums. Students are specifically trained to curate museums and initiate programs at their pueblo art centers.*

#### Museum of New Mexico (7/2–3/73)

Proposed plans for a mobile unit bringing artists to rural community schools.

Studio classes in ceramics, painting, drawing, and design for elementary schoolchildren.

Education exhibition, "What Is Folk Art?": visual and verbal questions are posed to the viewer.

Study collection has objects in glass cases with minimal labels for visitors to inspect.

Suitcase exhibits: trunks with art objects circulated to rural schools.*

Education art kits.

Prop kits: minisuitcase exhibits.

Traveling exhibitions for children in a mobile van.

Community exhibits.

Consultant services to newly formed museums.

Portfolios on the Southwest.

Docent program (minimal).

Docent Touch Room.

Audiovisual programs.

Public lecture series.

Printing class using a 130-year-old Washington Hand Press. Design iş emphasized using the printing media. This course is offered to children in cooperation with the history division.

## New York

### Bronx

#### The Bronx Museum of Art

On-loan exhibitions from other institutions and exhibitions by local artists.

In-school classes including "Man the Physical Being."

Classes for local school district at Kelly Street, the community art center with which the museum is connected.

### Brooklyn

#### The Brooklyn Museum

In-Depth Series.*

### Buffalo

#### Albright-Knox Art Gallery (10/24, 12/16–17/73)

Art to the Schools: a series of visits to Buffalo classrooms by volunteers, introducing works of art, reproductions, tools, to schoolchildren.

Color Wheels: a van outfitted as a studio, manned by artists and museum staff, that travels into many Buffalo neighborhoods to serve inner-city schools, senior citizens, and other groups requesting the service.*

Evenings of New Music: series of programs by the Center for Creative Arts, an avant-garde music group, held in the gallery as another dimension to the museum's contemporary collection.

"Matter at Hand": exhibition and workshop designed for blind and other handicapped persons, most of whom had rarely visited a museum before this experience.*

### Cooperstown

#### New York State Historical Association

Graduate program in museum training.

Winter workshops for school groups.

Yorkers: high school history clubs.

Teacher-training seminars.

Regional exhibition workshops.

### Corning

#### Corning Museum of Glass

Scholarly research on glass.

Week-long series of lectures, discussions, and studies about glass; offered annually.

Elementary school tours.

Junior curatorship program.

### Ithaca

#### Herbert F. Johnson Museum of Art, Cornell University

Study galleries, study-storage area.

Tours tailored to individual needs.

**New York**

### American Crafts Council

Slide and film service provides craftspeople, artists, and instructors with material that is relevant to promoting deeper understanding of the media.

### American Museum of Natural History

People Center: programs designed to involve the visitors in a series of vital, basic human experiences that are meant to illuminate the anthropological concepts and the natural resources contained in the museum's displays.

### Bureau of Audio-Visual Instruction

"Invitations": monthly information bulletin covers plays, films, concerts, dance performances, and other events which are of interest to students and teachers.

### Children's Art Carnival

Classes for parents, teachers, and paraprofessionals in child development through artistic experience.

Studio classes: ceramic sculpture, puppetry, painting, printmaking, animation.

### Children's Art Workshop

Classes in photography and silkscreening for junior and senior high school students and adults.

Gallery exhibitions of work done in the workshop.

Printing service to the community.

### Frick Art Reference Library (1/15/75)

### Frick Collection (12/6 & 11/74; 1/15/75)

Frick Symposium.

Frick lectures program.

School tours.

### GAME*

### Genesis II

A gallery created to give black artists publicity and financial support through display and sale of their work.

### Great Lakes Colleges Association

Provides apprenticeships in the arts in New York City to students from colleges in the Great Lakes region.

### Guggenheim Museum

Children's programs: studio art program, reading-through-art.

### Institute of Fine Arts, New York University

Museum training at the Metropolitan Museum of Art.*

### Metropolitan Museum of Art

Rockefeller fellowships in museum education: students, all with B.A.'s or M.A.'s, spend a year studying and working with museum curators, client institutions, and other museum professionals. Goal is to train persons for museum education work.*

Program for high school students from local schools (especially low socioeconomic and culturally deprived areas); an approach to the museum's collection through body movement, visual elements.*

Use of the Cloisters building and collection to enlarge the children's understanding of the medieval period, especially through medieval techniques of making stained glass, banners, etc. A special goal: to increase vocabulary and reading skills.

Lectures for and by senior citizens.*

Museum training program with the Institute of Fine Arts.*

### El Museo del Barrio

### Museum of Modern Art*

### Museums Collaborative, Inc.*

### New York Jazz Museum

Jazz Touring Program: traveling program.

Jazz-in-school program.

Audiovisual presentation on history of jazz.

### New York Studio School

Painting at the Metropolitan. This program, the first of its kind at the MMA for many years, encourages students to paint regularly in the museum galleries. Effect is being felt in the interest of both visitors and museum guards, among the curators within the museum's European paintings department, and in the neglected aesthetic area of copying.*

### New York University, Department of Art Education

Educational Utilization of Museum Resources: a course designed to encourage student teachers to learn what museums can offer them and how they can use museum resources for curriculum-cultural enrichment in the schools.

### Seven Loaves*

Seven community organizations that have come together to share administrative services. The director investigates funding sources and assists in the assembling of proposals.

### Studio Museum in Harlem

Education-oriented programs that emphasize the black aesthetic.

Plans for a teacher-training program for the schools; resource library; educational seminars.

Artists in residence.

### Whitney Museum of American Art

Art Resources Center: high school students are given materials, access to professional artists, space, and privacy to work.*

Independent Study Program for university students in art history, museum training, and fine arts.*

Downtown Branch.*

**Rochester**

### George Eastman House

School tours.

School demonstrations.

Postgraduate internships.

### Memorial Art Gallery, University of Rochester*

Interaction between the Rochester community and an institution designed as an educational museum.

School tours.

Docent training.

Art workshops.

Loan materials for schools.

### Visual Studies Workshop

M.F.A. in visual studies with the State University of New York at Buffalo.

Workshop program.

Traveling exhibitions.

Media courses for the community.

Research center.

**Schenectady**

### Schenectady Museum (1/7/74)

Artist-in-residence: served as watchman, taught classes in the

museum, added his skills to the resources available in the museum, and used the available resources for his own work.*

### Syracuse

**Everson Museum of Art***
Use of videotape as both educational and aesthetic medium.
Studio classes for interested inmates in Auburn, a maximum security prison, and at the Jamesville rehabilitation center.

### Troy

**Rensselaer County Junior Museum**
School demonstrations (mobile exhibits program).
Please-touch room.
Teach-it-yourself exhibitions.
Free pass system.

### Yonkers

**Hudson River Museum**
Discovery kits.
Docent training.
Studio classes.
Guided tours.
Enrichment programs.
Young People's Arts Festival.
Art Cart (summer program).
Volunteer program.

## North Carolina

### Asheville

**Asheville Art Museum**
Plans for new space in new civic center.
Exhibitions for local and regional artists.

### Chapel Hill

**William Hayes Ackland Art Center**
First-year course for art history students using the collections.
Elementary museology course.
"Ackland Notes" written by students.

### Charlotte

**The Mint Museum of Art**
Cooperative program of art history classes at Central Piedmont Community College.
American art to the schools for 7th grade.
Puppet theater.
Audio- and visitor-activated guide to the installation of the ceramic collection.

### Raleigh

**North Carolina Museum of Art**
Teacher workshops.
Two-year docent training program.
Volunteers in the schools for 5th grades.
Slide lectures.

## North Dakota

### Grand Forks

**Art Gallery, University of North Dakota** (3/12/74)
Visiting artists and guest speakers.

## Ohio

### Akron

**Akron Art Institute** (10/9 & 16/73)
School tours: every 6th-grade class in Akron visits the institute, which is open for school visits four mornings a week.
Volunteer docents: complete turnover in docent corps, caused by dramatic policy change in the collection (which now features only contemporary art), prompted an ambitious year-long course in art history for the new docents willing to try teaching from unfamiliar traveling shows, which now constitute the institute's exhibits.

### Bowling Green

**Center for Popular Culture, Bowling Green State University**

### Cincinnati

**Cincinnati Art Museum** (11/13/73)
Summer institutes at University of Cincinnati—relationship of museum's docents to the institute.*

**Taft Museum** (11/13/73)
Summer institutes at the University of Cincinnati.*
Suitcase exhibits: demonstration kits taken to selected classrooms by volunteer docents, including tools, replicas, and photos.*

**University of Cincinnati** (11/13/73)
Two summer institutes for secondary art teachers and museum docents help them prepare students for art history advanced placement tests.*

### Cleveland

**Cleveland Museum of Art**
East Cleveland-Cleveland Museum of Art: school program of sustained systematic use of the museum classrooms, studios, and galleries, taught by museum instructors. For elementary and junior high students.*
Audiovisual center: tapes prepared by museum staff for varied audiences, dealing with museum collections or special exhibitions.*
Advanced placement program: classes for high school teachers, students, and other interested teachers or education department students, designed to put art history courses into high school curricula and prepare students for advanced placement tests. A follow-up to University of Cincinnati program.*
Museum studies program: a Ph.D. program using curators, collections, and other areas of the museum, along with university courses, to prepare students for academic or curatorial work in museums.*

**Greater Cleveland Teacher Center** (7/73; 10/31/73)
Helps classroom teachers adapt "informal classroom" techniques, especially involving the arts.

### Columbus

#### Columbus Gallery of Fine Arts (9/16/73)

Ohio Council of Art Museum Educators: a fledgling organization trying to foster cooperation among educators in art museums in the state.

Junior high intern program: in conjunction with nearby public schools, the gallery had students come in for a ten-week period after school.

Orientation gallery: a plan for a gallery that would introduce the collections and help the visitor learn to look at works of art.

### Dayton

#### Dayton Art Institute

### Mansfield

#### Mansfield Art Center (10/29/73)

Various programs: the center has no collection but plays host to many traveling exhibitions and to regional artists.

### Massillon

#### Massillon Museum

### Oberlin

#### Allen Memorial Art Museum, Oberlin College

### Toledo

#### Toledo Museum of Art (9/10 & 12, 10/27, 11/12/73; 2/12/74)

Museum education fellowship training program: ten-month program for persons with B.A. or M.A. interested in preparing for a museum career, not specifically education.*

Workshops for volunteer docents and staff using improvisational theater and dance techniques.

Saturday studio programs: a long-established sequential program for elementary and secondary students in Toledo schools.

School correlation program.

Toledo Museum-Toledo University art program.

### Youngstown

#### Butler Institute of American Art

## Oklahoma

### Oklahoma City

#### Arts Council of Oklahoma City (10/12/73)
#### Oklahoma Science and Arts Foundation, Inc. (10/12/73)

## Oregon

### Eugene

#### Museum of Art, University of Oregon

Artist Day-in-Residence program: places visual artists in workshop roles within the community.

### Monmouth

#### Oregon College of Education

ARB Council symposium: project credited to teach community arts management, involving all phases of exhibition organization, dramatic performances, funding seminars. Project is funded by Oregon State Arts Commission.

### Neskowin

#### Sitka

Program of art and ecology for young people (one- to two-week resident work sessions).

Eco-Aesthetics Center: in connection with public schools.

### Portland

#### Contemporary Crafts Gallery

Sponsors program of craftsmen in Portland schools. Artists go to the schools and execute special projects.

#### Oregon Museum of Science and Industry

Extensive education programs in science.

Sponsors workshop in ecology and visual awareness at Sitka in Neskowin.

Program ECONET specializes in the use of media developing a program in art and ecology for young people. Students live at Sitka for one- or two-week sessions. Activities include studying nature through drawing and the use of other media. Children learn to understand their environment through art and as art.

#### Portland Art Museum

Museum apprentice program: museology training through internship at the museum.

Docent tours (60 active docents).*

Suitcase Museums: thematic boxes that are sent to classrooms with a docent.

Noon Hour Conversations: lecture program for general public based on a particular exhibition.

Especially for Children: museum exhibitions and programs planned for children throughout the entire first floor of the museum (this is held every 18 months).

Understanding Art: curriculum planned for schools through a Ford Foundation grant. Subjects include painting, sculpture, prints, drawings.

Urban Walks: visual awareness of Portland environment cosponsored with the Women's Architectural League.

Tactile gallery: proposed gallery for children and adults where visitors can touch all of the objects.

#### Portland Center for the Visual Arts

Intern program for local college students to learn all phases of the gallery's programs.

Gallery specializes in exhibitions of contemporary art.

#### Portland City Schools

Schools sponsor programs where local artists volunteer their services to demonstrate techniques. Calligraphy and printmaking are emphasized.

Oregon State Arts Commission is working on a proposal to put an artist in residence in every Oregon school.

#### Portland Museum Art School

Accredited B.F.A. offered in studio art and art history.

Saturday and summer program for children and general public.

B.A. offered in affiliation with Reed College.

Book on Indian legends produced by Josephine Cameron with her class of 8- to 12-year-olds.

#### Portland Parks and Recreation

Park bureau maintains over 20 community centers throughout the

city that offer various opportunities for people to take classes in numerous art and craft areas.

### School of the Arts and Crafts Society

Media classes for children and adults.

Gallery series of contemporary craft exhibitions to acquaint the student with excellence and new directions.

Inner-city mural painting: sponsored and funded by local rock radio station. Purpose is to allow children to beautify the city through art.

### Western Forestry Center

Educational exhibitions dealing with nature and forestry industry.

Fantasy forest environmental room.

## Salem

### Oregon State Arts Commission

Services: consultant and technical assistance relating to artistic and organizational needs.

Funding to various schools and arts organizations throughout the state.

# Pennsylvania

## Philadelphia

### Philadelphia Museum of Art (11/19/73)

"Invisible Artist": three audiovisual areas within gallery exhibits allow viewers to watch televised man-in-the-street interviews about artists, to see slide-tape presentation on the exhibit, and to hear living Philadelphia artists respond to the interviews.*

Fleischer Art Memorial: offers free classes in the arts in downtown areas; student exhibitions and traveling exhibitions are sponsored by the Memorial.

Videotape project: filming as artistic expression, using community resources in filming activities and events of interest within the Spring Garden community (located near the museum).*

School programs: special tours for students; apprentice program.*

Duchamp exhibition.

Professional docents paid by Philadelphia school system conduct all school tours.

## Pittsburgh

### Pittsburgh Museum of Art (10/23/73)

Pittsburgh Children's Museum Project: experimental effort to establish a museum for children and serve various neighborhoods in the city (closed).

There is no education department within the Pittsburgh Museum of Art; all education programs are handled by an education department that also serves the Carnegie Museum (natural history) and other parts of the Carnegie Institute.

# Rhode Island

## Providence

### Museum of Art, Rhode Island School of Design

Visual Arts: Audience Development: program designed for Portuguese-speaking adults from communities in Providence, Bristol, and Warren, Rhode Island; Fall River and New Bedford, Massachusetts.

# South Carolina

## Columbia

### Columbia Museum of Art

Story Hour program using the collections.

## Greenville

### Greenville County Museum of Art

Electragraphics department turns out technically excellent films and other audiovisual aids, tailormade for specific audiences throughout the state.*

Sequenced planning of tours and docent training.

Mobile units.

Art Interaction: docent training.

Museum School of Art.

Video production of puppet programs on art elements.

# Tennessee

## Chattanooga

### George Thomas Hunter Gallery of Art

Slide program to schools.

Downtown gallery and new museum building.

## Knoxville

### Frank H. McClung Museum

Exhibitions installed by the local university's department of art.

## Memphis

### Brooks Memorial Art Gallery (10/10/73)

"Consortium 1974": a cooperative educational venture to explore the relationships between science and the arts.

### Memphis Board of Education

### Memphis Pink Palace Museum (10/10/73)

Involved with "Consortium 1974."

## Nashville

### Tennessee Arts Commission

Support of Tennessee arts.

Artist-in-the-schools programs.

### Tennessee Botanical Gardens and Fine Arts Center (Cheekwood)

Film series.

Summer drama program.

University student memberships from the university activities fee.

Trustee education.

Volunteer program.

Program for collectors.

### Tennessee State Museum

Traveling exhibitions.

# Texas

## Austin

### KLRN, Public Broadcasting Corporation (6/22/73)

### Laguna Gloria Art Museum (11/9/73)

**Texas Commission on the Arts and Humanities** (6/15 & 25, 10/3, 11/8/73)
Museums consortium project.*

**Texas Education Agency** (10/2/73)

**University Art Museum** (5/6, 9/5 & 19/73)
Docent program.*

**University of Texas** (6/26, 9/7, 10/5/73)

## Cedar Hill

**Northwood Contemporary Arts Council**
Council brings distinguished professionals in the art world to Northwood as lecturers.

## Corpus Christi

**Art Museum of South Texas** (6/14 & 27/73)
''Art in Action'': one-week program for local schoolchildren in 1974.*

**South Texas Artmobile, Dougherty Carr Art Foundation** (6/27, 10/30, 11/16/73)
Artmobile travels to 27 South Texas communities, carrying art on loan from such museums as the National Gallery of Art and giving slide lectures in Spanish and English.*

## Dallas

**Dallas Museum of Fine Arts** (5/23, 7/17, 10/12/73)
Docent training program.
Tours of permanent collection offered to the schools.

**Southern Methodist University** (7/17, 10/12, 11/3, 6 & 10/73)
Innovations in art education, experimental arts program.
The arts for inner-city youth.
Travel and internships in the arts.

## Denton

**Department of Art, North Texas State University** (6/29/73, 3/1/74)
Doctoral program in art education and advanced art teaching at the university and college level.

## Fort Worth

**Amon Carter Museum of Western Art** (11/2 & 26, 12/12 & 13/73; 4/29, 7/16 & 22/74)
Slide presentations given by docents in the schools prior to pre-scheduled tours of the museum for all 5th graders in the Fort Worth Independent School District.
Newsletter from the education department to teachers, administrators, and educators in the area.
Research in American art and history.

**Carl J. Aldenhoven Foundation, Inc.** (6/19/73)
Invisible University: experimental programs in education, community action.

**Fort Worth Art Center Museum** (5/22, 6/8, 12, & 14, 7/5, 10/11, 11/1/73)
Orientation gallery.
Art classes.

**Fort Worth Museum of Science and History** (6/19 & 21, 8/11, 10/16/73)
Preschool classes.
Year-round classes in art, history, science offered to children, young adults, and adults.

Extensive school programs, including 7th–9th grade visits to the museum.

**Kimbell Art Museum**
Scholarly research on permanent collection.
Guided tour program.
Kimbell Clues: pilot project in visual perception conducted with two middle schools.*
Presentation of works of art in the galleries—lighting, space, installation in relation to other objects—as the salient means of interpretation and education.

**Three Art Museums Lecture-Tour Program***
Evening art history docent course.
Office of tour coordinator.

## Houston

**Contemporary Arts Museum** (6/18, 9/27/73)
Art after School: well-established, modest outreach program for grades 1–6.*

**High School for Performing and Visual Arts** (9/27/73)*

**Museum of Fine Arts, Houston** (6/18, 9/27/73)
Proposed three-way relationship with Rice University and the University of Texas, Houston, and professional artists working together to provide educational programs at all three institutions.

## San Antonio

**Learning about Learning** (9/21/73)
Study of relationship between the arts and cognitive development. Aimed at 3rd–5th graders and their parents and teachers.

**Marion Koogler McNay Art Institute** (10/30/73)

**Witte Memorial Museum** (6/21/73)

# Utah

## Provo

**B. F. Larsen Galleries, Brigham Young University** (9/16/74)
Televised gallery tour.

## Salt Lake City

**Utah Museum of Fine Arts, University of Utah**
Visiting artists in residence and exhibitions of their work.
Museum training for students.
Exhibitions related to university courses in art history.

**Utah Natural History Museum, University of Utah**
Goal is to bridge gap between town and campus.
Junior Science Academy: program emphasizing cross-age teaching. Students are taught by university professors and graduate students, who have access to university's laboratories and to the museum collection.
Basic resources of the university (labs, library, closed-circuit television, artifacts from anthropology division, animal specimens, bones for dinosaur construction) are used by the museum.
Faculty members act as curators.
Art students use collection for drawing classes and independent sketching.

# Virginia

## Richmond

### Valentine Museum
In-museum and in-school workshops on the use of artifacts in the classroom, inquiry process, and object analysis.
Inquiry method for tours.

### Virginia Museum of Art
Orientation galleries: "mini-art-history" approach through lecture and audiovisual installation.
Artmobile: four mobile units travel throughout the state and serve schools, clubs, museums, and libraries as well as the museum's chapters and affiliates. The program includes many educational materials.*

# Washington

## Seattle

### Henry Art Gallery, University of Washington

### Junior League of Seattle
Proposed visual arts center (to include studio art program and media program) for children, to be associated with the Seattle Art Museum.

### Seattle Art Museum
Docent program: slide-lecture program in the schools followed by museum visit.
Treasure Box: trained volunteers take boxes on various subjects (China, Mexico, and Africa and their arts and crafts) to the schools.

## Tacoma

### Tacoma Art Museum
Multimedia orientation gallery for children.

# West Virginia

## Charleston

### Charleston Art Gallery of Sunrise
"Learning to See": series for elementary schools.
Art classes with scholarships available.
Participation in Appalachia Educational Laboratory.

### The Children's Museum
Heritage trunks, statewide service.
Tri-cycle exhibit on ecology.
Suitcase exhibits.
Planetarium school program.
Discovery wall.
Classroom for puppet theater, films, dance.

Storybook room.
Junior curator program.

### West Virginia Arts and Humanities Council
Statewide program of local community art groups, primarily for adults in remote areas isolated from any museums.
Heritage trunks.
Artists in residence.

## Huntington

### Huntington Galleries
Studio courses.
High school students as guides to special exhibitions.
Cultural orientation to special exhibitions of another country (India, Africa).

## Morgantown

### Appalachian Center, West Virginia Agricultural and Homemaking Service, West Virginia University
Mountain heritage programing.

# Wisconsin

## Madison

### Elvehjem Art Center
Children's newspaper project.*
Docent program.
Library.
Gallery tours led by faculty.

## Milwaukee

### Milwaukee Art Center (10/11/73)
Art to the Schools: instructional materials. This is an effort to encourage classroom teachers in the Milwaukee area to introduce their students to art.*
Audiovisual systems of education in the galleries.
"Answer Game Machines" in galleries.
Docent program.
Teacher-training program.

# Wyoming

## Laramie

### University of Wyoming Art Museum (9/16/74)
Docent program: students at the university act as docents for school groups from the local public school systems.

## Rock Springs

### Rock Springs Fine Arts Center

—C. D. T.

# Indexes

# Indexes

## INSTITUTIONS AND ORGANIZATIONS

Abilene Fine Arts Museum
checklist, 674
participant in Texas Museums
Consortium, 667–675
Academy for Career Education,
Philadelphia, 324, 428–429
Addison Gallery of American Art,
Andover, Massachusetts
report in this study
Addison Gallery Television
(AGTV), 121, **170–176**
*For basic information about the museum,
see checklist in Appendix I.*
Albright-Knox Art Gallery
reports in this study
Color Wheels, 334, 335, 336, 337,
338, **350–353**
"Matter at Hand," 121, **167–170**
educational services, 350, 351
Junior Group, 167, 170 n.2
Members' Advisory Council, 167, 170
*For basic information about the museum,
see checklist in Appendix I.*
Alms, Eleanora, Trust
$2,500 grant to University of Cincinnati
for Summer Institute in Art History,
471
Amarillo Art Center
checklist, 674–675
participant in Texas Museums
Consortium, 667–675

American Association of Museums
Accreditation Committee, on the Fine
Arts Museums of San Francisco,
577
*America's Museums: The Belmont
Report.* 600, 607, 626, 633
Education Committee, 299
Mountain Plains conference in 1971, 668
Museum Studies Curriculum
Committee recommendations,
602–603
1946 annual meeting, 16
1974 annual meeting, 242, 246
1975 annual meeting, 37
President's Committee on Education,
660, 661
survey on museum use of video, 79
American Association of University
Women, 325, 327
American Crafts Council, 225, 580
American Indian Center, San Francisco,
580
American Indian Community House, New
York City, 231
American Indian Historic Society
on return of Indian art objects, 656
American Institute of Architects, 145, 325,
327
American Legion, 136
American Museum of Natural History, New
York City, 224, 373, 375, 377

cooperation with El Museo del Barrio,
227
participation in Museums Collaborative
voucher program, 231
petitioned for Sunday hours, 14–15
American Science and Engineering
Company
marketing of Children's Museum
MATCH units, 503
American University, Washington, D.C.,
431, 617
Amon Carter Museum of Western Art, Fort
Worth, 656
checklist, 674
participant in Fort Worth Art Museums
Docent Council, 253
participant in Texas Museums
Consortium, 667–675
Anacostia Neighborhood Museum of the
Smithsonian Institution, 108, 222
report in this study
"Anacostia Neighborhood Museum:
A Model of Community Control,"
**182–190**
Anacostia Studies Project, 184
checklist, 182
community relations, 183
educational services, 184–185
exhibition laboratory and training
program, 185
mobile program, 184–185

# ISSUES AND IDEAS

Pedagogy
  museum models, 465, 466
Peer group influence
  among high school arts students, 411
  of children's newspaper, 315, 318 n.3
  of high school students in liaison role, 448
  of senior citizen lecturers, 162
Perception
  museum programs on, 299–305, 324
  study of, 301
  theme of science museum exhibits, 300
Perceptual analysis
  inspired by copyist, 573
Performing artists
  in Elma Lewis School of Fine Arts, 379
  in mobile arts program, 345
  Paul Taylor Dance Company in school arts program, 411
  school residencies
    Urban Arts program, 417, 420–421, 422
Performing arts
  in branch museum, 150, 153
  in community festival, 195
  programs to supplement exhibitions, 93
  statewide program, 156, 394
  as tour theme, 316–317
Performing arts organizations
  in community arts
    Elephant Theater, 215
    El Teatro Ambulante-El Coco que Habla, 215
  in school arts program
    Children's Theatre Company, Minneapolis, 418
    Concentus Musicus, 417
    Fairmount Center for Creative and Performing Arts, 275
    Guild of Performing Arts, Minneapolis, 418
    Guthrie Theater, 418
    Metropolitan Cultural Arts Center, Minneapolis, 422
    Minneapolis Ensemble Theatre, 424
    Minnesota Ensemble Theater, 418
    Minnesota Orchestra, 418, 420–421, 422
    Paul Taylor Dance Company, 411
    St. Paul Chamber Orchestra, 422
Ph.D.
  art history, statistics on, 513, 536, 543 n.2, 548
  as goal for curator, 517
  as goal for museum professionals, 556
Photo-essay
  by VALUE participants, 443
Photograms
  demonstration at Museum of Modern Art, 70

Photographic blowups
  in children's exhibition, 391
  as clues in art treasure hunt, 318
Photographs
  Polaroid, for landscape painting class, 368
  Polaroid, in mural project, 371
Photography
  course, University City High School of the Arts, 414
  department, Museum of Modern Art, 57
  exhibitions, 57, 369
  museum workshops for public schools, 422
  Sioux Indian collection of, 655
  study center, Museum of Modern Art, 70
  work area in cultural resource center, 374
  workshop in professional facilities, 423
Photomurals
  as exhibition backdrops, 100
Physics
  in science museum, 301
Pictographs
  exhibit on, 370
Play
  coinciding with drawing exhibition, 531
Playgrounds
  design of, 147
  murals for, 147
Play-sculpture elephant, 434
Playwriting class
  arts high school, 410
Pleasure principle in learning, 277, 297, 301, 324
Poet
  as museum teacher, 66–67, 455–456
Poetry-writing
  in museums, 310, 317, 533
Political action
  for the arts
    of Bay Area artists, 192, 193–194
    of community coalition, 193
    festivals used for, 195
  of community arts groups, 217
  of museums
    antiwar festival, Everson Museum, 136
    in exhibitions, 184, 188
    as a forum for political debate, 136, 137
Political poster walls
  Anacostia Neighborhood Museum, 184
Politics of art
  in class for high school students, 428
Poor people
  alienation from art museums (Robert Coles), 120
Pop art
  classroom materials on, 65
  slide kit on, 482–483

Pop culture
  Louis Finkelstein on, 570, 589
Popularization of art
  vs. trivialization, 38, 78
Porcelains, Chinese
  in-school class on, 340
  resource kit on, 340, 341
Portraits
  children's exhibition on, 395, 397
  class for elementary schoolchildren, 297
  correlated with academic subjects, 449
  didactic exhibition on, 83–86
  in outline, 297, 346, illus.
  as tour theme, 319
Postcards
  for visitors' questions to curators, 109
Posters
  collection, Yale University Art Gallery, 527
  distribution of, to schools and colleges, 66
  service for community groups, 201, 207, 215
Pottery
  suitcase exhibit on, 503, illus.
  See also Ceramics; Clay.
Pottery collections
  use of in art instruction, 284, 578
Poverty programs
  of Johnson administration, 183
  "Real Great Society," 214
  state subsidies for arts classes, 296
Power tools workshop
  for museum trainees, 620, 637
Practice teaching
  in museum education internships, 618, 620
  museum as laboratory for, 530
  museum opportunities for, 298, 453, 614
  in museums, for schoolteachers, 477
  recommended for museum training, 633
Practicum
  University of Michigan, 615 n.22
Pre-Columbian art
  in children's project, 375
  pottery, 284
  Taino Indians, 227
Pre-schoolers
  as museum audience, 260
  programs for
    Elma Lewis School of Fine Arts, 380
Primitive art
  university studies in, 538
  See also African art; Folk art; Pre-Columbian art.
Printing facilities
  in cultural resource center, 374, 375, illus.
Printing services
  for community arts, 201, 207, 215, 216

# PEOPLE AND PROPER NAMES

# PROGRAM TITLES

—N. R.